P9-CRX-494

Cézanne to Picasso
Ambroise Vollard, Patron of the Avant-Garde

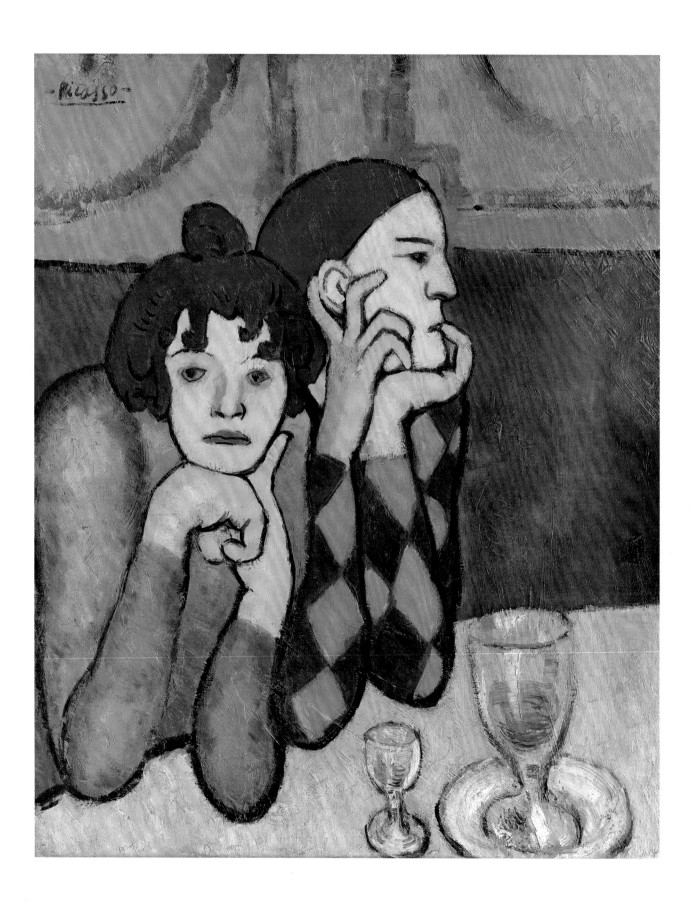

Cézanne to Picasso
Ambroise Vollard, Patron of the Avant-Garde

Rebecca A. Rabinow, Editor

Douglas W. Druick, Ann Dumas, Gloria Groom, Anne Roquebert, and Gary Tinterow

With essays by Maryline Assante di Panzillo, Isabelle Cahn, Anne Distel, Emmanuelle Héran, Robert Jensen, Albert Kostenevich, Jean-Paul Morel, Jacqueline Munck, Diana Widmaier Picasso, and Jonathan Pascoe Pratt

The Metropolitan Museum of Art, New York

Yale University Press, New Haven and London

This publication accompanies the exhibition "Cézanne to Picasso: Ambroise Vollard, Patron of the Avant-Garde," held at The Metropolitan Museum of Art, New York, September 13, 2006–January 7, 2007; at the Art Institute of Chicago, February 17–May 13, 2007; and at the Musée d'Orsay, Paris, June 18–September 16, 2007.

In New York, the exhibition is made possible by The Florence Gould Foundation.

Additional support for education programs is provided by The Georges Lurcy Charitable and Educational Trust.

The exhibition was organized by The Metropolitan Museum of Art, New York, the Art Institute of Chicago, the Musée d'Orsay, Paris, and the Réunion des Musées Nationaux, Paris.

It is supported by an indemnity from the Federal Council on the Arts and the Humanities.

Front jacket/cover illustration: Paul Cézanne, *Ambroise Vollard* (detail), 1899 (cat. 47)
Back jacket/cover illustration: Pablo Picasso, *Ambroise Vollard,* 1910 (cat. 153)
Frontispiece: Pablo Picasso, *The Two Saltimbanques (Harlequin and His Companion),* 1901 (cat. 145)

Published by The Metropolitan Museum of Art, New York

John P. O'Neill, Editor in Chief
Gwen Roginsky, Associate General Manager of Publications
Margaret Chace, Managing Editor
Cynthia Clark and Ruth Lurie Kozodoy, Senior Editors
Bruce Campbell, Designer
Christopher Zichello and Gwen Roginsky, Production Managers
Robert Weisberg, Assistant Managing Editor
Kathryn Ansite, Desktop Publishing Specialist
Jayne Kuchna and Jean Wagner, Bibliographic Editors
Jane S. Tai, Photography and Permissions Coordinator

Translations from French by Mark Polizzotti
Translation from Russian by Daniel Rishik
New photography by Mark Morosse, the Photograph Studio, The Metropolitan Museum of Art

Typeset in Adobe Garamond
Printed on 135 gsm Burgo R400 matte satin
Color separations by Professional Graphics, Inc., Rockford, Illinois
Printed and bound by Conti Tipocolor, S.p.A., Florence

Cataloging-in-Publication Data is available from the Library of Congress.
ISBN 1-58839-195-7 (hc: The Metropolitan Museum of Art)
ISBN 1-58839-196-5 (pbk: The Metropolitan Museum of Art)
ISBN 0-300-11779-5 (Yale University Press)

Contents

Directors' Foreword

Ambroise Vollard (1866–1939) was without question the most influential art dealer in Paris at the turn of the twentieth century. His activities as promoter of artists, author, and publisher of many of the landmark prints and illustrated books of his epoch earn him a singular place in the history of art. Vollard's groundbreaking 1895 exhibition of the works of Paul Cézanne established the artist's reputation and proclaimed the twenty-nine-year-old Vollard a major new presence in the Paris art world. Throughout the remainder of the decade Vollard organized significant displays of the Nabis and of the works of Paul Gauguin and Vincent van Gogh. He gave Pablo Picasso his first Paris exhibition in 1901 and Henri Matisse his first solo exhibition in 1904, and he commissioned André Derain to paint his colorful London series of Thames River pictures (1906–7). At the time of his death in 1939, Vollard was still busy selling art and producing editions of sculpture, prints, and illustrated books.

Despite his importance in shaping the direction of modern art, this enterprising and perspicacious man has remained something of an enigma. In organizing the exhibition our curators have set out to take a closer look at Vollard and his accomplishments, drawing on the voluminous archives of his papers that were acquired for the Direction des Musées de France and the Musée d'Orsay in 1989. Although maddeningly incomplete and at times cryptic, these fascinating documents contain an enormous trove of information. The Vollard Archives, along with archives of artists and other resources, have enabled the many authors of this catalogue to arrive at fresh insights into Vollard's activities, his relationships with artists, and the business of art as it was conducted in the pivotal decades of his career.

Every work chosen for "Cézanne to Picasso" passed through Vollard's hands, having been commissioned, exhibited, sold, or owned by him. Some of them—such as Gauguin's monumental *Where Do We Come From? What Are We? Where Are We Going?*—were featured paintings in Vollard's exhibitions. Others he sold (or traded) to artists: Cézannes were acquired by Edgar Degas, Claude Monet, Auguste Renoir, and Matisse; Picasso purchased Degas monotypes and paintings by Matisse and Henri

Rousseau. Also included are paintings that Vollard sold to some of the major collectors of modern art, among them Louisine and H. O. Havemeyer, Auguste Pellerin, Isaac de Camondo, Sergei Shchukin, Ivan Morozov, Karl-Ernst Osthaus, and Gertrude Stein.

The idea of an exhibition devoted to Vollard's career has intrigued scholars ever since his death. Five years ago the London-based art historian Ann Dumas proposed the concept to Gary Tinterow and Rebecca Rabinow of the Metropolitan Museum. Douglas Druick and Gloria Groom of the Art Institute of Chicago soon joined the team, as did Anne Roquebert and Isabelle Cahn of the Musée d'Orsay. We thank these organizing curators for their collaborative effort, which has yielded exciting and significant results. We are grateful as well to the many institutions and individuals who agreed to lend works of art and without whose generosity and sacrifice this exhibition would not have been possible.

Our profound thanks also go to supporters of this project. In New York and Chicago, the exhibition is supported by an indemnity from the Federal Council on the Arts and the Humanities, and we particularly recognize Alice M. Whelihan, Indemnity Administrator, National Endowment for the Arts. We thank Charles S. Moffett, Executive Vice President and Co-Chairman of Impressionist, Modern, and Contemporary Art Worldwide at Sotheby's, for providing third-party insurance values. In New York, the exhibition is made possible by the generosity of The Florence Gould Foundation.

Philippe de Montebello, Director
The Metropolitan Museum of Art

James Cuno, President and Eloise W. Martin Director
The Art Institute of Chicago

Serge Lemoine, Président de l'établissement public
Musée d'Orsay

Thomas Grenon, Administrateur général
Réunion des Musées Nationaux

Acknowledgments

Ambroise Vollard's profound impact on the fine arts has long been recognized without being fully understood. Over the past five years, as we have studied his life and researched works of art for possible inclusion in this exhibition, we are fortunate to have had exchanges with a great many scholars whose areas of inquiry touch on Vollard or the artists with whom he was involved.

An outstanding group of authors contributed to this catalogue; we thank them for their participation. We are also grateful to our many colleagues who contributed in significant ways to the advancement of this project: Simon André-Deconchat, Maryline Assante di Panzillo, Colin Bailey, Martin Bailey, Joseph Baillio, Quentin Bajac, Vivian Endicott Barnett, G. de Beauvillé, Sylvain Bertoldi, Olivier Bertrand, Jérôme Le Blay, Marc Blondeau, Catherine Bossis, Claudine Brohon, Günther Butkus, Natalina Castagna, Catherine Cazin, Mathias Chivot, Guy Cogeval, Isabelle Collet, Philip Conisbee, Sylvie Crussard, France Daguet, Maygene Daniels, Guy-Patrice Dauberville, Virginie Devillez, James Draper, Caroline Durand-Ruel Godfroy, Laird Easton, Walter Feilchenfeldt, Marina Ferretti-Bocquillon, Jay Fisher, Valerie Fletcher, Claire Frèches, Flemming Friborg, Christian de Galéa, Armelle Le Goff, Ted Gott, Catherine Granger, Paul Gray, Catherine Guillot, Charlotte Hale, Michelle Harvey, Mark Henderson, Günter Herzog, Ann Hoeningswald, Erika Holmquist-Wall, Waring Hopkins, John House, Ay-Whang Hsia, Yoshihiro Iwasa, Paul Josefowitz, Samuel Josefowitz, Richard Kendall, Dorothy Kosinski, Katherine Kuenzli, M. Labatut, Brigitte Lainé, Caroline Lang, Marc Larock, Fred Leeman, Raimond Livasgani, Catherine Longin, Maureen McCormick, Achim Moeller, Charles Moffett, Dominique Morel, Dominique Morelon, Karen Nangle, Jorgelina Orfila, Michael Pantazzi, Robert MacDonald Parker, Pascal Perrin, Sophie Pietri, Anne Pingeot, Theodore Reff, Mariantonia Reinhard-Felice, Angela Rosengart, Cynthia Saltzman, Carina Schäfer, Manuel Schmit, Didier Schulman, Hélène and Louis Sébastien, Pierre Sébastien, Gregory Selch, Lisa Sepel, Geneviève Simonot, Julio Sims, Veerle Soens, Simon Shaw, Julien Spinner, Hilary Spurling, Laurie Stein, Susan Stein, MaryAnne Stevens, John Tancock, Artur Tanikowski, Belinda and Richard Thomson, Louis van Tilborgh, Jennifer Tobias, Isabelle Vazelle, Gabriel Weisberg, Guy Wildenstein, Juliet Wilson-Bareau, Wim de Wit, and Peter Zegers.

An exhibition of this scope could never have been realized without the resources of the Vollard Archives, which were given as a *dation* (in lieu of estate taxes) to the French State in 1989. Thanks to the generosity of Isabelle le Masne de Chermont, Curator of the Library and Archives of the Musées Nationaux, Serge Lemoine, Director of the Musée d'Orsay, and Catherine Chevillot, Curator of the Research Division, Musée d'Orsay, the organizers of this exhibition were given full access to the archives, making possible an in-depth study of the material. We are grateful as well to those who shared other archival information or made available unpublished diaries, letters, receipts, and photographs for specific artists: Antoine Terrasse, a scholar of Bonnard, Paris; Claire Denis, author of the catalogue raisonné of the works of Maurice Denis, Saint-Germain-en-Laye; Agnès Delannoy, Head Curator of the Musée Départemental Maurice Denis "Le Prieuré," Saint-Germain-en-Laye, and Marie El Caïdi, archivist at the museum; Dina Vierny, founder of the Fondation Dina Vierny–Musée Maillol, Paris; Jean-Pierre Manguin, Villeneuve-les-Avignon; Claude Duthuit, Georges Matisse, and Wanda de Guébriant at the Archives Matisse, Paris; Marion Chatillon of the Amis de Jean Puy and Fonds Jean et Michel Puy; Jean-Yves Rouault, Gilles Rouault, and Anne-Marie Agulhon at the Fondation Georges Rouault, Paris; and others who choose to remain anonymous.

We thank our directors and administrators, without whose encouragement this ambitious undertaking would never have been realized—Philippe de Montebello, Emily Rafferty, and Mahrukh Tarapor at the Metropolitan Museum; James Cuno, Patricia Woodworth, and Dorothy Schroeder at the Art Institute of Chicago; Serge Lemoine at the Musée d'Orsay; and Thomas Grenon at the Réunion des Musées Nationaux.

We greatly appreciate the generosity of all the lenders to this exhibition and extend to them our sincere thanks. Several who went to extraordinary effort deserve special mention: Malcolm Rogers and George Shackelford, Museum of Fine Arts, Boston; Irina Antonova, State Pushkin Museum of Fine Arts, Moscow; Glenn Lowry, John Elderfield, Cora Rosevear, Deborah Wye, and Raimond Livasgani, Museum of Modern Art, New York; Suzanne Pagé and Sophie Krebs, Musée d'Art Moderne de la Ville de Paris; Gilles Chazal, Petit Palais, Musée des Beaux-Arts de la Ville de Paris; Gérard Regnier and Dominique Dupuis-Labbé, followed by Anne Baldassari and

Nadine Lenhi, Musée Picasso, Paris; Mikhail Piotrovsky and Albert Kostenevich, The State Hermitage Museum, St. Petersburg; and Earl Powell, Alan Shestack, and Philip Conisbee, National Gallery of Art, Washington, D.C. We also gratefully acknowledge Malcolm Wiener's loan to the Metropolitan Museum of one hundred Picasso etchings—the complete *Suite Vollard*—which was confirmed too late to be listed in this catalogue.

Administration of the exhibition was carried out at the Metropolitan Museum. Our sincere thanks go to Nicole Myers, who over the past two years managed the database with cheerful efficiency and assisted with every aspect of the project. Christel Hollevoet-Force thoroughly researched the provenance of each work in the exhibition, and Jayne Warman generously shared her vast expertise about both Cézanne and the Vollard Archives. Asher Miller meticulously assisted Gary Tinterow with his research and was a contributor to the catalogue as well. Research was conducted with the assistance of Margaret Samu and also Christopher Meyer and Elizabeth Williams, all exceptionally capable graduate students.

This large and complex catalogue was produced by the Metropolitan's Editorial Department under the oversight of John P. O'Neill, Editor in Chief and General Manager of Publications. It was superbly edited by Ruth Kozodoy and Cynthia Clark; essential editorial work was also carried out by Margaret Donovan, Sue Potter, and Elizabeth Block. Jayne Kuchna and Jean Wagner were the tireless bibliographic editors, and Jane Tai was a scrupulous picture coordinator. The handsome design is the work of Bruce Campbell. Christopher Zichello expertly managed the production of the book; Gwen Roginsky supervised the demanding color correction and printing. Robert Weisberg and Kathryn Ansite were the unflappable desktop publishers. We are also grateful for the valuable contributions made by Margaret Chace, Margaret Aspinwall, Cathy Dorsey, Liz Allen, Carol Fuerstein, Dale Tucker, Mary Gladue, and Sarah Jean Dupont.

At the Metropolitan Museum, the curators would additionally like to thank Martha Deese and Emily Vanderpool in the Director's Office; Sharon Cott and Beth Vrabel in the Counsel's Office; Dorothy Kellett, Lisa Cain, Patrice Mattia, Gary Kopp, Theresa King-Dickinson, and John McKanna in the Department of European Paintings; Kay Bearman, Ida Balboul, Susan Stein, Kathryn Galitz, Nykia Omphroy, Cynthia Iavarone, Anthony Askin, Sandie Peters, and Dennis Kaiser in the Department of Nineteenth-Century, Modern, and Contemporary Art; George Goldner, Colta Ives, David del Gaizo, Catherine Jenkins, and Elizabeth Zanis in the Department of Drawings and Prints; Laurence Kanter, Dita Amory, and Manus Gallagher in the Lehman Collection;

Jeanie James and Barbara File in Archives; Barbara Bridgers in the Photograph Studio; Linda Sylling, Michael Langley, and Barbara Weiss in Design; and Herb Moskowitz and Nina Maruca in the Registrar's Office.

At the Art Institute of Chicago, the curators wish to extend deepest thanks to Jennifer Paoletti, Exhibitions Manager in the Department of Medieval through Modern European Painting, and Modern European Sculpture, who expertly and graciously oversaw every detail of the project; Jill Shaw, Research Assistant, whose painstaking work in the archives provided invaluable assistance to Douglas Druick's work on Gauguin; and Dorota Chudzicka, Research Assistant, who tirelessly worked with Gloria Groom on research and translations for her essays. We would also like to thank Geri Banik, Darren Burge, Stephanie D'Alessandro, Rachel Drescher, Adrienne Jeske, Tiffany Johnston, and Severine Seba in Medieval through Modern European Painting, and Modern European Sculpture; Caesar Citraro, Jay Clarke, Christine Conniff-O'Shea, Kristi Dahm, Suzanne Folds McCullagh, Barbara Hinde, Elvee O'Kelley, Barbara Korbel, Suzanna Rudofsky, Harriet Stratis, Lucia Tantardini Lloyd, and Peter Zegers in Prints and Drawings; Frank Zuccari, Kelly Keegan, Kristin Lister, Suzie Schnepp, and Faye Wrubel in the Conservation department; Mary Solt, Darrell Green, John Molini and the art packers and handlers in Museum Registration; Susan Rossen, Katie Reilly, and Betsy Stepina in Publications; Robert Eskridge, David Stark, and Jeffery Nigro in Museum Education; Bernice Chu, Joseph Cochand, and Brian Tapia in Design and Construction; Meredith Mack in Finance and Operations; the staff of Physical Plant; Lyn DelliQuadri, Jeff Wonderland, and the staff in Graphics, Photographic and Communication Services; Carrie Heinonen, Erin Hogan, Chai Lee, and Beth Balik in Marketing and Public Affairs; Mary Jane Drews, Karen Victoria, and Amy Radick in Organizational Giving; and Maria Simon in the General Counsel department.

At the Musée d'Orsay, we would like to thank all those who assisted with the exhibition. We are also grateful to Patrick Alvez, Stéphanie de Brabander, Alexis Brandt, Laurence des Cars, Philippe Charles, Catherine Chevillot, Suzanne Diffre, Noémie Étienne, Martine Ferretti, Audrey Haristoy, Marie Josèphe Lesieur, Laure de Margerie, Caroline Mathieu, Sylvie Patin, Sylvie Patry, Marie-Pierre Salé, Patrice Schmidt, Philippe Thiébaut, Rebecca Tilles, and Claire Villeneuve. We would also like to acknowledge Ute Collinet, Juliette Armand, Anne Freling, Florence Canel, and the editorial team Catherine Marquet and Aube Lebel at the Réunion des Musées Nationaux.

The Curators of the Exhibition

Lenders to the Exhibition

Curators of the Exhibition

GARY TINTEROW
Engelhard Curator in Charge
Department of Nineteenth-Century, Modern, and Contemporary Art
The Metropolitan Museum of Art, New York

REBECCA A. RABINOW
Associate Curator and Administrator
Department of Nineteenth-Century, Modern, and Contemporary Art
The Metropolitan Museum of Art, New York

DOUGLAS DRUICK
Prince Trust Curator of Prints and Drawings
Searle Curator of Medieval through Modern European Painting, and Modern European Sculpture
The Art Institute of Chicago

GLORIA GROOM
David and Mary Winton Green Curator of 19th-Century European Painting
The Art Institute of Chicago

ANNE ROQUEBERT
Curator
with the assistance of ISABELLE CAHN, *Documentary Researcher*
Musée d'Orsay, Paris

ANN DUMAS
Independent Art Historian and Curator, London

Contributors to the Catalogue

MAdP Maryline Assante di Panzillo
Curator
Petit Palais, Musée des Beaux-Arts de la Ville de Paris

Isabelle Cahn
Documentary Researcher
Musée d'Orsay, Paris

IC Isabelle Collet
Curator of Modern Painting
Petit Palais, Musée des Beaux-Arts de la Ville
de Paris

Anne Distel
Senior Curator and Head of Collections Department
Direction des Musées de France

DD Douglas W. Druick
Prince Trust Curator of Prints and Drawings;
Searle Curator of Medieval through Modern European
Painting, and Modern European Sculpture
The Art Institute of Chicago

AD Ann Dumas
Independent Art Historian and Curator, London

GG Gloria Groom
David and Mary Winton Green Curator of 19th-
Century European Painting
The Art Institute of Chicago

EH Emmanuelle Héran
Curator
Musée d'Orsay, Paris

Robert Jensen
Associate Professor of Art History
University of Kentucky

Albert Kostenevich
Senior Curator of Modern European Painting
The State Hermitage Museum, St. Petersburg

AEM Asher Ethan Miller
Research Associate, Department of Nineteenth-Century,
Modern, and Contemporary Art
The Metropolitan Museum of Art, New York

Jean-Paul Morel
Journalist and Vollard Scholar

JM Jacqueline Munck
Curator
Musée d'Art Moderne de la Ville de Paris

NM Nicole R. Myers
Research Assistant, Department of Nineteenth-Century,
Modern, and Contemporary Art
The Metropolitan Museum of Art, New York

Diana Widmaier Picasso
Independent Art Historian, Paris

JPP Jonathan Pascoe Pratt
Independent Art Historian, London

RAR Rebecca A. Rabinow
Associate Curator and Administrator, Department of
Nineteenth-Century, Modern, and Contemporary Art
The Metropolitan Museum of Art, New York

AR Anne Roquebert
Curator
Musée d'Orsay, Paris

Gary Tinterow
Engelhard Curator in Charge, Department of
Nineteenth-Century, Modern, and Contemporary Art
The Metropolitan Museum of Art, New York

JSW Jayne S. Warman
Independent Art Historian, New York

Note to the Reader

Ambroise Vollard's papers—many of them archived in the Bibliothèque and Archives of the Musées Nationaux, Paris—are an essential source for the research presented in this catalogue. A brief explanation of the Vollard Archives is given on page 409.

Catalogued works are illustrated throughout this volume; in the captions, catalogue numbers appear in parentheses following the figure numbers.

Catalogues raisonnés of artists' works are generally referred to by letter abbreviations. A key to the abbreviations is on page 410.

References are cited in the notes in an abbreviated form. The corresponding full citations are found in the Bibliography.

Quotations from French published works have been translated into English for this catalogue. When no source is named, the translation has been provided by the author and editors.

Catalogue entries for artworks produced in multiples (prints, books, bronze casts) do not include provenances unless ownership can be traced from Vollard.

Unless otherwise indicated, works reproduced in the catalogue are exhibited at all three venues: New York, Chicago, and Paris.

Vollard: The Man and His Artists

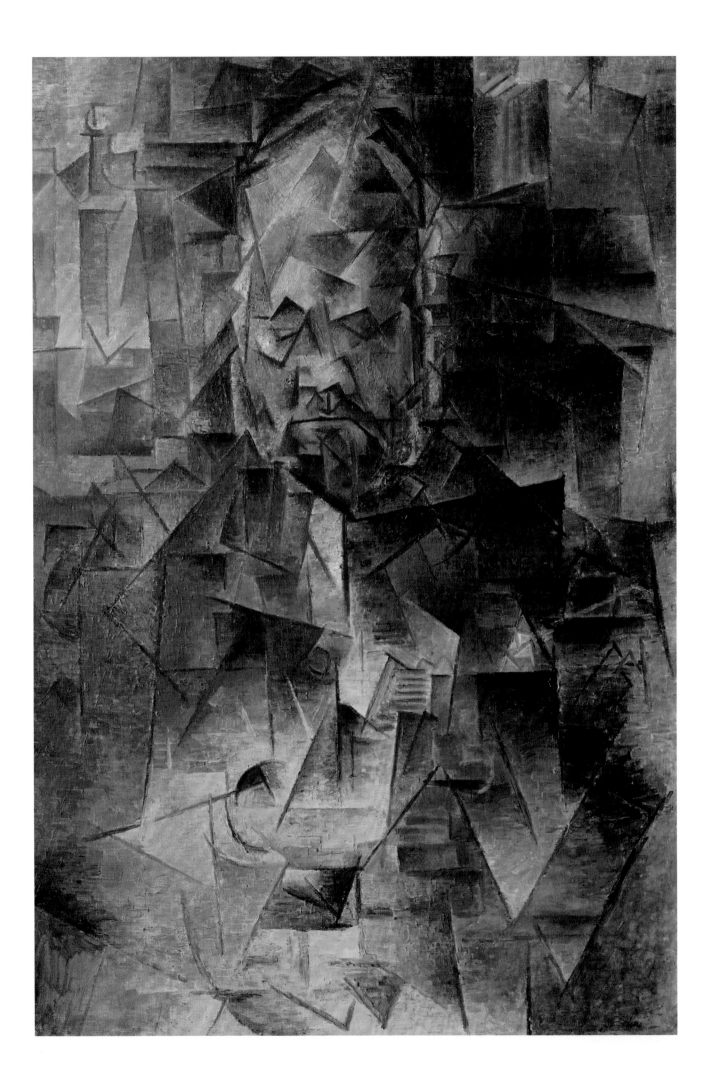

Ambroise Vollard, Patron of the Avant-Garde

Ann Dumas

Ambroise Vollard (1866–1939) was a legend in his lifetime. Arriving in Paris in 1887 from the remote Île de la Réunion, the French island colony in the Indian Ocean that was his birthplace, he had few contacts in and no credentials for the world he was entering; nevertheless he rapidly became the leading contemporary art dealer of his generation and a principal player in the history of modern art. Vollard launched the careers of Paul Cézanne, Pablo Picasso, and the Fauves, and mounted exhibitions of the Nabis, Odilon Redon, Henri Matisse, and many others. He was also an author and a highly innovative publisher of original prints and *livres d'artiste*, or limited-edition artists' books.

Yet Vollard, a profoundly secretive man, remains an enigma.[1] Contemporaries all remembered his familiar "Dites-moi" ("Tell me, then"), the beginning of many a conversation in which he elicited a fund of information from his interlocutor while revealing little of himself. The most comprehensive account of his life is his own *Recollections of a Picture Dealer,* first published in English in 1936;[2] but in this lively narrative the author hides behind a smoke screen of anecdotes about artists and collectors, divulging practically nothing about his personal and inner life or his business practices. For information on the works of art that passed through Vollard's hands, his working methods, his relations with artists, and his vast network of clients we must turn primarily to the extensive archives of his gallery, which were acquired by the Réunion des Musées Nationaux in 1989.[3] These mostly handwritten records of sales and purchases, stockbooks, and correspondence are often indecipherable and difficult to interpret—especially because specific titles or descriptions of paintings are frequently lacking—but are nevertheless an invaluable resource.[4]

A very different group of writings by Vollard offers deeper insights into the man and his outsider's views of the world. He greatly admired the satirical writer Alfred Jarry, creator of the character Père Ubu, who is best known from Jarry's play *Ubu roi* (*King Ubu*). "Adopting" Ubu into his own writings, Vollard devised narratives about this subversive and scatolog-

ical character who was in a sense his dark alter ego.[5] These highly original works express Vollard's deep skepticism about society's institutions (war, colonialism, hospitals) and also reveal his insecurity and need for recognition.

Vollard was full of contradictions, and opinions of him differed widely. Artists who complained that he exploited them found a convenient pun equating his name with the word *voleur,* meaning "thief": to Matisse he was "Fifi voleur,"[6] to Émile Bernard "Vole-art."[7] But others valued his loyalty and generosity. "I believe absolutely in Vollard as an honest man," insisted Cézanne, who was eternally grateful to Vollard for rescuing him from obscurity.[8] Auguste Renoir was a lifelong friend. In matters of dress, the dealer struck some as dapper, others as shabby.[9] Subject to abrupt shifts of mood,[10] he was an amusing and voluble raconteur but often lapsed into morose silence. In his autobiography he makes the detached and knowing observations of an amused observer of the Paris art world yet displays the transparency of a picaresque hero naively receptive to chance events that shape his destiny. In short, Vollard evades easy categorization. This can be seen from two great portraits of him: Cézanne's, a monumental likeness that captures the dealer's impenetrable allure, and Picasso's, a faceted Cubist rendering that suggests his opaque, many-sided personality (figs. 4, 1).

Vollard was physically imposing: "To see him coming, you would take him for a giant; but a gentle giant."[11] That quality was endearingly captured by Pierre Bonnard in a painting of Vollard stroking his cat, also named Ambroise (fig. 5). Exceptionally tall and heavily built, Vollard had darkish skin and heavy-lidded eyes. He spoke with a slight lisp, in a voice surprisingly light and high-pitched for a man of his bulk.[12] He was unhurried and ponderous in his movements, and patience was one of his virtues.[13] His general aspect was dour. Describing Vollard in his gallery, Gertrude Stein remembered "a huge dark man glooming. This was Vollard cheerful. When he was really cheerless he put his huge frame against the glass door that led to the street, his arms above his head, his hands on each upper corner of the portal and gloomed darkly into the street. Nobody thought then of trying to come in."[14]

Opposite: Fig. 1 (cat. 153). Pablo Picasso, *Ambroise Vollard*, 1910. Oil on canvas, 36⅛ x 26 in. (93 x 66 cm). Pushkin State Museum of Fine Arts, Moscow (3401)

The strangest thing about Vollard was his excessive somnolence. He would fall asleep anywhere, and at any time. Was this a physical condition such as narcolepsy,[15] a protective shield allowing him to secretly absorb what was going on around him, a subtle sales tactic? Whatever the cause, Vollard's torpor belied his intense activity during the late 1890s and early 1900s, when he was holding a dozen or more exhibitions a year showcasing a wide range of artists and selling huge numbers of pictures to a rapidly expanding international clientele. "Dreaming and sleeping, like this, alone in his shop, Vollard was wasting no time. Month by month, in solitude and silence, the price of his pictures rose!"[16]

Vollard's exotic origins contributed to his aura of mystery and difference.[17] Of French descent, he was born on July 3, 1866, at Saint-Denis in Réunion.[18] His father, Alexandre Ambroise Vollard, had come from the Île-de-France region as a young man and, hardworking and ambitious, had been employed as a lawyer's clerk, studying at night to qualify as a lawyer. He married Marie-Louise-Antonine Lapierre; Ambroise was the eldest of their ten children. The family formed part of the island's white elite, which, "surrounded as it was by foreign elements . . . took the greatest care to maintain its racial integrity,"[19] a priority that may well have fueled the virulent attack on French colonialism Vollard later expressed through the anarchic Ubu.[20] Despite a strict upbringing—his father set great store by the study of such works as Descartes's *Discourses* and disapproved of Hans Christian Andersen, while his redoubtable aunt Noémie presided over religious and moral discipline—Vollard in his retrospective account paints a picture of a happy childhood in a tropical paradise. A boy with a precocious visual sense, he delighted in the variety of tones in an all-white bouquet; his accumulations of pebbles and bits of broken blue crockery were early signs of a collecting instinct.[21]

At age nineteen Vollard was sent to study law in Montpellier[22] in southern France. He never returned to Réunion. In autumn 1887 he moved to Paris and began studying for a doctorate at the Faculté de Droit.[23] Between lectures he often hunted through boxes of books, prints, and drawings at the stalls along the quais of the Seine, in the course of which he "developed a passion for engravings and drawings."[24] A year later Vollard had stopped actively studying the law, had lost his allowance (which his father cut off), and had embarked on a career as an art dealer. Turned down by the eminent dealer Georges Petit because he knew no foreign languages, Vollard

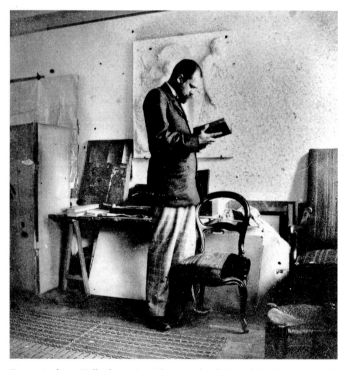

Fig. 2. *Ambroise Vollard*, ca. 1899. Photograph, 3½ in x 3½ in. (8.9 x 8.9 cm). Private collection. Perhaps taken during the time Vollard was posing for his portrait by Cézanne (fig. 4)

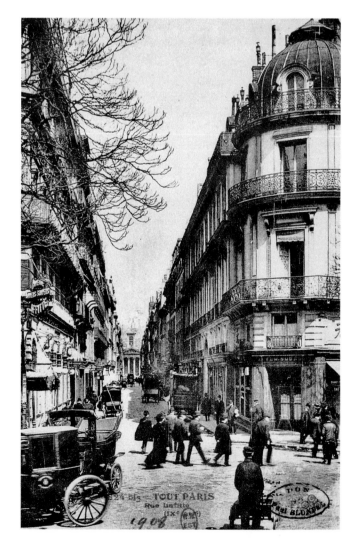

Fig. 3. Rue Laffitte, 1908. Bibliothèque Nationale de France, Paris

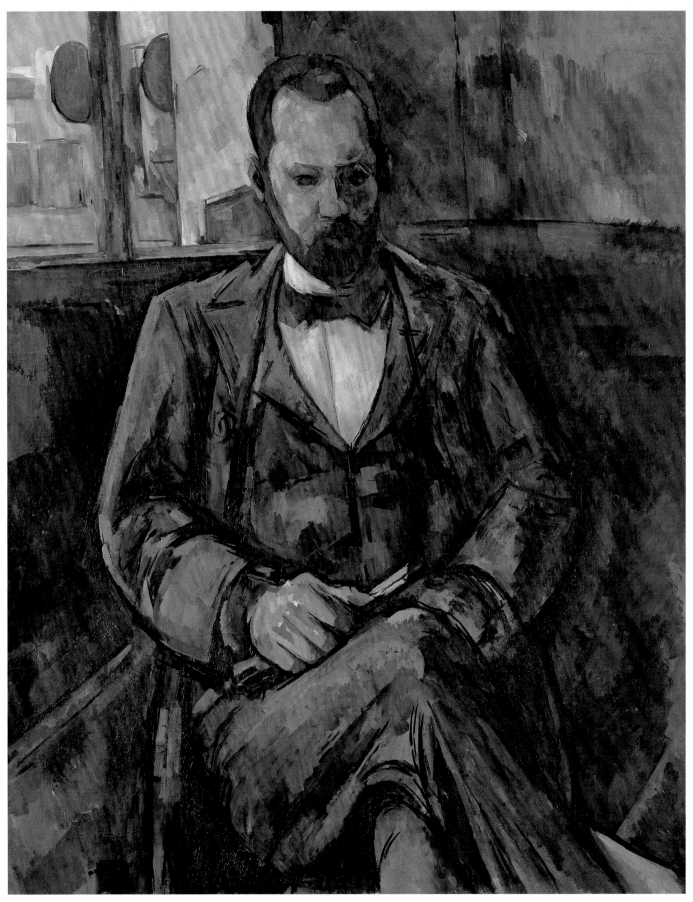

Fig. 4 (cat. 47). Paul Cézanne, *Ambroise Vollard*, 1899. Oil on canvas, 39¾ x 31⅞ in. (101 x 81 cm). Petit Palais, Musée des Beaux-Arts de la Ville de Paris (PPP 2100)

served a brief apprenticeship at the gallery L'Union Artistique with Alphonse Dumas, who specialized in academic painting and rejected Vollard's suggestion that he show the Impressionists.

Striking out on his own in about 1890, Vollard struggled for the next few years to earn a living and learn his trade. His lodging as well as his shop consisted of two small rooms under a mansard roof on the seventh floor of 15, rue des Apennins at the end of the avenue de Clichy at the foot of the Sacré Coeur. One of the rooms was used as a dining room and was decorated by Bonnard.[25] From these modest premises Vollard began trading in drawings and prints by Félicien Rops, Théophile Alexandre Steinlen, and Constantin Guys, picked up for next to nothing on the quais.[26] But Vollard already had greater ambitions, not only, as he recalled, wistfully admiring paintings by Jean-Baptiste-Camille Corot in Hector Brame's gallery window,[27] but apparently also, as his ledgers reveal, actually buying one in June 1894.[28]

The young man was trying to build a stock of work by established artists, but, coming from nowhere, he lacked the advantages and the inventory of such dynastic dealers as Petit and Paul Durand-Ruel.[29] Most Impressionist paintings were beyond his reach. However, in 1892 Vollard exhibited pastels and oils by Armand Guillaumin,[30] and moreover had the shrewd idea of acquiring from Édouard Manet's widow a group of the artist's drawings and unfinished paintings, which he exhibited to rave reviews in his first gallery in November 1894.[31] It was probably as a result of the Manet exhibition that Vollard met Auguste Renoir and Edgar Degas.[32] He began dealing in the works of both artists at about that time. One of his early purchases was a Renoir nude (fig. 160) that he soon sold for 400 francs (Auguste Rodin paid 20,000 francs for it many years later).[33] In October 1894 Vollard traded to Degas the central fragment of Manet's *The Execution of Maximilian* (fig. 167) in exchange for 2,000 francs worth of Degas's own work.[34]

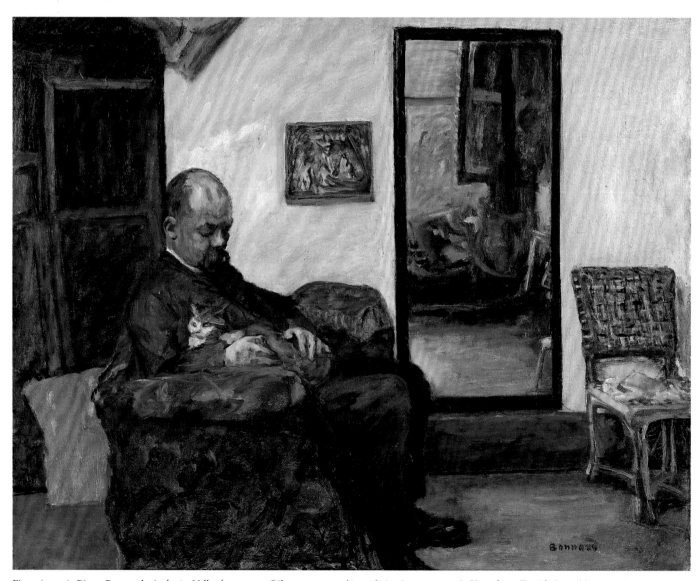

Fig. 5 (cat. 9). Pierre Bonnard, *Ambroise Vollard*, ca. 1904. Oil on canvas, 29⅛ x 36⅜ in. (74 x 92.5 cm). Kunsthaus Zürich (1950/7)

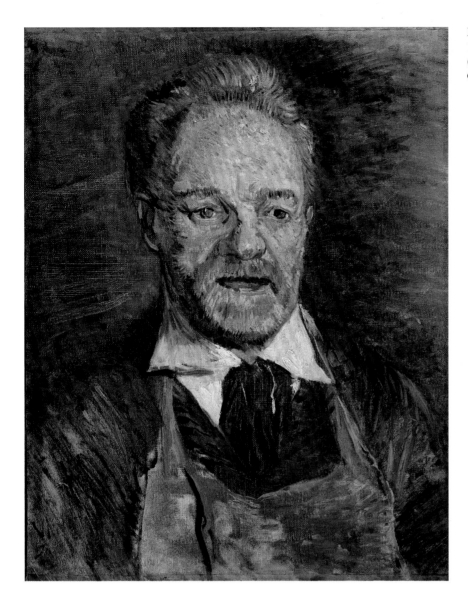

Vollard was also beginning to acquire works by young, avant-garde artists: "About 1893 I was put in touch with the *nabis* by Maurice Denis, who had noticed the little exhibition of Manet's drawings I was holding at the time. Thanks to this meeting I obtained pictures from Bonnard, Denis, [Ker-Xavier] Roussel and [Édouard] Vuillard and entered into cordial relations with them which permitted me to call upon their talent when I started as an art publisher."[35] In June 1894 the sale following the death of the color merchant and picture seller Julien (Père) Tanguy (fig. 6) presented Vollard with the opportunity to purchase at very low prices works by three unrecognized artists—Cézanne, Paul Gauguin, and Vincent van Gogh—as well as others by Camille Pissarro and Guillaumin.[36]

In September 1893 Vollard was able to rent a small shop at 37, rue Laffitte, a modest street running north from the boulevard des Italiens to the lower slopes of Montmartre (fig. 3).[37] Although the shop was nothing more than a lock-up stall only ten feet wide, the move was crucial because in the 1890s the rue Laffitte was the very heart of the Paris art world. This "street of pictures,"[38] around the corner from the newly expanded Hôtel Drouot auction house, was where most art dealers were to be found. The elegant Durand-Ruel and Bernheim-Jeune galleries were down the street from more humble premises, and at no. 1 was the office of the famous art and literary journal *La Revue blanche*. Pissarro noticed the newcomer's arrival on the scene and described the range of Vollard's stock in these early days: "He shows nothing but pictures of the young. There are some very fine early Gauguins, two beautiful things by Guillaumin, as well as paintings by [Alfred] Sisley, Redon, [Jean-François] Raffaëlli, [Henry] de Groux, of this last a very beautiful work. . . . I believe this little dealer is the one we have been seeking, he likes only our school of painting or works by artists whose talents have developed along similar lines. He is very enthusiastic and knows his job. He is already beginning to attract the attention of certain collectors who like to poke about."[39]

Vollard had opened his gallery in propitious times. The 1890s witnessed the decline of the unwieldy state-sponsored Salon system, which for a century had been the principal forum for the exhibition and sale of art, and the simultaneous

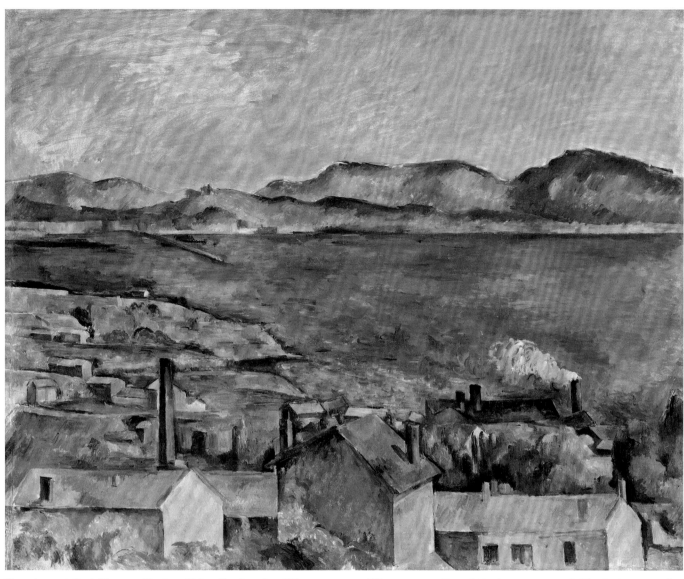

Fig. 7 (cat. 37). Paul Cézanne, *The Bay of Marseilles, Seen from L'Estaque*, ca. 1885. Oil on canvas, 31⅝ x 39⅝ in. (80.2 x 100.6 cm). The Art Institute of Chicago, Mr. and Mrs. Martin A. Ryerson Collection (1933.1116)

breakthrough of an alternative operation, that of the commercial dealer, which had been growing since midcentury. In the buoyant, affluent climate of fin-de-siècle Paris, established dealers such as Durand-Ruel and Petit plied their trade alongside a variety of small, experimental galleries dealing in avant-garde work. These included Louis-Léon Le Barc de Boutteville, who showed the Nabi artists; Theo van Gogh at Boussod and Valadon, who exhibited paintings by his brother Vincent and by Gauguin; and Père Tanguy, whose shop was almost the only place to see paintings by Cézanne.[40] By 1896 all three had died, leaving the field open for an enterprising newcomer like Vollard.

In 1895 Vollard defined his position as a dealer in avant-garde art with two one-man exhibitions devoted to Van Gogh and Cézanne. He also showed a selection of Brittany landscapes and ceramics by Gauguin in his gallery. The very alienation of these artists gave them a certain cachet, making Vollard's little gallery a place where one went to be shocked.[41] With each of

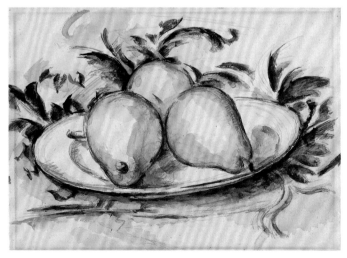

Fig. 8. Paul Cézanne, *Three Pears*, 1888–90. Watercolor, gouache, and graphite on cream laid paper. The Henry and Rose Pearlman Foundation; on long-term loan to the Princeton University Art Museum (L. 1988.62.32)

these neglected artists he was taking a risk. Van Gogh had sold only one painting in his lifetime,[42] and in the five years since his death, the market for his work had been thin. "The boldest were unable to stomach his painting," Vollard remembered.[43] It was probably at Émile Bernard's suggestion that Vollard assembled fourteen paintings for the exhibition, which opened on June 4 and inaugurated his new and larger premises at 39, rue Laffitte.[44] The show met with little commercial success but attracted favorable notices.[45]

By far the most significant exhibition for both dealer and artist was the Cézanne retrospective that Vollard mounted in November 1895. Cézanne's work was virtually unknown in Paris. He had hardly exhibited since the third Impressionist exhibition in 1877 and had retreated to his native Aix-en-Provence.[46] Vollard described his first sight of a Cézanne, in Tanguy's shop, as "a kick in the stomach."[47] Although it was apparently on the advice of Renoir, Pissarro, Bernard, and Denis that Vollard took up Cézanne, there is no doubt that he believed in the artist totally. Vollard was opportunistic enough to recognize Cézanne as the only major figure of the Impressionist generation without a dealer (most of the others were represented by Durand-Ruel) and courageous enough to be the first in Paris to give him a one-man exhibition. Looking back, a friend remembered Vollard saying, "An innovator like Cézanne was considered a madman or an imposter, and even the avant-garde

dealers like Durand-Ruel and Bernheim regarded him with contempt. . . . On the spot, I managed to buy 150 canvases from him, almost his entire output. . . . I risked a great deal of money by doing that—everything I owned, my entire fortune went into it. And I anxiously wondered whether my audacity might not turn out to be the ruin of me. I didn't even have enough money left over to frame Cézanne's canvases decently. At the exhibition, most of them were hung with two-sou wooden slats."[48] Vollard claimed that his exhibition was a slap in the face for the art establishment, and he made his point by displaying in the window Cézanne's *Bathers at Rest* (1876–77), a work in the bequest of Gustave Caillebotte that the state had rejected the year before; it stood in stark contrast to the tame flower pieces and academic subjects on view in some windows along the rue Laffitte.[49] Vollard's pride in his antiestablishment stance and his role as a "marchand-découvreur"—a dealer-connoisseur with the eye to recognize contemporary talent in a philistine world—stayed with him throughout his life and is a persistent theme in his autobiography.

The exhibition attracted a favorable review from Thadée Natanson, the editor of *La Revue blanche,* and mixed reactions from others.[50] For artists and collectors it was a revelation; practically overnight, Cézanne became a revered master. Artists were the first to buy. Vollard recalled Claude Monet, visiting on the first day dressed as a country gentleman.[51] At some

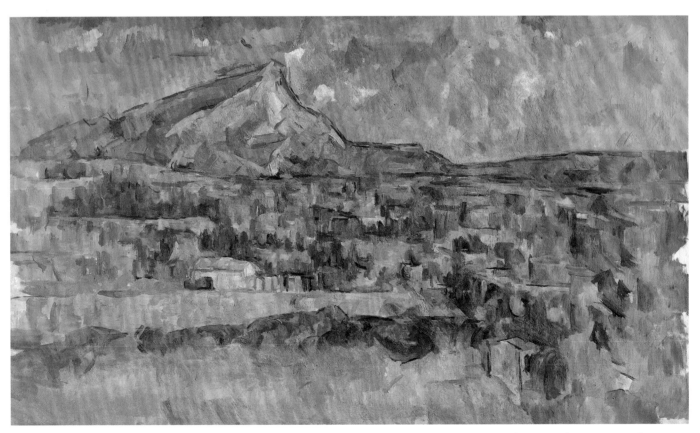

Fig. 9 (cat. 49). Paul Cézanne, *Mont Sainte-Victoire*, ca. 1902–6. Oil on canvas, 22½ x 38¼ in. (57.2 x 97.2 cm). The Metropolitan Museum of Art, New York, The Walter H. and Leonore Annenberg Collection, 1996, Gift of Walter H. and Leonore Annenberg, 1994, Bequest of Walter H. Annenberg, 2002 (1994.420)

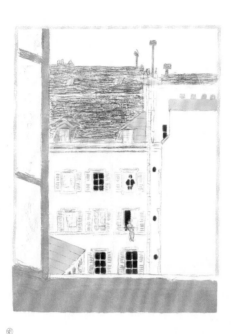

Fig. 10 (cat. 14). Pierre Bonnard, *Houses in the Courtyard,* 1895–96, from *Quelques Aspects de la vie de Paris* (*Some Aspects of Paris Life*), ca. 1898, published 1899. Color lithograph, image 13⅝ x 10¼ in. (34.7 x 26 cm), sheet 21 x 16 in. (53.4 x 40.6 cm). The Art Institute of Chicago, gift of Walter S. Brewster (1936.181)

Fig. 11 (cat. 71). Maurice Denis, *"Attitudes Are Easy and Chaste,"* from *Amour* (*Love*), 1898, published by Vollard, 1899. Color lithograph, image 15⅛ x 10⅞ in. (38.4 x 27.5 cm), sheet 20⅞ x 16 in. (52.9 x 40.6 cm). The Art Institute of Chicago, John H. Wrenn Memorial Collection (1946.432d)

point Monet acquired *The Negro Scipion* (fig. 40), which he later hung in his bedroom at Giverny. Degas and Renoir drew lots for a still life in watercolor (fig. 8);[52] Degas won. He also bought two other works from the exhibition and five more over the next couple of years.[53] Pissarro acquired a number of pictures.[54]

Collectors followed. The margarine millionaire Auguste Pellerin acquired his first Cézannes in 1898, as did the government minister Denys Cochin.[55] By the end of the century, foreign collectors had began to build their holdings of Cézannes. The American Charles Loeser and the eccentric Dutchman Cornelis Hoogendijk,[56] among the first, provided the impetus for a rapidly expanding international clientele that would eventually include the Russians Sergei Shchukin and Ivan Morozov, the German Count Harry Kessler, the Hungarian Marczell de Nemes, and the Americans Gertrude and Leo Stein, Louisine and H. O. Havemeyer, and Albert C. Barnes. The 1895 exhibition enabled Vollard to become Cézanne's sole dealer and thus gain a monopoly on his output; this, together with the fact that Vollard had begun to attract sophisticated French and international customers, laid the foundations for his subsequent success.[57] Five years after the exhibition, Denis

honored both painter and dealer in his *Homage to Cézanne* (fig. 82), which depicts Vollard, a group of Nabi painters, and Redon gathered around a Cézanne still life displayed in Vollard's gallery.

The financial success of his Cézanne show allowed Vollard to move in May 1896 into spacious new premises, which he painted in yellow ochre, in no. 6 at the other end of the rue Laffitte,[58] a prestigious location near the boulevards.[59] The legendary gallery that flourished at this address became famous throughout Europe and the focus of the Paris art world until the outbreak of World War I. Vollard was a brilliant opportunist. Whether because of an eye for artistic quality, a sure instinct for spotting undiscovered talent, or a sense of whose advice to listen to[60]—or, more likely, a combination of all three—Vollard mounted a series of singularly impressive exhibitions throughout the 1890s and the first decade of the twentieth century.

Vollard played a key role in the rebirth of printmaking (particularly the emergence of the color lithograph) that took place at the end of the nineteenth century. "I was hardly settled in the rue Laffitte when I began to dream of publishing fine prints, but I felt they must be done by 'painter-printmakers.'

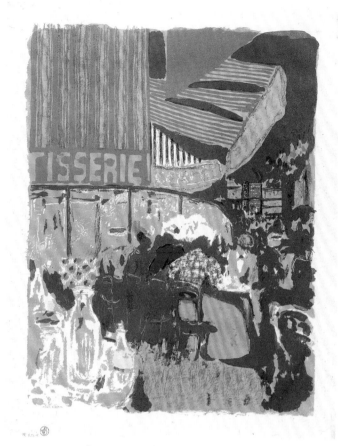

Fig. 12 (cat. 202). Édouard Vuillard, *The Pastry Shop,* from *Paysages et intérieurs* (*Landscapes and Interiors*), 1899. Color lithograph, image 14 x 10⅞ in. (35.6 x 27.7 cm), sheet 15⅞ x 12½ in. (40.3 x 31.8 cm). The Art Institute of Chicago, gift of Walter S. Brewster (1936.192)

My idea was to obtain works from artists who were not printmakers by profession."[61] He opened his new gallery in June 1896 with a large exhibition of prints linked to his first ambitious publishing venture in the field, *Album des peintres-graveurs* (fig. 199).[62] Pissarro remarked, "Vollard is going to have a press for lithographs in his place, rue Laffitte. This Creole is amazing; he wheels from one thing to another with startling ease."[63] The first *peintres-graveurs* show was followed in 1897 by a second, likewise accompanied by a print album, *Album d'estampes originales de la Galerie Vollard* (fig. 201). Nabi artists, whom Vollard had met at the offices of *La Revue blanche,* were contributors to the print albums. In 1897 and 1898 he mounted two large group exhibitions of the Nabi group and produced individual print albums by Bonnard (*Quelques Aspects de la vie de Paris,* 1895–99), Denis (*Amour,* 1892–98), and Vuillard (*Paysages et intérieurs,* 1899) (figs. 10–12).

But extensive group shows were not to become Vollard's standard practice; he promoted artists principally through one-man exhibitions. The solo show, a form established in the mid-nineteenth century by Durand-Ruel, was an effective way to build an artist's reputation.[64] Such a show attracted reviews in the press and was often accompanied by a catalogue with a text by a well-known critic. For an early one-man show in his new gallery, Vollard assembled the largest group of Van Gogh's works ever displayed. Although the exhibition contained such masterpieces as *The Potato Eaters* (1885) and *Wheatfield with Crows* (1890; both Van Gogh Museum, Amsterdam), it was not a commercial success. Unable to gain control of the artist's work as he had of Cézanne's, Vollard never again devoted an exhibition to Van Gogh, but later he observed, "I was totally wrong about van Gogh! I thought he had no future at all, and I let his paintings go for practically nothing."[65]

In November 1898 Vollard seized an opportunity to show some magnificent examples of Gauguin's latest work, sent from Tahiti.[66] The monumental *Where Do We Come From? What Are We? Where Are We Going?* (fig. 13) was presented with nine related paintings. Vollard showed Gauguin again in 1903 and later boosted the artist's posthumous reputation by lending a significant number of works to his 1905 retrospective at the Salon d'Automne.

In June 1901 Vollard exhibited oils, pastels, and watercolors of Parisian subjects by an unknown nineteen-year-old called Pablo Picasso, along with work by the artist's older compatriot Francisco Iturrino.[67] The German Expressionist artist Käthe Kollwitz was among the buyers. Although Vollard's interest in Picasso's later work has been downplayed—he is said to have been horrified by *Les Demoiselles d'Avignon*[68]—he did give the artist a further exhibition in 1910–11. He issued two series of Picasso's prints, *Les Saltimbanques* of 1913 and the *Vollard Suite* of 1930–37, and he sold some of the artist's proto-Cubist and Cubist works to the Czech collector Vincenc Kramář.[69]

Other significant exhibitions by Vollard included the first major show of work by Bernard (1901) and the first ever to be devoted to Aristide Maillol (1902), whose terracotta sculptures Vollard subsequently cast in bronze. In 1904 it was the turn of Kees van Dongen and Henri Matisse.[70] Although pleased to receive his first solo exhibition, Matisse resented Vollard's using his pictures as decoys, then shamelessly producing Cézannes and Renoirs for inspection by visitors at the private opening.[71] Vollard failed to anticipate the significant development to come of Van Dongen and Matisse, both of whom were soon taken up by other dealers: Daniel-Henry Kahnweiler, Eugène Druet, and Bernheim-Jeune.

By no means have all the artists Vollard exhibited become celebrated. He was eclectic and wide-ranging in those he chose to promote. In his early years he mounted a new show every three or four weeks, thus including work by a great number of lesser-known artists and some now completely forgotten. For instance, in 1898, the year of the Nabi, Gauguin,

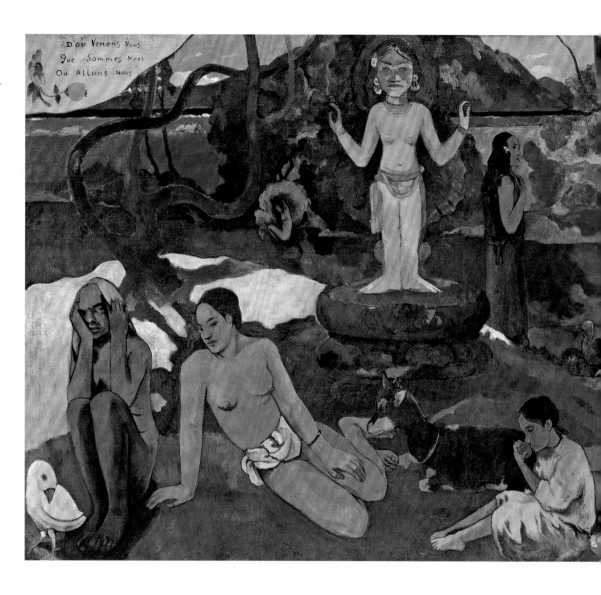

Fig. 13 (cat. 96). Paul Gauguin, *Where Do We Come From? What Are We? Where Are We Going?*, 1897–98. Oil on canvas, 54¾ x 147½ in. (139.1 x 374.6 cm). Museum of Fine Arts, Boston, Tompkins Collection—Arthur Gordon Tompkins Fund (36.270)

and Cézanne exhibitions, Vollard showed watercolors by Charles Guéroult (a protégé of Degas) in January, about thirty-five pastels by Eugène Murer in late February and March, about forty landscapes by the Swedish artist Gustave Albert in March, and work by Alfred Müller in April. The following year saw exhibitions of the works of Paul Vogler in February and March; of the "young mystic painter so much admired by Huysmans"[72] Charles Dulac (who had just died at the age of thirty-one), Picasso's friend Isidre Nonell i Monturiol, and André Sinet, specialist in *la femme mondaine,* all in April; and of about twenty landscapes by the Norwegian Edvard Diriks in May and a large number of works by the Provençal colorist René Seyssaud in May and June. In the catalogue of the last-named, Arsène Alexandre praised Vollard for supporting young artists so energetically.[73]

Vollard accumulated a vast inventory of works, and this stockpiling proved to be an essential ingredient of his success. While Kahnweiler, for instance, insisted on exclusivity contracts with artists, Vollard only occasionally entered into such agreements. The best known is his 1900 commitment to pay

Gauguin a stipend of 300 francs a month as an advance against purchasing all his paintings for 200 francs each, the price reflecting the extreme difficulty of selling them;[74] Vollard also entered into contractual agreements with the Fauve painter Jean Puy and with Georges Rouault.[75] More typically, Vollard invested in large stocks of many artists' work, which he could sell over time as prices rose. Losing an artist to another dealer, as happened when André Derain, Maurice de Vlaminck, and Picasso moved to Kahnweiler, did not disconcert him, largely because the other dealer's promotion of the artist created a demand that Vollard was able to cater to from his own stock.[76]

Frequently Vollard bought the entire contents of an artist's studio (the first, in 1899, was Cézanne's studio at Fontainebleau). Bernard sold him a total of 184 paintings and a large number of drawings and watercolors in May and July 1901 and remembered, perhaps fancifully, Vollard taking them away wrapped in a carpet.[77] In 1906 he acquired a substantial portion of the contents of Picasso's studio, this time taking them away with a horse and cart.[78] But it was from the Fauves that Vollard made his most comprehensive bulk purchases; he

also conceived the idea of commissioning ceramics from them, which were executed by André Metthey.[79] Vollard's enthusiasm for the Fauves is consistent with his demonstrated taste for painting that was bold, colorful, and figurative, qualities that he had also admired in Van Gogh, Gauguin, and the early Picasso. Impressed by the brilliant, simplified color of Derain's and Vlaminck's paintings in the "cage aux fauves" at the 1905 Salon d'Automne, he bought up Derain's studio in November 1905 and Vlaminck's in summer 1906.[80] The same year he commissioned Derain to paint fifty views of London and the Thames, an idea inspired by the successful exhibition of Monet's London pictures at Durand-Ruel in 1904.[81] Studio buyout was the tactic Vollard pursued with most of the Fauves, among them Henri Manguin,[82] Charles Camoin, and Puy,[83] and a flamboyant, lesser-known figure, Jacqueline Marval. He also stockpiled the work of minor artists, including the whole output of Charles-Emmanuel Serret,[84] a now-forgotten draftsman in the Ingres tradition who was admired and collected by Degas, and the complete oeuvre of the Impressionist Stanislas Lépine, which Vollard bought from the deceased artist's sister-in-law in 1903.

Vollard's last set of registers, January 1922 to October 1929, show that the only artists whose work he acquired in quantity and on a regular basis after World War I were Puy and Rouault.[85]

From a number of other artists Vollard acquired substantially but not their entire output. One such was Odilon Redon; Vollard bought his *noirs* first in 1893–94, and increasingly in 1897 and 1899, then over the next few years went on to acquire drawings, pastels, and paintings from the artist.[86] He took a chance with Henri (le Douanier) Rousseau as early as 1895 but, unable to sell any of the works, returned them;[87] then in 1909 and 1910, when his confidence in the artist had returned, he bought a number of his pictures.[88] Vollard acquired Georges Seurat's *Models* (*Poseuses*) (fig. 241), which he sold to Count Harry Kessler,[89] but never embraced the artist's work.[90] Although he mounted an exhibition of Maximilien Luce's work in April 1902, Vollard admitted to having little taste for the Pointillists—at first thinking that they had something to do with needlework (petit point).[91]

Vollard did from the outset seek to acquire works by established Impressionists, in order to balance his purchase of items

Fig. 14 (cat. 182). Georges Rouault, *Twilight*, 1937. Oil on canvas, 25¾ x 38⅞ in. (65.4 x 98.8 cm). The Metropolitan Museum of Art, New York, Gift of Mr. and Mrs. Nate B. Spingold, 1956 (56.230.2)

by young, avant-garde artists, add weight to his inventory, and draw in a wider clientele. Yet the only true Impressionist to whom Vollard gave a solo exhibition at the rue Laffitte was Mary Cassatt, whose paintings, pastels, and etchings he showed in 1908. However, over the years he acquired and sold a great many individual works by Impressionists. He bought a canvas from the impoverished Sisley in 1897 and also acquired works by Caillebotte, Cassatt, and Berthe Morisot. Such acquisitions were often made in exchange for paintings by other artists. In November 1894, for instance, Pissarro traded paintings of his own for Manet's *The Funeral* (fig. 281).[92]

Degas was another Impressionist who exchanged his own work for items in Vollard's stock, particularly during the 1890s, when the artist was forming his great collection. From the dealer Degas acquired eight paintings by Cézanne between 1895 and 1897, two by Gauguin in 1898, and four paintings and one drawing by Manet between 1894 and 1897.[93] Vollard also purchased many works by Degas over the years, but the absence of titles in his records makes it difficult to identify them. After Degas's death, Vollard was appointed an executor of his estate; with Durand-Ruel and Jacques

Seligmann, he formed a consortium that made spectacular purchases at the four sales of Degas's studio contents held in 1918, including *Mlle Fiocre in the Ballet "La Source"* (1867–68, Brooklyn Museum) and *Young Spartans* (ca. 1860–62, reworked until 1880, National Gallery, London). Then, beginning in 1921 with the famous sale held by Seligmann at the Plaza Hotel in New York, regular sales of works by Degas continued to augment Vollard's already substantial wealth.[94] Degas's late work was the subject of one of the rare exhibitions mounted by Vollard in the 1930s at his premises on the rue de Martignac. He was also involved in the major Degas retrospective held in 1937 at the Orangerie in Paris.

Renoir was the Impressionist to whom Vollard was closest. In 1906 he sold one of the artist's most important early works, *The Clown* (fig. 163), to a major client, the prince de Wagram.[95] Thereafter he continued to trade in Renoir's works, and the two remained intimate friends until the artist's death in 1919. During Renoir's later years, when his hands were crippled by arthritis, Vollard persuaded him to take up soft-wax sculpture and had the results cast in bronze.

Vollard's profound admiration for and friendships with Cézanne, Renoir, and Degas are reflected in the monographs

Fig. 15 (cat. 2). Émile Bernard, *The Buckwheat Harvest*, 1888. Oil on canvas, 28⅜ x 36⅛ in. (72 x 92 cm). Private collection

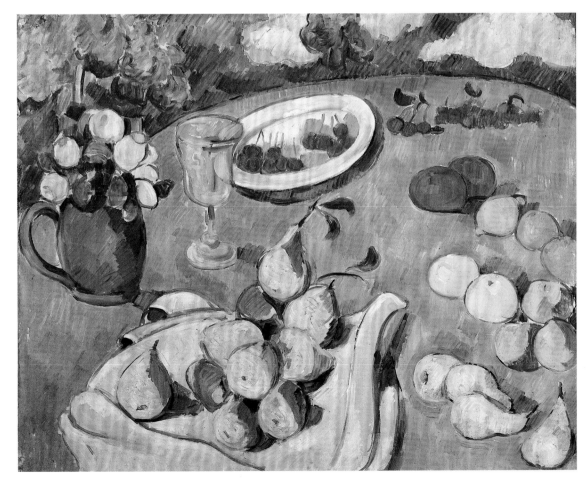

Fig. 16 (cat. 3). Émile Bernard, *Still Life: Fruit on a Round Table*, 1892. Oil on canvas, 25⅝ x 31¾ in. (65.1 x 80.7 cm). Collection of Mrs. Arthur G. Altschul

he wrote during a respite imposed by World War I: *Paul Cézanne* (1914), *La Vie et l'oeuvre de Pierre-Auguste Renoir* (1919), and *Degas (1834–1917)* (1924).[96] Vollard had long entertained an ambition to write, perhaps springing from an outsider's deep-seated need for recognition. Anecdotal and in many ways lightweight, these books nonetheless retain the freshness of firsthand accounts, and art historians have relied on them as a unique fund of information. Roger Fry wrote that Vollard "has played Vasari to Cézanne and done so with the same directness and simplicity, the same narrative ease, the same insatiable delight in the oddities and idiosyncrasies of his subject."[97] At this time Vollard also collaborated with Julie Manet on a catalogue of the paintings, pastels, and watercolors of her mother, Berthe Morisot; however, he gave the project up in 1930.[98]

Vollard's practice of buying in bulk at low prices has contributed to a view of him as a ruthless opportunist. Naturally, conflicts over money are not unusual between artists and dealers, and artists' letters to Vollard are full of demands for money.[99] Gauguin described him as "a crocodile of the worst kind."[100] Picasso would later complain that the dealer had bought the contents of his studio for a derisory sum, although, as the artist's friend Jacques Prévert was quick to remind him, the prices offered were not notably low at the time for work by an unknown name.[101] And there is another side to the story. Daniel Wildenstein remembered Vollard's devotion to his artists.[102] He could be loyal and generous. He provided studios in his own homes to Picasso (in Tremblay-sur-Mauldre) and Rouault (in Paris, on the top floor at the rue de Martignac).[103] Some artists confided in him as a friend. Letters from Renoir reveal a warm and close friendship,[104] and Cézanne wrote to Vollard: "I have made some progress. Why so late and with such difficulty? Is art really a priesthood that demands the pure in heart who must belong to it entirely? I am sorry about the

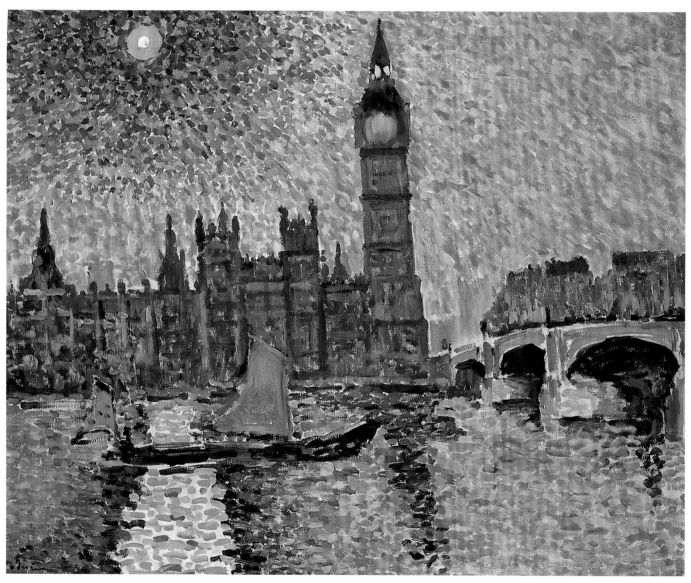

Fig. 17 (cat. 75). André Derain, *Big Ben*, ca. 1906. Oil on canvas, 31⅛ x 38⅝ in. (79 x 98 cm). Musée d'Art Moderne, Troyes. Gift of Pierre and Denise Lévy (MNPL 103)

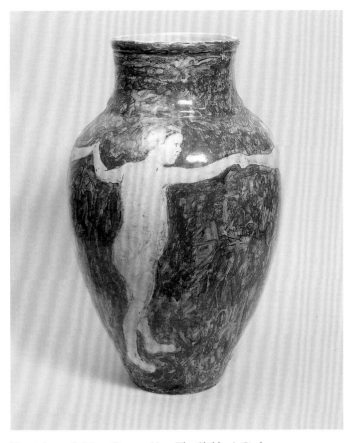

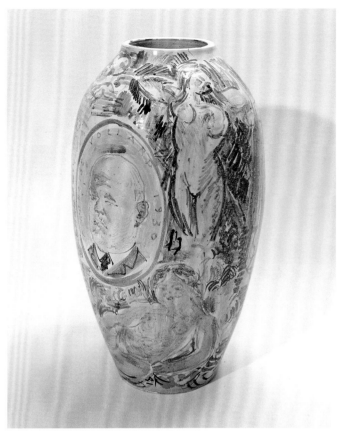

Fig. 18 (cat. 23). Mary Cassatt, *Vase: The Children's Circle*, ca. 1903. Glazed ceramic, H. 21⅝ in. (55 cm), Diam. 15¾ in. (40 cm). Petit Palais, Musée des Beaux-Arts de la Ville de Paris, gift of Ambroise Vollard, 1937 (PPO 1835)

Fig. 19 (cat. 85). Raoul Dufy, *Vase with Portrait of Ambroise Vollard*, 1930. Tin-glazed ceramic, H. 16½ in. (42 cm), Diam. 9¼ in. (23.5 cm). Centre Pompidou, Paris, Musée Nationale d'Art Moderne/Centre de Création Industrielle, Bequest of Mme Raoul Dufy, 1963 (AM 1157 OA)

distance which separates us, for more than once I should have turned to you to give me a little moral support. . . . If I am still alive we will talk about all this again."[105] Touching evidence of friendship is found in the intense, feeling letters that Puy wrote to Vollard from the trenches in World War I (the dealer had intervened to have Puy transferred from the front line to a camouflage unit): "We wait peacefully and philosophically for the difficult end of this war, with few regrets for the glory of arms, the roar of the shells, or those heart-pounding victories that bestow a laurel wreath . . . on the bodies . . . of the wounded."[106] The horrors of war contained in these letters would provide the material for Vollard's first large Ubu publication, the bitingly satirical *Le Père Ubu à la guerre* (1923), illustrated by Puy.

The breadth of Vollard's relations with artists is reflected in the numerous portraits made of him. As Picasso observed, "The most beautiful woman who ever lived never had her portrait painted, drawn, or engraved any oftener than Vollard—by Cézanne, Renoir, Rouault, Bonnard, Forain, almost everybody, in fact. I think they all did him through a sense of competition, each one wanting to do him better than the others. He had the vanity of a woman, that man . . . my Cubist portrait

of him [fig. 1] is the best one of them all."[107] Other names can be added—of Denis, Vallotton, Rouault, Louis Valtat, and the great Hungarian photographer Brassaï (Gyula Halász), who very effectively captured Vollard's magnetic, brooding presence. Degas too planned to paint his portrait, according to Vollard, but increasing blindness and infirmity prevented him from doing so.[108] In addition to painting his great Cubist portrait, Picasso also captured Vollard's likeness in a beautiful Ingresque drawing (fig. 118)—an image of the dealer with his cat far less benign than Bonnard's of the same subject—and in four etchings made toward the end of Vollard's life (figs. 121–124).[109] Renoir painted at least three portraits of Vollard: as a youthful vagabond in a red head scarf (fig. 165), as a connoisseur in the Renaissance tradition examining a Maillol figurine (fig. 296), and, most flamboyantly, as a toreador (fig. 20). While Cézanne's majestic portrait (fig. 4) was commissioned by Vollard, little is known about the circumstances surrounding the many other portraits. Perhaps Vollard asked to have them painted—a remark of Renoir's[110] suggests that this was the case at least once—but whether out of pure vanity, as Picasso would have it, or in order to promote his reputation as a dealer of successful artists can only be surmised. Along with Renoir's

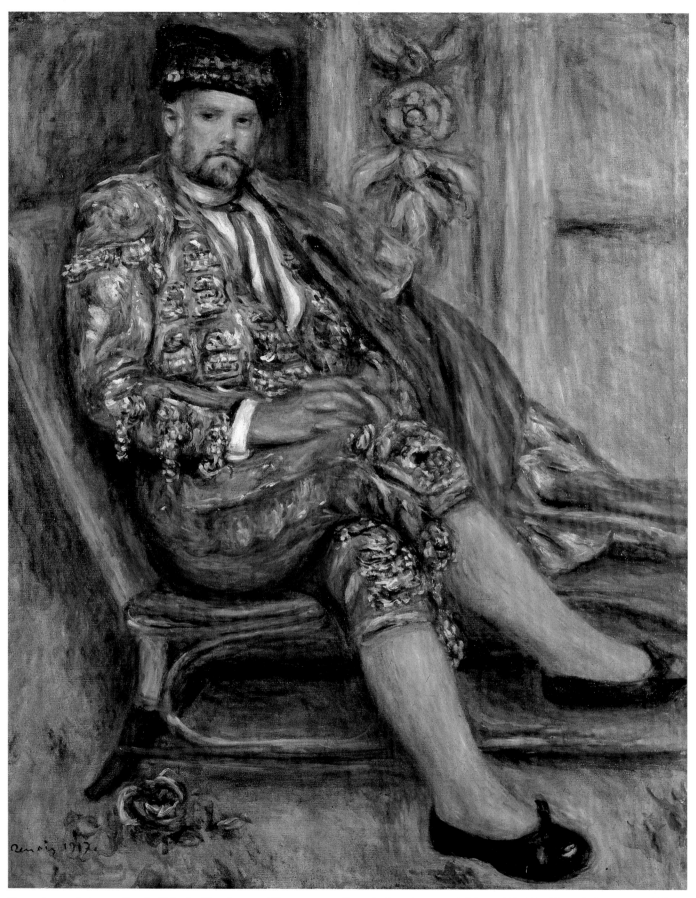

Fig. 20 (cat. 177). Auguste Renoir, *Vollard as Toreador*, 1917. Oil on canvas, 40¼ x 33 in. (102.6 x 83.6 cm). Nippon Television Network Corporation, Tokyo

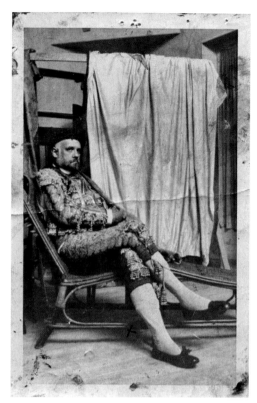

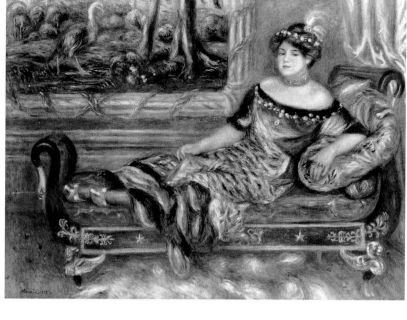

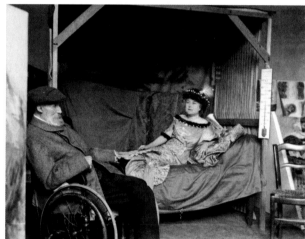

Above: Fig. 21. Vollard, dressed as a toreador, posing for Renoir, ca. 1917. Photograph, 5 ½ x 3 ½ in. (14 x 9 cm). Fondation Georges Rouault, Paris

Above right: Fig. 22. Auguste Renoir, *Madame de Galéa*, 1912. Oil on canvas. Location unknown

Right: Fig. 23. Madame de Galéa posing for Renoir, 1912. Vollard Photo Archives (ODO 1966 56 1987)

toreador portrait, which Vollard displayed prominently in his home on the rue de Martignac, the Cézanne painting seems to have been particularly valued by the dealer, who bequeathed it to the Musée du Petit Palais, Paris.[111] Vollard revealed little about his private life and never wrote of it in his memoirs. Yet he appears to have had an enduring friendship with Madame Madeleine de Galéa (née Moreau), who was also Creole, having been born on the island of Mauritius, not far from Réunion. She married a French businessman (she was later widowed), and Vollard was a close friend of the family.[112] The aging Renoir painted Madame de Galéa in a pose recalling David's *Madame Récamier,* her costume and props having been assembled by Vollard (fig. 22).[113] Vollard never married.[114] When he died in 1939, half of his estate went to Madame de Galéa.

When Vollard was building his business, little contemporary art was on display in museums; the official museum of modern art in Paris, the Musée du Luxembourg, principally showed recent Salon painting and only reluctantly accepted the Caillebotte bequest of Impressionist paintings in 1897.

While work by Cézanne and the Impressionists was temporarily on view at the Exposition Universelle of 1900,[115] in general it was only in those commercial galleries willing to show it that modern art could be seen in quantity.

Vollard's practice of vigorous acquisition turned his gallery on the rue Laffitte into an extraordinary repository of modern art. He had by far the largest stock of Cézannes in Paris, along with considerable holdings of works by Gauguin, Redon, the Nabi artists, early Picasso, the Fauves, Rouault, and a number of Impressionists.

The gallery thus became a vital resource and a vibrant meeting place for artists. Impressionist painters of the old guard could mingle here in person with the younger generation just as the pictures of both were juxtaposed on the walls and in the stockroom. Artists not only exchanged their works for those of others but also made (or attempted) numerous straightforward purchases, as Vollard's archives record. Renoir obtained a Van Gogh drawing. Wassily Kandinsky wanted to buy a Rousseau but could not afford it (he complained, "to buy at Vollard's you

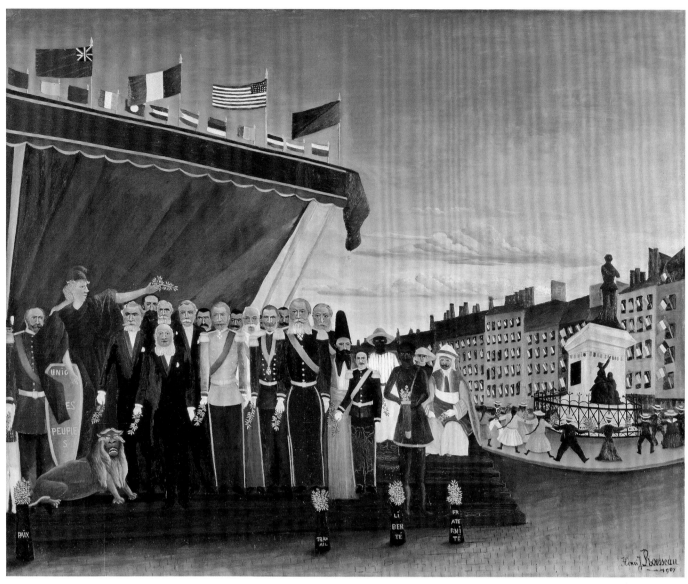

Fig. 24 (cat. 187). Henri Rousseau, *The Representatives of Foreign Powers Coming to Greet the Republic as a Sign of Peace*, 1907. Oil on canvas, 51⅛ x 63 in. (130 x 160 cm). Musée Picasso, Paris (RF 1973-91)

have to have another profession")[116]—unlike Picasso, who bought Rousseau's *The Representatives of Foreign Powers Coming to Greet the Republic as a Sign of Peace* (fig. 24) in 1913. Matisse pawned his wife's much-prized emerald ring to purchase Cézanne's *Three Bathers* (fig. 147), which, he said in 1936 when donating the work to the city of Paris, "has sustained me morally at critical moments in my venture as an artist; I have drawn from it my faith and my perseverance."[117]

Vollard did little to advertise his extensive holdings and was notoriously blatant in his disregard for presentation. One observer remembered seeing Pellerin, the Havemeyers, the prince de Wagram, and other distinguished visitors peering through the gallery's large, dusty windows and inside, picking their way among empty packing cases.[118] Gertrude Stein recalled, "It was an incredible place. It did not look like a picture gallery. Inside there were a couple of canvases turned to the wall, in one corner was a small pile of big and little canvases thrown pell

mell on top of one another."[119] Vollard's gallery thus presented a striking contrast to Petit's sumptuous premises on the rue de Sèze and Durand-Ruel's elegant showroom on the rue Laffitte. Similarly, Vollard's exhibitions were often hastily put together. The opening of a Picasso show in December 1910, as described by Guillaume Apollinaire, lacked a catalogue, invitations, and frames around the paintings–"slightly less casual treatment would have not been out of place."[120]

Vollard's unique blend of "somnolence and evasion"[121] was the opposite of the hard sell. Frequently he would sit dozing in his gallery, wearily raising an eyelid if a customer entered. He made a point of not showing his clients what they asked to see. Picasso explained: "Vollard was very secretive. He knew how to weave a mystery around his pictures in order to fetch a higher price for them."[122] He concealed the vast majority of his paintings behind a divider at the back of the shop and never allowed anyone to look through them. Gertrude Stein, who with her

brother Leo began buying from Vollard in 1904, described the dealer's maddeningly deliberate response when they attempted to buy a Cézanne landscape.[123] To another supplicant who years later asked to see a painting, Vollard's protracted and secretive foraging behind locked doors in his mansion on the rue de Martignac evoked images of Bluebeard's mysterious, sinister cupboards.[124]

A special feature of the rue Laffitte gallery were the dinners held in its cellar, the legendary *cave,* where Vollard served his native Creole chicken curry to a galaxy of artists, writers, and some of the more unconventional collectors. These celebrated gatherings were captured in paintings and sketches by Bonnard (fig. 26) and recalled nostalgically by Brassaï: "For thirty years, his famous cellar—a white vaulted room without a single picture on the walls—had been the center of Parisian artistic life. What joyful feasts, what parties and conferences, what planning sessions had been held there with all those artists, writers, critics, and collectors who were now famous: Renoir, Cézanne—the two pillars of the shop— Derain, Vlaminck, Rouault, Picasso, Odilon Redon, Matisse, Pissarro, Sisley, Monet, Bonnard, Roussel, Émile Bernard, Forain, Gauguin, Rodin, Gertrude and Leo Stein, [Bernard] Berenson, Count Kessler, Misia Edward—who later became Misia Sert—Auguste Pellerin, Max Jacob, Apollinaire, Alfred Jarry, [Stéphane] Mallarmé . . . and countless others I have forgotten."[125] As Apollinaire observed in *Flâneur des deux rives*: "It was even considered chic [*de bon ton*] to be invited there for lunch or dinner."[126] Undoubtedly Vollard was more at ease in the milieu of artists and writers than in high society, and with these bohemian soirées his shabby gallery acquired an alternative cachet that contributed to its success.

As even a cursory study of Vollard's ledgers reveals, after the Cézanne exhibition of 1895 he rapidly developed an international network of clients. He expanded his range farther through contact with foreign dealers—notably Bruno Cassirer in Berlin[127]—and by making loans to exhibitions. Vollard lent sixty works to the Miethke Gallery in Vienna in 1907;[128] works by Cézanne, Denis, Gauguin, Maillol, and Van Gogh to Roger Fry's exhibition "Manet and the Post-Impressionists" of 1910–11 at the Grafton Gallery in London;[129] and a Cézanne, a Van Gogh, and a Gauguin to the 1913 Armory Show in New York.[130] Later he established connections with New York dealers: Knoedler, which mounted an exhibition of his "collection" in 1933, and Étienne Bignou, who organized Vollard's visit to America in 1936.[131]

Meanwhile, about 1908 Vollard had begun reducing the number of his exhibitions. Then in 1914 the outbreak of World War I forced him and almost every other dealer in Paris to close their galleries.[132] After the war, the center of the Paris art world shifted to the rue de la Boétie, off the Champs-Elysées in the eighth arrondissement. Vollard chose not to maintain a working gallery and promote new art, operating instead as a private dealer from his apartment at 28, rue de Gramont.

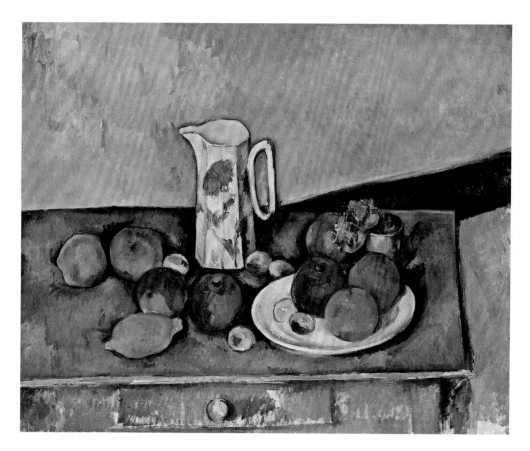

Fig. 25 (cat. 40). Paul Cézanne, *Still Life: Milk Pitcher and Fruit on a Table*, 1890. Oil on canvas, 23⅜ x 28½ in. (59.5 x 72.5 cm). The National Museum of Art, Architecture, and Design, Oslo (NG.M.00942)

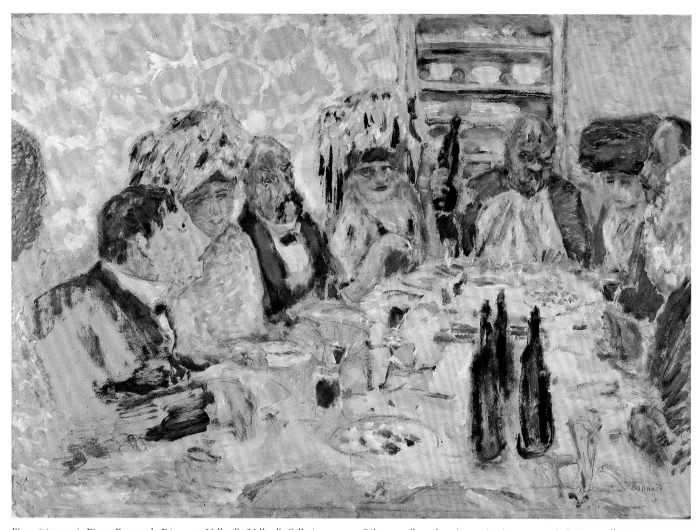

Fig. 26 (cat. 10). Pierre Bonnard, *Dinner at Vollard's (Vollard's Cellar)*, ca. 1907. Oil on cardboard, 29½ x 41 in. (75 x 104 cm). Private collection

By 1918 Vollard was thought to be "the wealthiest dealer in modern pictures. He is a millionaire ten times over."[133] Speculation about his riches and the number of pictures in his possession augmented his legendary mystique but also fed invidious notions of his greed and sharp business practices. Vollard, however, was now channeling his energy and enthusiasm into commissioning and publishing *livres d'artiste*—projects that were the passion of his life and no doubt regarded by him as his greatest achievement, but not often lucrative. Working closely with artist and printer, deliberating over the choice of paper, type, binding, and the relationship of image to text, he expanded his dealer's role to encompass active participation in artists' creative processes (as he had earlier in collaborations with *peintres-graveurs*).

Beginning about 1924, Vollard pursued his activities as dealer, publisher, and printer in a mansion at 28, rue de Martignac, in the seventh arrondissement.[134] Hadn't Vollard's move to the elegant Faubourg Saint-Germain, Brassaï later speculated, "been prompted by a desire to flaunt his rise in society? The young Creole boy whose chief collection in Réunion had been of parrot feathers, the small-time picture dealer of

Epinettes, had become the greatest picture dealer in all France, if not in the entire world, and was now the country's most outstanding art publisher as well!"[135] Vollard, who had always eschewed luxury (he admired the sugar millionaire Havemeyer for his lack of pretension),[136] "ended his life in an immense hôtel in which he occupied only two rooms, the dining-room and the bedroom. . . . All the rest was hermetically sealed because it contained his collection, piled up under a thick layer of dust, in an impressive disorder."[137] Brassaï's photographs, taken in 1936, show rooms cluttered with *livres d'artiste,* sculptures by Maillol, and pictures stacked against the wall, as well as an imposing entrance hall (fig. 292) with Renoir's *Venus Victorious* (fig. 164) and Maillol's *Venus with a Necklace* (fig. 193) on either side of the staircase. A few paintings hung in the upstairs dining room—his toreador portrait by Renoir (fig. 20), Cézanne's portrait of him (fig. 4), a Renoir bather, and Picasso's *The Burial of Casagemas* (fig. 263)—but most of Vollard's vast stock was kept in locked cupboards.[138]

It seems likely that Vollard's instinct was to hoard rather than to create a true collection,[139] although there are vague indications that he considered founding a Musée Ambroise

Vollard.[140] He certainly made substantial gifts to French museums—no doubt to enrich their collections but perhaps also to provide a memorial to himself. Ever since the Musée du Luxembourg's rejection of the Caillebotte bequest in 1894 he had held a lingering contempt for that state institution and so made his donations to municipal museums: the Petit Palais and the Musée National des Arts de l'Afrique et de l'Océanie in Paris, and the Musée de Grenoble.[141] There was only one exception, his presentation of Gauguin's *La Belle Angèle* (fig. 28) to the Luxembourg in 1927.

The problematic story of the dispersal of Vollard's collection after his death in 1939 is the stuff of a detective thriller.[142] Difficulties begin with the absence of any exact record of the number of works involved, although all agree that it was enormous,[143] with estimates varying from five thousand to ten thousand.[144] Vollard died without direct heirs. In his only will, drawn up in 1911 long before his death, he left most of his assets to his brothers and sisters and to the de Galéa family.[145] However, apparently much of the art was sold or disappeared during the war, and the postwar period saw speculation in the press about the fate of the collection.[146] Several hundred works were appropriated by a young Yugoslav, Eric Chlomovitch, who seems to have been briefly in contact with Vollard at the end of the dealer's life and who claimed that Vollard had given them to him in order to create a museum bearing the dealer's name.[147] After depositing a number of pictures with the Société Générale bank in Paris,[148] Chlomovitch took the remainder to Yugoslavia in 1939. Some of them were lost in Yugoslavia during his flight, and he himself was killed by the Nazis. The remaining 360 works are now in the National Gallery of Belgrade. A separate substantial group, sent out of France with the consent of Vollard's brother Lucien, was seized en route to New York and transferred to Ottawa,[149] then subsequently mostly dispersed.

Ambroise Vollard had his limitations, certainly. He failed to appreciate the full potential of Matisse and Picasso and ignored some of the major movements of his time, such as Cubism and Surrealism. Yet in exhibiting and promoting the works of Gauguin, Picasso, Matisse, and above all Cézanne, he displayed courage and persistence. "Vollard's mistakes can be counted on the fingers on one hand,"[150] wrote Kahnweiler, who regarded Vollard as a mentor and, apart from Durand-Ruel, the greatest dealer of his time. The international outlook of this brilliant entrepreneur helped spread modern French art far beyond France.

Vollard's death, like his life, was an enigma. He was killed on July 22, 1939, at the age of seventy-three, on the way to Paris from his house in Tremblay-sur-Mauldre, when his chauffeur-driven black Talbot convertible skidded off the road. The writer André Suarès informed his friend Rouault: "Vollard

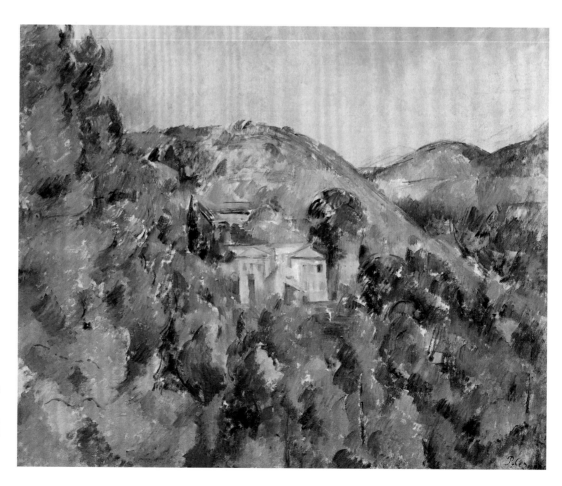

Fig. 27 (cat. 39).
Paul Cézanne, *View of the Domaine Saint-Joseph*, 1888–90. Oil on canvas, 25⅝ x 32 in. (65.1 x 81.3 cm). The Metropolitan Museum of Art, New York, Catharine Lorillard Wolfe Collection, Wolfe Fund, 1913 (13.66)

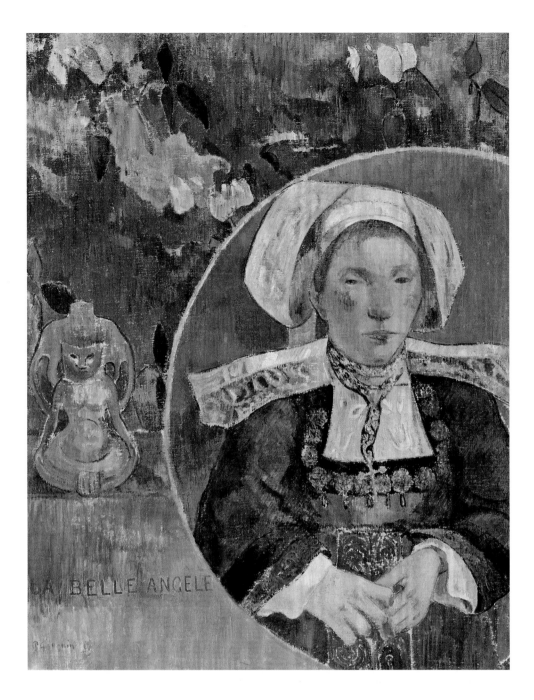

Fig. 28 (cat. 86). Paul Gauguin, *La Belle Angèle (Madame Angèle Satre, 1868–1932)*, 1889. Oil on canvas, 36⅛ x 28¾ in. (92 x 73 cm). Musée d'Orsay, Paris, Gift of Ambroise Vollard, 1927 (RF 2617)

was killed on the road from Tremblay. . . . He remained there all night, without any aid or assistance. He suffered considerably, his cervical vertebrae having been fractured. All the details are horrible. I am very upset."[151] Accounts of what actually killed Vollard differ.[152] Among the least fanciful are that he was struck by an engraver's copperplate lying on the shelf behind his head in the car and (from Picasso) that he was struck in the head by a small Maillol bronze balanced on that shelf. Such explanations at least possess a certain poetic truthfulness, attributing as they do to art a central role in the death of a man who had recognized and promoted many of the greatest artists of modern times.[153]

In this essay, the following abbreviations are used in citing catalogue raisonné numbers: for works by Cézanne, "R" refers to Rewald 1996; for works by Van Gogh, "F" refers to Faille 1970.

1. "Vollard was an extremely secretive man. No one, I think, had knowledge of his affairs." Suarès 1940, p. 188.
2. Vollard 1936. The French edition, *Souvenirs d'un marchand de tableaux,* appeared the following year (Vollard 1937b). Vollard spent twenty years writing his autobiography. See Dormoy 1963, p. 157. This affectionate account of Vollard given by his friend and secretary Marie Dormoy, who clearly knew Vollard well, is also full of valuable information and insights. Forthcoming is a biography of Vollard by Jean-Paul Morel, to be published by Éditions Séguier, Paris.
3. The original documents are housed in the Bibliothèque and Archives of the Musées Nationaux, Paris, and a microfilm version exists at the Musée d'Orsay, Paris. Some records, particularly for the period 1903–5, are missing. Vollard made a photographic record of his inventory (the name of the photographer Delétang appears often in his account books).
4. See Jonathan Pratt, "The Accounts of Ambroise Vollard," in this volume.
5. After Jarry's death in 1907, Vollard began to produce his own Ubu literature. See the essay by Jean-Paul Morel in this volume and Morel 1994.
6. Spurling 1998, p. 263.
7. Émile Bernard to his mother, July 1894, cited in Welsh-Ovcharov 1998, p. 186.
8. Cézanne to Charles Camoin, March 11, 1902, in Rewald 1984, p. 281.
9. Jean Renoir remembered Vollard's "superb light brown tweed suits" and that he "was very natty, and had his clothes made by one of the best tailors." J. Renoir 1962, pp. 398–99. On the other hand, Marie Dormoy recalled "son pardessus de clochard," his tramp's overcoat, which was famous for years in the sale rooms. Dormoy 1963, p. 142.
10. Dormoy 1943, p. 23172, on Vollard's "inégalités d'humeur."
11. Suarès 1940, p. 191.
12. Ibid., p. 192.
13. "He has the courage of laziness and draws his strength from slowness." Yvonne Mille Serruys, "Ambroise Vollard portraitiste": Vollard Archives, MS 421 (10,12), fol. 5 (manuscript), fol. 6 (typescript).
14. G. Stein 1933, p. 36.
15. See Devoize 2001. I am grateful to Dr. Devoize of the Centre Hospitalier d'Angoulême for sending me his article.
16. Billy 1945, p. 150.
17. Daniel Wildenstein called him "un enfant des îles." D. Wildenstein and Stavridès 1999, p. 64.
18. His name was recorded as Henri-Louis-Ambroise Vollard: Vollard Archives, MS 421 (10,1), fol. 7.
19. Vollard 1936, p. 2.
20. For the complete *Ubu Colonial* see Morel 1994, which contains Morel's essay, "Comment Ambroise le Dionysien rencontra le Père Ubu du pays de Nulle Part."
21. Vollard 1936, pp. 8, 4–6.
22. Ibid., p. 12. Enrollment records at the Faculté de Montpellier confirm Vollard's attendance in 1885–86 and 1886–87. See Guillot 2004–5, p. 10.
23. He passed only the first exams before abandoning his studies: Archives Nationales, Paris, AJ16 1663.
24. Vollard 1936, p. 14.
25. Ibid*.,* p. 18; Brassaï 1982, p. 210. Beginning on April 8, 1893, Vollard paid 89 francs 35 centimes for three months' rent (until July 8, 1893) for an apartment on the sixth floor at 15, rue des Apennins: Vollard Archives, MS 421 (10,6), fol. 1.
26. He also bought the often caricatural drawings of Jean-Louis Forain, Léon-Adolphe Willette, Georges d'Espagnat, and Louis Legrand.
27. Vollard 1936, p. 65.
28. On June 28, 1894, Vollard bought a painting by Corot from Chapuis for 50 francs: Vollard Archives, MS 421 (4,3), fol. 1.
29. Vollard received some financial support from a banker who lent him money at 150 percent for "sureties worth at least double the loan." Vollard 1936, p. 46.
30. Mentioned in a letter from Guillaumin to Vollard, July 27, 1892: Vollard Archives, MS 421 (2,2), p. 145. Guillaumin was an established artist who had already exhibited with Boussod and Valadon and Durand-Ruel. Jacquinot 1999, p. 17.

31. "Received from Mr. Vollard, the sum of 470 francs for a group of drawings and oil sketches by my husband. Veuve Édouard Manet, Genevilliers, March 18, 1894": Vollard Archives, MS 421 (2,3), p. 114. See also Mauclair 1895a, pp. 118–19.
32. Manet, who had died in 1883, was greatly admired by other artists. Paul Gaugin, Guillaumin, Camille Pissarro, and Renoir were among those who took advantage of the opportunity offered by Vollard's exhibition to buy inexpensive works by Manet.
33. "A canvas by Renoir, the *Femme Nue* [fig. 160], now at the Musée Rodin, was for sale in my little shop in the rue Laffitte for 400 francs." Vollard 1936, p. 22. See also Pia 1955, p. 21.
34. See New York 1997–98, vol. 2, p. 87, no. 796. For a complete listing of Degas's purchases from Vollard, see Gary Tinterow, "Degas and Vollard," in this volume, note 10.
35. Vollard 1936, p. 197.
36. For a list of the works Vollard bought at the Tanguy sale, see Anne Roquebert, "A Widening Circle: Vollard and His Clients," note 31, in this volume.
37. Les Archives de Paris, cadastral register, Paris D1P4, 1876, 37, rue Laffitte. The monthly rent was 240 francs.
38. This is the title of chapter 9 in Vollard 1936, pp. 70–80.
39. Camille Pissarro to his son Lucien, January 21, 1894, in Rewald and L. Pissarro 1943, p. 227, and Bailly-Herzberg 1980–91, vol. 3, p. 419, no. 979.
40. See Thomson 1999.
41. "To be alienated was as much a role, a way of establishing a professional identity, as occupying a position in the academy." Jensen 1994, p. 10; and see p. 15 on the "rhetoric of exclusion or neglect and subsequent vindication."
42. A small exhibition of ten of Van Gogh's works had been included in the 1891 Salon des Indépendants, and in 1892 Émile Bernard had arranged a small exhibition at Le Barc de Boutteville gallery.
43. Vollard 1936, p. 24.
44. Les Archives de Paris, cadastral register, D1P4, 1876, 39, rue Laffitte. The monthly rent was 300 francs.
45. Particularly, Den Dulk 1895.
46. Cézanne showed isolated works at the 1882 Salon, the 1889 Centennale de l'Art Français, and in 1893 at Le Barc de Boutteville. See Cahn 1996, pp. 544, 548, 550.
47. Vollard 1948, p. 79.
48. Quoted in Brassaï 1982, p. 212.
49. Vollard 1938b, pp. 64–65. Cézanne's *Bathers at Rest* is in the Barnes Foundation, Merion, Pennsylvania.
50. Natanson 1895a.
51. Vollard 1936, pp. 167–68.
52. Julie Manet, diary entry for November 29, 1895, in R. de B. Roberts and J. Roberts 1987, p. 76.
53. See New York 1997–98, vol. 2, pp. 16–17, nos. 108–15.
54. On November 19, 1895, Pissarro received three sketches, a Cézanne "petit portrait" (possibly R 385), a "baigneur" (R 250), and a "scène champêtre" (R 162) worth 400 francs in exchange for a landscape of his own (1870): Vollard Archives, MS 421 (4,2), fol. 24. On December 12, 1895, Pissarro bought "1 peinture femme nue debout en hauteur de Cézanne" (R 114) for 200 francs: Vollard Archives, MS 421 (4,2), fol. 26.
55. Pellerin, who would become a major collector of Cézanne, paid 3,000 francs for four unspecified works on December 20, 1898: Vollard Archives, MS 421 (4,3), fol. 117. Cochin paid 350 francs for unspecified works on June 23, 1898: Vollard Archives, MS 421 (4,3), fol. 106.
56. Hoogendijk, who bought impulsively in large quantities, spent 12,800 francs on eleven pastels by Steinlen, seven Cézannes, one Van Gogh, and a Monet on May 17, 1899, and a further 5,200 francs for five Cézannes and two Caillebottes on June 3 of the same year. Vollard Archives, MS 421 (4,3), fols. 131, 134.
57. Prices for Cézanne's works rose rapidly. While at the 1895 exhibition Vollard charged just a few hundred francs per work, on October 16, 1909, for example, the Hungarian collector Marczell de Nemes paid 20,000 francs for a single Cézanne. Vollard Archives, MS 421 (2,2), fol. 193.
58. The new gallery comprised "a fine square shop with no dividing wall [with no back shop] built over a cellar, . . . a mezzanine with a dark landing and entrance hall used as a shop, to the right a dark office, a kitchen and a dining room with no fireplace, a bedroom with no fireplace, another bedroom without fireplace, and then a toilet." Les Archives de Paris, cadastral register Paris D1P4, 1876, 6, rue Laffitte.

59. J. Renoir 1962, p. 353.

60. "Vollard . . . never had any idle curiosity, he always wanted to know what everybody thought of everything because in that way he found out what he himself thought." G. Stein 1933, quoted in Brassaï 1982, p. 212.

61. Modification of the translation given in Vollard 1936, p. 247.

62. This contained twenty-two prints by Bonnard, Denis, Henri Fantin-Latour, Edvard Munch, Felix Vallotton, Vuillard, and others.

63. Pissarro to his son Lucien, September 4, 1896, in Rewald and L. Pissarro 1943, p. 294, and Bailly-Herzberg 1980–91, vol. 4, p. 246, n. 2.

64. Green 1987. See also Jensen 1994, pp. 1, 123–34.

65. Quoted in Brassaï 1982, p. 212. This is an oversimplification, however; Vollard did make profits selling works by Van Gogh.

66. Gauguin had wanted his exhibition to be presented at Siegfried Bing's or Durand-Ruel's gallery, but his agent in Paris, Georges Chaudet, took charge once the pictures had arrived in Paris and offered the exhibition to Vollard—who "couldn't have asked for anything better, and sent out invitations to his friends." Chaudet to Gauguin, January 15, 1899, typescript, Loize Archives Musée de Tahiti et des Îles, Punaauia; photocopy in the Service de Documentation, Musée d'Orsay, Paris.

67. The Vollard archives show purchases of several groups of works by Iturrino in various years.

68. Brassaï 1982, p. 213.

69. See Claverie et al. 2002.

70. The Van Dongen exhibition was held in November 1904; the catalogue preface was written by Félix Fénéon. The Matisse exhibition was June 1–18, 1904; the catalogue preface was by Roger Marx.

71. Flam 1995, p. 216. Although Vollard never gave Matisse another exhibition, he continued to buy works from the artist.

72. Vollard 1936, p. 202.

73. Arsène Alexandre, preface to Paris 1899. Sometimes, however, the exhibitions were at the initiative of the artist, who paid Vollard to rent his space. This was the case with Murer in March 1898, Dulac in May 1899, and Diriks in June 1899: Vollard Archives, MS 421 (4,3), fols. 99, 130, 135.

74. Vollard to Gauguin, December 1, 1901, confirming that Vollard will pay 200 francs per picture and will send Gauguin 300 francs a month: Vollard Archives, MS 421 (4,1), p. 39. See also Morel 2003.

75. He placed Puy under contract from 1906 to 1926. Rouault received a studio, a stipend, and additional payments in exchange for his output.

76. About 1907, Kahnweiler began to show Vlaminck's work and offered him a contract. Vlaminck asked the advice of Vollard, who told him: "Do it; it will get your painting known. It will move your paintings, and paintings must move along, change places, travel." Kahnweiler 1971, p. 35, quoted in Assouline 1990, p. 33.

77. Vollard Archives, MS 421 (2,3), pp. 1–10. For the carpet story see Émile Bernard, "L'Aventure de ma vie," Bibliothèque du Louvre, Paris, MS 374 (1,4), p. 168.

78. Dormoy 1963, p. 148. In early May 1906, Vollard bought twenty-seven paintings from Picasso for 2,000 francs: Vollard Archives, MS 421 (2,3), p. 132.

79. Vollard Archives, MS 421 (2,3), p. 369, is a page of drawings for ceramics by Vlaminck.

80. On November 23, 1905, Vollard bought eighty-nine paintings and eighty drawings from Derain for 3,300 francs: Vollard Archives, MS 421 (2,3), p. 57. He bought up Vlaminck's studio (forty-eight works) at the end of May 1906 for 1,200 francs: Vollard Archives, MS 421 (5,1), fol. 101. Vollard recalled Matisse taking him to Vlaminck's studio, where the artist was wearing a painted tie made of wood. "I bought everything Vlaminck showed me: I did the same with Derain." Vollard 1936, p. 201.

81. Vollard financed Derain's three trips to London in March 1906, late March–April 1906, and January–February 1907. See Labrusse and Munck 2005a, p. 13. A receipt dated July 6, 1906, records a price of 150 francs each for Derain's London views: Vollard Archives, MS 421 (2,3), p. 58.

82. He acquired 152 paintings and drawings from Manguin for 7,000 francs on March 24, 1906: Vollard Archives, MS 421 (2,3), p. 119.

83. Vollard took sixty-five works from Puy for exhibition in September 1906: Vollard Archives, MS 421 (2,3), p. 142. Vollard bought paintings valued at 2,755 francs in 1908 and 6,450 francs worth of works in 1910 through 1913, throughout the war years, and continuing in 1919, 1920, and 1924: Vollard Archives, MS 421 (2,3), pp. 152–275. After cessation of his contract with

84. He bought Serret's drawings for 1,000 francs: Vollard Archives, MS 421 (2,3), p. 349.

85. Vollard Archives, MS 421 (4,8).

86. Stockbook B, nos. 3307–28. For later acquisitions, see Chicago–Amsterdam–London 1994–95, pp. 263–65.

87. The receipt from Rousseau confirming that the pictures had been returned is published in Viatte 1962, pp. 331, 334. The original receipt is in the Musée du Vieux Château, Laval. I am grateful to Nancy Ireson for this information.

88. For example, on August 5, 1909, Vollard bought *The Bad Surprise* (*La Mauvaise Surprise*), usually known as *The Hunter* or *The Bear Hunt*, (ca. 1891, Barnes Foundation, Merion, Pennsylvania), a small version of *Fight between a Tiger and a Buffalo*, and *View from the Porte de Vanves*, paying 190 francs for the three works. Viatte 1962, p. 332; Vollard Archives, MS 421 (5,4), fol. 158. On September 12, 1909, he bought from Rousseau *View of the Quai d'Ivry* and *View of the Fortifications*. On September 26, 1909, Rousseau offered to sell Vollard *The Representatives of Foreign Powers Coming to Greet the Republic as a Sign of Peace* (fig. 24) and *Fight between a Tiger and a Buffalo* (1908, Cleveland Museum of Art). On December 12 Vollard purchased the first for 10 francs as a snub to the uninterested French government and the second for 200 francs. See Viatte 1962, pp. 332–33.

89. For 1,200 francs: Vollard Archives, MS 421 (4,3), fol. 94, entry for January 3, 1898.

90. Vollard sent two Seurat drawings to Henry van de Velde (who seems to have been an agent for Baron Kurt von Mutzenbecher) on April 25, 1904: Vollard Archives, MS 421 (4,1), p. 71. *Clothing on the Riverbank* (1883, Tate Britain, London) also passed through Vollard's hands as possibly did *Village Road* (1882–83, Mrs. Alexander Lewyt).

91. Vollard 1936, p. 171.

92. In a letter to his son Georges dated November 24, 1894, Pissarro wrote of this "extraordinary sketch, a superb size 30 canvas." Bailly-Herzberg 1980–91, vol. 3, p. 515.

93. See New York 1997–98, vol. 2, and Gary Tinterow, "Vollard and Degas" note 10, in this volume.

94. A letter from Durand-Ruel to Vollard dated March 31, 1921, concluding the accounts of the Degas sale in New York (after paying Seligmann) records a profit of 151,475.65 francs for Vollard: Vollard Archives, MS 421 (2,3), p. 49. Vollard put up 150,000 francs for his share of the consortium, Durand-Ruel 200,000 francs, Seligmann 823,606.40 francs, and Bernheim 100,000 francs. Undated document [ca. May 1, 1918], signed by all parties (private collection); and Vollard Archives, MS 421 (3,1), fol. 211–12, 272, 273, 277–78, 280–85, 289.

95. On November 22, 1906, Vollard sent the prince de Wagram a bill for 141,000 francs for a number of works, including the Renoir, which was priced at 35,000 francs: Vollard Archives, MS 421 (4,1), pp. 101–2.

96. A compilation of the three biographies was published in 1938 as *En écoutant Degas, Cézanne, Renoir.* See Vollard 1938a.

97. Fry 1917, p. 53.

98. It was completed by Marie-Louise Bataille and published in 1961; see Bataille and G. Wildenstein 1961. See also Johnson 1977, p. 30.

99. See Vollard Archives, MS 421 (2,2), for artists' letters to Vollard. A letter from Maurice Denis dated September 3, 1907 (p. 81), and one from Derain dated May 20, 1908 (p. 101), are two of numerous examples.

100. Rewald and L. Pissarro 1943, p. 28.

101. Brassaï 1982, p. 213.

102. "He excused his painters. He understood them. He was sensitive to them. He loved them." D. Wildenstein and Stavridès 1999, pp. 68–69.

103. However, Vollard's relations with Rouault were fraught. Also see note 75.

104. Vollard Archives, MS 421 (2,2), pp. 321–44. Letters to Vollard from Renoir's model Gabrielle Renard also indicate the warmth of the relationship between artist and dealer: Vollard Archives, MS 421 (2,2), pp. 311–17.

105. Cézanne to Vollard, January 9, 1903, in Rewald 1976, pp. 293–94.

106. Puy to Vollard, September 12, 1916: Vollard Archives, MS 421 (2,2), p. 243. Puy's letters from the front are also remarkable for the way they show him, in the most adverse conditions, keeping on top of his business dealings with Vollard and asking him to send payments to his wife.

107. Gilot and Lake 1964, p. 49. In 1910 Picasso also painted the portraits of three other dealers, Wilhelm Udhe, Daniel-Henry Kahnweiler, and Clovis Sagot.

108. Vollard 1936, p. 224.

109. Vollard was flattered by Picasso's proposal to sketch him every time he visited, until an entire suite would be completed. Vollard's death in July 1939 cut short this scheme. See Johnson 1977, p. 39.

110. "Cher Ami, vous m'avez demandé à maintes reprises de faire votre portrait, j'accepte de le faire mais . . . en habit de toréador." Dortmund 1991, unpaged, quoted in Ottawa–Chicago–Fort Worth 1997–98, p. 343, n. 9.

111. Vollard also bequeathed Renoir's painting of him in a red scarf (fig. 165) to the Musée du Petit Palais. Vollard sold his painted portrait by Picasso (fig. 1) to Ivan Morosov in 1913: Vollard Archives, MS 421 (2,3), p. 34, receipt dated February 24, 1913, and MS 421 (5,9), fol. 42, datebook entry for February 24, 1913.

112. Johnson 1977, p. 15.

113. On Renoir painting this portrait, see J. Renoir 1962, p. 355.

114. Marie Dormoy claimed, "All his life he was in love with a woman for whom he did everything possible, saving himself entirely for her, but who never consented to marry him." Vollard's other liaisons, according to Dormoy, were with women attracted by his great wealth. Dormoy 1963, p. 157.

115. It was shown in the section of the exhibition named the *Centennale,* which contained French art since 1800.

116. Kandinsky to Robert Delaunay, November 5, 1911: Département des Manuscrits, Bibliothèque Nationale de France, Paris, microfilm, 7025. I am grateful to Nancy Ireson for this reference.

117. Flam 1995, p. 124.

118. Pia 1955, p. 26.

119. G. Stein 1933, p. 36.

120. Apollinaire 1910; translated in Breunig 2001, p. 123.

121. Spurling 1998, p. 274.

122. Quoted in Brassaï 1982, p. 210.

123. G. Stein 1933, pp. 37–38.

124. "When a client came, Vollard would draw from his pocket a bunch of no fewer than eighteen keys of all sizes, undo the three locks, pull the door slightly ajar, slip into the storeroom, close the door behind him, and after an indeterminate time reemerge, a single canvas in his hand." Dormoy 1963, p. 153.

125. Brassaï 1982, p. 210. Marie Dormoy (1963, p. 151) refers also to the presence of Le Douanier Rousseau, Willette, Pissarro, Misia Sert, and Mme de Galéa, "le grand amour de Vollard."

126. Apollinaire 1913 (1918 ed.).

127. For example, on September 3, 1904, Vollard sent a large group of works, including Cézannes and Van Goghs, to Cassirer: Vollard Archives, MS 421 (4,1), p. 78.

128. Vollard Archives, MS 421 (4,1), pp. 114–20.

129. London 1910–11.

130. The loans were secured by John Quinn. A Western Union telegraph he sent to Vollard on January 25, 1913, asked him to send three pictures, "Portait of Madame Cézanne," "Portrait by van Gogh," and "Picture of Gauguin Tahiti." John Quinn Memorial Collection, Manuscripts and Archives Division, The New York Public Library, Astor, Lenox and Tilden Foundations.

131. Vollard complained that on this visit he was paraded like a donkey who plays the trumpet. Dormoy 1963, p. 157. For the Knoedler exhibition, see New York 1933.

132. During the war, Vollard's stock was removed to Saumur, in the Loire Valley, and put under Rouault's charge. Vollard retained the premises at 6, rue Laffitte until 1924, when they were demolished to make room for an extension of the boulevard Haussmann.

133. Gimpel 1966, p. 23 (diary entry for May 14, 1918).

134. In his autobiography Vollard claimed that fate dictated his choice of the property in the rue de Martignac because the number, 28, was the same as that of his address in the rue de Gramont; Vollard 1936, pp. 319–20. See also Dormoy 1963, p. 152.

135. Brassaï 1982, p. 210.

136. Vollard 1936, pp. 140–41.

137. Dormoy 1963, pp. 142–43. Dormoy states further (p. 152) that the ground floor had been arranged as a gallery by the famous architect Auguste Perret, who built the Théâtre des Champs-Elysées, but that Vollard never put on an exhibition there. While Rewald remembered that Vollard lived in complete retirement (Rewald 1991, unpaged), according to Dormoy Vollard liked to entertain, giving dinners at the rue de Martignac and informal suppers at his two country properties at Tremblay-sur-Mauldre and Bois-Rond, near Arbonne. Dormoy 1963, p. 156.

138. Rewald 1991, unpaged.

139. "Everything was on the floor, in piles, always. Never any frames. He loved his stock. The more his stock increased, the more pleasure it gave him." D. Wildenstein and Stavridès 1999, p. 65.

140. Dormoy wrote that she suggested the idea of forming a museum to Vollard. "He was more than happy to demonstrate to numerous visitors to the future museum that a simple picture seller had more flair all by himself than all the curators of museums combined." Dormoy 1963, p. 161. Vollard mentioned that after World War I he traveled to Wiesbaden, Germany, where he was thinking of opening a gallery of modern art. Vollard 1936, p. 297.

141. See Dormoy 1963, p. 160.

142. A thorough analysis and assessment of the complex history of the dispersal of Vollard's collection is provided by Jacquinot 1999. The subject is also discussed by Catherine Guillot in her unpublished doctoral thesis for the École du Louvre, Paris; see Guillot 2004–5, pp. 49–55.

143. See Jacques-Émile Blanche to Maurice Denis, December 15, 1939, in Collet 1989, quoted in Jacquinot 1999, p. 25.

144. Jean-Paul Morel has suggested that the total was about ten thousand paintings, not counting drawings and prints. *Le Journal de l'île,* February 16, 2002, p. 22 (Centre de la Documentation de la Direction des Musées de France; box, Musée Léon Dierx, Saint-Denis de la Réunion); quoted in Guillot 2004–5, p. 46, n. 218. A partial inventory drawn up at Vollard's death by Martin Fabiani and Étienne Bignou apparently listed 5,232 works. However, it must be pointed out that Fabiani was fined 146,000,000 francs in 1945 for illegal trafficking in art with the Nazis. The inventory cannot be consulted until one hundred years after Vollard's death. See Guillot 2004–5, p. 48.

145. At the time of Vollard's death, one of his three sisters in La Réunion, one brother, and Monsieur de Galéa senior were no longer living. His estate was divided between Mme de Galéa and his brother Lucien. Four paintings, two by Cézanne and two by Renoir, were left to the Musée du Petit Palais, Paris. Vollard also specified that his collection be sold gradually in at least ten sales over a period of six years or less. Later, Lucien made donations to a number of museums, including the Musée du Petit Palais, the Bibliothèque Nationale de France, Paris, and the Musée Léon Dierx in Saint-Denis de la Réunion, and donated many Vollard publications to the Kunstmuseum in Winterthur, Switzerland. Lucien also sold large parts of the collection. He died in 1952, without issue.

146. "On a perdu la richissimes collections d' Ambroise Vollard" (The Incredibly Rich Collection of Ambroise Vollard Has Been Lost), *Ici Paris,* March 30–April 5, 1948; "5,000 chefs-d'oeuvre de la collection Ambroise Vollard ont disparu: La justice demande des comptes au frère du collectionneur" (5,000 Masterpieces of the Ambroise Vollard Collection Have Disappeared; Justice Demands an Accounting from the Collector's Brother), *France-Soir,* March 23, 1948. Both articles quoted in Jacquinot 1999, p. 25.

147. Jacquinot 1999, p. 26. Daniel Wildenstein's later observation was: "[Chlomovitch] said that Vollard had given them to him. Vollard *giving* something. I'm still laughing . . ." D. Wildenstein and Stavridès 1999, p. 70.

148. The Société Générale decided to organize a sale of these works in 1981, but the sale was cancelled because of a legal dispute between the heirs of Chlomovitch and those of Vollard.

149. The works seized included several hundred Renoirs and dozens of Cézannes, as well as works by Degas, Gauguin, Manet, Monet, and Picasso. "Art Shipment Seized" 1940.

150. Assouline 1990, p. 41.

151. Suarès to Rouault, August 23, 1939, in *Rouault—Suarès Correspondance* 1960, letter 252, quoted in Brassaï 1982, p. 215.

152. Marie Dormoy gives a detailed and less sinister account of the accident and Vollard's death. Dormoy 1963, pp. 162–63.

153. Vollard's funeral was held at the church of Sainte-Clotilde, Paris. It was attended by many artists, including Picasso, who made a special journey from the south of France.

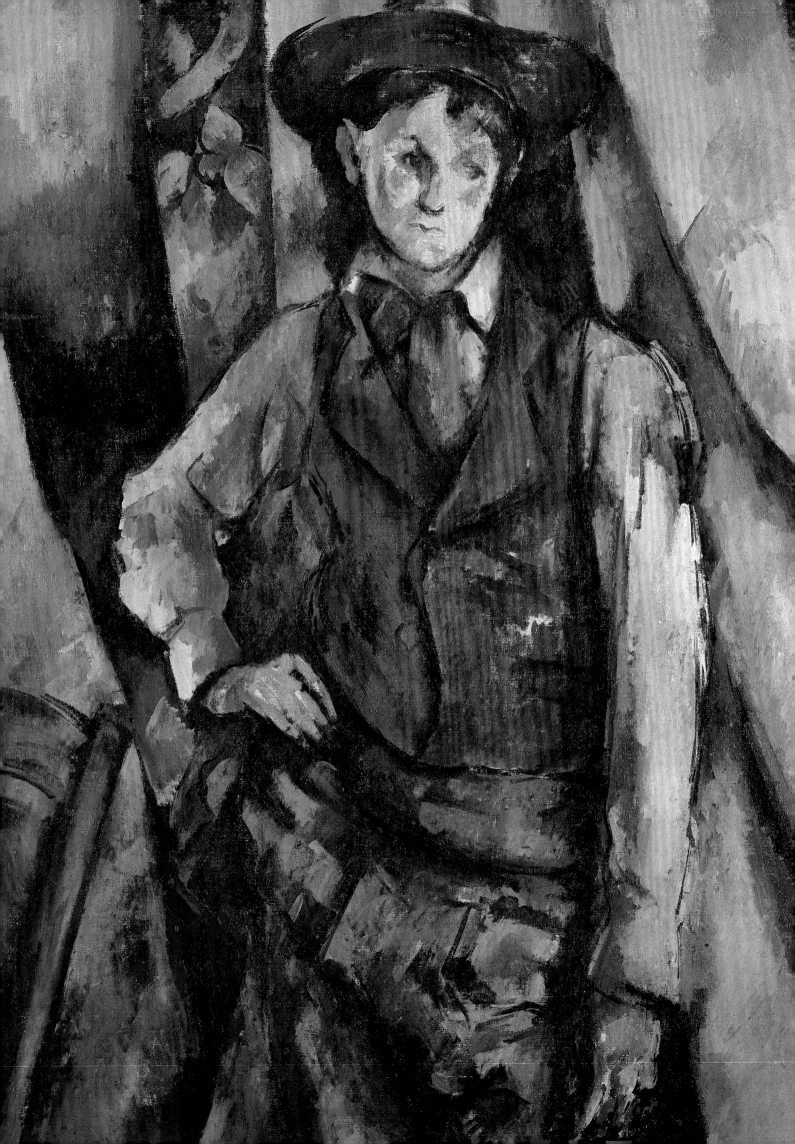

Vollard and Cézanne: An Anatomy of a Relationship

Robert Jensen

The Cézanne exhibition held in November–December 1895 at Ambroise Vollard's gallery marked the beginning of a relationship that would make the dealer wealthy and enable the artist to become the most influential painter of the nineteenth century. Paul Cézanne (1839–1906) was the first important French artist to forge his reputation within the context of a commercial gallery rather than through public art exhibitions.[1] Much of what we know about the interactions between the two men comes through the filter of Vollard's retrospective accounts published long after Cézanne's death.[2] This essay takes a fresh look at their relationship based exclusively on the documentary record. The picture that emerges is of a less-than-scrupulous dealer and an artist who allowed himself to be exploited in exchange for the opportunity to present his work to the public, set against the speculative market for Postimpressionist art that was rapidly developing in the late 1890s.

CÉZANNE AND VOLLARD IN 1895

For the better part of two decades prior to the Vollard show, Cézanne's almost only public showcase had been the tiny shop of Julien (Père) Tanguy, yet barely a handful of his paintings were sold by Tanguy, according to the provenances compiled by John Rewald.[3] Moreover, the artist apparently had not entrusted recent work to him, since in the auction of Tanguy's holdings conducted after his death in 1894, the Cézannes all dated from before the mid-1880s.[4] If one wished to see Cézanne's paintings in 1894, there were few places to go. The largest collections belonged to the artists Gustave Caillebotte and Camille Pissarro, the collectors Victor Choquet, Dr. Paul Gachet, and Eugène Murer, and the writer Émile Zola, who had been Cézanne's childhood friend.[5] These paintings were almost entirely from Cézanne's early career; only Choquet's collection contained any works from later than 1882, and only five at that.[6] Of Cézanne's recent work there could have been

at most a handful of pictures in Paris, scattered among various owners.[7] Thus, Vollard's 1895 Cézanne show made visible what theretofore had not been seen.

Vollard himself acquired his first four Cézannes at the Tanguy auction in June 1894; he paid between 95 and 215 francs apiece, 655 francs altogether. He lost little time turning his purchases around, within a year selling all four for a total of 1,630 francs. The dealer later maintained that he had recognized the value of Cézanne's work from the beginning,[8] but a look at Vollard's early business practices does not unambiguously support that claim. His initial, modest investment in Cézanne was consistent with his scattershot approach to acquiring artists' works at that time; he bought sometimes astutely (Van Gogh, Gauguin) and at other times less so.

In every case Vollard paid a very low price, and he apparently could not afford to tie up his money by holding on to work for very long.[9] He frequently had to reimburse the artist through a protracted schedule of payments. He often acquired pictures through exchanges. It is possible that Vollard was not able to keep his Cézannes long enough to get a better price, but it is equally possible that he did not see any reason to do so.

It is likely, in fact, that Vollard was educated to appreciate the importance of Cézanne's work by the artist's fellow Impressionists.[10] The dealer's association with the Impressionists began with his November 1894 exhibition of Édouard Manet's pastels. Through Mme Manet, Vollard met Berthe Morisot, and through her, Auguste Renoir; and Edgar Degas, Claude Monet, and Pissarro all bought Manets from Vollard in 1894 and 1895.[11] To varying degrees, all of them subsequently helped Vollard identify which artists to buy, made purchases of their own, and brought important collectors to his shop.

Vollard later claimed that the stimulus for his 1895 Cézanne exhibition was the French government's refusal earlier that year to accept the entire contents of Caillebotte's bequest of mostly Impressionist pictures,[12] with the rejected paintings including three of Caillebotte's five Cézannes.[13] Vollard also linked this cause célèbre to the scandal that he described as surrounding his first Cézanne exhibition.[14] What Vollard remembered, however, does not match the public debate and press discussion of the Caillebotte bequest, which largely

Opposite: Fig. 29 (cat. 38). Paul Cézanne, *Boy in a Red Waistcoat*, 1888–90 (detail). Oil on canvas, 35¼ x 28½ in. (89.5 x 72.4 cm). National Gallery of Art, Washington, D.C., Collection of Mr. and Mrs. Paul Mellon, in Honor of the 50th Anniversary of the National Gallery of Art (1995.47.5)

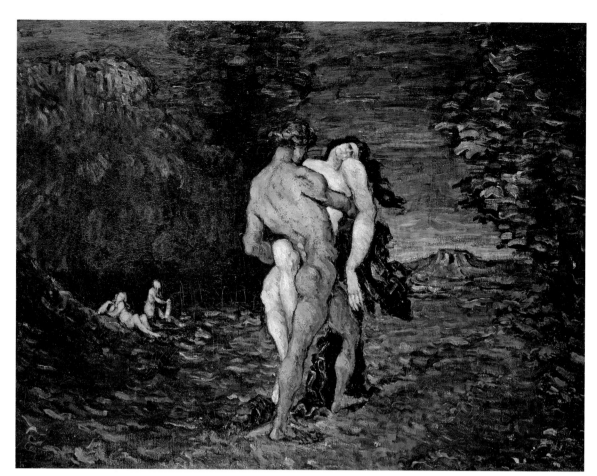

Fig. 30 (cat. 24). Paul Cézanne, *The Abduction*, 1867. Oil on canvas, 35⅝ x 46 in. (90.5 x 117 cm). The Provost and Fellows of King's College, Cambridge University (Keynes Collection), on loan to the Fitzwilliam Museum, Cambridge

occurred in 1894 (when the decision to accept the bequest was first announced) and 1897 (when the collection in its reduced form finally went on view).[15] As for Vollard's show, contemporary reviews of the exhibition were largely positive and give no hint of strong controversy.[16]

Remarkably, because the artist could not be found, the 1895 show was initially planned without Cézanne's involvement. Renoir, one of the Caillebotte estate's executors, probably arranged for the loan of at least one of the refused Cézanne paintings from the collection, *Bathers at Rest* (1876–77, Barnes Foundation, Merion, Pennsylvania), and Pissarro agreed to lend his collection of as many as thirteen (mostly pre-1880) Cézannes.[17] When for unknown reasons Pissarro backed out, Vollard finally located Cézanne's son, then living in his father's Paris studio, and through him gained the artist's permission to show his works.[18] Vollard recalled, "I secured nearly one hundred and fifty canvases from Cézanne himself. He sent them rolled up to spare them as much as possible, because he decided that in transportation the stretchers took up too much space."[19]

Recently some scholars have discounted Vollard's account because they believe that Cézanne did not participate in the exhibition arrangements[20] and ship his works from Aix but rather that Vollard selected them, with the assistance of Cézanne's son, from among the paintings the artist had left in his Paris studio. This scenario is used to explain why some of the paintings offered for sale at the exhibition were radically unfinished; had Cézanne been involved, the thinking goes, he could never have wanted to sell such work. (At the time, one unfriendly critic described the show as a collection of "studio leavings.")[21] In support of this theory it has been pointed out that Cézanne subsequently entrusted to his son most business dealings with Vollard.

Further, Cézanne's presumed lack of interest in the marketing aspects of his career has been connected to a presumed negligence toward his paintings—an interpretation much enhanced by Vollard, who colorfully described Cézanne's mistreatment of some of his works, abandoning canvases in trees, striking them in fits of temper, allowing them to be cut up and sold in pieces, and so on.[22] The negligent Cézanne of this reading, wanting nothing to do with business, was happy to entrust to the dealer exclusive curatorial power.

How we evaluate these theories has a direct bearing on how we understand the character of Cézanne's late paintings, paintings that often display above all a high degree of incompleteness. Is this a sign of the artist's "unprofessionalism," as Richard Shiff once wrote,[23] or, from a very different perspective, is it the result of a deliberate choice by Cézanne?

Opposite: Fig. 31 (cat. 26). Paul Cézanne, *The Feast (The Orgy),* ca. 1867–70. Oil on canvas, 51⅛ x 31⅞ in. (130 x 81 cm). Private collection

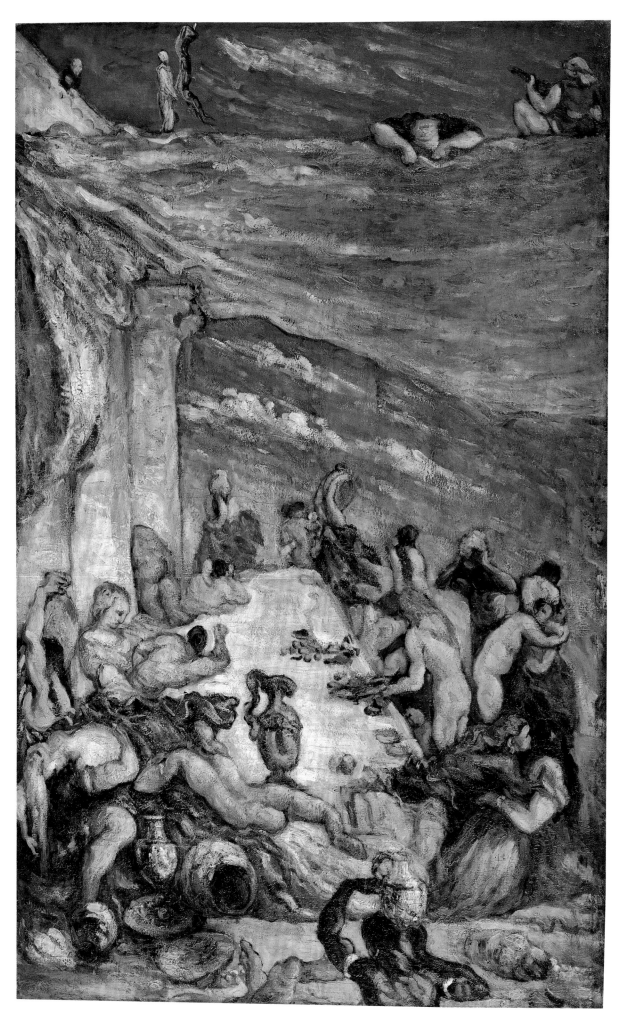

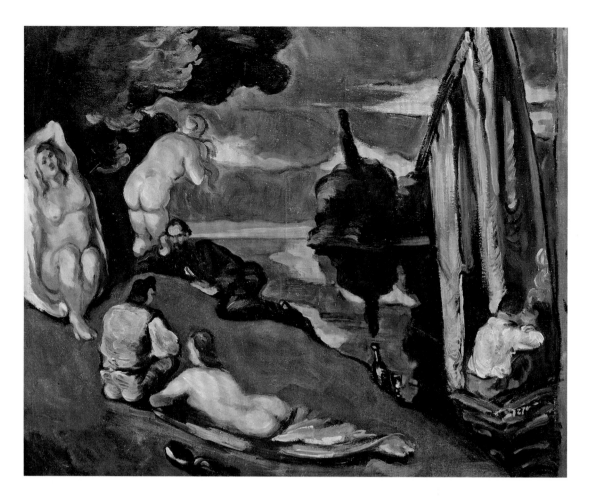

Fig. 32 (cat. 27). Paul Cézanne, *Pastoral (Idyll),* ca. 1870. Oil on canvas, 25⅝ x 31⅞ in. (65 x 81 cm). Musée d'Orsay, Paris (RF 1982-48)

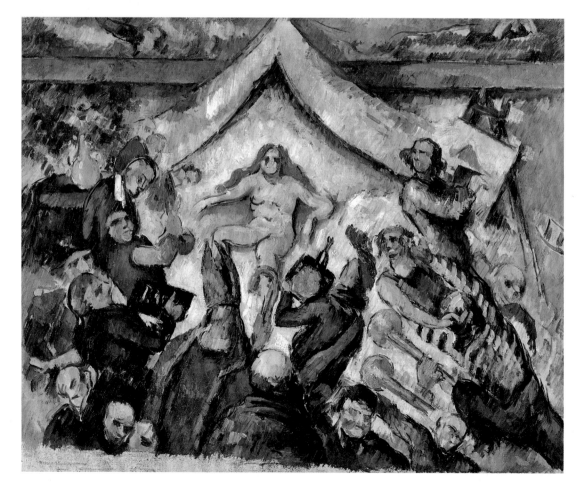

Fig. 33 (cat. 29). Paul Cézanne, *The Eternal Feminine,* ca. 1877. Oil on canvas, 17 x 20⅞ in. (43.2 x 53 cm). The J. Paul Getty Museum, Los Angeles (87.PA.79)

To answer this question we have, as it happens, some quite specific evidence with which to test the validity of Vollard's story that Cézanne shipped rolled canvases to him from Aix. Rolled paintings should exhibit specific cracking patterns on their surfaces. And the cracking patterns are there. So far I have been able to identify twenty-six works, among them *Madame Cézanne in a Yellow Chair* of 1890 (fig. 44), that show signs of having once been rolled.[24] With the exception of one canvas that the artist sent (rolled) to a German friend in 1868,[25] all the paintings in question passed through Vollard's hands. All possess provenances that could have placed them in the 1895 show. And so far I have found no once-rolled canvases that Rewald dated later than 1895. Vollard complained of the inconvenience of receiving his paintings rolled; it would surely have made no sense to remove the canvases from their stretchers merely to transport them across Paris.

Rolled canvases stand out in Cézanne's oeuvre because, despite stories about the artist's abuse of his pictures, the paintings are in fact in excellent condition overall.[26] Few paintings were in circulation before 1895 and even fewer had ever been shipped for exhibitions. In 1896 the young poet Joachim Gasquet wrote of seeing a thousand canvases stacked in Cézanne's studio in Aix.[27] Gasquet's figure may be too high— it exceeds the total number of paintings in Rewald's catalogue raisonné—but clearly a great number were still in the artist's possession in his Aix studio.[28]

We have, then, quite specific evidence supporting Vollard's story that Cézanne himself submitted at least some of the paintings in this major show.[29] With this knowledge, we can turn to the question of Cézanne's artistic ambitions. Take the example of *Gardanne* (1885–86; fig. 37); the picture suffered significant damage from rolling (as has long been known by conservators at the Metropolitan Museum) and is probably the painting that Vollard sold to Enrico Costa on February 27, 1896.[30] Although *Gardanne* is radically incomplete, the painter clearly intended it for exhibition and sale, and thus it would seem that in his own mind it was as complete as he could make it. Cézanne may not have considered such a canvas fit for the Salon, the goal and standard of his early years as an artist, but it was clearly good enough to send to Vollard.

Vollard's 1895 show both encouraged a perception of Cézanne as a producer of flawed works foisted on the public by unscrupulous dealers[31] and gave rise to a far more profound idea, that Cézanne's paintings were nothing short of revelatory. Both reactions are expressed in a remarkable letter Pissarro wrote to his son Lucien in November 1895:

I also thought of Cézanne's show in which there were exquisite things, still lifes of irreproachable perfection, others much worked on and yet unfinished, of even greater beauty,

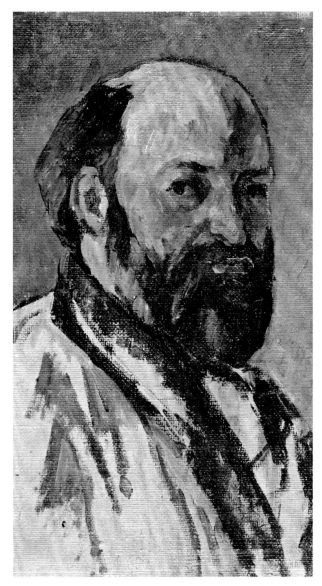

Fig. 34 (cat. 30). Paul Cézanne, *Self-Portrait*, ca. 1877–80. Oil on canvas, 10 x 5¾ in. (25.5 x 14.5 cm). Musée d'Orsay, Paris, Painting recovered by the Allies after World War II and entrusted to the care of the Musées Nationaux Récupération (MNR228)

landscapes, nudes and heads that are unfinished but yet grandiose, and so painted, so supple. . . . Curiously enough, while I was admiring this strange, disconcerting aspect of Cézanne, familiar to me for many years, Renoir arrived. But my enthusiasm was nothing compared to Renoir's. Degas himself is seduced by the charm of this refined savage, Monet, all of us. . . . Are we mistaken? I don't think so. The only ones who are not subject to the charm of Cézanne are precisely those artists or collectors who have shown by their errors that their sensibilities are defective. They properly point out the faults we all see, which leap to the eye, but the charm—that they do not see.[32]

The first striking thing about this letter is that Pissarro writes as if none of his fellow Impressionists were prepared for what they saw in Vollard's shop. Clearly the exhibition was not a retrospective in the conventional sense; regardless of when

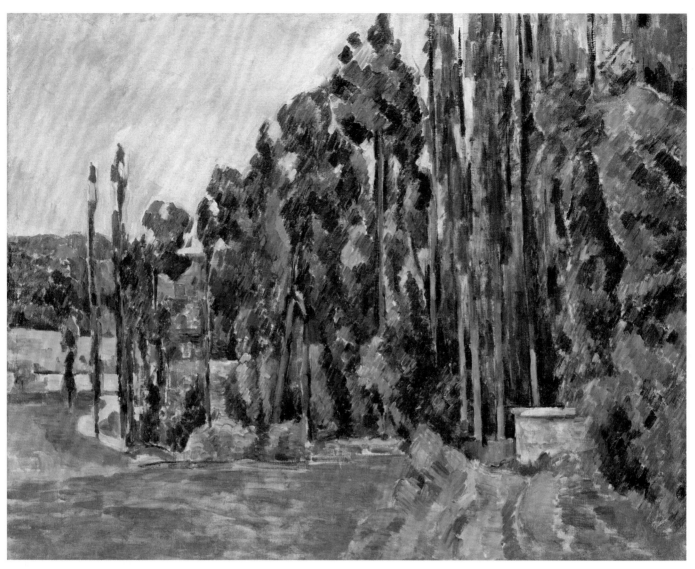

Fig. 35 (cat. 31). Paul Cézanne, *Poplars*, ca. 1879–80. Oil on canvas, 25½ x 32 in. (65 x 81 cm). Musée d'Orsay, Paris, Bequest of Joseph Reinach, 1921 (RF 2324)

they were painted, almost none of these works had been seen before so that in essence the show was an exhibition of new work. Second, Pissarro's reaction makes us wonder what kind of artist Monet, Pissarro, and Renoir had thought they were promoting to Vollard. Except for Renoir, they had had little contact with him or his work since the early 1880s.[33] Did they understand the painter Cézanne had become since his last significant exhibition eighteen years ago at the third Impressionist show of 1877?

Cézanne's paintings of the early 1880s were generally tightly structured compositions rendered in relatively simple color arrangements, as exemplified by such landscapes as *Poplars* of circa 1879–80 (fig. 35). This is when Cézanne developed what Theodore Reff called his "constructive stroke": discrete, often thickly painted blocks of color applied in parallel strokes, generally running in the same direction, which the artist used to organize his observations and unify his compositions.[34] In the years that followed, Cézanne's growing confidence was

expressed in his new, more ambitious figure paintings, such as the Cardplayers series (fig. 45); more complex compositions, especially in the still lifes; and the use of increasingly saturated colors applied in juxtaposed complements laid down in regular sequence. This technique achieved what Cézanne called "color modulation." Now he often painted with transparent washes of color, applied in increasingly larger blocks and frequently laid in multiple, opposing directions, which suggest, without defining, the objects to which they refer. Some aspects of this approach can be seen in an early example, *The Pool at the Jas de Bouffan* of the late 1880s (fig. 36). Cézanne also began habitually to leave significant areas of the canvas unpainted while occasionally working up other areas of the same canvas with thickly applied paint.

Pissarro responded to the new directions Cézanne's work had taken with words like "savage" and "incomplete," terms that had already been used by critics to describe both the artist and his work.[35] When he noted Cézanne's "charm" despite "the

Fig. 36. Paul Cézanne, *The Pool at the Jas de Bouffan*, late 1880s. Oil on canvas, 25½ x 31⅞ in. (64.8 x 81 cm). The Metropolitan Museum of Art, New York, Bequest of Stephen C. Clark, 1960 (61.101.5)

faults we all see," Pissarro was—perhaps unconsciously—subscribing to the belief that Cézanne was not the master of his own art. Pissarro appears not to have understood that by selecting such works for exhibition, Cézanne was very far from conceding that there were "faults" within his pictures. Perhaps Pissarro's characterization was the only way he could begin to acknowledge that Cézanne had outgrown him as an artist, an admission he had not been required to make before the 1895 show.

Also new to the critical reception of Cézanne's work in 1895 was a perceived linkage between the artist and the protagonist of Zola's 1886 novel *L'Oeuvre,* Claude Lantier.[36] On the book's initial publication, Lantier—portrayed by Zola as a failed artist and eventual suicide—was widely thought to be modeled on Manet, or the Impressionists in general.[37] But in 1895 Lantier became firmly identified with Cézanne; Arsène Alexandre's at-best-equivocal review of the Cézanne show was even entitled "Claude Lantier."[38] Years later, in a conversation related by Émile Bernard, Cézanne himself famously demonstrated his deep identification with another fictional artist, Frenhofer, the old master painter at the center of Balzac's novella *Le Chef-d'oeuvre inconnu* (*The Unknown Masterpiece*).[39] As Bernard emphatically noted, Frenhofer was not to be confused with Lantier, an artist "born without talent." No, Frenhofer was "blocked by his very genius" from producing the work of his dreams. Here Bernard reproduces what I am certain Cézanne believed: that he was the greatest painter of his generation. In Cézanne's view, *even he* was incapable of realizing his exalted ambitions for painting.

THE DEALER'S SHARE

In 1895 Cézanne was already fifty-six, and closely connected with the Impressionists. Why then was Vollard the first dealer to show the painter's work in any quantity? One reason is that Cézanne's achievement had not yet been fully recognized by the critics; the first lengthy article on the artist, by Gustave Geffroy, appeared only in 1894, and memorably described Cézanne as "somebody at once unknown and famous."[40] Another reason is that even as late as the early 1890s, only a handful of dealers in Paris were seriously selling advanced contemporary art. Paul Durand-Ruel, the Impressionists' dealer, was blind to the value of the Postimpressionists Van Gogh, Seurat, and Gauguin, and did not actively pursue Cézanne's work before 1899.[41] Theo van Gogh and Tanguy were both dead by the end of 1894. The gallery of Louis-Léon Le Barc de Boutteville did, during the early 1890s, present group shows of many of the artists Vollard later pursued, such as the Nabis, and solo shows of Van Gogh (in 1892) and Maxime Maufra (in 1894). But Le Barc de Boutteville was already in his late fifties (he died in 1896), and it appears that artists willingly abandoned him to sign up with Vollard and other young dealers who followed in Vollard's wake.

Fig. 37. Paul Cézanne, *Gardanne*, 1885–86. Oil on canvas, 31½ x 25¼ in. (80 x 64.1 cm). The Metropolitan Museum of Art, New York, Gift of Dr. and Mrs. Franz H. Hirschland, 1957 (57.181)

Fig. 38 (cat. 45). Paul Cézanne, *Curtain, Jug, and Dish of Fruit*, 1893–94. Oil on canvas, 23¼ x 28½ in. (59 x 72.4 cm). Private collection

Stepping first into this market vacuum, Vollard, through a combination of luck and perspicacity, acquired a monopoly over Cézanne's work that lasted almost a decade. During those years, when Cézanne was admired by only a few prescient collectors and imitated by even fewer painters, Vollard emptied the artist's studio in Aix of most of the great cache of paintings and watercolors Gasquet had seen stored there—a stockpiling that eventually made Vollard's fortune. Rewald's catalogue raisonné shows 678 Cézannes, more than two-thirds of the artist's oils, passing through Vollard's hands.[42]

Vollard's agreements with Cézanne must be deduced from circumstantial evidence, since no contracts survive. Fortunately, the gallery's earliest years are documented by the richest assemblage of the dealer's business records: a number of account books[43] and two stockbooks, Stockbook A, begun in 1899, and Stockbook B, begun about 1904.[44] So numerous, in fact, are these early documents that we might wonder what they were all for, especially since they also present formidable problems to anyone seeking to understand Vollard's business practices. The stockbooks often lack such critical information as the purchase date of a painting, its purchase price, and to

whom, and when, Vollard eventually sold the work. Also unspecified is whether Vollard was holding a painting on consignment from an artist or had purchased it outright.[45] The less-structured account books present similar problems; some information is continuous from book to book, some is not. Specifics of sales or expenditures recorded in one book might contradict those in another.[46] And for all the recordkeeping on hand, there are still many major omissions, especially in regard to the Cézannes.

The dealer entered in his account books the sales of at least 128 of Cézanne's paintings between November 1895 and March 1901 that were not recorded in Stockbook A.[47] The total sales price of these pictures is likely to have exceeded 81,000 francs. Sales between 1899 and 1901 of an additional seventeen paintings that were recorded in Stockbook A raise Vollard's total recorded intake for Cézanne's works to about 125,000 francs. Did Cézanne know the extent of Vollard's profit from his work during the early years of their relationship? The records suggest some subterfuge on Vollard's part. For example, the Dutch collector Cornelis Hoogendijk acquired thirty-one Cézannes from Vollard between 1897 and late 1899

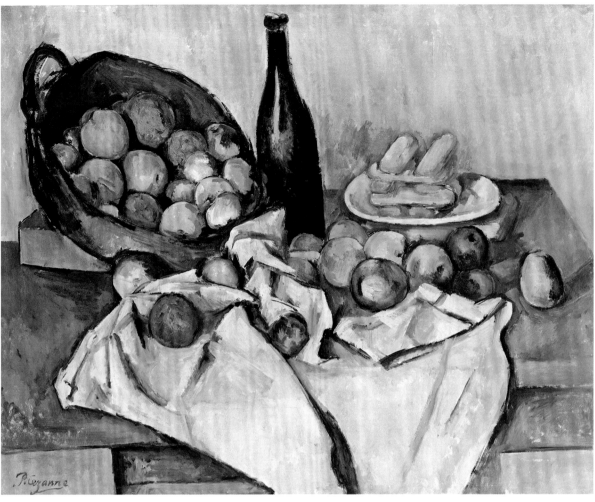

Fig. 39 (cat. 44). Paul Cézanne, *The Basket of Apples*, ca. 1893. Oil on canvas, 25⅝ x 31½ in. (65 x 80 cm). The Art Institute of Chicago, Helen Birch Bartlett Memorial Collection (1926.252)

(when Hoogendijk returned permanently to the Netherlands), but none of these sales is recorded in Stockbook A. In one of his account books Vollard recorded twenty-one separate payments Hoogendijk made to the dealer, but the first to refer to a Cézanne purchase does not appear until May 1899.[48] Even a very close perusal of this account book would suggest to an outside examiner that Hoogendijk purchased only eleven Cézannes, among the many other pictures he acquired.[49]

It is impossible to know how many Cézannes Vollard sold without record. But I looked at the acquisitions of just five other major collectors who bought numerous Cézannes from Vollard during these same years: Egisto Fabbri, H. O. and Louisine Havemeyer, Octave Mirbeau, Claude Monet, and Auguste Pellerin. Seventeen of Fabbri's acquisitions are not entered by name in the account books or the stockbooks; also missing are five of the Havemeyers', four of Mirbeau's, four of Monet's, and fifteen of Pellerin's, including such works as *The Eternal Feminine* of circa 1877 (fig. 33), which we know was exhibited at Vollard's in 1899, and *Leda and the Swan* (fig. 236) of circa 1880, which Vollard himself said he sold to Pellerin in 1895.[50] These together with Hoogendijk's

pictures add up to at least seventy-six paintings for which there are no clear sales records among Vollard's papers.[51] Assuming a very modest average price of 500 francs, these pictures represent a minimum of 40,000 francs in undeclared sales. To put this figure in perspective, we know that Cézanne's share of his father's estate—which his artist friends believed had made the painter wealthy—amounted to about 51,000 francs.[52] And Cézanne certainly could have used a percentage of these earnings. According to Rewald the artist was "heartbroken" when in 1899 the family estate, Jas de Bouffan, was sold out from beneath the artist by his brother-in-law, for financial reasons.[53]

In recording his expenses, Vollard was, not surprisingly, more scrupulous. In the account book containing payments from Hoogendijk, one also finds careful records of his gas bills and sundry items as well as other regular payments, such as those made to artists. It is probable, then, that most if not all of Vollard's payments to Cézanne were registered in this account or its supplement, which contains transactions of 1900 and 1901.[54] Vollard's payments to either Cézanne or his son (as his father's agent) during these years can be divided into three distinct parts. The first occurred in the period

December 1895–May 1897, during which he paid the family 7,250 francs.[55] No payments to the Cézannes are recorded between June 1897 and January 1898. Early in 1898 Vollard made a more substantial commitment to the family, agreeing to pay 13,700 francs in three promissory notes for an unspecified number of paintings. The final payment on this agreement was made on March 31, 1899, which, interestingly, is about when Vollard began Stockbook A.[56] At this time Vollard also first recorded buying a specified number of paintings from the Cézannes for a set amount.[57] A third schedule of payments probably began at this time and ended in the spring of 1901 with the last entry in the account book supplement.[58] During this period Vollard paid the Cézannes 19,424 francs. In the course of some six years, Vollard paid the Cézannes 41,374 francs in exchange for an unknown quantity of pictures.

In Stockbook A, Vollard recorded purchase prices for nearly three hundred paintings by Cézanne. After eliminating from the tally pictures he acquired from secondary sources or repurchased from collectors, we arrive at 228 works, recorded with their purchase prices, that Vollard acquired directly from the Cézannes.[59] We can then add 128 Cézannes whose sales are clearly recorded in the account books but do not appear in the stockbooks, and the at least seventy-six Cézannes with unrecorded sales, for a total of at least 432 paintings.

Vollard's total payments to Cézanne between January 1898 and March 1901 amounted to 33,124 francs, only 500 francs less than the total of his Cézanne purchases entered in Stockbook A. This close correlation strongly suggests that Vollard's commitment to buy up Cézanne's studio occurred in January 1898. It also suggests that the purchase prices recorded in Stockbook A reflect a financial reconciliation made with the Cézannes, in which they agreed to let Vollard have all the paintings already in his possession, plus whatever they would sell him in 1898–1901, for a little more than 33,000 francs; altogether, less than 100 francs per picture.[60] Finally, if these calculations are correct, then the 7,250 francs Vollard paid the Cézanne family between December 1895 and May 1897 should be considered his total payment to them for all the works shown in the 1895 Cézanne exhibition (and subsequently sold).[61] If we accept Vollard's account that he received almost 150 paintings from the artist for that show, it appears that he paid the Cézannes about 50 francs per painting for them.

Initially, Vollard's profit margin was fairly small. Costa, for example, bought *Gardanne* for 500 francs. Monet later recalled buying one of his Cézannes, *The Negro Scipion* of circa 1867 (fig. 40), from Vollard during these years, at what he felt was a bargain price of 400 francs.[62] Even then, however, the Cézannes received less than 25 percent of Vollard's average sales price. This disparity grew significantly over the next half decade.

The July 1899 auction of the estate of Cézanne's great patron Victor Choquet effectively closed the window on Vollard's ability to acquire Cézanne's work cheaply and announced to the world that these paintings were now the object of significant speculation. Choquet's Cézannes sold for an average price of 1,489 francs.[63] Collectors bought only four paintings; Vollard and rival Parisian dealers purchased the remaining twenty-six. While Vollard henceforth paid significantly higher prices to the Cézannes, the seeds of his great fortune had already been planted. By 1900 he owned nearly two-thirds of all the Cézannes that would ultimately pass through his hands. Consider the example of *The Bather*, circa 1885 (Museum of Modern Art, New York), for which Vollard recorded a purchase price of 200 francs in Stockbook A. In about 1910, John Quinn reported, Vollard offered to sell him the painting for 50,000 francs.[64] Even allowing for inflation, no Parisian dealer ever achieved such dramatic rates of return for so many works by a single artist as Vollard did with his Cézannes.

CÉZANNE'S MARKET

In nineteenth-century France it was unprecedented for an artist's prices to rise precipitously before his work had attracted widespread public attention. How much should Vollard be credited for bringing Cézanne's remarkable market into existence?

Even a year before the 1895 show, Gustave Geffroy described collectors already anxiously pursuing Cézanne's hard-to-find canvases.[65] Some confirmation that this nascent market existed is found in the early 1894 auction of the collection of the respected critic Théodore Duret, where the Cézannes sold for prices ranging between 650 and 800 francs.[66] (At the time, 650 francs was more than the monthly salary of a typical white-collar worker in France.)[67] On the other hand, a few months later the six Cézannes sold in the Tanguy auction yielded an average price of only 126 francs,[68] and the thirteen Cézannes Vollard sold before the end of December 1895 also brought him on average only a modest 316 francs.

Starting from these mixed early sales figures, we can roughly calculate the impact Vollard's exhibitions had on the prices of Cézanne's pictures.[69] In the wake of the first Cézanne exhibition, Vollard's recorded average price for a Cézanne rose slightly to 339 francs, less than a 10 percent increase. In the next year, 1897, without the benefit of another show, the average increased more than 25 percent, to 454 francs. Directly after Vollard's second Cézanne show in May–June 1898, the average rose by about 17 percent, to 545 francs. Then, in 1899, there was a substantial jump, about 64 percent, to almost 850 francs per picture. Vollard's third Cézanne exhibition was not held until the end of 1899.

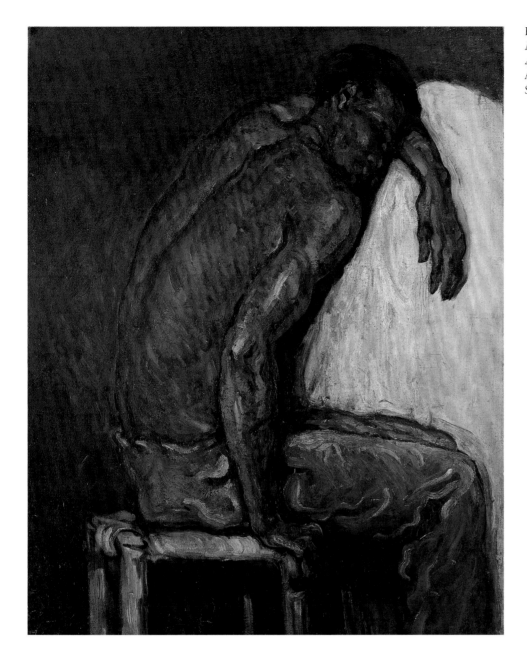

Fig. 40 (cat. 25). Paul Cézanne, *The Negro Scipion*, ca. 1867. Oil on canvas, 42⅛ x 32¾ in. (107 x 83 cm). Museu de Arte de São Paulo Assis Chateaubriand, São Paulo (85.1950)

This history suggests that the exhibitions did not in themselves produce immediate rises in the value of Cézanne's work; outside factors must have been at least as influential in establishing Cézanne's market value as any public action by Vollard on the artist's behalf. It is particularly worth noting that two Cézannes went on permanent display in the Musée du Luxembourg early in 1897 as part of the Caillebotte bequest, and, also in 1897, the Nationalgalerie of Berlin purchased a Cézanne. But an even more potent force driving up Cézanne's prices was the international competition for his work among collectors and dealers. French collectors like Baron Denys Cochin and the industrialist Pellerin competed with the likes of the Dutch Hoogendijk and the Americans Charles Loeser, Fabbri, and Havemeyer (who probably purchased his first Cézanne in 1898). All of them bought in quantity.

Dealers followed collectors. In 1896 and 1897 only a few unimportant dealers bought Cézannes from Vollard. However,

in December 1898 Vollard recorded his first sales of Cézanne paintings to the dealer Jos Hessel,[70] followed immediately by numerous sales both to Hessel and to his cousins Josse and Gaston Bernheim-Jeune. The Galerie Bernheim-Jeune brought a new level of professionalism, visibility, and competition to Cézanne's market. Finally, the Galerie Durand-Ruel began to take an active interest in Cézanne beginning in 1899 at the Choquet auction, where Durand-Ruel was the most aggressive bidder.

Cézanne's erstwhile colleagues among the Impressionists also contributed significantly to the development of the artist's early market, being the most active purchasers of his work during and immediately following his first show. Monet probably purchased eleven of his fourteen Cézannes in the period after 1895.[71] Degas bought all seven of his from Vollard beginning in November 1895,[72] and Pissarro and Renoir also acquired some pictures at this time.[73] Monet, interestingly, was the sole

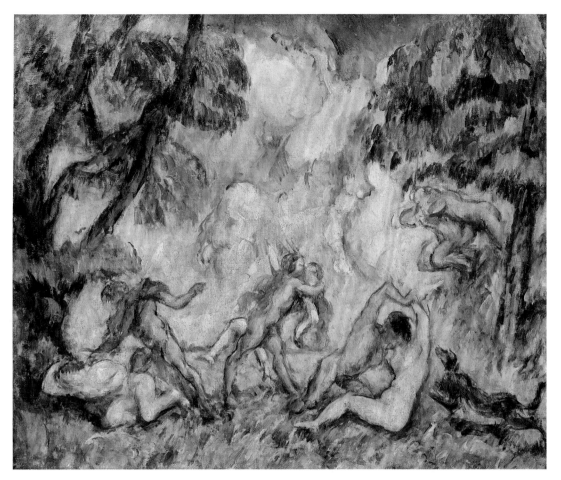

Fig. 41 (cat. 34). Paul Cézanne, *The Battle of Love*, ca. 1880. Oil on canvas, 14⅞ x 18¼ in. (37.8 x 46.4 cm). National Gallery of Art, Washington D.C., Gift of the W. Averell Harriman Foundation in memory of Marie N. Harriman (1972.9.2)

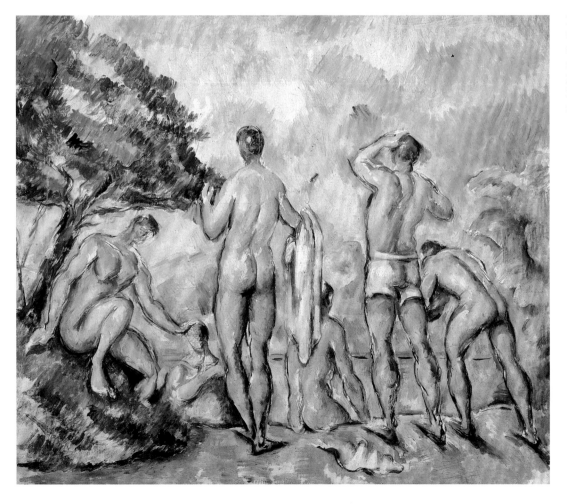

Fig. 42 (cat. 41). Paul Cézanne, *Bathers*, 1890–92. Oil on canvas, 21⅜ x 26 in. (54.3 x 66 cm). St. Louis Art Museum, Funds given by Mrs. Mark C. Steinberg (2:1956)

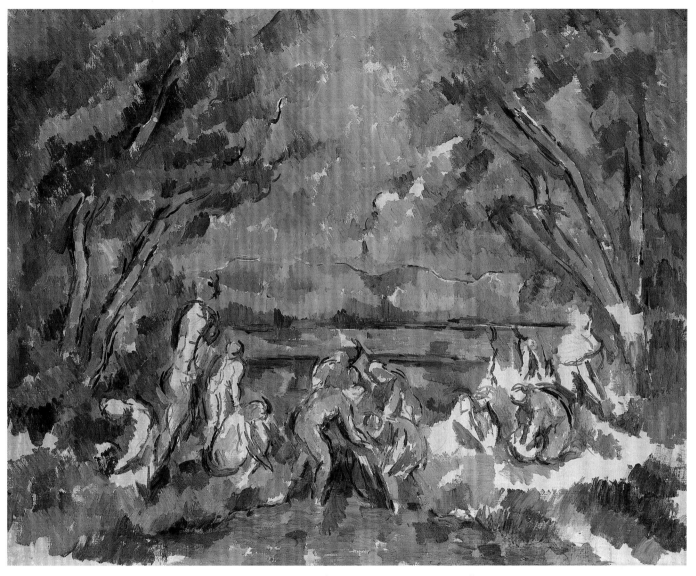

Fig. 43 (cat. 48). Paul Cézanne, *Bathers*, 1902–6. Oil on canvas, 29 x 36⅜ in. (73.5 x 92.5 cm). Private collection

Impressionist to buy both early and later Cézannes, clearly the only one who appreciated the direction taken in the artist's more recent work. Monet prized his Cézannes over the paintings of all other artists, even hanging one over his bed (*Château Noir*, 1903–4, Museum of Modern Art, New York).[74] These artists also guided collectors to Vollard's shop. Degas brought the dealer some of his wealthiest and most aristocratic clients, such as Baron Cochin—who eventually owned at least twenty-two Cézannes, including *Madame Cézanne in a Striped Dress*, 1882–85, and *The Pool at the Jas de Bouffan*, 1886 (fig. 36)—and Count Isaac de Camondo, who acquired fifteen. The critics and collectors who often gathered around Monet at Giverny included Mirbeau (twelve Cézannes) and Geffroy (as many as eight). Pissarro was instrumental in introducing Fabbri, an amateur painter, to Cézanne's work; he bought thirty-two paintings, including *Boy in a Red Waistcoat*, 1888–90 (fig. 29), and, according to Gertrude Stein, initiated in turn another American, Loeser, who bought fifteen.[75] Mary Cassatt advised the Havemeyers; before 1900 they acquired as

many as four of their thirteen Cézannes, including *The Bay of Marseilles Seen from L'Estaque* (Metropolitan Museum).[76] Vollard credited Cassatt with keeping his gallery afloat by finding such buyers.[77]

Only two major collectors, Pellerin and Hoogendijk, bought their Cézannes without the documented advice of artists. Hoogendijk, if we believe Vollard, essentially stumbled into the dealer's shop;[78] in a short four years his collection of Cézannes outnumbered Choquet's. Pellerin, according to Vollard, bought his first Cézanne at the 1895 show.[79] By 1906 he may have possessed as many as 150 Cézannes.[80]

Although the collectors and dealers who bought Cézannes between 1895 and 1900 were not significantly more numerous than those who owned works by the artist before Vollard's show, only ten individuals (excluding Vollard) belonged to both categories. Of these, three were dealers and four were artists—Monet, Pissarro, Renoir, and Émile Schuffenecker.[81] Prior to 1895, most of Cézanne's paintings were in the possession of an intimate circle consisting of the artist's family, his

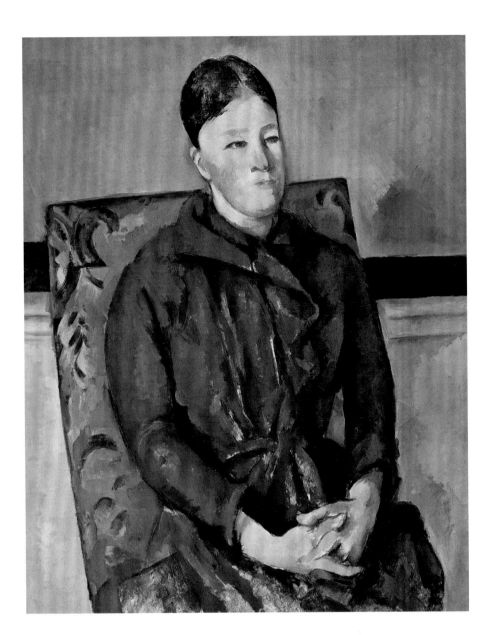

Fig. 44 (cat. 46). Paul Cézanne, *Madame Cézanne in a Yellow Armchair*, 1893/95. Oil on canvas, 31⅞ x 25½ in. (80.9 x 64.9 cm). The Art Institute of Chicago, Wilson L. Mead Fund (1948.54)

childhood friends, and persons with whom he came into daily contact: fellow artists, maids, shopkeepers, innkeepers, etc. Fewer than a third of the owners were collectors, and the artist knew almost all of them personally. But after 1895 well over half were collectors, and almost none of them had a personal relationship with the artist. These figures embody a dramatic if not surprising shift from a private to a public appreciation of the artist's work.

It is noteworthy too that in these pre-1895 collections only 5 percent of the paintings had been painted after 1884 (until 1895, pictures dating later than that had been largely unavailable). However, a third of the Cézannes acquired by collectors after Vollard's show had been painted between 1885 and 1895, a percentage that is about the same as their representation within the artist's oeuvre overall. Some post-1895 collectors even concentrated on recent work: twenty-one of Hoogendijk's thirty-one paintings date from after 1885, all seven of Geffroy's known Cézannes postdate 1885, and half of Monet's Cézannes were painted after 1890.

Thus Vollard was the conduit but certainly not the driving force behind the development of Cézanne's market—a role that belonged largely to Cézanne's fellow artists. Vollard did not actively promote Cézanne and except for the exhibitions did very little on his behalf. However, simply by presenting *all* of Cézanne's oeuvre to the public, Vollard's shows redefined Cézanne's achievement, which was enthusiastically embraced by his fellow artists, a small but committed group of collectors, and, eventually, rival dealers.

THE ARTIST'S SHARE

There is little reliable documentation of Cézanne's response to his public success after 1895. We know that Cézanne had been looking for a dealer before he was contacted by Vollard.[82] It is not surprising, then, that when approached by Vollard (as the dealer tells it), the artist not only agreed to an exhibition but also sent many more paintings than could be shown

at one time in the small gallery. We also know that some months after the exhibition, Cézanne expressed satisfaction at having his paintings sell.[83] Once committed, he retained great faith in Vollard, whom he described as a "sincere man"; Cézanne even rebuffed his son's attempts in 1902 to negotiate a better financial arrangement with the dealers Hessel and Bernheim-Jeune.[84]

It is also undisputable that Cézanne willingly divested himself of the great majority of the paintings that had piled up in his studios. That Vollard took advantage of him may not have mattered much to the artist, so grateful was he for the opportunity to show his work.

What did Cézanne think about his work and especially about the degree of its completeness when he was placing nearly the entire contents of his studios on the market? We can gain some insight through two relatively objective measures. The first concerns the artist's signatures. Some scholars have assumed that a Cézanne is finished when it is signed, yet Cézanne failed to sign even highly worked up canvases, and there are a few fairly sketchy canvases that bear signatures. Cézanne would probably have agreed that the final act in completing a painting was to sign it; what changed over the years was his belief that he could actually bring a painting to a state of completion that warranted a signature. Whereas signed works constitute almost 14 percent of the artist's production before 1878, after the early 1880s less than 2 percent of his production was signed, and no paintings later than 1894 bear signatures. At about the same time that signatures virtually disappeared from his corpus, in 1884, the artist finally gave up submitting canvases to the Salon juries.

Even though the Salon had become irrelevant for the display of significant art, for Cézanne, the perennial rejection of his submissions may have transformed it into a symbol of ultimate artistic validation. How else to explain his decision to paint a succession of never-to-be-juried, Salon-scaled projects, beginning with the *Standing Bather* of 1885 (Museum of

Fig. 45 (cat. 42). Paul Cézanne, *The Cardplayers*, ca. 1890–95. Oil on canvas, 18¾ x 22⅜ in. (47.5 x 57 cm). Musée d'Orsay, Paris (RF 1969)

Fig. 46 (cat. 50). Paul Cézanne, *Château Noir*, 1905. Oil on canvas, 28¾ x 36¼ in. (73 x 92 cm). Musée Picasso, Paris (RF 1973-60)

Modern Art, New York), continuing through the Cardplayers series of the early 1890s, and concluding with the Large Bathers series, which was begun sometime after the first show at Vollard's? The late Cézanne worked large. In the period between 1870 and 1884, paintings at least 81 centimeters tall or wide (size 25 in the manufactured canvases the artist normally used) had counted for less than 8 percent of his overall production, while between 1885 and the end of his life, almost 45 percent of his canvases were of those dimensions or larger.[85] In addition to his Salon-scaled pictures like the *Cardplayers,* he consistently painted still lifes, landscapes, and portraits that were larger than those of the 1870s and early 1880s. The artist's growing self-confidence and ambition can be measured by the increased size of his canvases.

For artists everywhere, once the Salon's importance had collapsed, sales prices effectively replaced its medal system as the external gauge of artistic achievement. (Cézanne, for example, was well aware that Monet had received 15,000 francs apiece for the Rouen Cathedral paintings when they were shown at Durand-Ruel's gallery in the spring of 1895.)[86] It may well be that when Cézanne took the Salon as his standard he

remained unsatisfied with all of his paintings after the 1870s, but when he took the market as his standard he was willing to have a great many of his works exhibited and in that sense regarded them as complete.[87] Until close to the end of his life, Cézanne withheld from the market the larger versions of such paintings as the *Cardplayers* while freely selling to Vollard many other paintings, including works far less complete than the large canvases.

Cézanne's willingness to show radically incomplete work certainly contributed to the contemporary misperception of him as Lantier, an unprofessional naïf whose primitive pursuit of reality nonetheless gives rise to objects of great value. On the other hand, it was also at Vollard's in 1895[88] that the artist's Cézanne—the one closest to his self-perception—was first unveiled: Cézanne as Frenhofer, the genius whose heroic quest is the pursuit of representational perfection, who believes himself to be the best painter of his generation. In the years that followed, Cézanne was able to see the value of his work established in the market while simultaneously remaining disdainful of that success and continuing to pursue his self-defined pictorial project.

In this essay the following abbreviation is used in citing catalogue raisonné numbers: for works by Cézanne, "R" refers to Rewald 1996.

1. While working at the Getty Research Institute, my research assistant Elena Shtromberg and I surveyed twenty-eight European and American textbooks covering nineteenth- and twentieth-century European and American art, identified 159 painters whose works appeared at least three times, and examined their careers. Cézanne was the striking exception to what we otherwise discovered: that French artists born in the 1870s represented the first generation in which any painter counted solo shows among his first three exhibitions. But even artists born as late as the 1890s very rarely received a solo show as even a second or third exhibition. Cézanne, born in 1839, had exhibited twice in Impressionist group shows in the 1870s, but his Vollard "debut" came many years later.

2. See especially Vollard 1936 and Vollard 1937a.

3. Rewald 1996.

4. See Bodelsen 1968.

5. Gustave Geffroy commented in 1894 that he had recently seen a "score" of Cézannes. One wonders where; but even if he saw this many, they would mostly have been pre-1883 works. See Geffroy 1894 (1995 ed.), p. 48.

6. Choquet's collection became inaccessible following his death in 1891; see Rewald 1969, esp. pp. 70–72.

7. The most significant collection belonged to Paul Alexis, childhood friend of the artist and Zola, who reputedly received four pictures from Cézanne on a visit to Aix in January 1892. See the discussion of R 636 and R 756 in Rewald 1996, vol. 1, p. 461.

8. Vollard 1936, p. 60.

9. For example, when he was unable to sell the paintings Henri Rousseau consigned with him, Vollard returned them to the artist. See Adriani 2001, p. 82.

10. Renoir explicitly claimed this role. See J. Renoir 1962, p. 305. According to John Rewald (1968, p. 180), Pissarro insisted that Vollard give Cézanne an exhibition. However, Monet had probably already done the most for the artist, introducing him in 1894 to his influential friends who gathered at Giverny and likely inspiring Geffroy to write his articles on Cézanne.

11. See J. Renoir 1962, p. 305. Among other things, Degas traded the center fragment of *The Execution of Maximilian,* now in the National Gallery, London (fig. 167), in exchange for paintings of his own worth 2,000 francs; see New York 1997–98, vol. 1, pp. 20, 24, 69, nn. 111, 112, and pp. 46–47, fig. 60. Pissarro exchanged some paintings with Vollard to acquire Manet's *Funeral* (Metropolitan Museum); see Bailly-Herzberg 1980–91, vol. 3, p. 515. Monet purchased a Manet sketch for 40 francs on December 19, 1894: Vollard Archives, MS 421 (4,3), fol. 11.

12. Vollard 1937a, pp. 50–51.

13. The state's controversial decision has been thoroughly documented by Berhaut and Vaisse 1983. See also Varnedoe 1987, pp. 197–203, and Paris–Chicago–Los Angeles 1995.

14. Vollard 1937a, pp. 54–59.

15. Private negotiations between the Caillebotte family and the state occurred during the spring of 1895. If Vollard knew of them it would likely have been through Renoir, one the estate's executors; however, Vollard did not meet Renoir until later, in early autumn 1895. See J. Renoir 1962, pp. 303–4.

16. The only outright hostile review was by Georges Denoinville (1895). Favorable reviews included those by Gustave Geffroy (1895) and Thadée Natanson (1895a).

17. Only the *Bathers at Rest* is known (because Vollard remembered showing it) to have been in the 1895 Cézanne show. However, since Martial Caillebotte, the artist's brother, agreed to lend this painting, he might very well also have lent the other two rejected Cézannes, *On the Banks of the Pond,* 1876–77 (R 244) and *Rococo Vase,* 1875–77 (R 265). See note 88.

18. Vollard 1937a, p. 52.

19. Ibid. See also Vollard 1936, p. 61.

20. See, for example, Cahn 1997 and Athanassoglou-Kallmyer 2003, p. 234.

21. Alexandre 1895.

22. Vollard 1937a, pp. 62–63.

23. Shiff 1984, p. 162.

24. See note 88 below. The paintings so far identified may in the future be supplemented with other canvases not yet examined. There may be paintings that were shipped from Aix but fail to exhibit signs of rolling because they were on the outside of the roll, because they were small enough to not

require rolling, because the paint was applied so thinly that it resisted cracking, or even because restoration has effaced the telltale signs.

For help in this undertaking I owe debts to too many conservators and curators to name them all. Special thanks go to Elisabeth Mention at the Getty Museum, who helped me get the project off the ground, to Barbara Buckley, in whose company I spent an extraordinary day with the Barnes Foundation's Cézannes, and to Ann Hoenigswald at the National Gallery of Art, Washington, D.C., who provided assistance in many ways.

25. In 1868, Cézanne sent, rolled up, *Skull and Candlestick,* 1866, to his friend in Stuttgart, the musician Heinrich Morstatt. See the discussion of R 83 in Rewald 1996, vol. 1, p. 89.

26. A survey of Rewald's catalogue raisonné indicates that probably no more than thirty or forty pictures were damaged or cut from larger canvases, less than 5 percent of Cézanne's total work. All the cut-down paintings are still lifes. Most canvases that show physical damage through obvious mistreatment (slashing with a palette knife, for example) are portraits.

27. Gasquet's article in the periodical *Les Mois dorés* in July 1896 is cited in translation in Rewald 1976, pp. 248–49.

28. Presumably, most of the paintings Gasquet saw in 1896 were still on their original stretchers. There is some physical evidence suggesting that once Vollard received the canvases, he routinely gave them a reinforcing lining as well as varnishing them. Such buffing up would have made the paintings appear more finished and therefore more marketable, as well as helping to preserve them.

29. It is still entirely possible that some of the paintings came out of the Paris studio.

30. See the entry for this date in the Vollard Archives, MS 421 (4,3), fol. 42.

31. The English painter Walter Sickert claimed that a cabal of dealers, "brewers of affairs," exhibited works that "had no market value. [Cézanne] left them anywhere, as one leaves the shell of a walnut or a half-eaten apple." Gruetzner-Robins 2000, p. 276.

32. Pissarro to his son Lucien, November 21, 1895, in Rewald and L. Pissarro 1943, pp. 275–76.

33. Monet appears not to have encountered Cézanne in the period between December 1883 and the autumn of 1894, when he invited Cézanne to paint with him at Giverny; Cézanne stayed only a few days. Pissarro probably met Cézanne more often, but he rarely mentioned the artist in his correspondence dating from the early 1880s to 1895. Renoir, however, visited the artist in Aix in January 1888 and February 1891 and perhaps in the early autumn of 1895. See Cahn 1996.

34. Reff 1962, pp. 214–27. See also Reff 1977 for a discussion of Cézanne's patterns of development.

35. On the early Cézanne criticism, see especially Hamilton 1977.

36. Available in English as *The Masterpiece;* newly translated by Thomas Walton and Roger Pearson in 1993.

37. For a discussion of the novel and its reception, see Rewald 1968, pp. 141–52. See also Aruna D'Souza's 2004 discussion of the impact of Zola's book on subsequent Cézanne criticism.

38. Alexandre 1895. Alexandre claimed that "modestly well-informed critics" had written that Cézanne was the inspiration for Lantier when *L'Oeuvre* was first published in 1886.

39. Bernard 1907 (2001 ed.), p. 65.

40. Geffroy 1894 (1995 ed.), p. 45.

41. Three Cézanne paintings passed through Paul Durand-Ruel's hands before 1895; none was directly purchased from the artist or even from Tanguy.

42. The actual number is probably significantly larger. Because Vollard failed to record numerous sales during the early years, Rewald could not trace with certainty many paintings Vollard probably sold to their first known collectors.

43. This essay draws on material in the following account books: Vollard Archives, MS 421 (4,2), (4,3), (4,4), and (4,9).

44. Stockbook A, John Rewald Papers, Gallery Archives, National Gallery of Art, Washington, D.C.; Stockbook B, Vollard Archives, MS 421 (4,5).

45. That Vollard's general practice was to purchase works from artists and arrange to make scheduled payments finds further confirmation in the agreement he worked out with Gauguin, which called for Vollard to pay a standard price of 200 francs per painting, without regard to size, for twenty-five paintings per year, to be paid in regular installments. See Gauguin's letter to Vollard in January 1900 translated in Rewald 1986, esp. p. 190.

46. For an explanation of the differing sales prices for the same painting in different account books, see Jonathan Pratt, "The Accounts of Ambroise Vollard," in this volume.

47. Vollard often recorded picture sales in lots in which a number of artists might be represented, and without indication of what or how many works by a given artist might be included in the sales.

48. Vollard Archives, MS 421 (4,3), fol. 131, May 17, 1899.

49. The twenty-one payments from Hoogendijk recorded in this account book begin August 30, 1897: Vollard Archives, MS 421 (4,3), fol. 81. The first mention of Cézannes is in the nineteenth entry (dated June 3, 1899), which notes the sale to Hoogendijk of five Cézannes and two Caillebottes for 5,200 francs. The twentieth entry (July 12, 1899) similarly records the sale of seven more pictures, this time including two Van Goghs, for a total of 7,900 francs. The final Hoogendijk entry, dated December 6, 1899, records the purchase of one Van Gogh and one Cézanne for 3,000 francs. Vollard Archives, MS 421 (4,3), fols. 134, 138, 148.

50. Vollard 1937a, p. 60.

51. Omitting all the paintings that Vollard itemized (as identified by Rewald), I checked the naming of these collectors in Rewald's provenances against entries in Vollard's stockbooks and account books. As with the Hoogendijk purchases, these documents sometimes record a payment made by a collector but do not indicate what he was buying. For example, an entry dated December 7, 1895 (while the first Cézanne show was in progress), records Monet's payment of 800 francs for an unidentified artist's work or works: Vollard Archives, MS 421 (4,3), fol. 37. While some of these seventy-six paintings (but not the Hoogendijk pictures) could have been acquired after the period of the second stockbook, that is, sometime after 1905, there is good external evidence supporting early rather than later acquisitions of the pictures.

52. Isabelle Cahn (1996, p. 547) provides the estate figures. In a letter to Vollard in January 1900, Gauguin described Cézanne as "exceedingly rich." See Rewald 1996, p. 191.

53. See Rewald 1968, p. 171.

54. Vollard Archives, MS 421 (4,9).

55. Vollard Archives, MS 421 (4,3), payments recorded on December 21, 1895 (fol. 37); January 3, 1896 (fol. 39); March 31, 1896 (fol. 44); May 7, 1896 (fol. 47); July 31, 1896 (fol. 52); December 31, 1896 (fol. 61); and May 31, 1897 (fol. 75).

56. See Vollard Archives, MS 421 (2,3), pp. 16–21. Payments on these promissory notes are recorded in the Vollard Archives, MS 421 (4,3), on March 15, 1898 (fol. 99); May 31, 1898 (fol. 104); June 5, 1898 (fol. 104); June 30, 1898 (fol. 106); July 25, 1898 (fol. 108); September 24, 1898 (fol. 110); October 23, 1898 (fol. 112); December 1, 1898 (fol. 115); December 16, 1898 (fol. 116); January 17, 1899 (fol. 120); January 31, 1899 (fol. 121); February 9, 1899 (fol. 122); March 1, 1899 (fol. 124); and March 31, 1899 (fol. 128).

57. See Vollard Archives, MS 421 (4,3), fol. 130, April 26, 1899, recording Vollard's purchase of three paintings for 850 francs.

58. Unlike earlier agreements between Vollard and the Cézannes, no promissory notes survive to document this arrangement.

59. There are forty-seven Cézannes recorded in Stockbook A as acquired from the family without indication of a purchase price. Perhaps they were purchased by Vollard after the initial agreement or simply consigned with him by Cézanne.

60. Gauguin complained to Daniel Monfreid in a letter of February 22, 1899, "Vollard never comes but when he already has a buyer and 25% commission is not enough for him; he cares not a damn for anything but success." Cited in the preface to Malingue 1948, p. xiv. In Cézanne's case, the dealer's percentages were far higher.

61. Vollard's success at selling paintings both out of the exhibition and during the months that followed makes it likely that he had retained all the pictures the artist sent him.

62. See the discussion of R 120 in Rewald 1996, vol. 1, p. 108.

63. Durand-Ruel paid the highest price, 4,400 francs, for the large painting *Mardi Gras* (Pushkin State Museum of Fine Arts, Moscow).

64. See Rewald 1996, vol. 1, p. 376, no. 555.

65. Geffroy 1894 (1995 ed.), p. 46.

66. See Bodelsen 1968, pp. 345–46.

67. For example, at the end of the 1880s Theo van Gogh earned 335 francs per month before commissions and paid a monthly rent of 205 francs for his large apartment. See Stolwijk and Veenenbos 2002.

68. Bodelsen 1968, p. 348.

69. The averages that follow are calculated only from entries of Vollard's that specify the number of Cézannes sold and the specific amount. There were other significant sales, but they were either not recorded or confusingly recorded.

70. See Vollard Archives, MS 421 (4,3), fols. 115–17, for this and later acquisitions by Hessel and the Bernheims.

71. Rewald was able to establish with certainty the existence of only one Cézanne in Monet's possession before 1895, *Still Life with Apples and a Pot of Primroses,* early 1890s (Metropolitan Museum), which the painter Paul Helleu must have purchased from Tanguy and given to Monet in 1894. See Rewald 1996, vol. 1, p. 434, no. 680. Helleu also purchased *Turn in the Road,* ca. 1881 (Museum of Fine Arts, Boston, R 490), at the Duret 1894 auction; it too eventually belonged to Monet. Rewald thought that Monet might have acquired two other, very early Cézannes (R 110 and R 245) via trades with his first dealer, Père Martin. According to Vollard, Monet—whom he inaccurately remembered not having met before—bought three "important" pictures on the first day of the Cézanne exhibition; see Vollard 1936, p. 167. Unsurprisingly, the only recorded evidence supporting Monet's purchases is an account book entry dated December 7, 1895 (near the *end* of the exhibition), mentioning Monet's payment of 800 francs for an unspecified number of pictures by an unnamed artist or artists: Vollard Archives, MS 421 (4,3), fol. 37.

72. Six of Degas's seven purchases (R 297; R 346; R 369; R 374; R 424; R 557) are recorded in Vollard's account books.

73. Renoir bought one picture; he already owned three Cézannes, two as gifts from the artist and one (R 485) acquired in an exchange of paintings. Pissarro added three Cézannes to his collection in 1895 by trading one of his early landscapes to Vollard for them, and bought another for 200 francs. Significantly, both Pissarro and Renoir acquired pictures painted in the early 1880s or before; Rewald dated all four of Pissarro's acquisitions (R 162, R 250, R 385, and R 391) to 1877 or earlier.

74. In a recorded exchange that must have occurred years after Cézanne's death, Monet is quoted as saying to Georges Clemenceau, "Yes, Cézanne, he's the greatest of us all. . . ." Cited in Rewald 1996, vol. 1, p. 424, no. 657.

75. See G. Stein 1933, p. 36. Stein may have been mistaken, however, since in Vollard's account books, Loeser is named before Fabbri as a purchaser of Cézannes. On the Florentine collections of Fabbri and Loeser, see Bardazzi 1997.

76. *The Bay of Marseille Seen from L'Estaque* (R 625) is one of the pictures that shows signs of being rolled and therefore might have been shown in Vollard's first Cézanne exhibition. Vollard possibly sold this and as many as four other Cézannes to the Havemeyers in 1898 or shortly thereafter; according to the dealer, Henry Havemeyer visited his shop in 1898 looking for Cézannes and immediately purchased two (Vollard 1936, p. 140). We know that the Havemeyers bought Manet's *In the Garden* at a Hôtel Drouot auction in late March 1898 and thus were in Paris at the time of Vollard's recollection. The Havemeyer Cézannes that do not appear in Vollard's stockbooks are, according to Rewald's catalogue, R 174, R 189, R 210, R 623, and R 625. The Havemeyers' first recorded purchases of Cézannes from Vollard were in 1902.

77. Vollard 1936, pp. 180–81.

78. On the Hoogendijk collection, see Henkels 1993.

79. Pellerin's first recorded purchase of Cézannes, however, was dated December 20, 1898: Vollard Archives, MS 421 (4,3), fol. 117.

80. Paula Modersohn-Becker, in a letter to her friend Clara Rilke-Westhoff dated October 21, 1907, claimed that Pellerin already possessed 150 Cézannes at the time of her last stay in Paris in 1906. See Busch and Reinken 1983, p. 425.

81. Count Armand Doria, Duret, and Loeser were the collectors straddling both groups.

82. In a draft of a letter by Cézanne addressed to the critic Octave Mirbeau, probably written toward the end of December 1894, the artist wrote: "Make see—I would ask you to put me in touch with an art dealer." However, Cézanne crossed out this line and rewrote the sentence: "Make see . . . if you are intelligent—you see. Make the reader see what you see." Reprinted in Rewald 1976, p. 238. It is not known whether Cézanne actually sent the letter.

83. These sentiments were recorded in a letter sent by Numa Coste to Émile Zola, cited without source or exact date in Rewald 1984, pp. 232–33.

84. Letter to Charles Camoin, February 3, 1902; see Rewald 1976, p. 282. Cézanne again expressed to Camoin his faith in Vollard and his rejection of his son's attempts to negotiate with the Bernheims in a letter dated March 11, 1902; see ibid., p. 286.

85. To arrive at these percentages I surveyed the paintings in Rewald 1996, ranging from R 169 to R 520 for works dated from 1871 to 1884 and from R 521 to R 954 for the post-1884 paintings.

86. In several letters Pissarro records encountering Cézanne at Monet's Rouen Cathedral show and the sale of three of these paintings to Count Isaac de Camondo for 15,000 francs each. See Rewald and L. Pissarro 1943, pp. 331, 341.

87. Of course, sometimes Cézanne could not resist the temptation to work further on canvases already in Vollard's possession. For example, in 1904 Paul Cézanne fils wrote Vollard asking that some still lifes consigned with the dealer be returned to the artist, "my father being not at all sure he wants to part with them just yet." Translated in Rewald 1984, p. 310.

88. A list of paintings attributed to the 1895 Cézanne show at Vollard's:

Vollard mentioned twenty-three paintings as included in the exhibition (Vollard 1914, p. 58); not all of the titles he gave may be firmly identified with known works. John Rewald associated the following fourteen paintings with Vollard's list; they are arranged here according to their catalogue numbers in Rewald 1996: R 261, *Bathers at Rest, III,* 1876–77; R 351, *The Abandoned House,* 1878–79; R 421, *Portrait of Louis Guillaume,* 1879–80; R 447, *Leda and the Swan,* ca. 1880; R 536, *Mme Cézanne in a Striped Dress,* 1885; R 553, *Bather before a Tent,* 1878; R 601, *Great Pine Tree,* 1887; R 628, *Banks of the Marne,* 1888; R 688, *Jas de Bouffan,* 1890–94; R 700, *Mme Cézanne in a Green Hat,* 1891–92; R 703, *Mme Cézanne in the Conservatory,* 1891–92; R 800, *Basket of Apples,* ca. 1893; R 806, *Young Girl with a Doll,* 1894; R 815, *Underbrush,* 1893–94.

Ten paintings further assigned to the show by Rewald in his catalogue raisonné (either described as possibly belonging to Vollard's list or identified through external evidence) are: R 128, *Feast (Orgy),* ca. 1867; R 281, *Bay at Marseilles Seen from the Village of St. Henri,* 1877–79; R 370, *Bather with Outstretched Arm,* 1877–78; R 373, *Le Déjeuner sur l'herbe,* ca. 1878–80; R 445, *Self-Portrait,* ca. 1882; R 458, *Four Bathers,* 1880; R 674, *Still Life,* ca. 1890; R 729, *The Bridge over the Marne at Créteil,* ca. 1894; R 774, *Self-Portrait Wearing Soft Hat,* 1894; R 802, *Still Life,* ca. 1895.

Twenty-six paintings recorded in the Vollard Archives, MS 421 (4,2) and (4,3) as having been purchased from Vollard before August 1896 are: R 114, *Standing Nude Drying Hair,* ca. 1869 (bought by Pissarro, December 12, 1895); R 250, *Bathers by the Water,* 1875–77 (bought by Pissarro November 19, 1895); R 297, *Portrait of Victor Choquet,* ca. 1877 (bought by Degas May 6, 1896); R 339, *Apples and Napkin* (bought by Cassatt April 16, 1896); R 346, *Apples,* ca. 1878 (bought by Degas November 29, 1895); R 353, *Still Life with Two Pears,* ca. 1875 (bought by Hazard February 1, 1896); R 369, *Bather with Outstretched Arm,* 1877–78 (bought by Degas November 20, 1895);

R 385, *Self-Portrait,* ca. 1877 (bought by Pissarro November 20, 1895); R 424, *Glass and Apples,* 1879–80 (bought by Degas January 6, 1895); R 425, *Bowl and Milk Pitcher,* ca. 1879 (bought by Murat June 19, 1896); R 443, *L'Estaque,* 1883 (bought by Monet March 23, 1896); R 454, *Harvesters,* ca. 1880 (bought by Sumners July 16, 1896); R 456, *The Struggle of Love, II,* ca. 1880 (bought by Renoir December 31, 1895); R 470, *Begonias in a Pot,* ca. 1880 (bought by Fabre November 14, 1895); R 505, *Auvers,* 1881 (bought by Costa January 11, 1896); R 533, *Sketch of Mme Cézanne,* ca. 1883 (bought by Geffroy April 15, 1896); R 534, *Sketch of Artist's Son,* 1883–85 (bought by Geffroy April 15, 1896); R 538, *Chestnuts and Farm at the Jas de Bouffan* (bought by Geffroy April 19, 1896); R 557, *Two Fruit,* 1885 (bought by Degas March 19, 1896); R 558, *Still Life,* ca. 1885 (bought by Halévy March 7, 1896); R 569, *Gardanne (Horizontal View),* ca. 1885 (bought by Fabbri March 21, 1896); R 570, *View of Gardanne,* ca. 1886 (bought by Costa February 27, 1896); also rolled; R 659, *Boy in a Red Vest,* 1888–90 (bought by Fabbri January 11, 1896); R 674, *Still Life,* ca. 1890 (bought by Geffroy December 24, 1895); R 724, *Banks of the Marne,* ca. 1892 (bought by Fabbri January 6, 1896); R 741, *Still Life,* 1894 (bought by Blot November 26, 1895).

Twenty-four paintings that exhibit clear indications of having once been rolled are: R 101, *Artist's Father Reading Newspaper,* 1866; R 107, *Uncle Dominique,* ca. 1866; R 138, *Still Life with Bottle, Cup, and Fruit,* ca. 1869; R 263, *Seated Bather at Water's Edge,* ca. 1876; R 291, *Afternoon in Naples with Black Servant,* 1877–78; R 293, *The Seine at Bercy* (after Guillaumin), 1876–78; R 308, *House at Auvers,* ca. 1877; R 323, *Mme Cézanne Knitting,* ca. 1877; R 324, *Mme Cézanne in Yellow Dress,* ca. 1877; R 531, *View of L'Estaque and Chateau d'If,* 1885; R 532, *Mme Cézanne,* 1883–85; R 544, *Underbrush,* 1887; R 561, *Still Life with Plate of Cherries,* 1885–87; R 566, *Basin at Jas de Bouffan,* 1886; R 569, *Horizontal View of Gardanne,* ca. 1885; R 572, *Hamlet at Payennet near Gardanne,* 1886–90; R 625, *Bay of Marseilles Seen from L'Estaque,* ca. 1885; R 626, *Bay of Marseilles Seen from L'Estaque,* ca. 1885; R 635, *Still Life,* 1886; R 651, *Mme Cézanne in a Yellow Chair,* 1888–90; R 653, *Mme Cézanne in Armchair,* 1890; R 658, *Young Man in a Red Vest,* 1888–90; R 693, *Pigeonnier at Bellevue,* ca. 1890; R 699, *Underbrush,* 1892.

Although these two paintings rejected from the Caillebotte bequest were not mentioned by Vollard as having been in the 1895 Cézanne exhibition, they might have been lent by Martial Caillebotte along with *Bathers in Repose, III* (R 261): R 244, *On the Banks of the Pond,* 1876–77; R 265, *Rococo Vase,* 1875–77.

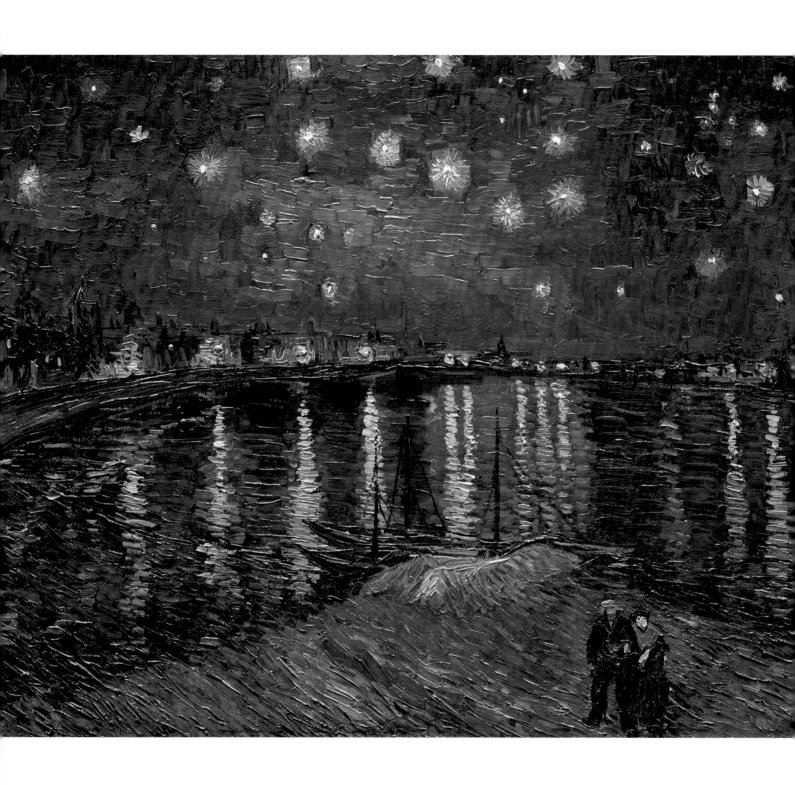

Patron or Pirate? Vollard and the Works of Vincent van Gogh

Jonathan Pascoe Pratt

In the early 1890s, one could find at Ambroise Vollard's small gallery a great number of works not just by young artists hoping to be discovered but also by deceased artists in danger of being forgotten. There were Édouard Manet's drawings, purchased directly from his impoverished widow; several works by Stanislas Lépine, whose widow made more than fifty individual sales to Vollard in a single year; and paintings by Vincent van Gogh (1853–1890). Vollard was soon to develop two highly influential exhibitions, in 1895 and in 1896–97, that would contribute in a major way to the establishment of the artist's reputation.

There is no record of the two men having met, although Vollard did recall just missing such an opportunity when he arrived at Madame Segatori's café Au Tambourin, on boulevard Clichy, only minutes after Van Gogh had left.[1] Five years after this near-meeting, Vollard selected Van Gogh to be the featured artist of the opening exhibition at his new gallery at 39, rue Laffitte (figs. 49 and 50 were among the paintings exhibited).

Van Gogh had died in July 1890. When Vollard dealt with the oeuvres of deceased artists, his relationship with the artist's heir, usually the widow, was critical. In the case of Vincent van Gogh, the heir was Theo van Gogh's widow, Johanna van Gogh-Bonger, the artist's sister-in-law (fig. 48).

Issues surrounding the promotion and sale of works by a living artist are quite unlike those for an artist who has died. Without personal contact, there is no opportunity for dealer and artist to enter into the kind of fertile relationship that generates commissions and directs the artist's output toward the marketplace. The dealer cannot influence choices of subject, format, and medium. Furthermore, the artist's death leaves a finite number of works, a fact that has a bearing on their value. How works are supplied to the market is ultimately determined by the relationship between dealer and heir, and the nature of this relationship depends on the aims and motivations of both. Vollard was motivated by profit, but to what extent was he also interested in the establishment of Van Gogh's reputation?

Immediately after Vincent's death, Theo, his brother and dealer and the heir to his estate, had attempted to arrange an exhibition of the recent paintings. Failing to find a gallery, he decided to hold an exhibition in his own apartment at 6, cité Pigalle. The young artist Émile Bernard, an ardent promoter of Vincent, assisted him. It is unclear how many paintings were shown—possibly as many as 350.[2] In October 1890 Theo himself suffered a mental and physical collapse and was transferred to the Willem Arntzkliniek in Utrecht, where he died on January 25, 1891. Control of the Vincent van Gogh estate passed to Jo van Gogh-Bonger, who remained in the Netherlands. Meanwhile, Bernard continued to show Vincent's paintings at the Van Gogh apartment in Paris. But his plans for a gallery exhibition collapsed, and the canvases and drawings were shipped to Jo. Paul Signac, a loyal friend and supporter of Van Gogh, arranged the small Van Gogh memorial exhibition at the 1891 Salon des Indépendants in Paris and offered to help Octave Maus organize an exhibition devoted to the artist for "Les XX" in Brussels.[3] Although the paintings had left Paris, Bernard continued his efforts to arrange an exhibition, drawing on only a limited choice of works from those

Fig. 48. Johanna van Gogh-Bonger and child.
Van Gogh Museum Foundation, Amsterdam (T750)

Opposite: Fig. 47 (cat. 122). Vincent van Gogh, *Starry Night over the Rhone (Starry Night, Arles)*, 1888. Oil on canvas, 28½ x 36¼ in. (72.5 x 92 cm). Musée d'Orsay, Paris, Life interest gift of M. and Mme. Robert Kahn-Sriber, 1975; entered the collection in 1995 (RF 1975-19)

Fig. 49 (cat. 113). Vincent van Gogh, *Sunflowers*, 1887. Oil on canvas, 17 x 24 in. (43 x 61 cm). The Metropolitan Museum of Art, New York, Rogers Fund, 1949 (49.41)

Theo had deposited with the color merchant Julien (Père) Tanguy. From these paintings Bernard subsequently assembled the first one-man exhibition of Van Gogh's work held in a Parisian commercial gallery since the artist's death; it took place in 1892 at the gallery Le Barc de Boutteville and consisted of sixteen paintings and several drawings.[4] The following year Bernard left for Italy, not to return for eight years. The second Van Gogh exhibition would be in 1895, at Vollard's gallery.

The pattern of Van Gogh's career, combined with his early death at the age of thirty-seven, had peculiar consequences. During his lifetime only a small number of early works, which did not have wide appeal to collectors, were available, and thus sales were insufficient to create a market for his paintings. Toward the end of his life his work developed rapidly and his output increased, and it is the paintings from this period, done in Paris, Arles, and Saint-Rémy, that were to become most popular with collectors. However, upon the artist's death the majority of these paintings passed to his estate and were sent to the Netherlands.

With so few pictures available for exhibition in Paris,[5] any plan to present the artist's work may have appeared extremely ambitious. Nevertheless, when Vollard's move to a larger gallery in April 1895 gave him the opportunity to promote artists on a greater scale, he chose to exhibit the works of Van Gogh at the opening on June 4. The decision suggests that among Vollard's criteria for the selection of artists, the combined opinions of critics and artists—to whom he "knew how to listen"[6]—figured powerfully. Although Van Gogh was not particularly championed by such critics as Gustave Kahn and Félix Fénéon, others praised him in assessments that were highly influential. As early as January 1890, Albert Aurier published his admiring essay "Les Isolés: Vincent van Gogh" in the *Mercure de France*. Aurier, with his "exuberantly poetic imagery," belonged to a new generation that hailed Van Gogh as a pioneer.[7]

The following year, 1891, the well-known writer Octave Mirbeau published in *L'Écho de Paris* an article entitled simply "Van Gogh," in which he sought to link the artist's expressive paintwork to his agonized state of mind. This image of Van Gogh as a tortured soul was responsible for a great deal of the attention his work received; Signac later remarked in his diary that Van Gogh "is interesting only because of his aspect as an insane phenomenon."[8] Still, it was Émile Bernard's tireless promotion that kept the artist in the public eye. By 1892 there was sufficient interest in Van Gogh for the *Mercure de France* to begin publishing in installments his extensive correspondence with Bernard.[9] Excerpts from these letters had already found their way into exhibition texts and essays about Van Gogh, contributing to the growth of his reputation.[10]

Artists of Vollard's own generation were the ones who championed Van Gogh.[11] By taking up his cause, Vollard identified himself with the outsider and his gallery with avant-garde artists; he was making a statement about the artists he would

exhibit in the future. Several younger artists gravitated to his gallery.

It is difficult to ascertain to what extent Vollard calculated the financial potential of Van Gogh's work. He had surely discovered the opinions of those around him: in Holland, where the works were available, collectors were showing increasing interest, and contemporary correspondence offers plenty of evidence that both artists and dealers in Vollard's circle had been predicting an increase in the value of Van Gogh's works.[12] However, there was no market confirmation. There had been no sensational sales and therefore no high prices to entice a dealer. The courage Vollard demonstrated in committing himself to an artist who had repeatedly been denied success distinguishes him from other dealers of his generation and is evidence that his motivation was not entirely financial.

VOLLARD'S VAN GOGH SALES BEFORE 1895
Prior to his 1895 exhibition, Vollard's accounts show little activity relating to Van Gogh, probably an indication that few works were available on the market. Among Vollard's earliest transactions were the purchase of a Van Gogh painting from Eugène Blot and two from Madame Bernard, the mother of the artist Émile Bernard.[13] Vollard sold three Van Gogh paintings to the

entrepreneur and café proprietor Auguste Bauchy in August 1894[14] and a sunflower painting to the dealer Félix Roux.[15]

Armand de Roche, writing for the Dutch publication *Kunstwereld,* described a visit in October 1894 to Vollard's gallery and two paintings he saw there by Van Gogh: one that was probably *Patience Escalier* (private collection; F 444) and "another small panel of the same artist also well worth looking at."[16] At one time it was thought that he also saw the paintings obtained from Van Gogh's friend Joseph Roulin, the postal agent from Arles, who owned a number of paintings by Van Gogh, including portraits of Roulin's wife (fig. 52) and son (fig. 51).

Vollard had planned to mount his first exhibition without requesting anything from the Van Gogh estate. However, since he was unable to find enough works he contacted Jo van Gogh-Bonger, just six days before the exhibition was due to open.[17] She sent ten canvases and four drawings, but they arrived after the exhibition had closed.

THE 1895 VAN GOGH EXHIBITION AT THE GALERIE VOLLARD
Vollard's first exhibition of the works of Van Gogh was held to inaugurate his gallery at 39, rue Laffitte. He had managed to borrow works "on consignment" from the painters Paul Gauguin

Fig. 50 (cat. 121). Vincent van Gogh, *Tarascon Diligence (The Tarascon Coaches)*, 1888. Oil on canvas, 28⅛ x 36⅜ in. (71.4 x 92.5 cm). The Henry and Rose Pearlman Foundation; on long-term loan to the Princeton University Art Museum

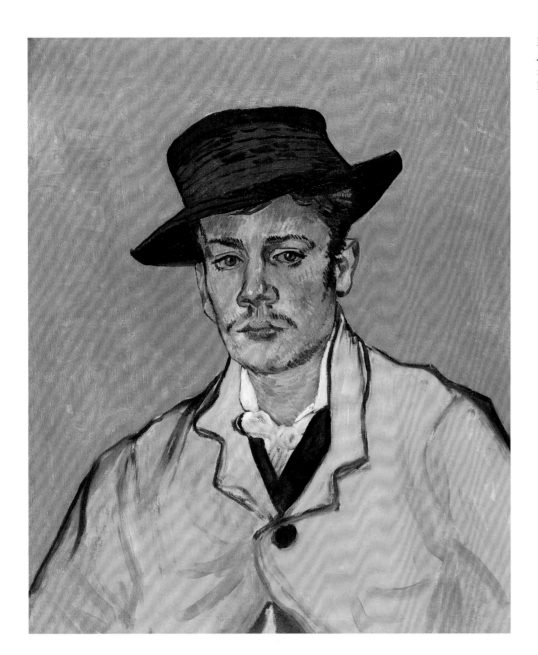

Fig. 51 (cat. 118). Vincent van Gogh, *Armand Roulin*, 1888. Oil on canvas, 26 x 21¾ in. (66 x 55 cm). Museum Folkwang, Essen (G 63)

and Émile Schuffenecker and from Madame Grammaire-Aurier, mother of the critic.[18] Originally planned to begin in mid-May, the exhibition finally opened on Tuesday, June 4, 1895, and ran until Sunday, June 30.[19] This critical event, the first commercial Van Gogh exhibition drawn from many sources, was the opening step toward the establishment of the painter's reputation in the art market. It was so little recorded that it is not even included in the list of exhibitions in J.-B. de la Faille's catalogue raisonné of Van Gogh works.[20] While no record of the exhibited pictures exists, a probable list can be compiled from contemporary reviews published in Paris and Amsterdam. The small exhibition—possibly as few as twenty works—was most comprehensively described by E. den Dulk in *Kunstwereld;*[21] there were French reviews by Thadée Natanson in *La Revue blanche*[22] and Charles Morice in *L'Art et les lettres: Expositions.*[23]

Paintings immediately identifiable from the reviews are *Road with Cypress and Stars* (Kröller-Müller Museum, Otterlo; F 683), *Tarascon Diligence* (fig. 50), *Café Terrace on the Place du Forum,* *Arles, at Night* (Kröller-Müller Museum, Otterlo; F 467), *View of Paris from Montmartre* (Kunstmuseum, Basel; F 262), and *Still Life with Bloaters* (Kröller-Müller Museum, Otterlo; F 203). Some designations, such as *Seated Woman, Roses,* and *Sunflowers,* could describe a number of paintings. However, since Vollard borrowed works from Gauguin, Schuffenecker, Madame Aurier, and other collectors, it is possible from brief descriptions to identify additional loans, such as *Self-Portrait with Bandaged Ear and Pipe* (private collection; F 529)[24] from Schuffenecker and *Madame Roulin Rocking the Cradle (La Berceuse)* (Art Institute of Chicago; F 506) from Gauguin.

Financially, the exhibition was not a success. Indeed, Vollard's accounts do not record the sale of a single work by Van Gogh during this period. However, the show attracted the attention of Henri Laget, founder and editor of the periodical *Provence artistique,* who sent Vollard a copy of an article he had written about Van Gogh and suggested that a certain M. Ginoux would be happy to lend paintings for exhibition.[25] Joseph Ginoux

Fig. 52 (cat. 124). Vincent van Gogh, *La Berceuse (Woman Rocking a Cradle) (Augustine-Alix Pellicot Roulin, 1851–1930)*, 1889. Oil on canvas, 36½ x 29 in. (92.7 x 73.7 cm). The Metropolitan Museum of Art, New York, The Walter H. and Leonore Annenberg Collection, Gift of Walter H. and Leonore Annenberg, 1996, Bequest of Walter H. Annenberg, 2002 (1996.435)

was the proprietor of the Café de la Gare in Arles, where Vincent had lived from May to September 1888 and where he and Gauguin had spent many hours. It was Joseph's wife who modeled for Van Gogh's series of portraits called *Arlésienne* (see fig. 55). Vollard was quick to establish a relationship with Laget, who became his intermediary to Ginoux. The first purchase Vollard made from this source, in October 1895, was an *Arlésienne (Madame Ginoux)* (F 488), for which he paid 60 francs to Ginoux and a commission of 10 francs to Laget. The second purchase, in January 1896, was a painting described in the accounts as *Arlescamp* (probably *Les Alyscamps;* F 569) that was purchased for 70 francs 70 centimes, again with a further 10-franc commission; and for his third purchase, *Spectators in the Arena at Arles* (State Hermitage Museum, St. Petersburg; F 548), Vollard paid 70 francs 60 centimes (including the commission). Ginoux was a valuable source for Vollard. His prices, even with Laget's commission, were considerably lower than those demanded by Jo van Gogh-Bonger for works from the artist's estate.

Of the nine Van Gogh paintings sold after the first exhibition (that is, from June 1895 to December 1896), five were bought by artists—Edgar Degas, Schuffenecker, Count Antoine de la Rochefoucault (two paintings), and Mrs. Esther Sutro;[26] two by dealers (Eugène Blot and Maurice Clouet); and two by collectors (Denys Cochin and Adrien Hébrard). These two early collectors were important both for the establishment of Van Gogh's reputation and for the growth of Vollard's business. *Les Alyscamps* was the first purchase from Vollard made by Cochin, a politician and a *député de Paris* (member of parliament), who in time amassed an important collection of paintings, many bought from Vollard. Hébrard was a lawyer, journalist, and politician whose contact with the writers, publishers, and artists of his time opened new opportunities in these circles for Vollard.

The profile of the clients for Van Gogh's pictures was shifting. While Vollard's Van Gogh sales at the time of the first exhibition in June 1895 had been predominantly to

dealers, by the end of the next year they were primarily to artists and collectors.

THE SECOND VAN GOGH EXHIBITION AT THE GALERIE VOLLARD, 1896–97

Vollard clearly was not satisfied with the small Van Gogh show of 1895 and wanted to give the artist his first major retrospective exhibition. The next year, having established a business relationship with Jo van Gogh-Bonger, he held an exhibition of works drawn from Van Gogh's estate at his new gallery at 6, rue Laffitte (soon to become a legendary address). The show ran from December 1896 through February 1897.[27]

Fifty-six paintings, fifty-four drawings, and one lithograph[28] from the estate were included in the exhibition (see fig. 238). Among them were spectacular paintings from all periods of the artist's life, from *The Potato Eaters* (Van Gogh Museum, Amsterdam; F 82) of 1885 to *Starry Night over the Rhone* (fig. 47) to *Wheatfield with Crows* (Van Gogh Museum, Amsterdam; F 779). Also exhibited were *Moulin de la Galette* (Van Gogh Museum, Amsterdam; F 346), *Four Cut Sunflowers* (Kröller-Müller Museum, Otterlo; F 452), and many other important works. Vollard had asked Jo van Gogh-Bonger to set her prices reasonably; in return he would guarantee the sale of

Fig. 54 (cat. 119). Vincent van Gogh, *Still Life with Plaster Statuette*, 1888. Oil on canvas, 21⅝ x 18¼ in. (55 x 46.5 cm). Collection Kröller-Müller Museum, Otterlo (KM 105.676)

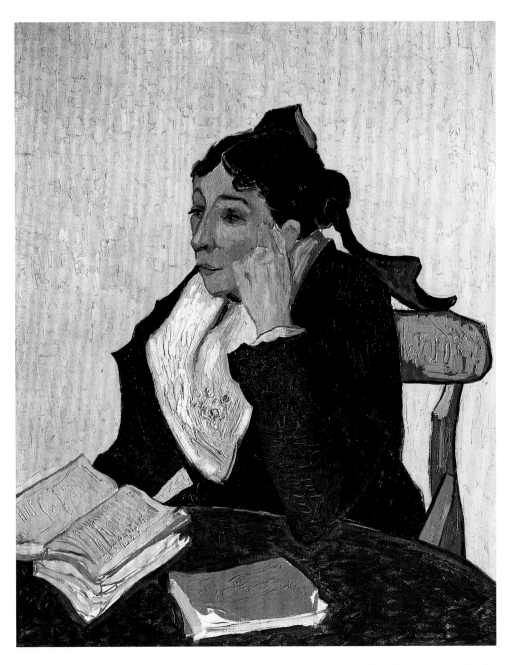

Fig. 55 (cat. 123). Vincent van Gogh, *L'Arlésienne: Madame Joseph-Michel Ginoux (Marie Julien, 1848–1911)*, 1888 or 1889. Oil on canvas, 36 x 29 in. (91.4 x 73.7 cm). The Metropolitan Museum of Art, New York, Bequest of Sam A. Lewisohn, 1951 (51.112.3)

works totaling at least 1,500–2,000 francs. When the paintings arrived, Vollard was dismayed to learn that she had raised the prices beyond the agreed-upon amounts. Further disappointment came when the exhibition was hardly reviewed in the press and the public showed little interest; his accounts record the sale of only two drawings in January and February.

Still, Vollard continued trying to buy and sell works from the estate in order to cover his costs. Finally he purchased, according to his letter, "the three triptychs; the canvas in bad condition representing laundresses; the portrait of Van Gogh; the portrait of Dr. Gachet; and ten drawings all at one price. Altogether: 2000 francs."[29] Although the list of works sent by Jo van Gogh-Bonger only appeared to record one triptych (made up of the three listed paintings), other documentary evidence[30] indicates that she sent three triptychs comprising nine paintings. The concept of Van Gogh's triptychs and their identification have stimulated much debate.[31] Shown together

in this catalogue, the three works *Banks of the Seine with Pont de Clichy in the Spring* (fig. 56), *Fishing in Spring, the Pont de Clichy (Asnières)* (fig. 57), and *Woman in a Garden* (fig. 58) present what the artist may have conceived of as a triptych frieze. Each work has a red border, suggesting that they were all painted as part of a decorative scheme; and the two outer paintings, of similar size, contrast with the larger central canvas in a way consistent with Van Gogh's description of his later planned triptych consisting of *La Berceuse* flanked by two sunflower paintings.[32] Of the other works included in Vollard's purchase, the laundresses was *The Langlois Bridge with Women Washing* (Kröller-Müller Museum, Otterlo; F 397), which he sold to the Dutch collector Cornelis Hoogendijk; the portrait of Van Gogh was *Self-Portrait with Bandaged Ear* (Courtauld Institute, London; F 527), which he sold to Rochefoucault; and the *Portrait of Dr. Gachet* (private collection; F 753) he sold to Madame Alice Faber (see fig. 59).

Fig. 56 (cat. 115). Vincent van Gogh, *Banks of the Seine with Pont de Clichy in the Spring*, 1887. Oil on canvas, 19 x 22½ in. (48.3 x 57.2 cm). Dallas Museum of Art, gift of Mr. and Mrs. Eugene McDermott in memory of Arthur Berger (1961.99)

Fig. 57 (cat. 116). Vincent van Gogh, *Fishing in Spring, the Pont de Clichy (Asnières)*, 1887. Oil on canvas, 19⅞ x 23⅝ in. (50.5 x 60 cm). The Art Institute of Chicago, gift of Charles Deering McCormick, Brooks McCormick and Roger McCormick (1965.1169)

Fig. 58 (cat. 117). Vincent van Gogh, *Woman in a Garden*, 1887. Oil on canvas, 20⅛ x 24⅝ in. (51 x 62.5 cm). Private collection

Vollard hoped to continue selecting works from the Van Gogh estate. However, the slow return of unsold works, delayed payments, and infrequent communication infuriated Jo van Gogh-Bonger, and Vollard's relationship with her deteriorated.

AFTER THE EXHIBITIONS, 1897–1900

Vollard never again borrowed such a large number of pictures from the Van Gogh estate or held another exhibition of the artist's works, but he did continue to acquire them, through Laget,[33] including eight works from the Roulin family,[34] and from Bernard. Between the second exhibition and 1900, he bought ten Van Gogh paintings and five drawings from Bernard (reflecting the dire financial circumstances in which Bernard found himself more than any demand for Van Gogh's paintings).[35] In this period Vollard bought at least twenty-four Van Gogh paintings and possibly as many as fourteen drawings altogether—not, in the context of his business, a large number. Over time, some of these works would achieve enormous

prices. Although he never established a reputation for himself as a dealer in Van Gogh, Vollard's two exhibitions kept the artist's works in the public eye, making them available to inspire the next generation of artists[36] and attracting the interest of some of the period's most influential collectors.

New clients drawn to Vollard's gallery included Hoogendijk, a young collector endowed with enthusiasm, wealth, and impatience. who made at least seven visits to the gallery.[37] His large purchases of works by several artists, including Van Gogh, were each made up of so many items that Vollard did not list them separately in his accounts, making it difficult to identify the works.[38] Another client who was an important collector, Julius Meier-Graefe, made his first purchase of a Van Gogh painting during this period.[39] An art historian, Meier-Graefe championed many of the French artists and encouraged the reception of modern French art in Germany, activities that would profoundly affect the market for Van Gogh's works.[40]

Vollard's decision to cease promoting Van Gogh is now surrounded by legends, for instance an anecdote narrated by

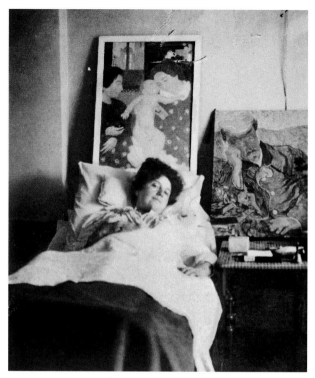

Fig. 59. Madame Alice Ruben Faber (Alice Bloch) in bed, with paintings bought from Vollard: Maurice Denis's *Madonna with the Apple* and Van Gogh's *Portrait of Dr. Gachet*. John J. A. Hunov Collection, Copenhagen

Brassaï: "Unhappy over the sales, he got rid of all his van Gogh paintings in a fit of bad temper. As he was later to admit to Raymond Escholier, 'I was totally wrong about van Gogh! I thought he had no future at all, and I let his paintings go for practically nothing.'"[41] But Vollard's accounts tell a very different story. They confirm that he made several sales of paintings and drawings by Van Gogh, at consistently high prices. Perhaps "practically nothing" was a retrospective evaluation made years later, when the value of Van Gogh's work had greatly increased.

It may have been the low opinion of Van Gogh expressed by Vollard's loyal advisers Renoir and Cézanne that finally persuaded him to end his promotion of the artist.[42] However, while Vollard would have taken note of those views, he would also have considered the admiration expressed by Degas and the younger generation of artists.

Perhaps ultimately Vollard stopped promoting Van Gogh's work because he realized that the benefits derived from his initiative, effort, and assumption of financial risk would eventually accrue to the Van Gogh estate rather than to Galerie Vollard. By 1900 Jo van Gogh-Bonger had started to consolidate her position in the Van Gogh market and to play a significant role in the establishment of Vincent's reputation. As Vollard's accounts reveal, there were very few sources from which works were available at a price level that could make Van Gogh's art an attractive commercial proposition. Because Jo controlled the supply of a substantial number of works onto the market, she dictated the prices and thus ultimately controlled the profits that could be derived from exhibitions. The number of Vollard's Van Gogh transactions therefore dwindled, although he continued to buy and sell the artist's work when the opportunity arose.

It was Émile Bernard's support for Van Gogh that had initially encouraged Vollard to promote the artist; it was Bernard's collection of paintings and drawings by Van Gogh[43] that provided Vollard with an important supply of works; and, paradoxically, it was Bernard's paintings that figured among those replacing the Van Goghs at Galerie Vollard. In May 1901, Vollard bought 122 pictures from Bernard's studio,[44] and after an exhibition in June he purchased another large group. With Bernard's work, Vollard achieved the kind of control that he never had over Van Gogh's. Moreover, Vollard was able to indulge his passion for publishing with Bernard, with books such as *Lettres de Vincent van Gogh à Émile Bernard*. It is tempting to speculate: if Vincent van Gogh had not died so tragically young, would Ambroise Vollard have been the dealer who made him into a legend?

In this essay the following abbreviation is used in citing catalogue raisonné numbers: for works by Van Gogh, "F" refers to Faille 1970.

1. Vollard 1936, p. 21.
2. Stolwijk and Veenenbos 2002, pp. 24–25.
3. S. A. Stein 2001, p. 75.
4. See S. A. Stein 2005b, p. 28–29.
5. "Netherlanders who are in Paris and even the French art lovers who have come to me to see the pictures always regret that there are so few things by Vincent in Paris," wrote Johanna van Gogh-Bonger to Vollard, December 14, 1895: Vollard Archives, MS 421 (2,2), pp. 402–3.
6. "Vollard, who was extremely perspicacious, knew how to listen; and he willingly listened to the advice of Pissarro and of Octave Mirbeau, that person of great sensitivity, both of whom visited him often, especially at no. 6 rue Laffitte, when he was beginning to have dealings with Cézanne." Blot 1934, p. 18.
7. Evert van Uitert, "An Immortal Name," in Van Uitert and Hoyle 1987, p. 24.
8. Paul Signac, "Journal," September 15, 1894, in Rewald 1949, translation p. 168.
9. April 1892, May–August and November 1893, January, March, July, and September 1894, February 1895, and August 1897.
10. Van Uitert, "An Immortal Name," p. 24.
11. Signac noted as early as 1894 that "the young ones are full of admiration for . . . van Gogh." Signac, "Journal," September 15, 1894, in Rewald 1949, translation p. 168. See Dorn 1990, pp. 189–91; and S. A. Stein 2005b, pp. 22–26.
12. "In the interest of your child, the heir of all these works, it is your duty to show them in the place where they will come into their own. It is a fortune that you have there, don't spoil it—a double fortune, a fortune of fame and a fortune of money." Émile Bernard to Johanna van Gogh-Bonger, undated (ca. 1892): Archives, Van Gogh Museum, Amsterdam, MS b833V/1962. Gauguin offers the same sentiments in his letter to Jo of May 4, 1894: Archives, Van Gogh Museum, MS b1484, quoted in Stolwijk and Veenenbos 2002, p. 22.

13. In an unpublished letter to his mother dated July 1894 (private archives), Bernard notes the possible sale of three Van Goghs to Vollard: *Le Bateau, Les Raisins et les pommes,* and *Les Usines.*

14. Vollard recorded the sale of these three paintings as *Tête de paysan; Paysage;* and *Femme dans une fauteil:* Vollard Archives, MS 421 (4, 2), fol. 6.

15. Roland Dorn (1999, p. 59) identifies the painting sold to Roux as *Two Cut Sunflowers* (Kunstmuseum Bern; F 376). For another view, see Van Tilborgh and Hendriks 2001, p. 25, n. 51.

16. Armand de Roche, in *Kunstwereld* (Amsterdam), October 1894; copy of article in Documentation, Van Gogh Museum, Amsterdam.

17. "If I take the liberty of writing you, it is to ask if you would be so kind as to send me some paintings (in this case, preferably of flowers), or otherwise drawings, to augment the rather small number that I have been able to assemble." Vollard to Jo van Gogh-Bonger, May 9, 1895: Archives, Van Gogh Museum, MS b1306V/1962.

18. Vollard to Jo van Gogh-Bonger, June 7, 1895: Archives, Van Gogh Museum, MS b1369V/1962.

19. Invitation: Archives, Van Gogh Museum, MS b7199/1962.

20. Faille 1970, p. [691].

21. "What we saw there was one of his most curious canvases, not so much from the viewpoint of painting as from the grandeur of the conception and the truth of the immense emotion of a most profound sense of the eternal marvels of nature. It concerns a landscape in which a few listless farmers followed by a wobbly little cart are returning home in the sultry evening light. A deep blue summer night sky, with a dark red half-moon surrounded by a few planets, extends above this whole scene, in which a million colorful rays float as they circle through the expanse.

 "It was the visible emotion of the artist in this painting that moved me so deeply, while he expressed himself, wanting to speak his love for that magnificent nature that breathed life into him, and the more beautiful she appeared to him the greater the distance between them.

 "One of his praise-songs is a stand of coaches beneath stifling air. Then there are the well-known poplar trees, singing to the sky in broad waves of harmony. And his bedrooms of such tender intimacy that any description would be offensive.

 "There is his 'Arlésienne'; the 'terrace' of a café by night, a pure masterpiece of contrasts; his self-portrait containing all the particularity of his being; a 'peasant' telling you of his burdens; . . . a few faces of farmers; a still life (just a pair of simple, hard leather shoes); and a few 'herrings.' This small latter work is of especially great value. There is also a small piece showing a gray Montmartre landscape, a sad view from Montmartre on the panorama of the gray mass of Paris. A few 'roses' and 'sunflowers' were of lesser interest to me." Den Dulk 1895.

22. "An exhibition that will christen M. Vollard's new galleries (which so far contain, in some people's estimation, too few works by Vincent van Gogh), gives us an opportunity to pursue some reflections. . . .

 "However characteristic, robust, novel, and attractively unpolished some of Van Gogh's paintings might seem; whatever pleasure one might derive from his green carts with their hard yellow-wood wheels, from his celebrated sunflowers, so colorful and straightforward, from the new forms he gave to poor, simple furnishings, from his nocturnal or sunlit landscapes, from the compositional or coloristic qualities in his portraits of the Provencal girl or the seated woman, or in the masterful self-portrait he painted after cutting off his ear, shortly before taking his own life—despite all this, the exhibition is too limited to allow for a study of his work.

 "Nor do the oddly emotive letters published in the *Mercure de France* provide a sufficiently clear idea of his life. We simply don't have the documents." Natanson 1895b, p. 572.

23. "This is also what the painter Vincent van Gogh was searching for, though by very different means. For many, the exhibition of his works on rue Laffitte was a revelation. This cursory exhibition does not give a full idea of the highly varied mind of Van Gogh, a passionate man who gave himself over, flung himself down the paths toward which each new desire beckoned. It nonetheless gives us some idea of his principal endeavors, and allows us a whiff of the divine scent of genius with which his soul—at once complicated and naive, ardent and reflective—was imbued. Van Gogh sought and found something new. He was an extraordinary arranger of lines, a marvelous colorist, a painter in the strictest sense of the word, and a true poet. His *Café d'Arles, Peupliers, Tournesols, Harengs,* and that horrifying image of himself on the eve of his death are unforgettable." Morice 1895.

24. The other version of this subject (F 527) was sent by Jo van Gogh-Bonger in 1896 to Vollard for his second exhibition of the artist's work and subsequently sold to Antoine de la Rochfoucault (see below).

25. Henri Laget to Vollard, June 15, 1895: Vollard Archives, MS 421 (2,2), pp. 122–23.

26. Degas bought *Two Cut Sunflowers* (F 376); Schuffenecker bought *The Good Samaritan (after Delacroix)* (F 633); Antoine de La Rochefoucauld bought *Self-Portrait with Bandaged Ear* (F 527) and *Vase with Twelve Sunflowers* (F 455); and Sutro bought *Interior of the Restaurant Carrel in Arles* (F 549).

27. Although it is difficult to establish the exact date the exhibition began, the accounts offer a good indication. On November 20, 1896, Vollard settled the invoice for the shipment from Amsterdam: Vollard Archives, MS 421 (4,3), fol. 57. On November 23 he wrote to Jo van Gogh-Bonger to acknowledge the receipt of paintings: Archives, Van Gogh Museum, MS b1372V/1962, 1–4. This was followed by another letter to her on November 30 expressing dismay that she had raised the prices so high that there would be little chance of selling the works: Archives, Van Gogh Museum, MS b1309V/1962, 1–4. However, on December 1 Vollard paid for the printing of the exhibition notifications as well as postage for them (Vollard Archives, MS 421 [4,3], fol. 59), suggesting a date for the exhibition in the first or second week of December 1896.

28. Typed list of works lent by Jo van Gogh-Bonger to Vollard: Archives, Van Gogh Museum, MS b1437V/1962. The consignment list of paintings contained fifty-six items but, including the individual works in the triptychs, sixty-two paintings altogether. The list of drawings contained fifty-four items but fifty-six drawings altogether, as item 16 comprised three drawings. See also S. A. Stein 2005b, p. 38, n. 27.

29. The total also included a Pissarro and a Renoir that Vollard had seen on his visit to Jo. "Les trois tryptiques; la toile en mauvais état représentant des laveuses; le portrait de van Gogh; le portrait du Dr. Gachet; et enfin dix dessins aux choix parmi ceux qui n'étaient pas catalogués quant aux prix. Ensemble 2000 fr. Le Pissarro 400; Le Renoir 200; [total] 2600." Vollard to Jo van Gogh-Bonger, March 29, 1897: Archives, Van Gogh Museum, MS b1376V/1962.

30. As early as 1890, Émile Bernard and Andries Bonger listed these three works (Bonger numbers 70, 81, and 82) as triptychs: Archives, Van Gogh Museum, MS b3055. Vollard referred to these paintings as "trois tryptiques" in his letter to Jo van Gogh-Bonger of March 29, 1897: Archives, Van Gogh Museum, MS b1376V. And in his accounts he wrote "tryptiques" against numbers 17–19 on the list (both times using the plural form): Vollard Archives, MS 421 (4,4), fol. 25. Finally, where Jo recorded receipt of the funds from Vollard, the entry is marked "3 triptieken"; see Stolwijk and Veenenbos 2002, p. 47.

31. Paris, 1988, p. 14; Martigny 2000, p. 294; Feilchenfeldt 2006, p. 121.

32. "You must realize that if you arrange them this way, say La Berceuse in the middle, and the two canvases of the sunflowers to the right and left, it makes a sort of triptych. . . . The frame for the central piece is the red one." Vincent van Gogh to his brother Theo, May 25, 1889, in Van Gogh Letters 1999, vol. 3, p. 171.

33. Vollard bought a total of fifteen paintings from the Ginoux family, which Walter Feilchenfeldt (2006, pp. 301–4) identifies as (in order of acquisition) F 488, F 569, F 548, F 455, F 604, F 568, F 486, F 490, F 496, F 529, F 432, F 497, F 477, F 533, F 547.

34. Vollard Archives: MS 421 (4,9), fols. 17, 24, 43.

35. Émile Bernard to his mother, 1899: Private collection, France, MS L.HM.

36. "The drawing is entirely beautiful. My admiration for Van Gogh grows greater and greater; I have seen marvels of his at Vollard's." Letter from Armand Séguin to Roderic O'Conor, June 1897, in Sutton and Puget 1989, pp. 51–52.

37. See Henkels 1993.

38. Faille 1970 records eighteen works that at one time belonged to Hoogendijk; it is possible that the following nine paintings were bought from Vollard: F 203, F 353, F 354, F 368, F 375, F 395, F 397, F 432, F 502.

39. The accounts record his purchase of a Van Gogh for 400 francs on February 15, 1899, and of another on May 6, 1899 (Vollard Archives, MS 421 [4,3], fols. 123, 131), probably the pen-and-ink with watercolor *Harvest in Provence* (Amsterdam–New York 2005, pp. 192–93, no. 62).

40. For Van Gogh's reception in Germany, see Feilchenfeldt 1988.

41. Brassaï 1982, p. 212.

42. See Vollard 1936, p. 24.

43. See S. A. Stein 2005a, pp. 269–72; and S. A. Stein 2005b, pp. 32–33.

44. List of Bernard works: Vollard Archives, MS 421 (2,3), fols. 1–8.

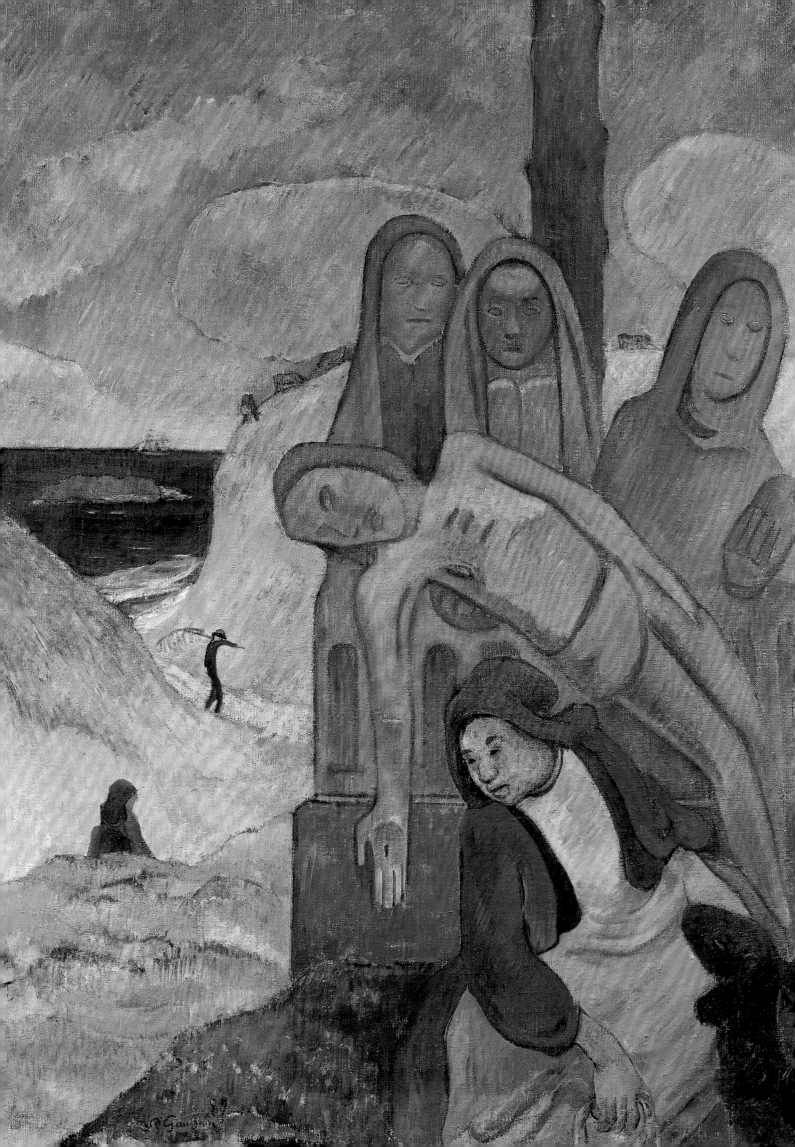

Vollard and Gauguin: Fictions and Facts

Douglas Druick

"You could even insinuate [to Vollard] that *he will lose nothing* in showing himself honest and conscientious. *Entre nous* I reckon that if Vollard proves himself upright in this matter, he will be entitled to serious respect; because it's largely to him that Gauguin is indebted for having lived sheltered from want during his last years. He had faith in Gauguin as a man and as an artist, when all is said and done."[1] Four months after Gauguin's death, his artist friend Daniel de Monfreid, executor of the estate,[2] with these words enlisted a mutual acquaintance (the painter Amédée Schuffenecker) to help him tempt Vollard to good behavior in the settling of accounts. Vollard's reward would be an upstanding reputation and the role of protector in the mythic construction of Gauguin's life that was already underway.

Paul Gauguin (1848–1903) had met Ambroise Vollard some time after returning to Paris from Tahiti in late August 1893. The complexity of their ensuing interaction is signaled, as John Rewald observed, by a significant imbalance in the content of their surviving writings. Gauguin frequently expressed vehement hostility to Vollard in letters to friends over the period 1895–1903, while Vollard was uncharacteristically reticent about Gauguin in his retrospective writings on artists. To date it has been principally the artist's voice that has shaped our understanding of the relationship, and that primarily for the time from 1900—when the dealer and artist entered into a contractual agreement—until the latter's death in 1903. In this period Monfreid played a critical role, acting as both sounding board and mediator in Gauguin's dealings with Vollard.

However, fresh information yielded by the Vollard archives and by previously unpublished correspondence, as well as recent scholarship, newly illuminates this fraught relationship and its shaping forces. Notable is the centrality to the story of Gauguin's feckless friend Georges Chaudet, the young painter-photographer who preceded Monfreid as intermediary between the artist and Vollard—with disastrous consequences. From Gauguin's perspective, the period from 1893 to 1899 took shape as a history of disinclination, deception, protracted resistance,

and desperate capitulation. The painter's animus toward the dealer was fed not only by events but also by personal antipathy; he maintained that Vollard was manipulative, selfish, and calculating. In fact, these traits characterized Gauguin as well.

PARIS, 1893–1895

Gauguin returned to Paris brimming with ambition to secure his reputation through his Tahitian works. But he lacked a dealer to market them. Theo van Gogh, who previously championed his work at the Boussod et Valadon gallery, had died just months before Gauguin's departure for Tahiti in 1891. So Gauguin sought out Paul Durand-Ruel, who had played a critical role in launching the Impressionists and was an old acquaintance.[3] Durand-Ruel's enthusiasm was, however, tempered, although he gave Gauguin an exhibition,[4] which ran November 10 to 25 and comprised forty-one Tahitian paintings, three earlier Breton canvases, wood sculptures, and a ceramic piece.

The show was not a success, and only eleven pictures sold. The prices Gauguin put on his work ranged from 1,000 to 4,000 francs, comparable to those for senior Impressionists Auguste Renoir and Camille Pissarro,[5] but Gauguin was a far less market-proven painter than they, and the art world was deeply divided in its assessment of his Tahitian work. Gauguin's old mentor Pissarro denounced the exoticism of the Tahitian pictures as pretentious. At the exhibition, Pissarro reported that "all the men of letters" (referring to the Symbolist writers) are "completely enthusiastic," while "the collectors are baffled and perplexed" and the painters as well. "Only Degas admires, Monet and Renoir find all this simply bad." Edgar Degas would eventually acquire canvases he had seen in the show.[6]

Vollard, at the time a novice with little decided taste or acumen, relied on the counsel of both Degas and Pissarro.[7] But he had known Pissarro longer,[8] and with regard to Gauguin apparently listened to him more. Evidence suggests that, like Pissarro, Vollard preferred the artist's earlier work produced closer to home.[9] A very early Gauguin had been one of his first painting acquisitions.[10] In October 1893, one month before the opening of the Tahitian retrospective, he sold it

Opposite: Fig. 60 (cat. 87). Paul Gauguin, *Green Christ (The Breton Calvary)*, 1889. Oil on canvas, 36¼ x 29 in. (92 x 73.5 cm). Musées Royaux des Beaux-Arts de Belgique, Brussels (4416)

Fig. 61 (cat. 88). Paul Gauguin, *The Red Cow*, 1889. Oil on canvas, 35¾ x 28¾ in. (90.8 x 73 cm). Los Angeles County Museum of Art, Gift of Mr. and Mrs. George Gard De Sylva Collection (M.48.17.2)

and acquired an infinitely more important Breton canvas, Gauguin's *Green Christ (The Breton Calvary)* (fig. 60), which he included in the inaugural exhibition held at his new gallery in January 1894.

Though later to reverse his opinion, Pissarro regarded Vollard as an intelligent, enthusiastic antidote to the cold calculations of the marketplace.[11] Gauguin never for a moment shared this view of Vollard as a new Theo van Gogh, and there is no evidence to suggest that he was gratified by the inclusion of his early work in Vollard's inaugural show. The indifference seems to have been mutual: when recalling visits to Gauguin's studio in early 1894, Vollard focused on the artist's collection of Van Goghs and Cézannes, not on the Tahitian work that covered the walls.[12]

In the spring of 1894 Gauguin left Paris for Brittany, where he stayed until the fall. During his absence Vollard acquired and sold several of his early canvases, paying little and realizing only modest profits in sales to colleagues such as the dealer

Lévy.[13] In September Gauguin announced his plans to leave Brittany for Paris, sell his paintings "en bloc," and, the coming February, set off for Tahiti.[14] In November a banquet honoring the artist was held at the Café des Variétés, whose owner, Auguste Bauchy, was then collecting Gauguin's work.[15] Early in December Gauguin organized a weeklong exhibition at his Paris studio, showing his recent graphic work (figs. 70, 71) together with Tahitian pictures and sculptures. It generated few buyers, Degas being a notable exception.[16] In December Gauguin also reinvolved himself with ceramics (see figs. 64, 65).

Gauguin next tried to do business with Vollard. On January 2, 1895, he sold the dealer two early ceramics that he highly valued, but at prices low enough to signal his desperation and to incur his enmity (fig. 67). Soon after that, Vollard bought a canvas by Van Gogh from Gauguin for 400 francs and paid him another 400 for three paintings already "on deposit" (*en dépôt*)—that is, on consignment—with him: one by Guillaumin and two by Gauguin.[17]

Fig. 62 (cat. 92). Paul Gauguin, *Breton Women (Two Peasants on a Road)*, 1894. Oil on canvas, 26 x 36¼ in. (66 x 92.5 cm). Musée d'Orsay, Paris, Gift of Max and Rosy Kaganovitch, 1973 (RF 1973-17)

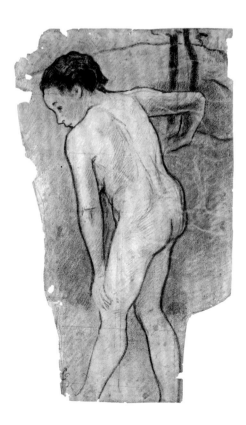

Fig. 63 (cat. 101). Paul Gauguin, *Breton Bather*, 1886–87. Charcoal and pastel, with brown ink, squared in graphite, 23⅛ x 14⅛ in. (58.8 x 35.8 cm). The Art Institute of Chicago, gift of Mrs. Charles B. Goodspeed (1946.292)

That Vollard's interest fell far short of Gauguin's hopes can be inferred from the ambitious proposal the artist made to Durand-Ruel exactly a week afterward: to sell the dealer thirty-five canvases for 21,000 francs, roughly 600 francs apiece. Likening his imminent departure to a kind of death, Gauguin argued that Durand-Ruel would be cornering the market on his work and would soon be able to increase the prices for his pictures.[18] When nothing came of this offer, Gauguin made plans for a public sale of his art at the Hôtel Drouot, hoping to repeat the successful auction of 1891 that helped fund his first trip to the South Pacific.

The sale, on February 18, included forty-nine mostly Tahitian pictures as well as drawings and prints. It was a disaster, with Degas among the few purchasers and the artist himself forced to buy back forty items.[19] (Vollard made only a token purchase of a woodcut, for a nominal sum; see discussion for cat. 104.) Pissarro saw the sale as a rout for Gauguin and the Symbolists.[20] A negative perception was also abetted, however inadvertently, by Vollard's decision to feature Gauguin's Breton canvases and ceramics at his gallery in March (figs. 61, 66, 67). Camille Mauclair, critic for the influential *Mercure de France,* seized upon this as an opportunity to laud Gauguin's early work at the expense of his later production, suggesting that the artist had lost his way in Tahiti.[21]

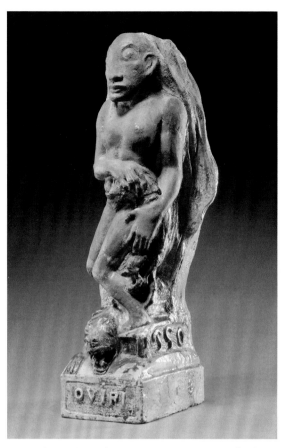

Fig. 64 (cat. 109). Paul Gauguin, *Oviri*, 1894. Partially glazed stoneware, 29½ x 7½ x 10⅝ in. (75 x 19 x 27 cm). Musée d'Orsay, Paris (OAO 1114)

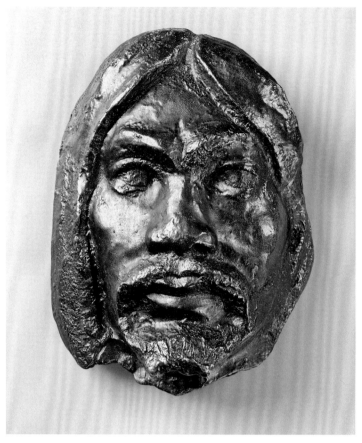

Fig. 65 (cat. 110). Paul Gauguin, *Mask of a Savage*, 1894. Bronze, 9⅞ x 7⅛ x 4¾ in. (25 x 18 x 12 cm). Musée d'Orsay, Paris, Gift of Lucien Vollard, 1944 (AF 14392)

Pressed for money and in debt, Gauguin postponed his departure and pursued various schemes to realize funds.[22] He worked out several arrangements with collectors, including Bauchy, to sell them pictures on credit and receive payments later in Tahiti.[23] Gauguin also twice authorized Bauchy to trade to Vollard works by other artists from his own personal collection, in exchange for canvases by Cézanne, among others.[24] This did not address his need for cash, but by refining his collection—trading up—Gauguin was evidently banking on the future worth of artists he admired; while deploring the speculative practices of dealers, he appears to have been intent on beating them at their own game. Gauguin's use of a middleman seems an indication that his relationship with Vollard had soured, although he may also have thought Bauchy might be more effective in negotiating with the dealer. Possibly Vollard never knew Bauchy was acting as Gauguin's agent.[25] Just weeks before his departure for Tahiti, Gauguin bought back a picture of his from Vollard for 250 francs.[26] At a moment when he was scrambling for funds, this seems a defiant gesture expressing his dissatisfaction with Vollard's neglect of him and a means of asserting his own worth.

Gauguin was coming to view Vollard as the embodiment of exploitative market practices and as his personal nemesis. It was with Bauchy that, in preparation for his departure, he deposited most of his collection of works by contemporaries.[27] But Gauguin did not trust Bauchy entirely either, for he asked Lévy to collect the monies owed to him by the restaurateur. Gauguin then entrusted to Lévy, who had shown commitment to his work, the majority of his own paintings.[28] There remained drawings and sculpture, as well as additional canvases by Cézanne and Van Gogh; the responsibility for these Gauguin gave to Chaudet, who was part of his artistic circle and who apparently also worked as a middleman in sales of art.[29] A "contract" that Gauguin devised with Chaudet and Lévy (and possibly Bauchy)[30] seems to have given them authority to sell and acquire on his behalf, but it has been lost. What survives is the record of Gauguin's totally unrealistic expectation that Lévy and Chaudet would be able to create an audience for his work and thus through sales raise money on which he could live in Tahiti. In distraught letters for years thereafter, Gauguin blamed the two for having given him misleading assurances that emboldened him to leave France.[31] Whether they actually made them or whether Gauguin, characteristically, heard what he wished to hear can only be surmised.

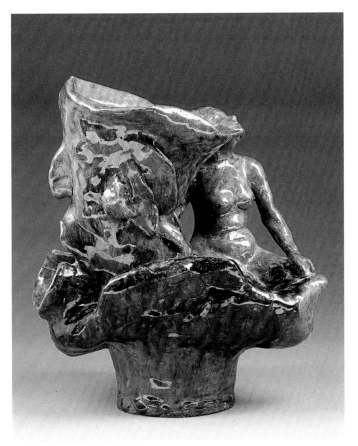

Fig. 66 (cat. 108). Paul Gauguin, *Marchand d'esclaves (Fantastic Vase)*, 1889. Glazed stoneware, H. 10⅜ in. (26.5 cm). Private collection

Fig. 67 (cat. 107). Paul Gauguin, *Decorated Pot*, ca. 1886–87. Stoneware, 5⅛ x 6 x 4⅝ in. (13 x 15.1 x 11.6 cm). Musée d'Orsay, Paris, Gift of Lucien Vollard, 1943 (AF 14329-6)

THE TAHITI PERIOD, 1895–1900

Gauguin departed in June 1895. His elaborate plan to minimize risk and maximize profits by spreading responsibility among three individuals—who would police one another—began to unravel while he was still en route to Tahiti. Bauchy, apparently beset by financial problems, renounced his role as agent for Gauguin's collection and turned the items deposited with him over to Chaudet,[32] who by the fall was trading Gauguin's drawings with Vollard (fig. 63). As fall passed into winter, Gauguin, in Tahiti, vainly awaited money from Paris, his expectation further thwarted by the painful slowness of the mails.[33]

In early spring of 1896 Vollard wrote to Gauguin, proposing that he make a woodcut and asking him to lower his prices on two small Van Gogh sunflowers, but Gauguin was dismissive.[34] He was still counting on Lévy to sell his work and collect sums due him, even though the dealer's silence had disturbed him enough to ask his friend Monfreid to investigate.[35] Lévy's apparent plans for a Gauguin exhibition in April fell through,[36] and in May the artist learned that Lévy had "dropped" him[37] and withdrawn from their understanding.

Desperate, Gauguin floated an idea with Monfreid, among others: find fifteen people willing to commit to a five-year sub-scription at 160 francs per year, for which each would receive one painting annually. He proposed that Monfreid take the first fifteen pictures from those held by Lévy.[38] But Lévy's stock was being set on a different course, without Gauguin's knowledge, by Chaudet. The young man—feeling besieged by Gauguin's repeated requests for money he couldn't advance against pictures that weren't selling, and criticized by him for losing sales opportunities—had on his own consigned fifteen pictures to Vollard, to be sold at "very low prices." He subsequently wrote Vollard that he must absolutely send him 500 francs for Gauguin by the end of July.[39]

Vollard's records indicate no immediate response to Chaudet's plea but in October display the first sign that Vollard was beginning to take advantage of the situation to acquire works at bargain prices. Chaudet, having reclaimed all of Gauguin's work from Lévy (as previously from Bauchy), now controlled virtually everything that the artist had left in Paris.[40] Opportunism doubtless informed two deals that followed, in which Vollard gave Chaudet (on November 9) two drafts made out to Gauguin totaling 1,035 francs and (on December 1) two more totaling 1,100 francs. What Vollard received for these large disbursements remains a mystery.[41]

Fig. 68 (cat. 89). Paul Gauguin, *Arearea (Joyousness I),* 1892. Oil on canvas, 29½ x 37 in. (75 x 94 cm). Musée d'Orsay, Paris, Bequest of Mr. and Mrs. Frédéric Lung, 1961 (RF 1961-6)

In November 1896 Vollard held a Gauguin exhibition in his new quarters at 6, rue Laffitte. The thirty canvases on view included Tahitian work shown at Durand-Ruel's in 1893 (Lévy's former stock), complemented by earlier canvases (from Vollard's existing inventory); there was also a group of virtually unknown "glazed stoneware, faience, and wood sculptures." It was, as Thadée Natanson astutely observed in *La Revue blanche,* an exhibition worth seeing.[42]

Occurring at the same moment, the disbursements Vollard made out to Gauguin and the exhibition of his work are likely to be linked. But how? And how do these elements fit into the ultimately deeply perplexing triadic business relationship among Vollard, Chaudet, and Gauguin—the scandalous "affaire Chaudet" first laid out by Daniel Malingue in 1987?[43]

A potential source of illumination is a curious document written in several hands. It is headed, in handwriting whose author has not been identified, "Inventaire des tableaux et objets d'art de Paul Gauguin mis *en dépôt* chez Monsieur Vollard—6 rue Laffitte" (fig. 72).[44] Beneath, in a different hand that is probably Chaudet's,[45] is a list in two columns: the left-hand column is numbered on the left from 1 to 27 (and 27bis); the right-hand column continues the numbering, but on the right, going from 28 (and 28bis) to 42. Also accompanying the listed items are letters that belong to partial alphabetical sequences, and additional numbers.[46] Each item on the list is assigned an amount ranging from 100 to 500. These, as Vollard would later explain to Gauguin, were the prices in francs that Chaudet assigned to the art—but that, the dealer assured him, were regularly reduced by 40 to 50 percent "when I made him a firm offer."[47]

The inventory obscures as much as it reveals. Despite Vollard's suggestion of regular purchases and discounts, only one item on the list (labeled AI) is marked "sold," with the

Fig. 69 (cat. 91). Paul Gauguin, *Self-Portrait with Hat* (*Portrait of William Molard*, on reverse), ca. 1893–94. Oil on canvas, 18⅛ x 15 in. (46 x 38 cm). Musée d'Orsay, Paris (RF 1966-7)

original price of 300 crossed out and reduced to 150.[48] Moreover, its identity remains a blank, as do those of all but one of the forty-four objects listed.[49] In place of a title or description for each item on the list one finds a scribble followed by a letter, a pair of letters, or a number—a designation that could be understood only by those who knew the code. Who the initiates were, beyond Vollard and Chaudet, is uncertain.[50]

The document apparently dates at the latest to early 1897, shortly after the close of Vollard's Gauguin exhibition.[51] Notes and comments on the second page in Vollard's hand shed light on some aspects of the inventory while underscoring its complexities. Particularly puzzling is a list of canvases Chaudet took back from Vollard,[52] which includes "homme à la hache" (*Man with an Ax*, 1892, private collection; W 430), a picture that according to his account books Vollard had sold during the recent exhibition to the dealer Duhem for 400 francs, realizing a profit of 150 francs.[53] How could the same

picture have been sold by Vollard and also returned by him to Chaudet?

The inventory, though itself opaque, when studied alongside others of Vollard's accounts permits a simple conjecture about the four drafts totaling 2,135 francs that Chaudet received for Gauguin at the time of the 1896 exhibition—namely that they represent Gauguin's share from the sale of his works or those from his personal collection, or both. The sale may well have included the seven pictures missing from the Chaudet sequences, but there must have been others as well, since it is clear that Vollard was paying less than 300 francs per picture.[54] Because the account books reflect only a few sales, the other works must have been bought up by Vollard for stock.[55] Between works purchased outright and those on deposit, Vollard had cornered the market for all but Gauguin's most recent works (and at prices below those the artist had paid when buying back the same work at the 1895

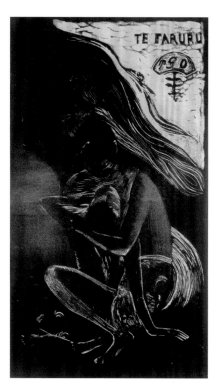

Fig. 70 (cat. 105). Paul Gauguin, *Te Faruru (Here We Make Love)*, Winter/Spring 1894. Woodcuts, *left:* in black with hand-colored additions in red watercolor; *right:* in ochre and black with hand-applied and transferred watercolors and waxy media; each image 14 x 8 in. (35.6 x 20.2 cm). The Art Institute of Chicago, Clarence Buckingham Collection (1948.257, 1950.158)

auction).[56] Existing records suggest Gauguin did not clearly understand the transaction between Chaudet and Vollard (see below), but we do know that Chaudet dutifully sent along the funds, for which the artist was grateful.[57]

Meanwhile, Gauguin worried that he had angered Chaudet by sending recent paintings not to him but to Monfreid, who arranged for their display.[58] Nonetheless, he beseeched Monfreid to continue selling his new work, hoping that Chaudet would simultaneously be selling his earlier paintings and sculptures and his Van Goghs.[59] When it became clear that Monfreid had more new pictures than he could handle, Gauguin suggested that he give them to Chaudet, but only after skimming off "*some of the best*" to reserve for the stronger market that would exist eventually.[60] However, Monfreid assured Gauguin that Chaudet was actively working on the artist's behalf,[61] and there is evidence that Chaudet was indeed attempting to keep Gauguin's work before the public (see fig. 252).

Gauguin was unimpressed by Monfreid's news of the 1896 show Vollard had mounted of his work: "[Theo] Van Gogh alone knew how to sell and to create a clientele: no one today knows how to engage the amateur . . . it is necessary . . . to know how to place a picture for six months, a year, with a serious collector, who, having . . . learned to love it, will buy it. . . . That is the true exhibition for my works."[62] Character as well as business strategy was at issue, as Gauguin's dyspeptic response to a friend's praise for Vollard revealed: first alluding to the reputation of the dealer's island compatriots as "bluffers," he continued, "Vollard's father is known as the *most wily* rascal

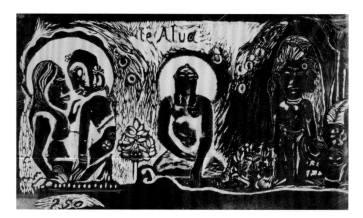

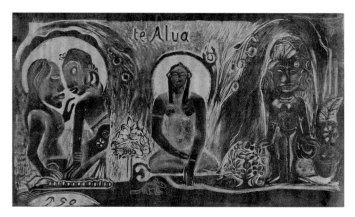

Fig. 71 (cat. 104). Paul Gauguin, *Te Atua (The Gods)*, Winter/Spring 1894. Woodcuts, *top:* in black, image 8 x 13⅞ in. (20.2 x 35.4 cm). The Art Institute of Chicago, William McCallin McKee Memorial Collection (1942.349); *bottom:* in brown, orange, and black, image 8 x 14 in. (20.4 x 35.5 cm). The Art Institute of Chicago, gift of the Print and Drawing Club (1953.326)

there ever was, but all the Vollards are very intelligent. Vollard requires a watchful eye."[63]

In the spring of 1897 Vollard wrote to Gauguin reiterating his interest in prints and asking for drawings as well as sculpture. The artist responded with undisguised suspicion: "I have just received your letter with many requests, many propositions, but I find myself unable to discern its true meaning."[64] Works in which Vollard professed interest, he reasoned, had been around "for a long time and without any benefit for me."[65] Moreover, Gauguin's response to the dealer's request for drawings—"I have no old drawings here, since I left everything with Chaudet who takes care of my affairs"[66]—suggests his ignorance of the earlier Chaudet-Vollard transactions.

Gauguin continued to bemoan his lack of a *serious* dealer intelligent enough to "get his clients to see and understand my pictures!!!"[67] Chaudet was clearly not dependable. Although Gauguin received from him the second of Vollard's two large drafts in March 1897, not until November did Chaudet send 700 francs from additional transactions with Vollard that had transpired the previous April (see discussion for cat. 93). Nor was there any sign of the 150-franc monthly payments that Chaudet (having replaced Lévy) was to collect on Bauchy's debt. Chaudet offered excuses and a less-than-transparent account of his dealings;[68] Gauguin, confused and skeptical, asked the faithful Monfreid to keep a close eye on Chaudet and report back.[69]

In the fall of 1897 Chaudet wrote that to keep Gauguin's work in the public eye, he, Monfreid, and Schuffenecker had decided to mount an exhibition of the artist's recent work "chez Vollard, who put his shop at our disposal."[70] It is telling that Gauguin made no mention of this plan when he wrote Monfreid in February 1898; a month later he critiqued the idea obliquely, suggesting that a different new painting be put on view at Vollard's gallery every month "without fuss," simply to advance sales.[71] But when in July 1898 Gauguin wrote Monfreid announcing his shipment of his "grand tableau" *Where Do We Come From? What Are We? Where Are We Going?* (fig. 13) together with other paintings, he himself raised the possibility of an exhibition. Significantly, he excluded Vollard: "The most recent canvases should be exhibited at Bing's or at Durand-Ruel's: if not—and I think that would be perfectly fine, in Chaudet's studio or your own." Gauguin wanted invitations sent and drafted a list of invitees, including Degas. He mentioned Vollard, along with the dealer Arsène Portier, only as a source for a mailing list of names. It was Portier, not Vollard, whom he suggested might act "as dealer" were the exhibition to be held at Chaudet's.[72]

Gauguin's reasoning can be inferred from his previous response to news received from Monfreid that Degas and his

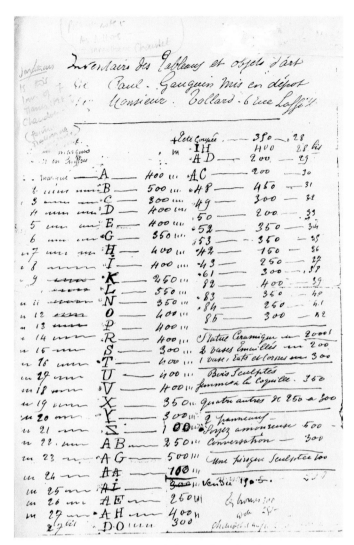

Fig. 72. "Inventory of pictures and objects of art of Paul Gauguin on deposit with Monsieur Vollard, 6 rue Laffitte" (the "Chaudet inventory"). Documentation du Musée d'Orsay, Paris

friends the collectors Henri and Ernest Rouart had visited Monfreid's studio, seen Gauguin's recent canvases, and made purchases. Gauguin took this as proof that "one can do *one's business better* than the dealers; they know only one thing, how to 'take a big commission,' and sell only what people are looking for and often in spite of themselves. With the exception of Durand-Ruel, they never create a clientele to their own taste." An exhibition of his recent work in Monfreid's or Chaudet's studio, he concluded, "is a better sales strategy."[73] His comments were aimed implicitly at Vollard.

But Gauguin's wishes were not granted. On November 11, 1898, Monfreid wrote that he had just sold Vollard four of the artist's recent pictures (including *The Bathers,* fig. 75) for 600 francs total.[74] Moreover, Monfreid, planning to be away for the winter, had left the remaining pictures from Gauguin's last shipment with Chaudet to sell and exhibit according to Gauguin's instructions;[75] but just days later, Chaudet informed

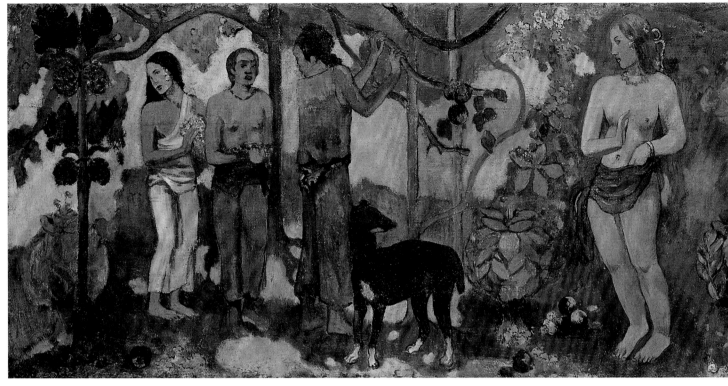

Fig. 73 (cat. 98). Paul Gauguin, *Faa Iheihe (Tahitian Pastoral)*, 1898. Oil on canvas, 21¼ x 66½ in. (54 x 169 cm). Tate, Presented by Lord Duveen 1919 (N03470)

Monfreid that he too was leaving Paris (for reasons of health) and had given the canvases to Vollard to exhibit.[76] This was a fait accompli; an exhibition of Gauguin's recent work, with *Where Do We Come From?* as its centerpiece, had already opened at Vollard's gallery on November 17.

Monfreid forwarded Chaudet's letter to Gauguin, adding an apologetic postscript but also observing that the exhibition "seems to have made a favorable impression on the public."[77] In a separate letter Chaudet explained to Gauguin what had transpired, adding that Vollard had sent out invitations, that the exhibition had been well attended, and that in early December Monfreid had sold Vollard "the nine canvases mak-

ing up the exhibition" for 1,000 francs (see fig. 77).[78] *Where Do We Come From?* was not among these.

While Gauguin had responded philosophically to news of Monfreid's first (October) sale to Vollard,[79] learning that Vollard had staged this exhibition and had bought the balance of the works (with the notable exception of the "grand tableau") at roughly 115 francs each struck him as a complete disaster: Vollard now not only controlled the market for his recent work but also was devaluing it. Sensing a conspiracy in which Degas and Rouart might be implicated, he railed against Vollard for predatory, exploitative practices and despaired for the future: the dealer, having dropped the prices a further 20 percent in

Fig. 74 (cat. 106). *Left:* Paul Gauguin, *Change of Residence*, 1899. Woodcut in black (second state) laid down over woodcut in ochre (first state), sheet 6½ x 11⅞ in. (16.4 x 30.1 cm). The Art Institute of Chicago, The Albert H. Wolf Memorial Collection (1939.322). *Right:* Paul Gauguin, *Love, and You Will Be Happy*, 1898. Woodcut in black (second state) laid down over woodcut in ochre (first state), 6⅜ x 10⅞ in. (16.2 x 27.6 cm). The Art Institute of Chicago, Joseph Brooks Fair Collection (1949.932)

But the events of 1899 would effect a sea change in Gauguin's relationship with the dealer, despite his lingering bitterness over the "Vollard speculation."[81] With Monfreid spending less time in Paris and Chaudet in ill health, Gauguin realized something must be done.[82] He imagined Monfreid might find him someone to provide materials and 2,400 francs annually for five years, in return for which he would produce whatever was wanted.[83] When Monfreid suggested that Vollard wanted to help and that Gauguin ought to write him, the painter balked. "Write to him!!! I'm always afraid, and with reason, that he sees *my letters only as self-seeking,* I know him." If Vollard wished to be of assistance, he should contact the artist first.[84] Nonetheless Gauguin had begun rousing himself with the prospect of an exhibition at Vollard's gallery to coincide with the Exposition Universelle scheduled for 1900 in Paris, and he was discouraged when by late summer Vollard had neither written nor made an offer for *Where Do We Come From?*[85]

In early September 1899 Georges Chaudet died at the age of twenty-nine. On learning of this at year's end, Gauguin went into action. His first thought was that the painter Paul Sérusier might "replace" Chaudet; his second contained an instruction to Monfreid reflecting the artist's ignorance of his own affairs, which he now belatedly tried to correct: "*Go see at Vollard's what Chaudet left on deposit, because he did not, as far as I know, sell pictures of mine to Vollard.*"[86] Over the next months came revelations that Chaudet had lied and embezzled funds—including money from Bauchy, who had actually paid off his debt, contrary to Chaudet's representation that he had not—and Gauguin woke up to the implications

this most recent transaction, would be positioned with his stock of new paintings to offer the artist still less in the future; his instincts and motives were strictly commercial. In 1899 he wrote Monfreid that "Vollard never comes around except when there is already a buyer, and 25 percent commission doesn't satisfy him."[80]

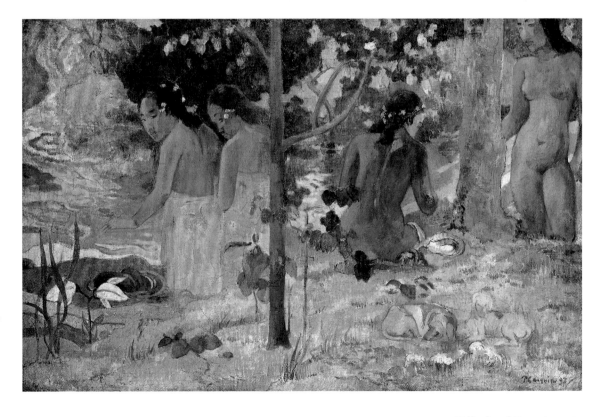

Fig. 75 (cat. 94). Paul Gauguin, *The Bathers*, 1897. Oil on canvas, 23¾ x 36¾ in. (60.4 x 93.4 cm). National Gallery of Art, Washington, D.C., Gift of Sam A. Lewisohn (1951.5.1)

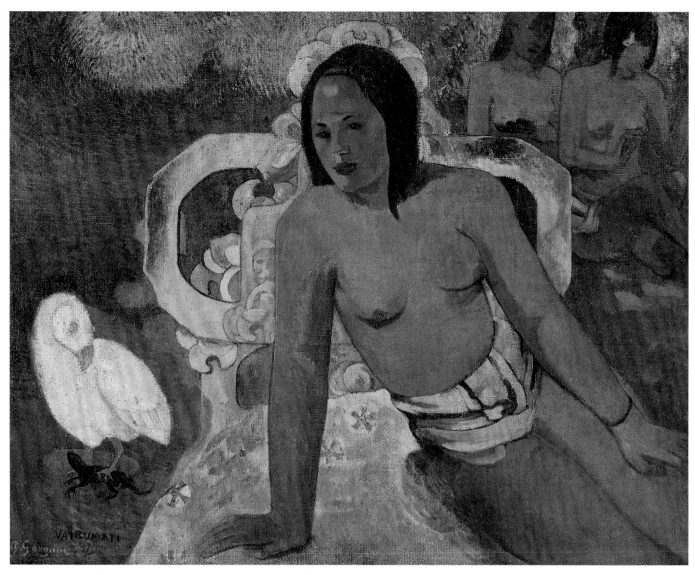

Fig. 76 (cat. 95). Paul Gauguin, *Vairumati*, 1897. Oil on canvas, 28½ x 37 in. (73 x 94 cm). Musée d'Orsay, Paris, Kojiro Matsukata Collection; acquired by the Musée du Louvre in application of the peace treaty with Japan, 1959 (RF 1959-5)

of his predicament. Having so trusted Chaudet that he had not bothered to keep his letters, he recognized that his only hope of reconstructing events lay with Vollard.[87] "To be investigated," he wrote Monfreid, "is . . . which are the *paintings that Chaudet* would have entrusted to Vollard, who must have evidence of them in his books! . . . That is . . . worth the trouble of doing because in short Chaudet had my *entire* studio. . . . In any event my paintings and sculptures must be safeguarded."[88]

In fact, immediately following Chaudet's death, his brother Jean-Léon had written to Monfreid citing the inventory described above as a basis on which the two of them could discuss what was owed to Gauguin.[89] But clearly Gauguin was still unaware of the inventory's existence. And in any case the document could not have revealed the whereabouts of his Van Goghs, five of which Chaudet had sold to Vollard as recently as June 1899,[90] or that Chaudet had indeed directly sold to Vollard Tahitian paintings left in Paris by Gauguin. Vollard's Stockbook B includes as inventory three

canvases that are cross-referenced to the Chaudet inventory of works on deposit.[91]

Monfreid, from his residence in the Pyrenees, attempted to seek restitution on Gauguin's behalf. Gauguin himself informed the slippery Jean-Léon Chaudet that he couldn't make sense of his brother Georges's "accounts."[92] Possibly this was a reference to the inventory, a copy of which seemingly was in Gauguin's hands by late 1901, when Vollard discussed it with him.[93] How far Monfreid got with Jean-Léon is unclear. Four pictures listed in the inventory that were in Monfreid's possession by October 1900—when he sent them to Vollard—might possibly represent works recovered from Jean-Léon on Gauguin's behalf (see fig. 68).[94]

Although he would not show Monfreid his books, Vollard became the unofficial go-between with the Chaudet family.[95] In the summer of 1900 Vollard told Monfreid and Gauguin that Jean-Léon had located no pictures in his brother's atelier but had found from his papers that an outstanding balance of

Fig. 77 (cat. 97). Paul Gauguin, *The Purau Tree (Te bourao [II])*, 1897–98. Oil on canvas, 28¾ x 36¼ in. (73 x 92 cm). Private collection

400 francs was owed to Gauguin. Jean-Léon would send the money, but only if Gauguin first provided a receipt declaring all accounts with the Chaudets settled.[96] Gauguin was indignant but complied and in October sent, via Monfreid, the receipt that would essentially exculpate Chaudet's heirs.[97] In February 1901 Gauguin asked Vollard to inquire whether Jean-Léon had sent the funds; in the following month Jean-Léon died.[98] To the end of Gauguin's life, Monfreid harbored hopes that Vollard might be able to pry more money loose from Chaudet's mother.[99] These expectations were tied up with a surprising new development: Vollard had become Gauguin's principal dealer.

THE CONTRACT, 1900–1903
Shortly after Georges Chaudet's death in the fall of 1899, Vollard wrote to Gauguin asking for drawings and flower paintings and offering, pending an agreement on prices, to

"buy everything" he produced.[100] Highly ambivalent but desperate, Gauguin responded via Monfreid: he demanded an advance of 300 francs a month against the delivery of a maximum of twenty-five pictures annually at 200 francs per canvas.[101] Anxious that the deal might fall through, Gauguin told Monfreid he would be willing to take less,[102] but Vollard accepted his terms, and from then until Gauguin's death, the two were contractually bound.[103]

Not surprisingly, there were constant tensions fed by mutual suspicion, questionable behavior, and miscommunication about monies and pictures sent, exacerbated by postal delays that only worsened after Gauguin moved to the Marquesas Islands in 1901. Consistent in his manipulations, Gauguin attempted to regain control of his oeuvre through Monfreid. Thus when in the fall of 1900 Vollard asked Gauguin if he could buy canvases from Monfreid's stock at the agreed-upon price of 200 francs each, Gauguin, suspecting a speculative campaign to buy up all his work as

Fig. 78 (cat. 100). Paul Gauguin, *Flowers and Cats*, 1899. Oil on canvas, 36¼ x 28 in. (92 x 71 cm). Ny Carlsberg Glyptotek, Copenhagen (MIN 1835)

cheaply as possible, urged Monfreid to bypass Vollard and sell as much as possible to other buyers so that "in a year we can make him dance to our tune."¹⁰⁴ Shortly thereafter Monfreid sold two canvases to the collector Gustave Fayet for 600 francs each. Gauguin's reaction was to express regret that Fayet's friends went to Vollard for his work rather than to Monfreid.¹⁰⁵

Monfreid and Gauguin continued to maintain a "reserve" of Gauguin's best pictures, kept in a space Monfreid maintained in Paris, both to offer to "*serious* clients" who valued the artist's work more than Vollard did and as a hedge against the future.¹⁰⁶ Although the contract with Vollard was a godsend for Gauguin, he regarded it as a bargain for the dealer and since it was not exclusive felt free to work in his own best interests, so long as he also fulfilled the annual quota of pictures.¹⁰⁷ Gauguin some-

times sent his shipments of paintings to Monfreid so that he could keep aside "les plus belles" before passing on the balance to Vollard.¹⁰⁸ And Monfreid was quick to emphasize his importance in this role,¹⁰⁹ even though he was occasionally queasy about selling "au dehors de Vollard."¹¹⁰

Gauguin was highly ambivalent about his dealings with Vollard. Sometimes he talked of breaking with the dealer and fantasized that he would live off the land in the Marquesas, save money, and reach the point where he could tell him to pay more for his canvases or go without.¹¹¹ But when Gauguin had not heard from Vollard for several months, anxiety replaced bravado. The artist was concerned for his survival should the dealer drop him¹¹² and worried that silence might indicate his displeasure with the quality of the works. To these thoughts Gauguin defensively countered that if the

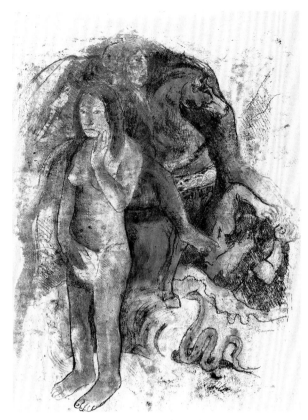

Fig. 79 (cat. 102). Paul Gauguin, *The Nightmare*, ca. 1899–1900. Transfer drawing in black and ochre, 23 x 17 in. (58.5 x 43 cm). Private collection

had forced him to accept,[115] Vollard, at Monfreid's urging, agreed late in 1900 to increase payments to Gauguin, by 50 francs per picture and 50 francs per monthly advance.[116] But Vollard pulled back from this commitment, for in September of 1901 he told Monfreid that while he had indeed increased the monthly advances to 350 francs, the payment per picture would not be raised until the future. Gauguin was not treating him well, he confided to Monfreid, but he wanted the artist to be "happy with me." To this end and in order to bring up to date his accounts of money paid to and pictures received from Gauguin, he would provisionally factor in "the paintings coming from Chaudet at the prices Chaudet set . . . when the pictures left Lévy's care and we hoped to sell them." These, he said, were much higher than what he currently paid Gauguin per canvas (although, he noted, Chaudet used to discount the prices by half). Nonetheless, Vollard allowed that he had sold two or three pictures for "strong prices" and stressed that he would *not* take out the 20 percent dealer's commission to which he was entitled. He volunteered this information to Monfreid by way of introducing his desire to sell a picture from Gauguin's first Tahitian sojourn that, though it had found its way into his hands, was not on the Chaudet inventory (fig. 244).[117] The market was showing interest.

Two months later the story had changed. Vollard informed Gauguin that he simply could not pay more than the contractual 200 francs per painting, since the work he had been receiving was too difficult to sell; moreover, he added, apparently hoping to win the artist over, "on the pictures for which Chaudet gave me the inventory, I will not ask any discount except the 20 percent commission that was agreed upon with Chaudet . . . and as I will finally be looking after them, all that will represent important resources for you."[118]

With Gauguin lacking full information, Vollard could make these belated representations regarding the "affaire Chaudet" without fear of being contradicted.[119] But his somewhat sibylline

pictures weren't all "masterpieces," Vollard was only getting what he paid for.[113]

Vollard, who also dealt with Fayet, knew what was going on, once inquiring discreetly of Monfreid, "Gauguin tells me that he is sending me several canvases but he does not say whether he is doing so directly or by means of an intermediary."[114] Understanding the competition that Monfreid's dealings represented and wishing to be responsive to Gauguin's expressed displeasure about the "ridiculous prices" necessity

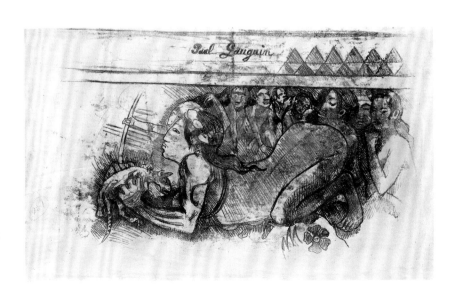

Fig. 80 (cat. 103). Paul Gauguin, *Crouching Tahitian Woman*, 1900. Transfer drawing in brownish black ink, image 12 x 20 in. (30.5 x 50.8 cm). The Art Institute of Chicago, through prior bequest of the Mr. and Mrs. Martin A. Ryerson Collection (1991.217)

accounting did little to dispel Gauguin's suspicions. When Bauchy contacted the artist early in 1902 about the whereabouts of an early Tahitian picture, Gauguin remembered it as among those that went from Lévy to Chaudet and wondered, "What's become of them. Are they now with Vollard?"[120] At about the same time, Gauguin, fearing another Chaudet "fraud," questioned Vollard about how pictures of his had come into the possession of the painter Władysław Ślewiński. It is unlikely that he found the dealer's response adequate.[121]

In the spring of 1902, Monfreid attempted to reassure Gauguin of Vollard's goodwill. Perhaps they had been "wrong to believe him such a crook," he volunteered; certainly he was no more dishonest a dealer than the Bernheim brothers, and was Durand-Ruel really more loyal? So long as Vollard continued to evince an intensified commitment to Gauguin's work, Monfreid counseled, he should be encouraged.[122] At year's end Monfreid reported to Gauguin that his reputation was on the rise, adding that Vollard was working little by little to this end, perhaps already anticipating Gauguin's ultimate "fame."[123] Gauguin was only partially convinced. Asked by a critic why his work wasn't more visible in Paris, he replied bluntly, "Vollard . . . hides the pictures, no doubt with an eye to speculation."[124] But Gauguin had enough in common with Vollard to see that the strategy was probably excellent in the long term, even if this would benefit him little.[125]

However, Vollard's subsequent neglect—his failure to send Gauguin the supplies he had promised—undercut the grounds for Monfreid's optimism.[126] On May 9, 1903, Monfreid again wrote asking Gauguin to send him paintings directly, since Vollard would not pay what the canvases were worth, whereas others quite clearly would. In closing, Monfreid raised the subject of what Gauguin, long in ill health, would want him to do in the event of his death: retrieve for his estate the pictures or credits that were "chez Vollard"?[127] The question came too late; Gauguin had died on May 8. The news had still not reached France in mid-August, when Monfreid wrote to give Gauguin the good news that Fayet was buying three pictures from the reserve for 3,300 francs.[128]

POSTSCRIPT

Feeling his responsibility for the deceased artist's affairs (later made specific by Gauguin's widow), Monfreid contacted Vollard on August 29 requesting an updated statement of the dealer's transactions with Gauguin.[129] As it happens, Vollard had written the day before in response to an earlier request for an account-ing, noting that he had received per the contract with Gauguin a total of thirty-six pictures from the artist but that a statement would have to await his recovery of the missing "little book" in which he kept part of his accounts.[130] The next day, having received the news of Gauguin's death, the dealer wrote again, promising quickly to dispatch a "copie du compte."[131] A week later, Monfreid, as quoted at the head of this essay, enlisted Schuffenecker to nudge Vollard toward an honest accounting, appealing to the dealer's self-interest if not his better self and reminding him of the new, public dimension of his relationship with the suddenly mythic artist.[132]

Vollard's response was in character. He informed Monfreid that his calculations would be based on a payment of 200 francs per picture (only now revealing his withdrawal of the promise of 250 francs and offering to produce a copy of his letter to Gauguin as proof). He also broached the unresolved issue of the Chaudet affair, noting he had sold a certain number of works, that Chaudet himself had "taken back" many, and that any settlement would require the "cooperation" of Chaudet's mother—who had offered to share her son's accounts, including Chaudet's duplicate of the inventory he and Vollard had drafted.[133] Monfreid countered that drawing up the accounts as "exactly" and "conscientiously" as possible and obtaining a "settlement" from Madame Chaudet would benefit Vollard's interests as much as those of the Gauguin heirs; he also expressed shock at the dealer's having reneged on the promised price of 250 francs.[134] Indignant and defensive in turn, Vollard held firm. As proof of his probity he recounted how he had declined to get involved in the resale of a picture for which Chaudet had not collected all the monies due Gauguin, because "it wasn't in my character." Nonetheless, Vollard took the opportunity to propose a deal—he would keep the picture in question and for it give Madame Gauguin something extra.[135] Vollard's own grievances emerged in the sour observation that the pictures Gauguin had sent him had been difficult to sell and included work "of very little importance."[136]

Monfreid registered Vollard's displeasure; his own agenda was to protect Gauguin's posthumous reputation. Sanitizing the difficult relationship between these two difficult personalities was important, not least perhaps because of his own role in it. His advice to Vollard was pragmatic: "It is very important, don't you think, that the appearance of our departed friend not be too disfigured, that his reputation, already so manhandled during his lifetime, not be utterly spoiled. For me this would be a sorrow; for you it would in a way be prejudicial. For art it would be a disservice."[137]

Rewald concluded, no doubt correctly, that in settling the estate Vollard satisfied his contractual agreement with Gauguin.[138] The Chaudet affair is another matter; although

Monfreid pursued a settlement with Vollard, there does not appear to have been any resolution before Madame Chaudet's death in 1905.[139] Malingue concluded that the Chaudet family retained paintings by Gauguin as well as from his personal collection and continued to sell them through World War II.[140] If Vollard reached a settlement with the Gauguin heirs regarding the Chaudet canvases in his keeping, nothing is known of it.

Monfreid was ready to gloss over unpleasant truths about the Gauguin-Vollard relationship, knowing that in the history of art the two would inevitably be linked. Vollard apparently heeded Monfreid's advice, remaining reticent on the subject. Both artist and dealer were guilty of bad behavior. Yet what the new information supports is the assessment voiced by Henri Matisse in 1952: "Vollard acted shamefully toward Gauguin."[141]

The author gratefully acknowledges assistance in the preparation of this essay from: Joseph Baillio, Ann Dumas, Sylvie Crussard, Stephanie D'Alessandro, Gloria Groom, Fred Leeman, Jonathan Pascoe Pratt, Anne Roquebert, Susanna Rudofsky, George Shackelford, Harriet Stratis, Gabriel Weisberg, the Wildenstein Institute, Wim de Wit, and Peter Zegers.

Special thanks are due to Jill Shaw, Research Assistant in the Department of Medieval through Modern European Painting, and Modern European Sculpture at the Art Institute of Chicago.

In this essay, the following abbreviations are used in citing catalogue raisonné numbers: for works by Gauguin, "W" refers to G. Wildenstein 1964, and "W-2001" refers to D. Wildenstein 2001; for works by Cézanne, "R" refers to Rewald 1996.

1. "Et vous pourriez meme lui insinuer *qu'il ne perdra rien* à se montrer honnete et consciencieux. Entre nous j'estime que Vollard, s'il se montre probe, en cette circonstance, aura droit à de sérieux égards; car c'est a lui que Gauguin doit, au grande partie, d'avoir vécu à l'abri du besoin ces dernières années. Il a eu foi en Gauguin comme homme et comme artiste, somme toute!" Monfreid to Schuffenecker, September 8, 1903: Research Library, The Getty Research Institute, Los Angeles, 2001.M.24.

2. Georges-Daniel de Monfreid (1856–1929), a painter and sculptor, met Gauguin in November 1887 and became his faithful and dependable friend.

3. Washington–Chicago–Paris 1988–89, pp. 6–7.

4. He required that Gauguin cover the cost of invitations, posters, and catalogue.

5. See Frèches-Thory 2004, p. 87, and Washington–Chicago–Paris 1988–89, p. 292. Gauguin did sell one of his most prized canvases, *Ia Orana Maria (Hail Mary)* (Metropolitan Museum; W 428) to the collector Manzi for 2,000 francs. For relative markets of established artists, see Rewald 1943 (1986 ed.), p. 174.

6. See Pissarro to Lucien Pissarro, November 23 and 27, 1893, in Bailly-Herzberg 1980–91, vol. 3, p. 400, letter 962, and p. 401, letter 963; for the English translation, see Rewald and L. Pissarro 1943, p. 221. On Degas's acquisitions, see New York 1997–98, vol. 2, p. 54, nos. 480, 481, and Gary Tinterow, "Degas and Vollard," in this catalogue, note 10t.

7. Later Vollard recalled that "Degas ranked Gauguin very high. He only reproached him for having gone to the ends of the earth to paint." See Vollard 1936, p. 174.

8. In a letter to Lucien on January 21, 1894, Pissarro mentions that he had met Vollard through the painter John Lewis Brown, who (as is observed in Bailly-Herzberg 1980–91, vol. 3, pp. 419–20, letter 979) died in 1890, when Vollard was still a law student buying and selling prints on the side.

9. Vollard later recalled scouring the countryside around Pont-Aven "in the hope of acquiring some of Gauguin's paintings." See Vollard 1936, p. 199.

10. The painting was *La Seine au Pont d'Iéna*; see D. Wildenstein 2001, pp. 15–16, no. 12 (W 13). Vollard apparently purchased the picture in May 1892.

11. Pissarro to Lucien, March 7, 1894, in Bailly-Herzberg 1980–91, vol. 3, pp. 438–39, letter 993, and on Pissarro's change of heart, Pissarro to Lucien, May 2, 1896, in Bailly-Herzberg 1980–91, vol. 3, pp. 201–2, letter 1242. For an English translation of the latter, see Rewald and L. Pissarro 1943, p. 289: "here's the rub, he is in with people who have reputations, *he doesn't give a damn about the others.*"

12. Vollard 1936, p. 174, Vollard 1937b, pp. 196–97. Vollard would subsequently purchase Gauguin's Cézannes and Van Goghs. Gauguin's weekly receptions began in January 1894.

13. For example, Vollard purchased *Green Christ* for 200 francs on October 14, 1893 (see G. Wildenstein 1964, p. 126, no. 328) and a year later placed a value on it of 250 francs in a deal with Lévy: Vollard Archives, MS 421 (4,2), fol. 6, October 27, 1894 [Registre des ventes, a sales book; hereafter cited as Ventes].

14. Gauguin to his Paris neighbor, musician William Molard, Pont-Aven, in Malingue 1946, pp. 259–61, letter CLII; Gauguin to Daniel de Monfreid, in Joly-Segalen 1950, p. 79, letter XIX, where dated as October/November 1894. Redated to September 20, 1894, in Loize 1951, p. 20.

15. For example, on December 5, 1894, Bauchy acquired from Vollard Gauguin's *Jeux d'oies* (W 277; W-2001 274) in trade for an assigned value of 350 francs: Vollard Archives, MS 421 (4,2), fol. 7, December 5, 1894 [Ventes]. The picture may have hung in Vollard's January 1894 exhibition.

16. From Gauguin's December 1894 studio exhibition Degas acquired the painting *Day of the God (Mahana No Atua)*, 1894 (Art Institute of Chicago; W 513) for 500 francs, the monotype *Ia Orana Maria (Hail Mary)*, 1894 (variant of Field 1973, no. 1) for 50 francs, and probably a suite of woodcut illustrations for *Noa Noa*. See New York 1997–98, vol. 2, pp. 55–57, nos. 483, 492, 498.

17. Vollard gave Gauguin two IOUs (due in February) for 400 francs each: one for a "Soleils de Van Gogh" and the second for the Guillaumin and Gauguin canvases: Vollard Archives, MS 421 (2,3), p. 72 ("Soleils de Van Gogh") and p. 73 ("Guillaumin toile de 20 et 2 Gauguin neige, et paysage en hauteur/toiles qui etaient en dépot chez moi"). The snowscape is possibly *Pont-Aven sous la neige*, 1888 (Göteborgs Konstmuseum; W 248, W-2001 264) according to D. Wildenstein 2001, p. 371.

18. Gauguin to Durand-Ruel, January 16, 1895, Archives Durand-Ruel, Paris.

19. Degas acquired two Gauguin paintings, *Copy after Manet's "Olympia,"* 1891 (private collection; W 413), for 230 francs, and *Woman of the Mango (Vahine No Te Vi)*, 1892 (Baltimore Museum of Art; W 449), for 450 francs, as well as a number of works on paper. See New York 1997–98, vol. 2, pp. 55–57.

20. Pissarro to Lucien, February 28, 1895, in Bailly-Herzberg 1980–91, vol. 3, pp. 39–40, letter 1116. For an English translation, see Rewald and L. Pissarro 1943, pp. 261–62.

21. Mauclair 1895b, pp. 358–59.

22. Gauguin had signed Vollard's IOUs for 800 francs over to the framer Ch. Dosbourg: Vollard Archives, MS 421 (2,3), pp. 72, 73.

23. Bauchy purchased landscapes of Brittany and Tahiti from Gauguin before the artist's June departure (Gauguin no doubt knew that the restaurateur also purchased from Vollard on credit). The painter Maxime Maufra, the framer Dosbourg, and the dealer Talboum likewise owed Gauguin money at the time of his departure.

24. On February 16 Vollard sold Bauchy a Cézanne in partial trade for a Guillaumin, a trade reflected in Bauchy's accounting as well as Vollard's: Vollard Archives, MS 421 (4,2), fol. 9, February 16, 1895 [Ventes]. On April 18, 1895, Vollard sold Bauchy another Cézanne (possibly *La Plage*, R 382, according to Rewald 1996, vol. 1, p. 251), a Van Gogh, a Gauguin, and a Félix Pissarro in exchange for works by Maufra, Lautrec, Renouard, and Colin: Vollard Archives, MS 421 (4,2), fol. 12, April 18, 1895 [Ventes]. Bauchy would identify the works exchanged "avec l'assentiment de M. Gauguin" as numbers 44, 41, 54, and 7 on the list of works in Gauguin's collection he later drew up; see note 27.

25. Vollard's records for the trades do not mention Gauguin's name.

26. See Vollard Archives, MS 421 (4,3), fol. 23, May 31, 1895 [Registre de caisse, an account book; hereafter cited as Caisse]: "Vendu à Gauguin 1 toile de

Gauguin [in column labeled *entrée*] 250 [francs]." Gauguin apparently paid cash, since the 250 francs is listed as an entrée.

27. On August 12, 1895, Bauchy drew up a list of the more than sixty paintings and drawings Gauguin had left with him, also indicating which works had been exchanged for others. The list is published in Malingue 1987, pp. 233–34.

28. Lévy had the majority of the Tahitian paintings that had failed to sell at Durand-Ruel in 1893 or at auction in 1895, as is evident from a number of letters: Georges Chaudet to his brother Jean-Léon Chaudet, July 24, 1896, in Malingue 1987, p. 232; Gauguin to Monfreid, October 1900, in Joly-Segalen 1950, pp. 163–66, letter LXVIII; Vollard to Monfreid, September 16, 1901, in Joly-Segalen 1950, pp. 223–25; and Gauguin to Bauchy, March 1902, in Ribaud-Menetière 1947, p. 8.

29. Georges Chaudet (1870–1899) and Gauguin both had paintings in the sixth exhibition of Impressionist and Symbolist artists at the gallery Le Barc de Boutteville that opened March 2, 1894. Each owned a few canvases by the other. Chaudet was evidently part of the circle of artists who had surrounded Gauguin in Brittany; see Malingue 1987, p. 231. Malingue (1987, pp. 145, 234) describes Chaudet as a "courtier en tableaux."

Exactly what works were entrusted to whom is not certain. That Chaudet had the drawings is suggested in Gauguin's letter to Vollard, April 1897, in Rewald 1943 (1986 ed.), pp. 178–79; that he had sculpture is mentioned in Gauguin's letters to Monfreid of January 1900 and March 1902, in Joly-Segalen 1950, pp. 152–53, letter LX, and pp. 186–87, letter LXXIX; that he also had one Cézanne and five Van Goghs from Gauguin's collection is stated in Chaudet's letter to his brother Jean-Léon, July 24, 1896, in Malingue 1987, p. 232.

30. The "contract" is mentioned in Gauguin's letter to Monfreid, October 1897, in Joly-Segalen 1950, pp. 112–13, letter XXXVXII. Gauguin refers to the contract as with Lévy and Chaudet, but it may be that Bauchy was included but not mentioned because he broke the agreement so early on.

31. Typical are the recriminations leveled in a letter from Gauguin to Monfreid, October 1897, in Joly-Segalen 1950, pp. 112–13, letter XXXVXII.

32. See the Bauchy list of Gauguin's private collection, cited in note 27, which bears the heading "Désignation des tableaux et dessins laissés en dépôt chez M. Chaudet pour le compte de M. Gauguin." Gauguin alludes to Bauchy's bankruptcy in his letter to Monfreid, April 1896, in Joly-Segalen 1950, p. 86, letter XXI.

33. Gauguin writes that there are "delays of five months between a letter and its reply" in Gauguin to Vollard, January 1900, in Rewald 1943 (1986 ed.), p. 189.

34. Gauguin to Schuffenecker, April 10, 1896, transcribed in *Précieux Autographes de Monsieur Alfred Dupont,* sale cat., Hôtel Drouot, Paris, December 3–4, 1958, no. 115.

35. For Gauguin's annoyance at Lévy regarding Bauchy, see Gauguin to Monfreid, November 1895, in Joly-Segalen 1950, pp. 83–84, letter XX. For his expectations of Lévy's sales, see Gauguin to Monfreid, April 1896, in Joly-Segalen 1950, pp. 85–88, letter XXI.

36. See Loize 1951, p. 101, n. 212, and Charles Morice's article on Gauguin that appeared in the *Journal des artistes,* April 19, 1896, editor's note preceding, signed N.D.L.R.

37. Gauguin to Morice, May 1896, in Malingue 1946, pp. 273–74, letter CLXII.

38. Gauguin to Monfreid, June 1896, in Joly-Segalen 1950, pp. 88–91, letter XXII. Gauguin proposed the same idea in a letter to the artist Maxime Maufra, June 1896 (in Quimper 1950, p. 59), and no doubt also to Chaudet.

39. See Georges Chaudet to Jean-Léon Chaudet, July 24, 1896, in Malingue 1987, p. 232.

40. That Chaudet got all that was left with Lévy was confirmed by Vollard in his letter to Monfreid (in Joly-Segalen 1950, pp. 223–25). Gauguin's letter to Monfreid of October 1900 likewise states that after Bauchy and Lévy backed out of the agreement "en somme Chaudet *avait tout* mon atelier"; see Joly-Segalen 1950, pp. 163–66, letter LXVIII. In his letter to his brother of July 24, 1896 (in Malingue 1987, p. 232), in which he mentions leaving fifteen pictures with Vollard, Chaudet indicates that the only Gauguin pictures in his possession are those coming from Bauchy, "plus 1 Cézanne"—evidently the *Still Life with Compotier* (R 418)—"et 5 van Gogh."

41. See Vollard Archives, MS 421 (4,3), fol. 57, November 9, 1896 [Caisse], and MS 421 (4,3), fol. 59, December 1, 1896 [Caisse]. It is strange for the recording of such large payments not to be accompanied by any indication of the transaction involved.

42. Natanson 1896, pp. 517–18. Natanson's review confirms the mix of works shown. A review in the *Studio* (Mourey 1896) specifies that there were thirty canvases and makes reference to carvings.

43. See "L'Affaire Chaudet," in Malingue 1987, pp. 234–53. See also Malingue 1987, p. 232.

44. A photocopy of this document is in the Documentation du Musée d'Orsay, Paris.

45. While no example of Chaudet's handwriting has been available for this author to consult, one reason for suspecting that Chaudet wrote the alphabetical lists is their reversal of the letters Y and Z, which suggests dyslexia. Chaudet "a *beaucoup de peine* à s'exprimer par lettre," Gauguin reported to Monfreid in a letter of February 1898, in Joly-Segalen 1950, pp. 118–20, letter XL.

46. Corresponding to the forty-four numbers are three successive letter sequences: The first consists of letters from the alphabet running A through Z, but missing the letters F, J, M, Q, W; the second of letter combinations AA through AI, but listed out of sequence and missing AF and AJ; the third is a discontinuous numerical sequence of 12 numbers, listed out of sequence and ranging from 42 to 85.

47. "lorsque je lui faisais une offre ferme." Vollard to Gauguin, December 9, 1901: Vollard Archives, MS 421 (4,1), p. 41.

48. Vollard referred specifically to this transaction when describing his operations with Chaudet on Gauguin's behalf. Ibid.

49. Number 28 has, instead of a letter the designation, "Tête coupée" and can be identified as Gauguin's 1892 canvas *Arii Matamoe (La Fin royale)* (*The End of the Royal Line*) (private collection; W 453), which was in the 1893 Durand-Ruel exhibition (Paris 1893, no. 12).

50. Vollard assumes Gauguin's knowledge of the list when on December 9, 1901, he cites as an example of the discount Chaudet gave him "le tableau marqué AI à l'inventaire." However, in the letter from Vollard to Monfreid, September 17, 1903 (Research Library, Getty Research Institute, 2001.M.24), Vollard writes that the duplicate of the inventory is in Chaudet's hands; his use of "the" suggests that there was only one copy in addition to the original.

51. The address on the heading—6, rue Laffitte—indicates that the document was drawn up after Vollard's move to this address in August 1896. A possible indicator of an early 1897 date is the note in Vollard's hand referring to pictures sent to the Stockholm exhibition (see discussion for cat. 89). Vollard would later write (Vollard to Monfreid, September 16, 1901, in Joly-Segalen 1950, pp. 223–25) that the prices were "established by Chaudet when the pictures left Lévy's"—that is, summer or fall of 1896. A second Chaudet inventory dated March 7, 1898, and headed "2ᵉ inventaire d'oeuvres mises en dépôt chez Monsieur Vollard, dont les tableaux repris et vendus" is cited in D. Wildenstein 2001, p. 150, no. 132, as located in the "anciennes archives Malingue." The details of this inventory, unknown to this author, can be assumed to inform the account in Malingue 1987 of "L'Affaire Chaudet."

52. The list begins "Chaudet a pris la" and includes six works described as: "Vue de Rouen," "tableau rouge" (W 481?), "paysage de Rouen" (W-2001 132?; see D. Wildenstein 2001, p. 150), "homme à la hache" (W 430), "négresse," and "Buveur à la fontaine" (W 498). There follows a second list of eight letters and numerals that refer to works in the inventory, perhaps including the six works identified.

53. It was under this title that the picture was exhibited at Durand-Ruel's (Paris 1893, no. 15). On the Duhem transaction, see Vollard Archives, MS 421 (4,2), fols. 35–36, November 14, 1896 [Ventes], and MS 421 (4,4), fol. 7, November 1896 [Mouvements de tableaux, a book of gallery activities, hereafter cited as Mouvements; 2 entries].

54. The seven designations of works missing from the inventory are F, J, M, Q, W, AF, and AG. Additional canvases may have included nos. 3302, 3304, and 3306 in Stockbook B, which are identified in the stockbook by the letters K, N, and X (see note 91).

55. The Vollard sales that can be connected by chronology to this transaction would at best account for half the sum Vollard paid to Gauguin via Chaudet. See entries in the Vollard Archives for sales to Chausson: MS 421 (4,4), fol. 6, October 1896 [Mouvements]; MS 421 (4,2), fol. 35, October 10, 1896 [Ventes]; MS 421 (4,3), fol. 60, December 11, 1896 [Caisse]; to Clouet: MS 421 (4,4), fol. 6, October 1896 [Mouvements]; to Duhem: MS 421 (4,4), fol. 7, November 1896 [Mouvements; 2 entries]; MS 421 (4,2), fol. 35, November 14, 1896 [Ventes]; and to Dosbourg: MS 421 (4,4), fol. 7, December 1896 [Mouvements].

56. At the 1895 sale, the *Man with an Ax* was bought back at 500 francs, twice the price for which Vollard acquired it.

57. Gauguin informed Monfreid in January 1897, "This month I received 1,200 fr. and soon [will receive another] 1,600 fr."; Joly-Segalen 1950, pp. 98–99, letter XXVII. On March 12, 1897, he wrote Monfreid: "I received 1,035 and 1,200 fr. from Chaudet two months ago"; Joly-Segalen 1950, pp. 102–3, letter XXX. While the former sum accords exactly with the Vollard payment of November 9, 1896 (Vollard Archives, MS 421 [4,3], fol. 57 [Caisse]), the latter represents 100 francs more than the sum Vollard recorded on December 1, 1896 (MS 421 [4,3], fol. 59 [Caisse]). It would seem that the two mentions of 1,200 francs refer to the same payment.

Chaudet's accounting to Gauguin for sales involving Vollard prior to this is far from clear. According to Gauguin, the only monies he had received from Chaudet were a 200-franc "loan" and 150 francs from sales, despite Chaudet's having informed him of a sale to Vollard of "3 tableaux de la collection Bauchy pour 400 fr." See Gauguin to Monfreid, December 1896, in Joly-Segalen 1950, pp. 96–97, letter XXVII. That transaction involved two Cézannes and a Van Gogh sunflowers, as Gauguin seems to have been aware; see Gauguin to Monfreid, November 1896, in Joly-Segalen 1950, pp. 95–96, letter XXVI. However, the sum of 400 francs is at odds with Vollard's records, which indicate that he paid 225 francs for Van Gogh's "Tournesols" (Vollard Archives, MS 421 [4,3], fol. 45, April 10, 1896 [Caisse]), and 150 francs for the two Cézannes (MS 421 [4,3], fol. 48, May 23, 1896 [Caisse]). A further complication is Chaudet's claim that he had sent Gauguin 600 francs in two installments ("en deux fois"); see Georges Chaudet to Jean-Léon Chaudet, July 24, 1896, in Malingue 1987, p. 232.

58. Gauguin to Monfreid, January 1897, in Joly-Segalen 1950, pp. 98–99, letter XXVII.

59. Gauguin to Monfreid, February 14, 1897, in Joly-Segalen 1950, pp. 99–102, letter XXIX.

60. Gauguin to Monfreid, March 12, 1897, in Joly-Segalen 1950, pp. 102–3, letter XXX.

61. Monfreid to Gauguin, March 12, 1897, in Joly-Segalen 1950, pp. 205–6.

62. Gauguin to Monfreid, February 14, 1897, in Joly-Segalen 1950, pp. 99–102, letter XXIX.

63. Gauguin to Monfreid, August 1896, in Joly-Segalen 1950, pp. 92–94, letter XXIV.

64. "Je reçois votre lettre avec beaucoup de demandes, beaucoup d'offres, mais je ne parviens pas à en démêler le fond véritable." Gauguin to Vollard, April 1897: typescript, Department of Medieval through Modern European Painting, and Modern European Sculpture, Art Institute of Chicago. English translation in Rewald 1943 (1986 ed.), pp. 178–79.

65. "depuis longtemps et sans profit pour moi." Gauguin to Monfreid, April 1897, in Joly-Segalen 1950, pp. 104–5, letter XXXI.

66. "Je n'ai pas ici de dessins anciens, j'ai tout laissé à Chaudet qui est chargé de mes affaires. . . ." Gauguin to Vollard, April 1897: typescript, Department of Medieval through Modern European Painting, and Modern European Sculpture, Art Institute of Chicago.

67. "Marchand *sérieux*"; see Gauguin to Monfreid, July 14, 1897, in Joly-Segalen 1950, pp. 108–10, letter XXXIV. See also Gauguin to William Molard, August 1897, in Malingue 1946, pp. 276–77, letter CLXIV.

68. The excuses had to do with financial problems caused him by his brother Jean-Léon. Specifically, Chaudet's financial account concerned monies received from Vollard and given to Monfreid on Gauguin's behalf, as well as his actions vis-à-vis the debts of Bauchy, Talboum, Maufra, and Dosbourg. Chaudet to Gauguin, November 10, 1897: Loize Archives, Musée de Tahiti et des Îles, Punaauia (hereafter cited as Loize Archives).

69. Gauguin to Monfreid, February 1898, and May 15, 1898, in Joly-Segalen 1950, pp. 118–20, letter XL, and pp. 124–25, letter XLII. In Gauguin's mind, Chaudet's avowed difficulty with writing explained his incomprehensibility and his youth explained the fecklessness.

70. Chaudet to Gauguin November 10, 1897: Loize Archives. See also Chaudet to Schuffenecker, December 18 (?), 1897, which specifies that Vollard promised his gallery "gratuitement"; cited and partially quoted in Loize 1951, pp. 141–42, n. 419.

71. Gauguin to Monfreid, February 1898, and March 1898, in Joly-Segalen 1950, pp. 118–20, letter XL, and pp. 120–22, letter XLI.

72. "comme marchand." Gauguin to Monfreid, July 1898, in Joly-Segalen 1950, pp. 126–28, letter XLV.

73. Gauguin to Monfreid, August 15, 1898, in Joly-Segalen 1950, pp. 128–30, letter XLVI.

74. The average price of 150 francs per picture contrasts with Monfreid's sale of *Nevermore* (W 558) to Frédéric Delius for 500 francs, which Monfreid sent on to Gauguin. Monfreid to Gauguin, November 11, 1898, in Joly-Segalen 1950, pp. 209–10.

75. Ibid.

76. Chaudet to Monfreid, November 21, 1898, in Malingue 1987, p. 248.

77. Ibid. Monfreid's postscript is not dated.

78. Chaudet to Gauguin, January 15, 1899: Loize Archives. See Vollard Archives, MS 421 (4,3), fol. 116, December 8, 1898 [Caisse]: "Acheté à Monfreid neuf toiles de Gauguin [in column labeled *sortie*] 1000 [francs]." For the complicated question of how many and which works were included in the exhibition, see Shackelford 2004.

79. Gauguin to Monfreid, January 12, 1899, in Joly-Segalen 1950, pp. 135–36, letter L.

80. See Gauguin to Monfreid, February 22, 1899, in Joly-Segalen 1950, pp. 136–38, letter L. Gauguin suspected that Degas and Rouart had advised Vollard on the purchase with a view to making acquisitions more cheaply from him than from Monfreid.

81. Gauguin to Monfreid, June 1899, in Joly-Segalen 1950, pp. 145–46, letter LV.

82. Gauguin to Monfreid, July 1899, in Joly-Segalen 1950, pp. 146–47, letter LVI. On Monfreid's chronology, see Pessey-Lux and Lepage 2003, pp. 9–12.

83. "tout ce qu'on voudra." Gauguin to Monfreid, May 1899, in Joly-Segalen 1950, pp. 141–45, letter LIV.

84. Gauguin to Monfreid, June 1899, in Joly-Segalen 1950, pp. 145–46, letter LV.

85. Ibid. and Gauguin to Monfreid, August 1899, in Joly-Segalen 1950, pp. 148–49, letter LVII.

86. Gauguin to Monfreid, January 1900, in Joly-Segalen 1950, pp. 152–55, letter LX.

87. Gauguin to Monfreid, October 1900, in Joly-Segalen 1950, pp. 163–66, letter LXVII. "Embezzlement" (*malversation*) is the term Gauguin used apropos Chaudet in his letter to Molard, March 6, 1902, in Malingue 1946, pp. 303–4, letter CLXXV.

88. Gauguin to Monfreid, October 1900, in Joly-Segalen 1950, pp. 163–66, letter LXVII.

89. Jean-Léon Chaudet to Monfreid, October 9, 1899, in Malingue 1987, pp. 236–37. The letter may have been in response to an inquiry received from Monfreid.

90. Vollard Archives, MS 421 (4,3), fol. 134, June 6, 1899 [Caisse]: "Acheté à Chaudet cinq Van Gogh [in column labeled *sortie*] 600 [francs]." The pictures in question were probably the five Van Goghs owned by Gauguin that Chaudet mentioned as in his keeping and not among the seven Van Gogh paintings that appear on Bauchy's list as numbers 31 through 36. See Georges Chaudet to Jean-Léon Chaudet, July 24, 1896, in Malingue 1987, p. 232.

91. Listed in Stockbook B as no. 3302, "Femmes et idoles dans paysage Tahiti (K)"; no. 3304, "Femmes assises et devisant dans paysage (N)" (possibly *Les parau parau: Paroles, paroles* or *Les Potins (I) (Les Parau Parau: Conversation)* (State Hermitage Museum, St. Petersburg; W 435); no. 3306, "Paysage avec terrain rouge. Petit cavalier (X)" (*Fatata Te Moua: At the Foot of a Mountain*, State Hermitage Museum, St. Petersburg; W 481). The provenance for all three is given as Chaudet. Curiously, none of the three entries record (as do other entries) the prices paid; nor do these paintings appear in Vollard's earlier stockbook begun around 1899, though presumably they were in the dealer's hands by the time of Chaudet's death.

92. In his letter to Monfreid, August 1900, Gauguin says that he wrote to Jean-Léon; see Joly-Segalen 1950, pp. 161–62, letter LXVI. Monfreid discusses pursuing Chaudet's heirs in his letters to Gauguin of April 13 and December 1, 1900, in Joly-Segalen 1950, pp. 213–15.

93. Vollard to Gauguin, December 9, 1901: Vollard Archives, MS 421 (4,1), p. 41. See note 50.

94. See the receipt Vollard made out to Monfreid dated October 17, 1900 (Loize Archives) listing and describing the pictures H, E, AG, Y (see entry for cat. 89). It seems that Jean-Léon, like his brother, dealt in pictures and had offered to help sell Gauguins in Georges's possession. See Georges Chaudet to his brother, July 24, 1896, in Malingue 1987, p. 232.

95. Malingue 1987, p. 237.

96. "un reçu en règle lui donnant quittance de tout." Malingue 1897, p. 237.

97. Gauguin to Vollard, October 1900, in Rewald 1943 (1986 ed.), p. 195, and Gauguin to Monfreid, October 1900, in Joly-Segalen 1950, pp. 163–66, letter LXVII.

98. Jean-Léon Chaudet died March 2, 1901; see Malingue 1897, p. 238.

99. See Gauguin to Vollard, February 1901, in Rewald 1943 (1986 ed.), p. 198, and Monfreid to Gauguin, December 11, 1902, in Joly-Segalen 1950, pp. 232–33.

100. Vollard to Gauguin, fall 1899, in Rewald 1943 (1986 ed.), pp. 188–89.

101. Gauguin to Vollard, January 1900, English translation in Rewald 1943 (1986 ed.), pp. 189–92.

102. Gauguin to Monfreid, January 1900, in Joly-Segalen 1950, pp. 152–55, letter LX, describing a fallback requirement of 200 francs per month and 175 francs per picture, and Gauguin to Monfreid, March 1900, in Joly-Segalen 1950, pp. 156–57, letter LXII.

103. An unpublished letter from Gauguin to Vollard, May 1900 (Research Library, Getty Research Institute, 2001.M.24), acknowledges the sealing of the agreement. For the competing interest in Gauguin's work, at the very same moment, of collector Emmanuel Bibesco, see Rewald 1943 (1986 ed.), pp. 188–96.

104. Gauguin to Monfreid, October 1900, in Joly-Segalen 1950, pp. 163–66, letter LXVIII, partially published in English in Rewald 1943 (1986 ed.), p. 194.

105. Gauguin to Monfreid, December 1900, in Joly-Segalen 1950, pp. 167–69, letter LXX.

106. See Gauguin to Monfreid, April 1901, in Joly-Segalen 1950, pp. 171–72, letter LXXIII. The pictures were kept in Monfreid's "grenier rue Liancourt"; see Monfreid to Gauguin, June 9, 1903, in Joly-Segalen 1950, pp. 236–37. The same letter is published and dated May 9, 1903, in Malingue 1987, pp. 308–10.

107. So Gauguin argued in his letter to Monfreid, July 1901, in Joly-Segalen 1950, pp. 179–80, letter LXXVI.

108. See Monfreid to Gauguin, June 7, 1902, in Joly-Segalen 1950, pp. 228–29. Here the instruction is to send "the most beautiful" pictures to Monfreid's country residence rather than to Paris.

109. Monfreid to Gauguin, December 11, 1902, after Monfreid learned from Fayet that Gauguin had sent a shipment to Vollard; Joly-Segalen 1950, pp. 232–35.

110. Gauguin to Monfreid, July 1901, in Joly-Segalen 1950, pp. 179–80, letter LXXVI.

111. For Gauguin discussing breaking with Vollard, in the context of the collectors Bibesco and Fayet, see Gauguin to Monfreid, November 1900, and December 1900, in Joly-Segalen 1950, pp. 166–67, letter LXIX, and pp. 167–69, letter LXX. On the Marquesas and Vollard, see Gauguin to Monfreid, June 1901, in Joly-Segalen 1950, pp. 175–77, letter LXXV.

112. "Que deviendrais-je si Vollard venait à flancher." Gauguin to Monfreid, February 1903, in Joly-Segalen 1950, p. 194, letter LXXXIV.

113. Gauguin to Monfreid, October 1902, in Joly-Segalen 1950, pp. 191–93, letter LXXXIII.

114. Vollard to Monfreid, October 2, 1901: Research Library, Getty Research Institute 2001.M.24.

115. Gauguin to Vollard, December 1900: typescript, Department of Medieval through Modern European Painting, and Modern European Sculpture, Art Institute of Chicago. For an English translation, see Rewald 1943 (1986 ed.), pp. 196–97.

116. Gauguin mentioned that Monfreid had informed him of the raise to 250 francs per picture in Gauguin to Monfreid, December 1900, in Joly-Segalen 1950, pp. 167–69, letter LXX. Vollard confirmed his intention in Vollard to Monfreid, December 19, 1900, in Malingue 1987, pp. 262–63. Monfreid applauded Vollard's decision in Monfreid to Vollard, December 27, 1900: unpublished letter, copy in the Department of Medieval through Modern European Painting, and Modern European Sculpture, Art Institute of Chicago.

117. Vollard complained that he was sending Gauguin money but not receiving pictures and that the tone adopted in Gauguin's letters was preemptory. Vollard to Monfreid, September 16, 1901, in Joly-Segalen 1950, pp. 223–25.

118. "Sur les toiles dont Chaudet m'a remis l'inventaire, je ne vous demanderai pas de rabais sauf la commission de 20% convenue avec Chaudet . . . et comme j'arriverai finalement à les garder tous cela vous fera de ce coté des resources assez importants." Vollard to Gauguin, December 9, 1901: Vollard Archives, MS 421 (4,1), p. 41. Vollard also indicates his intention to send

Gauguin 350 francs per month rather than 300—an increase that his September 16 letter to Monfreid he had indicated was already in effect.

119. Malingue 1987, p. 238.

120. Gauguin to Bauchy, March 1902, in Ribaud-Menetière 1947, p. 8.

121. Vollard replied, "For the pictures with Schlewinski [sic], there must be some exaggeration—I know that I sold him two Gauguins, and Mollard [sic], whom I saw recently, told me that he had heard it vaguely said that Schlewinski had pictures from you. It must be those; moreover, when I see him I will ask him what he has from you—" ("Pour les tableaux de chez Schlewinski [sic] il doit y avoir en exageration—Je sais que je lui ai vendu deux Gauguin, et Mollard [sic] que j'ai vu ces jours ci m'a dit qu'il avait entendu dire vaguement que Schlewinski avait des tableaux de vous. Ce doit être ceux là; d'ailleurs quand je le verrai je lui demanderai ce qu'il a de vous—"). Vollard to Gauguin, May 18, 1902: unpublished letter, copy in the Department of Medieval through Modern European Painting, and Modern European Sculpture, Art Institute of Chicago. See also Gauguin to Vollard, March 1902, in Rewald 1943 (1986 ed.), pp. 202–3; Gauguin to Molard, March 6, 1902, in Malingue 1946, pp. 303–4, letter CLXXV.

122. Monfreid to Gauguin, April 10, 1902, in Joly-Segalen 1950, pp. 225–28.

123. Monfreid to Gauguin, December 11, 1902, in Joly-Segalen 1950, pp. 232–35.

124. Gauguin to André Fontainas, February 1903, in Malingue 1946, pp. 308–10, letter CLXXVII; English translation in Rewald 1943 (1986 ed.), pp. 209–10. See also Gauguin to Monfreid, February 1903, in Joly-Segalen 1950, pp. 193–95, letter LXXXIV.

125. Gauguin to Monfreid, February 1903, in Joly-Segalen 1950, pp. 193–95, letter LXXXIV.

126. Rewald (1986, pp. 211–12) cites Gauguin's letter to Vollard of April 1903: "It is now more than eight months since you advised me of the shipment of canvases, paper . . . and flower seeds. / At the present moment my health would permit me to work hard, and I have nothing to work with."

127. Monfreid to Gauguin, May 9, 1903, as dated in Malingue 1987, pp. 308–10; it had been dated June 9, 1903, in Joly-Segalen 1950, pp. 236–38.

128. Monfreid to Gauguin, August 14 and 21, 1903, in Joly-Segalen 1950, pp. 238–40 and 240–41.

129. Monfreid to Vollard, August 29, 1903: unpublished letter, copy in the Department of Medieval through Modern European Painting, and Modern European Sculpture, Art Institute of Chicago. Mette Gauguin authorized Monfreid to act on her behalf in her letter to him of September 25, 1903, in Joly-Segalen 1950, pp. 216–17 (where dated "25.9.03"). Monfreid informed Vollard of this in an unpublished letter of October 3, 1903: copy in the Department of Medieval through Modern European Painting, and Modern European Sculpture, Art Institute of Chicago.

130. "petit livre." This is possibly the "petit registre" in the Vollard Archives, MS 421 (4,9). Vollard to Monfreid, August 28, 1903: Research Library, Getty Research Institute, 2001.M.24. That Vollard received thirty-six works directly from Gauguin as part of the contract was reiterated in the unpublished letter from Vollard to Monfreid, September 17, 1903: Research Library, Getty Research Institute, 2001.M.24. In it Vollard specifies that he had received first ten canvases, then five, then twenty-one.

131. Vollard to Monfreid, August 29, 1903: Vollard Archives, MS 421 (4,1), p. 51.

132. Monfreid to Schuffenecker, September 8, 1903: Research Library, Getty Research Institute, 2001.M.24.

133. Vollard to Monfreid, September 17, 1903: Research Library, Getty Research Institute, 2001.M.24. For Vollard's offer of the letter as proof of honest dealing, see also Vollard to Monfreid, October 8, 1903: Research Library, Getty Research Institute, 2001.M.24.

134. Monfreid to Vollard, October 3, 1903: unpublished letter, copy in the Department of Medieval through Modern European Painting, and Modern European Sculpture, Art Institute of Chicago. A small portion of this letter is published in English in Rewald 1943 (1986 ed.), p. 213 (dated October 8, 1903).

135. "Je vais m'occuper de Madame Chaudet. Je vais voir aussi un peintre (Maufra) qui avait un tableau de Gauguin sur lequel il avait avancé à Chaudet une certaine somme et qu'il m'avait offert autrefois de me vendre pour le prix avancé, ce que je n'avais pas fait n'ayant pas qualité pour cela. Si cela se fait nous pourrons nous arranger je pense pour que je le garde, moyennant un supplement à Mad. Gauguin." Vollard to Monfreid, October 8, 1903: Research Library, Getty Research Institute, 2001.M.24. The matter was finally resolved and the sum of 500 francs for Mme Vve Gauguin acknowledged in the receipt Monfreid made out to Vollard dated March 17, 1905: unpublished document, copy in the Department of

Medieval through Modern European Painting, and Modern European Sculpture, Art Institute of Chicago.

136. "très peu importants." And, "Je vous prie de croire que mon compte sera établi aussi consciencieusement que possible" ("Please believe that my accounts will be drawn up as conscientiously as possible"). Vollard to Monfreid, October 8, 1903, Research Library, Getty Research Institute, 2001.M.24.

137. "Il importe, n'est-ce pas, qu'on ne défigure pas trop la physionomie de notre malheureux ami, et qu'on ne gâche pas sa reputation, déjà si malmenée pendant sa vie. Pour moi, ce serait une tristesse; pour vous se serait en quelque sorte un prejudice. Pour l'art ce serait servir la mauvaise cause." Monfreid to Vollard, October 11, 1903: unpublished letter, copy in the Department of Medieval through Modern European Painting, and Modern European Sculpture, Art Institute of Chicago.

138. Rewald 1943 (1986 ed.), pp. 212–13. Unaware of the unpublished letters concerning Vollard's change of mind about the price, Rewald assumed that Vollard paid less per picture than usual in settling the estate.

139. Monfreid encouraged Vollard to obtain "un règlement avec Mme Chaudet" in his unpublished letter to him of October 11, 1903: copy in the Department of Medieval through Modern European Painting, and Modern European Sculpture, Art Institute of Chicago. In another unpublished letter to Vollard of January 19, 1904 (copy in the Department of Medieval through Modern European Painting, and Modern European Sculpture, Art Institute of Chicago), Monfreid wrote that he had received back his own letter to Gauguin of March 12, 1897 (in Joly-Segalen 1950, pp. 205–6), touching on Chaudet, which had been found among Gauguin's papers. He thought it might serve them in pursuing monies owed the Gauguin estate. Mme Chaudet died on March 5, 1905.

140. Malingue 1987, pp. 238–39. Malingue believes that a number of the pictures in Gauguin's personal collection were destroyed in a fire that consumed the residence of a Chaudet heir.

141. Henri Matisse, interview with André Verdet, 1952, quoted in Flam 1995, p. 216. See also Verdet 1952, p. 69.

Vollard, the Nabis, and Odilon Redon

Gloria Groom

In February 1901 at La Libre Esthétique in Brussels and in April of that year at the salon of the Société des Artistes Indépendants in Paris, Maurice Denis exhibited his celebrated group portrait *Homage to Cézanne* (fig. 82). The painting features the artists who are known collectively as the Nabis (after the Arabic word for "prophet"): Pierre Bonnard, Paul Ranson, Ker-Xavier Roussel, Paul Sérusier, Édouard Vuillard, and Denis himself. Included also are Denis's wife, Marthe, the older artist Odilon Redon, and André Mellerio, Redon's first cataloguer and biographer.[1] Ambroise Vollard, in whose cramped gallery the scene takes place, appears to cling to the vertical bar of the easel that holds Paul Cézanne's *Still Life with Compotier* of 1879–80.[2] The wild-eyed tabby cat at Vollard's feet, which seems ready to pounce, was the dealer's trademark but may also allude to his well-known rapaciousness when it came to finding and selling art.

Although the title of the painting suggests that its focus is Cézanne, it can be seen as Denis's summation of the Nabis' rise to success and as a representation of their place within a larger artistic milieu—a milieu in which Vollard performed a central role.[3] The part Vollard played in the careers of all these artists is in fact the subplot of the painting. Within the space of Vollard's gallery, Denis and his Nabi friends not only revere a painting by the dealer's most lucrative artist, Cézanne, but are also in the presence of a work by another important touchstone, Paul Gauguin, the "artist in exile" whose work Vollard began exhibiting in 1894.[4] The canvas on the wall directly behind Redon and Vuillard is an amalgam of two paintings Gauguin created during his first voyage to Tahiti in 1891–93, before he met Vollard.[5] By connecting his circle with the two older artists, Denis reinforced their group identity, as well as their legacy within the avant-garde pantheon. Denis's own relationship to Vollard was historically linked to Cézanne, whose landmark exhibition at Vollard's in November– December 1895 may have overlapped the gallery's first presentation of works by Denis.[6]

Whereas Cézanne and Gauguin are represented in Denis's painting by their work, Redon appears in person. Redon was a central figure for his younger Nabi friends, and the sanguine drawings of Bonnard, Denis, Sérusier, and Vuillard he began in 1899–1900 and printed as lithographs between 1900 and 1903 speak to a mutual admiration.[7] Indeed, the group portrait originated in March 1898 as an homage to Redon; Denis made a note to himself to paint "Redon in Vollard's gallery with Vuillard, Bonnard, etc." and early on made charcoal studies (see fig. 83) and a painted portrait of Vollard (private collection, France).[8] In his contribution to "Hommage à Redon," an article published in *La Vie* in November 1912, Denis stated that for the generation of the 1890s, positioned between Gauguin and Émile Bernard on the one side and Cézanne on the other, Redon had been the greatest influence.[9] Denis's painted genealogy thus acknowledged where the Nabis had started, with Gauguin's "one or two very simple, incontestably true ideas at a time when [they] were totally without guidance," and their current interest in both Redon and Cézanne.[10] All three figures enjoyed public success in part because of Vollard's efforts.

By the time *Homage to Cézanne* was first exhibited, its meaning had become diluted, for by early 1901 the Nabis had ceased to exist as a coherent movement and had found other dealers to represent them, although their interactions with Vollard would continue throughout the decade.[11] From 1896 to 1900, however, Vollard had been pivotal in promoting their work. He helped to shape their careers at important turning points, and in particular acted as a catalyst for their work in color lithography. In March and April 1898, for example, when Denis first conceived the group portrait, Vollard exhibited paintings and works on paper by Bonnard, Denis, Ranson, Roussel, Sérusier, Vuillard, and others.[12] In May and June of that year he showed Redon drawings and pastels and Cézanne paintings in overlapping exhibitions.[13] These shows coincided in turn with the publication of Mellerio's groundbreaking history of color lithography, *La Lithographie originale en couleurs,* which included the announcement of Vollard's forthcoming publication of lithographic albums by Bonnard, Denis, Vuillard, and Roussel (see, for example, figs. 10, 11, 12, 208).[14]

Opposite: Fig. 81 (cat. 165). Odilon Redon, *Strange Flower (Little Sister of the Poor),* 1880 (detail). Various charcoals, with touches of black chalk and black conté crayon, 15⅞ x 13⅛ in. (40.4 x 33.2 cm). The Art Institute of Chicago, David Adler Collection (1950.1433)

Fig. 82. Maurice Denis, *Homage to Cézanne*, 1900. Oil on canvas, 70⅞ x 94½ in. (180 x 240 cm). Musée d'Orsay, Paris (1977-137)

These projects, which would come to be known as the "Vollard Albums," were exhibited, with the exception of Roussel's, at Vollard's gallery in March and early April 1899 together with Redon's black-and-white prints for the album *Apocalypse de Saint Jean,* which Vollard had also commissioned.[15]

Maurice Denis (1870–1943) was the first of the Nabis to make contact with Vollard, undoubtedly in 1893.[16] It was in

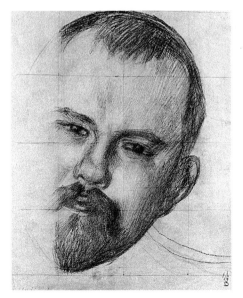

Fig. 83. Maurice Denis, *Ambroise Vollard*, 1899. Pencil and red chalk on tracing paper, 10¼ x 8¼ in. (26 x 21 cm). Private collection

this year that Denis recorded the sale to Vollard for 400 francs of three panels "for the bedroom of a young girl" exhibited at the Salon des Indépendants.[17] By May 1893 their correspondence had begun.[18] When Vollard met the Nabis they were already participating in exhibitions at Saint-Germain-en-Laye (1891–93), the Indépendants, and La Libre Esthétique. In the early 1890s their works could be seen at Père Tanguy's and between 1891 and 1896, at the triennial exhibitions of Impressionists and Symbolists held at Le Barc de Boutteville, a gallery that has been described as "the veritable cradle of modern painting."[19] As a fledgling dealer Vollard would have been aware of these smaller venues for cutting-edge art. In May 1893, several months after he established his own gallery at 39, rue Laffitte, Vollard wrote to Denis and asked him to give him a price for the painting of "deux têtes" that was currently with Père Tanguy.[20] Even at this early date Vollard was trying to circumvent the competition, asking Denis to let him pick the work up elsewhere so as not to seem to be taking away Tanguy's business. He added that he would also prefer that he not leave it with Le Barc de Boutteville, who was "absolutely furious" with him since he had sold at auction a painting that he bought from him, "at a much higher price, of course."[21]

By the fall of 1894 Vollard had acquired a Denis painting identified only as "un tableau," which he exchanged to a Monsieur Lévy for 150 francs credit, initating a series of purchases from the artist that would continue over the next ten

years.[22] In September 1895 Vollard purchased 300 francs worth of paintings and drawings by Denis,[23] many of which were sold shortly thereafter when Vollard showed some of the artist's works at his gallery.[24] For Denis, Vollard was an important source of income and supporter of his graphic work, especially when he helped realize the artist's longtime dream to illustrate Paul Verlaine's 1889 book of poems "Sagesse."[25] Denis's long, frustrated effort to convince Verlaine and his publisher, Vanier, to proceed ended when Vollard salvaged the project, which finally appeared in a hand-colored edition of 250 copies in 1910 (fig. 211).[26] By then Denis had created original lithographs for Vollard for the 1896 and 1897 albums *Les Peintres-graveurs* and *Estampes originales de la Galerie Vollard,* thirteen color lithographs for the album *Amour* (figs. 11, 84, 204, 205, 246), and illustrations for the book *L'Imitation de Jésus-Christ* (1903; fig. 212).[27]

Both Vollard and Denis were savvy entrepreneurs who understood the beneficial terms of their collaboration. In 1897 Vollard wrote to Denis that he would be "devastated" if he left *Amour* mid-project, a phrase that can be taken as showing either empathy or frustration.[28] Vollard's tactic was to sell as quickly as possible the works Denis sold him. Sometimes he would sell paintings on speculation, asking the artist to hike up his price if he thought he had a ready buyer. For instance,

he asked Denis to price the painting *Maternity (Mother's Kiss)* (fig. 86), one of several "maternités" that Denis created between 1892 and 1895, at 400 (from which Denis would receive 340) instead of 300 francs.[29] For a large painting (possibly *Virginal Spring,* 1897, private collection, Tokyo), however, he asked the artist to decrease the price from 1,200 to 1,000 francs, because he had "a very good chance" of selling it for him.[30] Vollard's pricing strategy was based on a mixture of market pressures, aesthetics, and opportunism. In early 1899, when Denis needed cash to pay for the enlargement of the new house he was about to rent in the rue de Mareil in Saint-Germain, Vollard purchased thirty-four paintings dating from 1893 to 1899 at the low price of 3,000 francs. *Figures in a Springtime Landscape* (1897, State Hermitage Museum, St. Petersburg) accounted for 1,000 francs of the total, and *Visitation* (1894), a variant of the color lithograph Vollard had commissioned for his first album of prints, *Les Peintres-graveurs* (1896), presumably cost 500 francs, which would mean that he bought the remaining thirty-two pictures for 1,500 francs, or approximately 47 francs each.[31]

Vollard also brought Denis to the attention of Russian as well as German collectors. In February 1899 Julius Meier-Graefe illustrated his article on Denis for *Dekorative Kunst*

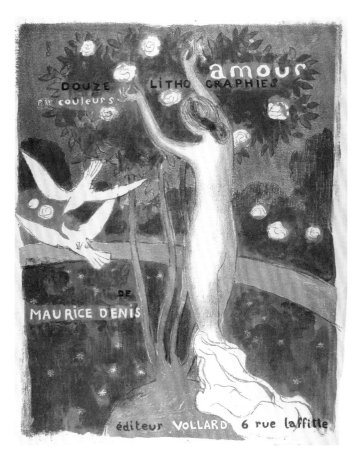

Fig. 84 (cat. 71). Maurice Denis, *Amour (Love),* 1898, published by Vollard 1899. Color lithograph, cover for a suite of twelve, image 20⅞ x 16⅛ in. (53 x 41 cm). The Art Institute of Chicago, John H. Wrenn Memorial Collection (1946.432a)

Fig. 85 (cat. 69). Maurice Denis, *Pines at Loctudy,* 1894. Oil on canvas, 21 x 17 in. (53.3 x 43.2 cm). Private collection, United States

Fig. 86 (cat. 70). Maurice Denis, *Maternity (Mother's Kiss)*, ca. 1896–1902. Oil on canvas, 31½ x 25¼ in. (80 x 64 cm). Private collection

with a wood engraving, a stained-glass window, and four decorative panels, some of which Count Harry Kessler would purchase a few years later from Vollard (see fig. 245).[32] When in 1897 Vollard exhibited works by the Nabis, he included a number of Denis's "gracieuses madones" (gracious Madonnas), one of which was likely purchased in 1904 by Karl-Ernst Osthaus for his Museum Folkwang in Hagen.[33] By the time Denis exhibited *Homage to Cézanne* in 1901, his works were still available through Vollard, but Kessler, Osthaus, and other German collectors were increasingly bypassing the dealer to work directly with Denis for purchases of his paintings and drawings and for commissions for decorative ensembles.

Denis's contract with the prestigious Druet gallery in 1906 provided him with regular exhibitions and better prices, but it was not the end of his professional and social dealings with Vollard. Cézanne described a wild party the dealer hosted for

"la jeune école" in 1904.[34] By that time "les jeunes" included not only Denis and Vuillard but also the Fauve painters, whose style was antithetical to Denis's more overtly classical bent. Vollard either ignored or enjoyed the opposing aesthetics, commissioning Denis as well as Henri Matisse, Maurice de Vlaminck, and Jean Puy in 1906 to make designs that would be transferred and fired onto ceramic vases by André Metthey (figs. 88, 141, 144). That a year earlier Denis had publicly declared modern art (and especially the art of Matisse and the Fauves) dangerous in its proclivity for abstraction was apparently not problematic for Vollard.[35] And when Denis's ceramics were shown in the same vitrine with the others' at the Salon d'Automne in 1907, the effect was seen as more homogenous than discordant. Taken together, in fact, the decorative designs mirrored the two facets of an artistic moment in which artists strove to achieve, however differently

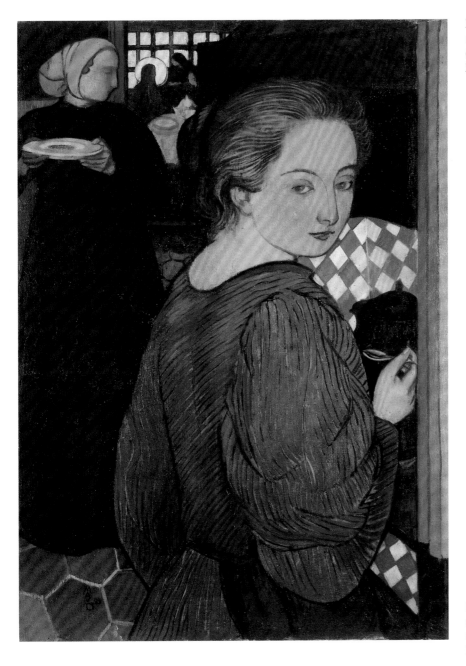

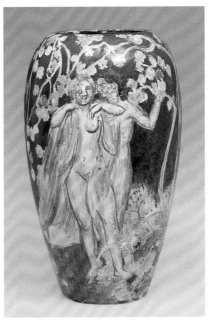

Fig. 87 (cat. 68). Maurice Denis, *The Cook,* 1893. Oil on canvas, 31½ x 23⅝ in. (80 x 60 cm). John C. Whitehead (courtesy Moeller Fine Arts, New York)

Fig. 88 (cat. 74). Maurice Denis, *Vase,* ca. 1906–7. Tin-glazed ceramic, H. 11 in. (28 cm), Diam. 5⅞ in. (15 cm). Collection Larock-Granoff, Paris

in style, a sense of balance, harmony, and purity associated with antiquity and the Mediterranean.[36]

By 1906 Odilon Redon, too, was part of the larger "retour à l'ordre" whose goal was to bring order and balance to art. Thirty years older than the Nabis (and Matisse), Redon (1849–1916) met Vollard at a propitious moment in his life and career, when he turned from his larger charcoal drawings (*noirs*) to works in color. In March 1896 he showed 120 works at the Galerie Durand-Ruel, 36 of which were in color. Although the exhibition was not monetarily successful, it seems to have motivated him to continue his new explorations, possibly encouraged by Denis, Vuillard, and his Nabi friends. Developments in his personal life (the birth of a son in 1889 and the need to make more money to pay off the debts of his family home at Peyrelebade, near Bordeaux) were also likely factors. In Denis's *Homage to Cézanne,* Redon is shown looking at the still life

Fig. 89 (cat. 171). Odilon Redon, *Armor,* 1891. Charcoal and conte crayon, 20 x 14½ in. (50.7 x 36.8 cm). The Metropolitan Museum of Art, New York, Harris Brisbane Dick Fund, 1948 (48.10.1)

Fig. 90 (cat. 173). Odilon Redon, *Profile of a Woman in Shadow,* ca. 1895. Various charcoals, 18½ x 13⅞ in. (47.1 x 35.4 cm). The Art Institute of Chicago, David Adler Collection (1950.1422)

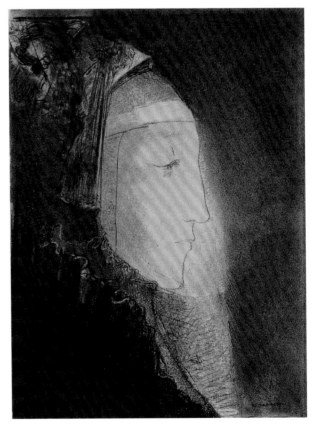

Fig. 91 (cat. 169). Odilon Redon, *The Beacon,* 1883 (reworked ca. 1893). Pastel with various charcoals and touches of black chalk, 20¼ x 14⅝ in. (51.5 x 37.2 cm). The Art Institute of Chicago, gift of Mrs. Theodora W. Brown and Mrs. Rue W. Shaw in memory of Anne R. Winterbotham (1973.513)

Fig. 92 (cat. 170). Odilon Redon, *Profile of Light,* ca. 1885–91. Charcoal, 15¼ x 11⅜ in. (38.8 x 28.9 cm). Musée d'Orsay, Paris, on deposit in the Department of Graphic Arts at the Musée du Louvre, Gift of Mme Renée Asselain, 1978 (RF 36816)

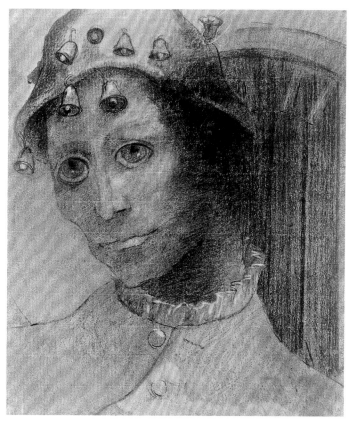

Fig. 93 (cat. 168). Odilon Redon, *The Cask of Amontillado,* 1883. Charcoal, 14¼ x 12⅜ in. (36.2 x 31.4 cm). Musée d'Orsay, Paris, on deposit in the Department of Graphic Arts at the Musée du Louvre, Gift of Claude Roger-Marx, in memory of his father, brother, and son, who died for France, 1974 (RF 35822)

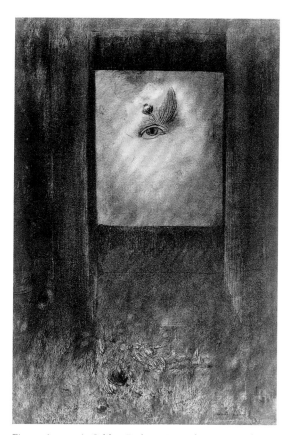

Fig. 94 (cat. 172). Odilon Redon, *Eye with Poppy Head,* 1892. Charcoal, 18⅛ x 12⅝ in. (46 x 32 cm). Musée d'Orsay, Paris, on deposit in the Department of Graphic Arts at the Musée du Louvre, Gift of Claude Roger-Marx, in memory of his father, brother, and son, who died for France, 1974 (RF 35821)

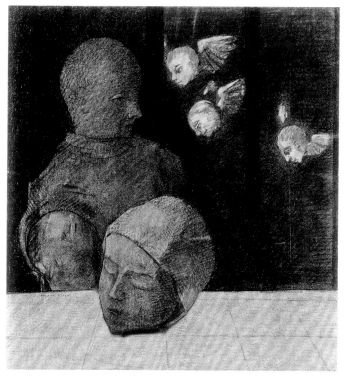

Fig. 95 (cat. 166). Odilon Redon, *The Prisoner,* ca. 1880. Charcoal, 15¼ x 14⅛ in. (38.8 x 36 cm). Musée d'Orsay, Paris, on deposit in the Department of Graphic Arts at the Musée du Louvre, Gift of Claude Roger-Marx, in memory of his father, brother, and son, who died for France, 1974 (RF 35819)

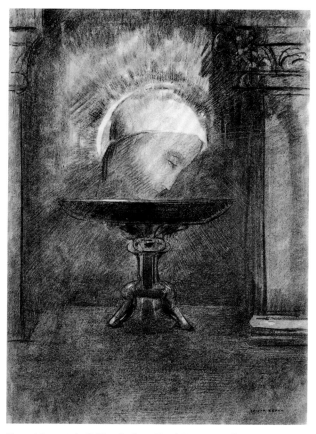

Fig. 96 (cat. 167). Odilon Redon, *Head Wearing a Phrygian Cap, on a Salver,* 1881. Charcoal with black chalk, 19⅛ x 14¼ in. (48.6 x 36.3 cm). The Art Institute of Chicago, David Adler Collection (1950.1416)

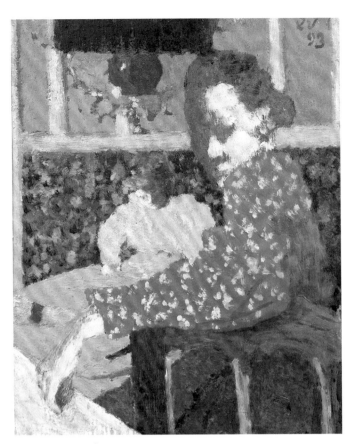

Fig. 97 (cat. 198). Édouard Vuillard, *The Blue Sleeve,* 1893. Oil on cardboard mounted on cradled panel, 10½ x 8¾ in. (26.6 x 22.3 cm). Collection of Malcolm Wiener

Fig. 98 (cat. 199). Édouard Vuillard, *Woman at the Cupboard,* ca. 1894–95. Oil on cardboard mounted on panel, 14⅝ x 13⅛ in. (37 x 33.5 cm). Wallraf-Richartz-Museum–Fondation Corboud, Cologne (WRM 3049)

on the easel, wiping his glasses in a gesture that may refer to his increasingly clear observation and appreciation of the external (and colorful) world.[37]

Vollard may also have encouraged Redon's turn to color work. In 1896 he commissioned a color lithograph from him for his second album of prints, *Estampes originales de la Galerie Vollard* (1897).[38] The print, *Béatrice,* was inspired by a pastel of the same title from 1885 that Redon had sold to Vollard in 1896.[39] For this, Redon's second lithograph for the album (his first contribution was *Old Knight,* in black and white), Vollard may have insisted on a color print; he had asked the same of Camille Pissarro, who refused. For Vollard, who later boasted of his efforts to encourage painters to work in the graphic arts, color lithography more clearly embodied the shared aesthetic of the *peintres-graveurs,* and it was also, as Pissarro ruefully noted, "the fashion."[40]

As part of his move to color, Redon began reworking *noirs* such as *The Beacon* of 1883 (fig. 91) in pastel.[41] Vollard very likely owned examples of these *noirs* reworked in pastel.[42] His interest in Redon's color production was undoubtedly market-driven, but he also clearly esteemed Redon's earlier

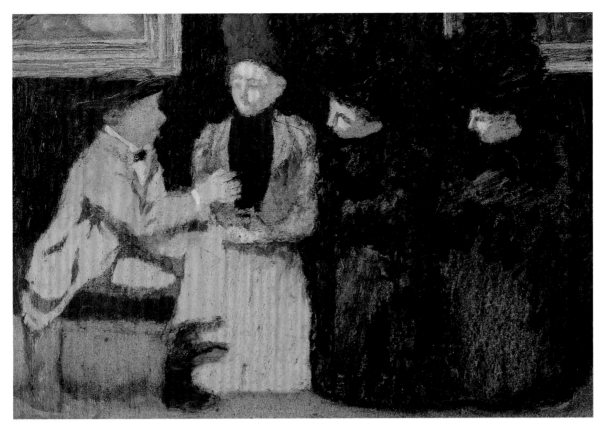

Fig. 99 (cat. 200).
Édouard Vuillard,
The Lecturer, or *The
Guide,* ca. 1897. Oil
on cardboard, 10 ⅛ x
15 ¼ in. (26 x 40 cm).
Private collection
(courtesy Galerie
Schmit, Paris)

Below: Fig. 100
(cat. 201). Édouard
Vuillard, *The
Widow's Visit,* or
The Conversation,
1898. Oil on paper
mounted on panel,
19 ¾ x 24 ¾ in. (50.2 x
62.9 cm). Art Gallery
of Ontario, Toronto,
Purchase, 1937 (2422)

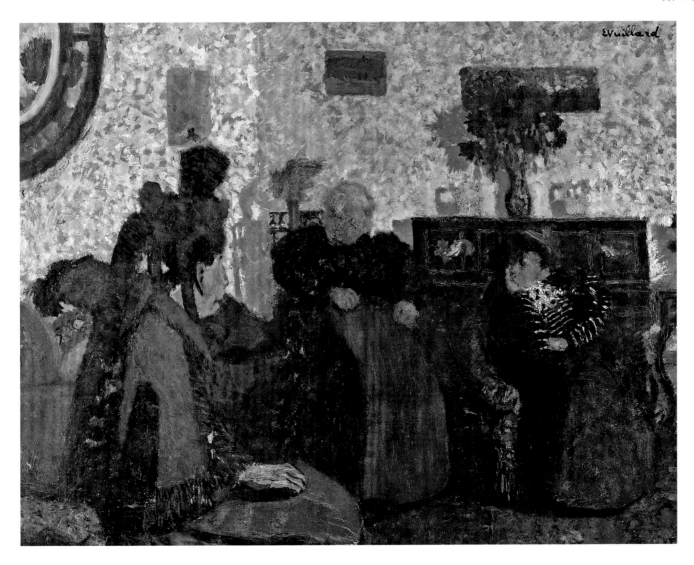

Fig. 101. Pierre Bonnard, *At Vollard's Rue Laffitte Gallery*, 1910. Brown and black ink, graphite, and gray wash on paper, 12⅜ x 9½ in. (31.5 x 24 cm). Musée d'Orsay, Paris, on deposit in the Department of Graphic Arts at the Musée du Louvre (RF 52756, fol. 4 recto)

drawings, which he continued to purchase.[43] Redon's black-and-white album for Vollard, *Apocalypse de Saint Jean*, moreover, appeared at the same time as the albums of three-color lithographs by Denis, Bonnard, and Vuillard that Vollard published in 1899.

Vollard's significant purchases of Redon's *noirs* in 1897, his exhibition in May 1898 of eighteen pastels and charcoal drawings, and his purchases through 1899 may have been last-minute attempts to help Redon save the family estate,[44] but his support also freed Redon to work more fully in color without having to worry about cultivating clients or taking on illustration work.[45] While buying his works in color, Vollard also continued to support Redon's graphic projects, commissioning lithographs intended to illustrate Stéphane Mallarmé's *Un coup de dés jamais n'abolira le hasard* and Gustave Flaubert's *La Tentation de Saint-Antoine*, although neither was realized.[46]

Redon had spent the first fifteen years of his career moving canvases from one gallery to another, dropping his prices with each relocation but without selling a single painting. The death of Theo van Gogh in 1891 ended one venue, Boussod et Valadon, and at that time he removed his paintings and

drawings from the Durand-Ruel gallery, leaving the dealer with lithographs only.[47] After years of self-promotion and what might today be called hustling, Redon found in Vollard what other dealers did not offer: a ready and consistent source of cash and a showcase for his works alongside a group of contemporary and younger artists known for their works on paper and canvas.[48] That between 1894 and 1909 Vollard purchased more than one hundred works by Redon, only a fraction of which found purchasers, indicates his belief in the artist and his willingness to take risks on his behalf.[49]

Redon's view of Vollard was not as positive. He seems to have looked upon Vollard as a means to an end, letting his wife, Camille, do much of the "business" (especially when he needed a cash advance or another favor).[50] Writing to his friend and patron Andries Bonger in 1911, Redon reiterated his diffidence toward the trade: "I congratulate myself more than ever on having passed through life without the help of dealers' galleries. They are somewhat necessary, but not too much."[51]

To Édouard Vuillard (1868–1940), Pierre Bonnard (1867–1947), and Ker-Xavier Roussel (1867–1944)—the three artists sometimes referred to as the "secular Nabis" to distinguish them from the more esoteric Sérusier and the religious Denis—Vollard's financial support was less critical. Judging from his account books and stockbooks, Vollard seems to have handled and exhibited works by these artists more often than he purchased from them. The reference in Vollard's accounts to a purchase of three works from "Wuillard [*sic*]" on November 3, 1895,[52] coincides with the first time Denis's works were presented at the gallery, suggesting he may have introduced his friend to the dealer. Vuillard's meticulously kept diaries for 1896–1906, the most important years of his dealings with Vollard, are missing, so their relationship can only be speculated. Whereas Vollard commissioned book illustrations from Bonnard and Denis throughout their careers, his interaction with Vuillard on graphic projects was limited to the two lithographs Vuillard made for the 1896 and 1897 albums and *Paysages et intérieurs* (see figs. 12, 206, 207), the album of color lithographs Vuillard completed in 1899. Vollard was agreeable to Mallarmé's recommendation that Vuillard illustrate his *Hérodiade* in 1898, but the poet died before Vollard had committed to the project, and there is no evidence that Vuillard ever began his contribution.[53]

By the 1900s Vuillard's relationship with Vollard was largely a by-product of his own involvement with the art dealers Josse and Gaston Bernheim and their cousin Jos Hessel. Not only were these men Vuillard's dealers, they were also his extended family, through his friendship with Félix Vallotton (who had married the Bernheims' sister) and, beginning in 1900, through his intimate relationship with Hessel's wife,

Lucie. Vollard's name appears a number of times in Vuillard's diaries between 1906 and 1917. The artist noted seeing Vollard at the Bernheim and Hessel soirées in Paris, during *villégiatures,* and on occasional car rides, accompanied by Vollard's intimate friend, Madame de Galéa. The "business" between the two is referred to in only a handful of entries dating from the summer of 1908, when Vollard visited his studio and hinted at a possible arrangement between them.[54] Vuillard's discreet and coded language sheds no further light on this "deal," although his entry for June 16, 1908, when he asked Vollard "to wait for his response regarding possible negotiation," coincides with his difficulties with the Bernheims and the adjustments to his contract, which eventually led him to switch allegiance from the Bernheims to Hessel.[55]

Bonnard had also moved from Vollard's to Bernheim-Jeune by 1900, although he continued to exhibit with Vollard as late as 1906. Early on, he was Vollard's favorite. As the unofficial court painter, as it were, he depicted the dealer at least seven times. One painting (ca. 1907; fig. 26) shows him entertaining in his *cave;* in two others (figs. 5, 161) he is posed in Bonnard's studio (ca. 1904) and in his own gallery (1924).[56] The drawing of the rue Laffitte gallery (fig. 101) that Bonnard created in 1910 as part of a series of vignettes commemorating important people and places in his career shows a very slim Vollard (with lots of hair) standing front and center. He presents to the viewer a Bathers painting by Cézanne that is similar in scale and subject to the painting in the background of Bonnard's portrait of him from about 1904 (fig. 5). At the far left of the drawing is Renoir, recognizable by his fragile build and beret. The other three figures have been identified as Camille Pissarro (seated at the left, examining paintings),[57] Edgar Degas (seated at the right with another man bending over to look at piled-up canvases), and Bonnard himself (standing at the far right). As Denis did in *Homage to Cézanne,* Bonnard linked Vollard to the artists he promoted throughout his career, while indicating his importance to the younger artists who visited his gallery both as part of his stable and for their own collecting interests.[58]

In the beginning of their acquaintance, Vollard commissioned Bonnard to make the poster for the "Peintres-graveurs" exhibition in 1897 (fig. 199) and to decorate the dining room in his Paris apartment about 1899.[59] He seems not yet to have been sure of Bonnard's abilities as an illustrator, and for his first attempt at luxury book publishing, *Parallèlement* (fig. 209), he approached Bonnard only after the established illustrator and woodcut artist Lucien Pissarro refused him. He paid Bonnard in installments beginning in March 1897, although it was not until July 1899 that Vuillard remarked to Vallotton that Bonnard was working on *Parallèlement,* "and

Fig. 102 (cat. 7). Pierre Bonnard, *Seated Girl with Rabbit,* 1891. Oil on canvas, 37¾ x 16⅞ in. (96 x 43 cm). The National Museum of Western Art, Tokyo (P.1987-001)

not surprisingly doing something marvelous."[60] Although the book, featuring 109 lithographs and 9 woodcuts, was not a commercial success after publication, it was a sufficiently successful aesthetic venture to motivate the dealer to collaborate with Bonnard again on *Daphnis et Chloé* (1902; fig. 213), a pastoral prose romance by the classical Greek poet Longus (but even then he seems to have asked Denis first).[61]

About the same time, Vollard challenged Bonnard to take up sculpture. "One day," he wrote in his memoirs,

> *I saw Bonnard kneading a piece of bread. In his fingers it gradually assumed the shape of a little dog.*
> *"I say, Bonnard, that looks like sculpture to me?"*
> *"I beg your pardon?"*
> *"Suppose you were to do me some statuettes?"*
> *Bonnard was not averse, and after a few attempts he undertook an important centrepiece for a table.*[62]

In this he was encouraging a penchant for decorative art that Bonnard had already manifested earlier in his career, when he made puppets and posters and even tried his hand at furniture designs. The earliest example of Bonnard's work in porcelain, purportedly commissioned by Vollard and possibly fired by the Nabis' friend and fellow artist George Rasetti, is a small vase from about 1894–95 (fig. 103) that features skating figures similar to the figures in his contemporary painting of the subject, *Ice Palace* or *The Skaters* (1896–98, private collection), and to the silhouetted carriages in his large four-panel lithographic screen *Nannies' Promenade, Frieze of Carriages* (ca. 1895–97, private collection).[63] In 1902 Vollard exhibited Bonnard's first attempt at bronze sculpture, a large circular centerpiece of intertwined nudes, issued in an edition of one hundred (fig. 104). A suite of small nude female figurines he showed at Vollard's four years later marked the last time he would dabble in this medium.[64]

Of the Nabis, Bonnard is the only artist that Vollard seems to have actively collected, and his purchases at auction, through dealers, and from the artist himself did not stop when Bonnard changed his gallery affiliation.[65] That Bonnard's painting *Dinner at Vollard's* (or *Vollard's Cellar*), showing Vollard at a table with Count Kessler and Degas (fig. 26), which Vollard bought for 800 francs in 1910,[66] and a variant of Bonnard's *The Terrasse Family (Afternoon of a Bourgeois Family)* (fig. 105) remained in Vollard's collection throughout his life suggests the personal meaning they held for him. As for Bonnard's feelings toward Vollard, one has only to compare his numerous depictions of Vollard with his only portrait of the Bernheims, painted in 1920 (fig. 106). Although not strictly a formal portrait, the Bernheim painting has none of the intimacy of his representations of the portly Ambroise relaxing with his feline companion (fig. 5), at the artist's studio, or, later in life, in the back room of his gallery (fig. 161). Instead, Bonnard depicted Gaston (at the front) and Josse Bernheim as successful businessmen, seated at their enormous desks and staring bleary-eyed away from the paperwork that threatens to overwhelm them.[67]

Fig. 103 (cat. 22). Pierre Bonnard, *Small Vase*, ca. 1894–95. India ink on unglazed painted ceramic, H. 3⅜ in. (8.6 cm). Private collection

Fig. 104 (cat. 21). Pierre Bonnard, *Surtout de Table (The Terrasse Children)*, ca. 1902. Bronze, 5 x 31⅞ x 20 in. (12.7 x 81 x 50.8 cm). The Art Institute of Chicago, bequest of Grant J. Pick (1963.927)

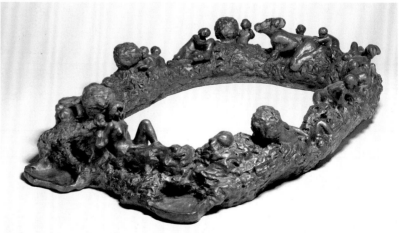

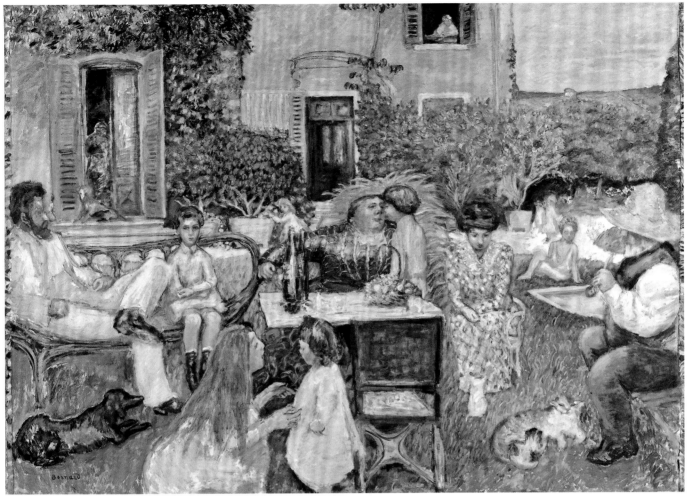

Fig. 105 (cat. 8). Pierre Bonnard, *The Terrasse Family (Afternoon of a Bourgeois Family)*, ca. 1902. Oil on canvas, 57⅞ x 82¼ in. (147 x 209 cm). Staatsgalerie, Stuttgart (2545)

The relationship between Roussel and Vollard is perhaps the most difficult to categorize. Roussel's relationship to dealers and even to his friends was often complicated by his personality, which tended toward bouts of depression (to the extent that he was hospitalized during World War I), and also by the fact that he was more well-off than his friends and thus less motivated by exhibitions and sales. Apart from Ivan Morozov's purchase in 1913 of two large decorative panels that had been shown at the Salon d'Automne in 1911, *Triumph of Bacchus* and *Triumph of Ceres* (at 10,000 francs for the pair), Vollard's sales of Roussel's work were largely pastels and works on paper.[68] The artist's erratic and anxious nature may have appealed to Vollard, who was himself a true eccentric and also a procrastinator.[69] By all accounts, Roussel was frustratingly incapable of finishing works; he repainted the two panels Vollard sold to Morozov, for example, so many times that the collector had to wait two years before they arrived at his Moscow mansion.[70] Roussel's breakdown during the war and his ongoing affair with the Swiss Berthe Waad and the continuing tensions it caused in his marriage to Vuillard's sister, Marie, have been cited to justify his relatively small output in the first two decades of the century.

Through it all, however, Vollard remained Roussel's close friend, hosting him at luncheons and dinners, visiting his studio at L'Étang-la-Ville, advancing him money "pour tableaux à recevoir" (for paintings to be received) and commissioning etchings and lithographs.[71] At some point Vollard commissioned Roussel to illustrate Mallarmé's *L'Après-midi d'un faune,* and beginning in 1919–23 Roussel made a number of pastels, paintings, and larger-scale decorative works on the motif of the sleeping nymphs and spying faun that may have been intended for the project. As early as 1910 Vollard had also commissioned him to illustrate Maurice de Guérin's *Centaure* (1833) and *Bacchante* (1840), even going so far as to provide space in his gallery where Roussel could work.[72] Although Roussel made numerous drawings and lithographs for these projects, they remained, as did many of his paintings and lithographs, unfinished.

By 1900 Vollard had added "éditions de livres" to his letterhead and done away with "dessins," indicating his primary

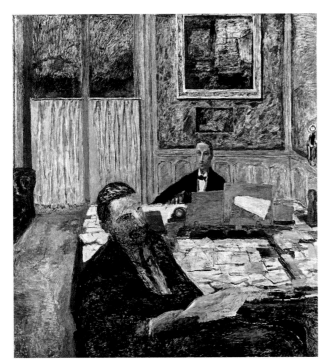

Fig. 106. Pierre Bonnard, *Gaston and Josse Bernheim-Jeune*, 1920. Oil on canvas, 65⅛ x 61¼ in. (165.5 x 155.5 cm). Musée d'Orsay, Paris (RF 1977-78)

interest in paintings and prints. His importance as a mentor and printmaker, as a voice of encouragement and sometimes a ready source of income, overshadowed any official contractual dealings with his artists. By 1913, when he was asked to contribute to the New York exhibition known as the Armory Show, he was less interested in exhibiting the work of the artists he had promoted early on. The most significant loans came from Denis's dealer Eugène Druet, who lent many paintings by Neoimpressionists (Henri Cross, Paul Signac), Fauves (Charles Camoin, Albert Marquet, Henri Manguin), *décorateurs* (Charles Guérin, Pierre Laprade), and independents (Félix Vallotton, Georges Rouault). Vollard, who had once represented several of those artists, only lent paintings by his blue-chip artists, Gauguin and Cézanne. On the other hand,

he sent a group of lithographs by Redon and the Nabis for the Vollard Albums, which he sold for twelve dollars each (while asking double or triple that for the single prints he had commissioned from Renoir and Cézanne).[73]

After 1913 (and especially from 1914 to 1920) fewer Nabi transactions are noted in Vollard's account books. In his *Recollections* he offered anecdotes and reminiscences about the Nabis and Redon, but they would never be the subject of either his lectures on art or his monographic studies, which explore Cézanne (1914), Renoir (1917), and Degas (1924). In 1917 he asked Denis to write a preface to the Cézanne volume and an introduction for a book on Degas that was only realized (with etchings by Denis) in 1935.[74] After Redon's death in 1916, Vollard dealt with his widow and supported her by lending works to exhibitions and supplying photographs for publications on the artist, such as André Mellerio's 1923 monograph.[75] Likewise, when in 1924 Marius Pératé wanted to publish a lengthy text on Denis, Vollard provided photographs.[76] As for Bonnard, not only did Vollard continue to collect his work, he also commissioned book illustrations: *Dingo* (1924; fig. 295) and *La Vie de Saint Monique* (1926–27). Roussel, too, would remain a house favorite; as late as 1939, Vollard lent two paintings to the exhibition of contemporary French art at the New York World's Fair.[77]

Vollard's place in the careers of Redon and the Nabis was never as intense and dramatic as his involvements with Cézanne and Gauguin, but his role was nonetheless a crucial one, not only because he encouraged them personally but also because, as Denis's *Homage to Cézanne* suggests, he placed them before the public in the company of the best-known older artists and "les jeunes." Although Camille Pissarro complained that Vollard was "fluttery" and had "so many projects that he can hardly carry out everything he has in mind,"[78] he was also, as Vuillard described him, "serious, ironic, enormous, and spirited," a larger-than-life individual who for the Nabis and Redon was both a loyal supporter and a friend.[79]

In this essay, the following abbreviations are used in citing catalogue raisonné numbers: for works by Bonnard, "D" refers to J. Dauberville and H. Dauberville 1966–74; for works by Gauguin, "W" refers to G. Wildenstein 1964; and for works by Redon, "W" refers to A. Wildenstein 1992–98.

1. Mellerio first introduced the Nabis to Redon in 1889, and he became an advocate and at times the publisher of their prints (see Wang 1974, p. 56). Redon was very unhappy with Élie Faure's hierarchical depiction of himself paying homage to one of his peers, and he expressed his complaints to Faure after reading his article "Paul Cézanne" in *Portraits d'hier,* May 1, 1910, in which Faure called Redon one of Cézanne's disciples and said he had been "subjected" to his influence; Redon to Faure, 1910, translated in Rewald 1986, pp. 238–40.

2. Rewald 1996, vol. 1, pp. 277–80, no. 418.

3. Immediately after its Paris showing, *Homage to Cézanne* was purchased, not by Vollard, but by the author André Gide, a close friend of Denis. Denis wrote to Octave Maus on April 27, 1901: "I have some good news (for me). The day before yesterday I sold *Homage to Cézanne,* do you know to whom? To Gide. I was delighted! The publicity I've gotten in the press over this picture has been absurd: some violently attack it, others overzealously defend it." See Maus 1926, p. 265.

4. The still life on the easel was once owned by Gauguin (and was admired by Vollard in his *Recollections* [1936, p. 62]), although at the time of the portrait it belonged to Paris collector Georges Viau. See Rewald 1996, vol. 1, pp. 277–80, no. 418. If Denis actually painted his picture in Vollard's gallery, he could have been in temporary possession of the painting, or perhaps Viau had consigned it with Vollard to see what price it might bring. I am grateful to Robert Jensen for these observations (e-mail correspondence, January 3, 2006).

5. The large zones of pinks in the foreground of the Gauguin painting relate it to his *Aha oe feii? (Are You Jealous?)* of 1892 (Pushkin State Museum of Fine Arts, Moscow; W 461), and the blue-and-white striped dress recalls his painting of his young mistress, *The Ancestors of Tehamana* or *Tehamana Has Many Parents (Merahi metua no Tehamana)* of 1893 (Art Institute of Chicago; W 497).

6. Although it was not a solo exhibition, Denis's works were on display, as noted by Thadée Natanson (1895c), who described seeing "a very pretty series by the too quiet Maurice Denis."

7. See Chicago–Amsterdam–London 1994–95, pp. 203–4, 306, 405, n. 26. See also Redon to Denis, May 5, 1896 (Collection of the Denis Family, Saint-Germain-en-Laye): "I want you to know that I am very interested in your work, yours and that of the *jeunes*." For the lithographic portraits, see Mellerio 1913, p. 125, nos. 190–93.

8. In Denis's first idea for the painting, he grouped his artist friends (and Mellerio) in Vollard's gallery without the easel, and without Vollard (see Lyon and other cities 1994–95, p. 259). On the significance of Denis's earlier and later intentions for the canvas, see Bouillon 1997, pp. 145–47. See also Bouillon 1998, p. 135.

9. Denis 1912 (1993 ed.), p. 29; Groom 1994, pp. 306–8. See also Denis's 1907 article on Cézanne (1912 ed., p. 254, cited in Lyon and other cities 1994–95, p. 260), wherein he described Redon's subject matter as more subjective and Cézanne's as more objective, "but both express themselves by means of a method which has, at its goal, the creation of a concrete object, one that is not merely beautiful but also reflects the artist's own sensibility." Vuillard, for one, admitted that he was under the spell of Redon's art and seems to be gazing intently at him alone in *Homage to Cézanne;* see Salomon and Cogeval 2003, vol. 1, p. 359.

10. Denis 1934, p. 165.

11. At the end of 1898, when Denis and Paul Signac searched for a gallery to exhibit works by Nabi artists along with those by Neoimpressionists, Vollard was not a candidate. This was perhaps due to the condition of Vollard's "boutique," which by all accounts was claustrophobic, more conducive to discovering a single artist almost by accident than to a clear presentation of a variety of artists in the encyclopedic way that Denis, backed by the Rosicrucian artist and collector Count Antoine de la Rochefoucault, envisioned. (For more information on la Rochefoucault, see Anne Roquebert's essay in this volume.) The exhibition was eventually held at Durand-Ruel in March and early April 1899, during the same time that Vollard exhibited the lithographs for the albums he had commissioned from Bonnard, Denis, Redon, and Vuillard. See "Petites Expositions" 1899.

12. See "Expositions nouvelles" 1898.

13. See Natanson 1898a.

14. Mellerio 1898, p. 28.

15. "Petite Expositions" 1899. On Redon's album, see also Johnson 1977, p. 46.

16. Vollard 1936, p. 197; Wang 1974, p. 159: "About 1893 I was put in touch with the *nabis* by Maurice Denis, who had noticed the little exhibition of Manet's drawings I was holding at the time. Thanks to this meeting I obtained pictures from Bonnard, Denis, Roussel and Vuillard." Though the earliest known Manet exhibition at Vollard's dates to 1894, the 1893 date is supported by the fact that Vollard's correspondence with Denis begins during this year. Unfortunately the Vollard Archives do not include transactions from 1893, and all the surviving receipts from Vollard to Manet's widow are dated 1894 and 1895: Vollard Archives, MS 421 (2,3), pp. 113–16, February 21, March 18, and May 20, 1894, and February 1, 1895.

17. See Lyon and other cities 1994–95, nos. 31, 32. According to Claire Denis, the artist entered the transaction in his CDV (*carnet de dons et ventes du peintre*) as 1892, but that was probably an error on his part.

18. Vollard to Denis, postmarked "Pont Aven 30 Mai 93": Archives, Musée Départemental Maurice Denis, Saint-Germain-en-Laye, Donation de la famille Denis, MS Vollard 11349a.

19. Humbert 1954, p. 85, cited in Wang 1974, p. 99.

20. Vollard to Denis, May 20, 1893: Archives, Musée Maurice Denis, MS Vollard 11347a. Vollard said he could not pay Denis in full just then because he "had taken a little boutique at 37, rue Lafitte, which [was] costing quite a lot of money." Vollard to Denis, September 13, 1893: Archives, Musée Maurice Denis, MS Vollard 11352a,b. The "deux têtes" was possibly a painted version of *Tenderness* or *Madeleine,* a lithograph from 1893 published in the first edition of *L'Estampe originale* (March 20, 1893); see Paris 2002, nos. 89–95.

21. Vollard to Denis from the rue des Apennins, May 20, 1893: Archives, Musée Maurice Denis, MS Vollard 11347a,b. This early interest in Denis helps dispel the myth that it was Tanguy's death in 1894 that led Vollard to support the Nabis, although it might be that the loss of that gallery precipitated his more active involvement with them.

22. Vollard Archives, MS 421 (4,2), fol. 6, October 27, 1894. For more about Lévy, see Douglas Druick's essay on Vollard and Gauguin in this volume.

23. Vollard Archives, MS 421 (4,3), fol. 30, September 21, 1895. On September 25, 1895, Vollard wrote two IOUs promising to pay Denis 100 francs and 270 francs: Vollard Archives, MS 421 (2,3), pp. 53, 54.

24. The Denis works were sold or exchanged both to well-known collectors Arsène Alexandre, Théodore Duret, Maurice Fabre, and Georges Viau and to lesser-known collectors and dealers Charpentier, Count of Takovo, Humbert, Méaux, and Félix Roux: Vollard Archives, MS 421 (4,2), fols. 18, 19, 21–23, 32, and MS 421 (4,3), fol. 32.

25. Vollard to Denis, undated but probably 1896 ("39" in the address on the letterhead crossed out and replaced with a "6"): Archives, Musée Maurice Denis, MS Vollard 11346a,b.

26. See Wang 1974, pp. 71–72, and also Paris 2002, nos. 106–8.

27. See Lyon and other cities 1994–95, p. 352, no. 289, and also Paris 2002, no. 104.

28. Vollard to Denis, June 19, 1897: Archives, Musée Maurice Denis, MS Vollard 12229a,b.

29. Vollard to Denis, undated but probably 1896 ("39" in the address on the letterhead crossed out and replaced with a "6"): Archives, Musée Maurice Denis, MS Vollard 11345.

30. Vollard to Denis, September 29, 1897: Archives, Musée Maurice Denis, MS Vollard 11354a,b. I am grateful to Claire Denis for the potential identification of the painting.

31. See Lyon and other cities 1994–95, pp. 212, 240. Vollard's account books do not mention this mass purchase, although there were three cash payments in 1899 that totaled 1,500 francs, or half of what Denis claims to have received: Vollard Archives, MS 421 (4,3), fols. 121 (January 30, 1899, 200 francs), 126 (March 16, 1899, 800 francs), 131 (May 2, 1899, 500 francs). On March 2, 1900, Vollard recorded paying 1,200 francs for "Maurice Denis un lot de peintures": Vollard Archives, MS 421 (4,3), fol. 154. It is possible that this was a second installment. Lyon and other cities 1994–95 (p. 212) cites Denis's CDV (*carnet de dons et ventes du peintre,* no. 226) for the sale of *Visitation* to Sergei Shchukin for 500 francs; it is possible that this is the sale recorded, along with that of a Renoir(?), in the Vollard Archives, MS 421 (4,4), fol. 41, April 1899: "Stchoukin Ren [*sic*] Denis 2500 [francs]."

32. Meier-Graefe. The same article was published in French in the February 1899 issue of *L'Art décoratif* with an additional wood engraving by Denis. See also my essay "Vollard and German Collectors" in this volume.

33. Fontainas 1897. In 1904 Vollard sold another "maternité" to the American Leo Stein, which Stein returned four years later in exchange for a painting of a nude by Renoir: Vollard Archives, MS 421 (4,10), p. 30, October 28, 1904.

34. Cézanne to Émile Bernard, June 27, 1904, in Rewald 1937, p. 263, letter 170.

35. Denis 1905b (1920 ed.), p. 196. He singled out Matisse's *Luxe, calme et volupté* (1904, Musée d' Orsay, Paris) in particular.

36. See Groom 2001, p. 146, and Bouillon 1993, p. 122.

37. See Groom 1994, p. 308.

38. An entry for February 23, 1896 ("Redon payé la lithographie [Vte.?] pour ma publication [in column labeled *sortie*] 100 [francs]"), may document Vollard's payment to Redon for this lithograph: Vollard Archives, MS 421 (4,3), fol. 41.

39. On October 27, 1896, Vollard bought Redon's pastel *Béatrice* (W 145) for 150 francs: Vollard Archives, MS 421 (4,3), fol. 56. This pastel was inspired by an earlier charcoal *Béatrice* (W 144). Often, Redon retained older works as templates for newer ones. For example he kept *Head of a Martyr* in order to reproduce it as a lithograph, but as he increasingly worked in color during the early 1890s he began using his lithographs as sources for painted and pastel variants. *Mystical Conversation, Druidess, Parsifal,* and even the lithograph for *Yeux clos* served as the compositional basis for a considerable number of color versions. See Sharp 1994b, p. 244.

40. Pissarro to his son Lucien, July 12, 1896, in Rewald and L. Pissarro 1943, p. 292.

41. Redon subsequently reworked the finished *noir* in pastel, probably in the early 1890s, after which it retained the same title; see Stratis 1994, p. 371, for details of what infrared reflectography reveals. *Salomée* was also reworked, but here the *noir* and the pastel are about the same date (1893); see Stratis 1994, fig. 32.

42. Vollard recorded numerous drawings by Redon in his Stockbook A, but it is difficult to say whether these could have been *noirs* reworked in pastel. For an itemization of Vollard's mass purchases of Redon's works in 1899, see the entry for cats. 165–168.

43. Although Vollard's first major purchase of *noirs* was recorded in 1897, it is very difficult to identify individual works, especially as Redon left the titles up to Vollard and collectors often retitled works as they saw fit; see Sharp 1994a, esp. pp. 263, 265ff.

44. Peyrelebade was sold in 1897 but transfer of the title did not take place until January 1898; see Chicago–Amsterdam–London 1994–95, p. 252, and Redon to Andries Bonger, September (redated to August) 12, 1898, in Levy 1987. Dario Gamboni (1989, pp. 174–75) believes the Durand-Ruel exhibition in March 1896 marked Redon's integration into the art market, which was then followed by his showings with Vollard in 1896 and 1898.

45. Roseline Bacou (Paris 1956–57, p. xxv) lists a 1901 exhibition of pastels and paintings at Vollard's; however, subsequent research has not been able to confirm this.

46. According to Gamboni (1989, pp. 186–88), the failure of the Mallarmé project was due less to a change of heart on Mallarmé's part than to a change in attitude by Vollard and Redon. Gamboni believes that the fact that as late as 1913 Mellerio catalogued three of the four Redon prints (noting that a fourth stone was lost) intended for *Coup de dés* generically as "planches d'essai," or trial plates, suggests that Redon did not want them published (they were not clearly identified as illustrations for *Coup de dés* until Una Johnson did so in 1944). Another version has it that Vollard planned to publish the book, but the printers, Firmin-Didot, refused to set Mallarmé's text, with its unconventional typographical pattern, calling it "the work of a madman"; see Lake 1976, no. 373, and Johnson 1944, pp. 123–24, no. 140. Even after Redon's death, Vollard pursued the *Tentation de Saint-Antoine* project with Flaubert's niece, who balked at the idea. Vollard lost the lithographs and recovered them in about 1936; Vollard 1936, p. 257.

47. See Kevin Sharp's analysis of Redon's strategies in Sharp 1994b, pp. 240–41, 246.

48. By 1900 Redon was able to buy a Cézanne "portrait d'homme" from Vollard, paying 200 francs, which tallied with other prices recorded in Vollard's stockbooks; see Stockbook A, no. 3868, and Rewald 1996, vol. 1, pp. 474–75, no. 789.

49. In addition to the large purchases of Redon's works he noted in his account books in 1899 (see cats. 165–168), Vollard also documented substantial pur-

chases of drawings and paintings on December 18, 1906 ("Redon chèque 2000 fr[ancs] pour un lot de dessins—reste de 445 fr[ancs]") and October 19, 1909 ("Redon douze dessins et esquisses / 1300 fr[ancs] chèque"): Vollard Archives, MS 421 (5,1), fol. 203, and MS 421 (5,4), fol. 198.

50. For example, Camille Redon asked Vollard to finalize the publication of *La Tentation de Saint-Antoine,* for which they were owed 725 francs, and also to advance 1,000 francs toward the old Bordeaux debt, as their rent was 2,000 francs: Vollard Archives, MS 421 (2,2), p. 307, December 1899 (? the letter is dated "Le decembre 9"). See also Camille Redon to Vollard, undated, MS 421 (2,2), p. 306: "My dear Vollard, I absolutely must have 200 francs by tomorrow—I hope I can get them from you. . . . I'll come by about 11:30 in the morning with fingers crossed. Amicably, Cam. Redon."

51. Redon to Bonger, March 28, 1911, in Levy 1987, p. 204, cited by Sharp 1994a, pp. 277, 416, n. 88. Redon's last one-man exhibition was at Galerie Druet in 1908, at which time he declared that he only wanted private commissions but at the same time bemoaned the lack of recognition he received from the press. On Redon's ambivalence to the art market in general, see Gamboni 1989, p. 196.

52. Vollard Archives, MS 421 (4,3), fol. 35: "fillette assise (26 x 13?) [sortie] 50 [francs]"; "(29 x 7?) Petite Fille [illegible] [sortie] 40 [francs]"; and a pastel "silhouette de femme, [sortie] 10 [francs]."

53. See Mallarmé to Vollard, ending with "mon cher Editeur," September 14, [1897], in Nectoux 1998, pp. 130–31.

54. Vuillard "Journal," vol. 2, *carnet* 3, June 16 and July 6, 1908: Institut de France, Paris, MS 5397. I am grateful to Mathias Chivot, formerly of the Vuillard Archives, for providing me with these entries. Guy Cogeval is currently working with the Wildenstein Foundation to publish annotated notebooks of Vuillard's *carnets,* which have been housed in the Institut de France since the artist's death in 1940.

55. Vuillard "Journal," vol. 2, *carnet* 3, May 22 and July 3, 1908: Institut de France, MS 5397. Vuillard noted that his "deep-seated reason" for deciding to go to the Bernheims and demand a new contract was his "desire for liberty." In 1912 Vuillard ceased being part of the Bernheim-Jeune gallery and joined the gallery of Jos Hessel on the rue Richepanse.

56. For Bonnard's other portraits of Vollard, see D 303, D 304, D 1260, and the etching in the Art Institute of Chicago (Bouvet 1981, no. 89). In addition to the portrait of Vollard by Denis (in preparation for *Homage to Cézanne*), Vallotton (fig. 276) and Vuillard (Salomon and Cogeval 2003, vol. 2, p. 641, no. VII-195; sale, Sotheby's, New York, May 6, 2004, pt. 2, no. 207) both made portraits of the dealer in about 1900–1901.

57. Pissarro was nearly bald by the 1890s, so perhaps Sérusier, known for his heavy mane, might be a better fit.

58. Denis, for example, wrote to Vollard in December 1903 reminding him that he had given him a painting to sell (*Mother and Child at Loctudy [Virgin wih Bottle at Family's Table],* 1901) in exchange for a Gauguin (*Self-Portrait with Yellow Christ,* 1899–90, Musée d'Orsay, Paris; W 324) and that he was also waiting for reimbursement for *Vollard derrière le chevalet,* which he had given him six months before. In the same letter he referred to the Cézanne *Coin de table* Vollard had promised him, which he may have hoped his portrait would help pay for: Vollard Archives, MS 421 (2,2), p. 82. I am grateful to Claire Denis for identifying the Gauguin and the Cézanne. Vuillard also sold a Cézanne painting to the dealer, along with two Pissarros, in April 1899 for 1,400 francs: Vollard Archives, MS 421 (4,3), fol. 130, April 22, 1899.

59. In his memoirs (1936, pp. 17–18), Vollard related that when Lautrec visited his home while Bonnard was at work on the *décoration* for his dining room, he left a self-portrait on the verso of an *étude* as a "visiting card." See also Giambruni 1983, p. 331, n. 63, and Groom in Chicago–New York 2001, pp. 76, 259, n. 16. Bonnard also painted a portrait of Vollard's intimate friend, Madame de Galéa, which Vollard acquired from her on September 1, 1926: Vollard Archives, 1922 Inventory, no. 5540.

60. Vuillard to Vallotton, July 26, 1899, in Guisan and Jakubec 1975, p. 15.

61. Vollard to Denis, undated but probably 1896 ("39" in the address on the letterhead crossed out and replaced with a "6"): Archives, Musée Maurice Denis, MS Vollard 11346a.

62. Vollard 1936, pp. 249–50.

63. On the date of the screen, see Watkins 1994, p. 44.

64. "Expositions nouvelles" 1906. Vollard's account books do not indicate that he sold any of these, nor are they listed in Stockbooks A, B, or C or in the 1922 Inventory. On Bonnard's sculpture, see Pingeot 2006.

65. For example, he purchased works directly from the playwright Henry Bernstein (D 543) and Bernheim-Jeune (D 216, D 911). As late as April 27, 1929, Vollard sold Gaston Lévy five works by Bonnard for a total of 52,000 francs (one at 20,000, two at 10,000 each, one at 7,000, and one at 5,000): Vollard Archives, MS 421 (4,8), fol. 93.

66. Vollard Archives, MS 421 (5,5), fol. 146, October 11, 1910.

67. See Rewald 1996, vol. 1, p. 241, no. 363, and Watkins 1994, p. 103. Bonnard's *Loge* (1908, Musée d'Orsay, Paris; D 496), includes a seated Gaston with a semidecapitated Josse standing behind him, but it is more a portrait of their wives (who were also sisters).

68. Albert Kostenevich (in Toronto–Montreal 2002–3, p. 211) says *The Triumph of Bacchus* was purchased by Morozov from Galerie Vollard for 10,000 francs, but the Vollard Archives indicate that the *two* panels were purchased for that amount: Vollard Archives, MS 421 (5,9), fol. 29, February 5, 1913, and MS 421 (2,3), p. 310, March 1, 1913. Of the fifty-three works by Roussel recorded in Vollard's Stockbook A, forty-four are pastels, two are paintings, one is a drawing ("bistre"), and six are not identified.

69. After being hospitalized for five weeks with no word from Vollard, John Quinn wrote to Rouault on April 26, 1918, "I know that Vollard is a very busy man. But he is also a great procrastinator": John Quinn Memorial Collection, Manuscripts and Archives Division, New York Public Library, Astor, Lenox and Tilden Foundations.

70. And then he was displeased with the results; see Groom in Chicago–New York 2001, pp. 213–16, no. 64. The two panels, shown at the 1911 Salon d'Automne, were completely redone in 1913; see Vollard 1936, p. 90. On the changes in palette, see Groom in Chicago–New York 2001, p. 273, n. 5. On May 30, 1911, after seeing Roussel's decorative panels at Vollard's, Vuillard noted his admiration for these "grandes compositions" in his journal: Vuillard, "Journal," vol. 2, *carnet* 5: Institut de France, MS 5397.

71. See Vollard Archives, MS 421 (5,1), fol. 13, January 20, 1906: "Remis à Roussell [*sic*], K. X. 2000 frs en un chèque pour tableaux à recevoir."

72. See Groom in Chicago–New York 2001, pp. 225, 275, n. 7, and Vollard 1936, p. 260. For the lithographs made for *Le Centaure*, see Alain 1968, vol. 1, pls. 32–53. Bernheim-Jeune also provided Roussel with a special room where for more than thirty years he retouched and repainted canvases held by the gallery (see Groom in Chicago–New York 2001, pp. 215, 273, n. 11).

73. See Vollard Archives, MS 421 (4,13), fol. 80. He also lent books, including Bonnard's *Parallèlement* and *Daphnis et Chloé* and Denis's *Sagesse;* see Brown 1963, pp. 50–51. For lists of works included in the Armory Show, as well as lenders, buyers, and prices, see Brown 1963, pp. 217–302. What is surprising, given Vollard's interest in Redon's *noirs,* is that he lent none of them to the exhibition. The Redons came largely from Artz and de Bois and Jos Hessel, although it is quite possible that Hessel acquired the paintings and pastels he lent through Vollard.

74. For the Cézanne commission, see Vollard to Denis, April 21, 1914: Archives, Musée Maurice Denis, MS Vollard 11366.

75. Camille Redon to Vollard, December 3, 1921 (Vollard Archives, MS 421 [2,2], p. 310) undoubtedly referring to Mellerio's then forthcoming publication *Odilon Redon: Peintre, dessinateur et graveur* (1923), in which Vollard is credited for several reproductions (pp. 19, 45, 123, 142, 145, 158).

76. Denis to Vollard, May 1, 1924: Vollard Archives, MS 421 (2,2), p. 83.

77. The paintings were listed in the exhibition catalogue (New York 1939, p. 38) as nos. 131, *Printemps olympien*, and 132, *Bacchanale-automne*. See also Vollard Archives, MS 421 (3,6), fol. 28, March 26, 1939.

78. Pissarro to his son Lucien, July 1, 1896, in Rewald and L. Pissarro 1943, p. 291.

79. Vuillard "Journal," vol. 2, *carnet* 5 (Institut de France, MS 5397), August 10, 1911 (describing a visit to Vollard in Normandy): "verve ironie, sérieux, énorme."

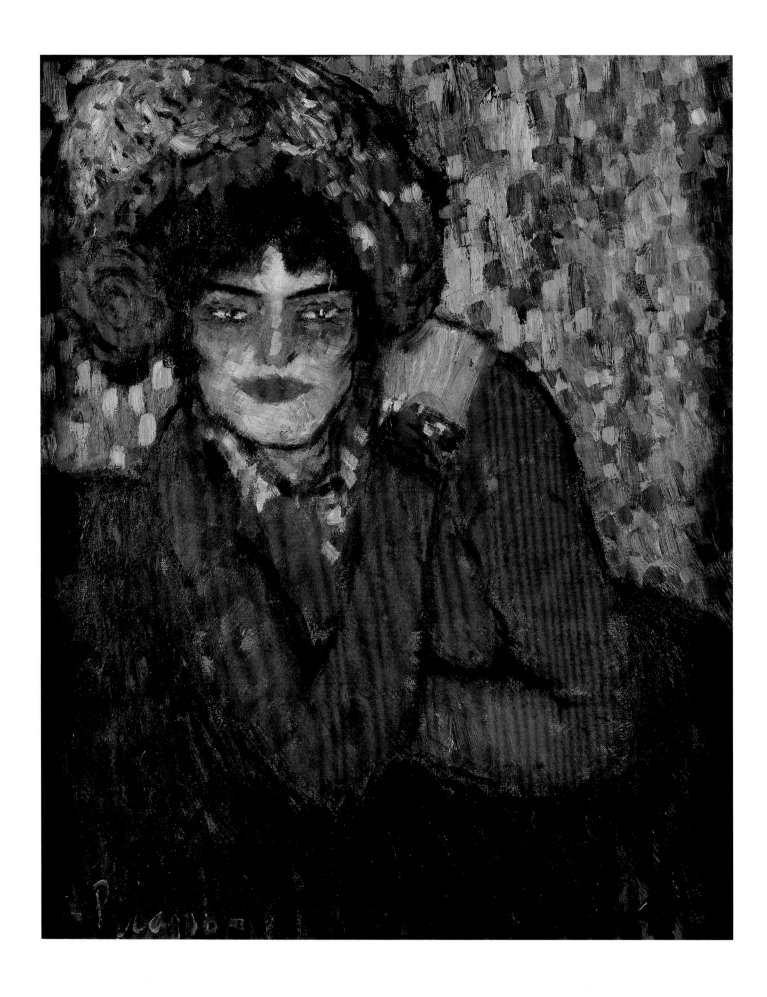

Vollard and Picasso

Gary Tinterow, with research by Asher E. Miller

I was at Vollard's to send those Cézannes to Prague and he promised that he would send them immediately through the post. The old man [Vollard] looked like the devil, quite terrifying, but compared to last year he was exceptionally kind. He again had a Picasso head on the counter and a large landscape by Cézanne in the window.[1]

The relationship between Ambroise Vollard and Pablo Picasso (1881–1973) was constantly evolving. Beginning in 1901 with a nineteen-year-old Spaniard (who spoke no French) arriving as a supplicant to an already legendary Parisian art dealer, it terminated in 1939 with the fifty-seven-year-old painter, himself now legendary and rich, indulging an elderly, old-fashioned publisher of prints and illustrated books. Through their nearly forty years of acquaintanceship, Picasso and Vollard passed through the various phases typical of the relations between artist and dealer at the beginning of the twentieth century, ranging from a calculated wariness on both sides to a relationship of convenience based on mutual regard. Vollard gave Picasso his first show in Paris, selling perhaps a large number of paintings at very low prices but refusing, as he always did, to buy the unsold remainder. As the decade progressed and Picasso's reputation grew, Vollard made several important purchases from the artist and intervened at crucial moments, but he never offered the artist the security of a contract.

At times, Vollard and Picasso would seem to be working at cross-purposes. In 1910, as Picasso's Cubism crystallized into luminous, shimmering, near-abstractions, Vollard mounted from his own stock a retrospective exhibition of work from 1901 through the present, emphasizing the artist's earlier Blue and Rose Period works. Simultaneously, Picasso, hoping to secure an outlet for his new Cubist work, continued to flirt with other dealers: Clovis Sagot, Wilhelm Uhde, and Daniel-Henry Kahnweiler. As Kahnweiler began to define himself as the principal dealer of Cubism and sought contracts with Juan Gris, Fernand Léger, and Georges Braque, Vollard commissioned casts in bronze of Picasso's Cubist *Head of Fernande* (fig. 198) as well as a handful of other sculptures, and, in 1911, he bought the plates and the rights to publish a suite of Picasso's charming, winsome Saltimbanque prints.

On the eve of the First World War, temporarily secure financially thanks to a generous contract with Kahnweiler, Picasso made his first purchase from Vollard: an ambitious painting by Henri (le Douanier) Rousseau, *The Representatives of Foreign Powers Coming to Greet the Republic as a Sign of Peace* (fig. 24).[2] After the war, Picasso continued to buy paintings from Vollard, although Vollard was no longer buying paintings from the artist, who by then had landed a lucrative contract with Paul Rosenberg and Georges Wildenstein. In the 1920s and 1930s, however, Vollard continued to sell his existing stock of prewar Picassos at high prices, and he commissioned from Picasso several *livres d'artiste*—among them Balzac's *Chef-d'oeuvre inconnu* (fig. 119) and Buffon's *Histoire naturelle* (fig. 120)—as well as the monumental series of etchings known as the *Vollard Suite*. While he was never Picasso's exclusive dealer, it is no exaggeration to say that Vollard was Picasso's principal dealer from 1906 to 1911 and that through Vollard's activities as an *éditeur*—of bronzes, prints, and books—Picasso's work became more widely known in Europe and America. For all the vicissitudes of their relationship, Picasso drew basic lessons from Vollard, the dealer whom he most respected. More than forty years after exhibiting at Vollard's gallery, Picasso told his companion Françoise Gilot that he still "based his own maneuvers on Vollard's tactics."[3] Above all, it was the fortuitous association, through Vollard, of Picasso's art with that of Cézanne that cemented Picasso's reputation among French, American, Russian, and German cognoscenti in the first decade of the twentieth century.

PICASSO'S 1901 EXHIBITION AT GALERIE VOLLARD

Picasso arrived in Paris for the first time soon after his nineteenth birthday, in October 1900. According to biographer John Richardson, he visited the well-known galleries on the rue Laffitte, including those of Paul Durand-Ruel and Vollard, during this initial two-month stay.[4] He lodged with another artist, Carlos Casagemas, whose suicide on February 17, 1901, would profoundly mark him. Through the Catalan painter Isidre Nonell i Monturiol, Picasso met Pere Mañach, an aspiring

Opposite: Fig. 107 (cat. 144). Pablo Picasso, *Pierreuse, Her Hand on Her Shoulder,* or *Waiting (Margot),* 1901. Oil on board, 27 ⅞ x 22 ½ in. (69.5 x 57 cm). Museu Picasso, Barcelona (MPB 4.271)

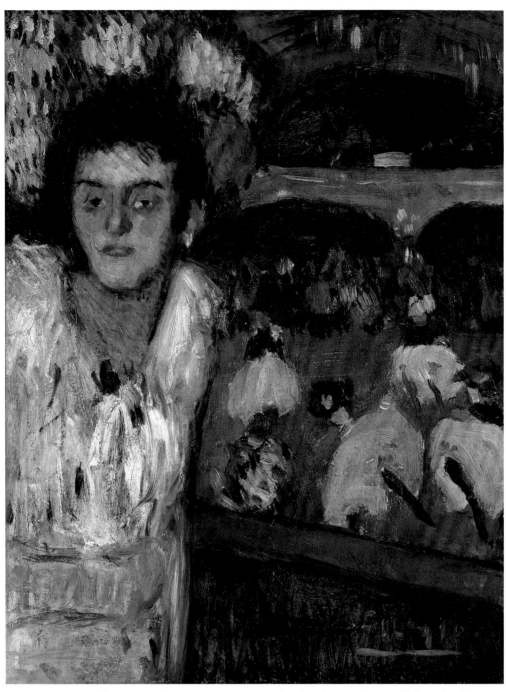

Fig. 108 (cat. 141). Pablo Picasso, *The Divan Japonais,* 1901. Oil on board mounted on cradled panel, 27½ x 21 in. (70 x 53.4 cm). Mugrabi Collection

art dealer from Barcelona resident in Paris. Mañach sold perhaps three of Picasso's pictures to Berthe Weill, proprietor of a small gallery for young artists. On the strength of that encouraging start, Mañach agreed to give Picasso a monthly allowance of 150 francs in exchange for his output and soon arranged for a showing at the Galerie Vollard of recent work by Picasso and Francisco Iturrino, another painter from the group associated with the Barcelona café Els Quatre Gats.[5] Vollard recalled the visit of "a young Spaniard, dressed with the most studied elegance."[6] While Picasso spent the spring of 1901 in Barcelona and Madrid, by May 15, 1901, he had returned to Mañach's

Paris apartment (formerly Casagemas's) with as many as two dozen pictures, feverishly painting prior to the opening at Vollard's on June 25.

For the exhibition, Mañach hung sixty-four paintings and an unknown number of works on paper by Picasso[7] and invited the worldly art critic Gustave Coquiot to write a preface for the catalogue. Picasso later recalled the canvases "on top of one another [almost to] the ceiling and unframed, while some were not even on stretchers but in large folders."[8] The poet Max Jacob remembered how Picasso "was accused of imitating Steinlen, Lautrec, Vuillard, Van Gogh, etc., but everyone recognized

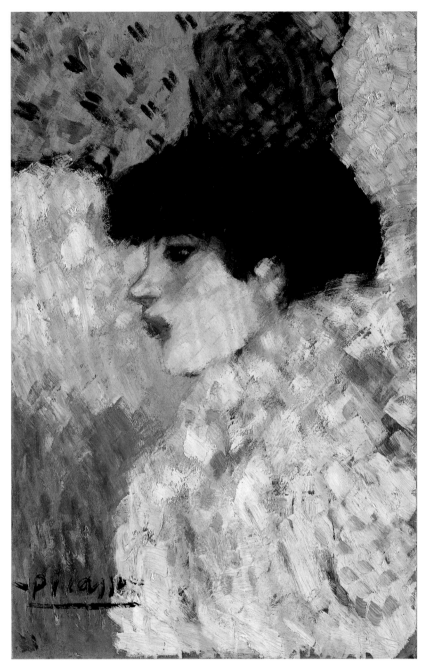

Fig. 109 (cat. 142). Pablo Picasso, *Girl in Profile*, 1901. Oil on board mounted on masonite, 20⅝ x 13½ in. (52.5 x 34.3 cm). The Metropolitan Museum of Art, New York, Jacques and Natasha Gelman Collection, 1998 (1999.363.58)

that he had fire, a real brilliance, a painter's eye."[9] Although the show was virtually a catalogue of the various subjects and styles currently practiced by better-known French artists, with an emphasis on salacious scenes from the shadowy world of dance halls and prostitution at Montmartre, Picasso's facility immediately attracted those attuned to recognizing an emerging talent. As Félicien Fagus wrote in *La Revue blanche,* "In addition to the great forefathers, we can easily distinguish a host of likely influences. . . . Each one fleeting, caught for a moment then gone. What's clear is that his passion has not yet left him time to forge a style of his own; his personality is all in that

passion, that youthful, impetuous spontaneity (they say he's not even twenty, that he paints up to three canvases a day)."[10]

Vollard recalled that the show was unsuccessful;[11] in contrast, modern writers such as Richardson have pointed to the fifteen pictures listed in the catalogue as previously sold, and Pierre Daix believes that the "quasi-totality" of the exhibition found owners.[12] While Picasso and Mañach must have been thrilled with the effusive press and the promising sales, Vollard, accustomed to the steady movement of paintings by Cézanne and Gauguin at substantial prices, understandably thought little of the effort. Iturrino, whose pictures were characterized

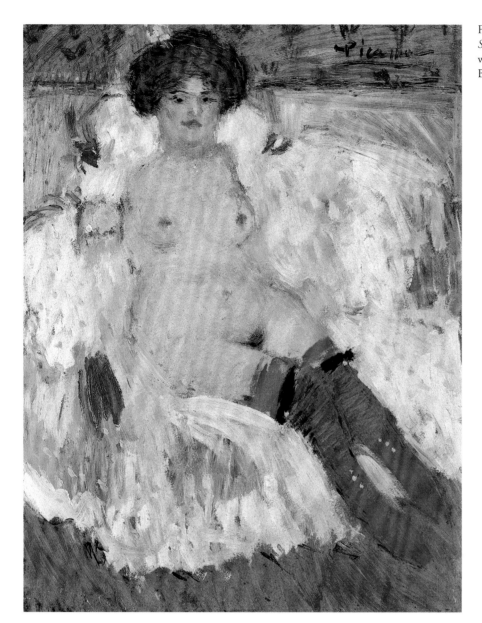

Fig. 110 (cat. 143). Pablo Picasso, *Nude with Red Stockings,* 1901. Oil on cardboard mounted on wood, 26⅜ x 20¼ in. (67 x 51.5 cm). Musée des Beaux-Arts, Lyon (1997-44)

as "deeply melancholy," attracted almost no notice. Vollard's archives are mute on the exhibition, and it is not known what financial arrangements Mañach made with Vollard, nor who, if anyone, paid Coquiot for his catalogue text. Daix speculates that Coquiot invented the titles given to the pictures in the catalogue, since they continued to annoy Picasso sixty years after the fact.[13] Later in 1901, after Casagemas's suicide, Picasso moved away from fin-de-siècle gaiety toward his morose Blue Period manner and broke with his agent, Mañach, returning to Barcelona.[14] Presumably, Picasso's pictures became Mañach's property in exchange for the stipend; in 1902 a number of them were exhibited in another show arranged by Mañach, this time at Berthe Weill's gallery.[15] Years later Vollard recalled seeing Mañach in Barcelona, running his family's safe and locksmith business.[16] Picasso did not return to Paris until 1904.

From Vollard's perspective in 1901, the Picasso–Iturrino exhibition was no different from any of the fleeting exhibitions he hosted that were devoted to other artists to whom he had no personal commitment, such as Theodore Butler, Charles Maurin, or Ernest Chamaillard; indeed, he may well have simply rented his quarters to Mañach. For Picasso, the exhibition may have seemed a brilliant announcement of talent and ambition. But Vollard—perhaps put off by Picasso's youth and inexperience—was not impressed; he bought nothing from the artist until 1906. Yet evident at this initial show in Paris were the first of the many portraits Picasso would paint of the dealers and agents who could help ensure his financial success, in this instance, Mañach and Iturrino; his portraits of Coquiot and Vollard and his own now famous self-portrait, *Yo, Picasso,* may have been exhibited as well.[17]

THE STEINS AND VOLLARD, 1905–1910

Enter Gertrude and Leo Stein, the affluent American bohemians, resident in Paris, who would bring Picasso, Matisse, and Vollard together with other new collectors: "The first visit

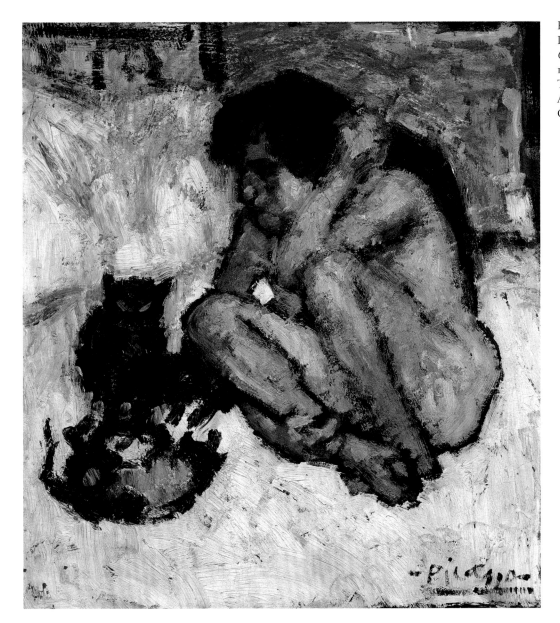

Fig. 111 (cat. 140). Pablo Picasso, *Crazy Woman with Cats,* 1901. Oil on pulp board, 17¾ x 16⅛ in. (45.1 x 40.8 cm). The Art Institute of Chicago, Amy McCormick Memorial Collection (1942.464)

to Vollard has left an indelible impression on Gertrude Stein."[18] Vollard in turn was equally impressed: "But you have only to encounter her glance to perceive in Miss Stein something far beyond the ordinary *bourgeoise.*"[19] Leo believed that "Vollard liked to sell us pictures because we were the only customers who bought pictures, not because they were rich, but despite the fact that they weren't [*sic*]."[20]

In November 1905 Leo Stein discovered a Picasso at Clovis Sagot's gallery. His younger sister, Gertrude, did not approve of the selection, so together they bought instead *Little Girl with Basket of Flowers* (private collection). A mutual friend, Henri-Pierre Roché, took Leo to meet Picasso at the Bateau-Lavoir studios in Montmartre, and he returned soon thereafter with Gertrude.[21] They purchased pictures for 800 francs on their first studio visit, including *Nude with Clasped Hands* (Museum of Modern Art, New York).

Picasso and Gertrude immediately took to each other, and Picasso offered to paint her portrait (Metropolitan Museum of Art).[22] The endless number of sittings for the portrait through the first half of 1906—ninety, according to Gertrude—cemented their friendship, and Picasso's companion, Fernande Olivier, established her own relationship with Gertrude and her companion, Alice B. Toklas. Revealing a new world to Picasso, Gertrude, Leo, and their brother Michael introduced him to their friends, including artists such as Henri Matisse, as well as to the community of wealthy expatriates, many of whom, like themselves, were clients of Vollard.[23]

The Steins were undoubtedly at the root of Vollard's first purchase from Picasso, in May 1906.[24] A letter from Vollard to Picasso—carefully preserved by the artist—documents the choreography of the event: "Dear Sir, I could not get to you on May 1st as I intended[.] Please excuse me[.] I will come by without fault Sunday [May 6] in the morning and ask that you assemble all that you want to show me. I will come a little earlier than last Sunday, around *10 o'clock*[.] Best wishes Vollard, 6 rue Lafitte."[25] Two days later, Leo Stein confided to

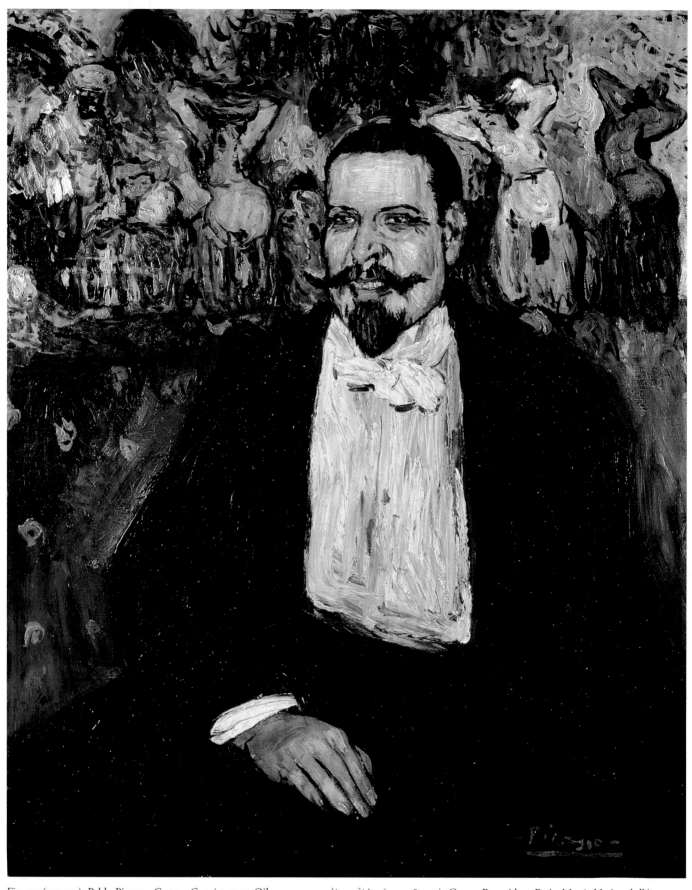

Fig. 112 (cat. 139). Pablo Picasso, *Gustave Coquiot,* 1901. Oil on canvas, 39⅜ x 31⅞ in. (100 x 81 cm). Centre Pompidou, Paris, Musée National d'Art Moderne/Centre de Création Industrielle, Gift of Mme Gustave Coquiot, 1933 (JP 652 P)

Fig. 113 (cat. 147). Pablo Picasso, *The Old Guitarist,* 1903/4. Oil on panel, 43⅜ x 32½ in. (112.9 x 82.6 cm). The Art Institute of Chicago, Helen Birch Barrett Memorial Collection (1926.253)

Matisse: "I am sure that you will be pleased to know that Picasso has done business with Vollard. He has not sold everything but he has sold enough to give him peace of mind during the summer and perhaps longer. Vollard has taken 27 pictures, mostly old ones, a few of the more recent ones, but nothing major. Picasso was very happy with the price."[26] Picasso signed a receipt on May 11.[27]

Vollard could not have ignored the Steins' enthusiasm for the young Spaniard, and he must have noticed that they had made their purchases directly from the artist rather than through

him. Similarly, as Michael FitzGerald has observed, Vollard may have been stimulated by the growing collection of another client, a businessman named André Level. In 1904 Level had founded a syndicate to purchase art that would be sold at a future date. Called "La Peau de l'Ours" after an old French expression ("il ne faut pas vendre la peau de l'ours avant de l'avoir tué," the French equivalent of "don't count your chickens before they're hatched"), the syndicate began its collection with works by Gauguin but soon featured Matisse and Picasso, the same two artists emphasized in the Steins' holdings.

Fig. 114 (cat. 149). Pablo
Picasso, *La Coiffure,* 1906.
Oil on canvas, 68⅞ x 39¼
in. (174.9 x 99.7 cm). The
Metropolitan Museum of
Art, New York, Catharine
Lorillard Wolfe Collection,
Wolfe Fund, 1951; acquired
from The Museum of
Modern Art, Anonymous
Gift (53.140.3)

Fig. 115 (cat. 150). Pablo Picasso, *La Toilette*, 1906. Oil on canvas, 59 ½ x 39 in. (151 x 99 cm). Collection Albright-Knox Art Gallery, Buffalo, New York, Fellows for Life Fund, 1926

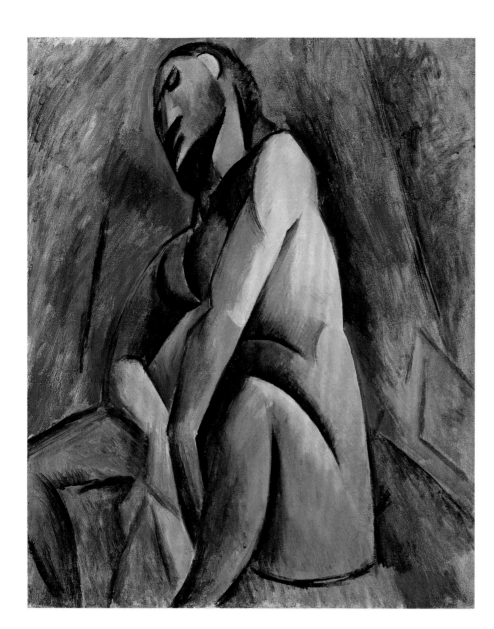

Fig. 116 (cat. 152). Pablo Picasso, *Seated Female Nude,* 1908–9. Oil on canvas, 24 x 20 in. (61 x 50.8 cm). Private collection

Relatively few Picasso sales are documented by Vollard before 1911; however, the dealer sold his first work by the artist within a week of its purchase from Picasso in May 1906.[28] Maddeningly, it is not possible to identify all of the Picassos that Vollard bought; it is clear, however, that many remained with him for years, some not finding owners until after the First World War. Vollard's first acquisition from Picasso is most notable for what it did not include, the artist's large *Family of Saltimbanques* (National Gallery of Art, Washington, D.C.). A manifest masterpiece and the summation of Picasso's Rose Period regard for Velázquez, the *Family* was probably deemed by Vollard to be too big and therefore too risky to take on. Instead, André Level bought it for his Peau de l'Ours consortium, and its sale at auction in Paris in 1914 created a sensation.[29]

The records in the Vollard archives indicate that, contrary to traditional wisdom, the dealer continued to make regular purchases from Picasso even after the artist's sharp turn toward primitivism in 1906–7. Vollard bought six paintings for 1,000 francs on November 16, 1906. On February 4, 1907, Picasso sent a note to Gertrude Stein with the portentous words, "Vollard was here."[30] On February 13, 1907, the dealer paid Picasso 2,500 francs for "a batch of canvases and drawings." Vollard retrieved twelve paintings on July 31, eleven paintings on September 13–14, and an unspecified number on December 5.[31] Picasso wrote Leo Stein on December 5 to say "I saw Bollard [*sic*]. He promised he'll come tomorrow afternoon to fetch his paintings."[32] While these purchases may have consisted of older work, they also contained new pictures, such as the *Bust of a Nude* done as a study for *Demoiselles d'Avignon* and eventually bought by the Russian collector Sergei Shchukin (fig. 117). It appears that Vollard was paying on average 150 francs for an easel painting by Picasso. On April 29, 1908, Vollard sold a number of works to the Russian collector Ivan Morozov, including a painting by Cézanne for 20,000 francs, three Gauguins at 8,000 francs apiece, a Puy for 1,200 francs, and Picasso's *The Two Saltimbanques* (frontispiece) for 300 francs, the standard markup for a picture costing

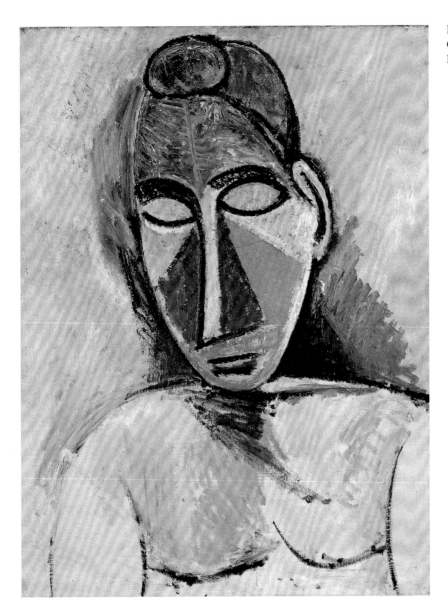

Fig. 117 (cat. 151). Pablo Picasso, *Bust of a Nude,* 1907. Oil on canvas, 24 x 18 ¼ in. (61 x 46.5 cm). The State Hermitage Museum, St. Petersburg (9046)

Vollard 150 francs.[33] Three hundred francs in 1908 can be converted to $1,200 in today's money, using standard inflation tables. Picasso's prices were still quite low. That a Picasso should sell for one-fourth the price of a Jean Puy is yet another reminder of the unpredictability of art prices.

Vollard continued to engage Picasso throughout 1908 and 1909. He advanced the artist 200 francs in May 1908[34] and noted several appointments with him in October and November, when he advanced a further 600 francs.[35] In 1909 the sums become more important: Vollard bought "un lot de peintures . . . non-livrés" for 1,600 francs, some of which had already been advanced to Picasso.[36] On the eve of the artist's departure for Barcelona and Horta de Ebro, Vollard gave Picasso 2,200 francs, and following his return in September he gave him 1,000 francs in October and another 1,000 in November.[37] Yet despite the growing number of purchases, only a few other sales are recorded, to the Steins and to the Bremen collector Alfred Walter Heymel, in addition to the sale to Morozov.[38]

THE 1910 EXHIBITION AND THE EDITIONS OF SCULPTURE AND PRINTS

Pierre Assouline raises the tantalizing possibility that it was Picasso who in July 1907 first brought Vollard to see the new gallery established in Paris by Daniel-Henry Kahnweiler, and that both visitors went unrecognized.[39] By 1910 two German dealers in Paris, Wilhelm Uhde and Kahnweiler, were circling Picasso; the minor dealer Sagot continued to make occasional purchases, but so did Vollard, who bought seven works for 2,000 francs in April.[40] According to Richardson, when Kahnweiler purchased only one of the pictures that Picasso had brought back from Cadaqués in the summer of 1910, Vollard bought the rest.[41] He paid 950 francs for nine paintings and advanced 1,000 francs on future work.[42] Although Uhde had given Picasso a small show in his gallery, Vollard remained Picasso's most loyal—and prestigious—dealer, even if prices continued to be low. Picasso expressed his gratitude to Vollard with his magnificent Cubist portrait of the art dealer (fig. 1). (Currying favor, he also painted Cubist

portraits of Sagot, Kahnweiler, and Uhde.) As Picasso told Françoise Gilot thirty years later, "The most beautiful woman who ever lived never had her portrait painted, drawn, or engraved any oftener than Vollard—by Cézanne, Renoir, Rouault, Bonnard, Forain, almost everybody. . . . Renoir did him as a toreador, stealing *my* stuff, really. But my Cubist portrait of him is the best one of them all." [43] Vollard must not have agreed, since he sold it in 1913 to the Russian collector Morozov. Years later he was content in his memoirs to call it "notable" and to say that a boy of four was able to recognize his features, despite the hermetic Cubist style. [44]

Making what appears to be a last-minute decision, Vollard mounted a Picasso exhibition in December 1910. [45] The artist's close friend and unofficial press agent Guillaume Apollinaire complained in the press that "some readers have been asking about the catalogue of the Picasso exhibition currently at the Vollard Gallery in the rue Laffitte. No catalogue has been printed, just as no invitations were sent out for the opening. The paintings have not even been framed. Although works of such great artistic merit can do without the luxury of frames, it does seem probable that a slightly less casual treatment would not have been out of place." [46] The exhibition was a retrospective of the purchases that Vollard had made from 1906 through 1910, although the dates of the works displayed reached back to 1902. A press unfamiliar with Picasso's Blue Period was struck by major pictures such as *Two Sisters* (State Hermitage Museum, St. Petersburg). [47] Apollinaire mentioned the arrival of some recent work that was added to the exhibition after New Year's—perhaps the fruit of the trip to Cadaqués the previous summer—as well as the fleeting appearance of a further "grand tableau." [48]

Though it is difficult to confirm Apollinaire's assertion of the exhibition's success with the evidence from Vollard's archives, the show does seem to mark a turning point in Picasso's commercial viability. (It was also the last exhibition Vollard was to mount in his rue Laffitte gallery.) Vollard had bought from Picasso five sculptures (and the rights to reproduce them) probably in or by autumn 1910. The large Cubist *Head of Fernande* (fig. 198) attracted attention as soon as the bronze became available: the Czech collector Vincenc Kramář purchased the first on May 26, 1911. [49] In September 1911 Vollard bought fifteen copper etchings from Picasso's Blue and Rose periods, which he had steel-faced so that they could be printed in a large run: evidently he anticipated printing 250 sets, an enormous edition. [50] In the years between the 1910–11 exhibition and the outbreak of world war, sales of Picasso's work picked up markedly. The clients were rarely French, however. Vollard sent Picassos to Berlin, Budapest, Cologne, Düsseldorf, Frankfurt, Mannheim, Moscow, Munich, Prague,

Stockholm, and even to Alfred Steiglitz's gallery in New York. Vollard recalled that "before forcing itself on Paris, Cubism—which was to exert so profound an influence on decorative art and on a whole group of young artists—was first to conquer Germany, greedy as ever for everything new, and soon after, America and Scandinavia." [51] Morozov and Shchukin bought almost all of their Picassos in 1912 and 1913. Typically, Vollard's clients were buying Cézannes and Gauguins; the bronze *Head of Fernande* that Vollard kept on his counter was intended to direct attention to Picasso.

THE WAR

The First World War brought enormous changes for Vollard, Picasso, and the Parisian art market. Picasso's dealer at the time, Kahnweiler—who had finally signed a contract with the artist on December 18, 1912 [52]—fled the capital as an enemy alien, as did Uhde and all of their German clients. Vollard closed his gallery, and Picasso, as a Spaniard, waited out the hostilities with more than a little embarrassment as his friends—most notably Braque and Apollinaire—returned from the front with wounds. With Kahnweiler's and Uhde's stocks of Cubist Picassos sequestered by the French government as enemy assets, new dealers, such as Léonce Rosenberg and Paul Guillaume, hoped to sign up Picasso and carry the flag for Cubism. Meanwhile, Vollard, even with his gallery closed, was not inactive. Following the 1913 Armory Show in New York and Chicago, interest in avant-garde French painting awakened in America. John Quinn, a New York collector who had been instrumental in arranging the Armory Show, sent the writer Walter Pach to Paris in 1915 to arrange an important consignment of Vollard's Picassos to Harriet C. Bryant's Carroll Galleries in New York. Over the next two years, Quinn bought the works, quickly creating a collection of Picassos to rival that of Gertrude and Leo Stein; Quinn's selections ranged from an early *Femme au Chignon* of 1901 (Fogg Art Museum, Cambridge, Massachusetts) to the Blue Period *Old Guitarist* (fig. 113), the primitive *Two Nudes* of 1906 (Museum of Modern Art, New York), and the Cubist *Figure* of 1909 (Albright-Knox Art Gallery, Buffalo). Although we do not know who initiated the commission of Picasso's exquisite, Ingres-like pencil portrait of Vollard of 1915 (fig. 118), it may be bound up with the artist's hope of new clients in America at a time when the war reduced French art dealing to a trickle. Picasso drew his likeness of Vollard with the same tender regard that he brought to his contemporaneous portraits of Apollinaire, Max Jacob, and Léonce Rosenberg, taking stock of the men who were dear to him at a time when literally millions were being injured or killed.

VOLLARD *ÉDITEUR: LIVRES D'ARTISTE* AND THE *VOLLARD SUITE*

At the close of the war, Picasso's milieu shifted from the bohemian intelligentsia of Gertrude Stein and the French poets Guillaume Apollinaire, Max Jacob, and André Salmon to the posh salons of socialites such as Eugenia Errázuriz and the worldly dealers Paul Rosenberg (brother of Léonce) and Georges Wildenstein. Picasso did not forget Vollard, but their relationship evolved yet again. "Cher Monsieur Picasso"[53] was now a highly successful artist no longer dependent on Vollard's occasional purchases.

In the early 1920s the art market quickly regained its strength. Despite the dumping of Kahnweiler's and Uhde's entire stock of Picasso's Cubist works (as well as works by Braque, Léger, Gris, and others) in a series of ill-timed sales, American collectors such as John Quinn and Albert C. Barnes, German collectors such as G. F. Reber, and dealers Justin Thannhauser and Alfred Flechtheim resumed regular pur-

Fig. 118 (cat. 154). Pablo Picasso, *Ambroise Vollard*, 1915. Graphite, 18⅜ x 12⅝ in. (46.7 x 32.1 cm). The Metropolitan Museum of Art, New York, The Elisha Whittelsey Collection, The Elisha Whittelsey Fund, 1947 (47.140)

chases of Picassos from Vollard. (Picasso's neoclassical work of the 1920s most probably stimulated a new interest in his earlier classical work of 1904–6.) The New York dealer Ernest Weyhe proved to be a reliable agent for Picasso prints and bronzes. Perhaps it was the strength of this market (Paul Rosenberg helped foster a strong appreciation for Picasso in America) that encouraged Vollard to commission new illustrated books from the artist. It was a mark of respect for Vollard to offer Picasso the project of illustrating Honoré de Balzac's *Le Chef-d'oeuvre inconnu* (fig. 119), a book about the difficulty—if not impossibility—of painting that had become central to the creation myth of the modern French avant-garde.[54] Picasso returned the favor with a remarkable notebook of near-abstract line drawings that Vollard reproduced in wood engravings, in addition to a set of etchings, in his sweet neoclassical style, that more closely follows Balzac's text. By contrast, the commission to illustrate Buffon's *Histoire naturelle* (fig. 120) is more likely an indication of a shared sense of humor. From Rome in 1936, Vollard sent Picasso a postcard of the Etruscan she-wolf at the Capitoline Museum: "Dear Mr. Picasso, the other side shows a magnificent animal that is not in our collection but deserves to be, except that in the last century someone added the two children, who do not strike me as entirely necessary. I've told those who love you here that you were reviving Buffon and they can't wait to see the book. . . ."[55] The next month Vollard made his country house at Tremblay-sur-Maudre available to Picasso's companion, Marie-Thérèse Walter, and their child, Maya, just as Picasso was initiating a relationship with Dora Maar (Picasso's wife Olga had occupied the artist's home at Boisgeloup). This arrangement would seem to reveal a complicity between men who understood each other.

The one hundred plates of the *Vollard Suite* mark the culmination of Vollard's dealings with Picasso. Again, the archives are incomplete, and little is known of the terms that artist and publisher set, although it would seem that Picasso took his payment in the form of works of art, including a Cézanne and a Renoir (see fig. 158).[56] The *Vollard Suite* was commissioned around 1927, perhaps about the same time as the *Chef-d'oeuvre inconnu,* and it could well be that the theme of much of it, the sculptor in his studio, was conceived by Vollard and Picasso as complementary to Balzac's story of the painter Frenhofer in his studio. In the late 1920s Picasso devoted much of his energy when at his country house at Boisgeloup to sculpture, and many plates of the *Vollard Suite* show a sculptor comparing works that resemble Picasso's own sculptures to a model who resembles Picasso's lover, Marie-Thérèse Walter. But an entirely new revelation has emerged: by 1939, Vollard had decided to pair two texts by the poet

Fig. 119 (cat. 159). Pablo Picasso, *Le Chef-d'oeuvre inconnu,* by Honoré de Balzac, published by Vollard 1931. Illustrated book with 13 etchings, 67 wood engravings, and 16 pages reproducing dot-and-line drawings, page (irreg.) 12 ¹⁵⁄₁₆ x 9 ¹⁵⁄₁₆ in. (33 x 25.2 cm); frontispiece and title page shown. The Museum of Modern Art, New York, The Louis E. Stern Collection, 1964 (967.1964.1–13)

complemented the illustrations that Picasso had completed. This is confirmed by a *compte rendu* of unfinished publications that the engraver Lacourière prepared for Vollard's brother Lucien, in which a text titled *Minotaure* is mentioned in addition to *Minos et Pasiphaé.*[62] The entire edition— 250 sets each comprising 100 works—was printed on Vollard's especially luxurious Montval paper, many watermarked "Vollard" and "Picasso." With Vollard's death in 1939 and the German occupation of France, the 25,000 sheets languished in storage. The sets were distributed only after the liberation of France and the settlement of Vollard's estate. Today a number of the plates from the *Vollard Suite*—of which *The Blind Minotaur* is supreme—rank among the most coveted of Picasso's copious corpus of printed work. It would be difficult to imagine a more magnificent monument to the collaboration of these two singular personalities, Vollard and Picasso.

André Suarès, *Minotaure* and *Minos et Pasiphaé,* with the one hundred etchings by Picasso that had already been printed (see Rebecca Rabinow's essay on *livres d'artiste* in this volume).[57] "Finally two other poems were in hand, for which Vollard had reserved for me two series of plates and drawings due from Picasso."[58]

As seems always to be the case with the affairs of Vollard and Picasso, the actual history of the *Vollard Suite* remains mysterious. Suarès noted in July 1927, "I'm working on several texts for Vollard."[59] The project was first mentioned in print in André Breton's article "Picasso in His Element," in his review *Minotaure,* dated June 1, 1933. By that date Picasso had made sixty-five of the plates—fifty-three were made in an extraordinary burst of activity from March 14 to May 30, 1933; it is no coincidence that the first appearance of the Minotaur in Picasso's etchings coincides with the first two issues of Breton's magazine. Through the course of 1934, Picasso produced plates 66 to 97. Perhaps the most magnificent of the etchings, and the most complicated from a technical point of view, *Faun Uncovering a Woman,* was created in June 1936.[60] In 1937, to round the suite up to one hundred plates, Picasso made four sober, unsparing portraits of Vollard—each in a different technique—although only three of them were used in the final set.[61]

Vollard had his printer Lacourière pull proofs by October 1938. According to the colophon of Suarès's *Minos et Pasiphaé,* Vollard showed Suarès the "dessins de Picasso" (presumably the etchings of the *Vollard Suite*) on October 1, 1938, and he finished his text, begun in 1913 and revised in 1927, on October 7, 1938. As Rabinow has surmised, Vollard probably asked Suarès to finish texts, already drafted, that

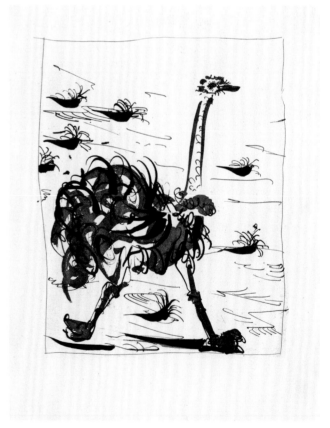

Fig. 120 (cat. 160). Pablo Picasso, page from *Eaux-fortes originales pour des textes de Buffon (Histoire naturelle),* by Buffon (Georges-Louis Leclerc, Comte de Buffon), published 1942. Illustrated book with 31 prints: aquatint, drypoint, etching, and/or engraving, page (irreg.) 14 ⁹⁄₁₆ x 11 in. (37 x 28 cm). The Museum of Modern Art, New York, The Louis E. Stern Collection, 1964 (976.1964.1–31)

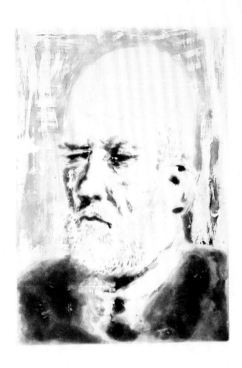

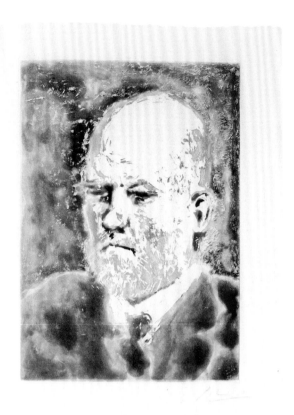

Fig. 121 (cat. 156). Pablo Picasso, *Ambroise Vollard,* 1937. Aquatint with some engraving, image 13¾ x 9⅞ in. (35 x 25 cm). The Museum of Modern Art, New York, Gift of Klaus G. Perls, in memory of Frank Perls, Art Dealer (by exchange), 1983 (229.1983)

Fig. 122 (cat. 157). Pablo Picasso, *Ambroise Vollard,* 1937. Aquatint, image 13¾ x 9¾ in. (35 x 24.7 cm). The Museum of Modern Art, New York, Acquired through the Lillie P. Bliss Bequest, 1947 (253.1947)

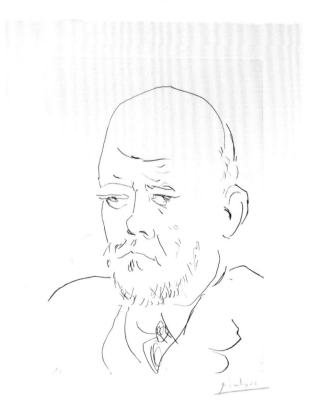

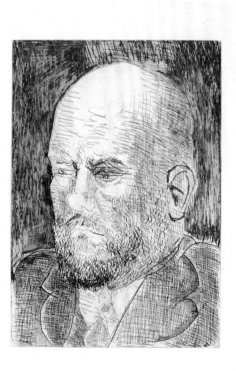

Fig. 123 (cat. 158). Pablo Picasso, *Ambroise Vollard,* 1937. Etching, image 13⅝ x 9¾ in. (34.6 x 24.8 cm). The Museum of Modern Art, New York, The Marnie Pillsbury Fund, 2004 (46.2004)

Fig. 124 (cat. 155). Pablo Picasso, *Ambroise Vollard,* 1937. Etching and aquatint, image 13¾ x 9¾ in. (34.8 x 24.8 cm). Musée Picasso, Paris (MP 2740)

In this essay, the following abbreviation is used in citing catalogue raisonné numbers: for works by Picasso, "DB" refers to Daix and Boudaille 1967.

1. Archives, Národní Galerie, Prague, Kramář deposit, individuals I, 2945/148, translated in Prague–Paris 2000–2002, "Chronology," p. 227, entry for spring 1913.

2. Adriani 2001, pp. 199–200. Vollard acquired the painting for very little. Although the price Picasso paid for the Rousseau is not known, at the same time (August 1913), Vollard sold to Shchukin a Rousseau for 3,500 francs and a Picasso for 3,000 francs, indicating that Vollard's prices for paintings by both painters were by then similar. Vollard Archives, MS 421 (5,9), fol. 138, August 5, 1913. For further information, see note 56 below.

3. Françoise Gilot quoted in Gilot and Lake 1964, p. 287.

4. Richardson 1991, pp. 159, 495, n. 3.

5. It is thought that Isidre Nonell introduced Picasso to Mañach; see Daix 1995, p. 556.

6. Vollard 1936, p. 219.

7. Information on the 1901 exhibition, its contents, and their identification must be traced through three progressively complementary studies. These are: Daix and Boudaille 1967, pp. 154–90, 333; Palau i Fabre 1981, pp. 228–57; Daix 1993, "Appendix," pp. 437–39.

8. Recounted in Palau i Fabre 1981, p. 246.

9. Jacob 1927, p. 199, translated in McCully 1982, p. 37.

10. Fagus 1901. The figures were confirmed by Picasso; see Daix 1977, p. 41, n. 18, and Richardson 1991, pp. 193–94, 498, n. 2.

11. Vollard 1936, pp. 219–20.

12. Richardson 1991, pp. 195, 498, n. 6; Daix 1995, p. 898.

13. Daix 1995, p. 556.

14. Daix implies that the large number of pornographic watercolors produced by Picasso in 1901 may have been made to sell subsequent to the loss of Mañach's support; see ibid., p. 558.

15. The invitation reads: "Galerie B. Weill / 25, Rue Victor-Massé / 5ᵐᵉ Exposition / Organisée par P. Mañach / Tableaux et Pastels / de / Louis Bernard-Lemaire et de Picasso / du 1ᵉʳ au 15 Avril 1902." Reproduced in Daix and Boudaille 1967, p. 334.

16. Daix's version of this anecdote (1995, p. 557) adds some details to Vollard's own account (1936, p. 219), which suggests that it was corroborated by another source, presumably Picasso himself.

17. The *Self-Portrait* (DB v.2) is in a private collection. The Iturrino portrait was discovered by Anatolii Podoksik beneath the Pushkin's 1905 *Young Acrobat on a Ball* (DB xII.19) and is visible behind Picasso, Mañach, and Torres Fuster in a group portrait photograph taken in Picasso's boulevard Clichy studio in 1901 (see Podoksik 1989, pp. 156–57, under no. 4; the photograph, now in the Musée Picasso, Paris, is reproduced in Richardson 1991, p. 195). The portrait of Mañach (DB v.4) is in the National Gallery of Art, Washington, D.C. These portraits were shown in the 1901 exhibition as nos. 1, 2, and 3, respectively. The catalogue for the exhibition also lists a single "Portrait" under no. 25 and multiple "Portraits" under no. 62. The identification of these works is discussed in Daix and Boudaille 1967, pp. 156, 159; Palau i Fabre 1981, pp. 251, 257; and Daix 1993, p. 439.

18. G. Stein 1933, pp. 35–36.

19. Vollard 1936, p. 138.

20. L. Stein 1947, p. 194. See also *G. Stein—Picasso* 2005, pp. 41–42, n. 2.

21. See Richardson 1991, p. 397, for the various accounts of the first meeting.

22. According to Fernande Olivier, "Picasso had met them both [the Steins] at Sagot's, and attracted by the woman's physical personality he had offered to do her portrait, before he really knew her." Quoted in Olivier 1964, pp. 82–83.

23. Gertude Stein may have asked friends like the Cone sisters to assist Picasso; see Richardson 1991, p. 410.

24. Adding to the growing web of personal associations that resulted in Vollard's spring 1906 purchase from Picasso was the exhibition of the artist's work held at the Galeries Serrurier, Paris, from February 25 to March 6, 1905. The show signaled Picasso's break from his Blue Period, which began in the aftermath of the artist's 1901 Vollard exhibition. It is not known if Vollard attended the Serrurier show.

25. "Cher monsieur, Je n'ai pu aller chez vous le 1ᵉʳ mai comme j'ai eu l'intention je vous prie de m'excuser je passerai sans faute chez vous Dimanche [May 6] dans la matinée et vous prie de rassembler tout ce que vous avez chez vous à me faire voir. Je viendrai un peu de meilleur heure que dimanche dernier; vers *10 heures* à peu près salutations Vollard, 6 rue Lafitte, Paris." Vollard to Picasso, May 4, 1906: Archives, Musée Picasso.

26. Leo Stein to Matisse, May 8, 1906: Archives Matisse, Paris; cited in London–Paris–New York 2002–3, p. 363.

27. The receipt reads "Reçu de Monsieur Vollard pour 27 tableaux la somme de 2000 fr[anc]s Picasso Paris 11 mai 1906": Vollard Archives, MS 421 (2,3), fol. 132. This accords with the notation in Vollard's datebook on May 11: "Picasso deux mille francs payé pour 27 tableaux": MS 421 (5,1), fol. 89. Picasso's friend the poet André Salmon recalled that he and Max Jacob watched Vollard fill his carriage with Picasso's paintings and gouaches and drive away; see Salmon 1945, p. 222.

28. "Vendu à Julius Stern Director G[ran]d Hôtel no. 626 . . . un Picasso": Vollard Archives, MS 421 (5,1), fol. 93, May 17, 1906.

29. Munich art dealer Heinrich Thannhauser's famous remark to the effect that he would have paid double the price of 12,650 francs for the painting is noteworthy as a counterpoint to Vollard's more cautious approach; see FitzGerald 1995, p. 277, n. 55.

30. "Vollard venu." Postcard from Picasso to Gertrude Stein, February 4, 1907: Archives, Musée Picasso; published in *G. Stein—Picasso* 2005, p. 41, no. 7.

31. The sales are recorded in the Vollard Archives: MS 421 (5,1), fol. 182, November 16, 1906; MS 421 (5,2), fol. 24, February 13, 1907; MS 421 (5,2), fol. 131, July 31, 1907; MS 421 (5,2), fol. 147, and MS 421 (2,3), p. 133, September 13–14, 1907.

On August 24, 1907, Fernande Olivier wrote Gertrude Stein to say that she and Picasso had decided to separate and that Picasso would use the next payment from Vollard to settle with her: Beinecke Library, Yale University, New Haven, Connecticut; quoted in Richardson 1996, pp. 47, 445, n. 3; see also G. Stein 1933, pp. 22–23. In the event, Fernande and Picasso remained together until he fell in love with the woman he called "Ma Jolie," Eva Marcoussis, in 1910.

32. Pneumatic letter from Picasso to Leo Stein dated December 5, 1907: Archives, Musée Picasso; published in *G. Stein—Picasso* 2005, pp. 49–50, no. 13. That same day Vollard noted, "Vendu et livré à Stein un tableau de Picasso p[ou]r 300 f[rancs] non payés": Vollard Archives, MS 421 (5,2), fol. 202. On December 6, Stein wrote to Picasso to say that he too saw Vollard, who assured him that he would have [Picasso's] paintings by that day: Archives, Musée Picasso; published in *G. Stein—Picasso* 2005, pp. 50–51, no. 14.

33. Vollard Archives, MS 421 (5,3), fol. 79.

34. Vollard Archives, MS 421 (5,3), fol. 97, May 30, 1908. This was preceded by a lunch appointment with Picasso and Mme Vlaminck on May 4, 1908: MS 421 (5,3), fol. 83.

35. There was an appointment on October 21, 1908: Vollard Archives, MS 421 (5,3), fol. 168; it had originally been scheduled for the 19th, but Vollard needed to reschedule: Vollard Archives, MS 421 (5,3), fol. 170 (datebook entry), and Vollard to Picasso, October 19, 1908, Archives, Musée Picasso. Picasso and Vollard's next appointment was November 2, 1908: Vollard Archives, MS 421 (5,3), fol. 180. They met again on November 19: MS 421 (5,3), fol. 194. Vollard advanced Picasso 600 francs on November 30, 1908: MS 421 (5,3), fol. 204 (datebook entry) and MS 421 (2,3), p. 134 (receipt signed by Picasso).

36. On January 14, 1909, Vollard wrote, "Remis à Picasso deux cents francs à compte sur un lot de peintures acheté 1600 fr[ancs] non livrés," for which he had already advanced 600 francs (on November 30, 1908; see note 35 above): Vollard Archives, MS 421 (5,4), fol. 4. The balance of 800 francs was disbursed to Picasso on February 9, 1909: MS 421 (5,4), fol. 25.

37. Vollard and Picasso were scheduled to meet on May 8, 1909: Vollard Archives, MS 421 (5,4), fol. 96. On May 10, 1909, Picasso received a check for 2,200 francs: MS 421 (5,4), fol. 97. On that same day, he wrote to the Steins and to Apollinaire to say that he was leaving with Fernande Olivier for Spain on the twelfth, and he requested to see Apollinaire beforehand; *G. Stein—Picasso* 2005, p. 91, letter 46, and *Picasso/Apollinaire* 1992, pp. 71–72, letter 30. Fernande and Picasso returned to Paris around September 11, 1909, and the artist met with Vollard on the seventeenth: Vollard Archives, MS 421 (5,4), fol. 171. Vollard paid Picasso 1,000 francs on October 14, 1909, and a further 1,000 francs on November 5, 1909: MS 421 (5,4), fols. 194, 212. Picasso made drawings and paintings of Fernande throughout the summer of 1909 and began work on his Cubist sculpture of her in the fall: could the 4,200 francs enumerated here be linked to negotiations for sale of the five sculptures that Vollard would begin to cast in late 1910? Fernande's journal does not give specifics, but it remains one of the few sources close to the event; see McCully 2001, pp. 198–99.

38. The Steins bought a single Picasso for 300 francs on February 8, 1908: Vollard Archives, MS 421 (5,3), fol. 27. Heymel selected three Picassos in 1907: MS 421 (5,2), fol. 224. Vollard sent two of them to him on April 18, 1908: MS 421 (4,13), fol. 8.

39. Assouline 1988, pp. 95–96.

40. Vollard Archives, MS 421 (5,5), fol. 60 (datebook entry for April 15, 1910), and MS 421 (2,3), p. 135 (receipt dated April 16, 1910).

41. Richardson 1996, pp. 165, 456, n. 41.

42. Vollard Archives, MS 421 (2,3), p. 136 (receipt dated November 2, 1910); see also MS 421 (5,5), fol. 156.

43. Quoted in Gilot and Lake 1964, p. 49.

44. Vollard 1936, p. 224.

45. Vollard simultaneously exhibited ceramics by Maurice de Vlaminck.

46. Apollinaire 1910, translated in Breunig 2001, p. 123.

47. The critic Henri Bidou wrote, "There are in the stylizations of Mr. Picasso some passages which escape me, and perhaps it archaicizes to excess to draw women in the style of pre-Mycenean potters. But there are some very beautiful and very noble draperies in this encounter of two women, one of whom nurses a child; a free and charming hand is revealed in the body of the child seated on the ground near two other women." Bidou 1911.

48. See Apollinaire 1910, p. 2. The "grand tableau" is likely the 1905 gouache *Acrobat and Young Harlequin,* which measures 41¼ x 29½ in. (105 x 75 cm), in 1910 owned by the Galerie Marseille & Vildrac, Paris.

49. The price was 600 francs: Vollard Archives, MS 421 (5,7), fol. 66. It was shipped by July 11, 1911: MS 421 (4,13), fol. 34; see also MS 421 (5,6), fol. 43. The cast purchased by Kramář is now with the rest of his collection in the Národní Galerie, Prague.

50. Vollard's purchase of the plates took place in the final week of September 1911. An appointment for September 26 was evidently rescheduled for the twenty-seventh: Vollard Archives, MS 421 (5,6), fols. 51, 52. On the twenty-eighth Vollard wrote, "Acheté à Picasso 15 planches avec droit de reproduction et 4 tableaux avec droit de reproduction pour 3,700 fr[ancs] payé chèque": MS 421 (5,6), fol. 53; he further noted, "Picasso 3,700 fr[anc]s chèque pour 15 planches à l'eau forte et 4 toiles à [recevoir]": MS 421 (5,7), fol. 112. And on the same day, Picasso signed the receipt, which states, "Recu de Monsieur Vollard 6 rue Laffitte la somme de trois mille sept cents francs en un chèque pour la vente à lui faite de quinze planches gravures à l'eau forte et point sèche avec le droit d'éditions et quatre toiles avec le droit de reproduction—Reste dû à M. Vollard la somme de mille francs sur travaux à fournir": MS 421 (2,3), p. 137.

51. On November 29, 1911, Picasso wrote to Apollinaire stating that Vollard did not want a preface "pour les gravures." Six of the plates, eventually published in 1913, are dedicated to Apollinaire; see *Picasso/Apollinaire* 1992, pp. 90–92, letter 60, esp. n. 3.

51. Vollard 1936, p. 220.

52. Archives of Galerie Louise Leiris, Paris. For a reproduction of the three-page contract, see Daix and Rosselet 1979, p. 359.

53. This was to remain Vollard's standard salutation. See, for example, Vollard to Picasso, letter of October 19, 1908, and postcard of September 22, 1936: Archives, Musée Picasso.

54. For a discussion of Picasso illustrations for Honoré de Balzac's *Le Chef-d'oeuvre inconnu,* see cat. 159.

55. "Cher Monsieur Picasso, voilà ci-contre un magnifique animal qui n'appartient pas à notre collection, mais qui serait digne d'en être, sauf qu'on lui a ajouté au siècle dernier les deux enfants qui ne me paraissent pas de la première utilité. J'ai annoncé à ceux ici qui vous aiment que vous étiez en train de faire revivre Buffon, et l'on se fait une joie voir le livre. Je rentre le premier juin ou la semaine prochaine et vous envoie en attendant tous mes meilleurs souvenirs." Postcard dated Rome, September 22, 1936: Archives, Musée Picasso. *Eaux-fortes originales pour des texts de Buffon* was published in 1942 (see cat. 160).

56. Aside from his only known early purchase from Vollard, Henri Rousseau's *The Representatives of Foreign Powers Coming to Greet the Republic as a Sign of Peace* (fig. 24) in August 1913 (see note 2 above), Picasso's later acquisitions are poorly documented. The sole invoice, dated February 19, 1934, simply states, "Vente à M. Picasso: / 1 Renoir 130,000 / 1 Cézanne 80,000 / [total] 210,000": Archives, Musée Picasso. The Cézanne listed in the invoice may be the *Château Noir* (fig. 46) but is more likely the contemporaneous watercolor *La Cathédrale d'Aix vue de l'atelier des Lauves* (Musée Picasso, Paris, RF 35794, donation Picasso 1973–78). Likewise, the Renoir may be *Seated Bather in a Landscape,* also known as *Eurydice* (see fig. 158), an oil, but it could also be *La Coiffure,* a large (57¼ x 41⅜ in. [145.5 x 105 cm]) red-and-white chalk drawing on paper, laid down on canvas (1900–1901, Musée Picasso, Paris, RF 35793, donation Picasso 1973–78). Hélène Seckel-Klein (1998, nos. 8–9, 66–67) presents judicious but ultimately inconclusive arguments about each of these works.

57. On August 19, 1939, Roger Lacourière produced a detailed list documenting the state of Vollard's unfinished books: Vollard Archives, MS 421 (8,16), fol. 29. For the full list, see Rebecca Rabinow's essay on Vollard's *livres d'artiste* in this volume, note 88.

58. Suarès 1940, pp. 192–93. For more information on Suarès's unfinished book collaborations with Vollard, see *Paulhan—Suarès* 1987, pp. 256–59, letters 293, 295, 297. See also Suarès to Rouault, July 25, 1939, in *Rouault—Suarès Correspondance* 1983, p. 133, letter 252.

59. In a journal entry made in Les Baux, Suarès writes, "I'm working on several texts for Vollard. I can't decide between 'The Clowns' or 'Passion,' or maybe both. The title 'Buffoons' would suit me better. I reassured Rouault that I haven't forgotten him. Vollard is clever, but I'm a bit wary of him: he seems timid and dangerous at the same time." Quoted in Parienté 1990, p. 303.

60. Geiser, Scheidegger, and Baer 1933–96, vol. 3, no. 609.

61. Picasso made one further portrait of Vollard, undated but probably posthumous, now in a private collection (oil on canvas, 24 x 18⅛ in. [61 x 46 cm]). It shows Vollard seated in a chair cradling a cat (see Pierre Daix in New York–Paris 1996–97, p. 282, ill.). There is also an etching with aquatint, about 1960, printed in colors after the painting.

62. Letter from Roger Lacourière to Lucien Vollard, August 19, 1939: Vollard Archives, MS 421 (8,16), fol. 29 (also see note 57 above). *Minos et Pasîphaé* was eventually published in a modest edition by La Table Ronde, Paris, in 1950.

Vollard and the Fauves: Derain and Vlaminck

Jacqueline Munck

At the close of the 1905 Salon d'Automne, Ambroise Vollard became the principal promoter of the rising generation of young painters, those whom critic Louis Vauxcelles had dubbed *fauves* (wild beasts). On November 23, 1905, at Henri Matisse's suggestion, Vollard acquired the entire studio—comprising eighty-nine paintings and eighty watercolors—of André Derain (1880–1954), a newcomer to the art scene who had exhibited for the first time at the Salon des Indépendants that spring. He also established a right-of-first-refusal contract with Jean Puy (1876–1960), then did the same with Henri Manguin (1874–1949) in March 1906 and with Maurice de Vlaminck (1876–1958) at the end of April. Vollard already represented Louis Valtat (1869–1952) and Matisse (1869–1954), whom he had given his first one-person show in June 1904, before Matisse signed with Eugène Druet. In 1904 Vollard had also organized the first one-person show of Kees van Dongen (1877–1968), Pablo Picasso's friend and neighbor at the Bateau-Lavoir studios in Montmartre.

All of these painters had met one another years before. Matisse and Manguin, for instance, were veterans of Gustave Moreau's studio. Following their teacher's death in 1898, both men had become friends with Puy and Derain, who attended the small Académie Camillo on the rue de Rennes, where Eugène Carrière taught. They often worked together from live models—notably Bevilacqua, a famous Italian model—at the home of another colleague, Jean Biette; they were sometimes joined by Matisse, as witnessed by a trilogy of standing nudes painted in the studio. Derain and Vlaminck—the latter a former racing cyclist, violin teacher, and self-taught artist—had met in July 1900, when the train carrying them back to Chatou, near Paris, crashed. Within six months they were working together in a modest space rented in the abandoned hotel-restaurant Levanneur, until Derain's military service called him away for three years (late September 1901–September 1904). Immediately after his service, Derain again took up his palette, returning to Vlaminck, Chatou, Le Pecq, and the banks of the Seine. He then spent the summer of 1905—a crucial period in his artistic development—in the Pyrenees at Collioure, this time with Matisse. (Through Derain, Vlaminck had apparently met Matisse at the Van Gogh exhibition at Galerie Bernheim-Jeune in March 1901.)[1]

Indeed, Vollard was not so much discovering the Fauves in the fall of 1905 as he was surrounding himself with individuals in Matisse's network. The recent Salon d'Automne (organized by former members of Moreau's studio and supportive critics like Louis Vauxcelles and Roger Marx) and the ensuing

Fig. 126. André Derain, *St. Paul's Cathedral Seen from the Thames,* from London sketchbook 1, 1906. Private collection

Opposite: Fig. 125 (cat. 79). André Derain, *London: St. Paul's Cathedral Seen from the Thames,* ca. 1906 (detail). Oil on canvas, 39¼ x 32¼ in. (99.7 x 80.9 cm). The Minneapolis Institute of Arts, Bequest of Putnam Dana McMillan (61.36.9)

Fig. 127. André Derain, study for *Regent Street,* from London sketch-book 1, 1906. Pencil, 8½ x 11 in. (21.5 x 28 cm). Private collection

media hubbub over Room 7 (the "wild beasts' cage") had legit-imized the Fauvists' standing as provocateurs—regardless of whether the controversy centered on their "barbarous and primitive games," their "artificiality," their abstraction, their "pure act of painting," or their "excessive theorizing."[2]

From the start, Vollard worked at placing his new artists with his clients.[3] In addition, promoting the artists did not simply mean holding specific exhibitions (Vlaminck, in fact, was one of the few artists in the gallery to enjoy a one-person show, in March 1910); it also involved partnering with other Parisian gallery owners, such as Druet, Berthe Weill, and Eugène Blot, or making consignment arrangements, notably with Georges Bernheim. The works began to spread interna-tionally through Vollard's impressive loans to group shows throughout Europe and even in Russia, such as those in Moscow organized by Nikolai Ryabushinsky through the artis-tic and literary magazine *Golden Fleece* (held at the Tretiakov Gallery) and at the Berlin Secession, as well as those in Prague (organized by the Mánes Union of Artists) and the United States (the Armory Show of 1913). Vollard also participated in new organizations, such as the Cercle de l'Art Moderne in Le Havre, which held its first exhibition in June 1906 under the aegis of Othon Friesz and Georges Braque. This show brought together works by Vlaminck, Derain, Manguin, Valtat, and Bonnard. In the meantime, the dealer ensured the artists' regular participation in the Salon des Indépendants and the Salon d'Automne.

DERAIN IN LONDON

Apart from commissioning illustrations for his publications, Vollard seldom gave the Fauves artistic direction. Still, it was at his request that Derain made his first trip to London, in March 1906,[4] an enterprise that—judging from Vollard's memoirs and the painter's later recollections—has taken on the coloration of a pictorial joust, a challenge to the "striking vision" of Claude Monet's views of the Thames, painted between 1902 and 1904 and shown to great acclaim at Durand-Ruel in May and June 1904. Derain had seen that exhibition, along with the first Matisse retrospective at the Vollard gallery, while on military leave, and had been greatly impressed. Derain confided to Vlaminck that "in spite of everything, I adore him [Claude Monet], even his mistakes teach me valuable lessons. . . . As for myself, I'm looking for something different: something in nature which, on the con-trary, is fixed, eternal, complex."[5] A certain polarity in Derain's nature always made him swing from fascination with his mod-els to rejection of them, a tendency exacerbated on his arrival in London by his discovery of non-Western creations, notably the sculptures of New Zealand—"mind-boggling, alarmingly expressive," as he told Vlaminck.[6] Derain returned to Paris on March 17 to help Matisse hang his first one-person show at the Druet gallery and to attend the opening of the Salon des Indépendants. No sooner was he back in London (by the end of March) than he told Vollard he wanted to return home again.[7] "The work isn't progressing. This damned painting is so bothersome," he wrote to Vlaminck.[8] Paradoxically, his first trip was devoted almost entirely to discovering the city's tourist attractions, from the zoo to the port, and especially the museums.[9]

Two sketchbooks, containing more than twenty-nine preparatory sketches for the London paintings, bear witness to the painter's itinerant observations and curiosity. In them we can follow him in his wanderings, from Charing Cross and Westminster to St. Paul's Cathedral and London Bridge. The second book contains excellent sketches of Maori, Vanuatu, and Solomon Island sculptures—much like those he drew in his letters to Vlaminck and Matisse—which count among the very first instances of a European artist showing aesthetic interest in "primitive art." The drawings in the two London sketchbooks act as patterns and as a repertory of motifs that are repeated from work to work, for instance the pounced drawing for *Regent Street* (fig. 127), which captures the urgent movements of the passers-by and teams of horses while establishing their contours. But while these graphic notations show the painter honing his craft and his technique, most of them are simply sketches of things seen, temporary solu-tions of brief duration. The difference is striking between the graphic precision (including a provisional notation of col-ors, advertising billboards, and the dance of barges on the river) of these sketches—such as those for *London: St. Paul's Cathedral Seen from the Thames* and *Houses of Parliament at*

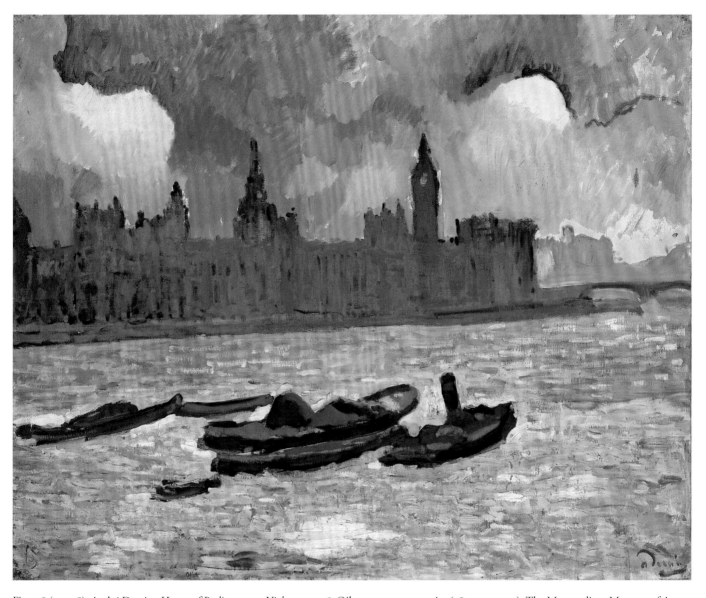

Fig. 128 (cat. 78). André Derain, *Houses of Parliament at Night,* ca. 1906. Oil on canvas, 31 x 39 in. (78.7 x 99.1 cm). The Metropolitan Museum of Art, New York, Robert Lehman Collection, 1975 (1975.1.168)

Fig. 129. André Derain, *Houses of Parliament at Night,* from London sketchbook 1, 1906. Private collection

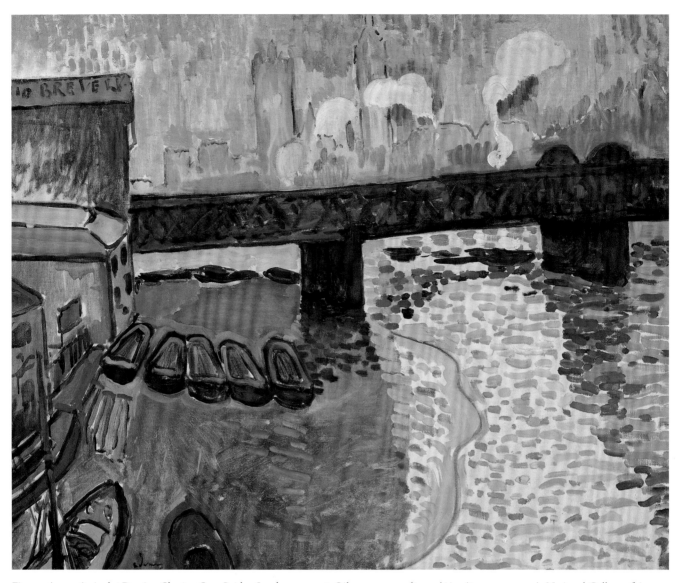

Fig. 130 (cat. 76). André Derain, *Charing Cross Bridge, London,* ca. 1906. Oil on canvas, 31⅝ x 39½ in. (80.3 x 100.3 cm). National Gallery of Art, Washington, D.C., John Hay Whitney Collection (1982.76.3)

Fig. 131. André Derain, *Charing Cross Bridge, London,* from London sketchbook 1, 1906. Private collection

Night—and the finished paintings (figs. 126, 125; 129, 128). While the artist maintains the color relations as indicated in the sketches, in the paintings the originality of his vision is demonstrated in his varied brushstrokes, which can convey anything from splashes of light to abstract solarizations to an expressive layer of wavelets on the water's surface (fig. 130; compare fig. 131), and which release an energy barely evident in the sketches.

Some of Derain's London paintings were executed in situ, but many of the thirty known views—out of fifty that Derain and Vollard had originally planned—were created in the

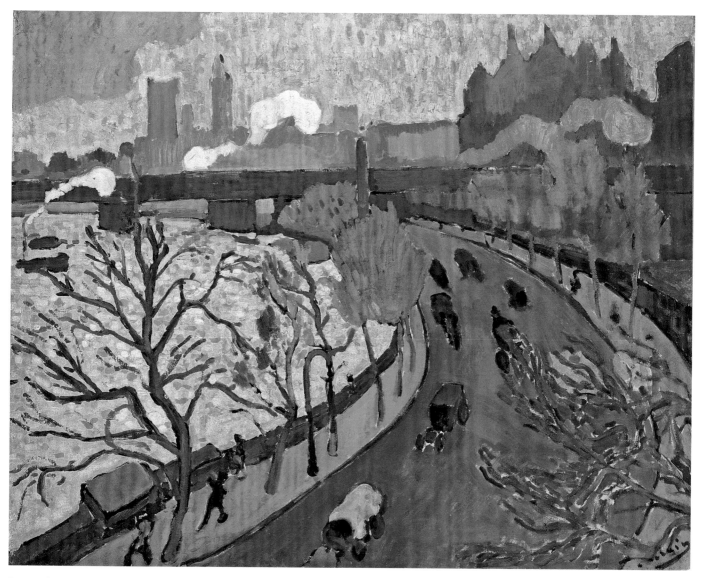

Fig. 132 (cat. 77). André Derain, *Charing Cross Bridge, London,* ca. 1906. Oil on canvas, 31⅞ x 39⅜ in. (81 x 100 cm). Musée d'Orsay, Paris, Gift of Max and Rosy Kaganovitch (RF 1973-16)

studio, between 1906 and spring 1907. The chronological gap between the original sketch and its realization on canvas allowed the painter to work more from memory, freeing him to develop his pictorial variations in different ways: sometimes using the divisionist techniques of Seurat and Signac with expressive broad dashes of color, sometimes synthesizing them, arranging his "intentional disharmonies" with the aim, as he told Matisse, to "make of the Thames something other than colored photographs."[10] Derain's three trips to London (his last brief stay was in early 1907), during which he maintained a constant dialogue with Matisse, were crucial to his elaboration of a theory of "pure painting," one that would integrate form and meaning.

Although Vollard seems to have had this remarkable series of paintings in hand as of summer 1907, he never showed it in its entirety.[11] The London canvases circulated around Europe, notably through the efforts of the Bignou Gallery in Paris and

Alex Reid & Lefèvre in London, which in 1937 organized a show entirely devoted to this group of paintings, the most dazzling of the Fauvist period.

VLAMINCK

Maurice de Vlaminck's athletic prowess and exuberant energy seduced Vollard, who described him at their first meeting as "a tall, powerful fellow whose red scarf, knotted round his neck, might have suggested some militant anarchist, if, from the way in which he was carrying a canvas, I had not immediately recognized him for an artist. As far as I remember, the picture in question represented a sunset which appeared to have been squeezed out of tubes of paint in a fit of rage. The effect was startling."[12] At a time when the shocking colors employed by the young Fauves "were so many challenges to the *bourgeois* whose idea of nature is of something tame and tidied up,"[13] the

Fig. 133 (cat. 190). Maurice de Vlaminck, *Harvest*, 1904. Oil on canvas, 27⅛ x 37¾ in. (69 x 96 cm). Private collection; courtesy of Sotheby's

dealer figured he now had, with Derain and Vlaminck, the most radical painters of the young generation. In the summer of 1906, then, Vollard put his efforts into his youngest and least experienced painters, establishing his position as a promoter at the vanguard of contemporary art.

The gallery archives say little about the relationship of trust between Vollard and Vlaminck, detailing only their business transactions: the regular payments made to the artist, the purchases at the close of the salons and one-person shows. In March 1910 Vlaminck had his first solo exhibition at Vollard's, showing both paintings and ceramics. Guillaume Apollinaire, art critic of *L'Intransigeant,* called the artist "one of the most talented painters of his generation. . . . His simple and intensive technique allows the lines their full liberty, the volumes their full relief, and the colors their full clarity, their full beauty." The ceramics he found "a bit barbaric, but of the most rare and most sumptuous effect."[14] Indeed, the two men's collaboration seems to have been particularly productive with painting on ceramic, a medium in which Vlaminck proved an important contributor (see below).

Vlaminck mixed gesture, speed, and provocative color pushed to maximum intensity, as if he feared that the image

might get away from him: "I heightened all the tones, I transposed in an orchestration of pure colors all the feelings I could grasp. I was a tender barbarian filled with violence," the artist later said.[15] His paintings mainly depict landscapes (Chatou, Argenteuil, and the banks of the Seine; figs. 134, 133, 259), a few luxurious still lifes, and women (*Dancer at the Rat Mort,* 1906, private collection), their bodies tightly framed and eyes made up like those of Van Dongen's female subjects,[16] set against a shimmering colored background reminiscent of Picasso's *Pierreuse* (fig. 107). Luminous harmonies between blue, red, and green are built up in compositions that play sometimes on fixed verticals such as factory smokestacks, buildings (as in the *Bridge at Chatou,* Annonciade Museum, Saint-Tropez), trees along the road, or electrical poles (as in *The Road,* circa 1905, private collection) and sometimes on highly varied brushstrokes that invade the entire canvas and create contradictory directional flows (as in the *Landscape near Chatou,* 1905, Stedelijk Museum, Amsterdam) or seem on the verge of losing control (fig. 134). Vlaminck creates an impressive flood of energy, a dazzling burst that, unlike his friend Derain's canvases, seldom relies on blinding the eye or selective distortion. The critics were quick to recognize his undeniable

qualities as a colorist, while downplaying his efforts at composition: "De Vlaminck is attempting . . . to create compositions: how much more interesting he is when he relies only on his remarkable talents as a born colorist, juggling vermilion and Veronese green as if they were plain neutral tones!"[17]

THE FAUVES AND CERAMICS

Vollard encouraged his protégés to branch out into other media, including sculpture, prints, and even furniture. Derain, for instance, made his first attempt at wood carving during his two short stays in London in March and April 1906 (fig. 299). On his return, he carved a bed, inspired by primitive sculptures, in the spirit of collaboration among the arts, both major and minor, that the generation of Gauguin, Georges Lacombe, and the Nabis had cultivated at the turn of the century.

The Fauves' involvement in painting on ceramic under the master ceramist André Metthey extended primarily from early 1906 to the end of 1909, after which only Vlaminck, Puy, and Rouault continued with any regularity.[18] This group effort reinforced the idea of a "Vollard class," itself the origin of the short-lived "Asnières school," named after the suburb where the ceramist had his workshop and kilns. According to Puy, "At one point, Vollard tried to revive the art of painting on ceramic, and he sent us to Asnières where a friend had set up a small pottery studio—mainly earthenware, with a little sandstone." (Vollard sent Pierre Laprade, Derain, Vlaminck, Matisse, Rouault, Puy, and Rousseau.) "Metthey the potter provided us with terracotta vases, dishes, and tiles covered with a layer of raw pewter dust. We painted on it using special paints that could withstand firing, after which the piece was put in the oven at high heat; the coating melted but retained the designs and colors in its vitrified state."[19]

Vollard's sales strategy (in association with the Eugène Druet gallery) of using painting on ceramic as a vehicle for bringing art to the wider public went hand in hand with a major change in artistic practice and with a technical innovation. Not knowing how the enamel would react to heat, the painters worked with an unusual degree of chance and spontaneity, with no opportunity to make revisions (although in Derain's case, color tests on earthenware tiles and preparatory watercolors,

Fig. 134 (cat. 191). Maurice de Vlaminck, *Bank of the Seine at Chatou*, ca. 1905. Oil on canvas, 23¼ x 31½ in. (59 x 80 cm). Musée d'Art Moderne de la Ville de Paris, Gift of Henry-Thomas in 1976 (AMVP 2587)

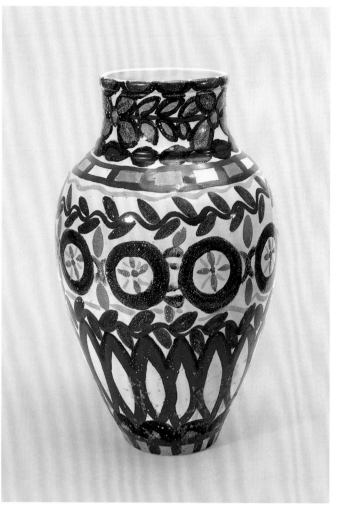

Fig. 135 (cat. 82). André Derain, *Vase with Geometric Pattern,* 1907. Tin-glazed ceramic, H. 21⅝ in. (55 cm). Musée d'Art Moderne de la Ville de Paris, Gift in 1937 (Vollard) (AMOA 129)

Fig. 136 (cat. 197). Maurice de Vlaminck, *Large Vase,* ca. 1906–7. Tin-glazed ceramic, H. 21¼ in. (54 cm). Musée d'Art Moderne de la Ville de Paris, Gift in 1937 (Vollard) (AMOA 203)

Fig. 137 (cat. 194). Maurice de Vlaminck, *Plate,* ca. 1906–7. Tin-glazed ceramic, Diam. 10¼ in. (26 cm). Collection Larock-Granoff, Paris

Fig. 138 (cat. 195). Maurice de Vlaminck, *Plate,* ca. 1906–7. Tin-glazed ceramic, Diam. 10¼ in. (26 cm). Collection Larock-Granoff, Paris

which afforded him greater control over the effects of firing on his colors and designs, have been found). In addition, Metthey sought out "a very solid form of earthenware, resonant, perfectly homogenous, and easy to work with" for this new experiment. He found a local clay from Fresnes, "which he mixed with a marl taken from near Meudon . . . and sand from Fontenay-aux-Roses, thereby obtaining a product that allowed him to apply stanniferous enamel under the best conditions."[20] For Metthey, who was himself a "decorator, sensitive to the logic of colors and forms," the main goal was to create "a very bright palette that would allow the decorative artist to paint freely on the raw material and to effect certain blends, which on firing have yielded results that surpassed all [his] hopes."[21]

According to the critic Tristan Klingsor, painting on ceramic was better suited than easel painting to developing an audience, in that it could familiarize the public with the arbitrary use of pure color, independent of subject matter: "[André Metthey] conceived the idea of working with painters such as Vlaminck, Valtat, Matisse, Puy, and Derain. What seems jarring in their painting is on the contrary perfectly suited to ceramics. Indeed, in the latter case, the decoration aims less at translating forms than at arranging harmoniously colored areas, and some of the ceramics decorated by Vlaminck are of rare quality."[22] Louis Vauxcelles, who had seen in Asnières "vases and saucers and carafes and teacups . . . displaying a bold innovativeness," raved about the enterprise. For the official

presentation of roughly a hundred pieces created between 1906 and 1907 by the painters of the 1907 Salon d'Automne, he wrote: "These color-drunk young men . . . have enhanced Metthey's pots with whimsically fanciful themes." Flowers, geometric patterns, an exotic bestiary (Puy, *Homage to Rousseau,* Musée d'Art Moderne, Paris), or more typical motifs (figs. 140, 141), and especially female figures, such as dancers, bathers, and nymphs (figs. 142–144), cover these plates and dishes. "These primitive creations were inspired by Rhodes, Crete, Africa, and Precolumbian art," Claude Roger-Marx recalled. "The skilful brutality of the line or touches of color . . . gave the rustic pieces a certain charm, an unexpected quality."[23] The designs for the ceramics came from paintings, watercolors, and etchings, and sometimes retained the format of easel paintings. Others took advantage of the vase's circular shape to let the milky white undercoat run onto the protruding belly, covering the entire object with color.

The simplicity and limited choice of shapes on which each painter worked reinforced the appearance of a uniform or consistent production and of a new school that brought together diverse generations and aesthetics, despite the artists' differences in temperament. Although many of these pieces remained unsold, they further enhanced Vollard's standing as the promoter of the Fauve generation and the architect of a revolution in seeing via decoration, which he meant to apply to the most disparate fields of contemporary creation.

Fig. 139 (cat. 81). André Derain, *Plate,* ca. 1906–7. Tin-glazed ceramic, Diam. 9 in. (23 cm). Collection Larock-Granoff, Paris

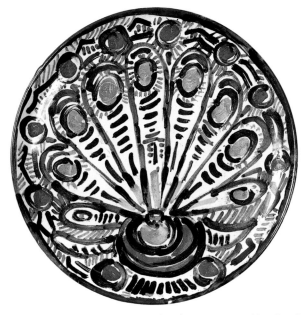

Fig. 140 (cat. 196). Maurice de Vlaminck, *Plate,* ca. 1906–7. Tin-glazed ceramic, Diam. 9 in. (23 cm). Collection Larock-Granoff, Paris

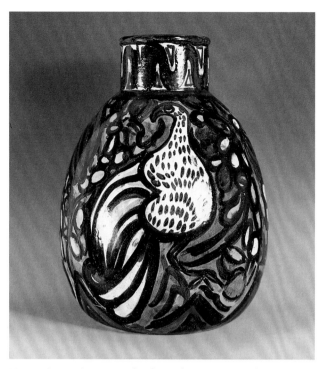

Fig. 141 (cat. 193). Maurice de Vlaminck, *Large Vase with Rooster,* ca. 1906–7. Tin-glazed ceramic, H. 21¼ in. (54 cm), Diam. 15¾ in. (40 cm). Collection Larock-Granoff, Paris

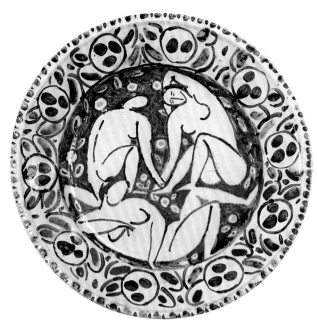

Fig. 142 (cat. 83). André Derain, *Large Plate with Bathers,* 1907–9. Tin-glazed ceramic, Diam. 11 in (28 cm). Collection Larock-Granoff, Paris

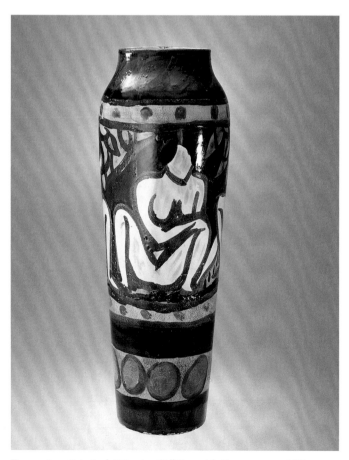

Fig. 143 (cat. 80). André Derain, *Tall Vase with Figures,* ca. 1906. Tin-glazed ceramic, H. 21¼ in. (54 cm). Musée d'Art Moderne de la Ville de Paris, Gift in 1937 (Vollard) (AMOA 128)

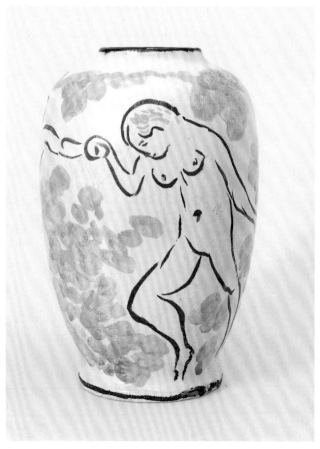

Fig. 144 (cat. 138). Henri Matisse, *Green and White Vase with Nude Figures,* ca. 1907. Tin-glazed ceramic, H. 9½ in. (24 cm), Diam. 7⅞ in. (20 cm). Musée d'Art Moderne de la Ville de Paris, Acquisition (AMOA 459)

1. There is nonetheless a certain vagueness surrounding the real date of Matisse's meeting with Vlaminck: if they were in fact introduced in 1901, they do not seem to have pursued relations for several years after that. It is also possible that they met not at the Van Gogh exhibition of 1901 but at the retrospective held during the Salon des Indépendants of 1905, the year of Vlaminck's and Derain's first official participation in the salon. We also know of a rivalry between Vlaminck and Matisse, and Vlaminck's insistence on his preeminent role in the emergence of Fauvism, no doubt heightened by their further rivalry over their mutual friend Derain; see especially Vlaminck 1955.

2. For the press reviews of the 1905 Salon d'Automne, see Paris 1999–2000, and, especially, Denis 1905a.

3. In January 1906, for example, Gustave Fayet purchased three Derains from him for 500 francs: Vollard Archives, MS 421 (5,1), fol. 17. In May 1906 Denys Cochin acquired a Derain and two Matisses (MS 421 [5,1], fol. 93); Émile de Costa, a Vlaminck painting for 500 francs (MS 421 [5,1], fol. 14); and André Level (founder of the artists' association La Peau de l'Ours), a work by Puy from the Salon d'Automne on November 19, 1906, as well as "a Vlaminck and a Puy for 250 francs" in February 1907 (Vollard Archives, MS 421 [5,1], fol. 184, and MS 421 [5,2], fol. 28). Count Doria, the prince de Wagram, and the critics Théodore Duret and Octave Mirbeau also frequented Vollard's gallery and bought paintings; Vollard's active foreign trade involved both collectors and intermediaries such as H. O. Miethke in Vienna, Vincenc Kramář in Prague, and Paul Cassirer in Berlin. In March 1906 Baron von Bodenhausen in Essen acquired a Derain (300 francs); Jean Puy's *Reclining Woman*, exhibited at the Salon des Indépendants; a Manguin; and a Valtat that Vollard had shown at the Berlin Secession. Vollard Archives, MS 421 (5,1), fol. 55, March 23, 1906. The year 1907 was notably marked by the sale to the Russian collector Ivan Morozov of paintings by Cézanne, Gauguin, Valtat, Derain, and Vlaminck for 45,000 francs, followed in April 1908 by his purchase of works of Cézanne, Degas, Gauguin, Puy, Picasso, and Vlaminck, and in 1909 his acquisition of six important works by Cézanne, a Matisse still life, and Gauguin's *Tahitian Pastoral* for 82,000 francs; Sergei Shchukin was another avid Russian collector (see also the essays in this volume on Vollard's French, German, and Russian collectors).

4. Derain's first trip to London, March 6–17, 1906, was immediately followed by a second, from late March to mid-April; the third took place from late January to February 7 or 10, 1907. On Derain's trips to London, see especially Labrusse and Munck 2005b, as well as London 2005–6.

5. Derain to Vlaminck, undated [June 1904], in Dagen 1994, p. 175 (where letter is wrongly dated 1905); for an English translation, see Labrusse and Munck 2004, p. 244.

6. Derain to Vlaminck, London, March 7, [1906]; for English translation, see London 2005–6, p. 133.

7. "My dear Monsieur Vollard, The most appalling sun has been beating down on London for the past two weeks and is making the city into a second Marseilles. I am thus utterly deprived of fog. It doesn't seem worth it to me to bring back only studies of sunlight. So I wanted to ask if you would agree to take only 40 paintings for now. I can come back in October–November and bring you the ten remaining paintings then." Vollard 1957, p. 256 (letter not included in the original French edition or English translation).

8. Derain to Vlaminck, March 1906: Archives, Musée des Beaux-Arts de Chartres.

9. He paid several visits to the British Museum, conveying his enthusiasm to Matisse: "In it you can find piled up, seemingly at random—get this— the Chinese, the Negroes of New Guinea, New Zealand, Hawaii, the Congo, the Assyrians, the Egyptians, the Etruscans, Phidias, the Romans, *India.* . . . I have seen the whole world, even more than if I had experienced it because each form, in its universal language, taught me the aspirations, the ideas of other races, of other times. . . . Hence, I have expanded my consciousness by something other than words: by sensations alone, defined with and by shapes, colors." Derain to Matisse, undated [between March 25 and April 15, 1906]: Archives Matisse, Paris. At the National Gallery, Derain saw Rembrandt and Uccello, and commented on the paintings of Claude Lorrain and Turner, "who authorizes us to create forms beyond real, conventional objects." Derain to Matisse, March 8, 1906: Archives Matisse. He concluded, "It is imperative that we get out of the circle in which the realists have shut us." Derain to Vlaminck, March 7, 1906: Archives, Musée des Beaux-Arts de Chartres.

10. Derain to Matisse, March 15, 1906: Archives Matisse.

11. In a summary of Derain's account with Vollard for July 20, 1907, he identifies one lot of twenty-six canvases and one of four, all at the price of 150 francs. Only one view of London was shown at the 1906 Salon d'Automne, followed by four at the Libre Esthétique exhibition in Brussels and four at the first Golden Fleece salon in Moscow in 1908. Most likely the dealer gave up on the project, as Derain was moving away to join the Kahnweiler gallery. Daniel-Henry Kahnweiler entered into contract with Derain and Matisse in April 1907, during the Salon des Indépendants, and then signed Picasso, Friesz, Braque, and Vlaminck. It was only at the end of 1912 that Derain signed a one-year exclusive agreement with Kahnweiler, with Vlaminck following suit in the spring of 1913.

12. Vollard 1936, p. 200.

13. Ibid., p. 201.

14. Apollinaire 1910a.

15. Quoted in Lodève 2001.

16. Vlaminck, like Derain, was a friend of Van Dongen and Picasso and was part of the Bateau-Lavoir group (Derain took a studio on the rue Tourlaque in the spring of 1906). Indeed, critics often mentioned Vlaminck and Van Dongen in the same breath, as in this review of the 1906 Salon des Indépendants: "The Maurice de Vlamincks hanging alongside the Kees van Dongens provoke the hilarity of the wags. These latter are wrong, but they are also right: for while the two painters are clearly talented, they squander their talent on canvases whose exuberant colors and tortured invention do have something ridiculous about them"; see Lantoine 1906. In September 1909 the Kahnweiler gallery organized an exhibition of works by Derain, Vlaminck, and Van Dongen.

17. Jean-Aubry 1908.

18. On this subject, see especially Nice–Bruges 1996.

19. Jean and Michel Puy Archives, Lyons. Matisse did not start working at Metthey's until September 1907; the works he created there were exhibited with those of the other Fauves as part of the Salon d'Automne that same year; see also Labrusse and Munck 2005b.

20. Lapauze 1909, pp. 133–36.

21. Metthey 1907. According to Marie Dormoy (1922), "Each firing is a new experiment, the occasion for impassioned debates, and everyone marvels at the results obtained. The painters, just as much as the ceramist, venture further and further, and their success is everything they had hoped."

22. Klingsor 1907.

23. Roger-Marx 1946.

Vollard and Matisse

Rebecca A. Rabinow

ollard had a remarkable eye for undiscovered artistic talent, but even he misjudged the potential of Henri Matisse (1869–1954). For a brief time in the early 1900s, the still-unknown artist piqued Vollard's interest: the dealer purchased several of Matisse's paintings at the beginning of the twentieth century, organized the artist's first solo exhibition in 1904, and, almost two years later, acquired an additional twenty works from him. Nonetheless, during those initial years when Matisse craved financial support and critical affirmation, Vollard did not offer to purchase the artist's entire studio output, as he had for several of Matisse's acquaintances. Indeed, Matisse was Vollard's most flagrant missed opportunity; he simply failed to anticipate how the artist's style would evolve.[1]

Matisse was already in his twenties when he abandoned his job as a law clerk to pursue a career as an artist. He moved from northeastern France to Paris, where he studied art, exhibited in a few conservative salons, and sold a handful of works, two of which were commissioned copies after paintings by Jean-Siméon Chardin. Throughout the second half of the 1890s, he lacked both critical recognition and dealer representation.

In 1899 Matisse made his first attempt to purchase a work from Vollard, having become intrigued by a Van Gogh painting, *L'Arlésienne*.[2] Vollard supposedly quoted him a price of 150 francs for it, but when the artist returned to finalize the purchase, the dealer more than tripled the figure, and there was no sale.[3] Matisse soon was back at the gallery in his quest for a Van Gogh. He later recalled that when Vollard left the room to retrieve Van Gogh's landscape *Les Alyscamps*,[4] his eyes drifted to a small Cézanne painting of three bathers (fig. 147) hanging on the wall. Unable to decide between the two, he again left without making a purchase. The memory of the Cézanne haunted him over the following weeks. Despite his limited means, he bought it that summer, along with Rodin's plaster bust of the politician and author Henri Rochefort.[5] Vollard set aside both works for him, and Matisse paid his 1,600-franc debt in six installments, ranging from 50 to 1,100

Opposite: Fig. 145 (cat. 136). Henri Matisse, *Studio Interior*, ca. 1903–4. Oil on canvas, 21⅝ x 18⅛ in. (55 x 46 cm). Tate, Bequeathed by Lord Amulree 1984 (T03889)

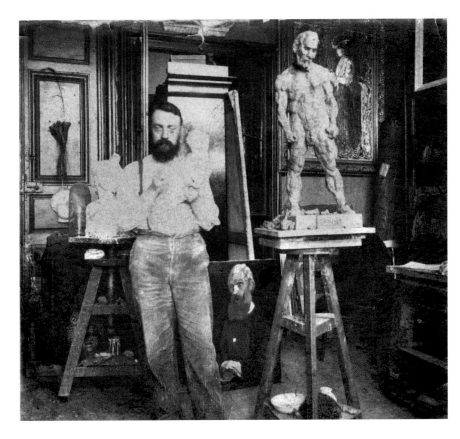

Right: Fig. 146. Henri Matisse in his Paris studio on the Quai Saint-Michel, ca. 1903. On the floor to the right of the artist is *The Monk* (private collection), which was included in the 1904 Matisse exhibition at Vollard's gallery. Photograph, Archives Matisse, Paris

Fig. 147 (cat. 33). Paul Cézanne, *Three Bathers,* 1879–82. Oil on canvas, 21⅝ x 20½ in. (55 x 52 cm). Petit Palais, Musée des Beaux-Arts de la Ville de Paris (PPP2099)

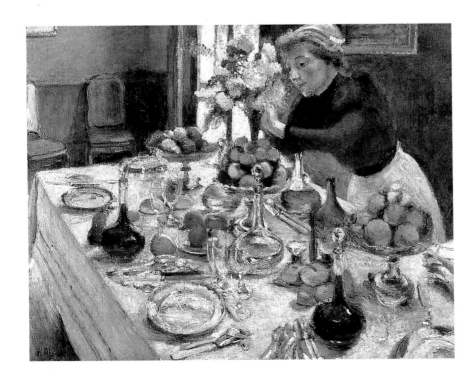

Fig. 148. Henri Matisse, *The Dinner Table (La Desserte),* 1896–97. Oil on canvas, 39⅞ x 51½ in. (100 x 131 cm). Private collection

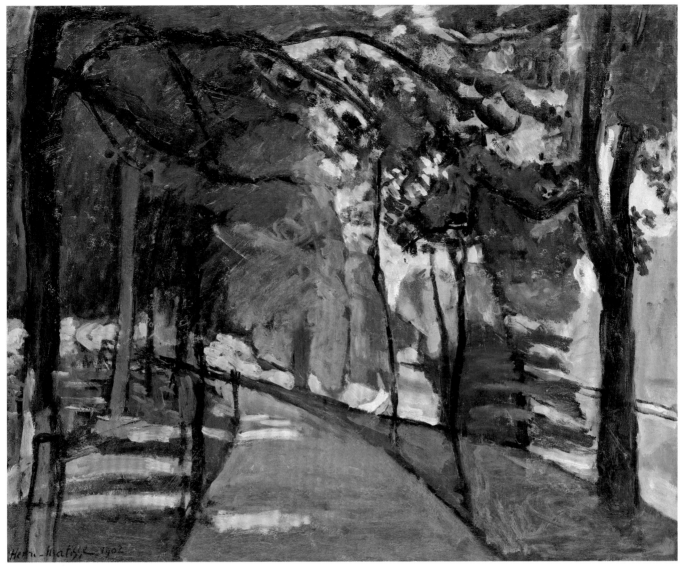

Fig. 149 (cat. 134). Henri Matisse, *View of the Bois de Boulogne,* 1902. Oil on canvas, 25⅝ x 32⅛ in. (65 x 81.5 cm). Pushkin State Museum of Fine Arts, Moscow (3300)

francs, from July 24, 1899, to August 14, 1900.[6] The following summer, in early July 1900, Matisse purchased Gauguin's *Young Man with a Flower* (1891, Mavrommatis collection; W 422) from Vollard for 200 francs.[7] The day he made his second and final payment on that painting, October 7, 1900, he seems to have purchased a Cézanne lithograph.[8] During these early years Matisse acquired at least one Van Gogh drawing from Vollard as well.[9]

The story of a struggling artist who makes material sacrifices to purchase art is the stuff of novels. In *The Autobiography of Alice B. Toklas,* Gertrude Stein recounts that Matisse's "Cézanne had been bought with his wife's marriage portion, the Gauguin with the ring which was the only jewel she had ever owned. And they were happy because he needed these two pictures."[10] Her recollection of the transaction so rankled Matisse that he contributed to the rebuttal of her book, in which he vehemently denied having applied his wife's dowry to the purchases.[11]

Certainly, at the turn of the century Matisse was in difficult financial straits. He contemplated trading his easel and paintbrushes for an "insipid but lucrative" job in order to support his wife and three children.[12] Before taking such drastic measures, though, he considered alternative ways of generating income. He formulated the idea of creating a syndicate of twelve investors who would each pay him 200 francs annually; in return he would paint two canvases per month, which, after a few years, would be exhibited and sold. In July 1903 Matisse informed his friend the painter Simon Bussy that he had identified three interested parties.[13] Meanwhile, he carefully considered how this plan would affect his relationship with Vollard.[14] On November 28, 1901, the dealer paid Matisse 700 francs, presumably for some of his paintings. A year later he purchased five or six more.[15] Matisse surely hoped the acquisitions would continue. He also did not want to ruin his opportunity to have a solo exhibition—his

first ever—at Vollard's, a prospect the dealer was contemplating for winter 1903–4.[16]

Matisse never organized his syndicate, and the plans for his exhibition at Vollard's gallery were postponed. Instead, during this period Matisse contributed to the inaugural Salon d'Automne (October 31–December 6, 1903) and the Salon des Indépendants (February 21–March 24, 1904). In April 1904 he participated in a group exhibition at Berthe Weill's gallery. By the middle of that month he was busy preparing his exhibition at Vollard's, which was scheduled to open on May 3 "if everything is ready."[17]

The installation seems to have run late, however, since "Oeuvres du peintre Henri Matisse" did not debut until June 1. The forty-five paintings and one drawing listed in the exhibition catalogue—still lifes, landscapes, and portraits—were on view through the eighteenth. Matisse personally installed the pictures, placing at eye level those he considered most interesting. He regretted the result: smaller works were hung high on the walls and were difficult to see.[18] Nevertheless, reviews were generally positive. Charles Morice, a critic for *Mercure de France* who had not cared for Matisse's earlier work, changed his opinion based on this "important" exhibition. He found Matisse to have "a limited vision but [one that is] exquisite and sincere. . . . Matisse's painting bears witness to the pleasure he finds in colors, tones, and their relationships."[19] Like most of his colleagues, the critic at *Chronique des arts* (none other than Roger Marx, who at Vollard's behest had written the preface to the exhibition catalogue) commented on Matisse's progress as a colorist.[20] Among the influences the critics cited were Matisse's former instructors Gustave Moreau and Eugène Carrière, as well as Paul Cézanne.[21] Of all the paintings mentioned in the reviews, none was praised as consistently as *The Dinner Table (La Desserte)* (fig. 148).[22]

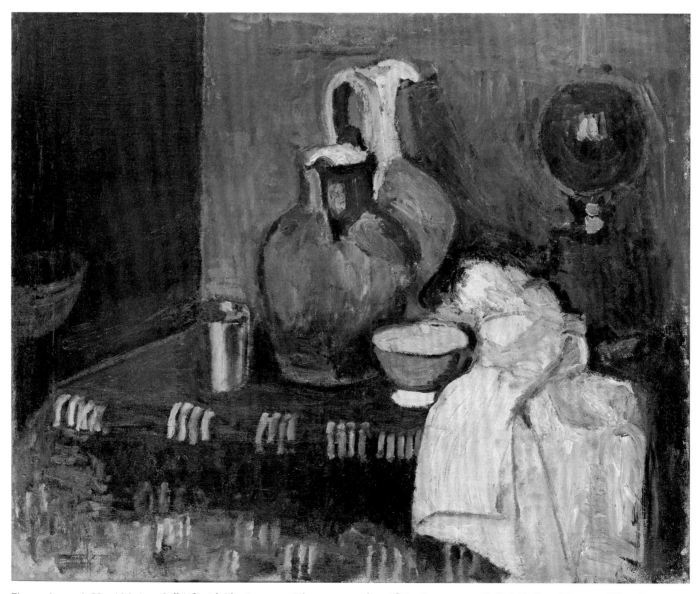

Fig. 150 (cat. 131). Henri Matisse, *Still Life with Blue Pot,* 1900. Oil on canvas, 23⅜ x 28⅞ in. (59.5 x 73.5 cm). Pushkin State Museum of Fine Arts, Moscow (3369)

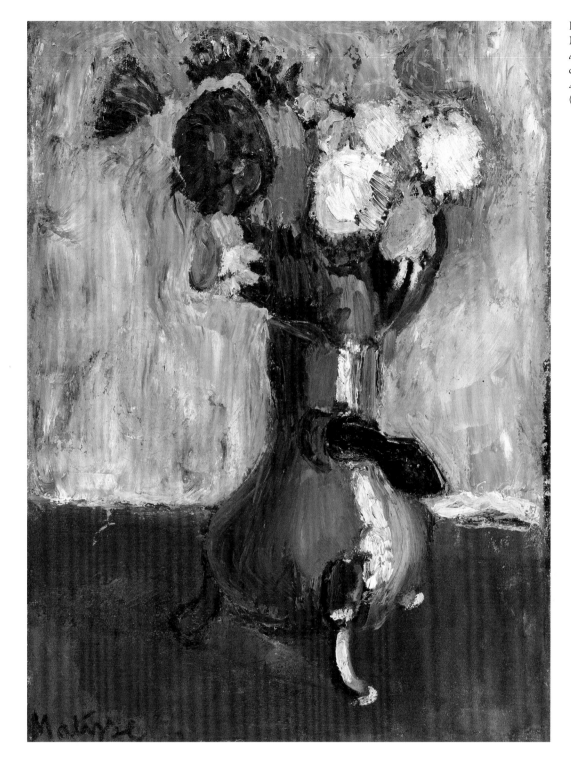

Fig. 151 (cat. 133). Henri Matisse, *Bouquet of Flowers in a Chocolate Pot,* 1902. Oil on canvas, 24¾ x 17⅞ in. (63 x 45.5 cm). Musée Picasso, Paris (RF 1973–73)

Vollard presumably owned a handful of the paintings on display at the gallery, but most of them still belonged to Matisse. An exception was *Still Life with Eggs* (location unknown), which was loaned by André Level, who had purchased it a few months earlier for the Peau de l'Ours syndicate of collectors.[23] Vollard's undated Stockbook B lists eleven paintings by Matisse, including still lifes, landscapes, and a painting of a musketeer (fig. 154), that were either consigned to him or purchased by him about this time.[24] Other than a crossed-out reference in Vollard's datebook (June 19, 1904) to a small painting sold from the exhibition, no other transactions are noted.[25] It is possible that the politician Olivier Sainsère, whom Matisse remembers as buying his first paintings from Vollard, may have purchased a picture.[26] Vollard's clients who later avidly collected Matisse's art—Ivan Morozov, Sergei Shchukin, and Leo Stein—were not yet interested in his work. All in all, the lackluster sales proved disappointing. To add insult to injury, Matisse later recalled that "Vollard had no consideration for the canvases of young artists. . . . On the day of an opening, without respect for the artist's work, etchings by Cézanne, Renoir and others were soon brought out."[27]

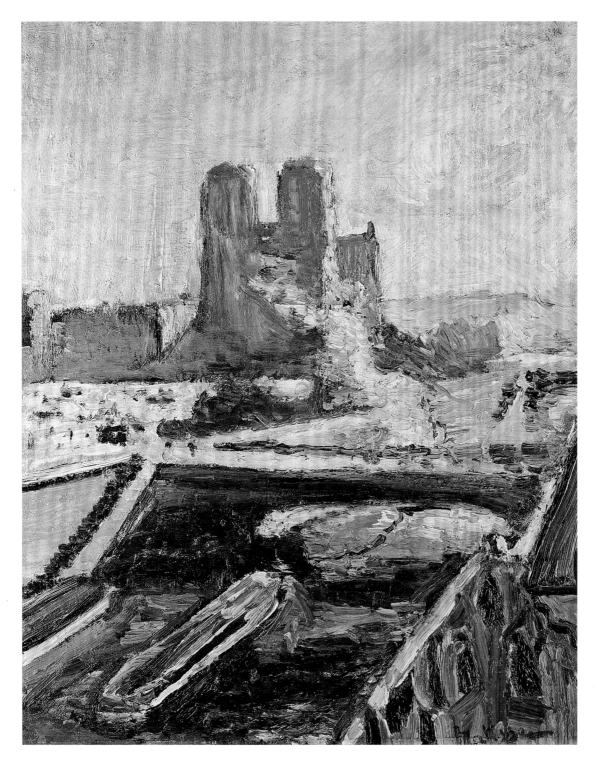

Fig. 152 (cat. 132). Henri Matisse, *Notre-Dame,* ca. 1900. Oil on canvas, 18⅛ x 14¾ in. (46 x 37.5 cm). Tate, Purchased 1949 (N05905)

Later that summer, as preparations were underway for the second Salon d'Automne, Jean Puy informed Matisse that certain artists would be permitted to submit an unlimited number of canvases to create the impression of a series of small solo exhibitions. "You could redo the Vollard exhibition *plus augmenté,*" he wrote.[28] Ultimately, the catalogue of the Salon d'Automne, held in Paris from October 15 to November 15, 1904, listed fourteen paintings and two sculptures by Matisse.[29] Most of the paintings had probably been exhibited at Vollard's.

Matisse's reputation grew as his style evolved. Reviewers of the 1905 Salon d'Automne considered him a leader of the Fauves, "one of the most robustly gifted of today's painters."[30] He began to attract the attention of collectors such as Leo Stein, who purchased his first Matisse painting, *Woman with the Hat* (1905, San Francisco Museum of Modern Art), on the final day of the salon. In his memoirs Stein claimed that he was responsible for rekindling Vollard's enthusiasm for Matisse's work, but surely many factors inspired the dealer to give Matisse another look.[31] On April 24, 1906, a week before

the close of the Salon des Indépendants that included Matisse's *Bonheur de vivre* (1905–6, Barnes Foundation, Merion, Pennsylvania), which Leo Stein also bought, Vollard purchased twenty paintings and studies from Matisse for 2,200 francs.[32] It seems likely that this group of paintings, which consisted of earlier works by the artist, included some of the paintings that Vollard had exhibited in 1904.[33]

About this time Matisse was involved in other Vollard projects. It seems likely that the dealer commissioned him to create a woodcut, *Le Grand Bois,* to be included in an album of prints that was never realized; though little documentation exists, Vollard's heirs are known to have owned the block from which the print was made.[34] Additionally, some of the ceramics that Matisse decorated with André Metthey seem to bear the painted monogram of Vollard on the underside (figs. 153, 154).[35]

Parisian dealers' interest in Matisse intensified in 1906. On February 28, 1907, Henri Manguin advised Matisse, who was in Collioure, to stay firm on his prices because Eugène Druet, Vollard, and perhaps Félix Fénéon were prepared to fight for his new work on his return to Paris.[36] Manguin's information was accurate albeit hardly surprising. Ten days earlier, Vollard had asked Matisse for the right to have the first look at his recent paintings from the Midi, and five days after that proposal, Fénéon, the new director of Bernheim-Jeune et Cie, had suggested that his gallery represent the artist.[37]

Vollard lost this battle of the dealers and was more or less relegated to selling whatever early Matisses he had in stock.[38] His records document several of these transactions. On February 19, 1906, a "Nature morte, Pots et fruits" by Matisse

was acquired by the winegrower and collector Maurice Fabre in exchange for 300 francs' worth of art: two ceramics by Maillol and a sculpture in the shape of a canoe by Gauguin.[39] In mid-May Denys Cochin purchased two paintings by Matisse: a view of the Bois de Boulogne and a small landscape.[40] Two years later, on April 28, 1908, Vollard sold three paintings by Matisse, at a price of 800 francs each: Oskar Moll of Charlottenburg acquired "Vue du Pont" (*Pont Saint-Michel,* ca. 1900, formerly collection of Mrs. William A. M. Burden, New York), a picture that had been in Vollard's 1904 Matisse exhibition, and Shchukin purchased a still life and a landscape.[41] Less than two months later, on June 10, 1908, Michael Stein purchased a painting for 800 francs,[42] and sixteen days after that Carl Rinninghaus of Vienna purchased another two.[43] Vollard raised the prices of his Matisses significantly over the next year. On September 16, 1909, he sold, for 2,000 francs apiece, two paintings that had been included in the 1904 show and that are listed in his Stockbook B at 150 francs each: a floral still life (*Purple Primrose,* location unknown) purchased by Michael Stein and *Still Life with Blue Pot* purchased by Morozov (fig. 150).[44]

When Vincenc Kramář, future director of what is now the Národní Galerie, Prague, visited Vollard's gallery on October 7, 1910, Vollard showed him paintings by various artists, including Picasso and Rousseau. The Matisse he saw was a portrait of "ca. 1900 (v. Manet ca. 1860)."[45] Six months later Vollard enticed Fritz Meyer, a prospective client in Zurich, with the "large number of canvases by young painters"—Bonnard, Denis, Laprade, Manguin, Matisse, Picasso, Puy, Roussel, Vlaminck—he had

Fig. 153 (cat. 137). Henri Matisse, *Three Bathers,* 1906–7. Tin-glazed ceramic, Diam. 13¾ in. (34.9 cm). The Metropolitan Museum of Art, New York, The Pierre and Maria-Gaetana Matisse Collection, 2002 (2002.456.117); *above,* monograms of André Metthey and Ambroise Vollard on the underside

in stock.[46] On July 12, 1937, Vollard sold *Le Pont Saint-Michel* to the gallery Alex Reid & Lefèvre, London, for 5,000 francs[47] and shortly before his death, Vollard sold yet another early Matisse, *Bouquet of Flowers in a Chocolate Pot* of circa 1902 (fig. 151), to the artist's longtime friend and rival Pablo Picasso.[48]

Meanwhile, Matisse had returned to Vollard's shop to make purchases of his own. In December 1908 he bought six Cézanne watercolors, which ultimately hung in his dining room.[49] It took him more than four years to repay the 2,000-franc debt, but Vollard sent only the gentlest of reminders. He clearly preferred to receive a painted still life by Matisse in lieu of cash.[50] Vollard succeeded in obtaining several Matisse paintings of this period, probably from sources other than the artist. *Boy with a Butterfly Net* (fig. 155) depicts Gertrude and Leo Stein's young nephew, Allan, and may have been acquired by Vollard from the sitter's parents.[51] Vollard is also known to have owned a version of *Cyclamen on a Table* (1911, private collection).[52]

As the two men became increasingly famous, they saw one another only occasionally (figs. 156, 157). In late spring 1923 Vollard asked Matisse to be a juror of his first (and only) "Prix des peintres," a prize to be awarded to a writer by a jury of painters.[53] A few weeks later, in June, Vollard purchased "une planche" from Matisse with the right to reproduce it. He seems to have purchased another in 1925, presumably for inclusion in an album of etchings that he envisioned as a "sequel" to his early lithograph albums.[54]

For his part, Matisse recalled Vollard not just as a dealer but as a personality. He recognized Vollard's enormous importance and applauded his early appreciation of untraditional works— in particular his willingness to promote canvases not entirely covered in paint, which other dealers shunned as unfinished sketches. And though he regaled collectors with amusing accounts of Vollard, Matisse also admitted to having a soft spot for the dealer who had given him his first solo exhibition.[55]

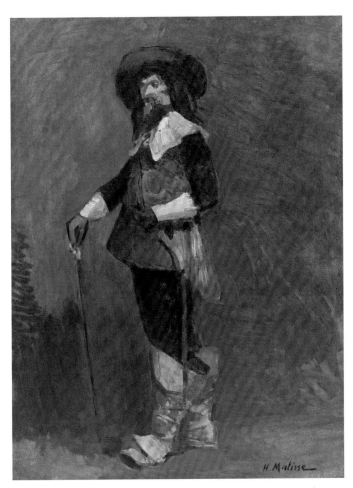

Fig. 154 (cat. 135). Henri Matisse, *Musketeer,* 1903. Oil on canvas, 31¾ x 23½ in. (80.6 x 59.7 cm). The Museum of Modern Art, New York, The William S. Paley Collection (SPC70.1990)

Opposite: Fig. 155. Henri Matisse, *Boy with Butterfly Net,* 1907. Oil on canvas, 69¾ x 46 in. (177.2 x 116.7 cm). The Minneapolis Institute of Arts, The Ethel Morrison Van Derlip Fund (51.18)

In this essay, the following abbreviation is used in citing catalogue raisonné numbers: for works by Van Gogh, "F" refers to Faille 1970.

1. In *Recollections of a Picture Dealer,* Vollard wrote, "Matisse has been a disappointment to those who like an artist to stick to the same manner all along. Forsaking those greys that please his admirers so much, he suddenly turned to the most brilliant colours." Vollard 1936, pp. 201–2.
2. Based on Matisse's recollection that *L'Arlésienne* had a pink background, it is possible to narrow the work down to two versions that were in Vollard's possession at the time: F 540 (Galleria Nazionale d'Arte Moderna, Rome), per Stockbook A, no. 3423, purchased from Mme Bernard in January 1899 for 150 francs; or F 542 (Museu de Arte de São Paulo), per Stockbook A, no. 3909, acquired from Chaudet on Gauguin's behalf for 100 francs. This identification is courtesy of Jayne Warman and is based on information from an unpublished interview with Matisse ("Entretiens avec Pierre Courthion 1941, IV") supplied by Wanda de Guébriant, Archives Matisse, Paris, as well as unpublished information from Walter Feilchenfeldt and Roland Dorn.
3. Flam 1986, p. 69.
4. Jayne Warman has suggested this might have been F 569 (private collection); Isabelle Monod-Fontaine (in Essen–Amsterdam 1990, p. 300) suggests F 568.
5. Flam 1986, pp. 69, 72, and the unpublished interview with Matisse supplied by Wanda de Guébriant (see note 2 above). Matisse recalled that Rodin had given the bust to Manet, whose widow sold it to Vollard. He remembered the bust as an "épreuve unique," in which Rochefort is looking straight out, rather than tilting his head down. Although the bust Matisse owned has not been identified, a similar one is illustrated in Goldscheider 1989, pp. 184–85, no. 139a.
6. For more information on the transaction, see Flam 1986, p. 72. Matisse misremembered the price he paid for the works. Datebooks, receipts, and letters in both the Matisse and Vollard archives confirm that the dealer charged 1,600 francs for the two works, 1,450 francs for the Cézanne and 150 for the Rodin. Matisse paid off his debt as follows: 150 francs for the Rodin on July 24, 1899; 1,150 francs on December 7, 1899; 100 francs on May 3, 1900; 50 francs on July 4, 1900; 100 francs on July 5, 1900; and half of a 100-franc payment on August 14, 1900. Vollard to Matisse, June 21, July 24, and December 7, 1899, Archives Matisse; see also Vollard Archives, MS 421 (4,3), fols. 139, 148, 161.
7. Based on a questionnaire that Matisse reluctantly completed near the end of his life, art historians have long believed that the artist exchanged one of his own paintings for the Gauguin; however, the Matisse and Vollard archives clearly indicate that Matisse paid 50 francs toward the Gauguin on August 14, 1900, and the remaining 150 on October 7, 1900: Vollard Archives, MS 421

Fig. 156. Vollard and Matisse at the spa town of Vittel, ca. 1931. Archives Matisse, Paris

Fig. 157. Matisse, Vollard, and Marie Dormoy at Vittel, ca. 1931. Archives Matisse, Paris

(4,9), fols. 25, 41, 122, and receipts dated August 14 and October 7, 1900, in the Archives Matisse. In 1908 Matisse attempted to exchange the Gauguin for a Renoir painting of a girl in red. The deal fell apart when the director of the Galerie Bernheim-Jeune asked Matisse to add 1,500 francs to the transaction. Matisse ultimately sold the painting during World War I. Fénéon to Matisse, July 18, 1908: Archives Matisse.

8. It seems to indicate that Matisse paid 30 francs for the print: Vollard Archives, MS 421 (4,9), fols. 41, 122.

9. Flam 1986, pp. 73, 485–86, n. 13. Susan Stein and Colta Ives have identified three Van Gogh drawings owned by Matisse, two of which were acquired from Vollard: *Portrait of Patience Escalier* (private collection; F 1461) and *Arles: View from the Wheat Fields* (National Gallery of Art, Washington, D.C.; F 1491). See Amsterdam–New York 2005, pp. 33, 208–9, and p. 225, no. 70, fig. 154.

10. G. Stein 1933, pp. 44–45.

11. Braque et al. 1935, p. 4. Spurling claims that Amélie Matisse did indeed sell an emerald ring given to her as a dowry in order to finance the picture. Spurling 2005, p. 177.

12. Matisse to Simon Bussy, July 15, 1903, in Flam 1986, pp. 80, 82.

13. Ibid. See also FitzGerald 1992, p. 139, n. 18.

14. "The tricky part of my plan is that in trying to interest the collectors I cannot work against Vollard (who has purchased a decent amount from me). It is very difficult." Matisse to Simon Bussy, July 31, 1903: Bibliothèque Centrale des Musées Nationaux, Paris.

15. Vollard Archives, MS 421 (4,9), fol. 106. According to Jean Puy, Matisse sold five or six studies (including *Chrysanthemums in a Coffee Pot*) to Vollard in late 1902 for 1,200 francs; see Spurling 1998, p. 256. See also Matisse to Manguin, August 10, 1903, in Benjamin 1987, p. 273, n. 31. In an interview in 1941, Matisse recalled, "Then, one fine day, Vollard was convinced: for a thousand francs, he took five works from me among which were three large *dessertes* which were not too bad." Matisse interview with Francis Carco, in Flam 1995, p. 139. Matisse may have been referring to this early purchase, or perhaps to Vollard's purchases of 1906.

16. Matisse to Manguin, August 10, 1903, in Benjamin 1987, p. 273, n. 31. Vollard had supposedly contemplated holding the Matisse exhibition even earlier, in the summer of 1903; see Spurling 1998, p. 274.

17. Matisse to Level, April 22, 1904, Research Library, The Getty Research Institute, Los Angeles. Roger Marx's preface to the exhibition catalogue is dated May 20.

18. Pierre Courthion's unpublished interview with Matisse, Research Library, Getty Research Institute.

19. Morice 1904.

20. Marx 1904.

21. The painter Eugène Carrière, who was too ill to visit the exhibition, sent the artist a note on June 9, 1904 (Archives Matisse): "Je le regrette profondément car je m'intéresse sincèrement à vos efforts." He later offered to help Matisse install his next exhibition.

22. See, for example, Saunier 1904 and Vauxcelles 1904.

23. Matisse to Level, April 22, 1904, Research Library, Getty Research Institute. Wanda de Guébriant suggests that Level may have also lent no. 4, *Effet de neige*.

24. Stockbook B, nos. 3401, "Interieur d'appartement avec table servie," 100 x 131 cm (400 francs) (fig. 148); 3408, "Nature morte. Fleurs dans vase," 71 x 52 cm (150 francs); 3409, "Poteries roses et bleues. Nature morte," 60 x 73 cm (150 francs) (fig. 150); 3410, "Vue de Paris, effet de neige," 60 x 73 cm (150 francs) (*The Pont Saint-Michel Paris*, 1903, Foundation E. G. Bührle Collection, Zurich); 3411, "Nature Morte. Cafetière, soupière, etc. sur une table," 95 x 80 cm (150 francs) (*Dishes on a Table*, 1900, State Hermitage Museum, St. Petersburg [It has long been believed that *Dishes on a Table* was the first painting that Sergei Shchukin purchased directly from Matisse. That may be the case; however, Vollard's connection to it has been confirmed via archival information and by the discovery of Vollard's stock sticker and blue pencil notation on the painting's stretcher.]); 3412, "Nature morte. Pot de fleurs sur une table," 60 x 73 cm (150 francs); 3413, "Cafetière avec des fleurs," 63 x 46 cm (150 francs) (fig. 151); 3414, "Rochers au bord de la mer," 60 x 73 cm (150 francs); 3415, "Mousquetaires," 81 x 60 cm (150 francs) (fig. 154); 3449, "Nature morte, Pots et fruits," 50 x 61 cm (150 francs); 3470, "Poteries et fruits," 25 x 33 cm (75 francs).

25. Vollard Archives, MS 421 (4,10), fol. 12: "Recu de M. Matisse 100 f[rancs] pour commission du petit tableau vendu pour lui pendant son exposition."

26. In an interview with Francis Carco, Matisse claimed that Vollard sold his first pictures to Olivier Sainsère; see Flam 1995, p. 139.

27. Matisse interview with André Verdet in Flam 1995, p. 216. Matisse also recalled that at one point during the run of his exhibition Vollard asked him to show a Gauguin to Hugo von Tschudi, director of the Nationalgalerie, Berlin. Spurling 1998, p. 277.

28. Puy to Matisse, August 1904: Archives Matisse.

29. Paris (Salon d'Automne) 1904, nos. 607, *Fruits (nature morte)*; 608, *Intérieur*; 609, *Guitariste*; 610, *Guitariste*; 611, *Nature morte*; 612, *Intérieur*; 613, *Nature morte*; 614, *Intérieur d'atelier*; 615, *Vue du Bois de Boulogne*; 616, *Intérieur*; 617, *Fleurs*; 618, *Fleurs*; 619, *Vieux chêne (paysage)*; 620, *Nature morte*.

30. Vauxcelles 1905b.

31. L. Stein 1947, pp. 192–93.

32. This group purchase is noted in Vollard's datebook on April 24, 1906: Vollard Archives, MS 421 (5,1), fol. 77. See also Matisse to Manguin, June 7, 1906, in Céret–Le Cateu-Cambrésis 2005–6, p. 279.

33. One painting that may have been included in this purchase is *The Monk* (no. 36, *Moine méditant*, in the 1904 exhibition; sold at Sotheby's, New York, May 14, 1985, no. 49). Vollard's ownership of the painting is implied in correspondence between him and Matisse. Vollard to Matisse, April 28, 1908: Archives Matisse.

34. For more information, see Castleman 1986, p. 7.

35. Nice–Bruges 1996, p. 77.

36. Manguin to Matisse, February 28, 1907: Archives Matisse.

37. Vollard to Matisse, February 18, 1907, and Fénéon to Matisse, February 23, 1907: Archives Matisse.

38. In a letter to Raymond Escholier written on November 29, 1939, Matisse claims that he has not sold a single painting to Vollard for more than twenty-five years. (Sale of the Pierre Berès collection, Hôtel Drouot, Paris, October 28, 2005, no. 181.)

39. Vollard Archives, MS 421 (5,1), fol. 32. This painting had been exhibited in the 1904 exhibition and was purchased by Vollard about that time for 150 francs. Stockbook B, no. 3449. See also note 24 above.

40. Two Matisses and two Derains were sold to Cochin for 1,400 francs on May 17 and 18, 1906: Vollard Archives, MS 421 (5,1), fols. 93, 94.

41. Vollard Archives, MS (5,3), fols. 78, 79, April 28 and 29, 1908. At least one

and possibly both of Shchukin's paintings had also been included in the 1904 exhibition. For more on the still life (Stockbook B, no. 3411), see note 24 above.

42. Vollard Archives, MS 421 (5,3), fol. 105.

43. The two paintings were included in a large order; Vollard listed them at 800 francs apiece but billed only 1,500 francs for the two. Rinninghaus seems not to have paid his bill. Vollard to Rinninghaus (which Vollard sometimes spelled Reininghaus), June 26 and October 24, 1908, and December 21, 1909: Vollard Archives, MS 421 (4,1), pp. 123, 132, and MS 421 (5,2), fol. 34 (datebook entry for March 4, 1907), and MS 421 (4,1), fol. 163.

44. Vollard Archives, MS 421 (5,4), fol. 170. In Stockbook B, no. 3412 (see note 24 above), Vollard referred to the Stein picture as "Nature morte. Pot de fleurs sur une table, 60 x 73." Wanda de Guébriant has identified this picture as no. 29 in the 1904 exhibition at Vollard's. Regarding Morosov's purchase, see Vollard to Morosov, November 30, 1909: Vollard Archives, MS 421 (4,1), p. 146.

45. Claverie et al. 2002, p. 203. The day after visiting Vollard's gallery, Kramář wrote to his brother, "These last days I could scarcely sleep after the artistic establishments and what I saw there. Yesterday was one of the best days ever. After that I couldn't even get off to sleep at all." Prague–Paris 2000–2002, p. 221.

46. Vollard to Fritz Meyer, January 19, 1911: Vollard Archives, MS 421 (4,1), p. 184.

47. Vollard Archives, MS 421 (3,1), fol. 105.

48. London–Paris–New York 2002–3, p. 381.

49. Vollard Archives, MS 421 (5,3), fol. 216. The watercolors, two of which are double-sided, have been identified by Wanda de Guébriant and are illustrated in Rewald 1983, nos. 256, 316, 323 (recto) and 416 (verso), 340, 415 (recto) and 334 (verso), 541.

50. Vollard to Matisse, February 25, 1910, and November 28, 1912: Archives Matisse. See also Matisse to Vollard, February 13, 1913: Vollard Archives, MS 421 (2,4), p. 74.

51. Vollard sold the painting to the Galerie Bernheim-Jeune on May 6, 1909; G.-P. Dauberville and M. Dauberville 1995, vol. 1, p. 458, no. 91.

52. A photograph of the painting is in the Vollard Archives, photograph no. 199566483. Photographs of two additional Matisse paintings, both from 1920, can be found in the Vollard Archives (nos. 199566484 and 199566485), although he is not known to have owned either: *Woman with a Green Parasol* (Christie's, New York, November 9, 1999, no. 528) and *Woman with a Mandolin (Woman in a Checked Skirt)* (Sotheby's, London, June 26, 1990, no. 36A).

53. See chapter 28 in Vollard 1936, pp. 243–46. The authors under consideration were above all Paul Léautaud, André Suarès, and Paul Valéry (who won). Other contenders included Alexandre Arnoux, Canudo, Charles Derennes, Maurice Guierre, Claude Harlès, Marc Lafargue, Michel, Edmond Pilon, Achille Segard, and Henri Vincent. Vollard to Picasso, May 10, May 20, and June 8, 1923: Archives, Musée Picasso; Suarès to Rouault, May 11, 1923, in *Rouault—Suarès Correspondence* 1983, p. 83, letter 125; Basler 1925.

54. Vollard paid Matisse 1,000 francs for the etching plate on June 3, 1923. On July 24, 1925, Vollard signed a "mandat lettre" stipulating payment of 1,000 francs to Matisse on August 5, 1925: Vollard Archives, MS 421 (2,3), fols. 124, 125. For more information on the etching *Femme nue au collier (Odalisque)* and Vollard's unpublished album of nudes for which it was intended, see Lieberman 1956, p. 19, n. 15. In a letter to Maurice Denis, Vollard mentions that he is creating an album of etchings and that Bonnard, Matisse, Rouault, Roussel, L. Simon, and Vuillard have agreed to submit prints to an album of etchings he is creating. He goes on to discuss the project, for which he anticipates the participation of twenty-five to thirty artists, and his intention to publish it in an edition of two hundred. Vollard to Denis, undated [ca. 1924–25]: Archives, Musée Départmental Maurice Denis, Saint-Germain-en-Laye, Donation de la famille Denis, MS Vollard 11794. The Vollard Archives confirm the additional participation of Camoin, Cassatt, Chagall, Denis, Foujita, Laprade, Marval, Morisot, and Vlaminck, among others. See Chronology entry dated June 3, 1923. Vollard Archives, MS 421 (2,2), fol. 424, MS 421 (8,10), fol. 20, and MS 421 (9,10), fol. 1.

55. Unpublished interview with Matisse supplied by Wanda de Guébriant (see note 2 above). See also Shone 1993, p. 484.

Vollard and the Impressionists: The Case of Renoir

Anne Distel

Early in 1894, Camille Pissarro visited the shop that Vollard had opened only a few months before at 37, rue Laffitte. As he wrote to his son Lucien, he saw "nothing but pictures of the young"[1]—a rather curious claim, given that among the painters he listed (apart from Henry De Groux, who was born in 1867) were a number no longer exactly "young," such as Paul Gauguin, Armand Guillaumin, Alfred Sisley, Odilon Redon, and Jean-François Raffaëlli. And while the Van Gogh exhibition of June 1895, with which Vollard inaugurated his second shop at 39, rue Laffitte, was a sign of the dealer's interest in the young avant-garde, his intent from the start was clearly to build his reputation on the generation then gaining mainstream acceptance, that of Édouard Manet and the pioneer Impressionists. At the same time Vollard kept his distance from the "young" Neoimpressionists, who tended to gather at the gallery Lucien Moline had opened in December 1893 at 20, rue Laffitte, a few doors down from Vollard's.[2]

The exhibition of Manet's drawings held in the shop at no. 37 from November 17 to December 20, 1894,[3] exemplified Vollard's approach: the drawings and small-scale watercolors he showed were "minor pieces," in the language of the trade. They came from the artist's widow, whose financial straits forced her to settle for the low prices offered by the young Vollard (he paid her in installments after his customers had paid him).[4] There were paintings in the exhibition as well, but they were either simple sketches or of "difficult" subjects, among them the central fragment of the dismembered *Execution of Maximilian* (fig. 167), *Woman with a Cat (Portrait of Madame Manet)* (ca. 1867, Tate Britain, London), and the unfinished *Funeral* (fig. 281). These three sold for 2,000, 500, and 1,000 francs, respectively, the first two to Edgar Degas, the third to Pissarro—both of whom paid with their own works rather than in cash, fattening Vollard's inventory but not his coffers.[5] Renoir, too, yielded to temptation and bought two Manet watercolors, for which he also paid in kind. The prices were high by Vollard's standards (he rarely priced anything above 500 francs), but they were modest compared with the contemporary market.[6]

Vollard did not compete directly with the established dealers, but he took advantage of opportunities left by the deaths of potential rivals such as Theo van Gogh (1857–1891), who had been the innovative manager at Boussod et Valadon, and Julien Tanguy (1825–1894). His enthusiasm, which so impressed Pissarro, contrasted sharply with the less aggressive tactics of other small-time dealers, even those, like Portier or Le Barc de Boutteville, who enjoyed good reputations. The exhibition of Paul Cézanne's works that Vollard mounted in November and December 1895 established him as the exclusive dealer of the then little-known painter—the only one of his generation that Durand-Ruel had not taken on—and brought some major collectors to his door. In addition, it strengthened

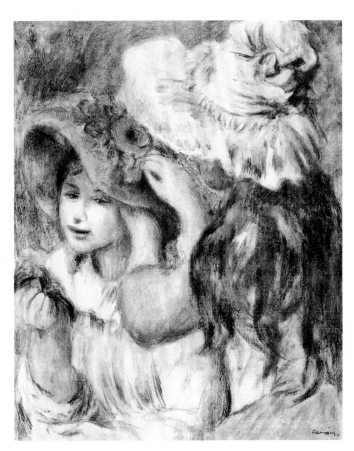

Fig. 159. Auguste Renoir, *Pinning the Hat,* 1898. Transfer lithograph, image 23⅝ x 19¾ in. (60 x 50.2 cm). The Museum of Modern Art, New York, Lillie P. Bliss Collection (117.1934)

Opposite: Fig. 158 (cat. 175). Auguste Renoir, *Seated Bather in a Landscape,* 1895–1900. Oil on canvas, 45⅝ x 35 in. (116 x 89 cm). Musée Picasso, Paris (RF 1973-87)

Fig. 160 (cat. 174). Auguste Renoir, *Nude*, 1880. Oil on canvas, 32⅛ x 25⅝ in. (81.5 x 65 cm). Musée Rodin, Paris (P 7334)

the fledgling dealer's relations with artists who wanted to own a Cézanne: not just Degas (an impenitent collector), Pissarro, and Renoir, but also Claude Monet, the only one who paid in cash and who did not develop an ongoing relationship with Vollard. (Indeed, Monet was already an expensive artist—he was asking 15,000 francs for a *Cathedral*—and could not afford to alienate his titular dealers.) Ultimately, everyone benefited from these arrangements, most of all Vollard, who managed to build both an inventory and a clientele.

Of all the Impressionists, Auguste Renoir (1841–1919) was the one who would forge the most lasting bond with Vollard. The first mention of "Renoir, painter, rue Girardon" in Vollard's account ledgers seems to be for the artist's purchase, on October 15, 1894, of two Manet watercolors, *Port of Bordeaux* for 200 francs and *Small Boats* for 150. The posthumous inventory of Renoir's estate lists a watercolor and a drawing by Manet, no doubt the same ones.[7] The date of the purchase, one month before the official opening of the Manet

show at Vollard's, suggests that the young dealer allowed the artist an early look, or that Renoir—like Pissarro, and like Degas, who had made his first purchase in June 1894[8]—had already visited the new gallery prior to the exhibition. Moreover, this transaction was recorded at the same time as the sale of a Manet sketch to "Degas, painter, rue Ballu,"[9] which could mean that the two painters, despite their often stormy relations, had visited the gallery together on that day. For his part, Vollard (and there is no reason to doubt his recollection) claimed that he first visited Renoir in Montmartre, in the so-called Château des Brouillards (Castle of Fog) at 13, rue Girardon, to ask his help in identifying the model for a Manet portrait he owned.[10] Renoir's son Jean, born on September 15, 1894, was too young to remember the event himself, but in his memoirs he quoted the description given by Gabrielle, the family maid, of Vollard's first visit in 1894: "A tall, lanky fellow, with a little beard, called to me over the fence. He said he wanted to talk to the boss. His clothes were rather

shabby. His swarthy skin and the way the whites of his eyes showed made him look like a gypsy, or at any rate a savage. I thought he was some rug-seller; so I told him we didn't need anything in that line. Just then your mother came out and asked him in. He said that he came from Berthe Morisot. He looked so pathetic that your mother gave him some grape tart and a cup of tea. [Renoir] came downstairs just after that."[11]

That either Berthe Morisot (Madame Eugène Manet) or Manet's widow was behind the two men's meeting also seems entirely plausible, all the more so as Renoir and Degas often saw each other at Morisot's during that period. What is certain is that Vollard established contact with Renoir very early in his professional career, in 1894. The painter, then in his fifties and at the pinnacle of a career spanning more than thirty years, was already a respected and highly visible figure. In 1892 the French state had bought his *Young Girls at the Piano* (Musée d'Orsay, Paris). From the moment he arrived in Paris, Vollard had ample opportunity to see works by Renoir. But the painter was often out of town, and meeting him probably required some persistence.

Several times throughout 1895 Renoir gave Vollard pastels or works on paper to sell. The paintings the dealer sold were either very small and inexpensive sketches or fragments he had to have remounted.[12] Some works were also consigned to Vollard by third parties, including members of the painter's family. The subjects were invariably women and children, and the prices ranged from 25 to 300 francs, even though in that same time Durand-Ruel rarely bought works from Renoir for less than 1,000. Still, Renoir ended up making not inconsiderable sums from Vollard at times when Durand-Ruel was buying nothing from him.[13] So the arrangement was apparently to everyone's advantage: Vollard could quickly sell the "minor pieces" that appealed to modest collectors, often other artists,[14] while Durand-Ruel continued to offer the major works, his more solid financial standing allowing him to sell them at a more leisurely pace, even as he also steadily bought small-format studies. However, Vollard's business strategy encouraged the diffusion of poorly executed works that tarnished the artist's reputation during the last years of his career.

At the same time, Vollard encouraged Renoir to venture into making original prints, which until then had not much interested him. In particular, by coaxing Renoir to create several black-and-white and color lithographs (aided by superb

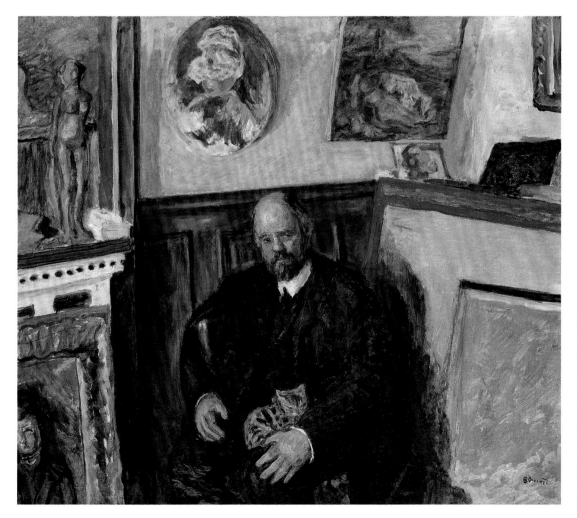

Fig. 161 (cat. 11). Pierre Bonnard, *Ambroise Vollard with His Cat,* ca. 1924. Oil on canvas, 38 x 43¾ in. (96.5 x 111 cm). Petit Palais, Musée des Beaux-Arts de la Ville de Paris (PPP 3052). Vollard is depicted in his rue Martignac town house. The rectangular painting behind him is Renoir's *Reclining Woman* (1893, private collection).

craftsmen like Auguste Clot), he led Renoir to discover a technique in which the painter could express his sensibility. The 1898 color lithograph *Pinning the Hat* (fig. 159), printed in a sizable quantity, became one of Renoir's most famous compositions. The presence of his works in albums of original prints published by Vollard was also good for business.

Starting in 1897 Vollard paid regular advances to Renoir and his wife. Madame Renoir also received works of art, though whether they were intended for her or her husband is unclear.[15] One proof of Renoir's trust in Vollard is that in 1899 he directed the dealer to send money to Jeanne, the daughter he had had with his model Lise Tréhot. Her existence was apparently unknown to Madame Renoir—and, until only recently, to Renoir's biographers.[16] Vollard thus became the custodian of an intimate secret that he kept faithfully hidden and that few of Renoir's friends knew. His sons discovered it only after their father's death and in turn never spoke of it, even after Jeanne died in 1934.

Most of Vollard's clients in the years before 1900, including some of the most prominent ones, bought Renoirs. Dr. Georges Viau, in particular, developed a long-standing interest in the artist. Another collector, Baron Robert de Domecy, who is best remembered for his patronage of Redon, not only bought Renoir's works but also commissioned portraits of himself and his family. Dealers and brokers also visited Vollard's gallery, among the most remarkable being (in 1896) the Bernheim-Jeune brothers, his neighbors at 8, rue Laffitte. In 1892 their

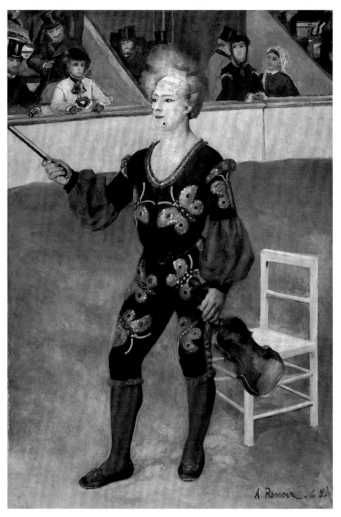

Fig. 163. Auguste Renoir, *The Clown (James Bollinger Mazutreek)*, 1868. Oil on canvas. Collection Kröller-Müller Museum, Otterlo, The Netherlands

Fig. 162. Renoir in his studio, ca. 1912. Vollard Photo Archives (ODO 1966 56 1975)

gallery had begun to sell works by Impressionist artists, but in very small numbers. They seem not to have sold their first Renoir until 1897, which might mean that it was Vollard who introduced the brothers to the artist, whose fervent champions they became.[17] Although the focus in Maurice Denis's famous *Homage to Cézanne* (fig. 82) is on Cézanne's still life,[18] hanging on the wall behind the group of figures is (along with a composition by Gauguin) a painting of a young woman wearing a hat that could only be by Renoir; its inclusion signals how important Renoir was to the dealer at the turn of the century.

After 1900 Vollard's transactions rose in volume as his clients rose in prominence. His most illustrious client was surely Alexandre Berthier, prince de Wagram, who first made purchases from Vollard and other dealers at the beginning of 1906. Barely a year later, Vollard was one of the first to break off relations with the prince because he was unable to extract payment within a reasonable amount of time. He had offered Berthier works by Cézanne, Gauguin, Van Gogh, and Renoir. Typical of the Renoirs were *The Clown* (fig. 163), offered at

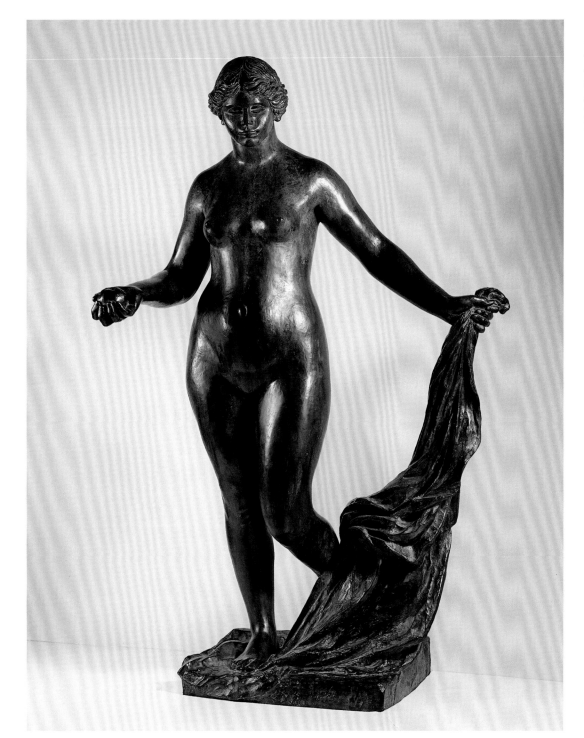

Fig. 164 (cat. 178). Auguste Renoir, *Venus Victorious,* ca. 1914–16. Bronze, 71⅞ x 43¾ x 32 in. (182.6 x 111.1 x 81.3 cm). The Sterling and Francine Clark Art Institute, Williamstown, Massachusetts (1970.11)

35,000 francs (and listed on the same invoice, dated November 6, 1906, as Cézanne's admirable *Young Man with a Skull* of 1896–98, now in the Barnes Foundation, Merion, Pennsylvania, which sold in 1906 for 30,000 francs),[19] and the 1871 *Still Life with Bouquet* (Museum of Fine Arts, Houston), two of the early works that Vollard seems to have systematically sought out either at the painter's home or from more obscure owners such as concierges or former models. These paintings from the beginning of Renoir's career, which were probably surprising to contemporaries who knew only the later Renoir, appealed to Vollard and his more daring collectors, who were already noticing Picasso and the Fauves. And then there were

novice collectors like Alfred C. Barnes, who on the eve of World War I came to Vollard's initially to acquire a Renoir or a Cézanne and took home a Picasso instead. Picasso himself had several Renoirs in his collection; the most significant, *Seated Bather in a Landscape* (fig. 158), though probably purchased through Paul Rosenberg, had initially come from Vollard's stock.

Renoir's move to the south of France, which became quasi-permanent in 1908, did not loosen his bonds to his dealer. On the contrary, Vollard acted as the aging painter's link with Paris. Renoir gladly welcomed Vollard to Les Collettes, his residence at Cagnes-sur-Mer, but behind Vollard's back he

Fig. 165 (cat. 176). Auguste Renoir, *Ambroise Vollard with a Red Scarf*, 1906. Oil on canvas, 11⅞ x 9⅞ in. (30 x 25 cm). Petit Palais, Musée des Beaux-Arts de la Ville de Paris (PPP 0827)

also made fun of the dealer's personal quirks to other friends such as Albert André and Georges Besson. The dealer René Gimpel repeated what were probably often-told anecdotes about Vollard and Renoir:

> *There's someone who knows how to manage him. One day he brought [Renoir] a parcel of fish from the market, threw them on a table, and told him, "Paint me that." Amused, Renoir did it, and Vollard carried off the canvas. Another time Vollard appeared before the painter in toreador dress, and Renoir, ravished by the color, did his portrait. On the other hand, Vollard holds his spittoon, brings him his chamber pot, and helps him to pee.*[20]

Indeed, Renoir painted Vollard's portrait many times (see figs. 20, 165). In addition, Vollard also made it possible for Renoir to experiment with sculpture (see fig. 164) by finding

him able craftsmen, which in return created work for him to sell. The connection between the two is captured perfectly in the fictitious conversation Vollard included in his biography of the painter, published in 1919, the year Renoir died.[21] Even today our view of Renoir remains strongly conditioned by this work of Vollard's, and the album of abundant but low-quality black-and-white reproductions that accompanies it has fixed for posterity, in rather shoddy plates, the most unpolished efforts from late in the artist's career.[22] These volumes, an ambivalent celebration, constitute the final stage in the two men's relations.

After Renoir's death, Vollard continued to sell his works, but less assiduously: he was now finding it more lucrative to sell Cézannes. Still, in the portrait Pierre Bonnard made of Vollard in about 1924 (fig. 161), several Renoirs occupy a privileged place. Symbolically, one of the major events of

this period was Vollard's 1927 sale of the portrait Renoir had painted of him in 1908 (fig. 296) to Samuel Courtauld. Knowing that Courtauld envisioned leaving his collection to a prestigious public institution, Vollard was very likely hoping to ensure his own personal glory. Nonetheless, thanks to the convincing strength of this portrait, the personalities of the two men are forever linked, and the long dialogue between the painter and his dealer will be remembered.

1. Rewald and L. Pissarro 1943, p. 227.
2. See Distel 2001, p. 43.
3. Étienne Moreau-Nélaton kept the invitation card, which read, "Exhibition of drawings and sketches by Manet, from his studio—A. Vollard Gallery, 37 rue Laffitte, from 17 November to 20 December 1894, 10:30 a.m. to 6:30 p.m., except Sundays and holidays": Service d'Études et de Documentation du Musée du Louvre, Fonds Moreau-Nélaton (fig. 230). The exhibition was briefly mentioned by R. Sertat in *La Revue encyclopédique,* December 15, 1894, p. 386. Nonetheless, payments to Madame Manet and revenues from sales of Manet's works appear in the accounts ledgers as early as June 1894.
4. Vollard did exactly the same thing, at the same time, with the widow of Stanislas Lépine (1855–1892).
5. See New York 1997–98, vol. 2, nos. 796, 799. Pissarro acquired *The Funeral* on November 21: Vollard Archives, MS 421 (4,2), fols. 6, 7.
6. In January 1894, for example, Count Isaac de Camondo bought Manet's *Fife Player* (1866, Musée d'Orsay, Paris) from Durand-Ruel for 30,000 francs. In May 1895 Durand-Ruel bought back another large Manet canvas, *Boating* (1874, Metropolitan Museum), from a collector for 25,000 francs, and then sold it to the Havemeyers on September 19 of that year for 55,000 francs. In January 1898 the final version of *The Execution of Maximilian* (1868–69, Kunsthalle Mannheim) sold for 8,000 francs, again to Durand-Ruel, who in turn sold it to Denys Cochin several months later for 12,000.
7. First Tabarant (1931), then Rouart and D. Wildenstein (1975, vol. 2, no. 249) mentioned a watercolor called *Bathers* (13.5 x 18 cm)—most likely *Small Boats*—in the collection of Pierre Renoir in 1947. Rouart and D. Wildenstein (1975, vol. 2, no. 234) catalogue a *Port of Bordeaux* (watercolor, 18 x 24 cm), without a Renoir provenance, as having been painted by Manet in February 1871 from a hotel window on the quai des Chartrons; it was then in the collection of Jeanne Castel. The current location of both these works is unknown.
8. Degas bought a Delacroix, most likely a drawing, for 50 francs on June 25, 1894: Vollard Archives, MS 421 (4,3), fol. 1.
9. *Woman with a Cat (Portrait of Madame Manet);* see note 5 above.
10. Vollard 1919b, p. 9. Vollard called the painting "portrait of a man camped in the middle of the Bois de Boulogne"; it is probably *Monsieur Armand Brun* (1880, National Museum of Western Art, Tokyo; Rouart and D. Wildenstein 1975, vol. 1, no. 326), which Degas bought from Vollard on July 16, 1895, according to New York 1997–98, vol. 2, no. 795. Vollard also asked Gustave Geffroy about the model's identity, as shown by a letter to the critic dated October 16, 1894, reproduced in the illustrated edition of Vollard's memoirs; Vollard 1957, pp. 57–58.
11. J. Renoir 1962, p. 304.
12. See Vollard Archives, MS 421 (4,3), fol. 37, December 12, 1895, which records that he paid 2 francs to Foulard, his usual restorer, for "remounting 2 small canvases by Renoir."
13. For example, Vollard paid him 1,500 francs in October 1895, whereas Durand-Ruel had bought nothing from him since June and would not make a new purchase until the beginning of December: Vollard Archives, MS 421 (4,3), fols. 33, 34; Archives Durand-Ruel, Paris.
14. On November 14, 1895, Camille Pissarro bought "1 pastel by Renoir 2 little girls with hats, C. 33," valued at 400 francs, in exchange for one of his old landscapes; on April 29, 1896, Maufra bought "1 painted study by Renoir (577), 1 painted study by Renoir (584)," each valued at 75 francs, against a group of pastels: Vollard Archives, MS 421 (4,2), fols. 23, 31.
15. Madame Renoir received a Lebourg and an album "L.O.," presumably original lithographs referring to the *Peintre-graveurs,* for 350 francs on April 7, 1897, as well as a "beachscape by Renoir, 55 x 46" for 500 francs on July 26, 1899, and "4 sketches by Renoir" on July 31: Vollard Archives, MS 421 (4,3), fols. 70, 139.
16. Vollard's payment of 1,500 francs was made on February 9, 1899, to "Renoir (Robinet Mᵃᵈᵉ boulangère)": Vollard Archives, MS 421 (4,3), fol. 122. In 1893 Jeanne had married Mr. Robinet, a baker in Madré, in the Orne. This curious mystery is illuminated by Jean-Claude Gélineau (2002). Vollard would again serve as middleman on several occasions, at Renoir's express request.
17. With few exceptions, Vollard's sales in those years were for less than 500 francs, and he was obliged to wait for money to come in before he could invest anew. Bernheim-Jeune generally sold paintings for more than 3,000 and sometimes as much as 9,000 francs, which put the gallery on a par with Durand-Ruel.
18. Denis saw Cézanne's still life at the home of Dr. Viau, who owned it at the time (it had belonged first to Gauguin; see Vollard 1936, p. 62 and plate caption on the following page).
19. Archives Nationales, Paris, AP 430, 173*bis.*
20. Gimpel 1966, p. 56 (diary entry for August 15, 1918).
21. Vollard 1919b.
22. Vollard 1918. The idea for an album of Renoir's works reproducing photographs signed by the painter and certified by the Cagnes mayor's office had (for the older ones) dated at least to 1911.

Vollard and Degas

Gary Tinterow, with research by Asher E. Miller

In 1913 Mary Cassatt, the ever-sharp and plain-speaking observer of the Paris art market, put her finger on the essence of the relationship between Edgar Degas (1834–1917) and Ambroise Vollard:

> [Paul Durand-Ruel] . . . would not buy the things from Degas that Vollard gladly took and sold again at large profits. Vollard is a genius in his line he seems to be able to sell _anything_.[1]

She also clearly understood the ramifications of the transactions between the clever young dealer Vollard and Degas, "the greatest of living painters,"[2] who was nevertheless seventy-nine in 1913, feeble and no longer working. "Vollard says he has some of the finest Degas pastels. . . . As for old M. Durand Ruel he groans over Vollard buying Degas, thinks it dreadful of Vollard, but Degas is the one to blame."[3]

The Durand-Ruels, both father (Paul) and son (Joseph), had good reason to feel proprietary about Degas. Though they had no contract, their gallery had been the primary—though never exclusive—outlet for the works that Degas wished to sell since 1874.[4] During the 1870s and 1880s Degas wished to sell almost anything he made (with the notable exception of sculpture), and he even developed a new medium, pastelized monotypes, in order to generate up to three works from the same composition and thus increase his salable "articles," as he called his commercial output.[5] He needed the income because in addition to paying for an affluent bachelor's life— three to five nights a week at the opera, models, and a maid whose tasteless macaroni and veal was dreaded by all[6]—he undertook, with his brother-in-law Henri Fevre, to redeem the debts accumulated at his father's bank by his profligate brother René.[7] It was not uncommon for Degas to send his maid or a porter to Durand-Ruel, pastels in hand, with a note demanding that the dealer hand over 500 francs in cash to the bearer. Degas treated the gallery like his private bank, depositing work and withdrawing cash. He never shrank from asking Durand-Ruel to pay his bills or to buy something—usually a work of art—that he wanted. Characteristically, he reproached

Paul Durand-Ruel in a note of 1886: "*One* delays coming to see the pastel, [therefore] I am sending it to you. . . . Please send me some money *this afternoon*. Try and give me half the sum each time I send you something. Once my fortunes have been restored I might well keep nothing for you and so free myself completely from [your] debt."[8] On average Degas withdrew about 500 francs three times a month from Durand-Ruel. His account was often overdrawn.

By the 1890s Degas was no longer compelled to generate sales to repay his brother's debts, but he embarked instead on a spending campaign that would result in one of the most significant collections of nineteenth-century French paintings and drawings ever assembled by a living painter. In little more than a decade, from the early 1890s to about 1904, Degas accumulated some twenty paintings and eighty drawings by Ingres, thirteen paintings and more than two hundred drawings by Eugène Delacroix, seven works by Camille Corot, hundreds of prints by Honoré Daumier and Constantin Guys, and important groups of works by his contemporaries Mary Cassatt, Paul Cézanne, Paul Gauguin, Vincent van Gogh, Édouard Manet, and Camille Pissarro.[9]

It was Degas the grand acquisitor, not Degas the fabricator of "articles," who in 1894 first walked into Vollard's gallery

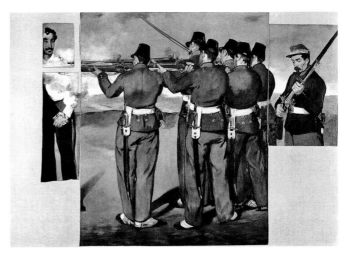

Fig. 167. Édouard Manet, *The Execution of Maximilian, Emperor of Mexico*, ca. 1867–68. Oil on canvas, four fragments mounted together, 76 x 111⅞ in. (193 x 284 cm). National Gallery, London (NG 3294)

Opposite: Fig. 166 (cat. 55). Edgar Degas, *Dancers at the Barre*, ca. 1900–1905. Oil on canvas, 51 x 38 in. (129.5 x 96.5 cm). The Phillips Collection, Washington, D.C., acquired 1944

at 37, rue Laffitte, just down the hill from his own apartment in the rue Ballu.[10] Among his contemporaries, Manet held a singular place in Degas's pantheon; Degas hoped to assemble a complete set of Manet's prints, and he bought the paintings, pastels, watercolors, and drawings that he could afford. On October 15, 1894, Degas, perhaps in the company of Auguste Renoir, bought Manet's *Woman with a Cat (Madame Manet)* (Tate Britain, London) from Vollard for 500 francs. Vollard noted a "payment in merchandise," an exchange of work.[11] Two weeks later Degas returned to buy another Manet. He had already acquired a fragment (presumably cut by Manet's widow and her son to facilitate sale) of Manet's *Execution of Maximilian* (fig. 167) from Alphonse Portier and had probably heard about the remaining pieces from the picture restorer. Vollard recounted the meeting thus:

> With his hand on [the Maximilian fragment] by way of taking possession, [Degas] added: You're going to sell me that. And you'll go back to Mme Manet and tell her I want the legs of the sergeant that are missing from my bit, as well as what's missing from yours: the group formed by Maximilian and the generals. I'll give her something for it.[12]

Of the nine oils by Manet in Degas's collection, four were bought from Vollard. Apart from the small oil painting of a pear bought at auction, Degas paid for all of his Manet paintings and one large pastel through exchanges of his own work.[13]

The first mention in Vollard's business papers of the sale of a Degas is a reference to a "dessin de Degas" sold for 800 francs to a Monsieur Dufau on July 2, 1894.[14] It is impossible to discern where Vollard obtained the drawing, perhaps at auction or perhaps through a runner or an acquaintance. But when Vollard began to sell Manets to Degas, he concurrently opened a new source of inventory. Degas paid for Manet's *Portrait of Armand Brun* (National Museum of Western Art, Tokyo) with five of his own works (three pastelized monotypes at 400 francs each, one at 500, and a pastel valued at 2,000).[15] Vollard sold three of these three months later to Milan, Count of Takovo, at his customary markup: a 400-franc pastelized monotype, for instance, was resold for 900.[16]

Vollard may not yet have known that the bather and brothel scenes Degas brought to him for exchange were the kind of work that Durand-Ruel typically shunned. Degas made several hundred pastels, drawings, and monotypes of female bathers (bourgeois women as well as prostitutes) in the 1880s and 1890s; Durand-Ruel bought only a dozen or so. Theo van Gogh had purchased several bathers for Galerie Boussod-Valadon, but that association ended with Van Gogh's death in 1891. Vollard eagerly accepted licentious scenes such as *Three Seated Girls Awaiting a Client* (Rijksmuseum, Amsterdam) and *Three Prostitutes (Two Making Love)* (whereabouts unknown) and seemed to sell them on average within a year of acquiring them. Moreover, after the posthumous sales of Degas's studio in 1918, Vollard contacted the purchasers of the brothel monotypes (Vollard bought some himself) and reproduced them to illustrate editions of Guy de Maupassant's account of a modern brothel, *La Maison Tellier* (fig. 169) and an account of prostitution in the antique era, *Mimes des courtisanes* by Lucian of Samosata (1935). In his memoirs Vollard recounted the difficulty of reproducing these subtle masterpieces, "little *plats du jour*, as Degas called them."[17] Vollard recalled that Renoir, who owned a brothel scene, had remarked that "any treatment of such subjects is likely to be pornographic, and there is always a desperate sadness about them. It took a Degas to give to the *Name Day of the Madam* [fig. 170] an air of joyfulness, and at the same time the greatness of an Egyptian bas-relief."[18]

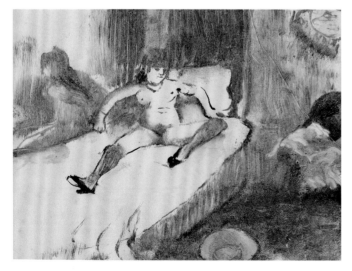
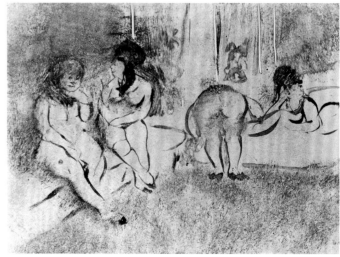

Above and facing page: Fig. 168 (cats. 59–66). Edgar Degas, Brothel scenes, ca. 1878–80. Monotypes in black ink. Musée Picasso, Paris (RF 35783–35788, 35790, 35792). *Above: Waiting* (cat. 60); *Waiting* (cat. 61); each, image 4¾ x 6½ in. (12.1 x 16.4 cm)

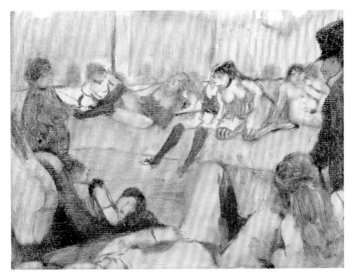

In a Brothel Salon (cat. 63), image 6¼ x 8½ in. (15.9 x 21.6 cm)

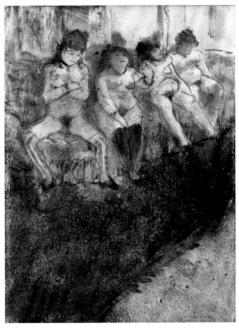

Waiting, second version (cat. 62), image 6½ x 4¾ in. (16.4 x 12.1 cm)

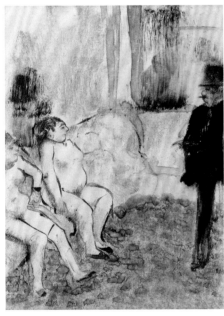

The Client (cat. 65), image 6½ x 4¾ in. (16.4 x 12.1 cm)

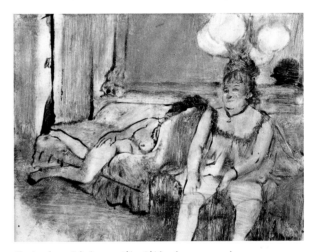

Resting (cat. 64), image 6¼ x 8¼ in. (15.9 x 21 cm)

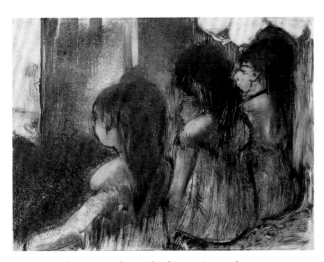

Three Seated Girls Seen from Behind (cat. 59), pastel over monotype, image 4¾ x 6¼ in. (12.1 x 16.4 cm)

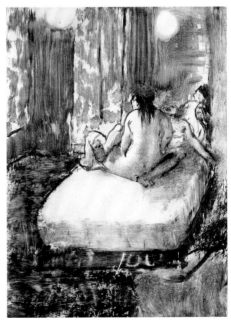

On the Bed (cat. 66), image 8½ x 6¼ in. (21.6 x 15.9 cm)

GUY DE MAUPASSANT

LA MAISON TELLIER

ILLUSTRATIONS D'EDGAR DEGAS

PARIS
AMBROISE VOLLARD, ÉDITEUR
28, RUE DE MARTIGNAC, 28
MCMXXXIIII

Fig. 169 (cat. 67). Edgar Degas, *La Maison Tellier,* by Guy de Maupassant, 1934. Book illustrated with 19 etchings and aquatints after monotypes and 17 wood engravings after drawings, page 12¹³⁄₁₆ x 9¹⁵⁄₁₆ in. (32 x 25.2 cm). The Museum of Modern Art, New York, The Louis E. Stern Collection, 1964 (773.1964)

All of the Cézannes in Degas's collection came from Vollard—seven paintings and one, perhaps two, works on paper, bought between November 1895 and 1897. For Degas, Cézanne's painting was a revelation. As Pissarro wrote to his son on November 21, 1895, "Degas himself is seduced by the charm of this refined savage."[19] That is not to say that Degas forgot the prejudices he had formed—when he bought Cézanne's *Portrait of Choquet* he described it to Renoir as "the portrait of one madman by another"[20]—it is rather that he could appreciate the paintings even if he would not have chosen to dine with the painter. Degas drew straws with Renoir to see who could buy a Cézanne watercolor of pears (fig. 8).[21] Whether Degas paid for the Cézannes with cash or work is not certain: a typical small painting by Cézanne was valued at 400 francs, the price of a monotype by Degas. Nevertheless, the Vollard papers do not show exchanges for the Cézannes, and the prices were affordable. Degas also acquired from Vollard two still lifes by Van Gogh, in 1895, and two of his eleven canvases by Gauguin, *Sulking* and *The Bathers* (fig. 75), in 1898. For the Van Gogh *Two Sunflowers* (Kunstmuseum, Bern), Degas exchanged two drawings of dancers valued at 400 francs.[22] For the two Gauguins (a total of 800 francs), he appears to have given Vollard 200 francs and a pastel valued at 1,000 francs.[23] Degas may have been at the root of Vollard's

Fig. 170 (cat. 58). Edgar Degas, *The Name Day of the Madam,* 1878–79. Pastel over monotype, image 10½ x 11⅛ in. (26.6 x 29.6 cm). Musée Picasso, Paris (RF 35791)

purchase of the contents of Gauguin's studio in 1896, for Degas took an avuncular interest in the younger artist.[24]

The impact of these purchases on Degas's own art has been explored elsewhere.[25] But the experience of buying Manets, Cézannes, Van Goghs, and Gauguins from Vollard appears to have cemented a cordial relationship between him and the dealer. In the mid-1890s Degas warmed to Vollard in a way that he never did to Durand-Ruel, *père et fils*. The two bachelors, one in his early sixties, the other in his early thirties, may have shared an approach to life very different from that of the reserved, family-oriented Durand-Ruels. Vollard's date-books record several dinners with Degas, and his souvenirs relate how demanding a guest Degas could be: the meal could have no butter, the famous cat was banished, guests could bring no dogs, flowers were banned, and women were even prohibited from wearing perfume. "How horrible all those odors are when there are so many things that smell really good, like toast, and even manure!"[26] One can only wonder whether Vollard encouraged Degas's anti-Semitic remarks, which Vollard repeated with relish in his memoirs. But it is thanks to the dealer's reminiscences, first in his chatty, illustrated appreciation *Degas (1834–1917)* (1924) and later in his *Recollections of a Picture Dealer* (1936), that many insights into Degas's working practice and views on his contemporaries have been handed down.

Nevertheless, Vollard was never overly familiar with Degas. For example, he evidently hesitated to make Degas a business proposal in 1896, and Pissarro had to encourage him: "I told Vollard he ought to make Degas a proposition for his lithographs—no danger!"[27] Another sign of the businesslike distance between the two is that Vollard did not think twice about charging Degas his standard markup. Two examples should suffice: On April 10, 1895, Vollard recorded the purchase at auction for 105 francs of an album of Delacroix watercolors, which he sold to Degas for 200 francs on April 13.[28] And on March 20, 1897, Vollard bought an early Degas, a copy after Thomas Lawrence, at the Lepic sale for 1,050 francs. Degas wanted it back for his private collection of his own work, so Vollard sold it to him two months later for 2,000 francs, along with Manet's portrait of Berthe Morisot in mourning for an additional 1,000 francs.[29] (That a Degas copy after Lawrence should have sold for twice the price of an original Manet is fascinating.)

In the 1890s all of Degas's sales to Vollard were related (generally by exchange) to purchases, but Vollard also continued to acquire works by Degas on the open market and to resell them at good prices. However, while Degas charged both dealers comparable prices, Durand-Ruel charged his clients more than Vollard did his. For example, Durand-Ruel bought a good-sized pastel, *Danseuses en bleu,* from Degas for 8,000 francs on December 12, 1898. He sold it to Sergei Shchukin in 1903 for 50,000 francs. In contrast, the most expensive Degas that we have a record of Vollard selling in the first decade of the twentieth century was *Danseuses rouges,* which he sold in 1909 for 9,000 francs.[30]

The Vollard accounts are nearly silent on Degas from the end of 1899 to early 1906, thus depriving us of information on sales of his work to important collectors such as Shchukin and the Havemeyers (though these transactions can be partially reconstructed through external evidence). Vollard's purchases from Degas through 1908 were desultory, but in 1909 he bought ten pastelized drawings (six in April for 12,000 francs and four in June for the same amount), two large compositions (in September for 6,000 francs), and a single large pastel (in October for 4,000 francs). In 1910 Vollard paid Degas 16,300 francs in June and 20,000 francs in December.[31] In 1911 the sums were even larger: 82,000 francs in January; 20,000 francs in May; 85,000 francs in September. Facing eviction from his apartment at 37, rue Victor Massé in early 1912, Degas sold six pastels for 100,000 francs (on January 12), five works for 50,000 (on January 18), and seven works for 60,000 (on February 5).[32] These would be Vollard's last direct purchases from Degas.

In this same period, Degas ceased to make new work and placed in storage with Durand-Ruel the large canvases in his collection. While Degas continued to rely on Durand-Ruel for some services, in the years just prior to his final move he seems to have lived primarily on the income from his sales to Vollard. The last dinner with Degas that Vollard recorded was on June 7, 1912.[33] "I walk well. But since I moved I no longer work," Degas told his young friend Daniel Halévy on December 10, 1912.[34] A year later, Cassatt called Degas, whose sight was failing, "a mere wreck."[35]

By 1913, when Cassatt wrote Louisine Havemeyer about Vollard's success in teasing items from the reluctant Degas, the dealer had indeed acquired a large stock of impressive late work. He embarked on two projects the likes of which Durand-Ruel had never ventured:[36] he created an album of reproductions titled *Degas: Quatre-vingt-dix-huit reproductions signées par Degas (peintures, pastels, dessins et estampes),* consisting of photographs commissioned in recent years from the Paris photographer Étienne Delétang, and he consigned a considerable stock of Degases, most of which had been acquired in the previous two years, to the exhibition "Degas/Cézanne" held by Paul Cassirer at his Berlin gallery in November 1913. With the aid of Cassirer's partly illustrated catalogue and the 1914 "Album Vollard," one can well appreciate the modernity of the exhibition.[37] It is likely that most of the works in the "Album Vollard" were made in the twentieth century, and

Fig. 171 (cat. 56). Edgar Degas, *Russian Dancer,* 1899. Pastel over charcoal on tracing paper, 24⅜ x 18 in. (62 x 45.7 cm). The Metropolitan Museum of Art, New York, H. O. Havemeyer Collection, Bequest of Mrs. H. O. Havemeyer, 1929 (29.100.556)

some, such as *Dancers in the Wings* (St. Louis Art Museum) could well have been made between 1910 and 1912, nearly a decade later than is commonly thought.[38] In Berlin, where the painter Max Lieberman and Nationalgalerie director Hugo von Tschudi encouraged collectors to covet the latest developments from Paris, Degas's late work, pulsating with electric color and bold summary contours, must have appeared advanced, even compared to the recent work of Matisse and Picasso that also made its way to Berlin. The art museum in Dresden immediately purchased a large, vibrant pastel of dancers, and other works found their way to German collections. Astute collectors outside France, notably in Russia, Scandinavia, and Germany, responded eagerly to Degas's late work, whereas French collectors, conditioned perhaps by Durand-Ruel's preference for early works with highly finished surfaces (*léchées*), eschewed it.

Vollard's album of ninety-eight reproductions provides a useful glimpse into the work that Degas sold to the young dealer, and at first glance, it confirms Mary Cassatt's appraisal: the late works, astounding in their strength but violent in their strong color and slashing lines, are precisely the kind that Durand-Ruel avoided.[39] The album itself, however, is disappointing. Unlike George William Thornely's handsome lithographic reproductions, published in 1888, or Michel Manzi's extraordinary heliographic reproductions of Degas's drawings and pastels, Vollard's album is gray and lifeless. Nevertheless, in 1913 or early 1914

Fig. 172 (cat. 54). Edgar Degas, *Racehorses,* ca. 1895–99. Pastel on tracing paper, 22 x 25½ in. (55.8 x 64.8 cm). National Gallery of Canada, Ottawa, Purchased 1950 (5771)

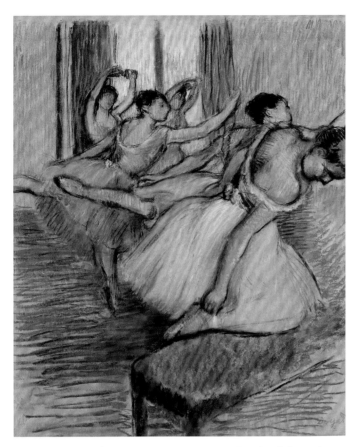

Fig. 173 (cat. 57). Edgar Degas, *Dancers,* ca. 1900. Pastel and charcoal on paper, 28 x 23¼ in. (71.1 x 59.1 cm). The Metropolitan Museum of Art, New York, Gift of George N. and Helen M. Richard, 1964 (64.165.1)

Degas cooperated by re-signing each of the photographic plates, establishing the authenticity of these startling works.

Vollard was one of the hundred mourners, "a little crowd of friends and admirers,"[40] who followed Degas's casket to Montmartre Cemetery on September 28, 1917. By December he had been named to supervise the sale of the contents of Degas's studio and private collection, alongside Joseph Durand-Ruel, who commented, "Vollard and I were astonished by the considerable number of superb drawings and pastels that Degas had never shown anyone."[41] Not everyone concurred, however. The dealer René Gimpel wrote, "Seeing these paintings destroyed one of my illusions. . . . There are some pretty pastels, some very fine paintings, but very many elementary studies that tell us nothing, mere notes for the artist alone; numerous pastels which are quite incomplete or partially effaced—evidence of shocking carelessness and neglect." Gimpel then broached an issue that has ever since haunted the story of Vollard and Degas. "Some pastels are covered over in thirty years' accumulation of dust, so much so that Durand-Ruel, in an effort to prevent forgers if possible from finishing these pastels and even the paintings, has had very detailed photographs taken of all the Degas."[42] Mary Cassatt worried about this as well, and wrote with relief to Louisine Havemeyer, "As to the Degas sale it was perfectly genuine,

and not one single touch has been added to the pictures or the pastels."[43]

The photographs that Vollard and Durand-Ruel had made were reproduced in the sales catalogues and used again by Paul Lemoisne in his preparation of the monumental four-volume catalogue raisonné that was published in Paris upon the close of the Second World War.[44] Vollard bought heavily at the sales, 261 lots at all four sales compared to Durand-Ruel's 165 lots. In order to guarantee the success of the sales, which commenced in wartime Paris with German cannons audible in the distance, Vollard and Durand-Ruel brought in two competitors, Jacques Seligmann and the Bernheim brothers, as co-experts. Together, the four firms bought an additional 69 lots. Vollard bought unusual early works as well as later drawings and pastels that related to works that Degas had sold him during his life. He bought some magnificent late canvases, daring in their *non finito.* He also bought monotypes and some of the brothel scenes that escaped destruction by the artist's brother, René Degas. But in all instances the works Vollard bought were inexpensive. Many were unfinished. Art historians have subsequently noticed that some works owned by Vollard—those bought from Degas and reproduced in Vollard's 1914 album as well as items bought at the 1918–19 studio sales—have been reworked by a hand other than Degas's and no longer resemble their earliest reproductions, manifestations of precisely what Cassatt and others feared.[45]

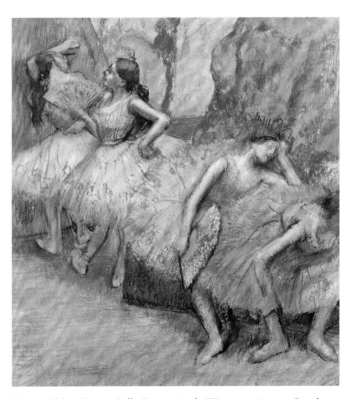

Fig. 174. Edgar Degas, *Ballet Dancers in the Wings,* ca. 1890–95. Pastel, 28 x 26 in. (71.1 x 66 cm). St. Louis Art Museum, Museum Purchase (24:1935)

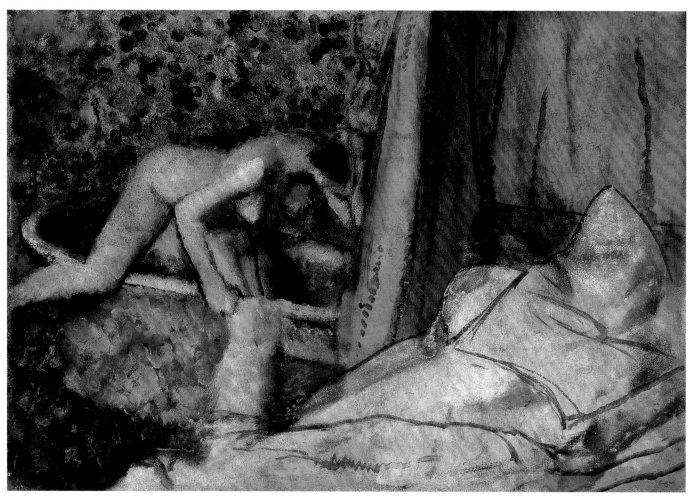

Fig. 175 (cat. 52). Edgar Degas, *The Bath,* ca. 1895. Oil on canvas, 32 x 46¼ in. (81.3 x 117.5 cm). Carnegie Museum of Art, Pittsburgh, Acquired through the generosity of Mrs. Alan M. Scaife, 1962 (62.37.1)

Over the next twenty years, Vollard sold many of the Degases he bought at the studio sales, though others remained in his hands and have since been passed to his heirs. But his primary involvement with the artist after his death was literary. Using his copious archives as a resource, he published his warm, somewhat wicked appreciations of Degas in 1924 and 1936 and used Degas's monotypes (figs. 168, 170) to illustrate

La Maison Tellier (fig. 169) and *Mimes des courtisanes* in 1935 and 1936, bringing these little-known works to the attention of other artists in his circle, notably Pablo Picasso. And in 1938 he published the most elegant examination of Degas's art, Paul Valéry's *Degas, Danse, Dessin.* Thanks to Vollard's efforts, a very human Degas, grand in his imperfections, has been recorded for posterity.

The story of the Degas studio sales, and Vollard's important role therein, is told in the exhibition catalogue *The Private Collection of Edgar Degas* (New York 1997–98). An attempt has been made to update that catalogue in the notes and appendices to this essay, although limited space has not permitted integrating all the information to be gleaned from the newly available Vollard Archives.

In this essay, the following abbreviations are used for citing catalogue raisonné numbers: for works by Degas, "L" refers to Lemoisne 1946–49; for works by Cézanne, "R" refers to Rewald 1996; for works by Gauguin, "W" refers to G. Wildenstein 1964.

1. Mary Cassatt to Louisine Havemeyer, December 4, 1913, transcript in Weitzenhoffer files, Department of European Paintings, Metropolitan Museum; quoted in Mathews 1984, p. 313.
2. Vollard 1936, p. 29, quoting the painter John Lewis-Brown.
3. Mary Cassatt to Louisine Havemeyer, March 30, 1913, transcript in Weitzenhoffer files, Department of European Paintings, Metropolitan Museum.
4. Degas was never faithful to a single dealer, nor was a dealer ever faithful to him. In the 1870s he had some dealings with Charles Deschamps, Adrien

Beugniet, and Theo van Gogh at the firm of Boussod-Valadon. Durand-Ruel bought heavily from Degas in 1872 but then bought virtually nothing until December 27, 1880. Durand-Ruel made regular purchases throughout the 1880s. By the end of the decade Degas was also selling to Theo van Gogh at Boussod-Valadon, Hector Brame, Alphonse Portier, and someone named Clauzet; in the 1890s he sold to Bernheim-Jeune as well as Vollard.
5. Starting in 1876 Degas would typically make a rich black-and-white monotype and a colored version, sometimes two, by applying pastel over the faint second and third proofs of the monotype. The pastelized monotypes often varied markedly from the underlying monotype, one example being the *Ballet Rehearsal* (L 365) in the Nelson-Atkins Museum of Art, Kansas City.
6. Valéry 1960, p. 21. Vollard records dinner dates with Degas on November 11, 1908, and January 15 and June 7, 1912: Vollard Archives, MS 421 (5,3), fol. 189, and MS 421 (5,8), fols. 8, 103.
7. A judgment was rendered in January 1877 requiring Degas and Fevre to repay a total of 40,000 francs in monthly installments. Rewald 1946, pp. 122–23, cited in Paris–Ottawa–New York 1988–89, p. 215.
8. Degas to Paul Durand-Ruel, August 13, 1886, in Guérin 1947, p. 121, no. 106; see also Guérin 1945, p. 123, no. xcvi *bis.*

9. Fully explored in New York 1997–98.
10. Between October 1894 and November–December 1898 Degas acquired, in this order, the following works of art from Vollard:
 a. Delacroix, unidentified work. Bought for 50 francs cash "au comptant" on June 25, 1894: Vollard Archives, MS 421 (4,3), fol. 1.
 b. Manet, *Woman with a Cat (Madame Manet)*, ca. 1880, Tate Britain, London; New York 1997–98, vol. 2, no. 799. Acquired on October 15, 1894, in exchange for a pastel worth 500 francs: Vollard Archives, MS 421 (4,2), fol. 5.
 c. Manet, *The Execution of Maximilian* (central fragment; fig. 167), New York 1997–98, vol. 1, pp. 20, 24, vol. 2, no. 796. Acquired on October 29, 1894, in exchange for "marchandises" worth 2,000 francs: Vollard Archives, MS 421 (4,2), fol. 6. An anecdote recounting Degas's encounter with this work is related in Vollard 1936, pp. 54–57.
 d. Delacroix, unidentified watercolor. Acquired on November 7, 1894, "Degas—aquarelle de Delacroix achetée au comptant 20 [francs]": Vollard Archives, MS 421 (4,3), fol. 7.
 e. Manet, tentatively identified as *Bazaine before the War Council*, 1873, Museum Boijmans Van Beuningen, Rotterdam; New York 1997–98, vol. 2, no. 804. Acquired on December 24, 1894, "Degas, un croquis de Manet, et un meuble [vendu] au comptant 150 [francs]": Vollard Archives, MS 421 (4,3), fol. 11. The item of furniture has not been identified.
 f. Delacroix, unidentified album of drawings. Purchased by Vollard at Hôtel Drouot for 105 francs: Vollard Archives, MS 421 (4,3), fol. 19, April 11, 1895. Sold to Degas two days later as "album de croquis de Delacroix celui acheté à l'Hotel Drouot (folio 19) c. 200 [francs]": Vollard Archives, MS 421 (4,2), fol. 11. This was possibly the album described by Degas in his inventory (private collection) as "petit album vert / 11? c – 6? / 20 feuilles / petits traits d'après statues"; see New York 1997–98, vol. 2, pp. 49–50.
 g. Manet, *Monsieur Armand Brun*, 1880, National Museum of Western Art, Tokyo; New York 1997–98, vol. 2, no. 795. Described by Vollard as "tableau de Manet, portrait d'homme / grandeur nature, chapeau gris, jaquete violet pantalon blanc" and acquired by Degas on July 16, 1895, for one pastel and four pastelized monotypes worth 3,700 francs: Vollard Archives MS 421 (4,2), fol. 16. In the account book entry the Degas pastel is described as "femme nue renversée sur un fauteuil, la tête perdu, en train de se faire coifer [*sic*] dans son cabinet de toilette 36 x 29 signé en haut à droite 2,000 [francs]." The "zinc rehaussé femme nue vue de dos enlevant sa chemise 500" may be identical with one on the New York art market in 1985 (L 554; "Album Vollard" 1914, pl. 31). The brothel scene Vollard described as "zinc rehaussé trois femmes assises attendant le client 400" has not been identified but is likely no. 3617 in Stockbook A, where it is described as "provenance Degas . . . 16 x 20, 390 [francs]." The "zinc à [fond?] jaune trois femmes trois femmes [*sic*] postures differents 400 [francs]" has not been identified, either.

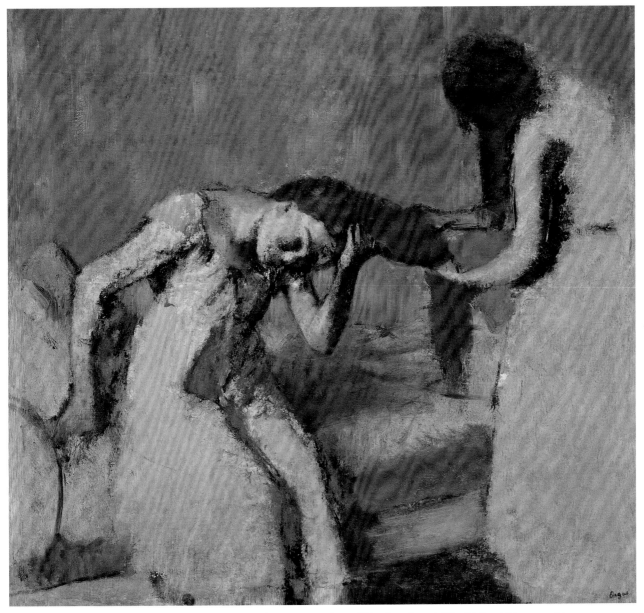

Fig. 176 (cat. 53). Edgar Degas, *The Coiffure*, 1892–95. Oil on canvas, 32¼ x 34¼ in. (82 x 87 cm). The National Museum of Art, Architecture, and Design, Oslo (NG. M. 01292)

The "zinc entièrement repris au pastel 2 femmes sur un lit, [faisant] la causette 400" may be the one now in the Bibliothèque d'Art et d'Archéologie, Fondation Jacques Doucet, Paris (BAA Degas 9); see "Album Vollard" 1914, pl. 16; Janis 1968, checklist, no. 68.

h. Van Gogh, *Two Sunflowers,* 1887 (Kunstmuseum, Bern); New York 1997–98, vol. 2, no. 596. Acquired on October 29, 1895, in exchange for two sketches of dancers valued at 400 francs: Vollard Archives, MS 421 (4,2), fol. 22. Vollard had received the painting on consignment from Gauguin the prior February.

i. Van Gogh, *Still Life with Apples, Pears, Lemons, and Grapes,* 1887 (fig. 53); New York 1997–98, vol. 2, no. 595. Possibly acquired about the same time as *Two Sunflowers* (10h).

j. Van Gogh, *Peasant Woman Gleaning,* 1885, probably Sotheby's, London, May 4, 1960, no. 183; New York 1997–98, vol. 2, no. 597. Probably acquired from Vollard, possibly about the same time as Degas's other Van Goghs.

k. Cézanne, *Bather with Outstretched Arms,* ca. 1883, Jasper Johns collection; New York 1997–98, vol. 2, no. 111. Acquired on November 20, 1895; described by Vollard as "'baigneur' de Cézanne (32 x 34) 200 [francs]": Vollard Archives, MS 421 (4,2), fol. 24. See also Vollard Archives, MS 421 (4,4), fol. 4, March 1896.

l. Cézanne, *Three Pears,* ca. 1888–89 (fig. 8); New York 1997–98, vol. 2, no. 115.

m. Cézanne, *Apples,* 1875–77, on loan to Fitzwilliam Museum, Cambridge; New York 1997–98, vol. 2, no. 109. This still life and *Three Pears* (10l) were sold to Degas on November 29, 1895, as "aquarelle de Cezanne (poires / une assiette) 100 [francs]" and "etude de Cezanne peinture 7 pommes 200 [francs]": Vollard Archives, MS 421 (4,2), fol. 25. See also MS 421 (4,4), fol. 4 (*Apples* only). For an anecdote about Degas's acquisition of *Three Pears,* see note 21 below. A third work, "tableau de Cézanne (Déjeuner sur l'herbe / 80? x 59?) (manière noir)," priced at 600 francs, was also recorded on November 29, 1895, and subsequently struck out; see London–Chicago 1996–97, pp. 148, 307, n. 130 (as probably Venturi 1936, no. 130).

n. Cézanne, *Glass and Apples,* 1879–82 (fig. 240); New York 1997–98, vol. 2, no. 113. Acquired on January 6, 1896, as "toile de Cézanne (pommes, linge et verre) 400 [francs]": Vollard Archives, MS 421 (4,2), fol. 27.

o. Cézanne, *Two Fruits,* ca. 1885, Galerie Yoshii, Tokyo; New York 1997–98, vol. 2, no. 112. Acquired on March 19, 1896, as "étude de Cézanne (une poire, un citron une ? assiette) 200 [francs]": Vollard Archives, MS 421 (4,2), fol. 32.

p. Cézanne, *Victor Chocquet,* ca. 1877, Virginia Museum of Fine Arts, Richmond; New York 1997–98, vol. 2, no. 114. Acquired on May 6, 1896, as "toile de Cézanne portrait Choquet (107) 150 [francs]": Vollard Archives, MS 421 (4,2), fol. 32. See also Julie Manet, diary entry for July 1, 1899, in R. de B. Roberts and J. Roberts 1987, p. 177.

q. Degas, *Miss Murray, after Thomas Lawrence* (private collection); see Tinterow 1997, p. 106, n. 26. Sold to Degas on May 22, 1897, for 2,000 francs: Vollard Archives, MS 421 (4,2), fol. 40. Vollard had acquired it from the sale of the painter's friend Ludovic Lepic, March 20, 1897, no. 50, for 1,050 francs.

r. Manet, *Berthe Morisot in Mourning,* 1874, private collection; New York 1997–98, vol. 2, no. 798. Sold to Degas on May 22, 1897, for 1,000 francs: Vollard Archives, MS 421 (4,2), fol. 40.

s. Cézanne, *Venus and Cupid,* 1873–75, Takei Art Museum, Kurioso, Japan; New York 1997–98, vol. 2, no. 108. Sold to Degas as "peinture de Cezanne (nymphe et amour) 150 [francs]" on June 15, 1897: Vollard Archives, MS 421 (4,2), fol. 40.

t. Gauguin, *Sulking (Te faaturuma),* 1891, Worcester Art Museum; New York 1997–98, vol. 2, no. 481. Purchased on November 11, 1898, for 300 francs.

u. Gauguin, identified as *The Bathers,* 1897 (fig. 75); New York 1997–98, vol. 2, no. 487. Degas's relations with Vollard at this time come into focus with an examination of the fragmentary evidence about the artist's acquisition of this painting and *Sulking* (10t). On November 25, 1898, when Degas purchased the *Bathers* picture, Vollard wrote in his account book, "Degas à cpte / Gauguin négresse(s?) à 500 [francs] . . . 200 [received]": Vollard Archives, MS 421 (4,3), fol. 114. Given the predilection for lacunae in Vollard's recordkeeping, how much Degas actually owed by November's end remains unclear, although on the face of it the balance due at this point was 600 francs. Yet, although no payment in cash or by check is recorded, Vollard seems to have considered the matter closed by the end

of the month, when he posted a net profit of 350 francs and 100 francs on two Gauguins—*Bathers* and *Sulking,* respectively—sold to Degas: Vollard Archives, MS 421 (4,4), fol. 33. This suggests a promise on the part of Degas to pay for the balance of these two paintings in kind, that is, with a work of art, which is borne out by a notation in the Vollard records for December 28 of the receipt of a "Degas pour solde de compte un dessin pastellisé / danseuse rose, valeur mille francs": Vollard Archives, MS 421 (4,3), fol. 118. Such an explanation supports Degas's recollection of having acquired *Sulking* in December (rather than November), as recorded in his handwritten collection inventory (private collection). Another transaction sheds light on Degas's treatment of his dealers. On December 2, with the balance on the Gauguins presumably still in Vollard's favor, Degas received a loan from Vollard of 100 francs: Vollard Archives, MS 421 (4,3), fol. 115. Degas's request would seem to have put Vollard on the spot, which was indeed his long-standing modus operandi with Durand-Ruel. Reimbursement was made on December 13 (Vollard Archives, MS 421 [4,3], fol. 116), that is, exactly one day following Degas's sale of the spectacular pastel *Dans les coulisses (Danseuses en bleu)* (Pushkin State Museum of Fine Arts, Moscow; L 1274) to Durand-Ruel for 8,000 francs (sold to Sergei Shchukin on October 29, 1903, for 50,000 francs). The records show that years would pass before Degas offered Vollard works of this scale (see note 31 below). But at this relatively early stage, the business of November–December 1898 must have resonated in Vollard's circle: on January 15, 1899, Georges Chaudet mentioned the "échange" Degas made with Vollard to Gauguin himself. Loize Archives, Musée de Tahiti et des Îles, Punaanuia.

11. See note 10b above.
12. Vollard 1936, p. 55. See also note 10c above.
13. The sources for these pictures, other than Vollard, were Berthe Morisot and her husband, Eugène Manet, the artist's brother, as a gift (New York 1997–98, vol. 2, no. 794); the dealers Portier (the right-hand Maximilian fragment; ibid., no. 796), Manzi (ibid., no. 797), and Durand-Ruel (ibid., no. 800); auction (ibid., no. 801); and the artist himself, as a gift (ibid., no. 802).
14. Vollard Archives, MS 421 (4,2), fol. 2, and MS 421, (4,3), fol. 1. Degas is first mentioned as a customer in the Vollard Archives on July 25, 1894, in connection with his purchase of an unidentified work by Delacroix: Vollard Archives, MS 421 (4,2), fol. 1. See note 10a above.
15. See note 10g above.
16. The sale to Milan, who was known as the Count of Takovo, took place on October 10, 1895, and consisted of three works: "femme assise se peignant" and "femme nue debout" at 900 francs apiece and "femmes au canapé" for 540 francs: Vollard Archives, MS 421 (4,2), fol. 18. On March 31, 1890, Vollard sold Takovo a "dessin de Degas (495)" for 750 francs, together with a Monet pastel and two Cézanne watercolors: Vollard Archives, MS 421 (4,2), fol. 30. See also Vollard Archives, MS 421 (4,4), fol. 4, March 1896). Vollard's purchases at the Takovo sale are discussed by Anne Roquebert in her essay in this volume.
17. Vollard 1936, p. 258. Vollard indicated that René Degas destroyed some seventy of the brothel monotypes and that the remaining brothel scenes were not included in the Degas atelier sales, but in fact several were, including *In a Brothel Salon* (fig. 168), which Vollard bought at the sale, perhaps on behalf of Maurice Exteens, the next owner; see Degas Print Sale 1918, no. 222 (*Salon de maison close*).
18. Vollard 1936, p. 258.
19. Rewald and L. Pissarro 1972, p. 275.
20. See Julie Manet, diary entry for July 1, 1899, in R. de B. Roberts and J. Roberts 1987, p. 177.
21. Julie Manet, diary entry for November 29, 1895, in R. de B. Roberts and J. Roberts 1987, p. 76, and Camille Pissarro to his son Lucien, December 4, 1895, in Rewald and L. Pissarro 1972, p. 277. See also note 10l and m above.
22. See note 10h above.
23. See note 10t and u above.
24. Johnson 1977, p. 21.
25. See Tinterow 1997.
26. Vollard 1924a, pp. 3–4, 22–23.
27. Camille Pissarro to his son Lucien, July 16, 1896, in Rewald and L. Pissarro 1972, p. 293.
28. Vollard Archives, MS 421 (4,3), fol. 19, April 11, 1895, and MS 421 (4,2), fol. 11. See also note 10f above.
29. See notes 10q and r above.

30. This *Danseuses rouges* is the "danseuses" sold to the Budapest collector Marczell von Nemes, or de Nemes von Janoshaza (1866–1930) along with another Degas and works by Monet, Cézanne, Renoir, Gauguin, and Manet for a total of 87,000 francs; it was included in the von Nêmes sale held at Galerie Manzi-Joyant, Paris, June 17–18, 1913, no. 104. The work sold to von Nemes may be the one now in the Burrell Collection in the Glasgow Art Gallery and Museum (L 1250).

31. On June 1, 1910, Vollard paid Degas 16,300 francs, but the transaction is otherwise undescribed: Vollard Archives, MS 421 (5,5), fol. 89. This may have been belated payment of a 12,000-franc purchase made on June 14, 1909, as well as for additional works, perhaps including the rare first state of the etched *Self-Portrait* now in the Metropolitan Museum (1972.625) that he sold to Marcel Guérin on July 5, 1910, for 4,000 francs: MS 421 (5,4), fol. 121, and MS 421 (5,5), fol. 111. But another possibility also presents itself. It has long been supposed that it was around 1910 that Vollard purchased upwards of twenty cancelled etched plates from Degas, which he had printed in 1919–1920; see Shapiro 1984, pp. 264–66. The 16,300 francs may represent payment for these plates, and presumably the rights to reproduce them. The self-portrait could have been a gift from Degas to Vollard on this occasion.

32. Vollard Archives, MS 421 (5,8), fols. 6, 10, 22. A comparison of the total value in francs of Degas's recorded sales (including exchanges of works of art) to Durand-Ruel and to Vollard in the 1880s and 1890s is instructive:

Year	Durand-Ruel	D-R Notes	Vollard	V Notes
1881	9,000			
1882	14,650			
1883	6,875			
1884	6,880			
1885	6,525			
1886	5,600			
1887	800			
1888	4,800			
1889	1,350			
1890	7,300			
1891	14,900			
1892	22,200	No price given for one further work, "La repasseuse, v. 1874," February 29, 1892		
1893	29,200			
1894	11,200		2,500	
1895	14,380		4,100	
1896	43,000		—	
1897	19,000		—	
1898	34,000		1,000	
1899	28,000		—	
1900	15,500		—	
1901	19,000		—	
1902	23,000		—	
1903	—		—	
1904	1,000	No price given for one further work, "Danseuses attachant leurs sandales," September 19, 1904		
1905	25,000		—	
1906	9,200	total for year may be 9,300	—	
1907	—		—	
1908	—		9,000	
1909	10,000		34,000	
1910	—		20,000	Figure does not include 16,300 paid on June 1, which may be payment for 1909 purchases or else separate payment for approx. twenty etched plates
1911	?	One pastel "Danseuses," Sept. 11, 1911, no price given	207,000	
1912	—		210,000	
1913	—	Nine large works deposited, not included in the ventes	—	

33. See note 6 above.

34. Halévy 1964, p. 110.

35. Mary Cassatt to Louisine Havemeyer, December 4, 1913; see note 1 above.

36. Evidence suggests that in 1908 Cassatt had been helping Durand-Ruel accumulate works by Degas for an exhibition that never came to pass.

37. Berlin 1913; "Album Vollard" 1914. The importance of the little-known Cassirer exhibition was first signaled by Richard Kendall; see London–Chicago 1996–97. Twenty-six Degases are described and priced in two consignment lists compiled by Vollard and dated October 17 and 18, 1913 (Vollard Archives, MS 421 [5,9], fols. 163, 164), and in a further shipping record from the eighteenth (Vollard Archives, MS 421 [4,13], fols. 82–87), while the exhibition catalogue lists twenty-nine, some of which must have come from other sources, for example, no. 24, *Place de la Concorde (Vicomte Lepic and His Daughters)* (State Hermitage Museum, St. Petersburg). Only some of the works can presently be identified, in most instances by extrapolating from details in these lists, the catalogue text and illustrations, plates in the "Album Vollard," and other records in the Vollard Archives. In one case, for example, Cassirer gave a pastel the title "Sängerin," which must have been copied from documentation of Vollard's, where it is called "Chanteuse" (Vollard Archives, MS 421 [5,9], fol. 163, October 17, 1913); were it not reproduced by Cassirer in his catalogue (Berlin 1913, no. 21), we might never have known that it is actually a pastel of a dancer (whereabouts unknown; L 1350; "Album Vollard" 1914, pl. 79).

Only a few works in the Cassirer exhibition can be traced from Degas's studio to the present day; one such is the oil *Actress in Her Dressing Room* (Norton Simon Museum, Pasadena, F.1972.03.P; L 516; "Album Vollard" 1914, pl. 77), exhibited as no. 10, *Schauspielerin in der Garderobe*. This is undoubtedly "Actrice d[an]s la loge," one of three paintings purchased from Degas on September 19, 1911, for 15,000 francs: Vollard Archives, MS 421 (5,7), fol. 109. It is next found listed in Vollard's datebook on October 18, 1913, as "5144 Degas L'actrice peint": Vollard Archives, MS 421 (5,9), fol. 164. Vollard's archives contain many references to 5,000-series stock numbers, but as yet no stockbook serving as the key to these works has surfaced. *Actress in Her Dressing Room* is included in a shipping ledger entry for October 18, 1913, as no. 25, "actrice dans sa loge soixante mille francs" (Vollard Archives, MS 421 [4,13], fol. 85), before turning up illustrated in Cassirer's catalogue. It must eventually have been returned to Vollard unsold, as on June 15, 1915, the New York critic Henry McBride, who had been introduced to Vollard by Gertrude Stein, recorded in his notebook: "He showed us superb Degas pastels larger than any I had seen, quantities of them, and one painting of a woman in the Stevens-Manet costume at Mirror, her back in superb shadows. Very Venetian. Ought to be in a museum." Watson and Morris 2000, pp. 110–11; thanks to Rebecca Rabinow for calling attention to this quotation.

The 1913 Cassirer exhibition warrants full presentation. Walter Feilchenfeldt, the son of Cassirer's successor, intends to publish a study of the exhibition. We are grateful to him for providing a copy of the Cassirer catalogue.

38. L 1066; "Album Vollard" 1914, pl. 15.

39. According to Una Johnson, Vollard printed and assembled 800 copies of the album but the edition was taken over in 1918 by Bernheim-Jeune; see Johnson 1977, p. 158, no. 176. This may help to explain why Vollard distributed so few of the albums, according to his shipping ledgers for 1914 and immediately following, when he was sending out his books on Renoir hand over fist: Vollard Archives, MS 421 (4,13). The so-called "Album Vollard" was published initially by Vollard in 1914, and the remaining sets were issued by Bernheim-Jeune in 1918 with the addition of colorplates.

40. Mary Cassatt to Louisine Havemeyer, October 2, 1917, transcript in Weitzenhoffer files, Department of European Paintings, Metropolitan Museum; quoted in New York 1997–98, vol. 1, p. 99.

41. Joseph Durand-Ruel to Georges Durand-Ruel, December 4, 1917, in Godfroy 1997, pp. 268–69.

42. Gimpel 1966, p. 10 (diary entry for March 20, 1918).

43. Mary Cassatt to Louisine Havemeyer, June 26, 1918, transcript in Weitzenhoffer files, Department of European Paintings, Metropolitan Museum; quoted in New York 1997–98, vol. 1, p. 101.

44. Lemoisne 1946–49.

45. Two examples are now owned by the Metropolitan Museum: *Two Dancers, Half-Length* (1974.356.31) and *Dancers* (fig. 173).

Vollard and Rouault

Rebecca A. Rabinow

The relationship between Ambroise Vollard and Georges Rouault (1871–1958) bridged more than thirty years. No other artist worked in as close proximity to Vollard for as long a time. In 1913 Vollard offered to purchase hundreds of pictures from the artist's studio. Soon thereafter, during the turbulent years of the First World War, Rouault helped safeguard Vollard's stock. In the 1920s and 1930s Rouault worked in studios located on the top floors of Vollard's rue Martignac town house. For decades the two men were bound together by hundreds of unfinished paintings and numerous illustrated book projects. Rouault exhibited a perfectionist's reluctance to sign off on his work, which frustrated Vollard, who wished to sell it. In turn, the artist was exasperated by Vollard's lack of organization and somewhat compulsive need to undertake many projects simultaneously. Despite threatened lawsuits and harsh words, their collaboration ended only with Vollard's death in 1939. Throughout it all, Vollard remained convinced of Rouault's artistic genius.

In his memoirs Vollard recalled his encounters in the mid-1890s with Rouault, a quiet young man with a short red beard who wore a hooded cape fastened with large metal buckles.[1] In the summer of 1907, impressed by Rouault's watercolors and ceramics, Vollard inquired about the price of one of his tea services and a frieze composed of three plaques.[2] He also requested exclusive rights to produce ceramics with Rouault. Rouault declined to enter into a contract with Vollard but sold him a few items, some of which presumably were included among Vollard's loans to the Salon d'Automne a few months later.[3] Rouault and Vollard's interaction increased over the following years. The artist occasionally partook of the dealer's famous lunches ("the menu is not very varied but it is excellent: *riz à la créole,* usually with pigeon or light meat and vegetables")[4] and acted as an intermediary for his friend the author André Suarès, who was intrigued by Cézanne's art.[5] In the meantime, Rouault was busy working both as an artist and as the curator of the Musée Gustave Moreau, a museum

devoted to the memory of his former teacher.[6] In July 1913 it was clear to him that Vollard was seriously interested in acquiring some of his work.[7] Not long thereafter Vollard offered to purchase the contents of Rouault's studio, which amounted to 770 "paintings, distempers, studies, etc." in various stages of completion.[8] The agreed-upon price was to be paid in installments as works were finished, but the outbreak of World War I delayed any monetary transactions, and Rouault did not receive the 49,510 francs due him until May 1917.[9]

Rouault was instrumental in safeguarding Vollard's stock during the war years. At Vollard's request Rouault spent days scouting the French countryside for a potential safe house.[10] He tried in vain to convince Vollard to rent the old "Chateau de lisle," but Vollard ultimately settled on a more modest property at Saumur, a Loire Valley town accessible by rail from

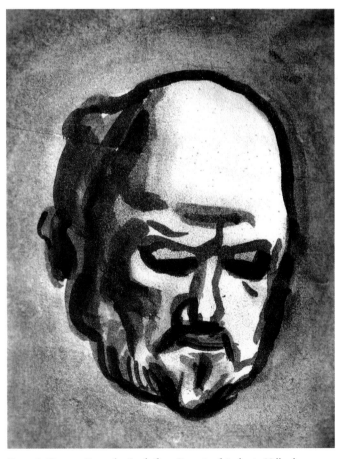

Fig. 178. Georges Rouault, *Study for a Portrait of Ambroise Vollard,* 1925. Black ink, 5½ x 4½ in. (14 x 11.5 cm). Fondation Georges Rouault, Paris

Opposite: Fig. 177 (cat. 184f). Georges Rouault, *Douce Amère,* from *Cirque de l'étoile filante,* 1934, published by Vollard 1938. Proof impression with heavy annotations, aquatint, page 17⅜ x 13⁵⁄₁₆ in. (44 x 33.6 cm). Fondation Georges Rouault, Paris

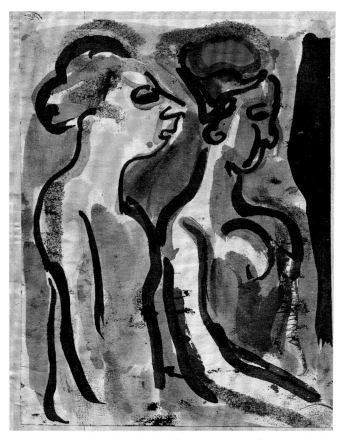

Fig. 179. Georges Rouault, *Women of the Haut-Quartier*, from a notebook of first studies for *Miserere* and *Guerre*, 1912–13. Colored ink, 8¾ x 6¾ in. (22 x 17 cm). Fondation Georges Rouault, Paris

Fig. 180. Georges Rouault, *Christ Crowned with Thorns*, cover of a notebook of first studies for *Miserere* and *Guerre*, 1912–13. Colored ink, 8¾ x 6¾ in. (22 x 17 cm). Fondation Georges Rouault, Paris

Paris.[11] As might be expected, the transport of the pictures from Paris proved stressful. At one point a dog "lifted a leg" on some Cézannes that Vollard had put down in order to purchase tickets at a train station teeming with American soldiers.[12] Rouault was nonplussed that the arrival of the pictures at Saumur on June 23, 1918, was complicated by Vollard's lack of organization and communication.[13] Nonetheless, in the long months that followed Rouault seems to have enjoyed his role as guardian of the Cézannes, Degases, Gauguins, and Renoirs that filled approximately seventy-one crates. In response to queries from curious villagers, Rouault replied that he was minding a stash of chamber pots.[14]

The war years—bringing displacement, scarcities, bombings, and uncertain future for his four young children—strained Rouault.[15] Repeatedly he asked Vollard for a gas lamp or at the very least some gasoline and matches that would generate enough light for him to work into the evening.[16] He offered to trade fresh eggs for India ink, which he needed for various projects, including one begun at the war's onset, *Miserere* and *Guerre* (figs. 179, 180).[17]

Miserere and *Guerre* were originally conceived as individual illustrated books, each with fifty plates, on the topic of death. Rouault created most of his ink drawings for them during the

war, between 1914 and 1918. Later Vollard asked Rouault to translate the drawings into paintings.[18] After they were finished, photoengravings were made of them. Displeased with the result, Rouault spent years reworking these large copper plates, at times creating as many as fifteen states of a single image. He worked on the plates simultaneously to avoid repetition.[19] The scope of *Miserere* and *Guerre* continually evolved. By the summer of 1922, they were envisioned as oversized albums of between fifty and sixty etchings and color lithographs each.[20] Suarès was later asked to write a text to complement the prints in each volume.[21] Although the printing of the plates was completed in 1927, *Miserere* (the ultimate title of the combined album that includes captions but no text) was not published until 1948, nearly a decade after Vollard's death.[22]

With the publication of *Miserere* and *Guerre* as his goal, Rouault had agreed to undertake numerous projects for Vollard, among them the illustration of a group of texts written by Vollard and based on Alfred Jarry's character Ubu.[23] Jarry's *Almanach illustré du Père Ubu,* illustrated by Bonnard and published by Vollard in 1901 (fig. 224), shows the creature with what appears to be a stylized rat's head, but for *Réincarnations du Père Ubu* (fig. 228) Rouault reimagined the character with

the head of a calf.[24] Of the many additional book projects that Rouault began for Vollard, two were published during Vollard's lifetime. The artwork for another two was complete before he died in 1939 (figs. 177, 220, cat. 185; fig. 185).[25] The unhurried pace of Vollard's publishing efforts frustrated Rouault, who nonetheless appreciated Vollard's willingness to give him complete artistic freedom.[26]

Rouault was overwhelmed by Vollard's enthusiasm for new projects: paintings, illustrated books, prints, and ceramics.[27] The artist vacillated between reassuring himself that his work would soon fall into an orderly pattern and complaining vociferously. After learning of the situation, the American lawyer and collector John Quinn offered assistance. Quinn considered Vollard's publication of Rouault's books "very sporty" but felt that an artist of Rouault's "age and ability and reputation" had no need to bind himself for life to a dealer.

> You told me that each time he saw you there was another agreement drawing the circle a little tighter. It was in answer to that that I suggested that you keep free and said that I would be glad to guarantee you 75,000 francs a year for three or five years and for that you could give me such of your paintings as you thought were worth that amount. I said that I thought you could easily sell another 75,000 francs to the public or to those who appreciate you, and that the 150,000 francs would make you independent.[28]

It seems unlikely that Rouault would have been tempted by the offer. For all his complaints, he was curiously loyal to Vollard. In any case, the offer proved moot, as Quinn died eight months later.

The 770 mostly unfinished works of art that Vollard agreed to purchase just before the war formed an underlying current in his and Rouault's relationship. Beginning in 1920, Rouault's letters and contracts clearly illustrate his desire to dedicate more time to his painting.[29] In a typed document dated January 25, 1923, for example, it was agreed that Rouault would be paid a bonus for all finished paintings, ranging from 4,000 francs for canvases larger than 1.5 meters to 200 francs for the smallest works, measuring 20 by 15 centimeters.[30] In 1924, presumably to expedite the process, Vollard offered Rouault the use of studios on the upper floors of his home at 28, rue Martignac.[31] The artist hesitated. He was particularly concerned that no one be allowed to touch his pictures or disturb him while he worked.[32]

By March 7, 1927, the date of another agreement, Rouault had finished approximately 244 of the original 770 paintings purchased by Vollard. Vollard agreed to pay between 200 and 350 francs for Rouault's final retouching (and presumably his signature) of each of these already completed pic-

tures, which were marked with a red circle on the verso. At Rouault's request, a new bonus system was initiated for the remaining paintings.[33] In the meantime he had begun hundreds of other works.

During this period, admirers of Rouault's paintings of kings and judges, prostitutes and circus performers had little opportunity to purchase them. Collectors were turned away from Vollard's door, having been told that the paintings in question had already been sold or were kept elsewhere. Rouault implored the dealer simply to tell the truth, namely that the artist preferred his work not be shown before it was finished and signed.[34]

For decades there was talk of a Rouault exhibition at Vollard's gallery, although one never took place.[35] In November 1924 Rouault was interviewed on the subject:

> INTERVIEWER: *Why do you never show your paintings?*
>
> ROUAULT: *Vollard does not want me to exhibit.*
>
> INTERVIEWER: *Yet Ambroise Vollard claims that it is you who does not want to have an exhibition.*
>
> ROUAULT: *Yes, it is true that my canvases are still rough, and I will only show them when they are finished. But all the same, if I do not exhibit it is because of Vollard. He*

Fig. 181. Envelope decorated by Rouault and sent to Vollard, postmarked March 14, [1917]. 6⅞ x 4½ in. (17.6 x 11.4 cm). Fondation Georges Rouault, Paris

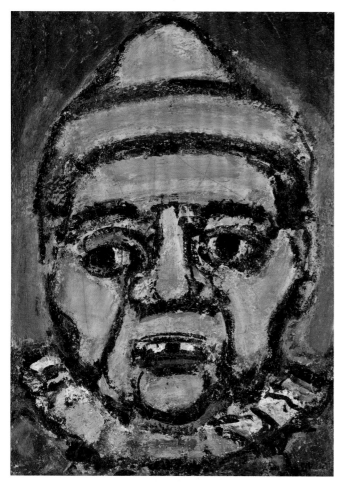

Fig. 182 (cat. 180). Georges Rouault, *The Dwarf*, 1937. Oil on canvas, 27¼ x 19¾ in. (69.2 x 50 cm). The Art Institute of Chicago, Gift of Mr. and Mrs. Max Epstein (1946.96)

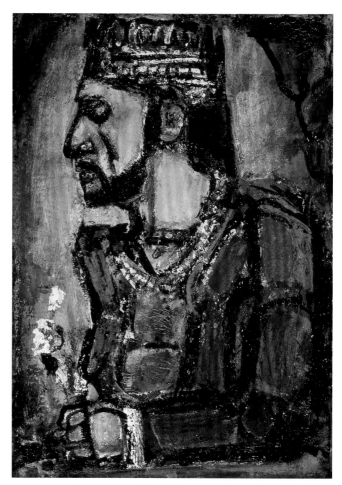

Fig. 183. Georges Rouault, *The Old King*, 1937. Oil on canvas, 30¼ x 21¼ in. (76.8 x 54 cm). Carnegie Museum of Art, Pittsburgh, Patrons Art Fund (40.1-5)

overloads me with work; he makes me do too many books; he asks me to do a painting for each plate, and to begin with I thought I could settle for black-and-white, then I began to put a bit of colour on each canvas, and the result is that I do not want to exhibit these paintings until they are all at the same point.[36]

Just as Rouault felt enslaved by his many projects for Vollard, so was the dealer frustrated by the artist's seeming inability to finish his pictures. Both Suarès and the artist's daughter, Isabelle, encouraged him to finish and sign his paintings.[37] It was thanks to Isabelle's urging (at Vollard's behest), for example, that Rouault allowed important works such as *The Old King* (fig. 183) to leave his studio. New contracts were drawn up in the early 1930s. One dated March 25, 1932 (and consisting of more than forty-five pages), addressed various points of contention. But a storm was brewing. In June 1935 Rouault tried to gain access to Vollard's records concerning his work (Vollard agreed, provided that they be consulted in his lawyer's office); around the same time, Vollard asked for the 133 paintings due him.[38] A month later Vollard informed Rouault that upon entering the rue Martignac studios (ostensibly to have them cleaned) he had found many of the still-wet paintings

sticking to one another. He moved the 133 paintings he considered to be his property, as well as a second group of paintings, to another room ("l'atelier Lehman") to dry, changing the lock for added security. In his letter, Vollard suggested that on Rouault's return to Paris he finish the paintings in groups of four or five.[39] Matters deteriorated to the point that both men consulted lawyers in the summer of 1936, and Rouault avoided the rue Martignac studios for several months.[40]

Despite all the bickering, the two continued to work together. Vollard loaned quantities of Rouaults to "Les Maîtres de l'art indépendant, 1895–1937" (which featured a room devoted to the artist), held at the Musée du Petit Palais in Paris in 1937,[41] and to "The Prints of Georges Rouault," held at the Museum of Modern Art in New York the following year.[42] As Suarès reported to Rouault, "One has to do [Vollard] justice. Even when he is complaining about you, he praises your talent and your works sky-high, beyond all measure."[43] At about this time the printer Roger Lacourière, informing Rouault that Vollard had just come to see the proofs for the artist's illustrations of *Les Fleurs du mal*, wrote, "I have never seen Mr. Vollard happier."[44]

On July 8, 1939, Vollard and Rouault signed yet another agreement intended to clarify their collaborations.[45] The

contract specified that Vollard had in his possession 563 completed and signed paintings by Rouault; another 30 were also completed and signed and were to be transferred to Vollard immediately; and an additional 819 were in progress. Vollard agreed to have batches of twenty to fifty paintings delivered to Rouault. In return for his final revision and signature, Rouault would receive 1,000 francs for each of the 781 small pictures and 3,000 francs for each of the 38 canvases larger than one meter. Furthermore, Vollard committed to photographing all the paintings in their current state for authentication and documentation.[46] The contract also mentions the illustrated books at some length. Notably, Vollard agreed to publish *Miserere* and *Guerre* in two volumes, along with the text by Suarès, at his earliest convenience. The timing of the contract proved critical, as Vollard died fourteen days later. Suarès was devastated by the news: "Your anger and your wrath, my old Rouault, will be swept away by this funeral blast. Now that Vollard is no longer here, whatever he has been like, one will discover that he was nevertheless unique."[47]

It has been repeatedly suggested that Rouault would be better known today had Vollard not admired his art to such a degree. Vollard is commonly perceived as someone who was interested in making money rather than building an artist's career, someone who would sequester paintings until their market value increased, even if at the artist's expense. This perception is not entirely accurate. Vollard's constant proposals for new projects and payments of more than two million francs over a twenty-year period provided Rouault with a sense of security. An outpouring of public interest in Rouault's art in the mid-1930s prompted Vollard to expedite the publication of the artist's books *Cirque de l'étoile filante* (1938)(figs. 177, 220; cat. 185) and *Passion* (1939)(fig. 185).[48] There is every indication that he was preparing others for publication when he unexpectedly died. Had Vollard lived longer, his legacy vis-à-vis Rouault might have been significantly different. For years Rouault had been convinced that the book projects would be the jewel in his crown. "When *Miserere & Guerre, Fleurs du mal, Passion, Cirque*, etc. will have at last been published, they will proclaim me ready for the *Institute*, thereupon they will arrange an exhibition of paintings and will declare me the conventional follower of Cubism."[49]

Vollard's death was a disastrous blow to Rouault. The town house was sealed, thereby depriving him of access to his

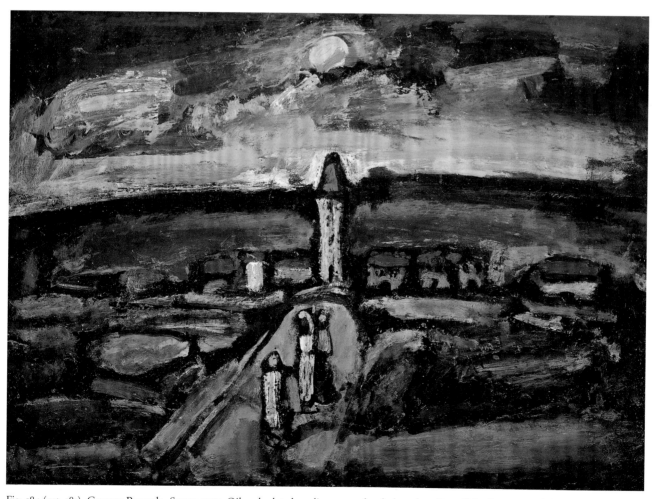

Fig. 184 (cat. 181). Georges Rouault, *Sunset,* 1937. Oil and related media on wood pulp board, 29⅛ x 41⅜ in. (74 x 105 cm). Worcester Art Museum, Worcester, Massachusetts, Gift of Mrs. Aldus C. Higgins (1965.396)

des tiens ? Prends ma chair ; sers-toi de mon corps ; tue-
moi, crève la bête de louage ; paye-la : mais tais-toi. Tu n'as
pas à savoir d'où je viens, ni pourquoi ni comment. Et si
j'ai perdu la mémoire, si je l'ai enfouie sous un monceau
d'ordures, qui t'a permis de fouiller là-dedans pour me la
rendre ? Ma mère m'a vendue ? Et puis après ? Ta mère
s'est vendue, elle. Tu as vomi ton vin sur ma gorge. Tu as
vomi de ta vie dans ma vulve ; mais ce n'était pas assez :
il fallait que tu ramènes mon âme du néant, pour me la
vomir dans la bouche et sur les yeux. Va-t'en ! Je ne veux
pas de ton argent. Va retrouver ta mère, tes sœurs et ta
fille. Lâche, qui viens souiller les morts, pour passer le
temps, et qui les tires de la tombe par la peau du ventre ;
lâche, qui rends la tête au décollé pour la lui couper
encore, lâche, hors d'ici. »

ELLE n'a pas dîné ; elle n'a pas mangé depuis la veille ;
elle a été battue ; elle a tout subi. Elle n'est pas ivre. Mais elle
vacille dans une rafale d'horreur et de dégoût.

Vagues fielleuses de la vie ! Elle roule sur la nausée :
elle meurt de se sentir elle-même. Il lui semble que le
monde tourne entre ses cuisses, suspendu à son ventre,
et que ce poids l'entraîne.

D'une main, elle s'accroche au gond d'une fenêtre :
elle appuie sa tête contre le mur. Et, les yeux fermés, elle
se voit, telle hier, telle ce soir, et demain telle. Du sang, du
sang, une source, un tourbillon de sang noir.

La rivière n'est pas loin : le flot nocturne précipite son
appel : viens, viens.

Se voir toute, se voir ainsi ! En finir, en finir, le sommeil

94

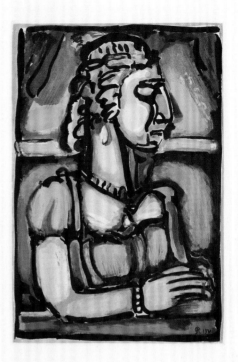

Fig. 185 (cat. 186). Georges Rouault, *Passion,* by André Suarès, published by Vollard 1939. Book illustrated with color aquatints with etching, drypoint and engraving; aquatints; and wood engravings, page 17½ x 13⁹⁄₁₆ in. (44 x 34.5 cm). The Museum of Modern Art, New York, The Louis E. Stern Collection, 1964 (1044.1964.1-103). *Above,* pages 94–95, with aquatint, *Dame à la Huppe* (*Woman in a Headdress*); *below,* title page

studio and artwork.[50] World War II and the German occupa-
tion further complicated matters. Finally, in the summer of
1946, Rouault sued Vollard's heirs for the recovery of his
unfinished paintings.[51] The case gained international interest
because its outcome rested on a single point: does an artist
retain rights to unfinished pictures?[52] On March 19, 1947, the
court ruled in the affirmative, and Vollard's heirs were ordered
to return all of Rouault's unfinished works.[53] Of the 807 paint-
ings owed him, 119 were missing from the estate. Frustrated
and saddened, Rouault burned 315 of the 688 works that were
returned to him. The seventy-five-year-old artist simply felt
that he would never be able to complete them.

ANDRÉ SUARÈS

PASSION

EAUX-FORTES ORIGINALES EN COULEURS
ET BOIS DESSINÉS PAR GEORGES ROUAULT

AMBROISE VOLLARD, ÉDITEUR
28, RUE DE MARTIGNAC, 28
PARIS
M CM XXXIX

Georges Rouault was a prolific writer, and his extensive correspondence (published and unpublished) sheds a great deal of light on his relationship with Vollard. Much of this essay is based on his unpublished archives, housed at the Fondation Georges Rouault in Paris. I am very much indebted to the kindness of Anne-Marie Agulhon, Gilles Rouault, and Jean-Yves Rouault, all descendants of the artist and keepers of the foundation.

1. Vollard 1936, p. 213. Vollard remembered Rouault visiting his earliest exhibitions. Supposedly Rouault was particularly taken with Gauguin's *Yellow Christ* (1889, Albright-Knox Art Gallery, Buffalo), which he saw at Vollard's. Dorival and I. Rouault 1988, vol. 1, p. 353. As no evidence has been found that the painting was ever on Vollard's premises, Rouault may have been referring to a similar Gauguin, *Green Christ (The Breton Calvary)* (fig. 60), which Vollard acquired on October 14, 1893. Vollard's Cézannes made an impression on Rouault as well. For more information, see Gohr 1992.

2. Vollard to Rouault, July 3, 1907: Fondation Georges Rouault, Paris. Rouault recalled that it was the critic Gustave Coquiot who first recommended him to Vollard; "Leurs débuts" 1933, p. 8.

3. Vollard to Rouault, July 3, 1907, and Rouault to Vollard, February 24, 1917: Fondation Georges Rouault. The catalogue for the Salon d'Automne (October 1–22, 1907) includes no. 1787: "Metthey, Exposition de grès, porcelaine et faïence stannifère. Collaborateurs: MM. Denis, Guy [*sic*], Rouault, Vlammck [*sic*], Maillol, Lajarde [*sic*], Valtat, Matisse. (Les faïences appartiennent à M. Vollard.)." It is not clear if Vollard loaned all 108 ceramics that Metthey is thought to have exhibited. See Nice–Bruges 1996, p. 75.

4. Rouault to Suarès, March 3, 1913, in *Rouault–Suarès Correspondence* 1983, p. 35, letter 25.

5. Suarès wished to see Cézannes in both Vollard's and Pellerin's collections. Rouault to Suarès, July 2, 1912, in Dorival and I. Rouault 1988, vol. 1, p. 353, and Rouault to Suarès, July 23, 1912, in *Rouault–Suarès Correspondance* 1960, pp. 24–25, letter 13. There is a reference to a "Cézanne de Suarès" in Rouault to Vollard, February 24, 1917: Fondation Georges Rouault. In 1919 Éditions Georges Crès published a reduced-format edition of Vollard's book on Cézanne (1914). The Crès edition lacks illustrations but features a section devoted to critical praise for the original volume, including a letter from Suarès.

6. Rouault was named curator of the Musée Gustave Moreau, Paris, in July 1902. In August it was decided that he would be paid 2,400 francs annually; the museum itself was inaugurated on January 14, 1903. Citing his poor health, his need to devote more time to his art, and his frequent travel away from Paris, Rouault announced his intention to resign in November 1928. His resignation was not accepted until July 2, 1929, at which time he was named "conservateur honoraire." In May 1933 Rouault was appointed a member of the museum's managing committee, from which he resigned the following December. Archives, Musée Gustave Moreau, courtesy of the Fondation Georges Rouault.

7. Despite Vollard's disinterest in publishing an album of popular songs illustrated with Rouault's color lithographs, Rouault continued to feel optimistic. "As for Vollard, it is quite sure that it is neither in my character nor my custom to push myself on him, however, I certainly get the impression that he is ready to act." Rouault to Suarès, December 16, 1912, in *Rouault–Suarès Correspondence* 1983, pp. 28–29, letter 18, and Rouault to Suarès, July 25, 1913, in Dorival and I. Rouault 1988, vol. 1, pp. 353–54.

8. Receipt signed by Rouault, May 5, 1917: Vollard Archives, MS 421 (9,17), fol. 1.

9. Rouault to Vollard, April 18 and May 1, 1917, and contract dated March 7, 1927: Fondation Georges Rouault.

10. Rouault was staying with cousins at L'Isle-sur-Serein in Burgundy when Vollard enlisted his help. The artist initially looked for lightly furnished rental properties in that town and nearby Avallon. "Tell me," he wrote, "will you be bringing 1000, 2000, or 3000 works?" Rouault to Vollard, June 5, 1918: Fondation Georges Rouault.

11. Presumably Rouault was espousing the eighteenth-century château at L'Isle-sur-Serein, rooms of which were rented to refugees from the north. Rouault suggested that Vollard obtain a lease on the entire property in order to ensure adequate security; ibid. The house chosen was located at 8, rue Bodin, at Saumur. Rouault to Vollard, June 5, 19, and 22, 1918: Fondation Georges Rouault.

12. Rouault in New York 1945 (1947 ed.), p. 34.

13. Rouault to Vollard, July 9, 1918: Fondation Georges Rouault. Rouault's frustration may have been compounded by the fact that he was not getting

paid for his assistance. According to his notes for his autobiography (Fondation Georges Rouault), he also had hoped to bring the watercolors from the Musée Gustave Moreau to the same location for safekeeping, a plan the museum's administrator dismissed.

14. Rouault to Vollard, July 15, 1918: Fondation Georges Rouault.

15. Rouault to Quinn, received October 11, 1917, and Rouault to Quinn, postmarked March 25, 1918: John Quinn Memorial Collection, Manuscripts and Archives Division, New York Public Library, Astor, Lenox and Tilden Foundations [hereafter cited as Quinn Collection].

16. There was no electricity and a dearth of coal. Rouault to Vollard, January 15 and July 15, 1918, and other undated letters written in 1918: Fondation Georges Rouault.

17. Rouault to Vollard, May 10, 1918: Fondation Georges Rouault.

18. See Rouault's preface to the facsimile of *Miserere* published by the Museum of Modern Art, New York, in 1952 (Rouault 1952). See also Rouault to Vollard, undated [ca. 1922]: Fondation Georges Rouault.

19. Rouault to Vollard, October 21, 1922: Fondation Georges Rouault.

20. Rouault described them as "reproductions 65 x 55; these are more properly albums of that size; 50 to 60 etchings and lithographs in colors for each volume." Rouault to Quinn, August 1, 1922, Quinn Collection.

21. Vollard asked Suarès to produce a text no longer than 228 pages (for the two volumes), for which he was to be paid 40,000 francs. Vollard to Suarès, July 10, 1937: Vollard Archives, MS 421 (9,17), fol. 22.

22. Published by L'Étoile Filante, Paris. For more information, see Monroe Wheeler's introduction and Rouault's preface to the reduced-format facsimile of *Miserere* published by the Museum of Modern Art, New York (Rouault 1952).

23. *Les Réincarnations de Père Ubu* (a compendium of Vollard's texts on Ubu, illustrated by Rouault) was published by Vollard in 1932, but Rouault's correspondence contains numerous references to his illustrations for Vollard's *Ubu aux colonies* and *Ubu enchaîné*, as well as for Jarry's *Ubu Roi*. Vollard was enthralled by Ubu and wrote short texts devoted to the character in addition to those found in *Réincarnations*. Also in the fall of 1917 Rouault informed Quinn, "But would you believe that besides that book about Ubu (twenty reproductions in colour), one hundred drawings in black and white, and *text* (50 pages) all in my own handwriting to harmonize with the illustrations, would you believe, I say, that I have gathered all my letters written on that subject *and I am making a second book out of them*: 'Père Rouault's Letters to M. Ambroise Vollard concerning Père Ubu.' There is everything in these letters—I speak about Don Quixotte, Cathedrals, the classic movement, etc. . . . and it will also have drawings in black and white and in colours." Rouault to Quinn, received October 11, 1917, Quinn Collection. For more information on Rouault's involvement with the Ubu books, see Dorival and I. Rouault 1988, vol. 1, pp. 267–71.

24. Rouault to Vollard, undated [ca. 1918]: Fondation Georges Rouault.

25. On Rouault's and Vollard's illustrated books, see Chapon and I. Rouault 1978 and Chapon 1992.

26. "I think, and I do not say this to flatter you, that you are the rare fellow who understands that an artist needs his freedom when conceiving his work." Rouault to Vollard, undated [1917]: Fondation Georges Rouault. Rouault expressed a similar sentiment in a 1924 interview: "[Vollard] has some great qualities; he gives me complete freedom, I can do my illustrations exactly as I intend." See Georges Charensol's article on Rouault in *Paris-Journal*, November 14, 1924, quoted in Dorival and I. Rouault 1988, vol. 1, p. 355.

27. "Either you are in denial or you just don't notice . . . how much you put on my shoulders." Rouault to Vollard, August 24, 1919: Fondation Georges Rouault. Rouault returned to this theme repeatedly in his correspondence.

28. Quinn to Rouault, November 28, 1923: Quinn Collection.

29. "Ultimately I profoundly regret not painting exclusively. In general, painters who make books, they are better suited to that than to painting; for better or worse, I think the opposite is true about me." Rouault to Vollard, April 14, 1921: Fondation Georges Rouault. "I don't think I shall do any new books for another ten years. I exaggerate, but I want to give myself up completely to painting for an unlimited period of time. Books will wait for the future." Rouault to Quinn, August 1, 1922: Quinn Collection. According to Rouault, during the late 1910s and 1920s he painted several hours each day, on Sundays, and during his vacation. New York 1945 (1947 ed.), p. 36.

30. Other sizes and prices indicated are: 1.25 x 1 m (2,000 francs); 1.05 x .75 m (1,000 francs); .75 x .60 m (850 francs); .6 x .5 m (600 francs); .5 x .4 m (500 francs); .4 x .3 m (400 francs); .3 x .2 m (300 francs). Rouault and Vollard contract dated January 25, 1923: Fondation Georges Rouault.

31. Paris–Fribourg 1992, p. 222. Claude Roulet, who visited Rouault at the town house about 1937–38, recalled the space. Studio A (the door of which was marked with an A in the artist's handwriting) was a large room that served as a drying space. It "was lit by three windows that formed a sort of glass wall. Many works were hung vertically on racks. Others were left to dry on a table in the center of the room. Several rested against the wall. There was a fireplace in one corner. Nearby, a pile of albums and boxes rose from the floor. A tall easel could be found in another corner of the room. There was also an armoire." Two other workspaces were located upstairs, one of which was known as Studio B. There "paintings [were] hung on tall racks and others [were] propped with their face to the wall, just as in the drying room downstairs." Roulet 1961, pp. 60–61, 69.

32. Rouault to Vollard, March 29, 1924: Fondation Georges Rouault.

33. Because the small paintings often required more effort than large ones, Rouault asked to be paid the same price regardless of canvas size.

34. Rouault to Vollard, July 27, 1928: Fondation Georges Rouault.

35. For example: "I hope that in a year or two I can give an important exhibition of these works [*Ubu Roi, Ubu aux colonies, Guerre, Miserere*] and of paintings on which I am engaged, at the gallery of Ambroise Vollard, 28 rue de Martignac, in his new building." Rouault to Quinn, August 1, 1922: Quinn Collection. See also Lhote 1923, reprinted in Paris–Fribourg 1992, pp. 220–21.

36. Georges Charensol's article on Rouault in *Paris-Journal,* November 14, 1924, quoted in Dorival and I. Rouault 1988, vol. 1, p. 355. Later, in a published letter, Rouault explained that Vollard intended to give him "an exhibition in less troubled times, when the franc has stabilized." Warnod 1926, quoted in Warnod 1965, pp. 70–73. The idea of an exhibition became more pressing in the late 1920s, when Rouault decided that he would like to be named to the Académie des Beaux-Arts. Although Vollard considered Rouault's chances slim, he was nonetheless supportive of the idea and offered both to present Rouault's prints and paintings to current academicians and to arrange a press luncheon on the artist's behalf: "You do not need to tell me that you would like to present yourself as a painter. Nonetheless, even if you had only made prints, there is more painterly talent in one square centimeter of your prints than in the largest canvas of three-quarters of those gentlemen." Vollard to Rouault, January 18 and February 12, 1930: Fondation Georges Rouault. The effort went unrewarded, and the position instead went to Jean-Pierre Laurens (1875–1932). See also Rouault to Suarès, September 27, 1928, in *Rouault–Suarès Correspondence* 1983, p. 109, letter 179.

37. As Suarès pointed out to Rouault, "[Vollard] thinks that you ask more of yourself than he does of you. He is not absolutely wrong, you must confess. The real artist is like that. The most difficult thing is not to create, but to relinquish at last what one creates; because fundamentally one is never satisfied enough to decide that one has finished. One always dreams of something better." Suarès to Rouault, September 30, 1934, in *Rouault–Suarès Correspondence* 1983, p. 121, letter 221. Rouault wanted to finish his paintings, if only for his peace of mind. "I am anxious to take up many of my unfinished paintings again, . . . which is both in [Vollard's] material interest and in my spiritual one." Rouault to Suarès, June 1930, in *Rouault–Suarès Correspondence* 1983, p. 114, letter 192.

38. Vollard to Rouault, June 7, 1935: Fondation Georges Rouault.

39. Vollard to Rouault, July 5, 1935: Fondation Georges Rouault. See also Durand-Ruel's view of the situation in D. Wildenstein and Stavridès 1999, p. 67.

40. Isabelle Rouault to Matisse, undated [1947]: Archives Matisse, Paris. See also Vollard to his lawyer Fettweis, May 5, 1936: Vollard Archives, MS 421 (9,17), fols. 20, 21.

41. Vollard was on the organizing committee of this exhibition; see Paris 1937.

42. New York 1938.

43. Suarès to Rouault, January 29, 1937, in *Rouault–Suarès Correspondence* 1983, p. 124, letter 235.

44. Lacourière to Rouault, undated [ca. 1939]: Fondation Georges Rouault.

45. The initial points of the contract are quoted in "Rouault Case" 1948, p. 92.

46. Rouault and Vollard, contract dated July 8, 1939: Fondation Georges Rouault. Ironically, the contract considers the possibility of Rouault's death but not Vollard's.

47. Suarès to Rouault, July 25, 1939, in *Rouault–Suarès Correspondence* 1983, p. 133, letter 252.

48. Rouault to Suarès, December 12, 1938, in *Rouault–Suarès Correspondence* 1983, p. 129, letter 243.

49. Rouault to Suarès, September 27, 1928, in *Rouault–Suarès Correspondence* 1983, p. 109, letter 179.

50. According to Rouault's unpublished "En Souvenir d'Ambroise Vollard," written between December 1, 1946, and July 14, 1947, for his lawyer and friend Maurice Coutot (Fondation Georges Rouault), he and Vollard's heirs were initially in complete agreement concerning the fate of his unfinished paintings and illustrated books. He was therefore "dumbfounded" by the consequent turn of events.

51. Rouault had finished twelve paintings since the July 8, 1939, contract that lists 819 incomplete paintings, and thus he sued for the recovery of the 807 works he considered to be unfinished. "Rouault Case" 1948, p. 92.

52. "Action by M. Rouault" 1946; "Rouault Sues Dealer" 1946.

53. For a recapitulation, see "Rouault Case" 1948.

Vollard, Éditeur

Vollard, Publisher of Maillol's Bronzes: A Controversial Relationship

Emmanuelle Héran

It is difficult these days to evaluate Vollard's efforts as a publisher of limited-edition sculptures. The disparity among the various publications on each of the sculptors he represented—Auguste Renoir, Paul Gauguin, Aristide Maillol, Pierre Bonnard, and Pablo Picasso[1]—renders any summary premature. One constant does emerge, however: Vollard had a penchant for what is generally called "painterly sculpture."

Maillol (1861–1944) presents a special case in this regard, in that Vollard's efforts were a key factor in turning the artist toward sculpture, and it is as a sculptor that Maillol has passed into posterity—unlike the other artists in this group, who are primarily considered painters. For this reason, it is worth studying the relationship between the two on its own terms. But this raises a difficult question: did the artist benefit from this association, or was he taken advantage of? Though a catalogue of the Maillol sculptures issued by Vollard was published in 1977 (by Una E. Johnson),[2] recently discovered documents and works allow us to shed new light on the subject.

By all accounts, it was Édouard Vuillard who introduced Maillol to Vollard around 1900. Interviewed by Judith Cladel toward the end of his life, Maillol recalled how his wood and terracotta objects "made an impression on the painters Vuillard, Bonnard, and Maurice Denis, whom I had the good fortune to know. One of them brought Vollard to see me."[3] Nonetheless, Vollard must have known of Maillol's work well before this, as suggested by a letter from Maillol's friend and supporter Daniel de Monfreid to Vollard on Christmas Day 1901: "I think Maillol is pursuing an excellent course. You'll recall you mentioned him to me quite some time ago."[4]

According to Vollard, it was upon seeing a wood sculpture by Maillol that he got the idea of casting in bronze: "I persuaded Maillol to let me have one of his wooden statuettes cast in bronze, with such happy results that he repeated the experiment more than once."[5] Cladel offers a different version: "[Vollard] immediately bought several of those terracottas, charming like Tanagrine [Tanagra] figurines renewed by the

dawning spirit of the twentieth century, and cast them in bronze."[6] Rewald confirms this: "[Maillol] told me how Vollard, in the early days, would buy his small terracottas to have them in bronze."[7] Whatever the case, by offering to cast the sculptor's work in bronze, Vollard introduced a radical change in material: until then Maillol had modeled his figures in clay, which he fired in Monfreid's kiln, or had carved them in wood.

From June 15 to 30, 1902, Vollard exhibited thirty-three works by Maillol. This was not the first time Maillol's works were shown: he had already been represented at the Salon des Artistes Français since 1890, and at the Société Nationale des Beaux-Arts (SNBA) since 1893. With the Nabis, Maillol had exhibited with dealers such as Le Barc de Boutteville[8] and Bernheim-Jeune. In 1902, before the exhibition at Vollard's, he had already shown works at Berthe Weill in January[9] and at Bernheim in May.[10] Vollard, howevever, was the first to give him a one-man show.[11]

The exhibition offered Maillol a chance to display the full range of his creations other than paintings. Tending toward the decorative, his art included utilitarian objects, often created for his own home, such as tapestries, his son's cradle, a mirror, an indoor fountain, a door knocker, a pendulum, and some night lights.[12] While certain works were new to Vollard's visitors, others had been seen before, among them three tapestries—*Music for a Bored Princess* (Det Danske Kunstindustrimuseum, Copenhagen), *The Book* (whereabouts unknown), and *The Garden* (Musée Maillol, Paris)—that had already been shown at the SNBA exhibitions of 1896, 1897, and 1899, respectively.

Maillol's sculpture, in particular, found favor, which is why Vollard is often credited with having turned Maillol toward that medium.[13] (In fact, the artist had been making sculptures since 1896, perhaps even the year before; he began showing wood objects in 1896, terracottas in 1897.) The first article devoted exclusively to Maillol, signed Félicien Fagus, appeared in the May–August 1902 issue of the Natanson brothers' periodical *La Revue blanche*, hardly surprising given the Nabi connection. In it the author drew attention to the artist's "female nudes."[14]

Opposite: Fig. 186 (cat. 127). Aristide Maillol, *Kneeling Woman*, ca. 1900. Bronze, 7⅝ x 5⅜ x 3¾ in. (19.5 x 13.8 x 9.5 cm). Musée d'Orsay, Paris, Bequest of Mr. and Mrs. Raymond Koechlin, 1931 (RF 3234)

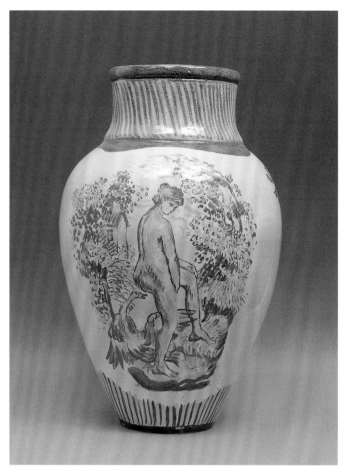

Fig. 187 (cat. 130). Aristide Maillol, *Large Vase,* ca. 1906–7. Tin-glazed ceramic, H. 21⅝ in. (55 cm), Diam. 13 in. (33 cm). Collection Larock-Granoff, Paris

"wooden statue standing woman, original in wood" was "not to be reproduced in said material," meaning that it could not be issued in bronze like the others. This was most likely the *Standing Woman* with a clinging drape that uncovers the breasts, which in fact does not exist in a bronze version.[20]

What overall effect did this exhibition have on Maillol's career? In July 1902 Monfreid wrote to Gauguin, "Our friend Maillol had an exhibition at Vollard's. Vollard has commissioned work from him, ceramics, wood, etc. In short, Maillol is beginning to sell and is finally emerging from poverty. It's about time."[21]

But the version the artist himself gave to his friend the Hungarian painter Jozsef Rippl-Rónai was more pessimistic: "My exhibition at Vollard's got me noticed by some real artists but in terms of income *not a cent,* even though Vollard sold a fair number of the little statuettes he'd bought from me—so there you have it."[22] Later, at the age of eighty, Maillol had something slightly different to say about the show: "Articles started appearing. The first buyers began showing up: my wife, my young son, and I were saved, saved from the horrible misery that was threatening to last forever."[23] It seems that Maillol derived a real benefit from the exhibition at Vollard's, though it took longer than expected for the effects to be felt.

The buyers who came to him through the exhibition were not insignificant. Octave Mirbeau acquired a bronze *Leda* and other works. The Mirbeau auctions[24] offered no fewer than nine statuettes by Maillol: four bronzes; one wood (*Woman in a Tunic*); three terracottas; and a plaster, *Seated Girl with Arm over Her Eyes.* Auguste Rodin bought a *Standing Bather* (fig. 188) on April 2, 1904, a bronze based on an original in wood that Maillol had sold to Vollard on September 10, 1902.[25] Renoir showed interest in an earthenware fountain.[26]

The German art historian Julius Meier-Graefe was then living in Paris and preparing his major study, *Die Entwicklungsgeschichte der modernen Kunst* (The History of the Development of Modern Art).[27] In it he spoke of Maillol in flattering terms and reproduced some of his works. The book had a considerable effect on German and Swiss collectors and museum curators, who soon began buying statuettes. One of these, Count Harry Kessler, bought works from Maillol and eventually became his patron.[28] On August 21, 1904, Kessler visited the sculptor for the first time, in the company of his friend Kurt von Mutzenbecher, who bought a *Seated Draped Woman* in terracotta.[29] That same year, Karl Ernst Osthaus bought a wood sculpture from Maillol for his museum of avant-garde art, the Folkwang, which he had opened in Hagen in 1902 on the advice of the Belgian artist Henry Van de Velde. This was the *Standing Woman* with clinging drape and bared breasts mentioned above.[30] After that came purchases by the Nationalgalerie in

After the show Vollard bought a number of works from the artist,[15] as indicated by a document signed by the sculptor and dated September 10, 1902. This is the first written trace of a relationship between the two men. For 6,500 francs Maillol sold Vollard five paintings and fourteen objects and sculptures, not all of which have been identified.[16]

Unlike other sculptors who had arrangements with founders or dealers,[17] Maillol had no contract with Vollard, not to mention any exclusivity. The Vollard archives contain several documents—comparable to the one of September 10, 1902—that acted as bills of sale and granted the dealer rights to reproduce the work. (This type of transfer of rights was common at the time; indeed, until April 1910, when a sculptor sold a work he automatically granted the purchaser the reproduction rights, unless otherwise indicated.)[18] In the same document, Maillol stated that he was ceding "complete ownership of the following objects, including reproduction rights," even though it was not necessary to specify this. Similarly, Vollard's invoice to Maillol, dated December 20, 1905, explicitly mentioned "publication and reproduction rights."[19] However, in the September 10, 1902, document, Maillol also stipulated one condition: a

Berlin (1905–6), the Kunsthalle in Bremen (1906–10), the Städtische Galerie in Frankfurt (1908), and the Kunsthalle in Mannheim (1913), as well as the Ny Carlsberg Glyptotek in Copenhagen (1907).[31]

Maillol's friends bought or were given copies of his statuettes. They readily included them in their paintings, helping to increase and publicize the spread of these objects throughout the world. Vuillard, Bonnard, Denis, Renoir: a circle was being formed, made up of Nabis, people around Vollard, and patrons such as the Natanson brothers, Joseph Hessel, Arthur Fontaine, and Raymond Koechlin. Vuillard, for instance, frequently portrayed his copy of *Leda*. This terracotta, white as plaster, began to figure in his paintings in 1900 and appeared nearly a dozen more times, even in his late portraits. Vuillard also depicted *Women Wrestlers* and *Standing Bather.*[32] Following Vuillard's lead, Bonnard included Maillol's statuettes in his interior scenes:[33] the *Standing Bather,* with her arm behind her back, appears in a painting from 1917 (private collection; D 2117), while *Leda* can be seen in a still life of about 1925 (private collection; D 1306). In addition, Vollard's artists immortalized the dealer himself in the company

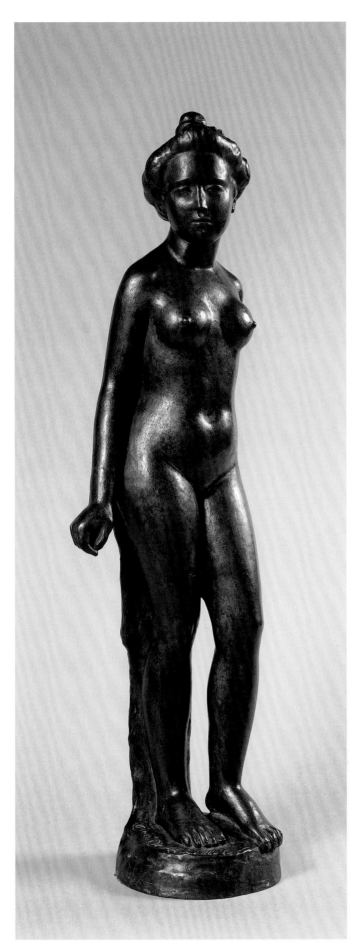

Fig. 188 (cat. 126). Aristide Maillol, *Standing Bather,* 1900. Bronze, 26⅜ x 5⅞ x 5⅞ in. (67 cm x 15 x 15 cm). Musée Rodin, Paris (s. 579)

Fig. 189. Brassaï (Gyula Halász), *A Corner of Ambroise Vollard's Stockroom with Sculptures by Maillol, Picasso, and Renoir,* 1934. Private collection

of Maillol statuettes: in 1908 Renoir painted him holding a terracotta of *Kneeling Girl* (fig. 296), and, about 1924, Bonnard painted Vollard at home with a *Standing Bather* on his mantel (fig. 161).

While Maillol often fired his own terracotta reproductions, in a kiln financed by Vollard, we do not know who cast the bronzes that Vollard issued.[34] The archives suggest that even the sculptor might not have known. In a letter dated December 14, 1908, Maillol told Vollard that he was applying the patina to *Kneeling Girl,* adding, "If you have other bronzes to chisel, please send them—the little girl being [or was?] quite well cast— who did it?"[35] Several possibilities come to mind.

The recent discovery of information about the founder Florentin Godard, for instance, has added some new elements to the story; his connection is confirmed by the sale of small Maillol bronzes formerly owned by Godard's heirs.[36] A date can also be suggested, thanks to a letter of 1908 in which Maillol told Vollard, "I'll give the Renoir bust to Gaudard [*sic*]";[37] this was a portrait of the elderly painter that Vollard had commissioned from Maillol in 1907 (the sittings for which took place in Essoyes) and which was issued in bronze (fig. 190). According to another source—Maillol's friend François Bassères—the small *Seated Woman Holding Her Ankles* (also known as *Crouching Woman Holding Both Feet*) of 1905 might have been cast by Bingen and Costenoble in 1906 for 110 francs, as confirmed by a letter from Maillol of January 26, 1906.[38] An invoice from Vollard to Maillol, dated December 20, 1905, mentions the founder Alexis Rudier: "Purchased an original plaster Standing Woman to pick up at Rudier's for M. Vollard for one hundred fifty francs."[39] Dina Vierny has called it "erroneous to credit Rudier with casting any Vollard edition bronzes, as he made none."[40] But we know that the founder did work for Eugène Blot as an anonymous subcontractor, so why could he not have done the same for Vollard?[41]

One thing certain is that the expression "Vollard casting" is incorrect: Vollard was not the founder of the bronzes but the publisher. It would be more accurate to speak of a "Vollard edition," which consists of bronzes cast by various founders but sold by Vollard and which is not a homogenous edition of virtually identical bronzes.

How much control did the sculptor have over the number of copies issued? Maillol told Rippl-Rónai that "Vollard sold a fair number of the little statuettes he'd bought from me."[42] But John Rewald, who interviewed the sculptor in April 1938, painted a more damning picture of the dealer's reputation: "The artist would specify that the editions should be limited to ten casts; he added with resignation: 'Well, he made ten casts, all right, except they turned out to be ten thousand!'"[43] Still, this oft-quoted recollection seems somewhat anachro-

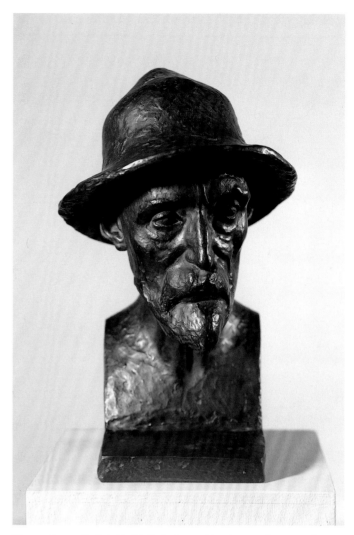

Fig. 190 (cat. 128). Aristide Maillol, *Auguste Renoir,* 1907. Bronze, 15 ⅜ x 11 x 10 in. (39 x 28 x 25.5 cm). Kunsthalle Mannheim

nistic. The practice of issuing limited, numbered editions dates only from the first decade of the twentieth century.[44] Moreover, the legal obligation to adhere to it is quite recent: in France, it is only since 1966 that bronze castings have been limited by law to eight copies plus four artist's proofs. Furthermore, Vollard himself limited the edition of certain bronzes: Bassères noted that the *Seated Woman Holding Her Ankles* was issued in only four copies.[45]

We do not know when Vollard stopped making these editions. Vierny recalled an animated discussion that took place in Marly in October 1937: "Vollard reassured Maillol that the castings were being discontinued." She concluded that "any Vollard editions subsequent to October 1937 are to be considered merely reproductions."[46] In a photograph by Brassaï taken at Vollard's in 1934, we can still see two Maillol statuettes, *Leda* and *Standing Bather,* posed on the floor in the midst of great chaos (fig. 189).

Maillol's distrust of his dealer-publisher, witnessed by Rewald, was the type of sentiment generally shared by a number

of sculptors. Such feelings increased when Adrien Hébrard, who had opened a foundry in 1902, signed exclusive contracts with artists, whom he underpaid and at whose expense he got rich. Very quickly sculptors' convictions of being exploited spread, and the well-worn quip "Vollard/voleur" (Vollard the thief) must be understood in this context. The situation worsened in the years between the two wars, following the Musée Rodin's highly publicized forgery suit against the founder Montagutelli in 1919.

It is against this background that we should reexamine Kessler's criticisms of Maillol: "He is satisfied with small 'approximative' works cast in sand, which he chisels a bit."[47] With the restoration of the lost-wax process early in the twentieth century—in reaction to the overabundance of sand-cast bronzes of mediocre quality—it is no surprise that Kessler would be shocked by Maillol's negligence in this regard. Like Vollard, Maillol favored sand casting, which was faster and less expensive but which required a great amount of retouching, chiseling, and patina to achieve a high-quality result. Old photographs show what a bronze might look like before being finished (fig. 191).

We have several early indications of what Maillol really thought about Vollard's bronzes and about the finishing work he did on some of them. In December 1903 Maillol wrote to the dealer from Banyuls-sur-Mer: "I would be happy to come see the pendulum, but if any retouching is needed I won't have time."[48] The reference is to *The Two Sisters,* which he had exhibited at Vollard's in 1902 and later sold to him. The dealer's copy is at the Musée Léon Dierx in Saint-Denis (Réunion island). In 1905 Mirbeau visited Maillol in Banyuls and found him chiseling a bronze. The sculptor complained, "I have to completely redo this bronze. . . . It's going to take me two weeks of hard work, at least. . . . Because I already sold this bronze . . . and I can hardly give it to the fellow who bought it from me the way it came out of the foundry, or let anyone else see it. . . . Just look at all those ropy lines on the parts I created smooth and round . . . those horrible rough patches, that outbreak of smallpox. . . . Nothing but disconnected, incoherent shapes."[49] Could these be the bronzes that Kessler bought? Maillol wrote to the count at the end of 1905, "I had 3 bronze statuettes, 2 of them entirely chiseled . . . I didn't chisel the 3rd bronze because it was too poor, no point in wasting any more money on it."[50] Nonetheless, in 1907 Kessler noted, "There are in circulation so many bronzes so abominably cast that they are but caricatures of the original work. He knows this, becomes upset about it, rants for a while against Vollard and the incapacity of his founders, but lets him get away with it because of the money." (This passage was later deleted from his journal.)[51]

We must therefore expunge the notion that Maillol did not care about the poor quality of the statuettes Vollard issued. According to Vierny, "He rejected some and accepted others, chiseling them and sometimes even applying patina to them."[52] Opinions about these bronzes are divided: Una E. Johnson, who mainly studied the later works, concluded that of "the nine known Maillol bronzes issued by Vollard, the majority are well executed."[53] On the other hand, Vierny says of the Vollard bronzes, "Technically, the casting is rudimentary; the chiseling is cursory, and certain bronzes haven't even been hollowed out, which weighs them down."[54] There are indeed some quite mediocre Vollard bronzes, which were not retouched by the artist. Such is the case with the *Standing Bather* of 1900, both the one in the Musée Rodin (fig. 188) and the one at the Städelsches Museum in Frankfurt, as well as with the *Leda* (fig. 192) and *Seated Girl with Arm over Her Eyes* in the Oskar Reinhart Collection at Winterthur.[55]

Maillol quickly picked up the technique for working bronze. It is said that he learned chiseling and how to apply patina at Bingen and Costenoble in 1905—perhaps even earlier

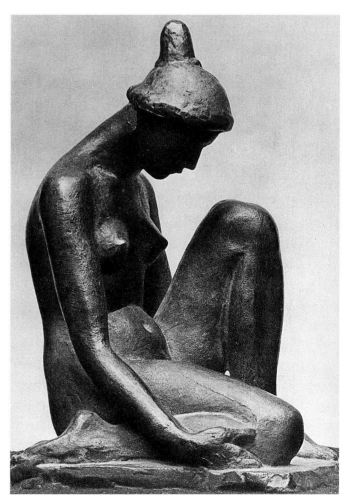

Fig. 191. Aristide Maillol, *Young Woman Kneeling* (with a pointed chignon), ca. 1905. Bronze, before chiseling, H. 7 in. (17.8 cm). Location unknown

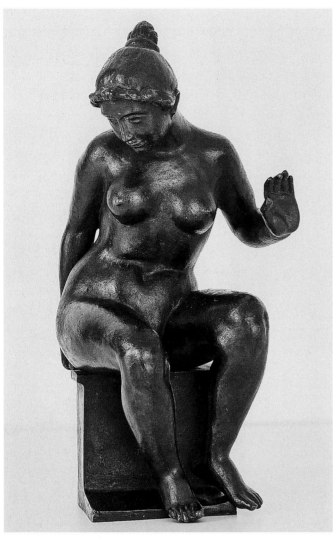

Fig. 192. Aristide Maillol, *Léda*, ca. 1898–1900. Bronze, 11⅛ x 5¼ in. (28.4 x 14.5 cm). Collection Oskar Reinhart "Am Römerholz," Winterthur, Switzerland

(the foundry opened in 1903).⁵⁶ Denis remembered Maillol's sense of "perfection . . . obstinately scraping, finishing, polishing his statues, softening the curves, the passages."⁵⁷ And Thadée Natanson related how "everything seems poor and destitute . . . next to his patience for tirelessly burnishing a casting, which to anyone else would seem long finished."⁵⁸

This practice seems clearly to have stemmed from the artist's dissatisfaction with the Vollard bronzes. And it was his taste, not the dealer's, that he expressed in the statuettes chiseled and finished by himself. On July 12, 1907, Maillol wrote to Vollard, "I finished the two bronzes . . . you can send 3 more bronzes to chisel . . . you'll notice the beautiful green tones I managed to obtain—you must keep for yourself the copy of the wrestlers I'll send you as the better of the two."⁵⁹

Comparing two *Ledas,* we can measure how much progress Maillol made: in 1902, the "Mirbeau" *Leda* in Winterthur showed a black patina, covering a bronze of mediocre quality;⁶⁰ in 1906, the *Leda* in the Kunsthalle Mannheim displayed

a beautiful green patina over an excellent casting. Maillol's taste evolved toward more colorful patinas, green or even very red, such as those on the casts made by Godard.⁶¹

A number of questions concerning Maillol and Vollard persist. "Vollard/voleur": is there any truth to the famous jibe? The archives suggest a certain negligence on the dealer's part in regard to the sculptor. In 1907, when Maillol was in Banyuls, chiseling and applying patina to bronzes, he complained to Vollard about never being paid. While parts of his letter have been torn away, we can nonetheless surmise that Vollard had promised "1,000 francs a month" but hadn't sent anything in "four months." While Maillol received no percentage on copies sold, he did expect to be compensated for the finishing work he carried out on each bronze. Then again, there is a letter to Vollard of December 14, 1908, in which Maillol acknowledges receipt of 1,000 francs,⁶² and another of August 14, 1913, in which he notes that he "received the sum of two thousand one hundred francs in payment for 3 statuettes at 400 francs and one at 900."⁶³ In a letter from the artist to his nephew Gaspard Maillol, Maillol wrote, embittered: "Know, dear Gaspard, that dealers only buy from artists whose works are sure to sell, and that's the only reason they buy. For myself, I can't manage to get Vollard to pay me."⁶⁴ Yet the payments, however irregular, lasted at least until the First World War.

Was Maillol adequately paid? We would have to know the going rate for finishing off a bronze and set it against the sale price of a bronze at the Vollard gallery. Unfortunately, we don't have these figures. The value of the first Maillol bronzes issued by Vollard rose slightly at the beginning of the twentieth century: a bronze *Leda* was sold by the dealer to a certain M. Mangin on March 2, 1923, for the sum of 1,000 francs,⁶⁵ whereas the earliest German, Swiss, and Russian buyers had paid about 250 to 400 francs for a small bronze. After that, prices took off, especially in the German market; however, inflation following the 1929 financial crisis accounted for this and makes any price analysis risky.

Are Vollard's relations with Maillol comparable to his relations with other sculptors? We can establish a parallel with Renoir; indeed, it was probably because of the success of Maillol's statuettes that Vollard encouraged Renoir to explore sculpture. The two artists knew and admired each other. Renoir could not model, as he suffered from rheumatoid arthritis that deformed his fingers, and Vollard initially thought of having Maillol assist him.⁶⁶ In fact, there is a striking kinship between Maillol's and Renoir's sculptures, with the younger man influencing the older one. The dealer himself juxtaposed two large bronzes in the foyer of his mansion (fig. 292): Maillol's *Venus with a Necklace* and Renoir's great *Venus Victorious* (figs. 193, 164).

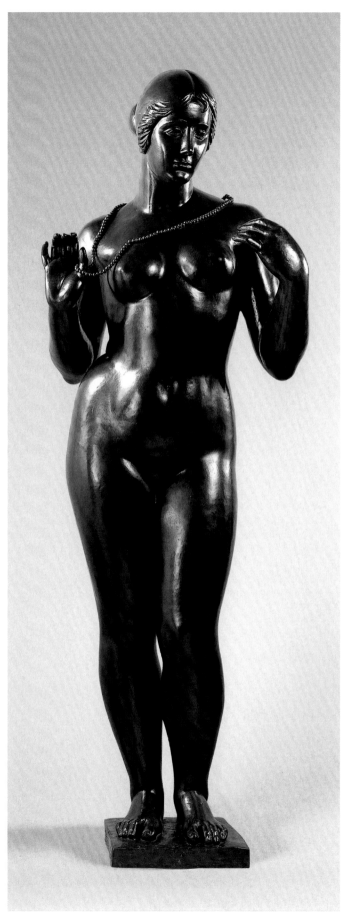

Fig. 193 (cat. 129). Aristide Maillol, *Venus with a Necklace*, 1918 (cast in 1928). Bronze, 68⅞ x 24 x 16 in. (175 x 61 x 40.5 cm). St. Louis Art Museum, Purchase (1:1941)

Did Vollard have a particular taste in sculpture? When it came to three-dimensional works, he favored a decorative approach, which no doubt was easier to sell. For him, issuing limited-edition statuettes was a way to attract clients who wanted to embellish their homes with figurines that offered innocuous subject matter but remarkable physical presence. In this his work as a publisher hardly differs from that of his contemporaries, such as Hébrard or Blot. His merit is to have emphasized artists who, by virtue of being painters, were able to devise new forms quite unlike the usual academic productions or Art Nouveau creations.

Maillol's relations with Vollard were cordial to the last. During the war, in 1915, the sculptor wrote to Vollard to congratulate him on his book about Cézanne. The tone of the letter was warm: "Whenever you'd like to come visit us, you would be most welcome."[67] Pierre Camo recounted how Maillol invited his friends to Marly: "We would gather on Sunday and eat around the large table in the dining room. I often saw Ambroise Vollard there."[68] At the dealer's death, Maillol sent these words: "Homage to Vollard, from his friend Aristide Maillol, July 30, 1939."[69]

In this essay, the following abbreviations are used in citing catalogue raisonné numbers: for works by Bonnard, "D" refers to J. Dauberville and H. Dauberville 1966–74; for works by Vuillard, "SC" refers to Salomon and Cogeval 2003.

1. The study on Renoir, Haesaerts 1947, dates back a number of years; on Gauguin, see Gray 1963; on Picasso, the essay by Diana Widmaier Picasso in this volume; finally, Anne Pingeot is preparing a publication on Bonnard's sculpture, with catalogue raisonné, scheduled to appear in 2006.

2. See Johnson 1977, published for the exhibition at the Museum of Modern Art, New York, in 1977, which featured only bronzes: *Bather Combing Her Hair, The Two Sisters, Women Wrestlers, Standing Bather, Seated Woman Holding Her Ankles, Crouching Woman, Leda, Kneeling Girl,* and *Bust of Auguste Renoir.* The relations between Vollard and Maillol were barely mentioned by Wendy Slatkin in her 1982 study on the early years, but Dina Vierny (Maillol's last model and founder of the Musée Maillol in Paris) consulted the Vollard Archives for her exhibition of Maillol's bronzes, Paris 1995–96.

3. Cladel 1941; see also Cladel 1937, p. 60; Denis 1943, p. 8. Vollard does not give any precise information in his memoirs. Maillol was already indebted to Vuillard for having introduced him to his first patrons, the Bibesco family, in February 1895; see Groom 1993, p. 150. Vuillard's diary, conserved at the Institut de France library, is unfortunately missing for these years.

4. Loize 1951, p. 32.

5. Vollard 1936, p. 249.

6. Cladel 1937, p. 61.

7. Rewald 1975, p. 11. The passage is preceded by these lines: "Vollard, that peculiar figure whose name Maillol always pronounced *Voleur* (thief). He told me how Vollard, in the early days, would buy his small terracottas to have them cast in bronze."

8. The first Nabi exhibition was held at Le Barc de Boutteville's gallery in 1891.

9. Berthe Weill, 25, rue Victor Massé. According to Félicien Fagus, he showed "portraits," "stoneware," and "vases"; see Fagus 1902a.

10. "Exposition d'oeuvres nouvelles de Bonnard—Maurice Denis—Maillol—K. X. Roussel—Vallotton—Vuillard," Galerie Bernheim-Jeune, Paris, May 15–25, 1902.

11. This was Maillol's only exhibition at Vollard's. Having no exclusive arrangement with the dealer, he continued to show his work in the Salons and with other dealers, such as Bernheim and Druet. The huge success of his sculpture *La Méditerranée* at the 1905 Salon d'Automne afforded him even greater autonomy.

12. Today a variety of these creations can be seen at the Musée Maillol, Paris.

13. See Cladel 1937, pp. 61–62: "Vollard's intervention was the latest and last means used by the Unknown to lead the polygenous artist toward sculpture."

14. Fagus 1902b. The offices of *La Revue blanche* were at 1, rue Laffitte, right near Vollard's gallery; see Bernier 1991. In the earlier January issue of *La Revue blanche*, Fagus had already published a note on Maillol's sculptures and vases exhibited at Berthe Weill's; see Fagus 1902a. Thadée Natanson owned one of Maillol's earliest wood sculptures, *Dancer*, given to the Musée du Louvre by his widow, Reine Natanson, in 1953 and now at the Musée d'Orsay, Paris. In his 1948 memoirs, Natanson discussed Maillol at great length; see Natanson 1948.

15. Vollard, however, was not the first to buy sculpture from Maillol. According to the notebooks of his friend Monfreid, Maillol sold his first statuette in the spring of 1897. Was this to Vollard? I suspect it was to Princess Bibesco: she knew Maillol by then, and we know that she owned a wood sculpture (today at the Stedelijk Museum, Amsterdam). On the Bibescos, see Groom 1993.

16. "Pendulum group two nude women on a base / Door knocker woman hanging laundry / Statue woman standing arm behind her back / other statue woman standing also with arm behind her back / Small statue kneeling woman / Small statue woman sitting on small bench / Small statue standing woman draped / Night light / Statue standing woman hands in hair behind her head / bust of young woman . . . A large wooden statue standing woman arm behind her head, unique original model / A wooden statue standing woman, original in wood, not to be reproduced in said material / A large statue in terracotta, unique original model / A statue bust of old woman original 6 unique model": Private archives.

17. The contracts between the artist Rembrandt Bugatti and art foundry and gallery owner Adrian Hébrard, signed in 1904 and 1905, are excellent examples.

18. Lebon 2003, p. 87.

19. Private archives.

20. Reproduced in the 1908 English edition of Meier-Graefe 1904, opposite p. 82 (as belonging to the "Vollard collection, Paris"), and in Rewald 1939, p. 126.

21. Loize 1951, p. 32.

22. Rippl-Rónai arrived in Paris in 1887. He had a successful show at the SNBA in 1894, where the Nabis noticed his work, as did Thadée Natanson and the circle around *La Revue blanche*. It is sometimes said that he was the one who put Maillol in touch with the Nabis. He returned to Hungary in 1900 and continued to maintain a correspondence with Maillol. In his 1911 memoirs, he boasts of having pushed the artist toward sculpture. The letters from Maillol to Rippl-Rónai were first published in Wertheimer 1953.

23. Cladel 1941, p. 5. Maillol's young son was Lucien, born in 1896; he died in 1972.

24. Three sales in Paris: at Durand-Ruel on February 24, 1919; at the Hôtel Drouot on March 21, 1919; and finally the estate sale of Mme Mirbeau at Drouot on June 6, 1932.

25. Both the work and the invoice are conserved at the Musée Rodin, Paris. This is without question a wooden sculpture that Maillol sold to Vollard: "A large wooden statue standing woman arm behind her head, unique original model." Therefore, the statement by Dina Vierny (in Paris 1995–96, p. 25) that "the original plaster of this work was sold by Maillol to Vollard and figures on the 1902 bill of sale" is mistaken. The confusion stems from a misinterpretation of the expression "unique original model," and an examination of the bronzes shows that they are the transcription of a wood object, showing traces of the gouge. On the other hand, Vierny thinks that Rodin's bronze is in fact made of white metal.

26. Maillol told this to Rippl-Rónai; see Rippl-Rónai 1911.

27. Meier-Graefe 1904, vol. 1, pp. 395–400, and vol. 3, pp. 190–91. Meier-Graefe was a frequent visitor to Vollard's gallery.

28. Raised in France and England, this wealthy German count devoted his fortune to supporting the arts. As of 1904, Kessler was Maillol's main patron, taking him on trips to London and Greece, commissioning *La Méditerranée, The Cyclist,* and *Desire* from him (as well as an illustrated edition of Virgil's *Eclogues*), and financing the production of the Montval paper that the sculptor invented. Kessler's journal, begun in 1880 (conserved at the Deutsches Literatur-Archiv Marbach, it is currently in the process of being published, with three volumes already available), provides firsthand testimony on the art of the early twentieth century. Well before he met Maillol, Kessler often went to Vollard's gallery—as he did with his friend Meier-Graefe on July 6, 1895—and bought works from him. Kessler was in Berlin during the last half of June 1902 and was unable to see the Maillol exhibition at Vollard's. However, the artists, dealers, and critics he knew had long spoken well of the sculptor.

29. Now in the Barlach Haus, Hamburg.

30. He also acquired a *Crouching Woman* and commissioned the statue *Serenity*—unfortunately now lost—for the garden of his villa in Hagen.

31. There were also purchases for the Ny Carlsberg Glyptotek in Copenhagen in 1907, as well as acquisitions by the Russians Sergei Shchukin and Ivan Morozov (Pushkin Museum of Fine Arts, Moscow). On these early buyers, see Berlin and other cities 1996–97, pp. 151ff., as well as Essen–Moscow–St. Petersburg 1993–94.

32. I have consulted Salomon and Cogeval 2003. The *Standing Bather* in bronze that Bonnard owned figured in 1905 in an oil on cardboard, *Bonnard in His Studio* (whereabouts unknown; SC VII-397), and, in the 1930s, quite visibly in the portrait of Bonnard in the *Anabaptists* series (Musée d'Art Moderne de la Ville de Paris; SC X-120.3). Salomon and Cogeval 2003, vol. 2, p. 1363, n. 17, mistakenly claims it is a wood sculpture. Bonnard is seen posing in his apartment at 48, boulevard des Batignolles, where he had lived since 1924. The series also includes a portrait of Maillol working on his monument to Cézanne: thus the sculptor is cited twice. The group *Women Wrestlers* can be seen in later canvases depicting the Hessels' home on the rue de Naples: *A Lady beneath a Lamp, Rue de Naples* (1933, private collection; SC XII-104) and *Evening in the Salon, Rue de Naples* (1933, National Gallery of Art, Washington, D.C.; SC XX-105). As for Denis, he also owned a *Standing Bather* in terracotta, which can be seen in a photograph dated around 1912 (reproduced in Berlin and other cities 1996–97, p. 131).

33. See J. Dauberville and H. Dauberville 1965–74 and 1992.

34. The certainties of the past need to be qualified. Dina Vierny states that "on Maillol's advice, Vollard's first editions were made by two different founders: Bingen and Godard. The pieces were retouched by Maillol and bear the stamp of the foundries that cast them." Vierny 1958. Una E. Johnson (1977, p. 169) believed that there was a numbered edition cast by Rudier.

35. Vollard Archives, MS 421 (2,2), p. 180.

36. See Lebon 2003 and Binoche Sale 2004.

37. Vollard Archives, MS 421 (2,2), p. 176.

38. Bassères 1979, pp. 100, 106, 107, and Paris 1995–96, p. 8.

39. Private archives.

40. Paris 1995–96.

41. Chevillot 2005.

42. See note 26 above.

43. Rewald 1975, p. 11.

44. Despite her research, Elisabeth Lebon was unable to date this practice precisely.

45. Bassères 1979, pp. 100, 106, and 107.

46. Vierny 1958, p. 14.

47. Kessler 2004–5, July 5, 1907.

48. Private archives.

49. Mirbeau 1905, pp. 335–36.

50. Letter of December 1, 1905, quoted in Hoetink 1963, pp. 30 and 46, n. 36.

51. Kessler 2004–5, July 5, 1907. This passage is crossed out on the manuscript.

52. Paris 1995–96, p. 25.

53. Johnson 1977, p. 40.

54. Paris 1995–96, p. 25.

55. From my observations, the patina is a homogenous, glossy black applied over a red undercoat that shows through clearly at the worn spots. This is apparently a sand casting: traces of very red sand are visible inside. Certain parts are not finished, in the academic sense of the word: the fingers, toes, face, and particularly the eyes, which are merely suggested.

56. Cladel (1937, p. 84) relates that Maillol "had bought a small foundry in Paris, on the rue de Belleville, and entrusted it to one of his students." As Florentin Godard was established at 248, rue de Belleville, it is possible that they partnered in this venture.

57. Denis 1943, p. 12.

58. Natanson 1948, pp. 146–47. See also Rey 1924 and Paul-Sentenac 1937, p. 58.

59. Maillol to Vollard, July 12, 1907: Vollard Archives, MS 421 (2,2), p. 178.

60. The patina—black, opaque, and glossy over a coffee-brown undercoat—conceals an imperfect casting: several air bubbles subsist, and the appearance is rough in places. This is most likely a sand casting, even though no sand can be seen inside the statuette: in fact, it is in two parts, with the figure attached to the base. Not every part of the statue has been chiseled to the same degree: the bottoms of the feet haven't been worked on, and the founder's seal was applied under the right hand, leaving the fingers unseparated; conversely, the face, hair, and arm are nicely detailed. See my entry on *Leda* in Héran 2003, p. 616.

61. The Godard sale of 2004 included eight bronzes: *The Shepherdess, Bather Combing Her Hair, Seated Girl Holding One Foot, Shading Her Eyes, Crouching Bather, Catalan Woman or Standing Girl without Arms, Chain Reaction,* sketch, and *Raised Elbow.* See Binoche Sale 2004.

62. Vollard Archives, MS 421 (2,2), p. 180.

63. Vollard Archives, MS 421 (2,2), p. 183. We can no longer claim, as does Berger in Berlin and other cities 1996–97, p. 61, n. 137, that Maillol received no further money from Vollard as of 1907.

64. Institut Néerlandais, Fondation Custodia, Paris.

65. A photograph of the receipt is in the auction catalogue, Christian Delorme and Vincent Fraysse, Hôtel Drouot, Paris, October 23, 2001, p. 14, no. 27.

66. It was ultimately Richard Guino who collaborated with the painter.

67. Vollard Archives, MS 421 (2,2), pp. 184–85.

68. Pierre Camo, "Souvenirs sur Maillol," unidentified press clipping, Service de Documentation, Musée d'Orsay, Paris.

69. Chlomovitch Sale 1981.

Vollard and the Sculptures of Picasso

Diana Widmaier Picasso

Ambroise Vollard first exhibited works by the young Pablo Picasso in his gallery on the rue Laffitte in 1901. But he did not take an active interest in Picasso's sculpture until 1910. That year he bought from Picasso, who was badly in need of money, five original pieces—*Head of a Jester* (1905), *Head of Fernande* (1906), *Kneeling Woman Combing Her Hair* (1906), *Bust of a Man* (1906), and *Head of Fernande* (1909).[1] Vollard had already "published" bronzes by Aristide Maillol, Auguste Renoir, and others, and he did the same with Picasso's sculptures, casting bronzes from the plaster originals. *Head of a Jester* (fig. 194) and the two heads of Fernande (figs. 197, 198) met with immediate commercial success; only a few copies of the others (figs. 195, 196) were issued. The Picasso bronzes issued by Vollard bear neither edition numbers nor founder's marks. Although numbers were not required until 1968,[2] at the turn of the century many founders were already in the habit of numbering their bronzes, and it was common practice to apply a founder's mark. Did Vollard intend to keep the founder's identity secret? Was he reserving the option to change foundries? His 1936 *Recollections* is silent on the matter.

Precisely how many bronzes Vollard had cast from Picasso's works is also not known, as none of his account books detail all the orders he placed with foundries.[3] The originals were sold without contracts, so Picasso must have given Vollard his verbal consent to cast as many copies as was necessary to fill his orders. After April 9, 1910, under French law, when sculptors sold their works, reproduction rights were no longer automatically granted and had to be explicitly conferred. Exactly when in 1910 Picasso made his agreement with Vollard is not documented. Valerie Fletcher suggests that it might have been in September or shortly thereafter, when Daniel-Henry Kahnweiler decided not to acquire Picasso's paintings. This left Vollard free to sell them,[4] and Vollard's exhibition of works by Picasso dating from 1902 to 1910 opened in December 1910. Fernande Olivier related in her memoirs that the sale of the sculptures coincided with Picasso's making Cubist portraits of Wilhelm Uhde, Vollard, and Kahnweiler in 1910.[5] Picasso and Vollard seem to have come to a tacit agreement on reproduction rights, regardless of the new law, and indeed Vollard's records document prior arrangements between the two regarding paintings or engraving plates that included such rights.[6] (Later, in the 1950s, when new editions were made from original plasters, Picasso specified by contract the name of the foundry to be used, the number of casts authorized, and the number of proofs he would receive.)

Vollard's account registers and datebooks for the period 1904–39 yield precious information about the provenances of the bronzes he "published."[7] The archives of the foundries he used, however, are very difficult or impossible to find, as many of them have been burned, lost, or hidden away, so that dating the initial orders for the works and determining the identity of the eventual owners are often problematic. Elisabeth Lebon's *Dictionnaire des fondeurs de bronze d'art,* published in 2003, offers new information, not only about the major French foundries in the first half of the twentieth century but also about small, unknown, even forgotten foundries, some of which turned out work of great quality on behalf of highly important artists.

The fact that technique and quality of execution vary significantly from one sculpture to the next is a clear indication that Vollard used several different foundries to cast Picasso's bronzes. Because he could not afford to have an entire series cast in advance, he had his casts made to order, one by one.[8] At the beginning of his career as a publisher of bronzes, he used small, modestly priced foundries such as Maucuit and Co. on the rue Delambre in Paris, which cast five female figures by an unknown artist for him in 1905.[9] Later, in order to satisfy more demanding artists and clients, he worked with foundries renowned for the quality of their sand casting, including Bingen et Costenoble and Florentin Godard. Vollard also employed the Claude Valsuani foundry for the *Kneeling Woman Combing Her Hair* (fig. 196), of which five casts were produced.[10] Claude Valsuani, son of the founder Marcello, opened his own foundry in 1908 in Paris at 74, rue des Plantes in the 14th arrondissement. The quality of his casts was highly appreciated, and Picasso later used this foundry regularly.

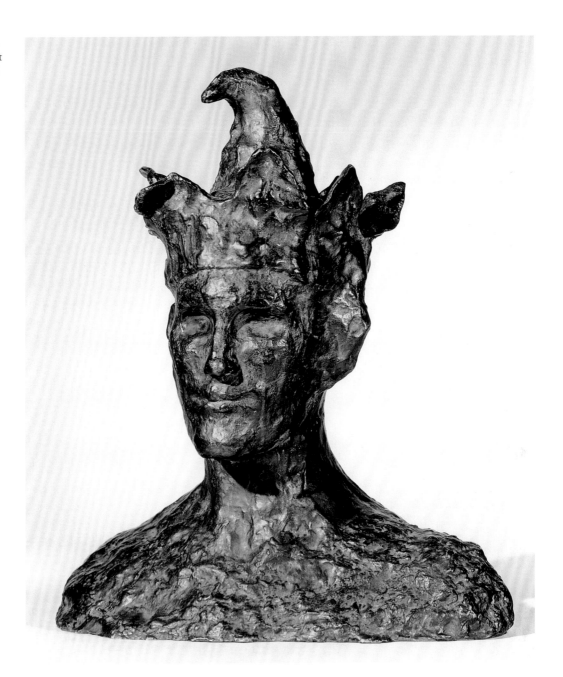

Fig. 194 (cat. 161). Pablo Picasso, *Head of a Jester,* 1905 (subsequent Vollard cast). Bronze, 16⅛ x 14⅞ x 9⅜ in. (41 x 37.8 x 23.7 cm). Musée Picasso, Paris (MP 231)

The name "Bingen Jeune" first appears in Vollard's archives in 1907.[11] The Bingen et Costenoble foundry, which was located in Paris at 26, rue Bezout in the 14th arrondissement, was active from 1903 until 1913, when Jean-Augustin Bingen went into business for himself. (Costenoble continued at the same address until 1920.) Lebon describes the foundry as an "active small business," with six employees on the payroll in 1910.[12] It offered both sand and lost-wax casting and enjoyed an excellent reputation. Henri Matisse and Maillol used its services; Maillol, who considered Bingen et Costenoble the best sand casters of the time, even decided to train there in 1905 to learn how to chisel and apply patina.[13] There is no proof that any Picasso sculptures were cast at Bingen, as the entries for the foundry in Vollard's datebooks do not give the sculptor's name. Bingen et Costenoble sometimes applied marks to their casts, notably those commissioned

directly by Maillol, but Vollard appears not to have requested this for his sculptures. In 1907 and 1908 Vollard commissioned work from both Bingen et Costenoble and Florentin Godard, as attested by his datebooks.[14] After that he worked exclusively with Florentin Godard.

The appearance on the art market in 2004 (following the publication of Lebon's *Dictionnaire des fondeurs*) of several bronzes from Florentin Godard's private collection spurred me to study previously untapped archives that add important details about the conditions under which Picasso's bronzes were cast, and when.[15] Florentin Godard (1877–1956) was the son and grandson of casters. His two brothers, Louis and Désiré, were also founders. Until Lebon's study and the discovery of Florentin's archives, his foundry was all but unknown, and it was often confused with the foundry owned by Désiré, even though Désiré did not begin large-scale production until 1918.

(Sadly, the archives of the Désiré Godard foundry, which is still in operation in the Paris suburb of Malakoff, have vanished.) Indeed, casts of a number of sculptures by such major artists as Matisse and Maillol have been mistakenly attributed to Désiré rather than Florentin Godard.[16] Lebon has underscored the quality of Florentin's work, particularly his sand casting and his beautiful patinas, though he worked in modest conditions, with only one assistant.[17] Florentin's foundry was located at 78, rue Compas, in Paris's 19th arrondissement. It later moved to 248, rue de Belleville in the 20th arrondissement, where it remained until 1937, when Florentin's professional activity seems to have ended following a serious injury in the workplace. That year he retired to his home in Ezy-sur-Eure.

The unpublished archives of the Florentin Godard foundry that I was able to study consist of a small notebook dating from 1929 and three account books giving order dates, prices, and sometimes clients' names for three separate periods: December 1910 to June 1914 (book 1), April 1924 to January 14, 1928 (book 2), and January 3, 1929, to February 28, 1931 (book 3).[18] The other logs of payables and receivables have disappeared. The descriptions of the works are rather cursory, as was common at the time, and usually do not allow a given sculpture to be identified with certainty. Consequently, I have often had to make hypothetical cross-references between dates, works, and prices and other available archival materials. Still, studying these documents yields important details. They reveal, for example, that other reputable dealers besides Vollard also made use of Godard's services.[19] Kahnweiler, for one, placed several orders with the foundry between December 1911 and June 1914. And the Godard account books offer proof that the artists themselves sometimes worked directly with the foundry. Such was the case with Picasso as well as with Maillol, whose monumental *La Méditerranée,* which he gave to the city of Perpignan, was cast by Florentin Godard in 1909.

Picasso's name appears in the foundry archives for October 15, 1913, when he ordered a bust. He is also mentioned in the small notebook from 1929 (the last page of which contains his telephone number, Elysée 03-44). He had left several wood statuettes to be reproduced in bronze.[20] In all likelihood these were small sculptures of Iberian influence depicting Marie-Thérèse Walter, who entered his life in 1927. Until now, we knew neither the exact date of their creation nor which foundry had cast them. Florentin Godard is known to have produced such small-scale bronze casts in his house at Ezy-sur-Eure, located near Anet, not far from the Boisgeloup chateau, which was Picasso's home beginning in 1930. Godard lived in the foundry premises on the rue de Belleville during the week, but he had no home address in Paris, his main residence being Ezy.[21]

Contrary to widely held belief, Picasso was interested in bronzes, as he was in every medium, and he was surely open to the variety of possibilities the material offered and to the effects of patina, which he preferred dark.[22] That he ordered work from the Godard foundry suggests that he had seen casts of his

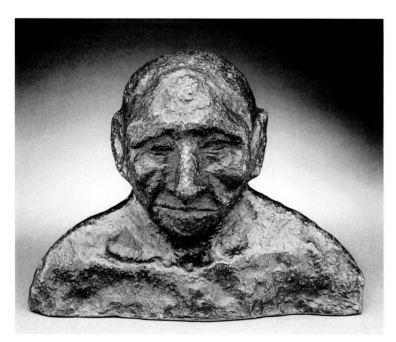

Fig. 195. Pablo Picasso, *Bust of a Man (Josep Fondevila),* 1906. Bronze, 6⅝ x 9 x 4⅝ in. (16.8 x 22.9 x 11.7 cm). Hirshhorn Museum and Sculpture Garden, Washington, D.C., Gift of Joseph H. Hirshhorn, 1966 (66.4047)

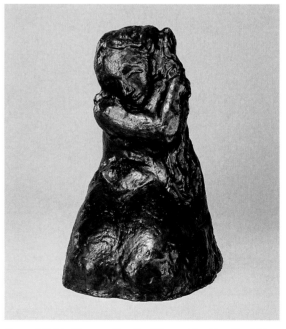

Fig. 196. Pablo Picasso, *Kneeling Woman Combing Her Hair,* 1906. Bronze, 16¼ x 10¼ x 12¼ in. (41.2 x 26 x 31 cm). Hirshhorn Museum and Sculpture Garden, Washington, D.C., Gift of Joseph H. Hirshhorn, 1972 (72.234)

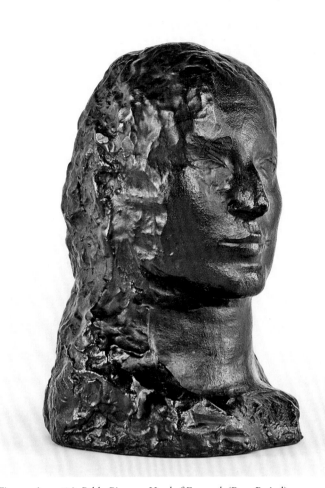

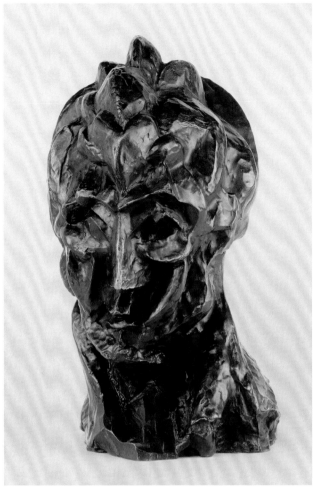

Fig. 197 (cat. 162). Pablo Picasso, *Head of Fernande* (Rose Period), ca. 1906 (subsequent Vollard cast). Bronze, 14¼ x 9½ x 10 in. (36.2 x 24 x 25.4 cm). Musée Picasso, Paris (MP 234)

Fig. 198 (cat. 163). Pablo Picasso, *Head of Fernande* (Cubist Period), 1909 (subsequent Vollard cast). Bronze, 16 x 10¼ x 10 in. (40.6 x 26 x 25.4 cm). Musée Picasso, Paris (MP 243)

works commissioned by Vollard. The existing documentation is too fragmentary to give a complete picture of the orders Vollard placed with the foundry. Just as there are orders for works by Picasso with no mention of a dealer's name, the foundry archives include numerous orders from Vollard with no mention of an artist's name.[23] A "Godard fondeur" with a Paris address is mentioned in Vollard's archives, but with no indication of the first name, which has led to the erroneous assumption that he meant the Désiré Godard foundry. The first such mention in Vollard's records dates from December 3, 1907.[24] Vollard initially appears in the Godard account books in December 1910, when he ordered a group of sculptures, "proofs and two heads," at a cost of 900 francs.[25] This order might indeed have included bronzes of Picasso's Cubist *Head of Fernande,* which Vollard bought that year.[26]

Godard's charges to his clients included the cost of metal, molding, casting, chiseling, and patina. As these prices were rather steep, dealers usually exhibited a single bronze cast and ordered further copies only when they had buyers. In 1913

Godard asked 300 francs for casting a Picasso bust or head in bronze. By 1926 the price he charged Vollard had climbed to 1,800 francs; in 1927 it rose to 2,600 francs, and in 1930 to 3,000.[27] In all likelihood these orders were for *Head of a Jester* or *Head of Fernande,* although the names of the works are not specified. Smaller-scale Picasso sculptures cost less; for casts of the *Small Head,* for example, Godard charged 400 francs in 1927.

Vollard gave Picasso a copy of each sculpture he had cast.[28] The first of the artist's sculptures that Vollard sold was the 1909 Cubist *Head of Fernande,* which went to the Czech collector Vincenc Kramář in May 1911.[29] The following January Alfred Stieglitz bought a copy of the same work.[30] Vollard no doubt sold other sculptures between 1912 and 1926, apart from the war years, but the dealer's documents for that period have not yet come to light.

In 1926 Florentin Godard received orders for ten busts by Picasso. Even though Vollard's name is not mentioned in the records, these were no doubt his bronzes, as he sold several

such works to important clients that year. In November 1926, for example, Vollard sold a *Jester* to Max Pellequer, Picasso's banker, for the sum of 5,500 francs.[31] The following January he sold two sculptures to Justin K. Thannhauser, *Head of a Jester* and *Head of Fernande* (1909), for 8,000 francs each.[32] Vollard's profit margin was therefore rather high: about 3,700 francs on the sale to Pellequer (who might have had a special rate) and about 6,200 francs on the Thannhauser transaction. That same January the Berlin dealer Hugo Perls bought a large bust;[33] in February Vollard sold a *Jester* to the Fletchtheim Gallery in Berlin,[34] as well as a large bust to the American dealer Weyhe.[35] In March Thannhauser bought from Vollard a lot of three sculptures (a *Jester* and two *Heads of Fernande*, 1906 and 1909).[36] In May Vollard sold a bronze to the Swiss collector Gottlieb Friedrich Reber,[37] and in June he sold Weyhe a *Jester*.[38]

Until his death in 1939, Vollard preserved the majority of Picasso's original plasters. After his death, a number of these were dispersed. Édouard Jonas, an antiques dealer who inherited many of Vollard's things via Lucien, recovered the *Jester* and the *Head of a Woman* (1906–7).[39] Paris dealer Jacques Ulmann acquired *Head of Fernande*, both the 1906[40] and 1909[41] versions. Two originals did not stay with Vollard: the *Kneeling Woman Combing Her Hair* (1906), which Vollard had apparently returned to Picasso, had been given by the artist to Raoul Pellequer, Max's brother, about 1940;[42] *Bust of a Man* (1906) seems also to have been returned to Picasso by Vollard.[43]

With the Vollard casts no longer available on the market, certain owners of the plasters sought Picasso's authorization to create new editions. Picasso, who was glad to see the originals of his sculptures again, agreed on condition that the casts be numbered and executed at the Claude Valsuani foundry. In 1959–60 Heinz Berggruen, an acquaintance of Jacques Ulmann, obtained permission to issue a bronze edition of nine proofs of the 1906 *Head of Fernande*.[44] Picasso stipulated that he be given three copies of each and asked to have the plaster of the Cubist *Head of Fernande* returned to him. Then, in 1968, Raoul Pellequer's son, Georges, obtained Picasso's consent for an edition of ten bronzes of *Kneeling Woman Combing Her Hair*, one copy of which was given to the artist.[45]

Vollard was the first art dealer to grasp the importance of Picasso's sculptures. He kept bronze copies of *Head of Fernande* (Rose Period) and *Head of a Jester*, which he gave to the Musée d'Art Moderne in Paris.[46] His collection also included a *Mask* (1907) in bronze.[47] The fact that Picasso entrusted these sculptures to Vollard attests to his friendship for and confidence in the dealer. Because of the circumstances of the times and Vollard's work methods, the study of the so-called Vollard casts can be difficult. However, the recent discovery of the foundries used for this work—Florentin Godard, Bingen et Costenoble, and Valsuani—confirms the special attention that Vollard devoted to the making of these casts. The dealer's role in disseminating Picasso's sculpted work was crucial, especially in regard to the critical fame of the Cubist *Head of Fernande*, a sculpture that marked a turning point in the history of art.

Extracts from the Archives of the Florentin Godard Foundry

Account Book No. 1

June 28, 1913	Vollard	Tête de Picasso	300 francs
October 15, 1913	Picasso	Buste	300 francs

Account Book No. 2

April 15, 1926	1 buste Picasso	1,600 francs
May 3, 1926	1 buste de Picasso	1,600 francs
May 21, 1926	1 buste de Picasso	1,700 francs
	1 buste de Picasso	1,700 francs
June 8, 1926	1 buste de Picasso Vollard	1,700 francs
June 23, 1926	1 buste de Picasso (Chanteclair)	1,800 francs
July 7, 1926	1 buste Picasso – Chanteclaire	1,800 francs
	1 buste de Picasso	1,700 francs
November 12, 1926	Tête de Picasso	1,700 francs
December 9, 1926	Tête femme de Picasso, Vollard	
February 2, 1927	1 buste Picasso	1,700 francs
April 14, 1927	Buste Picasso Chanteclair Vollard	1,700 francs
May 24, 1927	Buste Picasso Chelaine	1,700 francs
June 4, 1927	Buste Picasso	800 francs
June 24, 1927	Buste Chanteclair Picasso	1,700 francs
June 28, 1927	Buste Picasso	800 francs
July 6, 1927	Buste Picasso Chanteclair	1,800 francs
	Buste Picasso	800 francs
July 29, 1927	Tête Picasso	400 francs
August 5, 1927	Tête Picasso	400 francs
August 24, 1927	Statue de Picasso	2,600 francs
	Tête id	400 francs
October 10, 1927	Statue Picasso	2,600 francs
	Chanteclair Picasso	1,800 francs
	Petite tête	400 francs
November 8, 1927	Statue Picasso	2,600 francs
December 10, 1927	Statue Picasso	2,600 francs
January 14, 1928	Statue Picasso	2,600 francs
February 16, 1928	Statue Picasso	2,600 francs
November 21, 1928	Buste Picasso	1,800 francs
December 19, 1928	Buste Picasso	1,800 francs

Account Book No. 3

January 3, 1929	1 buste Picasso	1,800 francs
January 18, 1929	1 statue Picasso	2,600 francs
December 5, 1929	Buste chanteclair	2,000 francs
August 7, 1930	Tête picasso	2,000 francs
November 28, 1930	Grande figure Picasso	3,000 francs
January 19, 1931	Petite Statuette Picasso	3,100 francs
January 19, 1931	Groupe id. Picasso	2,715 francs
January 30, 1931	Statuettes Picasso	1,600 francs
February 14, 1931	Statuettes Picasso	5,350 francs
February 28, 1931	Statuettes Picasso	4,650 francs

1. Olivier 2001, p. 189.

2. In accordance with a law passed January 6, 1966 (which went into effect on January 1, 1968), the number of authorized casts in France is now limited to eight "original" bronzes and four artist's proofs.

3. Valerie J. Fletcher has inventoried the eighteen currently known cast bronzes from the 1909 *Head of Fernande*; see Fletcher 2003.

4. Ibid., pp. 171–72.

5. Olivier 2001, p. 89, cited in Fletcher 2003, p. 172. Fernande stated that "One day, when he needed a pretty large sum of money, he sold his sculptures to Vollard. . . . It was at about this time that he began to paint cubist portraits. . . . He spent a long time on these portraits, especially on the one of Vollard, which dragged over several months." Olivier 1964, pp. 143–44.

6. Fletcher 2003, pp. 171–72. The earliest record in the Vollard Archives for the dealer's acquiring reproduction rights from Picasso is dated April 16, 1910. Other such transactions are dated November 2, 1910, September 28, 1911, and February 10, 1928.

7. I have found no mention of Picasso's sculptures in Vollard's posthumous inventory, drawn up in October 1939, Stockbook C (1918–22) or the 1922 Inventory (of which I was allowed to consult only a portion).

8. Johnson 1977, p. 41.

9. Vollard Archives, MS 421 (8,18), fols. 1, 2: "Maucuit & Cie Successeurs, 9 Rue Delambre, 9 (Près le boulevard Montparnasse) / Fonderie de Cuivre et de Bronze / Ancienne Maison Kreber / "1 G^de figure femme, 110 [francs] / 1 Petite figure femme assise, 50 [francs] / 1 Figure femme et sa banquette, 70 [francs] / 1 Figure femme à genoux, 55 [francs]" (June 9, 1905) and "1 Figure femme, 65 [francs]" (September 7, 1905). The name of the artist is not specified, and I have been unable to find any further information about this foundry.

10. A handwritten note from Raoul Pellequer in 1968 states, "I telephoned Valsuani (bronzes), 74 rue des Plantes (14e), telephone number LEC 56-18, to ask him how many examples he had cast of 'La Femme se coiffant' of 1904. He answered: 5. As I told him that I had the mold, he said to me that one would need the authorization of his friend Picasso to cast again." Another note from Pellequer mentions that "He [Picasso] does not believe that they had been numbered because as usual Vollard did not require it and he believed that there had only been a small edition." I am grateful to Georges Pellequer for providing this information.

11. Vollard Archives, MS 421 (5,2), fol. 70, April 26, 1907. See also the notation in Vollard's datebook on January 19, 1907: MS 421 (5,2), fol. 7, "payé à Bingen 400 fr[ancs]."

12. Lebon 2003, p. 112. According to Lebon, Jean-Augustin Bingen, or Bingen *jeune* (the younger), might have been the son of Pierre Bingen, a well-known founder, but whether the two were related is not certain, as they maintained separate, concomitant businesses.

13. Ibid., pp. 111–12. On Maillol's bronzes, see the essay by Emmanuelle Héran in this volume.

14. Vollard Archives, MS 421 (5,2), (5,3). Godard's address is noted in Vollard's datebook on December 3, 1907: Vollard Archives, MS 421 (5,2), fol. 200.

15. Binoche Sale 2004, nos. 26–52. Lebon is writing an article about the Godard foundry. Two small bronze sculptures by Picasso were among the foundry's private collection: these were the *Head of a Man* (1906) published by Vollard and a "master" representing the *Head of a Woman* (1906–7). *Head of a Man* is now in a private collection; *Head of a Woman* was sold at auction in 2004 (Binoche Sale 2004, no. 34), is now in the André Bromberg Collection in Paris.

16. Lebon 2003, p. 167.

17. Patent registry, 1914: Les Archives de Paris, D9P4/959; see Lebon 2003, p. 167.

18. The archives are housed in a private collection in France. I thank the owners of these documents for granting me permission to study them. For extracts from the account books, see the chart on p. 186.

19. Florentin Godard archives, book 1.

20. Florentin Godard archives, notebook: "Picasso / sur modèle bois / —petites statuettes 400 f. les trois—grande tête creuse avec bas pendant 400 f. pièce— 1 statuette mince / 1 petit groupe singe / 4 petites terres, les 6 pièces 350 f." (Picasso / from wood model / —small statuettes 400 fr. for the three— large hollow head with lower portion hanging, 400 fr. each—1 narrow statuette / 1 small group of monkeys / 4 small terracottas, 350 francs for 6 pieces). These are no doubt the small sculptures reproduced in Paris 2000, nos. 86–101; the "small group of monkeys" might be the Couple reproduced in no. 103.

21. I am grateful to the owner of the Florentin Godard foundry archives for providing this information.

22. Madame Susse, former owner of the Susse foundry, confirmed that Picasso gave specific instructions. He did not come to the foundry himself but had the work brought to his home, sending it back if he was dissatisfied with the result (conversation with the author, June 14, 2003). Similarly, Heinz Berggruen, speaking of the new editions of *Head of Fernande*, specified, "Monsieur Valsuani often traveled to the South to show his work to Picasso, who would tell him to change this or that detail" (conversation with the author, May 29, 2003). At various points in the founders' correspondence with Picasso, we find requests for his approval of the works' finish. In a letter dated March 23, 1951 (archives, Musée Picasso, Paris), for instance, Émile Godard asked the artist "to send a note by return mail with your go-ahead."

23. I have not been able to identify the "Chanteclair" mentioned on several occasions in the foundry archives; he may have been one of Vollard's clients, a Picasso *amateur*.

24. Vollard Archives, MS 421 (5,2), fol. 200.

25. Florentin Godard archives, book 1. Fletcher (2003, p. 181) suggested that two bronzes of the sculpture were cast at that time, "one for the artist to keep for himself and one for display in the exhibition at Vollard's gallery (20 December 1910 to February 1911)."

26. Florentin Godard archives, book 1.

27. Florentin Godard archives, book 2.

28. *Head of a Jester* (Musée Picasso); *Bust of a Man* (private collection); *Head of Fernande*, 1906 (Musée Picasso); *Kneeling Woman Combing Her Hair* (private collection); *Head of Fernande*, 1909 (Musée Picasso).

29. Vollard Archives, MS 421 (5,7), fol. 66, May 26, 1911. Shipment of the sculpture to Kramář is noted in Vollard's datebook on July 10, 1911: "Expédié au Dr Kramar le bronze Picasso." Vollard Archives, MS 421 (5,6), fol. 43. It is now in the Národní Galerie in Prague.

30. "Vendu à Steichen un exemplaire de Picasso (tete) pour 600 fr[anc]s recu chèque": Vollard Archives, MS 421 (5,8), fol. 8, January 15, 1912. In 1949 Georgia O'Keeffe, widow of Alfred Stieglitz, for whom Steichen had bought the work, gave it to the Art Institute of Chicago.

31. "Payment received from Pellequer, 1 bronze de Picasso 5,500 [francs]": Vollard Archives, MS 421 (4,7), fol. 63, November 23, 1926. This sculpture is now in a private collection in Los Angeles.

32. "Payment received from Galleries Tannhauser à Berlin, registre exp^on [no.] 95 / 1 bronze de Picasso bronze, arlequin, 8.000 [francs] / 1 bronze de Picasso, tête cubiste, 8.000 [francs]:" Vollard Archives, MS 421 (4,7), fol. 65, January 22, 1927. The *Head of Fernande* (1906) is now in a private collection. The *Jester* is in a private collection in Switzerland, and the *Head of Fernande* (1909) is at the Norton Gallery and Museum of Art in Palm Beach, Florida.

33. "Payment received from Hugo Perls à Berlin, registre exp^on no. 96 / 1 bronze de Picasso, artiste vivant, 8.000 [francs]": Vollard Archives, MS 421 (4,7), fol. 65, January 27, 1927.

34. "Payment received from Galerie Fletchteim à Berlin, registre exportation no. 97 / 1 bronze Picasso, 8.000 [francs]": Vollard Archives, MS 421 (4,7), fol. 67, February 22, 1927. The work is now at the Phillips Collection, Washington, D.C.

35. "Bradley pour Vheye [Weyhe] pour Amerique 1 buste de Picasso tete de femme 8.000 [francs]": Vollard Archives, MS 421 (5,14), fol. 2, February 8, 1927. This sculpture was sent on March 11, 1927. "Payment received from Weyhe à New York no. 98 registre exp^on / 1 bronze Picasso Tête." Vollard Archives, MS 421 (4,7), fol. 68. The entire shipment, which also included three Maillol bronzes (respectively valued at 3,500, 2,500, and 3,600 francs), was worth 24,600 francs. By deduction, then, the Picasso bronze was valued at 8,000 francs. The accounts books of the Florentin Godard foundry indicate a bust made on February 2, 1927. An invoice dated July 29, 1926, and addressed to Vollard by William Aspenwall Bradley, a Paris dealer acting as Weyhe's agent, mentions a "Tête cubiste" by Picasso: private archives. This sculpture is now in the Leonard Lauder Collection, New York.

36. According to Thannhauser's archives (Zentralarchiv des Internationalen Kunsthandels e.V., Cologne), and the archives of the Rosengart Gallery in Lucerne, these works were purchased on March 11, 1927. Vollard's registers mention receipt of payment for another lot of three sculptures on July 1, 1927: "Galerie Tanhauser à Lucerne, registre exp^on no. 92 / 3 bustes de Picasso, artiste vivant, 24.000 fr[anc]s": Vollard Archives, MS 421 (4,7), fol. 73. These discrepancies in the archives urge caution in any attempt to

date the acquisition. I am grateful to Janet Brinnet and Angela Rosengart for their kind assistance.

37. "Payment received from Reber à Lugano, registre exp^on no. 107 / . . . 1 buste par Picasso, 9.000 [francs]": Vollard Archives, MS 421 (4,7), fol. 71, May 24, 1927. It is probably the *Head of Fernande* (1905), as the work appears in a photograph from 1930 taken in Reber's house in Bethusy, Switzerland. This sculpture's present location is unknown. Reber also bought from Vollard the *Jester* and the *Head of Fernande* (1909), as they appear in two photographs taken during the winter of 1924. I am grateful to Christopher Pudelko (Bonn), grandson of G. F. Reber, for providing these documents.

38. "Payment received from Weyhe à New York, registre exp^on no. 112 / 1 Tête arlequin de Picasso (bronze), 8.000 [francs]": Vollard Archives, MS 421 (4,7), fol. 72, June 24, 1927. An invoice dated June 4, 1927, and addressed to Vollard by William Aspenwall Bradley, acting as Weyhe's agent, mentions the purchase of a *Jester* (present location unknown): private archives.

39. These sculptures (present location unknown) were put up for sale by the heirs of Édouard Jonas (Galerie Charpentier, Paris, March 30, 1954, no. 69).

40. Private collection.

41. Two work plasters currently exist (the original seems to have been destroyed): one was bought from Ulmann by the Beyeler Gallery, which sold it to a collector in Toronto, Mr. Latner, and the other, from Picasso's collection, was sold by Marina Picasso, via the Jan Krugier Gallery, to Raymond and Patsy Nasher (now at the Nasher Sculpture Center in Dallas). Ulmann would therefore have owned two plasters.

42. The work was sold at auction by Georges Pellequer, Raoul's son (Christie's, London, July 2, 1998, no. 246). It is now in a private collection.

43. It is now in a private collection.

44. See Berggruen 1997, pp. 101–2. The edition contract, signed in Cannes on February 15, 1959, is reproduced in the book.

45. The edition contract, dated January 28, 1968, is in a private collection in Paris.

46. *Head of Fernande* was given to the museum in 1933, *Head of a Jester* in 1937.

47. Gift of Lucien Vollard, 1947, to the Musée Léon Dierx in Saint-Denis. The work is reproduced in Spies 2000, p. 347, no. 13.

Vollard's Print Albums

Jonathan Pascoe Pratt and Douglas Druick

Shortly after he opened his first rue Laffitte gallery in 1893, Ambroise Vollard became interested in the idea of commissioning and publishing original prints by contemporary artists. Prints made by painters (so-called *peintres-graveurs*) had been gaining popularity, thanks to impetus from the periodical *L'Estampe originale,* which first appeared in March 1893. Published by André Marty and issued quarterly, it contained limited-edition prints representing a variety of artists and stylistic trends. While diverse media were represented, the periodical had aroused particular interest in lithography and more specifically in color lithography.[1]

When *L'Estampe originale* ceased publication in 1895, there remained nothing else available of comparable content and quality. At this point Vollard made his first foray into print publishing, bringing an uncharacteristic passion to the enterprise, as the records he left now attest. In the next few years Vollard published two types of albums: assemblages of prints by many artists, and albums devoted to a single artist. All were marketed, like *L'Estampe originale,* in editions of one hundred.

Vollard's ambition sometimes led him to violate the accepted standard for an "original print." Some of the artists he invited to contribute prints—including Auguste Renoir, Paul Cézanne, and Alfred Sisley—were disinclined to work in the complicated medium of color lithography. Instead they gave Vollard maquettes, and he instructed his printer, Auguste Clot, to make lithographic color stones based on these models. The prints published in this way introduced confusion to the notions of originality and reproduction as generally understood in the market. On the other hand, with the individual albums Vollard commissioned from Nabi artists—all four of which are discussed later in this essay—Vollard's passion found a creative response, and the results earned a deserved place in the history of printmaking.

<div style="text-align: right">DD</div>

THE *ALBUM DES PEINTRES-GRAVEURS,* 1896
Beginning in January 1896, Vollard's records provide some detailed information about his transactions regarding his publication of prints.[2] Listed in his account book in two columns are the names of the artists he asked to contribute to his first album, the *Album des peintres-graveurs* (fig. 200). The first column most probably represents Vollard's early conception of the album; however, only sixteen from this first list of twenty-two artists produced a work for the album. It appears that the second column lists the artists Vollard approached next; indeed, there was even a third list on the same page. The initial agreement of an artist did not always ensure the completion of a work before the publication deadline. Vollard remained flexible and made some inspired choices, such as commissioning a lithograph from Edvard Munch almost immediately after the artist's arrival in Paris, even though the album by then had already been planned.

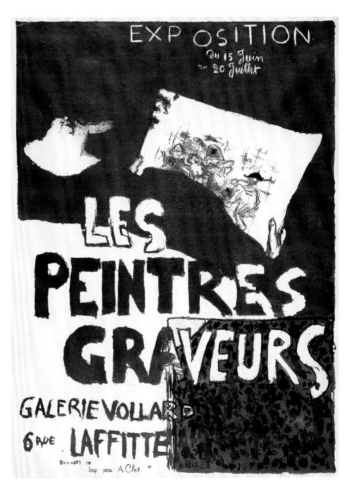

Fig. 199 (cat. 12). Pierre Bonnard, *Exposition, Les Peintres-Graveurs, Galerie Vollard,* 1896. Lithographed poster, sheet 25½ x 18⅞ in. (64.7 x 48 cm). The Museum of Modern Art, New York, Purchase 1949 (524.1949)

At the top of Vollard's first list of potential contributors were Maurice Denis, George Auriol, Félix Vallotton, Pierre Bonnard (see fig. 199), Édouard Vuillard, Georges de Feure, and Odilon Redon, all of whom had completed their commissions by late February or early March 1896. Bonnard was paid 100 francs for his contribution *La Petite Blanchisseuse,* for example, on February 27, 1896.[3] Since those named toward the end of the list did not complete their works until May or June, it seems that artists were listed in the order in which they were commissioned.

Near the end of the list are the names József Rippl-Rónai, James Pitcairn-Knowles, Théo van Rysselberghe, and Jan Toorop. These choices were significant, since in 1891 the Société Française des Peintres-Graveurs had decided to exclude foreign artists except by special invitation. Vollard seized this opportunity to invite foreign artists to participate in his publication. The above-named artists were Hungarian, Scottish, Belgian, and Dutch, respectively; Munch was Norwegian; and the Swiss artist Vallotton was also asked to contribute.

Vollard's second list of potential contributors included Eugène Carrière and Cézanne.[4] Neither produced a work for this first album, but both contributed to the second.

For his commissioned artists, Vollard provided technical advice and covered printing costs. Payment was in most cases 100 francs, or, if the artist preferred, an album.[5] The artist was responsible for providing a work from which 110 impressions would be printed (of these, 100 were to be numbered and signed by the artist), as well as two signed trial proofs of each state and two impressions printed from the canceled plate.

Most of the commissions for the *Album des peintres-graveurs* were completed and paid for between February and April 1896. Vollard intended to publish the album by the end of April,[6] but the accounts show that at that time at least five of the artists had not yet been paid, suggesting that they had not completed their commissions and the album was not ready. To complete the album Vollard had to make compromises and commission artists not initially invited, including Albert Besnard, Henri Fantin-Latour, Rupert Carabin, Suzanne Valadon, and Charles Maurin.

Of the first fourteen contributing artists, twelve made lithographs, ten of which were printed in color. Clearly the preference at the outset was for color lithography. But as the project stretched beyond its original publication date, Vollard was forced to seek commissions in other media; not one of the five last-recorded contributing artists[7] produced a lithograph in color. In the end, only thirteen of the twenty-two works in the album were lithographs.

Throughout the print section of his account book Vollard maintained a calculation of the costs of producing the album.[8]

Fig. 200. Two pages from one of Vollard's account books. Listed on the page at left are possible artists to contribute prints for the *Album des peintres-graveurs;* listed on the page at right are potential subscribers. Vollard Archives, MS 421 (4,4), fols. 68, 70

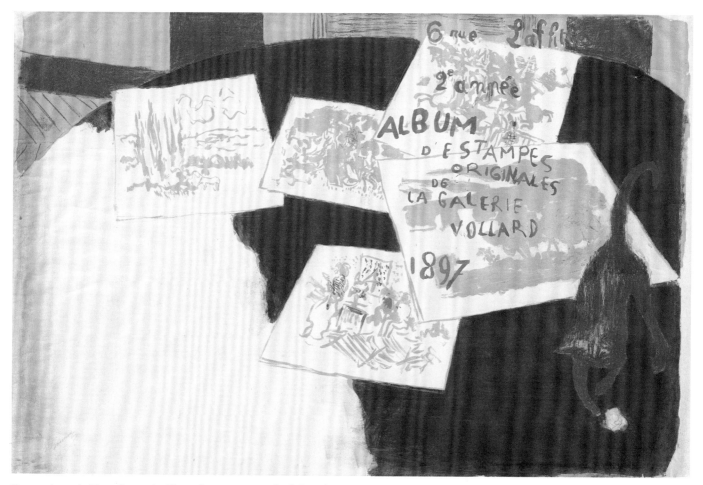

Fig. 201 (cat. 13). Pierre Bonnard, *Album d'estampes originales de la Galerie Vollard,* cover, 1897. Color lithograph, image 22¼ x 33½ in. (56.6 x 85.1 cm), sheet 22¼ x 34⅜ in. (56.6 x 87.7 cm). The Museum of Modern Art, New York, Purchase 1949 (526.1949)

On folio 69 the artists' fees and production costs were totaled, projecting an overall expenditure of 5,500 francs.[9] On the basis of these costs Vollard set the price of the album at 150 francs.[10]

Vollard listed potential subscribers on several pages, including folios 70 and 72, adding names as the project developed (fig. 200). The order of names is once again significant and reflects Vollard's strategy for marketing the albums. The first-named were primarily dealers and collectors of paintings,[11] suggesting that Vollard aimed his album toward the paintings market. The first person on the list was the dealer Eugène Blot, who was among the first to purchase the album—on June 19, 1896.[12] Two print dealers subscribed, Édouard Kleinmann and Édouard Sagot, whose positions of thirteenth and twenty-fifth on the list again indicate that the album was intended largely for buyers of paintings rather than of prints.[13] Only two print collectors, Pochet and Georges Humbert, subscribed, and although there were many collectors and connoisseurs of prints in Paris at this time, of them only the critic Roger Marx (one of the founders of *L'Estampe originale*) bought an album.[14] Overall, of the twenty-seven identifiable purchasers, twenty had not bought prints from Vollard before, and many had bought only paintings. Fifteen of them had not bought from Vollard a work by any of the

contributing artists. Perhaps they had greater confidence in the judgment of this dealer-publisher than in the contributing artists.

Vollard calculated that he needed to sell thirty-six or thirty-seven copies of the *Album des peintres-graveurs* to cover its production costs, yet in the course of 1896 he managed to sell only about twenty-four albums. In the *Mouvements* account book Vollard could compare the profits from his painting sales for the period with the costs of his print project. He made the decision to continue with a second album—in effect, to subsidize his print publishing with the profits from his paintings business.

THE *ALBUM D'ESTAMPES ORIGINALES DE LA GALERIE VOLLARD,* 1897

Artists for this second album (fig. 201) were selected in a process similar to that for the first. The initial choices included Paul Gauguin and Mary Cassatt. The album was planned to include works by seventeen or eighteen artists at the most, because Vollard did not wish merely to produce a repeat of the first album.[15] He wanted to publish artists whom he had not published before; from those who *had* contributed to the first album, he wanted a work in a different medium.[16]

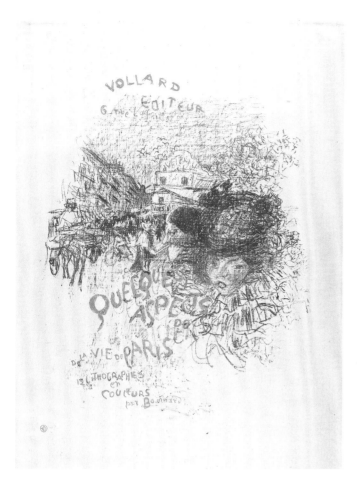

However, completion of the commissions was slow, and it became clear that the album would not be ready for publication in April 1897 as Vollard had hoped. Many artists—including Gauguin and Cassatt—turned down the invitation to participate, as the numerous deletions from the list testify. Vollard was forced to split the publication into two parts: he issued the first part in July 1897, and the commissions completed later he published in December 1897. Furthermore, by late July he seems to have compromised on his initial intentions and, in order to complete the album, returned to artists published in the first album, such as Bonnard, Denis, Vuillard, and Roussel, for works in the same medium as their previous contributions. The album as eventually completed contained thirty-two prints.

Fig. 202 (cat. 14). Pierre Bonnard, *Quelques Aspects de la vie de Paris* (*Some Aspects of Paris Life*), ca. 1898, published 1899. Cover for a suite of 12 color lithographs, image 16⅛ x 13 in. (41 x 33 cm), sheet 20⅞ x 15⅞ in. (53 x 40.3 cm). The Art Institute of Chicago, gift of Walter S. Brewster (1936.178)

Fig. 203. Pierre Bonnard, *Boulevard*, from *Quelques Aspects de la vie de Paris* (*Some Aspects of Paris Life*), ca. 1896, published 1899. Color lithograph, image 6⅞ x 16⅞ in. (17.5 x 43 cm), sheet 15⅞ x 21 in. (40.4 x 53.5 cm). The Art Institute of Chicago, gift of Walter S. Brewster (1936.183)

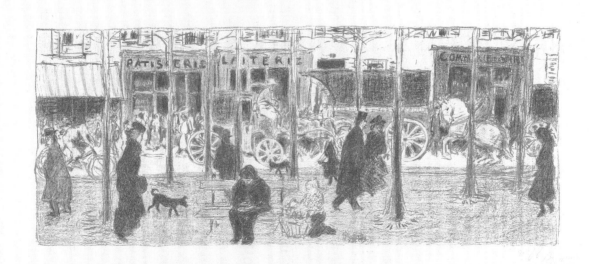

Fig. 204 (cat. 71). Maurice Denis, *"Our Souls, with Languorous Gestures,"* plate 9 from *Amour* (*Love*), 1898, published 1899. Color lithograph, image 11 x 15⅝ in. (27.8 x 39.8 cm), sheet 16 x 20¾ in. (40.5 x 52.8 cm). The Art Institute of Chicago, John H. Wrenn Memorial Collection (1946.432g)

Fig. 205 (cat. 71). Maurice Denis, *"The Morning Bouquet, Tears,"* plate 3 from *Amour* (*Love*), 1898, published 1899. Color lithograph, image 14¾ x 11⅛ in. (37.6 x 28.3 cm), sheet 20¾ x 15⅞ in. (52.7 x 40.2 cm). The Art Institute of Chicago, John H. Wrenn Memorial Collection (1946.432l)

"I set at 100 francs the price of the first album and at 150 francs that of the second, which contained a larger number of pieces,"[17] wrote Vollard in his *Souvenirs,* but the recollection is inaccurate. The first album actually sold for 150 francs and the second for 300 francs, 150 for each of its two parts. Vollard aimed the second album at the same clients as the first, and he launched the publication of the completed work with an exhibition of related drawings at his gallery, December 2–23, 1897.[18]

However, not only had he split the publication of this second album and released half in July, he had also been selling prints from it individually for several months before publication. Vollard had taken financial losses on his first album and had not been able to reduce the costs of publishing with the second album; on the contrary, since he had increased the size of the album, his costs substantially increased as well.

Despite his difficulties attracting the artists he wanted for his second album, Vollard initially made plans in 1897 to publish a third album. But he abandoned the idea a few months later, for reasons that probably included overwhelming financial loss, failure to attract the desired artists, and frustrating delays in production.[19]

BONNARD'S *QUELQUES ASPECTS DE LA VIE DE PARIS,* 1895–99

Vollard's first recorded transaction with Pierre Bonnard[20] is his payment of 100 francs for the artist's lithograph *La Petite Blanchisseuse* of 1896, which was included in the *Album des peintres-graveurs.* Bonnard also contributed to the *Album d'estampes originales de la Galerie Vollard* (fig. 201) and provided a work for the third, unpublished multi-artist album.

Although Bonnard's own album, *Quelques Aspects de la vie de Paris,* has been dated to 1898, the first reference to it in Vollard's accounts was on December 12, 1896, when the dealer paid Bonnard 70 francs "à compte sur album vues de Paris."[21] Over the next two years Bonnard made the thirteen lithographs (including the title page) in the set (figs. 202, 203), probably completing the last one shortly before the album's publication at the beginning of 1899.

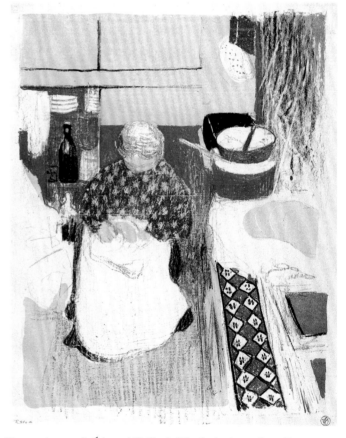

It appears from the accounts that Vollard paid for each lithograph individually after it was printed, until the set was complete. Initially he paid 70 francs for each work;[22] however, as the album progressed this probably rose to 100 francs, the same amount he paid artists for contributions to the *Album des peintres-graveurs*. It can be assumed that the printer, Auguste Clot, charged 100 francs to print the complete edition of each lithograph, since this was his price for printing the similar series of lithographs by Édouard Vuillard and the set by Maurice Denis. Vollard's expenses thus included a payment to the artist of about 900 to 1,300 francs; printing costs of 1,300 francs; and other, smaller outlays for China and wove papers and additional technical assistance. Thus the overall cost of issuing the album was somewhere between 2,300 and 2,600 francs. Since the price of the album was apparently 150 francs (see below), to cover his costs Vollard would have had to sell eighteen albums.

DENIS'S *AMOUR*, 1898
The first transaction concerning Maurice Denis recorded in Vollard's accounts is the sale of a Denis painting in October 1894.[23] Next Vollard purchased "un lot de tableaux et dessins" directly from the artist on September 21, 1895.[24] In February 1896 Vollard received Denis's lithograph *La Visitation à la villa Montrouge* for the *Album des peintres-graveurs,* and over the next two years there were many dealings concerning paintings by Denis.

Although Pierre Cailler states that Denis began work on the album *Amour* in 1892,[25] the first record in Vollard's accounts is for May 1, 1897, when Vollard paid Denis 130 francs for "two plates of *Amour*."[26] For the third plate he paid 100 francs.[27] On October 22, 1898, Vollard paid Denis 200 francs for the next two lithographs.[28] There are no identifiable records of payments to the printer, but for this edition of one hundred (see figs. 204, 205) Auguste Clot presumably charged 100 francs per image, as he did for the Bonnard and Vuillard albums.

In the March–April 1899 issue of *L'Estampe et l'affiche,* the album was advertised for sale at 175 francs, although this price seems to have been flexible. On May 7, 1900, Vollard sold an *Amour* album for 150 francs.[29] He adjusted the price for certain clients: A regular buyer named Madame Benard was charged 120 francs for an album on June 1, 1900.[30] A combined price was sometimes recorded when a collector bought more than one album—on August 30, 1900, Pochet bought a Denis

Fig. 208 (cat. 188). Ker-Xavier Roussel, *Cupids Playing near a Nymph,* plate 5 from *Paysages* (*Landscapes*), 1900. Color lithograph, image 8⅜ x 13⅜ in. (21.4 x 34 cm), sheet 15⅞ x 20½ in. (40.2 x 52.7 cm). The Art Institute of Chicago, Prints and Drawings Purchase Fund (1936.211)

Le Père Ubu au pays des Soviets (*Père Ubu in the Land of the Soviets*). [1924.] Published by Librairie Stock, Delamain, Boutelleau & Cie, Paris, 1930.

Les Réincarnations du Père Ubu (*The Reincarnations of Père Ubu*) (fig. 228). Deluxe and expanded edition. Illustrated by Georges Rouault. Published by Ambroise Vollard, Paris, 1932.

Tout Ubu colonial (*The Complete Ubu Colonialist*). Complete edition. Edited and annotated by Jean-Paul Morel. Published by Séguier, Paris, and Musée Léon Dierx/AAABMR, Saint-Denis (Réunion), 1994.

VOLLARD'S WRITINGS ON ARTISTS
Paul Cézanne (fig. 291). First deluxe edition published by Ambroise Vollard, Paris, 1914. Standard edition published by Georges Crès & Cie, Paris and Zurich, 1919; revised and expanded edition published by Georges Crès & Cie, Paris, 1924.

English edition: *Paul Cézanne: His Life and Art*. Translated by Harold L. Van Doren. Published by Crown, New York, and Constable, London, 1937.

La Vie et l'oeuvre de Pierre-Auguste Renoir. First deluxe edition published by Ambroise Vollard, Paris, 1919. Standard edition published under the title *Auguste Renoir (1841–1919)* by Georges Crès & Cie (in the series "Artistes d'hier et d'aujour-d'hui"), Paris, 1920; new edition, 1921.

English edition: *Renoir: An Intimate Record*. Translated by Harold L. Van Doren and Randolf T. Weaver. Published by Alfred A. Knopf, New York, and Constable, London, 1925.

Degas (1834–1917). Standard edition published by Georges Crès & Cie (in the series "Artistes d'hier et d'aujourd'hui"), Paris, 1924.

English edition: *Degas: An Intimate Portrait*. Translated by Randolph T. Weaver. Published by Greenberg, New York, 1927; new edition, Crown, New York, and Constable, London, 1937.

En Écoutant Cézanne, Degas, Renoir. Published by Bernard Grasset, Paris, 1938.

VOLLARD'S OTHER WRITINGS
Sainte Monique (Saint Monica). Standard edition published by Émile-Paul Frères, Paris, 1927. Deluxe edition published under the title *La Vie de Sainte Monique* (*The Life of Saint Monica*). Illustrated by Pierre Bonnard. Published by Ambroise Vollard, Paris, 1930.

Recollections of a Picture Dealer. Translated by Violet M. MacDonald. Published by Little, Brown, Boston, and Constable, London, 1936.

French edition: *Souvenirs d'un marchand de tableaux*. Published by Albin Michel, Paris, 1937; new edition with additional material, 1938; new edition, revised and expanded, published by Club des Libraires de France, Paris, 1957.

1. Louis de Rouvroy, duc de Saint-Simon (1675–1755), French diplomat and writer of the famous *Mémoires sur le règne de Louis XIV et la Régence,* a personal and critical history of the court of Louis XIV.
2. For the times, Ambroise Vollard was actually among the more "cultured" art dealers. After earning his bachelor's degree in 1885 and his law degree in 1888, he enrolled for a second year of doctoral studies in 1892, before finally abandoning higher education.
3. See Bavoux 1993.
4. Monica was the name of Saint Augustine's mother. In a note to himself from 1900, Vollard wrote: "buy Saint Augustine *Confessions,*" suggesting that he nurtured this project for quite some time. Private archives.
5. Teodor de Wyzewa, a little-known but important French avant-garde writer of Polish origin, was active at the end of the nineteenth century. See Paul Delsemme, *Teodor de Wyzewa et le cosmopolitisme littéraire en France à l'époque du Symbolisme* (Brussels, 1967).
6. These interviews are comparable to the first interviews in the literary domain by Jules Huret: *Enquête sur l'évolution littéraire* (Paris, 1891; Vanves, 1982) and *Interviews de littérature et d'art* ([1889–1905]; Vanves, 1984).
7. See, for example, Roger Marx, catalogue preface for an exhibition of Les Dix (a group of Nabi painters Vollard exhibited), April 1897; Gustave Coquiot, catalogue preface for the Iturrino and Picasso exhibition, June–July 1901; Félix Fénéon, catalogue preface for the Van Dongen exhibition, November 1904; and Octave Mirbeau, catalogue preface for the Manzana-Pissarro exhibition, April 1907. For more information on these shows, see the Appendix on the exhibitions at Vollard's gallery by Rebecca Rabinow in this volume.
8. See my critical edition of the Ubu saga (Morel 1994).
9. See the correspondence on this subject in Morel 2000, pp. 31–32.
10. This is the now classic story of the palimpsest, a story within a story within a story; see *The Manuscript Found in Saragossa* or, more recently, Umberto Eco's *The Name of the Rose.* I have followed Vollard's own remarks in his preface, which concludes: "My elderly housekeeper said to me one day, '[. . .] I found some old papers lying around. . . . They make great kindling for the fire!' 'They' were none other than the pages of this manuscript!"
11. Vollard painstakingly gathered information from the works of Louis Bertrand "of the Académie Française": in addition to Augustine's *Confessions,* he read Bertrand's *Saint Augustin* (Paris: Librairie Arthème Fayard, 1918), and especially his *Autour de Saint Augustin* (Paris: Arthème Fayard & Cie, 1921), which contains an entire chapter on Saint Monica and another on "Augustine's beloved." Moreover, Bertrand later devoted an entire book to the latter, *Celle qui fut aimée d'Augustin,* Les Grandes Repenties (Paris: Albin Michel, 1935).
12. Nick Carter was a character in a popular series of American detective stories, begun in 1884 by John Russell Coryell and first published in France in March 1907, adapted by Jean Petithuguenin and sold in weekly installments. Adventure stories featuring the Vulture of the Sierra (written by Georges Clavigny, pseudonym of Jules Besse) were serialized in 1913 and 1914. Vollard also enjoyed the adventures of Arsène Lupin (created by Maurice Leblanc), whose exploits appeared in stories and novels, beginning in July 1905.

Vollard and His Clients

Fig. 229 (cat. 99). Paul Gauguin, *Three Tahitian Women*, 1899. Oil on canvas, 26 ¾ x 28 ⅞ in. (68 x 73.5 cm). State Hermitage Museum, St. Petersburg (7708)

A Widening Circle: Vollard and His Clients

Anne Roquebert

"Relative to genius," said Charles Baudelaire, "the public is a clock that runs slow."[1] At the end of the nineteenth century, the chasm that existed between official, recognized art and independent modern art was still so broad that only a few, unusually effective individuals could make the crossing. Ambroise Vollard was such a man. Anyone who has followed the course of modern art from 1890 onward has necessarily encountered this singular character, who did not restrict himself to simply acting as intermediary but rather created a new kind of art dealer.

In Paris, the capital of the art world, a profusion of available art and especially of recent works had given rise to a flourishing market. Taking on a new role previously played by the Salon jury, the art dealer of this era simultaneously discovered artists, supported them, and stood as guarantor of their talents. When he first moved into this role, Vollard was a beginner in the art business. Self-educated and seemingly come out of nowhere, he lacked connections but also was free of the official prejudices. Quickly becoming a connoisseur, he nonetheless retained throughout his life a certain distrust of traditional art history. Rarely have artistic perspicacity, a head for business, curiosity, and a thirst for knowledge (which soon became true erudition) so coexisted in a single person. Over his fifty-year career, Vollard would discover and manage several generations of painters and collectors.

IN SEARCH OF ART LOVERS

During the time of his Parisian studies (begun in 1887 and soon terminated), Vollard displayed less interest in law than in the secondhand booksellers along the Seine, from whom he cadged engravings and drawings. Despite financial hardships, he set out to meet the artists whose works he was collecting[2] and to find his first buyers.

It is evidence of how important the international market was already becoming that because he spoke no foreign languages, young Vollard was turned away when he applied for a position with the prestigious art dealer Georges Petit (1856–1921).[3] But he found employment, at a salary of 125 francs per month, with Alphonse Dumas (1844–1913), an amateur dealer

and painter.[4] Dumas saw himself as a "man of the world who acts as intermediary between the painter and the collector" through his Galerie de l'Union Artistique.[5] Vollard learned his trade at Dumas's,[6] dealing with collectors and endeavoring to balance aesthetic choices against the search for clients and merchandise. Bored with selling academic paintings by the omnipresent Édouard Debat-Ponsan, Vollard left Dumas's employ (as he told it) when his boss refused his advice to buy some Impressionists, fearing it would give his gallery "a bad reputation."

But the reality is probably more complex, for Dumas was also a collector—or at least so he appears in the catalogue of the posthumous Édouard Manet exhibition of 1884 at the École des Beaux-Arts, to which he loaned about a dozen drawings.[7] The three largest of these, which later belonged to Auguste Pellerin, can be identified and are mentioned in Vollard's *Recollections of a Picture Dealer*, along with a "youthful sin" that Dumas apparently confessed to the author in 1892. Fifteen years earlier, taken to meet a "modern" painter by the dealer Père Noizy, Dumas had felt obliged to buy a group of drawings chosen by the artist himself. These turned out to be, Vollard wrote, "Manet's gorgeous water-colour, *Olympia* . . . then a roll containing the original drawings for *Le Chat Noir et le Chat Blanc;* a 'state' of the coloured lithograph *Polichinelle;* several admirable drawings in red chalk and a dozen sketches of cats." After telling Vollard about this earlier purchase, Dumas asked him to "get rid of the lot for me, at the best price you can," adding, "Today, it appears, the stuff is beginning to go up in value. All the more reason to get rid of it." Although the drawings were hung very discreetly in Dumas's gallery, Vollard sold the entire batch within a few days. Just who were the buyers of these Manets cited so allusively? Either Vollard tested the effect of the beautiful Manets on collectors or he bought them himself, quietly, as a way of building up his stock.[8]

Since he had exhibited the Manets under his own name, Dumas apparently wasn't as ashamed of them as Vollard claimed. Indeed, Dumas was undoubtedly more important to the young Vollard than the latter subsequently admitted. Mentions of Dumas that can be found in Vollard's archives prove that they were still in contact in 1894 and until at least

Fig. 230. Invitation to Vollard's 1894 exhibition of sketches by Édouard Manet. Musée du Louvre, Paris. Service d'Études et de Documentation, Fonds Moreau-Nélaton

1908,[9] and Vollard bought several classic works at the Dumas auction on June 18, 1895.[10] His apprenticeship with Dumas was decisive for Vollard. It was during that period that, taking his place in the art market, he made his first aesthetic choices and forged important contacts that he spun into a network of lasting connections.

At first, in order to survive, Vollard had to find clients so he could "turn to account the few drawings and engravings" he had collected out of his student savings.[11] His inventory had cost him hardly more than 500 francs. "With these marvels going for so low a price, it was obviously not with the dealers that I could hope to do good business," Vollard recalled, and therefore he had to go directly to the collectors —traveling clear across Paris, for instance, to offer a drawing by Jean-Louis Forain to a wine merchant in Bercy.[12] One of his first collectors "climbed the stairs painfully, pushed by two friends," convinced that "to see a beautiful Guillaumin was worth struggling up five flights." This took place in the two-room attic apartment on the seventh floor at 15, rue des Apennins that served him as both home and shop. At the time, Vollard was exhibiting paintings and pastels by Armand Guillaumin,[13] as is confirmed in an 1892 letter from the painter[14]—evidence that, despite the precariousness of his position as a broker, he had already moved on to organizing exhibitions as well.

Some of his early transactions seem to have been handled through Julien (Père) Tanguy, a paint-seller with a shop on rue Clauze. Tanguy exercised a determining influence on the young Vollard, who in his shop discovered Cézanne. In May 1893 the fledgling dealer paid Tanguy 300 francs for two paint-

ings that Maurice Denis had agreed to sell. Wanting to buy another small Denis, Vollard wrote to the artist, "I would prefer to take delivery of this painting neither through Tanguy, since it would look as if I were taking food from his mouth, nor through Boutteville, who is furious with me since I sold one of his clients a painting I had bought from him, naturally for a higher price."[15]

In emerging on his own, Vollard had to face competition from the start. Since Theo van Gogh had died in 1891, Vollard's most immediate rival for the market in young modern artists was the active dealer Louis-Léon Le Barc de Boutteville.[16] Vollard was admittedly fortunate enough to come along at a key moment in the history of painting, but he also seems to have had a knack for making the right choice. In September 1893 he told Denis that he was opening a small shop at 37, rue Laffitte.[17] Setting himself up on that street, the hub of the Paris art market and known the world over as the street for paintings (fig. 3), helped Vollard attract potential collectors and was an integral part of his business strategy. Many other art dealers also had shops on rue Laffitte, notably Bernheim-Jeune (at number 8) and Paul Durand-Ruel (at number 16).

The arrival of this newcomer who "knows his job" and "is already beginning to attract the attention of certain collectors who like to poke about" was mentioned in passing by Camille Pissarro in a letter to his son Lucien early in 1894. "A young man . . . warmly recommended to me by M. Viau, has opened a small gallery in the rue Laffitte," wrote Pissarro. "He shows nothing but pictures of the young."[18] In fact, Vollard, who had quickly learned what collectors were looking for, showed more than works by "young" painters. Perhaps grasping

Fig. 231. Édouard Vuillard, *Dr. Georges Viau, Dentist, in His Office,* 1914. Oil on canvas, 42⅛ x 54 in. (107 x 137 cm). Musée d'Orsay, Paris, Acquired with the participation of Madame Routley-Viau, 1955 (RF 1977-396)

the possibility of something overheard by chance, he went to see Manet's widow and from her acquired a group of sketches that the woman had vainly offered to all and sundry.[19] Around them he organized a small exhibition. Vollard's early decision to gamble on the Manets proved oddly prescient and ultimately quite profitable; once again, his determined interest in this artist stood him in good stead.

WAVES OF COLLECTORS: FROM *AMATEURS* TO AVANT-GARDISTS

Vollard might have dreamed of having major collectors such as Alfred Chauchard or Gabriel Cognacq as clients, but despite his efforts he rarely glimpsed their like. To draw them in he offered, with unerring instinct, a relatively unfamiliar kind of work—sketches—by the same painters they already loved and collected. In the fall of 1894 he sent invitations for

his Manet show to well-known collectors (one invitation card, fig. 230, was preserved by the prestigious and learned art lover Étienne Moreau-Nélaton).[20] Vollard was offering interesting pieces at affordable prices, and the collectors came in droves.

First to take an interest in Manet's sketches were the artists: Edgar Degas, Paul Gauguin, Guillaumin, Claude Monet, Pissarro, and Auguste Renoir bought drawings, often in exchange for their own works. By paying "in kind" they became both customers and suppliers, and this ingenious barter system allowed Vollard constantly to renew his inventory.[21] It was with works of Manet and Paul Cézanne, followed by those of Renoir and Degas, that Vollard realized his most lucrative sales in the years 1894–97.[22]

The Manets were appealing enough to also draw numerous dealer colleagues, who replenished their own stocks at Vollard's,[23] as well as individual collectors. One client who staunchly supported Vollard from early on—beginning with

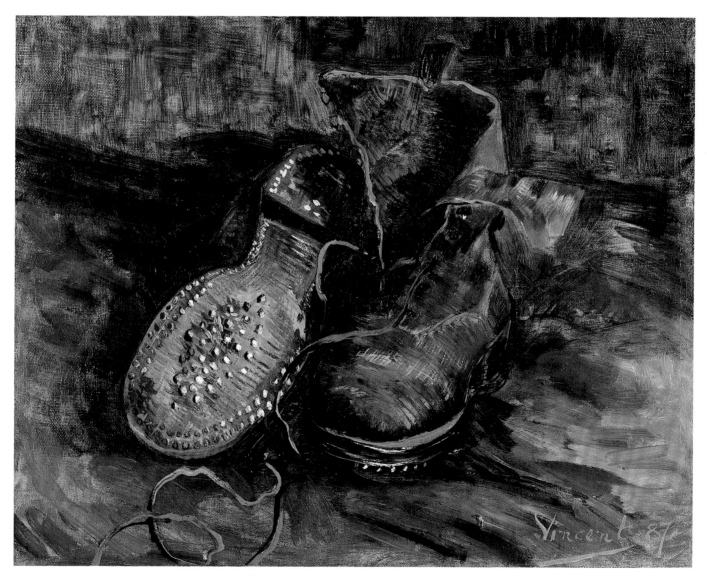

Fig. 232 (cat. 112). Vincent van Gogh, *A Pair of Boots,* 1887. Oil on canvas, 13½ x 16¼ in. (34 x 41.3 cm). The Baltimore Museum of Art, The Cone Collection, formed by Dr. Claribel Cone and Miss Etta Cone of Baltimore, Maryland (BMA 1950.302)

his purchase of two Manet drawings in 1894—was Dr. Georges Viau (1855–1939), a dentist (fig. 231) who practiced at 47, boulevard Haussmann, in the neighborhood of Dumas's shop.[24] There was also Gustave Cahen (ca. 1848–ca. 1928), a former attorney who mainly collected classic modernists such as Eugène Boudin, Honoré Daumier, and Manet.[25] Manet's inner circle appears to have responded as well to the availability of the artist's works: Madame Ménard Dorian (1850–1929), Méry Laurent (one of his models; 1849–1900), and even Manet's friend and former schoolmate Antonin Proust (1832–1905)[26] bought his works from Vollard. Several new names can also be gleaned from Vollard's records. Mondain[27] and C. Cerfils[28] were clients who lived in the provinces; M. Bourdin and Auguste Bauchy, the owner of the Café des Variétés,[29] traded works with Vollard and developed an interest in Manet and Cézanne even before Vollard had organized exhibits of those artists.

In less than a year, Vollard was able to resell for double their purchase prices all the Cézannes he had bought at the June 1894 Tanguy auction.[30] At that sale he had acquired nine very important works, all but one by the artists who would make his reputation: Cézanne, Vincent van Gogh (fig. 232), Gauguin, Pissarro, and Guillaumin.[31] His name was listed in the sale records as "Volat" until it was finally corrected to Vollard—proof that although unknown at first, Vollard was establishing an identity for himself. The Tanguy auction marked a turning point: Vollard very quickly gained a reputation as a specialist and later was recognized as an expert, consulted on sales of works by Pissarro[32] and Degas. He became a skilled purchaser at public auctions, generally buying low and mainly acquiring works by Cézanne.[33] For while Vollard established his reputation and had his first success with Manet, it was with Cézanne that he built his fortune. His gallery became an indispensable stop, the only place where one could see and obtain this artist's works.

The initial buyers were those who had advised Vollard to represent Cézanne in the first place, in other words, once again, fellow artists. Pissarro swapped one of his older landscapes for three Cézanne sketches: a small study of bathers, a country scene, and a self-portrait.[34] Degas was an intense and relentless buyer, as the "little art collector" (per Degas) Julie Manet, the daughter of Berthe Morisot, testified in her journal. She recorded her visit to Vollard's 1895 Cézanne exhibition accompanied by Degas and Renoir and her purchase of a watercolor there on November 29.[35]

The major collectors also took an interest in that first Cézanne exhibition. Vollard later sketched colorful but one-sided portraits of some of the more notable among them. In particular there was Isaac de Camondo (1851–1911)[36] (fig. 233), a frequent client chiefly of Durand-Ruel. Between 1894 and

Fig. 233. *Count Isaac de Camondo.* Photograph. Musée Guimet, Musée National des Arts Asiatiques, Paris

1907 Camondo bought from Vollard drawings by Suzanne Valadon, Degas, and Forain, and, in greater concentration, watercolors by Cézanne.[37] He later bequeathed several of the watercolors to the Louvre. Camondo, from a well-known Mediterranean Jewish family of financiers, had been born in Constantinople; his interest in avant-garde art, Vollard opined, was part of his "zest for the career of a gentleman." Vollard's overly caricatured image of Camondo and the fact that in his notebooks Camondo spelled the dealer's name "Vaulard" demonstrate that the two did not know each other very well. This was perhaps the reason for Vollard's slightly damning portrait characterizing the man as a parvenu, but Camondo was a complex personality with a real interest in art.[38] The paintings sent to his home on a trial basis were subjected to a harsh examination by a group of artists. How different from this client he so ironically skewered for buying "with his ears" was Vollard himself, who sought out the advice of his artist friends?[39]

One day in November 1895, during Vollard's Cézanne exhibition, Camondo arrived accompanied by the strange

MILAN

ROI DE SERBIE

Fig. 234. *Milan Obrenović, King of Serbia,* ca. 1880s. Photograph, from Album Félix Potin. Bibliothèque du Musée d'Orsay, Paris

DENYS COCHIN

HOMME POLITIQUE

Fig. 235. *Baron Denys Cochin.* Photograph, from Album Félix Potin. Bibliothèque du Musée d'Orsay, Paris

"Count of Takovo"—actually Milan Obrenović, ex-king of Serbia (1854–1901), who had abdicated in 1889 (fig. 234). "A tall man whose outrageously Parisian manners betrayed the foreigner," the newcomer was seeking out the haunts of "advanced art"; he enjoyed a stipend that would allow him to amass a sizable, and eclectic, art collection. Although he made numerous purchases from Vollard that month,[40] it was not until he returned to Paris in March 1896 that he bought Cézannes—two watercolors—as well as another by Monet and a work by Degas. When Milan's collection was dispersed posthumously at the Hôtel Drouot in 1906, Vollard acquired works by Renoir and Degas.[41]

Many collectors were interested in Renoir; the players changed, however, beginning about 1896, when other well-known collectors started coming to Vollard's, at first drawn by the painters he had "unearthed": Gauguin and Van Gogh. Thanks to Vollard, the work of these new artists began to gain acceptance by an ever-growing group of connoisseurs. Olivier Sainsère (1851–1923), a politician enthusiastic about modern art, collected works of painters ranging from Pissarro to Henri

Matisse.[42] The important collector Gustave Fayet (1832–1899), an admirer of Gauguin and Redon, often frequented the rue Laffitte gallery with his friend Maurice Fabre de Béziers. While the latter preferred Gauguin, between 1895 and 1906 he also bought from Vollard works by Cézanne, Denis, Matisse, and Renoir. The two Van Gogh exhibitions, in 1895 and 1896–97, attracted very few buyers, but Baron Denys Cochin (1851–1922) (fig. 235) early on took an interest in Van Gogh's work, which he began to buy in March 1896. A politician and writer, he was "the type of the genuine *amateur* who buys pictures with no thought of the profit to be made on them. In other words, he bought for pleasure. It was an expensive pleasure."[43] Enthusiastic and indecisive, Cochin was always tempted by the canvas he hadn't yet acquired but wanted each new purchase to harmonize with the rest of his collection. An audacious connoisseur, he also accumulated works by Cézanne and Gauguin—much like Cornelis Hoogendijk (1866–1911), to whom Vollard sold a large batch of Van Goghs on September 1, 1897. This idiosyncratic Dutchman conscientiously assembled, in Paris, a collection of staggering proportions

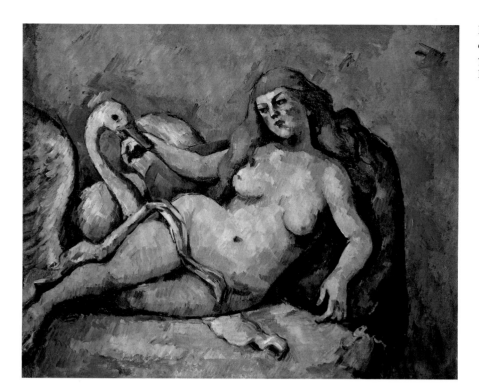

Fig. 236. Paul Cézanne, *Leda and the Swan*, ca. 1880. Oil on canvas, 23½ x 29½ in. (59.7 x 74.9 cm). The Barnes Foundation, Merion, Pennsylvania

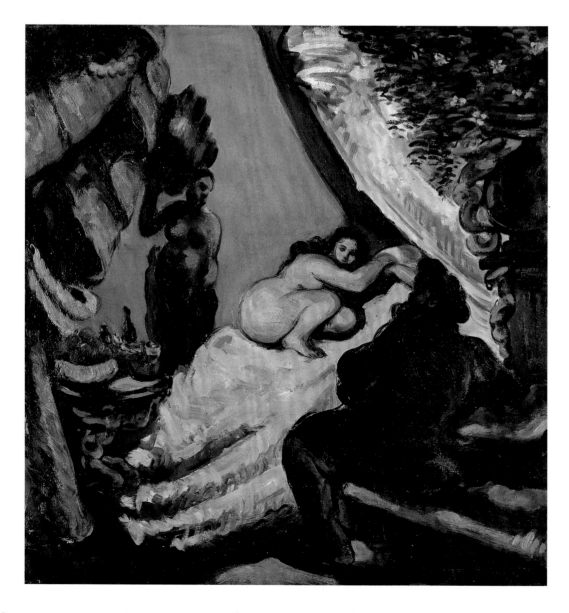

Fig. 237 (cat. 28). Paul Cézanne, *A Modern Olympia (Le Pacha)*, ca. 1870. Oil on canvas, 22 x 21⅝ in. (56 x 55 cm). Private collection

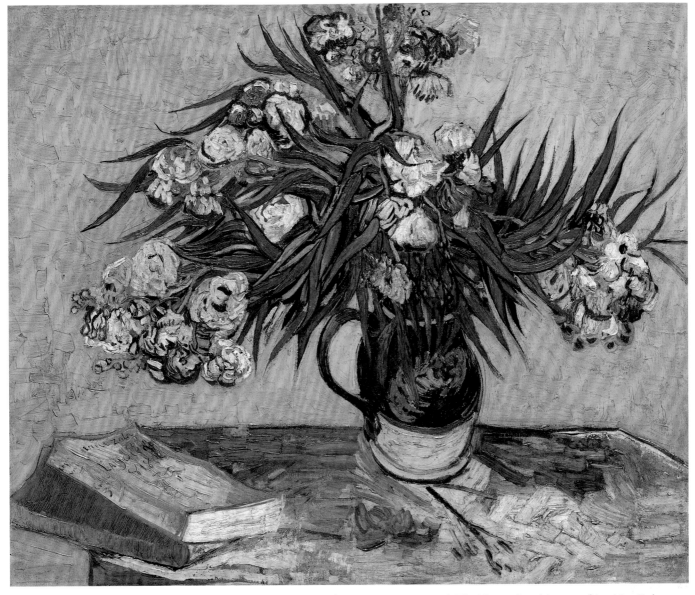

Fig. 238 (cat. 120). Vincent van Gogh, *Oleanders*, 1888. Oil on canvas, 23¾ x 29 in. (60.3 x 73.7 cm). The Metropolitan Museum of Art, New York, Gift of Mr. and Mrs. John L. Loeb, 1962 (62.24)

reaching from Camille Corot to Cézanne, largely acquired from Vollard between August 1897 and December 1899. Influential new collectors entered the game, such as Count Antoine de la Rochefoucault (1862–1960), a Symbolist painter and patron of the arts, who bought two Van Goghs from Vollard in 1896 and went on to acquire works by Gauguin and Charles Filiger. Those who displayed interest in Van Gogh and Gauguin at this time were a venturesome generation.

In 1898 a second Cézanne exhibition drew many other high-profile French collectors, such as Paul Gallimard (1850–1929), whose prodigious holdings—especially of modern paintings by artists from Daumier to Corot to Manet—were enriched by his purchase that year of several Cézannes.[44] Most notably, it was at Vollard's that Auguste Pellerin (1852–1929), a rich industrialist and collector called the "margarine king," bought his first Cézannes. Pellerin acquired *Leda and the Swan*

(fig. 236) not, as Vollard claimed, at the 1895 Cézanne exhibition,[45] but rather, as the gallery archives reveal, on March 16, 1900. Pellerin's collection of Cézannes became legendary; the number is unknown but was probably well over one hundred (see fig. 237). He gave many of them to France's national museums. Pellerin also owned a number of Manets.[46]

A few years later the art world witnessed the entry of another flamboyant figure: Alexandre Berthier, the fourth prince de Wagram (1883–1918). Vollard seemed to admire this man who "with the condescending familiarity of the great" managed to extract from the critic Gustave Geffroy Cézanne paintings that Vollard himself had vainly sought to acquire.[47] A wealthy lieutenant, Wagram started investing in art by 1906; Vollard's many dealings with him began on February 19 of that year, only to end a year later. The prestigious works ordered by the prince fill several long lists: seven Renoirs including

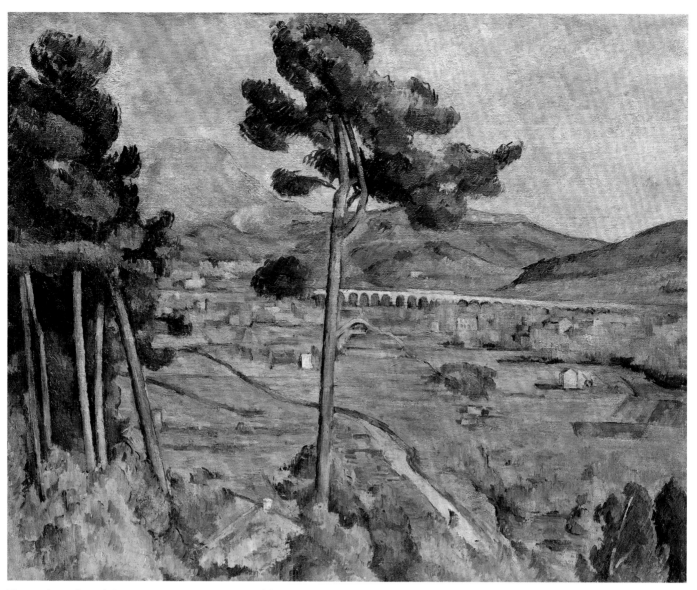

Fig. 239 (cat. 36). Paul Cézanne, *Mont Sainte-Victoire and the Viaduct of the Arc River Valley,* 1882–85. Oil on canvas, 25 ¾ x 32 ⅛ in. (65.4 x 81.6 cm). The Metropolitan Museum of Art, New York, H. O. Havemeyer Collection, Bequest of Mrs. H. O. Havemeyer, 1929 (29.100.64)

The Clown (fig. 163), some twenty Gauguins, more than thirty Cézannes, five paintings by Louis Valtat, and two by André Derain. But, although Vollard sent invoices on a regular basis, most of them remained unpaid. A severance contract was finally drawn up on April 29, 1907.[48] Far harsher was the break in relations between Wagram and the Bernheim brothers, who instigated a highly public lawsuit.

VOLLARD'S STRATEGY WITH COLLECTORS

Vollard's sales technique, which could be quite bewildering, was essentially based on experience and instinct. He had learned it in the field, sometimes at his own expense. He used his fair grasp of psychology to size up a visitor on sight, though sometimes he blundered. He realized early on that it was

essential to adapt and had no qualms about changing a work's title to suit the circumstances. When a client attempted to bargain, he *raised* his price.

Unlike most young dealers seeking to make themselves known, Vollard did not at first register with the Paris *Almanach de Commerce.* His name did not appear in the directory until 1897, and even then it suffered various misspellings and was not easily identifiable. From 1899 to 1921 he was cited correctly, at 6, rue Laffitte.[49] After that he disappeared from the directory entirely, evidence that he was no longer in search of clients (quite the contrary, his address was given only to initiates). On the other hand, in 1904 he did register in the select and fashionable directory *Tout Paris.*[50] The mature Vollard, admired and feared, seemed to withdraw a bit when he moved to the rue de Martignac, where, from 1922, the same address served him as art gallery, publishing house, and, later, residence.

A fierce, solitary pride was demonstrated by his decision to settle there on the Left Bank, so far from the artistic heart of Paris.

To acquaint collectors and the public with the artists he had chosen to represent, Vollard organized exhibitions that were often quite daring. He was showing artists he believed in—and ones to whom he owes his lasting renown—such as Cézanne, Gauguin, Van Gogh (fig. 238), and Picasso. Still, while most of these exhibitions reveal his enthusiasm for modern artists, not all of them were groundbreaking. Often, motivated by friendship, he sometimes simply rented space to painters who seemed to want to benefit from his aura and were willing to pay for the privilege. Among these were Theodore E. Butler, Eugène Murer, Edvard Diriks, and Paul Vogler.[51]

Vollard's strategy in organizing his exhibitions was also aimed at establishing and publicizing the character of his gallery. The graphic design of his exhibition catalogues seems to follow a conscious editorial policy. His name and address, always presented in the same typography, became easily identifiable. By means of posters, contacts with the press, and widely sent invitations to openings at which the rum flowed freely—and also of course by his choice of which artists to exhibit—Vollard fashioned an image and even a style of his own. He managed to draw the press into a kind of intellectual complicity with him, from the first mentions of his name in 1894 to reviews of his books to articles detailing his fabulous trip to America.[52]

Everyone frequented his shop at 6, rue Laffitte,[53] which for the Nabis became "the Temple," a place of creative ferment (fig. 82). Working with the artists and for them, Vollard was clearly their champion. His "cellar" located beneath the gallery—a place redolent of the Parisian bohemian lifestyle—proved to be an original and festive promotional tool. Vollard's dinners held there brought together artists, poets, and collectors: potential clients all.

To assist prospective buyers, Vollard even began to put together albums of reproductions. He had the truly original idea of systematically amassing photographs of Cézanne's works—at first the ones he owned, but later those he had seen elsewhere as well. His goal was probably to compile a reference catalogue of Cézanne's work, but he was never able to complete the project. Vollard did, however, publish reproductions of Degas's works in 1914 and a volume of photographs of Renoir's paintings in 1918.[54]

A wry eyewitness account of the tactics Vollard employed with clients is given by Gertrude Stein (1874–1946). When she and her brother Leo Stein (1872–1947) asked to see some Cézanne landscapes, Vollard, "looking quite cheerful . . . began

moving about the room, finally he disappeared behind a partition in the back and was heard heavily mounting the steps. After a quite long wait he came down again and had in his hand a tiny picture of an apple." But what they wanted was a landscape. At that, Vollard "looked even more cheerful, after a moment he again disappeared and this time came back with a painting of a back." They repeated their request. "This time after even a longer wait he came back with a very large canvas and a very little fragment of a landscape painted on it." Yes, but they wanted a smaller canvas entirely covered with paint. "Once more Vollard went off and this time he came back with a wonderful small green landscape. It was lovely, it covered all the canvas, it did not cost much and they bought it."[55] It was through Vollard that the Steins had discovered the art of Cézanne, in the years 1904–14.[56] Famously hospitable, they welcomed interested visitors from the world over who flocked to their rue de Fleurus apartment to see the Matisses and Picassos covering the walls.

In the period before World War I, Vollard was barely trying to sell anymore, since the prices attained by certain of his Cézannes, Renoirs, and Degases allowed him to live comfortably. Thanks to support in the press, his reputation was well established. He had also reached a clientele beyond France's borders and enjoyed international renown, becoming the epicenter of powerful Francophile circles. In very little time, Vollard had been able to win over select clients from abroad who were prepared to spend fortunes for a Cézanne or a Pissarro. There were the famous Russian collectors, and after them came the German collectors.

American collectors began frequenting the gallery as well. In addition to Gertrude and Leo Stein (whose purchases included Gauguin's *Three Tahitian Women,* fig. 229), they included the "sugar king" H. O. Havemeyer (1847–1907). He and his wife, Louisine (1855–1929), were introduced to Vollard by Mary Cassatt, their friend and art adviser. The Havemeyers bought frankly modern works by Degas and Cézanne (fig. 239). In Cassatt's version of the story, they saved Vollard from bankruptcy in 1901.[57] Other important American clients included the famous lawyer John Quinn, who provided artists with legal advice. The renowned Dr. Albert C. Barnes (1872–1951) was a client of Vollard's from 1912 on. His method was to take in some thirty paintings at a time, picking out the ones he wanted as they were paraded by. In this way he gathered nearly a hundred Cézannes; in 1925 he bought *The Cardplayers* (R 706) for an unprecedented one million francs,[58] a figure that tangibly symbolizes the unique natures of artist, dealer, and collector.

It is clear that Vollard attached more importance to his artists than to his clients, even the wealthiest ones. The proof of this comes from a visit Mrs. Havemeyer paid to Vollard's

gallery to see his Cézannes. While she waited, Vollard continued his conversation with an artist, probably his friend Forain. After half an hour had elapsed, then an hour, Mrs. Havemeyer expressed impatience, for her ship was about to sail. Vollard replied that there would always be another ship, and "she remained to see the works of that 'revolutionary' Cézanne."[59]

Vollard succeeded in becoming what he had dreamed of being, a "bridge between the public and the artist," between creators and collectors. With his energy and talent, he embodied the modern age. Guided by a remarkable sensibility, Vollard's enlightened choices today seem astonishingly prescient.

In the notes below, the following abbreviations are used in citing catalogue raisonné numbers: for works by Van Gogh, "F" refers to Faille 1970; for works by Cézanne, "R" refers to Rewald 1996; for works by Manet, "RW" refers to Rouart and D. Wildenstein 1976; and for works by Gauguin, "W" refers to G. Wildenstein 1964.

1. Baudelaire 1975–76, vol. 2, p. 751.

2. They were Félicien Rops and John Lewis-Brown (who died young in 1890); at the latter's home he met Camille Pissarro.

3. Vollard 1936, p. 33. Rops inscribed a photograph, "To the Georges Petit of to-morrow, Ambroise Vollard."

4. I am grateful to the government offices of the city of Paris, which allowed me access to information about Dumas. Registered as no. 2025 at the Salon des Artistes Français, Dumas lived on rue Chauveau in Neuilly. He presented himself as a student of Urbain Bourgeois and Édouard Debat-Ponsan when he exhibited, from 1884 to 1886 and then again in 1889; he resigned on January 30, 1912.

5. The 1893 *Almanach de Commerce: Ville de Paris* includes a listing for Dumas, art dealer, at 36, boulevard Haussmann, and one for the Cercle de l'Union Artistique at 5, rue Boissy d'Anglas.

6. Vollard humorously describes his experiences there in *Recollections.* Vollard 1936, pp. 33–41.

7. These are listed as no. 179 in the catalogue (Paris 1884); see also Moreau-Nélaton 1926, fig. 353.

8. Vollard 1936, pp. 40–41. Three works can be identified: a *Nude* in red chalk (Art Institute of Chicago; RW 363); a watercolor, *Olympia* (private collection; RW 381); and a large gouache, *Cats' Rendezvous* (RW 619); these drawings belonged to Auguste Pellerin, and Dumas is not mentioned in the provenances given in Rouart and D. Wildenstein 1976. The link with Dumas, by way of Vollard's *Recollections,* was established by Françoise Cachin in Paris–New York 1983, p. 186, no. 67. Aware of the rising value of Manet's work, Vollard might have bought these drawings himself and sold them back to Pellerin, since his accounts record that on December 30, 1898, he sold to Pellerin a lot of twenty-one drawings and sketches by Manet, for which he was paid 1,200 francs: Vollard Archives, MS 421 (4,3), fol. 118. In that case Vollard would have met Pellerin very early on.

9. On July 3, 1894, Vollard bought work from Dumas for 40 francs cash: Vollard Archives, MS 421 (4,3), fol. 1; on March 25, 1908, Vollard bought eight drawings by Constantin Guys from Dumas for 100 francs and settled all accounts to that date: MS 421 (5,3), fol. 56. Dumas, at 44, rue de Moscou, is noted in Vollard's address book: MS 421 (4,11), fol. 34.

10. *Catalogue des tableaux modernes* 1895 and sale records in Les Archives de Paris, D48E3 80, no. 8068. They were: no. 12-30, Clary, *Le Lac,* 13 francs; no. 68-18, Renouard, *Dessin au crayon noir,* 17 francs; no. 69-19, *Gens de Bourse,* three sketches, 41 francs; no. 85–77, School of Frans Hals, *Veillard en buste,* 76 francs. Vollard's records confirm these purchases at the Hôtel Drouot for 146.50 francs, but Dumas's name never appears: Vollard Archives, MS 421 (4,3), fol. 25, June 28, 1895.

11. For a long time, Vollard had lived on ship's biscuits because they were cheaper and more nourishing than bread. Vollard 1936, p. 44.

12. Ibid., pp. 47, 44. He had drawings by Guys, Forain, Adolphe Willette, and Rops, and a monotype by Edgar Degas.

13. Vollard 1989b, p. 59 (this passage is not included in the English edition).

14. Guillaumin to Vollard, September 27, 1892, writing about his upcoming visit to Paris: "While I'm there, I'd like to relieve you of the pieces left over from my exhibition of pastels and a few paintings you have, which need to be changed." Vollard Archives, MS 421 (2,2), p. 145.

15. Vollard to Maurice Denis, May 20, 1893: Archives, Musée Départemental Maurice Denis, Saint-Germain-en-Laye, Donation de la famille Denis, MS Vollard 11347.

16. Le Barc de Boutteville, who had a shop at 47, rue Le Pelletier, held exhibitions of the artists who would soon be called Nabis from 1891 until 1897, the year he died.

17. Vollard to Denis, September 13, 1893: "I am settling in (I believe I told you that I'm opening a little shop at 37, rue Laffitte, which entails a fair amount of unavoidable expenditure)." Archives, Musée Maurice Denis, MS Vollard 11352. Vollard rented the shop at 37, rue Laffitte from October 1893 to April 1895: Les Archives de Paris, cadastral register, D1P4, 1876, 37 rue Laffitte. This is also the address listed in the records of the Tanguy auction on June 2, 1894.

18. Camille Pissarro to his son Lucien, January 21, 1894, in Rewald and L. Pissarro 1943, p. 227.

19. For Vollard's accounts of this incident, see Vollard 1936, pp. 51–53. Vollard paid a regular stipend to Mme Manet from June 1894 to July 1895 (Vollard Archives, MS 421 [4,3], fols. 1–26) and also bought works individually.

20. The invitation to the "Exposition de Dessins & Croquis de Manet, provenant de son atelier, Galerie A. Vollard, 37, Rue Laffitte, du 17 Novembre au 20 Décembre 1894" is in the Fonds Moreau-Nélaton, Service d'Études et de Documentation, Musée du Louvre, Paris.

21. On October 15, 1894, Degas acquired Manet's *Woman with a Cat* for 500 francs and Renoir bought two Manet watercolors for 350 francs. But the terms of these purchases were apparently revised, with the initial notations being crossed out and replaced by "payment in merchandise": Vollard Archives, MS 421 (4,2), fol. 5.

22. As Catherine Guillot shows and backs up with figures, Vollard's investments in these years were profitable; see Guillot 2004–5, pp. 24–29.

23. The works circulated freely among various dealers, and Manets were bought first by Eugène Blot and Muhlfeld *fils,* then by Durand-Ruel and Chaudet, and later by Bernheim-Jeune. Dufeau *fils* was one of Vollard's biggest buyers over the years 1894–97. Vollard also sold Cézannes to dealers: Lucien Moline and Blot, but especially Bernheim-Jeune and Jos Hessel. Durand-Ruel often served as an intermediary between Vollard and foreign collectors.

24. Beginning on June 20, 1894, Viau bought two drawings by Manet, four by Renoir, eight by Degas, and others by Maxime Maufra and Guillaumin: Vollard Archives, MS 421 (4,2), fols. 10, 11, 13, 21, 22, 37. He also acquired works by Cézanne in 1895, Honoré Daumier in 1899, Alfred Sisley in 1896, and numerous Renoirs between 1895 and 1900; see Distel 1989, p. 51.

25. Cahen's collection was dispersed at his estate sale on May 24, 1929.

26. Proust bought Manet's *Portrait of Isabelle Lemonier* on February 9, 1897: Vollard Archives, MS 421 (4,3), fol. 65.

27. Mondain, who collected the work of artists ranging from Cézanne to Vuillard in 1894–97, was perhaps Joseph Remi (1848–1908) from Angers, the wealthy proprietor of the department store Palais des Marchands.

28. Cerfils had addresses in Paris and Biarritz: Vollard Archives, MS 421 (4,11), fols. 21 and 32. He may, however, in fact have been Alphonse Cherfils of Pau, a friend of Degas, notably around 1878. Cherfils is listed in Vollard's account books twice: MS 421 (4,3), fol. 3, August 6 and 9, 1894.

29. In 1894 Bauchy bought works by Charles Filiger, Manet, Vincent van Gogh, and Gauguin; in 1895 by Cézanne and Pissarro; and in 1906 by Degas and Henri Toulouse-Lautrec. He is listed in the address book as residing at 3, avenue Gambetta: Vollard Archives, MS 421 (4,11), fol. 7.

30. The paintings had all been sold, to Ferdinand Dufau, Charles Loeser, Bauchy, and Bourdin, by the end of May 1895—before the first exhibition that Vollard devoted to Cézanne.

31. Tanguy Sale 1894 and sale records in Les Archives de Paris, D48E3 79, no. 7994. From the sale catalogue and other documents in the Archives de Paris we can recapitulate the works bought by Vollard and their subsequent history. He bought: no. 7, Cézanne, *Village* [private collection; R 497], for 175 francs [Vollard sold it to Charles Loeser for 250 francs, December 18, 1894: Vollard Archives, MS 421 (4,2), fol. 8]; no. 8, Cézanne, *Les Dunes* [probably R 382; private collection, Texas], for 95 francs [Vollard sold it to Bauchy, Café des Variétés, with three other paintings in an exchange valued in total at 500 francs on April 18, 1895: Vollard Archives, MS 421 (4,2), fol. 12]; no. 9, Cézanne, *Corner of a Village* [Mr. and Mrs. David Kreeger, Washington, D.C.; R 502], for 215 francs [Vollard sold it to Dufau *fils* for 800 francs, June 20, 1894: Vollard Archives, MS 421 (4,2), fol. 1]; no. 10, Cézanne, *Pont Cézanne* [location unknown; R 500], for 170 francs [Vollard sold it to Bourdin for 400 francs on June 10, 1895: Vollard Archives, MS 421 (4,2), fol. 13]; no. 26, Gauguin, *Forest Interior* [Museum of Fine Arts, Boston; W 135], for 76 francs [Lévy, Maison Bing, bought it from Vollard on October 13, 1894, for 75 francs: Vollard Archives, MS 421 (4,2), fol. 5]; no. 54, G. Pissarro, *Le Paon,* for 36 francs; no. 64, Van Gogh, *A Pair of Boots* (fig. 232) for 30 francs; no. 92, Guillaumin, *Vache couchée,* for 41 francs; no. 96, Korochonsky, *La Prairie,* for 7 francs. Despite Mme Tanguy's claim (see Bodelsen 1968, pp. 346–48), Vollard did not get "all six Cézannes" but only four of them, or five according to his memoirs (Vollard 1936, p. 25). The auctioneer, Maître Chevallier, congratulated him on his daring and allowed him to take away all his purchases before making full payment.

32. Pissarro Sale 1906 and sale records in Les Archives de Paris, D 48 E3-89, no. 8888. Vollard was also one of the buyers. Manuscript, Bibliothèque Doucet, Paris, INHA, VP 1906/27-*bis.*

33. The sales he bought at included those of: Alfred Sisley, May 1, 1899; the widow of Victor Chocquet, July 1, 3, 4, 1899; Émile Zola, March 9–13, 1903; Eugène Carrière, June 8, 1906. He also bought works by Monet at the sale of the composer Emmanuel Chabrier on March 26, 1896; by Gustave Caillebotte at the auction organized by his colleague Eugène Blot on May 9–10, 1900; and by Gustave Courbet and Charles Daubigny at the Félix Gérard *père* auction on March 28 and 29, 1905.

34. The Cézannes were valued at 400 francs: Vollard Archives, MS 421 (4,2), fol. 24.

35. Julie Manet, diary entry for November 29, 1895, in R. de B. Roberts and J. Roberts 1987, p. 76. Her purchase was recorded by Vollard: Cézanne, "Sujet de genre, étude" (study), watercolor, on November 29, 1895, for 40 francs: Vollard Archives, MS 421 (4,2), fol. 25.

36. Vollard 1936, pp. 103–8.

37. On December 4, 1895, he bought Cézanne's *Rideaux, Pots de fleurs, Pot avec un plante, Portrait d'homme,* and *Petit Pot avec anse* for 600 francs: Vollard Archives, MS 421 (4,2), fol. 25.

38. As shown by Assouline 1997.

39. For instance, he followed the advice of Émile Bernard, who apparently suggested that Vollard take an interest in Cézanne's works; see Émile Bernard, "L'Aventure de ma vie," manuscript, Bibliothèque des Musées Nationaux, Paris, MS 374 (1,4), fol. 168. Vollard also listened to Redon, Pissarro, Denis, and Octave Mirbeau, who shared their admiration for Cézanne.

40. Vollard 1936, pp. 104–7. In November 1895 Milan bought Henry De Groux's *The Great Upheaval* for 650 francs but later exchanged it for Alfred Méry's *Standing Heron* (both, present location unknown). (De Groux and Méry were both profitable artists for Vollard.) He also bought from Vollard three pieces by Degas, three by Couturier, three by Denis, five Manet drawings, Charles Maurin's "Femme à sa toilette" (for 200 francs), two female nudes by Renoir, a seascape by Maximilien Luce (50 francs), several birds by Méry, and works by Paul Renouard, Renoir, Guillaumin, Sisley, Gauguin, Cazin, Constantin Guys, and Manet. Vollard Archives, MS 421 (4,2), fols. 18–20, 23, 26, 30.

41. Milan Sale 1906 and sale records in Les Archives de Paris, D 48 E3-89, no. 8839. On February 16, 1906, "Volard" bought: no. 146/142, [pastel], Renoir, *Jeunes filles,* 1,000 francs; no. 148 /144, Serret, *La Promenade,* 105 francs; no. 149/145, Serret, *Le Grande Soeur,* 72 francs. On February 17: no. 110/147, Bartholomé Léon, *Intérieur de paysan,* two under glass, 80 francs; no. 208, Degas, *La Toilette,* etching, 275 francs; no. 209/201, Degas, *Femmes,* 215 francs; no. 210 /202, a group of uncatalogued paintings, watercolors, etc., 55 francs. The purchases at the Milan auction are confirmed in Vollard's records on February 16, 1906: "Renoir pastel 2 têtes 1000 francs et 2 Serret pastels" (Vollard Archives, MS 421 [5,1], fol. 30); February 17, "Degas, Toilette / Degas, Intérieur" (MS 421 [5,1], fol. 31). On March 1, 1906, "Milan 1982 francs 30": MS 421 (5,1), fol. 38.

42. From Vollard Sainsère bought works by Pissarro in 1894, Renoir in 1895, Gustave Leheutre in 1896, Caillebotte, Cézanne, and Van Gogh in 1897, Édouard Vuillard in 1897 and 1899, Maurice Denis, Pierre Bonnard, and Redon in 1898, Isidre Nonell i Monturiol and René Seyssaud in 1899, Aristide Maillol in 1906, and Georges Manzana Pissarro in 1907. Vollard's records even contain a mention of Sainsère as secretary-general at the Elysée Palace in 1896: Vollard Archives, MS 421 (4,4), fol. 6.

43. Vollard 1936, p. 108.

44. By 1889 Paul Gallimard knew Monet, Renoir, and Pissarro. His important collection is known thanks to an article by Louis Vauxcelles (Vauxcelles 1908).

45. Vollard 1938a, pp. 44–45.

46. Pellerin first acquired a quantity of Manet's paintings and drawings from Mme Manet and Antonin Proust, then others from Vollard in 1898. He purchased works by Cézanne in 1898, 1900, 1904, 1907, 1909, 1910, 1911, 1912, and 1913. The five Picassos he bought in 1912 seem to have been taken back by Vollard several months later. Pellerin's collections were dispersed at an anonymous sale at the Hôtel Drouot on May 7, 1926, and again at the Pellerin auction at Galerie Charpentier on June 10, 1954. The catalogue for the latter sale lists eighty-five items, including two canvases by Cézanne, more than forty-one works by Manet, and six by Paul Vogler.

47. See Vollard 1936, p. 79.

48. I am grateful to Noémie Étienne for her research into the Vollard correspondence preserved in Wagram's papers: Archives Nationales, AP/173*bis*/430. Vollard's gallery records state that the "Clown . . . au fond des loges garnies" was sent on November 22, 1906, valued at 35,000 francs, to be sold to the prince de Wagram: Vollard Archives, MS 421 (4,1), p. 101. Certain works by Gauguin later recovered from Wagram were sold to Ivan Morozov; see Diffre and Lesieur 2004. Vollard sold the prince a painting by Maurice de Vlaminck in 1910, after the situation had calmed down.

49. *Almanach de Commerce, Ville de Paris,* 1897 edition: "Volland [sic], 39 rue Laffitte"; 1898 edition: "Vollard, 7 [sic] rue Laffitte." In the listing by streets he appeared in 1897–98 under 6, rue Laffitte as "Baullard, tableaux"; perhaps what was called his "Auvergnat accent" by Gimpel (1966, p. 78), explains this approximation. From 1899 to 1921 the listing was "Vollard, tableaux, 6 rue Laffitte."

50. Fees for inclusion in *Tout Paris* on December 16, 1904: 50 francs. Vollard Archives, MS 421 (4,10), fol. 44.

51. On November 9, 1897, Butler paid 350 francs in rental fees for his exhibition: Vollard Archives, MS 421 (4,3), fol. 88. On March 22, 1898, Murer paid 300 francs for his: MS 421 (4,3), fol. 99. Diriks paid 300 francs on June 17, 1899: MS 421 (4,3), fol. 135; and Vogler 400 francs on November 2, 1899: MS 421 (4,3), fol. 146. Vollard received as "payment for exhibition rights" Iturrino's painting "Scène espagnole," no. 3780 in his Stockbook B, for 500 francs, perhaps for the Iturrino exhibition of May 1904. An exhibit of Clément Faller's work was even specified to be "undertaken at Mr. Faller's sole risk and expense. Mr. Vollard is not responsible to any degree": MS 421 (3,6), fol. 37.

52. In 1894 Camille Mauclair was one of the first to write about Vollard, in his column in the *Mercure de France;* thereafter he mentioned the dealer regularly. Both brief notices and more literary write-ups about specific exhibitions appeared in *La Plume, La Chronique des arts,* and

La Revue blanche, often accompanied by lengthy commentaries, notably by Thadée Natanson.

53. Starting in late May 1896, Vollard rented a "square shop without partitions, built over a cellar" at 6, rue Laffitte: Les Archives des Paris, cadastral register, D1P4, 1876, rue Laffitte au no. 6.

54. Apparently it was Émile Bernard who in 1902 suggested that Vollard have the Cézannes hanging everywhere in the gallery photographed before selling them off; see Bernard's "L'Aventure de ma vie," manuscript, Bibliothèque des Musées Nationaux, MS 374 (1, 4), fol. 168. In 1907 Vollard asked the photographer Delétang to begin photographing the works of Cézanne. In 1914 Vollard published *Degas: Quatre-vingt-dix-huit reproductions signées par Degas (peintures, pastels, dessins et estampes),* known as the "Album Vollard," and in 1918 *Tableaux, pastels et dessins de Pierre-Auguste Renoir.* While the assembling of a photographic corpus was fairly new at the time, it had already been done before 1875 for Corot, by Alfred Robaut. *L'Atelier de Renoir,* the beginning of a corpus, was published by Bernheim-Jeune in two volumes in 1931.

55. G. Stein 1933, pp. 36–38. The recollections of Pierre Loeb, who visited Vollard on the rue Martignac in a time of financial crisis, tend to confirm Stein's remarks about Vollard's ceremonious and unpredictable nature; see Loeb 1945, pp. 42–45.

56. The first mention of purchases by the Steins in Vollard's records was on October 28, 1904: two Cézannes, two Renoirs, two Gauguins, and a Denis; Vollard Archives, MS 421 (4,10), fol. 30. At the end of the 1904 Salon d'Automne, having gone every day to admire Cézanne's portrait of Mme Cézanne in a red armchair, the Steins finally bought the painting from Vollard on December 16, 1904, for 8,000 francs: Vollard Archives, MS 421 (4,10), p. 44, and Stockbook B, no. 4061. See also Vollard 1936, p. 137.

57. Mary Cassatt to Louisine Havemeyer, July 6, 1913, Havemeyer correspondence, Department of European Paintings, Metropolitan Museum, transcript in Weitzenhoffer files, Department of European Paintings, Metropolitan Museum. See also Tinterow 1993, p. 47.

58. On December 23, 1925, Barnes bought "Scène de cabaret" by Cézanne from Vollard, stock no. 4808, for one million francs: Vollard Archives, MS (4,7), fol. 52. He bought other works by Cézanne in 1912, 1921, 1924, and 1925; by Renoir in 1912, 1921, and 1924; and by Picasso in 1921.

59. Terey 1929.

Vollard and German Collectors

Gloria Groom

In July 1897 the director of Berlin's Nationalgalerie, Hugo von Tschudi, purchased Paul Cézanne's *Mill on the Couleuvre in Pontoise* (1881) from the Galerie Durand-Ruel in Paris. This was the first work by Cézanne purchased by any museum, and its acquisition did not go unnoticed by the French, who regarded it as yet another sign of their own administration's failure to recognize modern painting.[1] Two years after Tschudi's purchase, however, Kaiser Wilhelm II passed a law forbidding state as well as private funds to be used for art acquisitions without his permission. There were sufficient cross-border ripples in the immediate aftermath that Vollard felt compelled to write Tschudi a few months later offering to "buy back" the painting that the museum seemingly no longer wanted.[2] Although Vollard had not been involved in the initial sale, he clearly not only felt proprietary about the artist he had "discovered," and had been the first to promote in 1895 (fig. 240), but also was on friendly enough terms to address his request to the Berlin director.

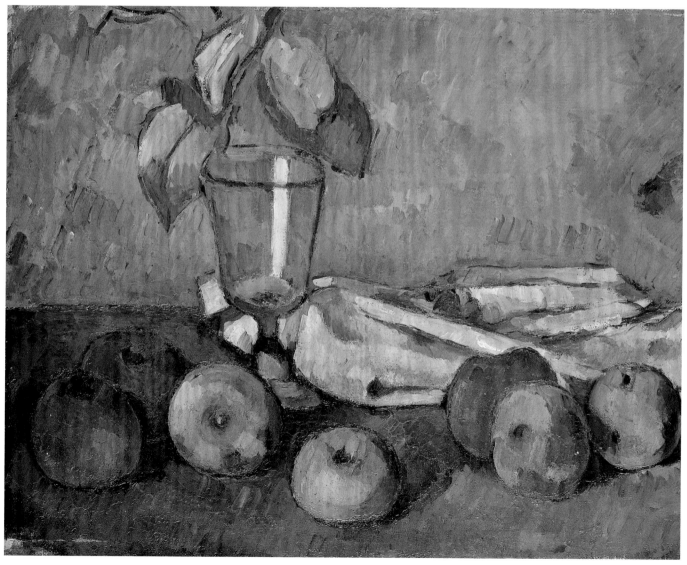

Fig. 240 (cat. 32). Paul Cézanne, *Glass and Apples,* 1879–82. Oil on canvas, 12⅜ x 15¾ in. (31.5 x 40 cm). Collection Rudolf Staechelin, on permanent loan to Kunstmuseum Basel

Fig. 241. Georges Seurat, *Models (Poseuses)*, 1886–87. Oil on canvas, 78¾ x 98⅜ (200 x 250 cm). The Barnes Foundation, Merion, Pennsylvania (BF 811)

How did Vollard, who had opened his gallery only a few years earlier, come to be on such familiar terms with the director of a major German museum? Although much has been written on the early collectors of French modernism in Germany and on the galleries of Bruno and Paul Cassirer, Heinrich Thannhauser, and Daniel-Henry Kahnweiler, Vollard's role has been little scrutinized. But in sheer numbers and early appearances in Vollard's account books, it is, after the French, the Germans who dominate. It was to his gallery that they went first not only for Cézanne's work but also for Paul Gauguin's.[3] Maurice Denis, Pierre Bonnard, Aristide Maillol, and later Henri Matisse and the Fauves also benefited from Vollard's relationship with German collectors, especially in the early 1900s, when Berlin was second only to Paris as a center for French avant-garde art.[4]

The Germans who purchased works from Vollard tended to be cosmopolitan, wealthy, well traveled, French-speaking, and connected to literary and artistic circles. Three collectors in particular—Count Harry Kessler, Baron Kurt von Mutzenbecher, and Karl-Ernst Osthaus—bought extensively from him in the first decade of the twentieth century.[5] All these men developed their collections under the guidance of the Belgian artist and designer Henry van de Velde, a strong proponent in Germany of modern French painting. Their purchases from Vollard also reflected the concerns of Julius Meier-Graefe, who exercised tremendous authority over German aesthetics with his art publication *Pan* (which he co-founded with Eberhard von Bodenhausen in 1894) and his groundbreaking study of modern art,

Entwicklungsgeschichte der modernen Kunst (1904).[6] Meier-Graefe perceived French art as aspiring to the decorative ideal of the *Gesamtkunstwerk,* an all-encompassing art linked to life, which he saw in the paintings of Cézanne, as well as in those of Denis and Bonnard.[7] The artists praised by Meier-Graefe are found in great numbers in Vollard's account books from the 1890s to the early twentieth century and made up the largest percentage of his sales.[8] The collections of Kessler, Mutzenbecher, and Osthaus, which to a considerable degree had at their core works purchased directly from Vollard or with Vollard as intermediary, thus reflect an aesthetic of modern art developing in Germany at this time—an aesthetic that they also helped shape.[9]

Vollard's account books also reveal his relationships with German dealers, particularly the cousins Bruno and Paul Cassirer, and with museum directors, including Dr. Friedrich Deneken (Kaiser-Wilhelm-Museum, Krefeld), Dr. Georg Swarzenski (Städelsches Kunstinstitut, Frankfurt), and Tschudi. Other private collectors less known today (Julius Elias, Emil Heilbut, Alfred W. Heymel, Robert von Hirsch, and Félix vom Rath) also made significant purchases from the rue Laffitte gallery.[10]

This essay examines a representative sampling of Vollard's German clients prior to World War I, with special emphasis on Kessler, Mutzenbecher, and Osthaus. Using Vollard's archives to identify purchases, it identifies both their patterns of collecting and the relevance of their Vollard purchases to the fundamental change in aesthetics that brought French art to the forefront in Wilhelmine Germany.

COUNT HARRY KESSLER

Count (Graf) Harry Kessler was key to Vollard's success with German collectors.[11] In addition to acting as the official art editor of *Pan,* an important German-language advocate for French artists, Kessler served as an adviser to wealthy German collectors.[12] He was deeply influenced in his aesthetic and collecting interests by Van de Velde, who for more than a decade was intimately involved with creating private interiors that in effect served as minimuseums for modern French painting. The two met through the industrialist Eberhard von Bodenhausen in November 1897, at the time of Van de Velde's debut in Berlin as a designer for the galleries of Keller and Reiner (1897) and the Cassirers (1898), two of the very few galleries in that city offering French contemporary art.[13] Between 1898 and 1899 Van de Velde designed a new interior that Meier-Graefe had commissioned in November 1897 for his Paris apartment, as well as his Paris gallery, Maison Moderne. In 1899 the new Paris offices of *La Revue blanche,* the literary and artistic journal that strongly promoted Gauguin, Neoimpressionism, and the Nabis, were among his projects.[14]

All these endeavors put Van de Velde in contact with Neoimpressionist and Nabi artists, whose works he recommended to his German patrons as being appropriate to the new style.[15] Van de Velde actively encouraged Kessler to turn from collecting the French Impressionists and such German artists as Hans Thoma and Max Klinger to acquiring works by Bonnard, Cézanne, Denis, Gauguin, and Maillol, as well as Henri Cross, Georges Seurat, Paul Signac, and Édouard Vuillard.[16] Kessler's purchase of *Models (Poseuses)* by Seurat (fig. 241) from Vollard in 1897 reflected Van de Velde's influence.[17] As Kessler wrote breathlessly in his diary, "Bought Seurat's *Poseuses* at Vollard for 1,200 francs!!!! A masterpiece of the French school!"[18]

So important was the Seurat purchase that Meier-Graefe assumed Kessler would be donating it to Tschudi's museum.[19] It may also have motivated Kessler to devote an issue of *Pan* to Neoimpressionism.[20] Kessler installed the painting in Van de Velde's redesigned interior of his Berlin apartment.[21] Both he and Van de Velde believed that a new era of aesthetic reform was dawning in which line and color in an interior would be in harmony with its works of art. They felt that the systematic application of paint and linear rhythms in the best works of Gauguin, Denis, and Maillol embodied an aesthetic lacking in German art, one that emphasized clarity (*Klarheit*).[22] It was through the idea of the artistic interior, which integrated painting and architecture, that they believed French modernism could best be understood by German collectors.[23]

To further promote their vision, Kessler arranged for Van de Velde's appointment as head of the Kunst- und Kunstgewerbeschule (School of Arts and Crafts) in Weimar

in 1902, which was followed by Kessler's own appointment in 1903 as honorary director of the Grossherzogliche Museum für Kunst- und Kunstgewerbe (Grand Ducal Museum of Arts and Crafts) in the same city. In 1902 Kessler asked Van de Velde to design his Weimar apartment, for which he made a number of important acquisitions. These were purchased from several major Parisian dealers, but those from Vollard were among the most important and included three Cézanne paintings—*Still Life, Plate, and Fruits* (ca. 1890, art market, London, 1996; R 677), *The Viaduct at Estaque* (1883, Ateneum Art Museum, Helsinki; R 439), and *Landscape in Provence* (1879–82, Pola Museum of Art, Japan; R 440) (see fig. 242)—and Denis's large canvas *Nymphs with Hyacinths* (now lost), which he glued to the wall of his dining room (see fig. 243).[24] A year later, following Vollard's posthumous Gauguin exhibition, he acquired two paintings by the artist: *Crouching Woman*

Fig. 242. In the library of Count Harry Kessler's apartment at Cranachstrasse 15, Weimar, 1909. The painting at the upper right is Cézanne's *Landscape in Provence* (Pola Museum of Art, Sengokuhara, Japan).

Fig. 243. In the dining room of Count Harry Kessler's apartment at Cranachstrasse 15, Weimar, 1902. On the wall is Denis's *Nymphs with Hyacinths,* 1900 (location unknown).

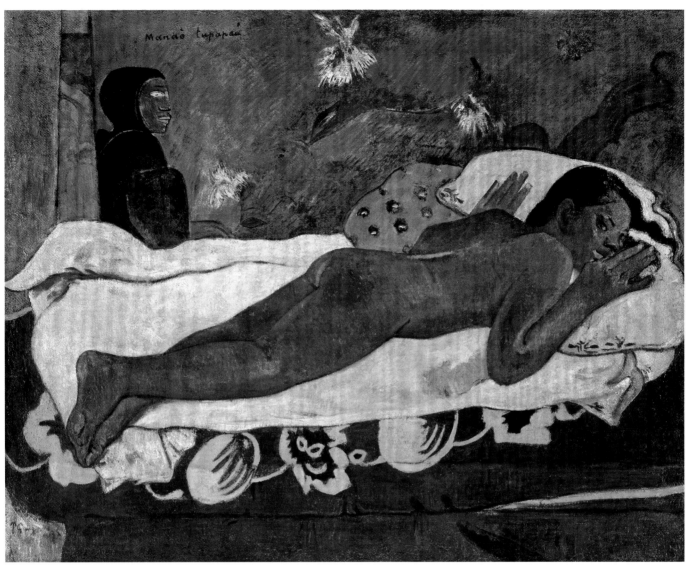

Fig. 244 (cat. 90). Paul Gauguin, *Manao Tupapau (Spirit of the Dead Watching)*, 1892. Oil on burlap mounted on canvas, 28½ x 36⅜ in. (72.4 x 92.4 cm). Albright-Knox Art Gallery, Buffalo, New York, A. Conger Goodyear Collection, 1965 (1965:1)

(not identified) and possibly *Manao Tupapau (Spirit of the Dead Watching)* (fig. 244), which had been among the first of the Tahitian works shown in Germany.[25] In his *Entwicklungsgeschichte,* published a few months later, Meier-Graefe cited *Manao Tupapau* as belonging to Kessler. He also reproduced other paintings owned by the collector: Renoir's *Apple Seller,* Van Gogh's *Plain of Anvers,* Signac's *Morning in Samoa,* and Denis's *Nymphs with Hyacinths.*[26]

Meier-Graefe not only included the Kessler-owned Denis in his original book, but also had a reproduction of the painting pasted onto the front covers of both volumes of the 1908 English edition.[27] For Kessler, Denis was the "blossom of Gauguin's genius."[28] Kessler met the artist in 1902 (possibly through Vollard); they became good friends, and the collector began to buy art directly from Denis's studio. In 1904 Vollard sold Kessler four of Denis's decorative panels collectively called

The Love and Life of a Woman, which had been shown at Bing's Maison de l'Art Nouveau in 1895 (fig. 245).[29] The panels were to be glued to the wall within a white lacquered framework in Kessler's dining room designed by Van de Velde.[30] By this method the wall and artwork were fused, fulfilling Van de Velde's *Gesamtkunstwerk* design concept.[31]

As part of his ambition to transform Weimar into a center of modernist culture, Kessler used his apartment as a showcase of avant-garde art. Through his position at the Grand Ducal Museum, he arranged for exhibitions of the French art he collected, although he was always diplomatic enough to include German artists as well. His program for 1903–4 included an exhibition of German and French Impressionists and Neoimpressionists, one entitled "Manet, Monet, Renoir, Cézanne," and another of German and French Impressionism and Postimpressionism.[32] To these he lent works from his own

Fig. 245. Maurice Denis, *Sleeping Woman*, one panel of *The Love and Life of a Woman*, 1895. Oil on canvas. Location unknown

collection, purchased primarily from Vollard and the Galerie Bernheim-Jeune.

BARON KURT VON MUTZENBECHER

Beginning in 1904, Vollard's account books list numerous shipments to Van de Velde on behalf of his German patron Kurt von Mutzenbecher,[33] for whom the Belgian designed a home in Wiesbaden in 1904–7. Correspondence between Mutzenbecher, Kessler, and Bodenhausen attests to their preference for the works of Bonnard, Denis, Maximilien Luce, Maillol, Auguste Rodin, Théo van Rysselberghe, and Vuillard—in short, the modern French artists represented by Vollard. Writing to Bodenhausen about his recent visit to Paris in August 1904, Mutzenbecher enthused, "It is unbelievable how many beautiful things I saw this time and I bought some of them. From now on I am linked by the brotherly 'Du' [the informal address rather than 'Sie'] with Druet, the extraordinary Vollard, Denis and Maillol."[34]

On August 24, 1904, Kessler noted, "With Mutzenbecher bought paintings at Vollard," referring to his friend's acquisition of two Cézanne still lifes, a Gauguin Tahitian painting and a drawing, a painting by Louis Valtat, two Seurat figure drawings, an Honoré Daumier drawing, and a terracotta statuette by Maillol.[35] That same year, Bodenhausen encouraged Mutzenbecher to buy Denis's *Holy Family* (1902, private collection).[36] Two years later, he accompanied Mutzenbecher to the rue Laffitte gallery, where they each purchased works by Jean Puy, and Bodenhausen bought a Valtat. In addition, Mutzenbecher bought a Renoir pastel, two paintings by Bonnard, and traded in a Renoir and Valtat.[37]

In late November 1904 Mutzenbecher lent the works he planned to install in his Wiesbaden home to an exhibition that Kessler had organized for the Grand Ducal Museum in Weimar.[38] Around that time, he commissioned Denis to make mural decorations for his music room. The ensemble of panels, titled *The Eternal Summer*, was exhibited at the Galerie Druet, Paris, and at the third Deutschen Kunstgewerbeausstellung,

Fig. 246 (cat.71). Maurice Denis, *"On the Pale Silver Sofa,"* plate 10 from *Amour* (*Love*), 1898. Color lithograph, image 16 x 11 ½ in. (40.6 x 29.2 cm), sheet 10⅞ x 15⅞ in. (53 x 40.4 cm). The Art Institute of Chicago, John H. Wrenn Memorial Collection (1946.432f)

in Dresden, before being installed.[39] Despite his strong commitment to the collecting and display of French art, Mutzenbecher ceased acquiring works by 1907 (with the exception of one painting by Cross), after which his name does not appear again in Vollard's account books.[40] In 1913 he sold his collection of Signac paintings to Bodenhausen, who later described the group as "unquestionably the most complete collection of this movement, and . . . Signac especially is represented in such quantity and quality as cannot be found anywhere else, not even in France."[41]

KARL-ERNST OSTHAUS

Karl-Ernst Osthaus's relationship with Vollard began in 1903, again with Van de Velde as a critical link.[42] Commissioned in 1900 to create the interiors for the Folkwang Museum, which was founded by Osthaus in Hagen, Van de Velde redesigned the galleries in the light, curvilinear modern style and helped Osthaus refine the collection so that it became the first public museum of French Impressionism and Postimpressionism in Germany.[43] In May 1903 Van de Velde encouraged the collector to buy a painting by Van Gogh, two paintings by Gauguin, and Denis's lithographic album *Amour* (fig. 246).[44] By December 1903 the Folkwang Museum had its first Gauguin exhibition; of the seven paintings, at least six were owned by Osthaus and purchased from Vollard.[45] Following Kessler's theories for certain of his acquisition patterns—namely, that Denis was the flowering of Gauguin and that both were notable for a decorative line that linked them to the emerging modern reform tradition—Osthaus bought additional Gauguins, as well as works by Denis and Maillol.[46] In 1906, after meeting Cézanne in Aix-en-Provence, Osthaus purchased from Vollard the artist's *Rock Quarry, Bibémus* (ca. 1895, Museum Folkwang, Essen; R 797) and *House in Bellevue* (1890–92, Museum Folkwang; R 690).[47]

Both Kessler and Osthaus felt a moral and patriotic imperative to share their acquisitions with their countrymen, hoping to introduce them to an aesthetic innovation that would benefit German culture.[48] In this sense, they were pioneers in a movement known as *Geschmackerziehung,* or education in taste. Along with inviting people to their homes, they were both active in organizing public loan exhibitions. One of the most important of these took place in February 1904 at the Kaiser-Wilhelm-Museum in Krefeld, an industrial town near Düsseldorf. Working with museum director Friedrich Deneken, Osthaus procured three Gauguins—*Woman with a Fan* (1902, Museum Folkwang; W 609), *Horses at the Seaside* (1902, Museum Folkwang; W 619), *Women on a Bench* (1892, Kunstmuseum Basel; W 476)—and

a Van Gogh landscape (not identified) from Vollard's gallery.[49] Writing to Deneken, Osthaus announced that he intended to buy all four paintings and asked that his name be included in the credit line even though he had still not finalized with Vollard the conditions of payments.[50] To Deneken's second exhibition that year, *Linie und Form* (Line and Form), Vollard sent four Gauguin transfer drawings as well as a Denis painting, *Madonna* (1900, Folkwang Museum).[51] This ambitious show included a wide array of works, ranging from Egyptian to modern. French art, which appeared unified and linked to historical French culture in a way that German art did not, clearly won the day, prompting a reassessment among many Germans.[52]

During the next year, from July to September 1905, Kessler exhibited thirty-three works by Gauguin at the Grand Ducal Museum in Weimar, including loans from Osthaus and Vollard.[53] In December 1907, Vollard lent four Gauguin paintings to the Schulte Galerie in Berlin for another show featuring both German and French art.[54] These exhibitions, while not resulting in many sales, did help attract more German collectors to Paris and influenced German taste for private acquisitions and museum collections.[55]

In 1906/1907, shortly before Osthaus all but ceased acquiring modern works of art, he commissioned Van de Velde to design one of his most ambitious residences, the Hohenhof. Completed in 1908, this building was planned as Osthaus's private home and integrates fine art and modernist architectural design.[56] By this time, however, Van de Velde's aesthetic preferences had shifted to non-French art. He advised Kessler in 1907 to dispose of his holdings of Renoir, Denis, and Gauguin, which he considered to be the art of museums; only Van Gogh and Cézanne remained "modern" in his estimation.[57] Whereas his designs for Kessler's Berlin and Weimar residences had highlighted primarily French art, for the Hohenhof, Van de Velde included only one work each by Vuillard, Matisse, and Maillol, which Osthaus had acquired in Paris. He selected a large mural by Swiss painter Ferdinand Hodler (*The Chosen,* 1902) and commissioned Dutch artist Johan Thorn Prikker to paint overdoors for the library.

OTHER COLLECTORS: RELATIONSHIPS AND SALESMANSHIP

After 1909 the names of Mutzenbecher and Osthaus are replaced in Vollard's account books by those of other collectors, including the businessmen Carl A. Jung in Elberfeld, Gottlieb Friedrich Reber in Barmen (near Wuppertal), Robert von Hirsch in Frankfurt, and Walter Epstein in Berlin. None, however, was as fervent in his efforts to promote French art

Fig. 247 (cat. 51). Edgar Degas, *On the Racecourse*, 1861–62. Oil on canvas, 16⅞ x 25¾ in. (43 x 65.5 cm). Kunstmuseum Basel, Gift of Martha and Robert von Hirsch, Basel, 1977 (G 1977.36)

and culture in Germany as Mutzenbecher, Osthaus, and Kessler, and none would acquire as intensively.

Vollard's policies for payments, consignments, and exhibition loans seem to have been largely contingent on the identity of his client. For Hamburg collector and "art agent" (*Kunstvermittler*) Emil Heilbut, who on October 21, 1895, purchased a Degas pastel, *Woman Combing Her Hair before the Fireplace,* with the option to sell it back, Vollard allowed the return seven days later but reimbursed Heilbut only 2,500 francs of the original sale price of 3,000.[58] In the case of another early collector, Berliner Julius Elias, a relative of Paul Cassirer, Vollard refused to send him a Pissarro painting until he paid the remaining 1,000 francs owed on the 3,500 francs total. In his letter to Elias, Vollard acknowledged their long history, dating from 1895, but reiterated that he could not send the painting before payment "because of the strict policy of the house."[59] The rule was not so strict, however, when he dealt with higher-level clients such as Kessler, Osthaus, and Mutzenbecher, or Gustav Pauli, director of the Kunsthalle Bremen, of whom he requested payment for works "already received."[60] Vollard could be hard-nosed even with long-standing

clients. When Bodenhausen, who with Kessler bought a Cézanne in 1909, asked for a two-year payment period instead of the agreed-upon year and a half, an angry Vollard marveled at his temerity and gave him until the end of December 1911 to pay up, after which the deal "will be purely and simply cancelled."[61]

If he had a ready client, Vollard seems to have favored the quick deal over established relationships. Writing to Tschudi in December 1910, Vollard asked him to return two Cézanne paintings, *Chestnut Trees* and *House in a Landscape,* as soon as possible, since he had another interested client waiting. Vollard sent the paintings to Paul Cassirer two months later, again with the stipulation that the paintings be sent back immediately for the same reason if they did not interest him.[62] In June 1911 Vollard sold Wilhelm Holzmann Degas's *Carriages and Racehorses* (fig. 247, now called *On the Racecourse*) for 60,000 francs. In a letter to Holzmann, Vollard asked that the collector not mention his name as the source. Vollard had apparently promised to let other German collectors know when he had an important Degas and had originally considered the Frankfurt museum for this one.[63] It could be that the dealer offered the Degas to Frankfurt, but the museum could

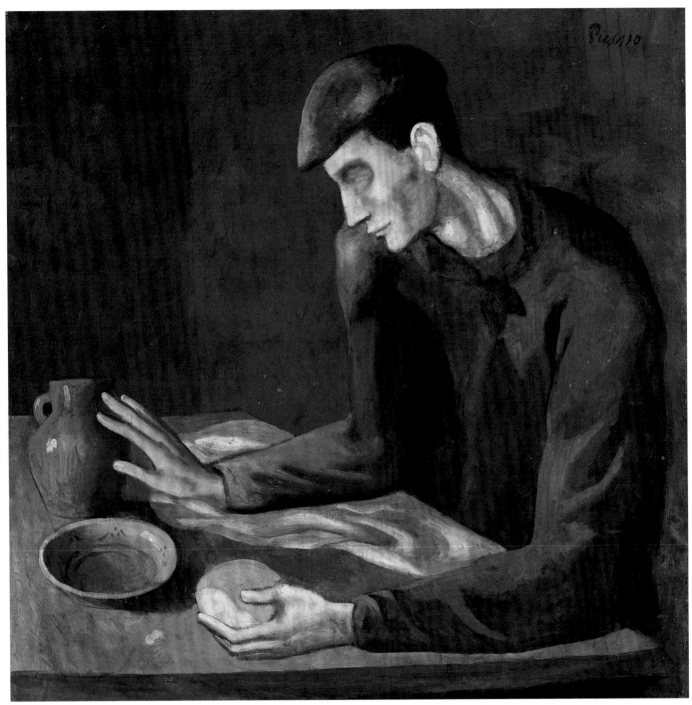

Fig. 248 (cat. 147). Pablo Picasso, *The Blind Man's Meal*, 1903. Oil on canvas, 37½ x 37¼ in. (95.3 x 94.6 cm). The Metropolitan Museum of Art, New York, Purchase, Mr. and Mrs. Ira Haupt Gift, 1950 (50.188)

not find the necessary funding, or perhaps he abandoned the idea when a collector offered the full price up front.

As Vollard became, in the words of Deneken, "generally difficult to deal with,"[64] some collectors, including Osthaus and Kessler, began bypassing his gallery, preferring to negotiate directly with such artists as Maillol and Denis. They continued, however, to go to Vollard's to exchange works and to avail themselves of the unique opportunity he offered to mingle with artists.[65] Indeed, the German collectors were able to circumvent Vollard and buy directly from the artists only because,

ironically, they had been given access to them through the dealer.[66] Many anecdotes attest to the informal atmosphere (despite the required attire of "tails") at dinners in Vollard's "cellar," to which visiting collectors would be invited.[67] Bonnard's painting (fig. 26), for instance, shows Kessler at the table with artists and other collectors. These gatherings were described in Kessler's diary entries, such as the following, from June 19, 1907: "Early from London to Paris. Dined at Vollard, who had organized a dinner to arrange a meeting between me and Degas. Besides us there were also Forain, Bonnard,

[José-Marie] Sert, and three women, two of whom were called 'mademoiselles': a small brunette Frenchwoman, Mlle Georges, and a Russian, who came in her automobile and had the manners of a great romantic heroine of the Comédie Française, half 'grande dame' half 'grande cocotte.' Mme Levell, a Creole from Jamaica, mature but still enticingly fresh, with artificial red roses in her hair, played hostess."[68]

VOLLARD'S LEGACY IN GERMANY

Although Vollard rarely traveled and neither spoke nor wrote German, he exerted a strong influence on the changing aesthetics in Germany. This can be measured not only by the collections he helped build but also by the exhibitions he lent works to: at Krefeld (1904, 1906, 1907), Weimar (1903, 1904, 1905), the Galerie Cassirer in Berlin (1909),[69] the Alfred Flechtheim gallery in Düsseldorf (1910), and the Galerie Ernst Arnold in Dresden (1910). Works he had sold to Osthaus and Mutzenbecher were exhibited publicly at various shows in Wiesbaden and Hagen, while Heinrich Thannhauser's exhibitions in 1909–10 of French modernist art at his Moderne Galerie, Munich, featured several works by Gauguin, Camille Pissarro, Alfred Sisley, Manet, and Van Gogh that had been owned by Vollard.[70] In 1909, when the director of the Mannheim museum wanted to borrow works for a show of contemporary French painting, Meier-Graefe told him Vollard's was among the three "must visit" galleries.[71]

Important paintings originally purchased from Vollard continued to circulate in Germany years after his death. Claude Monet's *Bridge at Argenteuil* (1874, Neue Pinakothek, Munich), which Tschudi bought from the Cassirer gallery, was first sold by him, as was Cézanne's *Still Life: Jugs, Bottle, Cup and Fruit* (1871, Nationalgalerie, Berlin).[72] In 1912 the Hoogendijk collection was sold in Amsterdam; if Osthaus had been successful in his original plan to purchase works before the sale, he would have acquired many of the thirty-one Cézanne paintings that Vollard had sold to Hoogendijk between 1896 and 1899.[73] Many works that Vollard sold to German private collectors were eventually donated to museums.[74] Were it not for Vollard's stockbooks from these years, these exchanges and interactions would be unrecorded.

After World War I, Swiss and American collectors largely replaced Vollard's German clients. The absence of German names in his accounts between June 1914 and January 1921 underscores the fact that in the last twenty years of his life, only a handful of the original private German collectors (Julias Elias and Gottlieb Friedrich Reber, among others) remained. Many, including Osthaus and Mutzenbecher, fell on hard times. Kessler's acquisitions became more sporadic and were increasingly limited to lithographs and works on paper.[75] New clients, including the leather industrialist Robert von Hirsch, appear, though with less consistency. German dealers Arnold, Cassirer, Flechtheim, and Thannhauser (see fig. 248) continued to buy from Vollard, while new names such as Hugo Perls in Berlin, I. B. Neumann in Frankfurt, and a number of book publishers and sellers including Steinthal Verlag in Berlin and Lengfeld'sche Buchhandlung in Cologne are entered more frequently. By 1933 few Germans other than Thannhauser were purchasing: he appears among the few entries during the years 1933 up to June 1939, when he bought a suite of Picasso Saltimbanque etchings—the last German entry in Vollard's account books.

Robert Jensen has surmised that by 1900 most ambitious dealers and collectors in Germany were attracted to French modernist art for its investment potential.[76] Although Vollard's account books attest to the Germans' penchant for buying back, exchanging, and buying for investment, it is too cynical to suggest that their interest in such art was solely market-driven. Meier-Graefe's continued belief in Vollard[77] and the enthusiasm with which the earliest collectors—Kessler, Mutzenbecher, and Osthaus—purchased from his gallery reveal a deep-seated belief that contemporary French painting, and with it French culture, offered a healing counteraesthetic to their own. Vollard, too, acted with genuine interest in the younger artists Bonnard and Vuillard, who, unlike Renoir, Degas, and Cézanne, were not initially profitable.[78] His strengths with the German market lay, at first, in Bonnard, Cézanne, Denis, Gauguin, Maillol, Roussel, and Vuillard. After 1906, when he represented Matisse and had contracts with Puy, Derain, Henri Manguin, and Rouault, both his clientele and the motivation behind the purchases had shifted.

In mid-April 1911, Karl Vinnen, a landscape painter, edited an infamous brochure, *Ein Protest deutscher Künstler* (A Protest by German Artists), denouncing the invasion of the German art market by outrageously priced French modernism.[79] The pamphlet, with a list of 140 names of the author's supporters, including museum directors and art critics, was the culminating response to a series of published letters between Vinnen and Gustave Pauli, director of the Kunsthalle Bremen, who had purchased Van Gogh's *Poppy Field* (1889–90, Kunsthalle Bremen) in 1910. Vinnen's diatribe against foreign art also indirectly targeted Tschudi, who had been aggressively acquiring French modernist art for the Nationalgalerie since 1897. Tschudi's aesthetic differences with Wilhelm II had already led to an involuntary leave of absence in 1908–9 and subsequent relocation to the Staatssammlungen

in Munich. Tschudi was able to take the significant collection of French art (Cézanne, Gauguin, the Neoimpressionists, Nabis, Matisse) that he had acquired for the Nationalgalerie, but that had never been approved by Wilhelm II, to Munich in the summer of 1909. The paintings and sculptures were stored there but remained unaccessioned until years after Tschudi's death in November 1911. Over the next few years (1912–14), the collection, known as the "Tschudi-Spende," was renegotiated among wealthy collectors, museum administrators, and Tschudi's widow; the director's friends and admirers added another group of works.[80] Vollard, too, wanted to honor Tschudi and donated a terracotta portrait bust of Renoir by Maillol (fig. 190) to the Staatssammlungen in December 1911. His gift recognized a loyal client of his gallery—the "Tschudi-Spende" in fact included seven works once owned by Vollard.[81] It was also self-referential, since both Maillol and Renoir were artists Tschudi had sought through him.[82] Just as Tschudi's collection bears Vollard's stamp, so Vollard's early success in Germany reflects the enthusiastic support for French art from Tschudi and his circle.

In the notes below, the following abbreviations are used in citing catalogue raisonné numbers: for works by Cézanne, "R" refers to Rewald 1996, and for works by Gauguin, "W" refers to G. Wildenstein 1964.

1. July 1897 date from Paul 1993, p. 359. For another dating of the sale of this work, see Rewald 1996, vol. 1, p. 325, no. 483. See, for example, Thadée Natanson's criticism (1897, pp. 503–4) of the state's handling of two Cézanne paintings acquired as part of the Caillebotte bequest. See also Feilchenfeldt 1995, p. 295.
2. See Vollard to Hugo von Tschudi, November 26, 1899, in Rewald 1996, vol. 1, p. 326. It is not clear why Vollard thought the kaiser's decree referred to Cézanne's painting, since it did not affect works of modern art that had already been acquired, although that history remains somewhat unclear; see Rewald 1996, vol. 1, p. 325.
3. For Cézanne, see Rewald 1996 and Robert Jensen, "Cézanne and Vollard: An Anatomy of a Relationship," in this volume. For Gauguin, see Kropmanns 1998a, p. 260. From 1897 to 1899 the Dutch collector Cornelis Hoogendijk dominates Vollard's account books, but this is an anomaly rather than the norm. Outside of Hoogendijk and several important American collectors, the majority of non-French purchasers are Germans, principally from Berlin.
4. Jensen 1994, pp. 7, 72.
5. See, for example, Easton 2002.
6. Known by the English title Modern Art: Being a Contribution to a New System of Aesthetics in 1908. See Anger 2005.
7. Anger 2005, p. 215.
8. See Guillot 2004–5, p. 25. In descending order, the artists with the greatest percentage of sales were Manet; Cézanne; Renoir and Degas; Redon, Monet, and Sisley; Gauguin; and Van Gogh.
9. See, for example, a letter by Hugo von Hoffmansthal written to Maximilian Harden in Paris in 1905 (in Ziegler 2001, p. 55): "The current painting, I am referring to French painting from Manet to Maurice Denis and Van Gogh, is for me one of the things that makes life entirely beautiful. This passion is what links me so strongly to Harry Kessler but also to other people I know on a less personal level such as Heilbut and Meier-Gräfe."
10. For Elias, see Kennert 1996, p. 90; for Heilbut, see Ziegler 2001; for Heymel, see Hansen 2001, pp. 186–208; for Rath, see Kropmanns 1998b; for Hirsch, see Hirsch Sale 1978, pp. ix–xi.
11. The first examination of Kessler's collection was Bismarck 1988, pp. 47–62.
12. See Kostka 1996, p. 198.
13. Jensen 1994, pp. 67–80, and Van de Velde 1992, pp. 407–8.
14. See Van de Velde 1992, pp. 409, 411; Anger 2005, p. 241, fig. 2, for a photo of the Van de Velde desk in Meier-Graefe's study.
15. Van de Velde met the Nabis through the Revue blanche circle; see Van de Velde 1992, p. 405.
16. Jensen (1994, p. 210) cites Van de Velde's statement that by 1898 Kessler already had a dazzling collection (by German standards) that included a Van Gogh, a Cézanne, a Renoir, a Vuillard, two Bonnards, a Denis, and the great Models by Seurat. Kessler's purchase of works by these artists intensi-

fies in 1902, coinciding with the decoration of his new apartment in Weimar and his introduction to Denis.
17. Van de Velde designed the room for the work, but Paul Signac advised Kessler on the purchase; see Kostka 1996, p. 200. See also Walter 2001, p. 70.
18. From Tagebuch, December 30, 1897; see Kessler 2004–5, vol. 3, p. 109. Kessler's payment was made on January 3, 1898: Vollard Archives, MS 421 (4,3), fol. 94.
19. See Meier-Graefe to Count Harry Kessler, January 11, 1898, in Krahmer 2001, p. 42, letter 22.
20. Pan 4, no. 1 (September 1898), with lithographs by Paul Signac, Hippolyte Petitjean, Maximilien Luce, Théo van Rysselberghe, Seurat, Cross, and a commercial poster by Van de Velde.
21. The Models remained installed on the rolling mechanism designed by Van de Velde in Kessler's Berlin apartment until 1923. In 1926 he sold the painting for 100,000 marks "to Scotland." Kessler does not specify which collection in Scotland, and the painting is now in the Barnes Foundation. See Kessler 1971, p. 285, Walter 2001, p. 70, and Kostka 2000, pp. 465–66, n. 19.
22. Kostka 1997, p. 176.
23. Anger 2005, pp. 211–17 passim.
24. According to Rewald, Vollard bought Cézanne's Landscape in Provence in January 1906 from Donop de Monchy for 2,600 francs; Rewald 1996, p. 297, no. 440. While Sabine Walter suggests that Kessler purchased this painting as well as The Viaduct at Estaque from Vollard on December 4, 1902, the editors of Kessler's Tagebuch identify the two paintings purchased on this date as The Viaduct at Estaque and Grove at Jas de Bouffan (possibly R 267); see Walter 2001, p. 87, and Tagebuch, December 4, 1902 (Kessler 2004–5, vol. 3, p. 520, n. 2). Denis's Nymphs remained with Kessler until August 1935, when it was sold at the count's estate sale; see Schäfer 1997, p. 78, n. 298.
25. The precise date of Kessler's acquisition of Manao Tupapau is unclear. See the discussion for cat. 90.
26. Walter 2001, pp. 74 and 84, n. 32.
27. See Krahmer 2001, pp. 352–53, notes to letter 23, and Meier-Graefe 1904, p. 138, and Meier-Graefe 1908, cover.
28. "Denis ist die liebenswürdige Blüte von Gauguins Genie," Tagebuch, November 21, 1903; see Kessler 2004–5, vol. 3, p. 638. Kessler's collection eventually included thirteen paintings and drawings by Denis. See Walter 2001, pp. 88–89.
29. See Thérèse Barruel in Chicago–New York 2001, pp. 96–100.
30. See Denis's description of the installation in his Journal (Denis 1957–59, vol. 2, p. 110).
31. For discussion on the Gesamtkunstwerk concept in German art and in the Osthaus interior, see L. A. Stein 1995, pp. 49–77.
32. Marbach am Neckar 1988, pp. 139–40. Denis exhibited at the latter exhibition as well as in an exhibition in Weimar in 1905. See Schäfer 1997, p. 102.
33. For example, see Vollard to Van de Velde, August 25, 1904, "Je viens d'expédier à votre adresse, pour le compte de M. Le Baron de

Mutzenbecher . . . ”: Vollard Archives, MS 421 (4,1), p. 71; and Vollard Archives, MS 421 (4,10), p. 39, November 30, 1904: “Remis à l'Elysee Palace de la part de M. de Van de Velde de la part du Baron de Mutzenbecher un petit tableau de Bernard . . . h 61 l 40[?] prix convenue 200 francs.”

34. Quoted in Schäfer 2001, p. 99.

35. *Tagebuch*, August 24, 1904, in Kessler 2004–5, vol. 3, p. 696. See also Vollard Archives, MS 421 (4,10), p. 21, August 24, 1904: “Vendu à M. le Baron de Mutzenbecher à Wiesbaden un tableau de Voltat [*sic*] 3356 / 2 Cezanne (nos. 4347 4348) / 1 peinture de Gauguin 3335 et un dessin 3406, 2 Seurat 3520 3521 un Daumier 3906 / une statuette terre cuite de Maillol pour le prix de six mille deux cent dix francs net / 2 Cézanne 3000 f[rancs] / Gauguin 1800 [francs] / dessin 800 [francs] / 2 Seurat 100 [francs] / 1 Valtat 800 [francs] / 1 Daumier 300 [francs] / 1 Maillol 100 [francs] / [total] 6900 f[rancs] / [less] 10% / 10% net 6210 f[rancs].”

36. Auktionshaus Neumeister, Munich, before 1996. See Schäfer 2001, pp. 116, nn. 26–27.

37. See Vollard Archives, MS 421 (5,1), fol. 55, March 23, 1906: “Vendu à M. de Mutzenbecher / 1 pastel de Renoir 1200 [francs] / 1 bord de Seine de Bonnard 1800 [francs] / 1 femme lisant de Bonnard 1000 [francs] / 1 dessin de Puys [*sic*] 300 [francs] / [total] 4300 [francs] / à recevoir 1 Renoir 400 [francs] / 1 Valtat 300 [francs]—[less] 700 [francs] / [total] 3600 [francs].”

Another entry for Baron de Bodenhausen on March 20, 1906, for a Renoir, “4373 1200 francs [illegible] 300 [illegible] un Valtat pour 300 M [illegible] à expédier à Weimar Van de Velde” is crossed out and marked “annulé”: Vollard Archives, MS 421 (5,1), fol. 52. See also two entries on March 23, 1906, for the baron's purchases of works by Puy, Manguin, and Valtat: Vollard Archives, MS 421 (5,1), fol. 55.

A week later, Kessler too is at Vollard's looking at this newer school: “Manguins, Derains, Puy at Vollard. What now counts are the sheer [and] brutally strong colors, departing from nature into [the] realm of the ornamental.” *Tagebuch*, Paris, March 30, 1906; see Kessler 2004–5, vol. 3, CD-ROM.

38. Van de Velde's furniture for Mutzenbecher was also displayed at the November 25, 1904, opening.

39. See Schäfer 2001, pp. 108–9. Denis expressed his disappointment with the Wiesbaden installation in Denis 1957–59, vol. 2, p. 59.

40. See Schäfer 2001, pp. 111–12. In 1919 Mutzenbecher resigned his directorship of the Wiesbaden theater because of health problems, and nineteen years later he died impoverished; Schäfer 2001, p. 97.

41. Eberhard von Bodenhausen to Edwin Redslob, July 30, 1914: Deutsches Literatur Archiv Marbach; quoted in Billeter 2001, p. 125. Despite Bodenhausen's claims, many Germans had comparable collections as a result of Bodenhausen's own unofficial art dealing. According to Billeter (p. 127), Bodenhausen took works on commission from French art dealers and encouraged his acquaintances to purchase them.

42. Jensen 1994, p. 211.

43. See Ploegaerts 1999, p. XLIX. See also Stonge 1993, pp. 92–93.

44. Receipt issued by Vollard, May 5, 1903, “Reçu de Monsieur Karl Ernst Osthaus la somme de deux mille francs pour deux tableaux de Gauguin, un tableau de Van Gogh et un album de Maurice Denis”: Karl Ernst Osthaus-Archiv, Karl Ernst Osthaus-Museum, Hagen, F1/104/1. Most records from the year 1903 are missing from the Vollard Archives (MS 421); information on Osthaus from Kropmanns 1998a, p. 267, n. 9.

45. Stonge 1993, p. 136, nn. 35, 36. See also Kropmanns (1998a, p. 254), who claims that all seven works came from Vollard. See also N.E.O., “Folkwang: Jahresbericht” in special edition of *Hagener Zeitung*, no date, commending the museum for its acquisitions of five major works by Gauguin, one by Denis, and one by Henri De Groux, in addition to three sculptures by Rodin, and one wooden statuette by Aristide Maillol, fragment in Karl-Ernst Osthaus-Archiv.

46. Vogt 1983, p. 14; Kropmanns 1998a, p. 255.

47. See Stonge 1993, p. 127, and Vogt 1983, p. 22. According to Rewald these paintings may be listed in Stockbook A, but the sale is not accounted for in Vollard's account books.

48. See Jensen 1994, p. 258, for the German's interpretation of “Impressionism” as synonymous with modernism in general and as rooted in the French cultural tradition.

49. See Kropmanns 1998a, p 255.

50. Osthaus to Deneken, February 19, 1904: Kaiser Wilhelm Archiv, Krefeld, Gruppe IV, nr. 17/43: “The Van Gogh [the landscape, bought for 2,000 francs] is splendid, I hope you are satisfied with it. . . . I also allowed myself to substitute one of Gauguin's paintings for a *much* better one. I remain in contact with Vollard about these four paintings.” Osthaus assures Deneken that the acquisitions would be confirmed as completed before the exhibition so that the Krefeld museum would not be perceived as the intermediary. (In an earlier letter the paintings mentioned are *Woman with a Fan*, 35,000 francs, *Horses at the Seaside*, 2,000 francs, and instead of *The Sister*, *Women on a Bench*, 2,000 francs). Vollard agrees to sell the three Gauguin paintings he lent to the Krefeld exhibition; see Vollard to Osthaus at the Folkwang Museum, Hagen, March 10, 1904: Vollard Archives, MS 421 (4,1), p. 55. The purchase price is payable by the end of the year, excepting the accounts that he owes now: “Maillol statuette (wood) 800 [francs] / 2 Terra cottas by Maillol 100 [francs] / painting by Maurice Denis 1200 [francs] (Madonna) / 2 Gauguins for 1800 each 3600 [francs] / 1 Gauguin for 3000 [francs] 3000 / [total] 8700 [francs].”

But it is possible that Vollard had another buyer for whom he postponed shipment of the paintings to Deneken, as a letter of February 8, 1904, to Deneken from the shipping firm Mitchell and Kimbell, suggests: “Honorable Mr. Director, Contrary to the promise made to you by Mr. Vollard, he did not deliver the paintings that are destined for the exhibition to us yesterday. He is afraid he has to show them to several clients on Monday so that we can only deal with them as late as Tuesday morning. Is this all right with you? Under these circumstances the shipment would probably not arrive in Krefeld until Thursday the 19th of the month.” Kaiser Wilhelm Museum Archiv, Gruppe V, nr. 19/101–102. Osthaus eventually bought the Gauguins and asked Deneken to return the Van Gogh. Osthaus to Deneken, March 10, 1904: Kaiser Wilhelm Museum Archiv, Gruppe IV, nr. 17/45.

51. See letter to Vollard from Deneken, March 30, 1904 (Kaiser Wilhelm Museum Archiv, Gruppe IV, nr. 101) and Kropmanns 1998a, p. 256.

52. Contributing to this development was the 1903 Vienna Impressionist retrospective, which led to a declaration of an “impressionistische Weltanschauung.” See the 1903 article by Karl Scheffler, the future editor of *Kunst und Künstler* (“Impressionistische Weltanschaung,” *Die Zukunft* 11 [October 24, 1903], pp. 138–47], as cited in Jensen 1994, pp. 232 and 337, n. 124.

53. See checklist in Kropmanns 1999, pp. 29–31.

54. See Kropmanns 1998a, p. 262, and Vollard Archives, MS 421 (5,2), fol. 192, November 21, 1907, for Vollard's list with prices in francs.

55. Writing to Osthaus in October 1907, Félix Fénéon made this point clearly: “We often sell paintings to Germans passing through Paris Yet, we never sell anything at exhibitions in Germany.” Cited in Feilchenfeldt 1988, p. 26.

56. For the Hohenhof, see Windsor 1981.

57. See Schäfer 1997, p. 91.

58. Vollard Archives, MS 421 (4,3), fol. 33, October 21, 1895: “Vendu à M. Heilbut à [illegible] (7 [illegible]) un pastel de Degas (femme se faisant coiffer devant la cheminée) [in column labeled *entrée*] 3000 [francs]”; MS 421 (4,3), fol. 34, October 28, 1895: “Heilbut espèces à lui remises [sortie] 500 [francs],” and October 29, 1895: “Racheté à Heilbut le pastel de Degas [sortie] 2000 [francs].” See also Ziegler 2001, p. 49.

59. Vollard to Julius Elias, May 21, 1900: Vollard Archives, MS 421 (4,1), pp. 33–34.

60. Vollard to director, Kunsthalle Bremen, July 22, 1908: Vollard Archives, MS 421 (4,1), p. 127. See also Vollard to A. Wittegund(?), July 22, 1908, asking for 13,500 francs owed: Vollard Archives, MS 421 (4,1), p. 128.

61. Vollard to Bodenhausen, December 14, 1909: Vollard Archives, MS 421 (4,1), pp. 161–62.

62. See Vollard to Tschudi (addressed now to the “directeur du musée d'art moderne à Berlin”), December 22, 1910: Vollard Archives, MS 421 (4,1), p. 182; Vollard to Cassirer, February 21, 1911: Vollard Archives, MS 421 (4,1), p. 191.

63. Vollard to Wilhelm Holzmann, June 21(?), 1911: Vollard Archives, MS 421 (4,1), p. 208.

64. Deneken made this remark in a letter to Van de Velde of April 10, 1907, in which he refers to an exhibition of French and German modernism held that year to which Vollard lent a few paintings (Bernard, Laprade) but

apparently not the ones requested: Kaiser Wilhelm Museum Archiv, Gruppe v, nr. 28/116.

65. Kessler frequently asked the dealer to buy back or take works in exchange for others; see, for example, Vollard Archives, MS 421 (4,10), p. 43, December 10, 1904: "Recu de M. Kessler le tableau de Cézanne et le tableau de Valtat qu'il me devait"; and Vollard Archives, MS 421 (5,2,), fol. 96, May 29, 1907: "Payé 33[?] fr[anc]s 15 cm[?] un caisse de tableaux venant de Berlin vendu à Kessler."

66. Matisse recalls having met Tschudi at Vollard's in 1904 when the dealer left him in charge with the admonition, "I'm expecting Monsieur Von Tschudi, director of the Imperial Museum in Berlin, to come and ask for me. Tell him, if you don't mind, that I'm out for the morning. If he looks irritated and mentions a Gauguin picture to you, then show him this canvas." Schneider 2002, p. 727. In 1910 Vollard wrote a letter for Julias Elias (whom he had refused to send a Pissarro painting without advance payment) to Gauguin's friend and collector Daniel de Monfreid, recommending him as "one of the most enlightened *amateurs* of Berlin who very much wishes to meet you." Vollard to Monfreid, October 8, 1910: Archives, Musée Départemental Maurice Denis, Saint-Germain-en-Laye, Donation de la famille Denis, MS Vollard 5407a (1)(2)a.

67. In contrast to the stacks and piles of artworks upstairs, the walls of the *cave* were devoid of paintings as described by Apollinaire (1913, p. 663, cited in Guillot 2004–5, p. 23).

68. Kessler 2004–5, vol. 3, CD-ROM.

69. November 27–December 10, 1909. See Feilchenfeldt 1995, p. 303.

70. For loans to Cassirer exhibitions, see Vollard Archives, MS 421 (4,1), pp. 149–50, and MS 421 (4,15), fol. 7. See also "Declarations pour l'exposition d'Art Francais au Musée Kaiser Wilhelm de Kréfeld en 1907, Bernard, La barque 600 f[rancs](Kaiser Wilhelm Museum Archiv, Gruppe IV, nr. 3); G. Manzana-Pissarro: No. 1: Coget poules faverolles projet de décoration pour panneau de porte 300 mark / No. 2: Panneau décoratif (Kaiser Wilhelm Museum Archiv, Gruppe IV, nr. 35); Valtat: Salon 800 f[rancs], Femme au chat 800 f[rancs], Paysage 1000 f[rancs] (Kaiser Wilhelm Museum Archiv, Gruppe IV, nr. 51)" (all marked "Adresse de retour: Vollard"). Also see Pophanken 1996, p. 424.

71. Krahmer 2001, p. 223.

72. Berlin–Munich 1996–97, p. 96, no. 27, and p. 154, no. 56.

73. See the essay by Robert Jensen on Vollard and Cézanne in this volume and Henkels 1993. My thanks to my colleague Peter Zegers at the Art Institute of Chicago for translating this article.

74. For example, industrialist Carl August Jung and then his widow donated works from his collection to the Von der Heydt–Museum in Wuppertal. Even the Degas originally purchased from Holzmann (see above, p. 237) entered the collection of Robert von Hirsch, who gave it to the Kunstmuseum Basel in 1977; see Geelhaar 1992, no. 138.

75. Despite his economic setbacks, which eventually forced him to sell the Seurat *Models* and to exchange artworks for currency with his sister, Kessler's last residence in Germany was an apartment redesigned by Van de Velde and located in one of the most exclusive districts of Berlin. Walter 2001, p. 79.

76. Jensen 1994, p. 74.

77. See Krahmer 2001, pp. 450–51.

78. See Vollard Archives, MS 421, (4,2), (4,3), and (4,4), for 1894–97: Bonnard, purchases (payouts) 1,158 francs, sales (approximately, given that the costs are sometimes listed for groups of artists) 260 francs; Vuillard, purchases 2,546 francs, sales approximately 1,100 francs. With Denis, his third-greatest expenditure after Renoir and Cézanne, he was more successful.

79. Jensen 1994, p. 79.

80. For the "Tschudi-Spende," a complicated affair, see Paul 1993, p. 347, and Lenz 1996.

81. For Tschudi provenance, see Paul 1993, pp. 347–413. For Vollard provenance not listed in Paul 1993, see Rewald 1996, vol. 1, pp. 129–30, no. 156, and p. 416, no. 635; for Gauguin, D. Wildenstein 2001, vol. 2, p. 304, no. 237, and Vollard's Stockbook B, no. 3821.

82. On January 3, 1907, Vollard sent two statuettes by Maillol valued at 800 francs (it is not clear whether the value was for 800 francs each or total for the pair) on approval to Tschudi for the "Musée de Berlin." See Vollard Archives, MS 421 (5,2), fol. 3. In addition to the Renoir portrait, which entered the Staatssammlungen on March 9, 1912, the Tschudi-Spende also included a Renoir, *Piazza San Marco, Venice,* 1881, bought by Cassirer from Vollard on behalf of Tschudi, May 26, 1910. See Paul 1993, pp. 402–3. This work appears to be in Vollard's Stockbook B, no. 3389, "St. Marc de Venise."

Russian Clients of Ambroise Vollard

Albert Kostenevich

The State Museum of Modern Western Art (SMMWA) was founded in Moscow in 1923. The first institution of its kind in the world, it united the celebrated collections of Sergei Shchukin and Ivan Morozov, which had been nationalized after the revolution. The museum immediately became a unique monument to the newest art, and the fact that it was approved by the authorities seemed to give the avant-garde the same weight as the classics. However, in less than ten years Soviet ideology lost its taste for "teaching the masses" about new Western art, and the SMMWA works were eventually dispersed to the State Hermitage Museum in St. Petersburg and the Pushkin State Museum of Fine Arts in Moscow.[1]

Who initiated the Russian acquisition of French avant-garde art? In Ambroise Vollard's memoirs, his chapter on Russian collectors contains various anecdotes—in the dealer's usual manner—about certain amusing Russian characters,[2] yet mentions nothing about transactions. The only sources of information from which we can piece together the puzzle are assorted archival documents and some old catalogues. Was the first Russian to collect the new art Moscow textile merchant Sergei Shchukin (1854–1936)? Was it one of his brothers? Perhaps it was the elder Morozov brother, Mikhail (1870–1903), who became interested in new French art at the very end of the 1890s? He was the first Russian, for example, to recognize the importance of Paul Gauguin: he purchased the artist's *Tarari Maruru (Landscape with Two Goats)* (1897–98), Hermitage), which Gauguin sent to Vollard from Tahiti in 1898,[3] and in early 1900 he bought *Te Vaa (The Canoe)* (1896, Hermitage).[4]

In fact, the first Russian collector to become associated with new French art was Ivan Shchukin (1869–1908), Sergei's younger brother. In November 1896 he bought from Vollard two paintings by Edgar Degas for 2,500 francs. In November 1897 and January 1898 he made several additional purchases, including a work by Édouard Vuillard, and in May 1899 he bought the print album *Amour* by Maurice Denis for 150 francs.

Fig. 249. Sergei Shchukin, ca. 1890s. Photograph. Private collection

Fig. 250. *Catalogue of Pictures in the Collection of Mr. Sergei Shchukin* (in Russian and French), Moscow, 1913

In general he bought relatively inexpensive and small paintings. Perhaps the most important acquisition he made from Vollard was Paul Cézanne's *Nature morte noire*, for a significant 1,000 francs, on August 29, 1897.[5] *Nature morte noire* may be *Bread and Eggs* (1865, Cincinnati Art Museum) or *Still Life with Green Pot and Pewter Jug* (1867–69, Musée d'Orsay, Paris). The latter is the more likely, as it was sold on March 24, 1900, at the Hôtel Drouot, Paris.[6]

Sergei Shchukin (fig. 249) began by collecting popular Russian Realist art, but in 1898 he quietly sold off his original Russian collection and charted his course toward "new Western art," which was soon limited only to French works. At first Paul Durand-Ruel, from whom he had already bought Claude Monet's *Cliffs of Belle Île* (1886, Pushkin Museum; W 1084) and Degas's *Woman Combing Her Hair, Toilette* (1885, Hermitage; L 848), appeared to Shchukin to be the most authoritative art dealer. In 1899 he obtained, also from Durand-Ruel, *Lilacs in the Sun* by Monet (1873, Pushkin Museum; W 204) and the *Avenue de l'Opéra, Paris* by Camille Pissarro (1898, Pushkin Museum; PV 1029). In 1900 he purchased Degas's *Race Horses* (1880, Pushkin Museum; L 594), Pierre Puvis de Chavanne's *The Poor Fisherman* and *Compassion* (1887, both Pushkin Museum); two years later he bought three "ballet pictures" by Degas (all Pushkin Museum).

At about the same time he acquired paintings that hardly anyone remembers anymore: *Moonlight* by Alfred Guilloux and *Town with Cathedral* by Fernand Maglin. Shchukin considered himself a trailblazer. In those years Symbolism became the talk of Moscow, and the collector was much taken by it. While Guilloux and Maglin did not seek new paths in painting, they were able to reproduce night illumination, which provided a longed-for air of mystery.

One may assume that it was his attraction to Symbolism that first brought Shchukin to Vollard. In 1899 he obtained from Vollard two pictures by Maurice Denis, *Portrait of Marthe Denis* (1893, Pushkin Museum) and *Visitation* (1894, Hermitage). Thus Denis became a key figure in Shchukin's Symbolist dealings and served as a precursor to Gauguin and Odilon Redon. Along with Denis, other Nabis entered Shchukin's field of vision, notably Pierre Bonnard and Vuillard. It is in connection with them that Shchukin appears in Vollard's account books in April 1899. At that time he spent 300 francs for two albums of lithography by Vuillard and Bonnard.[7] It seems that Shchukin bought *The Cab Horse* by Bonnard (1895, National Gallery of Art, Washington, D.C.) from Vollard but soon sold it.

By early 1903 Shchukin owned up to ten canvases by Monet. Although Auguste Renoir was not one of his favorite artists, Shchukin did own two pictures by the artist—*Lady in Black* and *Young Girls in Black*—which he evidently considered to be sufficient for his collection. The provenance of these "black harmonies" remains unknown. Perhaps it was Vollard, through whose gallery many Renoirs had passed. As for Cézanne, Gauguin, or Vincent van Gogh, Shchukin did not yet own any of their works, but by the end of the year the situation began to change: in 1903 Shchukin acquired his first canvas by Cézanne, *Fruit* (1879, Hermitage; R 427), from Durand-Ruel, and one year later he bought Cézanne's *Bouquet of Flowers in a Vase* (1877, Hermitage; R 315) and *Mardi-Gras* (1888–90, Pushkin Museum; R 618).

In 1904 Shchukin obtained his first Gauguin from Vollard—*Women on the Seashore (Motherhood)* (1899, Hermitage; W 581)[8]—and later *Her Name Is Vairaumati* (1892, Pushkin Museum; W 450). There were few new acquisitions

Fig. 251. Édouard Vuillard, *In a Room,* 1899. Oil on cardboard pasted on panel, 20½ x 31⅛ in. (52 x 79 cm). State Hermitage Museum, St. Petersburg (6538)

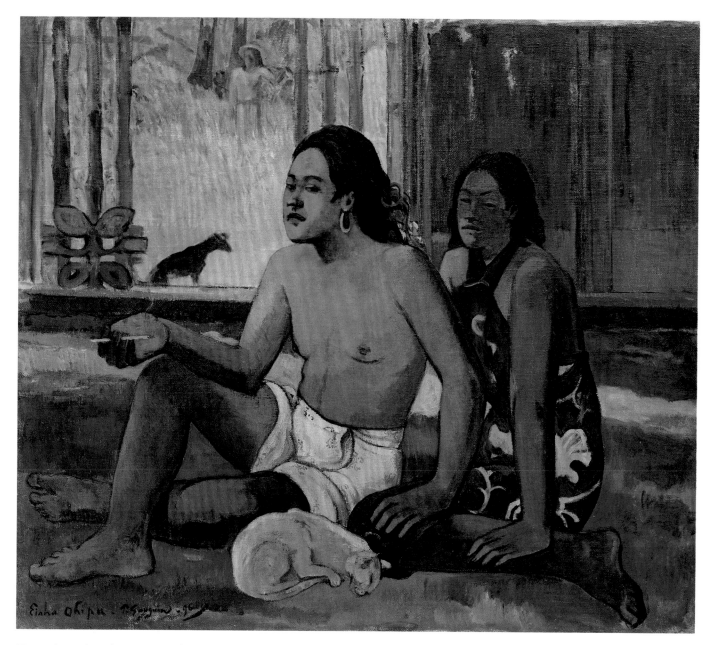

Fig. 252 (cat. 93). Paul Gauguin, *Eiaha Ohipa (Don't Work)*, 1896. Oil on canvas, 25½ x 29½ in. (65 x 75 cm). Pushkin State Museum of Fine Arts, Moscow (3267)

at this time. While he always preferred to purchase pictures personally in Paris, Shchukin stayed in Moscow during the first Russian revolution; in 1905, with his firm on the verge of ruin, he had things other than the expansion of his collection on his mind. He undertook the risky speculative venture of buying up all the existing textile goods in the warehouses, inflating the prices after the disturbances were put down, and thus making a huge profit. As a result, in 1906 his capital was greater than ever, which allowed him to act more decisively on the art market as well. At that time he acquired from Vollard several canvases by Gauguin, including *Eiaha Ohipu (Don't Work)* (fig. 252), and *BéBé (The Nativity)* (1896, Hermitage; W 540). In the Vollard datebook entries of November 19, 1906, three Gauguins are mentioned as given to Shchukin's agent; two have numbers (3334, 3333) and one does

not.[9] Among the inventory cards of the SMMWA there is a reference to number 3333, which was penciled on the stretcher of Gauguin's *BéBé*.

Some of Vollard's datebook entries contain only a small amount of information. One example is the entry for May 4, 1906: "Sold to Shchukin for thirty thousand francs blue landscape Cézanne, head by Cézanne, and figure by Gauguin."[10] Such brief entries are not easy to decipher at first glance. The "blue landscape" is most likely *Mont Sainte-Victoire* (1906, Pushkin Museum), which looked bluer before it was overvarnished; it appears in photographs of the artist taken by Denis and Ker-Xavier Roussel. "Head by Cézanne" is the artist's self-portrait (1882–83, Pushkin Museum; fig. 253) that was shown at Vollard's Cézanne exhibition of 1895. The "figure by Gauguin" could be either of two canvases with solitary

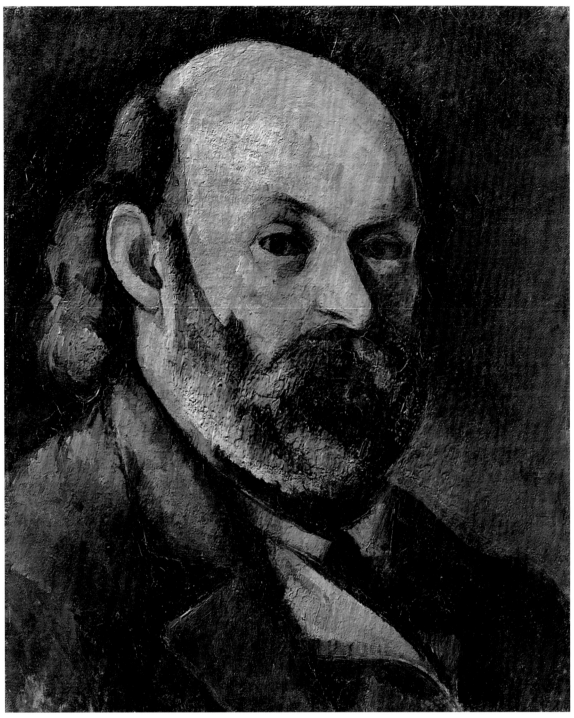

Fig. 253 (cat. 35). Paul Cézanne, *Self-Portrait*, 1882–83. Oil on canvas, 18⅛ x 15 in. (46 x 38 cm). Pushkin State Museum of Fine Arts, Moscow (3338)

figures, *Man Picking Fruit from a Tree* of 1897 (W 565) or *Te Avae No Maria (Month of Mary)* of 1899 (W 586; both Hermitage). On further examination of the registers, the second picture must be excluded: Shchukin bought it from Vollard, but two years later. Thus *Picking Fruit* must be the Gauguin figure.

Te Avae No Maria, under a different name (*Woman with Flowers*), appears in a curious entry dated April 28, 1908: "Sold to Mr. Ivan Shchukin from Moscow Gauguin, Horsemen,

8,000; Gauguin, Woman with flowers, 8,000; Matisse, Still life, 800; Matisse, Landscape. 800."[11] Having written the first line, Vollard, realizing his mistake, crossed out the name of Ivan, who had committed suicide four months earlier. The "Horsemen" of this small list could only be the picture that was later known as *The Ford* or *Escape* (1901, Pushkin Museum; W 597).[12]

The "landscape" by Matisse in the entry of April 28, 1908, was none other than the *View of the Bois de Boulogne* (fig. 149),[13] and the "Still life" paired with it was *Dishes and Fruit* (1901,

Fig. 254 (cat. 125). Vincent van Gogh, *Dr. Félix Rey,* 1889. Oil on canvas, 25¼ x 20⅞ in. (64 x 53 cm). Pushkin State Museum of Fine Arts, Moscow (3272)

Hermitage). Shchukin also owned another early Matisse still life connected with Vollard. Previously, in May 1906, Shchukin, having obtained Matisse's studio address from Vollard, made his way to the Saint-Michel embankment where, after making Matisse's acquaintance, he selected for himself *Dishes on a Table* (1900, Hermitage); this picture thus became the first work by Matisse to reach Russia. It had been exhibited at Matisse's solo exhibition at Vollard's gallery in 1904, included in the roster of exhibited works as *The Silver Coffee Pot*[14] and

priced at 150 francs. (As there were no buyers, the canvas returned to the artist.)

About this time, 1904–5, Shchukin had also bought several works by Van Gogh that had originally been acquired by Vollard. Van Gogh's *Dr. Félix Rey* (fig. 254), for example, had been purchased by Vollard from Félix Rey himself; in November 1904 it passed to Paul Cassirer, and four years later the painting found its way to Shchukin via the dealer Eugène Druet for 4,600 francs.[15]

Fig. 255 (cat. 43). Paul Cézanne, *The Smoker*, ca. 1891. Oil on canvas, 35¾ x 28⅜ in. (91 x 72 cm). State Hermitage Museum, St. Petersburg (6561)

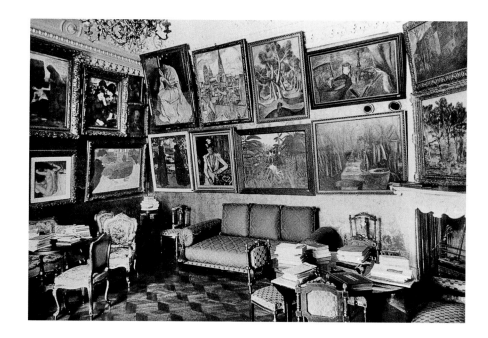

The files of the Vollard archives have allowed us to discover some previously unknown details about the best of the Russian Van Goghs. In January 1896 the young picture dealer received a letter from Arles journalist Henri Laget:[16] "I visited M. Ginoux concerning the proposal you made on the part of a buyer for another picture of Van Gogh. This picture represents not a fair but the spectators at the Arena of Arles. I talked to M. Ginoux about this proposal and he decided to sell the picture for sixty francs as you had suggested."[17] About a month and a half later, Laget sent the next letter: "I saw M. Ginoux today. He decided to accept your price of 110 francs for three paintings, no. 1 ladies in the garden, no. 2 nurse and her baby, no. 6 portrait of Van Gogh."[18]

From Laget's letters, we get a glimpse not only of a pushy journalist-middleman but also of the first "collector" of Van Gogh's Arles pictures. Joseph Ginoux, proprietor of the Café de la Gare in Arles, where Van Gogh had lived in 1888, owned many canvases by the artist. It is he who is depicted in the center of one of the best-known Van Gogh masterpieces, *The Night Cafe* (1888, Yale University Art Gallery, New Haven, Connecticut; F 463), a jewel in the collection of Ivan Morozov (see below).[19]

It is quite possible that both of Van Gogh's paintings, *The Arena at Arles* (F 548) and *Memory of the Garden at Etten* (F 496; both 1888, Hermitage), called in Laget's letter "Ladies in the Garden," did not remain long at Vollard's and came to Shchukin indirectly, much later, the first in 1905 and the other about that time or slightly earlier. The *Memory of the Garden at Etten*, for example, passed from Vollard to the painter Émile Schuffenecker[20] and later to Julien Leclerc, who also previously owned one of the best Shchukin Van Goghs, *The Bush* (1889, Hermitage; F 597).

Shchukin purchased Cézanne's *The Smoker* (fig. 255), on October 10, 1908.[21] After the entry for this transaction, the collector's name does not appear in the Vollard registers for four years. Why? There is only one explanation. Shchukin had already gained an understanding of the "pillars" of the Postimpressionist movement and had obtained a sufficient number of works from all of those whom he considered to be essential: Cézanne, Gauguin, and Van Gogh. Having done so, he wanted most to participate in a living creative process. He saw Matisse as the most important artist of the new wave.

It is customary to divide Shchukin's activity as a collector into three periods: the first, until 1904, is the period when he primarily pursued the work of Monet; the second, 1904–10, can be considered the period of Cézanne, Gauguin, and Van Gogh; and the last, 1910–14, is linked for the most part with the names of Matisse, Derain, and Picasso. Always attuned to the latest developments in French art, Shchukin would lose interest in those artists who became what he considered to be classics. Because of his continuing interest in the newest art, Shchukin could not avoid Vollard's gallery: it was there that he found the best canvases of Cézanne. And it was Vollard who made it possible for him to construct the famous Gauguin iconostasis in the great dining hall of his mansion, whose main wall was filled frame to frame with paintings in dominant hues of golden yellow: *Her Name Is Vairaumati, Eiaha Ohipa (Don't Work)* (fig. 252), *Horse on a Road in Tahiti* (W 589), *Still Life with Sunflowers on an Armchair* (W 603), *BéBé (The Nativity), Man Picking Fruit from a Tree,* and *Te Avae No Maria (Month of Mary),* among others.

Shchukin began to acquire paintings by Henri (le Douanier) Rousseau ahead of other major collectors (fig. 287). He understood that Le Douanier was not a "Sunday painter" and

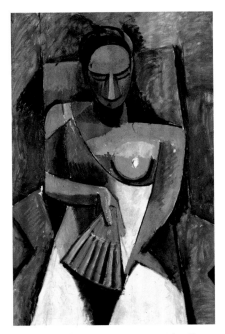

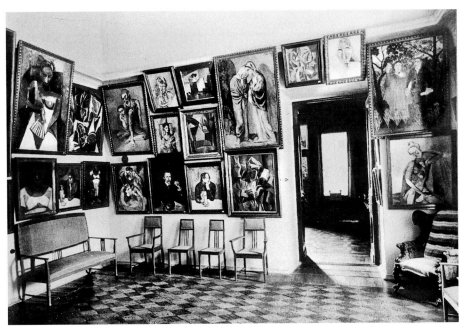

Fig. 257. Pablo Picasso, *Woman with a Fan,* 1908. Oil on canvas, 59⅞ x 39¾ in. (152 x 101 cm). State Hermitage Museum, St. Petersburg (7705)

Fig. 258. The Picasso room in Shchukin's Moscow mansion, 1913. Photograph. Private collection. *Woman with a Fan* is visible at the upper left.

applauded his original sense of color and arabesque. Seven paintings by Rousseau, selected by Shchukin from Vollard's holdings, formed a unique group.[22] On September 13, 1912, Shchukin first bought four canvases by Rousseau, then that very day added another Rousseau as well as a work by Picasso (see below).[23]

Shchukin especially stands out among his contemporary collectors as one who recognized in Matisse and Picasso two of the greatest artists of the twentieth century. In this area he acted with a rare decisiveness. One cannot fail to be impressed by his relationship with Matisse, which resulted in Shchukin's ownership of such masterpieces as *The Red Room (Harmony in Red), The Dance, Music, Conversation,* and so on. No less remarkable is his selection of fifty of Picasso's works, among them the most significant achievements of the artist's Blue Period and of Cubism. For several of these masterpieces, the Moscow collector was obliged to Vollard.

The first art dealer in Paris to recognize Picasso, Vollard arranged an exhibition of the artist's works at his gallery in 1901. Despite this exposure, prices for the young Spaniard's creations remained low for the next few years. In 1910 they increased noticeably, though they could not be considered high. In April of that year Picasso received 2,000 francs for seven paintings.[24] A major shift occurred in 1912, when on July 11 Shchukin paid 6,000 francs for two paintings by Picasso[25] and on September 13 paid 3,000 francs for another Picasso.[26] This change is all the more remarkable if one considers the fact that three years earlier Ivan Morozov bought Picasso's *Wandering Acrobats* from Vollard for only 300 francs.[27]

Even on the basis of several receipts hastily made out by Picasso, it can be seen that Vollard had at his disposal a considerable number of the artist's works, many of them from Picasso's Blue Period.[28] Unfortunately, only very few of them can be clearly identified. Among them are two masterpieces from Russian collections: *The Meeting (Two Sisters)* (1902, Hermitage) and *Old Jew with Boy* (1903, Pushkin Museum). Their presence at Vollard's is confirmed by photographs in the dealer's archive.

Vollard had a broad conception of art and kept in step with the times: he bought not only Picasso's Blue Period paintings, but also his Cubist works. In Shchukin's eyes, Vollard was an expert who had grasped the nature of the avant-garde, and his recognition of Cubism—at least that which emerged from Picasso's brush—played a not unimportant role in converting Shchukin to the new faith.

While the overwhelming majority of Picasso's Cubist works were sold through Daniel-Henry Kahnweiler's gallery (Picasso met Kahnweiler in 1907), a number of Picasso's Cubist canvases passed through Vollard's gallery. However, the provenances of such seminal works of early Cubism in the Hermitage collection as *Dance of the Veils* (1907) and *Woman with a Fan* (fig. 257), which bear on their stretchers the numbers 5172 and 5252, respectively, were unclear. It turns out that Shchukin obtained pictures with these numbers from Vollard on July 11, 1912, for 3,000 francs each.[29]

The impact of Shchukin's "rarities" on young Russian painters was felt rather quickly. As early as 1908, when Shchukin's home gallery had not yet acquired its final appearance, or its

Fig. 259 (cat. 192). Maurice de Vlaminck, *View of the Seine,* 1906. Oil on canvas, 21½ x 25¾ in. (54.5 x 65.5 cm). State Hermitage Museum, St. Petersburg (9112)

more radical canvases, the art historian Pavel Muratov, who was close to the collector, noted: "This gallery has had a decisive influence on the fate of Russian art in recent years. It is fated to become the dominant conduit of Western artistic currents into Russia as represented so vividly by the works of Claude Monet, Cézanne, and Gauguin in its collection."[30]

The Moscow painters from the group Bubnovy Valet (Jack of Diamonds), the most important association of Russian avant-garde artists, elected Shchukin as the group's first honorary member and were indeed influenced by the works in his collection, as the paintings of Mikhail Larionov and Natalia Goncharova clearly reflect. Larionov's *Smoking Soldier* (1910–11, Tretiakov Gallery, Moscow) exactly replicates the pose in Cézanne's *The Smoker* (fig. 255), while the variations of Goncharova's *Sunflowers* (1908–9, State Russian Museum, St. Petersburg) follow those of Gauguin's *Sunflowers.*

These paintings share an attachment to primitivism as a tool for overcoming academic artificiality. Larionov, Wassily Kandinsky, and Kasimir Malevich felt themselves to be the primitives of the new art. Shchukin's approach to "untutored" art was of a kindred nature and well matched to Vollard's unconventional sensibilities (especially in comparison to the dealers Durand-Ruel or Bernheim-Jeune).

Ivan Morozov (1871–1921) was Sergei Shchukin's sole rival in Russia as a collector of modern painting. Son of a wealthy Moscow industrialist, Morozov started collecting more than a decade later than Shchukin, after the death in 1903 of his elder brother, Mikhail. Although the circle of painters that initially interested Morozov had been defined by his brother, with each new purchase Ivan proved that he had a vision of his own.

Early on his acquisitions were marked by an element of competitiveness—not always clearly articulated—first with

Mikhail and then with Shchukin. Whereas Shchukin adhered to the mainstream of French painting—the Impressionists, Cézanne, Gauguin, Van Gogh, Matisse, and Picasso (the Nabis held little interest for him)—Morozov (fig. 260) explored varied paths for his treasures. In 1906 he acquired from Vollard his first paintings by Bonnard: *Dauphiné Landscape* (ca. 1899, Hermitage, bought for 1,500 francs) and *Corner of Paris* (ca. 1905, Hermitage, 1,000 francs), both pictures of rare color refinement.

At about the same time, Morozov's imposing mansion was being decorated with masterpieces by the founders of Impressionism: Alfred Sisley, Pissarro,[31] Degas,[32] and Renoir.[33] Among Morozov's most impressive Impressionist purchases were paintings by Monet, such as the *Boulevard des Capucines, Corner of the Garden at Montgeron,* and *Pond at Montgeron.* Morozov found *Corner of the Garden* at the Durand-Ruel gallery in 1907. In Vollard's vault the following year he found a not very presentable rolled-up canvas of the same size signed by Monet (*Pond at Montgeron*) and realized that the two paintings were linked to each other; indeed, they were part of a decorative series executed for the French collector Ernest Hoschedé.[34]

This was a critical moment for Morozov. The interior décor of his house was completed, and his residence was turning into a veritable museum; the previously dominant Russian canvases had to give way. Morozov began to put together a gallery of new French art to rival Shchukin's. Morozov did not concentrate on the work of one artist or even a group: the entirety of French painting of the past three decades was of interest to him, as were canvases on which the paint was not yet dry.

In 1907 Morozov bought from Vollard pictures painted not by renowned celebrities but by young painters who two years previously had been christened as the Fauves (wild beasts). At the Salon d'Automne of 1905, André Derain's *Drying the Sails* (1905, Pushkin Museum) had caused quite an uproar; his friend Maurice de Vlaminck's *View of the Seine* (fig. 259) also seemed subversive: Vollard asked 600 francs for each canvas. He further tempted Morozov with six canvases by Louis Valtat, who was close to the Fauves, asking 5,600 francs for all six. From these paintings by Valtat, Morozov selected works such as *The Boat* (1899, Hermitage, called "Paysage de Banyuls-sur-Mer" by Vollard) and *Anthéor Bay* (1906–7, Hermitage)—paying 1,000 francs for each one.[35]

Without abandoning his love of contemporary art, Morozov, in contrast to Shchukin, focused increasingly after 1907 on the classics of the new art, including the best canvases by Gauguin, Van Gogh, and Cézanne. Although at the time it seemed impossible to compete with Shchukin, especially when it came to works by Gauguin, one year later Morozov was the owner of eight outstanding paintings by the artist (he would collect a total of eleven.) He countered Shchukin's "iconostasis" with a group of canvases that while not as homogeneous were no less remarkable in quality. With the purchases he made in 1907–8, Morozov created the framework for a brilliantly thought-out ensemble distinguished by an extraordinary musicality. Starting with the majestic *Matamoe (Landscape with Peacocks)* (W 484) and the more modest but no less inventive *Les Parau Parau (Conversation)* (W 435),[36] he then acquired from Vollard *Café in Arles* (W 305),[37] the only Gauguin in Russia of the artist's Arles period, followed by a rare selection of Tahitian compositions: *Te Tiare Farani (Bouquet of Flowers)* (W 426),[38] *Fatata te Mouà (At the Foot of a Mountain)* (W 481),[39] *Tahitian Pastoral* (W 470),[40] *Ea Haere Ia*

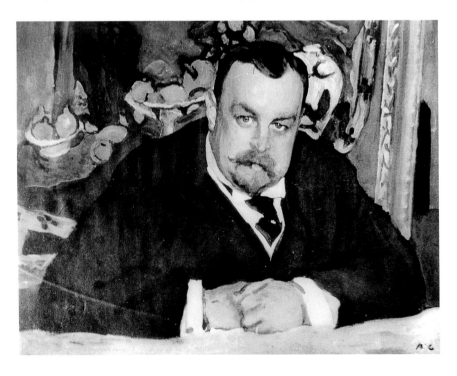

Fig. 260. Valentin Serov, *Ivan Morozov with a Painting by Matisse*, 1910. Oil on canvas. State Tretiakov Gallery, Moscow

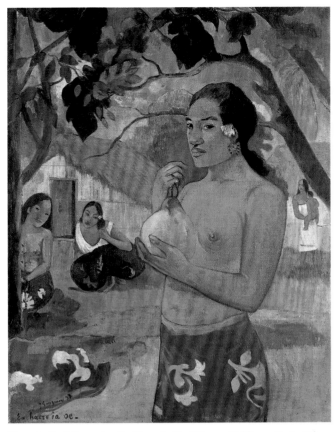

Fig. 261. Paul Gauguin, *Ea Haere Ia Oe (Woman Holding a Fruit; Where Are You Going?)*, 1893. Oil on canvas, 36⅜ x 29 in. (92.5 x 73.5 cm). State Hermitage Museum, St. Petersburg (9120)

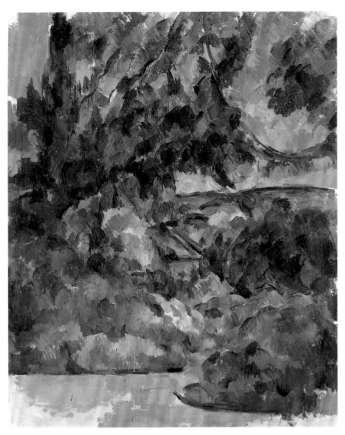

Fig. 262. Paul Cézanne, *Blue Landscape*, ca. 1904–6. Oil on canvas, 39⅝ x 31⅞ in. (100.5 x 81 cm). State Hermitage Museum, St. Petersburg (8993)

Oe (Woman Holding a Fruit; Where Are You Going?) (fig. 261),[41] *Nave Nave Moe (Sacred Spring)* (W 512),[42] and *The Great Buddha* (W 579).[43] Like Shchukin, Morozov tried to cover the full range of Gauguin's oeuvre, from landscapes and genre painting to symbolic compositions.

The impact of the posthumous exhibition of Cézanne's works, held at the Salon d'Automne in 1907, on the future of French and European art is well known. One of the most attentive visitors to the show was Morozov.[44] While there, he took note of the artist's *Madame Cézanne in the Conservatory* (1891–92, Metropolitan Museum; R 703), which he did not acquire until four years later; he did, however, buy from Vollard *Mont Sainte-Victoire Seen from the Valcros Road* (R 398), *Mont Sainte-Victoire* (R 899), and *Still Life with Drapery* (R 846)[45]— three additional unparalleled masterpieces. In 1911, when he purchased *Madame Cézanne*, he also bought the remarkable *Bridge over the Marne* (R 729; see below).[46]

It was not unusual for Morozov to take his time sizing up the great masters. Although his eye had become extremely discriminating, he nevertheless felt insecure and needed the advice of an artist friend or art dealer as an additional impulse. Matisse recalled, "When Morosoff went to Ambroise Vollard, he'd say: 'I want to see a very beautiful Cézanne.' Stchoukine,

on the other hand, would ask to see all the Cézannes available and make his choice among them."[47]

Without a doubt, at the beginning of the twentieth century Morozov's ensemble of eighteen of Cézanne's paintings was the finest in the world (although in terms of quantity it was surpassed by the Paris collection of Auguste Pellerin). Morozov was quite legitimately proud of the selection he put together over a period of six years, and when asked who his favorite artist was, he would reply simply, "Cézanne."[48]

He first acquired landscapes, then a still life, and, in 1908, a rare early figure composition, *Girl at the Piano (The Tannhäuser Overture)* (ca. 1869, Hermitage; R 149),[49] and the powerful, late *Large Pine near Aix* (1895–97, Hermitage; R 761).[50] In 1909 he added *Self-Portrait in a Cap* (ca. 1875, Hermitage; R 219).[51] *The Bouquet of Flowers* (ca. 1902, Pushkin Museum; R 894) is a unique development of a theme by Delacroix. Complementing earlier acquisitions, six Cézannes were selected in Vollard's gallery during the years 1911–12, among them *Peaches and Pears* (1895, Pushkin Museum; R 464),[52] *The Bridge over the Marne at Créteil* (ca. 1894, Pushkin Museum; R 729),[53] and *Madame Cézanne in the Conservatory* (R 703)[54]— the best still life, the best landscape, and the best portrait of the collector's Cézanne ensemble.

Morozov sometimes spent years pursuing an indispensable Cézanne work. His favorite painting, *Blue Landscape* (fig. 262), which he found at Vollard's in 1912, is a wonderful example of his persistent quest. "I remember one of my first visits to the gallery," wrote Sergei Makovsky, editor-in-chief of the journal *Apollon* and author of the first article on Morozov's gallery, "I was surprised to see a blank spot on a wall otherwise completely covered with Cézanne's works. 'This spot is reserved for the "blue Cézanne" [i.e., for a landscape of the artist's last period], explained I. A. Morozov– 'I have had my eye on it for a long time but haven't been able to make a selection.' . . . This Cézanne spot remained empty for more than a year, and only recently a new, magnificent 'blue' landscape, selected from among dozens of others, was put in place next to the previous selections."[55]

Morozov's purchasing technique was noteworthy. Like Shchukin, he would usually appear in Paris from the end of April to early May and again in September to early October, dates that were predicated in large measure by the business practices of the time: the amount of available funds became known in the spring and autumn when dividends were calculated (both collectors were prudent enough not to touch their basic capital).

Thus Morozov usually knew in advance how much he could spend, which Vollard surmised by making use of his insight and the experience of previous encounters. The figure was usually not only large but also round, or was rounded off at the end of the negotiations. The total amount he spent on the April visit in 1908 was 50,000 francs, that in September, 45,000 francs.[56] Vollard, who himself could not boast of an expansive nature, was impressed by the collector's approach, and for him Morozov remained the "Russian who never bargains." However, not bargaining did not mean that he acted hastily.

Morozov seems to have selected his last set of paintings from the Vollard gallery on February 1, 1913. Among the paintings he chose were a Cézanne (*Interior Scene*, 1870, Pushkin Museum; R 154), which he recalled from the 1907 Salon d'Automne, paintings by Renoir, Roussel, Puy, and perhaps the most important, Picasso's *Portrait of Ambroise Vollard* (fig. 1).[57] Although Morozov was not partial to Cubism—unlike Shchukin—he was captivated by the young Spaniard's keen characterization of the influential art dealer.

Having provided Shchukin and Morozov with works by the founders of modernism, Vollard decided that he could achieve better results if he entered the Russian market directly. The opportunity presented itself in the form of the 1912 St. Petersburg exhibition "One Hundred Years of French Art," which at the time was the most important exposition of the art of France outside its borders.[58] Vollard sent more than thirty-six canvases to St. Petersburg, almost all of them of the highest quality. About a week after the opening of the exhibition, Vollard notified Sergei Makovsky, one of the organizers of the show, that the only painting he would reserve the right not to sell was Bonnard's portrait of himself.[59]

The highest-priced painting in the exhibition was Renoir's *The Lovers,* set at 100,000 francs. Although the catalogue does not contain measurements of the paintings, and the theme of love was not unusual among Renoir's works, we can confidently assume, considering the title and the evaluation, that this masterpiece of Impressionism was the painting of that title now at the Národní Galerie in Prague.[60] Next in price were important canvases by Cézanne: *View of Auvers (Vue d'Auvers)* (R 199), *L'Estaque (Paysage au bord de la mer)* (R 530), *House among the Trees (Maison dans les arbres)* (R 402),[61] *Mountain (Montagne)*,[62] *Still Life with Sugar Bowl and Pears (Sucrier et poires)* (R 771),[63] *Harlequin* (R 619),[64] and *Self-Portrait* (R 383),[65] among others. Thirteen outstanding canvases by Gauguin were also for sale: six from his Breton period— *Young Wrestlers (Petits Lutteurs)* (W 273),[66] *Still Life with a Japanese Print (Bouquet de fleurs sur fond jaune)* (W 375),[67] *The Blue Roof (Maison en Bretagne)* (W 394),[68] *Harvest le Pouldu (Les Blés)* (W 396),[69] *Young Bretons (Jeune Bretonnes)* (W 400),[70] and *Haystacks in Brittany (Paysage en Bretagne)* (W 397)[71]—and a number of Tahitian masterpieces, including *Tahitian Family (La Famille Tahiti)* (W 618),[72] *Flowers and Cats (Bouquet de fleurs rouges)* (fig. 78),[73] *Two Women (Mère et fille)* (W 610),[74] *Man with a Red Cape (L'Homme au manteau rouge)* (W 616),[75] and *Faa Iheihe (Tahitian Pastoral)* (fig. 73).[76]

Vollard was very serious about the St. Petersburg exhibition. Based on the evidence, however, it would seem that the art-buying public of Russia's then-capital had no intention of reacting to his offerings. Although the prices were high by the standards of the time, they were not exceedingly so. Muscovites—traditionally cool to such St. Petersburg endeavors—also showed a lack of interest in Vollard's paintings. Indeed, they hadn't even bought the Cézannes that had been sent from Paris to Moscow for locally organized exhibitions, such as the "Salon of the Golden Fleece" (1908), organized by Nikolai Ryabushinsky through the artistic and literary magazine *Golden Fleece*. Thus the collaboration between Sergei Makovsky, *Apollon*, and the French dealer was not a success. (One reason for this may have been a lack of serious initiative on the part of Makovsky, who was characterized by Leonid Pasternak as too "lordly.")[77]

From any point of view, the collectors Shchukin and Morozov were unique—none of the other Russian connoisseurs of the new art, either in Moscow or St. Petersburg, ever came close to them.

In this essay the following abbreviations are used for citations of catalogue raisonné numbers: "F" refers to Faille 1970 (for works by Van Gogh); "L" refers to Lemoisne 1946–49 (for works by Degas); "PV" refers to Pissarro and Venturi 1939 (for works by Pissarro); "R" refers to Rewald 1996 (for works by Cézanne); and "W" refers to D. Wildenstein 1974–86 (for works by Monet).

1. In the 1930s the museum was still struggling for its survival. During World War II the pictures were kept in Siberia in crates; in 1948, following a secret order by Stalin, the SMMWA was completely eliminated, and its collections were divided up between the Hermitage and the Pushkin Museum of Fine Arts. All of the Cézannes, as well as the majority of Van Goghs and Gauguins, that are now in Russian museums came from the collections of Sergei Shchukin and Ivan Morozov. Information about how these collectors acquired them is incomplete. Morozov's paintings are fairly well documented, as his small archive survived the storms of the revolution and is now in the Pushkin Museum. Shchukin's records, however, have disappeared, and the exact dates of his purchases and their prices can be established only through disjointed bits of information.

2. Vollard 1936, pp. 131–36.

3. This landscape was one of the preparatory works for the Boston panel *Where Do We Come From? What Are We? Where Are We Going?* (fig. 13) which the artist had sent to Vollard on December 9, 1898, as part of a shipment of paintings. The title *Tarari Maruru* is almost untranslatable. In Wildenstein it is erroneously attributed to a supposed lost work (G. Wildenstein 1964, no. 566). On the stretcher of *Landscape with Two Goats* (W 562) there is an inscription and a label with the number 3917, which corresponds to entry 3917 in Vollard's Stockbook A.

4. *Te Vaa (The Canoe)* (W 544), the largest painting by Gauguin at the Hermitage (37⅞ x 51¼ in. [95 x 131.5 cm]), was number 3557 in Vollard's account book; it was priced at only 200 francs and came through the artist's friend Daniel de Monfreid. "Gauguin, huile; le Pauvre pecheur et un barque, un homme et une femme, à côté un gosse; ciel très eclatant de couleurs": Stockbook A, no. 3557.

5. Vollard Archives, MS 421 (4,2), fol. 36.; (4,3), fols. 81, 88, 95, 102; (4,4), fols. 7, 18.

6. John Rewald, who found the catalogue of this auction containing the name of Shchukin, has tried to ascertain as to whether it was "Sergei or his brother"; see Rewald 1996, no. 137. He was not aware that neither Sergei nor Pyotr would ever exhibit their property at an auction—businessmen of their stature would risk losing their reputation, especially since Sergei's purchases were regarded with suspicion in Moscow merchant circles. Ivan's case was different, in that he had torn himself free of the Russian milieu (he lived in Paris) and did not participate in business activities.

7. Vollard Archives, MS 421 (4,3), fol. 130, April 29, 1899.

8. By 1904 this painting was reproduced in the St. Petersburg journal *Mir Iskusstva* (nos. 8–9, p. 221). The stretcher bears the number 3375, and there is a corresponding entry for the painting in Vollard's Stockbook B. The sale to Shchukin of two Gauguins, nos. 3375 and 3379, is noted in Vollard's account book on November 10, 1904: Vollard Archives, MS 421 (4,10), p. 34.

9. Vollard Archives, MS 421 (5,1), fol. 184.

10. Vollard Archives, MS 421 (5,1), fol. 83.

11. Vollard Archives, MS 421 (5,3), fol. 78.

12. The painting was part of a group of his last works, which in April 1903 Gauguin sent from Atuona to Daniel de Monfreid; it later passed to Vollard.

13. At the 1904 Vollard exhibition the picture was shown under the title *Vue du Bois de Boulogne* (as number 37).

14. Number 25, "Nature morte (cafetière argent)." On the stretcher there is a pencil inscription, *cimaise* (picture rail) and the number 3411, for which there is a corresponding entry in Vollard's Stockbook B.

15. Bessonova and Georgievskaia 2001, p. 59.

16. For a discussion of Laget's relationship with Vollard, see Jonathan Pratt's essay on Van Gogh in this volume.

17. Laget to Vollard, early January 1896: Vollard Archives, MS 421 (2,2), p. 124.

18. Laget to Vollard, February 22, 1896: Vollard Archives, MS 421 (2,2), pp. 126–27.

19. Secretly sold by the Soviet government in 1933 to Stephen Clark, who bequeathed it to Yale University Art Gallery in 1960.

20. The painting was included in an exhibition of Van Gogh's work held at Galerie Druet, Paris, January 6–16, 1908, as no. 30, *Femme aux fleurs* (col-

lection Schuffenecker). Evidently it was at this gallery that Shchukin acquired it.

21. "Vendu à M. Stchoukine / une tête de Cezanne (à la pipe) / pour dix huit mille francs": Vollard Archives, MS 421 (5,3), fol. 161.

22. *View of the Pont de Sevres and the Clamar Hills, St. Cloud and Bellevue with a Biplane, a Balloon and a Dirigible*, 1908; *Muse Inspiring the Poet*, 1909; *Jaguar Attacking a Horse*, 1910; *View of Montsouri Park*, 1910 (all Pushkin Museum); *In the Tropical Forest*, 1908–9; *View of the Fortifications from the Vanve Gates*, 1909; *Luxembourg Gardens, Monument to Chopin*, 1909 (all Hermitage).

23. "Vendu à M. Stchoukine / 4 Rousseau pour 3000 fr[anc]s / nos 5300 & 5299 & / 5298 & 5301. Vendu à M. Stchoukine / 1 g[ran]d Picasso (5362) 3000 fr[anc]s / 1 petit Rousseau combat 800 fr[anc]s . . . (5303). Recu de M. Stchoukine 6800 fr[anc]s": Vollard Archives, MS 421 (5,8), fol. 160.

24. Vollard Archives, MS 421 (2,3), p. 135.

25. "Vendu à M. Stchoukine 2 tableaux de Picasso 5172 / 5252 pour 6000 fr[anc]s": Vollard Archives, MS 421 (5,8), fol. 130.

26. See note 23 above for the Picasso: Vollard Archives, MS 421 (5,8), fol. 160.

27. "Vendu à Ivan Morosoff . . . Picasso, Les 2 saltimbanques, 300 [francs]": Vollard Archives, MS 421 (5,3), fol. 79, April 29, 1909.

28. Picasso receipts are in the Vollard Archives, MS 421 (2,3), pp. 132–37, 140.

29. See note 25 above.

30. Muratov 1908, p. 116.

31. *Plowed Earth* (1874, Pushkin Museum), acquired by Ivan Morozov from Vollard in 1904 for 1,800 francs. Vollard himself had paid Pissarro 400 francs. Bessonova and Georgievskaia 2001, pp. 216–17.

32. In 1907 Morozov bought from Vollard Degas's wonderful pastel *After the Bath* (L 1179).

33. Morozov acquired Renoir's *The Frog Pond (La Grenouillère)* (1896, Pushkin Museum) in 1908 for 20,000 francs (invoice from Vollard, September 29, 1908: Archives, Pushkin Museum, XII, 1[2], fol. 10) and in 1913 the artist's *Child with a Whip* (1885, Hermitage; purchased from Vollard: inventory card of the Museum of Modern Western Art, Moscow). Unlike Shchukin, Morozov never lost interest in the Impressionists.

34. For *Pond at Montgeron*, Vollard charged Morozov one-quarter of what the collector paid Durand-Ruel for *Corner of the Garden at Montgeron* (40,000 francs). A Vollard record for September 29, 1908, reads, "Monet, bord de rivière, 10,000 [francs].": Vollard Archives, MS 421 (5,3), fol. 153.

35. I. Morozov to Vollard, October 5, 1907: Archives, Pushkin Museum, XII, 1(1), fols. 24–25. At the end of the letter there is a postscript: "annulé Octobre 1907 Vollard." Near the mention of *Jeune Fille assise* by Valtat is a note by Morozov that the work was sent back for an exchange.

36. 1892, Pushkin Museum, and 1891, Hermitage, respectively. Morozov acquired them for 15,000 francs: Archives, Pushkin Museum, XII, 1(1), fol. 20.

37. 1888, Pushkin Museum; 8,000 francs. Vollard to Ivan Morozov, August 2, 1908: Archives, Pushkin Museum, XII, 1(2), fol. 10.

38. 1891, Pushkin Museum; 8,000 francs. Invoice from Vollard, April 29, 1908: Archives, Pushkin Museum, XII, 1(2), fol. 3.

39. 1892, Hermitage; 8,000 francs. Erroneously named "Gros Arbre" in the April 29, 1908, invoice: Archives, Pushkin Museum, XII, 1(2), fol. 3.

40. 1892, Hermitage. Acquired for 10,000 francs. The picture is mentioned in Vollard's letter to Ivan Morozov, September 30, 1909: Archives, Pushkin Museum XII, 1(2), fol. 18.

41. 1893, Hermitage; 8,000 francs. Invoice from Vollard, April 29, 1908: Archives, Pushkin Museum, XII, 1(2), fol. 3.

42. 1894, Hermitage; 8,000 francs.

43. 1899, Pushkin Museum; 20,000 francs. Invoice from Vollard, October 10, 1908: Archives, Pushkin Museum, XII, 1(2), fol. 11.

44. In the archives of the Pushkin Museum there is a copy of the catalogue of this exhibition with notes written by Morozov in the margins.

45. The first painting is in the Pushkin Museum and the other two are in the Hermitage; they were acquired for 13,000, 20,000, and 17,000 francs, respectively. Archives, Pushkin Museum, XII, 1(1), fol. 24.

46. Invoice from Vollard, April 29, 1911, for 50,000 francs on two pictures by Cézanne, with a mention of receiving 10,000 francs in the transaction: Archives, Pushkin Museum, XII, 1(3), fol. 20. See also Vollard Archives, MS 421 (5,7), fols. 49 and 59, April 28 and May 12, 1911.

47. Tériade 1951, pp. 49-50.

48. Fénéon 1970, p. 356.

49. "Cézanne, La jeune fille au piano, 20000 [francs]": Vollard Archives,

MS 421 (5,3), fol. 79, April 29, 1908.

50. "Cézanne, Grand arbre, 15000 [francs]": Vollard Archives, MS 421 (5,3), fol. 153, September 29, 1908.

51. Morozov bought the self-portrait from Durand-Ruel for 12,000 francs; prior to 1909, the painting had been in Vollard's possession until 1904, and then passed to the Havemeyers.

52. Invoice from Vollard, January 22, 1912, for 30,000 francs: Archives, Pushkin Museum, XII, 1(3), fol. 20.

53. See note 46 above.

54. 1891–92, acquired in 1911 (probably in May). In 1933 the painting was secretly sold by the Soviet government to Stephen Clark, who bequeathed it to the Metropolitan Museum in 1960.

55. Makovsky 1912.

56. See notes 49 and 50 above.

57. Vollard's invoice to Morozov, dated February 1, 1913: "Somme de soixante dix francs pour les tableaux suivants a tout sept tableaux. Cézanne, Scene d'interieur, 35000; Renoir, Tête de femme, 20000; Deux pendants par Roussel, La fête dans le champs, 10000; Scene d'atelier par Puy, 2000; Mon portrait par Picasso, 3000; Paysage par Vlaminck n'est pas compte// 70000 f[rancs]." Archives, Pushkin Museum, XII, 1(4), fol. 4.

58. The exhibition, organized by the journal *Apollon* and the French Institute in St. Petersburg, contained almost one thousand works and opened on January 15, 1912, in F. F. Yussoupov's house on Liteiny Avenue. See St. Petersburg 1912.

59. This confidential information has become known only now that Vollard's archives have become accessible.

60. Executed about 1875, it is a portrait of the painter's brother Edmond and the actress Henriette Henriot. The picture was also exhibited in the same year at the Galerie Durand-Ruel ("Renoir Portraits," June 1912, no. 24). At the time of the St. Petersburg exhibition it belonged to Vollard. Vollard to Makovsky, January 23, 1912: Vollard Archives, MS 421 (4,1), pp. 220–23. All of the following prices are from this letter.

61. *View of Auvers*, ca. 1873, 15,000 francs (R 199; disappeared during World War II); *L'Estaque*, 1883–85, now in the Staatliche Kunsthalle, Karlsruhe; *House among the Trees* (R 402), about 1879, private collection. Each was valued at 40,000 francs.

62. Priced at 30,000 francs. More likely than not this is *Mount Sainte-Victoire,* but it has not been established which variation on the motif it is.

63. 1893–94, now at the Pola Museum, Japan; Vollard priced it at 25,000 francs. In his catalogue Rewald mistakenly indicated that this painting, instead of the still life *Peaches and Pears* (R 464), was from Morozov's collection.

64. 1888–90, now in a private collection, Japan; 15,000 francs.

65. 1878–80, now in the Phillips Collection, Washington, D.C.; 18,000 francs.

66. 1888, now in the Josefowitz collection, Lausanne; 12,000 francs.

67. 1889, Museum of Modern Art, Tehran; 16,000 francs. The painting is now better known by the name *Still Life with Japanese Print.*

68. 1890, private collection; 10,000 francs. The painting is now better known as *The Blue Roof* or *Farm at Pouldu.*

69. 1890, Tate, London; 12,000 francs. The painting is also known by the title *Harvest, Le Pouldu (La Moisson au bord de la mer).*

70. Evidently this is the lost painting *Baigneuses sur la plage* from the collection of Prince Matsukata; 12,000 francs.

71. More likely than not this was *Haystacks in Brittany (Les Meules),* 1890, National Gallery of Art, Washington, D.C.; 10,000 francs.

72. 1902, private collection, New York; 18,000 francs.

73. 16,000 francs.

74. 1901 or 1902, Metropolitan Museum; 16,000 francs.

75. 1902, Musée des Beaux-Arts, Liège; 16,000 francs. Vollard called it "L'Homme au manteau rouge (Tahiti)," but it is better known as *The Enchanter, or The Sorcerer of Hiva-Oa (L'Enchanteur, ou Le Sorcier de Hiva-Oa).* From the artist's Marquesan period.

76. 35,000 francs. The Tahitian title *Faa Iheihe* is usually translated as "preparing for the celebration" (*préparatifs de fête*). It is one of the two largest compositions of 1898 by Gauguin; the other one belonged to Daniel de Monfreid.

77. Pasternak 1975, p. 131.

The Vollard Estate

The Dispersal of the Vollard Collection

Maryline Assante di Panzillo

Are you aware of the enormity of the estate, discoveries everywhere, *valuable things, never sold nor noted, discoveries under piles of canvases, priceless, surpassing all calculation. And his daughter, unacknowledged, the heirs: an incredible disorder. . . . Lawsuit after lawsuit will follow.*[1]

When Ambroise Vollard died in a car crash on July 22, 1939, he left no direct heirs. His extended family and his close friends the de Galéas would share a considerable estate—including personal property, real estate holdings, and, especially, a stellar art collection—in accordance with the terms of a will drawn up three decades earlier on December 7, 1911, when Vollard's fortune was anything but assured. As one witness recalled, "In 1911, at the time he was writing his will, a bailiff would show up at rue Laffitte at the end of every month to seize his stock of paintings. He could not even afford to pay his rent. He had barely a thousand francs in his pocket. Moreover, in his will he left his heirs sums of money he didn't possess. . . . It was to raise this money that he asked for his paintings to be sold off little by little."[2] This was a bold assertion, certainly, but there is no denying that the prices for Vollard's artists rose dramatically between 1911 and 1939 or that the value of the thousands of works accumulated in his mansion on the rue de Martignac climbed even higher by the time the inheritance was settled ten years later. To take one example, a work by Degas, *The Artist's Father and His Secretary,* bought for 65,000 francs at Drouot in 1925, was valued at 2,800,000 francs in 1949.[3]

In his will Vollard bequeathed sums of money and lifetime annuities to his brothers, sisters, niece, cousin, and maid; to the de Galéa family he left money and his Norman property, La Marjolaine. To the city of Paris, for the Petit Palais, Vollard bequeathed the only artworks specifically cited in the document: portraits of him by Cézanne (fig. 4) and Renoir (fig. 165), Renoir's portrait of Madame de Bonnières (fig. 264), and a Cézanne "to be determined, except for the largest one." He asked that his paintings be sold off "little by little, at a minimum of ten auctions, over a period of at least six years." The sales were to be handled by Durand-Ruel and Bernheim-Jeune, and the revenues generated would be "divided among the heirs, proportionate to their legacy," with the exception of fifty thousand francs, which should be put

into government bonds. The accrued interest from these bonds would be given in part "to one or two independent toy makers exhibiting at the Concours Lépine" to reimburse the cost of "the toy that shows the greatest ingenuity, in other words that is made the most economically," and in part to "one or two of those old women who feed stray cats, even while depriving themselves."

After he had drawn up his will, Ambroise Vollard acquired several properties[4] and built a substantial stock portfolio, but these had nowhere near the value of his magnificent collection. During the summer of 1939, while the impending war was in all the headlines, several newspaper columns were devoted to the fate of this collection, which was all the more intriguing because it was little known, having been exhibited only rarely and never in its entirety. However, the times were hardly suited to the kinds of auctions Vollard had envisioned, and the division of property between the "natural" heirs (probably aided by Martin Fabiani, a dealer who had befriended Vollard) and the de Galéa family (who received two-thirds of the works) was quickly settled. A first cursory inventory, encompassing only the paintings and the most important works on paper, was established at the time. The materials relating to Éditions Vollard—prints, albums, illustrated books, bronzes, and ceramics—were not inventoried.

Lucien Vollard, a former colonial magistrate and one of Ambroise's brothers, was named executor to the estate; he immediately took steps to get the works under his charge safely out of Paris. In April 1940 he offered the Musée de Grenoble a group of Fauvist ceramics "in memory of Ambroise Vollard."[5] In May of that year, he gave eighteen paintings by Derain, Vlaminck, Forain, Valtat, Manguin, Puy, and Émile Bernard, along with a statuette by Maillol, to the Petit Palais, whose curator planned to "reopen the museum with an Ambroise Vollard gallery when this torment is over, which would be a fitting homage to that great champion of modern art."[6] These works—lost, then rediscovered in the museum's storage basement in 1950—would eventually be returned to the Vollard family as part of a settlement that ended a legal battle between the heirs and the city of Paris (see below). In 1947 the Musée Léon Dierx on Réunion island received 157

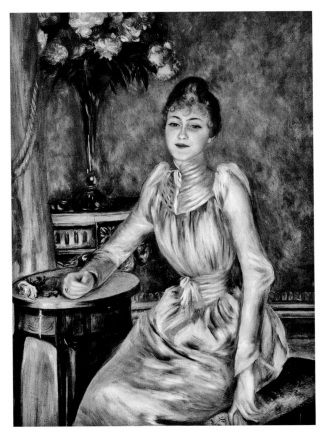

Fig. 264. Auguste Renoir, *Madame de Bonnières,* 1889. Oil on canvas, 46⅛ x 35 in. (117 x 89 cm). Petit Palais, Musée des Beaux-Arts de la Ville de Paris (PPP 2364)

paintings, drawings, ceramics, and prints.[7] In addition, several Swiss museums benefited from Lucien Vollard's largesse.

In 1939 Erich Chlomovitch, a young Jewish Yugoslav art lover who often visited Vollard, took possession of several hundred works, which he insisted had been given to him for the creation of a Vollard museum in his native country. In fact, most of these works were apparently sold to him by Lucien Vollard, who seems to have been in frequent need of cash. Having first shown up in Paris art circles in 1936, Chlomovitch returned to Belgrade at the beginning of the war and disappeared in 1943, a victim of the Holocaust. Part of his collection, claimed by both his family and by Vollard's heirs, is now at the National Museum in Belgrade. Another part, composed mainly of works on paper but also including a portrait of Émile Zola by Cézanne and paintings by Derain, Matisse, Bernard, and Valtat,[8] was placed in a safe at a Paris branch of the Société Générale bank. Although this group of works was put up for auction in 1981, the sale was cancelled by the French courts.

It seems most likely that Lucien Vollard kept a large number of studies, drawings, and pastels in France, selling off some of them during and after the war.[9] Yet as early as late 1939 he arranged for a major portion of the collection to be shipped to the United States; in this he was assisted by Martin Fabiani, who obtained the export authorization. According to lists found at the Foreign Exchange Office,[10] 702 works left France at that time, among them 469 works by Renoir (including *Vollard as Toreador* [fig. 20]), 78 by Cézanne, and a number of other paintings, notably by Bonnard, Degas, Gauguin, Picasso, and Rouault. The most important works were destined for the Bignou Gallery in New York. The collection left Lisbon on board the SS *Excalibur;* in Bermuda, on September 25, 1940, the British navy boarded the ship for inspection. Considered spoils of war, the collection was sent for storage at the National Gallery of Canada in Ottawa.

As a notorious collaborator indicted for trafficking in looted artworks, Martin Fabiani was sentenced to pay a hefty fine in 1945. Subsequently, it took four years to dispel the clouds of suspicion that had formed over the Vollard collection; on April 19, 1949, the London prize court lifted the impound and ordered the works in Ottawa to be restored to the rightful heirs. Returned to Fabiani, as proxy for Ambroise Vollard's brothers, and to Édouard Jonas (a former councilman and inaugural director of the Musée Cognacq-Jay in Paris who then became an art dealer before getting into the oil business in the United States) on behalf of Vollard's sisters, the works immediately appeared on the New York art market. It should be noted that a group of lithographs by Rouault and Chagall and a Gauguin painting remained at the National Gallery of Canada in Ottawa, donated by the Vollard family. (Martin Fabiani also gave the museum a Renoir drawing, *Gabrielle and Jean.*) Only days before his own death on February 1, 1952, Lucien Vollard designated Édouard Jonas as his sole heir.

Fig. 265. André Rogi (Rosa Klein), *Ambroise Vollard with Works in His Collection,* 1936. Photograph. Centre Georges Pompidou, Paris, Musée National d'Art Moderne

Following the settlement of a dispute between Vollard's heirs and Rouault, in April 1949 the heirs at last registered their declaration of inheritance; it was at this time that the city of Paris claimed its share of the collection. In February 1940 Lucien Vollard had given the Petit Palais the paintings mentioned in the will, with the exception of Renoir's portrait of Ambroise, which had been sold in 1927,[11] and in February 1945 the city of Paris had officially accepted the bequest. In May 1949, however, the Paris administration, reconsidering the will, judged that the sums produced by the sale of the collection should be "divided among the various heirs, proportionate to their inheritance" and demanded its due based on the relative value of the paintings bequeathed to it. A headline in *Le Figaro* on May 25, 1949, read, "550 Paintings from the Vollard Collection Seized as War Spoils in 1940 Will Be Returned to France."

A list of the 2,559 Vollard works still held by the de Galéa family was drawn up by the auctioneer Maître Rheims.[12] This highly inaccurate accounting tells us very little, other than the numerical size of the collection, which the consulted experts all agreed was of uneven quality. Major paintings figured next to sketches, studies, and drawings.[13] The most widely represented artists were Renoir (with 249 works), Rouault (325 paintings),[14] Valtat (656 works), and Puy (265 works). Also mentioned were Cézanne, Degas, Mary Cassatt, Berthe Morisot, Lautrec, Bonnard, Vuillard, Maurice Denis, Émile Bernard, Gauguin, Derain, Vlaminck, Matisse, and Picasso, among others. (The de Galéas had kept their collection hidden in the outskirts of Paris during the war. Some of these works, later sold off haphazardly, are now hanging in museums. With few exceptions, it is impossible to identify any of them with certainty.)

In June 1949 the city of Paris sequestered the de Galéa collection, froze the assets left in trust with the notary handling the inheritance, and insisted on the return to France of the previously seized works. But the paintings remained in New York, and the French embassy lodged an official complaint on June 20, 1949. As a sign of good faith, forty-two works, mainly drawings and watercolors, were repatriated from the United States by Édouard Jonas.

The Vollard family and the de Galéas maintained that only those who had been bequeathed sums of money could claim revenues from sales of the collection and that Ambroise Vollard had never intended to leave money to the city of Paris. City officials replied that in 1911, in the wake of the 1894–95 Caillebotte bequest debacle (in which the French government rejected portions of Caillebotte's bequest of largely Impressionist pictures), Vollard feared that a Parisian museum might refuse to hang certain works on its walls in the absence of any financial incentives.[15] The heirs countered that the Petit Palais was

Fig. 266. Paul Cézanne, *Autumn,* panel of *The Four Seasons,* decoration for the salon of the Jas de Bouffan, 1860–61. Oil on canvas, 10 ft. 3⅝ in. x 41⅜ in. (314 x 104 cm). Petit Palais, Musée des Beaux-Arts de la Ville de Paris (PPP 3046)

hardly a worthy custodian of the works that had been left in its care, as it had misplaced the paintings and statuette that Lucien Vollard had given it in 1940.[16] The press had a field day.

When its suit was dismissed, the city of Paris appealed. Meanwhile, the heirs began negotiations, and a settlement was finally ratified by the city council. Major works from the Vollard collection would go to the Petit Palais, including Cézanne's *The Four Seasons* (fig. 266), youthful paintings created for the salon of his parents' manor house, the Jas de Bouffan; *The Rouart Family* (*Madame Alexis Rouart and Her Children*) (fig. 267), an important pastel by Degas; *Christ and the Fishermen* by Rouault;[17] *Rocks in Agay* by Guillaumin; Bonnard's large portrait of Ambroise Vollard (fig. 161); a Degas self-portrait; a Dutch landscape by Jongkind; and Picasso's *Evocation* or *The Burial of Casagemas* (fig. 263).[18]

Would Vollard have been satisfied with this arrangement? He claimed to have nothing but disdain for museums[19] and famously spent his visit with Marie Dormoy to the Musée

Fig. 267. Edgar Degas, *The Rouart Family (Madame Alexis Rouart and Her Children)*, ca. 1905. Charcoal and pastel on tracing paper pasted on cardboard, 63 x 55¾ in. (160 x 141.5 cm). Petit Palais, Musée des Beaux-Arts de la Ville de Paris (PPD 3021)

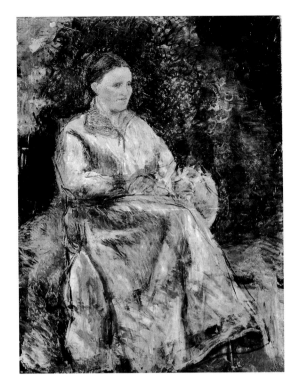

Fig. 268. Camille Pissarro, *Julie Pissarro in the Garden*, ca. 1874. Oil on canvas, 45⅝ x 34⅞ in. (116 x 88.5 cm). Petit Palais, Musée des Beaux-Arts de la Ville de Paris (PPP 854)

d'Unterlinden in Colmar reading his newspaper in front of the Grünewald triptych. Yet this "devil of a man" was no stranger to paradox, and Dormoy also recounted that Vollard had planned to found a museum of his own. Whatever the case, Vollard lent generously to exhibitions of avant-garde

artists at the Petit Palais between the wars, anticipating the opening of a proper modern art museum,[20] and during his lifetime he was one of the museum's major donors.[21] Perhaps he wouldn't have been displeased to know that there is now a gallery in the Petit Palais devoted entirely to him.

1. "Êtes-vous au courant de l'énormité de sa succession, des découvertes, partout, de valeurs dispersées, jamais placées, ni notées, des découvertes sous des piles de toiles, inestimables, dépassant tout calcul. Et sa fille, non reconnue, les héritiers: un désordre incroyable. . . . Procès sur procès, à venir." Jacques-Émile Blanche to Maurice Denis, December 15, 1939, in Collet 1989, p. 246, letter III.
2. Anonymous art dealer cited in Guth 1950.
3. *Le Figaro,* June 2, 1949.
4. Vollard acquired the property called Bois-Rond in Vaudoué, near Fontainebleau, in 1914; the mansion on the rue de Martignac in Paris, in 1920; and a property in Tremblay-sur-Mauldre, near Versailles, in 1926. Vollard Archives, MS 421 (10), (11), and (13).
5. Municipal Archives, Grenoble, R2-48.
6. Raymond Escholier, head curator at the Petit Palais, to Lucien Vollard, November 2, 1939: Vollard Archives, MS 421 (10,7), fols. 34–35.
7. See New Delhi and other cities 1999–2001.
8. See the catalogue for the March 19–20, 1981, sale at Hôtel Drouot, Paris.
9. See the catalogue of the Bignou collection auction in Cheverny, June 5, 2005, the *Portrait of Auguste Pellerin* by Cézanne, "acquired by Étienne Bignou from Lucien Vollard, Paris, March 21, 1944."
10. Les Archives de Paris, box 1672 W 17.
11. Now at the Courtauld Institute, London.
12. Les Archives de Paris, box 1672, W 17.

13. Report to the Directeur des Beaux-Arts de la Ville de Paris regarding the sequestration of some of the artworks from the Ambroise Vollard inheritance. The report was compiled by Germain Bazin, paintings curator at the Louvre; Jacques Wilhem, curator of the Musée Carnavalet; and a certain Jondot, assistant curator at the Petit Palais. Archives, Musée du Petit Palais, Vollard file.
14. A note on the list of works drawn up by Maître Rheims (see note 12 above) indicates that "489 works on canvas and on paper were delivered to M. Rouault," the outcome of a suit that the painter brought against the heirs in 1946 to recover the contents of the Rouault studio on the rue de Martignac.
15. Monsieur Thirion, city councilor; see *Bulletin municipal officiel de la Ville de Paris,* July 25, 1950.
16. They were rediscovered in May 1950 in the basement of the Petit Palais, among personal effects left by Raymond Escholier after the war.
17. Now at the Musée d'Art Moderne, Paris.
18. This work is also now at the Musée d'Art Moderne, Paris.
19. See Jacquinot 1999.
20. In particular for the exhibition "Les Maîtres de l'art independant, 1895–1937"; see Paris 1937.
21. Among the works he donated were paintings by Maurice Denis, Forain, Laprade, Marval, Pissarro, Renoir, and Vlaminck; a pastel by Roussel; a bronze by Picasso; a fine collection of prints and illustrated books; and Metthey ceramics decorated by Mary Cassatt, Derain, Laprade, Maillol, Puy, Valtat, and Vlaminck.

The Vollard Archives: Myth and Reality

Isabelle Cahn

Ambroise Vollard's numerous activities—from art dealing to publishing, not to mention his own writings—generated a huge mass of papers, which he carefully preserved and which today form his archives. Spanning more than fifty years, they contain two main types of documents, business papers and photographs, which provide extraordinary insights into Vollard's accomplishments and the workings of his gallery.

BUSINESS ARCHIVES

Not all the papers Vollard produced in the course of his career survive. Many are missing,[1] which can be explained by the gallery's several changes of address (resulting in the loss of some account books) rather than by willful destruction on the dealer's part. Following the interruption of his activities during World War I, Vollard kept his records at his home on the rue de Gramont. He then transported them to his mansion on the rue de Martignac, where he moved in the 1920s; the building had many rooms in which to house his collections and store his files. The archives most likely remained there for several years after his death, while the 249 consigned works listed in the posthumous inventory were moved to three secured rooms. From February 1944 to October 1945 the war ministry requisitioned fourteen rooms as offices for the army's social services

department.[2] Soon after, an apartment on the second floor was requisitioned by a diplomat from the Swiss legation, who began negotiations to buy the building; four years after Lucien Vollard's death on February 1, 1952, the house was sold.[3] At what point were the archives removed? Did they remain in the building, piled together in one room with furniture and miscellaneous objects, exposed to the ravages of "mice, mites, and other parasites"?[4] Just before the sale of the mansion, the contents were relocated to a former property of Vollard's in Tremblay-sur-Mauldre occupied by Lucien's surviving heir.

Throughout his life, Ambroise Vollard kept a record of his gallery's activities, making daily entries (fig. 269) that were sometimes precise, sometimes cryptic. The accounts information from these journals was then transcribed into his registers (fig. 272), which were used to calculate his financial holdings and establish his inventory. He also kept copies of his business correspondence as well as bank drafts, invoices, and numerous documents detailing which works were sent abroad or loaned to exhibits—belying his reputation as an impulsive individual, or one who is intentionally negligent about maintaining his accounts. This whirlwind of figures, this maelstrom of transactions and dealings couched in a spidery hand that became more lax over time, constitutes an essential source of information. Complementing this material are Vollard's personal papers and the documents relating to his activities as a publisher.

Fig. 269. Cover label and pages from Vollard's datebook for March 29–30, 1906. Musée d'Orsay, Paris, Vollard Archives, MS 421 (5,1)

Fig. 270. Edgar Degas, *Galloping Horse on Right Hoof,* 1865–81. Wax. Now destroyed. Photograph. Musée d'Orsay, Paris, Vollard Archives

VISUAL ARCHIVES

Vollard, like other dealers such as Durand-Ruel, assembled a vast library of photographs, mainly of artworks. Over a period of roughly ten years, Vollard amassed thousands of them, in the form of glass-plate and positive prints. In 1904 he stepped up his orders with the photographer Étienne Delétang;[5] the earliest known receipt dates from April 23, 1904.[6] Between May 14 and 28 of that year, Vollard paid Delétang 450 francs,[7] and every month thereafter he advanced him greater or lesser sums to pay for photographs, supplies, and even an enlarger.[8] We are missing the accounts registers for 1905, but we can imagine that Delétang's work continued unabated. Between June 1904 and December 1907 sixty-two works by Gauguin were photographed.[9] In 1907 Delétang's orders included shots of twenty-eight watercolors by Cézanne.[10] He was even busier in 1908, as attested by Vollard's registers: on November 23 he photographed thirty-six Renoirs[11] and was given 200 francs toward the purchase of a camera.[12] In 1912 and 1913 the photographer captured paintings and drawings by Renoir, Redon, and Cassatt.[13] The objects were brought to his studio, then returned to the gallery once the photos were taken. The dealer's registers are missing for 1914 through 1921, by which point Delétang's name has disappeared; in all likelihood, Vollard stopped ordering photography when World War I broke out. But the gallery's main artists (Renoir, Cézanne, Degas, Cassatt, Morisot, Forain, Gauguin, Picasso, and Redon) were already "in the can."

From these black-and-white images, which included photos of works that had not been shown in the gallery, Vollard assembled groups to be used in catalogues or gathered into albums for consultation at the gallery. The Vollard albums are similar in size, type of mounting, and binding to those of the dealer Étienne Bignou, his friend and associate.[14] Indeed, some of the prints tipped into the Bignou albums might have been made from Vollard's negatives, since the two galleries shared a number of artists. Vollard apparently did not offer these images for sale, even though multiple prints were made; they were mainly used to inform clients about the available merchandise and to send the works abroad without actually moving them. Vollard mailed photographs to his customers who lived outside Paris so that they could choose what to buy; the collectors then returned them to the gallery.[15]

Vollard had a few other uses for his photographs in mind. Several years after Berthe Morisot's death in 1895, Vollard convinced Julie Manet to have pictures taken of her mother's canvases, which were stored in the house Julie shared on the rue de Villejust. He began putting together a catalogue of Morisot's paintings as World War I was raging. By 1931 the publisher Les Beaux-Arts had taken over the project,[16] and Vollard sold them his 360 photos of Morisot's works for 5,400 francs.[17]

In 1904 Vollard had ordered photographs of Cézanne's oils and watercolors. After several months, the photos, collected in five albums, were sent to the artist's son in Aix-en-Provence[18] so that he could annotate them, probably in anticipation of a catalogue publication: "I'm awaiting the first batch of photographs that you have promised to send me. I will do my best to arrange them and to indicate on each one the date, place, and nature of the painting depicted,

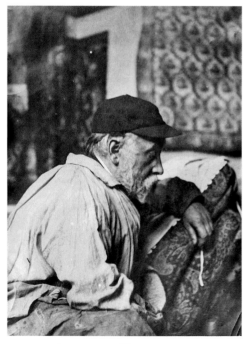

Fig. 271. Edgar Degas, *Self-Portrait,* ca. 1900.
Photograph. Musée d'Orsay, Paris, Vollard Archives,
MS 421 (3,9), fol. 21

Fig. 272. Page for June 1904–December 1907 from Vollard's Stockbook B. Vollard Archives, Musée d'Orsay, Paris, MS 421 (4,5), fol. 8

as per your request."[19] Unfortunately, the younger Paul Cézanne did not have time to ask his father about these images before the latter's death, and the photos remain mute. Not all of these works—apart from the watercolors, which probably belonged to Vollard—had been in the gallery; for instance, the Cézannes owned by Dr. Gachet were also included. These photos, unpublished to this day, comprise an invaluable set of documents from which to make expert appraisements and to compile a catalogue raisonné of the artist's works.[20]

Only one such publication came to fruition, in 1918: the two-volume Renoir catalogue, containing 1,741 illustrations.[21] Vollard spent almost twenty years finishing it, and the artist was satisfied with the quality of the reproductions. As Renoir wrote to the publisher, "I have received the reproductions you made for your book about me, and I'm pleased to say that I find them perfect."[22] Still, many of the images are not dated, as not even the painter could provide Vollard with that information.[23] The illustrations in the second volume are missing not only the dates but any indication of medium as well.

In 1914 Vollard published an album containing ninety-eight reproductions certified by Degas himself.[24] At an unknown date, he also procured photographs of fifty-three wax sculptures by Degas (fig. 270). These photos were taken in the artist's studio at 6, boulevard de Clichy by the photographer Gautier between December 1917 and March 1918.[25] They constitute a precious source of information on works that no longer exist today, having been melted down to make bronze castings.

THE VOLLARD ARCHIVES AT THE MUSÉE D'ORSAY

In 1988 Lucien Vollard's heirs offered a portion of the dealer's archives to the French government in lieu of payment of estate taxes;[26] on October 16, 1989, the bequest was accepted on behalf of the Musée d'Orsay. These business records, correspondence, personal papers, documents relating to Éditions Vollard, manuscripts, and large photographic library provide essential information about the history of art at the end of the nineteenth century and the beginning of the twentieth. The artists in question range from luminaries, such as Cézanne, Degas, Renoir, Gauguin, Van Gogh, Denis, Cassatt, Maillol, Matisse, Picasso, Derain, Vlaminck, and Rouault, to others now forgotten or of lesser import, such as Jean Puy, Henry De Groux, Laprade, or Valtat.

Vollard's original papers are housed at the Bibliothèque et Archives des Musées Nationaux, Paris (microfilm copies are available at the Musée d'Orsay). Catalogued in thirteen groups,[27] they encompass the full range of his activities. The oldest business record dates to 1891,[28] whereas the personal papers have a much greater chronological span, between 1885[29] and 1956, the

year the mansion on the rue de Martignac was sold.[30] Registers, datebooks, account books, a stockbook, records of transported works, and letters between Vollard and various artists constitute the most important documents of the bequest.

Among the financial records, the Vollard account books preserved here[31] cover two separate time periods, from June 1894 to December 1904 and from July 1920 to October 1929. Only one of the dealer's stockbooks, pertaining to June 1904 to December 1907 (Stockbook B; fig. 272), out of three known to exist,[32] is in the Musées Nationaux archives; while it does not provide a summary of purchases and sales, which would allow us to know what the gallery's holdings were at any given moment, it does establish a cumulative list of works.[33] These papers as a group furnish valuable and often new information about various works, such as the date and amount of transactions, the names of the buyers, and the travels of certain objects throughout the world because of sales or loans. They help us to verify the history of a painting or to confirm a pedigree (a Vollard stockbook number on the back of a picture constitutes a guarantee). These documents also illustrate Vollard's business strategy, showing how he occasionally joined forces with other dealers such as Durand-Ruel or Josse and Gaston Bernheim to enact a given

sale or purchase. In this regard, the information revealed concerning the business relationship between the dealer and the collector Albert C. Barnes is exemplary. Furthermore, these records constitute a kind of international social register of collectors, those who would visit Vollard's gallery to acquire works by French artists; indeed, the names of all the major players in cultural history are inscribed here, with their addresses.[34]

In addition, the Vollard archives include documents about the books the dealer published, his correspondence with artists, and invoices and statements from his suppliers, shedding light on a hitherto neglected aspect of his work. Waste sheets from albums featuring reproductions of Degas's works and cancelled prints of copper engravings by Maurice Potin after Degas monotypes (illustrations for Maupassant's *La Maison Tellier* [fig. 169], Lucian's *Mimes des courtisanes,* and, after Degas drawings, for *Degas, Danse, Dessin*, by Paul Valéry) complete this disparate collection, which is also rich in unpublished manuscripts by Vollard and documents relating to his work as a writer.[35] Despite his proclaimed modesty, Vollard was a prolific author throughout his life, composing notes, reflections, memoirs, and jarring fictions, such as his reincarnations of Père Ubu, alias Père Vollard.

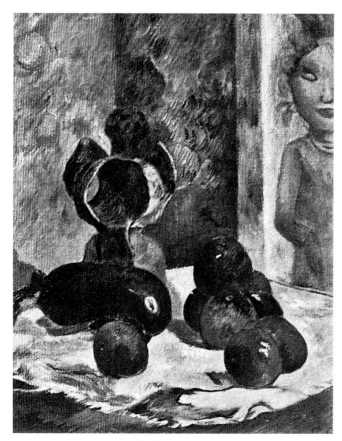

Fig. 273. Paul Gauguin, *Still Life with Idol*. Oil on canvas. Photograph from the Vollard Archives, Musée d'Orsay, Paris

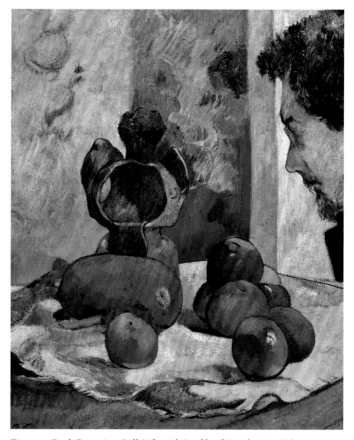

Fig. 274. Paul Gauguin, *Still Life with Profile of Laval,* 1886. Oil on canvas, 18⅛ x 15 in. (46 x 38.1 cm). Indianapolis Museum of Art, Samuel Josefowitz Collection of the School of Pont-Aven, through the generosity of Lilly Endowment, Inc.; The Josefowitz Family, Mr. and Mrs. James M. Cornelius, Mr. and Mrs. Leonard Betley, Lori and Dan Efroymson, and other Friends of the IMA

Fig. 275. View of the Cézanne exhibition at the 1904 Salon d'Automne. Photograph from the Vollard Archives, Musée d'Orsay, Paris

The roughly seven thousand photographs—4,500 glass-plate and 2,500 positive prints—in the Vollard visual archives are housed in Paris at the Musée d'Orsay. These photos are not gathered in albums but rather are in the form of individual prints, often in several copies, sometimes tipped onto cream-colored card stock that is glued onto marginal strips with holes to allow for subsequent binding (the photos prepared for binding bear a number written in pencil). Nearly all the photos from the original 1918 Renoir catalogues[36] (including 189 certified by the artist), as well as more than three hundred unpublished Renoir images, form the largest single share of this photo archive.[37] Photographs of works by Cézanne, Degas, Cassatt, Gauguin, Picasso, Redon, Forain,[38] and other gallery artists[39] complete this group. Since there are multiple prints, some of Vollard's photos can be found in other archives as well; and some, certified by Degas and Renoir, are occasionally put up for sale even today.[40]

These photos are an exceptional reference tool for scholars and art experts and bear witness to the works' original state. Vollard performed a real service by "taking the initiative in having canvases photographed," said Matisse. "This had considerable importance because without it others surely would have 'finished' all the Cézannes, as they used to add trees to all the Corots."[41] Conversely, we sometimes see the unauthorized removal of an element entirely. A Vollard photo of a Renoir drawing of two figures permitted an expert judgment to be made about a sheet, recently on sale, that today shows only one figure: the second figure was actually erased, most likely because it was deemed too sketchy and therefore liable to lower the work's value according to the criteria of the time.[42] The Vollard photographs also reveal how compositions have been reframed or even cropped after the fact: we can see that a Cézanne composition, for example, was cut in half to make two separate paintings, *Flowers in a Blue Vase* and *Flowers and*

Fruits, both today housed in the Walter-Guillaume collection at the Musée National de l'Orangerie, Paris.[43]

Another photograph, reproducing a painting of a still life with an idol that repeats the central portion of *Still Life with Profile of Laval,* which Gauguin painted in 1886 (figs. 273, 274), presents several problems.[44] Is the painting a copy or a forgery? The idol that replaces Laval's profile seems to have been made by quite a different hand from Gauguin's. Its presence in the window frame is artificial and makes no sense, unlike the inclusion of Charles Laval, who was with Gauguin in Martinique. The existence of this photo among Vollard's papers raises the question of authenticity among the works inventoried in the dealer's archives.

Alongside these images of artworks, the Vollard archive contains unpublished photographs of artists (fig. 271), portraits of the dealer himself, views of installations for various exhibitions and rooms in the Musée Léon Dierx in Saint-Denis (Réunion island), as well as odds and ends—such as an African mask, probably from Vollard's collection, that Picasso must have seen. Among the photographs relating to Cézanne we can cite several portraits of the artist, including a very famous one in front of the artist's *Large Bathers;* photos of his correspondence; and installation views of a show of his works at the 1904 Salon d'Automne. "My father is delighted with the success he had at the Salon d'Automne and he would like to thank you very warmly for all your efforts on behalf of his exhibition," Cézanne's son wrote to Vollard. "He will be very pleased to receive the four walls of the room that were devoted to him."[45] These views reveal a practice that we would never see today: hanging among the paintings are framed photographs of the canvases missing from the exhibition (fig. 275).

All of these fascinating documents, which until now have been hard to consult because of their fragile state and differing supports, will be made available as digital images with captions

and as an online database providing financial information from the Vollard archives. These key pieces in the puzzle of Vollard's archives are essential links in reconstituting the network by which the artistic avant-garde spread in the late nineteenth and early twentieth centuries—a network that the dealer did much to help create.

1. Missing are the stockbooks from before 1899 (if there were any) and those from 1907 to 1918 and 1922 to 1939. The collection of datebooks stretches from 1906 to 1932, with gaps between 1914 and 1921; also missing are the datebook for 1926 and those for the years 1928 to 1931, as well as those after 1932. The account books and registers are also sporadic. Generally speaking, almost all the financial records between 1906 and 1920 have vanished. There is also an inventory covering the years 1922 to 1938, known only through photocopies.

2. Vollard Archives, MS 421 (13).

3. The sale of the mansion at auction was held on June 30, 1956, with an adjudged value of 20 million francs. The Swiss legation, which had offered 28 million in February, became its owner. Vollard Archives, MS 421 (3,1).

4. Letter from Richard Aman (of the Swiss legation) to Édouard Jonas, April 16, 1956: Vollard Archives, MS 421 (13), fol. 330.

5. His name appears in Vollard's address book: Vollard Archives, MS 421 (4,11), Delétang, 12, rue de l'Université (fol. 40), and Delétang, 157, rue de Grenelle (fol. 41).

6. "Received from Monsieur A. Vollard, the sum of 100 francs as an advance against photographs to be taken of paintings": Vollard Archives, MS 421 (3,1), fol. 305.

7. Vollard Archives, MS 421 (4,10), pp. 9, 10.

8. Vollard advanced him 300 francs toward this purchase on November 8, 1904: Vollard Archives, MS 421 (4,10), p. 33.

9. Stockbook B, nos. 4481–4552.

10. On May 23, 1907, Vollard brought him the works to be photographed; on the 25th, he paid him 48 francs. On August 6, he paid him 52 francs for the album. Vollard Archives, MS 421 (5,2), fols. 91, 93, 136.

11. Vollard Archives, MS 421 (5,3), fol. 197.

12. Vollard Archives, MS 421 (5,3), fol. 174, October 27, 1908.

13. Datebooks for years cited: Vollard Archives, MS 421 (5,8), (5,9). On October 2, 1913, he photographed twenty-three canvases by Renior: Vollard Archives, MS 421 (5,9), fol. 152.

14. The bronze-green binding is identical to that used on the albums created by Bignou, who also owned albums with tan spines; the support for Bignou's photographs is dark gray, while Vollard's is cream white. The Bignou photographs are glossy prints made from glass plates; the ones in the Vollard archives are matte. Each bears a number that does not indicate the album order but rather seems to correspond to a stock number.

15. In 1935 he sent the Dudensing Gallery in New York photos of five pastels by Degas. On the back was "the height and width of the pastels, as well as the objects' indicative letters. As I believe this might interest you, I am sending you in Le Touquet a copy of the photographs with the indications on the back." Vollard to Dudensing, October 4, 1935: Vollard Archives, MS 421 (3,1), fol. 185. On December 17, 1938, Vollard sent M. Lo Duca nineteen photographs by Cézanne identified by numbers; fifteen were returned to him on February 27 and three on March 3, 1939. Vollard Archives, MS 421 (3,1), fol. 71.

16. Bataille and Wildenstein 1961, 815 entries.

17. Receipt on letterhead for "Les Beaux-Arts. Édition d'études & de documents," March 26, 1931: Vollard Archives, MS 421 (3,1), fol. 246.

18. Paul Cézanne *fils* to Vollard, April 20, 1905: Vollard Archives, MS 421 (2,4), p. 36.

19. Paul Cézanne *fils* to Vollard, November 11, 1904: Vollard Archives, MS 421 (2,2), p. 63.

20. See Rewald 1983 and Rewald 1996.

21. Vollard 1918.

22. Letter of March 3, 1918, in ibid., p. vii.

23. "I couldn't possibly assign dates to sketches made between sessions in search of a certain quality of line." Renoir to Vollard in Vollard 1989a, unpaged.

24. See "Album Vollard" 1914. For further discussion of this album, see the essay "Vollard and Degas" by Gary Tinterow in this volume.

25. Ten invoices from Gautier generated between December 29, 1917, and March 28, 1918, were included with the statement by Degas's heirs concerning the artist's estate. A series of these photos can also be found in the Archives Durand-Ruel, Paris, and in the (incomplete) Fèvre-Degas papers housed in the Bibliothèque et Archives des Musées Nationaux, Paris.

26. Committee meeting of October 6, 1988, and board meeting of October 12, 1988.

27. Writings by Vollard (MS 421 [1]); correspondence (MS 421 [2]); gallery archives (MS 421 [3]); registers and stockbooks (MS 421 [4]); datebooks (MS 421 [5]); papers relating to Éditions Vollard (MS 421 [6 to 9]); personal papers (MS 421 [10]); personal business papers: real-estate holdings (MS 421 [11]); personal business papers: bank transactions (MS 421 [12]); and the Ambroise Vollard estate (MS 421 [13]).

28. Draft signed by Vollard, March 2, 1891: Vollard Archives, MS 421 (3,3), fol. 131.

29. Certificate from the Lycée de Saint-Denis, 1885: Vollard Archives, MS 421 (10,1), fol. 3.

30. Vollard Archives, MS 421 (13), fols. 3–4.

31. Vollard Archives, MS 421 (4,3)–(4,10).

32. The other two, one covering the period from 1899 to 1904 and the other from 1918 to 1922, exist as photocopies in the John Rewald Papers, Gallery Archives, National Gallery of Art, Washington, D.C., and at the Research Library, The Getty Research Institute, Los Angeles.

33. My thanks to France Daguet for her information about Vollard's registers and financial records.

34. Vollard's address book: Vollard Archives, MS 421 (4,11).

35. Synopsis of his book about Degas (notes taken at the Hôtel Métropole, Brussels: Vollard Archives, MS 421 [9,6], fols. 13–14) and about Renoir (MS 421 [9,16], fols. 17–19; "running heads for *En Écoutant Degas*" (MS 421 [9,6], fols. 16–17); printer's proofs and unpublished manuscripts, including several of Ubu: "Le Père Ubu chirurgien" (Père Ubu the Surgeon) (MS 421 [1,1], fols. 1–8 and 9–16, "Suite à Ubu médecin" (Sequel to Ubu the Doctor) (MS 421 [1,2], fols. 1–2), and "Le Père Ubu vivisecteur" (Père Ubu Vivisectionist) (MS 421 [1,7], fols. 1–31).

36. The two catalogues from 1918 were reissued as a single volume under the title *Pierre-Auguste Renoir: Paintings, Pastels and Drawings/Tableaux, pastels et dessins;* see Vollard 1989a.

37. The total number including all glass plates and prints is 4,742 photographs (many of the images exist in several copies).

38. Cézanne (1,643 photos); Degas (935, including 1 certified photo); Mary Cassatt (309); Gauguin (136); Picasso (133); Redon (122); Forain (111).

39. Jeanne Baraduc, Émile Bernard, Bonnard, Boudin, Corot, Courbet, Charles-François Daubigny, Daumier, Dedreux, de Groux, Maurice Denis, Derain, Dufresne, Fantin-Latour, Géricault, Guillaumin, Legros, Guigou, Guys, Henner, Blanche Hoschedé-Monet, Iturrino, Laprade, Maillol, Manet, Matisse, Monet, Monticelli, Morisot, Pissarro, Puy, Raffaëlli, Rouault, Douanier Rousseau, Ker-Xavier Roussel, Sisley, Toulouse-Lautrec, Utrillo, Valtat, Van Gogh, Van Dongen, Vlaminck, Vuillard, Willette, and Ziem.

40. In June 1992, April 1998, September 1999, and March 2001, to cite only a few of the auctions; the latter three were handled by the Maison Charavay, Paris.

41. Henri Matisse, interview with Jacques Guenne, quoted in Flam 1995, p. 82.

42. I would like to thank Pascal Perrin, a member of the team currently preparing the Renoir catalogue raisonné at the Wildenstein Institute, for having pointed this out to me.

43. Hoog 1992, pp. 63–65.

44. A copy of the photograph can be found in the Archives Durand-Ruel and in the Fonds Vizzavona-Druet, no. 3908, in the Photographic Agency of the Réunion des Musées Nationaux in Paris. A Vizzavona-Druet photograph, no. 2964, shows the *Still Life with Profile of Laval.* Both of them are reproduced in Rewald 1938, nos. 98, 99.

45. Paul Cézanne *fils* to Vollard, November 11, 1904: Vollard Archives, MS 421 (2,2), p. 63.

Vollard's Accounts

Jonathan Pascoe Pratt

The following summary of the early accounts of Ambroise Vollard, covering the years 1894 to 1900, describes the content of some of the dealer's records and offers a reading that challenges previous interpretations.[1] The Registre des ventes (sales book)[2] recorded Vollard's sales; the Registre de caisse (account book)[3] recorded purchases, costs, and sales; and the Mouvements de tableaux (book of gallery activities)[4] recorded revenue from picture dealing. The Registre des entrées et sorties acted as a stockbook from 1899 to 1904 (Stockbook A). The first three registers mentioned above are in the Bibliothèque et Archives des Musées Nationaux, Paris, and Stockbook A is in the Wildenstein Institute, Paris. Because of the different functions of the registers, different information is contained in each. In general, the Ventes recorded the buyer and some information about the work; the Caisse usually recorded only the name of the buyer or the seller and the amount. When these two registers are read together they provide critical information about Vollard's business practice. However, when entries are taken out of context, they are misleading and give rise to the impression, as John Rewald remarked, that "the manner in which Vollard kept his ledgers is both mysterious and frustrating."[5]

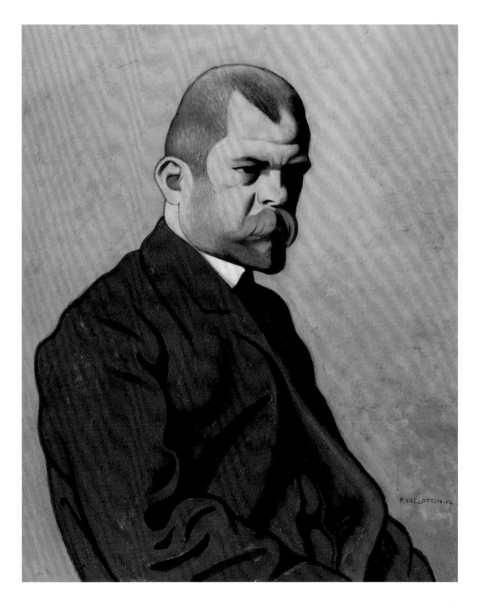

Fig. 276 (cat. 189). Félix Vallotton, *Ambroise Vollard,* 1902. Oil on panel, 31 x 24¾ in. (78.8 x 63 cm). Museum Boijmans Van Beuningen, Rotterdam (2390 [MK])

Fig. 277. Cover and pages from Vollard's account book for July 1920–September 1921. Vollard Archives, Musée d'Orsay, Paris, MS 421 (4,6)

REGISTRE DES VENTES (SALES BOOK)

The function of this register was to record sales on the date that they were agreed. The first entry in this notebook was on June 20, 1894, beginning at page 1, and the last entry was dated November 3, 1897, ending on page 42. The transactions were listed in chronological order, recording the name of the purchaser (some with addresses), the artist, the medium, occasionally the title of the work, and the price paid. Sales and exchanges (but not purchases) were listed.

The date recorded was the day that an agreement on the sale was reached. The payment date depended on the buyer; dealers appeared to make fairly regular payments over an extended period, suggesting installment payments. Although the majority of the sales recorded in the Ventes have corresponding entries in the Caisse, this is not always the case. Some payments were made in goods and were therefore not appropriate for the Caisse. On rare occasions a sale appears not to have been paid for and therefore is not recorded in the Caisse. The Registre des ventes lapsed in 1897.

REGISTRE DE CAISSE (ACCOUNT BOOK)

The first entry in this register was also made on June 20, 1894, beginning at page 1, and the last was made in June 1900, at page 163. As with the Registre des ventes, the Caisse follows a chronological sequence. It recorded both purchases and sales, probably at the time the payments were made and received, and it recorded cash sales paid for at the time of the transac-

tion and therefore not recorded in the Ventes. Purchases paid for in installments are listed as each payment was made. This register lapsed in 1900.

STOCK REFERENCES IN THE REGISTRE DES VENTES AND THE REGISTRE DE CAISSE

In both the Ventes and the Caisse, Vollard employed two systems of stock references. There are numbers listed after some of the works that refer to a stock list. In addition there are other "shorthand" references listed after the work that link one transaction to another recorded elsewhere in the registers.

What appear to be numerical stock references were first recorded in the Ventes on July 6, 1894. Félix Buhot exchanged five of his own works for a drawing by Camille Roqueplan. The five Buhot works were given the numbers 50–54. If these are indeed stock references, the low numbers indicate that this system had only recently started, most probably at the same time as the other registers (June 20, 1894). The next numerical reference was not until June 1895:[6] this was number 239 and suggests that Vollard had bought 239 works during his first year of trade. These types of numbers do not appear again in the Ventes until March 29, 1896, when they are used for a short period, finishing on May 18, 1896. After this date they do not appear on any transaction in the Registre des Ventes.

At the same time, stock numbers were recorded in the Caisse. For example, numbers 299 and 300 were allocated to

two drawings by Constantin Guys purchased from Charly (possibly an auctioneer or dealer) on July 10, 1895, followed by the number 301, assigned to a Stanislas Lépine painting, *Moulin à St. Ouen*, purchased from Madame Lépine on July 12, 1895, and number 302, given to another Lépine bought on July 17, 1895. This appears to be the allocation of consecutive numbers to stock as it was purchased. Whether these numbers were recorded elsewhere in a stockbook or listed in a register is not known, but they do suggest the existence of a stock list of some kind. It is important to note that the references are not recorded consistently in either the Ventes or the Caisse; indeed, the majority of transactions are listed without references.

A second form of stock identification was also employed in both the Ventes and the Caisse. This cross-referencing system used the provenance of the work as the form of identification in combination with the location of the entry in the register. For example, on April 13, 1895, Vollard sold a pastel by Henri De Groux to Monsieur Mondain of Angers; the entry in the Ventes was marked "(folio 1) gr. 1," referring to the Registre des ventes, page 1. The same day another reference was noted in the Ventes: "(folio 19)c," which refers to the Registre de caisse, page 19. Subsequently, the references were shortened to the name of the vendor, register, and page number.[7] This was further shortened to the name of the vendor, the initial of the register (*V* or *C* for Ventes or Caisse), and the page number.

The *V* and *C* references continue until the end of the Caisse, each reference corresponding to the appropriate page in the register. There are no gaps; each reference matches the entry; there are no references to pages that are not present (page 42 is the last page in the Registre des ventes); and there are no references to any later pages. This suggests that Vollard did not continue to keep a Registre des ventes after the first one lapsed in 1897.

MOUVEMENTS DE TABLEAUX (BOOK OF GALLERY ACTIVITIES)

This notebook contains monthly listings of Vollard's sales with the buyer's name and a figure, occasionally giving a general title of the work. Rewald's appraisal of the register was that it "lists transactions by month, usually giving merely the name of the purchaser with the name of the artist whose work was sold, followed by the price paid."[8] However, research shows that the figure listed in the Mouvements was the profit, not the price. For example, in July 1896 the Mouvements records 300 francs from Gustave Pellet for Félicien Rops's *Aphrodite:*

- The purchase price listed in the Caisse (June 15, 1896) was 100 francs.
- The sale price listed in the Caisse (June 30, 1896) was 400 francs.

The figure recorded in the Mouvements was the profit on the transaction and not the sale price.

Again, in the same month the Mouvements records the sum of 13 francs in relation to a payment from a Madame Stern for Eugène Carrière's portrait of Verlaine:

- The purchase price listed in the Caisse (July 3, 1896) was 27 francs.
- The sale price listed in the Caisse (July 7, 1896) was 40 francs.

In April 1897 the Mouvements records 38 francs in relation to a payment from Georges Viau for Maurice Denis's painting *Mère au coussin rouge:*

- The sale price listed in the Caisse (April 17, 1897) was 250 francs.
- The purchase price from the artist listed in the Caisse (May 1, 1897) was 212.50 francs.

In March 1896 the Mouvements records 310 francs in relation to a payment from Denys Cochin for Van Gogh's *Arles camp:*

- The purchase price listed in the Caisse (January 22, 1896) was 61 francs from Joseph Ginoux.
- The commission paid to Henri Laget listed in the Caisse (January 22, 1896) was 10 francs.

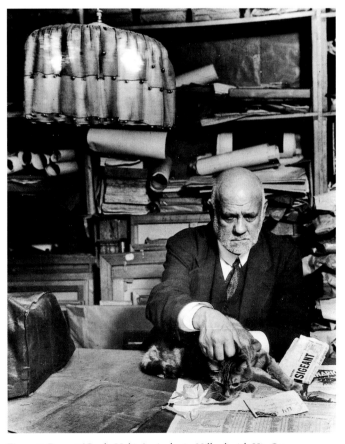

Fig. 278. Brassaï (Gyula Halász), *Ambroise Vollard with His Cat*, 1934. Private collection

- The sale price listed in the Caisse (March 20, 1896) was 400 francs.

In this example a commission has been paid to an agent. There is a discrepancy of 19 francs, suggesting a "rounding" of figures. The following example also includes a commission, but one that is retained by Vollard. In March 1896 the Mouvements records 120 francs in relation to a payment from Esther Sutro for Van Gogh's *Cabaret*:

- The purchase price listed in the Caisse (March 25, 1896) was 180 francs.
- The sale price listed in the Caisse (March 25, 1896) was 300 francs.

In this last example the commission charged by Vollard for the sale of the work is included in his profit figure. However, if the commission was paid to an agent, then it would be excluded, as in the case of Laget and the Van Gogh described above.

REGISTRE DES ENTRÉES ET SORTIES (STOCKBOOK A)

This book serves more as a record of the stock available in Vollard's gallery in 1899 than as a functioning stockbook. It comprises 821 undated entries (numbers 3301–4122) followed by 16 dated entries. The undated entries are purchases that Vollard had made over the previous years. They are entered into the stockbook in a random order: for example, the purchases that Vollard made at the Victor Chocquet sale in mid-1899 are listed individually on pages 1, 2, 4, 5, 9, and 27; his purchase from the Armand Doria sale (two months before that of Chocquet) can be found on page 36. From stock number 4157 on, the ledger was used to list artists' works (the majority being works by Cézanne) without date, provenance, price of acquisition or sale information. The widely varying handwriting and numerous spelling mistakes found in this book suggest that at least two different people made the entries, possibly Vollard and an assistant.

It is significant that while the stockbook was in use, stock numbers began to appear in the Caisse. On December 9, 1899, for example, Vollard bought a work by Pierre Puvis de Chavannes from Alphonse Tavernier, which was allocated number 4123 in the stockbook; this transaction was recorded in the Caisse with the stock number. In the stockbook the entry for the purchase of the Puvis de Chavannes was followed by one for the sale of a Renoir to Prince Georges de Bibesco, number 3551, which was also recorded in the Caisse. These numbers appeared for merely a short time in the Caisse, possibly only as long as Vollard maintained the stockbook.

CONCLUSIONS DRAWN FROM THE REGISTERS

The figures recorded in all four registers appear to be accurate, they correspond with each other, and they can be corroborated by independent documentation. The degree of accuracy is sufficient to make quantitative judgments and draw reliable conclusions from the information recorded. Conversely, it is not possible to make assumptions regarding the "omitted" information until all the accounts are available. Given that these accounts were not available for public inspection, and indeed were only for private use, any notion of "camouflaging" transactions by omission needs to be questioned.[9]

The four account books work together. While there are gaps, they are remarkably few considering Vollard's haphazard approach. The stock numbers are more likely to refer to stock lists than to a missing stockbook, as it is probable that Vollard used a series of consignment lists to identify his stock during this early period (what is missing from the archives are some of these consignment lists). As the demands of Vollard's enterprise changed, so did the information he required from his accounts. These registers allow us to examine the origins of his business at this critical moment in the history of art.

1. This summary forms part of an analysis of the accounts of Ambroise Vollard included in my Ph.D. thesis, submitted to the Courtauld Institute of Art, London, in May 2006.
2. Vollard Archives, MS 421 (4,2).
3. Vollard Archives, MS 421 (4,3).
4. Vollard Archives, MS 421 (4,4).
5. Rewald 1989, p. 44.
6. June 20, 1895, sale to Monsieur Anquetin, "1 tête de femme, anciennement en communication sous le no. 239": Vollard Archives, MS 421 (4,2), fol. 14.
7. April 29, 1895, sale to Monsieur Humbert, "1 toile de Renoir (Desmaziers c fo. 14)": Vollard Archives, MS 421 (4,2), fol. 12.
8. Rewald 1989, p. 44.
9. When Vollard wanted to maintain the anonymity of a client, the amount was entered into the accounts but identified only with an X.

Life and Exhibitions

Selected Chronology

Rebecca A. Rabinow and Jayne Warman

This abridged chronology is intended to provide an overview of Vollard's activities as a dealer and publisher, based largely on information gleaned from his archives. It is by no means complete and should be used in conjunction with the essays, entries, and list of exhibitions in this catalogue.

July 3, 1866 Henri-Louis-Ambroise Vollard born in Saint-Denis on the island of Réunion to Alexandre Ambroise Vollard, a notary, and Marie-Louise-Antonine Lapierre; he will be the eldest of ten children.[1]

October 1881–August 24, 1885 Attends Lycée de Saint-Denis de la Réunion, from which he graduates as a "bachelier ès lettres" (fig. 280).[2]

November 25, 1885 Residing at 28, rue Jean Jacques Rousseau in Montpellier, registers for the 1885–86 academic year at the Faculté de Droit, Montpellier. Remains at the law school through July 1887.[3]

Fall 1887–May 1892 Is enrolled at the Faculté de Droit, Paris, where, on December 28, 1888, he receives his "Diplôme de Licence en Droit," the first of a series of diplomas necessary to obtain a law degree. Receives a monthly stipend from his father. Never completes course work and begins to deal in prints.[4]

Ca. 1891 Sells academic paintings at Alphonse Dumas's gallery, L'Union Artistique, 36, boulevard Haussmann.

Ca. 1892 Occupies a seventh floor ("sixième étage") apartment at 15, rue des Apennins. While there, exhibits work by Armand Guillaumin.[5] Purchases from this period include Auguste Renoir, *Nude* (fig. 160), and possibly Gustave Caillebotte's *Plate of Peaches* (1882, private collection; B 239). Pays 89.35 francs for three months' rent (until July 8, 1893).[6]

Mid-September 1893–April 1, 1895 Rents a small two-room gallery at 37, rue Laffitte.[7]

January 1894 Displays works by Paul Gauguin, Henry De Groux, Guillaumin, Jean-François Raffaëlli, Odilon Redon, and Alfred Sisley at 37, rue Laffitte. Camille Pissarro reports that "a young man I knew through [the French artist] John Lewis Brown, and who was warmly recommended to me by M. Viau, has opened a small gallery in the rue Laffitte. He shows nothing but pictures of the young. . . . I believe this little dealer is the one we have been seeking, he likes only our school of painting or works by artists whose talents have developed along similar lines. He is very enthusiastic and knows his job. He is already beginning to attract the attention of certain collectors who like to poke about."[8]

February 21, 1894 Purchases drawings and oil sketches from Édouard Manet's widow, Suzanne, for 470 francs. Additional purchases and payments to her are recorded on March 18 (320 francs), June 25 (500 francs), and July 16 (375 francs).[9]

February 27, 1894 On Edgar Degas's recommendation, begins to use Charles Chapuis for relining and stretching canvases. The Vollard Archives contain canceled checks from this date to October 1899 as well as detailed receipts for works sent to Chapuis from 1904 to 1932. A number of works are relined "à l'italienne" (using a cold adhesive, possibly paste), "à la gaze" (using gauze as a lining fabric), and "préparés contre l'humidité" (possibly adding some sort of moisture barrier).[10]

June 1894 Records sales totaling 3,302 francs of art to Eugène Blot, Cahen, Ferdinand Dufau, G. Humbert, Mondain, Muhlfeld, Félix Roux, and Georges Viau.[12]

June 2, 1894 Buys nine works at the Julien (Père) Tanguy sale, Hôtel Drouot. Ten days later, in a letter lamenting the low prices, Mme Veuve Tanguy remarks that Vollard purchased all the Cézannes. In reality Vollard spends a total of 845 francs on four Cézannes, as well as one work each by Gauguin, Vincent van Gogh (fig. 232), Guillaumin, Pyotr Korochonsky, and Pissarro.[11]

September 18, 1894 Count Isaac de Camondo makes his first recorded purchase from Vollard, a drawing by Suzanne Valadon ("femme se déshabillant") for 40 francs. In March 1895 he buys a Degas pastel, *Woman Washing in Her Bath* (ca. 1892, Musée d'Orsay, Paris; L 1121) for 1,100 francs.[13]

October 1894 On October 15, 1894, Renoir acquires by exchange two watercolors by Édouard Manet, "Port de Bordeaux" (200 francs)

279. Eugène Murer, Poster for the Murer exhibition at the Galerie Vollard, 1898. Color lithograph, 32⅜ x 24 in. (82.2 x 61 cm). Herbert F. Johnson Museum of Art, Cornell University, Ithaca, New York (77.042.001)

280. Vollard's certificate of study from the Lycée de Saint-Denis, La Réunion, October 19, 1885. Vollard Archives, MS 421 (10,1), fol. 3

281. Édouard Manet, *The Funeral*, ca. 1867. Oil on canvas, 28⅝ x 35⅝ in. (72.7 x 90.5 cm). The Metropolitan Museum of Art, New York, Catharine Lorillard Wolfe Collection, Wolfe Fund, 1909 (10.36)

and "Petits Bateaux" (150 francs), and Degas trades one of his pastels valued at 500 francs for Manet's *Woman with a Cat (Madame Manet)* (ca. 1880, Tate, London; RW 337).[14] On October 29, trades the center fragment of Manet's *Execution of Maximilian* (ca. 1867–68, National Gallery, London; fig. 167) to Degas for 2,000 francs worth of artwork.[15]

November 17–December 20, 1894 Hosts "Dessins & croquis de Manet, provenant de son atelier." Purchases are made by Manet's former model, Méry Laurent, who buys five drawings in three transactions. On November 21 Pissarro trades his own "effet de neige, toile de 15" and possibly other works for Manet's unfinished canvas, *The Funeral* (fig. 281).[17] A month later, on December 24, Degas pays 150 francs for a Manet sketch (tentatively identified as *Bazaine before the War Council* [1873, Museum Boijmans Van Beuningen, Rotterdam]) and a piece of furniture.[18] Other buyers include Blot, Léon Bouillon, Charles Loeser, Mme Ménard-Dorian, Claude Monet, and Berthe Morisot.[19] Shortly after the exhibition closes, Vollard makes three payments to Suzanne Manet: November 24 (340 francs), December 31 (200 francs), and January 30, 1895 (590 francs).[20]

1895 Exhibits works by Van Gogh (June 4–30), Charles Maurin (September 16–October 31), Paul Cézanne (November–December).

January 23, 1895 Returns Henri Rousseau's paintings to the artist because of lackluster sales.[21]

February 1895 Pays Gauguin for his own paintings, as well as canvases by Van Gogh and Guillaumin.[22]

March 1895 Displays Manet's *Copy after Delacroix's "Barque of Dante"* (ca. 1859, Metropolitan Museum; RW 3), which Durand-Ruel purchases on August 24 for 400 francs, as well as works by Van Gogh and a group of Gauguin's Breton landscapes and pottery.[23]

March 24, 1895 In his first recorded transaction with Vollard, Eugène Donop de Monchy sells several works he inherited from his father-in-law, Dr. Georges de Bellio. On October 11 he trades a Monet (*The Garden, Hollyhocks*, 1876, private collection; W-1996 412) and a Gauguin (*Flower and Carpet (Pansies)*,

1880, private collection; W-2001 61)[24] for a Pissarro painting. The following day, he exchanges Gauguin's *Martinique Scene with Mango Tree* (1887, private collection; W-2001 244) for a panel by Ernest Quost, as well as Guillaumin's "pot de coquelicots" for Stanislas Lépine's "bord d'eau," both valued at 150 francs. Five months later, Vollard trades the Gauguin (valued at 700 francs) to Mondain.[25]

April 1895–June 1897 Leases space at 39, rue Laffitte.

April 13, 1895 Degas pays 200 francs for an album of drawings by Eugène Delacroix that Vollard had bought at the Hôtel Drouot three days earlier for 105 francs.[26] On July 16 Degas exchanges one small pastel and four monotypes of brothel scenes (a total value of 3,500 francs) for Manet's *Monsieur Armand Brun* (1880, National Museum of Western Art, Tokyo; RW 326).[27]

June 4–30, 1895 An exhibition of works by Van Gogh inaugurates Vollard's gallery at 39, rue Laffitte.

July 6, 1895 Sells thirty-four works: German art historian and collector Julius Meier-Graefe spends 1,100 francs on one panel each by Maximilien Luce and Pissarro and eighteen works on paper by Couturier, Auguste Delâtre, Jean-Louis Forain, Gauguin, Guillaumin, Henri de Toulouse-Lautrec, Manet, Monet, Renoir, Théodule Ribot, and Félicien Rops; Maurice Clouet spends 130 francs on two landscapes; and August Franzen spends 700 francs for nine works on paper plus a Manet sketch, and one painting each by Maxime Maufra and Renoir.[28]

October 1895 The former king of Serbia and present count of Takovo, Milan Obrenović, purchases two paintings from Vollard's Maurin exhibition: "femme à sa toilette" on October 10 for 210 francs and "femme couchée de dos" on October 16 for 350 francs. From October through December, he purchases about fifty works by various artists, totaling approximately 8,500 francs.[29]

October 17, 1895–December 2, 1897 Records a number of purchases of Van Gogh canvases from Joseph Ginoux, proprietor of the Café de la Gare in Arles. Corresponds with Henri Laget, who becomes the intermediary between Vollard and Ginoux.[30]

October 19, 1895 Georges Chaudet, a young artist-photographer, trades twenty pastels, drawings, and woodcuts by Gauguin (valued from 5 to 25 francs each) for two drawings by Manet and four sketches by Honoré Daumier. Vollard trades four of the Gauguin pastels (valued at 200 to 300 francs each) to the count of Takovo on November 19.[31]

October 22, 1895 Buys two paintings, five pastels, and five pages of drawings from Renoir for 600 francs. Five days later, buys eight more paintings for 800 francs.[32]

November–December 1895 Hosts Cézanne's first solo exhibition. According to Vollard, about 150 works are shown; reviews mention half that number. The discrepancy may be explained by the small size of the gallery; as works are sold, replacements are hung. Vollard displays *Bathers at Rest* from the state-rejected Caillebotte Bequest (1875–76, Barnes Foundation, Merion, Pennsylvania; R 261) in the window, prompting much comment. Among the artists who purchase works from the exhibition are Degas, Maufra, Monet, Pissarro, and Renoir. Other buyers include Blot, Isaac de Camondo, Maurice Clouet, Georges Charpentier, Egisto Fabbri, Maurice Fabre, Gustave Geffroy, Ludovic Halévy, Julie Manet, Auguste Pellerin, Charles Sumner, the count of Takovo, and Dr. Georges Viau. Cézanne does not attend the exhibition.

1896 Holds three exhibitions: "Les Peintres-Graveurs" (June 15–July 20), Paul Gauguin (November), Vincent van Gogh (December–early 1897).

January 11, 1896 Egisto Fabbri, an American living in Florence, buys three paintings by Cézanne, including *Boy in a Red Waistcoat* (fig. 29). His name appears often in Vollard's records for numerous purchases and trades, especially for works by Cézanne, of which he eventually owns about thirty.[33]

April 26, 1896 In a letter to his son Lucien, Pissarro mentions that "Vollard spoke to me about exhibiting color prints. . . . Vollard, of this you can be sure, doesn't bother with anything he can't sell; reputation! The rest means nothing to him!"[34]

Ca. spring 1896 Travels to Aix-en-Provence to meet Cézanne for the first time. While there, buys paintings from various local residents.[35]

May 26, 1896 Pays an advance of 1,500 francs for the gallery at 6, rue Laffitte. The space includes a mezzanine level and the famous cellar (*cave*), where Vollard entertains often. He notes a 400-franc purchase of "rum for the artists" in September 1897, just one of several such entries. Guillaume Apollinaire publishes an article in 1913 about the *cave*: "the humid, windowless basement where Vollard hosts meals for *tout Paris*."[36]

June 1896 Pays a six-month advance for space at 2, rue Laffitte. Seems to maintain the lease for at least a year, but he leases space at that address as late as January 1918.[37]

June 15–July 20, 1896 "Les Peintres-Graveurs" inaugurates Vollard's gallery at 6, rue Laffitte. Pierre Bonnard designs a color poster to advertise the exhibition (fig. 199), which celebrates the creation of a print album, published in an edition of 100 and priced at 150 francs. Pissarro writes that the "exhibition is a great success."[38]

Summer 1896 Increasingly interested in publishing prints, Vollard plans to purchase a lithograph press. Pissarro reports, "This blessed Vollard has grandiose ambitions; he wants to launch himself as a dealer in prints. All the dealers, Sagot, Dumont, etc., are waging a bitter war against him for he is upsetting their petty trade." "This Creole is amazing; he wheels from one thing to another with startling ease. Poor Vollard! I told him that he was venturing into a field that one has yet to understand thoroughly, that prints don't sell, the dealers don't know much about them and depend solely on tricks, like posters, color prints, etc."[39]

October 10, 1896 Sells an album of "Les Peintres-Graveurs," a drawing by Degas, and a painting by Gauguin ("femme accroupie") to the composer Ernest Chausson for a total of 950 francs.[40] Chausson first appears in the Vollard Archives in January 1896, when he purchases two studies by Renoir for a total of 200 francs, followed by a De Groux in April for 150 francs.[41]

November 15, 1896 Renoir exchanges a "grand tableau ancien (Idylle)" (probably *Lovers*, 1875, Národní Galerie, Prague; D 127) valued at an exorbitant 2,000 francs for Cézanne's "rochers rouges, collines lilas" (possibly *Mont Sainte-Victoire*, Berggruen Collection, Berlin; R 631) of the same value.[42]

November 16, 1896 Russian collector Ivan Shchukin buys two works by Degas for a total of 2,500 francs; in June 1897 he pays the enormous price of 2,000 francs for a single pastel by Manet. On August 29, 1897 he buys Cézanne's *Still Life with*

Kettle (ca. 1869, Musée d'Orsay; R 137) for 1,000 francs; he keeps the painting for only three years. Ivan stops acquiring modern art in the early 1900s, but his older brothers, Pyotr and particularly Sergei, buy works from Vollard beginning in April 1899.[43]

1897 Exhibits works by Guillaumin (February 16–March 15); students of the Académie Julian (March 15–31); Bonnard, Maurice Denis, Henri-Gabriel Ibels, Georges Lacombe, Paul Ranson, Georges Rasetti, Ker-Xavier Roussel, Paul Sérusier, Félix Vallotton, Édouard Vuillard (April 6–30); Theodore Butler (November 8–20); "Les Peintres-Graveurs" (December 2–23).

January 25, 1897 American expatriate Charles Loeser exchanges a Toulouse-Lautrec ("femme à sa toilette"), valued at 500 francs, plus cash, for four Cézanne oils valued at 1,900 francs (one of which he returns two days later).[44] Loeser eventually acquires fifteen Cézannes from Vollard.

March 1897 In the first issue of *L'Estampe et l'affiche*, André Mellerio singles out Vollard as an example of a paintings dealer who "nonetheless has given an important place to the flimsy piece of paper that is a print. . . . [He is] currently preparing an ambitious attempt at color lithography." This spring, publishes his second album of prints by various artists, *Album d'estampes originales de la Galerie Vollard* (fig. 201).

March 15–31, 1897 Rents out his gallery for 200 francs for the annual exhibition of the students of the Académie Julian.[45]

April 6, 1897 On the opening day of Vollard's group exhibition known as "Les Dix," Blot purchases Vuillard's painting "La cuisine" for 200 francs and Ibels's watercolor "Paradise" for 150 francs.[46]

April 30, 1897 Sells Van Gogh's *Portrait of Dr. Gachet* (1890, private collection; F 753) to the Danish artist and collector Alice Ruben Faber for 200 francs. In May she makes payments of 150 and 800 francs for additional Van Gogh paintings, one of which is "dame jaune,"[47] probably *L'Arlésienne* (fig. 55).

August 1897 Johanna van Gogh-Bonger receives payment of 1,120 guilders (2,000 francs) for "3 triptychs 1 portrait[;] Dr Gachet and some [10] drawings"; there were probably only six paintings in all (F 397, F 527, F 753, and F 353, F 354 [fig. 57], and F 368 [fig. 58], the last three probably forming a triptych). In addition, there was a small canvas by Renoir (200 francs less a 10 percent commission) and a work by Pissarro (400 francs less a 10 percent commission).[48] Pays Johanna a commission of 2,340 francs on August 6. Between 1896 and 1899 Vollard sells approximately twenty-five works from Van Gogh-Bonger's collection, including one painting by Pissarro, one by Guillaumin, and two by Renoir.[49]

August–October 1897 The Dutch collector Cornelis Hoogendijk buys aggressively from Vollard. By December 1899 he will have spent at least 100,000 francs for works by Cézanne, Degas, Gauguin, Van Gogh, Monet, Renoir, Théophile Alexandre Steinlen, and others.[50]

November 9, 1897 Monet's son-in-law, the American artist Theodore Butler, pays 350 francs to rent Vollard's gallery for an exhibition of his own work.[51]

December 30, 1897 Count Harry Kessler, a German collector and editor of the art review *Pan*, buys Georges Seurat's *Models (Poseuses)* (1886–88; Barnes Foundation; fig. 241), for which he pays 1,200 francs on January 3, 1898.[52]

1898 Exhibits works by Charles Guéroult (mid-late January); Eugène Murer (February 20–March 10; see fig. 279); Bonnard, Denis, Ibels, Ranson, Roussel, Sérusier, Vallotton, Vuillard (March 27–April 20); Alfred Muller (ca. April); Cézanne (May 9–June 10); Redon (May 10–31); Gauguin (November 17–early January 1899).

Plans a third album of "Les Peintres-Graveurs." Auguste Clot prints some images, but the album is never published.[53] Vollard's print editions are discussed at length in André Mellerio's *La Lithographie originale en couleurs*, which is published this year.

May 16, 1898 Lends approximately fifty prints to an exhibition of international art, London, organized by the International Society of Sculptors, Painters and Gravers, of which James McNeill Whistler is president.[54]

November 17, 1898–early January 1899 Exhibits paintings by Gauguin that were recently completed as an ensemble and sent by the artist to Daniel de Monfreid to sell. The centerpiece is *Where Do We Come From? What Are We? Where Are We Going?* (fig. 13). Before the end of the year Vollard has purchased at least thirteen Gauguin paintings through Monfreid, four for a total of 600 francs (October 30) and nine more for a total of 1,000 francs (December 8).[55]

December 23, 1898 In response to Vollard's offer to purchase his Cézannes, Paul Signac refuses to sell his largest (*The Oise Valley*, ca. 1880, private collection; R 434) but does exchange a small still life for "a pretty little Renoir—a trifle, the head of a woman, in pink, blue, yellow, but completely Renoir and his charm—two watercolors by Jongkind, and a Seurat from the beginning of [Divisionism]."[56]

1899 Exhibits works by Paul Vogler (February 23–March 12); Bonnard, Denis, Redon, Toulouse-Lautrec, and Vuillard (March–early April); Charles Dulac (April 12–27); Isidre Nonell i Monturiol (April); André Sinet (April 28–May 6); Edvard Diriks (May); René Auguste Seyssaud (May 25–June 10); Cézanne (November). Vollard is amenable to renting out his gallery; both Vogler and Diriks seem to pay a few hundred francs for the privilege.[57]

Asks Cézanne to paint his portrait (fig. 4), one of the earliest of Vollard. The artist and critic J.-F. Schnerb sees the portrait in Vollard's gallery in October 1906 and describes it as "very complete, very solid. . . . What modern painting can be hung at its side?"[58]

January 7, 1899 Buys from Mme Bernard four Van Gogh oils ("Arlésienne," "Cueillette d'olives," "Buveurs d'après Daumier" [*The Drinkers*, 1890, Art Institute of Chicago; F 667], "Citrons et gants" [1889, formerly Mr. and Mrs. Paul Mellon, Upperville, Virginia; F 502]) and one drawing by Daumier for a total of 700 francs.[59]

March–early April 1899 Exhibits lithographs by Bonnard, Denis, Fantin-Latour, Redon, and Vuillard. Mellerio praises Vollard for producing albums of prints by individual artists "*Éditions Vollard*. It is a name about which the world of collectors is already enthusiastic and which will soon have . . . a broad and important influence."[60] Sergei Shchukin makes his first purchase from Vollard: two albums by Bonnard and Vuillard (for a total of 300 francs) on April 29.[61] On April 18 his brother Pyotr buys Denis's *Figures in a Spring Landscape (Sacred Grove)* (1897, State Hermitage Museum, St. Petersburg) for 3,500 francs.[62]

May 1, 1899 Pays Dulac 2,028 francs for works sold from his exhibition of the artist's paintings and lithographs.[63]

Buys Cézanne's "Lestac"[*sic*] from the Sisley sale for 2,415 francs. On the same day, buys six paintings by Cézanne.[64]

June 1899 Sells a number of works by Seyssaud from his exhibition: thirteen paintings to Mme Bénard for a total of 1,400 francs, three to Lacroix (350 francs), and one each to Cretérier [?] (200 francs), Gérard (200 francs), and Pontremoli (100 francs). Pays the artist 1,620 francs for works sold.[65]

June 5, 1899 Andries Bonger, Théo van Gogh's brother-in-law, buys four Cézannes, including *Cup, Glass, and Fruit II* (ca. 1877, private collection; R 320), *Flowers in an Olive Pot* (1880–82, Fondation Socindec, Vaduz; R 477), *Still Life with Apples and Pear* (1888–90, Suita Trading Company, Japan; R 638). The fourth work is no longer considered to be by Cézanne. Vollard's written guarantee of authenticity is still visible on the stretcher of R 638.[66]

July 3–4, 1899 In the company of Cézanne, previews the sale of Victor Choquet's collection. The artist is especially interested in a Delacroix floral watercolor (1849–50, Musée du Louvre, Paris), which the dealer buys and in January 1902 gives to the artist, who copies it in oil (1902–4, Pushkin State Museum of Fine Arts, Moscow; R 894). Vollard pays a total of 7,421.20 francs for his purchases, which include (among other works) four Cézannes.[67]

September 1, 1899 Spends 150 francs for travel expenses to "find Cézannes" in Aix. Acquires twelve Cézannes for 1,150 francs from the artist's uncle, Dominique Aubert. Also purchases sculpted wood frames.[68]

Late November 1899–December 1899 Sells paintings from his Cézanne exhibition to Bernheim-Jeune, Blot, Fabre, Fabbri, Georges Feydeau, Hoogendijk, Henri Matisse, Pellerin, and Viau. Cézanne apparently sees the exhibition and is surprised that Vollard has framed all the works.

November 26, 1899 Writes to Hugo von Tschudi, director of the Nationalgalerie, Berlin, offering to acquire the Cézanne landscape (*The Mill at La Couleuvre, Pointoise*, 1881, Nationalgalerie, Berlin; R 483) in the collection, "having heard that the museum was not satisfied with the picture." Tschudi denies the rumor and declares it "one of the master's most beautiful works."[69]

December 7, 1899 Matisse buys Cézanne's *Three Bathers* (fig. 147) on account.[70]

December 18, 1899 Maxime Conil, Cézanne's brother-in-law, sells two Cézanne paintings for a total of 600 francs to Vollard: *House and Pigeon Tower at Bellevue* (1890–92, Museum Folkwang, Essen; R 690) and *The Pigeon Tower at Bellevue* (1889–90, Cleveland Museum of Art; R 692).[71] Vollard informs Conil that he does not find the landscapes sufficiently polished and prefers still lifes and flower pieces.[72]

1900 Exhibits works by Ernest Chamaillard (December).

Denis completes his *Homage to Cézanne* (fig. 82), which shows a group of artists and friends in Vollard's gallery admiring a Cézanne still life previously owned by Gauguin (1879–80, Museum of Modern Art, New York; R 418).

Ca. March 1900 German painter Paula Modersohn-Becker is enthralled with the works of Cézanne when she visits Vollard's gallery with sculptor Clara Westhoff.[73]

March 1900 Enters into a contractual relationship with Gauguin.[74]

March 3, 1900 Pissarro writes Lucien that he has seen galleys for what will be Vollard's first published book, Paul Verlaine's *Parallèlement*, with illustrations by Bonnard (fig. 209): "Here they don't look at a book as a totality, even the young artists who try to do good work haven't learned this. Thus, yesterday Vollard showed me a galley for a volume of Verlaine with a sixteenth-seventeenth century type. It was illustrated by Bonnard (a young artist), the drawings are rendered very freely by the [lithographic] process. . . . To my objections Vollard replied: 'But this is seventeenth century typography! . . . I have seen one of W. Morris's books; it horrified me!!!'"[75]

April 14, 1900 German critic Emil Heilbut pays 6,000 francs for three Cézannes: *Landscape with Poplars* (ca. 1885–87, National Gallery, London; R 545), *Still Life with Apples and Pears* (1885–87, Metropolitan Museum; R 701), and a Harlequin (possibly R 621). On the same day the young Norwegian artist Alfred Hauge buys a painting by Henri Fantin-Latour for 1,200 francs.[76] Four days later Dr. Julius Elias, a German writer, pays 3,500 francs for a Pissarro oil that Vollard had bought from Cerfils for 600 francs.[77]

April 22, 1900 Pays the Imprimerie Nationale 796 francs to print the text of *Les Pastorales de Longus ou Daphnis et Chloé* (fig. 213). Printing of the illustrations by Bonnard is not complete until October 31, 1902.[78]

May 1, 1900 Sends Cézanne *fils* 3,000 francs, beginning a pattern of payments at the start of each month; bills the artist's son 84 francs for relining some canvases.[79] Also makes payments to Bonnard and Mme Renoir.[80]

May 16, 1900 Sells a Degas monotype for which he paid 350 francs[81] to Fabre for 600 francs.[82]

June 1, 1900 Sends a Pissarro painting on panel (*Ploughing, Bérelles*, ca. 1860, location unknown; P 46),[83] which he had received from M. Barbarin on December 28, 1899, to art critic and politician Antonin Proust.[84]

June 5, 1900 Pays Joseph Roulin 100 francs for two Van Gogh oils.[85] Pays him another 140 francs for two Van Goghs on June 29.[86]

Ca. July 7, 1900 Matisse buys Gauguin's *Young Man with a Flower* (1891, Mavrommatis Collection; W 422) for 200 francs.[87]

August 15–16, 1900 Buys from the widow of Fortuné Marion, a childhood friend of Cézanne, two paintings by the artist, a portrait of a man and a seascape.[88]

October 25, 1900 Pays Martial Caillebotte 1,500 francs for a work, possibly his brother's *Still Life with Oysters* (1881, Josefowitz Collection, Switzerland; B 195).[89]

Early 1900s Mary Cassatt turns to Vollard as a possible art dealer. She sells him an early picture, *Little Girl in a Blue Armchair* (1878, National Gallery of Art, Washington, D.C.) and informs him that the sitter was the daughter of a friend of Degas and that Degas advised her on the composition.[90]

1901 Exhibits works by Cézanne (January 20–February 20); Bonnard, Cézanne, Denis, Fantin-Latour, Alexandre Lunois, Raffaëlli, Renoir, Vuillard, and others (ca. February); Émile Bernard (June 10–22); Francisco Iturrino and Picasso (June 25–July 14).

Acquires nine of the paintings that Jacqueline Marval exhibits at the Salon des Indépendants, including *Odalisque and Cheetah* (fig. 282). Continues to purchase her work over the next few years.[91]

January 1901 Publishes Alfred Jarry's *Almanach illustré du Père Ubu* (fig. 224), illustrated by Bonnard. Claims to have collaborated on the text; his interest in the character Ubu remains strong throughout his life.[92]

April 2, 1901 On their first visit together to Vollard's gallery, Louisine and H. O. Havemeyer select several works by Cézanne. They pay 10,000 francs on account, and thirteen days later another 9,000 francs. On June 5 Vollard sends them seven framed Cézanne oils. Cassatt claims that these payments save the dealer from financial ruin.[93]

May 5, 1901 Renoir thanks Vollard for sending the 500 francs the dealer owed an artist-friend of his: "I'm especially happy that business allows you to play the rich collector. . . . I will be back at the end of the month, and we'll go and see that restaurant."[94]

May 22, 1901 Acquires a number of canvases from Bernard: fifty-three works at 100 francs each, fifty-five at 200 francs each, and one at 300 francs, for a total of 17,900 francs. Acquires a second group of works on July 10.[95]

June 1901 In preparation for an exhibition of work by Iturrino and Picasso, begins acquiring pictures from Pedro Mañach, who acts as agent. Despite Vollard's assertion that the show is unsuccessful,[96] Picasso later recalls that the canvases were "on top of one another almost to the ceiling and unframed, while some were not even on stretchers but in large folders, at the mercy of any collector or visitor."[97]

1902 Exhibits works by Cézanne (March), Maximilien Luce (April 17–30), Iturrino (until May 23), Rodin (June 15–30), Aristide Maillol (ca. July), Bonnard (ca. November).

January 20, 1902 Cézanne *fils* thanks Vollard for sending a case of wine and promises to locate additional watercolors for an exhibition that the dealer hopes to organize. The show never comes to fruition.[98]

February 3, 1902 Cézanne informs Charles Camoin that he considers Vollard to be both sincere and serious. Writes again to Camoin in March describing the dealer as "gifted, striking, and courteous."[99]

June 15–30, 1902 Exhibits the recently published *Jardin des supplices* by Octave Mirbeau with illustrations by Rodin (fig. 210). In January 1930 presents a copy to the Musée Rodin, Paris.[100]

1903 Exhibits works by Pierre Laprade (May 14–30), Gauguin (November 4–28).

282. Jacqueline Marval, *Odalisque and Cheetah*, 1900. Oil on canvas, 39¼ x 78¾ in. (100 x 200 cm). Courtesy Gallery Aristoloches, Grenoble

January 6, 1903 Final printing of Thomas à Kempis's *L'Imitation de Jésus-Christ*, with wood engravings by Denis (fig. 212).

Spring 1903 Commissions a replica of Renoir's *Bathers* (1887), which he had seen on loan from Jacques-Émile Blanche at Bernheim-Jeune's 1900 exhibition.[101]

May 8, 1903 Gauguin is found dead in his cabin in Atuona on the island of Hiva Oa in the Marquesas. On August 29 Vollard writes Monfreid that he has just learned of the death. Two months later Vollard exhibits fifty paintings and twenty-seven transfer drawings by Gauguin.[102]

December 30, 1903 Armand Séguin dies, just four months before the printing of his illustrated edition of Louis Bertrand's *Gaspard de la nuit* is complete.[103]

1904 Exhibits works by Louis Valtat (February 3–20); Hermann Paul (March 7–20); Robert Besnard, Francis Jourdain, and Tony Minartz (through April 17); Bernard (through April 30); Iturrino (through May 20); Matisse (June 1–18); Kees van Dongen (through November); Berthe Zuricher (mid-November).

Ca. 1904–6 Cassatt sells increasing numbers of paintings, pastels, and prints to Vollard.[104]

February 12, 1904 Buys nine oil sketches and three drawings by Renoir from the artist's brother Edmond for 1,000 francs.[105]

March 2, 1904 Places on deposit at Galerie Bernheim-Jeune thirteen Cézannes. One of the works (*The Pool at the Jas de Bouffan*, ca. 1876, Collection of Dr. Otto Krebs, Wiemar; R 278) is earmarked for the 1904 St. Louis World's Fair but is rejected by the organizers. At about this time, the two dealers begin to own Cézanne's works jointly. Between March and May Vollard sends about thirty paintings to Bernheim-Jeune, transactions that are detailed in their correspondence. Some paintings have just been relined or stretched for the first time, presumably by Chapuis.[106]

April 1904 Makes an unusually large number of payments to artists, presumably for works sold: Bernard (600 francs), Bonnard (950 francs), Cassatt (1,000 francs), Cézanne (1,000 francs), Denis (500 francs), Laprade (300 francs), Maufra (600 francs for a Gauguin), [Mme] Renoir (500 francs), Ten Cate (400 francs), and Valtat (500 francs).[107]

May–December 1904 Beginning in May makes numerous payments to Étienne Delétang, who, in the course of about a decade, photographs most of the works that pass through Vollard's gallery. On November 8 advances 300 francs to Delétang to buy a photo enlarger. The photographer's glass negatives are extant in the Vollard Archives.[108]

June 27, 1904 Cézanne informs Bernard that Vollard has given a "soirée dansante" to which the entire young school has been invited, among them, Cézanne *fils*, Denis, Joachim Gasquet, and Vuillard.[109]

August 24, 1904 A German collector from Wiesbaden, Baron Kurt von Mutzenbecher, buys two Cézannes, a work by Honoré Daumier, a Gauguin, a Maillol, two Seurats, and a Valtat, for a total of 6,210 francs.[110]

October 11, 1904 Ivan Morozov, son of a Russian industrialist, buys his first painting from Vollard, Pissarro's *Plowed Fields* (1874, Pushkin Museum of Fine Arts; PS 341),[111] for 1,800 francs. In the course of about fifteen years, he amasses one of the two great collections of "new French art" in Russia.[112]

October 27, 1904 Sells eight paintings to M. Jansen for 11,000 francs, including four Renoirs; all paintings are described in Stockbook B.[113]

October 28, 1904 American expatriates Gertrude and Leo Stein spend 8,000 francs at Vollard's for seven paintings, all listed in Stockbook B: one Denis (no. 3942), two Renoirs (nos. 4366, 4369), two Cézannes—*Bathers* (1892–94, Barnes Foundation; R 753) and *Bathers* (1898–1900, Baltimore Museum of Art; R 861; nos. 4363, 4364)—and two Gauguins—*Still Life with Sunflowers on an Armchair* (1901, Stiftung Sammlung E. G. Bührle, Zürich; W 602) and possibly *Three Tahitian Women* (fig. 229; W 584; nos. 3305, 3505). The Steins' apartment on the rue de Fleurus becomes a magnet for young artists and collectors to view avant-garde art, much of it purchased from Vollard.[114]

November 2, 1904 Pays Bernard 1,000 francs for seventeen drawings by Van Gogh, three by Gauguin, and an album of lithographs by Gauguin. The day before, pays him 100 francs for a small study of a nude by Van Gogh.[115]

November 10, 1904 Sergei Shchukin buys his first two Gauguins from Vollard for 3,500 francs: *Women on the Seashore (Motherhood)* (1899, Hermitage; W 581) and *Horse on Road: Tahitian Landscape* (1899, Pushkin; W 589).[116]

November 11, 1904 Cézanne *fils* asks Vollard to send installation photographs of the Cézanne rooms at the 1904 Salon d'Automne (fig. 275). His father is very pleased with the reception his work has received and thanks Vollard for his efforts.[117]

Kessler exchanges a Cézanne landscape for another by the artist, *The Viaduct at l'Estaque* (1879–82, Ateneum Art Museum, Helsinki; R 439), valued at 3,500 francs. He also buys a third Cézanne oil, *Grove at Jas de Bouffan* (1875–76, private collection; R 267), a Gauguin watercolor and engraving, and a watercolor by Johan Barthold Jongkind (Stockbook B, no. 3527) for a total of 5,500 francs.[118]

December 31, 1904 An archival receipt lists Vollard as owning property at Villeneuve-Saint-Georges, a suburb southeast of Paris.[119]

1905 Exhibits works by Cézanne (through June 17), Gauguin (late June–July 12), Clément Faller (December 6–17)

Publishes *Les Fleurs du mal* by Charles Baudelaire, illustrated with thirty wood engravings by Bernard.[120]

Commissions Renoir to make a portrait drawing of Monet. In October Renoir writes that he is too ill to finish it. A year later Monet's wife Alice informs her daughter, "Monet is very satisfied with what Renoir has done. I believe they were very happy to see each other."[121]

1905–7 Commissions Georgette Agutte, Bonnard, Denis, Jean Puy (fig. 283), Georges Rouault, Signac, Valtat, and Maurice de Vlaminck to paint ceramics in collaboration with André Metthey. With the exception of his friend Rouault, Metthey ends these collaborations in 1909.

April 2, 1905 Has fourteen canvases by Gauguin relined "à l'italienne" by Chapuis and two paintings on board mounted on panel, probably in preparation for his Gauguin exhibition (late June–July 12).[122]

April 20, 1905 Cézanne *fils* thanks Vollard for the five albums of photographs he has received from the dealer. He understands that Vollard has purchased some of his father's watercolors that

283. Jean Puy, *Orpheus Charming the Beasts*, ca. 1907. Ceramic frieze composed of twelve painted tiles, 11⅞ x 15¾ in. (29.5 x 40 cm). Private collection

were at the framers. These works form the basis of an exhibition that closes on June 17.[123]

July 10, 1905 Miethke Gallery, Vienna, buys two Gauguins: *Tahitian Woman and Boy* (1899, location unknown; W 578) for 2,500 francs[124] and *The Call* (1902, Cleveland Museum; W 612) for 3,000 francs.[125]

November 23, 1905 Having been introduced to André Derain by Matisse, pays the artist 3,300 francs for approximately eighty-nine paintings and some eighty works on paper and puts him under contract. Supposedly has the works taken to his car without even looking at them and pays Derain with "a wad of bills, held together with an old rubber band" that he pulls "from his ratty overcoat."[126]

December 1905 Purchases 5,860 francs worth of art from Puy (76 drawings at 10 francs each, 155 paintings at 20 francs each, and 10 paintings at 200 francs each). Becomes Puy's dealer until 1926.[127]

1906 Exhibits works by Cézanne (through March 13), Alcide Le Beau (March 15–29), Bonnard (April 3–15), Muller (April 22–May 5), Monfreid (through April 28), Nicolas Tarkhoff (through May 16).

January 1, 1906 Buys eight paintings from Jean-Louis Forain for 1,600 francs.[128]

January 6, 1906 Buys a painting of a child holding a cat from Cassatt for 400 francs; on February 7, buys another Cassatt painting, a child with a green hat, for 300 francs. On March 1, buys two of her pastels: "Head of a Girl" (150 francs) and "Fillette au [chat?]" (350 francs).[129] Two weeks later, pays Cassatt 1,550 francs for a group of paintings, pastels, and etchings.[130]

February 16–17, 1906 At the posthumous sale of modern paintings from the collection of the count of Takovo (Hôtel Drouot), buys Renoir's pastel "Jeunes filles" ("2 têtes" in Vollard's notes; lot 146 for 1,000 francs); Charles-Emmanuel Serret's pastels "La Promenade" and "La Grande soeur" (lot nos. 148, 149, the first sold for 105 francs); two Degas counterproofs, "La Toilette" (lot no. 208; heightened with pastel, for 275 francs) and "Femmes" (lot no. 209 for 215 francs); and 3 *sous-verre*.[131]

March 13, 1906–January 1907 Prince de Wagram buys many Gauguins and Cézannes. Correspondence in the Vollard

Archives indicates that Wagram buys and trades numerous works until early 1907, when he sells his paintings through two rival galleries. Vollard later recounts how he tries unsuccessfully to buy Geffroy's Cézannes only to find out that they have been sold to a prince (Wagram), who by that time is an agent for Bernheim-Jeune. According to Diffre and Lesieur, the prince becomes less regular in paying his invoices. Some of his paintings are returned for nonpayment and others are bought back by Vollard.[132]

March 24, 1906 Buys one hundred and forty-seven paintings, five pastels, and additional drawings, dated between 1890 and 1905, from Henri Manguin for 7,000 francs (fig. 284).[133] In June, the artist Raoul de Mathan, a friend of Manguin, writes, "The other day, while passing by Vollard's, I saw your bather [*La Baigneuse, Jeanne;* S 106] and the nude and the woman 'aux images' [*Les Gravures;* S 135], which greatly pleased me even though they were unframed and presented in Vollard's special way."[134] Vollard is still paying off his debt to Manguin when, in late May, he purchases forty-eight works by Vlaminck for 1,200 francs.[135]

March 29, 1906 Sends Cézanne's *Bathers* (fig. 42) to Monet, who has purchased it for 2,500 francs. On October 26 Monet purchases another Cézanne, *Château Noir* (1903–4, Museum of Modern Art, New York; R 940) for 8,000 francs.[136] On May 10, 1907, sells Monet a Cézanne landscape that had been shown in the Salon d'Automne for 5,500 francs.[137]

March 31, 1906 Purchases for 200 francs Rousseau's large *Hungry Lion Throws Itself on the Antelope* (1905, Fondation Beyeler, Basel), which had been shown at the 1905 Salon d'Automne. It is supposedly the first Rousseau to enter the art market.[138]

April 1906 By this date, is making payments to a residence on the rue de Gramont, presumably no. 28, where he will live until ca. 1929.[139]

April 5, 1906 Buys from the naval doctor and writer Victor Segalen Gauguin's *Self-Portrait near Golgotha* (1896, Museu de Arte de São Paulo; W 534) for 600 francs. Sells it to the prince de Wagram (Alexandre Berthier) less than two months later for 3,500 francs.[140]

April 13, 1906 Karl-Ernst Osthaus, founder of the Museum Folkwang, Hagen, and his wife visit Cézanne in Aix. Afterward

284. Henri Manguin, *The Prints*, 1905. Oil on canvas, 31⅞ x 39⅜ in. (81 x 100 cm). Carmen Thyssen-Bornemisza Collection, on loan to the Thyssen-Bornemisza Museum

they stop in Paris and purchase from Vollard two Cézanne paintings for the museum: *House and Pigeon Tower at Bellevue* (1890–92; R 690) and *The Bibémus Quarry* (ca. 1895; R 797). On April 27 Osthaus leaves with Vollard four paintings by Bernard and one by Denis.[141]

April 24, 1906 Purchases twenty paintings and studies from Matisse for 2,200 francs.[142]

April 27, 1906 After a two-year hiatus, Sergei Shchukin again purchases works from Vollard. On April 27: Gauguin's "tournesols" for 4,000 francs (probably *Still Life with Sunflowers on an Armchair* (1901, Hermitage; W 603). On May 4: a Gauguin (possibly *Man Picking Fruit from a Tree*, 1897, Hermitage; W 565) and two Cézannes (*The Aqueduct*, ca. 1890, Pushkin; R 695 and *Self-Portrait* [fig. 253]) for a total of 30,000 francs. On November 19: Cézanne, *Mont-Sainte Victoire, Seen from Les Lauves* (1904–6, Pushkin; R 932) for 5,500 francs.[143]

May 4, 1906 Havemeyers buy 28,000 francs worth of art: Cézanne's *Still Life with a Ginger Jar and Eggplants* (1890–94, Metropolitan Museum; R 769) valued at 15,000 francs; two pastels by Degas (*Russian Dancer*, 1899 [fig. 171] and *Dancer with a Fan*, ca. 1890–95, both Metropolitan Museum) for 9,000 francs; four drawings by Constantin Guys (1,200 francs); and a Manet study (3,000 francs).[144] *Russian Dancer* is of interest to a member of the buying committee for the Musée des Beaux-Arts, Lyon, but, Cassatt writes, Vollard feels that the Havemeyers should have "first call." In July she informs the Havemeyers that Vollard is sending them a photograph of "the Greco in Paris belonging to the Russian" (presumably Shchukin) and "some photos of Cézannes which he says he can get."[145]

Early May 1906 Buys twenty-seven paintings from Picasso, including *Woman with Loaves* (fig. 285), for 2,000 francs. The transaction is noted in Vollard's datebook on May 11, but already in a letter dated May 8 Leo Stein informs Matisse of the sale: "[the paintings purchased are] mostly old ones, a few of the more recent ones, but nothing major. Picasso was very happy with the price."[146]

May 12, 1906 Cézanne *fils* sends photographs of two paintings attributed to his father that he says are not authentic.[147]

May 31–September 10, 1906 Pays Vlaminck a total of 2,120 francs for sixty-eight paintings in three transactions.[148]

June 13, 1906 Buys a portrait of Mme Cézanne from Schuffenecker for 3,000 francs (probably *Madame Cézanne in a Striped Dress*, 1883–85, Yokohama Museum of Art; R 536). On June 25 receives a check from Bernheim-Jeune for his half share of Cézanne's *Large Pine and Red Land (Bellevue)* (ca. 1885, Galerie Yoshii, Tokyo; R 537), which the dealers had bought from Schuffenecker (who had "enhanced" it, seemingly unbeknownst to them).[149]

Summer 1906 Cassatt opens her studio at Beaufresne to Vollard and sells him a large number of drawings, preliminary sketches, and unfinished paintings and pastels. Vollard, probably with Cassatt's assistance, makes counterproofs of some of her pastels (probably those acquired at this time).[150]

July 1906 Sends payments to Bernard, Derain, Manguin, Puy, and Valtat.[151]

August 20, 1906 Pays Forain 4,200 francs in four installments for twenty-one painted studies.[152]

September 12, 1906 Maillol has begun working on a statue of Renoir commissioned by Vollard.[153]

285. Pablo Picasso, *Woman with Loaves*, 1906. Oil on canvas, 39⅜ x 27½ in. (100 x 69.8 cm). The Philadelphia Museum of Art, Gift of Charles E. Ingersoll

October 6–November 15, 1906 Lends eighteen paintings, fourteen drawings, and two wood sculptures by Gauguin to the Salon d'Automne as well as works by Cézanne, André Metthey, Louis Valtat, and Jacques-Pierre Volot.

October 23, 1906 Cézanne dies. Partners with Bernheim-Jeune to acquire 29 "studies" (for 213,000 francs) and 187 watercolors (for 62,000 francs) by the artist. These works are all acquired some time before March 11, 1907, and are entered in Vollard's Stockbook B, nos. 4451–4480. Cézanne *fils* receives his first payment for the lot on February 13, 1907, in two checks of 81,000 francs and 50,000 francs. Other payments made to him on March 15 (16,000 francs), April 4 (8,000 francs), and June 15 and 26 (8,000 francs each).[154]

November 16, 1906 Buys six paintings from Picasso for a total of 1,000 francs. On the same day, pays Cassatt 8,000 francs for a large still life by Cézanne (possibly *Fruit Dish, Apples, and Bread*, 1879–80, Sammlung Oskar Reinhart "Am Römerholz," Winterthur; R 420).[155]

1907 Exhibits works by Georges Manzana-Pissarro (April 15–30).

January 21, 1907 Steins exchange one of their Gauguins (*Three Tahitian Women* [fig. 229] and possibly a Bonnard for a Renoir valued at 4,000 francs.[156]

February 1907 Gustave Fayet sells Vollard eight Gauguin paintings for 24,000 francs.[157]

February 13, 1907 Pays Picasso 2,500 francs for a group of paintings and drawings.[158]

March–April 1907 Lends sixty works by Bernard, Cézanne, Denis, Gauguin, Laprade, Luce, Manet, Puy, and Valtat to the

exhibition "Französische Postimpressionisten," at Miethke Gallery, Vienna.[159]

May 4, 1907 Morozov pays 15,000 francs for two Gauguins that had previously belonged to Wagram: *Matamoe (Landscape with Peacocks)* (1892, Pushkin; W 484) and "personnages sur l'herbe," which is either *Nave nave moe (Sacred Spring)* (1894, Hermitage; W 512) or *Les Parau Parau (Conversation)* (1891, Hermitage; W 435). He buys his first Cézanne paintings in October: *Mont Sainte-Victoire Seen from the Valcros Road* (1878–79, Pushkin; R 398) and *Still Life with Drapery* (ca. 1899, Hermitage; R 846). On October 5 Morozov pays 8,000 francs for Gauguin's "fête champêtre" (probably one of the two Gauguins cited as possible purchases on May 4).[160]

May 19, 1907 Buys from Maillol 3,950 francs worth of sculpture.[161]

May 23–28, 1907 In preparation for the first large-scale exhibition of Cézanne's watercolors (Galerie Bernheim-Jeune, June 17–29), sends fifty-three watercolors to his photographer Delétang and seventy-five watercolors to a framer, Lézin.[162]

August 6, 1907 Ships three landscapes and a figure study by Cézanne to Osthaus (Museum Folkwang, Hagen), and later a landscape of trees.[163]

Lends twenty-three paintings (including six Gauguins, two Cézannes, three Bernards, three Luces, two Laprades, and two Valtats) to an exhibition in Prague with which the critic Camille Mauclair is involved.[164]

September 22, 1907 Buys paintings and lithographs from Forain for 3,000 francs.[165]

October 10, 1907 Sends Cassatt a check for 5,000 francs.[166]

October 20, 1907 Buys four paintings from Renoir for 10,000 francs: *La Grenouillère* (1869, Pushkin Museum), "jeune femme assise en plein air," "jeune femme sur un fauteuil intériéur," "esquisse rouge de femme et enfant."[167]

December 3, 1907 Notes "Godard fondeur . . . Compte de Maillol" a sum of 7,850 francs for: "achats divers anciens." This is one of a number of similar entries in his datebooks relating to bronze casts being produced.[168]

1908 Exhibits works by Vlaminck (possibly March), Cassatt (March 24–April 15), Puy (November 30–December 30).

January 30, 1908 Städelmuseum, Frankfurt, purchases a Vlaminck (150 francs), a Maillol bronze (400 francs), a Van Gogh drawing ("femme courbée"; 300 francs) and a Gauguin drawing ("cheval et cavalier"; 300 francs).[169]

February 3, 1908 Uncharacteristically, buys an oval painted portrait by the Salon painter Jean-Léon Gérôme for 110 francs from Mme Mathilde Planus (81, rue Réaumur), which he sells on February 18 to Paul Meric for 400 francs.[170]

April 27, 1908 Steins exchange a Gauguin "sunflowers" and Denis's *Mother in a Black Bodice* (1895, private collection), plus cash, for a study of a female nude by Renoir valued at 3,750 francs.[171]

April 28, 1908 Sergei Shchukin purchases two Gauguins, "Les cavaliers" and "La femme aux fleurs" (probably *The Ford* or *Escape* [1901, Pushkin; W 597] and *The Month of Mary* [1899, Hermitage; W 586]) for 8,000 francs each, as well as a Matisse still life and landscape (*Dishes and Fruit* and *View of the Bois de Boulogne* [fig. 149]) for 800 francs each. The next day, Morozov buys Cézanne's *Girl at the Piano—The Tannhäuser*

Overture (1869–70, Hermitage; R 149) for 20,000 francs; three Gauguins for 8,000 francs each (*Ea Haere Ia Oe [Where Are You Going?]*, 1893, Hermitage; W 501; *Fatata te Mua [At the Foot of the Mountain]*, 1892, Hermitage; W 481; and *Te Tiare Farani [Flowers of France]*, 1891, Pushkin; W 426); Puy's *Summer* (fig. 286) for 1,200 francs; Picasso's *The Two Saltimbanques (Harlequin and His Companion)* (frontispiece) for 300 francs; and Degas's *Dancers* (1899, Hermitage; L 1358) for 4,500 francs. The dealer throws in Vlaminck's "Bord de l'eau" for free.[172] On September 29 Morozov buys Cézanne's *Large Pine near Aix* (1890–95, Hermitage; R 761) for 15,000 francs; Renoir's *La Grenouillère* (1869, Pushkin) for 20,000; and "Monet, Bord de riviere 10,000."[173] In October sells Gauguin's *The Great Buddha* (1899, Pushkin; W 579) for 20,000 francs to Morozov, and Cézanne's *Smoker* (R 790) for 18,000 francs and Gauguin's *Self-Portrait* (1888, Pushkin; W 297) for 2,000 francs to Shchukin.[174] Shchukin's last recorded Cézanne purchase from Vollard is in January 1909, when he buys *Woman in Blue* (ca. 1904, Hermitage; R 944) for 18,000 francs;[175] in 1912 he buys works by Picasso and Rousseau.

May 7, 1908 After agreeing to paint Vollard's portrait, Renoir writes from Cagnes, "Come whenever you like. Now I'm all set to work." The resulting portrait (fig. 296) shows Vollard holding a statue by Maillol (who had been commissioned by Vollard to sculpt Renoir's likeness two years earlier). Vollard encourages the arthritic Renoir to try soft-wax sculpture. The artist makes two small ones, both of which were later cast in bronze.[176]

May 9, 1908 Purchases two drawings (1,500 francs each) and two pastels (3,000 francs each) from Degas.[177]

June 2, 1908 Sends a Gauguin painting to Gustave Frizeau in Bordeaux; sends eight more Gauguins on December 11 and two more at the end of the month.[178]

July 15, 1908 Article by Tristan Klingsor mentions Laprade's relationship with Vollard and defends dealers against claims that they take advantage of artists.[179]

August 1, 1908 William Henry Fox, director of the John Herron Art Institute, Indianapolis, pays 100 francs for a Cassatt pastel (possibly B 422), which is shipped to him in December.[180]

November 30, 1908 Pays Picasso 600 francs of the 1,600 francs due him for a group of the artist's pictures.[181]

286. Jean Puy, *Summer*, 1906. Oil on canvas, 30⅛ x 44¼ in. (76.6 x 112.5 cm). The State Hermitage Museum, St. Petersburg

December 15, 1908 Matisse buys six watercolors by Cézanne of which Vollard owns half shares of with Bernheim-Jeune.[182]

1909 Holds exhibitions this year of works by Louis Valtat (through March 18) and Jean Hess (April 27–May 10).

January 5, 1909 Buys a group of studies from Renoir (at Cagnes) for 5,350 francs.[183]

January 18, 1909 Steins buy nine watercolors and a lithograph by Cézanne, three lithographs and a drawing by Renoir. In April Leo buys three large Renoir lithographs and two small ones.[184]

February 13, 1909 Sends three Cézannes to the Munich Secession.[185] This spring and summer, also lends works to museums and galleries in German cities, including Cologne, Breslau, Charlottenburg, Berlin, and Munich.[186]

March 6, 1909 Gives Cézanne *fils* a check for 10,000 francs. In May, makes two further payments of 12,000 and 15,000 francs.[187]

April 2, 1909 Pellerin, who prefers to transact business with Bernheim-Jeune, exchanges two landscapes by Cézanne ("l'étang" [R 130] and "clairière") for a small painting "après l'enterrement" (possibly R 142) valued at 10,000 francs. In June he exchanges a Cézanne landscape (R 201) for a study of bathers.[188]

July 23, 1909 Rousseau offers to sell *Unpleasant Surprise* (1901, Barnes Foundation) for 400 francs, as well as "the reproduction of my large canvas of the fight between the tiger and buffalo" (ca. 1908–9, Hermitage) and *The Luxembourg Gardens, Monument to Chopin* (fig. 287) for 100 francs (negotiable).[189] On August 5, Vollard purchases the three paintings not for the 500 francs requested by the impoverished artist but for a total of 190 francs. He buys two more paintings in September for 40 francs, *View of the Quai d'Ivry near the Port à l'Anglais, Seine* (1900, Baltimore Museum of Art), exhibited at the 1903 Salon des Indépendants, and *View of the Fortifications,* exhibited at the 1896 Salon des Indépendants.[190]

July 30, 1909 Sends ten paintings to Marczell de Nemes, an important Hungarian collector, for 87,000 francs: Monet's *Woman Seated on a Bench* (ca. 1874, Tate; W-1996 343) for 5,000 francs; Manet's *Portrait of Georges Clémenceau* (1879–80, Kimbell Art Museum, Fort Worth) for 5,000; Cézanne's *Boy in a Red Vest* (1888–90, Sammlung E. G. Bührle; R 658) for 20,000; Degas's *Dancers* (ca. 1896, Burrell Collection, Glasgow; L 1260) for 9,000; Degas, "femme nue torse," 6,000; Renoir, "Moulin de la galette," 13,000; Cézanne's *Buffet* (1877–79, Museum of Fine Arts, Budapest; R 338) for 13,000; "Gauguin, Tahiti, 7,000; Gauguin, Tahiti, 7,000; Manet (esquisse) 2,000."[191]

September 14–October 15, 1909 Morozov purchases: Cézanne's *Bouquet of Flowers, after Delacroix* (1902–4; R 894) for 20,000 francs; Gauguin's *Tahitian Pastoral* (W 470), which had belonged to Wagram, for 10,000 francs; Matisse's *Still Life with Blue Pot* (fig. 150) for 2,000 francs; a Gauguin ["de chez Hessel"] for 10,000 francs, which he returns five days later; seven decorated vases for 5,300 francs; Cézanne's *Smoker* (fig. 255) for 22,000 francs; Cézanne's "un paysage Ste Victoire" (1896–98; R 899) for 18,000 francs; and Cézanne's nude study (*Le Bain,* 1892–94; R 754) for 10,000 francs. On October 15 Vollard ships the pictures to Morozov.[192] On November 11, 1910, Vollard sells Morozov another Cézanne, *Blue Landscape* (1904–6; R 882), for 40,000 francs,[193] and on April 28, 1911, two more: Cézanne's *Bridge over the Marne at Créteil* (ca. 1894; R 729) and *Madame Cézanne in the Conservatory* (1891–92; R 703) for 50,000 francs.[194]

287. Henri Rousseau, *The Luxembourg Gardens, Monument to Chopin,* 1909. Oil on canvas, 15 x 18½ in. (38 x 47 cm). The State Hermitage Museum, St. Petersburg

September 16, 1909 Ships Manet's *Execution of the Emperor Maximilian* (1867, Museum of Fine Arts, Boston; RW 124) to Frank Macomber, care of the Museum of Fine Arts, Boston.[195]

September 26, 1909 Rousseau offers to sell Vollard *The Representatives of Foreign Powers Coming to Greet the Republic as a Sign of Peace* (fig. 24) and *Fight between a Tiger and a Buffalo* (1908, Cleveland Museum).[196] On December 14, Vollard purchases both, the first for 10 francs (as a snub to the uninterested French government) and the second for 200 francs.[197]

November 11, 1909 Sends Paul Cassirer titles of the eighteen Cézanne paintings that have been sent for exhibition. In December he sends Cassirer thirteen albums comprising 757 photographs of works by Cézanne.[198]

1910 Exhibits works by Vlaminck (March 15–26); Gauguin (April 25–May 14); Cézanne (June 27–July 23); Picasso (December–late February 1911). These appear to be the last exhibitions that Vollard holds at his 6, rue Laffitte gallery.

Lends works to a number of international exhibitions: "Les Indépendants," Prague (January–March);[199] "Prima mostra italiana del'impressionismo," Lyceum Club, Florence (April 20–May 15); one in Brighton (ca. May–June); "Manet and the Post-Impressionists," Grafton Galleries, London (November 8–January 15, 1911).[200]

January 14, 1910 Purchases Cézanne's *Bibémus Quarry* (ca. 1895, Barnes Foundation; R 836) for 11,500 francs from Bernheim-Jeune, who had acquired it five days earlier from the *aixois* Georges Dumesnil.[201]

January 26, 1910 Baron Ferenc Hatvany, a Hungarian collector, pays 8,000 francs toward the 17,500 francs price of Renoir's "La Loge."[202]

February 12, 1910 Sells six paintings to Blot: Renoir, "la nuit/l'aurore" (8,000 francs); Renoir, "étude de nues/etude de baigneuses" (2,500 francs); Renoir, "femme nue/baigneuse de dos" (3,500 francs); Renoir, "tête de femme/tete de fillette" (3,000 francs); Renoir, "paysage" (3,300 francs), and Cézanne, "paysage" (6,000 francs).[203]

March 22, 1910 Purchases Rousseau's *Horse Attacked by a Jaguar* (1910, Pushkin Museum) from the artist for 100 francs. This month lends Rousseau's *Dream* (1910, Museum of Modern Art, New York) to the Salon des Indépendants.[204]

April 5, 1910 Datebook shows entries regarding Blanquin castings of Maillol sculpture.[205]

April 6, 1910 The Metropolitan Museum pays 12,000 francs ($2,319) for Manet's *Funeral* (fig. 281), which Vollard has reacquired from Pissarro. Also offers the museum Cézanne's *Fishermen—July Day* (ca. 1875, private collection; R 237) for 15,000 francs, apparently acting on behalf of Paul Cassirer, who owns the picture. The offer is refused.[206]

April 15, 1910 Pays Picasso 2,000 francs for seven pictures.[207]

May 26, 1910 Noted in Vollard's agenda (possibly in the artist's handwriting): "Wassily Kandinsky, Ainmillerstrasse 36, Munich." On a subsequent visit to the gallery, the artist laments to Robert Delaunay, "I am sad that I am unable to buy a Rousseau. To buy from Vollard, etc . . . you need a different purse for that."[208]

July 4–5, 1910 Meets with Edward Steichen, who is in Paris to prepare for exhibitions he is organizing with Alfred Stieglitz for their New York gallery, "291."[209]

August 30, 1910 Final printing of Verlaine's *Sagesse* (fig. 211), illustrated by Denis.[210]

September 21, 1910 Paul Cassier purchases two Van Gogh paintings: *Self-Portrait* (1887, Detroit Institute of Arts; F 526) for 4,000 francs and *Nude Woman on a Bed* (1887, Barnes Foundation; F 330) for 2,000 francs.[211]

October 7, 1910 Vincenc Kramář, future director of the Czech Picture Gallery of the Society of Patriotic Friends of the Arts (later the Národní Galerie, Prague), visits Vollard's gallery, where he sees works by Cézanne, Degas, Derain, Gauguin, Matisse, Picasso, Rousseau, Valtat, and Vlaminck. The next day he writes his brother, "These last days I could scarcely sleep after the artistic establishments and what I saw there. Yesterday was one of the best days ever. After that I couldn't even get off to sleep at all."[212] In May 1911 starts to buy from Vollard, first a Picasso bronze, *Woman's Head (Fernande)* for 600 francs, and later in the month lithographs by Cézanne and Renoir.[213]

December 18, 1910 Buys three works from Degas for 20,000 francs: "Femme à sa toilette," "femme à la baignoire," "vues de danseuses." In January 1911 buys ten more for 82,000 francs and that May, a painting for 20,000 francs.[214]

By 1911 Owns *La Marjolaine,* a manor house with extensive grounds at Varaville, in Calvados, near the English Channel.[215]

April 28, 1911 Loeser, a customer of Vollard since 1894, informs Walter Pach that Vollard had been to see him and "brought with him a big and most beautiful Cézanne that I had much admired in his rooms in Paris, but which I had no thought of ever possessing at his price 30,000 frcs. . . . Still I had suggested that we might effect an exchange. This we finally agreed upon here. I [am] giving him no less than four Cézannes in exchange for the one. They are: a small and very fine still life (apples); one very early landscape; and two very complete and beautiful landscapes of his maturity. It is no doubt very good business for Vollard. I on the other hand wanted the big picture and saw no other way of securing it. One of the four

exchanged pictures is 'Costa's' [Count Enrico Costa; *The Road,* ca. 1871, private collection; R 169]."[216]

May 12, 1911 Buys twenty paintings from Iturrino for 4,000 francs.[217] In September and October makes additional purchases from the artist; in 1912 buys thirteen more canvases.[218]

May 31, 1911 Simon Meller, curator of drawings and prints at the Museum of Fine Arts, Budapest, buys fourteen watercolors and drawings by Cézanne, Gauguin, Van Gogh, and Pissarro, as well as lithographs and illustrated books totaling 7,075 francs, which are sent in July. In October Vollard sends another shipment of works on paper.[219]

July 11, 1911 Ships prints and illustrated books by Bonnard, Renoir, Rodin, and Vuillard to the Städelmuseum, Frankfurt.[220]

September 4, 1911 Sells Gustave Courbet's *Copy after Franz Hals's "Malle Babbe"* (1868, Kunsthalle Hamburg; F 670) for 9,000 francs to Romanelli.[221]

September 7, 1911 Meets with Russian impresario Sergey Diaghilev, who is staying at the Hotel Brighton on the rue de Rivoli.[222]

September 19, 1911 Buys three paintings from Degas for 85,000 francs: "Chevaux des courses, toile de 30, 40,000 francs; Femme à sa toilette dans sa loge, 30,000; Actrice dans sa loge, 15,000."[223]

September 28, 1911 Buys fifteen etching plates and four paintings from Picasso for 3,700 francs.[224]

October 18, 1911 Pays Bernard 2,000 francs for the rights to publish *Lettres de Vincent van Gogh à Émile Bernard.*[225]

November 28, 1911 Kramář buys Picasso's *Self-Portrait* for 400 francs (fig. 288) and *Woman* for 500 francs for the Národní Galerie, Prague.[226] On December 9 he spends 900 francs on another Picasso, *Woman in an Armchair,* which he later sells to the director of the Národní Galerie.[227]

1912 Lends to exhibitions: Institut de France's centennial exhibition, Saint Petersburg (ca. February)[228]; Manzi, Joyant, et Cie's exhibition at the Hôtel des Modes, Paris (ca. June);[229] "Second Post-Impressionist Exhibition," Grafton Galleries, London (October 5–December 31, 1912). Among his loans to the Saint Petersburg exhibition is Vallotton's *Bathing on a Summer Evening* (fig. 289), to which he assigns an insurance value of 6,000 francs.[230]

January 5, 1912 Buys from Renoir (in Cagnes) twelve studies painted on six canvases for 6,000 francs, to which Vollard assigns stock numbers 5002–5013.[231] Vollard's shipping receipts and datebooks refer to these 5000 numbers, which are sometimes found on the reverse of paintings that have gone through the gallery. No stockbook is known to exist, however.

January 12, 1912 Buys from Degas six pastels for 100,000 francs: two "danseuses russes" (each at 15,000 francs) and four "danseuses au repos" (two at 15,000 francs each and two at 20,000 francs each). He dines with Degas on January 15 and three days later buys five more works for 50,000 francs.[232]

January 25, 1912 Has lunch with Marius-Ary Leblond, creator of the newly founded Musée Léon Dierx on Réunion, and gives two paintings: a Valtat (1905) and a Vlaminck (*Fleurs,* 1910), both of which had been shown at the 1905 Salon d'Automne.[233]

February 29, 1912 Eugene Meyer, a New York banker, pays 50,000 francs for Cézanne's *Still Life with Apples and Peaches* (ca. 1905,

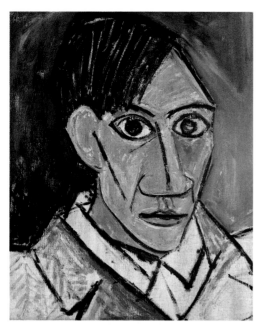

288. Pablo Picasso, *Self-Portrait*, 1907. Oil on canvas, 22 x 18⅛ in. (56 x 46 cm). Národní Galerie, Prague (O 8021)

National Gallery of Art, Washington, D.C.; R 936) through Steichen, a friend who acts as intermediary.[234]

May 21–22, 1912 At Hoogendijk's posthumous sale, purchases a Renoir pastel, *Portrait de filette* (lot no. 160 for 5,051 florins [guilders]); a Renoir lithograph heightened with pastel, *Les Jeunes Filles au chapeau* (no. 161 for 405 guilders); Roussel's pastel, *Deux Dames installées dans un coin de jardin, autre dame arrivant dans le fond à droite* (no. 168 for 51 guilders), and a group of nine drawings and watercolors, *Études d'animaux* by E. Saint-Marcel (no. 171 for 31 guilders).[235]

December 6, 1912 Pays Cézanne *fils* 40,000 francs for *The Feast (The Orgy)* (fig. 31). The next month pays Bernheim-Jeune a 6,000-franc commission for selling the painting to Pellerin.[236]

December 9, 1912 Notes in his diary that he has sold and delivered to Barnes Cézanne's portrait of Mme Cézanne for 40,000 francs

289. Félix Vallotton, *Bathers on a Summer Evening*, 1892–93. Oil on canvas, 38⅛ x 51⅛ in. (97 x 131 cm). Kunsthaus Zürich, Gottfried Keller-Stiftung, with support by Migros-Genossenschaftsbundes, 1965 (1965/41)

(R 607; Stockbook B, no. 3809). The following morning Barnes meets Vollard at rue Gramont, and on December 11 buys two small Cézannes for 20,000 francs (*Still Life* [R 335] and *Bathers* [R 362]), as well as two Renoirs for 30,000 francs. Barnes also purchases three frames for the works, at a total cost of 95 francs. The collector prefers not to pay Vollard directly and has Joseph Durand-Ruel act on his behalf with matters regarding "his Majesty, Vollard, the first." Durand-Ruel therefore "purchases" the three pictures on December 12 (per their invoice).[237]

1913 Lends to exhibitions: French art at Galerie D. Heinemann, Munich (ca. March–April)[238]; Galerie Arnold, Dresden (ca. August–September)[239]; Paul Cassirer, Berlin (November)[240]; Goupil & Co., Paris, "L'Exposition d'art contemporain" (November).[241]

January 4, 1913 Morozov buys a Cézanne for 30,000 francs, *Women and Girl in an Interior* (ca. 1870; R 154), which is retrieved by his agent seven weeks later with Picasso's portrait of the dealer (fig. 1).[242]

January 6, 1913 Attends the marriage of Cézanne *fils* and Renée Rivière in Paris.[243]

January 29, 1913 Ships paintings to the New York lawyer John Quinn: Gauguin's *Tahitian Family* (1902, private collection; W 618), 16,000 francs ($3,200); Cézanne's portrait of his wife (fig. 290), 25,000 francs ($5,000); and a Van Gogh portrait (*Self-Portrait*, 1887, Wadsworth Atheneum, Hartford, Connecticut; F 268), 8,000 francs ($1,600). Quinn becomes a regular client of Vollard and, with Pach, is instrumental in promoting the Armory Show in New York (February 17–March 15, 1913). His new purchases arrive just in time to be exhibited.[244] Vollard also lends paintings by Cézanne and Gauguin to the Armory Show, as well as prints and illustrated books by various artists. One of the paintings, Cézanne's *View of the Domaine Saint-Joseph* (fig. 27), is purchased on March 30, 1913, by the Metropolitan Museum for $6,700; it is the first Cézanne to enter an American museum.[245]

April 1913 Visits Renoir in Cagnes and proposes that the artist collaborate on sculpture with Richard Guino, a young Spaniard who had been Maillol's assistant. Vollard suggests that Guino translate some of Renoir's paintings into sculpture. Renoir would have creative control, Vollard would pay Guino's salary, and Renoir would receive the sale price less Vollard's commission. Renoir agrees. In a letter of April 28, Renoir writes, "When Vollard spoke to me about sculpture, at first I told him to go to hell. But after thinking it over, I let myself be persuaded in order to have some pleasant company for a few months." By June 16, 1914, Guino is still not finished with the clock based on *The Triumph of Love*.[246] On January 7, 1918, Renoir tells Vollard that he wants a respite from sculpture, "since I am extremely tired—very, very tired, I wouldn't mind taking a little rest for the time being, feeling as bad as I do, life too complicated for my age, and I reach the point where I no longer do either painting or sculpture or pottery while I want to do everything. Guino is a charming man whom I wouldn't want to hurt for all the world and who does everything he can to please me. That's why I am giving you this tip."[247]

April 12, 1913 Sends Cassatt 15,000 francs for Degas's portrait of her (ca. 1880–84, National Portrait Gallery, Washington, D.C.).[248]

June 2, 1913 Barnes visits Vollard's gallery and sees works that interest him. Instead of buying them directly, Barnes has Durand-Ruel act as his agent in the purchase of a Cézanne

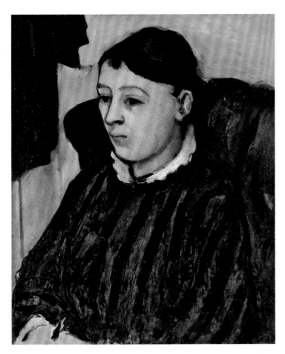

290. Paul Cezanne, *Mme Cézanne in a Striped Dress*, 1882–85. Oil on canvas, 22¼ x 18½ in. (56.5 x 47 cm). Yokohama Museum of Art

(*House and Trees*, 1888–90; R 629), Renoir ("tête d'enfant"), and two Picassos ("enfant," "les boeufs") for 57,000 francs.[249]

July 6, 1913 In a letter to Louisine Havemeyer, Cassatt writes, "Vollard has made a fortune. He has a house at Cabourg; he wants me to promise to call on him there, even to stay with him! He hasn't forgotten Mr. Havemeyer having saved his financial life in 1901. You remember when he came back from Italy."[250] On December 3 Cassatt writes, "[Joseph Durand-Ruel] would not buy the things from Degas that Vollard gladly took and sold again at large profits. Vollard is a genius in his line he seems to be able to sell *anything*."[251]

July 24, 1913 Named Chevalier du Mérite Agricole by the Ministère de l'Agriculture de la République Française.[252]

Late 1913 Publishes Picasso's *Saltimbanques*, an album of fourteen etchings and drypoints. Among the collectors who purchase it in 1913–14 are: Alfred Flechtheim (Düsseldorf), Frizeau (Bordeaux), Hoffmenstall (Vienna), Kessler (Weimar), Dr. Gottlieb Friedrich Reber (Barmen), Margherita Sarfatti (Milan), Schüller (Amsterdam), Baron von Simolin (Berlin), Karl Voll (Munich).[253]

1914–17 During the war years, Vollard is a generous lender to international exhibitions of French art, including "Art français du XIXᵉ siècle," which debuts at the Statens Museum for Kunst, Copenhagen (May 15–June 30, 1914), before traveling to Oslo and Stockholm, and "Ausstellung französischer Malerei," Kunstverein Winterthur (October 29–November 26, 1916). On October 11, 1916, he delivers four crates containing eighty-one framed prints to the "Service de la Propagante" [*sic*], Paris. In 1916–17, he lends paintings to "Exposition d'art français," Barcelona (ca. spring 1917) and "Französische Kunst des XIX. u. XX. Jahrhunderts," Kunsthaus Zürich (October 5–November 14, 1917), where Vollard delivers a lecture on October 11.[254]

1914 Vollard's *Degas: Quatre-vingt-dix-huit reproductions signées par Degas* (Paris: Galerie A. Vollard [and Bernheim-Jeune et Cie]) is published in an edition of 800 numbered copies.[255]

Mexican-born American art dealer Marius de Zayas visits Vollard, who reads him passages from his as-yet-unpublished manuscript on Cézanne. De Zayas buys two Cézannes, which are soon acquired by Agnes and Eugene Meyer, Mount Kisco, New York: *Vase of Flowers* (1900/1903, National Gallery of Art, Washington, D.C.; R 893) and *Château noir* (1900/1904, National Gallery of Art; R 937).[256]

January 11, 1914 Cassatt tells Louisine Havemeyer that Renoir "is doing the most awful pictures or rather studies of enormously fat *red* women with very small heads. Vollard persuades himself that they are fine."[257]

March 1914 By now a recognized authority on Cézanne, Vollard publishes "L'Atelier de Cézanne," *Mercure de France* (March 16, 1914), pp. 286–95. Soon thereafter, publishes *Paul Cézanne* (Ambroise Vollard, Éditeur, Paris, 1914; cover dated 1915) (fig. 29) in an edition of 1,000 numbered copies with an etched frontispiece by Cézanne. Gustave Kahn and Roger Fry are among the many reviewers. Gertrude Stein pays homage with her poem "M. Vollard et Cézanne," *The Sun*, October 16, 1915.[258]

May 2, 1914 Sends Renoir's *Girl against a Light Blue Background* (ca. 1884, Stiftung Langmatt, Baden) (15,000 francs) to Jenny and Sidney Brown at the Villa Langmatt in Baden, Switzerland, and Cézanne's *Portrait of Madame Cézanne* (1890–92, Philadelphia Museum; R 685) (27,000 francs) to Reber. A month later, on June 6, he sends another Cézanne, *Riverbank* (ca. 1895, National Gallery of Art, Washington D.C.; R 722) (27,000 francs) to Reber and Cézanne's "femme accoudée" (54,000 francs) to the Wallraf-Richartz-Museum, Cologne.[259]

August 1914 Germany's declaration of war on France seems to have little immediate effect on Vollard, who continues to sell art, write, and publish books.

1915 Publishes Pierre de Ronsard's *Les Amours*, illustrated by Bernard.

Quinn buys six Picasso paintings from Vollard via Carroll Galleries, New York, this year: *Woman at Table (Femme au chignon)* (1901, Fogg Art Museum, Harvard University) for 4,000 francs, or $800; *The Blind Guitarist* (fig. 113) for 5,000 francs, or $1,000; *The Sad Mother* (1901, Fogg Art Museum, Harvard University) for 6,000 francs, or $1,200; *Figure* ("cubist, black period") 1910, Albright-Knox Art Gallery, Buffalo) for 2,500 francs, or $500; and two unidentified works: "Study (cubist, black period)" ["Still Life"] for 1,500 francs, or $300, and "Woman with Hands under Her Chin" ["Woman at a Table"] for 2,500 francs, or $500. These works may include Picasso's *Woman Plaiting Her Hair* (1906) and *Two Nudes* (1906, both Museum of Modern Art, New York), which are thought to have been purchased by Quinn from Vollard via Carroll Galleries in March and April 1915, respectively.[260]

March 29, 1915 Barnes purchases Cézanne's *Woman in a Green Hat (Madame Cézanne)* (1894–95, Barnes Foundation; R 700) via Durand-Ruel, who obtains the painting from Vollard for 33,000 francs and sells it to Barnes for 40,000.[261]

Late May 1915 Sends copies of his recent monographs (on Cézanne and Degas) to important contacts: Galerie Bernheim-Jeune; Bibliothèque Municipale, Saint-Denis, Île de la Réunion; Carroll Galleries, New York; Mme Clementel, Versailles; Royal Cortissoz, "editor of the New York Tribune"; the

291. Cover of *Paul Cézanne* by Ambroise Vollard, cover dated 1915, title page dated 1914. Page 12¾ x 9½ in. (32.4 x 24.1 cm). Published by Ambroise Vollard, Éditeur, Paris. Thomas J. Watson Library, The Metropolitan Museum of Art, New York

designer Egisto Fabbri, Florence; A. Hahnloser, Winterthur; Louisine Havemeyer, New York; the art critic Paul Jamot, Toulouse; M. de Laguiome, Roanne; Pauline Macé, Saint Sebastien, Spain; Eric Maclagan, of the Victoria and Albert Museum, London; Henry McBride, "critic of the New York Sun"; Octave Mirbeau, Triel, France; the author and politician Adrien Mithouard, Sarthe, France; Monet, Giverny; C. Montag, Winterthur, Switzerland; Gertrude Muller, Soleure, Switzerland; Walter Pach, New York; Georges Reinhart, Wintherthur; the architect Alfred Rome, Grenoble; the artist and author Ardengo Soffici, Florence; the poet and sculptor Kotaro Takamura, Tokyo; Charles Tenney, East Grinstead, Sussex; Mme Étienne Vautheret, Lyon.[262]

June 15, 1915 Gertrude Stein introduces Vollard to the New York art critic Henry McBride, who notes, "(Chez Vollard, Art Dealer) Vollard is a tall, awkward person, earnest simple and engrossed in linking his name with modern art history. He has a trick of shutting one eye tighter than the other which gives an oblique line across the face. He has been painted by Cézanne, Bonnard and Renoir. The Bonnard gave the background of the very room we were in, and one could recognize the Renoir on the wall. He showed us superb Degas pastels larger than any I had seen, quantities of them, and one painting of a woman in the Stevens-Manet costume at Mirror, her back in superb shadows. Very Venetian. Ought to be in a museum. Saw a fine Cézanne nude with scratches by dissatisfied artist. Lovely color. Fine still life in hot color, vase in exact center of toile. Quantities of landscapes. Vollard indefatigable in showing me. Said, 'and will you make a little article sur moi?' All picture dealers are very affable now. A Mr. Strauss present, a collector of modern art, assured me prices had not tumbled since the war. He had not heard of a single instance. French were not like that. Preferred not to sell and to keep prices up. English were different."[263]

December 25, 1915 After the death of his wife, Renoir enlists Vollard's help: "I need you for the inventory that will take place in Paris and it's impossible to get a word from you. Are you sick or dead?"[264]

Ca. 1916 Collaborates on a Morisot catalogue raisonné with the deceased artist's daughter, Julie Manet (Mrs. Ernest Rouart). Vollard never finishes the project and on March 26, 1931, sells 360 slides ("clichés photographiques") of Morisot's works to "Les Beaux-Arts, Édition d'études & de documents," Paris. He is paid 5,400 francs for the lot.[265]

March 1, 1916 Final printing of *Les Fleurs du mal*, illustrated by Bernard.

December 1916 Publishes two articles, "Cézanne and Zola," *The Soil* (December 1916), pp. 13–14, and "Une Figure de 'grand amateur,' le Comte Isaac de Camondo," *Mercure de France* (December 16, 1916), pp. 592–99. Latter prompts a response from the Parisian art critic Pinturrichio (Louis Vauxcelles).[266]

February 23, 1917 After having recently lent thirty-two paintings by Laprade, Manguin, Marval, Puy, Valtat, and Vlaminck to an exhibition at the Kunstverein, Winterthur, sends the same museum a Renoir painting of a nude.[267]

March 1917 Two sculptures reproduced in the dealer Paul Guillaume's *Sculptures nègres; 24 photographies* (with a preface by Apollinaire) are listed as belonging to Vollard.

Publishes "Cézanne's Studio," *The Soil* (March 1917), pp. 102–11.

May 5, 1917 Pays Rouault 49,510 francs for 770 of his "paintings, temperas, sketches, etc," many of which are unfinished. It is understood that Rouault will be paid a bonus as the works are completed.[268]

July 1917 Publishes "How I Came to Know Renoir," *The Soil* (July 1917), pp. 189–93. In August, during a visit to Renoir in Essoyes, poses dressed as a toreador. A photograph of the session is given to Rouault, who notes on the verso that Vollard has padded his calves (fig. 21).[269] During this period, Vollard works on a book about Renoir and frequently visits "the impressionist master's house with a painter named Bernard. Vollard [sits] down at a table with writing paper and ink and [appears] to be catching up on his correspondence. It [is] Bernard's assignment to make Renoir talk while Vollard [takes] notes of everything he [says]."[270] In 1918 Vollard publishes *Tableaux, pastels et dessins de Pierre-Auguste Renoir* and the following year, *La Vie et l'oeuvre de Pierre-Auguste Renoir*. In general, Vollard's writing style wins high praise from critics, who find his prose as "lively as an intimate conversation . . . in refreshing contrast with the ponderous eulogies issued in the name of art. . . . M. Vollard gives us the feeling of a direct contact with a bright, active life."[271]

July 15, 1917 Pays rent for spaces at 2, 4, and 6, rue Laffitte.[272]

December 3, 1917 Vollard and Joseph Durand-Ruel begin taking an inventory of Degas's estate (the artist had died on September 27). The next day Durand-Ruel reports, "After our rapid examination yesterday, Vollard and I were astonished by the considerable number of superb drawings and pastels that Degas had never shown anyone." The inventory takes almost two months, and both men become ill as a result of spending three days a week sorting through artwork in Degas's filthy, unheated studio.[273]

December 10, 1917 Sends Degas's "Portrait de femme," Gauguin's "Scène des iles Océaniques," and three Daumiers ("Dans la

rue," "Spectateurs," "Trois têtes") to Duval Fleury. A month later, on January 18, 1918, Vollard sends him two oils and one pastel by Degas and a portrait of a man by Cézanne.[274]

Ca. February 1918 Cassatt asks Vollard to deliver one of her pastels as well as some works by Degas to Durand-Ruel, who will store them for the duration of the war.[275]

March 4, 1918 Sells Quinn seven works by Rouault: four paintings (all of which date to 1904–6 and measure 52 x 72 cm: *Clown's Head* [800 francs], *Nude* [800 francs]), *Circus Girl* [800 francs], *Two Nudes* [800 francs]) and three ceramics (*Head of Christ*, 41 cm [800 francs], *Clowns' Heads*, 43 cm [600 francs], and *Landscape*, 36 x 10 cm [200 francs]). Quinn, an avid collector of Rouault, waits until the war is nearly over (October 25, 1919) to pay for them.[276]

March 25, 1918 Sends three works to Werner Feuz, Bern: Renoir's painted study of "Jeunes filles au piano" (25,000 francs), Renoir's painting "femme assise dans l'herbe" (14,000 francs), and a Cézanne watercolor of a still life (20,000 francs).[277]

March 26–27, 1918 First posthumous Degas sale is held. Gaston and Josse Bernheim-Jeune, Joseph Durand-Ruel, and Vollard are listed as experts. Three sales devoted to Degas's personal collection and five devoted to his own work are held over the next sixteen months.[278] After the initial excitement, some critics lose patience: "The third Degas sale just took place [April 7–9, 1919]. When is the fourth? And will that one be the last? One is entitled to wonder, given the greed of the master's heirs who do their utmost to polish off even the least important scribbles, the most rudimentary projects, the little nothings, the nonentities. Do a few faint strokes of charcoal appear on a white page? Quick, the expert Vollard applies the red stamp that will transform the scrap into a Degas worthy of braving the fires of auction."[279] Vollard purchases heavily from the sales, buying both independently and as part of the consortium established by Jacques Seligmann in the late winter and early spring of 1918 with Joseph and Georges Durand-Ruel (who contributed 200,000 francs) and Josse and Gaston Bernheim (100,000 francs). The consortium is planned to last three years and has capital totaling 1,273,706.40 francs (Vollard contributes 150,000 francs and Seligmann, 823,706.40).[280]

May 2, 1918 With Picasso, witnesses the marriage of Apollinaire and Jacqueline Kolb. Apollinaire dies six months later of the Spanish Flu epidemic.

May 14, 1918 Meets the dealer René Gimpel, who writes in his diary, "Vollard [is] the wealthiest dealer in modern pictures. He is a millionaire ten times over. The beginning of his fortune goes back to the day in Cézanne's studio when he found the artist depressed and bought about 250 canvases from him at an average of fifty francs apiece. He parted with some but kept the majority until the time he could sell them for ten to fifteen thousand francs each."[281]

May 23, 1918 German shells land in Paris. Vollard, who has closed his gallery on the rue Laffitte and transferred much of the contents to his private residence at 28, rue de Gramont, decides to remove his art from the French capital. Within two weeks Rouault is looking for a safe house on his behalf. On June 23 seventy-one crates of paintings arrive at a rented house at 8, rue Bodin at Saumur (a town just southwest of Tours), where Rouault acts as guardian.

June 25, 1918 Final printing of *Oeuvres de François Villon*, with illustrations by Bernard (fig. 214).

August 4–5, 1918 Visits Renoir and Cassatt in the south of France. Discusses Louisine Havemeyer's desire to purchase Degas's wax statuette *Fourteen-Year-Old Dancer* (1879–1881, National Gallery of Art, Washington, D.C.), which Degas had been preparing to sell Havemeyer for 40,000 francs. Now that Degas is dead, Vollard estimates the sculpture to be worth 60,000 or 70,000 francs; in late December the artist's heirs offer to sell it for 500,000 francs.[282]

November 11, 1918 Germany and the Allies sign an armistice; the peace treaty is signed at Versailles the following June.

December 1918 Is possibly considering a move away from 28, rue de Gramont. On December 30 Rouault alerts him to a large photographer's building for rent in the 8th arrondisement, at the end of the passage de la Madeleine.[283]

Late winter 1919 An inexpensive (5 franc) edition of Vollard's *Paul Cézanne* is published by Crès et Cie, prompting a flurry of reviews, including "L'Historien cruel," *Aux Écoutes*, March 9, 1919, p. 11; "Revue de la quinzaine," *Mercure de France*, March 16, 1919, p. 375; and Aristide, "La Critique d'Aristide; Paul Cézanne," *Aux Écoutes*, July 20, 1919, p. 14.[284]

April 3, 1919 Reaches an agreement with the Librairie Ollendorff and Albin Michel regarding the rights to Guy de Maupassant's *Maison Tellier* (fig. 169), which he ultimately publishes in 1934 with illustrations after Degas's monotypes.[285]

April 10, 1919 Galerie E. Druet reports on the status of ceramics that Vollard has lent to their Vlaminck exhibition (February 3–14, 1919): fourteen of the eighteen plates sold (40 francs apiece), three are for C. Montag, one to be returned to Vollard; four of the ten platters sold (100 francs apiece), six to be returned to Vollard. Also sold: two large platters (150 francs apiece), four vases (100 francs apiece), one fountain (150 francs), and one large vase (400 francs). Vollard will be sent 1,624 francs and the seven unsold ceramics.[286]

July 9, 1919 Purchases Courbet's *Woman in a Podoscaphe* (1865, Murauchi Art Museum, Tokyo; F 449) for 15,100 francs at the auction "Tableaux, études et dessins par Gustave Courbet," Galerie Georges Petit.[287]

September 20, 1919 Rouault feels overwhelmed by his commitments to Vollard. André Suarès commiserates, "Vollard is unique in Paris for his taste and his sense of painting. But Vollard is an outcast. Vollard is a vampire."[288]

1920 Increasingly focuses on his writing. In March informs Leo Stein that he now prefers writing books to selling paintings, especially since people are buying art as an investment: "What's the use of letting the other fellow profit by it?" In November tells René Gimpel, "I'm bringing out a Degas with fifty pages of illustrations and fifty pages of text. My Renoir is also going to come out. I claim no merit in writing it, for all my life I've only had to note down the painter's words. But it's going to demolish all the books written on impressionism, full as they are of theories that have no connection whatsoever to the masters of the school. Listen! I find my book on Renoir quite satisfactory. I read it to Renoir, who listened only absent-mindedly, but his eldest son, the actor, wrote me: 'In the whole book on my father I've only one word to pick on: it's "sentiment" in place of "sentimentality." And yet it's true that that's the word my father used. You have been too faithful!'"[289] About this time, possibly to coincide with a large Renoir retrospective at Durand-Ruel (November 29–December 18), publishes *Auguste Renoir (1841–1919) avec onze illustrations, dont huit phototypies* (Paris: G. Crès et Cie).

June 19, 1920 After much negotiation, purchases a twenty-six-room *hôtel particulier* at 28, rue de Martignac for 330,000 francs.[290] The six-story house consists of a basement; a ground floor with a large gallery, two large rooms on the street, two street entrances, and a storage room; a second floor with a kitchen and six large rooms, three of which overlook the street; a third floor with nine rooms, three of which overlook the street; a fourth floor with two rooms, two studios, and six maids' rooms; a fifth floor with two studios; and a sixth floor with two studios. There is also a studio apartment for the concierge.[291] Beginning in the fall of 1922, Vollard uses the space for his work but continues to reside at the rue Gramont address until about 1929.[292]

Despite the increased space, the character of Vollard's establishment remains the same: "In the entryway, at the base of the stairs, one is welcomed by statues by Maillol that seem in dialogue with Renoir's *Bathers*, in front of an accumulation of frames, stretchers, and rolled canvases that would seem to suggest a bankruptcy or estate sale, the mysteries of a collector's residence or art dealer's gallery (fig. 292). Hundreds more canvases line the stairway and landing. Then, via a hallway off of which is Vollard's bedroom, simple as a student's, one comes to the dining room. A lightbulb with a paper shade hangs from the ceiling. The walls have not even been repainted but from the hanging rails are Renoir's portrait of the dealer as a toreador [fig. 20], Degas's nude in her bath, a *Mont Sainte-Victoire* by Cézanne, and Henri-Rousseau's virgin forest."[293] Although Vollard occasionally mentions the possibility of hosting exhibitions (of Degas and Rouault) at the address, few are known.[294]

September 23, 1920 Is named Commandeur de l'Ordre du Nichan Iftikhar by the Tunisian government. On July 1, 1931, promoted to the rank of Grand Officier de l'Ordre du Nichan Iftikhar.[295]

June 27, 1921 Sells Barnes, via Durand-Ruel, three paintings worth a total of 575,000 francs.[296]

December 24, 1921 Sells four Cézannes intended for the Kiyoharu Shirakaba Museum, Nagasaki, to Masanosuke Sōma for 60,000 francs: *Landscape* (1888–90, Ohara Museum of Art, Kurashiki; R 604) and three watercolors ("maisons," "rochers," and "vase de fleurs").[297]

February 19, 1922 Pays Forain 15,000 francs for the rights to publish three hundred studies.[298]

March 25, 1922 Ralph M. Coe of Cleveland, Ohio, pays 215,000 francs for two paintings by Cézanne: *The Pigeon Tower at Bellevue* (1889–90; Cleveland Museum; R 692) and a landscape (probably R 351 or R 546). As is his custom at the time, Vollard charges an additional 1,000 francs per frame. Two days later, sells a framed Cézanne *Mont Sainte-Victoire* (1904–6, Bridge-stone Museum of Art, Tokyo; R 939) to the Japanese collector Zenichiro Hara, Yokohama, for 200,000 francs.[299] On May 2, sells Robert von Hirsch, Frankfurt, another version of Cézanne's *Pigeon Tower* (ca. 1890, Kunstmuseum Basel; R 693), as well as two Renoirs ("Neige au Bois de Boulogne [4477]" and "Femme nue accoudée [4113]") for a total of 350,000 francs.[300]

Ca. May–June 1922 Lectures on Cézanne and Renoir in Strasbourg and Frankfurt.[301]

June 26, 1922 Buys a Van Gogh painting, *Femme dans les blés,* for 3,000 francs from Armand Altmann in Neuilly. This is the same amount Vollard routinely pays Puy for each of the many paintings he purchases during this period.[302]

292. Brassaï (Gyula Halász), Entrance hall of Vollard's home at 28, rue Martignac, 1934. Photograph, 11⅝ x 8⅞ in. (29.5 x 22.5 cm). Private collection

August 1, 1922 Rouault is simultaneously working on four *livres d'artiste* to be published by Éditions Vollard: Alfred Jarry's *Ubu Roi*, Vollard's *Ubu aux colonies*, and his own *Guerre* and *Miserere*: "I hope that in a year or two I can give an important exhibition of these *works and of paintings* on which I am engaged, at the gallery of Ambroise Vollard, 28 rue de Martignac, in his new building."[303]

November 10, 1922 Pays Edgar Malfère 10,000 francs for the rights to publish 500 copies of an illustrated edition of *La Danse macabre* by Félicien Fagus. In return Malfère agrees not to authorize another luxury edition of the book until 1927.[304]

December 5, 1922 Pays Bernard 25,000 francs to illustrate "Fioretti." The book, *Les Petites Fleurs de St. François*, is published in 1928,[305] printing having been completed on August 27 of that year (fig 215).

1923 Throughout the first half of the year, the Japanese artist Bakusen Tsuchida, Kyoto, purchases statuettes by Maillol and Renoir.[306]

May 1923 Organizes a literary prize, the winner to be chosen by a jury of about twenty artists, including Besnard, Paul Chabas, Van Dongen, Matisse, Picasso, Rouault, and Vlaminck. The authors under consideration include Alexandre Arnoux, Canudo, Charles Derennes, Maurice Guierre, Claude Harlès, Marc Lafargue, Paul Léautaud, Edmond Pilon, Achille Segard, André Suarès, Paul Valéry, and Henri Vincent. Valéry wins by a wide margin.[307] Within a few years Vollard proposes that Besnard illustrate one of Valéry's books; the project is never realized, but in 1936 Vollard publishes Valéry's text *Degas, Danse, Dessin*.[308]

May 4, 1923 Oskar Reinhart, Wintherthur, purchases one bronze and two paintings by Renoir and three watercolors by Cézanne for a total of 580,000 francs.[309]

June 3, 1923 Pays Matisse 1,000 francs for an etching to be included in an album of engravings. Vollard explains the project to Denis: "I am following up the litho albums by various artists that I published in the old days . . . with an album of etchings, and I don't need to tell you that it will mean a lot to me to have a plate by you, in black and white, of course. Bonnard, Roussel, Vuillard, Matisse, L. Simon, [and] Rouault, among others have agreed to collaborate. At a time when there are complaints about professional etchers growing weak, it strikes me of the utmost interest to show that painters can indeed make etchings. My format is *format raisin*. So it would be good if the subject is no wider than 40 centimeters. I am anticipating making an album with about 25 or 30 names. The edition will be about 200 copies, with the plates cancelled afterward. A last detail: I have structured the project so that each artist will receive one thousand francs per plate. I am well aware that it is not much. Finally, if I can have something from you, a Brittany beach or a view of Italy or really anything you choose would make me particularly happy."[310] It is unclear how the album of nudes that Vollard was also planning at about this time relates to this project.

Contributors to the projected "album of one hundred etchings by painters" include Camoin ("Les 2 amies" [paid on April 22, 1923]), Marc Chagall ("L'Acrobate au violin" [paid on January 21, 1924]), Denis ("La Madone au jardin fleuri"), Van Dongen ("Torse de jeune fille" [paid on April 26, 1923] and "Mouettes à Deauville" [paid on May 14, 1924]), Jules Flandrin ("Le Depart de Diane" and "Pâturage" [one of which was paid on June 27, 1923]), Tsuguharu Foujita (a self-portrait [paid on March 26, 1925]), Guillaumin (paid on December 21, 1922), Laprade (paid on October 11, 1923), Albert Marquet ("Vue de Notre Dame" [paid on June 25, 1923]), Henri Martin ("Vue d'un jardin avec bassin" [paid on February 28, 1923]), Marval (two plates, one of which is "Paysage" [paid on June 27, 1923]), Matisse (paid on June 3, 1923), Picasso ("L'Atelier" and "Homme et femme"), Roussel ("Le Jeux de l'amour" [paid on April 1, 1923]); Lucien Simon ("Chevaux à la campagne" [one of two plates sold on July 2, 1924]), and Vlaminck ("La Plaine de Boissy-les-Perches" [paid on October 19, 1923]).[311]

June 18, 1923 Asks Picasso to sign the back of a painting he has sold to a Czechoslovakian museum, probably one of the two Picassos Kramář purchases on August 4: "Nu assis," 1906 (45,000 francs), and "Paysage," 1909 (3,600 francs), both of which are signed on the verso.[312] In December Vollard lends paintings by Cézanne, Corot, and Picasso to an exhibition in Prague.[313]

July 28, 1923 Offers the Union Centrale des Arts Décoratifs, Paris, two panels by Forain ("La Bicycliste" and "La Femme aux courses," maquettes for the faience decoration of the Café Riche), two paintings by Valtat (a large oil, "Fleurs," and a decorative landscape), and a large drawing by Degas ("Femmes se baignant").[314]

October 16, 1923 Sells Georges Bernheim two Cézannes ("femme assise/femme à la poupée" and "paysage") for 275,000 francs and buys from him Cézanne's four early paintings *The Four Seasons* (1860–61, Musée de la Ville de Paris, Petit Palais, fig. 266) for 75,000 francs. The following day, sells another Cézanne landscape to a Mr. Kridel, New York, for 179,000 francs. By comparison, on November 6, Vollard sells a Picasso "Nu" for 10,000 francs.[315]

November 1923 Sells works to Quinn for 190,000 francs: a Rousseau (80,000 francs), Picasso's "Femme bleue et femme rose"

and "plusieurs personnages" (50,000 francs each), and Picasso's "toile cubiste"and "Léda" (5,000 francs each).[318]

December 8, 1923 Sells a Renoir bronze, "grande Vénus," to the Österreichische Staatsgalerie, Vienna, for 20,000 francs.[317]

December 19, 1923 Pays 6,250 francs to Éditions de la Sirène for the right to publish an edition of 350 copies of Verlaine's *Fêtes galantes*, to be illustrated with twenty-two watercolors by Laprade.[318]

1924 Another inexpensive (8.50 francs per copy) edition of Vollard's *Paul Cézanne. 8 phototypies d'après Cézanne* is published by G. Crès et Cie.[319] The same year Crès publishes Vollard's *Degas (1834–1917)*.[320]

January 3, 1924 Sells two paintings by Rousseau ("femme dans paysage" for 25,000 francs and "nue attaquée par un monstre" for 80,000 francs) to Juliana Force, New York, via De Zayas.[321] One of these is possibly *The Equatorial Jungle* (1909, National Gallery of Art, Washington, D.C.), which is thought to have been purchased from Vollard by Force in 1925.

February 12, 1924 Sells numerous prints and illustrated books, as well as three paintings by Picasso ("3 personnages," "femme assise," and "femme accroupie"), to the art dealer Hugo Perls, Berlin, for 41,460 francs.[322] About the same time, Claude Roger-Marx also buys many prints and print albums.[323] Other dealers who purchase large amounts of work from Vollard in the 1920s include Flechtheim (Berlin), Ernst Arnold (Dresden), Brown & Phillips (London), Leicester Galleries (London), Masamune (Japan), Thannhauser (Lucerne and Munich), E. Weyhe (New York), and De Zayas (New York).[324]

March 21, 1924 Ships to the Galerie Thannhauser, Lucerne, 391,500 francs worth of art: two paintings by Picasso ("buveuse d'absinthe" and "personnages nus et habillés"), two paintings by Cézanne (*Gardanne* [fig. 37] and *Léda aux fruits* [1885–87, Von der Heydt Museum, Wuppertal; R 590]), and three Renoir bronzes.[325]

April 1924 Lends eighteen paintings to the large Maurice Denis retrospective held at the Pavillon de Marsan, Union Centrale des Arts Décoratifs, Paris (April 11–May 11).[326]

May 24, 1924 Sends prints, illustrated books, and sculpture to the Kunsthalle Bremen.[327]

Summer 1924 At the suggestion of poet and writer Marcel Provence, Vollard plans a monument to Cézanne in Aix-en-Provence. Various sites are suggested by Vollard and the mayor of Aix. In December 1924 Vollard writes of a secretive new plan for the monument, to be created by "one of the best artists of our day." (Rouault, the artist in question, visits Aix but ultimately abandons his plans for the work; fig. 293). In 1926 Renoir's medallion portrait of Cézanne is installed as part of an eighteenth-century fountain on the rue des Baigniers. Vollard also presents the city library with a bust of Cézanne by Valtat.[328]

November 7, 1924 The actor Sacha Guitry purchases a Renoir bronze ("Vénus"), one of many sculpture casts that Vollard sells during this period.[329]

November 12, 1924 Signs a contract allowing Le Divan to publish his *Réincarnations du Père Ubu*, which appears the following year. Contract stipulates that the book will be marketed at 7.50 francs per copy and will be printed in an edition of 500, with an additional 200 copies printed, of which 125 are for the press and 75 for Vollard. In addition, Vollard is to receive

10 percent of the sales and a 40 percent discount on any copies he purchases. All rights of translation and/or theatrical adaptation will be equally divided.[330] In 1932 Vollard publishes the luxe version of the book, with etchings and wood engravings by Rouault (fig. 228).[331]

November 14, 1924 Rouault speaks of his relationship with Vollard in *Paris-Journal*: "[I]f I do not exhibit it is because of Vollard. He overloads me with work; he makes me do too many books; he asks me to do a painting for each plate. . . . I am currently illustrating seven books for Vollard. . . . He has some great qualities; he gives me complete freedom, I can do my illustrations exactly as I intend. Besides, his efforts in de luxe editions are not well enough known, but you will see that at the Exhibition of decorative art where he will have an important collection. It was he who enabled Bonnard to do his admirable *Daphnis et Chloé*, and just think that an edition like *Miserere et Guerre* costs three or four hundred thousand francs."[332]

November 21, 1924 Signs a contract with Degas's heirs (Maurice De Gas, Edmond De Gas, Mme Nepveu-Degas, Gabriel Fevre, Henri Fevre, Mlle Madeleine Fevre, and Jeanne Fevre) that allows him to reproduce 250 works by the artist in an edition of no more than 2,000 copies, to be priced at 300 francs each. Agrees to pay half the fee of 8,000 francs at signing of contract and the other half upon the work's publication or on October 31, 1926, whichever comes first. Each of the heirs will receive a copy of the book.[333]

December 29, 1924 Sells landscapes by Cézanne (228,000 francs) and Renoir (190,000 francs) as well as Picasso's "Scène antique" (95,000) to the Barnes Foundation. On July 24, 1925, sends the foundation Cézanne's "La Jardinière" (250,000 francs).[334]

January 31, 1925 Reber spends 35,600 francs on two oils and a sketch by Picasso, as well as a gilt frame. On March 20 Vollard

293. Georges Rouault, *Sketch for the Cézanne Fountain*, undated (transferred from the artist to Vollard on July 12, 1938). Oil on canvas, 41⅜ x 29½ in. (105 x 75 cm). Private collection, Japan

sells another Picasso and a Rousseau to Paul Guillaume for 8,500 francs and on April 3, another Picasso to Guillaume for 4,000 francs. Reber is sent additional Picasso paintings on May 30 (30,000 francs), August 13 (two for a total of 50,000 francs), March 1, 1926 (two for a total of 42,000 francs), and May 24, 1927 (a painting valued at 40,000 francs and a bust at 9,000).[335]

February 5, 1925 Pays his good friend Mme de Galéa (née Morau) 250,000 francs for Renoir's portrait of her (fig. 22) plus three works on paper by Degas.[336] Over the years, purchases a number of works from Mme de Galéa, including, on September 30, 1926, her portait by Bonnard, for 180,000 francs.[337]

April 28, 1925 Sells print albums by Bonnard, Denis, Picasso, Redon, Roussel, and Vuillard for 6,675 francs to the dealer Alexis Petiet, who buys additional albums on May 5 (1,767.50 francs) and May 20 (11,400 francs). On August 21 Henri Petiet buys thirty-one print albums for 24,000 francs.[338]

May 21, 1925 Is made a knight in the Légion d'Honneur ("homme de lettres et critique d'art").[339] The following year, the topic is addressed by Pinturrichio: "New digression about the Legion of Honor: MM. Bernheim jeune, Blot, Vollard, Hessèle, Schoeller, and still others among the big art dealers have been decorated. It is unfair that M. Paul Rosenberg has not been yet."[340]

June 15, 1925 Adolphe Basler, "Amateurs, curieux et marchands d'art: Monsieur Vollard," appears in *L'Art vivant*.[341]

Summer 1925 Vollard's stand in the "Bibliothèque" section of the Exposition des Arts Décoratifs, Paris, includes Rouault's etchings for *Miserere* and *Guerre*, as well as studies for *Ubu aux colonies*.[342]

August 21, 1925 An advertisement in the *New York Times* (p. 4) lists: "The Art Miser of Paris, Ambroise Vollard, as painted by the famous artist Renoir, to whom Vollard acted as a menial servant. Rotogravure picture in Mid-Week Pictorial, now on sale at leading news stands. 10c."

September 1, 1925 Gives the Musée de Cahors, in southwest France, three paintings: a still life by Laprade, a "marine" by Valtat, and a landscape by Vlaminck.[343]

October 7, 1925 Sends three Renoir statuettes (two "Laveuses" at 6,000 francs each and "Femme nue debout" at 8,000 francs) as well as two copies of his own book on Renoir (300 francs each) to the Städtische Galerie, Frankfurt.[344]

December 23, 1925 Barnes pays the staggering sum of 1,000,000 francs for Cézanne's *Cardplayers* (1890–92, Barnes Foundation; R 706), a painting Vollard had acquired from Cézanne's son on June 18, 1913, for 100,000 francs.[345]

January 30, 1926 In a letter published in *Comoedia*, Rouault writes, "It is said that Mr. Vollard has buried me alive. . . . There is in Mr. Vollard, to be fair, a non-negative and fairly artistic side to which, if I were a chronicler, I would offer a beautiful bouquet of spring flowers to recompense for all the rubbing the wrong way that he gets so often. He will give me an exhibition in less troubled times, when the Franc has stabilized, and if I were to paint Vollard this is the title I would choose: the solitary life of a picture dealer lost in the jungle."[346]

May 1, 1926 Signs a contract with Raoul Dufy and Eugène Montfort regarding the publication of *La Belle Enfant: L'Amour à quarante ans*. Vollard agrees to pay the author 15,000 francs and Dufy 40,000. Additionally both artist and author will receive

copies of the book, which ultimately is published by Vollard in 1930 (fig. 217).[347]

May 4, 1926 Signs a contract with Little, Brown, and Co., Boston, to write his memoirs, the first edition of which is published in English. Receives a $100 advance and is promised $900 on submission of his manuscript as well as twelve copies.[348] *Recollections of a Picture Dealer* is a success when it is published in 1936 and is recommended as summer holiday reading by the London *Times*.[349] The following year, the first French edition of the text, which is slightly expanded, *Souvenirs d'un marchand de tableaux*, is published by Albin Michel, Paris.

Summer 1926 Undertakes work at Bois-Rond, his extensive property in the Fontainebleau Forest. Supposedly his house is constructed atop an ancient rabbit warren, and the unstable foundation leads to its collapse before Vollard has even moved in; it is rebuilt. By this point Vollard also owns an attractive property west of Versailles, in the village of Tremblay-sur-Mauldre (fig. 294).[350]

August 4, 1926 Signs a contract with Mme Veuve Halévy to publish an edition of between 400 and 500 copies of her late husband's short stories, *La Famille Cardinal* and/or *Les Petites Cardinal*, illustrated with artwork by Degas. The contract stipulates that Mme Halévy will withdraw her opposition to the sale of the illustrations that Degas made for Halévy's "Les Petites Cardinal." In exchange she will receive three copies of the publication and half of the author's rights, amounting to no less than 30,000 francs.[351] On January 22, 1927, Vollard signs a contract with Edmond Degas regarding the same project and pays 20,000 francs for the rights to reproduce the artwork.[352]

February 1927 Although a printing date of December 15, 1923, is listed in copies of Mirbeau's *Dingo* (fig. 295), with illustrations by Bonnard, the book is not published until early 1927. Vollard charges 1,122 francs per copy on velin paper and twice that for the copies on japan paper. He often provides professional discounts. Purchasers include many Parisian bookstores and galleries: Aux Bons Livres, Blaizot, Blancheterre, Boisseau, Bonald Davis, Bonneau Libraire, Boutitie Éditeur, Caffin Librairie, Camille Bloch, Carteret Librairie, Crès, Flammarion, Fleury, Gallimard, Georg Rauch Libraire, Gonin, Guerguin, Hachette, Helft, René Hilsum, Hélène Legendre, Librairie des Champs Elysées, Librairie Los, Martin Libraire, Martineau Librairie, Meynial Libraire, Miguet, Palais de la Noveauté, Pellequer, Petiet, Poyet, Terquonu. On February 19 Roger-Marx receives the critics' discount of 50 percent for two copies. By late March Vollard sells copies to bookstores throughout France and Europe.[353]

February 8, 1927 Presents to the Musées Nationaux, Paris, Gauguin's *La Belle Angèle (Madame Angèle Satre, 1868–1932)* (fig. 28), one of the first Gauguins to enter the state's collection.[354]

March 11, 1927 Signs a contract with Éditions Émile Paul Frères to publish 250 copies of his *Sainte Monique*. Vollard will receive fifty free copies and a 40 percent discount off any he purchases. A certain number of copies will be printed on luxury paper, and 10 percent of those will be given to Vollard as well.[355] Vollard's luxe version with illustrations by Bonnard is published in late 1930 and draws the wrath of the Vatican.[356]

May 1927 Maillol works on his illustrations for Ronsard's *Livret de folastries*. The book is complete but not published at the time of Vollard's death in 1939.[357]

June 13, 1927 Sends his portrait by Renoir (fig. 296) to the British textile magnate Samuel Courtauld, for 800,000 francs.[358] On

294. Vollard's home at Tremblay-sur-Mauldre, 1936. Photograph. Musée Picasso, Paris

March 20, 1929, sells Courtauld a Seurat for 124,295 francs (possibly *Man in a Boat,* Courtauld Institute of Art, London).[359]

July 3, 1927 Pays Picasso 260,000 francs, presumably for permission to reproduce the artist's watercolors painted in Spain about 1905, which are already in Vollard's possession.[360]

August 4, 1927 Pays the Bibliothèque Nationale de France 55,095 francs to print the text of 400 copies of *Fleurs du mal*. The project, ultimately unrealized, is to be illustrated with engravings by Rouault.[361]

January 1928 Funds a "Prix Paul Cézanne" at the Lycée Mignet, Aix-en-Provence, and possibly also at the Université Aix-Marseille.[362]

January 17, 1928 Sells Cézanne's *Cardplayer* (1890–92, Berggruen Collection; R 709) for 360,000 francs, as well as a Cézanne watercolor, five Picasso albums, and a Valtat to the "maison Thannhauser." Heinrich Thannhauser and his son Justin are two of the many dealers who purchase extensively from Vollard during the 1920s and 1930s.[363]

January 26, 1928 Spends 169,570.50 francs on four paintings and three drawings by Degas at the posthumous sale of the artist's brother, René.[364]

February–March 1928 Acts as an expert in regard to the posthumous sale of Théodore Duret's collection, held on March 1, and consequently is involved in Jacob Baart de la Faille's accusation that a Van Gogh drawing in the sale (no. 40, sold to Guillaume Lerolle for 13,500 francs) is a fake.[365]

April 28, 1928 Pays Puy 6,000 francs for seventeen lithographs made for an illustrated edition of *Candide*, which is never realized.[366]

April 30, 1928 Musée des Arts Décoratifs, Paris, officially accepts Vollard's gift of Forain's "Le Souper," a study for a ceramic panel intended for the Café Riche, Paris.[367]

May 15, 1928 His gift to the Musée de Grenoble of ninety-six Chagall engravings made for Nikolai Gogol's *Âmes Mortes (Dead Souls)* is acknowledged by the mayor of the city. The book remains unpublished during Vollard's lifetime and finally appears twenty years later, published by Tériade.[368] The year after Vollard's death, his brother Lucien honors his memory by presenting the museum with a number of *livres d'artiste* and twelve ceramics by Derain, Laprade, Matisse, Valtat, and Vlaminck.

295. Pierre Bonnard, *Dingo*, by Octave Mirbeau. Published by Ambroise Vollard, Éditeur, Paris, 1924 ("Achevé d'imprimer": December 15, 1923). Etching facing page 46, image 11¼ x 9 in. (28.6 x 22.9 cm), page 14¾ x 10¾ in. (37.5 x 27.3 cm). The Metropolitan Museum of Art, New York, Harris Brisbane Dick Fund, 1928 (28.90.2)

June 7, 1928 The printer Georges Aubert acknowledges receiving an album containing forty-four pages of Picasso drawings for reproduction.[369]

June 15, 1928 Final printing of Verlaine's *Fêtes galantes*, illustrated by Laprade.[370]

September 26, 1928 Ruth and Harry Bakwin, doctors from New York, purchase two Cézannes (*Italian Woman at a Table* [ca. 1895–1900, J. Paul Getty Museum, Los Angeles; R 812] for 1,400,000 francs and *Sous-Bois* [1893–94, Los Angeles County Museum of Art; R 815] for 500,000 francs), and Renoir's *In the Rose Garden (Mme Léon Clapisson)* (1882, formerly Steve Wynn Collection, Las Vegas; D 428) (600,000 francs).[371] Ruth Bakwin, who had been introduced to Vollard by Pach the previous year, recalled:

Vollard was a big man who always wore a beret. He enjoyed acting sullen and arbitrary. Doing business with Vollard was always something of a feat because most of the time he discouraged buyers from purchasing one of his paintings.

. . . 28 rue Martignac had a gallery on the first floor and living quarters on the second floor. It was much larger and he did give several shows in the gallery. You viewed the paintings and later on made an appointment to buy the painting in which you were interested. He never sold anything at a show. On the second floor, there was a large room with a closet at the end in which all the paintings were kept. Vollard never let you look inside the closet and would only bring out what he wanted to show you. . . .

If we saw something that we liked, Harry and I would go away and talk about it. We'd then come back, not showing much interest in it the first few times. Many times when we came back, Vollard would say that he didn't have that painting anymore, but we could see it sticking out of the end of the closet. So, we knew that he did

have it, but didn't want to sell it that day. We'd then come back another day when he was more agreeable.

Doing business with him was always interesting. We bought the "Sous-Bois" by Cézanne from him in the 1920s. He didn't want me to write a check for the total amount of the same because he would have to pay tax on the total sum. Everything became quite complicated. . . . It was finally decided that I would write two checks—a certain amount in one check and then another portion of the total would be written up as crating and moving. . . .

As we came to know him better, Vollard became aware that we were doctors and would quietly ask Harry for advice. Vollard's back bothered him and he sought help for his ailment constantly. He had exhausted the medical advice given to him in Paris and now thought my husband could help him.

Well, we didn't know any more than the doctors in Paris, but Harry prescribed an ointment for Vollard's back. We searched and found something that could be rubbed on the back to give him relief from his back pain. It was simply a common ointment, but Vollard claimed it was the only thing that had ever helped him.

After that, whenever we called to see a painting, Vollard had us come right over and asked Harry to bring more of that fabulous ointment with him. My husband was one of the most honest men I've ever known and this bothered him a great deal.[372]

January 6, 1929 Death of Louisine Havemeyer, who bequeaths the majority of her collection to the Metropolitan Museum.[373] In one of the many articles published on the topic, Edith de Terey recounts that "one day she [Mrs. Havemeyer] entered Monsieur Vollard's gallery in Paris. 'I am Mrs. Havemeyer,' she said, 'and would like to see your Cézannes.' Vollard, who at that time was the sole proud owner of Cézanne's pictures (having bought up his entire studio), asked the lady to be seated. He left her to continue a conversation with an artist. Half an hour elapsed. The young lady rose and said she had not much time left. Monsieur Vollard asked her to remain seated and resumed his conversation with the artist. Another half hour passed, and then Mrs. Havemeyer said that in an hour her boat was due to sail. Vollard politely answered: 'Madame, I am certain that you could take another boat.' She did."[374]

April 8, 1929 Pays 100,000 francs for the purchase of and reproduction rights to Picasso's copy of Gauguin's *Noa Noa*, which Picasso has highlighted with drawings and watercolors.[375] On August 21, pays Éditions Georges Crès et Cie 15,000 francs for the rights to reproduce *Noa Noa*.[376]

April 27, 1929 Gaston Lévy buys five Bonnard paintings for 52,000 francs.[377]

September 12, 1929 Sends Robert Lehman, New York, four paintings by Renoir: "Loge," *Figures on the Beach, Young Girl Bathing*, and *Versailles* (the last three of which are in the Metropolitan Museum) for a total of 460,000 francs.[378]

December 1929 His eleven-page text "Quelques souvenirs sur Cézanne" appears as the introduction to "Exposition Cézanne, 1839–1906," at the Galerie Pigalle, Paris. Vollard is listed as one of organizers of the exhibition.

December 15, 1929 Vollard, "Comment je devins éditeur," appears in *L'Art vivant* (December 15, 1929), pp. 979–80.

Late January 1930 Undergoes eye surgery, which necessitates a stay of almost two weeks at a clinic.[379]

January 30, 1930 Reports that he is busy with the exhibition "Bonnard, Maurice Denis, A. Maillol, K.-X. Roussel, Sérusier, Vallotton, Vuillard: Sept Artistes contemporains," Galerie Druet, February 10–21, 1930.[380]

March 28, 1930 His gifts to "la Ville de Paris, pour le Palais des Beaux-Arts" of a Pissarro painting of the artist's wife and a Forain painting, "Dans les coulisses," are accepted.[381]

April 1930 Vollard's essay explaining his choice of Chagall as an illustrator is included as the preface to "La Fontaine par Chagall: 100 Fables," Galerie Bernheim-Jeune, Paris. In December 1929 Vollard had sold Bernheim-Jeune most of Chagall's color gouaches made as illustrations for an edition of La Fontaine's *Fables* that Vollard was producing. Although the etchings were printed about 1927–30, the book is ultimately published by Tériade in 1952.[382]

July 30, 1930 Writes Wilfrid Meynell, Sussex, about the rights to publish an edition of Francis Thompson's *Poèmes*. Vollard anticipates an edition of 300 to 400 copies and offers to pay 3,000 francs for the rights to the text.[383] On November 25, 1931, Denis's wife is paid 10,000 francs for her translation; her husband creates the illustrations.[384] The book is published by Lucien Vollard and Martin Fabiani in 1942.[385]

August 4, 1930 Pays 10,000 francs for the rights to publish Pierre Louÿs's *Mimes des courtisanes* in an edition of 305 copies, each to be sold for no less than 200 francs. Vollard pairs the text with illustrations after Degas's monotypes.[386]

October 10, 1930 Pays Bonnard 46,200 francs for illustrations of Vollard's text *Sainte Monique*.[387]

November 15, 1930 Homer's *L'Odyssée* with illustrations by Bernard (fig. 216) has its final printing.

December 15, 1930–January 15, 1931 Exhibition celebrating Vollard's editions (primarily *livres d'artiste*, but prints and sculpture as well)—"Éditions Ambroise Vollard"—is held at the gallery Le Portique, Paris. The sixty-nine-page catalogue reprints

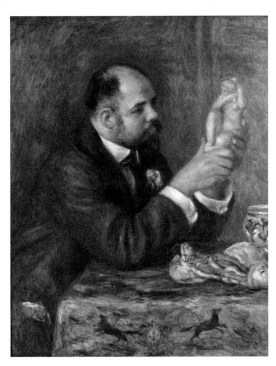

296. Auguste Renoir, *Ambroise Vollard*, 1908. Oil on canvas, 32⅛ x 25⅝ in. (81.6 x 65.2 cm). The Samuel Courtauld Trust, Courtauld Institute of Art Gallery, London, Gift of Samuel Courtauld, 1932 (P.1932.SC.340)

Vollard's essay from *L'Art vivant* (December 15, 1929). The show is heavily reviewed by international critics: "The most beautiful illustrated French books during the past thirty or forty years have been published by M. Ambroise Vollard. . . . Books and edited etchings by M. Vollard at the Galerie de Portique constitute one of the most interesting of the current exhibitions where one also admires certain bronzes of Renoir, Maillol and Picasso. M. Vollard has done for French sculpture and painting since Cézanne what Diaghalieff [*sic*] did for music since Debussy."[388]

1930s Throughout the decade, Vollard lends to numerous international exhibitions, including: "Masterpieces by Nineteenth-Century French Painters," Knoedler Galleries, New York (October–November 1930); "L'École de Paris; Francouzské moderní umění," Prague (1931); "Exposition Renoir," Galerie Braun & Co., Paris (November–December 1932); "Henri Rousseau," Kunsthalle Basel (March 1–April 2, 1933); "Exposición de arte francés contemporáneo," Museu Nacional de Arte Moderno y Sociedad Española de Amigo del Arte, Madrid (April–May 1933); "Réhabilitation du sujet," André J. Seligmann, Paris (November 17–December 9, 1934); "Meisterzeichnungen französischer Künstler von Ingres bis Cézanne," Kunsthalle Basel (June 29–August 18, 1935); "Paul Gauguin, 1848–1903," Wildenstein and Company, New York (March 20–April 18, 1936) and Fogg Art Museum, Harvard University (May 1–21, 1936); "Exposition de la peinture française, de Manet à nos jours," Muzeum Narodowe, Warsaw (February–March 1937); "Les Maîtres de l'art indépendant, 1857–1937," Musée du Petit Palais (June–October 1937); "International Exhibition of Paintings," Carnegie Institute, Pittsburgh (October 14–December 5, 1937); exhibition at the Société des Arts, Mulhouse (late November–December 1937); "Degas," Musée de l'Orangerie, Paris (March–April 1937); "The Prints of Georges Rouault," Museum of Modern Art, New York (1938); Renoir retrospective at the Venice Biennale (summer 1938); "International Exhibition of Paintings," Carnegie Institute (October 13–December 4, 1938); "Art sacré moderne," Musée des Arts Décoratifs, Paris (November 1938–January 1939); "Degas: Peintre du mouvement," Galerie André Weil, Paris (June 9–30, 1939).

1931 Vollard's "Souvenirs sur Cézanne" appears in *Cahiers d'art* (1931), pp. 386–95.

Late winter–spring 1931 Offers art to the City of Paris. A Renoir statue of a female nude is considered for the site of a former gas factory in Passy. The City rejects some works; others are accepted for the Petit Palais: Denis's *Sous-Bois*, Vlaminck's *La Péniche*, Roussel's pastel *Scène antique*, Forain's gouache *La Femme aux champs*, and Valtat's painting *Riviera*. Two others—Laprade's *La Femme à la fleur* and Marval's *Les Enfants dans un jardin*—are accepted but not assigned to a specific museum.[389]

February 1931 Marcel Zahar publishes an interview with Vollard about his editions.[390]

May-August 1931 Exhibits at the Salon International du Livre d'Art. Included are trial proofs of André Dunoyer de Segonzac's illustrations for Virgil's *Les Géorgiques*. The book is ultimately published by the artist in the mid-1940s.[391]

June 3, 1931 Sells property at Montesson, a suburb northwest of Paris.[392]

Summer 1931 Wins a prize at the Exposition Coloniale, Paris.[393]

September 1931 Marie Dormoy's "Ambroise Vollard's Private Collection" appears in *Formes*.[394]

November 23, 1931 Aimé Jourde sends an invoice for 47,690 francs for printing the text and wood engravings of Balzac's

Le Chef-d'oeuvre inconnu, with artwork by Picasso (figs. 119, 218). The bill includes printing, corrections, and proofs for 340 copies of the book as well as 1,000 prospectuses.[395] Louis Fort prints the etchings, for whifch Vollard is billed separately.

After 1931 For the last eight years of his life, Vollard is a regular guest at Georges Wildenstein's Sunday dinners. Georges's son, Daniel, remembers Vollard as

massive, with a baritone voice, small beard, and a beret that covered his bald spot. Also, he was deathly afraid of catching a cold. He wore his beret all year long. He only took it off when he posed for Renoir or Bonnard. . . . When I knew him he was a rich millionaire and pathologically stingy. . . . He loved beautiful books and had a passion for publishing. That is something he shared in common with my father. They enjoyed discussing the choice of typography, type size, alphabet [and] from whom one would order it. . . . He was extremely generous and nice to those with whom he worked on his books. . . . We would go to his place one or two times a week to attempt to buy a painting from him. . . . Everything was always on the ground, in piles. Nothing was framed. He loved his stock. The more his holdings increased, the happier he was: you could see it on his face. . . . If you wanted to buy a Cézanne from him, you needed to ask for a Renoir. Not a Cézanne, certainly not that. A Renoir. . . . And then, with a little luck, he would take out a Cézanne. . . . He was gruff, often disagreeable with those he didn't know, and he was terrified that someone would steal from him. Other than that, he was sensitive to others, simple, and particularly funny. . . . He loved to talk."[396]

January 1932 Presents the Bibliothèque Nationale with five *livres d'artiste*: Montfort's *La Belle Enfant*, illustrated by Raoul Dufy; Vollard's *Sainte Monique*, illustrated by Bonnard; Verlaine's *Fêtes galantes*, illustrated by Laprade; Homer's *Odyssée*, illustrated by Bernard; and Balzac's *Le Chef-d'oeuvre inconnu*, illustrated by Picasso (figs. 217, 216, 119, 218). The curator of the Cabinet des Estampes writes, "These magnificent volumes render great honor to you and occupy a very important place in the history of contemporary illustration."[397] In mid-March 1930 Vollard had presented the Bibliothèque with a copy of *Les Petites Fleurs de St. François* (illustrated by Bernard; fig. 215).[398]

June 20, 1932 Pays Chagall 22,500 francs for seven etching plates for *La Bible*, a project left incomplete at Vollard's death.[399]

August 2, 1932 "Aux Deux Ours," the printing studio run by Aimé Jourde, sends an invoice for 779,548.20 francs for work on various *livres d'artiste*: "*Père Ubu (petit format), Réincarnations du Père Ubu, Sainte Monique, L'Odyssé [sic] d'Homère, Cirque, Chef d'Oeuvre inconnu, Sainte Monique (prospectus), Fioretti, Eaux-fortes (repiquage)*."[400]

1933 Art dealer Berthe Weill writes disparagingly of Vollard (whom she refers to as "Dolikhos," Greek for "the crafty one") in her memoir, *Pan! Dans l'oeil*, published this year.

January 1933 Exhibition devoted to Éditions Vollard is held at the Palais des Beaux-Arts, Brussels.[401]

November 6–December 3, 1933 The much-anticipated and heavily reviewed "Paintings from the Ambroise Vollard Collection" is held at Knoedler Galleries, New York, before traveling to the Arts and Craft Club, Detroit. Catalogue contains an introduction by Étienne Bignou and a foreword by Barnes, which is reprinted the following year in *The London Studio*.[402]

February 19, 1934 Notes a payment to Picasso of 210,000 francs for seventy etching plates, but that same day Picasso "purchases" 210,000 francs of art: a Renoir and a Cézanne.[403]

March 13, 1934 Gimpel sees Braque's illustrations for Hesiod's *La Théogonie*, commissioned by Vollard but not published during his lifetime: "When some moments later I saw the painter's designs, I understood how he could illustrate this work. His design was a sort of amplification of Greek letters, his lines, at first glance, appearing as incomprehensible as the reading of that language to someone who hasn't studied it; a mingling of strokes and unending curves, in which silhouettes of people and things are barely there. It has the spirit of Gothic illuminated lettering, with its intricate tracery, but transposed into a Grecian mold by a modern artist who knows cubism and surrealism; I felt that this interpretation, allowing full play to the imagination, was nearer the texts than an illustration, in the eighteenth-century manner, of episodes of Roman history or mythology."[404]

March 23, 1934 Agrees to pay Derain 75,000 francs (35,000 as an advance and 40,000 in late June 1934) for about seventy original lithographs to illustrate the "Contes de la Fontaine."[405] The book is unfinished at Vollard's death.[406]

June 11, 1934 Sends thirteen paintings on consignment to Bignou, New York: six Cézannes, six Renoirs, and one Degas, worth a total of 950,000 francs.[407]

October 12, 1934 Vollard's "Renoir sculpteur" appears in *Beaux-arts magazine* (October 12, 1934), p. 1. Texts by Vollard and Raymond Cogniat are published in the exhibition catalogue, *Renoir l'oeuvre sculpté, l'oeuvre gravé, aquarelles et dessins*, Musée des Beaux-Arts, Paris, October 15–November 10.

January 31, 1935 Tax document lists Vollard's full-time salaried employees during 1934: three employees who live and work at 28, rue Martignac: Henri Coulie (also spelled Coulier; concierge and storage watchman), Eugénie Duboux (cook), and Aline Frequant (chambermaid); Marcel Delarue, live-in gardener at Tremblay-sur-Mauldre; Alexandre Peureau, live-in watchman at Bois-Rond, near Barbizon; Charlotte Augras, typist; Céline Dumont, housekeeper; and Marcel Zeien, chauffeur. Also listed as employees are Maurice Heine, a proofreader who assists with various aspects of Vollard's *livres d'artiste*, and M. Galanis, a printer. The annual wages total 92,840 francs. Similar documents for the years 1935–38 list art dealers, authors, and other people Vollard pays for their services.[408]

May 3, 1935 Receives a "sommation interpellative" from Redon's son, Arï, who has just learned of Vollard's imminent plans to publish Gustave Flaubert's *Tentation de Saint-Antoine* with original lithographs by Redon. Arï Redon reminds Vollard that the artist's estate must give permission for such an edition and also approve the proofs.[409]

June 12, 1935 Although he no longer represents Puy, Vollard nominates him for the Prix Paul Guillaume.[410]

August 5, 1935 Pays Derain 10,000 of a promised 75,000 francs for his illustrations for Petronius's *Satyricon*. The book is still unpublished at the time of Vollard's death.[411]

Late 1935 Vollard's "Souvenirs sur Cézanne" appears in *Minotaure* (1935), pp. 13–16.

December 31, 1935 In a tax document, Vollard estimates that he owns paintings worth 11,837,893.15 francs and inventoried books and prints worth 1,564,431.40 francs. Including all the unpublished works in progress, estimates the value of his stock

at 22,503,741.75 francs and reports selling 1,528,725 francs worth of art this year.[412]

January 1936 Exhibits works by Degas at his *hôtel particulier* at 28, rue Martignac.[413] Is known to host other exhibitions at this address, although no catalogues have been located.[414]

April 7–September 2, 1936 "Modern Painters and Sculptors as Illustrators" is shown at the Museum of Modern Art, New York. Exhibition includes many examples of Vollard's books, both published and unpublished, and catalogue is dedicated to him. The well-attended exhibition piques American interest in Vollard's publications; gratified, Vollard and Rouault present the museum with a series of Rouault's prints: "31 very rare inscribed proofs for the great *Miserere et Guerre*."[415]

May 1936 Claude Roger-Marx's "Un Grand Éditeur: Ambroise Vollard" appears in *L'Art vivant*.[416]

June 4, 1936 Pays Picasso 180,000 francs for thirty etched plates of animals. These images are intended as illustrations for the Comte de Buffon's *Eaux-fortes originales pour des textes de Buffon* (*Histoire naturelle*), which is ultimately published by Martin Fabiani in 1942 (figs. 120, 219).[417]

July 6, 1936 Sells twelve paintings and two watercolors (nine Cézannes, two Gauguins, and three Renoirs) to Alex Reid & Lefevre Ltd. for 155,000 francs. The document on which this information is recorded lists other (but by no means all) sales made by Vollard between 1935 and 1939.[418]

September 1936 Travels to Rome to present the pope with the first numbered copy of *L'Imitation de Jésus-Christ*, illustrated by Denis (1903; fig. 212).[419]

October 27, 1936 Possibly in hopes of wooing his growing American clientele, Vollard visits the United States for his first and only time. On October 28 he gives interviews at the Bignou Gallery, New York, in advance of "Paul Cezanne (1839–1906)," which will open at the gallery in November.[420] On November 8 he lectures at the Barnes Foundation,[421] and on November 10 gives a radio interview on WINS. Departs for France the next day.[422]

December 1936 Sales this month include two Renoirs (30,000 francs) to Bernheim-Jeune et Cie; two Renoirs to M. Pierre (65,000 francs); Degas's *Racehorses*, and seven drawings highlighted with watercolor or pastel by Pissarro (10,000 and 3,050 francs, respectively) to Étienne Bignou; and Rousseau's large "combat de fauves dans la forêt" (3 x 2 meters) (80,000 francs) to Mme Gregory, Paris.[423]

December 31, 1936 In a tax document, Vollard estimates that he owns paintings worth 11,072,534.15 francs and inventoried books and prints worth 1,563,437.40 francs. Including all the unpublished works in progress, estimates the value of his stock at 22,576,924.35 francs and reports selling 1,591,239 francs worth of art this year.[424]

February 13, 1937 Signs a contract with Éditions Bernard Grasset for *En Écoutant Cézanne, Degas, Renoir*. Negotiates 6,000 francs plus 10 percent of all copies sold. Also receives twelve copies, with a 40 percent discount on any additional copies he purchases.[425] The book is published the following year.

March 1, 1937 Valéry acknowledges receipt of his copy of *Degas, Danse, Dessin*. He feels it is a pity that the three D's in large capitals (with the full words in smaller type) was not used as

the design for title. He wants final payment of 15,000 francs and three copies of the book.[426]

March 4, 1937 Picasso executes four portraits of Vollard (figs. 121–124) based on a photograph (fig. 297). Three are selected to complete the *Vollard Suite*, which is printed and published in 1939.

April 29, 1937 Raymond Escholier, curator of the Musée du Petit Palais, writes of works Vollard has offered as a gift to the museum: ten paintings by Derain, a stone sculpture by Modigliani, one painting and two sculptures by Picasso, five paintings by Puy, and ten paintings by Vlaminck. In May Escholier requests additional works as loans.[427]

June–October 1937 Works on the organizing committee of and lends to "Les Maîtres de l'art indépendant, 1895–1937," held at the Petit Palais during the Exposition Internationale des Arts et Techniques dans la Vie Moderne. According to the catalogue Vollard lends almost fifty works by Bernard, Bonnard, Derain, Maillol, Picasso, Puy, Rouault, Roussel, Valtat, and Vlaminck.[428]

June 16, 1938 After watching Bernard's play *Les Modernes* in the artist's studio, writes a tribute: "Your paintings of the early years . . . used to take me aback a bit, with their flat color: it reminded me of wallpaper. But I ended up seeing that, in order to revive the tradition, one had to start by stripping painting of all the great masters' tricks; that, to put it simply, one had to turn away from official art."[429] The three-act comedy, published by Bernard on April 24, 1938, contains a preface by Vollard.

August 4, 1938 Imprimerie Bibliophile Aimé Jourde bills Vollard for work on three book projects: Chagall's illustrated edition of La Fontaine's *Fables*; Laprade's edition of Gérard de Nerval's *Sylvie*, the printing of which was completed on April 30, 1938 (fig. 298); and Dufy's edition of Édouard Herriot's *Dans la forêt normande*.[430]

September 15, 1938 Vollard's "Mes Portraits" appears in *Arts et métiers graphiques* 64 (September 15, 1938), pp. 39–44, and *Verve* (1939), p. 134.

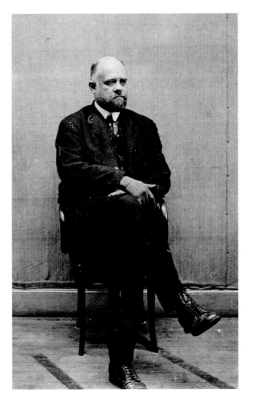

297. Thérèse Bonney, *Ambroise Vollard*, ca. 1915. Photograph. Vollard Archives, MS 421 (3,9), fol. 10

Fall 1938 Lends prints and books to Cercle de la Librairie for an exhibition in Bucharest.[431]

December 27, 1938 At Roger Lacourière's studio, Rouault examines prints for his two books that will soon be published: *Cirque de l'étoile filante* (with a text by Rouault) and *Passion* (with a text by Suarès).[432]

1939 Tax documents list Vollard's reported monthly profits during the first half of the year. January: 29,512 francs worth of *livres d'artiste* (minus 50 percent, possibly for dealer discounts) plus 36,500 francs of paintings (two Gauguins, a Renoir, and a Picasso to Bignou). February: 2,675 francs worth of *livres d'artiste* (minus 50 percent) plus 6,000 francs of paintings (three Picassos and a Cézanne). March: 79,450 francs of *livres d'artiste* (minus 50 percent) plus 11,500 francs (two Maillol statuettes and one Renoir print). April: 52,375 francs of *livres d'artiste* (minus 50 percent) plus 4,000 francs (for one Vuillard album and 10,500 francs of paintings (six Daumiers). May: 73,025 francs of *livres d'artiste* (minus 50 percent) plus 28,000 francs of paintings (four Renoirs). June: 78,040.70 francs of *livres d'artiste* (minus 50 percent) plus two of Picasso's Saltimbanques series (2,500 francs each). July: 13,500 francs of *livres d'artiste* (minus 50 percent) plus 36,175 francs (two Maillol statuettes, one Picasso statuette, two suites of Picasso prints, one Vuillard album).[433]

Early 1939 Offers extensive loans to the organizers of the French Section of the New York World's Fair.[434]

Ca. spring 1939 Picasso purchases Matisse's *Bouquet of Flowers in a Chocolate Pot* (fig. 151) from Vollard.

March 1, 1939 Vollard's "Cézanne, Champsaur et la beauté" appears in *Candide* (March 1, 1939).

April 19, 1939 Pierre Matisse orders additional copies of Rouault's *Cirque de l'étoile filante* and *Passion* (figs. 177, 220, 185) and asks if he may represent Éditions Vollard in America.[435]

April 25, 1939 Lectures in Strasbourg at the Société des Amis des Arts in connection with an exhibition of his publications at the Librairie de la Mésange in that city.[436]

July 21, 1939 According to Vollard's chauffeur, the car he is driving at Tremblay-sur-Mauldre crashes at approximately 1:05 P.M. on the "route Verte" between Trappes and Pontchartrain, just past the Shell service station. Vollard is alone in the back seat when the car skids on the wet road, hits an obstacle of some sort, and then flips over twice. Seriously injured, Vollard is taken by ambulance to a clinic in Versailles, where he dies at 2:40 A.M. on July 22.[437]

July 22, 1939 News of Vollard's unexpected death circulates through the art community. Gimpel writes, "Vollard is dead. He died yesterday in Versailles as the result of a fall. . . . Marie Dormoy had acted as his secretary and had copied out his journal, his memoirs. I scarcely knew Vollard; he was a sort of alert old bear. He was the first to recognize the talent of Cézanne, Gauguin, Douanier Rousseau, and by collecting their canvases he made a fortune. Publishing was his hobby and he was remarkably good at it. At Gleizes' I was told that he was beastly to artists, that only Picasso was paid in full, at 20,000 francs a copperplate, or a total of 600,000 francs."[438] Three days later Suarès writes Rouault, "No one, ever, will be able to follow in Vollard's footsteps in the publishing of our work. What will happen? I dread an irreparable catastrophe. Five works of mine were put into his hands. Our two volumes, those colossus [*sic*], would have been

GÉRARD DE NERVAL

SYLVIE

ILLUSTRATIONS
DE
PIERRE LAPRADE

PARIS
AMBROISE VOLLARD, ÉDITEUR
28, RUE DE MARTIGNAC, 28.
MCMXXXVIII

298. Pierre Laprade, *Sylvie*, by Gérard de Nerval (Gérard Labrunie). Published by Ambroise Vollard, Éditeur, Lucien Vollard, and Martin Fabiani, Paris, 1940 ("Achevé d'imprimer": April 30, 1938). Title page, 13 ¼ x 10 ¼ in. (33.7 x 26 cm). The Museum of Modern Art, New York, The Louis E. Stern Collection, 1964 (873.1964.1–38)

more than just books: they would have been monuments. And *Cirque* would have been published at the end of the year. While my two other poems, *Hélène chez Archimède* and *Minos et Pasiphaé* will not now see the light."[439] Both poems were intended to be embellished with contributions by Picasso.[440]

July 28, 1939 Vollard's funeral is held at 11:00 A.M. at the Église Sainte-Clotilde, Paris, just down the street from his residence. Denis, Picasso, and Rouault are among the artists who attend.[441] Vollard's will, written in 1911, almost thirty years earlier, lists his heirs in the following order: the City of Paris (to which he leaves his portraits by Cézanne and Renoir [figs. 4, 20], Renoir's portrait of Mme de Bonnières [fig. 264], and a choice of a Cézanne, except for the largest); his sisters Antoinette, Jeanne, and Léontine (all residing in Saint-Denis, Réunion); his brother Lucien; M. and Mme de Galéa; their son Robert de Galéa; André Lapierre, his cousin; Emmanuel and Félix Vollard, his brothers (Félix is in Paris); Germaine, the daughter of his brother Louis (Tananarive, Madagascar); his housekeeper Eugénie S. Hott; and Paul Cézanne *fils* (a work valued at 30,000 francs). Robert de Galéa and Cézanne *fils* are named executors in the will, which also includes a request that a series of small, posthumous sales be handled by the Bernheim-Jeune brothers and Durand-Ruel. At the time of Vollard's death, four of the beneficiaries are deceased: Antoinette Vollard, André Lapierre, Emmanuel Vollard, and M. de Galéa *père*.[442]

September 1939 France enters World War II.

November 2, 1939 Escholier, curator of the Musée du Petit Palais, writes Lucien Vollard and proposes a room dedicated to his brother. "I hasten to say that it [is] a wish entertained by Ambroise Vollard during his last years."[443] In May 1940 Lucien gives the museum eighteen paintings and a statuette.

December 15, 1939 Rumors about the dispersal of Vollard's estate continue to circulate: "Are you aware of the enormity of the

estate, discoveries *everywhere*, valuable things, never sold nor noted, discoveries under piles of canvases, priceless, surpassing all calculation. And his daughter, unacknowledged, the heirs: an incredible disorder. . . . Lawsuit after lawsuit will follow."[444]

1940 Between February 8 and March 5, Fabiani, who seems to have acquired more than six hundred pieces of art from Lucien Vollard, sells seventy-seven (one Cézanne, thirty-one Rouaults, forty-three Renoirs, one Toulouse-Lautrec, and Degas's "Jockeys et chevaux" [possibly *Racehorses* (fig. 172)], which is indicated as "one of the most important pieces in the Vollard collection") to Bignou for 1,707,000 francs.[445] Presumably these paintings are included in the shipment detained in Bermuda during the war and stored at the National Gallery of Canada, Ottawa, until after the fighting has ceased. The *Art Digest* announces, "More than 500 paintings and drawings by the modern French masters—possibly part of the famous Ambroise Vollard Collection—have been seized from the American Export Liner, *Excalibur*, at Bermuda by the British censors. Acting on the suspicion that the oils were being sent to America to raise foreign exchange for Germany, the British authorities forced Capt. S. N. Groves to open the freighter's strong box where the paintings [two hundred and seventy Renoirs, thirty Cézannes, twelve Gauguins, and Degases were kept. This is the first seizure of contents of an American ship's strong box in the present war. . . . [T]he collection probably contains part of the huge Ambroise Vollard collection and it is known that Mr. Fabiani has acquired earlier this year a number of the Vollard paintings."[446]

Ca. spring 1940 Erich Chlomovitch, who is reported to have met Vollard sometime between 1935 and 1939, leaves Paris with a significant quantity of art supposedly given to him by Vollard. He exhibits 415 paintings, watercolors, drawings, and books in a fine arts center in Zagreb in 1940; many of these works are now owned by the National Museum, Belgrade. An additional 190 works stored in a safe at the Société Générale bank in Paris are rediscovered when the bank puts the contents of the unpaid vault (rented by Chlomovitch, who died in 1943) up for sale at

Hôtel Drouot, Paris (March 19–20, 1981). Approximately fifteen parties step forward to claim the art, and the matter is settled in court.[447]

1946–47 Rouault sues Vollard's heirs for access to his unfinished paintings. "He [Rouault] considers that he in no way lost his moral right to finish and retouch his pictures when they were sold to M. Vollard. The heirs of M. Vollard . . . maintain that the original contract between M. Vollard and M. Rouault gave them an indisputable right to dispose of these pictures as and when they wish, even though many may not be finished or signed."[448] The courts rule that an artist is the owner of his work until he turns it over unconditionally; Rouault wins the lawsuit.

1957, 1992 Posthumous sales of works from Vollard's estate are held. "Succession A. Vollard, vente par suite d'acceptation bénéficiare," Galerie Charpentier, Paris, on June 25, 1957, includes Derain's carved bed (fig. 299) and Vlaminck's carved and painted table. "Fonds Vollard," Drouot Montaigne, Paris, is held on May 19, 1992. In addition to these specific sales, Vollard's name routinely appears in the provenance of works exhibited and sold.

299. André Derain, *Bed*, 1906–7. Carved wood, 50⅜ x 62¼ x 84¼ in. (128 x 158 x 214 cm). Private collection

In the Chronology, the following abbreviations are used in citing catalogue raisonné numbers: for works by Caillebotte, "B" refers to Berhaut 1994; for works by Cassatt, "B" refers to Breeskin 1979; for works by Cézanne, "R" refers to Rewald 1996; for works by Courbet, "F" refers to Fernier 1977–78; for works by Degas, "L" refers to Lemoisne 1946–49; for works by Gauguin, "W" refers to G. Wildenstein 1964 and "W-2001" refers to D. Wildenstein 2001; for works by Manet, "RW" refers to Rouart and D. Wildenstein 1975; for works by Henri Manguin, "S" refers to Sainsaulieu 1980; for works by Monet, "W" refers to D. Wildenstein 1974–86 and "W-1996" refers to D. Wildenstien 1996; for works by Pissarro, "PS" refers to J. Pissarro and Snollaerts 2005; for works by Renoir, "D" refers to Daulte 1971; and for works by Van Gogh, "F" refers to Faille 1970.

1. Vollard Archives, MS 421 (10,1), fol. 7.

2. Vollard Archives, MS 421 (10,1), fol. 3.

3. Archives Départementales de l'Hérault, Faculté de Droit, Université Montpellier 1, Montpellier.

4. Archives Nationales, Paris, section du XIX^e siècle; Dormoy 1963, p. 138; Vollard 1936, chap. 2; "Diplôme de Licence en Droit": Private archives.

5. Vollard Archives, MS 421 (2,2), p. 145.

6. Vollard Archives, MS 421 (10,6), fol. 1; Pia 1955, p. 21; Dormoy 1963, p. 139.

7. Les Archives de Paris, cadastral register, DIP4, 1876, 37, rue Laffitte.

8. Camille Pissarro to his son Lucien, January 21, 1894, in Rewald and L. Pissaro 1980, p. 227; Mauclair 1894, p. 285.

9. Vollard Archives, MS 421 (2,3), pp. 113–16, and MS 421 (4,3), fols. 1, 2; Vollard 1936, pp. 49–59.

10. Vollard Archives, MS 421 (4,3), fol. 33; MS 421 (3,3), fols. 102–21; Vollard 1924a, p. 81. The definitions of the conservation techniques cited in this entry are hypotheses provided by Ann Hoenigswald, Senior Conservator of Paintings, National Gallery of Art, Washington, D.C.

11. Vollard Archives, MS 421 (4,2), fols. 1, 2; MS 421 (4,11), fols. 23, 63, 86, 90.

12. Mme Veuve Tanguy to Andries Bonger, brother-in-law of Theo van Gogh, June 12, 1894, in Bodelsen 1968, p. 346; Vollard Archives, MS 421 (4,3), fol. 2; Anne Roquebert's essay in this volume, p. 229, n. 31.

13. Vollard Archives, MS 421 (4,2), fols. 4, 9.

14. Vollard Archives, MS 421 (4,2), fol. 5.

15. Vollard Archives, MS 421 (4,2), fol. 6; Vollard 1936, pp. 54–58; New York 1997–98, vol. 2, nos. 796, 799.

16. Vollard Archives, MS 421 (4,2), fols. 7, 8.

17. Vollard Archives, MS 421 (4,2), fols. 6–7, 18.

18. Vollard Archives, MS 421 (4,3), fol. 11; New York 1997–98, vol. 2, no. 804.

19. Vollard Archives, MS 421 (4,3), fols. 7–11.

20. Vollard Archives, MS 421 (4,2), fols. 7–9, 12, 14; MS 421 (4,3), fols. 9–16.

21. Viatte 1962, p. 331; see also Adriani 2001, p. 82.

22. Vollard Archives, MS 421 (4,2), fols. 8, 21–22; Welsh-Ovcharov 1998, p. 185.

23. Mauclair 1895b, pp. 358–59; Vollard Archives, MS 421 (4,2), fol. 17.

24. Stockbook A, no. 3967, and 1922 Inventory, no. 5278.

25. Vollard Archives, MS 421 (2,3), p. 117; MS 421 (4,2), fols. 18–19, 28.

26. Vollard Archives, MS 421 (4,2), fol. 11; MS 421 (4,3), fol. 19.

27. Vollard Archives, MS 421 (4,2), fol. 16; MS 421 (4,3), fol. 19; New York 1997–98, vol. 2, no. 795.

28. Vollard Archives, MS 421 (4,2), fols. 14–16.

29. Vollard Archives, MS 421 (4,2), fols. 18–26; MS 421 (4,3), fols. 32, 35–38.

30. Vollard Archives, MS 421 (4,3), fols. 32, 39, 40, 43, 90; MS 421 (2,4), fols. 122–37.

31. Vollard Archives, MS 421 (4,2), fols. 20, 24.

32. Vollard Archives, MS 421 (4,3), fols. 33, 34.

33. Vollard Archives, MS 421 (4,2), fol. 27.

34. Rewald and L. Pissarro 1980, pp. 288–89; Bailly-Herzberg (1980–91, vol. 4, p. 197) dates this letter April 25, 1896. Rewald's English translation has been slightly revised by the authors.

35. See Vollard 1914, pp. 73–83.

36. Vollard Archives, MS 421 (4,3), fols. 48, 83; Apollinaire 1913.

37. Vollard Archives, MS 421 (4,3), fol. 49; MS 421 (10,6), fols. 2–4, 9–11.

38. Camille Pissarro to his son Lucien, June 22, 1896, in Rewald and L. Pissarro 1980, p. 290.

39. Camille Pissarro to his son Lucien, July 3 and September 4 [18], 1896, in Rewald and L. Pissarro 1980, pp. 293–94. Bailly-Herzberg (1980–91, vol. 4, p. 246, n. 2) says that the passage which Rewald dates to September 4 actually comes from a letter dated September 18.

40. Vollard Archives, MS 421 (4,2), fol. 35, and MS 421 (4,4), fol. 6.

41. Vollard Archives, MS 421 (4,4), fols. 3, 4.

42. Vollard Archives, MS 421 (4,2), fol. 36.

43. Vollard Archives, MS 421 (4,2), fols. 36, 40; MS 421 (4,3), fols. 77, 81, 129, 130; MS 421 (4,4), fols. 7, 12–13.

44. Vollard Archives, MS 421 (4,2), fol. 38; MS 421 (4,3), fol. 63.

45. Vollard Archives, MS 421 (4,3), fol. 68.

46. Vollard Archives, MS 421 (4,2), fol. 39; for a handwritten list see: MS 421 (4,4), fols. 23–24.

47. Vollard Archives, MS 421 (4,3), fols. 72, 74; MS 421 (4,4), fol. 11.

48. Stolwijk and Veenenbos 2002, pp. 28, 47, 199.

49. Vollard Archives, MS 421 (4,3), fol. 80; Stolwijk and Veenenbos 2002, p. 28.

50. Vollard Archives, MS 421 (4,2), fols. 41, 42; see Henkels 1993.

51. Vollard Archives, MS 421 (4,3), fol. 88.

52. Kessler 2004–5, vol 3, p. 109; Vollard Archives, MS 421 (4,3), fol. 94.

53. Johnson 1977, pp. 20, 154, no. 156.

54. Athill 1985, p. 26.

55. Vollard Archives, MS 421 (4,3), fols. 112, 116; Rewald 1943, p. 28.

56. Ferretti-Bocquillon 2001, p. 55; MS 421 (4,4), fol. 35.

57. Vollard Archives, MS 421 (4,3), fol. 134; MS 421 (4,4), fol. 37.

58. See Vollard 1936, pp. 222–23, and Maurice Denis, journal entry of October 21, 1899, in Denis 1957–59, vol. 1, p. 157; Adhémar 1982, p. 149.

59. Vollard Archives, MS 421 (4,3), fol. 119.

60. Mellerio 1899.

61. Vollard Archives, MS 421 (4,3), fol. 130.

62. Vollard Archives, MS 421 (4,3), fol. 129.

63. Vollard Archives, MS 421 (4,3), fol. 130.

64. Vollard Archives, MS 421 (4,3), fol. 130.

65. Vollard Archives, MS 421 (4,3), fols. 133–37.

66. Vollard Archives, MS 421 (4,3), fols. 132, 135, 151. A letter from Vollard to Bonger indicates a purchase price of 5,000 francs: Archiv Bonger E.10 (courtesy Roland Dorn); the Vollard Archives indicate two payments totaling 4,500 francs: Vollard Archives, MS 421 (4,3), fols. 135, 151.

67. Vollard Archives, MS 421 (4,3), fol. 137.

68. Vollard Archives, MS 421 (4,3), fol. 142; see also MS 421 (4,11), fol. 4.

69. Letter reproduced in Rewald 1996, vol. 1, p. 326.

70. Vollard Archives, MS 421 (4,3), fols. 148; MS 421 (4,9), fol. 8.

71. Vollard Archives, MS 421 (4,1), pp. 22, 23; MS 421 (4,3), fol. 148.

72. Stockbook A, nos. 4127 and 4128; Vollard Archives, MS 421 (4,1), p. 33.

73. See Busch and Reinken 1983, pp. 173, 425, 479.

74. Paris–Boston 2003–4, p. 348.

75. Rewald and L. Pissarro 1980, p. 339, with last sentence from Bailly-Herzberg 1980–91, vol. 5, p. 75. Sales are recorded beginning in October: Vollard Archives, MS 421 (4,9), fols. 45–70.

76. Stockbook A, nos. 3361, 3773; Vollard Archives, MS 421 (4,3), fol. 158; MS 421 (4,9), fols. 2–3, 14.

77. Stockbook A, no. 3357; La Rue de l'Hermitage à Pontoise (PS 349). See also Vollard Archives, MS 421 (4,11), fol. 21.

78. Vollard Archives, MS 421 (4,9), fol. 5.

79. Vollard Archives, MS 421 (4,9), fols. 7, 17.

80. See Vollard Archives, MS 421 (4,9), fols. 10, 15, 22.

81. Stockbook A, no. 3617.

82. Vollard Archives, MS 421 (4,9), fol. 11.

83. Stockbook A, no. 4135.

84. Vollard Archives, MS 421 (4,3), fol. 149; MS 421 (4,9), fol. 17.

85. Vollard Archives, MS 421 (4,9), fol. 17.

86. Vollard Archives, MS 421 (4,9), fol. 24.

87. Stockbook A, no. 4093, and Vollard Archives, MS 421 (4,9), fol. 25.

88. Vollard Archives, MS 421 (4,9), fol. 33.

89. Vollard Archives, MS 421 (4,3), fol. 144.

90. Sharp 1998, p. 162.

91. Roussier 1987, pp. 63–64.

92. See Jean-Paul Morel's essay in this volume, pp. 215–16.

93. Vollard Archives, MS 421 (4,9), fols. 76, 80, 89.

94. Vollard Archives, MS 421 (4,9), fol. 83; White 1984, p. 218.

95. Vollard Archives, MS 421 (2,3), pp. 1–8; see also MS 421 (4,9), fol. 89.

96. Vollard Archives, MS 421 (4,9), fol. 89; Vollard 1936, pp. 219–20.

97. Palau i Fabre 1981, p. 246.

98. Vollard Archives, MS 421 (2,2), p. 61; MS 421 (2,4), fol. 14.

99. Vollard Archives, MS 421 (2,4), fols. 19–22; Rewald 1976, pp. 282, 286.

100. Acknowledgment from Georges Grappe, curator of the Musée Rodin, January 12, 1930: Vollard Archives, MS 421 (10,7), fol. 11.
101. White 1984, p. 221.
102. Vollard Archives, MS 421 (4,1), p. 51; Paris–Boston 2003–4, p. 349.
103. Johnson 1944, pp. 153–54, no. 186; Johnson 1977, p. 46.
104. Sharp 1998, p. 162; New York–Houston 2000, p. 9.
105. Vollard Archives, MS 421 (4,10), pp. 1–2.
106. Vollard 1914, p. 146; Vollard Archives, MS 421 (4,1), pp. 56, 58. See also John Rewald Papers, Gallery Archives, National Gallery of Art, Washington, D.C., and Stockbook A, nos. 4175–4180.
107. Vollard Archives, MS 421 (4,10), pp. 5–7.
108. Vollard Archives, MS 421 (4,10), pp. 9–35.
109. Rewald 1976, pp. 304–5.
110. Vollard Archives, MS 421 (4,10), pp. 21–22, 29.
111. Stockbook B, no. 3361.
112. Vollard Archives, MS 421 (4,10), p. 25.
113. Vollard Archives, MS 421 (4,10), pp. 29, 31; also MS 421 (4,1), pp. 75–77, 82.
114. Vollard Archives, MS 421 (4,10), pp. 30, 32; Paris–Boston 2003–4, pp. 310–11.
115. Vollard Archives, MS 421 (4,10), p. 32.
116. Vollard Archives, MS 421 (4,10), p. 34; Stockbook B, nos. 3375, 3379.
117. Vollard Archives, MS 421 (2,2), pp. 63–64[bis].
118. Stockbook B, nos. 3407, 3804, 3570, 4306; Vollard Archives, MS 421 (4,10), pp. 33, 34.
119. Private archives. See also Vollard Archives, MS 421 (4,1), p. 65; MS 421 (4,10), p. 15.
120. Johnson 1977, p. 46.
121. White 1996, p. 105.
122. Vollard Archives, MS 421 (3,4), fols. 3–4.
123. Vollard Archives, MS 421 (2,2), pp. 65–66.
124. Stockbook B, no. 3303.
125. Paris–Boston 2003–4, p. 310.
126. Dormoy 1963, p. 144. Vollard Archives, MS 421 (2,3), p. 57.
127. Jean Puy (1876–1960); see Limouzi and Fressonet-Puy 2000, p. 48.
128. Vollard Archives, MS 421 (5,1), fol. 3.
129. Stockbook B, nos. 4401, 4402.
130. Vollard Archives, MS 421 (5,1), fols. 6, 24, 38, 48.
131. Vollard Archives, MS 421 (5,1), fols. 30–31, and Milan Sale 1906 (annotated copy of catalogue, Frick Art Reference Library, New York).
132. Vollard Archives, MS 421 (4,1), pp. 95–97, 101–12; MS 421 (5,1), fols. 46, 100, 115. See also Vollard 1936, pp. 79–80; Paris–Boston 2003–4, p. 310.
133. Signed itemized receipt: Vollard Archives, MS 421 (2,3), p. 119, with additional information courtesy of Jean-Pierre Manguin, Villeneuve-les-Avignon.
134. Mathan to Manguin, June 17, 1906, courtesy of Jean-Pierre Manguin.
135. Vollard Archives, MS 421 (5,1), fol. 101.
136. Vollard Archives, MS 421 (5,1), fols. 59, 167, 197.
137. Vollard Archives, MS 421 (5,2), fols. 80, 85, 106.
138. Vollard Archives, MS 421 (5,1), fol. 61; Adriani 2001, p. 166.
139. Vollard Archives, MS 421 (5,1), fol. 72; see also MS 421 (3,1), fol. 263, and MS 421 (10,6), fols. 5–7, 13.
140. Vollard Archives, MS 421 (5,1), fol. 64; Paris–Boston 2003–4, p. 308.
141. Vollard Archives, MS 421 (5,1), fol. 80.
142. Vollard Archives, MS 421 (5,1), fol. 77.
143. Vollard Archives, MS 421 (5,1), fols. 80, 83, 184.
144. Vollard Archives, MS 421 (5,1), fol. 83.
145. New York 1993, pp. 242, 243.
146. Archives, Musée Picasso, Paris; Vollard Archives, MS 421 (5,1), fol. 89; G. Stein 1933, pp. 22–23; Archives Matisse, Paris, quoted in London–Paris–New York 2002–3, p. 363.
147. Vollard Archives, MS 421 (2,2), pp. 71–72.
148. Vollard Archives, MS 421 (5,1), fols. 101, 124, 146.
149. Vollard Archives, MS 421 (5,1), fols. 108, 115; Rewald 1996, vol. 1, no. 537.
150. See Sharp 1998, p. 164; Stratis 1998, pp. 221–22; Chicago–Boston–Washington 1998–99, p. 346; Vollard Archives, MS 421 (5,1), fol. 102.
151. Vollard Archives, MS 421 (5,1), fols. 119–21, 134.
152. Vollard Archives, MS 421 (5,1), fols. 143, 146, 147, 158.
153. White 1984, p. 235.
154. Vollard Archives, MS 421 (5,2), fols. 42, 43, 58, 107, 113.
155. Vollard Archives, MS 421 (5,1), fol. 182.
156. Vollard Archives, MS 421 (5,2), fol. 8.
157. Paris–Boston 2003–4, p. 308.
158. Vollard Archives, MS 421 (5,2), fol. 24.
159. Vollard Archives, MS 421 (4,1), pp. 114–20.
160. Paris–Boston 2003–4, p. 310; Vollard Archives, MS 421 (5,2), fols. 75, 159.
161. Vollard Archives, MS 421 (5,2), fol. 86.
162. Vollard Archives, MS 421 (5,2), fols. 91, 92, 95.
163. Vollard Archives, MS 421 (5,2), fol. 136; MS 421 (4,13), fol. 3.
164. Vollard Archives, MS 421 (5,2), fol. 136.
165. Vollard Archives, MS 421 (5,2), fol. 150.
166. Vollard Archives, MS 421 (5,2), fol. 164.
167. Vollard Archives, MS 421 (5,2), fol. 170.
168. Vollard Archives, MS 421 (5,2), fol. 200.
169. Vollard Archives, MS 421 (5,3), fols. 20, 30.
170. Vollard Archives, MS 421 (5,3), fols. 23, 32.
171. Vollard Archives, MS 421 (5,3), fol. 77.
172. Vollard Archives, MS 421 (5,3), fols. 78, 79.
173. Vollard Archives, MS 421 (5,3), fol. 153.
174. Vollard Archives, MS 421 (5,3), fols. 153, 161–62.
175. Vollard Archives, MS 421 (5,4), fol. 6; MS 421 (5,8), fols. 130, 160.
176. White 1984, pp. 237, 241.
177. Vollard Archives, MS 421 (5,3), fol. 88.
178. Vollard Archives, MS 421 (4,13), fols. 9, 14–15.
179. Klingsor 1908.
180. Vollard Archives, MS 421 (5,3), fol. 136; MS 421 (4,13), fol. 14.
181. Vollard Archives, MS 421 (2,3), p. 134; MS 421 (4,3), fol. 204; MS 421 (5,4), fols. 4, 25.
182. Vollard Archives, MS 421 (5,3), fol. 216.
183. Vollard Archives, MS 421 (5,4), fol. 2.
184. Vollard Archives, MS 421 (5,4), fols. 7, 75.
185. Vollard Archives, MS 421 (5,4), fol. 29.
186. Vollard Archives, MS 421 (4,13), fols. 16–19.
187. Vollard Archives, MS 421 (5,4), fols. 45, 96, 106.
188. Vollard Archives, MS 421 (5,4), fols. 69, 125.
189. Viatte 1962, pp. 332–33.
190. Vollard Archives, MS 421 (5,4), fol. 158.
191. Vollard Archives, MS 421 (5,4), fols. 154, 173; MS 421 (4,1), pp. 140–41, 144–45; MS 421 (4,13), fol. 18.
192. Vollard Archives, MS 421 (5,4), fols. 168, 179, 180, 184, 186, 190, 195.
193. Vollard Archives, MS 421 (5,5), fol. 163.
194. Vollard Archives, MS 421 (5,7), fol. 49; MS 421 (4,1), p. 145.
195. Vollard Archives, MS 421 (4,13), fol. 19; MS 421 (5,4), fol. 134; MS 421 (4,1), p. 143.
196. Adriani 2001, pp. 199, 210.
197. Viatte 1962, p. 333; Adriani 2001, pp. 199, 200.
198. Vollard Archives, MS 421 (4,1), fols. 149–50; MS 421 (5,4), fol. 257.
199. Claverie et al. 2002, pp. 27, 138.
200. Vollard Archives, MS 421 (5,4), fol. 257; MS 421 (5,5), fols. 74, 95, 154; MS 421 (4,1), pp. 187–88.
201. Vollard Archives, MS 421 (5,5), fol. 3; Rewald 1996, vol. 1, p. 298.
202. Vollard Archives, MS 421 (5,5), fol. 12.
203. Vollard Archives, MS 421 (5,5), fols. 22–23.
204. Viatte 1962, p. 334.
205. Vollard Archives, MS 421 (5,5), fol. 54.
206. Vollard Archives, MS 421 (5,5), fol. 55; Archives, Metropolitan Museum. The Manet was shipped to the Museum, presumably for inspection, in February 1910: Vollard Archives, MS 421 (4,13), fol. 22.
207. Vollard Archives, MS 421 (5,5), fol. 60.
208. Vollard Archives, MS 421 (5,5), fol. 84; Adriani 2001, p. 128.
209. Vollard Archives, MS 421 (5,5), fols. 110, 111.
210. Johnson 1944, p. 81, no. 48; Johnson 1977, p. 46.
211. Vollard Archives, MS 421 (5,5), fol. 134; MS 421 (4,13), fol. 26.
212. Claverie et al. 2002, pp. 203, 221, 260, 261.
213. Vollard Archives, MS 421 (5,7), fol. 66; MS 421 (4,13), fol. 34.
214. Vollard Archives, MS 421 (5,5), fol. 187; MS 421 (5,7), fols. 4, 15, 56.
215. In his will, written in 1911, Vollard bequeaths the property (which includes an apple orchard) to Mme de Galéa, who, he says, helped design it. This is the property to which he later invites Cassatt; see "July 6, 1913."
216. Walter Pach Papers, 1883–1980, Archives of American Art, Smithsonian Institution, microfilm, reel 4216, frames 23–26.
217. Vollard Archives, MS 421 (2,3), p. 92; MS 421 (5,7), fol. 59.

218. Vollard Archives, MS 421 (5,7), fol. 106; MS 421 (2,3), pp. 93–95.

219. Vollard Archives, MS 421 (5,7), fols. 70, 100; MS 421 (5,8), fol. 192; MS 421 (4,13), fols. 35–36, 61.

220. Vollard Archives, MS 421 (5,6), fol. 44; MS 421 (4,13), fol. 34.

221. Vollard Archives, MS 421 (5,6), fol. 48.

222. Vollard Archives, MS 421 (5,7), fol. 105.

223. Vollard Archives, MS 421 (5,7), fol. 109.

224. Vollard Archives, MS 421 (5,6), fol. 53; MS 421 (5,7), fol. 112.

225. Vollard Archives, MS 421 (2,3), p. 9.

226. Vollard Archives, MS 421 (5,6), fol. 43; MS 421 (5,7), fol. 131; Prague–Paris 2000–2002, pp. 223, 259; Claverie et al. 2002, pp. 30, 211, 214.

227. Prague–Paris 2000–2002, pp. 223, 259; Claverie et al. 2002, pp. 30, 214, 298–99.

228. Vollard Archives, MS 421 (4,1), pp. 220–23.

229. Vollard Archives, MS 421 (2,3), pp. 14–15.

230. Vollard Archives, MS 421 (4,1), p. 222.

231. Vollard Archives, MS 421 (5,8), fol. 2.

232. Vollard Archives, MS 421 (5,8), fols. 6, 8, 10.

233. Vollard Archives, MS 421 (5,8), fol. 16.

234. Vollard Archives, MS 421 (4,1), p. 232; MS 421 (5,8), fols. 41, 49.

235. Vollard Archives, MS 421 (3,1), fol. 296, and Hoogendijk Sale 1912.

236. Vollard Archives, MS 421 (5,8), fol. 222; MS 421 (5,9), fol. 4.

237. Vollard Archives, MS 421 (5,8), fols. 224–26; Rewald 1989, pp. 173, 175.

238. Vollard Archives, MS 421 (3,6), fol. 9.

239. Vollard Archives, MS 421 (5,9), fol. 140.

240. Vollard Archives, MS 421 (5,9), fols. 163, 164; MS 421 (4,13), fols. 82–87.

241. Vollard Archives, MS 421 (3,6), fol. 39.

242. Vollard Archives, MS 421 (5,9), fols. 5, 42.

243. Vollard Archives, MS 421 (5,9), fol. 6.

244. Vollard Archives, MS 421 (4,13), fol. 72; MS 421 (5,9), fols. 22–23; see also Quinn to Vollard, April 24, 1913: John Quinn Memorial Collection, Manuscripts and Archives Division, Astor, Lenox and Tilden Foundations, New York Public Library [hereafter cited as Quinn Collection, New York Public Library.]

245. Vollard Archives, MS 421 (4,13), fol. 67–68, 71, 79–80; MS 421 (5,8), fol. 230; Rewald 1989, pp. 204–5.

246. White 1984, pp. 261, 270.

247. Ibid., p. 280.

248. Vollard Archives, MS 421 (5,9), fol. 70.

249. Vollard Archives, MS 421 (5,9), fols. 102, 108; Rewald 1989, pp. 264–67.

250. Cassatt to Louisine Havemeyer, July 6, [1913]: transcript in Weitzenhoffer files, Department of European Paintings, Metropolitan Museum.

251. Mathews 1984, p. 91.

252. Vollard Archives, MS 421 (10,2), fol. 11.

253. Vollard Archives, MS 421 (4,13), fols. 88, 91–93, 96.

254. Vollard Archives, MS 421 (3,6), fols. 119, 122; MS 421 (4,13), fols. 95, 112–13, 115–17; MS 421 (10,3), fol. 1. "Miro's 'Standing Nude'" 1966; Forthuny 1916, p. 7.

255. Jentsch 1994, no. 12.

256. Rewald 1996, vol. 1, p. 288.

257. Cassatt to Havemeyer, January 11, 1914: transcript in Weitzenhoffer files, Department of European Paintings, Metropolitan Museum.

258. Vollard 1914a; Vollard 1914. For reviews, see Kahn 1915 and Fry 1917.

259. Vollard Archives, MS 421 (4,13), fols. 95, 98.

260. See the extensive correspondence between Quinn and Vollard during this period: Quinn Collection, New York Public Library. See also Washington 1978, p. 176.

261. Rewald 1989, p. 268.

262. Vollard Archives, MS 421 (4,13), fols. 101–11.

263. Watson and Morris 2000, pp. 110–11.

264. White 1984, p. 276.

265. Washington–Fort Worth–South Hadley 1987–88, pp. 15–16; Vollard Archives, MS 421 (3,1), fol. 246.

266. Pinturrichio 1917.

267. Vollard Archives, MS 421 (4,13), fols. 115–17.

268. Vollard Archives, MS 421 (9,17), fol. 1.

269. Archives, Fondation Georges Rouault, Paris.

270. Gimpel 1966, pp. 62–63, entry dated September 6, 1918.

271. Seligmann 1926, p. BR7.

272. Vollard Archives, MS 421 (10,6), fols. 9–10; see entry for June 1896.

273. Godfroy 1997, pp. 263–64, 268–69.

274. Vollard Archives, MS 421 (4,13), fols. 118, 122.

275. Transcript in Weitzenhoffer files, Department of European Paintings, Metropolitan Museum.

276. See the extensive correspondence between Quinn and Vollard during this period: Quinn Collection, New York Public Library.

277. Vollard Archives, MS 421 (4,13), fol. 122.

278. For a list identifying each sale, see New York 1997–98, vol. 1, p. 337.

279. "Les Ventes Degas continuent" 1919, p. 14; New York 1997–98, vol. 1, p. 337.

280. Undated document signed by all parties, ca. May 1, 1918: private archives; see also Vollard Archives, MS 421 (3,1), fols. 211–12, 272, 273, 277–78 280–85, 289, 292, and Godfroy 1997, pp. 266–67.

281. Gimpel 1966, p. 23, entry dated May 14, 1918.

282. Cassatt to Louisine Havemeyer, August 5, 1918: transcript in the Weitzenhoffer files, Department of European Paintings, Metropolitan Museum; see also New York 1993, p. 276, entry for "Late December 1919."

283. Rouault to Vollard, December 30, 1918: Archives, Fondation Georges Rouault.

284. "L'Historien cruel" 1919; "Revue de la quinzaine" 1919; and Aristide 1919. For reviews that Vollard saved, see Vollard Archives, MS 421 (10,11), fols. 1–17.

285. Vollard Archives, MS 421 (9,6), fol. 4; Johnson 1977, pp. 158–59, no. 177.

286. Vollard Archives, MS 421 (2,3), p. 371.

287. Vollard Archives, MS 421 (3,1), fol. 288; Courbet Sale 1919 (annotated copy of catalogue, Frick Art Reference Library).

288. *Rouault—Suarès Correspondance* 1960, pp. 157–58, letter 104.

289. Gimpel 1966, p. 117, entry dated November 30, 1920.

290. Vollard Archives, MS 421 (13), fol. 1.

291. Vollard Archives, MS 421 (13), fols. 2, 3.

292. Rouault to Quinn, August 1, 1922: Quinn Collection, New York Public Library; Rouault to Vollard, October 3, 1922: Archives, Fondation Georges Rouault; Vollard to unknown recipient, October 25, 1930: Vollard Archives, MS 421 (3,1), fol. 263; MS 421 (5,13), fol. 4, datebook entry for January 15, 1925.

293. Guenne 1944, pp. 8, 11.

294. See, however, "Décompte Exposition Ambroise Vollard, 28, rue de Martignac": Vollard Archives, MS 421 (3,1), fol. 6.

295. Vollard Archives, MS 421 (10,2), fols. 1–10.

296. Vollard Archives, MS 421 (4,14), fol. 2.

297. Vollard Archives, MS 421 (4,14), fol. 2; Rewald 1996, vol. 1, pp. 401–2, no. 604.

298. Vollard Archives, MS 421 (4,7), fol. 3*bis*; MS 421 (4,8), fol. 2*bis*; MS 421 (5,10), fol. 13.

299. Vollard Archives, MS 421 (4,7), fol. 4; MS 421 (4,8), fol. 3; MS 421 (5,10), fols. 25, 26.

300. Vollard Archives, MS 421 (4,7), fol. 6; MS 421 (4,8), fol. 5; MS 421 (4,14), fol. 3; MS 421 (5,10), fols. 39–40.

301. Vollard Archives, MS 421 (10,3), fols. 2–3.

302. Vollard Archives, MS 421 (4,7), fol. 7*bis*; MS 421 (4,8), fol. 6*bis*; MS 421 (5,10), fols. 53, 65, 72, 77, and others; 1922 Inventory, no. 5490.

303. Rouault to Quinn, August 1, 1922, Quinn Collection, New York Public Library.

304. Contract between Vollard and Malfère, November 10, 1922: Private archives; see also Vollard Archives, MS 421 (4,7), fol. 12*bis*; MS 421 (4,8), fol. 11*bis*; MS 421 (5,10), fol. 75.

305. Vollard Archives, MS 421 (4,7), fol. 13*bis*; MS 421 (4,8), fol. 12*bis*; MS 421 (5,10), fol. 79.

306. Vollard Archives, MS 421 (4,8), fols. 14, 15, 20; MS 421 (4,14), fol. 3; MS 421 (5,11), fols. 10, 11, 14, 15, 16, 42.

307. See chapter 28 in Vollard 1936, pp. 243–46; Suarès to Rouault, May 11, 1923, in *Rouault—Suarès Correspondance* 1983, p. 83; and Vollard to Picasso, May 10 and 20, and June 8, 1923: Archives, Musée Picasso, Paris.

308. Besnard to Vollard, March 12, 1928: Vollard Archives, MS 421 (3,1), fols. 268–69, and Valéry to Vollard, March 1, 1937: Vollard Archives, MS 421 (9,6), fols. 18–19.

309. Vollard Archives, MS 421 (4,7), fol. 19; MS 421 (4,8), fol. 18; MS 421 (4,14), fol. 3; MS 421 (5,11), fols. 32, 43, 52. Charles Montag, Vollard's Swiss agent, receives a commission of 58,000 francs.

310. Vollard to Denis, undated [ca. 1924], Musée Départemental Maurice Denis, Saint-Germain-en-Laye, Donation de la famille Denis, MS Vollard 11794.

311. Vollard Archives, MS 421 (2,3) pp. 91, 121–23, 358–59, 372; MS 421 (4,7),

fols. 13*bis*, 15*bis*, 17*bis*, 19*bis*, 23*bis*, 26*bis*; MS 421 (4,8), fols. 12*bis*, 14*bis*, 16*bis*, 18*bis*, 22*bis*, 25*bis*, 32*bis*; MS 421 (5,13), fol. 33; MS 421 (5,10), fol. 82; MS 421 (5,11), fols. 15, 22, 26, 28, 39, 46, 47, 67, 70; MS 421 (5,12), fols. 6, 53, 67; MS 421 (5,13), fol. 33; Johnson 1977, p. 168, nos. 213, 214.

312. Claverie et al. 2002, pp. 246, 250, 252.

313. Vollard Archives, MS 421 (4,7), p. 25; MS 421 (4,8), fol. 24; Claverie et al. 2002, p. 254.

314. Vollard Archives, MS 421 (10,7), fols. 5–6.

315. Vollard Archives, MS 421 (4,7), fols. 23, 23*bis*, 24; MS 421 (4,8), fols. 22, 23; MS 421 (5,11), fols. 68, 69, 76.

316. Vollard Archives, MS 421 (4,7), fol. 24; MS 421 (4,8), fol. 23; MS 421 (4,14), fol. 4; MS 421 (5,11), fol. 82.

317. Vollard Archives, MS 421 (4,8), fol. 24; MS 421 (5,11), fol. 88.

318. Vollard Archives, MS 421 (5,11), fol. 93; MS 421 (9,11), fol. 2.

319. "Revue de la quinzaine" 1924a and "Publications récentes" 1924.

320. "Revue de la quinzaine" 1924b; Puy 1925, pp. 236–37.

321. Vollard Archives, MS 421 (4,8), fol. 25; MS 421 (5,12), fols. 3–4; MS 421 (4,14), fol. 4.

322. Vollard Archives, MS 421 (4,7), fol. 28; MS 421 (4,8), fol. 27; MS 421 (4,14), fols. 4–5; MS 421 (5,12), fol. 14. The sale took place on the 12th, although it is recorded on the 16th in two of the account books.

323. Vollard Archives, MS 421 (4,7), fols. 27, 28; MS 421 (4,8), fols. 26–27, 33; MS 421 (5,12), fols. 15, 20.

324. See, for example, Vollard Archives, MS 421 (4,14), fols. 2–22.

325. Vollard Archives, MS 421 (4,7), fol. 29; MS 421 (4,8), fol. 28; MS 421 (4,14), fol. 6; MS 421 (5,12), fols. 19, 24, 33.

326. Vollard Archives, MS 421 (5,12), fol. 39.

327. Vollard Archives, MS 421 (4,7), fol. 33; MS 421 (4,8), fol. 32; MS 421 (4,14), fol. 8.

328. Vollard Archives, MS 421 (10,7), fols. 42, 43; Rouault to Vollard, undated [ca. early 1928]: Archives, Fondation Georges Rouault; Rouault 1971, pp. 29–30; Vollard to Marcel Provence, August 1 and December 18, 1924: Archives, Atelier Cézanne, Aix-en-Provence; Métérié 1924; Pinturrichio 1926b; Ely 2003, p. 87.

329. Vollard Archives, MS 421 (4,7), fol. 39; MS 421 (4,8), fol. 38.

330. Contract between Vollard and Le Divan, November 12, 1924: Private archives.

331. Vollard Archives, MS 421 (8,15), fol. 63; Johnson 1977, p. 164, no. 199.

332. Translated in Dorival and I. Rouault 1988, vol. 1, p. 355.

333. Contract between Vollard and Degas's heirs, November 21, 1924: Private archives; and Vollard Archives, MS 421 (5,12), fol. 103.

334. Vollard Archives, MS 421 (4,7), fols. 40, 47; MS 421 (4,8), fols. 39, 46; MS 421 (4,14), fols. 9–11; MS 421 (5,9), fol. 113.

335. Vollard Archives, MS 421 (4,7), fols. 41, 43, 46, 48, 55, 71; MS 421 (4,8), fol. 40; MS 421 (4,14), fols. 10–11, 15; MS 421 (5,13), fols. 8, 30, 38, 60, 68.

336. Vollard Archives, MS 421 (4,7), fol. 42*bis*; MS 421 (4,8), fol. 41*bis*. Vollard pays 210,000 francs for the works on February 5, having already advanced De Galéa 40,000 francs on January 29, 1925: Vollard Archives, MS 421 (4,7), fol. 41*bis*.

337. Vollard Archives, MS 421 (4,7), fol. 61*bis*.

338. Vollard Archives, MS 421 (5,13), fols. 46, 51, 61, 83; MS 421 (4,7), fols. 43–45, 48; MS 421 (4,8), fols. 42, 44, 47.

339. Légion d'Honneur certificate: Private archives.

340. Pinturrichio 1926a.

341. Basler 1925.

342. *Rouault—Suarès Correspondence* 1960, p. 207, letter 147; Vollard Archives, MS 421 (4,8), fol. 44*bis*.

343. Vollard Archives, MS 421 (4,7), fol. 49; MS 421 (4,8), fol. 48; MS 421 (5,13), fol. 86.

344. Vollard Archives, MS 421 (4,7), fol. 50; MS 421 (4,8), fol. 7; MS 421 (4,14), fol. 10.

345. Vollard Archives, MS 421 (4,7), fol. 52; MS 421 (4,8), fol. 51; MS 421 (4,14), fol. 11; MS 421 (5,9), fol. 113.

346. Warnod 1926, translated in Dorival and I. Rouault 1988, vol. 1, p. 354.

347. Contract between Dufy, Montfort, and Vollard, May 1, 1926: Private archives; Vollard Archives, MS 421 (4,7), fol. 57*bis*; MS 421 (4,8), fol 56*bis* records the payments (albeit with recipients' names seemingly reversed); Dufy was paid half his fee at the time the contract was signed.

348. Contract between Vollard and Little, Brown, & Co., May 4, 1916: Private archives.

349. "Books for Holidays" 1936.

350. Vollard Archives, MS 421 (11,2); Vollard 1936, pp. 303–7.

351. Contract between Vollard and Mme Halévy, August 4, 1926: Private archives.

352. Contract between Vollard and Edmond Degas, January 22, 1927: Private archives; Vollard Archives, MS 421 (4,8), fol. 64*bis*.

353. Vollard Archives, MS 421 (5,14), fols. 3–25.

354. Vollard Archives, MS 421 (10,7), fol. 7; an illustration of Gauguin's *La Belle Angèle* appears in *Comoedia*, March 11, 1927.

355. Contract between Vollard and Éditions Émile Paul Frères, March 11, 1927: Private archives.

356. Vollard Archives, MS 421 (1,5), fol. 6 (a typewritten draft of Vollard's "Comment j'ai ambitionné d'écrire dans la *Revue des Deux Mondes*").

357. Johnson 1977, p. 161, no. 190.

358. Vollard Archives, MS 421 (4,7), fol. 72; MS 421 (4,8), fol. 71; MS 421 (4,14), fol. 15.

359. Vollard Archives, MS 421 (4,8), fol. 92.

360. Picasso to Vollard, April 8, 1929: Vollard Archives, MS 421 (4,7), fol. 73*bis*; MS 421 (4,8), fol. 72*bis*; MS 421 (9,13), fol. 3.

361. Vollard Archives, MS 421 (4,7), fol. 74*bis*; MS 421 (4,8), fol. 73*bis*; MS 421 (8,16), fol. 29; Johnson 1977, p. 166, no. 203.

362. Vollard Archives, MS 421 (10,7), fols. 9, 44; MS 421 (3,1), fol. 4.

363. Vollard Archives, MS 421 (3,1), fol. 265.

364. Vollard Archives, MS 421 (4,7), fol. 79*bis*; MS 421 (4,8), fol. 78*bis*.

365. Lerolle to Bernheim-Jeune, March 8, 1928, and Bernheim-Jeune to Vollard, March 9, 1928: Vollard Archives, MS 421 (3,1), fols. 266–67.

366. Vollard Archives, MS 421 (4,7), fol. 82*bis*; MS 421 (9,14), fol. 2.

367. Vollard Archives, MS 421 (10,7), fol. 10.

368. Vollard Archives, MS 421 (10,7), fol. 41; Johnson 1977, pp. 157–58, no. 173.

369. Vollard Archives, MS 421 (9,13), fol. 4.

370. Johnson 1977, p. 161, no. 188.

371. Vollard Archives, MS 421 (4,7), fol. 87; MS 421 (4,8), fol. 86; MS 421 (4,14), fol. 18.

372. Ruth Morris Bakwin, unpublished memoirs, 1983: courtesy Gregory Selch, New York City.

373. See New York 1993.

374. Terey 1929.

375. Picasso receipt, April 8, 1929: Vollard Archives, MS 421 (9,13), fol. 6. The transaction is recorded in Vollard's account book on April 30: Vollard Archives, MS 421 (4,8), fol. 93*bis*.

376. Vollard Archives, MS 421 (4,8), fol. 97*bis*.

377. Vollard Archives, MS 421 (4,8), fol. 93.

378. Vollard Archives, MS 421 (4,8), fol. 98; MS 421 (4,14), fol. 21.

379. Vollard to unknown recipient, February 5, 1930: Private archives; Vollard Archives, MS 421 (10,7), fol. 47, and MS 421 (3,1), fol. 250; Vollard to Rouault, postmarked February 12, 1930: Archives, Fondation Georges Rouault.

380. Vollard Archives, MS 421 (3,1), fol. 250.

381. Vollard Archives, MS 421 (10,7), fol. 31; see also MS 421 (10,7), fol. 40.

382. Vollard Archives, MS 421 (3,1), fol. 264; MS 421 (9,5), fols. 45–50.

383. Vollard Archives, MS 421 (9,7), fol. 9; see also MS 421 (9,7), fols. 8, 10–12.

384. Vollard Archives, MS 421 (9,7), fols. 15–21. A publisher's dummy of the book is in the Spencer Collection, New York Public Library.

385. Johnson 1977, p. 159, no. 182.

386. Vollard Archives, MS 421 (9,6), fol. 11; Johnson 1977, p. 159, no. 178.

387. Vollard Archives, MS 421 (9,2), fol. 7.

388. Fierens 1931, p. 20.

389. Vollard Archives, MS 421 (10,7), fols. 15–18, 39.

390. Zahar 1931.

391. Geiger 1931; Vollard Archives, MS 421 (8,16), fol. 29.

392. L. Guerlon to Vollard, June 3, 1931: Private archives.

393. Vollard to the Directeur des Beaux-Arts, March 11, 1939: Vollard Archives, MS 421 (3,6), fol. 18.

394. Dormoy 1931.

395. Vollard Archives, MS 421 (8,15), fol. 45.

396. D. Wildenstein and Stavridès 1999, pp. 64–70.

397. Paul-André Lemoisne to Vollard, January 16, 1932: Vollard Archives, MS 421 (10,7), fols. 19–21, 22.

398. Lemoisne to Vollard, March 17, 1930: Vollard Archives, MS 421 (10,7), fols. 12–14.

399. Vollard Archives, MS 421 (9,5), fol. 34.

400. Vollard Archives, MS 421 (8,15), fol. 54.

401. Vollard to the secretary of the Society, Claude Spaak, December 16 and 21, 1932: Vollard Archives, MS 421 (3,1), fols. 240–43. See also Brussels 1933.

402. Jewell 1933a and Jewell 1933b; A. Barnes 1934.

403. Vollard Archives, MS 421 (9,13), fol. 15, and Gary Tinterow's essay on Vollard and Picasso in this volume, p. 117, n. 56.

404. Gimpel 1966, p. 427; Johnson 1977, p. 157, no. 171.

405. Vollard Archives, MS 421 (9,8), fol. 1.

406. Johnson 1977, p. 160, no. 183.

407. Vollard Archives, MS 421 (3,1), fol. 203.

408. Vollard Archives, MS 421 (3,1), fol. 156; for reports from later years, see MS 421 (3,1), fols. 74, 115–16, 147–48, 197.

409. MS 421 (9,15), fols. 1–2; Johnson 1977, p. 163, no. 195.

410. Vollard to Puy, June 12, 1935: Vollard Archives, MS 421 (3,1), fol. 172.

411. Vollard Archives, MS 421 (9,8), fol. 2; Johnson 1977, p. 160, no. 184.

412. Vollard Archives, MS 421 (3,1), fol. 195.

413. Waldemar George 1936, pp. 3–4.

414. For an undated list of expenses related to an exhibition held at this address, see Vollard Archives, MS 421 (3,1), fol. 6. See also entry "September 26, 1928" in this chronology.

415. Lynes 1973, pp. 342–43. The revised and extended dates of the exhibition appear in the third edition of the exhibition catalogue; see New York 1936 (1946 ed.).

416. Roger-Marx 1936.

417. Vollard Archives, MS 421 (9,13), fol. 16; Johnson 1977, p. 162, no. 192.

418. Vollard Archives, MS 421 (3,1), fol. 16; see also MS 421 (3,1), fols. 17–19, 130–31, which lists some of the same works at slightly different prices.

419. See also the entry for cat. 72.

420. "Paris Dealer Here" 1936.

421. Jewell 1936.

422. "Paris Dealer Here" 1936 and "Ocean Travelers" 1936. See also Rewald 1989, p. 343, and GreenWeld 1987, p. 186.

423. Vollard Archives, MS 421 (3,1), fols. 141–46.

424. Vollard Archives, MS 421 (3,1), fol. 151.

425. Contract between Vollard and Éditions Émile Paul Frères, March 11, 1927: Private archives.

426. Vollard Archives, MS 421 (9,6), fols. 18–19.

427. Vollard Archives, MS 421 (10,7), fols. 23–29. For a list of ceramics delivered to the Petit Palais in January 1937, see Vollard Archives, MS 421 (10,7), fol. 32.

428. Vollard Archives, MS 421 (3,6), fols. 17–18, 55–90; MS 421 (10,7), fols. 27–30. See also Paris 1937.

429. Vollard Archives, MS 421 (9,1), fols. 26–28.

430. Vollard Archives, MS 421 (8,15), fol. 67; Johnson 1977, nos. 174, 189, 208.

431. Shipping receipt dated October 27, 1938: Vollard Archives, MS 421 (3,6), fols. 4–5.

432. Vollard Archives, MS 421 (8,15), fols. 65, 76, 79–80; MS 421 (8,16), fols. 11–12, 16, 17, 20; MS 421 (9,17), fols. 15–21; Johnson 1977, pp. 164–65, nos. 200, 201.

433. Vollard Archives, MS 421 (3,1), fols. 26–27, 32, 34–37, 39, 42, 44–48; see also MS 421 (3,1), fols. 16–19; MS 421 (10,7), fols. 34–35.

434. Vollard Archives, MS 421 (3,6), fols. 16–36.

435. Vollard Archives, MS 421 (9,17), fol. 72.

436. Lenossos 1939; Vollard Archives, MS 421 (10,13), fol. 1.

437. Official statement made by Vollard's chauffeur, July 24, 1939: Vollard Archives, MS 421 (3,1), fol. 30.

438. Gimpel 1966, p. 445.

439. *Rouault—Suarès Correspondence* 1983, p. 133, letter 252.

440. Vollard Archives, MS 421 (6,8), fols. 1–157; MS 421 (8,16), fols. 7–10, 13, 15, 18, 19, 21, 22; Johnson 1977, p. 162, no. 193.

441. Roulet 1961, p. 220; London–Paris–New York 2002–3, p. 381; Collet 1989, pp. 230–31.

442. Clarifications courtesy of Anne Distel.

443. Escholier to Lucien Vollard, November 2, 1939: Vollard Archives, MS 421 (10,7), fols. 34–35.

444. Jacques-Émile Blanche to Denis, December 15, 1939, in Collet 1989, p. 246, letter 111.

445. Nicholas 1994, pp. 92–93; Vollard Archives, MS 421 (3,1), fol. 23.

446. "Art Shipment Seized" 1940, in which the number of works seized does not match with that recorded on the inventory; see Assante, p. 260. See also "In the Realm of Art" 1940; "Seized French Art" 1940; and Nicholas 1994, pp. 92–93.

447. Perry 2000; "Legal Battle Halts Sale" 1981; Milinovic 1991, p. 59.

448. "Action by M. Rouault" 1946.

Exhibitions *chez* Vollard, 1894–1911

Rebecca A. Rabinow

with contributions from Anne Roquebert

The lists of works derive from extant catalogues prepared by Vollard, unless otherwise noted.

November 17–December 20, 1894[1] "Dessins & croquis de Manet, provenant de son atelier"
Presumably featured drawings and oil studies Vollard had purchased from Manet's widow throughout the year. Held at Vollard's gallery at 37, rue Laffitte. Invitations for this exhibition were produced: Vollard Archives, MS 421 (4,3), fol. 10. One is now in the Service d'Études et de Documentation du Musée du Louvre, Fonds Moreau-Nélaton (fig. 230).

Reviews: Raoul Sertat, "Revue artistique," *Revue encyclopédique*, December 15, 1894, p. 386; Camille Mauclair, "Choses d'art," *Mercure de France,* January 1895, pp. 118–20

1. It is possible that Vollard exhibited works by Édouard Manet in 1893; see Bailly-Herzberg 1980–91, vol. 3, p. 420, n. 1. An 1893 display of Manet's etchings and lithographs is mentioned in "Chez les peintres-graveurs," *L'Estampe: Moniteur des collectionneurs artistique, littéraire, financier,* April 23, 1893, p. 1, but no location is given.

June 4–30, 1895 Paintings by Vincent van Gogh
Inaugurated Vollard's gallery at 39, rue Laffitte. Invitations for this exhibition were produced but have not been located: Vollard Archives, MS 421 (4,3), fol. 23.

Reviews: E. den Dulk, "Tentoonstellungwerken Vincent van Gogh," *De kunstwereld* 2 (October 1895), p. 384; Charles Morice, "L'art et les lettres: Expositions juillet 1895," *L'Idée libre* (Librairie de l'art independant, Paris), 1895, p. 342; Thadée Natanson, "Jean Carriès–Vincent van Gogh," *La Revue blanche,* June 15, 1895, pp. 572–73; *Mercure de France,* July 1895, p. 128

September 16–October 31, 1895 "Oeuvres nouvelles de Ch. Maurin; tableaux: suite de femmes nues; tapis, papiers, étoffes"
Two reviewers recommended that visitors also ask to see the Degas pastels, Cézannes, Denises, and Manet's *ébauches* in the back room.

Reviews: Vollard, "Chronique," *L'Estampe moderne*, October 2, 1895, p. 1 (ill.); Charles Saunier, "Revue artistique," *Revue encyclopédique*, October 15, 1895, pp. 383–84; Camille Mauclair, "Choses d'art," *Mercure de France*, November 1895, pp. 253–54; Thadée Natanson, "En passant," *La Revue blanche*, November 15, 1895, p. 473; Yvanhoé Rambosson, "Notes d'art: Expositions particulières," *La Plume*, November 15, 1895, p. 516

November–December 1895 Works by Paul Cézanne
Portraits, still lifes, and landscapes

Reviews: Camille Mauclair, "Choses d'art," *Mercure de France*, November 1895, pp. 253–54; Gustave Geffroy, "Paul Cézanne," *Le Journal*, November 16, 1895, reprinted in *La Vie artistique*, Paris, 1900, pp. 214–20; "La Vie artistique," *Gil Blas*, November 27, 1895; Georges Denoinville, "Un Comblé," *Le Journal des artistes, peintres, sculpteurs, dessinateurs, architectes, décorateurs et des associations artistiques*, December 1, 1895, p. 1258; Thadée Natanson, "Paul Cézanne," *La Revue blanche*, December 1, 1895, pp. 497–500; Thiebault-Sisson, "Petites Expositions," *Le Temps*, December 22, 1895; Camille Mauclair, "Choses d'art," *Mercure de France*, January 1896, p. 130; André Mellerio, "L'Art moderne," *La Revue artistique*, January–February 1896, pp. 13–15; Charles Saunier, "Les Expositions," *Revue encyclopédique*, February 1896, p. 40

June 15–July 20, 1896 "Les Peintres-Graveurs"
Inaugurated Vollard's gallery at 6, rue Laffitte. Catalogue published in *L'Estampe*, June 21, 1896, unpaged. A copy of the catalogue, with annotations by Camille Pissarro, is held at the Cabinet des Estampes, Bibliothèque Nationale de France, Paris (Yd2 1338 b).

1. Georges Auriol, *Jeune Femme assise*, color lithograph
2. Georges Auriol, *Sélim, enfant de Damas*, color lithograph
3. Paul Blanc, *Mendiant*, etching
4. Paul Blanc, *Mendiant*, etching
5. J.-B. Blanche, *Portrait de M. Maurice Barrès*, lithograph
6. J.-B. Blanche, *Tête de petite fille*, lithograph and drypoint, heightened with wash
7. J.-B. Blanche, *Enfant assise se retournant*, lithograph
8. J.-B. Blanche, *Fillettes lisant*, color lithograph
9. J.-B. Blanche, *Cheval normand*, lithograph, heightened with wash
10. Eugène Bejot, *La Seine au Trocadéro*, etching
11. Eugène Bejot, *Chargement de sable*, etching
12. Eugène Bejot, *Le Viaduc à Nogent-sur-Marne*, etching
13. Eugène Bejot, *Croquis*, etching
14. Eugène Bejot, *Croquis*, etching
15. Eugène Bejot, drawing
16. Albert Besnard, *Têtes d'enfants*, etching
17. Albert Besnard, *Le Plumet du rajah, conte oriental*, etching
18. Albert Besnard, *Cheval arabe*, etching
19. Albert Besnard, *Tête de femme*, 1st state, etching
20. Albert Besnard, *La Rêveuse*
21. Bonnard, *La Petite Blanchisseuse*, color lithograph
22. Bonnard, lithographs
23. Félix Buhot, *Westminster Palace*, etching
24. Félix Buhot, *Westminster Bridge*, etching
25. Félix Buhot, *La Taverne du Bagne*, etching
26. Félix Buhot, *La Falaise avec les marges symphoniques*, etching

156. Odilon Redon, *Tête de jeune femme*, drawing
157. Odilon Redon, *La Lucarne*, drawing
158. Odilon Redon, *Le Silence*, drawing
159. Odilon Redon, *La Méditation*, lithograph
160. Renoir, *Mère et enfant*, tinted etching
161. De los Rios, *Crépuscule*, landscape, etching
162. De los Rios, *Paysages avec animaux*, two states
163. De los Rios, *Paysages*, three drawings
164. De los Rios, *Paysages*, two drawings
165. De los Rios, *Tête d'études*, two drawings
166. Rippl Ronaï, *Fête de village*, color lithograph
167. Rippl Ronaï, *Maison*, drawing with highlights
168. Rippl Ronaï, *Tête de vieille femme*, drawing with highlights
169. Rippl Ronaï, *La Vierge*, color lithograph, unique state, proof
170. Henri Rivière, *L'Hiver*, color lithograph
171. To Roop, *La Dame aux cygnes,* color lithograph
172. Félicien Rops, *L'Impuissance d'aimer*, etching
173. Félicien Rops, *L'Incantation*, soft-ground etching
174. Rysselberghe, *Le Café-concert*, etching
175. Rysselberghe, *Été*, lithograph
176. Rysselberghe, *La Toilette*, lithograph
177. Rysselberghe, *Blanchisseuse*, lithograph
178. Rysselberghe, *Portrait d'homme*, lithograph
179. Rysselberghe, *Marine*, lithograph
180. Rysselberghe, *Le Graveur sur bois*, lithograph
181. A. Sisley, *Paysage*, etching
182. A. Sisley, *Paysage*, pastel
183. A. Sisley, *Maisons sur l'eau*, pastel
184. A. Sisley, *Bords de la rivière*, pastel
185. A. Sisley, *Bords de la rivière*, pastel
186. A. Sisley, *Bords de la rivière*, pastel
187. Suzanne Valadon, *Étude de femmes nues*, etching
188. Vallotton, *La Paresse*
189. Vallotton, *Roger et Angélique*
190. Vallotton, *Le Premier Janvier*
191. Vallotton, *La Nuit*
192. Vallotton, *L'Alerte: La Sortie*
193. Jean Weber, *La Grenouille*, three different states
194. Vuillard, *Les Tuileries*, color lithograph
195. Vuillard, lithograph
196. Willette, *Le Petit Chaperon rouge*, lithograph
197. Willette, *Pierrot et Pierrette*, color lithograph
198. Willette, *Scènes de Pierrots*, drawing

Reviews: "Les Peintres-Graveurs," *L'Estampe*, June 21, June 28, July 5, and July 12, 1896, pp. 1, 3, 1, 1, respectively; "Expositions nouvelles," *La Chronique des arts*, July 11, 1896, p. 240; Loys Delteil, "Les Salons: Les Peintres-Graveurs," *Le Journal des artistes*, July 12, 1896, pp. 1516–17

November 1896 Works by Paul Gauguin
Paintings, stoneware, ceramics, and carved wood, many already exhibited at Durand-Ruel in late 1893

Reviews: Gabriel Mourey, "Studio-Talk," *Studio* (London) 9 (November 1896), pp. 145–46; Thadée Natanson, "Peinture," *La Revue blanche*, December 1, 1896, pp. 517–18

December 1896–early 1897 Paintings and Drawings by Vincent van Gogh
Fifty-six oil paintings, fifty-six drawings, and one lithograph lent by Johanna van Gogh-Bonger [Archives, Van Gogh Museum, Amsterdam, MS b1437V/1962]

Invitations for this exhibition were produced but have not been located: Vollard Archives, MS 421 (4,3), fol. 59.

Reviews: André Fontainas, "Art," *Mercure de France*, January 1897, pp. 221–22; Gabriel Mourey, "Studio-Talk," *Studio* (London) 9 (January 1897), pp. 290–91

February 16–March 15, 1897 Works by Armand Guillaumin
Pastels

Invitations for this exhibition were produced but have not been located: Vollard Archives, MS 421 (4,3), fols. 65–66.

Reviews: "Expositions nouvelles," *La Chronique des arts*, February 20, 1897, p. 79; André Fontainas, "Art: Memento," *Mercure de France*, March 1897, p. 627; Thadée Natanson, "Petite Gazette d'art," *La Revue blanche*, March 1, 1897, p. 247

See also Guillaumin to Vollard, September 27, 1897: Vollard Archives, MS 421 (2,20), p. 145, and MS 421 (4,4), fol. 9.

March 15–31, 1897 "Exposition annuelle des élevès de l'Académie Julian"
D. O. Widhopf's poster for the exhibition is reproduced in "Some Images of Women in French Posters of the 1890s," *Art Journal*, Winter 1973–74, p. 124.

Review: "Expositions nouvelles," *La Chronique des arts*, March 20, 1897, p. 115

April 6–30, 1897 "Exposition des oeuvres de MM. P. Bonnard, M. Denis, Ibels, G. Lacombe, Ranson, Rasetti, Roussel, P. Sérusier, Vallotton, Vuillard"

P. Bonnard
1. *Tryptique,* painting
2. *Promenade,* painting
3. *Cirque,* painting
4. *Effet de théâtre,* painting
5. *Jardin du Moulin Rouge,* painting
6. *Paysage d'hiver,* painting
7. *Premier soleil,* painting

M. Denis
8. *Nativité,* painting
9. *Portrait de famille,* painting
10. *Matinée de printemps,* painting
11. *Vue de Toulouse,* painting
12. *L'Enfant nu,* painting
13. *La Mère dans le soir violet,* painting
14. *La Mère au jardin ensoleillé,* painting
15. *La Mère à la porte blanche,* painting
16. *La Mère aux coussins rouges,* painting
17. *Le Bain,* painting

Ibels
18. *La Charrette de blé,* painting
19. *Au jardin,* painting
20. *La Fête au matin,* painting
21. *Parade,* painting
22. *Paysage,* painting
23. *L'Épicière,* painting
24. *Soldats à la chambrée,* painting

G. Lacombe
25. *Marine,* painting
26. *Vague déferlant,* painting
27. *Houle,* painting

28. *Paysage breton*, painting
29. *Coucher de soleil*, painting
 Ranson
30. *Femmes vêtues de blanc*, tapestry
31. Needlepoint ("tapisserie au gros point")
32. Tapestry or needlepoint cartoon
33. *Trois projets de Bande*
34. *Les Princesses de la terrasse*, decorative panel
35. *Dans la forêt*, pastel
36. *Les Ouvrières en tapisserie*, pastel
37. *Tristesse*, pastel
38. *L'Étude*, pastel
39. *Printemps*, pastel
40. *Scène biblique*, decorative panel
41. Tapestry or needlepoint cartoon
 Rassetti
42. *Motif breton*, painting
43. *Paysage*
44. Ceramic panels
 Roussel
45. *Christ aux petits-enfants*, painting
46. *Printemps*, painting
47. *Baigneuses*, painting
48. *L'Auberge*, painting
49. *Paysage aux biches*, painting
50. *Bon Samaritain*, painting
 P. Sérusier
51. *Clair de lune*, painting
52. *Paysans et vaches*, painting
53. *Le Gosse rouge*, painting
54. *Crépuscule*, painting
55. *Matin de printemps*, painting
56. *Avant la procession*, painting
57. *Filles sur les dunes*, painting
58. *Bretonnes sous l'arbre en fleurs*, painting
59. *Paysage*, painting
60. *Filles de Douarnenez*, painting
 Vallotton
61. *Baigneuses*, painting
62. *Femme nue*, painting
63. *Femmes nues*, painting
64. *Le Piano*, woodcut
65. *La Flûte*, woodcut
66. *Le Violon*, woodcut
67. *La Guitare*, woodcut
68. *Le Violoncelle*, woodcut
69. *Le Piston*, woodcut
70. *Stendhal*, woodcut
71. *Le Bain*, woodcut
72. *L'Absoute*, woodcut
73. *La Nuit*, woodcut
74. *L'Alerte*, woodcut
75. *La Paresse*, woodcut
76. *Roger et Angélique*, woodcut
 Vuillard
77. *Intérieur*, painting
78. *Jardin d'automne*, painting
79. *Maisons*, painting
80. *Toits rouges*, painting
81. *Intérieur*, painting
82. *La Table*, painting

83. *La Cuisine*, painting
84. *Soir*, painting
85. *Intérieur*, painting
86. *Tête d'étude*, painting
87. *Effet de nuit*, painting
88. *Nature morte*, painting
89. Uncatalogued posters and lithographs

Reviews: "Expositions," *L'Estampe et l'affiche*, April 1897, pp. 63–64; "Expositions nouvelles," *La Chronique des arts*, April 10, 1897, p. 143; Thadée Natanson, "Petite Gazette d'art," *La Revue blanche*, April 15, 1897, pp. 484–85; André Fontainas, "Art," *Mercure de France*, May 1897, pp. 411–12; Roger Marx, "Le Mouvement artistique," *Revue encyclopédique*, July 17, 1897, p. 570; André Fontainas, "Art," *Mercure de France*, August 1897, pp. 374–75

November 8–20, 1897 "Exposition T.-E. Butler"
First solo exhibition of Monet's son-in-law, the American artist Theodore Butler (1861–1936)

Invitations for this exhibition, which was held entirely at Butler's expense, were produced but have not been located. Exhibition expenses are recorded in Vollard Archives, MS 421 (4,3), fol. 88.

1. *Étude de bain*
2. *Étude de bain*
3. *Étude de bain*
4. *Étude de bain*
5. *Étude de bain*
6. *Étude de bain*
7. *Étude de bain*
8. *Au piano*
9. *Intérieur*
10. *Intérieur*
11. *Les Premiers Pas*
12. *Intérieur*
13. *Portrait*
14. *Le Petit Moulin*
15. *Le Petit Moulin*
16. *Effet d'automne*
17. *Effet d'automne*
18. *Le Val*
19. *Bouleaux*
20. *Bouleaux*
21. *Bouleaux*
22. *Effet de printemps*
23. *Effet de printemps*
24. *Laboureur*
25. *Effet de brouillard*
26. *La Gelée blanche*
27. *Effet d'automne*
28. *Effet de neige*
29. *Effet de neige*
30. *Meule*
31. *Meule*
32. *Meule*
33. *Meule*
34. *Prairie de Limetz*
35. *Un Jardin*
36. *Dans le jardin*
37. *L'Église de Giverny*
38. *L'Église de Giverny*

39. *La Gelée blanche*
40. *La Gelée blanche*
41. *Effet d'automne*
42. *Partie de cartes*
43. *Soirée d'hiver*
44. *Effet de matin*
45. *Effet de matin*
46. *Effet de matin*
47. *Effet de matin*

Reviews: "Expositions nouvelles," *La Chronique des arts*, November 13, 1897, p. 340; André Fontainas, "Art moderne," *Mercure de France*, December 1897, pp. 923–24

December 2–23, 1897 *Album d'estampes originales de la Galerie Vollard*[2]

Also on view in a room of the gallery: large Pointillist painting by Signac, snowscape by Pissarro, and paintings by Bonnard, Denis, and Van Gogh

Reviews: "Expositions," *L'Estampe et l'affiche*, January 1898, pp. 10–11 (ills. of prints by Cézanne, Forain, and Whistler); André Fontainas, "Art moderne: Memento," *Mercure de France*, January 1898, p. 306

2. Dates of this exhibition from Lyon and other cities 1994–95, p. 363.

Mid–late January 1898 Works by Charles Guéroult
Watercolors and large China ink drawings

Reviews: Arsène Alexandre in *Le Figaro*, January 24, 1898 (in Bailly-Herzberg 1980–91, vol. 4, p. 432, n. 3); "Expositions nouvelles," *La Chronique des arts*, January 29, 1898, p. 40

February 20–March 10, 1898 "Exposition Murer; trilogie des mois"
Pastels, including a large series, "Trilogie des mois," representing each month of the year, seen at dawn, noon, and dusk. (After closing at Vollard's, the exhibition traveled to Nice, where a collector purchased "Trilogie des mois" for 25,000 francs.)

A catalogue for this exhibition, with a preface by Adolphe Tabarant, was produced but has not been located. Murer designed a poster for the exhibition (fig. 279).

Reviews: "Beaux-arts," *L'Intransigeant*, February 21, 1898, p. 3; "Expositions nouvelles," *La Chronique des arts,* February 26, 1898, p. 79; André Fontainas, "Art moderne: Memento," *Mercure de France*, March 1898, p. 943; "L'Exposition Murer," *L'Intransigeant*, March 9, 1898, p. 3; "Notes et nouvelles," *Revue encyclopédique*, March 5, 1898; *L'Estampe*, March 13, 1898, p. 2; O. F., "Petites Expositions: Les Pastels de M. Murer," *La Chronique des arts*, March 19, 1898, p. 98; "Les Estampes et les affiches du mois," *L'Estampe et l'affiche*, April 1898, p. 92; Yvanhoé Rambosson, "Petites Expositions: Exposition Murer (Galerie Vollard)," *La Plume*, April 1, 1898, p. 222; "L'Exposition Murer," *L'Intransigeant*, April 3, 1898, p. 3; "La Trilogie de Murer," *L'Intransigeant*, April 23, 1898, p. 3

March 27–April 20, 1898 "Exposition des oeuvres de MM. P. Bonnard, M. Denis, Ibels, Ranson, X. Roussel, Sérusier, Vallotton, Vuillard"

P. Bonnard
1. *Nature morte*
2. *Café*
3. *Le Déjeuner*
4. *Paysage*
5. *Mère et enfant*
6. *Soirée*
7. *Étude de femme nue*
8. *Pluie*
9. *Intérieur*
10. *Place publique*
11. *Fillette*

M. Denis
Sketches of Italy
12. *Le Forum*
13. *Le Colysée*
14. *La Rue Saint-Jean-de-Latran, à Cortone*
15. *Sangimignano*
16. *La Badia de Fiesole*
17. *Gorge du Mugnone à Fiesole*
18. *Villa Salviati, près de Fiesole*
Studies after Florentine masters
19. *Portrait de Mme C . . . (l'Angelico)*
20. *Portrait*
21. *Bon Samaritain*
22. *Déjeuner (Filippo Lippi)*
23. *Femme nue (Lorenzo di Credi)*
24. *Portrait renaissance (Lorenzo di Credi)*

Ibels
25. *Paysans*
26. *Vagabonds*
27. *La Parade*
28. *Vagues*
29. *Le Petit Port*
30. *La Baraque de lutteurs*
31. *Les Marins*

Ranson
32. Tapestry cartoon
33. *Tigre couché,* tapestry cartoon
34. *La Femme verte*
35. *La Malade*
36. *La Bonne renvoyée*
37. *Avant de se coucher*

X. Roussel
38. *Danse*
39. *Bethsabée*
40. *Scène d'été*
41. *Marronnier rose*
42. *Bord de rivière*
43. *Petite Baigneuse*
44. *Esquisse décorative*
45. *Baigneuses*
46. *La Tour Eiffel*
47. *Marronnier blanc*
48. *Femmes sous bois*

Sérusier
49. *Les Lutteurs*
50. *Paysage*
51. *Bretonnes*

F. Vallotton
52. *Le Bon Marché*
53. *Le Soir*
54. *Portrait de M. E. N.*

55. *Portrait de M. E. V.*
56. *Portrait de Mlle M.*

Vuillard

57. *La Conversation*
58. *Intérieur*
58.[*sic*] *Le Thé*
59. *Paysage*
60. *Le Cirque*
61. *Intérieur*
62. *Intérieur*
63. *Intérieur*

Reviews: André Fontainas, "Art moderne: Memento," *Mercure de France*, April 1898, p. 300; "Expositions nouvelles," *La Chronique des arts*, April 2, 1898, p. 120; "Notes et nouvelles," *Revue encyclopédique*, April 2, 1898; Thadée Natanson, "Petite Gazette d'art," *La Revue blanche*, April 15, 1898, pp. 615–18; "Expositions," *Revue encyclopédique*, April 16, 1898, p. 26; André Fontainas, "Art moderne," *Mercure de France*, May 1898, pp. 598–99

Ca. April 1898 Paintings, Drawings, and Etchings by Alfred Muller

Works by Maurice Denis also on view in a room of the gallery

Reviews: Thadée Natanson, "Petite Gazette d'art," *La Revue blanche*, May 1, 1898, pp. 67–68; Yvanhoé Rambosson, "Petites Expositions," *La Plume*, May 1, 1898, p. 287; "Notes et nouvelles," *Revue encyclopédique*, May 7, 1898, p. 1

May 9–June 10, 1898 "Exposition Cézanne"

1. *Nature morte*
2. *Nature morte*
3. *Nature morte*
4. *Paysage*
5. *Nature morte*
6. *Paysage*
7. *Paysage*
8. *Paysage*
9. *Nature morte*
10. *Nature morte*
11. *Paysage*
12. *Nature morte*
13. *Nature morte*
14. *Joueur de cartes*
15. *Paysage*
16. *Paysage*
17. *Nature morte*
18. *Paysage*
19. *Intérieur*
20. *Paysage*
21. *Nature morte*
22. *Nature morte*
23. *Nature morte*
24. *Nature morte*
25. *Le Fumeur*
26. *Paysage*
27. *Paysage*
28. *Paysage*
29. *Paysage*
30. *Paysage*
31. *Paysage*
32. *Nature morte*
33. *Paysage*
34. *Fleurs*
35. *Nature morte*
36. *Fleurs*
37. *Portrait*
38. *Portraits*
39. *Fleurs et fruits*
40. *Paysage*
41. *Nature morte*
42. *Nature morte*
43. *Fleurs*
44. *Paysage*
45. *Fleurs et fruits*
46. *Fleurs*
47. *Nature morte*
48. *Marine grise*
49. *Fleurs et fruits*
50. *Fleurs et fruits*
51. *Marine*
52. *Paysage*
53. *Marine*
54. *Portrait de Mme C.*
55. *Portrait de Mme C.*
56. *Le Cabaret*
57. *Portrait*
58. *Le Cygne et Léda*
59. *Paysage*
60. *Nature morte*

Reviews: Yvanhoé Rambosson, "Petites Expositions," *La Plume*, May 1, 1898, p. 287; *L'Estampe*, May 15, 1898, p. 3; "Expositions nouvelles," *La Chronique des arts*, May 21, 1898, p. 187; André Fontainas, "Art moderne," *Mercure de France*, June 1898, p. 890; Thadée Natanson, "Notes sur l'art des Salons," *La Revue blanche*, June 1, 1898, p. 220; "Expositions," *Revue encyclopédique*, June 11, 1898, p. 43; "Expositions nouvelles," *La Chronique des arts*, June 25, 1898, p. 219

May 10–31, 1898 Drawings and Pastels by Odilon Redon

Thirteen pastels and five charcoal drawings. The exhibition overlapped with that of Cézanne.

Reviews: "Expositions nouvelles," *La Chronique des arts*, May 28, 1898, p. 196; "Expositions," *L'Estampe et l'affiche*, June 1898, p. 132; Thadée Natanson, "Notes sur l'art des salons," *La Revue blanche*, June 1, 1898, p. 220; *Revue encyclopédique*, June 11, 1898, p. 43

November 17, 1898–early January 1899 Paintings by Paul Gauguin

Where Do We Come From? What Are We? Where Are We Going? (Museum of Fine Arts, Boston) and nine other paintings

Invitations for this exhibition were produced but have not been located.

Reviews: "Expositions nouvelles," *La Chronique des arts*, November 26, 1898, p. 340; Thadée Natanson, "Petite Gazette d'art: De M. Paul Gauguin," *La Revue blanche*, December 1, 1898, pp. 545–46; André Fontainas, "Art moderne," *Mercure de France*, January 1899, pp. 235–38; Yvanhoé Rambosson, "La Promenade de Janus: Causeries d'art," *La Plume*, January 1, 1899, p. 29 See also Shackelford 2004, pp. 186–92.

February 23–March 12, 1899 "Exposition Paul Vogler"
Title and dates from Vollard's announcement card

Thirty-eight landscape paintings, including *Brouillard et soleil, Neige, Nuit claire, Nuit à Jouy-la-Fontaine, Neige au bord de la Seine, Givre à Jouy-la-Fontaine, Clair de lune, Pluie au Blanc-Mesnil,* and *Une Mare au Blanc-Mesnil*

Reviews: "Exposition de M. Paul Vogler," *La Revue des beaux-arts et des lettres,* March 15, 1899, p. 156; André Fontainas, "Art moderne: Memento," *Mercure de France,* April 1899, p. 252

March–early April 1899 Lithographs by Bonnard, Denis, Fantin-Latour, Redon, and Vuillard
Lithograph albums in color by Bonnard, Denis, and Vuillard and in black and white by Redon, as well as a series of lithographs by Fantin-Latour

Reviews: André Mellerio, "Expositions: Les Éditions Vollard (Exposition d'estampes)," *L'Estampe et l'affiche,* April 1899, pp. 98–99; "Petites Expositions: Galerie Vollard," *La Chronique des arts,* April 1, 1899, p. 114; André Mellerio, "La Lithographie aux deux Salons," *L'Estampe et l'affiche,* May 1899, p. 112

April 12–27, 1899 "L'Exposition rétrospective de l'oeuvre de Charles Dulac"
Title and dates from Vollard's invitation

Retrospective of paintings, lithographs, and etchings by the recently deceased artist

Reviews: "Expositions nouvelles," *La Chronique des arts,* April 8, 1899, p. 126; Notice in *Le Bulletin de l'art ancien et moderne,* April 15, 1899, p. 126; Yvanhoé Rambosson, "La Promenade de Janus: Causeries d'art," *La Plume,* May 1, 1899, p. 316; Gabriel Mourey, "Studio Talk," *International Studio* (London) 8 (July 1899,) p. 52

Ca. April 1899 Works by Isidre Nonell i Monturiol
Watercolors and sketches

Reviews: André Fontainas, "Art moderne: Memento," *Mercure de France,* May 1899, p. 535; Félicien Fagus, "Petite Gazette d'art: Les Aquarelles de Nonell-Monturiol," *La Revue blanche,* May 1, 1899, p. 60; Félicien Fagus, "Les Aquarelles de Nonell-Monturiol," *La Revue des beaux-arts et des lettres,* May 1, 1899, p. 235; Yvanhoé Rambosson, "La Promenade de Janus: Causeries d'art," *La Plume,* May 1, 1899, p. 316

April 28–May 6, 1899 "André Sinet: Tableaux de voyages, impressions de promenades, notes & souvenirs"
Catalogue preface by Frantz Jourdain

1. *Une Matinée de printemps (Villennes)*
2. *Les Saules*
3. *Le Gros Nuage*
4. *Les Berges*
5. *Début d'une belle journée*
6. *Crépuscule*
7. *Brouillard séquanien*
8. *Le Sentier*
9. *Brume londonienne (Regent's-Park-Lake)*
10. *Rouen* (collection of M. Louis Dumoulin)
11. *Calme plat*
12. *Le Torrent (Lonsdale Castle)*
13. *Vagues dorées*

14. *Vent du nord (Ostende)*
15. *Matin de juillet*
16. *Le Soleil derrière les nuages (Mer du Nord)*
17. *Le Brise-lames*
18. *Le Pavillon (Nieuport)*
19. *Le Boulevard Saint-Germain*
20. *La Barre rose*
21. *Coucher de soleil gris*
22. *Lames du soir*
23. *Venise (Les Derniers Feux du soleil)*
24. *Le Lac*
25. *Le Bleu de l'Adriatique*
26. *Au Lido*
27. *La Déclaration* (collection of M. le baron de l'Espée)
28. *Capri*
29. *Le Vésuve (à mi-chemin du cratère)*
30. *Saint-Germain (Souvenir de promenade)*
31. *Rue Ampère (Soleil couchant)*
32. *Naples (Vue du steamer)*
33. *Les "Innocenti"* (collection of M. Villain)
34. *Crépuscule suburbain*
35. *Le Simplon*
36. *La Plage (Trouville)* (collection of M. Souché)
37. *Les Champs-Élysées*
38. *Tête de jeune fille à la robe rouge*
39. *Les Chevaux de Marly* (collection of M. Paul Gallimard)
40. *Les Arbres de Saint-Cloud*
41. *Les Cheveux blonds*
42. *Femme nue au bord de l'eau*
43. *Printemps*
44. *Ophélie* (collection of M. Paul Gallimard)
45. *Le Repos à l'ombre des arbres*

Reviews: "Expositions nouvelles," *La Chronique des arts,* April 29, 1899, p. 156; Yvanhoé Rambosson, "La Promenade de Janus: Causeries d'art," *La Plume,* June 1, 1899, p. 383

May 1899 Works by Edvard Diriks
About twenty landscapes and seascapes, most depicting a small Norwegian fishing village, Drøbak, south of Oslo, including *Drøbak en mai, Matinée d'automne,* and *Drøbak, premières neiges*

A catalogue was produced but has not been located.

Reviews: Julien Leclercq, "Petites Expositions: Galeries Vollard," *La Chronique des arts,* May 13, 1899, pp. 166–67; "Exposition de M. Edvard Diricks [*sic*]," *La Revue des beaux-arts et des lettres,* June 1, 1899, p. 282; Félicien Fagus, "Petite Gazette d'art: Exposition Edvard Diriks" *La Revue blanche,* June 1, 1899, p. 221

May 25–June 10, 1899 "Tableaux de René Seyssaud"
Catalogue preface by Arsène Alexandre

1. *Bord de la mer à Cassis*
2. *Ramasseurs de lavande*
3. *Cap Canaille au couchant, Cassis*
4. *Cap Canaille, Matin*
5. *Bord de la mer, Cassis*
6. *Ramasseurs de lavande*
7. *Chemin dans le Ventoux*
8. *Soleil couchant sur les bois*
9. *Ravin de la Nesque*

10. *Paysage de montagne*
11. *Chêne*
12. *Mûriers*
13. *Chataigniers*
14. *Champ de Luzerne*
15. *Champ de Sainfoin fleuri*
16. *Sarcleuse*
17. *Abords d'un village*
18. *Sentier dans le Ventoux*
19. *Sentier dans les blés verts*
20. *Gerbier*
21. *Terrains rouges*
22. *Pins sur la mer*
23. *Côte de Cassis*
24. *Ramasseurs de lavande*
25. *Marine*
26. *Étude de vagues*
27. *Crépuscule*
28. *Paysans*
29. *Vue de Cassis*
30. *Sarcleuse*
31. *Sarcleuse*
32. *Ramasseurs de lavande*
33. *Côteaux*
34. *Marine, matin*
35. *Mulets à l'abreuvoir*
36. *Chemin au bord de la mer*
37. *Côte de Cassis*
38. *Pins*
39. *Paysage du Ventoux*
40. *Cap Canaille (couchant)*
41. *Cap Canaille (contre-jour)*
42. *Poiriers*
43. *Champ d'épeautre*
44. *Ventoux neigeux*
45. *Crépuscule*
46. *Village à l'aube*
47. *Moisson*
48. *Arbres*
49. *Moisson*
50. *Ramasseurs de lavande*
51. *Labour*
52. *Parc en automne*
53. *Moisson*
54. *Côteaux*
55. *Châtaigniers*
56. *Paysans au travail*

Reviews: Félicien Fagus, "Petite Gazette d'art: Tableaux de René Seyssaud," *La Revue blanche*, June 15, 1899, pp. 309–10; André Fontainas, "Art moderne," *Mercure de France*, July 1899, pp. 245–46; Yvanhoé Rambosson, "La Promenade de Janus: Causeries d'art," *La Plume*, July 1, 1899, p. 447; Félicien Fagus, "Gazette d'art: René Seyssaud," *La Revue blanche*, April 1, 1901, p. 540

November 1899 Works by Paul Cézanne

A catalogue was produced but has not been located. The following list is taken from Rewald 1996, vol. 1, p. 562.

1. *Giroflées*
2. *Le Bassin du Jas de Bouffan (Aix-en-Provence)*

3. *La Maison lézardée*
4. *Paysage*
5. *L'Arlequin*
6. *La Belle Imperia*
7. *Maison dans les arbres (Auvers-sur-Oise)*
8. *La Maison du pendu (Effet de neige)*
9. *Baigneur*
10. *Nature morte (Deux assiettes de fruits)*
11. *Nature morte*
12. *Oliviers & maison rouge (paysage)*
13. *Peupliers*
14. *Paysage de montagnes*
15. *Le Jardin du Jas de Bouffan*
16. *Les Joueurs de cartes*
17. *Nature morte (Bouteilles, oranges et citrons)*
18. *Bords de la Seine à Paris*
19. *Nature morte (Tenture & fruits)*
20. *Fumeur*
21. *Nature morte (Table servie)*
22. *D'après Delacroix (Agar & Ismael)*
23. *Fête au bord de la mer*
24. *Les Marronniers du Jas de Bouffan*
25. *Bouquet de fleurs*
26. *Portrait de M.C.*
27, 28. [missing from Rewald]
29. *Personnages au bord de l'eau*
30. *Portrait*
31. *La Tentation de Saint-Antoine*
32. *Portrait de M. A.*
33. *Buffet avec fruits & gateaux*
34. *Paysage de l'Estaque*
35. *Nature morte (Oignons, pommes, pot vernissé, etc.)*
36. *Le Chemin dans la montagne*
37. *Roses jaunes*
38. *Paysage*
39. *Paysage*
40. *Paysage*

Reviews: "Expositions nouvelles," *La Chronique des arts*, November 18, 1899, p. 327; Julien Leclercq, "Petites Expositions: Galerie Vollard," *La Chronique des arts*, November 25, 1899, pp. 330–31; Gustave Coquiot, "La Vie artistique," *Gil Blas*, November 27, 1899, p. 2; André Fontainas, "Art Moderne," *Mercure de France*, December 1899, p. 816; G. Lecomte, "Paul Cézanne," *Revue de l'art*, December 1899, pp. 81–87; Félicien Fagus, "Petite Gazette d'art: Quarante Tableaux de Cézanne," *La Revue blanche*, December 15, 1899, pp. 627–28

December 1900 "Ernest Chamaillard"
Catalogue preface by Arsène Alexandre

Paintings
1. *Le Buisson rouge*
2. *L'Ilot du Moulin*
3. *Les Peupliers*
4. *La Grève de Rospico*
5. *La Presqu'île de Raguenez*
6. *Nature morte*
7. *Le Bois d'Amour à Pont-Aven*
8. *La Rivière de Pont-Aven*
9. *L'Écluse du moulin*
10. *Une Tempête à Doëlan*

11. *Le Moulin*
12. *Les Pavots*
13. *Nature morte*
14. *La Vallée de Rospico*
15. *Les Saules*
16. *Pont-Aven*
17. *Nature morte*
 Objets d'art
18. Item of carved furniture
19–29. Ten [*sic*] carved panels

Reviews: "Expositions nouvelles," *La Chronique des arts*, December 22, 1900, p. 392; Félicien Fagus, "Petite Gazette d'art: Un Meuble de Chamaillard," *La Revue blanche*, January 1, 1901, p. 63; Émile Verhaeren, *Mercure de France*, February 1901, p. 547

January 20–February 20, 1901 Paintings by Paul Cézanne
About thirty-six paintings

A catalogue for this exhibition was produced but has not been located.

Reviews: "Expositions nouvelles," *La Chronique des arts*, January 26, 1901, p. 32; Jean Béral, "Impressionistes: Cézanne," *Art et littérature*, February 5, 1901, pp. 6–7; Raymond Bouyer, "Petites Expositions: Exposition Cézanne," *La Chronique des arts*, February 16, 1901, p. 51; Roger Marx, "La Saison d'art," *Revue universelle*, July 13, 1901, pp. 649–52

See also Rewald 1996, vol. 1, p. 562

Ca. February 1901 Prints by Bonnard, Cézanne, Denis, Fantin-Latour, Lunois, Raffaëlli, Renoir, Vuillard, and others
Review: "Expositions ouvertes ou prochaines," *L'Art décoratif*, February 1901, p. 225

June 10–22, 1901 "Tableaux d'Émile Bernard (Paris, Bretagne, Egypte)"
Catalogue preface by Roger Marx

1885
1. *Vue prise par ma fenêtre, à Courbevoie*
2. *Effet de neige par ma fenêtre, à Courbevoie*
 1886
3. *Les Femmes du petit boulevard (effet du soir)*
4. *Bouquet de fleurs dans un vase, au soleil*
 1887
5. *Maisons à Asnières (effet du matin)*
6. *La Femme aux oies*
7. *Un Jardin public, à Mayenne*
8. *Vue de village de la Chapelle, à Saint-Briac*
9. *Le Bois d'amour, à Pont-Aven*
 1888
10. *Portrait de ma soeur*
11. *Vue prise vers Ploubalay (effet d'orage et de soleil)*
12. *La Moisson, à Pont-Aven*
13. *L'Abîme, "composition"*
 1889
14. *Le Christ décloué de la croix, "composition"*
 1890
15. *L'Annonciation, "composition"*
16. *Les Toits d'Asnières (effet d'automne)*, study

1891
17. *Le Linge sur le pré, à Saint-Briac*
18. *Portrait de mon aubergiste à Saint-Briac*
19. *Sorte de messe, à Médréac (Ille-et-Vilaine)*
20. *Une Tête d'enfant de Saint-Briac*, study
21. *Le Ravin de Saint-Briac*, sketch
22. *L'Église de Couilly (effet de neige)*
 1892
23. *Les Musiciens, "composition"*
24. *Nature morte*
25. *Vue de vallon de Pont-Aven*, study
26. *Effet de soleil au Bois d'amour*
27. *Soleil couchant*
28. *Dans le parc d'autrefois*, decoration
29. *Nature morte bretonne*
30. *Nature morte bretonne*
31. *Bretonnes au Pardon*
 1893
32. *Les Fumeurs de haschich à Tantah (Egypte)*
 1894
33. *Croquis d'une tête*
34. *Nature morte, grenades et poires*
35. *Baigneuses, "composition"*
36. *Danseuse arabe au Caire*
37. *Femmes puisant de l'eau au Nil*
38. *Ma Cour, au Caire*
 1895
39. *Pleureuses au Caire*
40. *Le Nil à Boulac*
41. *Les Femmes dans le jardin du harem*
 1897
42. *Mon Portrait*
 1901
43. *Ombre et lumière*

Reviews: "Echos: Exposition d'É. Bernard," *La Plume*, June 15, 1901, unpaged; Claude Anet, "Gazette d'art: Oeuvres d'Émile Bernard," *La Revue blanche*, July 1, 1901, pp. 381–82

June 25–July 14, 1901 "Exposition de tableaux de F. Iturrino et de P.-R. Picasso"
Catalogue preface by Gustave Coquiot

F. Iturrino
1. *Cabaret*
2. *Joueurs de cartes*
3. *Buveurs*
4. *Paysage*
5. *Étude de nu*
6. *Cirque*
7. *Loge aux courses*
8. *Danseuses; fête intime*
9. *Portrait*
10. *Initiation à l'amour*
11. *L'Idiot*
12. *Andalouse au fichu blanc*
13. *Paysage, boulevard Clichy*
14. *Groupe de femmes au soleil*
15. *Causerie de l'après-midi*
16. *Paysage*
17. *Marché aux cochons*
18. *Gitanes*

19. *Visite*
20. *Les Couseuses*
21. *Danse de gitanes*
22. *Grands Cavaliers*
23. *Le Déjeuner*
24. *Les Liseuses*
25. *La Danse*
26. *Étude de femme*
27. *Femme au chapeau gris*
28. *Les Vierges*
29. *Las Charras*
30. *Mysticisme*
31. *Groupe de femmes à Salamanque*
32. *Promenade*
33. *Étude de nu en plein air*
34. *Intimité*
35. *Après-midi*
36. *Dessins*

P.-R. Picasso
1. *Portrait de l'artiste*
2. *Portrait de M. Iturrino*
3. *Portrait de M. Mañach*
4. *Toledo*
5. *Femme nue*
6. *Iris*
7. *Portrait*
8. *La Mère*
9. *Morphinomane*
10. *L'Absinthe*
11. *Moulin-Rouge*
12. *La Buveuse*
13. *La Fille du roi d'Egypte*
14. *Le Soir*
15. *Une Fille*
16. *Les Blondes Chevelures*
17. *La Folle aux chats*
18. *Le Jardin enchanté*
19. *Germaine*
20. *Étude*
21. *Jardin de rêve*
22. *Le Square* (collection of Mme Besnard)
23. *Les Toits*
24. *Le Roi-Soleil* (collection of M. Fabre)
25. *Portrait*
26. *La Cruche verte* (collection of M. Ackermann)
27. *Fleur* (collection of Mme Besnard)
28. *Fleurs* (collection of Mme Besnard)
29. *Le Pot blanc*
30. *Boulevard Clichy* (collection of Mme Besnard)
31. *Les Gosses*
32. *Les Courses*
33. *Le Matador*
34. *Les Victimes*
35. *L'Arène*
36. *Café-concert*
37. *Brasserie*
38. *La Femme jaune* (collection of M. Personnas)
39. *Le Divan Japonais* (collection of M. Virenca)
40. *El Tango*
41. *La Bête* (collection of Mme K. Kollwitz, painter in Berlin)
42. *Monjuich*

43. *Courses de village*
44. *Église d'Espagne*
45. *Village d'Espagne*
46. *Buveurs*
47. *L'Enfant blanc*
48. *Jeanneton*
49. *La Méditerranée*
50. *Rochers*
51. *Les Buveuses* (collection of M. Ackermann)
52. *Danseuses* (collection of M. Sainsère)
53. *Madrileña* (collection of M. Sainsère)
54. *Chanteuse* (collection of M. Blot)
55. *L'Amoureuse* (collection of M. Blot)
56. *Au Bord de l'eau* (collection of M. Coll)
57. *Femme de nuit*
58. *Vieille Fille*
59. *La Foire*
60. *Les Roses*
61. *Carmen*
62. *Portraits*
63. *Don Tancredo*
64. *La Mère et l'enfant*
65. *Dessins*

Reviews: "Expositions nouvelles," *La Chronique des arts*, June 29, 1901, p. 196; Pere Coll, "L'Exposició d'en Picasso," *La Veu de Catalunya* (Barcelona), July 10, 1901 [translated by Francesc Parcerisas and Marilyn McCully in *Picasso Anthology* 1997, pp. 34–35]; Félicien Fagus, "Gazette d'art. L'Invasion espagnole: Picasso," *La Revue blanche*, July 15, 1901, pp. 464–65; Edmond Pilon, "Carnet des oeuvres et des hommes," *La Plume*, July 15, 1901, p. 564

See also Daix and Boudaille 1967, pp. 154–90, 333; Palau i Fabre 1981, pp. 228–57; Daix 1993, "Appendix," pp. 437–39

Ca. March 1902 Paintings by Paul Cézanne
About twenty paintings: still lifes, landscapes, and a replica of *The Bathers*

Reviews: Félicien Fagus, "Gazette d'art: Paysages de Cézanne," *La Revue blanche*, April 1, 1902, p. 546; "Carnet des oeuvres et des hommes: Notes d'art," *La Plume*, April 15, 1902, p. 526

April 17–30, 1902 "L'Exposition Maximilien Luce"
Title and dates from Vollard's invitation

Recent works, including Parisian views "as seen from the fifth floor," particularly views of Notre-Dame and the quais

Reviews: Félicien Fagus, "Gazette d'art: Les Indépendants," *La Revue blanche*, April 15, 1902, p. 625, n. 1; "Expositions nouvelles," *La Chronique des arts*, April 19, 1902, p. 128; Georges Riat, "Petites Expositions: Exposition Maximilien Luce," *La Chronique des arts*, April 26, 1902, pp. 130–31; Félicien Fagus, "Gazette d'art: Maximilien Luce," *La Revue blanche*, May 1, 1902, p. 66; Adolphe Dervaux, "Notes rapides sur la peinture sympathique: M. Maximilien Luce," *La Plume*, June 15, 1902, pp. 743–44

Until May 23, 1902 Paintings by Francesco de Iturrino
Reviews: "Expositions nouvelles," *La Chronique des arts*, May 10, 1902, p. 152; Georges Riat, "Petites Expositions: Exposition Francisco de Yturrino," *La Chronique des arts*,

May 17, 1902, p. 154; Félicien Fagus, "Gazette d'art: Espagnols," *La Revue blanche*, September 1, 1902, p. 67

June 15–30, 1902 Auguste Rodin's illustrations for Octave Mirbeau's *Le Jardin des supplices*
Review: "Expositions nouvelles," *La Chronique des arts*, June 21, 1902, p. 196

Ca. mid-June–July 1902 Works by Aristide Maillol
Ceramics, furniture, sculpture, tapestries

Reviews: Félicien Fagus, "Petites Expositions: Maillol," *La Plume*, August 1, 1902, p. 939; Félicien Fagus, "Gazette d'art: Maillol," *La Revue blanche*, August 1, 1902, pp. 550–51

Ca. November 1902 Pierre Bonnard's bronze *Surtout de Table* (The Terrasse Children)
Review: Félicien Fagus, "Gazette d'art: L'Art de demain," *La Revue blanche*, December 1, 1902, p. 542

May 14–30, 1903 Works by Pierre Laprade

1. *Nature morte*
2. *Matin*
3. *Été*
4. *L'Ouvrage*
5. *Intérieur*
6. *Orage sur Paris*
7. *Étude de nu*
8. *Étude*
9. *Nature morte*
10. *Soir*
11. *Les Rosiers*
12. *Nature morte*
13. *La Statue*
14. *Les Beaux Jours*
15. *Étude de femme*
16. *Les Amoureux*
17. *Étude de parc*
18. *Dans un jardin*
19. *Le Bouquet*
20. *L'Enfant à la pie*
21. *Luxembourg*
22. *Luxembourg*
23. *Nature morte*
24. *Les Amoureux*
25. *Luxembourg (temps gris)*
26. *Étude*
27. *Les Beaux Jours*
28. *L'Enfant au bouquet*
29. *Coin de parc*
30. *Intérieur*
31. *Femme à la mantille*
32. *Automne*
33. *Printemps*
34. *Statue dans un parc*
35. *Les Géraniums aux Tuileries*
36. *Les Lilas*
37. *Jardin à Paris*
38. *Jardin à Paris*
39. Decoration, fragment
40. Decoration, fragment
41. Decoration, fragment
42. Decoration for an apartment
43. *Le Jardin*
44. *Le Rendez-vous*
45. *Femmes en bleu*
46. *Femmes en rose*
47. *L'Été à Paris*
48. *Luxembourg*
49. *Femme peignant*
50. *Nature morte*
51. *L'Enfant à la poupée*
52. *L'Enfant au bouquet*
53. *Le Salon blanc*
54. *Nature morte*
55. *Femme à sa toilette*
56. *Nature morte*
57. *Vue de Paris*
58. *Femme en rouge*
59. *La Rencontre*
60. *Notre-Dame*

Reviews: "Expositions nouvelles," *La Chronique des arts*, May 9, 1903, p. 160; Roger Marx, "Petites Expositions: Exposition Laprade et Minartz," *La Chronique des arts*, May 16, 1903, p. 163; Charles Morice, "Art moderne: Exposition de M. Pierre Laprade," *Mercure de France*, June 1903, pp. 813–14

November 4–28, 1903 "Exposition Paul Gauguin"

Paintings

1. *Jeune Fille cueillant des fleurs*
2. *Mère allaitant son enfant*
3. *Jeunes Filles dans la campagne*
4. *La Joueuse de flûte*
5. *Paysage*
6. *Nus de femmes*
7. *Paysage*
8. *Paysage*
9. *Scène de paysans*
10. *Femme nue*
11. *Paysage*
12. *Paysage*
13. *L'Idole*
14. *Fleurs*
15. *Femme dans un fauteuil*
16. *Paysage*
17. *Causerie*
18. *Femmes sur le bord de la mer*
19. *Paysage*
20. *Nature morte*
21. *Fleurs*
22. *Paysage*
23. *La Toilette*
24. *Contes barbares*
25. *L'Ange*
26. *Le Cavalier*
27. *Pastorale*
28. *Nativité*
29. *Fleurs*
30. *Fleurs*
31. *Rêverie*
32. *L'Esprit veille*
33. *Étude de femmes*

34. *Cavaliers*
35. *Paysage*
36. *Paysage*
37. *Tahitiennes*
38. *La Soeur de charité*
39. *Cavaliers au bord de la mer*
40. *Nature morte*
41. *Nature morte*
42. *Cavaliers au bord de la mer*
43. *Tahitiennes*
44. *Nature morte*
45. *La Mère et l'enfant*
46. *Tahitiens sous des arbres*
47. *Nativité*
48. *Femmes nues*
49. *Portraits de femmes*
50. *Femmes sur le bord de la mer*
 Drawings
1. *La Femme au chat*
2. *Paysage*
3. *Buste de femme*
4. *Famille*
5. *Rêve*
6. *Maternité*
7. *Intérieur*
8. *Ève*
9. *Chevauchée*
10. *Tahitiennes*
11. *Étude*
12. *Deux Têtes*
13. *Le Cavalier*
14. *Tahitiennes*
15. *La Conversation*
16. *Femmes et enfant*
17. *Groupe de femmes*
18. *Le Départ*
19. *Homme à cheval*
20. *Fleurs*
21. *Étude de nu*
22. *Profil*
23. *Étude de femmes*
24. *Femme nue*
25. *Étude*
26. *Invocation*
27. *Deux Têtes*

Reviews: "Expositions nouvelles," *La Chronique des arts*, November 7, 1903, p. 292; Roger Marx, "Petites Expositions: Exposition Paul Gauguin," *La Chronique des arts*, November 14, 1903, pp. 294–95

For more information on this exhibition, see Shackelford 2004, pp. 289–91.

February 3–20, 1904 Paintings by Louis Valtat
Mediterranean views

Reviews: "Expositions nouvelles," *La Chronique des arts*, February 6, 1904, p. 52; Roger Marx, "Petites Expositions: Expositions Valtat et Wilder," *La Chronique des arts*, February 6, 1904, p. 43

March 7–20, 1904 "Hermann-Paul . . . vingt-deux tableaux (mars 1903–février 1904)"

1. *La Garde-malade* (collection of Mme P. M.)
2. *Le Convalescent*
3. *Scène conjugale*
4. *Les Ricochets*
5. *La Tisane*
6. *La Grand'mère*
7. *Petite Fille*
8. *Sous la lampe*
9. *La Belle et la Bête*
10. *Le Matin*
11. *Le Lever*
12. *Sur le lit*
13. *Le Modèle*
14. *La Naissance*
15. *Portrait*
16. *Le Soir*
17. *Sommeil*
18. *Portrait*
19. *Les Vainqueurs*
20. *La Poupée*
21. *Philosophe*
22. *Portrait*
23. *Dessins*

Reviews: "Expositions nouvelles," *La Chronique des arts*, March 5, 1904, p. 84; Louis Vauxcelles, "Notes d'art: Exposition Hermann Paul," *Gil Blas*, March 13, 1904, p. 2

Through April 17, 1904 Paintings by Robert Besnard, Francis Jourdain, and Tony Minartz
Reviews: "Expositions nouvelles," *La Chronique des arts*, April 16, 1904, p. 132; Léon Riotor, "Expositions: Robert Besnard, Francis Jourdain et Tony Minartz," *L'Art décoratif*, May 1904, suppl., unpaged

Through April 30, 1904 Paintings by Émile Bernard
Paintings include *Démon de la solitude, Promeneuses, Soirée de fièvre, Pont au soleil,* and *Les Tose sur la Riva.*

Reviews: "Expositions nouvelles," *La Chronique des arts*, April 23, 1904, p. 140; "Émile Bernard," *L'Art décoratif*, June 1904, suppl., unpaged

Through May 20, 1904 Paintings by Francisco de Iturrino
Reviews: "Expositions nouvelles," *La Chronique des arts*, May 14, 1904, p. 168; "Petites Expositions: Exposition Francisco de Iturrino," *La Chronique des arts*, May 21, 1904, p. 170; Louis Vauxcelles, "Notes d'art," *Gil Blas*, May 31, 1904, p. 1

June 1–18, 1904 "Exposition des oeuvres du peintre Henri Matisse"
Catalogue preface by Roger Marx

1. *Nature morte, fruits*
2. *Intérieur d'atelier*
3. *Nature morte, les oeufs*
4. *Effet de neige (vue du Pont Saint-Michel, Paris)*
5. *La Desserte*

6. *Marine (Belle-Île en mer)*
7. *Le Jardin du moulin vu de la cour (Corse)*
8. *Amandiers fleuris (Corse)*
9. *Liseuse en robe violette*
10. *Olivier au bord de la mer (Corse)*
11. *Nature morte, la tasse*
12. *Nature morte, fruits*
13. *Nature morte, fruits*
14. *Environ du Pont Saint-Michel (Toulouse)*
15. *Nature morte, fruits*
16. *Intérieur au camaïeu bleu*
17. *Intérieur, le lit*
18. *Soleils (fleurs)*
19. *Soleils (fleurs)*
20. *La Nature morte au pot bleu*
21. *Une Rue à Arceuil*
22. *Vue de Notre-Dame (Paris)*
23. *Nature morte, fruits*
24. *Nature morte, fruits*
25. *Nature morte (cafetière argent)*
26. *Vue du Pont Saint-Michel (Paris)*
27. *Le Mousquetaire*
28. *Nature morte, fruits*
29. *Primevères*
30. *Guitariste (debout)*
31. *Guitariste (assis)*
32. *Chrysanthèmes*
33. *Vue de Suisse, sentier du Chamossaire*
34. *Vallée du Rhône, vue de Chésières*
35. *Route de Chésières à Villars*
36. *Moine méditant*
37. *Vue du Bois de Boulogne*
38. *Tulipes*
39. *Paysage des environs de Bohain (Aisne)*
40. *Vieux Chêne à Bohain*
41. *Paysage de Lesquielles-Saint-Germain*
42. *Paysage de Lesquielles-Saint-Germain (dessin)*
43. *Paysage de Boheries*
44. *Les Fleurs sur la cheminée*
45. *Dévideuse picarde*
46. *Le Petit Pêcheur*

Reviews: Charles Saunier, "Les Petites Expositions," *La Revue universelle*, 1904, p. 537; "Expositions nouvelles," *La Chronique des arts*, June 4, 1904, p. 192; Louis Vauxcelles, "Notes d'art: Exposition Henri Matisse," *Gil Blas*, June 14, 1904, p. 1; Roger Marx, "Petites Expositions: Exposition Henri Matisse," *La Chronique des arts*, June 18, 1904, pp. 195–96; Léon Riotor, "Expositions: Henri Matisse (Galerie Vollard)," *L'Art décoratif*, July 1904, suppl., unpaged; Charles Morice, "Art moderne: Exposition Henri Matisse," *Mercure de France*, August 1904, pp. 533–34

Through November 25, 1904 Works by Kees van Dongen

Landscapes and paintings of Montmartre, prostitutes, and old men, as well as a series of drawings of saltimbanques

A catalogue for this exhibition, with a preface by Félix Fénéon, was produced but has not been located.

Reviews: "Expositions nouvelles," *La Chronique des arts*, November 19, 1904, p. 300; Louis Vauxcelles, "Notes

d'art: Exposition Kees Van Dongen," *Gil Blas*, November 21, 1904, p. 1

Mid-November 1904 Paintings by Berthe Zuricher

Paintings of flowers and fruit

Reviews: "Expositions nouvelles," *La Chronique des arts*, November 19, 1904, p. 300; Louis Vauxcelles, "Notes d'art: Exposition Bertha Zuricher," *Gil Blas*, November 21, 1904, p. 1; Charles Morice, "Art moderne," *Mercure de France*, January 15, 1905, p. 300

Through June 17, 1905 Watercolors by Paul Cézanne

Reviews: "Expositions nouvelles," *La Chronique des arts*, June 17, 1905, p. 187; Roger Marx, "Petites Expositions: Exposition Paul Cézanne (Galerie Vollard)," *La Chronique des arts*, July 1, 1905, p. 192; Charles Morice, "Art moderne: Les Aquarelles de Cézanne," *Mercure de France*, July 1, 1905, pp. 133–34

Late June–July 12, 1905 Works by Paul Gauguin

About sixty paintings, watercolors, ceramics, and sculpture. Several large paintings from the artist's Tahiti period went on display early, while the Cézanne watercolor exhibition was still on view.

Reviews: Louis Vauxcelles, "La Vie artistique: Exposition Paul Gauguin," *Gil Blas*, June 25, 1905, p. 1; "Expositions nouvelles," *La Chronique des arts*, July 1, 1905, p. 200; Charles Morice, "Art moderne," *Mercure de France*, July 1, 1905, p. 134

December 6–17, 1905 Paintings by Clément Faller

A list of the nine nonconsecutively numbered paintings intended for display in the exhibition appears in the Vollard Archives, MS 421 (3,6), fol. 37:

2. *L'Yvette en perspective et bordée de saules de chacque côté*, 29.5 x 46 cm
4. *Plateau de Montlhéry, automne avec femme et enfant*, 31.5 x 46 cm
6. *Touffe d'arbres avec soleil couchant derrière, gardeuse et 2 ou 3 moutons*, 43 x 58 cm
7. *Paysage avec arbres et coup de vent de droite à gauche*, 31 x 46.5 cm
8. *Chemin en perspective bordé d'arbres à gauche avec femme assise*, 46 x 32.5 cm
9. *Paysage avec arbres à gauche et torrent à droite*, 46 x 33 cm
10. *Paysage avec trois arbres dont deux près l'un de l'autre avec effet de soleil très vif derrière*, 46 x 32.5 cm
11. *Chemin entre bois avec troupeau de moutons et berger qui rentrent à la tombée du jour*, 31 x 45.4 cm
13. *Paysage avec touffe de 3 arbres légèrement à gauche sur terrain en pente et soleil très vif derrière*, 25 x 33 cm

Reviews: "Expositions nouvelles," *La Chronique des arts*, December 9, 1905, p. 324; Léon Rosenthal, "Petites Expositions: C. Faller," *La Chronique des arts*, December 16, 1905, p. 327; Louis Vauxcelles, "La Vie artistique: Exposition Faller," *Gil Blas*, December 16, 1905, p. 1

Through March 13, 1906 Paintings by Paul Cézanne

A dozen paintings

Reviews: Louis Vauxcelles, "La Vie artistique: Exposition Cézanne," *Gil Blas*, March 6, 1906, p. 2; "Expositions nouvelles," *La Chronique des arts*, March 10, 1906, p. 80; Léon Rosenthal, "Petites Expositions: M. Cézanne," *La Chronique des arts*, March 17, 1906, p. 84

March 15–29, 1906 "Alcide Le Beau"
Catalogue preface by Louis Vauxcelles

1. *Après la pluie. Rivière du Bélon,* 1905
2. *A travers les pins. Anse du Poulguin,* 1905
3. *Au coucher du soleil. Rivière de l'Aven,* 1905
4. *Le Pardon de Saint-Léger,* 1905
5. *Pleine lumière. Port-Manech,* 1905
6. *Les Reflets. Anse du Poulguin,* 1905
7. *Matin clair. Rivière de l'Aven,* 1905
8. *La Charette de foin. Pont-Aven,* 1905
9. *Le Muret. Port-Manech,* 1905
10. *Le Petit Champ de blé. Anse du Poulguin,* 1905
11. *L'Anse du Pouldon à sec,* 1905
12. *Effets de nuages. Rivière de l'Aven,* 1905
13. *Le Séchage des filets. Port-Manech,* 1905
14. *Le Petit Port. Port Manech,* 1905
15. *Port à sec. Loguivy,* 1904
16. *Matin d'été. Rivière du Trieux,* 1904
17. *Les Bateaux blancs. Loguivy,* 1904
18. *Matin calme. Rivière du Trieux,* 1904
19. *Effet de contre-jour. Rivière du Trieux,* 1904
20. *Avant le coucher du soleil. Rivière du Trieux,* 1904
21. *La Vieille Chapelle. Îles Chausey,* 1904
22. *Les Chênes verts. Noirmoutier,* 1903
23. *La Tempête. Île d'Yeu,* 1903
24. *Le Vieux Pin. Morbihan,* 1903
25. *Coin de rivière en automne. Morbihan,* 1903
26. *Brume du matin. Morbihan,* 1902
27. *Effet du soir. Golfe du Morbihan,* 1902
28. *Rivière en automne (Morbihan),* 1902
29. *Gros Temps à l'île d'Ouessant,* 1902
30. *Bords de la Seine en octobre,* 1905
31. *Bords de la Seine en novembre,* 1905
32. *Bords de la Seine en décembre,* 1905
33. *Soleil d'automne. Bas-Meudon,* 1905
34. *Matin d'automne. Saint-Cloud,* 1905
35. *Les Fumées roses. Soir d'hiver à Puteaux,* 1905
36. *Un Coin de parc. Le soir,* 1905
37. *Le Chemin de fer. Effet de nuit,* 1905
38. *Les Pêcheurs à la ligne,* 1905
39. *Intérieur,* 1905
40. *Portrait du peintre Émile Dezaunay,* 1905
41. *La Seine à Marly au printemps,* 1904
42. *Chez un sculpteur,* 1904
43. *Bords de la Seine. Effets de brume,* 1903

Reviews: "Expositions nouvelles," *La Chronique des arts,* March 17, 1906, p. 88; Paul-Louis Hervier, "Cimaises," *L'Intransigeant,* March 18, 1906, p. 2; Louis Vauxcelles, "La Vie artistique: Exposition Alcide Le Beau," *Gil Blas,* March 18, 1906, p. 1; Léon Rosenthal, "Petites Expositions: M. Alcide Le Beau," *La Chronique des arts,* March 31, 1906, p. 100

April 3–15, 1906 "Exposition P. Bonnard, tableaux, paysages et intérieurs, livres illustrés, surtout de table en bronze"
About thirty works from various periods

Reviews: "Expositions nouvelles," *La Chronique des arts,* April 7, 1906, p. 112; Roger Marx, "Petites Expositions: Pierre Bonnard," *La Chronique des arts,* April 21, 1906, p. 124

April 22–May 5, 1906 "Peintures, dessins, eaux-fortes Alfred Muller"
Dates from Vollard's invitation

Paintings

1. *Suzanne Després dans "La Cloche engloutie" de Hauptmann*
2. *Portrait de Francis Jourdain*
3. *Oliviers en Toscane*
4. *Étude pour une décoration*
5. *Les Trois Soeurs*
6. *Femme au lit*
7. *Paysage (Toscane)*
8. *Neige le soir*

Drawings

9. *Portrait*
10. *Femme au tub*
11. *Femme au tub*
12. *Femme au tub*
13. *Femme au tub*
14. *Étude pour un portrait*
15. *Étude*
16. *Étude pour un portrait*

Etchings

17. *La Petite Fille à la robe noire*
18. *Fragment de frise*
19. *La Liseuse*
20. *L'Abat-jour rose*
21. *La Jeune Femme au Tanagra*
22. *Femme se poignant,* softground etching, unique proof
23. *La Jeune Femme au livre*
24. *La Jeune Femme au livre*
25. *La Bibliothèque*
26. *Suzanne Després*
27. *"La lueur étroite de la lampe"* (P. Verlaine)
28. *La Petite Fille au chat*
29. *Les Trois Soeurs*
30. *Jeune Homme lisant*

Through April 28, 1906 Works by Daniel de Monfreid
Portraits and landscapes in paintings, pastels, and prints

Reviews: "Expositions nouvelles," *La Chronique des arts,* April 21, 1906, p. 128; Léon Rosenthal, "Petites Expositions: M. D. de Monfreid," *La Chronique des arts,* April 28, 1906, p. 130

Through May 16, 1906 Paintings by Nicolas Tarkhoff
Paintings include *Porte Saint-Denis, Carnaval, Grands Boulevards, Ballons,* and flower compositions.

Reviews: "Expositions nouvelles," *La Chronique des arts,* May 5, 1906, p. 148; Léon Rosenthal, "Petites Expositions: M. Tarkhoff," *La Chronique des arts,* May 12, 1906, p. 151; Louis Vauxcelles, "La Vie artistique," *Gil Blas,* May 19, 1906, p. 2; Charles Morice, "Art moderne," *Mercure de France,* June 15, 1906, p. 624

April 15–30, 1907 "Oeuvres de Manzana-Pissarro"
Catalogue preface by Octave Mirbeau

1. *"Enfant, l'amoureuse rosée du matin mouille les fleurs entr'ou-vertes, et la brise édénique balance leurs tiges! Mais tes yeux . . . Tes yeux, petit ami, c'est la source limpide où désaltérer longuement le calice de mes lèvres! et ta bouche . . . Ta bouche, ô jeune ami, est la ruche de perles où boire une salive enviée des abeilles!"*
2. *"Jasmins de son ventre aromatique sous le vêtement très léger, jasmin de sa peau douce et lactée comme une pierre de lune."*

3. *"Un morceau de pain, une gorgée d'eau et une pincée de gros sel suffisent à me nourrir, car je suis seule, une robe toute usée me sert de vêtement, et c'est déjà trop!"*

4. *"Flambeau dans les ténèbres, elle apparaît, et c'est le jour! elle apparaît et de sa lumière s'illuminent les aurores.*
Les soleils s'irradient de sa clarté et les lunes du sourire de ses yeux!
Que les voiles de son mystère se déchirent, et aussitôt les créatures à ses pieds se prosternent ravies:
Et devant les doux éclairs de son regard, l'humidité des larmes, passionnées mouille les coins de toute paupière!"

5. *"Les heures heureuses, ô jeunes gens, s'écoulent comme l'eau, rapides comme l'eau. Croyez-moi, amoureux, n'attendez pas. Profitez du bonheur lui-même. Les promesses sont vaines! Usez de la beauté de vos années et du moment qui vous unit."*

6. *"Sur la terre je me sens seule, bien que mon cœur soit débordant de désirs, comme la femme aux flancs féconds qui ne trouve point la semence de gloire."*

7. *Abriza et ses zèbres*

8. *La Petite Princesse et l'Hamadryas*

9. *La Sorcière et les quatre zèbres*

10. *Coqs padoues*

11. *Combat de coqs*

12. *Coq et poules faverolles*

13. *La Gardeuse de dindons et la pomme d'or*

14. *Les Zèbres à l'abreuvoir*

15. *La Gardeuse de vaches*

16. *"Tu commettrais tous les délits, que ta beauté, ô jeune fille, est là pour les effacer et en faire un délice de plus."*

17. *"Regarde la pureté de ses flancs argentés, et tu verras la pleine lune apparaître à tes yeux émerveillés.*
Regarde la rondeur de sa croupe bénie, et tu verras, dans le ciel, deux croissants juxtaposés!"

18. *"Si Izzat, devant un juge digne d'elle et de sa beauté, se présentait avec le doux soleil matinal pour rival, certes elle serait la préférée!"*

19. *"Le dindon dit alors, . . .*
O belle trompeuse, tu ne souhaites que ma mort, et tous tes désirs s'arrêtent-là! Et pourtant, malgré tout, c'est toi seule que je désire parmi toutes les filles de la tribu!"

20. *Fumeuse*

21. *Pigeons et fruits*

22. *Pigeons*

23. *Pigeon mâle*

24. *Sujet décoratif tiré des Contes de mille nuits et une nuit* [sic]

25. *Panneau décoratif (nature morte)*

26. *Boîte à mouchoirs*

27. *Boîte à mouchoirs*

28. *Panneau en bois gravé et peint*

29. *Panneau en bois gravé noir et or*

Reviews: Louis Vauxcelles, "La Vie artistique: Exposition Manzana-Pissarro," *Gil Blas*, April 19, 1907, p. 2; "Expositions nouvelles," *La Chronique des arts*, April 20, 1907, p. 140, and April 27, 1907, p. 148; Intérim, "Petite Expositions: Exposition Manzana (Galerie Vollard)," *La Chronique des arts*, April 27, 1907, p. 142

March 24–April 15, 1908 "Peintures, pastels et gravures de Mlle Mary Cassatt"

Pastels

1. *Mère et enfant*

2. *La Mandoline*

3. *Mère et enfant*

4. *Jeunes Filles*

5. *Fillette au chapeau bleu*

6. *Fillette au chapeau blanc*

7. *Mère et enfant*

8. *Enfant à la toque rouge*

9. *Mère et enfant*

10. *Mère et enfant*

11. *Mère et enfant*

12. *Tête d'enfant*

13. *Tête d'enfant*

14. *Tête d'enfant*

15. *Tête d'enfant*

16. *Petite Fille et son chien*

17. *Mère et enfant*

18. *L'Enfant au perroquet*

19. *Mère et enfant*

20. *Tête d'enfant*

21. *Tête d'enfant*

22. *Petite Fille et son chien*

23. *Étude de femme*

24. *Fillette et son chien*

25. *Mère et enfant*

26. *Mère et enfant*

27. *Tête d'enfant*

28. *Fillette et son chien*

29. *Fillette et son chien*

30. *Fillette et son chien*

31. *Femme et enfant*

32. *Femme et enfant*

33. *Tête de fillette*

34. *Tête de fillette*

35. *Tête de fillette*

36. *Tête d'enfant*

37. *Tête d'enfant*

Paintings

38. *Enfant dans le salon bleu*

39. *Femme et bébé*

40. *Intérieur*

41. *Enfant au chat*

42. *Tête de fillette*

43. *La Femme au miroir*

44. *Femme dans un intérieur*

45. *Femmes dans un jardin*

46. *Tête de femme*

47. *Femme accoudée*

48. *La Femme au chapeau gris*

49. *Essai de décoration*

50. *Femme et enfant*
Series of engravings in black and white and color

Reviews: "Expositions nouvelles," *La Chronique des arts*, March 28, 1908, p. 124; Raymond Bouyer, "Expositions et concours," *Bulletin de l'art ancien et moderne*, April 4, 1908, pp. 109–10; Charles Morice, "Art moderne," *Mercure de France*, April 16, 1908, p. 736; Pierre Hepp, "Petites Expositions: Exposition Mary Cassatt (Galerie Vollard)," *La Chronique des arts*, April 18, 1908, pp. 146–47; "Art at Home and Abroad," *New York Times*, May 3, 1908, p. X1

November 30–December 30, 1908 "Exposition Jean Puy"

1. *Hameau de pêcheurs*

2. *Paysage à Benodet*

3. *Étude de nu*

4. *Fleurs et fruits*
5. *Paysage*
6. *Paysage au Pouldu*
7. *Étude de femme*
8. *La Rivière de Benodet*
9. *Sous un arbre*
10. *Marine à Concarneau*
11. *Essai pour "La Belle Nonchalante"*
12. *Portrait au bord de la mer*
13. *Étude de fleurs*
14. *Dans le hamac*
15. *Flânerie sous les pins*
16. *Le Repos*
17. *Femme et fleurs*
18. *Le Repos sur la plage*
19. *Étude à Concarneau*
20. *Bassin de carénage à Belle-Isle*
21. *Bassin de l'échouage à Belle-Isle*
22. *L'Étreinte*
23. *Nature morte*
24. *Jeune Femme dans un jardin*
25. *La Petite Italienne*
26. *Femme voilée*
27. *Étude pour triptyque*
28. *Baigneuses*
29. *Étude de femme*
30. *Portrait et antique*
31. *Nu au soleil*
32. *Étude*

The Vollard Archives, MS 421 (2,3), fols. 142–45, contain the following handwritten list under the heading "Exposition Puy":

1. *Trois Têtes à contre jour*
2. *Repos dans le hamac*
3. *Sous un arbre*
4. *Le Passage à Concarneau*
5. *Portrait en plein air*
6. *Paysage du soir à Saint-Alban*
7. *Plateau à Saint-Alban*
8. *Le Repos*
9. *Concarneau. Temps morne*
10. *Le Mât Pilote du Pouldu*
11. *Port de Belle-Îsle*
12. *Rivière de Benodet*
13. *Femme et fleur*
14. *Sous bois*
15. *Portrait au bord de la mer*
16. *Le Repos sur la plage*
17. *Portrait et tête d'antique*
18. *Fleurs et fruits*
19. *Une Goëlette*
20. *Hameau de pêcheurs*
21. *Paysage au Pouldu*
22. *Étude d'atelier*
23. *Étude d'atelier*
24. *Étude d'atelier*
25. *Étude d'atelier*
26. *Un Arbre à Concarneau*
27. *Figure nue*
28. *La Belle Nonchalante*, study
29. *Portrait de fillette*

30. *Le Femme au tub*
31. *Portrait et tête d'antique*
32. *Portrait*
33. *Le Beïgnoir*, sketch
34. *Marine à Belle-Isle*
35. *Sous bois, le soir*
36. *Les Calfats à Belle-Isle*
37. *Dans un jardin le soir*
38. *Ébats de baigneur*
39. *Tête d'antique*
40. *Nature morte*
41. *Jeune Femme dans un jardin*
42. *La Petite Italienne*
43. *Le Bassin d'échouage à Belle-Isle*
44. *Le Bassin de carénage à Belle-Isle*
45. *Tête d'étude*
46. *Femme voilée*
47. *Pochade pour la flanerie sous les pins*
48. *Flanerie sous les pins* [note: "is in the apartment"]
49. *Cycliste au bord de l'eau*
50. *Essai à Concarneau*
51. *Note sur le Port de palais à Belle-Isle*
52. *Nature morte*
53. *Un Chantier à Belle-Isle*
54. *Paysage noble à Benodet*
55. *Fleurs dans un coin*
56. *La Toilette*
57. *Après-midi sous les pins* [note: "bring on Thursday"]
58. *L'Endormie*
59. *Nature morte d'hiver*
60. *Pochade*
61. *Marine*
62. *Coin de forêt*
63. *Étude pour tryptique*
64. *Courtisane couchée*
65. *Portrait de femme cousant* [note: "is in the apartment; others also at the apartment"]

Reviews: "Expositions nouvelles," *La Chronique des arts*, December 5, 1908, p. 392; Charles Morice, "Art moderne," *Mercure de France*, December 16, 1908, pp. 734–35

Through March 18, 1909 Works by Louis Valtat
About fifty works, including many landscapes

Reviews: *La Chronique des arts*, February 17, 1909, p. 72; Adrien Bovy, "Petites Expositions: Louis Valtat (Galerie Vollard)," *La Chronique des arts*, March 6, 1909, p. 75; Louis Vauxcelles, "La Vie artistique: Exposition Valtat," *Gil Blas*, March 8, 1909, p. 2; Charles Morice, "Art moderne," *Mercure de France*, March 16, 1909, pp. 367–68

April 27–May 10, 1909 "Dessins Marocains de Jean Hess"
[note: "Drawings marked with an asterisk are illustrated in a book by the author of *Israël au Maroc*"] [Paris: J. Bosc, 1907]

CHARCOAL DRAWINGS
Scenes of Jewish life in Morocco
1. *La Danse*
2. *Les Trois Dames et le touriste*
3. *Le Bain dans la cour*
4. *La Surprise au bain*
5. *L'Impudique Suzanne et les 2 vieillards*

6. *Tu aimeras l'étranger,* * charcoal, color
7. *Les Amazones du cap Spartel*
8. *Le Coucher de la mariée*
9. *Les Cousins de Paris*
10. *La Bourse à Tanger*
11. *Le Café de la Bourse*
12. *À la Brasserie de Tanger*
13. *Les Saleurs de têtes à Fez*
14. *L'Usurier de Tanger*
15. *En Première Classe à bord du bateau de Gibraltar*
16. *Jacob est décoré*
17–19. *Abraham est gourmand*
 Scenes of military life in Morocco
20. *Une Charge de cavalerie*
21. *Au bar. Infanterie contre cavalerie*
22. *Au bar. Le Cafard s'agite*
23. *Dans la rue. La Maîtresse du zouave*
24. *Au mess. La Tombola*
25. *At Home. Le Cousscouss [sic] du colonel*
 Miscellaneous
26. *Mendiante et sa fille*
27. *Bal public à Oran*
28. *Le Marché à Oran*
29. *Café-concert à Oran*
30. *". . . Jardin de l'Alcasar, Délices des rois maures . . ."*
31. *La Gloire de la chair. Conte arabe*
32. *Portrait,* collection of Mme B.
COLORED DRAWINGS
 Scenes from Tangier
33. *Le Bazar*
34. *La Dame qui donne le ton*
35. *Réjouissance mondaine*
36. *Réjouissance populaire*
37. *Erreur dans la recherche du 'sujet'*
38–39. *Scènes de rue le samedi*
40. *La Vieille et la nouvelle mode*
41. *Gourmandise familiale*

Review: "Expositions nouvelles, "*La Chronique des arts,*
May 8, 1909, p. 156

March 15–26, 1910 "Peintures et faïences décoratives de Vlaminck"
Introductory note by Roger Marx declining a request to write the catalogue preface

Paintings
1. *Le Pont de Meulan*
2. *Voiles à Chatou*
3. *Soleil d'automne*
4. *Les Grands Quais au Hâvre*
5. *Le Pont de Bezons*
6. *Bougival*
7. *Nature morte*
8. *Le Pont de Triel*
9. *Le Viaduc*
10. *Versailles (Le Château)*
11. *Bords de la Seine*
12. *La Sablière*
13. *Le Côteau*
14. *La Seine à Chatou*
15. *Fleurs*

16. *Le Pont*
17. *Voiles*
18. *Nature morte*
19. *Le Village*
20. *Bouquet de fleurs*
21. *Le Garage*
22. *Une Rue à Carrières-Saint-Denis*
23. *Le Jardin*
24. *Soir*
25. *Brouillard dans la vallée*
26. *Poissy*
27. *Les Chalands*
28. *Fleurs*
29. *Fleurs*
30. *Le Port*
31. *Saint-Cloud*
32. *Bords de Seine*
33. *Bords de Seine*
34. *Le Pont du chemin-de-fer*
35. *Nature morte*
36. *Le Pecq*
37. *La Seine à Meulan*
 Ceramics, plates, decorative vases

Reviews: Guillaume Apollinaire, "La Vie artistique: Exposition Maurice de Vlaminck," *L'Intransigeant,* March 16, 1910, p. 2; "Expositions nouvelles," *La Chronique des arts,* March 19, 1910, p. 96; J.-F. Schnerb, "Petites Expositions: Exposition Vlaminck (Galerie Vollard)," *La Chronique des arts,* March 26, 1910, p. 99; Louis Vauxcelles, "La Vie artistique: Exposition de Vlaminck," *Gil Blas,* March 27, 1910, p. 3

April 25–May 14, 1910 "Oeuvres de Paul Gauguin"
Catalogue preface by Charles Morice

Series of paintings from Brittany, Arles, Tahiti, and the Marquesas Islands

Brittany
La Lutte de Jacob et de l'Ange (1888)
Fleurs sur fond jaune (1889)
Bretonnes (1894; after the first voyage to Tahiti)
Maison dans les arbres (after the first voyage to Tahiti)
Arles
Le Christ au Jardin des Oliviers (1889) (Portrait of Gauguin)
Tahiti
Femme dans un fauteuil (1891)
Le Repos dans la campagne (1891), landscape
La Montagne sacrée (1892), landscape
L'Esprit du mal (1892)
Paysage bleu (1897)
Panneau décoratif (1898)
Bouquet de fleurs avec chats (1899)
Femme sur fond jaune (1899)
Fleur de tournesol (1901)
La Famille (1901)
Deux Têtes
Marquesas Islands
L'Appel (1902)
Le Bain (1902)
Femme nue vue de dos (1902)
Maternité (1902)

Reviews: "Expositions nouvelles," *La Chronique des arts*, April 30, 1910, p. 144; J.-F. Schnerb, "Petites Expositions: Exposition Gauguin (Galerie Vollard)," *La Chronique des arts*, April 30, 1910, p. 141; Charles Morice, "Art moderne: Memento," *Mercure de France*, May 1, 1910, p. 163; Guillaume Apollinaire, "La Vie artistique, Exposition Gauguin," *L'Intransigeant*, May 11, 1910, p. 2; Charles Morice, "Art moderne," *Mercure de France*, May 16, 1910, pp. 359–60; Léon Werth, "Exposition d'oeuvres de Paul Gauguin," *La Phalange*, June 1910, pp. 726–27

June 27–July 23, 1910 "Figures de Cézanne"

Paintings

1. *Baigneur*
2. *Portrait de Valabrègue*
3. *Portrait de Cézanne*
4. *Portrait d'un jeune garçon*
5. *Le Joueur de cartes*
6. *Portrait de Cézanne*
7. *L'Apprenti philosophe*
8. *Portrait de Madame Cézanne*
9. *Portrait de Cézanne*
10. *Tête de paysan*
11. *Portrait de Madame Cézanne*
12. *Portrait d'un jeune Italien*
13. *Portrait de Madame Cézanne*
14. *Paysan dans un intérieur*
15. *Portrait de Madame Cézanne*
16. *Paysan les bras croisés*
17. *Femme assise tenant un livre*
18. *Buste d'homme*
19. *Paysan assis les jambes croisées*
20. *Portrait du père de Cézanne*
21. *Le Liseur*
22. *Portrait de Monsieur J. G.*
23. *Étude d'Arlequin*
24. *Portrait de Cézanne*

Lithographs

25. *Baigneurs*
26. *Baigneurs*

Reviews: "Exposition nouvelles, "*La Chronique des arts*, June 18, 1910, p. 192; "Expositions nouvelles, "*La Chronique des arts*, July 2, 1910, p. 200; Louis Vauxcelles, "La Vie artistique: Quelques Figures de Cézanne et Maillol," *Gil Blas*, July 4, 1910, p. 3; Léon Werth, "Figures de Cézanne (Galerie Vollard)," *La Phalange*, July 20, 1910, pp. 86–87

December 1910–late February 1911 Paintings by Pablo Picasso

No catalogue was produced or invitations sent for this exhibition, which was extended past its original closing date. Ceramics by Vlaminck seem also to have been on view.

Reviews: Guillaume Apollinaire, "La Vie artistique," *L'Intransigeant*, December 21, 23, 25, 30, 1910, p. 2; "Expositions nouvelles," *La Chronique des arts*, December 31, 1910, p. 322; Henri Guilbeaux, "Exposition Pablo Picasso," *Hommes du jour*, January 1911, p. 8; Guillaume Apollinaire, "La Vie artistique," *L'Intransigeant*, January 4, 1911, p. 2; Henry Bidou, "Petites Expositions: Exposition Picasso (Galerie Vollard)," *La Chronique des arts*, January 14, 1911, p. 11; Léon Werth, "Exposition Pablo Picasso," *La Phalange*, January 20, 1911, p. 86

Catalogue

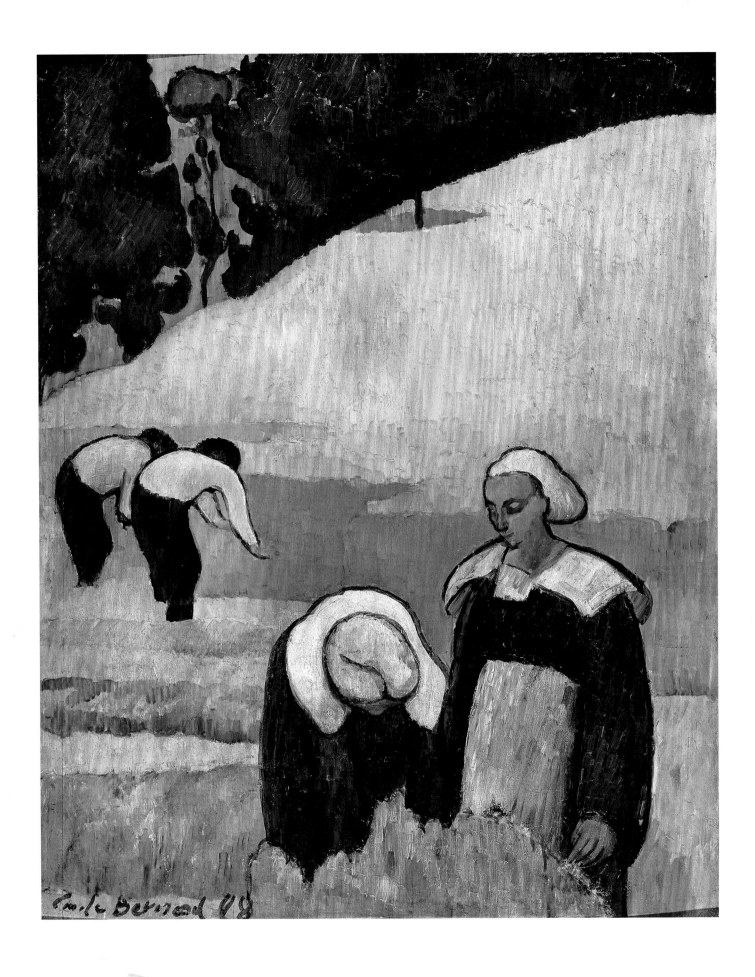

1

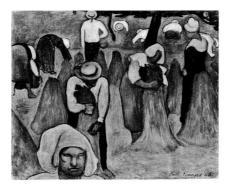

2

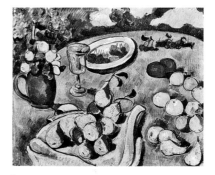

3

1. *fig. 300*

ÉMILE BERNARD
Breton Landscape

1888
Oil on panel
22¼ x 17¾ in. (56.5 x 45 cm)
Musée d'Orsay, Paris RF 1977-42

CATALOGUE RAISONNÉ: Luthi 1982, no. 121

PROVENANCE: Gift of the artist to Mme Gloannec, Pont-Aven, 1888 (intended for the dining room of the Pension Gloannec in Brittany); returned to the artist by Mme Gloannec; acquired from Bernard by Paul Gauguin, Paris, by exchange, 1888; Ambroise Vollard, Paris; Marcel Guérin, Paris; Galerie Daniel Varenne, Paris, after 1959; Musée National d'Art Moderne, Paris, 1965; Musée du Louvre, Paris, 1977; Musée d'Orsay, Paris, 1986

Two labels affixed to the back of this painting provide interesting information: one lists its prestigious successive owners—among them Madame Gloannec, Paul Gauguin, and Ambroise Vollard—while the other details the context in which it was made.

Bernard painted the *Breton Landscape* in Pont-Aven in 1888. On the label describing the creation of the work, he wrote that he intended it "to be hung in the dining room of the Gloannec boardinghouse, where traveling artists habitually left a souvenir of their stay," and added that "because of its novelty and its simple and complete nature, the panel caused great discord among the fifty boarders."[1] The picture was the target of numerous gibes, not to mention bread balls. When Mme Gloannec was begged to remove it, Gauguin asked Bernard if he could have it in exchange for one of his own paintings. The panel went to Gauguin, then to Vollard, and after that to Marcel Guérin, all in 1888.

The year 1888 is key, for it was then that Bernard reunited with Gauguin in Pont-Aven in a stimulating encounter that gave them the opportunity to explore each other's aesthetic and theoretical innovations. The simplicity of the flatly applied colors, the strong outlines, and the audacious diagonal form in *Breton Landscape* are characteristic of paintings by the Pont-Aven group. This highly synthetic work is exemplary in its simplified and separated fields of color. Bernard used the harvest subject of this landscape for one of the five zincographs in his Bretonneries series.

AR

1. Luthi 1982, p. 22, no. 121.

2. *fig. 15*

ÉMILE BERNARD
The Buckwheat Harvest

1888
Oil on canvas
28⅜ x 36⅛ in. (72 x 92 cm)
Private collection

CATALOGUE RAISONNÉ: Luthi 1982, no. 123

PROVENANCE: Ambroise Vollard, Paris, Collection de Galéa, Paris (Mme de Galéa, d. 1955; her son Robert, d. 1961); bought by curent owner, 1957

This monumental composition showing Breton women harvesting buckwheat was painted in Pont-Aven in Brittany in 1888. Its bold planes of flat color and strong contours reveal the influence of Paul Gauguin, with whom Bernard worked at Pont-Aven. In particular its red background appears to be indebted to Gauguin's *Vision of the Sermon* (National Gallery of Scotland, Edinburgh), which was painted in September 1888.[1] When *The Buckwheat Harvest* was shown at the Salon des Indépendants in Paris in 1892, together with Bernard's *Breton Women in the Meadow*, 1888 (private collection), it attracted the notice of the critic Gustave Geffroy, who described it as "monumental in scale, with flat and clearly marked areas of colour, of a simple humanity, which [Bernard] brought back with him from Brittany four years ago."[2]

Exactly when Vollard acquired *The Buckwheat Harvest* is not known. He bought a large number of works from Bernard on May 22, 1901, and another group on July 10.[3] In June Vollard gave Bernard a one-man exhibition. A second exhibition followed in April 1904. Although *The Buckwheat Harvest* is not specifically mentioned in Vollard's inventory of paintings acquired, it is possible that it was included in the 1901 acquisition. Certainly, Vollard owned the work in 1934 when it appeared in an exhibition entitled "Gauguin et Ses Amis" with Vollard listed as the lender in the catalogue.[4] The work was probably still in Vollard's possession at his death in 1939.

AD

1. For a discussion of the exact dating of this work and the rift between Bernard and Gauguin over who was the pioneer in the development of "pictorial symbolism," see Stevens et al. 1990, p. 146.
2. Geffroy, in *La Justice*, May 29, 1892, cited in Stevens et al. 1990, p. 152.
3. Vollard Archives, MS 421 (2,3), pp. 1–4, 5–8. In May Vollard bought sixty-six works at 100 francs each, fifty-five

at 200 francs each, and one at 300 francs, a total expenditure of 17,900 francs.
4. Exhibition organized by Raymond Cogniat; see Paris 1934b, no. 9, "Récolte de blé noir, 1888, peinture . . . Collection de M. Vollard." I am grateful to Fred Leeman for this information.

3. *fig. 16*

ÉMILE BERNARD
Still Life: Fruit on a Round Table

1892
Oil on canvas
25⅝ x 31¼ in. (65.1 x 80.7 cm)
Collection of Mrs. Arthur G. Altschul
New York and Chicago only

CATALOGUE RAISONNÉ: Luthi 1982, no. 359

PROVENANCE: Bought from the artist by Ambroise Vollard, Paris; Stephen Higgins, Paris, by 1959; Mr. and Mrs. Arthur G. Altschul, New York, January 4, 1961–his. d. 2002; Mrs. Altschul, from 2002

Still Life: Fruit on a Round Table is almost certainly the work recorded in Bernard's second unpublished inventory, drawn up in 1905, where it is listed as: "Still life: apples, plums, pears, blue pot, clouds" and as sold to Ambroise Vollard.[1] This large, confident painting demonstrates Bernard's admiration for Paul Cézanne both in its subject, a still life on a tabletop, and in the use of a number of different viewpoints. In an indignant letter that Bernard wrote to Vollard just three months before the dealer's death in 1939, many years after the incident that provoked it, the artist protested vigorously against accusations that he had "finished" Vollard's Cézannes and accused the rumor's perpetrator of setting out to poison his friendship with Vollard.[2]

Vollard met Bernard at some point in the early 1890s, and it was partly as a result of the artist's advice that the dealer pursued the work of Cézanne and Van Gogh. In his unpublished autobiography, Bernard recalled being introduced to Vollard by Odilon Redon.[3] He wrote that the next day Vollard came to his studio and bought up its entire contents, carrying it away wrapped in a carpet.[4] But, in fact, it was not until May 22, 1901, after Bernard had returned from eight years in Egypt, that Vollard bought 122 works from him for a total of 17,900 francs.[5] The next month he gave Bernard a one-man exhibition. Vollard acquired an additional group of

Opposite: Fig. 300 (cat. 1). Émile Bernard, *Breton Landscape,* 1888. Musée d'Orsay, Paris (RF 1977-42)

paintings, watercolors, drawings, and lithographs from Bernard on July 10, 1901.[6]

Bernard's talents took many directions: he was a poet, playwright, novelist, critic, and printmaker as well as a painter. He and Vollard remained lifelong friends. Vollard gave Bernard a second exhibition, in 1904, and thereafter continued to acquire works from him. In 1911 he published Van Gogh's letters to Bernard.[7] Vollard commissioned Bernard to illustrate luxury-edition books: Pierre de Ronsard, *Amours,* 1915; Charles Baudelaire, *Les Fleurs du mal,* 1916; François Villon, *Oeuvres de François Villon,* 1919; *Les Petites Fleurs de Saint-François,* 1928; and Homer, *L'Odyssée,* (cats. 4, 5, 6). AD

1. The date is given as 1891 and the size as 25, which corresponds to the measurements of this painting. Bernard archives, courtesy of MaryAnne Stevens.
2. Bernard to Vollard, April 20, 1939: Vollard Archives, MS 421 (2,2), p. 44.
3. "L'Aventure de ma vie," undated [after 1938], p. 168: Bibliothèque, Musée du Louvre, Paris.
4. Ibid.
5. Vollard Archives, MS 421 (2,3), pp. 1–4.
6. Vollard Archives, MS 421 (2,3), pp. 5–8.
7. Vollard 1911.

4

fig. 214

ÉMILE BERNARD
Oeuvres de François Villon

Published by Ambroise Vollard, Éditeur, Paris, 1919 ("Achevé d'imprimer" June 25, 1918)
Illustrated book with 312 woodcuts; this copy embellished in gouache by the artist specifically for Vollard
Page (irreg.) 12 13/16 x 9 13/16 in. (32.5 x 25 cm)
Printer: The artist, on the handpresses of Émile Féquet
Copy no. 21 (of a numbered edition of 250, plus additional copies lettered A–D)
Private collection

CATALOGUES RAISONNÉS: Johnson 1977, no. 163; Stevens et al. 1990, no. 153; Jentsch 1994, no. 13; Morane 2000, no. 97

PROVENANCE: Ambroise Vollard, until his death, 1939; private collection; by descent to current owner

In the summer of 1902, the painter Armand Seguin wrote to Vollard with his ideas for an illustrated edition of *Oeuvres de François Villon.* The fifteenth-century author's semiautobiographical and often humorous musings on wasted youth, sex, morality, and religion were popular in nineteenth-century

France. Seguin suggested using Pierre Jannet's 1854 edition of Villon's *Oeuvres complètes,* without a preface, philosophical remarks, or attributed poems. He proposed a full-page frontispiece; one large decoration to balance each of the three sections of the book —the *Petit Testament,* the *Grand Testament,* and a group of assorted poems; thirty-seven vignettes *en tête* for the thirty-seven rondeaux, lays, and ballades; thirty-seven each of ornamental letters and *culs-de-lampe* (tailpieces); and one vignette for the last page. "In short . . . an entertaining book using imaginative design but not a contemporary style."[1] Seguin died in 1903 before his work was finished.

When Vollard finally published the book in 1919, it featured illustrations by Émile Bernard. Vollard had presented a solo exhibition of Bernard's work in the summer of 1901, shortly after he made his initial purchase from the artist—consisting of 122 canvases bought for 17,900 francs[2]—and he hosted a second one in the spring of 1904. In the meantime, Vollard and Bernard had begun collaborating on an illustrated edition of Charles Baudelaire's *Les Fleurs du mal,* which was published in 1916. On January 25, 1910, Vollard paid Bernard 2,000 francs for the rights to reproduce his correspondence with Vincent van Gogh;[3] the agreement allowed Vollard to print an unlimited number of copies of the Van Gogh book for a period of up to six years. The two men also collaborated on an illustrated edition of *Les Amours de Pierre de Ronsard* (1915), for which Vollard paid Bernard 18,700 francs between March 8, 1914, and March 2, 1916.[4]

It is not known when Bernard began working on *Oeuvres de François Villon,* but a receipt in the Vollard Archives dated August 3, 1916, records a payment of 500 francs to Bernard for the volume.[5] In a letter to Vollard thought to date to the same year, Bernard inquires, "Are you happy with François Villon? I am considering a range of illustrations so that rather than be repetitious the book will be something new."[6] Bernard's completed book features significantly more artwork than Seguin had envisioned.

Vollard, who had been stung by disappointing critical reaction to Bernard's calligraphied text for *Les Amours de Pierre de Ronsard* (1915), was pleased with the artist's choice of a Gothic typeface for *Villon.* The dealer wrote, "[It] went so well with his work that one could have sworn he had designed it himself."[7] At Vollard's urging Bernard embellished several copies of the book with gouache and watercolor.[8] Because he did not care for the look of gouache on the Holland paper on which a few additional copies of the book had been printed, Bernard chose to embellish number 21, one of the 225 examples printed on japan paper, for Vollard's personal collection.[9] RAR

1. Seguin to Vollard, August 25, 1902: Vollard Archives, MS 421 (2,2), pp. 371–72.
2. "Inventaire des toiles acquisés par M. Vollard a E. Bernard le 22 mai 1901": Vollard Archives, MS 421 (2,3), pp. 1–4. See also "Inventaire du second achat de M. Vollard le 10 juillet 1901": Vollard Archives, MS 421 (2,3), pp. 5–8.
3. Contract signed by Bernard and Vollard, January 25, 1910: Vollard Archives, MS 421 (2,2), pp. 23–24; and receipt signed by Bernard, October 18, 1911: MS 421 (2,3), p. 9.
4. Itemized account summary by Bonnard, March 2, 1916: Vollard Archives, MS 421 (9,1), fols. 22–23.
5. Receipt, August 3, 1916: Vollard Archives, MS 421 (9,1), fol. 25.
6. Bernard to Vollard, undated [ca. 1916]: Vollard Archives, MS 421 (2,2), p. 28.

7. Vollard 1936, p. 255.
8. Receipt acknowledging 3,000 francs for a highlighted copy of *Villon* and another 3,000 francs for work on the "Stigmates de St. François" (also referred to as "Fioretti"): Vollard Archives, MS 421 (9,1), fol. 3, and MS 421 (5,12), fol. 30; see also Bernard to Vollard, March 16, 1925: Vollard Archives, MS 421 (2,2), p. 29.
7. Bernard to Vollard, December 1, 1922, handwritten dedication inside the present book.

5

5. *fig. 215*

ÉMILE BERNARD
Les Petites Fleurs de Saint-François

Published by Ambroise Vollard, Éditeur, Paris, 1928 ("Achevé d'imprimer" August 27, 1928)
Illustrated book with 330 woodcuts
Page (irreg.) 12 13/16 x 9 13/16 in. (32.5 x 25 cm)
Printer: Marthe Féquet
Copy no. 7 (of a numbered edition of 350, plus additional copies lettered A–Y)
The Museum of Modern Art, New York, The Louis E. Stern Collection, 1964 677.1964.1–324
New York and Chicago only

CATALOGUES RAISONNÉS: Johnson 1977, no. 164; Stevens et al. 1990, no. 156; Jentsch 1994, no. 18; Morane 2000, no. 100

Both Vollard and Bernard surely were familiar with Maurice Denis's colorful edition of *Les Petites Fleurs de Saint-François d'Assise* (Jacques Beltrand, Paris, 1913) when they agreed to collaborate on an illustrated edition of the book. On March 1, 1922, Vollard negotiated the rights to publish Maurice Beaufreton's translation of the text.[1] At the time, Bernard was still working on *Oeuvres de François Villon* (cat. 4). Nonetheless, he soon began designing the more than three hundred decorative elements of *Les Petites Fleurs de Saint-François* (usually referred to in the Vollard Archives as *Fioretti*). On December 5, 1922, Vollard paid Bernard 25,100 francs for 108 large woodcuts, 4 medium woodcuts, and 84 *culs-de-lampe* and ornamental letters, all of which had already been taken to the printer, Marthe Féquet.[2] Other known payments to Bernard for the project date to March 17, 1924 (3,000 francs); May 17, 1925 (9,600 francs for the woodcut borders); January 11, 1927 (8,150 francs for 11 large woodcuts at 400 francs each, 6 smaller designs at 300 francs each, and 13 vignettes at 150 francs each); and June 9, 1928 (10,350 francs).[3] Bernard received an additional 12,000

francs for the watercolor embellishments he added to three copies of the book.[4]

As was so often the case with Vollard's books, production lagged, and on September 21, 1926, Beaufreton requested permission to allow Éditions Publiroc de Marseille to put out an inexpensive edition of the text.[5] In August 1928, after learning from Georges Crés that the Éditions Vollard version was about to be published, Beaufreton's widow contacted Vollard, in hopes of collecting the 1,000 francs he still owed to her husband.[6] RAR

1. See Beaufreton to Vollard, July 21, 1926: Vollard Archives, MS 421 (2,2), p. 3.
2. Receipt signed by Bernard, December 5, 1922: Vollard Archives, MS 421 (9,1), fol. 17.
3. Vollard Archives, MS 421 (9,1), fols. 1, 3, 6, 11; MS 421 (5,12), fol. 30; and MS 421 (5,13), fol. 58.
4. Of the total, 5,000 francs was part of the June 9, 1928, payment, and 7,000 francs was paid on November 30, 1929: Vollard Archives, MS 421 (9,1), fols. 6, 11.
5. Beaufreton to Vollard, September 21, 1926: Vollard Archives, MS 421 (2,2), p. 3. Publiroc's 318-page edition, *Les Fioretti de Saint-François d'Assise,* appeared in 1929.
6. Mme Veuve Beaufreton to Vollard, letter dated July 27, 1928. Mme Beaufreton's sister, Claire de la Rochette, acknowledged receipt of the funds on September 1, 1928: Vollard Archives, MS 421 (2,2), pp. 4–5.

6

6. *fig. 216*

ÉMILE BERNARD
L'Odyssée, by Homer

Published by Ambroise Vollard, Éditeur, Paris, 1930 ("Achevé d'imprimer" November 18, 1930)
Illustrated book, in 2 volumes, with 53 woodcuts with hand additions, 45 woodcuts and line block reproductions, and supplementary suite of 51 woodcuts
Page (irreg.) 15⅛ x 11¼ in. (38 x 28.5 cm); composition 9¼ x 6½ in. (23.5 x 16.6 cm)
Printer: Aimé Jourde
Copy no. 4 (of a numbered edition of 165, plus additional copies lettered A–J, as well as three exhibition copies)
The Museum of Modern Art, New York, The Louis E. Stern Collection, 1964 678.1964.B
New York and Chicago only

CATALOGUES RAISONNÉS: Johnson 1977, no. 165; Stevens et al. 1990, no. 157; Jentsch 1994, no. 20; Morane 2000, no. 101

Bernard had not yet finished his work on *Les Petites Fleurs de Saint-François* for Vollard when he turned his attention to an illustrated edition of Homer's *Odyssey,* in a French translation by Madame Dacier.

The epic account of Odysseus's journey home after the decade-long Trojan War comprises twenty-four books, each containing four hundred to five hundred lines of poetry. Bernard and Vollard planned to illustrate their two-volume edition with fifty-one full-page illustrations: a frontispiece facing the title page and two full-page illustrations in each book except for books XXII and XXIV, which would each be embellished with three plates.[1] There were also to be smaller decorations.

Receipts and letters in the Vollard Archives indicate that Bernard's principal work on the book took place between March 1927 and December 1930, during which time he was paid at least 105,000 francs: 1,000 francs for each large plate, 500 francs for each *cul-de-lampe,* and 250 francs for each ornamental letter,[2] as well as thousands of francs to highlight each illustration with a sepia wash.[3] In addition to Bernard's fees and the cost of materials (the project was estimated to require thirty-five reams of Arches paper and six reams of japan paper),[4] Vollard's expenses also included Aimé Jourde's charge for printing, which came to 149,815.80 francs.[5] In short, it seems likely that Vollard spent more than 300,000 francs to publish *L'Odyssée.*

L'Odyssée was unanimously well reviewed when it debuted at the exhibition of Vollard's editions at Le Portique in Paris in December 1930. The artist was pleased with it too. In his note thanking Vollard for dropping off a copy, he wrote: "I found it superb. Paper, typeface, everything a success. Jourde printed it splendidly. The plates are very beautifully glued in, and the simple presentation shows them to their best advantage. It is a pièce de résistance that will be a winner, you can be sure."[6] RAR

1. Bernard's notes ("Pages blanches & réservées pour l'illustration de l'Odyssée"): Vollard Archives, MS 421 (9,1), fols. 20–21.
2. Bernard's "Relevé du compte de l'Odyssée," December 10, 1928: Vollard Archives, MS 421 (9,1), fol. 5.
3. Vollard to Emil Handloser [*sic*], March 3, 1933: Vollard Archives, MS 421 (7,1), fol. 61.
4. Aimé Jourde to Vollard, January 2, 1929: Vollard Archives, MS 421 (8,15), fols. 12–13.
5. Aimé Jourde, account summary, August 24, 1931: Vollard Archives, MS 421 (8,15), fol. 39.
6. Bernard to Vollard, undated [ca. 1930]: Vollard Archives, MS 421 (2,2), p. 43.

7. *fig. 102*

PIERRE BONNARD
Seated Girl with Rabbit

1891
Oil on canvas
37¾ x 16⅞ in. (96 x 43 cm)
The National Museum of Western Art, Tokyo P.1987-001
Chicago and Paris only

CATALOGUE RAISONNÉ: J. Dauberville and H. Dauberville 1966–74, vol. 1, no. 24

PROVENANCE: Arsène Alexandre, Paris; his sale, Galerie Georges Petit, Paris, May 18, 1903, no. 4; bought by Bonnard; Elie Faure, Paris; unidentified sale, Paris, 1912; bought by Bernheim-Jeune, Paris; sale, Hôtel Drouot, Paris, February 9, 1925, no. 7; Félix Fénéon, Paris, by 1933; his sale, Hôtel Drouot, Paris, December 3, 1941, no. 33; Albert Kleinmann, Paris; E. and A. Silberman Galleries, New York; William Rubin, New York; National Museum of Western Art, Tokyo

Dauberville cited this early decorative canvas as having been exhibited chez Vollard in an 1893 exhibition that has not been identified. Vollard would certainly have seen the work when it was first shown in 1891 at the Château de Saint-Germain-en-Laye, where the Nabis exhibited off and on for more than three years.[1] Félix Fénéon, who later owned the canvas, was the first to recognize in print its special qualities of whimsy, decadence, and decorative line. Reviewing the painting in 1891 for the *Chat noir,* he spoke of the Botticellian quality of the female figure, at the same time noting her cruel come-hither expression.[2]

Much has been written about Bonnard's debt to Japanese prints. Their non-illusionistic space and decorative line provided new ideas about style at a time when the artist was attempting to free his art from academic tradition. Here, as in his *tableaux-affiches* of about 1890–91 in which the figure of his sister Andrée, his cousin Berthe Schaedlin, and his dog, Ravageau, are compressed into square or vertical formats, the curly-haired woman is inspired by his cousin. Berthe appears with the same gesture— one shoulder raised and head cocked—in the poster *France Champagne* (1891).

In this painting, however, the composition is less readable. Bonnard embedded the arabesque figure wearing a patterned dress in a busy design of autumn foliage that negates any sense of depth. The woman is seated in a bentwood rocker whose undulating golden lines merge with the curving hem of her dress to form a decorative border. The starlike leaves that fall upon her dress further flatten and confuse the space, while the white rabbit with a red collar amounts to merely another light area balancing the yellow-white of the artist's signature and date at top left, serving the decorative needs of the whole.

Berthe's body appears twisted, as if held up by invisible strings like the marionettes that Bonnard created for the puppet shows at the Théâtre des Pantins (founded by Alfred Jarry, Franc-Nohain, and Claude Terrasse) and for impromptu performances held at the home of Nabi Paul Ranson. With these puppets too, the goal was to stylize and simplify forms in order "to express essential movements."[3] It

7

was at Ranson's that the figure of Abbé Prout was born, the avaricious and overweight precursor to Alfred Jarry's "Ubu Roi," whom Bonnard would also help bring to life and Vollard would "reincarnate" in publications illustrated by Bonnard, Jean Puy, and Georges Rouault.[4] Bonnard's talent for caricature and his abililty to enchant and challenge the viewer were qualities that Vollard admired in his friend, who, though fiercely independent as far as marketing his own work was concerned, nonetheless remained a loyal supporter of the dealer.

<div align="right">GG</div>

1. I am grateful to Dr. Katherine Kuenzli, Professor of Art History at Wesleyan University, Middletown, Connecticut, for having made available her research on the various exhibitions and exhibitors at Saint-Germain-en-Laye.
2. Comparing Bonnard's work to Jules Chéret's poster imagery, Fénéon continued: "We would see on the walls effigies of a serpentine and cruel eroticism, as if, following Chéret and his joyously lyrical masques, he was charged with marketing Cirques, Elysées, Jardins, Moulins." Fénéon, 1891 (1970 ed.), p. 201.
3. See the poet Franc-Nohain's description of a marionette performance, cited in Paris 2005, p. 101.
4. See Rebecca Rabinow's essay on Vollard's *livres d'artiste* in this volume.

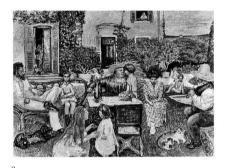

8

8. *fig. 105*

PIERRE BONNARD
The Terrasse Family (Afternoon of a Bourgeois Family)

Ca. 1902
Oil on canvas
57⅞ x 82¼ in. (147 x 209 cm)
Staatsgalerie Stuttgart 2545
New York and Chicago only

CATALOGUE RAISONNÉ: J. Dauberville and H. Dauberville 1966–74, vol. 1, no. 272

PROVENANCE: Ambroise Vollard, Paris, until 1939; his brother Lucien Vollard, Paris; Étienne Bignou, Paris, by 1946; bought by Galerie Amante, Paris, not before 1947; bought by Marlborough Fine Arts Ltd., London, by 1953; bought by Ragnar Moltzau, Oslo, 1953; bought by Marlborough Fine Arts Ltd., London, 1960; bought by Staatsgalerie Stuttgart, 1960

About 1902 Bonnard painted a second, to-scale version of the painting he would later exhibit at the 1903 Salon de la Société Nationale des Beaux-Arts as *Bourgeois Afternoon* (*L'après-midi bourgeoise*, Musée d'Orsay, Paris). His reasons for copying this unusual painting are not clear, especially since he exhibited the original version. Although the jury reluctantly accepted it for exhibition and critics characterized it

as a "bizarre social caricature," Bonnard clearly felt the picture to be a worthy example of his oeuvre.[1]

The group portrait was a novel departure from his work before that date. Bonnard had painted several large decorative panels—possibly for Vollard's dining room—showing his sister Andrée's children playing in the orchards behind Le Grand-Lemps, the Bonnard ancestral home in southeastern France. In the present painting the artist depicted his relatives in front of the same house in what is essentially a large group caricature. Composing the work as a frieze divided by parallel bands of people, lawn furniture, and architecture, Bonnard presented, from left to right, an overtly bored Claude Terrasse, the composer who married Bonnard's sister in 1890; their eldest child, Jean, seated primly at his father's side; a neighbor and close friend, Madame Prudhomme, who fawns over Bonnard's nephew Charles (the artist's future biographer); Andrée; and, as a closing bookend at right, M. Prudhomme, a local archivist. Other family members include his niece, Vivette, in the foreground, kneeling with her maid; Renée, the eldest Terrasse daughter, at the window; Robert Terrasse, another nephew, seated statuelike on the grass at far right; and the artist's mother, Mère Mertzdorff-Bonnard, at the doorway to the house. The additional children were created by Bonnard to fill in the composition.[2]

The differences between the Orsay and Stuttgart canvases are subtle. Most important, this later version lacks the second dog in the foreground and the little girl in the doorway that are present in the original. About the composition's meaning we have few clues. Bonnard may have been playing on the highly suggestive name "Prudhomme," recalling in his use of a light palette Courbet's celebrated family portrait of the philosopher-socialist Pierre-Joseph Proudhon and his children in their country home (1865–67; Musée du Petit Palais, Paris). If this is the case, then perhaps the linen-suited brother-in-law Terrasse represents the city of Paris, while the straw-hatted and pipe-smoking neighbor M. Prudhomme symbolizes the provinces.

The Orsay canvas was Bonnard's first sale to the Bernheim-Jeunes, possibly around the time of the 1903 exhibition. When Vollard purchased this second canvas is not known. Like so many of Bonnard's works, which the artist was loath to sell, this canvas may have lingered, face to wall, for many years. Once Vollard had bought the painting he kept it throughout his life. Perhaps he saw in it not only an ironic reflection of his own *embourgoisement* but a nod to the *primitif* Henri Rousseau, whose equally hieratic *Representatives of Foreign Powers Coming to Greet the Republic as a Sign of Peace* (cat. 187) the dealer also owned.

<div align="right">GG</div>

1. See Charles Cottet to Félix Vallotton, March 18, 1903, in Guisan and Jakubec 1973–75, vol. 2, p. 74, letter 165 and note a.
2. "Les deux autres enfants sont simplement de petits personnages accessoires." Charles Terrasse to Ragnar Moltzau, March 6, 1956, in Copenhagen 1956, no. 8.

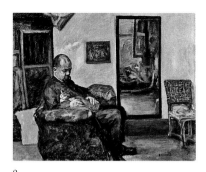

9

9. *fig. 5*

PIERRE BONNARD
Ambroise Vollard

Ca. 1904
Oil on canvas
29⅛ x 36⅜ in. (74 x 92.5 cm)
Kunsthaus Zürich 1950/7

CATALOGUE RAISONNÉ: J. Dauberville and H. Dauberville 1966–74, vol. 2, no. 306

PROVENANCE: Ambroise Vollard, Paris; [Galerie Jean?] Dufresne, Paris; bought by Kunsthaus Zürich, 1950

Vollard was about thirty-eight when Bonnard painted this portrait of him. The two men had met at some point in the early 1890s, probably through Maurice Denis and the circle around *La Revue blanche*. Vollard maintained a particularly friendly relationship with Bonnard, who painted him at least five times[1] (although in his *Recollections of a Picture Dealer* Vollard recalled sitting for him only twice). Vollard's tendency to fall asleep posed a problem for most artists who painted his portrait, but, as he observed, "With [Bonnard] I did not go to sleep, for I had a little cat on my knees to stroke."[2] Bonnard, who shared Vollard's love of cats, captured his bulky sitter's tender gesture as he caresses the animal. The dealer is posed with a cat on his lap in two other paintings and an etching by Bonnard (see cat. 11).[3]

The setting here is Bonnard's studio; the cane chair and mirror appear in a number of other paintings of about the same date.[4] Hanging on the wall is one of Cézanne's Bathers compositions. The same picture appears in the background of another, sketchier portrait of the dealer (Musée National d'Art Moderne, Centre Georges Pompidou, Paris), and in a drawing of 1910 of the interior of the rue Laffitte gallery, Vollard holds up the same or a very similar painting (fig. 101). John Rewald identified this Cézanne as the *Four Bathers* of 1877–78 (private collection, Japan);[5] Ursula Perucchi-Petri suggested the *Four Bathers* of 1876–77 (Barnes Foundation, Merion, Pennsylvania) as the more likely candidate,[6] a view seconded recently by Walter Feilchenfeldt.[7] In either case, the painting belonged to Vollard, not Bonnard. Did Bonnard suggest that Vollard bring the Cézanne with him, or did the idea come from his sitter? Vollard had launched Cézanne's career, as well as his own, with the solo exhibition of the artist that he held in his rue Laffitte gallery in 1895. It seems plausible that he would wish to include the painting in his portrait, to promote himself as Cézanne's principal dealer and to emphasize his historic connection with the artist. Conceivably

this is the Cézanne *Bathers* that Vollard claimed he displayed in the gallery window during the exhibition.[8]

AD

1. J. Dauberville and H. Dauberville 1966–74, nos. 303, 304, 306, 1259, 1260.
2. Vollard 1936, p. 223.
3. J. Dauberville and H. Dauberville 1966–74, nos. 1259, 1260. The etching dates from about 1924 and is now in the Museum of Fine Arts, Boston.
4. Ibid., nos. 300, 344, 350, 351, 360, 361, 374, 375 (for the mirror) and nos. 345, 367, 370 (for the chair.)
5. Rewald 1996, no. 363.
6. Perucchi-Petri 1972, p. 69 and n. 95; Rewald 1996, no. 362.
7. Walter Feilchenfeldt in Essen 2004–5, p. 28, n. 11.
8. Vollard 1938a, p. 64. Vollard claimed that the Cézanne was one of the works from the Caillebotte bequest that had been rejected by the state, although Robert Jensen argues in his essay in this volume that the timing of the bequest and its controversy does not fit with the 1895 exhibition.

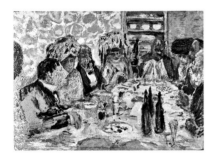

10

10. *fig. 26*

PIERRE BONNARD
Dinner at Vollard's (Vollard's Cellar)

Ca. 1907
Oil on cardboard
29½ x 41 in. (75 x 104 cm)
Private collection

CATALOGUE RAISONNÉ: J. Dauberville and H. Dauberville 1966–74, vol. 2, no. 441

PROVENANCE: Bought from the artist by Ambroise Vollard, Paris, October 11, 1910, for 800 francs (as *Dîner dans la cave*);[1] Collection de Galéa, Paris (Mme de Galéa, d. 1955; her son, Robert de Galéa, d. 1961); private collection

Among the many portrayals of Vollard, only Denis's *Homage to Cézanne* (fig. 82) and this view by Bonnard of Vollard's cellar show the dealer in company with artists and clients. Bonnard gave the guests at Vollard's table only vague physiognomies, inviting numerous possibilities for identification. Vollard claimed that the painting shows the German collector Count Harry Kessler, artists Odilon Redon and Jean-Louis Forain, and "a severe-looking man, a manufacturer in business in the French Indies."[2] Others have suggested that the guests include Degas, the dealer Jos Hessel, and even Misia (Thadée Natanson's first wife, who later married the wealthy Alfred Edwards).[3] The only sure identifications are those of Vollard (at the head of the table wearing a napkin and raising a bottle in his right hand) and the white-whiskered Redon at right. Comparison with contemporary photographs seems to show that the man with tousled hair in the left foreground is Forain and that the figure next to Redon is Count Kessler.[4]

As a frequent participant at Vollard's soirées, Bonnard may have amalgamated into a single scene the guests at several dinners, such as those recorded by Count Kessler on June 19, June 27, and December 28, 1907, at all of which Bonnard was present.[5] Apparently in this work Bonnard was commenting on the kinds of people invited to his friend's inner sanctum, as he had done in his familial parody *The Terrasse Family (Afternoon of a Bourgeois Family)* (cat. 8). Here, rather than arranging the figures in a frieze to accommodate a horizontal composition, Bonnard positioned the dinner guests along two diagonals, with Vollard at the apex. Both paintings are whimsical and teasing depictions of bourgeois leisure. In this dinner scene the women wear elaborate lampshade-like hats whose trimmings seem to drip downward, further obscuring their identities. Indeed, with the exception of a dramatically made-up brunette *en décolleté* seated at the right of Vollard (possibly the Russian woman Kessler described as half "grande dame," half "grande cocotte"), the ladies appear fashionably generic, alluding perhaps to their ornamental function.[6]

Bonnard took liberties as well with the basement/dining-room setting, animating the normally naked white walls with an Art Nouveau circular pattern.[7] This evokes a tropical atmosphere, complementing Vollard's spicy chicken creole, cooked in the adjacent kitchen where the heat "condensed in heavy moisture."[8]

GG

1. Volard Archives, MS 421 (5,5), fol. 146. Vollard also listed the painting in his 1922 Inventory, no. 2, as "Cave de la rue Laffitte" with a considerably higher price, 4,000 francs, than the 800 francs he recorded as having paid in 1910.
2. Vollard 1936, p. 96. Vollard's "recollections," however, are many times misremembered.
3. For Hessel, see, for example, Geneva 1981, no. 26; for Misia, see Hyman 1998, p. 72.
4. See Kessler's diary, December 28, 1907, when he wrote that he sat "between two pretty young women — as Vollard says — two lesbians." Kessler 2004–5, vol. 3, CD-ROM.
5. Two of these, on June 19 and December 28, also included Forain. See Kessler's diary, June 19 and 27, and December 28, 1907, in Kessler 2004–5, vol. 3, CD-ROM.
6. Kessler described the three female guests, among them the "Russian, who came in her automobile and had the manners of a great romantic heroine of the Comédie Française." See Kessler's diary, June 19, 1907, in Kessler 2004–5, vol. 3, CD-ROM.
7. Vollard 1936, p. 93.
8. Ibid., p. 81.

11. *fig. 161*

PIERRE BONNARD
Ambroise Vollard with His Cat

Ca. 1924
Oil on canvas
38 x 43¾ in. (96.5 x 111 cm)
Petit Palais, Musée des Beaux-Arts de la Ville de Paris
PPP 3052

CATALOGUE RAISONNÉ: J. Dauberville and H. Dauberville 1966–74, vol. 3, no. 1259

PROVENANCE: Ambroise Vollard, Paris, until his d. 1939; gift of the Vollard heirs to the City of Paris, 1950; Musée des Beaux-Arts de la Ville de Paris (Petit Palais), 1950

When Bonnard met Vollard, who had just opened his first gallery on the rue Laffitte, neither man was yet thirty years old. Vollard immediately recognized the painter's talents as an illustrator, and their col-

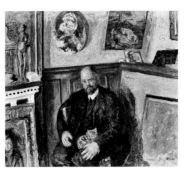

11

laboration stretched over nearly thirty-five years. Bonnard became a regular at Vollard's shop, sketching the joyful chaos of the place. Although theirs was never an entirely close friendship, the two men developed a certain complicity, no doubt born in Vollard's cellar while concocting the *Almanach illustré du Père Ubu* alongside Alfred Jarry and Claude Terrasse. Until the day he died, the dealer kept a painting in which Bonnard had depicted him presiding over one of his celebrated dinners held in that cellar (cat. 10).

Vollard posed several times for Bonnard. The sittings of 1924 (when Bonnard was preparing the illustrations for Octave Mirbeau's *Dingo,* published by Vollard) yielded two painted portraits and an etching.[1] The composition for all three works is essentially the same: Vollard is seated, a cat on his lap, in an interior crowded with paintings. The setting is probably the large house on the rue de Martignac into which Vollard had recently moved.

Now fifty-eight years old, Vollard has grown mature and a bit heavier than he appears in Bonnard's 1906 portrait of him with a cat. The delightful striped tabby barely manages to keep him awake, and, his head tilted slightly, Vollard seems to be looking at the viewer with eyes half shut, like a large, sleepy tomcat nestled in a corner of the room. The pictures hanging above his head and the diagonal interplay of the wainscoting and frames (reminiscent of the Japanese prints Bonnard loved) accentuate the sense that the dealer is immersed in his works. Vollard probably selected the included artworks carefully as so many tributes to "his" artists. In particular, we can make out Cézanne's *Portrait of the Painter Alfred Hauge* at his feet;[2] a small nude by Maillol on the mantelpiece; and hanging on the wall at the right, *Reclining Women* by Renoir.[3]

Vollard kept this emblematic portrait for the rest of his life.

MAdP

1. Bouvet 1981, no. 89.
2. Oil on canvas, 1899 (Norton Museum of Art, West Palm Beach).
3. Oil on canvas, 1893; originally in the De Galéa Collection; sale, Christie's, New York, November 6, 2001.

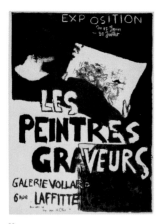

12

13

On June 15, 1896, Vollard inaugurated his new gallery at 6, rue Laffitte with an exhibition devoted to "Les Peintres-Graveurs." The poster for the show, a color lithograph designed by Bonnard, depicts a woman looking at a print, ostensibly taken from the portfolio behind her. The exhibition featured 198 works on paper and included all the prints found in Vollard's *Album des peintres-graveurs,* which was published later that year. Vollard commissioned twenty-two artists to contribute one print each to the album, which was published in an edition of 100. It is stylistically and thematically eclectic, ranging from Edvard Munch's two-color lithograph *Le Soir* to René-Georges Hermann-Paul's color lithograph of six women busy at their typewriters.

Despite the album's limited success, Vollard was inspired to publish a second—the *Album d'estampes originales de la Galerie Vollard*—the following year. Bonnard's cover design for it and the majority of the thirty-one additional loose prints are color lithographs. Again, the styles and subject matter are diverse: Eugène Grasset's vividly colored depiction of a young drug addict injecting morphine into her thigh, for example, is all the more shocking when contrasted with Odilon Redon's subdued and sublime *Béatrice.* The dimensions of the prints in the album vary: Bonnard's cover lithograph is twice the width of most and was intended to be folded in half and used as a wrapper, which explains why the text appears exclusively on the right side of the print.

Although Vollard's archives record a number of sales of these albums, in his memoirs the dealer blamed his decision to abandon a third album (despite the fact that a number of the images were already printed) on poor sales: "In spite of the low prices (100 francs for the first album, 150 for the second) the *amateurs* continued to fight shy, and twenty years later the edition was not sold out. But the times have greatly changed. Not so long ago, a print of Lautrec's *Governess-cart* [*Partie de campagne,* a color lithograph included in the second print album] sold for fifteen thousand francs at the Hôtel Drouot."[1]

RAR

1. Vollard 1936, p. 248.

12. *fig. 199*

Pierre Bonnard

Exposition, Les Peintres-Graveurs, Galerie Vollard

1896
Lithographed poster
Sheet 25½ x 18⅞ in. (64.7 x 48 cm)

a. The Museum of Modern Art, New York, Purchase 1949
524.1949
New York and Chicago only

b. Petit Palais, Musée des Beaux-Arts de la Ville de Paris
PPG 4639
Paris only

Catalogues raisonnés: Johnson 1977, no. 12; Bouvet 1981, no. 38; *Ambroise Vollard* 1991, no. 4

13. *fig. 201*

Pierre Bonnard

Cover of the *Album d'estampes originales de la Galerie Vollard*

1897
Color lithograph

a. The Museum of Modern Art, New York, Purchase 1949
526.1949
Image 22¼ x 33½ in. (56.6 x 85.1 cm), sheet 22¼ x 34⅜ in. (56.6 x 87.7 cm)
New York only

b. The Art Institute of Chicago, John H. Wrenn Memorial Collection, 1960 1960.20
Image 23⅛ x 34 in. (58.7 x 86.3 cm), sheet 28⅛ x 36⅝ in. (71.4 x 92.9 cm)
Chicago only

Catalogues raisonnés: Johnson 1977, no. 14; Terrasse 1989, no. 24; *Ambroise Vollard* 1991, no. 19

14. *figs. 10, 202, 203*

Pierre Bonnard

Quelques Aspects de la vie de Paris (Some Aspects of Paris Life)

Published 1899
Suite of 12 color lithographs, plus cover

a. The Art Institute of Chicago, gift of Walter S. Brewster 1936.178–190
Chicago only

b. The Metropolitan Museum of Art, New York, Harris Brisbane Dick Fund, 1928 28.50.4.1–13
New York only

c. Petit Palais, Musée des Beaux-Arts de la Ville de Paris
PPG 2244, 2245, 2247, 4638
Paris only

Catalogues raisonnés: Floury 1927, nos. 16 (1–13); Roger-Marx 1952, nos. 56–68; Bouvet 1981, nos. 58–70

Cover, ca. 1898
Image 16⅛ x 13⅛ in. (41 x 33.3 cm), sheet 20⅞ x 15⅞ in. (53 x 40.3 cm)*

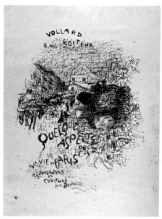

14

1. *Avenue du Bois de Boulogne,* ca. 1898
Image 12¼ x 18⅛ in. (31 x 46 cm), sheet 16 x 21⅛ in. (40.6 x 53.5 cm)
2. *Street Corner,* ca. 1897
Image 10⅞ x 14 in. (27.5 x 35.5 cm), sheet 16 x 20⅞ in. (40.8 x 53 cm)
3. *Houses in the Courtyard,* 1895–96
Image 13⅝ x 10¼ in. (34.7 x 26 cm), sheet 21 x 16 in. (53.4 x 40.6 cm)
4. *Street Seen from Above,* ca. 1897
Image 14⅝ x 8⅞ in. (37 x 22.5 cm), sheet 21 x 16⅛ in. (53.5 x 40.9 cm)
5. *Boulevard,* ca. 1896
Image 6⅞ x 16⅞ in. (17.5 x 43 cm), sheet 15⅞ x 21 in. (40.4 x 53.5 cm)
6. *The Square at Evening,* 1897–98
Image 11 x 16⅞ in. (28 x 43 cm), sheet 16 x 21 in. (40.8 x 53.2 cm)
7. *The Pushcart,* ca. 1897
Image 11⅜ x 13¼ in. (29 x 33.5 cm), sheet 16 x 21 in. (40.7 x 53.2 cm)
8. *The Bridge,* 1896–97
Image 10⅞ x 16 in. (27.5 x 40.5 cm), sheet 15¾ x 20¾ in. (40 x 52.7 cm)
9. *At the Theater,* 1897–98
Image 8⅛ x 15¾ in. (20.5 x 40 cm), sheet 16 x 20⅞ in. (40.5 x 53 cm)
10. *Street at Evening in the Rain,* 1896–97
Image 10 x 14 in. (25.5 x 35.5 cm), sheet 16 x 21 in. (40.5 x 53.2 cm)
11. *Arc de Triomphe,* ca. 1898
Image 12⅝ x 18⅛ in. (32 x 46.2 cm), sheet 16 x 21 in. (40.8 x 53.4 cm)
12. *Narrow Street Viewed from Above,* 1896–97
Image 14⅝ x 8¼ in. (37 x 21 cm), sheet 20½ x 16 in. (52.2 x 40.5 cm)

Like the other Vollard albums, Bonnard's *Quelques Aspects de la vie de Paris* was printed under the direction of Auguste Clot. Bonnard, who was already an experienced printmaker, made fewer trial proofs than did Vuillard (see cat. 202); the title itself, however, underwent several permutations.[1] In comparison to Denis's album with its love declarations, or Vuillard's album featuring his mother and friends, Bonnard's lithographs, like the artist himself, are detached, whimsical, and urbane. As one reviewer remarked in April 1899, "Bonnard, energetic, highly imaginative, amusing, prefers the street and its surprises; his powers of observation are extreme."[2]

In addition to drawing from the same motifs used in the artist's earlier lithographs *The Schoolgirl's Return,* circa 1895, and *The Little Laundress,* published in the 1896 *Peintres-graveurs,* the lithographs for *Quelques Aspects* also repeat and exaggerate to some extent the iconography of his paintings, a number of which were owned by Vollard.[3] The

Vollard album lithographs, possibly begun as early as 1895, show a similar stylistic evolution to that of Bonnard's paintings—from the dramatic forms and silhouettes of his Nabi works to the more open, free compositions dissolved in atmosphere that would characterize his style after 1900.[4] Only one print in this suite, *At the Theater* (no. 9), represents an interior, and it may have been a late addition to the series, recycled from an earlier lithograph illustrating the frontispiece of André Mellerio's *La Lithographie originale en couleurs* (1898).[5]

GG

*Dimensions given here are for cat. 14a.

1. For successive titles given to the suite, see New York–Houston–Boston 1989–90, p. 224, no. 59.
2. "Petits Expositions" 1899.
3. See *On the Boulevard,* 1893 (D 49; Stockbook A, no. 4095; Vollard Archives, MS 421 [4,1], p. 79, 22 9bre [November] 1904[?]; MS 421 [5,8], fol. 84, May 7, 1912; MS 421 [4,13], p. 51, June 3, 1912); Place Clichy, 1906 (D 409); *A Corner of Paris,* 1905 (D 332); *Child with Scarf,* 1895 (D 01774); *La Place Clichy,* 1898 (D 01786); *L'Avenue du Bois,* ca. 1900 (D 01813); *Street Scene in Paris,* ca. 1905 (D 01863).
4. New York–Houston–Boston 1989–90, p. 224. See also Nicholas Watkins 1994, p. 91, for a description of Bonnard's dissolving of the busy traffic in a dreamlike mist.
5. See New York–Houston–Boston 1989–90, pp. 224, 227. In his only print for Vollard's third and never-realized album (*Child in Lamplight*), Bonnard returned to the intimate interiors of his earlier paintings.

15

15. *fig. 209*

PIERRE BONNARD
Parallèlement, by Paul Verlaine

Published by Ambroise Vollard, Éditeur, Paris, 1900 ("Achevé d'imprimer" October 31, 1900)
Illustrated book with 109 lithographs (including a frontispiece) and 9 woodcuts (engraved by Tony Beltrand after drawings by Bonnard)
Page (irreg.) 11¹⁵⁄₁₆ x 9¹³⁄₁₆ in. (30.3 x 25 cm)
Printers: Auguste Clot (lithographs); L'Imprimerie Nationale (text)

a. The Metropolitan Museum of Art, New York, The Elisha Whittelsey Collection, The Elisha Whittelsey Fund, 1970 1970.713
Copy no. 190 (of a numbered edition of 200, plus additional copies lettered A–U and two additional copies with suites of prints)
New York and Chicago only

b. Petit Palais, Musée des Beaux-Arts de la Ville de Paris, bequest of Dr. Maurice Girardin, 1953 PPL 0039
Copy no. 124
Paris only

CATALOGUES RAISONNÉS: Johnson 1977, no. 166; Bouvet 1981, no. 73; Chapon 1987, p. 279; Jentsch 1994, no. 1

The innovative way in which Bonnard's lithographs seem to float around and occasionally through Paul Verlaine's text makes *Parallèlement* a masterpiece of book design. Credit is largely due to Bonnard's creativity, but Vollard's inexperience as a book publisher should also be taken into account. *Parallèlement* was his first book, and it may never have occurred to him that bibliophiles would want their illustrations presented in dark ink in neat, bordered areas. After all, Vollard's previous publishing experience was limited to fine-art prints and posters, where colorful text and image often comingle.

Parallèlement as we know it today almost never came into existence. Intrigued by Verlaine's musings about the parallel nature of faith and impurity, pure love and sexual perversion, Vollard first considered entrusting the illustrations to Lucien Pissarro before turning to Gustave Leheutre, an artist whose work Vollard exhibited in his 1896 and 1897 "Peintres-Graveurs" exhibitions and who contributed prints to all three of the dealer's group print albums. Leheutre seems to have designed most of the book before the project was turned over to Bonnard, who had participated in the same early exhibitions and who had created a print portfolio for Vollard, *Quelques Aspects de la vie de Paris* (cat. 14).[1]

In 1896 Vollard paid the publisher Léon Vanier 500 francs for the rights to publish an illustrated edition of *Parallèlement.*[2] Vollard's request to have the Imprimerie Nationale print the text with an elegant seventeenth-century typeface was granted in early March 1897 by Jean-Baptiste Darlan, Minister of Justice/Garde des Sceaux, whose insignia of a seated Minerva was printed on the cover and title page.[3] Supposedly, when a subsequent minister, Ernest Monis, received his honorary copy of the book in 1900 he was so scandalized by Bonnard's illustrations that he demanded the edition be recalled. Vollard asked subscribers who had already received their copies to replace the cover and title pages with new versions.

The recall raised the scorn of critics, who accused the ministry of negligence and artistic censorship. Rémy de Gourmont pointed out that Bonnard's lithographs had been printed before the text, so they should hardly have come as a surprise to officials at the printing house. Why, he questioned, had the text been approved in the first place? Darlan, Gourmont deduced, had simply assumed that Vollard's request to have the Imprimerie Nationale print the text of three books—*L'Imitation de Jésus-Christ, Sagesse,* and *Parallèlement*—indicated his intent to create some sort of religious trilogy. To put the blame for the recall on Bonnard's illustrations, Gourmont argued, was absurd.[4]

The ministry's recall of Vollard's first book must have been a blow to the dealer, morally as well as financially. To make matters worse, sales of the book, which was priced from 150 to 450 francs, lagged. By 1918 Vollard had raised the price of the basic edition to only 300 francs and in 1920, to 500 francs. In the late 1920s, however, critical opinion of *Parallèlement* reversed, and prices soared.

RAR

1. For payments to Leheutre, see p. 209, n. 8, in this volume. Payments from Vollard to Bonnard specifically for *Parallèlement* date to October 30, 1899 (200 francs), and December 15, 1899 (300 francs), although there are many other non-specified payments to the artist during this period: Vollard Archives, MS 421 (4,3), fols. 145, 148.
2. Vollard paid Vanier 250 francs for the rights to publish 200 copies of *Parallèlement* on June 26, 1896, and again on March 15, 1897: Vollard Archives, MS 421 (4,3), fols. 50, 68. See also Camille Pissarro to his son Lucien, July 16, 1896, in Rewald and L. Pissarro 1980, p. 293.
3. On March 8, 1897, Vollard paid the Imprimerie Nationale 625 francs for *Parallèlement:* Vollard Archives, MS 421 (4,3), fol. 67. Payments for paper for *Parallèlement* are recorded on August 31, 1899 (747.90 francs) and September 29, 1899 (124 francs): MS 421 (4,3), fols. 141, 143.
4. Gourmont 1900, pp. 778–80. For Vollard's account, see Vollard 1929b, p. 979.

16

16. *fig. 224*

PIERRE BONNARD
Almanach illustré du Père Ubu, by Alfred Jarry, possibly in collaboration with Ambroise Vollard

Published anonymously [Ambroise Vollard, Éditeur, Paris], 1901
Illustrated book with 78 photolithographs
Page (irreg.) 11¼ x 7⅞ in. (28 x 20 cm)
Copy no. 3 (of a numbered edition of approximately 1,000)
The Museum of Modern Art, New York, The Louis E. Stern Collection, 1964 687.1964
New York and Chicago only

CATALOGUES RAISONNÉS: Johnson 1977, no. 167; Terrasse 1989, no. 10; Jentsch 1994, no. 2

Alfred Jarry (1873–1907) was in high school when he wrote *Ubu Roi* as a parody of his physics teacher, Félix Hebert. The story revolves around the cowardly Père Ubu, who, at his wife's insistence, murders the royal family. The couple become the tyrannical monarchs of Poland until they are banished to France by the czar. When Jarry's reworked manuscript premiered at the Théâtre de l'Oeuvre in Paris on December 10, 1896, the play's obscene language and anarchistic message resulted in its immediate cancellation. The production featured set design and masks by Jarry and his friends Paul Ranson, Paul Sérusier, Henri de Toulouse-Lautrec, Édouard Vuillard, and Bonnard, whose brother-in-law Claude Terrasse composed the music.

A few years later Bonnard illustrated Jarry's *Almanach du Père Ubu illustré (janvier–février–mars*

1899). Perhaps to commemorate the advent of the twentieth century, Vollard published fifty numbered copies of the *Almanach illustré du Père Ubu* on January 1, 1901. The absurd text includes a calendar annotated not with Christian saint days but with the days of St. Boat, St. Hair, St. Asparagus, and St. Toad, among others. Feast Days are treated in the same irreverent manner, with July 14 (Bastille Day) listed as "Fête du Père Ubu." Vollard claimed to have collaborated with Jarry on the text, taking specific credit for "Colonial" Ubu, who laments the end of slavery.[1] Among Bonnard's many designs for the pamphlet is an alphabet of vowels, each drawn to coincide with Père Ubu's anatomy: the "i" is a phallus, the "o" is an anus, and so forth. Also of note are two crude illustrations titled "Parallèlement," one of which features a painting of embracing naked women. The reference is to Bonnard's illustrated edition of Paul Verlaine's text of that title (cat. 15), which Vollard had published the previous year.

The pamphlet is also of importance for its list of Vollard's publications in preparation: *Le Jardin des supplices* (cat. 179), *L'Imitation de Jésus-Christ* (cat. 72), Mallarmé's *Un coup de dés jamais n'abolira le hasard,* and a third and final album of *peintres-graveurs.* The last two items on this list were never published, although significant work took place on both. RAR

1. Vollard to the publisher Eugène Fasquelle, April 6, 1917: Vollard Archives, MS 421 (4,1), p. 289.

Disant ces mots, il mit la pomme au giron de
Chloé, et elle, comme il s'approcha, le baisa si
soevement qu'il n'eut point de regret d'être monté
si haut pour un baiser qui valoit mieux à son gré
que les pommes d'or.

17

17. *fig. 213*

PIERRE BONNARD
Les Pastorales de Longus, ou Daphnis et Chloé, by Longus

Published by Ambroise Vollard, Éditeur, Paris, 1902
("Achevé d'imprimer" October 31, 1902)
Illustrated book with 156 lithographs and 1 wood engraving
Page (irreg.) 11⅞ x 9⅝ in. (30.2 x 24.5 cm)
Printers: Auguste Clot (lithographs); L'Imprimerie Nationale (text)
Copy no. 145 (of a numbered edition of 250)
The Metropolitan Museum of Art, New York, Harris Brisbane Dick Fund, 1928 28.90.1
New York and Chicago only

CATALOGUES RAISONNÉS: Johnson 1977, no. 168; Bouvet 1981, no. 75; Chapon 1987, p. 279; Jentsch 1994, no. 4

PROVENANCE: Ambroise Vollard, Paris; bought by The Metropolitan Museum of Art, New York, 1928, for 11,000 francs[1]

While Vollard's decision to publish Paul Verlaine's *Parallèlement* had been risky given the scandalous nature of the text, the choice of *Daphnis et Chloé* could not have been safer. One of the most popular Greek romances, it had been illustrated many times before, and the story served as the basis of contemporary operettas and operas by Jacques Offenbach (1860), Charles Raffalli-Henri Büsser (1897), and Jules and Pierre Barbier-Henri Maréchal (1899). Vollard chose to use a standard translation by Jacques Amyot, which had first been published in 1559 and was subsequently revised and completed by Paul-Louis Courier.

It is not known when Bonnard began working on the project, but it is worth noting that in an undated letter to Maurice Denis (written sometime in late 1896 or in 1897), Vollard discussed an album of twelve lithographs on the theme of *Daphnis and Chloé* that he and Denis were contemplating.[2] By the spring of 1900, the Imprimerie Nationale had agreed to print the book's text; a payment of 796 francs from Vollard to the Imprimerie for work on the project is dated April 22, 1900.[3] According to the book's colophon, printing was finished on October 31, 1902.

The presentation of Bonnard's illustrations in *Daphnis et Chloé* is significantly more restrained than in *Parallèlement.* The lithographs adhere to rectangular or square shapes and are consistently placed in the upper two-thirds on the right-hand pages of the book. Printed in dark ink, they have been likened to bas-reliefs.[4] Despite Vollard's efforts to create a book that would have greater appeal for conservative bibliophiles, he was reproached for using lithographic illustrations. Furthermore, he was told, "Painters are not illustrators. The liberties they permit themselves are incompatible with the 'finish' which is the whole merit of an illustrated book."[5] As before, the book languished in Vollard's stock for years. However, critical opinion of it had reversed by the time of the Éditions Vollard exhibition at Le Portique in 1930. A copy of the book (presumably a luxe copy with an additional suite of loose prints) sold at auction in January 1930 for 15,000 francs,[6] and the following year the critic Claude Roger-Marx called Bonnard's edition of *Daphnis et Chloé* "possibly the greatest illustrated book published since the 18th century."[7]

 RAR

1. Vollard Archives, MS 421 (4,7), fol. 84.
2. Vollard to Denis, undated [ca. late 1896–97]: Archives, Musée Départemental Maurice Denis, Saint-Germain-en-Laye, Donation de la famille Denis, MS Vollard 11346.
3. Vollard Archives, MS 421 (4,3), fol. 159.
4. Vauxcelles 1933, pp. 352–53.
5. Vollard 1936, p. 254.
6. *Art et métiers graphiques* no. 15 (January 15, 1930), p. CLXXXVII.
7. Roger-Marx 1931a, p. 2.

18. *fig. 227*

PIERRE BONNARD
Père Ubu à l'aviation, by Ambroise Vollard

Published by Éditions Georges Crès et Cie, Paris, 1918
12-page pamphlet
Page 10⅝ x 6¾ in. (27 x 17.1 cm)
Printer: L'Imprimerie Lahure, 9, rue de Fleurus, Paris

The Metropolitan Museum of Art, New York, The Elisha Whittelsey Collection, The Elisha Whittelsey Fund, 1967 67.763.3
New York and Chicago only

CATALOGUE RAISONNÉ: Terrasse 1989, no. 34

18

Produced at the same time as *Père Ubu à l'hôpital* (cat. 19), this pamphlet attests to Vollard's continuing interest in Alfred Jarry's character *Père Ubu.* It must have been something of a shock when Vollard received a cease-and-desist letter in late March 1917 from the publisher Eugène Fasquelle challenging Vollard's right to use the character's name. On April 6 Vollard defended himself, saying that not only was his character quite different from Jarry's and thus impossible to confuse with it, but that he had collaborated with Jarry on the text of the *Almanach illustré du Père Ubu,* in particular on the "colonial part."[1] Vollard seems to have worried that the Jarry estate would interfere with the publication of *Les Réincarnations du Père Ubu,* illustrated with original prints by Rouault (see cat. 183). RAR

1. Vollard Archives, MS 421 (4,1), pp. 289–90.

19. *fig. 226*

PIERRE BONNARD
Père Ubu à l'hôpital, by Ambroise Vollard

Published by Éditions Georges Crès et Cie, Paris, 1918
16-page pamphlet
Page 10⅝ x 6¾ in. (27 x 17.1 cm)
Printer: L'Imprimerie Lahure, 9, rue de Fleurus, Paris
The Metropolitan Museum of Art, New York, The Elisha Whittelsey Collection, The Elisha Whittelsey Fund, 1967 67.763.4
New York and Chicago only

CATALOGUE RAISONNÉ: Terrasse 1989, no. 33

In his memoirs, Vollard recalled meeting a wounded soldier, who recounted his experiences during World War I: "I was wounded at Les Eparges. In [the] hospital they found I had moist gangrene in one leg. It didn't worry me too much, because I knew there was a scientific chap from the Institut Pasteur on our staff, Doctor Winberg, who had discovered a serum that cured it in two shakes. But apparently this doctor only held the rank of a lieutenant. So the 'Four-stripes,' who couldn't allow a 'Two-stripes' to cure people without them, refused to let him apply his

19

20

21



remedy, and went on cutting off arms and legs worse than ever. . . . [A]t last the Service got frightened at the number of pensions that would have to be served out to the mutilated, and decided to bestow on Doctor Winberg the four stripes that would give him the right officially to use his serum. So I was able to keep my leg."[1] According to Vollard, this encounter was the inspiration for *Père Ubu à l'hôpital.* The censored text eventually evolved into *Père Ubu à la guerre.*

Known versions of this text date to 1916, 1917, and 1918. Clarification is provided by a mention in a September 1917 *Mercure de France,*[2] which appeared at the time of publication of the third edition of this pamphlet. According to the article, the first privately printed edition of *Ubu à l'hôpital* was distributed to friends of Vollard and bibliophiles, and the second was given to medical leaders (including directors of hospitals and medical professors). "Emboldened by this success, M. Ambroise Vollard . . . [already has] a fourth edition at press." It is the fourth edition that is displayed here.

RAR

1. Vollard 1936, pp. 284–85.
2. "Echos," *Mercure de France,* September 1, 1917, pp. 186–87.

20. *fig. 295*

PIERRE BONNARD
Dingo, by Octave Mirbeau

Published by Ambroise Vollard, Éditeur, Paris, 1924
("Achevé d'imprimer" December 15, 1923)
Illustrated book with 54 etchings (including pictorial initials and cover)
Page (irreg.) 14¾ x 10¾ in. (37.5 x 27.3 cm)
Printer: Louis Fort (etchings), Émile Féquet (text)

a. The Metropolitan Museum of Art, New York, Harris Brisbane Dick Fund, 1928 28.90.2
Copy no. 313 (of a numbered edition of 350, plus additional copies lettered A–T)
New York and Chicago only

b. Petit Palais, Musée des Beaux-Arts de la Ville de Paris, bequest of Dr. Maurice Girardin, 1953 PPL 0041
Copy no. 217
Paris only

CATALOGUES RAISONNÉS: Johnson 1977, no. 169; Bouvet 1981, no. 90; Chapon 1987, p. 280; Jentsch 1994, no. 17

PROVENANCE: a. Ambroise Vollard, Paris; bought by The Metropolitan Museum of Art, New York, 1928, for 1,760 francs[1]



Five years after Vollard published Octave Mirbeau's *Jardin des supplices* (1902), Mirbeau wrote the catalogue preface for a Manzana-Pissarro exhibition held at Vollard's gallery in April 1907. Meanwhile, the author had purchased several works from Vollard, including a Cézanne still life, Daumier's head of a woman, and two Maillol bronzes.[2] Most of these items had been purchased about 1904, and by the summer of 1909, when Mirbeau had still not settled his bill, Vollard began to lose patience. Given the nature of their relationship, it is possible that Mirbeau offered Vollard the opportunity to publish his latest work to defray his debt.

One of the author's final texts (finished with the assistance of Léon Werth), *Dingo* is the story of a semiwild Australian dog living in "civilized" France. The book was first published by Eugène Fasquelle in May 1913, but in a letter dated January 23, 1913, Vollard had already informed Mirbeau that the Imprimerie Nationale had just agreed to print *Dingo* for Éditions Vollard. "When will the text be ready?" he asked. In the same letter Vollard requested permission to produce a 200-copy edition of Mirbeau's earlier text, *Le Journal d'une femme de chambre* (*Diary of a Chambermaid*).[3]

Although the Vollard Archives are incomplete for this period, it is documented that on December 29, 1916, Vollard paid Bonnard 9,200 francs for illustrations for both *Dingo* and another book he was illustrating, "St. Augustin."[4] Mirbeau's death on February 16, 1917, surely intensified Vollard's frustration, and it is with evident relief that he wrote Mirbeau's widow on November 26, 1917, to announce that the printing of *Dingo* would begin that day. "I was held up by Bonnard, and it is only now, after much trial and error, that he has finally produced something worthy of such a book."[5] Vollard inquired if she possessed a copy of the text annotated with Mirbeau's corrections, or if he should simply use Fasquelle's edition.

Ultimately, the text of *Dingo* was printed by Émile Féquet rather than the Imprimerie Nationale. The reason for the change is unclear, but it is known that Vollard had mixed feelings about the Imprimerie Nationale. While he favored the typefaces to which the printing house had the exclusive rights, he was often disappointed by delays and the quality of the work.[6] *Dingo* features a small typeface and many dense pages devoid of art. While in some of Vollard's illustrated books the text seems almost incidental, the opposite is true here.

RAR



1. Vollard Archives, MS 421 (4,7), fol. 84.
2. Vollard to Mirbeau, August 3, 1909: Vollard Archives, MS 421 (4,1), p. 136. See also Vollard to Mirbeau, April 21, 1906, June 24 and 30, 1911, and February 9, 1912: Vollard Archives, MS 421 (4,1), pp. 94, 211, 212, 230.
3. Vollard to Mirbeau, January 23, 1913: Vollard Archives, MS 421 (4,1), p. 247.
4. Receipt signed by Bonnard, dated December 29, 1916: Vollard Archives, MS 421 (9,2), fol. 4.
5. Vollard to Mirbeau's widow, November 26, 1917: Vollard Archives, MS 421 (4,1), p. 296. See also Vollard to Mirbeau's widow, November 24, 1917: Vollard Archives, MS 421 (4,1), p. 295.
6. See Vollard's two pages of complaints against the Imprimerie Nationale: Vollard Archives, MS 421 (8,14), fols. 1, 2.

21a. *fig. 104*

PIERRE BONNARD
Surtout de Table (The Terrasse Children)

Ca. 1902
Bronze, with travertine base
5¾ x 32 x 20¼ in. (14.6 x 81.3 x 51.4 cm)
The Art Institute of Chicago, bequest of Grant J. Pick 1963.927
New York and Chicago only

CATALOGUE RAISONNÉ: Pingeot 2006, pp. 16–30, 72–79, ill.

PROVENANCE: Probably Ambroise Vollard, Paris; Charles Slatkin, New York; bought by Grant J. Pick, Chicago, for $15,000; his bequest to The Art Institute of Chicago, 1963

21b.

PIERRE BONNARD
Surtout de Table (The Terrasse Children)

Ca. 1902
Bronze, with mirror
5⅞ x 32⅞ x 19¾ in. (15 x 83 x 50 cm)
Musée d'Orsay, Paris RF 3171
Paris only

CATALOGUE RAISONNÉ: Pingeot 2006, pp. 16, 30, 72–79, ill.

PROVENANCE: Probably Ambroise Vollard, Paris; Galerie Charpentier, Paris; bought by the Musée National d'Art Moderne, Paris, 1953; Musée du Louvre, Paris, 1977; Musée d'Orsay, Paris, 1986

In the announcement for its first known public exhibition at the Galerie Vollard in November 1902, and again in April 1906, this vibrant, oblong composition was titled "Un Surtout de table en bronze."[1] According to Vollard, it was the first sculpture Bonnard made for him after he caught the artist kneading bread dough into a little dog and suggested that he turn this interest in "modeling" to the making of sculpture.[2] Although the exact chronology for the work's creation

AMBROISE VOLLARD

LE PÈRE UBU
A L'HOPITAL
CROQUIS PAR P. BONNARD

LE PÈRE UBU

PARIS
ÉDITIONS GEORGES CRÈS ET Cⁱᵉ,
116, BOULEVARD SAINT-GERMAIN, PARIS
7, BAHNSTRASSE, ZURICH
1918
Prix : 2 fr. 50

is not known, its iconography—languishing females, a faun, children, dogs, goats (?)—links it to his illustrations for Longus's pastoral poem *Daphnis et Chloé,* which Vollard published in 1902 (see cat. 17).

Here, two of Bonnard's inspirations at that time—classical pastoral and his immediate family—come together. If the intertwined female figures recall the lovers of Longus's third-century poem, the faunlike male figure on the shorter side is a thinly disguised reference to Claude Terrasse, Bonnard's heavily bearded brother-in-law (see cat. 8), who is pulled by two children, possibly his sons, Charles and Jean.[3] The idea for an oval centerpiece ringed with figures may also have originated in the "bassin" at Le Grand-Lemps, the Bonnard family home.[4] Though rooted in the idea of the pastoral, the centerpiece's heavily interlaced figures also recall Rodin's anguished figures and the writing surfaces of Lalique vases.[5] Bonnard would continue this exploration in what one critic described as forms "teeming with eels, leeches, and worms, which are really satyrs, nymphs, animals . . . and grotto-like structures" in the series of figurines featuring women emerging from rocks. The latter were also created under Vollard's guidance and exhibited together with the bronze centerpiece in April 1906.[6]

Since Bonnard had little experience with sculpture and since it was Vollard who encouraged him to take up this medium, the dealer likely chose the foundry and oversaw the casting from a plaster model.[7] The Chicago and Paris pieces are the only known bronzes presumed to be realized by Vollard (although there are at least twelve posthumous versions).[8] Vollard's comments about Bonnard "hammering his bronze" in the basement of his shop indicates, however, that at least one cast of the centerpiece was hand-tooled by the artist. Neither are numbered, nor do they bear foundry or casting markings. In 1909, however, Vollard paid 800 francs to the Fondeur Godard for "le surtout de Bonnard," which may also have cast the circa 1902 work.[9] As was typical, Vollard produced bronzes only on an "as-need" basis.

By 1914, Bonnard had exhausted his sculptural experimentation. Unlike the case of Matisse, for whom sculpture was an important adjunct to his painted oeuvre, Bonnard's foray into bronze was, similar to his experiments with ceramics (cat. 22), a satisfying yet short-lived venture that would not prove essential to his art. GG

1. Fagus 1902c, p. 542; "Expositions nouvelles" 1906.
2. Vollard 1936, pp. 249–50, and in Groom above "Vollard, Redon and the Nabis," p. 94.
3. See Pingeot 2006, p. 11 (photograph taken by Bonnard of Claude in a similar chin-up, tongue-out pose) and p. 20, where the author compared the figures to those in Bonnard's painting of Claude with his sons, *The Composer Claude Terrasse and Two of His Sons,* of ca. 1902–3 (Musée d'Orsay, Paris). I am grateful to Anne Pingeot for having sent me an advance copy of her remarkable book, which details the many editions of Bonnard sculptures after his death.
4. See Paris 1987, pp. 118–19, 135–37.
5. See also Pingeot 2006, pp. 29–31, for other sources in Rodin, Camille Claudel, Degas, Gauguin, and Gustave Doré (p. 29, fig. 21).
6. See Fagus 1902c, p. 542, and Lausanne 1991, nos. 100, 101, 102, and 107, "Cheval marin."
7. Vollard owned a plaster of the centerpiece all his life; see Pingeot 2006, p. 72. A photograph of the centerpiece in Bonnard's studio (ca. 1905) shows it at an earlier stage, possibly as a terracotta or wax; see Pingeot 2006, pp. 24–25.

8. In 1971, a posthumous edition was authorized by Charles Terrasse and Charles Slatkin from the Parisian Foundry C. Valsuani, which bears their mark, "CIRE/D. VALSUANI PERDUE, and is signed "Bonnard." Only twelve of the proposed thirty versions were realized. See Sotheby's sale cat., New York, February 21, 1990, no. 94. Fortunately, a proposal to make smaller individual sculptures from some of the figures in the centerpiece was rejected by the Terrasse family; see Pingeot 2006, p. 77.
9. Vollard Archives, MS 421 (5,4), fol. 254, December 28, 1909: "Paye [*sic*] à Godard 800 fr[ancs] pour le surtout de Bonnard." It is also possible that there are two similar but different casts. Comparing the Paris bronze with Chicago's, one sees that the latter has none of the negative spaces at the base. This difference is apparent in photographs; see Pingeot 2006, p. 73 (Paris) and p. 74 (Chicago). Although the Chicago version was cast this way, the "fill" that extends about one inch from the bottom of the base has none of the textural quality of the grottolike surface of the Paris version. I am grateful to Suzie Schnepp, Objects Conservator at the Art Institute of Chicago, for her in-depth analysis of the Chicago cast.

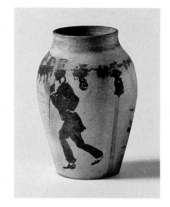

22

22. *fig. 103*

PIERRE BONNARD
Small Vase

Ca. 1894–95
India ink on unglazed painted ceramic
H. 3⅜ in. (8.6 cm)
Private collection
Not in exhibition

By the time his first poster, *France Champagne,* was published in 1891, Bonnard had made it clear that he would work in all possible forms, not to abandon the fine arts but to link art with life: "At that time I personally envisaged a popular art that was of everyday application: engravings, fans, furniture, screens, etc."[1] At the heart of this quest to combine art with decoration were the teachings of Paul Gauguin, whose hand-thrown terracotta vases and vessels successfully transformed new ideas about painting into uniquely personal art objects (see cats. 107, 108).[2] Although this small vase is not hand thrown (it is painted on a piece of Sèvres porcelain), it exemplifies this crossover aesthetic; the subjects depicted on it are drawn from Bonnard's work in graphics and paintings. While the origin of the vase remains unclear, the facts both that Vollard owned it and that he commissioned decorative ceramic plates from Bonnard as well as plates and vases from Denis (see cat. 74) suggest that he may have played some role in Bonnard's decision to take on the medium for the first time. The 1894–95 dating is also an approxima-

tion, relating it to posters and prints produced at that time. Bonnard's earliest known exchanges with the dealer date from 1895, possibly involving the poster Vollard commissioned from the artist for his first "Exposition des Peintres-Graveurs" held in the summer of 1896 (cat. 12).[3]

As Nicholas Watkins has noted, Bonnard was fascinated with tripartite and four-part compositions, which early in his career the artist used more literally in three-panel screens and three-sectioned paintings that he exhibited as triptychs at Vollard's gallery.[4] In many ways the wraparound composition necessitated by the vase's shape is part of this same interest in the divided image, since it too unfurls in scroll-like fashion into three discrete areas: the male and female skaters filling the height of the vase and in between them a female head topped with an extravagant plumed hat. As a continuous image with discrete vignettes, the vase can also be linked to *Nannies' Promenade, Frieze of Carriages* (private collection), painted in 1894 and published in 110 lithographic sheets about 1895–97: in this celebrated four-panel screen the central images are related, yet when folded they can be viewed as separate vignettes. Also in *Nannies' Promenade,* a top row of carriages serves as a solid decorative edging, much as the band of carriages and people on the horizon unifies the vase imagery.[5] Both vase and screen, moreover, reveal the artist's interest in the cutout silhouetted shapes of popular shadow theater as well as the bold woodcut illustrations by Félix Vallotton. Bonnard would return to the subject in a work known as *Ice Palace* or *The Skaters* (1896–98, private collection), which Vollard owned, where again the gliding figures presented the artist with a perfect foil for exploring the ornamental in subjects of modern-day life.

 GG

1. Translated in Watkins 1994, p. 25.
2. See Frèches-Thory 2000.
3. Johnson notes that the imprint on *Quelques Aspects de la vie de Paris* is 1895, although the album was not issued until 1899.
4. Watkins, speaking of Bonnard's later, larger canvases described the effect as "'wrapping' a painting around space in a sequence of rectangular divisions, which were then flattened out across the surface." London 1998, p. 38.
5. Frèches-Thory 2000, p. 27.

23. *fig. 18*

MARY CASSATT
Vase: The Children's Circle

Ca. 1903
Glazed ceramic (vase made by André Metthey)
H. 21⅝ in. (55 cm), Diam. 15¾ in. (40 cm)
Petit Palais, Musée des Beaux-Arts de la Ville de Paris, gift of Ambroise Vollard, 1937 PPO 1835

PROVENANCE: Ambroise Vollard, Paris, his gift to the City of Paris, 1937; Musée des Beaux-Arts de la Ville de Paris (Petit Palais), 1937

Cassatt had met Vollard by 1896, when she purchased from him a still life by Cézanne.[1] In the early 1900s she approached Vollard and sold him *Little Girl in a Blue Armchair* (1878, National Gallery of Art, Washington, D.C.). During the next few years Vollard acquired paintings, pastels, and prints from her,[2] most notably in 1906, when Cassatt opened her

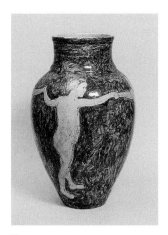

23

24

25

Column 1

studio to the dealer, who bought a substantial number of sketches and unfinished paintings and pastels.[3] In 1908 (March 24 to April 15) Vollard gave Cassatt a one-woman exhibition that consisted of fifty pastels and paintings and also etchings.[4] Five years later, she asked Vollard to sell the portrait that her friend Edgar Degas had painted of her, *Mary Cassatt Seated, Holding Cards* (ca. 1880–84, National Portrait Gallery, Smithsonian Institution, Washington, D.C.), which she had never liked. She also introduced Vollard to her wealthy friends the Havemeyers, who made numerous acquisitions from him. As Vollard observed, "Mr. Havemeyer was usually advised in his purchases by Mary Cassatt. She had persuaded him that he could make no better use of his money, since his pictures were to enrich the artistic heritage of the United States."[5]

About 1903 Cassatt wrote to Vollard concerning some vases she was working on: "In thinking of the vases that I saw at your place, I see that I have been wrong, I was about to scrape the one that was fired, because I'm sure it won't come out, as with anything a trial run is needed. I'm going to see if I can do something with the other because I'm not very well pleased with the band of flowers."[6] Vollard commissioned a number of ceramics from Renoir, Cassatt, Bonnard, Denis, and the Fauve painters Derain, Vlaminck, Puy, and Maillol, working with the ceramicist André Metthey, who produced simple shapes that the artists then painted (figs. 135–143). This green-and-white vase, decorated with children dancing in a circle, is unusual in Cassatt's work. It was part of the donation of works that Vollard made to the Petit Palais in 1937.

AD

1. Possibly *Bottle of Liqueur* (ca. 1890, private collection, Japan; R 681). Two other works by Cézanne that may have belonged to Cassatt are *Compotier, Apples, and Bread* (1879–80, Oskar Reinhart Collection "Am Römerholz," Winterthur; R 420) and *Apples and Napkin* (1879–80, private collection, Japan; R 339).
2. For example, on March 15, 1906, he paid 1,550 francs for a group of paintings, pastels, and etchings: Vollard Archives, MS 421 (5,1), fol. 48. On October 10, 1907, Vollard sent Cassatt a check for 5,000 francs for sales: MS 421 (5,2), fol. 164.
3. Cassatt to Louisine Havemeyer, July 27 [1906], transcript in Weitzenhoffer files, Department of European Paintings, Metropolitan Museum; see also Chicago–Boston–Washington 1998–99, p. 163, p. 174, n. 61.
4. Reviewed in Hepp 1908.
5. Vollard 1936, p. 142.
6. Letter dated Tuesday [1903], in Mathews 1984, p. 282.

Column 2

24. *fig. 30*

PAUL CÉZANNE
The Abduction

1867
Oil on canvas
35⅝ x 46 in. (90.5 x 117 cm)
The Provost and Fellows of King's College, Cambridge University (Keynes Collection), on loan to the Fitzwilliam Museum, Cambridge
Chicago and Paris only

CATALOGUES RAISONNÉS: Venturi 1936, no. 101; Rewald 1996, no. 121

PROVENANCE: Probably a gift from the artist to Émile Zola, Médan, after 1867–his d. 1902; his sale, Hôtel Drouot, Paris, March 9–13, 1903, no. 115, for 4,200 francs; bought by Ambroise Vollard, Paris; bought through Durand-Ruel, Paris, by Mr. and Mrs. H. O. Havemeyer, New York, by May 7, 1903–his d. 1907; his widow, 1907–her d. 1929; her sale, American-Anderson Galleries, New York, April 10, 1930, no. 80, for $24,000; bought by Chester Dale, New York; Étienne Bignou, Paris; Société La Peinture Contemporaine, Lucerne; their dissolution sale, Galerie Charpentier, Paris, June 26, 1934, no. 4; Wildenstein Galleries, London until 1935; J. Maynard Keynes, London; Lady Keynes, London, 1935–46; The Provost and Fellows of King's College, Cambridge University (Keynes Collection), on loan to the Fitzwilliam Museum, Cambridge

The Abduction has a rich early history, in which Vollard played a key role. The dealer recounted visiting the first owner, Émile Zola, on the pretext of looking for a suitable typeface for his forthcoming edition of Octave Mirbeau's *Jardin des supplices*,[1] but really "in the hopes of seeing some of the pictures of Cézanne's youth in his possession."[2] He was told that they were hidden away in a Breton wardrobe "under triple lock and key," with this painting among them, because he could never put them on the walls. Responding to Vollard's request to see the works, Zola replied, "Do not ask me to get them out; it pains me so to think of what my friend might have been if he had only tried to direct his imagination and work out his form."[3] Vollard may not have seen the painting on that visit, but he did buy three Cézannes from the writer's posthumous sale, including *The Abduction*, for which he paid 4,200 francs.[4] Without even recording the painting in his stockbook, Vollard quickly sold it to the American collectors Louisine and H. O. Havemeyer for 6,500 francs (see also cat. 36).[5]

JSW

1. It is not known when the meeting took place, but Vollard signed a contract with Mirbeau and Auguste Rodin in February 1899. The book was published in 1902. See Rebecca Rabinow's essay on *livres d'artiste* in this volume.
2. Vollard 1936, p. 227.
3. Vollard 1937a, p. 100.

Column 3

4. The other two paintings were *Corner of the Studio* (National Gallery, London; R 90) and *Portrait of a Woman* (private collection; R 75).
5. The transaction took place on May 7, 1903, through the intermediary of Durand-Ruel, and included a second Cézanne painting (*Gustave Boyer in a Straw Hat*, Metropolitan Museum; R 174), for which the collectors paid 1,500 francs.

25. *fig. 40*

PAUL CÉZANNE
The Negro Scipion

Ca. 1867
Oil on canvas
42⅛ x 32¾ in. (107 x 83 cm)
Museu de Arte de São Paulo Assis Chateaubriand, São Paulo 85.1950
New York and Chicago only

CATALOGUES RAISONNÉS: Venturi 1936, no. 100; Rewald 1996, no. 120

PROVENANCE: Ambroise Vollard, Paris; bought by Claude Monet, Giverny, possibly by 1899–his d. 1926; by descent to Michel Monet, Giverny, 1926; Paul Rosenberg, Paris, by 1939; Wildenstein Galleries, Paris, London, New York; bought by the Museu de Arte de São Paulo, 1950

Between 1894 and 1907 Claude Monet assembled an extraordinary collection of paintings by Cézanne consisting of at least fourteen oils and two watercolors. Monet greatly admired his colleague and once declared to his friend the statesman Georges Clemenceau: "Yes, Cézanne, he is the greatest of us all."[1] By Vollard's account, the admiration was mutual. "Monet is only an eye, " said Cézanne, "but good Lord what an eye!"[2]

Guests to Giverny were often invited to see Monet's collection, particularly to admire the artist's favorite works, which were hung in his bedroom. Paintings by Edgar Degas, Auguste Renoir, Camille Pissarro, Édouard Manet, Berthe Morisot, and Monet, as well as several canvases by Cézanne, filled the walls of this room. *The Negro Scipion* was among them. Louis Vauxcelles saw the work with Monet, who declared it "a brilliant masterpiece."[3] Later, the artist proclaimed the painting "a work of primary power."[4] The dealer René Gimpel recalled seeing the painting in 1920 with Georges Bernheim. Monet told them, "Look at this Negro by Cézanne. I paid four hundred francs for it, and it was Vollard, too, from whom I bought it; he was only a novice. He's caught up since!"[5] It is not clear from the text if Monet was referring to the artist or the dealer as the

"novice"—the painting was executed in 1867, in the artist's formative years, and it was sold by the dealer when he was still learning his trade. Vollard's records do not indicate the date of purchase, but judging from the modest price, Monet probably acquired the painting by 1899.

Monet purchased at least six other Cézannes from Vollard, the first, a view of L'Estaque (Museum of Modern Art, New York; R 443), in March 1896 for 600 francs.[6]

JSW

1. Georges-Michel 1942, p. 35.
2. Vollard 1914, p. 88; Vollard 1937, p. 74.
3. Vauxcelles 1905a, p. 89.
4. Elder 1924, p. 49.
5. Gimpel 1966, p. 128.
6. Vollard Archives, MS 421 (4,4), fol. 3.

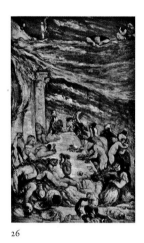

26

26. fig. 31

PAUL CÉZANNE
The Feast (The Orgy)

Ca. 1867–70
Oil on canvas
51⅛ x 31⅞ in. (130 x 81 cm)
Private collection

CATALOGUES RAISONNÉS: Venturi 1936, no. 92; Rewald 1996, no. 128

PROVENANCE: Paul Cézanne *fils*, Paris; bought by Ambroise Vollard, Paris, December 6, 1912, for 40,000 francs; Galerie Bernheim-Jeune, Paris; Auguste Pellerin, Paris, 1913–his d. 1929; by descent to M. and Mme René Lecompte, née Pellerin, Paris, 1929; by descent through their family, sale, Christie's, New York, November 8, 1999, no. 135; private collection

The Feast was first exhibited in Vollard's pioneering exhibition of Cézanne's work in 1895, where it was hung in the rear of the gallery. The journalist Gustave Geffroy was particularly impressed by the "luxury of the colors" and the "unprecedented sparkling light." He added that the painting was "a capital point of departure in the artistic stock here on exhibit. . . . It is respectful of past masters, but how ardently it wants to speak in its own turn! Its ambition is betrayed by the violence it expresses, by the couple of lovers, so tightly knotted together, by the rhythmic disorder of the orgy, by the haughty figure presiding over this melee of instincts, by the other figure, so robust, placed at the summit, leaning over

the balustrade from which draperies joyously unfurl with an air of freedom."[1]

The painting did not find a buyer, however, and may have been returned to the artist or his son after the exhibition, or simply kept in Vollard's stock (although it never received a stock number). Vollard's records indicate that on December 6, 1912, he paid Cézanne *fils* 40,000 francs for the painting, and on January 3, 1913, he paid 6,000 francs to Bernheim-Jeune as a commission; the painting had been purchased by Auguste Pellerin for an unknown sum[2] and remains with his heirs.

Vollard dated *The Feast* to 1868 in his 1914 monograph on the artist; Cézanne *fils* annotated a photograph of the work in the Vollard Archives, dating it to 1867.

JSW

1. Geffroy 1895 (1900 ed.), pp. 216–17; translated in Paris–London–Philadelphia 1995–96, p. 104.
2. Vollard Archives, MS 421 (5,8), fol. 222, and MS 421 (5,9), fol. 4.

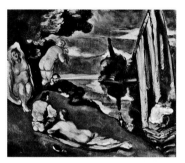

27

27. fig. 32

PAUL CÉZANNE
Pastoral (Idyll)

Ca. 1870
Oil on canvas
25⅝ x 31⅞ in. (65 x 81 cm)
Musée d'Orsay, Paris RF 1982-48

CATALOGUES RAISONNÉS: Venturi 1936, no. 104; Rewald 1996, no. 166

PROVENANCE: Acquired from the artist by Ambroise Vollard, Paris (Stockbook A, no. 3307, 1899 for 200 francs); acquired by Galerie Bernheim-Jeune, Paris, by December 24, 1910 (stock no. 18493); bought by Auguste Pellerin, Paris, in exchange for three paintings by Cézanne, plus cash, December 24, 1910–his d. 1929; his son Jean-Victor Pellerin, Paris, 1929; by descent through his family until 1982; their gift to the Musée d'Orsay, Paris, 1982

This painting was bought from the artist for 200 francs and entered in Vollard's stockbook in early 1899.[1] It was shown later that year in an exhibition of Cézanne's paintings at the rue Laffitte gallery as *Fête au bord de la mer*. One reviewer described a man who could not be still in front of the painting and who declared: "What a feast! Carnal giddiness, triumphal decoration, perspective, and a startling blaze of fabrics and nude flesh—this narrow painting opens onto the sun-drenched expansiveness of the great Venetian decorators. One has to stop and ponder this miraculous canvas, in which all of Cézanne is contained."[2] In spite of the eloquent declaration, the painting did not sell and was recorded in Vollard's

second stockbook about 1904.[3] *Pastoral* eventually entered Auguste Pellerin's collection and was hung in his library in Neuilly. Pellerin owned about 150 Cézannes, buying and trading works for more than a quarter of a century to create the greatest collection of Cézanne pictures ever assembled. Most of the works originated from Vollard's gallery, although the collector began in 1900 to buy more extensively through Galerie Bernheim-Jeune (purchasing works that often had been consigned to Bernheim by Vollard).

Pastoral has been known by a number of different titles, including *Idylle*, *Scène de plein air*, *Fête au bord de la mer*, and *Don Quichotte sur les rives de Barbarie*, no doubt because of its enigmatic subject. According to Vollard, the recumbent male figure is the artist.[4]

JSW

1. Stockbook A, no. 3307, "Manière noire du peintre époque 1870—Personnages nus et habillés dans diverses positions au bord de l'eau, 65 x 81, 200 [francs]."
2. Fagus 1899, p. 628.
3. Stockbook B, no. 3783, "Le repas sur l'herbe. Personnages nus et habillés, 65 x 81, 300 f[rancs]."
4. Vollard 1914, p. 34, n. 1.

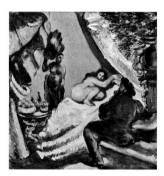

28

28. fig. 237

PAUL CÉZANNE
A Modern Olympia (Le Pacha)

Ca. 1870
Oil on canvas
22 x 21⅝ in. (56 x 55 cm)
Private collection

CATALOGUES RAISONNÉS: Venturi 1936, no. 106; Rewald 1996, no. 171

PROVENANCE: Estate of the artist, 1906, bought by Ambroise Vollard, Paris (Stockbook B, no. 4455 [as "Olympia"]) in shares with Galerie Bernheim-Jeune, Paris (stock no. 15670), possibly for 6,000 francs paid to Paul Cézanne *fils*, February 12, 1907; acquired from Bernheim-Jeune by Auguste Pellerin, Paris, in exchange for a painting by Renoir plus cash, November 14, 1908–his d. 1929; by descent to M. and Mme René Lecomte, née Pellerin, Paris, 1929; by descent through their family; sale, Sotheby's, New York, November 13, 1997, no. 112; private collection

This canvas was one of twenty-nine paintings found in Cézanne's studios in Aix-en-Provence and purchased jointly by Vollard and the Galerie Bernheim-Jeune in early 1907.[1] Most of the paintings in the group were late, unfinished subjects, but this early work from about 1870 and a portrait of the artist's father from 1866 were included among Cézanne's effects.[2] No doubt they had a special significance to the artist—the present work for its association with

Édouard Manet's provocative painting *Olympia* and the portrait for its association with an imperious father, whose relationship with his son was at best strained.

Soon after its arrival in Paris, *A Modern Olympia* was brought to the attention of Hugo von Tschudi, director of the Nationalgalerie, Berlin, and an admirer of French nineteenth-century art.[3] It is not known how much interest, if any, Tschudi showed in the painting, but it was not acquired for the museum. It did, however, enter the Auguste Pellerin collection in November 1908 and was hung in the collector's library in Neuilly.

JSW

1. Stockbook B, nos. 4451–4480. For each entry Vollard gave two figures, the first (and lower figure) presumably the amount paid to Cézanne *fils* and the second the value of the picture or a sale price agreed upon with Bernheim-Jeune.
2. *Portrait of Louis-Auguste Cézanne* (National Gallery of Art, Washington, D.C.; R 101).
3. See Rewald 1996, p. 137, no. 171. Vollard must have consigned the picture to the Parisian dealer Lucien Moline, who contacted Von Tschudi. Von Tschudi was instrumental in introducing Cézanne's work to German collectors and museums.

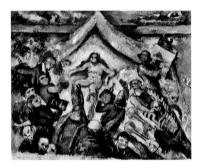

29

29. *fig. 33*

PAUL CÉZANNE
The Eternal Feminine

Ca. 1877
Oil on canvas
17 x 20⅞ in. (43.2 x 53 cm)
The J. Paul Getty Museum, Los Angeles 87.PA.79
New York and Chicago only

CATALOGUES RAISONNÉS: Venturi 1936, no. 247; Rewald 1996, no. 299

PROVENANCE: Ambroise Vollard, Paris, by 1899; Auguste Pellerin, Paris, ca. 1899–his d. 1929; his son Jean-Victor Pellerin, Paris, 1929; Wildenstein Galleries, Paris, London, New York; Stavros S. Niarchos, Paris and Saint-Moritz, 1954; Wildenstein Galleries, New York; Harold Hecht, Beverly Hills, by 1959; private collection, New York, 1970; Wildenstein Galleries, New York, 1973; Mrs. John Goulandris, New York; Galerie Beyeler, Basel; bought by the J. Paul Getty Museum, Los Angeles, 1987

Vollard visited Aix-en-Provence probably in late August 1899 in search of Cézanne's paintings. He returned with twelve paintings from the artist's uncle Dominique Aubert and a flower picture from a Monsieur Borelli, as well as some wood frames, which he recorded in his account book.[1] He may have acquired more works because he boasted to

Gauguin that he had purchased all of the paintings that were in Cézanne's studio. "I have already held three or four exhibitions of them."[2] Vollard did indeed mount an exhibition of forty paintings in late November. *The Eternal Feminine* was listed in the catalogue as *La Belle Impéria,* no. 6. No doubt some of the dealer's acquisitions from his trip in August were included in that show, and it is possible that this painting was in the group. Cézanne had returned to Aix in September to collect his belongings from his childhood home, the Jas de Bouffan, that was sold on the eighteenth of the month. Is the artist's studio at the Jas the one to which Vollard referred in his letter to Gauguin? In any event, Vollard must have acquired *The Eternal Feminine* about that time and sold it (perhaps in an exchange) to Auguste Pellerin from the exhibition; unlike most of the other known paintings in the show, it was never recorded in his first stockbook.

No mention of this dynamic and sensational subject appeared in the rather lengthy reviews of the exhibition. The artist's still lifes garnered much of the praise. JSW

1. Vollard Archives, MS 421 (4,3), fol. 142, entry for September 1, 1899.
2. Rewald 1943, p. 28.

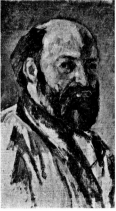

30

30. *fig. 34*

PAUL CÉZANNE
Self-Portrait

Ca. 1877–80
Oil on canvas
10 x 5¾ in. (25.5 x 14.5 cm)
Musée d'Orsay, Paris, Painting recovered by the Allies after World War II and entrusted to the care of the Musées Nationaux Récupération MNR228
Paris only

CATALOGUES RAISONNÉS: Venturi 1936, no. 371; Rewald 1996, no. 385

PROVENANCE: Acquired from the artist by Ambroise Vollard, Paris, 1895; acquired by Camille Pissarro, Paris, by exchange, November 19, 1895–his d. 1903; Octave Mirbeau, Paris, by February 1919; his sale, Galerie Durand-Ruel, Paris, February 24, 1919, no. 10; Charles Comiot, Paris (likely purchased at Mirbeau sale); Jean Dieterle, Paris; private collection, Paris; André Schoeller, Paris; bought by Wallraf-Richartz-Museum, Cologne, November 1941; Musée du Louvre, Paris; Musées Nationaux Récupération, 1950; Jeu de Paume, Paris, 1951; Musée d'Orsay, Paris, 1986

This self-portrait was one of three known to have been included in Vollard's groundbreaking exhibition of Cézanne's work in 1895 (see also cat. 35).[1] A number of Cézanne's colleagues demonstrated their support for the painter by purchasing (or trading their own) paintings from that exhibition. Camille Pissarro was an enthusiastic buyer and informed his son that he had exchanged an 1870 landscape of his own for "an admirable small canvas of bathers and one of his self-portraits."[2] Although Pissarro already owned several works by Cézanne, no doubt acquired while the two were painting together in the 1870s and early 1880s, he nonetheless felt compelled to purchase from this exhibition. The two artists shared a mutual respect for one another that lasted throughout their lives. Cézanne referred to his friend as the "humble and colossal Pissarro" and said that "he was like a father to me."[3] Pissarro recognized in Cézanne "all of [his] great and rare qualities."[4]

It was Pissarro who encouraged Vollard to show Cézanne's work. The artist seemed quite taken with the dealer because "he shows nothing but pictures of the young [artists]. . . . I believe this little dealer is the one we have been seeking. . . . He is very enthusiastic and knows his job."[5]

JSW

1. The other was *Self-Portrait with a Felt Hat* (Bridgestone Museum of Art, Tokyo; R 774).
2. Camille Pissarro to his son Lucien, November 21, 1895, in Rewald and L. Pissarro 1943, p. 276. See also Vollard Archives, MS 421 (4,2), fol. 24, November 19, 1895, where a third work, "scène champêtre," is also listed as part of the exchange. All three works were described as "esquisses" (sketches).
3. Paul Cézanne to Émile Bernard, Aix, 1905, in Rewald 1976, p. 314; Cézanne, interview with Jules Borély, July 1902, in Doran 2001, p. 22.
4. Camille Pissarro to his son Lucien, Paris, December 4, 1895, in Rewald and L. Pissarro 1950, p. 392.
5. Camille Pissarro to his son Lucien, Paris, January 21, 1894, Rewald and L. Pissarro 1943, p. 227.

31

31. *fig. 35*

PAUL CÉZANNE
Poplars

Ca. 1879–80
Oil on canvas
25½ x 32 in. (65 x 81 cm)
Musée d'Orsay, Paris, Bequest of Joseph Reinach, 1921
RF 2324

CATALOGUES RAISONNÉS: Venturi 1936, no. 335; Rewald 1996, no. 407

PROVENANCE: Acquired from the artist by Ambroise Vollard, Paris, 1899 (Stockbook A, no. 3316), for 200 francs; bought by Georges Feydeau, Paris, February 16, 1900 (for 2,000 francs); his sale, Hôtel Drouot, Paris, February 11, 1901, no. 42; Joseph Reinach, Paris, until his d. 1921; his bequest to the Musée du Louvre, Paris, 1921; Musée d'Orsay, Paris, 1986

Vollard paid the artist 200 francs for this work in early 1899[1] and sold it a year later for 2,000 francs to the playwright Georges Feydeau, who must have seen the painting in the gallery's Cézanne exhibition of December 1899. *Poplars* was featured in a review of that exhibition as one of "two significant paintings by Cézanne" shown.[2]

Shortly after the sale of *Poplars*, Vollard wrote to Feydeau about another unidentified Cézanne painting that was with an "amateur" in Avignon; Vollard was going to be away from the gallery for Mardi Gras, so he offered to put him in touch directly with the owner of the work.[3] Vollard's records do not indicate if Feydeau followed up on this offer, but it seems that their relationship became strained. In December 1901 Vollard demanded payment of 1,400 francs for two pastels by Jean-Louis Forain sold to Feydeau several months earlier—the dealer was in urgent need of money at that time.[4] Vollard's records are sparse in this period, and the outcome of this transaction is unknown.[5] JSW

1. Stockbook A, no. 3316, "Paysage tout vert; rideau d'arbre tenant les ¾ du tableau—au premier plan une maçonnerie, de l'autre côté un petit chemin qui tourne, 65 x 81, 200 [francs]. The sale to Feydeau was also recorded in the account book on February 16, 1900: Vollard Archives MS 421 (4,3), fol. 52.
2. Leclercq 1899, p. 331.
3. Vollard Archives, MS 421 (4,1), p. 27, letter dated February 26, 1900.
4. Vollard Archives, MS 421 (4,1), pp. 42–44, letters dated December 11 and 21, 1901.
5. Vollard received 500 francs on June 10, 1901, but it is not clear what the payment represents: Vollard Archives, MS 421 (4,9), fol. 90.

PROVENANCE: Acquired from the artist by Ambroise Vollard, Paris; by 1895; bought by Edgar Degas, Paris, January 6, 1896, for 400 francs; his sale, Galerie Georges Petit, Paris, March 26–27, 1918, no. 14, for 24,700 francs; bought by Galerie Bernheim-Jeune, Paris; Rudolf Staechelin Family Foundation, Basel

This still life was presumably shown in Vollard's 1895 exhibition because, shortly after it closed, Edgar Degas purchased the painting for 400 francs.[1] It was one of eight works by Cézanne that he acquired between November 1895 and June 1897, all of them modest in scale and all from Vollard. Degas's ardent enthusiasm for his colleague's work was such that he exclaimed to his friend Daniel Halévy: "Here is my new Van Gogh, and my Cézanne. I buy! I buy! I can't stop myself!"[2] He even drew straws to determine who, between Renoir and himself, would win a watercolor of three pears. "Degas so mad about Cézanne's sketches—what do you think of that!" wrote Camille Pissarro to his son Lucien.[3]

Still life was virtually absent in Degas's oeuvre, so it is telling that of his eight Cézannes half were in this genre. Notably, Degas's private collection included only two still lifes by Van Gogh purchased from Vollard and three by Manet acquired from various sources.[4]

It was Degas who recommended Charles Chapuis to Vollard, a "picture doctor" who was the only one he trusted to reline and restore paintings. Indeed, Vollard seems to have used Chapuis exclusively between 1904 and 1907 to prepare his recent acquisitions for exhibition or sale.[5] JSW

1. Vollard Archives, MS 421 (4,2), fol. 27, January 6, 1896.
2. Halévy 1960, p. 86.
3. Camille Pissarro to his son Lucien, December 4, 1895, in Rewald and L. Pissarro 1943, p. 277.
4. See New York 1997–98, vol. 2, pp. 16–17, nos. 109, 112, 113, 115, p. 66, nos. 595, 596, and pp. 87–88, nos. 797, 801, 802.
5. Vollard Archives, MS 421 (3,4), fols. 1–17. See also Vollard 1924a, p. 81. Chapuis is first noted in Vollard's account book in October 1895: MS 421 (4,3), fol. 33.

33

life! In moments of doubt, when I was still searching for myself, frightened sometimes by my discoveries, I thought: 'If Cézanne is right, I am right.' Because I knew that Cézanne had made no mistake."[2] Writing specifically of this work when he gave it to the Petit Palais in 1936, he explained, "In the thirty-seven years I have owned this canvas, I have come to know it quite well, though not entirely, I hope; it has sustained me morally in the critical moments of my venture as an artist; I have drawn from it my faith and my perseverance; for this reason, allow me to request that it be placed so that it may be seen to its best advantage. . . . I know that I do not have to tell you this, but nevertheless I think it is my duty to do so; please accept these remarks as the excusable testimony of my admiration for this work which has grown increasingly greater ever since I have owned it."[3]

Camille Pissarro introduced Matisse to Cézanne's work. Matisse noticed *Three Bathers* in Vollard's gallery on one of his frequent visits there, where the small canvas captured his attention. He could not get it out of his mind. Although it was a financial sacrifice to buy it, he made an agreement with Vollard to make a down payment and to fulfill the balance over a year.[4] JSW

1. This work was recorded in Vollard's Stockbook A, no. 4121, as "baigneuses trois femmes celle de gauche tient une linge; feuilles vertes." Matisse owned a total of five paintings and seven watercolors by Cézanne. The watercolors came directly from Vollard, perhaps in an exchange with his own work because they are not recorded individually in the account books and ledgers; the paintings were acquired from various sources (except for *Three Bathers*), but most probably came originally from Vollard.
2. Matisse, interview with Jacques Guenne, 1925, in Flam 1995, p. 80.
3. Matisse to Raymond Escholier, Nice, November 10, 1936, in Flam 1995, p. 124.
4. See Barr 1951, pp. 38–40.

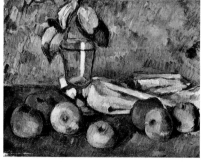

32

32. *fig. 240*

PAUL CÉZANNE
Glass and Apples

1879–82
Oil on canvas
12⅜ x 15¾ in. (31.5 x 40 cm)
Collection Rudolf Staechelin, on permanent loan to Kunstmuseum Basel
Paris only

CATALOGUES RAISONNÉS: Venturi 1936, no 339; Rewald 1996, no. 424

33. *fig. 147*

PAUL CÉZANNE
Three Bathers

1879–82
Oil on canvas
21⅜ x 20½ in. (55 x 52 cm)
Petit Palais, Musée des Beaux-Arts de la Ville de Paris
PPP2099

CATALOGUES RAISONNÉS: Venturi 1936, no. 381; Rewald 1996, no. 360

PROVENANCE: Acquired from the artist by Ambroise Vollard, Paris (Stockbook A, no 4121), ca 1899; bought by Henri Matisse, Paris and Nice, December 7, 1899 for 1,200 francs; his gift to the Musée des Beaux-Arts de la Ville de Paris (Petit Palais), 1936

Henri Matisse, who bought this painting directly from Vollard in December 1899 for 1,200 francs, wrote passionately throughout his career about Cézanne's influence on his own work and especially about this purchase.[1] In 1925 he professed, "If only you knew the moral strength, the encouragement that [Cézanne's] remarkable example gave me all my

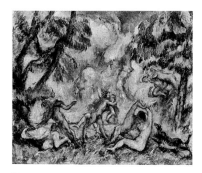

34

34.

fig. 41

PAUL CÉZANNE
The Battle of Love

Ca. 1880
Oil on canvas
14⅞ x 18¼ in. (37.8 x 46.4 cm)
National Gallery of Art, Washington D.C., Gift of the
W. Averell Harriman Foundation in memory of Marie
N. Harriman 1972.9.2

CATALOGUES RAISONNÉS: Venturi 1936, no. 380; Rewald
1996, no. 456

PROVENANCE: Acquired from the artist by Ambroise Vollard,
Paris, by November 1895; acquired by Auguste Renoir,
Cagnes, probably 1895?–1912; acquired by Ambroise Vollard,
Paris, 1912; Gottlieb Friedrich Reber, Barmen, then Lausanne,
by 1913; bought by Marie N. and W. Averell Harriman, New
York, through the Marie Harriman Gallery, May 1931;
W. Averell Harriman Foundation, New York; their gift to
the National Gallery of Art, Washington, D.C., 1972

According to Jean Renoir, his father met Vollard for
the first time in fall 1895.[1] He recalled, "Vollard was,
of course, well acquainted with Cézanne's painting.
But it is very possible that Renoir was instrumental
in convincing him of its value, 'which has not been
equaled since the end of Romanesque art.'"[2] Auguste
Renoir went to the Cézanne exhibition at Vollard's in
1895, where he certainly would have seen this paint-
ing. The artist (or his wife) may have acquired it
shortly thereafter, although the sale is not recorded
in the Vollard archives. Mary Cassatt referred to the
painting in a letter to her friend Louisine Havemeyer,
"Mme Renoir bought a little *pochade* by Cézanne for
100 francs long ago, not so very long ago, and now
they offer her 18,500 francs for it, but she wants
20,000. It is folly."[3]

Vollard's records are unclear, but he must have
bought the picture back from Madame Renoir in
1912. In July of that year it was valued at 35,000
francs and shipped to Gottlieb Friedrich Reber, a
German industrialist and *marchand-amateur*.[4] The
painting was shown with Reber's growing collection
of Cézannes in Berlin in January 1913 and again in
Darmstadt later that year. Reber bought almost
exclusively from Vollard, acquiring and selling a total
of twenty-nine canvases by Cézanne. In the 1920s
Reber began to sell his Cézannes in order to purchase
Cubist masters, and in the 1930s for financial reasons.
JSW

1. Vollard actually met Renoir the year before. The artist pur-
chased two watercolors by Manet on October 15, 1894:
Vollard Archives, MS 421 (4,2), fol. 5. See also Vollard
1919b, pp. 9–14.
2. J. Renoir 1962, p. 305.
3. Mary Cassatt to Louisine Havemeyer, Fall 1912: transcript

in Weitzenhoffer files, Department of European Paintings,
Metropolitan Museum; quoted in Rewald 1996, p. 308.
4. Vollard Archives, MS 421 (4,13), fol. 54, July 8, 1912.

35

35.

fig. 253

PAUL CÉZANNE
Self-Portrait

1882–83
Oil on canvas
18⅛ x 15 in. (46 x 38 cm)
Pushkin State Museum of Fine Arts, Moscow 3338
New York and Chicago only

CATALOGUES RAISONNÉS: Venturi 1936, no. 368; Rewald
1996, no. 445

PROVENANCE: Ambroise Vollard, Paris, by 1895; bought by
Sergei Shchukin, Moscow, May 4, 1906; Museum of Modern
Western Painting, Moscow, from 1918; State Museum of
Modern Western Art, Moscow, 1923; Pushkin State Museum
of Fine Arts, Moscow, 1948

The name "Stchoukine" appears often in Vollard's
records. The earliest entries relate to works bought
by Ivan Shchukin, including a Cézanne still life
(*Still Life with Green Pot and Pewter Jug*, Musée
d'Orsay, Paris; R 137),[1] and his brother, Pyotr, who
purchased Maurice Denis's *Sacred Forest* in April
1899.[2] Sergei, another brother and the creator of a
superb collection of modernist art, bought at least
five Cézanne paintings from Vollard beginning in
1906.[3] *Self-Portrait* was purchased in May of that
year, along with a Cézanne landscape and a Gauguin
figure for 30,000 francs.[4] It is remarkable that this
self-portrait, which was shown in Vollard's 1895 exhi-
bition, was never entered into either of the dealer's
stockbooks, it being on his premises for more than
ten years.

Henri Matisse, who was well acquainted with
both Shchukin and his fellow Russian collector, Ivan
Morozov, once described the contrast between the
two: "When Morosoff went to Ambroise Vollard,
he'd say: 'I want to see a very beautiful Cézanne.'
Stchoukine, on the other hand, would ask to see all
the Cézannes available and make his choice among
them."[5]
JSW

1. Vollard Archives, MS 421 (4,4), fol. 5. Ivan's modernist col-
lection was sold at auction on March 24, 1900, as he turned
more toward acquiring works by old masters.
2. Vollard Archives, MS 421 (4,3), fol. 129, April 18, 1899.
Vollard had paid Denis 1,000 francs and sold it to
Shchukin for 3,500 francs. The painting is in the State
Hermitage Museum, St. Petersburg.

3. His name first appears in Vollard's records, however, on
April 29, 1899, when he bought a Bonnard album and a
Vuillard album from the exhibition of lithographs
(March–early April): Vollard Archives, MS 421 (4,3),
fol. 130. His last Cézanne purchase was for *Dame en bleu*
(R 944), for which he paid 18,000 francs on January 16,
1909: Vollard Archives, MS 421 (5,4), fol. 6.
4. Vollard Archives, MS 421 (5,1), fol. 83, May 4, 1906.
The landscape was described simply as "paysage bleu."
Shchukin owned only two landscapes by Cézanne (R 695
and R 932). Six months after purchasing "paysage bleu"
(R 695), the collector bought a second landscape that
Vollard had acquired from the Eugène Carrière sale (June
8, 1906) (probably R 932): Vollard Archives, MS 421 (5,1),
fols. 108, 184, June 13 and November 19, 1906.
5. Tériade 1952, pp. 49–50.

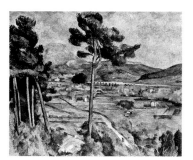

36

36.

fig. 239

PAUL CÉZANNE
*Mont Sainte-Victoire and the Viaduct of
the Arc River Valley*

1882–85
Oil on canvas
25¾ x 32⅛ in. (65.4 x 81.6 cm)
The Metropolitan Museum of Art, New York,
H. O. Havemeyer Collection, Bequest of Mrs. H. O.
Havemeyer, 1929 29.100.64

CATALOGUES RAISONNÉS: Venturi 1936, no. 452; Rewald
1996, no. 511

PROVENANCE: Acquired from the artist by Ambroise Vollard,
Paris (Stockbook A, no. 3753), 1899/1900, for 250 francs;
bought by Mr. and Mrs. H. O. Havemeyer, New York, spring
1901–his d. 1907; his widow, 1907–her d. 1929; her bequest to
the Metropolitan Museum, New York, 1929

Vollard described H. O. Havemeyer's purchase of
this landscape in his *Recollections*. Quoted a price of
15,000 francs, the collector at first hesitated but even-
tually enthusiastically accepted the offer, saying that
the painting reminded him of the frescoes he had
recently admired in Pompeii.[1] This exchange must
have occurred in April 1901 when he and his wife,
Louisine, first visited Vollard's gallery together.
Shortly thereafter Havemeyer made two cash pay-
ments on account to the dealer, totaling 19,000
francs.[2] Two months later Vollard sent seven paint-
ings by Cézanne and seven frames to Havemeyer in
New York, including this work.[3] According to Mary
Cassatt, the advance "saved [Vollard's] financial life
in 1901."[4] Despite Havemeyer's largesse in helping
Vollard on that occasion, the collector remained
loyal to his longtime dealer Durand-Ruel; there are
few instances when he dealt directly with Vollard
again and some of those were through the interme-
diary of Mary Cassatt.

Vollard acquired *Mont Sainte-Victoire and the Viaduct of the Arc River Valley* from Cézanne in 1899 or early 1900,[5] as it appears in his first known stockbook.[6] He paid 250 francs for it or received it on consignment from the artist at that figure.

JSW

1. Vollard 1936, p. 142. Cézanne paintings usually did not command such a high price in 1901, not even at Vollard's. Havemeyer did, however, pay 15,000 francs for a still life (*Still Life with a Ginger Jar and Eggplants*; R 769), in May 1906, a figure more in line with what the dealer was asking from his well-to-do clients that year: Vollard Archives, MS 421 (5,1), fol. 83.
2. The advances were made on April 2, 1901, for 10,000 francs and April 21, 1901, for 9,000 francs: Vollard Archives, MS 421 (4,9) fols. 76, 80.
3. Vollard Archives, MS 421 (4,9), fol. 89, June 5, 1901. The paintings were R 189, R 210, R 322, R 469, R 511, R 625, and R 775.
4. Mary Cassatt to Louisine Havemeyer, July 16, 1913: transcript in Weitzenhoffer files, Department of European Paintings, Metropolitan Museum.
5. Vollard makes note in his account book that he has spent 150 francs for travel expenses to "find Cézannes" in Aix-en-Provence: Vollard Archives, MS 421 (4,3), fol. 142, September 1, 1899. It is possible that this painting was among the works found. Also, in late November 1899, Vollard exhibited forty paintings by Cézanne, many of which cannot be identified because the catalogue entries are so vague. This work may have been exhibited.
6. Stockbook A, no. 3753, "aqueduc avec au fond Ste. Victoire, à gauche massif de pins, au milieu pin parasol, 65 x 81, 250 [francs]."

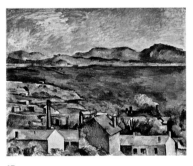

37.

37. *fig. 7*

PAUL CÉZANNE
The Bay of Marseilles, Seen from L'Estaque

Ca. 1885
Oil on canvas
31⅝ x 39⅝ in. (80.2 x 100.6 cm)
The Art Institute of Chicago, Mr. and Mrs. Martin A. Ryerson Collection 1933.1116

CATALOGUES RAISONNÉS: Venturi 1936, no. 493; Rewald 1996, no. 626

PROVENANCE: Aquired from the artist by Ambroise Vollard, Paris, ca. 1899; bought by Cornelis Hoogendijk, Amsterdam, possibly May 1899–his d. 1911; Hoogendijk heirs, 1911–20 (on deposit at the Rijksmuseum, Amsterdam); bought by Paul Rosenberg, Jos Hessel, and Durand-Ruel, Paris, in shares, 1920; sold through Jos Hessel to Martin A. Ryerson, Chicago, June 12, 1920; acquired as part of the Ryerson collection by The Art Institute of Chicago, 1933

Cornelis Hoogendijk's collection of more than thirty paintings by Cézanne was acquired at Vollard's in less than two and a half years beginning in August

1897; most of Hoogendijk's other modern masters were bought there in the same time period.[1] Vollard's records are rarely detailed, so it is often impossible to determine exactly what was sold and when. For example, he would register a sale to Hoogendijk as "un lot tableaux Van Gogh, Méry, Maurin, payé 2000 [francs]" or, more simply, "Hoogendijk espèces, 25000 francs."[2] There are more than twenty entries of sales to Hoogendijk in Vollard's account book between August 30, 1897, and the end of December 1899, and about a half dozen more in his sales book. Hoogendijk bought in quantity and Vollard took full advantage of his client's acquisitiveness; he sold, for example, a lot of fifty drawings and watercolors by Théophile-Alexandre Steinlen for 3,000 francs, for which he had paid the artist 800 francs only a month before.[3] Similar transactions with other collectors, such as Auguste Pellerin, can be found throughout Vollard's records, a practice that may account for their eventual preference to use other dealers as intermediaries.

This view of the bay of L'Estaque was probably sold to Hoogendijk in May 1899. On the seventeenth of that month, Hoogendijk bought a group of paintings by various artists that included two maritime scenes by Cézanne for a total of 12,800 francs.[4] Of the eight landscapes in his collection, only three depict water—one of a lake, another of a village along a river, and this painting.[5] If Vollard's description is apt, then this canvas is one of the "marines" recorded, although only cursorily.

JSW

1. See Henkels 1993.
2. Vollard Archives, MS 421 (4,2), fol. 41, September 1, 1897, and MS 421 (4,3), fol. 82, September 1, 1897.
3. Vollard Archives, MS 421 (4,3), fols. 110, 112, September 26 and October 22, 1898.
4. Vollard Archives, MS 421 (4,3), fol. 131, May 17, 1899.
5. *Lac d'Annecy* (Courtauld Institute of Art Gallery, London; R 805); *Village au bord de l'eau* (Barnes Foundation, Merion, Pennsylvania; R 280).

38. *fig. 29*

PAUL CÉZANNE
Boy in a Red Waistcoat

1888–90
Oil on canvas
35¼ x 28½ in. (89.5 x 72.4 cm)
National Gallery of Art, Washington, D.C., Collection of Mr. and Mrs. Paul Mellon, in Honor of the 50th Anniversary of the National Gallery of Art 1995.47.5

CATALOGUES RAISONNÉS: Venturi 1936, no. 682; Rewald 1996, no. 659

PROVENANCE: Acquired from the artist by Ambroise Vollard, Paris, by November 1895; bought by Egisto Fabbri, Paris and Florence, January 11, 1896, for 600 francs; acquired from Fabbri by Vollard by exchange (Stockbook B. no. 4349), ca. 1904; repurchased by Fabbri, Florence, October 25, 1907; Paul Rosenberg, Paris; Wildenstein Galleries, Paris; Jakob Goldschmidt, Berlin and then New York, 1929–his d. 1955; his estate sale, Sotheby's, London, October 15, 1958, no. 6; bought by Mr. and Mrs. Paul Mellon, Upperville, Virginia, through Carstairs Gallery, New York; their gift to the National Gallery of Art, Washington, D.C., 1995

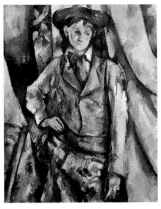

38

There were three versions of the boy in a red vest shown at Vollard's in 1895, described by a contemporary journalist as "a lanky youth, the type of an Italian artist's model, slumped in an armchair; elsewhere he leans against a drapery or, in yet another painting, relaxes his awkward body."[1] American expatriate artist and collector Egisto Fabbri (1866–1933) bought this version in January 1896 along with two other Cézannes—a landscape and a small scene of drinkers.[2] By 1899 he claimed to have assembled sixteen paintings by Cézanne and wrote to the artist to say that he valued their "artistocratic and austere beauty." He continued, "For me they represent what is most noble in modern art. And often when looking at them I have felt the urge to tell you in person what emotions they arouse in me."[3] There is no record indicating that Fabbri ever met Cézanne, but he eventually owned more than thirty canvases representing a broad range of the artist's work, both in subject matter and date.

About 1904 he exchanged this painting at Vollard's, valued at 3,000 francs plus 2,000 francs cash, for a large canvas of a seated man that once belonged to Odilon Redon (*Seated Man*, National Museum of Art, Architecture, and Design, Oslo).[4] It seems, however, that the collector had a change of heart, as he later returned to Vollard's to reclaim his painting in 1907. The dealer informed him that because the price of Cézanne's work had increased in value in the meantime, Fabbri would have to pay a premium to recover his painting.[5]

JSW

1. Natanson 1895a, p. 498.
2. Vollard Archives, MS 421 (4,2), fol. 27, January 11, 1896. Fabbri paid 600 francs for "Italien debout" and 600 for the other two paintings.
3. Egisto Fabbri to Cézanne, Paris, May 28, 1899, in Rewald 1976, p. 269.
4. Stockbook B, no. 4349, "Portrait de jeune homme italien debout (voir le no. 4157), 92 x 73, 3000 [francs]."
5. Vollard Archives, MS 421 (5,2), fol. 174, October 25, 1907. See also New York 1942, no. 18.

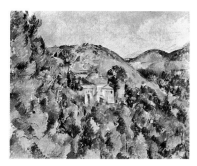

39

39. *fig. 27*

PAUL CÉZANNE
View of the Domaine Saint-Joseph

1888–90
Oil on canvas
25⅝ x 32 in. (65.1 x 81.3 cm)
The Metropolitan Museum of Art, New York, Catharine
Lorillard Wolfe Collection, Wolfe Fund, 1913 13.66

CATALOGUES RAISONNÉS: Venturi 1936, no. 660; Rewald
1996, no. 612

PROVENANCE: Possibly acquired from the artist by Ambroise
Vollard, Paris, ca. 1899 (perhaps Stockbook A, no. 3759) for
200 francs; Auguste Pellerin, Paris, by 1910; acquired from
Pellerin by exchange by Galerie Bernheim-Jeune, Paris,
December 24, 1910; bought by Ambroise Vollard, Paris,
December 30, 1910; bought by the Metropolitan Museum,
New York, March 1913

The significance of the Armory Show[1] to modern art
and its collectors in America is well known.
Although criticized in the press, the effect of the
exhibition was to overthrow the provincialism of
American academic art. Organized by artists Walt
Kuhn and Arthur B. Davies, as well as the writer
and critic Walter Pach, the Armory Show was the
American public's first real introduction to mod-
ernism and especially to the painting of Paul
Cézanne. Thirteen Cézannes were shown, of which
six were lent by Vollard.[2] One of the canvases, *View
of the Domaine Saint-Joseph,* was singled out by the
Metropolitan Museum's curator of paintings Bryson
Burroughs as worthy of acquisition. Burroughs was
intent on having the artist represented in the
Museum's collection and seemed to instinctively
know that any Cézanne more modern than this
work would not have been accepted by the
Museum's Board of Trustees.[3]

The Armory Show was an unqualified success in
terms of sales—almost 250 works were sold, most of
them what would be considered as "advanced" art.
The highest priced work in the exhibition turned
out to be *View of the Domaine Saint-Joseph,* at 6,700
dollars (the asking price was 8,000 dollars). The
painting was also the first Cézanne acquired by an
American museum.[4] Shortly after the Armory Show
closed in New York, Walter Pach wrote to Burroughs,
"*La Colline des Pauvres* was painted in 1887 [sic],
according to the statement of Paul Cézanne *fils,* M.
Vollard having consulted him especially on the sub-
ject for our benefit. It was from that excellent dealer
that we got it."[5]

The painting may have entered Vollard's stock
about 1899[6] and was sold to Auguste Pellerin, per-
haps in a trade. By December 1910 the canvas came

back to Vollard and was assigned a new number,
although no stockbook for this period is known.[7]

JSW

1. New York 1913. The exhibition traveled to Chicago and
 Boston, but *View of the Domaine Saint-Joseph* was not
 included at these venues. See especially Rewald 1989,
 pp. 179–209.
2. Besides the Cézannes, Vollard sent three Gauguin oils and
 a group of lithographs and books by various artists in three
 separate shipments: Vollard Archives, MS 421 (4,13),
 fols. 67–68, 71, 79–80.
3. "To the students of art who rely exclusively upon the
 Metropolitan Museum for their knowledge of contempo-
 rary French art, why the advent of so innocuous a land-
 scape should be considered momentous must be puzzling."
 McBride 1913.
4. Vollard included the work in his 1914 monograph on
 Cézanne, illustrating it with paintings he had sold to
 European museums.
5. Walter Pach to Bryson Burroughs, March 30, 1913:
 Archives, Metropolitan Museum. Vollard was not new to
 Burroughs, nor was *View of the Domaine Saint-Joseph* the
 first Cézanne discussed for the Museum. When in late
 1909–early 1910 the Museum was negotiating with Vollard
 for the purchase of Manet's *Enterrement,* the dealer offered
 the Metropolitan Cézanne's *The Fishermen—July Day*
 (private collection; R 237), a proposal that was declined:
 Archives, Metropolitan Museum.
6. Stockbook A, no. 3759, "paysage; au milieu d'une verdure
 deux maisons jaunes, 65 x 81, 200 [francs]."
7. See Vollard Archives, MS 421 (5,8), fol. 230. The new stock
 number was 5293.

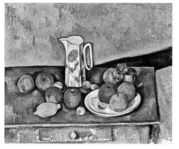

40

40. *fig. 25*

PAUL CÉZANNE
*Still Life: Milk Pitcher and Fruit
on a Table*

1890
Oil on canvas
23⅜ x 28½ in. (59.5 x 72.5 cm)
National Museum of Art, Architecture, and Design, Oslo
NG.M.00942

CATALOGUES RAISONNÉS: Venturi 1936, no. 593; Rewald
1996, no. 663

PROVENANCE: Acquired from the artist by Ambroise Vollard
(Stockbook A, no. 3518; Stockbook B, no. 4054), 1899, for 400
francs; bought by Paul Cassirer, Berlin (stock no. 613),
October 1904; bought by Alexandre Berthier, Prince de
Wagram, Paris, March 1906; consigned to Galerie Bernheim-
Jeune, Paris, April 17, 1907; bought by Josse and Gaston
Bernheim-Jeune for their personal collection, 1910; bought
back by Galerie Bernheim-Jeune, July 16, 1910; bought by the
National Museum of Art, Architecture, and Design, Oslo,
July 16, 1910

Vollard first acquired this still life in 1899, possibly as
a consignment from the artist. It was entered in the

dealer's first known stockbook[1] and reentered in
April 1904 in his second,[2] each time with a "purchase
price" of 400 francs. The painting was shipped to
Galerie Paul Cassirer in Berlin for a Cézanne exhi-
bition held there from April to June 1904. Cassirer
bought the painting outright in October of that
year.[3] Two years later, the German dealer sold or con-
signed the work to Alexandre Berthier, Prince de
Wagram (1883–1918), whose dealings with Vollard
were many, but strained because he was known for
long delays in paying his bills.[4] The Cassirer gallery,
on the other hand, was on good terms with Vollard
and was instrumental in contributing to the knowl-
edge of nineteenth- and twentieth-century French
art in Germany.

JSW

1. Stockbook A, no. 3518, "nature morte pommes, et d'apies,
 citron, bouquet de violettes, vase blanc à dessin de fleurs;
 fond gris, 60 x 73, 400 [francs]."
2. Stockbook B, no. 4054, "Nature morte, Fruits et pichets,
 60 x 73, 400 [francs]."
3. Vollard Archives, MS 421 (4,10), p. 30, October 31, 1904.
 Cassirer paid 3,500 francs for this painting and a still life
 sketch (Stockbook B, no. 3794) and 800 francs for Van
 Gogh's *Dr. Félix Rey* (cat. 125) (Stockbook B, no. 3728;
 F 500).
4. Cassirer's purchase-book entry dated November 2, 1904,
 indicates that he paid 3,500 deutsche marks for two paint-
 ings. He sold this one to Wagram with six Van Goghs and
 three Cézannes, the latter for a total of 8,140 deutsche
 marks, on March 20, 1906. Information courtesy of Walter
 Feilchenfeldt, Zürich.

41

41. *fig. 42*

PAUL CÉZANNE
Bathers

1890–92
Oil on canvas
21⅜ x 26 in. (54.3 x 66 cm)
St. Louis Art Museum, Funds given by Mrs. Mark C.
Steinberg 2:1956
New York and Chicago only

CATALOGUES RAISONNÉS: Venturi 1936, no. 581; Rewald
1996, no. 666

PROVENANCE: Ambroise Vollard, Paris; bought by Claude
Monet, Giverny, March 29, 1906, for 2,500 francs; by descent
to Michel Monet, Giverny, from 1926; acquired by Paul
Rosenberg Gallery, Paris, and Rosenberg & Helft, London;
bought by Mrs. Edith Chester Beatty, London, by 1936;
acquired by Paul Rosenberg & Co., New York, March 16, 1955;
bought by the St. Louis Art Museum, November 12, 1955

Cézanne's figures of nudes and bathers must have
had a fascinating appeal to his colleagues—Gustave
Caillebotte, Camille Pissarro, Auguste Renoir, Edgar
Degas, Claude Monet, and Paul Gauguin each

possessed at least one of these compositions. The younger generation of artists also seemed particularly attracted to Cézanne's nudes—Paul Signac, Henri Matisse, Maurice Denis, Pierre Bonnard, Pablo Picasso, and Henry Moore acquired works that would inspire their own. Bonnard even painted a Cézanne bather in the background of several of his portraits of Vollard (cats. 9, 11). Vollard hung the controversial *Bathers at Rest* from the Caillebotte Bequest in the window of his gallery during his Cézanne exhibition of 1895, an act that could have had a dual effect: the artists who saw the show may have been prompted to acquire works depicting bathers not only as a declaration of support for Cézanne but also as a protest against the French state's exclusion of the painting from the artist's 1894 bequest.

Monet owned two nude compositions by Cézanne: *The Negro Scipion* (cat. 25) and this composition of male bathers, both purchased from Vollard.[1] Michel Georges-Michel recalled seeing it hanging in Monet's bedroom along with some of his other favored Cézannes and works by his artist friends.[2] JSW

1. Vollard Archives, MS 421 (5,1), fol. 109, June 14, 1906.
2. Georges-Michel 1942, pp. 34–35.

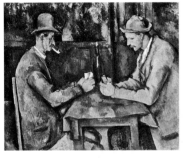

42

42. *fig. 45*

PAUL CÉZANNE
The Cardplayers

Ca. 1890–95
Oil on canvas
18¾ x 22⅜ in. (47.5 x 57 cm)
Musée d'Orsay, Paris RF1969

CATALOGUES RAISONNÉS: Venturi 1936, no. 558; Rewald 1996, no. 714

PROVENANCE: Acquired from the artist by Ambroise Vollard, Paris (Stockbook A, no. 3338), ca. 1899, for 125 francs; Baron Denys Cochin, Paris, Durand-Ruel, Paris; Count Isaac de Camondo, Paris, until his d. 1911; his bequest to the Musée du Louvre, Paris, 1911; Jeu de Paume, Paris, 1947; Musée d'Orsay, Paris, 1986

This work was first recorded in Vollard's stockbook about 1899[1] and probably purchased by Baron Denys Cochin (1851–1922) at the turn of the century, when he began collecting in earnest. In Vollard's opinion, "Cochin was the type of the genuine *amateur* who buys pictures with no thought of the profit to be made on them. In other words, he bought for pleasure. It was an expensive pleasure, for no sooner had

he bought a picture than another would tempt him, and then there would be an exchange, with adequate compensation—adequate, that is, for the dealer."[2] Such was the relationship between Vollard and Cochin, lucrative, albeit frustrating, for the former and speculative for the latter.[3]

Vollard gives an amusing account of a chance encounter between Cézanne and the baron in the outskirts of Paris, where the artist was at work. Cochin apparently invited Cézanne to his home, an invitation the artist declined, later telling Vollard that "I don't know how to act in society."[4]

Cochin eventually sold or traded *The Cardplayers* to Durand-Ruel, who in turn sold it to Count Isaac de Camondo (1851–1911). Camondo preferred to buy at auction (on the advice of Monet) or through the dealers Durand-Ruel and Bernheim-Jeune.[5] Camondo did, however, purchase five Cézanne watercolors directly from Vollard in early December 1895.[6] No doubt he saw them while attending the Cézanne exhibition the month before. Camondo bequeathed his collection, which included five Cézanne oils and four watercolors, to the French state in 1908; it was accepted at his death in 1911.

JSW

1. Stockbook A, no. 3338, "peinture à l'huile. Deux joueurs de cartes dont un fumeur. une table au milieu du tableau sur laquelle ils s'accoudent porte une petite bouteille noire, 46 x 55, 125 [francs]."
2. Vollard 1936, p. 108.
3. Cochin owned twenty-two Cézanne paintings, all but seven of which were acquired from or traded to Vollard. Because of the numerous exchanges between the two men, it is virtually impossible to pinpoint when the transactions were made and which works were involved.
4. Vollard 1937a, pp. 90–91.
5. Of the five Cézanne canvases that he bequeathed to the French state in 1911, only this work originated from Vollard.
6. Vollard Archives, MS 421 (4,2), fol. 25, December 4, 1895. Camondo paid 600 francs for the lot.

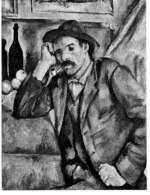

43

43. *fig. 255*

PAUL CÉZANNE
The Smoker

Ca. 1891
Oil on canvas
35¾ x 28⅜ in. (91 x 72 cm)
State Hermitage Museum, St. Petersburg 6561

CATALOGUES RAISONNÉS: Venturi 1936, no. 686; Rewald 1996, no. 757

PROVENANCE: Acquired from the artist by Ambroise Vollard, Paris, 1899 (Stockbook A, no. 3563), for 250 francs; bought by Ivan Morozov, Moscow, October 2, 1909, for 22,000 francs; Museum of Modern Western Painting, Moscow, from 1918; State Museum of Modern Western Art, Moscow, 1923; State Hermitage Museum, St. Petersburg, 1931

Ivan Morozov's first recorded purchase of a Cézanne painting from Vollard's gallery was in October 1907 for a still life (R 846) and a landscape (R 398), for which he paid 17,000 francs and 13,000 francs, respectively.[1] By 1913 the collector had acquired eighteen paintings by Cézanne, each one a masterpiece. *The Smoker* was purchased in October 1909 for 22,000 francs.[2] When asked which painter he loved the most, Morozov was said to have named Cézanne,[3] and, indeed, his collection of the artist's paintings was perhaps the most distinguished in the world during the first decades of the twentieth century.

Vollard lent twenty-four Cézanne canvases to the 1904 Salon d'Automne, including this work.[4] Morozov was in Paris at the time and must have seen the exhibition, although it would be several years before he acquired his first work by the artist. He did, however, buy a painting by Camille Pissarro in October of that year.[5] JSW

1. Vollard Archives, MS 421 (5,2), fol. 159, October 5, 1907.
2. Stockbook A, no. 3563, "un paysan est accoudé dans un coin de tableau un petite bouteille noir et q.q. fruits, 92 x 73, 250 [francs]." The datebook entry of October 2, 1909, lists this work and "un paysage Ste Victoire" (R 899) for 18,000 francs; Morozov returned a Gauguin valued at 10,000 francs in the same transaction: Vollard Archives, MS 421 (5,4), fol. 184. Three days later he bought Cézanne's *The Bather* (R 754) for 10,000 francs: MS 421 (5,4), fol. 186. In a letter to Morozov dated November 30, 1909, Vollard gives the titles for the paintings he has just sent: MS 421 (4,1), p. 146.
3. Fénéon 1970, p. 356, cited in Kostenevich 1993, p. 103.
4. Cézanne's son asked Vollard to send installation photographs of the Salon, and Vollard obliged. Paul Cézanne *fils* to Vollard, November 11, 1904, Vollard Archives, MS 421 (2,2), pp. 63–65.
5. Vollard Archives, MS 421 (4,10), p. 25, October 11, 1904. Stockbook B, no. 3361, "Terres labourées, 57 x 66, 400 f[rancs]: *Ploughed Fields*, J. Pissarro and Snollaerts 2005, no. 341.

44. *fig. 39*

PAUL CÉZANNE
The Basket of Apples

Ca. 1893
Oil on canvas
25⅝ x 31½ in. (65 x 80 cm)
The Art Institute of Chicago, Helen Birch Bartlett Memorial Collection 1926.252

CATALOGUES RAISONNÉS: Venturi 1936, no. 600; Rewald 1996, no. 800

PROVENANCE: Ambroise Vollard, Paris, by November 1895; Galerie Bernheim-Jeune, Paris, by July 1907; acquired by Paul Cassirer, Berlin, July 1907; acquired by Bernheim-Jeune, Paris, November 1908; Jos Hessel, Paris by 1913; Paul Rosenberg, Paris; French Galleries, New York; bought by Frederick Clay Bartlett, Chicago, (through Josef Stransky of Wildenstein Galleries, New York), by 1925; The Art Institute of Chicago, 1926

Unlike some of his colleagues, the critic Thadée Natanson wrote an effusive review of Vollard's exhibition of Cézanne's work in November 1895. He may

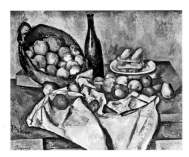

44

have been thinking of *The Basket of Apples,* which was included in the show, when he wrote, "Given the love with which [Cézanne] paints them and imbues them with all his gifts, he is and remains a painter of apples—apples that are smooth, round, fresh, ponderous, dazzling, of shifting color, not the ones you'd like to eat, the ones whose illusionism stops gourmands in their tracks, but rather of forms that ravish. . . . He has made apples his own."[1]

It is not clear from Vollard's records if this still life was simply consigned by the artist's son for the exhibition or if the dealer entered it into his stock. The painting was listed among the works exhibited in 1895 and reproduced in Vollard's 1914 monograph on the artist, where it was dated 1885.[2] It was eventually sold to Bernheim-Jeune, although the exact date of the transaction is not known.

JSW

1. Natanson 1895a, p. 500; translated in Paris–London–Philadelphia 1995–96, p. 34.
2. Vollard 1914, pl. 33.

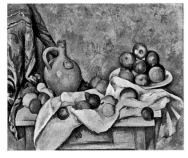

45

45. *fig. 38*

PAUL CÉZANNE
Curtain, Jug, and Dish of Fruit

1893–94
Oil on canvas
23¼ x 28½ in. (59 x 72.4 cm)
Private collection
New York and Chicago only

CATALOGUES RAISONNÉS: Venturi 1936, no 601; Rewald 1996, no 739

PROVENANCE: Acquired from the artist by Ambroise Vollard, Paris, ca. 1899; bought by Cornelis Hoogendijk, Amsterdam, ca. 1899–his d. 1911; Hoogendijk heirs, 1911–20 (on deposit at the Rijksmuseum, Amsterdam); bought by Paul Rosenberg, Jos Hessel, and Durand-Ruel, Paris, in shares, 1920; sold through Durand-Ruel to Albert C. Barnes, Merion,

Pennsylvania; Barnes Foundation, Merion, Pennsylvania; Carroll Carstairs Gallery, New York, in 1951; bought by Mr. and Mrs. John Hay Whitney, New York, by 1951–his d. 1982; his widow, 1982–her d. 1999; her sale, Sotheby's, New York, May 10, 1999, no. 23; bought by Stephen Wynn, Las Vegas; sold through Richard Gray Gallery, Chicago, to current owner, 2004

In the last decade of the nineteenth century, Dutch collector Cornelis Hoogendijk (1866–1911) amassed a collection of old master and modern art that was arguably the most important in Holland. His paintings and watercolors by Cézanne numbered more than thirty works, most of them still lifes and all acquired from Vollard in a veritable buying frenzy between August 1897 and July 1899.[1] None of these paintings are recorded in Vollard's stockbooks, although some canvases bear the dealer's handwritten guarantee on the verso. Hoogendijk's collecting abruptly stopped when he was institutionalized in early 1900: "We've got a fellow in the lunatic asylum at the Hague," quoted a fellow Dutchman to Vollard. "The experts were unanimous in declaring that . . . the Cézannes and the Van Goghs . . . could only have been bought by a madman. The mental specialists having confirmed the conclusions of the experts, the connoisseur was immediately shut up."[2]

Between 1911 and 1920, while a lawsuit against Hoogendijk's estate was pending, *Curtain, Jug, and Dish of Fruit* was exhibited at the Rijksmuseum.[3] This still life and two dozen other Cézannes were bought by a "foreign syndicate" consisting of the Parisian dealers Paul Rosenberg, Jos Hessel, and Durand-Ruel. Soon afterward this work was sold through the last to American collector Albert C. Barnes (1872–1951).[4]

Dr. Barnes, whose extraordinary collection of paintings by Cézanne would become the largest in the world, was familiar to Vollard. The dealer's records indicate that Barnes purchased three canvases by the artist in December 1912.[5] However, the collector preferred Durand-Ruel as his intermediary because "he felt that Vollard did not treat him as a financially responsible businessman should be treated."[6] He claimed that Vollard was untrustworthy, and he referred disparagingly to the dealer as "his Majesty, Vollard, the first." When he received *Curtain, Jug, and Dish of Fruit* from Durand-Ruel in the summer of 1920, Barnes apparently was dissatisfied with the entire shipment of thirteen Cézannes and even questioned their authenticity.[7] Durand-Ruel assured Barnes that all of the Cézannes in the Hoogendijk collection were unquestionable simply because they came from Vollard. Still, for reasons that have not yet come to light, Barnes later decided to sell this canvas and three others from the Hoogendijk group, as well as two paintings that he had acquired directly from Vollard.[8]

For all of his bravado and seeming antipathy toward Vollard, Barnes would eventually champion the dealer's reputation, first in his introduction to an exhibition of Vollard's collection in 1933—"[He should be held in] high esteem as an educator, a leader in moulding intelligent, well-informed public opinion"[9]—and again when he invited Vollard to come to America in October 1936—"The cultural world in America has rarely been excited to the extent that it is at this moment, all because the most important figure in the art history of the nineteenth and twentieth centuries has arrived in New York on his first [and only] visit to this country."[10] During

his stay, Vollard traveled to Merion, Pennsylvania, to see Barnes's pictures and remarked: "I am still under the spell of my visit to the Barnes Foundation, where I saw so many of the paintings which I knew, defended and loved and which I had not seen since the turn of the Century." [11] JSW

1. The dealer's account books list cash purchases during these years totaling in excess of 100,000 francs, which included paintings by Monet, Renoir, Caillebotte, Corot, and others. Vollard Archives, MS 421 (4,2) and (4,3).
2. See Vollard 1936, pp. 126–30.
3. See Henkels 1993, pp. 290–95.
4. Thirteen Cézannes were sent to Barnes. See Rewald 1989, pp. 268–73; Barnes paid 199,650 francs for the painting.
5. Barnes bought a portrait of Madame Cézanne (R 607) on December 9, 1912; the following day he visited the gallery and negotiated the purchase of a small still life and a Bathers composition (R 335 and R 359): Vollard Archives, MS 421 (5,8), fols. 224–26. See also Rewald 1989, p. 263.
6. Rewald 1989, p. 265.
7. Barnes saw the works for the first time upon their receipt in America; see ibid., pp. 270–72.
8. The three ex-Hoogendijk pictures are a landscape (R 597) and two still lifes (R 739 and R 742); the two acquired from Vollard are the portrait of Madame Cézanne that he had bought in 1912 (R 607) and a small figure piece (R 784).
9. New York 1933. As noted in the press, however, Barnes refused to lend his great *Bathers,* which he had bought from Vollard the previous summer.
10. Radio speeches by Barnes and Vollard, November 10, 1936, WINS Broadcasting Station, New York, quoted in Rewald 1989, p. 343; see also Greenfeld 1987, p. 186.
11. Ibid.

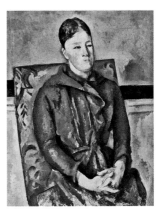

46

46. *fig. 44*

PAUL CÉZANNE
Madame Cézanne in a Yellow Armchair

1893/95
Oil on canvas
31⅞ x 25½ in. (80.9 x 64.9 cm)
The Art Institute of Chicago, Wilson L. Mead Fund
1948.54

CATALOGUE RAISONNÉS: Venturi 1936, no. 572; Rewald 1996, no. 653

PROVENANCE: Ambroise Vollard, Paris, possibly by 1904; acquired by Galerie Bernheim-Jeune, Paris, February 22, 1907; bought by Théodore Duret, Paris, April 16, 1907; bought by Bernheim-Jeune, Paris, ca. April 1908; bought by [?August] Deusser, Düsseldorf, October 15, 1909; Paul Rosenberg, Paris, by 1926; bought by Alphonse Kann, Saint-Germain-en-Laye, October 31, 1929; bought by Paul Rosenberg, New York, October 1947; bought by The Art Institute of Chicago, April 22, 1948

The early history of this portrait of Madame Cézanne is difficult to establish with any certainty. A photograph of the painting was shown at the Salon d'Automne of 1904, so it would have been known to Vollard by that date.[1] Gertrude Stein recalled a visit to the gallery in 1904 with her brother Leo to buy a Cézanne portrait: "In those days practically no big Cézanne portraits had been sold. Vollard owned almost all of them. . . . There were about eight to choose from and the decision was difficult."[2] It is possible that this work was in that group, although it is not clear if it was on consignment (it is not recorded in Vollard's second stockbook) or simply on the premises to be photographed. According to the records of the Galerie Bernheim-Jeune, Vollard sold the painting to them in February 1907, at about the time the two dealers were negotiating the joint purchase of works in Cézanne's estate with the artist's son. There are no portraits of Madame Cézanne listed in the inventory of paintings found in the artist's rue Boulegon domicile nor are there any among the paintings removed from the artist's studio at Les Lauves.[3] Vollard must have acquired the work before then, perhaps directly from the sitter.

The working relationship between Bernheim-Jeune and Vollard was somewhat fluid, especially in terms of Cézanne's pictures. By 1904 the two dealers had established joint ownership of a group of paintings, which moved back and forth between the two galleries,[4] and by March 1907 they had divided the paintings and watercolors in the artist's estate between them. JSW

1. By mid-1904 Vollard had photographed many of Cézanne's paintings with the intention of publishing an illustrated catalogue of the artist's works. Five albums of these photographs were sent to Cézanne in Aix-en-Provence in April 1905.
2. G. Stein 1933, p. 40. The Steins selected *Madame Cézanne with a Fan* (Stiftung Samlung E. G. Bührle, Zurich; R 606).
3. See Tiers 1985, pp. 176–78; Warman; 2003, pp. 169–73.
4. See Stockbook A, nos. 4161–4185, and correspondence dated March–July 1904 (John Rewald Papers, Gallery Archives, National Gallery of Art, Washington, D.C.).

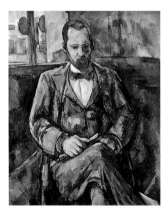

47

47. *fig. 4*

PAUL CÉZANNE
Ambroise Vollard

1899
Oil on canvas
39¾ x 31⅞ in. (101 x 81 cm)
Petit Palais, Musée des Beaux-Arts de la Ville de Paris
PPP 2100

CATALOGUES RAISONNÉS: Venturi 1936, no. 696; Rewald 1996, no. 811

PROVENANCE: Ambroise Vollard, Paris, 1899–his d. 1939; Vollard estate, 1939–45; his bequest to Musée des Beaux-Arts de la Ville de Paris (Petit Palais), 1945

Vollard commissioned Cézanne to paint his portrait in 1899 and described in colorful detail the countless sittings (115, he claimed) that he endured.[1] He was instructed by the artist to remain silent and to remain completely still, "like an apple." If Vollard is to be believed, he sat sometimes from eight in the morning until eleven-thirty at night. He observed that the artist worked very slowly and sometimes with great frustration. When asked about two white patches on Vollard's right hand that remained to be painted, Cézanne replied: "If I put something there at random, I should have to redo the entire picture, starting from that very spot." Cézanne stopped working on the portrait before departing from Aix-en-Provence in June 1899, but told the dealer: "I am not dissatisfied with the shirt front." He intended to restme work on the portrait, but never had the opportunity to do so.

Cézanne did not trust many people, but he said that he believed absolutely in Vollard's honesty: "I remain true to Vollard, and am only sorry that my son has now given them [the Bernheims and another dealer] the impression that I would ever give my pictures to anyone else."[2]

Vollard's records indicate that the painting was relined in October 1932, presumably in preparation for exhibition.[3] The portrait (then valued at 500,000 francs) was shown in New York at the Bignou Gallery in 1936.[4] The exhibition occasioned a visit to America by Vollard, who gave afternoon interviews at Bignou,[5] a lecture at the Barnes Foundation in Merion, Pennsylvania,[6] and a radio interview.[7] JSW

1. Vollard 1914, p. 92. In his monograph on Cézanne, Vollard devoted an entire chapter to describing, in colorful detail, the painting of this portrait.
2. Paul Cézanne to Charles Camoin, Aix, March 11, 1902, in Rewald 1976, p. 286. Cézanne's son handled the artist's financial arrangements with dealers.
3. Vollard Archives, MS 421 (3,4), fol. 20.
4. Vollard Archives, MS 421 (3,5), fol. 41.
5. "Paris Dealer Here" 1936, p. 9.
6. Jewell 1936, p. X9.
7. Interview on WINS Broadcasting Station, New York, on November 10, 1936. See Greenfeld 1987, p. 186; and Rewald 1989, p. 343.

48. *fig. 43*

PAUL CÉZANNE
Bathers

1902–6
Oil on canvas
29 x 36⅜ in. (73.5 x 92.5 cm)
Private collection
New York and Chicago only

CATALOGUES RAISONNÉS: Venturi 1936, no. 725; Rewald 1996, no. 877

PROVENANCE: Ambroise Vollard, Paris, by 1923–his d. 1939; acquired from his estate by M. and Mme Paul Cézanne *fils*, Paris, 1939; bought through Maurice Renou, Paris, by Marianne Feilchenfeldt, Zurich, ca. 1945; private collection

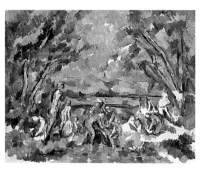

48

Exactly when Vollard acquired this painting is not known, as it does not appear in the dealer's second stockbook nor among the works purchased from the artist's estate. It was listed, however, in Georges Rivière's 1923 chronology of Cézanne's works as "Collection A. Vollard"[1] and was first shown in 1929 at the Galerie Pigalle, a loan exhibition organized by Vollard. Vollard and Cézanne's son maintained a fruitful and cordial relationship, as evidenced by the fact that after they met or dined together an exchange of paintings for cash usually resulted. Vollard even attended the marriage of Paul Cézanne *fils* to Renée Rivière on January 6, 1913.[2]

Vollard's will, drawn up in 1911, directed his executors to sell his paintings at auction little by little. In an interesting role reversal, the dealer also stipulated that Cézanne *fils*, who was his father's business manager and Vollard's erstwhile supplier, be allowed to choose any work by the artist valued at 30,000 francs. He chose this canvas. JSW

1. Rivière 1923, p. 223.
2. Vollard Archives, MS 421 (5,9), fol. 6, January 10, 1913.

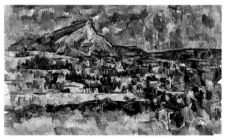

49

49. *fig. 9*

PAUL CÉZANNE
Mont Sainte-Victoire

Ca. 1902–6
Oil on canvas
22½ x 38¼ in. (57.2 x 97.2 cm)
The Metropolitan Museum of Art, New York, The Walter H. and Leonore Annenberg Collection, Gift of Walter H. and Leonore Annenberg, 1994, Bequest of Walter H. Annenberg, 2002 1994.420
New York only

CATALOGUES RAISONNÉS: Venturi 1936, no. 804; Rewald 1996, no. 915

PROVENANCE: Estate of Paul Cézanne, 1906; bought by Ambroise Vollard, Paris (Stockbook B, no. 4478), in shares with Galerie Bernheim-Jeune, Paris, 1907; Charles Montag, Lucerne; private collection, Switzerland; Ambroise Vollard, Paris, by 1935; bought by Wildenstein Galleries, Paris and

New York, 1935; bought by Walter H. and Leonore Annenberg, Rancho Mirage, California, May 8, 1964; owned jointly with the Metropolitan Museum, 1994–his d. 2002; his bequest to the Metropolitan Museum, New York

The unusual format of this painting makes possible its identification as one of ten views of Mont Sainte-Victoire dispersed from Cézanne's studio in Aix-en-Provence shortly after the artist's death in October 1906. These landscapes, plus nineteen other canvases and 187 watercolors, were purchased jointly by Vollard and Galerie Bernheim-Jeune in two lots, one in February and the other a month later,[1] and recorded in Vollard's second stockbook. Payments were made to the artist's son, who was Cézanne's sole heir.[2] According to the stockbook entry, this work was valued at 12,000 francs, although only 5,000 was paid to the estate.[3]

Many of the paintings were late, unfinished works and still show evidence of having been rolled. Vollard even referred to the twelve landscapes in the second lot as "études peintures à l'huile."[4] It seems inaccurate, however, to describe this very complete painting as an "étude." JSW

1. The two dealers paid an aggregate total of 213,000 francs for the paintings and an additional 62,000 francs for the watercolors. See Warman 2003, pp. 169–73.
2. Vollard received 82,500 francs from Bernheim-Jeune on February 13 and made two payments the same day to Cézanne *fils* (81,000 francs and 50,000 francs); he received a further 55,000 francs from Bernheim-Jeune in mid-March and paid the artist's son 16,000 francs. By the end of 1907, Cézanne *fils* had received a total of 191,000 francs from Vollard: Vollard Archives, MS 421 (5,2), fols. 24, 42, 43.
3. Stockbook B, no. 4478, "paysage, Panorama de Ste Victoire, 55 x 95."
4. Vollard to Bernheim-Jeune, March 11, 1907: John Rewald Papers, Gallery Archives, National Gallery of Art, Washington, D.C.

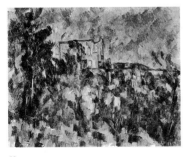

50

50. *fig. 46*

PAUL CÉZANNE
Château Noir

1905
Oil on canvas
28¾ x 36¼ in. (73 x 92 cm)
Musée Picasso, Paris RF 1973-60

CATALOGUES RAISONNÉS: Venturi 1936, no. 795; Rewald 1996, no. 941

PROVENANCE: Estate of Paul Cézanne, from 1906; bought in shares by Ambroise Vollard (Stockbook B, no. 4464) and Galerie Bernheim-Jeune, Paris, 1907; Ambroise Vollard, Paris, by 1935; bought by Pablo Picasso, Paris, then Mougins, probably by 1934–his d. 1973; Donation Picasso, 1973–78 (on view at the Louvre, 1978–85); Musée Picasso, Paris

Pablo Picasso once declared to the photographer Brassaï: "[Cézanne] was my one and only master! Don't you think I looked at his pictures? I spent years studying them."[1] The younger artist eventually bought three Cézanne paintings and one watercolor for himself. Two of those works came from Vollard and were purchased in the 1930s,[2] although there is no record of the date this canvas was acquired.

André Malraux referred to this work while speaking about a Japanese scroll of the twelfth to thirteenth century: "In the Occident, mat painting means frescoes. But frescoes remain in the shade. I have found the substance of this scroll only in the Château Noir of Picasso's collection. Vollard, faithful to Cézanne, had not varnished it."[3]

The subject of the Château Noir must have had a special appeal for artists because Monet had selected a similar painting (Museum of Modern Art, New York; R 940), purchased from Vollard in 1906, for his own collection. Picasso's version was among the paintings that were found in Cézanne's studio at the time of his death and bought jointly by Vollard and Bernheim-Jeune; it was entered in Vollard's second stockbook.[4] JSW

1. Brassaï 1964, p. 99.
2. Picasso paid Vollard 80,000 francs for the watercolor *Cathédrale d'Aix* (Rewald 1983, no. 580) and 30,000 francs for Renoir's "en coiffure" on February 19, 1934, and an unknown amount for *Château Noir*.
3. Malraux 1974, p. 191.
4. Stockbook B, no. 4464, "Château noir, 73 x 92." Two figures are listed: 6,000 francs, the amount paid to Paul Cézanne *fils*, and 11,000 francs, the agreed-upon value of the work. See cat. 28.

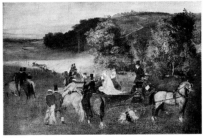

51

51. *fig. 247*

EDGAR DEGAS
On the Racecourse

1861–62
Oil on canvas
16⅞ x 25¾ in. (43 x 65.5 cm)
Kunstmuseum Basel, Gift of Martha and Robert von Hirsch G1977.36
Paris only

CATALOGUE RAISONNÉ: Lemoisne 1946–49, no. 77

PROVENANCE: Acquired from the artist by Ambroise Vollard, Paris, May 8, 1911; bought by Wilhelm Holzmann, Berlin, June 9, 1911; Robert von Hirsch, Frankfurt, then Basel, until his d. 1977; bequest to the Kunstmuseum Basel, 1977

Vollard's records are unusually complete with respect to this painting. Vollard acquired it on May 8, 1911, for 20,000 francs,[1] paying the artist by check three days later.[2] Vollard handled early works by Degas infrequently, but he must have sought one

out in order to gain an edge on the well-stocked Durand-Ruel, at a time of growing interest in the artist's work among European museums. He owned it just long enough to have it photographed.[3] One month later, on June 9, it was sold to Berlin collector Wilhelm Holzmann for 70,000 francs, a mark-up of 250 percent. Payment was received on June 15,[4] Vollard writing to the bank acknowledging receipt of payment on June 19[5] and to Holzmann himself on June 21:

> As Mr. Degas told you personally that I got this painting directly from him, I beg of you to tell your friends if they ask that you got it directly from him, without it having passed through my hands, because I have promised numerous German collectors to allow them to see it first, without having shown it to them, since it was on reserve for the museum of Frankfurt [Städelsches Kunstinstitut]. Since I believe you offered to Mr. Degas to send him a photograph of the painting by Ingres in your own collection [unidentified], I call your attention to his address, which is Victor Massé 37.[6]

In March 1912, Vollard sent the Städel another work on approval, presumably the pastel of the *Three Dancers* (not identified), asking the same price that Holzmann had paid for the oil; it was evidently turned down, and the museum eventually acquired *Orchestra Musicians* (L 295), an oil of the 1870s, in January 1913, for 125,000 francs.[7]

AEM

1. Vollard Archives, MS 421 (5,7), fol. 56.
2. Vollard Archives, MS 421 (5,7), fol. 58.
3. It was reproduced as plate 90 in the 1914 "Album Vollard."
4. Vollard Archives, MS 421 (5,6), fol. 37.
5. Vollard Archives, MS 421 (4,1), p. 207.
6. Vollard Archives, MS 421 (4,1), p. 208.
7. For the shipment of the *Three Dancers* to the Städelsches Kunstinstitut on approval, see Vollard's datebook entry for March 6, 1912 (Vollard Archives, MS 421 [5,8], fol. 46), where it is referred to as stock no. 5029. That the work was not purchased by the museum is confirmed by the fact that it was later consigned to Paul Cassirer for the exhibition "Degas / Cézanne" (Berlin 1913, no. 4). For the Städelsches Kunstinstitut's acquisition of *Orchestra Musicians*, see Henri Loyrette in Paris–Ottawa–New York 1988–89, no. 98.

52. *fig. 175*

EDGAR DEGAS
The Bath

Ca. 1895
Oil on canvas
32 x 46¼ in. (81.3 x 117.5 cm)
Carnegie Museum of Art, Pittsburgh, Acquired through the generosity of Mrs. Alan M. Scaife, 1962 62.37.1

CATALOGUE RAISONNÉ: Lemoisne 1946–49, no. 1029

PROVENANCE: Degas Atelier Sale I, Galerie Georges Petit, Paris, May 6–8, 1918, no. 39, for 10,100 francs; bought by Ambroise Vollard, Paris, possibly in shares with Durand Ruel; ?Durand-Ruel, Paris, 1918 (stock no. 11296); possibly purchased May 6, 1940, by Sam Salz, Inc., New York (stock no. 11301); Carnegie Museum of Art, Pittsburgh, 1962

Although their dates cannot be precisely determined, this work and *Dancers at the Barre* (cat. 55; see

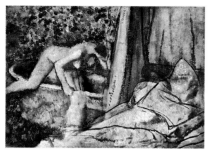

52

extended discussion at that entry) bookend Degas's last phase of painting in oil. *The Bath* is one of a number of pictures of the mid-1890s in which the subject dematerializes in favor of radically bold color and facture.[1] Toward the turn of the century, Degas would increasingly take up pastel and other graphic media at the expense of oil painting.

AEM

1. See Jean Sutherland Boggs in Paris–Ottawa–New York 1988–89, no. 337, and related works, nos. 338–42.

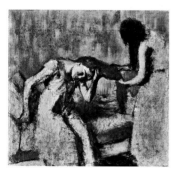

53

53. *fig. 176*

EDGAR DEGAS
The Coiffure

1892–95
Oil on canvas
32¼ x 34¼ in. (82 x 87 cm)
The National Museum of Art, Architecture, and Design, Oslo NG.M. 01292

CATALOGUE RAISONNÉ: Lemoisne 1946–49, no. 1127

PROVENANCE: Degas Atelier Sale I, Galerie Georges Petit, Paris, May 6–8, 1918, no. 99, for 19,000 francs; bought by Jos Hessel, Paris, 1918; probably Ambroise Vollard, Paris, by 1919; bought by the Nasjonalgalleriets Venner as a gift to the National Museum of Art, Architecture, and Design, Oslo, 1919, for 32,000 francs

Vollard tried to place works by Degas with museums outside France when he could (a notable failed attempt being the racecourse scene now in Basel, cat. 51). In 1914 he sent a number of works by Cézanne, Renoir, Gauguin, and Degas to an exhibition of nineteenth-century French art organized by the Royal Museum in Copenhagen, which then traveled to Oslo and Stockholm.[1]

Vollard later resumed his efforts to sell to foreign museums and collectors who were unable to bid at the first Degas sales, which took place while Paris was being shelled in 1918. Although the highest bid-

der for *The Coiffure* was the dealer Jos Hessel, it is likely that he acquired it in shares with Vollard, or else traded it in the months following the sales. It appears to have been Vollard who made the sale to the Nasjonalgalleriets Venner, a group founded in 1917 and dedicated to acquiring major works for the Oslo museum by pooling its members' resources. At 32,000 francs, however, *The Coiffure* was still too expensive until Walther Halvorsen pledged 10,000 francs to secure it.[2] Among Degas's most impressive late oils, this work belongs to a series focusing on the intimate theme of women combing their hair that Degas explored in all media from the mid-1880s until the early twentieth century.

AEM

1. Copenhagen 1914.
2. Willoch 1967, p. 100. Another member of the Venner was Tryggve Sagen, an Oslo collector who purchased *Woman with a Dog* (L 390) from Vollard for 20,000 francs out of the 1914 exhibition (see note 1 above), presenting it to the Nasjonalgalleriets in 1916: Vollard Archives, MS 421 (4,13), fol. 95. On this exhibition and the painting *Woman with a Dog,* see Marit Lange in Atlanta–Seattle–Denver 1999, pp. 130–31, no. 14, 241, and also p. 95.

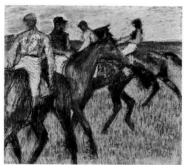

54

54. *fig. 172*

EDGAR DEGAS
Racehorses

Ca. 1895–99
Pastel on tracing paper, with strip added at bottom
22 x 25½ in. (55.8 x 64.8 cm)
National Gallery of Canada, Ottawa, Purchased 1950
5771

CATALOGUE RAISONNÉ: Lemoisne 1946–49, no. 756

PROVENANCE: Acquired from the artist by Ambroise Vollard, Paris, possibly January 29, 1911; Vollard estate, 1939 (held at the National Gallery of Canada, Ottawa, 1940–49; bought by the National Gallery of Canada, Ottawa, 1950

This pastel is among Degas's last racecourse scenes.[1] It almost certainly corresponds to the entry for a "pastel de chevaux de courses 10,000 [francs]," which Vollard purchased from Degas on January 29, 1911, and it was reproduced as plate 8 in the 1914 "Album Vollard."[2] Vollard probably lent this major late work to an exhibition that concluded only three weeks before his fatal auto accident on July 21, 1939.[3] After his brother's death, Lucien Vollard sold or consigned much of his considerable inheritance to the Paris dealer Martin Fabiani. The prospect of war led Fabiani to enter into an agreement with New York and London dealers to sell the works abroad. The 635-piece shipment, which included this pastel, was

seized by the British Admiralty in 1940 and held in the care of the National Gallery of Canada, where it remained sequestered until the belated settlement of both the Vollard estate and an accounting of Fabiani's especially lucrative dealings during the German occupation of Paris.[4]

AEM

1. See Jean Sutherland Boggs in Paris–Ottawa–New York 1988–89, no. 353.
2. Vollard Archives, MS 421 (5,7), fol. 15. This is the only entry in the Vollard archives for a pastel of this subject not sold to another collector.
3. See Paris 1939, no. 40.
4. See Nicholas 1994, pp. 92–93, 415, 425–26, 450, nn. 26–28.

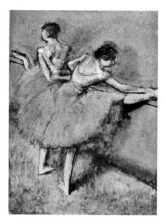

55

55. *fig. 166*

EDGAR DEGAS
Dancers at the Barre

Ca. 1900–1905
Oil on canvas
51 x 38 in. (129.5 x 96.5 cm)
Phillips Collection, Washington, D.C., acquired 1944
0479
New York only

CATALOGUE RAISONNÉ: Lemoisne 1946–49, no. 807

PROVENANCE: Degas Atelier Sale I, Galerie Georges Petit, Paris, May 6–8, 1918, no. 93, for 15,200 francs; bought by Ambroise Vollard, Paris, 1918; possibly Durand-Ruel, Paris; Jacques Seligmann, Paris; his sale, American Art Association, New York, January 27, 1921, no. 65; Mrs. W. Averell Harriman, New York, until 1944; Phillips Collection, Washington, D.C., 1944

Of *Dancers at the Barre,* painted when the artist was about sixty-five, Jean Sutherland Boggs wrote, "a strong, mad painting in which the dancers, in Mallarmé's terms, are not women and do not dance."[2] It is the culmination of Degas's lengthy explorations of these figures in charcoal and pastel, and one of his last oil paintings.

This final phase of the artist's work in oil—whose beginnings are represented here by *The Bath* (cat. 52)—happens to have coincided with Degas's discovery of Vollard. Degas occasionally brought in works to tempt the eager and clever young dealer in the 1890s, when Vollard's stock featured reciprocal temptations by the aging artist's peers. After several years during which no direct contact between artist and dealer are documented, Degas, still undiminished, reentered Vollard's life as a source of pictures in 1908, content to find a ready outlet for the sale of

recent works (which Durand-Ruel was less inclined to take). But as the "Album Vollard," the 1914 compendium of recent and current work by Degas, and the posthumous sale catalogues, make clear, Degas had not parted with key late works such as these.

One can only speculate what the tiny constellation of dealers with whom Degas dealt during his lifetime would have made of these works if the painter had offered to sell them. But at his estate sales they became the objects of complicated arrangements between Vollard, Durand-Ruel, and Bernheim-Jeune—the dealers who catalogued the atelier—all of whom were active bidders at the sales for which they also served as experts. Lots were purchased in shares or else by one dealer on behalf of another, the details often remaining unknown down to the present. AEM

1. Jean Sutherland Boggs in Paris–Ottawa–New York 1988–89, no. 375.

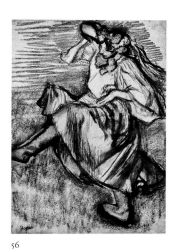

56

56. *fig. 171*

EDGAR DEGAS
Russian Dancer

1899
Pastel over charcoal on tracing paper
24⅜ x 18 in. (61.9 x 45.7 cm)
The Metropolitan Museum of Art, New York,
H. O. Havemeyer Collection, Bequest of
Mrs. H. O. Havemeyer, 1929 29.100.556

CATALOGUE RAISONNÉ: Lemoisne 1946–49, no. 1184

PROVENANCE: Ambroise Vollard, Paris, until 1906; bought by Mr. and Mrs. H. O. Havemeyer, New York, May or June 1906; Mrs. H. O. Havemeyer, née Louisine Waldron Elder, 1907–her d. 1929; her bequest to the Metropolitan Museum, New York, 1929

On May 4, 1906, Vollard noted: "Recu de Havemeyer 28000 fr[anc]s pour—Nature morte bleue de Cezanne 15000 / 2 pastels de Degas 9000 / 4 dessin de Guys 1200 / 3 ?esquisses de Manet 3000 / 28000 [total]."[1] One month later, on June 2, 1906, Mary Cassatt wrote to the Havemeyers, stating that Vollard was reserving drawings by Degas for them, including the present work and another, probably *Dancer with a Fan* (1890–95, Metropolitan Museum, 29.100.557). The former drawing was of interest to a member of the buying committee for the Lyon

museum, but Vollard, Cassatt wrote, felt that the Havemeyers should have "first call."[2]

The Havemeyer pastel may have been the first of at least eight known works on the theme of Russian dancers that Vollard owned at one point or another. Although we do not know when or from whom he acquired the sheet, it appears to have been one of perhaps five that passed through his hands during Degas's lifetime.[3] The figure has been excerpted from a fully developed pastel in a private collection (ex-Lemoisne; Degas Atelier Sale III, April 7–9, 1919, no. 286), but this work was almost certainly made by Degas as an independent colored drawing designed for ready sale.[4] AEM

1. Vollard Archives, MS 421 (5,1), fol. 83. The Cézanne is probably identical with New York 1993, no. 76 (private collection), while the Guys drawings can be identified with New York 1993, nos. 306, 315, 317, 318.
2. See New York 1993, p. 242.
3. This figure is based on the number of Russian dancers illustrated in the 1914 "Album Vollard," where the Metropolitan's pastel is reproduced as plate 87.
4. The history and dating of the Russian Dancer series are recounted by Jean Sutherland Boggs in Paris–Ottawa–New York 1988–89, pp. 581–85, nos. 367–71 (see esp. p. 581 and the entry for the present work, no. 369). While Boggs considered the Havemeyer pastel a study for the fully developed pastel in a private collection cited here, Richard Kendall has described it as one among other "self-contained works of art to be signed, sold, and exhibited alongside his grandest creations"; see London–Chicago 1996–97, p. 187.

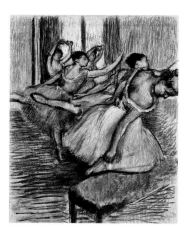

57

57. *fig. 173*

EDGAR DEGAS
Dancers

Ca. 1900
Pastel and charcoal on paper
28 x 23¼ in. (71.1 x 59.1 cm)
The Metropolitan Museum of Art, New York, Gift of George N. and Helen M. Richard, 1964 64.165.1
New York only

CATALOGUE RAISONNÉ: Lemoisne 1946–49, no. 589

PROVENANCE: Ambroise Vollard, Paris, by 1914; Matignon Art Gallery (a.k.a. Galerie André Weil), Paris, ca. 1942; acquired by Durand-Ruel, New York, March 8, 1943; bought by Mr. and Mrs. George N. Richard, New York, October 17, 1949, for $11,500; their gift to the Metropolitan Museum, New York, 1964

This large pastel seems to be a reprise of a composition explored in a group of works that extend from the late 1870s through the early twentieth century.[1] It has not been possible to identify it in Vollard's records, but its photograph appears in the 1914 "Album Vollard" (plate 17). This indicates that it was most likely acquired from Degas himself in the years prior to his final move in 1912.

Rumors have persisted since Vollard's time that the dealer altered works in his possession to render them more salable. There is no question that this pastel has changed since Degas himself endorsed the photographic plate from which the reproduction in the Vollard album was made. This is most obvious in the formerly blank area of the paper along its right edge, immediately beneath the profile of the rightmost dancer. The discrepancy raises more questions than can be answered. While it is possible that the artist added a few final touches to the sheet after it was photographed, it is even more likely that the pastel was altered after Vollard's death. For now, the evidence is inconclusive. AEM

1. It is closely related to two oils, one formerly in the Robert Treat Paine collection, Boston (L 587), the other in the National Gallery, London (L 588), and to a less finished pastel (L 590), acquired by Vollard at the second Degas atelier sale (Degas Atelier Sale II 1918, no. 153).

58. *fig. 170*

EDGAR DEGAS
The Name Day of the Madam

1878–79
Pastel over monotype
Image 10½ x 11⅝ in. (26.6 x 29.6 cm)
Musée Picasso, Paris RF 35791
Paris only

CATALOGUES RAISONNÉS: Lemoisne 1946–49, no. 549; Janis 1968, no. 89

PROVENANCE: Degas atelier print sale, Galerie Manzi-Joyant, Paris, November 22–23, 1918, no. 212, for 7,000 francs; bought by Gustave Pellet, Paris, until his d. 1919; by descent to his son-in-law, Maurice Exsteens, Paris, 1919 (consigned to Paul Brame and César M. de Hauke, Paris, 1958); bought through the Lefevre Gallery, London, by Pablo Picasso, not before August 1958–his d. 1973; Donation Picasso, 1973–78; Musée Picasso, Paris, 1978

59. *fig. 168*

EDGAR DEGAS
Three Seated Girls Seen from Behind

Ca. 1878–80
Pastel over monotype
Image 4¾ x 6¼ in. (12.1 x 15.9 cm)
Musée Picasso, Paris RF 35790
Paris only

CATALOGUES RAISONNÉS: Lemoisne 1946–49, no. 548; Janis 1968, no. 63

PROVENANCE: Maurice Exsteens, Paris (consigned to Paul Brame and César M. de Hauke, Paris, 1958); bought through the Lefevre Gallery, London, by Pablo Picasso, August 1958–his d. 1973; Donation Picasso, 1973–78; Musée Picasso, Paris, 1978

60. *fig. 168*

Edgar Degas
Waiting

Ca. 1878–80
Monotype in black ink
Image 4¾ x 6½ in. (12.1 x 16.4 cm)
Musée Picasso, Paris RF 35783
New York only

Catalogue raisonné: Janis 1968, no. 91

Provenance: Degas atelier print sale, Galerie Manzi-Joyant, Paris, November 22–23, 1918, no. unknown; traditionally thought to have been bought by Gustave Pellet, Paris, until his d. 1919; by descent to his son-in-law, Maurice Exsteens, Paris, 1919 (consigned to Paul Brame and César M. de Hauke, Paris, 1958); bought through the Lefevre Gallery, London, by Pablo Picasso, August 1958–until his d. 1973; Donation Picasso, 1973–78; Musée Picasso, Paris, 1978

61. *fig. 168*

Edgar Degas
Waiting

Ca. 1878–80
Monotype in black ink
Image 4¾ x 6½ in. (12.1 x 16.4 cm)
Musée Picasso, Paris RF 35784
New York only

Catalogue raisonné: Janis 1968, no. 67

Provenance: Degas atelier print sale, Galerie Manzi-Joyant, Paris, November 22–23, 1918, one of sixteen monotypes in no. 221, for 8,850 francs; bought by Gustave Pellet, Paris, until his d. 1919; by descent to his son-in-law, Maurice Exsteens, Paris, 1919 (consigned to Paul Brame and César M. de Hauke, Paris, 1958); bought through the Lefevre Gallery, London, by Pablo Picasso, August 1958–his d. 1973; Donation Picasso, 1973–78; Musée Picasso, Paris, 1978

62. *fig. 168*

Edgar Degas
Waiting (second version)

Ca. 1878–80
Monotype in black ink
Image 6½ x 4¾ in. (16.4 x 12.1 cm)
Musée Picasso, Paris RF 35786
Chicago only

Catalogue raisonné: Janis 1968, no. 65

Provenance: Degas atelier print sale, Galerie Manzi-Joyant, Paris, November 22–23, 1918, one of sixteen monotypes in no. 221, for 8,850 francs; bought by Gustave Pellet, Paris, until his d. 1919; by descent to his son-in-law, Maurice Exsteens, Paris, 1919 (consigned to Paul Brame and César M. de Hauke, Paris, 1958); bought through the Lefevre Gallery, London, by Pablo Picasso, August 1958–his d. 1973; Donation Picasso, 1973–78; Musée Picasso, Paris, 1978

63. *fig. 168*

Edgar Degas
In a Brothel Salon

Ca. 1878–80
Monotype in black ink
Image 6¼ x 8½ in. (15.9 x 21.6 cm)
Musée Picasso, Paris RF 35785
New York only

Catalogue raisonné: Janis 1968, no. 82

Provenance: Degas atelier print sale, Galerie Manzi-Joyant, Paris, November 22–23, 1918, no. 222 (as *Salon de maison close*), for 300 francs; bought by Ambroise Vollard, Paris; bought by Maurice Exsteens, Paris, by 1939 (consigned to Paul Brame and César M. de Hauke, Paris, 1958); purchased through the Lefevre Gallery, London, by Pablo Picasso, August 1958– his d. 1973; Donation Picasso, 1973–78; Musée Picasso, Paris, 1978

64. *fig. 168*

Edgar Degas
Resting

Ca. 1878–80
Monotype in black ink
Image 6¼ x 8¼ in. (15.9 x 21 cm)
Musée Picasso, Paris RF 35787
Chicago only

Catalogue raisonné: Janis 1968, no. 83

Provenance: Degas atelier print sale, Galerie Manzi-Joyant, Paris, November 22–23, 1918, one of sixteen monotypes in no. 221, for 8,850 francs; bought by Gustave Pellet, Paris, until his d. 1919; by descent to his son-in-law, Maurice Exsteens, Paris, 1919 (consigned to Paul Brame and César M. de Hauke, Paris, 1958); bought through the Lefevre Gallery, London, by Pablo Picasso, August 1958–his d. 1973; Donation Picasso, 1973–78; Musée Picasso, Paris, 1978

65. *fig. 168*

Edgar Degas
The Client

Ca. 1878–80
Monotype in black ink
Image 6½ x 4¾ in. (16.4 x 12.1 cm)
Musée Picasso, Paris RF 35788
Chicago only

Catalogue raisonné: Janis 1968, no. 85

Provenance: Degas atelier print sale, Galerie Manzi-Joyant, Paris, November 22–23, 1918, one of sixteen monotypes in no. 221, for 8,850 francs; bought by Gustave Pellet, Paris, until his d. 1919; by descent to his son-in-law, Maurice Exsteens, Paris, 1919 (consigned to Paul Brame and César M. de Hauke, Paris, 1958); bought through the Lefevre Gallery, London, by Pablo Picasso, August 1958–his d. 1973; Donation Picasso, 1973–78; Musée Picasso, Paris, 1978

66. *fig. 168*

Edgar Degas
On the Bed

Ca. 1878–80
Monotype in black ink
Image 8½ x 6¼ in. (21.6 x 15.9 cm)
Musée Picasso, Paris RF 3592
Paris only

Catalogue raisonné: Janis 1968, no. 109

Provenance: Degas atelier print sale, Galerie Manzi-Joyant, Paris, November 22–23, 1918; bought by Gustave Pellet, Paris, until his d. 1919; by descent to his son-in-law, Maurice Exsteens, Paris, 1919 (consigned to Paul Brame and César M. de Hauke, Paris, 1958); bought through the Lefevre Gallery, London, by John Richardson, April or May 1958; gift to Pablo Picasso, 1958–his d. 1973; Picasso heir, 1973–79; Donation Picasso, 1979; Musée Picasso, Paris, 1979

Vollard acquired monotypes depicting brothel scenes directly from Degas at least as early as July 1895, and although they were not exhibited during the artist's lifetime, they were hardly unknown to collectors. The full extent of Degas's production in this medium, however, was finally revealed by the posthumous sale of his prints in November 1918. Vollard acquired a number of *scènes de maisons closes* at this sale. There was stiff competition for these works from dealers and collectors alike. Notable among them was the publisher Gustave Pellet, one of the most active bidders throughout the sale. Vollard bought lot 220, fourteen brothel scene monotypes, for 8,100 francs, while the very next lot, 221, consisting of sixteen such scenes, went to Pellet for 8,580 francs. Thus it is most likely that the impressions Vollard borrowed from Maurice Exsteens (who inherited them from Pellet) in about 1928 for replication in his prospective editions of Guy de Maupassant's *La Maison Tellier* (1934; see cat. 67) and Pierre Louÿs's *Mimes des courtisanes de Lucien* (1935) all constituted a portion of lot 221. But it remains possible that works reproduced in these books came from lot 220 and that Vollard sold them to Pellet (or, later, to Exsteens), then borrowed them back for this purpose.

Whatever the case, the publications demonstrate Vollard's first success at presenting works by Degas in the context of a deluxe edition.[1] For twenty years Vollard had dealt with Degas directly, while promoting *belles épreuves* (sculpture was a separate but related endeavor) by just about every other artist in his orbit.[2] One measure of the importance that Vollard placed on his Degas publications of the 1930s was his proposal to hold a Degas exhibition in November 1935 accompanied by yet another publication, a catalogue, for which he invited Maurice Denis to write the preface.[3] The effort Vollard lavished on these books can also be attributed to his disappointment with the etchings he had printed from Degas's canceled plates in 1919–20.[4]

It is not only their early provenance that makes these monotypes relevant to the present exhibition. In addition, Picasso, who acquired them in 1958, may have seen similar ones in Vollard's possession by early winter 1906–7, when he began working on *Les Desmoiselles d'Avignon*.[5] Presumably Picasso previewed the Degas studio sales in 1918, and he must have known Vollard's publications of the 1930s. In the 1960s Picasso referred to the monotypes constantly in his

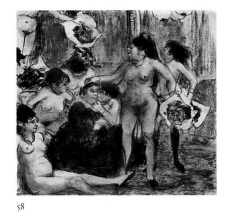

58

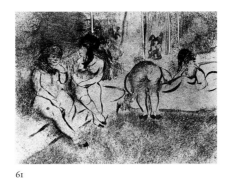

61

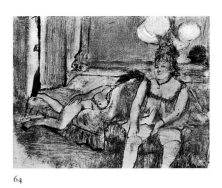

64

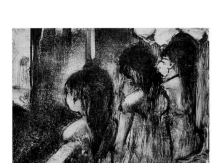

59

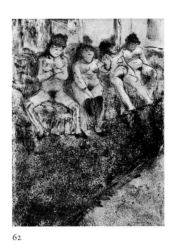

62

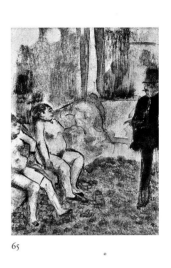

65

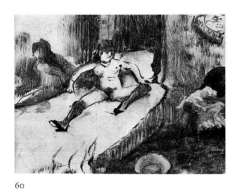

60

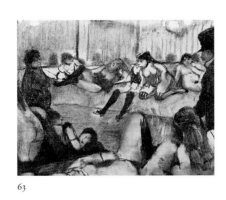

63

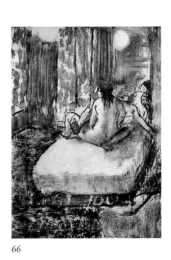

66

own etchings, perhaps prompted in part by the receipt of Eugenia Parry Janis's catalogue of the exhibition "Degas Monotypes" held at the Fogg Art Museum, Harvard University, Cambridge, Massachusetts, in 1968.

AEM

1. According to Una Johnson, the engraver Pottin required six years to faithfully reproduce the monotypes—requiring up to three plates apiece—for these publications; Johnson 1977, p. 27. The third book was Paul Valéry, *Degas, Danse, Dessin,* Paris, 1936 (Johnson 1977, no. 179).
2. On July 16, 1896, Camille Pissarro wrote to his son Lucien: "I told Vollard he ought to make Degas a proposition for his lithographs—no danger!" Bailly-Herzberg 1980–91, vol. 4, p. 232; English translation in Rewald and L. Pissarro 1943, p. 293.

There is at least one noteworthy exception to Vollard's ownership of an early etching by Degas, the 1857 *Self-Portrait* (Delteil 1919, no. 1; Reed and Shapiro 1984, no. 8, i/iv) now in The Metropolitan Museum of Art (1972.625). See Gary Tinterow's essay "Vollard and Degas" in this volume.

3. Vollard, Splendid Hotel, Vittel, to Denis, September 8, 1935: Archives, Musée Départemental Maurice Denis, Donation de la famille Denis, Saint-Germain-en-Laye. Thanks to Rebecca Rabinow for bringing this to the author's attention. The Degas exhibition was eventually held in 1936.

4. See Johnson 1977, no. 28. See also Gary Tinterow's essay "Vollard and Degas" in this volume.

5. The probability that Picasso saw Degas's brothel monotypes at Vollard's seems to have been first proposed in print by the late William Rubin, who implicitly acknowledged that Picasso did not say when he first saw the works; Rubin 1994, pp. 62–63, 108–9, 142, nn. 277–79. Alternatively, Robert Rosenblum has suggested that Picasso may have seen brothel monotypes that could have been owned by Eugène Rouart, who had firsthand knowledge of the development of the *Desmoiselles*; Rosenblum 1986, p. 58. Essential reading on Picasso's acquisition of the Degas monotypes is Seckel-Klein 1998, pp. 111–21.

GUY DE MAUPASSANT

LA MAISON TELLIER

ILLUSTRATIONS D'EDGAR DEGAS

PARIS
AMBROISE VOLLARD, ÉDITEUR
28, RUE DE MARTIGNAC, 28
MCMXXXIII

67

67.

fig. 169

EDGAR DEGAS
La Maison Tellier, by Guy de Maupassant

Published by Ambroise Vollard, Éditeur, Paris, 1934
("Achevé d'imprimer" December 27, 1934)
Illustrated book with 19 etching and aquatints after
monotypes, 17 wood engravings (executed by Georges
Aubert after Degas's drawings), and line block table of
plates after sketches
Page 12⅞ x 9¹⁵⁄₁₆ in. (32 x 25.2 cm)
Printers: "Aux Deux Ours," the hand press of Aimé and
Henri Jourde (wood engravings); Maurice Potin
(aquatint, etchings); L'Imprimerie Nationale (text)

a. The Museum of Modern Art, New York, The Louis E.
Stern Collection, 1964 773.1964
Copy no. 276 of a numbered edition of 305, plus addi-
tional copies lettered A–T
New York and Chicago only

b. Petit Palais, Musée des Beaux-Arts de la Ville de Paris
PPL 0037
Copy no. 305
Paris only

CATALOGUES RAISONNÉS: Johnson 1977, no. 177; Chapon
1987, p. 282; Jentsch 1994, no. 27

In the mid-1930s, Vollard published three books
of identical dimensions illustrated with reproduc-
tions after original compositions by Degas: Guy de
Maupassant's *La Maison Tellier* (1934), Pierre Louÿs's
translation of Lucian's *Mimes des courtisanes* (1935),
and Paul Valéry's *Degas, Danse, Dessin* (1936). Since
the art was not created with any of the texts in mind,
the books are hardly artist's books in the truest sense
of the term. Nonetheless, Vollard was immensely
proud of them and took the same care with their
printing as with that of his books containing origi-
nal prints.

The inspiration for *La Maison Tellier* (and, for
that matter, for *Mimes des courtisanes*) was a group of
brothel monotypes included in the posthumous
Degas atelier sales of 1918–19. Vollard purchased
several of these prints at auction; others were later
acquired by the Belgian art publisher Louis Exsteens.
Even as the sales were still in progress, Vollard began
exploring the possibility of using them as illustra-
tions. On April 3, 1919, Vollard signed an agreement
with Maupassant's literary heir, the Librairie
Ollendorff; he renewed his option with Albin
Michel on April 14, 1932.[1]

It is curious that Vollard lavished such care on a
book of reproductions. He chose his printer care-

fully: "In order to reproduce these compositions of
Degas, I had to find an artist capable of fathoming
the sensitiveness of his drawing, the subtlety of his
tone. I turned to the painter-engraver Maurice Potin,
who accomplished wonders. He spared neither time
nor trouble. To reproduce a certain monotype, even
in black, as many as three copperplates had to be
engraved!"[2] The book's design apes Vollard's more
important *livres d'artiste* from the period. Each con-
tains an album of nineteen loose prints, as well as an
illustrated note to the binder indicating where the
plates should be inserted. Vollard went so far as to
order a new font of characters (Grandjean) for the
book, the text of which was printed by the
Imprimerie Nationale. Vollard was particularly
proud of the resulting volume. Amazingly, when he
loaned a group of books to a 1938 exhibition in
Bucharest, he assigned the same insurance value to
La Maison Tellier (2,500 francs) as to *Le Chef-d'oeuvre
inconnu* (cat. 159), a book of original prints by Picasso.[3]

RAR

1. Vollard Archives MS 421 (9,6), fol. 4. Albin Michel pur-
 chased the rights to the work from the Librairie Ollendorff
 in the first half of the 1920s.
2. Vollard 1936, pp. 258–59.
3. Vollard Archives MS 421 (3,6), fol. 5.

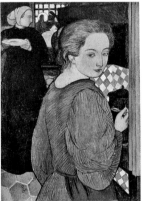

68

68.

fig. 87

MAURICE DENIS
The Cook

1893
Oil on canvas
31½ x 23⅝ in. (80 x 60 cm)
John C. Whitehead (courtesy Moeller Fine Arts,
New York)

PROVENANCE: Bought from the artist by Ambroise Vollard,
Paris, 1901; various private collections; Moeller Fine Arts, New
York; John C. Whitehead, New York

Denis's painting of Marthe Meurier, whom he mar-
ried in June 1893, the year this image was painted, is
the largest of three vertical canvases dating between
1893 and 1895 that show her in the role of the bibli-
cal Martha. In one, *Sancta Martha,* dated 1893 and
signed with the same vertical monogram seen here
but on the opposite side, the composition is nearly
identical to the present canvas but reversed.[1] In both,
Marthe wears a textured blue collarless dress with
billowing sleeves, differentiated only by the apron

colors and style (blue and half length in *The Cook*
versus pink, floral-patterned, and full length in
Sancta Martha). Denis linked the name of his
beloved with the Gospel story of Christ in the House
of Mary and Martha (the two sisters of Lazarus).
Here, Martha, the active one, as the text describes
her, busies herself in the kitchen, while a maid-
servant carries out domestic tasks behind her. In the
background, Christ shares with Martha and Mary,
the contemplative one, the spiritual feast that Martha
has helped prepare.[2]

While Count Harry Kessler felt that Martha's
round, doll-like face was not a good subject for his
artist friend, she nonetheless played a primary role in
Denis's art.[3] The artist saw in her not only a willing
acolyte to his passionate spirituality but also the
embodiment of purity and innocence—he admired
"her shy love and her taste for what is beautiful
among humble domestic tasks."[4] It is likely that
both *The Cook* and *Sancta Martha* show Denis's wife
during their one-month honeymoon in Perros-
Guirec (Brittany), where he noted admiringly how
Marthe "carries out the essential household tasks
with total dedication."[5] Marthe's modest downcast
gaze and her position in the foreground also link
this image to Denis's lithographic designs for *Amour,*
a series conceived during the period of his engage-
ment and first years of marriage to Marthe, although
not published until 1899. Especially close is the ver-
tical lithograph in the cycle showing Martha in the
right-hand corner, entitled "Attitudes Are Easy and
Chaste" (cat. 71).

Vollard undoubtedly knew the close variant, *Sancta
Martha,* from the gallery of Louis-Léon Le Barc de
Boutteville where it was exhibited in 1893, and a few
months later in the offices of the review *Dépêche de
Toulouse.*[6] Since Denis apparently kept the present
work in his studio, Vollard may have acquired *The
Cook* as a close representative of the better-known
painting. Chosen for the catalogue cover for the
1994–95 Denis retrospective where it was exhibited
for the first time, it harks back to earlier art that told
consecutive stories in a radically compressed space.
At the same time, the painting reflects the artist's
desire to dedicate his evolving ideas about his per-
sonal life and about art to the service of Christ.

GG

1. See *Sancta Martha* or *Marthe at the Dresser,* 1893, private
 collection; see Lyon and other cities 1994–95, p. 190,
 no. 62.
2. In the third canvas (*Mary and Martha* or *Intérieur,* 1895,
 Didier Imbert Fine Art, Paris; Lyon and other cities
 1994–95, p. 170, no. 46), also smaller in format, Marthe,
 now his wife, is shown with Eva, her sister. Although
 Denis's own title signifies the Gospel context, the work,
 dated 1895, has few references to the biblical story and is
 linked as well to the play *Intérieur* by the Belgian poet and
 playwright Maurice Maeterlinck, written in 1894; see Lyon
 and other cities 1994–95, p. 170.
3. See diary entry for November 28, 1904, in Schäfer 1997,
 p. 205.
4. Denis 1957–59, vol. 1, p. 97.
5. Ibid., p. 100.
6. See Lyon and other cities 1994–95, p. 190, no. 62.

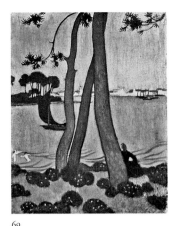

69

69.

MAURICE DENIS
Pines at Loctudy

fig. 85

1894
Oil on canvas
21 x 17 in. (53.3 x 43.2 cm)
Private collection, United States

PROVENANCE: Bought from the artist by Ambroise Vollard,
Paris, 1899; various private collections; private collection,
United States

Denis may have exhibited this small, monochro-
matic view of the sea from Loctudy, south of
Brittany, at one of the three exhibitions held at the
Barc de Boutteville gallery in 1894. Although often
seen as analogous to his designs for stained-glass win-
dows that were commissioned by Siegfried Bing and
exhibited in April 1895 at the Salon du Champ-de-
Mars, in scale, composition, and style *Pines at Loctudy*
is closer to a small canvas of nearly identical format,
Young Girls Picking Flowers by the Sea (with Galerie
Huguette Berès, Paris, in 1992). Both share a tripar-
tite composition beginning with zones of land,
speckled with flowers growing on the grass or
on bushes, and umbrella pines cut off at the top
by the picture's edge and silhouetted against the sea.
It is possible that Denis conceived these two small
canvases as complementary, with the blue tonalities
of the *Pines* playing off the primarily pink tones
of *Young Girls Picking Flowers* (anticipating the Blue
and Rose periods of Picasso). They are also more
secular than many of Denis's paintings, which so
often drew upon allegorical, religious, and chivalric
themes, with Marthe playing a leading role. In
many ways, this highly decorative seascape is closer
to Denis's wallpaper designs, dating from about
1893–94, with their simplified waves and arabesque
sailboats. Stylistically and thematically, the paint-
ing also recalls the Pont-Aven aesthetic of large
planes of colors enclosed by decorative line, first
espoused by Gauguin, and echoed in the landscapes
and seascapes of Paul Sérusier, Jan Verkade, and
Georges Lacombe.

From Denis's book of sales, we know that Vollard
acquired *Pines* from the artist in 1899, but whether
Vollard exhibited it in the exhibition he held of the
Nabis' works that year (to publicize the lithographic
albums) is not known. Although of a very different
style and subject matter from *The Cook, Maternity
(Mother's Kiss)* (cats. 68, 70), and other works acquired
at that time, Vollard described it in his stockbook as

simply "Landscape, tall vertical trees at the banks of
the sea, in the horizon a range of white houses."[1]

GG

1. Stockbook A, no. 3866: "Paysage arbres en hauteur sur le
bord d'un cours d'eau à l'horizon une rangée de petites
maisons blanches."

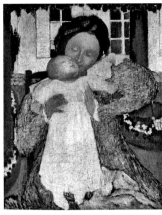

70

70.

MAURICE DENIS
Maternity (Mother's Kiss)

fig. 86

Ca. 1896–1902
Oil on canvas
31½ x 25¼ in. (80 x 64 cm)
Private collection

PROVENANCE: Probably bought from the artist by Ambroise
Vollard, Paris, 1901; Collection de Galéa, Paris (Mme de Galéa,
d. 1955; her son Robert de Galéa, d. 1961); bought by Samuel
Josefowitz, Lausanne, 1957; private collection

The births of Denis's four children, beginning with
Jean-Baptiste in 1894 (who lived only a few months),
inspired a series of "maternité" paintings based
loosely on works by Sandro Botticelli and the Italian
Primitifs in the Louvre, and always featuring the
artist's wife, Marthe, as the Virgin and modern-day
mother. This work, and many others, set in his par-
ents' garden on the rue de Mantes in Saint-Germain-
en-Laye, combined the theme of "maternité" with
the idea of new beginnings and a redemptive, all-
encompassing love.

Probably acquired by Vollard in 1901, this paint-
ing has been dated circa 1896–1902 and is said to rep-
resent Marthe with her daughter Noële, who was
born in 1896.[1] But its larger format and central motif
of a child with head back and open arms who is
lifted up by the mother link it to the *Virgin's Kiss*
(ca. 1902, Museum Folkwang, Essen), a version of
which was exhibited in 1902 at the Salon of the
Société Nationale des Beaux-Arts (location un-
known).[2] In the Essen painting, which is slightly
larger than the present work, Denis's borrowings
from the Italian Primitifs are apparent not only in
the halos but also in the Tuscan setting seen beyond
the window framing the Madonna-Marthe. In 1901
the artist noted in his diary the idea to make "a series
of paintings of the Virgin and Child, all the same
size, elaborately drawn, in few colors, reusing old
motifs as well as new ones."[3] Thus it is possible that
the artist revisited the image shown here, to make the
more elaborate composition datable to about 1902.

In this smaller, less formal version, the child is
shifted slightly to the left so that the mother kisses
the cheek instead of the forehead, as she does in the
more hieratical *Virgin's Kiss*.[4] Marthe is dressed sim-
ply in a patterned cotton dress with a large rounded
collar, suggesting the colonial missionary dresses
worn by Paul Gauguin's young Tahitians. The "hor-
tus conclusus" (enclosed garden) of Denis's parents'
backyard, with its neatly trimmed paths, is clearly
domestic, as are the French doors framing the figure
of Marthe as the Madonna. On the other hand, this
image of a mother with child is more formal than
those set in the Denis bedroom, or where Marthe
nurses or plays with her child. In its frontality and in
its emphasis on the child's body literally being given
up to its mother's arms, this painting is one of
Denis's more successful amalgams of his favorite
themes of love, family, and Christian faith.

Vollard acquired several of the "maternités,"
including one he sold to Gertrude and Leo Stein in
1904 (seen in a ca. 1906 photograph of their rue de
Fleurus apartment) and another he sold to Karl-
Ernst Osthaus in 1904 for 1,200 francs.[5]

GG

1. I am grateful to Paul Josefowitz, who dates the painting to
1896–97, based on a letter from Denis's son, Dominique.
2. In the version exhibited at the 1902 Salon of the Société
Nationale des Beaux-Arts (Paris 1902, p. 61, no. 343), Denis
blocked off the space with two apertures on either side and
framed it with a border of flowers. In this case, the baby
represented is likely Bernadette, born in 1899. For examples
of this theme in Denis's art, see Lyon and other cities
1994–95, nos. 67–71, 216.
3. Denis 1957–59, vol. 1, p. 172 (ca. October 1901), translated
in Lyon and other cities 1994–95, p. 264, no. 112.
4. In another smaller painted sketch in which the hills of
Tuscany are barely discernible in the back two windows,
the child is also shifted slightly to the left and held simi-
larly, but is further away from the mother's face: *Maternity*
(Musée d'Orsay, RF 1985–18).
5. Vollard Archives, MS 421 (4,10), p. 30, October 28, 1904;
Vollard Archives, MS 421 (4,1), p. 55, March 10, 1904. See
also Gloria Groom, "Vollard, the Nabis, and Odilon Redon"
and "Vollard and German Collectors" in this volume.

71.
figs. 11, 84, 204, 205, 246

MAURICE DENIS
Amour (Love)

Published 1899
Suite of 12 color lithographs on wove paper, plus cover

a. The Art Institute of Chicago, John H. Wrenn
Memorial Collection 1946.432a–m
Chicago only

b. The Metropolitan Museum of Art, New York, Harris
Brisbane Dick Fund, 1941 41.19.3.1–13
New York only

c. Petit Palais, Musée des Beaux Arts de la Ville de Paris
PPG 2225, 2227, 2228, 4639
Paris only

CATALOGUE RAISONNÉ: Cailler 2000, nos. 107–119

Cover
Image 20⅞ x 16⅛ in. (53 x 41 cm), sheet 23⅛ x 17½ in.
(58.7 x 44.5 cm)*

1. *Allegory*
Image 10⅜ x 16 in. (26.5 x 40.7 cm), sheet 15⅞ x 20⅛ in.
(40.4 x 53.1 cm)

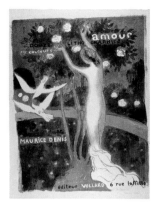

71

72

rent motifs in Denis's decorative panels between 1892 and 1897. *Allegory* (pl. 1) and *Life Becomes Precious, Restrained* (pl. 11), for example, reprise the subjects and blue-green palette of the panels Denis made as a bedroom frieze for Siegfried Bing's Maison de l'Art Nouveau, which opened in December 1895.[3] Others, showing Marthe alone or with her suitor, are analogous to Denis's easel paintings.[4]

In June 1897 Vollard wrote worriedly to Denis that he would "be devastated if this [*Amour*] remains unfinished."[5] By the following year, however, he had printed both Denis's album and Henri Fantin-Latour's suite of six lithographs.[6]

GG

*Dimensions given are for cat. 71a.

1. Vollard to Denis, undated [probably 1896 because of content and letterhead, with the "39" of the address crossed out and replaced by a handwritten "6"]: "Pour *Daphnis et Chloé* j'y tiendrais beaucoup je vous l'avoue de la façon que je vous ai dit, càd une suite d'estampes (12) en album. Comme j'aurai une presse litho. c'est là peut être une facilité de plus comme je vous l'ai dit, plus haut—Je vous envoie mes meilleurs salutations": Archives, Musée Départemental Maurice Denis, Saint-Germain-en-Laye, Donation de la famille Denis, MS Vollard 11346a,b.
2. Paris 2002, no. 99.
3. See Chicago–New York 2001, p. 99, fig. 1(b), *Sleeping Woman*, and fig. 1(c), *Crown*. Denis copied and made variants of these seven panels between 1897 and 1900; see Thérèse Barruel in ibid., pp. 101–4.
4. One of these, *Our Souls with Languorous Gestures*, shares a similar subject (figure cut off by a table or piano, lit by artificial light of table lamp) as the lithograph *Child in Lamplight*, which Bonnard began about 1897 for the third Vollard album, which was never realized. For Bonnard, see Bouvet 1981, pp. 54–55, no. 43.
5. Vollard to Denis, urging him to keep working: Archives, Musée Maurice Denis, MS Vollard 12229/12229a,b: "Clot m'a dit que pour le moment vous laissez la lithographie; je pense que plus tard vous pourrez continuer la suite d'*Amour* je serais trop navré si cela restait en train—."
6. Although it was not until March–April 1899 that these were officially publicized along with the albums by Redon, Bonnard and Vuillard. See the essay by Douglas Druick and Jonathan Pascoe Pratt in this volume.

2. *Attitudes Are Easy and Chaste*
Image 15⅛ x 10⅞ in. (38.4 x 27.5 cm), sheet 20⅞ x 16 in. (52.9 x 40.6 cm)
3. *The Morning Bouquet, Tears*
Image 14¾ x 11⅛ in. (37.6 x 28.3 cm), sheet 20¾ x 15⅞ in. (52.7 x 40.2 cm)
4. *It Was A Religious Mystery*
Image 16⅛ x 11⅜ in. (41 x 29 cm), sheet 20⅞ x 15⅞ in. (52.5 x 40.3 cm)
5. *The Knight Did Not Die on the Crusades*
Image 15⅛ x 10⅞ in. (38.5 x 27.5 cm), sheet 20⅞ x 15⅞ in. (53 x 40.2 cm)
6. *Twilights Have the Softness of Old Paintings*
Image 15½ x 11⅛ in. (39.5 x 29.5 cm), sheet 20⅞ x 15¾ in. (52.3 x 40 cm)
7. *She Was More Beautiful Than Dreams*
Image 16 x 11½ in. (40.5 x 29.3 cm), sheet 20⅞ x 15⅞ in. (53 x 40.3 cm)
8. *And It Is the Caress of Her Hands*
Image 15¼ x 11¼ in. (38.8 x 28.5 cm), sheet 20⅞ x 15¾ in. (53 x 40 cm)
9. *Our Souls, with Languorous Gestures*
Image 11 x 15⅝ in. (27.8 x 39.8 cm), sheet 16 x 20¾ in. (40.5 x 52.8 cm)
10. *On the Pale Silver Sofa*
Image 16 x 11½ in. (40.6 x 29.2 cm), sheet 20⅞ x 15⅞ in. (53 x 40.4 cm)
11. *Life Becomes Precious, Restrained*
Image 10¾ x 16 in. (27.2 x 40.5 cm), sheet 20⅞ x 15⅞ in. (52.9 x 40.2 cm)
12. *But It Is the Heart Which Beats Too Fast*
Image 17¼ x 11⅝ in. (43.9 x 29.6 cm), sheet 20⅞ x 15⅞ in. (52.9 x 40.2 cm)

It is not known when Vollard commissioned this suite of twelve lithographs, but it is perhaps not coincidental that Vollard's first idea for the book *Daphnis et Chloé* was for a portfolio-like publication with "12 lithographs in an album."[1] Was *Amour* (*Love*) Vollard's second commission for Denis, or was this Vollard's initial proposal, abandoned for *Daphnis* but serving as a template for the single-artist albums yet to come?

The dating of *Amour* is complicated by the fact that Denis conceived it as early as 1892 as a "record of courtly engagement" to his fiancée Marthe, whom he married in 1893.[2] In direct contrast to the loosely related images of the Bonnard and Vuillard albums (cats. 14, 202), *Amour* is an illustrated poem, insofar as each print is accompanied by evocative captions taken from the private notes of the artist, written from June 1891 through 1893. The women crowned with flowers and accompanied by doves are recur-

72. fig. 212

MAURICE DENIS
L'Imitation de Jésus-Christ, by Thomas à Kempis

Published by Ambroise Vollard, Éditeur, Paris, 1903 ("Achevé d'imprimer" January 6, 1903)
Illustrated book with 218 wood engravings
Page (irreg.) 12¹³⁄₁₆ x 10¼ in. (32.4 x 26 cm)
Printers: Tony Beltrand for Le Syndicate des Graveurs sur Bois, under the supervision of the artist (wood engravings); L'Imprimerie Nationale (text)
Copy no. 243 (of an edition of 400)
The Metropolitan Museum of Art, New York, Harris Brisbane Dick Fund, 1926 26.88
New York and Chicago only

CATALOGUES RAISONNÉS: Johnson 1977, no. 180; Chapon 1987, p. 279; Jentsch 1994, no. 5

It speaks to the contradictory interests of Vollard that he would simultaneously prepare extraordinarily risqué texts such as *Parallèlement* (cat. 15) and *Jardin des supplices* (cat. 179) and the conservative *Imitation de Jésus-Christ*. Until the early 1930s, Vollard's edition of the last was by far the most sought-after of the three.

First published in Latin in 1418, *L'Imitation de Jésus-Christ*—instructions on how to perfect one's soul using Jesus as a divine model—is believed to be the most widely read spiritual book in the Christian world after the Bible. Vollard presumably proposed an illustrated edition of *L'Imitation de Jésus-Christ* in early 1899. In mid-March of the following year Vollard reported to the artist that he had been shown a copy of Adolphe Hatzfeld's translation and found it to be written in "very modern and very beautiful language." He was particularly impressed by a letter (dated July 21, 1869) from Pope Pius IX to Hatzfeld.[1] This version (letter and all) is the one used by Vollard and Denis.

Vollard claims to have prepared the book with the taste of conservative bibliophiles in mind. "Well, if they want woodcuts," Vollard recalls thinking, "why shouldn't I give them woodcuts?"[2] In truth, Vollard and Denis's initial collaboration on this book predates *Parallèlement*'s publication by almost two years and thus was created well before Vollard witnessed the negative critical reaction to Bonnard's lithograph illustrations. The Vollard Archives record a payment of 2,667 francs to Beltrand for his work on Denis's woodcuts from March 1899 through March 1900.[3] It is a mark of Vollard's enthusiasm for the project that he hired the photographer Étienne Delétang to photograph each "bois" as it was completed.

Vollard was so proud that he had reserved the first copy of the book for Pope Leo XIII that he printed the information on the colophon; however, the presentation did not go as smoothly as planned. After Vollard sent the book to his binder, along with a copy of *Parallèlement*, which had been ordered by another client, the title pages of the books were inadvertently swapped, so that the title page of *L'Imitation de Jésus-Christ* was followed with pages of lithographs of naked women and sonnets about lesbianism. The owner of the bound *Parallèlement*, which contained the text of *L'Imitation de Jésus-Christ*, refused to return his copy, and it was only some twenty-seven years later, when the price of *Parallèlement* had significantly increased, that the trade was finally arranged. Vollard traveled to Rome to personally present *L'Imitation de Jésus-Christ* to the reigning pope, Pius XI.[4]

RAR

1. Vollard to Denis, March 14, 1900: Archives, Musée Départemental Maurice Denis, Saint-Germain-en-Laye, Donation de la famille Denis, MS Vollard 11357.
2. Vollard 1936, p. 254.
3. March 31 (160.40 francs), June 3 (70.85 francs), August 8

(236.65 francs), October 9 (413.87 francs), November 27 (490.80 francs), and December 30, 1899 (two payments totaling 103.60 francs), and February 1 (457 francs) and March 1, 1900 (700 francs): Vollard Archives, MS 421 (4,3), fols. 128, 134, 136, 140, 144, 147, 149, 152, 153.

4. Vollard 1929b, p. 980.

73

73. *fig. 211*

MAURICE DENIS
Sagesse, by Paul Verlaine

Published by Ambroise Vollard, Éditeur, Paris, 1911
("Achevé d'imprimer" August 30, 1910)
Illustrated book with 71 wood engravings and 18 wood-engraved ornaments
Page (irreg.) 11 x 8¹⁵⁄₁₆ in. (28 x 22.4 cm); composition, various dimensions
Printer: Émile Féquet for Jacques Beltrand
Copy no. 119 (of an edition of 250)
The Museum of Modern Art, New York, Curt Valentin Bequest (by exchange), 1975 160.1975.1–71
New York and Chicago only

CATALOGUES RAISONNÉS: Cailler 1968, nos. 11–28; Johnson 1977, no. 181; Chapon 1987, p. 280; Jentsch 1994, no. 8

While Paul Verlaine's *Parallèlement* (cat. 15) consists of lesbian sonnets and musings about prostitutes and various sexual acts, *Sagesse* concerns the author's struggles with the church and his religious beliefs. A devout Catholic, Denis had been interested in illustrating *Sagesse* since reading the text in 1889. He had tried to no avail to interest a publisher in the project and had even showed his designs to Verlaine himself.[1] As soon as Denis learned that Vollard was accepting book projects, he rushed to propose the idea of publishing it.[2] Vollard was familiar with Denis's work on the book; several of his wood engravings for *Sagesse* had been included in Vollard's first "Exposition des Peintres-Graveurs" in the summer of 1896. Vollard enthusiastically urged Denis to illustrate the book with color lithographs but cautioned that its publication would have to wait until *Parallèlement* appeared.[3]

By March 14, 1900, it was understood that Denis's designs for the book would take the form of wood engravings. Vollard hoped to save a step (and, no doubt, some money) by having Denis draw directly onto the wood.[4] Denis agreed and informed Vollard that he would charge 1,800 francs to re-create his forty-eight existing designs in the format Vollard wanted, while adding a few additional *culs-*

de-lampe and other decorations.[5] On March 19, 1900, Vollard signed a contract with the widow of Verlaine's publisher Léon Vanier (1847–1896) for the rights to create an edition of 250 numbered copies of *Sagesse*. In return for 2,000 francs and two copies of the book, Madame Vanier agreed to wait two years before approving another "edition de luxe" of *Sagesse* and three years before approving a more general illustrated edition.[6]

As always, Vollard took great care with every aspect of the book; among other things, he sent Denis samples of the various typefaces he was considering.[7] Suffering from a deficit of funds, Vollard apologized for his late payments but tried to mollify Denis by suggesting a future collaboration of lithographic illustrations for an edition of Jacques de Voragine's *The Golden Legend* or *The Life of the Saints*.[8] *Sagesse* ultimately appeared in 1911, eight years after the publication of another book on which they had worked simultaneously, *L'Imitation de Jésus-Christ* (cat. 72).

RAR

1. For more information, see Wang 1974, pp. 71–73.

2. It has been suggested that Vollard first proposed the idea to Denis in 1889 and then reneged on the offer, but as Vollard was still enrolled in law school in 1889 and had yet to publish a single print, this seems unlikely. See Paris 2002, no. 106.

3. Vollard to Denis, undated: Archives, Musée Départemental Maurice Denis, Saint-Germain-en-Laye, Donation de la famille Denis, MS Vollard 11346.

4. Vollard to Denis, March 14, 1900: Archives, Musée Maurice Denis, MS Vollard 11357.

5. Draft or copy of a letter from Denis to Vollard, March 15, 1900, on the verso of letter in note 4 above.

6. Contract signed by Vollard and Mme Vve Vanier, March 19, 1900: Vollard Archives, MS 421 (8,30), fols. 1–2.

7. Vollard to Denis, April 20, 1902: Archives, Musée Maurice Denis, MS Vollard 11360.

8. Ibid.

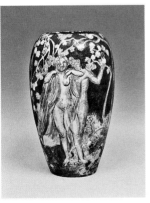

74

74. *fig. 88*

MAURICE DENIS
Vase

Ca. 1906–7
Tin-glazed ceramic
H. 11 in. (28 cm), Diam. 5⅞ in. (15 cm)
Collection Larock-Granoff, Paris

In 1906, when Vollard commissioned André Derain, Pierre Laprade, Henri Matisse, Jean Puy, Louis Valtat, and Maurice de Vlaminck to make designs for ceramic plates and vases, it was a novel undertaking,

in contrast to other commissions involving Pierre Bonnard, Maurice Denis, Aristide Maillol, and Ker-Xavier Roussel, who already had experience decorating ceramics.[1] In his choice of artists, Vollard clearly adhered to the philosophy of Paul Gauguin, who once remarked "pick artists and not workers," when it came to commissioning decorative objects.[2] When Vollard commissioned painters to make prints, he engaged the master printer Auguste Clot; for the ceramics, he similarly brought in the master ceramist André Metthey. Metthey also felt strongly that these well-known painters should not be treated as *decorateurs* but as artist-*collaborateurs*.[3] According to Puy, Metthey provided the actual porcelain, ceramic, or stoneware vessels, covered with a slip of tin that the artists painted directly upon; they were then glazed by Metthey.[4] The resulting designs on the vases and plates were surprisingly homogeneous, with thickly outlined female nudes predominating.[5] This is true of Denis's work as well, despite his aesthetic distance from the Fauve artists with whom he shared the commission.

In the two or three vases bearing the blue Metthey monogram from about 1907, however, Denis chose male and female nudes as subjects. Instead of employing strong contours against a neutral setting to emphasize their classical attributes (as Maillol did in his *Vase with Bathers* of about 1907 [fig. 187]),[6] Denis intertwined the figures with foliage, fountains, and grapevines, which recalled Greek tradition yet also reflected his pattern-on-pattern Nabi compositions. For whatever reasons, Vollard continued this experiment only with a few artists, such as Valtat and Georges Rouault. Denis, however, returned to Metthey (probably independently) when he received a commission from the Moscovite Ivan Morozov to make large vases, also with nudes, to complement the artist's decorative mural ensemble, *The History of Psyche,* installed in Morozov's music room.[7]

GG

1. For Roussel's tile, see Forest 1996, p. 17. See also Marseille 2000, p. 142, figs. 015, 016 (Roussel), pp. 142–43, nos. 017–019 (Maillol), p. 141, no. 010 (Bonnard), and p. 142, nos. 013, 014 (Denis).

2. Cited in Forest 1996, p. 21.

3. In his article written to coincide with the showing of some one hundred of the *grès, porcelaines,* and *céramique stan-nifères,* Metthey claims—rather surprisingly, since there is no evidence to support it—to have worked not only with the Fauves and Nabis (Bonnard, Denis, Roussel, and Maillol) but also with Odilon Redon; see Metthey 1907, p. 749, cited in Munck 2000, pp. 32–33. Between January 1906 and June 1907 there are numerous payouts to Metthey and Mme Metthey for ceramics, stoneware (*grès*), and porcelains, although the only artist Vollard references is Vlaminck: Vollard Archives, MS 421 (5,1), fol. 142, August 13, 1906.

4. Jean Puy, "Documents," Jean and Michel Puy Archives, Lyon, cited in Munck 2000, p. 32.

5. See examples in Marseille 2000, esp. p. 143, no. 023 (Derain), pp. 143–44, nos. 024, 025 (Friesz), p. 146, nos. 039, 040, 042 (Valtat), p. 147, nos. 043–045 (Van Dongen), p. 147, no. 046 (Vlaminck); and Nice–Bruges 1996, p. 82 (Matisse).

6. See Marseille 2000, pp. 28, 142, fig. 018, and Nice–Bruges 1996, p. 18.

7. On this see Kostenevich 2002, pp. 149–67, 182.

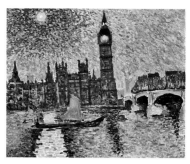

75

76

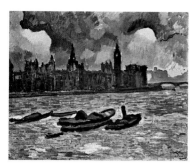

78

75.

fig. 17

ANDRÉ DERAIN
Big Ben

Ca. 1906
Oil on canvas
31⅛ x 38⅜ in. (79 x 98 cm)
Musée d'Art Moderne, Troyes, Gift of Pierre and Denise
Lévy MNPL 103
Chicago only

CATALOGUE RAISONNÉ: Kellermann 1992–99, vol. 1, no. 77

PROVENANCE: Bought from the artist by Ambroise Vollard,
Paris, 1906; possibly on consignment with Maurice Renou,
Paris, by 1936; Max Kaganovitch, Paris; Pierre Lévy, Troyes;
gift of Pierre and Denise Lévy to Musée d'Art Moderne,
Troyes, 1976

76.

fig. 130

ANDRÉ DERAIN
Charing Cross Bridge, London

Ca. 1906
Oil on canvas
31⅝ x 39½ in. (80.3 x 100.3 cm)
National Gallery of Art, Washington, D.C., John Hay
Whitney Collection 1982.76.3

CATALOGUE RAISONNÉ: Kellermann 1992–99, vol. 1, no. 88

PROVENANCE: Bought from the artist by Ambroise Vollard,
Paris, July 6, 1906; John Quinn, New York, purchased from
Vollard through Walter Pach and Carroll Gallery, New York,
1918–his d. 1924; his estate, 1924–ca. 1925; Paul Guillaume,
Paris, probably purchased from Quinn estate, ca. 1925; bought
by Alex Reid & Lefèvre Ltd., Glasgow and London, 1927;
bought by Étienne Bignou, Paris, 1931; bought by Georges
Keller for M. Knoedler and Co., New York and Paris, 1932;
acquired in Paris by Mme Kaethe Perls, Paris, by 1938; Walter
P. Chrysler Jr., New York, Warrenton, and Richmond,
Virginia (possibly purchased from Kaethe Perls), by 1939; his
sale, Parke-Bernet Galleries, New York, February 16, 1950, no.
54; Julius H. Weitzner, London and New York, from February
1950; bought by John Hay Whitney, Manhasset, New York,
April 12, 1950; deeded to the John Hay Whitney Charitable
Trust, New York, 1982; gift of the Trust to the National
Gallery of Art, Washington, D.C., 1982

77.

fig. 132

ANDRÉ DERAIN
Charing Cross Bridge, London

Ca. 1906
Oil on canvas
31⅛ x 39⅜ in. (81 x 100 cm)
Musée d'Orsay, Paris, Gift of Max and Rosy Kaganovitch,
1973 RF 1973-16
Paris only

CATALOGUE RAISONNÉ: Kellermann 1992–99, vol. 1, no. 93

77

PROVENANCE: Bought from the artist by Ambroise Vollard,
Paris, 1906; bought by Étienne Bignou, Paris and New
York, June 30, 1935, or February 29, 1936; bought by Max
Kaganovitch, Paris, April 23, 1940; Collection Max and Rosy
Kaganovitch, Paris, on extended loan to Kunsthaus Zürich,
from 1968; their gift to the Musée du Louvre, Paris (Jeu de
Paume), 1973–86; Musée d'Orsay, Paris, 1986

78.

fig. 128

ANDRÉ DERAIN
Houses of Parliament at Night

Ca. 1906
Oil on canvas
31 x 39 in. (78.7 x 99.1 cm)
The Metropolitan Museum of Art, New York, Robert
Lehman Collection, 1975 1975.1.168
New York only

CATALOGUE RAISONNÉ: Kellermann 1992–99, vol. 1, no. 83

PROVENANCE: Bought from the artist by Ambroise Vollard,
Paris, 1906; bought through Walter Pach by John Quinn,
New York, 1919–his d. 1924; his estate, 1924–26; Delius
Gallery (F. Delius Giese), London and New York, by 1948;
acquired by Robert Lehman, New York, November 1948–
his d. 1969; bequest to Robert Lehman Foundation 1969;
gift to the Metropolitan Museum, New York, 1975

79.

fig. 125

ANDRÉ DERAIN
*London: St. Paul's Cathedral Seen from
the Thames*

Ca. 1906
Oil on canvas
39¼ x 32¼ in. (99.1 x 80.1 cm)
The Minneapolis Institute of Arts, Bequest of Putnam
Dana McMillan 61.36.9

CATALOGUE RAISONNÉ: Kellermann 1992–99, vol. 1, no. 103

79

PROVENANCE: Bought from the artist by Ambroise Vollard,
Paris, 1906; Étienne Bignou, New York, by May 1936; Alex
Reid & Lefèvre Ltd., London, by December 1937; French Art
Gallery, New York, by 1941; ?George Bergen; Perls Galleries,
New York, by 1946; Putnam Dana McMillan, Minneapolis;
her bequest to the Minneapolis Institute of Arts, 1961

André Derain began his intense yet short-lived rela-
tionship with Vollard on November 23, 1905, just
two days before the close of the Salon d'Automne,
where he had emerged as a prominent member of
the Fauves. At Matisse's urging, Vollard visited
Derain in his studio and purchased his entire stock,
a total of eighty-nine paintings and eighty-one draw-
ings, for 3,300 francs.[1] Derain promptly signed on
with the dealer and, a few months later, received
an ambitious commission for fifty painted views
of London. According to Derain, the motive for
Vollard's unusually specific directive was twofold:
"After a visit to London, he was very enthusiastic
about the city and wanted some paintings inspired
by its atmosphere. He sent me there because he
wanted to renew the expression that Claude Monet
had tackled so successfully, and which had made such
a powerful impression in Paris a few years earlier."[2]

The paintings that had made such an impact
were Monet's views of the Thames River, which were
exhibited to great acclaim at the Galerie Durand-
Ruel in Paris in the spring of 1904. That show, which
Derain visited and admired, featured thirty-seven
paintings of London's iconic bridges and architec-
ture rendered in various effects of light and atmo-
sphere. Durand-Ruel bought eighteen of the paint-
ings for 10,000 to 11,000 francs apiece before the
show even opened, and Monet continued to sell
paintings to collectors, dealers, and museums both
during and after its run.[3] The success of this land-
mark exhibition was not lost on Vollard, who was
probably also aware of the album of the paintings
published by the commercial photographer Eugène
Druet.[4] Vollard's commission of fifty canvases was
undoubtedly intended to rival and surpass Monet's

series, and Derain rose to the occasion despite the completion of only thirty paintings.

Funded by Vollard, Derain made three short excursions to London between the spring of 1906 and early 1907.[5] He modeled his pictures on Monet's, selecting similar subject matter and painting on a comparable scale. With its divisionist brushstrokes and view from the Albert Embankment (slightly east of where Monet had painted), *Big Ben* (cat. 75) invites a direct comparison with Monet's Impressionist renderings of Westminster Palace. Derain gradually moved away from this precedent, however, to capture the modernity of the city and its thriving industrial activity in exuberant colors and boldly simplified forms. The subject of the Musée d'Orsay's *Charing Cross Bridge, London* (cat. 77) is not the bridge, as in Monet's versions, but the bustling traffic of the Victoria Embankment, a structure built in the 1860s that vastly improved London's sewage and transportation systems. Derain was equally fascinated with the commercial activity along the Thames. *Houses of Parliament at Night* (cat. 78) and *London: St. Paul's Cathedral Seen from the Thames* (cat. 79; the only vertical canvas in the series) each set working tugboats and barges against a backdrop of London's most celebrated landmarks. This contrast between the city's historical monuments and its modern industry is most salient in the National Gallery of Art's *Charing Cross Bridge, London* (cat. 76), which emphasizes the progressive character of London's industrialized South Bank through broad, flat patches of antinaturalistic colors.

Although some canvases were painted on site, Derain probably worked on most of them back in France from sketches he had made in London.[6] By July 1906 twelve paintings were completed and sold to Vollard for 150 francs each.[7] Vollard seems to have received the remaining canvases by the summer of 1907, as recorded by Derain in a letter to the dealer in which he inventories one lot of twenty-six London views and another lot of four, all priced at 150 francs apiece.[8] While the paintings were presumably conceived with an exhibition in mind, Vollard never showed the series in its entirety, perhaps because the artist was signing on with Daniel Henry Kahnweiler in the spring or early summer of 1907.[9] Another factor that may have contributed to Vollard's decision not to exhibit all of them was the positive reception of Gaston Prunier's series Views of the Thames, which was exhibited in 1908 at both the Galerie Allard, Paris, and the Salon d'Automne.[10] Nevertheless, Vollard was clearly satisfied with the paintings, for he lent many of them to international shows from New York to Moscow. Reflecting on the controversy and success he sparked by sending both Derain and Maurice de Vlaminck to paint abroad, Vollard later quipped, "I was bitterly reproached at the time for having taken these artists 'out of their element' by diverting them from their usual subjects. Now that time has done its work it is easy to see, on putting the French paintings beside those done in England, that a painter 'who has something to say' is always himself, no matter in what country he is working."[11]

NM

1. Vollard Archives, MS 421 (2,3), p. 57, November 23, 1905.
2. Derain to Ronald Alley, April 30, 1953: Archives, Tate, London, NA2626; cited in Labrusse and Munck 2004, pp. 243–44.

3. Chicago 1995, p. 237; Patin 1994, p. 84.
4. Chicago 1995, p. 237.
5. The three trips were made on March 6–17, 1906, from late March to mid-April 1906, and from late January 7 or 10 to February 1907; see Labrusse and Munck 2005a, p. 13.
6. The sketches are contained in two notebooks that Derain purchased in London in 1906 and used during his three trips. Labrusse and Munck 2005a, p. 14.
7. Derain's handwritten receipt of July 6, 1906, records that Vollard paid 1,800 francs for a collection of views of London at 150 francs each: Vollard Archives, MS 421 (2,3), p. 58.
8. Vollard Archives, MS 421 (2,3), p. 59.
9. Dagen 1994, p. 28; Labrusse and Munck 2005a, p. 14.
10. Céret–Le Cateau-Cambrésis 2005–6, p. 308.
11. Vollard 1936, p. 201.

80. *fig. 143*

ANDRÉ DERAIN
Tall Vase with Figures

Ca. 1906
Tin-glazed ceramic
H. 21¼ in. (54 cm)
Musée d'Art Moderne de la Ville de Paris, Gift in 1937 (Vollard) AMOA 128

PROVENANCE: Ambroise Vollard, Paris, from ?1909; his gift to the city of Paris, 1937; Musée des Beaux-Arts de la Ville de Paris (Petit Palais), 1937; Musée d'Art Moderne de la Ville de Paris

81. *fig. 139*

ANDRÉ DERAIN
Plate

Ca. 1906–7
Tin-glazed ceramic
Diam. 9 in. (23 cm)
Collection Larock-Granoff, Paris

82. *fig. 135*

ANDRÉ DERAIN
Large Vase with Geometric Pattern

1907
Tin-glazed ceramic
H. 21⅝ in. (55 cm)
Musée d'Art Moderne de la Ville de Paris, Gift in 1937 (Vollard) AMOA 129

80

83. *fig. 142*

ANDRÉ DERAIN
Large Plate with Bathers

1907–9
Tin-glazed ceramic
Diam. 11 in. (28 cm)
Collection Larock-Granoff, Paris

In his memoirs Vollard recalled an exhibition of decorative art that he visited in 1905: "I had no idea till then how beautiful pottery could be, and from that moment I longed to 'publish' vases, plates and dishes. At that time there was a Master-ceramist called Methey [*sic*]. At my request he put his kilns at the disposal of the younger artists—Bonnard, Maurice Denis, Derain, Puy, Matisse, Roussel, Rouault, Valtat, Vlaminck—and they decorated a number of fine pieces for me."[1] In a brief but productive

81

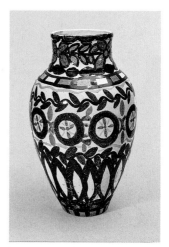

82

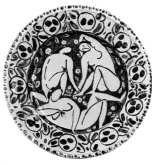

83

partnership, Vollard supplied André Metthey with funds to purchase raw materials and the conceptual freedom to choose the forms of the pottery. Metthey in turn provided Vollard's artists with stoneware and faience pieces, enamel glazes, and access to his workshop in Asnières. This artistic experiment resulted in a bold and colorful group of Fauve ceramics that reflected Vollard's interest in diverse artistic media.

Derain produced about twenty faiences between 1906 and 1908, the period of his collaboration with Metthey.[2] As in his paintings, the artist gave primacy to the human form, taking inspiration from "primitive," classical, and contemporary art sources. The reclining women and the arabesques of *Large Plate with Bathers* reflect the influence of both Cézanne and Matisse. Derain also created purely ornamental motifs that are characterized by rhythmic lines and vibrant, contrasting colors.

The Vollard-Metthey ceramics were received enthusiastically by critics, who appreciated the revival of painting on pottery. In his review of Rouault's ceramic exhibition at the 1907 Salon des Indépendants, Louis Vauxcelles wrote, "M. Metthey had the happy inspiration . . . to address himself to all the young artists with an eye for the decorative and to associate them with his work. We only see here the Rouault-Metthey display. But I saw in Asnières at Metthey's workshop . . . vases and small dishes and pitchers and teacups decorated by MM. Bonnard, Derain, de Vlaminck, Valtat that possess a bold originality."[3] Despite the positive press, Vollard failed to interest the general public in his ceramics, and the enterprise was a financial failure. With the exception of Vlaminck and Rouault, the production of the Asnières School came to a close by 1910.[4]

Vollard remained one of the primary collectors of Fauve pottery until 1937, when he donated nearly sixty pieces decorated by Cassatt, Derain, Laprade, Maillol, Puy, Valtat, and Vlaminck to the city of Paris (housed today in the collections of the Petit Palais and Musée d'Art Moderne de la Ville de Paris).[5] Commenting on the eventual popularity of "these little masterpieces," the critic Claude Roger-Marx marveled, "Their authors did not at all aim to make museum pieces, but to conduct experiments for their amusement. They did not suspect that these 'objects accidentally preserved' (to borrow Valéry's charming words) would one day be so coveted."[6]

NM

1. Vollard 1936, p. 249. It is likely that Vollard romanticized this account, since in 1907 Metthey claimed that the idea for this collaboration was his own; see Metthey 1907, cited in Saint-Tropez 2002, pp. 17–18.
2. Paris 1994–95, p. 334. Metthey's account summary of October 20, 1907, records Derain receiving a set of two dishes, twelve plates, three bowls and two little vases, two vases, a tea service, and one flute valued at 228 francs: Vollard Archives, MS 421 (2,3), pp. 126–28. An invoice that Derain sent to Vollard in the summer of 1907 lists an undisclosed amount of faience for a total of 150 francs: Vollard Archives, MS 421 (2,3), p. 59. For complete information on Derain's ceramics, see Jacqueline Munck in Nice–Bruges 1996, pp. 89–102, 105–7.
3. Cited in Saint-Tropez 2002, pp. 19–20.
4. The destruction of Metthey's kilns in the great flood of the Seine in 1910 also contributed to the dissolution of the Vollard-Metthey partnership; Nice–Bruges 1996, p. 102.
5. Nice–Bruges 1996, pp. 71, 107. Vollard also distributed his ceramic collection to the Musée de Grenoble and the Musée Léon-Dierx in Réunion; Saint-Tropez 2002, p. 19.
6. Cited in Nice–Bruges 1996, p. 75.

84

84. *fig. 217*

Raoul Dufy
La Belle-Enfant, ou L'Amour à quarante ans, by Eugène Montfort

Published by Ambroise Vollard, Éditeur, Paris, 1930 ("Achevé d'imprimer" November 15, 1930)
Illustrated book with 94 etchings and supplementary suite
Page (irreg.) 12 ¹³⁄₁₆ x 9 ¹³⁄₁₆ in. (33 x 25 cm)
The Museum of Modern Art, New York, The Louis E. Stern Collection, 1964 818.1964.a–b
New York and Chicago only

Catalogues raisonnés: Courthion 1951, no. 39; Johnson 1977, no. 185; Chapon 1987, p. 281; Jentsch 1994, no. 22

The novel *La Belle-Enfant, ou L'Amour à quarante ans,* by Eugène Montfort (1877–1936), was first published in 1918. The title comes from the name of the ship that takes one of the protagonists and his mistress to Marseilles. There, after she falls in love with a poet who is indifferent to her charms, another acquaintance, a wealthy businessman, falls in love with her. His love unrequited, the businessman eventually kills her and commits suicide. The story concludes with references to Jason and the Golden Fleece and the moral that wise men find ways to avoid being consumed by love.

On May 1, 1926, Vollard signed a contract with Montfort and Dufy to produce an illustrated edition. The book was to appear as soon as possible and was to include at least forty-five etchings made specifically to accompany the text. Montfort was to be paid 15,000 francs and Dufy 40,000, and both were to receive two copies of the finished book (one on japan paper and one on vellum).[1]

Dufy, already recognized for his illustrated edition of Apollinaire's *Le Bestiaire, ou Cortège d'Orphée* (1911), impressed Vollard with his enthusiasm. The dealer wrote, "[Dufy's] conscientiousness was extraordinary. After several journeys to Marseilles—a Marseilles that is beginning to disappear, which adds still more to the interest of these illustrations—just as he was about to engrave one of the last plates, representing Aline's 'salon,' the artist felt doubtful. It seemed to him that his drawing did not express the atmosphere sufficiently. He had tried to find it in Paris, in *maisons closes* of the same order, but had not succeeded. He decided to go to Marseilles again."[2]

Printing of the book was finished on November 15, 1930, just in time for the exhibition devoted to the Éditions Vollard at Le Portique. Vollard had intended to price the book fairly high, but because of the stock market crash of 1929 he ended up taking

the opposite approach and priced it as low as he could bear (or so he claimed). The book was initially sold for 4,000 francs for copies on japan nacré paper and 2,500 francs for copies on vellum. Dufy's crisp etchings that evoke life in Marseilles blend in and around the passages of text in a whimsical manner, in some ways echoing the fluid design of *Parallèlement* (cat. 15). The book was an instant success. Critics praised Dufy's "ingenious arabesques that play around the text" and the sophisticated yet whimsical manner in which he so charmingly depicted life in Marseilles.[3] The edition was so popular that the first thirty copies, with a suite of additional prints on Montval paper, quickly sold out.[4]

Meanwhile Dufy and Vollard had already begun working on another project, an illustrated edition of Édouard Herriot's *Dans la forêt Normande,* which, the author reported to Vollard, was written in Normandy to give it more sincere color. On September 15, 1931, Herriot informed Vollard that he had finished the text and was sending copies to both him and Dufy.[5] At Vollard's death, the text of the book had been set in type and was awaiting its final printing.

RAR

1. Contract signed by Dufy, Montfort, and Vollard, May 1, 1926: Private collection. Vollard made his second payment of 20,000 francs to Dufy on February 16, 1931: Vollard Archives, MS 421 (9,9), fol. 1.
2. Vollard 1936, pp. 257–58.
3. "Nouveau Livre de Raoul Dufy" 1930–31.
4. Vollard to Emil Handloser [sic], March 3, 1933: Vollard Archives, MS 421 (7,1), fol. 59.
5. Herriot to Vollard, September 15, 1931: Vollard Archives, MS 421 (2,2), fol. 153. Also found among Vollard's papers was a typewritten copy of Herriot's three essays *La Porte océane, Sur les terres des abbayes,* and *Les Foyers spirituel de Rouen,* which had first been published in one volume in 1932: Vollard Archives, MS 421 (6,1), fols. 1–81.

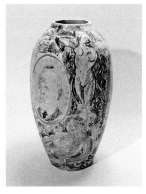

85

85. *fig. 19*

Raoul Dufy
Vase with Portrait of Ambroise Vollard

1930
Tin-glazed ceramic
H. 16½ in. (42 cm), Diam. 9¼ in. (23.5 cm)
Centre Pompidou, Paris, Musée Nationale d'Art Moderne / Centre de Création Industrielle, Bequest of Mme Raoul Dufy, 1963 AM 1157 OA

Dufy, who was always curious about different artistic techniques, made ceramics from 1924 to 1930

and from 1937 to the beginning of World War II in collaboration with the Catalan ceramicist Llorens Artigas (1892–1980). Together they produced miniature ceramic gardens, tiles, and vases.[1] Although Dufy sometimes included portraits on tiles, this portrait vase is unusual in his work. One side of the vase is decorated with a group of female bathers, a theme that Dufy had taken up in his painting around 1913–14. The medallion portrait of Vollard on the other side is based on an etching printed in sanguine that Dufy made for the frontispiece of a catalogue of Vollard's editions, *Catalogue complet des éditions Ambroise Vollard,* published in 1930.[2] In the same year Vollard published Eugène Montfort's *La Belle Enfant,* illustrated with etchings by Dufy (cat. 84).

AD

1. Forest 2003.
2. Paris 1930–31.

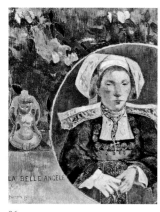

86

86. *fig. 28*

PAUL GAUGUIN
La Belle Angèle (Madame Angèle Satre, 1868–1932)

1889
Oil on canvas
36⅛ x 28¾ in. (92 x 73 cm)
Musée d'Orsay, Paris, Gift of Ambroise Vollard, 1927
RF 2617
Paris only

CATALOGUE RAISONNÉ: G. Wildenstein 1964, no. 315

PROVENANCE: Boussod et Valadon, Paris (Theo van Gogh, director), on consignment from the artist, from September 1889; retrieved by the artist, by February 23, 1891; Gauguin Collection Sale, Hôtel Drouot, Paris, February 23, 1891, no. 3; bought by Durand-Ruel on behalf of Edgar Degas, Paris, until his d. 1917; Degas Collection Sale I, Galerie Georges Petit, Paris, March 26–27, 1918, no. 42; bought by Ambroise Vollard, Paris; his gift to the Musée du Luxembourg, 1927; Musée du Luxembourg, 1927; Musée du Louvre Paris, 1929; Jeu de Paume, Paris, 1947; Musée National d'Art Moderne (Palais de Tokyo), Paris, 1977; Jeu de Paume, Paris, 1986; Musée d'Orsay, Paris, 1986

Gauguin painted *La Belle Angèle* in the summer of 1889, its subject being a young Breton woman whose mother kept an inn not far from the pension in Pont-Aven where the painter was staying.[1] Soon thereafter he sent it to his dealer, Theo van Gogh, at the Boussod et Valadon gallery in Paris. Theo, while

critical of much of Gauguin's production that summer as overly stylized, saw *La Belle Angèle* as an exception. He praised what he saw as its fresh, countrified qualities, the simplicity he also admired in his brother Vincent van Gogh's *Berceuse* (cat. 124), a version of which Gauguin had accepted as a gift early in July. *La Belle Angèle* can be seen as Gauguin's response to Van Gogh's picture.[2]

After Theo's death the picture came back into Gauguin's possession, and he included it in the February 1891 auction of his works at the Hôtel Drouot. There Degas, through Paul Durand-Ruel, acquired the canvas for 450 francs, the third-highest price realized.[3]

Vollard acquired the painting at the sale of Degas's collection in March 1918. He paid 3,200 francs for it, more than twice what he had given the artist for *Where Do We Come From?* (cat. 96) and sixteen times more than Gauguin had received per picture under his contract with the dealer.[4] The respect that Vollard had developed for Gauguin since his death is suggested by the picture's subsequent history, summarized by Claire Frèches-Thory, chief curator at the Musée d'Orsay, Paris: "Robert Rey, assistant curator of the Musée du Luxembourg, has related how Vollard lent him the painting for one of his courses at the École du Louvre, then 'made it known that since *La Belle Angèle* had come as far as the Louvre, he proposed that she should stay there. An elegant and witty gesture.' The committee 'none too warmly, but nonetheless without visible disgust, decided to accept the offer. And that is how *La Belle Angèle* entered the Louvre' or, to be precise, the Musée du Luxembourg in 1927."[5]

DD

1. This entry draws on the catalogue entry by Claire Frèches-Thory in Washington–Chicago–Paris 1988–89, pp. 158–60, no. 89.
2. See Chicago–Amsterdam 2001–2, pp. 293–94.
3. Frèches-Thory in Washington–Chicago–Paris 1988–89, p. 160, n. 10, cites Journal, Archives, Durand-Ruel, Paris, October 18, 1889, to May 31, 1890, 142, 177. See also New York 1997–98, vol. 2, p. 54, no. 482.
4. Frèches-Thory in Washington–Chicago–Paris 1988–89, p. 160. See also Stockbook C, no. 7017.
5. Ibid., with quotes from Rey 1927, p. 106, and Rey 1950, p. 42.

87. *fig. 60*

PAUL GAUGUIN
Green Christ (The Breton Calvary)

1889
Oil on canvas
36¼ x 29 in. (92 x 73.5 cm)
Musées Royaux des Beaux-Arts de Belgique, Brussels
4416

CATALOGUE RAISONNÉ: G. Wildenstein 1964, no. 328

PROVENANCE: Boussod et Valadon, Paris (Theo van Gogh, director), September 1889; bought by Jules Chavasse, Paris/Cette, May 19, 1891; bought by Boussod et Valadon, Paris, October 14, 1893; bought by Ambroise Vollard, Paris, October 14, 1893; bought by Lévy, October 27, 1894; anonymous sale, December 2, 1899, no. 11; possibly Alphonse Kann, Paris; anonymous sale, May 2, 1900, no. 22 (coll. A.K., possibly Alphonse Kann); Maurice Fabre; Dr. Jean Keller, Paris, by 1908; Dr. J. Souliès, sale, November 14, 1921, no. 35; Maurice Fabre; Joseph Breckpot, Brussels, by 1922; bought by Musées Royaux des Beaux-Arts de Belgique, Brussels, December 6, 1922

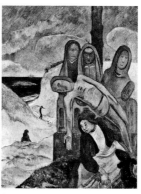

87

Green Christ is one of two pictures based on Breton *calvaires*—the distinctive carved crucifixes erected at public squares—that Gauguin painted late in the summer of 1889; the other was *Yellow Christ* (Albright-Knox Art Gallery, Buffalo, New York; W 327). When he sent the two canvases along with other recent work to Theo van Gogh at the Boussod et Valadon gallery in Paris, Gauguin noted his particular satisfaction with them, describing his aim in *Green Christ* "to make everything exude belief, passive suffering, primitive religious style, and the power of nature with its cry."[1]

Theo van Gogh did not share Gauguin's positive assessment, finding in the work the same pernicious mannerist tendency he discerned in Vincent van Gogh's new pictures—a "search for style" at odds with "the true feeling of things" expressed in the earlier work. It was a criticism that Edgar Degas, and one might assume Camille Pissarro, agreed with.[2] Influenced as he was at this point in his early career by these artists' opinions, Vollard's purchase of *Green Christ* in October 1893 suggests personal conviction.

The work had just come back on the market. According to John Rewald's research in the Goupil-Boussod & Valadon Successeurs Ledgers, in May 1891 Boussod et Valadon had sold *Green Christ* along with another of the artist's pictures to Jules Chavasse, a collector from Cette who had acquired two canvases at Gauguin's February auction. Chavasse paid the gallery 450 francs for each. Gauguin having left for Tahiti, the gallery remitted his share—720 francs—to a friend of the artist, the poet Charles Morice. Gauguin never saw any of this money.[3] Within a few years Chavasse started reselling, consigning *Green Christ* to Boussod et Valadon in 1893.[4]

The Boussod et Valadon stockbook, now in the Research Library of the Getty Research Institute, Los Angeles, confirms the information published by Georges Wildenstein. Though the picture was apparently assigned a much higher value, the gallery sold it to Vollard for 200 francs in a complicated transaction recorded as follows: "Chavasse; bought from the latter on 14 October 1893 by Boussod et Valadon, 900, marked down by 700, leaving 200;—Sold to Vollard on 14 October 1894, 500, marked down by 300, leaving 200."[5] This information differs from that in the ledgers published by Rewald, which indicate that the work was purchased from Chavasse for 900 francs on October 14, 1893, and sold the same day to Vollard for 600 francs.[6] In a concurrent transaction Vollard sold that gallery a very early picture, *The Seine at Pont d'Iéna* (Musée d'Orsay; W 13, W-2001 12) for 500 francs; acquired the previous year, it had been one of Vollard's first purchases of Gauguin's

work.[7] Vollard either had made a profit of 300 francs (per the stockbook) or paid 100 francs (per the ledger), but in any event he had come away with what came to be regarded as a much superior picture.

Gauguin was instantly aware of the transaction. He informed his wife, Mette, that the early riverscape originally given to a friend had sold for 500 francs—evidence that the dealers were looking to buy his early work for "prices easy on the pocket."[8]

In all likelihood, *Green Christ* was among the Breton works by Gauguin featured in Vollard's inaugural exhibition held at his new gallery in January 1894. But he still had the picture in stock a year after he bought it. And when, on October 27, 1894, it was acquired by the dealer Lévy, the profit was modest: Vollard gave Lévy the Gauguin, listed at 250 francs, together with a Maurice Denis canvas, listed at 150, receiving in exchange "6 japanese albums," assigned a value of 300 francs, leaving a cash balance of 100 francs owed him.[9]

Vollard's experience with this remarkable canvas suggested that the market for Gauguin's work was weaker in 1893–94 than it had been in 1891, particularly for works, whether Breton or Tahitian, perceived as difficult. Though history would bear out Vollard's perspicacity in acquiring *Green Christ,* the reality Vollard dealt with was that Gauguin was not an easy sell. This would be the dealer's mantra for the remainder of the artist's life, and one important factor in his hard-nosed financial relations with him.

DD

1. See Chicago–Amsterdam 2001–2, pp. 297ff.
2. Ibid., p. 306.
3. See Rewald 1973, pp. 78 and 91 (ledger typescript).
4. In 1891 Chavasse bought at least four Gauguins, including two at the Gauguin sale, a "Coin de rivière" (perhaps W 261, W-2001 268) and "La Vague" (W 286, W-2001 303). From Boussod he bought *Green Christ* and *The Turkeys* (W 276, W-2001 283). See D. Wildenstein 2001, pp. 16, 377, 395. I am indebted to the Wildenstein Institute, Sylvie Crussard, and Joseph Baillio for this information.
5. See G. Wildenstein 1964, p. 126, no. 328.
6. Rewald 1973, p. 91. I thank Wim de Wit and Mark Henderson of the Research Library, Getty Research Institute, Los Angeles, for verifying that the information in the Boussod et Valadon stockbook (accession no. 900239) is the same as that published by Wildenstein. Rewald clearly had access to another source.
7. Rewald 1973, p. 91, confirmed in D. Wildenstein 2001, p. 15, no. 12.
8. Gauguin to Mette Gauguin, October 1893, in Malingue 1946, p. 249, letter CXLIII. English translation in Malingue 1948, pp. 186–87, no. 143; translation modified by the author.
9. Vollard Archives, MS 421 (4,2), fol. 6, October 27, 1894 [Registre des ventes, a sales book], and MS 421 (4,3), fol. 9, November 24, 1894 [Registre de caisse, an account book].

88.

fig. 61

PAUL GAUGUIN
The Red Cow

1889
Oil on canvas
35¾ x 28¾ in. (90.8 x 73 cm)
Los Angeles County Museum of Art, Gift of Mr. and Mrs. George Gard De Sylva Collection M.48.17.2
New York and Chicago only

CATALOGUE RAISONNÉ: G. Wildenstein 1964, no. 365

PROVENANCE: Gift of the artist to Émile Bernard, Paris; bought from Mme Bernard on behalf of her son by Ambroise Vollard, Paris, August 14, 1894; acquired from Vollard by Georges Chaudet, Paris, on behalf of Gauguin, May 6, 1895, by exchange; bought from Chaudet, acting on behalf of Gauguin, by Vollard, October 12, 1896; Louis-Henri Devillez, Mons, Belgium, before 1931; possibly Étienne Bignou, Paris; H. S. Southam, Ottawa, by 1934; possibly on consignment with Dominion Gallery (Max Stern), Montreal, 1944; Mr. and Mrs. George Gard De Sylva Collection, Los Angeles, by 1946; their gift to the Los Angeles County Museum of Art, 1948

88

Painted in Britanny during the summer of 1889, *The Red Cow,* with its willful stylizations, speaks to Gauguin's ongoing dialogue with Vincent van Gogh, with whom he spent the previous fall in Arles, and his current conversations with their mutual friend, painter Émile Bernard. Sketchbook drawings indicate that Gauguin labored over this picture, which he seems to have given to Bernard before their subsequent falling-out.[1]

In August 1894, while Gauguin was once again painting in Brittany, Vollard purchased *The Red Cow* along with two Van Goghs, for a total of 300 francs, from Bernard's mother, clearly acting on the instructions of her son, then living in Cairo, Egypt.[2] The canvas may have been among the group of Gauguin's Breton canvases that Vollard exhibited at his gallery in March 1895. The sale would have displeased Gauguin on several accounts.

First, Gauguin was anxious to attract and gain support for his recent Tahitian oeuvre and was also in need of money. Vollard's preference for his earlier pictures, which he acquired from various sources, was of no help on either score. Moreover, by featuring Gauguin's early canvases—probably including *The Red Cow*—at his gallery in March 1895, the dealer, albeit inadvertently, opened the door to critics' negative comparison with the artist's recent work. Notable was Camille Mauclair, who lauded the "landscapes from M. Gauguin's good period" for a beauty, subtlety, luminosity, and harmonious color sense that he found lacking in the Tahitian pictures, plagued as they were with "fetishistic philosophy and rather humdrum symbolism."[3] Gauguin was also enraged that Bernard, himself now among the artist's antagonists, would profit from selling canvases to Vollard that he himself had given him.[4]

Gauguin's anger, possibly stoked by Vollard's acquisition of a major pre-Tahitian canvas for so little, may explain the curious developments of spring 1895. On May 6, seven weeks before Gauguin's departure, Georges Chaudet acquired *The Red Cow*

from Vollard in an exchange in which the dealer valued the canvas at 200 francs (twice what he had paid) and received both an antique mirror and a landscape by Maxime Maufra.[5] There is every indication that the Maufra in question was from Gauguin's personal collection and that, despite the fact that Gauguin was still in Paris, Chaudet was acting on his behalf in acquiring *The Red Cow.*[6]

Gauguin's attempt to control the destiny (and market value) of his work seems, in this case, to have had a particularly ironic outcome. In October 1896, Chaudet, responding to Gauguin's desperate pleas from Tahiti for money, entered into several transactions with Vollard. One of them involved Vollard's purchase of a "Gauguin paysage vache rouge" (landscape red cow) from Chaudet. The dealer, taking advantage of the situation, apparently bought back the impressive 1889 landscape for a mere 50 francs.[7]

DD

1. See Chicago–Amsterdam 2001–2, pp. 293ff.
2. Vollard Archives, MS 421 (4,3), fol. 4, August 14, 1894 [Registre de caisse, an account book]. The identification of the present picture as one of these would be confirmed when it formed part of a later exchange Vollard made with Chaudet (see note 5 below). That the Mme Bernard noted in Vollard's account book was indeed the painter's mother has been confirmed by Fred Leeman. Bernard was in Cairo from winter 1893–94 until 1904, according to Stevens et al. 1990, p. 101.
3. Mauclair 1895b, p. 358.
4. On this subject see Gauguin's later letter to Maurice Denis, June 1899 (in Malingue 1946, pp. 290–92, letter CLXXI), where he discusses Bernard and mentions "the thirty or so canvases I gave him and that he sold to Vollard."
5. Vollard Archives, MS 421 (4,2), fol. 12, May 6, 1895 [Registre des ventes, a sales book], which describes the work as "landscape with cow with head cropped and Breton woman with pitcher."
6. In the list of Gauguin's personal collection that Auguste Bauchy drew up in August 1896, item no. 44 is listed: "Maufra, *Paysage* (manque)." Bauchy notes, "The missing objects were exchanged with M. Gauguin's consent and also deposited with M. Chaudet." The document is published in Malingue 1987, pp. 233–34.
7. Vollard Archives, MS 421 (4,3), fol. 55, October 12, 1896 [Registre de caisse, an account book].

89.

fig. 68

PAUL GAUGUIN
Arearea (Joyousness [I])

1892
Oil on canvas
29½ x 37 in. (75 x 94 cm)
Musée d'Orsay, Paris, Bequest of Mr. and Mrs. Frédéric Lung, 1961 RF 1961-6
Paris only

CATALOGUE RAISONNÉ: G. Wildenstein 1964, no. 468

PROVENANCE: The artist, Tahiti and France, 1892–presumably until his d. 1903 (his sale, Hôtel Drouot, Paris, February 18, 1895, no. 8, bought in; consigned by Gauguin to Lévy, Paris, ca. February 1895–early 1896; consigned by Gauguin to Georges Chaudet, Paris, early 1896; consigned by Chaudet on behalf of Gauguin to Ambroise Vollard, Paris, possibly by November 1896; consigned by Gauguin to Daniel de Monfreid, Paris, by 1900; consigned by Monfreid on behalf of Gauguin to Vollard, October 17, 1900); bought from Vollard by Alexandre Berthier, 4th Prince de Wagram, Paris, May 30, 1906; perhaps reclaimed or bought back from him by Vollard, by October 1906; Else Von Guaita, Sonnenleithen, by 1928 (or 1938); Galerie J. B. Neumann, Munich; Frédéric Lung, Algiers, by 1961; bequest of Mr. and Mrs. Frédéric Lung to the Musée du Louvre (Jeu de Paume), Paris, 1961; Musée d'Orsay, Paris, 1986

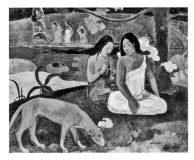

89

Painted late in 1892, *Arearea,* Gauguin's imaginative evocation of a mythic Tahiti, appeared in his one-man show of 1893 and again in the February 1895 auction of his work, where it was bought in at 420 francs.[1] Gauguin left it on consignment with the dealer Lévy. Its subsequent history is as confusing to make out as Gauguin's tangled business arrangements. Vollard's involvement, however, is clear.

Lévy renounced responsibility for Gauguin's work in early 1896 and *Arearea* passed into the hands of Georges Chaudet. It was among the pictures Chaudet left "on deposit" with Vollard, listed as number 7 on Chaudet's inventory (see fig. 72).[2] Like most items on the list, it is designated only by a letter—in this case "H"—with an assigned value of 400 francs. The identity of "H" as *Arearea* is established by Vollard's receipt dated October 17, 1900, "Received from Monsieur de Monfreid, four canvases by GAUGUIN (old) marked H—E—AG—Y—on the reverse, formerly part of the Inventory established by Chaudet on Gauguin's behalf at the price the Chauvet inventory indicated—price to be determined—." This is accompanied by a list of the four works, where "H" is described as "'Arearea.' Red dog and 2 crouching women, playing the flute (?)."[3]

This evidence suggests that *Arearea* was included in the Gauguin exhibition Vollard organized in November 1896, but unexplained is how the picture subsequently passed from Vollard's hands and was in Daniel de Monfreid's before going back to the dealer in October 1900.

The literature points to the exhibition of modern French art that Gauguin's friend the writer Julien Leclercq organized in Stockholm early in 1897 or 1898 in collaboration with the Vollard and Bing galleries.[4] *Arearea* has been identified as among three Gauguin canvases that Leclercq procured for the show from Gauguin's friend William Molard (see cat. 91).[5] The latter indeed sent "several canvases" to the exhibition.[6] However, the appearance of *Arearea* on the Chaudet inventory indicates that early in 1897 the picture was not with Molard but with Vollard. Moreover, an annotation on the verso of the inventory—"exposition Stock[holm] nos [sic] R"—indicates that Vollard indeed sent work by Gauguin to Sweden. This in turn establishes that the Chaudet inventory was drafted, and the works transferred to Vollard, before the opening of the Stockholm exhibition—which becomes its terminus ante quem. However the failure of "H" to appear along with "R" suggests *Arearea* was not sent to Stockholm.

When, why, and how the picture left Vollard's hands only to be returned to them in 1900 by Monfreid remains a mystery related to the "affaire Chaudet." Conceivably *Arearea* was among works that Georges Chaudet took back from Vollard, that on Chaudet's death in 1899 passed to his brother Jean-Léon Chaudet, and that was subsequently reclaimed by Monfreid on Gauguin's behalf. The description in the 1900 receipt of transfer from Monfreid to Vollard suggests it was this canvas, rather than *Tahitian Pastoral,* the version with one woman standing (State Hermitage Museum, St. Petersburg; W 470), that Vollard featured in his Gauguin exhibition of 1903 as number 4, *La Joueuse de flûte,* sold in spring of 1906 to the Prince de Wagram for 7,000 francs, then either reclaimed for nonpayment or bought back in time to show at the Salon d'Automne that fall as number 75, *La Joueuse de flûte.*[7]

DD

1. See Claire Frèches-Thory's catalogue entry in Punaauia 2003, pp. 98–99. It was no. 8 in the 1893 exhibition held at Durand-Ruel's gallery (Paris 1893) and no. 8 in the 1895 auction catalogue (Gauguin Sale 1895).
2. Chaudet inventory, Documentation du Musée d'Orsay, Paris.
3. The unpublished receipt made out by Vollard for Monfreid is dated October 17, 1900: Loize Archives, Musée de Tahiti et des Îles, Punaauia.
4. The opening of the Stockholm exhibition has been dated February 9, 1898, by Bengt Danielsson and Marja Supinen; see Danielsson 1964 and Supinen 1990. Danielsson's dating partly relies on a letter from Leclercq to Molard said to be dated January 7, 1898 ("Extraits de lettres de Julien Leclercq concernant Paul Gauguin," pp. 168–72: typescript in Bengt Danielsson's archives), in which Leclercq says he needs Gauguins for his show. However, two published letters (Gauguin to Monfreid, July 14, 1897, in Joly-Segalen 1950, pp. 108–10, letter XXXIV; Gauguin to Molard, August 1897, in Malingue 1946, pp. 276–77, letter CLXIV) that discuss the exhibition as being under way are both clearly dated 1897; photocopies of the original letters are in the Department of Medieval through Modern European Painting, and Modern European Sculpture, Art Institute of Chicago. Unfortunately, in both instances the excerpts of the letters published in Joly-Segalen and Malingue do not include the parts that deal with the exhibition. Furthermore, in a letter from Gauguin to Molard of March 1898 (in Malingue 1946, pp. 281–82, letter CLXVII) Gauguin says he has heard nothing about the exhibition in Sweden and suggests that a long time had elapsed. See Supinen 1990, p. 7, for a reference to Vollard and Bing.
5. Bengt Danielsson (1964) identifies the three paintings as *Arearea, Manao Tupapau* (cat. 90), and *Te Arii Vahine* (Pushkin Museum, Moscow; W 542). Supinen (1990, p. 8, n. 17) cites Danielsson but confusingly states that Vollard sent all three paintings. Since *Manao Tupapau* was not exhibited (see cat. 90), *Arearea* is considered one of the first two Tahitian canvases by Gauguin to be exhibited in Sweden.
6. See Gauguin to Monfreid, July 14, 1897, in Joly-Segalen 1950, pp. 108–10, letter XXXIV.
7. Vollard Archives, MS 421 (4,1), p. 95, June 11, 1906: Vollard writes to the prince de Wagram, "I am pleased to enclose an invoice for your latest purchases, up through Wednesday, May 30, for the sum of five hundred thousand francs . . ." and lists the works, including "1 Gauguin painting landscape format women playing flute red dog seven thousand 7000 [francs]." See Diffre and Lesieur 2004, where the painting mentioned in this letter is assumed to be the Hermitage picture.

90. *fig. 244*

PAUL GAUGUIN

Manao Tupapau (Spirit of the Dead Watching)

1892
Oil on burlap mounted on canvas
28½ x 36⅜ in. (72.4 x 92.4 cm)
Albright-Knox Art Gallery, Buffalo, New York, A. Conger Goodyear Collection, 1965 1965:1
New York and Chicago only

CATALOGUE RAISONNÉ: G. Wildenstein 1964, no. 457

PROVENANCE: The artist, Tahiti and France, 1892–until his d. 1903 (his sale, February 18, 1895, bought in; consigned by Gauguin to Lévy, Paris, ca. 1895; on deposit with William Molard, Paris, at the request of Gauguin, by 1897/98; consigned with Ambroise Vollard, Paris, by September 1901); bought from Vollard by Count Harry Kessler, Weimar, likely November 1903, certainly by 1904; consigned to Eugène Druet, Paris, 1908–10; bought by Druet, February 1910 (possibly consigned to Roger Fry, London, November 1910); Sir Michael Sadler, Oxford; Lord Ivor Churchill, London; Percy Moore Turner, London; Jacques Seligmann and Germain Seligmann, New York; General Anson Conger Goodyear, New York, by 1938–his d. 1964; Albright-Knox Art Gallery, Buffalo, New York, A. Conger Goodyear Collection, 1965

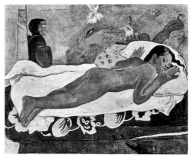

90

Gauguin considered *Manao Tupapau* definitive of his achievement in Tahiti[1] and used it in attempting to promote his work. Reviewers of his 1893 exhibition recognized the picture as a provocative recasting of Édouard Manet's infamous *Olympia.*[2] Photographed by his new artist friend Georges Chaudet, *Manao Tupapau* was reproduced in a review by Roger Marx, the most comprehensive article on Gauguin to date.[3] Gauguin made a print after it, featured it in a self-portrait (cat. 91), and sent it to an exhibition in Brussels with a price tag of 3,000 francs—notably higher than prices of his other work.[4]

Bought in for 900 francs at Gauguin's 1895 auction, *Manao Tupapau,* like the other unsold canvases, was left with Lévy. But unlike most, it did not pass to Chaudet after Lévy disengaged himself. As Gauguin learned from Lévy and wrote to Monfreid, "Chaudet, styling himself (I don't know why), as creditor on my behalf, demanded from Lévi [sic] the painting Manao Tupapau, which he wasn't given."[5] Perhaps through Gauguin's intervention, the picture was entrusted instead to his former neighbor William Molard.[6]

The writer Julien Leclercq borrowed the "Olympia noire" and other Tahitian pictures from Molard for the exhibition of modern French art held in Stockholm in 1897 or 1898.[7] Skeptical about the Stockholm project's worth, Gauguin was subsequently disquieted to learn that Leclercq had taken two of his pictures to Norway.[8] In 1901 Gauguin asked Monfreid to find out whether the pictures "this pimp Julien Leclercq" had borrowed initially for Sweden and subsequently Norway had been returned to Molard.[9] They had not. "No doubt," Monfreid ventured, "the pictures were returned to Vollard."[10]

When Monfreid contacted Vollard, Vollard began by belatedly raising the unresolved issue of the credit due Gauguin for the pictures deposited with

the dealer by Chaudet, now dead two years. Brazenly, Vollard continued: "By the way, there is a painting that's not listed in the inventory and for which I was asked the price. It's a very handsome size 70 canvas, a nude Negress lying on her stomach. . . . What should I ask for it, since Gauguin told me to contact you for all such matters? My sense is that somewhere between 4 and 500 francs would be a good amount."[11] But Monfreid corrected his ignorance: "You are referring to a painting that Gauguin (if it's the same one) considers one of his best canvases. . . . It is titled, in Polynesian, 'Manao tupapau.' I would say this canvas is worth at least 7 to 800 francs. It's one of Gauguin's outstanding works. I thought it had been sold to Joyant or someone else. . . . Do not sell this painting for too little. At one point, Gauguin wanted me to keep it in reserve at my home and not let it go for any price."[12]

The painting was featured in Vollard's 1903 Gauguin exhibition (no. 32), as *L'Esprit veille*.[13] Count Harry Kessler purchased it, but whether before, during, or after the exhibition has been debated. On this score the Vollard Archives are silent.

<div style="text-align:right">DD</div>

1. See Claire Frèches-Thory's catalogue entry in Washington–Chicago–Paris 1988–89, pp. 279–82, no. 154. Gauguin sent the picture from Tahiti for inclusion in the Copenhagen exhibition "Den frie Udstilling" (Free Exhibition of Modern Art), which opened in March 1893; see Copenhagen 1893, no. 159.
2. See Danielsson 1975, p. 125. Gauguin had copied *Olympia* before leaving France (W 413).
3. Marx 1894. On Chaudet's photographs, see Loize Archives, Musée de Tahiti et des Îles, Punaauia.
4. The Brussels exhibition, the first group exhibition of "La Libre Esthétique," opened February 17, 1894. On the paintings included and their pricing, see Washington–Chicago–Paris 1988–89, pp. 282, 293.
5. Gauguin to Monfreid, December 1896, in Joly-Segalen 1950, pp. 96–98, letter XXVII.
6. This explains how in 1896 Molard's future son-in-law came to offer the French State the chance to buy Gauguin's "finest work." See Claire Frèches-Thory in Washington–Chicago–Paris 1988–89, p. 282, no. 154, citing information from Danielsson 1975, pp. 304–5, n. 125; see also Danielsson 1964.
7. "Extraits de lettres de Julien Leclercq concernant Paul Gauguin" (typescript in Bengt Danielsson's archives), pp. 168–72. Though evidently listed in the catalogue, *Manao Tupapau* was apparently not shown because the president of the Swedish Academy of Arts thought it too provocative; see Danielsson 1964. On the date of the Stockholm exhibition, see cat. 89, note 4. See also Supinen 1990.
8. See Gauguin to Molard, August 1897, in Malingue 1946, pp. 276–77, letter CLXIV; see also Gauguin to Monfreid, July 14, 1897, in Joly-Segalen 1950, pp. 108–10, letter XXXIV. By March of 1898 he had heard nothing regarding the results of the Stockholm show; see Gauguin to Monfreid, March 1898, in Joly-Segalen 1950, pp. 120–22, letter XLI, and Gauguin to Molard, March 1898, in Malingue 1946, pp. 281–82, letter CLXVII.
9. Gauguin to Monfreid, June 1901, in Joly-Segalen 1950, pp. 175–79, letter LXXV.
10. Monfreid to Gauguin, September 7, 1901, in Joly-Segalen 1950, pp. 218–20.
11. Vollard to Monfreid, September 16, 1901, in Joly-Segalen 1950, pp. 223–25.
12. Monfreid to Vollard, September 29, 1901: unpublished letter, photocopy in the Department of Medieval through Modern European Painting, and Modern European Sculpture, The Art Institute of Chicago.
13. When Kessler purchased *Manao Tupapau* is unclear. According to Cynthia Saltzman (1998, p. 113), it was in 1901; Peter Kropmanns (1999, p. 25) posits that it was bought from Vollard's 1903 exhibition. In his journal Kessler noted his visit to Vollard's Gauguin exhibition on

November 21, 1903, and on November 25 compared the Gauguin painting he had bought at Vollard's with another of "a cowering woman" in the Sainsère collection; see Kessler 2004–5, vol. 3, pp. 638, 641–43. A number of scholars have identified the former work as *Manao Tupapau* (Bismarck 1988, pp. 53, 60, n. 38; Kropmanns 1997, p. 62; Kessler 2004–5, vol. 3, p. 643, n. 2) and the latter as *Otahi Seule* (W 502) (Kropmanns 1998a, p. 259; Kessler 2004–5, vol. 3, p. 643, n. 1). Julius Meier-Graefe established that the painting was in Kessler's collection by 1904; see Meier-Graefe 1904, p. 378, and Walter 2001, pp. 74, 84, n. 32. *Manao Tupapau* was not included in the checklist of the Gauguin exhibition organized by Kessler in Weimar in 1905 nor mentioned in its review in *Deutschland* (July 9, 1905); for the exhibition checklist as well as excerpts from the review, see Kropmanns 1999. A letter from Vollard to Kessler dated March 1, 1904, mentions a Gauguin, but the work is not identifiable: Vollard Archives, MS 421 (4,1), p. 54. The archives seem to contain records of only two Gauguins purchased by Kessler, an "estampe" and an "aquarelle": Vollard Archives, MS 421 (4,10), pp. 34, 35, November 11, 1904.

91

91. *fig. 69*

PAUL GAUGUIN
Self-Portrait with Hat (Portrait of William Molard on reverse)

Ca. 1893–94
Oil on canvas
18⅛ x 15 in. (46 x 38 cm)
Musée d'Orsay, Paris RF 1966-7

CATALOGUE RAISONNÉ: D. Wildenstein 1964, nos. 506, 507

PROVENANCE: Gift of the artist to the sitter, William Molard (verso), Paris, 1894–his d. 1936; by descent to his stepdaughter, Mme Edmond Gérard, Paris; Ambroise Vollard, Paris, ca. 1936–39; private collection, Switzerland, by 1944; Douglas Cooper, London; Charles W. Boise, London; Musée du Louvre (Jeu de Paume), Paris, 1966; Musée d'Orsay, Paris, 1986

Although this canvas was included in the Gauguin retrospective at the 1906 Salon d'Automne, the painter's self-portrait was not on view. Rather, as was acknowledged in catalogue number 223—"Portrait de M. Mollard. Au dos, un Portrait de Gauguin"—visitors saw instead the full-face portrait the artist had painted on the other side of the canvas, loaned to the exhibition by the sitter: Gauguin's friend the composer William Molard.[1]

Molard, a young musician with a wife and stepdaughter, was Gauguin's neighbor in the building at 6, rue Vercingétorix, where in December 1893 the artist rented two large rooms that served as home and studio. Here, early in the new year, he began to receive friends at weekly gatherings, where visitors

were treated to the artist's readings from his manuscript *Noa Noa* (see cats. 105, 106) and the presence of his "exotic" new girlfriend Annah, a teenage native of Ceylon to whom Vollard had introduced him.[2] Gauguin's self-portrait wearing a jaunty hat and knowing expression is set in this space, whose walls the artist painted chrome yellow and olive green, brilliant foils for the various objects—South Pacific artifacts, reproductions of old and modern masters, original works by contemporaries like Paul Cézanne and Vincent van Gogh, and his own paintings, prints, and drawings—that he hung on them.

Behind Gauguin in a yellow frame and above a blue Polynesian fabric draped on a chair hangs *Manao Tupapau (Spirit of the Dead Watching)* (cat. 90), the picture Gauguin regarded as his quintessential Tahitian work. Its composition, however, is reversed, the figure facing toward the viewer's left. The most obvious reason is that Gauguin is representing what he saw in the mirror in which he studied his own likeness. However, both the diminutive scale and the compositional reversal remind us that at the time of this self-portrait Gauguin was probably at work on or had just completed his lithograph based on *Manao Tupapau*, undertaken in response to publisher André Marty's invitation to contribute to his landmark periodical *L'Estampe originale*.[3] Working directly on the lithographic stone, Gauguin drew his composition in the same direction as the painting, and as a result it was reversed in the printing.

Gauguin's promotion of *Manao Tupapau* was connected to his current literary project, *Noa Noa*. In it his claim for artistic regeneration in the South Pacific was interwoven with an account of his going native and "marrying" the teenage Tehura, whom he depicts lying on her bed at night, terrified, as he wrote, of "legendary demons or specters."[4]

This was not the first time Gauguin had chosen to represent himself together with work he considered symbolic of his recent achievement. In 1889 he had painted himself in the company of his ceramic self-portrait as a grotesque head and the painting *Yellow Christ* (Musée d'Orsay, Paris; W 324).[5] The flair for dramatic self-presentation evident in the two Musée d'Orsay canvases was exaggerated in two other self-portraits in which Gauguin explicitly identified himself with Christ's sufferings: the 1889 *Christ in the Garden of Olives* (Norton Museum of Art; W 326) and an 1896 self-portrait inscribed "Près du golgotha / P. Gauguin—96" (Museu de Arte de São Paulo; W 534).

In light of the fraught relationship between painter and dealer, it is somewhat ironic that Vollard would acquire so many of Gauguin's self-portraits. In 1902 he purchased the self-portrait with the *Yellow Christ* from Daniel de Monfreid, trading it the following year to Maurice Denis.[6] In 1904 Vollard acquired from Boussod the *Christ in the Garden of Olives*, exhibited in his 1910 Gauguin exhibition, listed fifth on its checklist.[7] Vollard purchased the *Self-Portrait near Golgotha* from Victor Segalen in April 1906, after the latter's return from Tahiti, where he had bought the work. Vollard paid him 600 francs. Two months later Vollard sold it to Alexandre Berthier, Prince de Wagram, for 3,500 francs[8] (one recalls Gauguin's complaints of markups). It was toward the end of his own life that Vollard purchased the picture shown here from Molard's stepdaughter.

<div style="text-align:right">DD</div>

1. For Molard's portrait see Washington–Chicago–Paris 1988–89, pp. 311–13, no. 164.
2. Vollard 1936, p. 173; Vollard 1937b, pp. 195–96.
3. For the print, see Mongan, Kornfeld, and Joachim 1988, no. 23. In his prospectus for *L'Estampe originale*, seemingly issued before the appearance on March 30, 1893, of the first installment, Marty listed Gauguin among those whose cooperation had been promised, but this may have been wishful thinking. (Camille Pissarro, also listed, had only agreed to participate in early March 1893.) Gauguin's lithograph was published in fascicle 6 (April–June 1894).
4. Washington–Chicago–Paris 1988–89, p. 280, no. 154.
5. See ibid., pp. 177–78, no. 99.
6. See Monfreid to Vollard, May 21, 1902: unpublished letter, photocopy of original letter in the Department of Medieval through Modern European Painting, and Modern European Sculpture, The Art Institute of Chicago. See also Denis to Vollard, December 1903: Vollard Archives, MS 421 (2,2), p. 82.
7. Paris 1910; Stockbook B, no. 3507, "Le Christ aux oliviers."
8. Vollard Archives, MS 421 (5,1), fol. 64, April 5, 1906, and MS 421 (4,1), p. 95, June 11, 1906. See also Diffre and Lesieur 2004, p. 308.

92

92. *fig. 62*

Paul Gauguin
Breton Women (Two Peasants on a Road)

1894
Oil on canvas
26 x 36¼ in. (66 x 92.5 cm)
Musée d'Orsay, Paris, Gift of Max and Rosy Kaganovitch, 1973 RF 1973-17

CATALOGUE RAISONNÉ: G. Wildenstein 1964, no. 521

PROVENANCE: Bought from the artist by Władysław Ślewiński, Paris, 1894 or 1895; bought by Ambroise Vollard, Paris, by 1910; [?Dr. Robert] Witzinger, Basel; Collection Max Kaganovitch, Paris, possibly by 1938; gift of Max and Rosy Kaganovitch to the Musée du Louvre (Jeu de Paume), Paris, 1973; Musée d'Orsay, Paris, 1986

On his return to France from the South Pacific in fall 1893, Gauguin at first continued to make works on Tahitian subjects. But in the spring of 1894, when he returned to Brittany to spend the summer, his interest in Breton themes naturally revived. The artist painted few canvases during his seven months' stay, however, because of injuries sustained to his leg in a brawl in late May with local sailors.

Breton Women is one of the few ambitious canvases Gauguin realized before returning to Paris in November. Featuring two young women in local costume conversing in a landscape, the composition shares the monumentality of earlier Tahitian canvases in which the artist has the human figure physically dominate the natural setting. This strategy is even more apparent in a bizarre contemporary canvas featuring a fair-skinned young woman wearing a

Tahitian missionary dress, standing with hands folded in prayer against a Pont-Aven landscape (Sterling and Francine Clark Art Institute; W 518).

While the latter was included in the February 1895 auction of Gauguin's work under the title *Young Christian, Breton Women* cannot be readily identified with any of the works with Breton themes listed in the sales catalogue.[1] The picture disappears from sight until Vollard's Gauguin exhibition of 1910, where it is listed third in the catalogue: "Bretonnes (1894)" with the note "(Après le 1er voyage de Tahiti)"[2] —one of two canvases in the group of Breton pictures so designated. Unmentioned in the Vollard Archives, the Orsay canvas seems to have come into the dealer's possession only recently.[3]

Where was the picture in the interim? Either Gauguin brought it back with him from Brittany— in which case it would inevitably have been included in the auction—or he left it there. Either scenerio may have included Gauguin's close friend and Vollard's client, the Polish painter Władysław Ślewiński.[4]

Early in his summer 1894 stay in Brittany, Gauguin had briefly lodged at Ślewiński's Le Pouldu villa.[5] Ślewiński later became a buyer at Gauguin's February 1895 auction, paying 430 francs for a picture listed under catalogue number 14 as *Piti Teina* (or *Two Sisters*).[6] Matching the picture with Gauguin's oeuvre has proven elusive: Władysława Jaworska identified it as a pastel featuring two Breton girls (W 341), a thesis Georges Wildenstein only partially endorsed.[7] Indeed, the amount paid seems unlikely for a modestly scaled pastel. Wildenstein assigned a second number (W 479) to *Piti Teina,* listing it as "unidentified." It is possible that the picture sold as *Piti Teina* was in fact the Orsay canvas of the two young Breton women—Gauguin could have clothed a Breton subject in a Tahitian title much as he had clothed the Breton girl in Tahitian missionary garb and the title *Young Christian.*

The other possibility is that Gauguin gave or sold the picture to Ślewiński before he left Brittany. In 1902, Gauguin, established in the Marquesas, inquired of Vollard how it had come about that Ślewiński was in possession of a group of his pictures. Vollard allowed that he had sold the Polish painter two of his canvases and had moreover understood, from their mutual acquaintance William Molard (see cat. 91), that Ślewiński had also acquired canvases directly from Gauguin.[8] Both scenarios presuppose that Vollard bought the picture from Ślewiński, as he bought from other clients.

DD

1. See Chicago–Amsterdam 2001–2, p. 344.
2. Paris 1910; and see "Exhibitions *chez* Vollard" in this volume.
3. The only possible reference in the Vollard Archives is to the photographic negative; in Stockbook B, no. 4537 (cliché).
4. See Gauguin's portrait of Ślewiński (National Museum of Western Art, Tokyo; W 386).
5. See Washington–Chicago–Paris 1988–89, p. 293.
6. See Gauguin Sale 1895, no. 14.
7. Jaworska 1957.
8. Gauguin to Vollard, March 1902: French typescript, Department of Medieval through Modern European Painting, and Modern European Sculpture, The Art Institute of Chicago. English translation in Rewald 1943 (1986 ed.), pp. 202–3. See also Vollard to Gauguin, May 18, 1902: unpublished, photocopy of original letter in the Department of Medieval through Modern European Painting, and Modern European Sculpture, The Art Institute of Chicago.

93

93. *fig. 252*

Paul Gauguin
Eiaha Ohipa (Don't Work)

1896
Oil on canvas
25½ x 29½ in. (65 x 75 cm)
Pushkin State Museum of Fine Arts, Moscow 3267

CATALOGUE RAISONNÉ: G. Wildenstein 1964, no. 538

PROVENANCE: Sent by the artist from Tahiti to Daniel de Monfreid, November 1896; on consignment from Monfried (acting on behalf of Gauguin) to Georges Chaudet, Paris, by February 1897; bought by Ambroise Vollard, Paris, probably April 1897; bought by Sergei Shchukin, Moscow, November 1906; Museum of Modern Western Painting, Moscow, 1918; State Museum of Modern Western Art, Moscow, 1923; State Hermitage Museum, St. Petersburg, 1948; Pushkin State Museum of Fine Arts, Moscow

Eiaha Ohipa (Don't Work) is one of many compositions realized in the South Pacific in which Gauguin based the figures' postures on photographs he had brought with him of the bas-reliefs of the Buddhist temple of Borobudur in Indonesia. This particular canvas was painted in the artist's studio in Punaauia, on the island of Tahiti, in 1896 and sent to Paris, where Daniel de Monfreid received it in early November.[1]

It was one of three recent pictures in the group of six Tahitian canvases that it seems Georges Chaudet arranged to have shown in the fourth exhibition of "La Libre Esthétique" that opened on February 25, 1897, in Brussels.[2] It appeared as number 280 in the catalogue as *Eiaha Ohipa*–1896, and was priced at 600 francs, the amount asked for all but the Nativity subject *Te Tamari no atua* (Bayerische Staatsgemälde Sammlungen, Munich; W 541), which cost 400 francs more.

After the exhibition's close on April 1 it seems that at least four of the six canvases passed from Chaudet to Vollard.[3] Two drafts paid to Chaudet for Gauguin listed in Vollard's archives—of April 5 for 400 francs and of April 17, 1897, for 300—probably reflect the transfer, but it is unclear how many pictures were involved.[4] The former payment possibly included *Te Tamari no atua,* which later appears in Stockbook B as number 3821, "La Nativité, 96 x 131," with Chaudet listed as the provenance and 500 francs as the price Vollard paid. The discrepancy of 100 francs may arguably involve the 20 percent commission Vollard later discussed with Gauguin, or more than one picture could have been involved.[5]

Eiaha Ohipa appears in Stockbook B as number 3334, described as "Femme nue, assise et femme robe bleue, 66 x 76." Chaudet is listed as the source, but the column for the purchase price is left blank.

Possibly the April 17, 1897, transaction involving 300 francs—half of what the picture was listed as in Brussels—is pertinent.

Eiaha Ohipa was shown as catalogue number 67 in the Gauguin retrospective at the Salon d'Automne in the fall of 1906, held in the Grand Palais. It was among the eighteen paintings listed as coming from Vollard's collection (he also lent fourteen drawings and two sculptures).[6] Shortly thereafter it was acquired by Russian collector Sergei Shchukin. The Vollard Archives contain a note of November 19, 1906, documenting the delivery of this painting to Shchukin's agent.[7]

DD

94

1. See Washington–Los Angeles–New York 1986, p. 80, no. 23. See also Loize 1951, p. 100, no. 200.
2. Monfreid to Gauguin, March 12, 1897, in Joly-Segalen 1950, pp. 205–6. The Gauguin works in the 1897 "La Libre Esthétique" (Brussels 1897) were: no. 277, *Fatata te miti* (1892, National Gallery of Art, Washington, D.C.; W 463); no. 278, *Te'oa no Areais* [*sic*] (1892, Museum of Modern Art, New York; W 451); no. 279, *Hina Maruru* (1893, private collection; W 500); no. 280, *Eiaha Ohipa* (1896, Pushkin Museum; W 538); no. 281, *Bébé* (1896, Hermitage; W 540); no. 282, *Te Tamari no atua* (1896, Bayerische Staatsgemälde Sammlungen, Munich; W 541).
3. A Vollard provenance was identified in G. Wildenstein 1964 for W 463, W 538, and W 540. W 541 appears in Vollard's Stockbook B, no. 3821.
4. Vollard Archives, MS 421 (4,3), fol. 70, April 5, 1897 [Registre de caisse, an account book]; MS 421 (4,3), fol. 71, April 17, 1897 [Caisse].
5. Vollard to Gauguin, December 9, 1901: Vollard Archives, MS 421 (4,1), p. 41.
6. See Paris (Salon d'Automne) 1906, pp. 65–66. In the catalogue, the paintings Vollard lent are numbered 61–78; the drawings are numbered 79–92; the sculptures are numbered 93 and 93bis.
7. "Livré à Schreder[?] pour Stchoukine no. 3334, 3333 et sans no. de Ch. Leclanché—nu[?] Gauguin": Vollard Archives, MS 421 (5,1), fol. 184, November 19, 1906. Suzanne Diffre and Marie-Josèphe Lesieur (2004, pp. 307–8) cite an earlier archival entry dated November 5, 1906, in which Vollard records, "Vendu à Stchoukine 3 Gauguin La couronne de marguerites / Nativité et La femme à la cigarette": Vollard Archives, MS 421 (5,1), fol. 172, and identify *Eiaha Ohipa* with "La femme à la cigarette." The latter reference, however, applies instead to *Vaïraumati Tei Oa (Her Name Is Vaïraumati)* (1892, Pushkin Museum; W 450). Diffre and Lesieur correctly note that *Eiaha Ohipa* is mentioned as one of a number of pictures on a bill from Charles Chapuis dated September 27, 1906: Vollard Archives, MS 421 (3,4), p. 10.

94. *fig. 75*

PAUL GAUGUIN
The Bathers

1897
Oil on canvas
23¾ x 36¾ in. (60.4 x 93.4 cm)
National Gallery of Art, Washington, D.C., Gift of Sam A. Lewisohn 1951.5.1

CATALOGUE RAISONNÉ: G. Wildenstein 1964, no. 572

PROVENANCE: Sent by the artist from Tahitit on consignment to Daniel de Monfreid, summer of 1898; bought by Ambroise Vollard, Paris, October 30, 1898; bought by Edgar Degas, Paris, November 1898–his d. 1917; Degas Collection Sale I, Galerie Georges Petit, Paris, March 26–27, 1918, no. 47; probably bought by Jos Hessel, Paris; probably bought by Ambroise Vollard, Paris; Adolph Lewisohn, New York (probably bought from Vollard), by 1921–his d. 1938; by descent to his son Sam A. Lewisohn, New York, 1938– his d. 1951; his bequest to the National Gallery of Art, Washington, D.C., 1951

On October 30, 1898, Daniel de Monfreid, briefly in Paris to take care of Gauguin's interests, sold Vollard four of the paintings from the artist's last shipment—that of mid-July—for a total of 600 francs.[1] Monfreid left the rest of the canvases with Georges Chaudet, following Gauguin's directive regarding the exhibition of his recent work. In his letter informing Gauguin of the Vollard transaction and conveying the proceeds, Monfreid described each of the four pictures involved. The National Gallery *Bathers* can be identified with the one Monfreid listed second—"Women bathing, in a shimmering landscape"—because he likened it to an earlier composition that had been purchased by a Dr. Gouzer (W 539).[2] Monfreid also noted that the new picture was exceptionally beautiful.[3]

Featuring the canvases just acquired plus those left with Chaudet (see cats. 95–97), Vollard's exhibition of Gauguin's recent work that opened on November 17, 1898, included *The Bathers*.[4] It may be the "very successful landscape" to which the reviewer Thadée Natanson referred.[5] Listed at 500 francs, *The Bathers* is the canvas that Edgar Degas purchased from Vollard eight days after the opening,[6] as Chaudet's subsequent communication to Gauguin explaining the events leading to the rue Laffitte show leaves no doubt: "Among those paintings there was one, the smallest one you sent, I think, a small horizontal-format canvas of nude women in a marvelous landscape. / I was mad to have it, to my mind it's one of the loveliest works you've ever created. Unfortunately I was too late, since Vollard had already bought it and set the price too high for my means / *Degas got it from him on exchange*."[7]

The Bathers is indeed somewhat smaller than Gauguin's habitual size 30 (73 x 92 cm) format. Whether or not the transaction with Degas involved an exchange is uncertain. Vollard's accounts indicate Degas's immediate payment of 200 francs against the 500. Another account book entry for November 1898 indicates a 350-franc profit on the picture that squares with the cost to the dealer of 150 francs.

Gauguin greatly admired Degas, but any pleasure potentially derived from Chaudet's news was poisoned upon learning of Monfreid's December sale to Vollard of nine pictures for roughly 115 francs apiece. Sick, disheartened by the "incessant battle" for survival, and now highly agitated, Gauguin interpreted Degas's interest as potential duplicity: "I know Degas and Rouart: they no doubt told Vollard to buy, preferring, in return for a small price difference, to purchase [my pictures] from Vollard rather than from you. That way there's no shame in buying cheaply." He counterstrategized: Monfreid should sell his work to a select clientele at more flexible prices with no further discounts for Vollard, and inform Degas of the details of the two recent

sales—"Vollard's coup"—to make him appreciate the large markup he had paid for *The Bathers* and realize he could do better by dispensing with intermediaries and buying directly from Monfreid.[8]

DD

1. Vollard Archives, MS 421 (4,3), fol. 112, October 30, 1898 [Registre de caisse, an account book]. See also receipt signed by Monfreid, October 30, 1898 (unpublished document: photocopy of original receipt in the Department of Medieval through Modern European Painting, and Modern European Sculpture, The Art Institute of Chicago) and letter from Monfreid to Gauguin, November 11, 1898, in Joly-Segalen 1950, pp. 209–10.
2. Monfreid to Gauguin, November 11, 1898, in Joly-Segalen 1950, pp. 209–10. This is W 539, *Trois tahitiennes*, 1896, 24.7 x 43.2 cm, Private collection. The work listed as no. 3 may be *Faa Ara* (1898, Ny Carlsberg Glyptotek; W 575), according to Munk and Olesen 1993, p. 110.
3. Monfreid to Gauguin, November 11, 1898, in Joly-Segalen 1950, pp. 209–10.
4. For the most inclusive discussion to date of the November 1898 exhibition and the works featured in it, see Shackelford 2004 (where *The Bathers* is not specifically listed as in the 1898 exhibition; see p. 191). Brettell (in Washington–Chicago–Paris 1988–89, p. 416, no. 224) implies that the work was in the 1898 exhibition. We know that *Faa Ara* (see note 2 above), another of the four canvases acquired October 30 from Monfreid, was in the exhibition; see Eckermann 2003. I thank George Shackelford for confirming its inclusion.
5. Natanson 1898c, p. 545; cited by Shackelford 2004, p. 187, who suggests (p. 191) that the reference could be to *Te Vaa* (State Hermitage Museum, St. Petersburg; W 544).
6. Vollard Archives, MS 421 (4,3), fol. 114, November 25, 1898 [Caisse]: "Degas à c[om]pte / Gauguin négresses à 500 [in column labeled *entrée*] 200 [francs]." The possible identification with this picture was made in New York 1997–98, vol. 2, p. 55, no. 487.
7. Chaudet to Gauguin, January 15, 1899: unpublished letter, Loize Archives, Musée de Tahiti et des Îles, Punaauia.
8. Gauguin to Monfreid, February 22, 1899, in Joly-Segalen 1950, pp. 136–38, letter LI.

95

95. *fig. 76*

PAUL GAUGUIN
Vairumati

1897
Oil on canvas
28½ x 37 in. (73 x 94 cm)
Musée d'Orsay, Paris, Kojiro Matsukata Collection; acquired by the Musée du Louvre in application of the peace treaty with Japan, 1959 RF 1959-5
Paris only

CATALOGUE RAISONNÉ: G. Wildenstein 1964, no. 559

PROVENANCE: Sent by the artist from Tahiti on consignment to Daniel de Monfreid, Paris, summer 1898 (consigned by Monfreid on behalf of Gauguin to Georges Chaudet, Paris, October 1898; consigned by Chaudet on behalf of Gauguin to Ambroise Vollard, Paris, November 1898); bought from Gauguin through Monfreid by Vollard, December 8, 1898; Prince Kojiro Matsukata, Kōbe, Japan, by 1923; acquired with the Kofiro Matsukata Collection by the Musée du Louvre, Paris, as part of the terms of the peace treaty between France and Japan, 1959; Musée du Louvre (Jeu de Paume), Paris, 1959; Musée d'Orsay, Paris, 1986

Vairumati is the goddess in the Tahitian creation myth that Gauguin twice depicted on his first Tahitian trip.[1] This canvas from the second sojourn was among the group of nine pictures that, along with *Where Do We Come From?* (cat. 96), Daniel de Monfreid left with Georges Chaudet in October 1898, with the idea that Chaudet would hold an exhibition of Gauguin's recent work in his studio, following the artist's wishes.[2] Instead, Chaudet, forced by ill health to leave Paris and claiming that his studio was too small for an exhibition, "asked Vollard to take charge of it."[3] The dealer readily accepted, and the exhibition, with *Where Do We Come From?* as its centerpiece and including additional work Vollard had acquired in late October (see cat. 94), opened on November 17.

Vairumati is among the pictures directly related to motifs in *Where Do We Come From?* that critic Thadée Natanson noted "might just as well be fragments or replicas as preparatory studies."[4] As George Shackelford has noted, *Vairumati,* which reprises and recasts the figure that appears second from the left in the large canvas, is the work that Natanson described as representing "a sort of altar or bed . . . in precious metals"; he also remarked that "the nude female body that stretches out upon it displays a grace to which we were no longer accustomed from the painter."[5] This praise was at the expense of *Where Do We Come From?* Natanson, like other critics, found the smaller pictures of separate motifs more successful because he considered them less "obscure" and more compositionally resolved than the large, multifigured composition.

On December 8, Vollard paid Monfreid 1,000 francs for nine canvases by Gauguin, including *Vairumati.*[6] Since they had come to him directly from Chaudet, Vollard wrote to inform him of the transaction, and Chaudet in turn alerted Gauguin in mid-January.[7]

Displeased with this sale, Gauguin was indignant that Monfreid should refer to the pictures involved as "small canvases," since, albeit smaller than *Where Do We Come From?,* they were size 30 canvases. Moreover, the price Vollard paid averaged less than the 150 francs per picture Vollard had given Monfreid in October. Feeling bested, Gauguin denounced Vollard as "a predator of the worst kind" and accused Chaudet and Monfreid of letting him down.[8]

This picture did not appear in Vollard's Gauguin exhibition of 1903, nor has any record of it been found in Vollard's stockbooks. Whether Prince Matsukata acquired the work directly from Vollard is uncertain. DD

1. See Cachin 1988, p. 224.
2. Chaudet framed the nine pictures that Monfreid subsequently sold to Vollard and which Shackelford has for the most part persuasively identified. See Rotonchamp 1925, p. 172, and Shackelford 2004, p. 327, n. 42.
3. Chaudet to Gauguin, January 15, 1899: French typescript, Loize Archives, Musée de Tahiti et des Îles, Punaauia.

English translation in Shackelford 2004, p. 186; translation modified by author.
4. Natanson 1898c, p. 545, translated in Shackelford 2004, p. 187.
5. Natanson 1898c, p. 546, translated in Shackelford 2004, p. 187.
6. Vollard Archives, MS 421 (4,3), fol. 116, December 8, 1898 [Registre de caisse, an account book].
7. Chaudet to Gauguin, January 15, 1899: Loize Archives, Musée de Tahiti et des Îles, Punaauia. Chaudet notes that he had received Vollard's letter about a month ago.
8. Gauguin to Monfreid, February 22, 1899, in Joly-Segalen 1950, pp. 136–38, letter LI.

96. *fig. 13*

PAUL GAUGUIN
Where Do We Come From? What Are We? Where Are We Going?

1897–98
Oil on canvas
54¾ x 147½ in. (139.1 x 374.6 cm)
Museum of Fine Arts, Boston, Tompkins Collection—Arthur Gordon Tompkins Fund 36.270
New York and Chicago only

CATALOGUE RAISONNÉ: G. Wildenstein 1964, no. 561

PROVENANCE: Sent by the artist from Tahiti to Daniel de Monfreid, Paris, summer 1898, for consignment (consigned by Monfreid on behalf of Gauguin to Georges Chaudet, Paris, October 1898; consigned by Chaudet on behalf of Gauguin to Ambroise Vollard, Paris, November 1898); bought by Gabriel Frizeau, Bordeaux, 1901; bought by Galerie Barbazanges, Paris, probably 1913; bought by J. B. Stang, Oslo/Kristiana, Norway, before 1920; Alfred Gold, Paris, 1935; Harriman Gallery (Marie Harriman), New York, 1936; bought by the Museum of Fine Arts, Boston, April 16, 1936

Begun in December 1896, *Where Do We Come From? What Are We? Where Are We Going?* is Gauguin's masterpiece, self-consciously created to be superior to anything he had done previously or might do in the future.[1] In February 1898, Gauguin spoke of the completed picture to Daniel de Monfreid as a kind of testament he wished to make before dying and prefaced his remarks with an account of his recent failed suicide attempt. Ambitious in scale—with the intended appearance of a fresco, upper corners damaged, attached to a golden wall—the multifigured composition was far-reaching in its complex web of suggestive themes, which Gauguin outlined for Monfreid. He summed up by stating that with *Where Do We Come From? What Are We? Where Are We Going?* he had realized "a philosophical work . . . comparable to the Gospel," that was essentially different from the more academically realized compositions of muralist Pierre Puvis de Chavannes.[2]

Notifying Monfreid in mid-July of the shipment

of his recent pictures, Gauguin expressed preferences about their exhibition and requested "As for the major painting ("grand tableau"), don't ask too much for it on account of its size; I'd rather it go into the right hands"—such as those of Henry Lerolle or Michel Manzi, who had acquired the most thematically ambitious picture of his first Tahitian stay, *Ia Orana Maria* (1891, Metropolitan Museum, New York; W 428), from his 1893 one-man show.[3]

Much to Gauguin's chagrin, Monfreid sold thirteen of the recent pictures, cheaply, to Vollard, who organized their exhibition at his gallery beginning on November 17. The "grand tableau," which Georges Chaudet had had framed in white, was the exhibition's centerpiece and the only canvas that Vollard had not acquired, whether because of his own lack of interest or Monfreid's disinclination to sell for little a work the artist prized so highly.

Gauguin anxiously awaited the response to his "grand canvas," which he hazarded "must be (it seems to me) either very good or very bad."[4] But the feedback was disappointing. Chaudet avoided mention of the picture. Monfreid was critical, apparently focusing on what he regarded as its insufficient technical realization.[5] André Fontainas, the most important critic to review the show, preferred the smaller works the artist deemed relatively "unimportant" to the large canvas, whose allegorical thrust he found illegible—unlike the more accessible murals by Puvis de Chavannes. Gauguin countered that his "large decorative canvas" was not literary in intention, and that while Puvis explained ideas, he painted them.[6]

Gauguin's belief in the picture withstood his disappointment that by August 1899 Vollard had yet to make an offer for it.[7] When the following spring the artist imagined an exhibition at Vollard's comprising the best of his recent and earlier work to coincide with the forthcoming Exposition Universelle, he was thinking of *Ia Orana Maria,* one or two of the pictures Edgar Degas owned (cat. 94), and *Where Do We Come From?*[8] Though no such exhibition materialized, in June 1900 Vollard finally wrote inquiring about the price of the picture.[9] Gauguin replied: "The large canvas you mention, where are we going!, I should prefer to keep in reserve until later; in any event I think that 1,500 francs is a very reasonable price and that you could easily find a buyer at 2,000 francs. The picture I sold to Menzy [*sic*] [*Ia Orana Maria,* for 2,000 francs] was much less important."[10] Subsequent events typified the problematic nature of their relationship.

In September 1900 Gauguin informed Monfreid of Vollard's inquiry and of the minimum price of 1,500 francs he had set.[11] He reiterated the dealer's interest in his letter of the next month[12] and yet again in December, but this time wrote, "I told him 2,000 francs, he'll immediately go to see clients

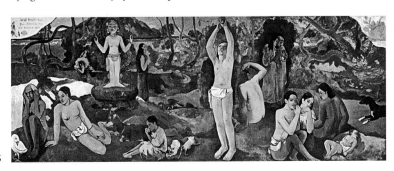

96

and come up with 10,000. Naturally he said he accepts my price of 2,000 francs—no doubt he's robbing me."[13]

Such thinking set the stage for Gauguin's response to the stratagem proposed in May 1901 by his old friend poet Charles Morice upon seeing the artist's "masterpiece" again at Vollard's gallery. The plan entailed getting a group of artists and collectors to buy the picture from Gauguin for 10,000 francs and offer it to the Musée du Luxembourg; the state museum would refuse it, offering the occasion for a "manifestation"—an exhibition of *Where Do We Come From?* and a conference organized around it—that would raise Gauguin's profile. To set this plan in motion, Gauguin would have to instruct Vollard to take the picture off the market and turn it over to a designated party. Morice closed his letter by observing that he had not mentioned a word of his plan to Vollard.[14]

Gauguin recognized this as another of Morice's hollow flights of fancy but could not resist the lure of a grand scheme; he put forth names Morice could tap for the subscription and suggested lowering the purchase price to a more reasonable 5,000 francs.[15] To Monfreid he wrote, *"You must also* see Vollard in case he's claiming he owns the picture, which would be *absolutely false,"*[16] and again, "Keep a close eye on what happens with the large painting."[17]

Monfreid warned Gauguin against counting on Morice, whom everyone mistrusted and whose efficacy was compromised by an absinthe habit. At the time Monfreid was away from Paris and could not supervise,[18] but he dutifully contacted Vollard, disingenuously inquiring whether he had heard of Morice's plan to raise a subscription "to buy a *major* picture from Gauguin (which one???)" for the state and observing that "it's necessary to push [this along] a bit, if need be, because that would raise the market for Gauguin's works."[19] Vollard's response reveals that he understood what was afoot—apparently having learned from the artist that he wanted to take back the large canvas, "you know with ten or more figures"—but thought the plan absurd: Morice was a "swindler" and there was no chance, given recent precedent, that the state would accept the picture.[20] Essentially, Monfreid agreed.[21]

However, a buzz had been created around the picture that marshaled both potential collectors and the dealer to action. On September 18, Morice wrote informing Gauguin that his plan had been thwarted because *Where Do We Come From?* had been sold. He explained that Francisco "Paco" Durrio y Madrón, a sculptor who was Gauguin's friend, had interested an acquaintance in buying it. Vollard had told Durrio he was asking 1,200 francs, of which 200 was the dealer's commission, but when Durrio returned with the potential client he found that Vollard had changed his mind, having received word from Émile Schuffenecker that he should not sell for less than 2,000 francs. The client went away angry, but to make things worse, when Durrio subsequently found another willing to pay 2,000 francs, Vollard upped the asking price to 2,500 francs and then sold the picture. Morice could only imagine what the dealer had received for the work from the client, Gabriel Frizeau, a Bordeaux collector who had bought two canvases from the 1898 exhibition.[22]

In November Gauguin received word of the sale from Vollard and, in light of Morice's news, was astonished to learn that the purchase price had been

1,500 francs.[23] Vollard did not mention his profit on the transaction. A certain defensiveness on this subject informs Vollard's letter to Monfreid of late December: "I believe I already told you that having sold Gauguin's large canvas for the price of *fifteen hundred francs,* a price set by Gauguin himself, I had asked him if he wanted to have this money put against the advances I had paid him." Consequently, as he informed Monfreid, he had sent Gauguin partial payment, adding sanctimoniously, "You see how easily errors can occur, no matter how many precautions one takes."[24] Several days later Vollard advised Gauguin that because he had not heard from him he had sent 750 francs, half the sale price.[25]

The Vollard Archives—slim for the early years of the twentieth century—are silent on the subject of the sale of *Where Do We Come From?* although sales of Gauguin's work to Frizeau are recorded for 1900 and 1902; and while other disbursements to Gauguin for 1901 are on record, none of them corresponds to the initial payment to Gauguin of 750 francs or the settlement of that account.[26] Gauguin, having for a moment thought it possible to work around Vollard, had again been bested by him. Undoubtedly disappointed, the artist only once again in surviving correspondence referred to the fate of the masterpiece he now alluded to as "the *grand canvas* that is in *Bordeaux*."[27]

DD

1. See Gauguin to Monfreid, February 1898, in Joly-Segalen 1950, pp. 118–20, letter XL. For the most recent literature on this much-discussed picture, see Shackelford 2004; bibliography in Paris–Boston 2003–4; and Washington–Chicago–Paris 1988–89, pp. 391–93 and 416–17, no. 225.
2. See Gauguin to Monfreid, February 1898, in Joly-Segalen 1950, pp. 118–20, letter XL.
3. "Grand tableau" refers to both the physical size and the grandeur of the work. Gauguin to Monfreid, July 1898, in Joly-Segalen 1950, pp. 126–28, letter XLV.
4. Gauguin to Monfreid, December 12, 1898, in Joly-Segalen 1950, pp. 133–34, letter XLIX.
5. Only Gauguin's response to the criticisms survives. See Gauguin to Monfreid, May 1899, in Joly-Segalen 1950, pp. 141–45, letter LIV.
6. Ibid., and Gauguin to Fontainas, March 1899, in Malingue 1946, pp. 286–90, letter CLXX. See also Gauguin's discussion of Fontainas in his letter to Charles Morice, July 1901, in Malingue 1946, pp. 299–303, letter CLXXIV.
7. Gauguin to Monfreid, August 1899, in Joly-Segalen 1950, pp. 148–49, letter LVII.
8. Gauguin to Monfreid, April 1900, in Joly-Segalen 1950, pp. 157–58, letter LXIII.
9. Vollard to Gauguin, June 13, 1900: Vollard Archives, MS 421 (4,1), pp. 39–40.
10. Gauguin to Vollard, September 1900: unpublished letter, French typescript, Department of Medieval through Modern European Painting, and Modern European Sculpture, Art Institute of Chicago. English translation in Rewald 1943 (1986 ed.), pp. 194–95, modified by the author.
11. Gauguin to Monfreid, September 1900, in Joly-Segalen 1950, pp. 162–63, letter LXVII.
12. Gauguin to Monfreid, October 1900, in Joly-Segalen 1950, pp. 163–66, letter LXVIII.
13. Gauguin to Monfreid, December 1900, in Joly-Segalen 1950, pp. 167–69, letter LXX.
14. Charles Morice to Gauguin, May 22, 1901, in Joly-Segalen 1950, pp. 217–18.
15. Gauguin to Charles Morice, July 1901, in Malingue 1946, pp. 299–303, letter CLXXIV.
16. Gauguin to Monfreid, July 1901, in Joly-Segalen 1950, pp. 179–80, letter LXXVI.
17. Gauguin to Monfreid, August 1901, in Joly-Segalen 1950, pp. 180–83, letter LXXVII.
18. Monfreid to Gauguin, September 7, 1901, in Joly-Segalen 1950, pp. 218–20.
19. Monfreid to Vollard, September 14, 1901: unpublished let-

ter, photocopy of original letter and typescript in the Department of Medieval through Modern European Painting, and Modern European Sculpture, Art Institute of Chicago.
20. Vollard to Monfreid, September 16, 1901, in Joly-Segalen 1950, pp. 223–25.
21. See Monfreid to Vollard, September 29, 1901: unpublished letter, photocopy of original letter and typescript in the Department of Medieval through Modern European Painting, and Modern European Sculpture, Art Institute of Chicago.
22. Morice to Gauguin, September 18, 1901, in Joly-Segalen 1950, pp. 222–23. On November 5(?), 1900, the Vollard Archives reveal the sale of three pictures to Frizeau identified as "3921—3569—3927": Vollard Archives, MS 421 (4,9), fol. 49, the numbers of entries in Vollard's Stockbook A. No. 3921 can be identified as *Te Bourao (II)* (1897–98, private collection; W 563), no. 3569 probably as *Aha Oe Feii? Are You Jealous?* (1892, Pushkin Museum, Moscow; W 461), and no. 3927 as *Tahiti—Figures for "What Are We?"* (1897–98, private collection; W 560). George Shackelford (2004, p. 188) has determined that W 560 and W 563 were exhibited in Gauguin's 1898 exhibition at Vollard's.
23. See Gauguin to Monfreid, November 1901, in Joly-Segalen 1950, pp. 183–86, letter LXXVIII.
24. Vollard to Monfreid, December 23, 1901: Research Library, The Getty Research Institute, Los Angeles, 2001.M.24.
25. Vollard to Gauguin, December 27, 1901, in Malingue 1987, p. 271.
26. The only "account book" of Vollard's for 1901 found in his archives is the "Petit registre des recettes et paiements au jour le jour du 14/04/1900 au 1/08/1902": Vollard Archives, MS 421 (4,9). The payment of 750 francs is not to be confused with the payment of 1,000 francs mentioned in Vollard's letter to Monfreid of December 23, 1901 (Research Library, Getty Research Institute, Los Angeles, 2001.M.24) and recorded in Vollard's "petit registre" on December 12 (or 17?), 1901: "Gauguin 1000 fr[anc]s Scharf et Kayser." Vollard Archives, MS 421 (4,9), fol. 108.
27. Gauguin to Monfreid, August 25, 1902, in Joly-Segalen 1950, pp. 189–91, letter LXXXII.

97

97. *fig. 77*

PAUL GAUGUIN
The Purau Tree (Te Bourao [II])

1897–98
Oil on canvas
28¾ x 36¼ in. (73 x 92 cm)
Private collection
Paris only

CATALOGUE RAISONNÉ: G. Wildenstein 1964, no. 563

PROVENANCE: Sent by the artist from Tahiti on consignment to Daniel de Monfreid, Paris, summer 1898 (consigned by Monfreid on behalf of Gauguin to Georges Chaudet, Paris, October 1898; consigned by Chaudet on behalf of Gauguin to Ambroise Vollard, Paris, November 1898); bought from Gauguin through Monfreid by Vollard, December 8, 1898; bought by Gabriel Frizeau, November 1900; reacquired by

Vollard, not before 1901/not after 1906–his d. 1939; Collection de Galéa, Paris (Mme de Galéa, d. 1955; her son Robert, d. 1961), 1939–61; by descent to Christian de Galéa, Paris, 1961; bought by the present owner by ca. 2000 (on extended loan to the Metropolitan Museum, New York)

The Purau Tree is perhaps the most overtly and purely decorative of the canvases directly related to *Where Do We Come From? What Are We? Where Are We Going?* (cat. 96) that were exhibited along with the large canvas at Vollard's gallery in 1898. This picture takes its inspiration, as George Shackelford has noted, from the great blue purau tree at upper right of that monumental canvas.[1] Reviewing the exhibition, the critic André Fontainas opined that "in Mr. Gauguin's art, it is landscape that is satisfying and exalting" and clearly referred to *The Purau Tree* when he spoke of "an entirely decorative panel . . . quite characteristic of the artist's personality: amid the dark blues and the greens, noble plant and animal forms intermingle in pure arabesques. Nothing more: it is a perfect harmony of forms and colors."[2]

Painted predominantly in cool blue tones relieved by a touch of red, the canvas may have been conceived, as Shackelford suggests, to play off warmer-toned pictures, like the gold-hued *Vairumati* (cat. 95), that likewise derive from motifs in the large canvas. It is when the works are experienced together —as at Vollard's gallery in 1898 or more recently in Boston and Paris—that the purposeful nature of Gauguin's decorative intentions is revealed.[3]

The Purau Tree, according to Jean de Rotonchamp, was among the group of nine canvases that Vollard purchased for 1,000 francs from Daniel de Monfreid in December 1898.[4] It also seems to correspond to the canvas listed under number 3921 in Stockbook A: "Marine scène de Tahiti: effet de mer bleue." However, the stockbook notes that the price paid to Monfreid was 150 francs, which would make it among the four pictures Vollard purchased from Monfreid in October 1898. The inventory number 3921 connects the picture with a sale to Gabriel Frizeau along with numbers 3569 and 3927 in November 1900 for a total of 1,000 francs.[5] A picture called "Paysage bleu," loaned by Vollard, was featured in the 1906 Salon d'Automne (no. 64), and "Paysage bleu (1897)" appeared in Vollard's 1910 exhibition, indicating that Frizeau sold *The Purau Tree* back to Vollard between 1901 and 1906.

DD

1. Shackelford 2004, p. 188.
2. Fontainas 1899, cited in Shackelford 2004, p. 188.
3. The exhibition "Gauguin Tahiti" (Paris–Boston 2003–4) brought together *Where Do We Come From?* and eight of the other pictures shown at Vollard's; see Shackelford 2004.
4. It appears as number 8 on the list that Rotonchamp published (1925) and that Shackelford annotates (2004, p. 327, n. 42).
5. Vollard Archives, MS 421 (4,9), fol. 49, November 1900 (2 entries): "Frizeau espèces 1000 fr[anc]s pour 3 Gauguin" and "3921—3569—3927—Frizeau." For more on this transaction, see cat. 96, note 22.

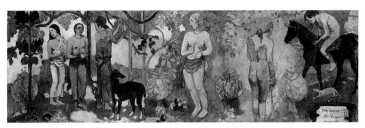

98

98. *fig. 73*

PAUL GAUGUIN
Faa Iheihe (Tahitian Pastoral)

1898
Oil on canvas
21¼ x 66½ in. (54 x 169 cm)
Tate, Presented by Lord Duveen 1919 NO 3470

CATALOGUE RAISONNÉ: G. Wildenstein 1964, no. 569

PROVENANCE: Sent by the artist from Tahiti on consignment to Daniel de Monfreid, Paris, early 1900; acquired from Monfreid (on behalf of Gauguin) by Maurice Fabre, after December 1902/by February 1904; acquired by Ambroise Vollard, Paris, by spring 1910–at least 1913; Lord Joseph Duveen, London; presented to Tate Gallery, London, 1919

Faa Iheihe is one of three ambitiously scaled canvases that Gauguin realized in 1898–99 in the aftermath of completing the monumental *Where Do We Come From? What Are We? Where Are We Going?* (cat. 96).[1] The Tate canvas includes the greatest number of figures and is arguably the most insistently decorative of all, its dense figural frieze organized in discrete zones creating a surface that recalls sculptural reliefs. As George Shackelford has observed, here the "inspiration of sculpture is present everywhere."[2]

More visually ravishing than the brooding *Where Do We Come From? Faa Iheihe* is also less symbolically freighted. Its figures, their compositional relationships, and the title (translating as "to embellish" or "glorify") are less overtly enigmatic, as the generally used English title, *Tahitian Pastoral*, underscores.

Though Gauguin informed Daniel de Monfreid in September 1899 that he would be sending "ten or so canvases" with an eye to the following year's Exposition Universelle,[3] it seems that the artist did not organize a shipment until early 1900, when he was also entering his contractual agreement with Vollard.[4] Monfreid took the best pictures, including *Faa Iheihe*, for an agreed-upon "reserve" of the best work—Gauguin rationalizing that the pictures and their shipment predated his arrangement with the dealer[5]—and turned over the remaining ten pictures to Vollard in October of that year (see cat. 99).[6] The dealer's grievance, later voiced to Monfreid, about the relative lack of importance of the pictures he had received through his agreement with Gauguin was informed by his awareness of *Faa Iheihe* and how it had come on the market.

Through the offices of Vollard's client and Monfreid's friend Gustave Fayet, collector and museum curator in Béziers, *Faa Iheihe* was evidently exhibited there in spring 1901. Although it does not appear in the catalogue, for which Fayet contributed the preface,[7] it is clearly the picture Monfreid referenced in spring 1902 when he informed Gauguin: "I was unable to conclude a deal, which had been in the works for a long time, for the large canvas of yours exhibited last year in Béziers: I don't want to let it go for less than 2,000 francs. The buyer is a

friend of Redon's and Fayet's, a very wealthy fellow from Narbonne named Maurice Fabre."[8]

Perhaps because of the price, Fabre was still undecided at year's end,[9] and whether the sale was consummated in Gauguin's lifetime is uncertain, as is the price paid. But it was Fabre who loaned the picture to the "Libre Esthétique" exhibition that opened in Brussels on February 25, 1904, where it appeared as catalogue number 54, "Faa Iheihe (frise decorative)."[10] And it was still with the collector at the time of the 1906 Gauguin retrospective, where it was among six canvases he loaned, there catalogued (no. 161) as "Frise peinte (Tahiti)."[11]

Vollard acquired the picture from Fabre before spring 1910, when he included it in his exhibition "Oeuvres de Paul Gauguin," which opened on April 25 ("Panneau décoratif" [1898] was thirteenth on the checklist). The picture was still with him at the end of 1912, when the dealer sent it along with three other Gauguins and canvases by Cézanne to the International Exhibition of Modern Art—the landmark "Armory Show"—held in the 69th Regiment Armory in New York (February 17–March 15, 1913) and subsequently at the Art Institute of Chicago (March 24–April 16, 1913) and Copley Society of Boston (April 28–May 19, 1913). Vollard's archives reflect the high value he placed on the "frise" relative to the other canvases by Gauguin that he lent. The dealer assigned "Faa-ihe-ihe–1898" a price of 35,000 francs, in contrast to 20,000 francs for *Parau Na Te Varua Ino (Words of the Devil)* (1892, National Gallery of Art, Washington, D.C.; W 458) and 15,000 francs each for *Self-Portrait Jug with Japanese Print and Flowers* (May 1889, Tehran Museum of Contemporary Art, Iran; W 375) and *Under the Palms* (1891, private collection; W 444), the last a picture acquired from Fabre before summer 1904 for a mere 500 francs.[12] Clearly Gauguin had earned the esteem of Vollard and the marketplace, the prices Vollard set approaching those he asked for Cézanne's paintings.[13]

DD

1. See also *The White Horse* (1898, Musée du Louvre; W 571) and *Rupe Rupe* (1899, Pushkin Museum of Fine Arts, Moscow; W 585). On *Faa Iheihe*, see Shackelford 2004, pp. 193–96.
2. Ibid., p. 194.
3. Gauguin to Monfreid, September 1899, in Joly-Segalen 1950, pp. 149–50, letter LVIII.
4. On January 27, 1900, Gauguin told Monfreid that he should soon receive some pictures he sent earlier; Gauguin to Monfreid, January 27, 1900, in Joly-Segalen 1950, pp. 155–56, letter LXI. It seems that this is the same shipment Gauguin worried had not arrived in August 1900; see Gauguin to Vollard, August 1900, English translation in Rewald 1943 (1986 ed.), pp. 193–94, as well as Gauguin to Monfreid, August 1900, in Joly-Segalen 1950, pp. 161–62, letter LXVI. The shipment was late arriving in Paris because it was held in customs and Monfreid's address was incorrect; see Vollard to Monfreid, September 17, 1903: Research Library, The Getty Research Institute, Los Angeles, 2001.M.24.
5. Gauguin to Monfreid, July 1901, in Joly-Segalen 1950, pp. 179–80, letter LXXVI.

6. Unpublished receipt dated October 17, 1900: French typescript, Loize Archives, Musée de Tahiti et des Îles, Punaauia.

7. See Loize 1951, pp. 146–47, no. 445.

8. Monfreid to Gauguin, April 10, 1902, in Joly-Segalen 1950, pp. 225–28.

9. Monfreid to Gauguin, December 11, 1902, in Joly-Segalen 1950, pp. 232–35.

10. Typescript of 1904 "La Libre Esthétique" catalogue in Gordon 1974, vol. 2, pp. 89–91.

11. See Paris (Salon d'Automne) 1906, p. 69, no. 161. Its inclusion rules out its identification as the picture designated "Ceylan" that Vollard purchased from Fabre for 2,000 francs on March 12, 1906 (Vollard Archives, MS 421 [5,1], fol. 45), suggested by Diffre and Lesieur 2004, pp. 311, 339, n. 45.

12. See Vollard Archives, MS 421 (5,8), fol. 230, December 17, 1912; see also Diffre and Lesieur 2004, p. 311. This three-tiered pricing structure is not reflected in the prices in American dollars published in Brown 1963, pp. 243–44: *Faa Iheihe* as $8,100, *Parau Na Te Varua Ino (Words of the Devil)* as $4,050, *Self-Portrait Jug with Japanese Print and Flowers* as $40,500 (which is clearly an error and should be $4,050), and *Under the Palms* as $4,050.

13. For the Cézanne works, Vollard's prices ranged from 15,000 to 35,000 francs: Vollard Archives, MS 421 (5,8), fol. 230, December 17, 1912.

99

99. *fig. 229*

PAUL GAUGUIN
Three Tahitian Women

1899
Oil on canvas
26¾ x 28⅞ in. (68 x 73.5 cm)
State Hermitage Museum, St. Petersburg 7708

CATALOGUE RAISONNÉ: G. Wildenstein 1964, no. 584

PROVENANCE: Bought from Daniel de Monfreid (on behalf of Gauguin) by Ambroise Vollard, Paris, October 17, 1900; bought by Leo Stein, Paris, October 28, 1904; reacquired by Vollard, January 21, 1907, by exchange; bought by Ivan Morozov, Moscow, probably May 13, 1910; Museum of Modern Western Painting, Moscow, 1919; State Museum of Modern Western Art, Moscow, 1923; State Hermitage Museum, St. Petersburg, 1948

This picture is among the works that appear in a receipt Vollard made out on October 17, 1900: "Received from Monsieur de Monfreid on behalf of Monsieur Paul GAUGUIN ten Tahitian canvases constituting the most recent shipment, for the account of Monsieur Paul GAUGUIN, total value *two thousand francs* following our earlier agreement."[1] This was the first of the three shipments that Vollard would subsequently indicate having received from the artist as part of the contractual understanding they reached in the first half of 1900. Vollard's letter

suggests why it took so long for him to receive this first shipment, brought back to France by a returning colonial—it was held in customs, and Daniel de Monfreid's address was incorrectly written.[2] *Three Tahitian Women* was the last of the ten works listed, described as "Three women standing against a yellow-gold marbled background, Veronese green at top."[3]

The motif of this canvas relates to two larger, multifigured compositions Gauguin painted in 1898–99: *Faa Iheihe* (cat. 98) and *Rupe Rupe* (Pushkin Museum of Fine Arts, Moscow; W 585). Monfreid, adhering to his understanding with Gauguin to not send the artist's best work to Vollard, had set aside these more ambitious works as part of a "reserve." In the summer of 1903 Monfreid took *Rupe Rupe* from this "reserve" stored in Paris and arranged to sell it to Gustave Fayet together with two other canvases for a total of 3,300 francs.[4] Vollard, perhaps aware of this instance of cherry-picking, later complained that some of the works he received from Gauguin were relatively unimportant.[5] The modestly scaled *Three Tahitian Women* may have fallen into this category precisely because of its connection to grander works. Nonetheless the beauty of the canvas was appreciated by two legendary collectors: Leo Stein, who acquired it from Vollard in October 1904, and Ivan Morozov, who in 1910 paid Vollard 10,000 francs for it—one hundred times the amount the dealer had paid the artist for it a decade earlier.[6]

 DD

1. Unpublished receipt dated October 17, 1900: French typescript, Loize Archives, Musée de Tahiti et des Îles, Punaauia.

2. See Vollard to Monfreid, September 17, 1903: Research Library, The Getty Research Institute, Los Angeles, 2001.M.24. Though the list of ten works was published in Rotonchamp (1925, pp. 221–22) the date was omitted and the wording of the receipt misinterpreted to suggest that the works were part of a last shipment Gauguin sent to Vollard in 1903.

3. Unpublished receipt dated October 17, 1900: French typescript, Loize Archives, Musée de Tahiti et des Îles, Punaauia. Following Rotonchamp (1925), various publications have indicated that this picture was part of a shipment sent directly by Gauguin from Atuona to Vollard in 1903; see Kostenevich 1999, p. 419, no. 141; Barskaya, Kantor-Gukovskaya, and Bessonova 1995, p. 157, no. 24; Anna Barskaya and Bessonova 1988, pp. 162–63, nos. 60, 61. However, Vollard's September 17, 1903, letter to Monfreid makes explicit that what was in fact the last shipment included twenty-one canvases.

4. Monfreid to Gauguin, August 14 and 21, 1903, in Joly-Segalen 1950, pp. 238–40, and 240–41. These letters correct the assertion in recent publications (see Barskaya and Bessonova 1988, pp. 148–55, nos. 52–55, and Barskaya, Kantor-Gukovskaya, and Bessonova 1995, pp. 149–50, no. 22) that Gauguin sent this painting from Atuona to Fayet in Paris.

5. Vollard to Monfreid, October 8, 1903: unpublished letter, Research Library, Getty Research Institute, 2001.M.24.

6. Vollard records on October 28, 1904, that he sold Stein, among other works, "3505 Gauguin": Vollard Archives, MS 421 (4,10), p. 30. This entry corresponds to Vollard's Stockbook B, no. 3505, "Groupes de femmes dans paysage Tahiti." On January 21, 1907, Leo Stein exchanged the Gauguin canvas and a Bonnard work for a Renoir painting from Vollard: Vollard Archives, MS 421 (5,2), fol. 8. See Barskaya, Kantor-Gukovskaya, and Bessonova 1995, p. 157, no. 24, on the picture as "the last Gauguin purchased by Morozov" for a price of 10,000 francs. The sale is probably that recorded by Vollard on May 13, 1910, in the Vollard Archives as "Morosoff 10000 [francs] reçu pour Gaug[*sic*] remis": Vollard Archives, MS 421 (5,5), fol. 75; also noted in Diffre and Lesieur 2004, p. 311.

100

100. *fig. 78*

PAUL GAUGUIN
Flowers and Cats

1899
Oil on canvas
36¼ x 28 in. (92 x 71 cm)
Ny Carlsberg Glyptotek, Copenhagen MIN 1835
New York and Chicago only

CATALOGUE RAISONNÉ: G. Wildenstein 1964, no. 592

PROVENANCE: Sent by the artist from Tahiti on consignment to Daniel de Monfreid, Paris, probably by early 1900; acquired from Monfreid by Ambroise Vollard, Paris, after August 1903 / before April 1910; probably bought from Vollard by Helge Jacobsen, Copenhagen, 1914; gift of Jacobsen to the Ny Carlsberg Glyptotek, Copenhagen, 1927

In the letter of fall 1899 that led to his contract with Gauguin, Vollard had two specific requests of the artist: large watercolors and floral still lifes. "If you care to do some flower paintings for the price of the pictures I bought from Daniel [de Monfreid] I will take a whole series of them; in short I am willing to buy everything you do."[1]

Vollard was referring to his purchase from Monfreid on October 30, 1898, of four canvases for a total of 600 francs. One of these was indeed a still life, a composition that featured "geraniums, grandes plantes (campanules? . . .) violettes etc."[2] Vollard was perhaps aware that in June 1898 Monfreid had sold Gauguin's *A Vase of Flowers* (1896, National Gallery, London; W 489) to Edgar Degas for 150 francs[3]—the price per canvas Vollard had established with Monfreid and was now proposing to Gauguin.

The artist's response was testy. He observed that Tahiti was "not really a land of flowers" and that in any event he painted few floral still lifes because "(as you have doubtless perceived), I do not paint from nature." His "exuberant imagination" was the source of all his creativity, and still lifes were of limited importance to him: "When I tire of painting figures (which I like best), I begin a still life and finish it without any model." Next Gauguin tried to pin down Vollard's offer to buy all he painted: "*I should like to understand clearly.* Do you mean flowers only, *or figures and landscapes as well?*"[4] The need for clarification was warranted, given the concern Vollard expressed about a market for Gauguin's work, "so different" from what collectors were accustomed to seeing.[5] For it was a given that still lifes by vanguard artists could be more appealing to potential buyers than subjects perceived as challenging.[6] As Monfreid himself would later observe, the "exoticism" of

Gauguin's figure pictures could be a stumbling block even to an admirer of his work like collector Gustave Fayet.[7]

Dated 1899, Gauguin's whimsical canvas featuring an impressive vessel that contains a seeming mix of European and tropical flowers and is flanked by two diminutive cats predates his receipt of Vollard's request.[8] Possibly Gauguin included it in the shipment of paintings to which he alerted Monfreid in January 1900.[9] Clearly, it was part of the group of special pictures Monfreid kept "in reserve" and stored in Paris. In July 1903 he retrieved it along with other canvases he wanted to show Fayet, who had expressed interest in acquiring a group of Gauguins. Monfreid strategized that if Fayet did not buy the still life he could always sell it on Gauguin's behalf to Vollard, who, he thought, would pay about 400 francs if he believed Monfreid owned it outright rather than having it on consignment from the artist. He may have thought that the subject would appeal to a cat lover.[10]

Fayet declined the picture in August 1903; how soon after that Vollard acquired it is unclear.[11] Possibly it was among the pictures listed as "fleurs" in Vollard's exhibition of Gauguin's works in November 1903. It was included in Vollard's photographic archive, and the canvas appeared in the 1910 Gauguin exhibition at Vollard's gallery (fourteenth on the checklist). He lent it to the "Exposition d'Art Français du XIXe" Siècle held at the Royal Museum in Copenhagen from May 15 to June 30, 1914.[12] It is likely that Helge Jacobsen acquired it from that exhibition. DD

1. Vollard to Gauguin, fall 1899: French typescript, Department of Medieval through Modern European Painting, and Modern European Sculpture, The Art Institute of Chicago. English translation in Rewald 1943 (1986 ed.), pp. 188–89.
2. Vollard Archives, MS 421 (4,3), fol. 112, October 30, 1898 [Registre de caisse, an account book]. Monfreid to Gauguin, November 11, 1898, in Joly-Segalen 1950, pp. 209–10 (this picture has not been identified).
3. See New York 1997–98, vol. 2, p. 55, no. 489. This is probably the "Bouquet de fleurs" that Gauguin listed in his letter to Monfreid of February 14, 1897 (in Joly-Segalen 1950, pp. 99–102, letter XXIX) as among the shipment Monfreid would shortly be receiving.
4. Gauguin to Vollard, January 1900: French typescript, Department of Medieval through Modern European Painting, and Modern European Sculpture, Art Institute of Chicago. English translation in Rewald 1943 (1986 ed.), pp. 189–90; here slightly modified by the author.
5. Vollard to Gauguin, fall 1899: French typescript, Department of Medieval through Modern European Painting, and Modern European Sculpture, Art Institute of Chicago. English translation in Rewald 1943 (1986 ed.) pp. 188–89.
6. On this subject, see Druick 1995.
7. Monfreid to Gauguin, May (or June) 9, 1903, in Joly-Segalen 1950, pp. 236–38 (as June); Malingue 1987, pp. 308–10, dates the letter to May. Monfreid notes that Fayet wanted to buy some of Gauguin's pictures but said of two figure paintings, "No; these canvases are very beautiful, but I don't want to have only figures of Negroes."
8. See Anne-Birgitte Fonsmark in Paris 1995–96a, pp. 181–82, no. 41.
9. Gauguin to Monfreid, January 27, 1900, in Joly-Segalen 1950, pp. 155–56, letter LXI.
10. See Monfreid to Gauguin, August 14, 1903, in Joly-Segalen 1950, pp. 238–40. Gauguin's large watercolor featuring a cat and a bouquet (ca. 1902, Art Institute of Chicago, 1981.409) may have been done with Vollard's fondness for cats in mind. Reproduced in Tedeschi 1985, pp. 158–59, no. 72. In an unpublished letter to Gauguin of May 18, 1902 (photocopy of original letter in the Department of Medieval through Modern European Painting, and

Modern European Sculpture, Art Institute of Chicago), Vollard reiterated his request for watercolors and mentioned shipping to Gauguin Japanese paper and "couleurs en poudre," the media Gauguin used for the drawing.
11. Fayet's rejection is evident in Monfreid to Gauguin, August 21, 1903, in Joly-Segalen 1950, pp. 240–41.
12. Copenhagen 1914, no. 105.

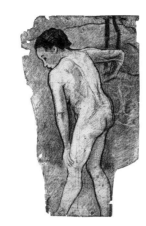

101

101. fig. 63

PAUL GAUGUIN
Breton Bather

1886–87
Charcoal and pastel, with brown ink, squared in graphite
23⅛ x 14⅛ in. (58.8 x 35.8 cm)
The Art Institute of Chicago, gift of Mrs. Charles B. Goodspeed 1946.292
New York and Chicago only

PROVENANCE: Georges Chaudet, on consignment from the artist; possibly Ambroise Vollard (possibly acquired from Chaudet on behalf of Gauguin), October 19, 1895, by exchange; Francisco "Paco" Durrio y Madrón, Paris, probably by 1906–at least 1931; Leicester Galleries, London, possibly 1931; Albert Roullier Art Galleries, Chicago, possibly 1931; Mrs. Charles B. Goodspeed, Chicago, by 1938; her gift to The Art Institute of Chicago, 1946

Gauguin drew this figure of a Breton bather and then squared it for transfer to canvas in preparation for his 1887 painting *Two Bathers* (Museo Nacional de Bellas Artes, Buenos Aires; W 215, W-2001 241). Subsequently he developed the drawing with pastel and cut the paper into an irregular format, so that the work appears both finished and at the same time a fragment. He followed a similar procedure with other drawings.

The traces of chrome yellow pigment on the verso suggest that the drawing was affixed to the like-colored walls of Gauguin's Paris studio at 6, rue Vercingétorix, where it was displayed with other works by the artist and the contemporaries he collected.[1] Beginning in January 1894, Gauguin hosted Thursday receptions at his studio, where the guests included Vollard.

Vollard clearly appreciated drawings like this one. In October 1895, Georges Chaudet made two trades with the dealer that involved more than twenty works on paper Gauguin had left with him, including seven listed in the account book as "pastelized drawings (*dessins pastellisés*)." These were mostly Breton subjects, and this sheet may have been among them. The works Vollard gave in exchange included drawings by Honoré Daumier

and Édouard Manet.[2] Having assigned values ranging from 10 to 25 francs for each of Gauguin's pastelized drawings, Vollard within the month re-evaluated four of them at ten times those amounts for a transaction (part sale, part exchange) with the Count of Takovo (Milan Obrenović).[3]

Early in 1897 Vollard wrote Gauguin inquiring whether he had any "early drawings," and Gauguin, apparently ignorant of the October transactions, replied, "I left them all with Chaudet, who takes care of my affairs."[4] It was the dealer's abiding interest in the "pastelized drawings" that in turn led Chaudet to advise Gauguin in the fall of 1897 that were he able to make "a series of drawings heightened [with pastel], I am convinced that we would sell them for good prices."[5] Gauguin did not respond, but following Chaudet's death in September 1899, Vollard contacted Gauguin directly with proposals that led to their contractual agreement. His letter began, "You will receive, at approximately the same time as this letter, two parcels . . . of Ingres paper and some watercolors. I am sending these in the hope that you will be good enough to make me some sketches in pencil washed with watercolor, covering the entire paper—something like the drawings you made in Brittany some time ago and afterward colored with pastels."[6]

 DD

1. As noted by Peter Zegers, Rothman Family Research Curator, and Harriet Stratis, Conservator of Prints and Drawings, Department of Prints and Drawings, Art Institute of Chicago.
2. See Vollard Archives, MS 421 (4,2), fol. 20, October 19, 1895 [Registre des ventes, a sales book], and MS 421 (4,2), fols. 21–22, October 25, 1895 [Registre des ventes, a sales book].
3. See Vollard Archives, MS 421 (4,2), fol. 24, November 19, 1895 [Registre des ventes, a sales book]. Though not identically described, the four works in the Takovo transaction are clearly from the group Vollard acquired from Chaudet. See Anne Roquebert's essay in this volume, pp. 222–23, for further information on the Count of Takovo.
4. Gauguin to Vollard, April 1897: French typescript, Department of Medieval through Modern European Painting, and Modern European Sculpture, Art Institute of Chicago. English translation in Rewald 1943 (1986 ed.), pp. 178–79; translation modified by the author.
5. Chaudet to Gauguin, November 10, 1897: Loize Archives, Musée de Tahiti et des Îles, Punaauia, and the Gauguin dossier in the documentation at the Musee d'Orsay, Paris.
6. Vollard to Gauguin, fall 1899, French typescript, Department of Medieval through Modern European Painting, and Modern European Sculpture, Art Institute of Chicago. English translation in Rewald 1943 (1986 ed.), pp. 188–89. The letter can be tentatively dated to October on the basis of Gauguin's January response and Vollard's notation that he sent watercolors to Gauguin on October 6, 1899: Vollard Archives, MS 421 (4,3), fol. 143 [Registre de caisse, an account book].

102. fig. 79

PAUL GAUGUIN
The Nightmare

Ca. 1899–1900
Transfer drawing in black and ochre
23 x 17 in. (58.5 x 43 cm)
Private collection
New York and Chicago only

CATALOGUE RAISONNÉ: Field 1973, no. 70

PROVENANCE: Sent by the artist from Tahiti on consignment to Ambroise Vollard, Paris, spring 1900; private collection

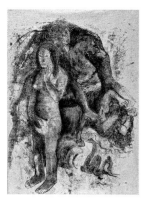

102

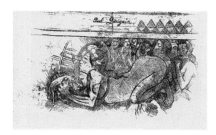

103

103. *fig. 80*

PAUL GAUGUIN
Crouching Tahitian Woman

1900
Transfer drawing in brownish black ink
Image 12 x 20 in. (30.5 x 50.8 cm), paper support 18¼ x
24½ in. (46.5 x 61.5 cm)
The Art Institute of Chicago, through prior bequest of
the Mr. and Mrs. Martin A. Ryerson Collection 1991.217

CATALOGUE RAISONNÉ: Field 1973, no. 73

PROVENANCE: Sent by the artist on consignment from Tahiti
to Ambroise Vollard, Paris, by summer 1900; bought by
Gustave Fayet, Béziers, by 1906; by descent through his fam-
ily's sale, Drouot Montaigne, Paris, June 15, 1991, no. 6;
bought by The Art Institute of Chicago

These impressive works are part of a group of ten
created using a process of the artist's invention that
Gauguin sent to Vollard in spring 1900 in response
to the dealer's expressed interest in his art.

In a letter of late 1899, Vollard had asked
Gauguin for drawings elaborated with watercolor to
cover the entire sheets of the Ingres paper he was
sending under separate cover (see cat. 101). He would
pay 40 francs a sheet.[1] Gauguin retorted that he
disliked Ingres paper and in any event he was
an artist, "not a mere machine for turning out
orders. . . . I like to experiment, but if my work must
be limited to watercolor, pastel, or anything else, all
the spirit goes out of it. You would lose by it too,
since it would look monotonous when exhibited."[2]
Gauguin instead sought to engage Vollard in the
"series of experiments in drawings with which I am
fairly well pleased, and I am sending you a tiny
sample. It looks like a print, but it isn't. I used a thick
ink . . . instead of pencil, that's all."[3]

Gauguin's "discovery" was based on the carbon
paper principle and involved applying a coat of ink
to one sheet of paper, placing a second sheet over it,
and drawing with pencil or crayon on the top sheet.
The pressure exerted by the drawing implement

transferred the ink from the first sheet of paper onto
the verso of the sheet on which he drew. Repre-
senting the drawn composition in reverse, this trans-
fer, rather than the initial drawing, became the
finished work of art. Gauguin clearly enjoyed the
process, which he characterized to Gustave Fayet as
"of childlike simplicity,"[4] for the way it transformed
the quality of the drawn line and, like the woodcuts
he printed, invited chance effects.

Though Gauguin's investigations of the process
were already under way when he received Vollard's
letter, the evidence suggests that the dealer's interest
in drawings spurred the artist to make some if not all
of the large-scale transfers.[5] Even while worrying
whether the deal Vollard proposed might fail,
Gauguin was imagining an exhibition that would
include his recent prints and transfer drawings, to
be held at Vollard's to coincide with the 1900 Paris
Exposition Universelle.[6] He sent the group of ten
directly to Vollard even before he received his letter
of agreement in May.[7] In his response securing their
understanding, Gauguin explained:

> Last month I sent you some drawings (terrible
> maybe but people will get used to them and
> they'll be more saleable later if they aren't now).
> I changed your price of 40 francs to 30 francs for
> that very reason, and I'm even giving you the
> option of refusing them, but make no mistake,
> from an artistic viewpoint they're worth more
> than what you're asking. . . .

He concluded his letter by observing that "I have
no desire to spend what little time I have left ruin-
ing my artistic reputation by making shabby work
for the marketplace: Please rest assured that I will
always do what is best."[8]

The "printed drawings"[9] fell short of Vollard's
desires, and he pursued the artist. In September 1901
Gauguin wrote that he had complied with Vollard's
request and made twenty-three "very finished draw-
ings," but unfortunately they had been eaten by rats
during his hospital stay. Evidence suggests they were
large and in color.[10] Vollard pressed Gauguin again
in May 1902, for drawings and watercolors.[11]

While Gauguin had Daniel de Monfreid retrieve
the woodcuts he had sent Vollard (see cat. 106), the
artist's monotypes remained with the dealer. In the
fall of 1903, in a response to Monfreid's request to
settle his accounts with the painter's estate, Vollard
wrote: "In addition [to paintings], I received a dozen
[*sic*] drawings, our agreement stipulating if I'm not
mistaken that they'll go for 30 francs apiece. . . ."[12]
Forty francs per drawing had been the initial under-
standing, but Vollard was sticking to the artist's pro-
posed reduction.

Vollard featured *The Nightmare* and *Crouching
Tahitian Woman* among the twenty-seven transfer
drawings—listed as "DESSINS"—included in his
November 1903 exhibition of Gauguin's work.[13]

DD

1. Vollard to Gauguin, fall 1899: French typescript,
 Department of Medieval through Modern European
 Painting, and Modern European Sculpture, Art Institute
 of Chicago. English translation in Rewald 1943 (1986 ed.),
 pp. 188–89.
2. Gauguin to Vollard, January 1900: French typescript,
 Department of Medieval through Modern European
 Painting, and Modern European Sculpture, Art Institute
 of Chicago. English translation in Rewald 1943 (1986 ed.),
 pp. 189–92.

3. Ibid. The ellipsis in the typescript at the Art Institute of
 Chicago suggests that a longer description of the process has
 been omitted. The ellipsis is not present in Rewald's translation.
4. Gauguin to Fayet, March 1902, in Joly–Segalen 1950,
 pp. 202–3. Gauguin could complicate the process by using
 two different color inks successively. See Shelley 2002 and
 Shapiro 2004, p. 218.
5. In his letter to Monfreid of January 27, 1900 (in Joly–
 Segalen 1950, pp. 155–56, letter LXI), Gauguin referred to
 his recent "recherches d'impression" and claimed they
 would change notions of printmaking. Since he had
 already discussed the woodcuts in this and earlier letters to
 Monfreid, it seems he was referring to the transfers. In
 March 1900 (in Joly–Segalen 1950, pp. 156–57, letter LXII)
 he wrote Monfreid that he would be sending Vollard ten
 "dessins" that month "au prix de 40 fr[ancs]."
6. Gauguin to Monfreid, March 1900, in Joly–Segalen 1950,
 pp. 156–57, letter LXII.
7. In his letter to Monfreid of March 1900 (ibid.), Gauguin
 mentions he will send Vollard the transfers "ce mois-ci."
 He mentions having sent them in April 1900 in his letter
 to Vollard of May 1900 sent via Monfreid: unpublished
 letter, Research Library, The Getty Research Institute,
 Los Angeles, 2001.M.24. Vollard (letter to Monfreid,
 September 16, 1901, in Joly–Segalen 1950, pp. 223–25)
 mentions having received the ten "dessins imprimés"
 directly from the artist.
8. Gauguin to Vollard, May 1900: unpublished letter,
 Research Library, Getty Research Institute, 2001.M.24.
9. "dessins imprimés," as described by Vollard writing to
 Monfreid, September 16, 1901, in Joly–Segalen 1950,
 pp. 223–25.
10. "dessins très soignés": Vollard to Monfreid, 18 7bre
 [September] 1901: unpublished letter, Research Library,
 Getty Research Institute, 2001.M.24, in which Vollard
 mentions having just received the letter. Gauguin had
 been in and out of the hospital during February and
 March of 1901.
11. Vollard to Gauguin, May 18, 1902: unpublished letter, pho-
 tocopy of original letter in the Department of Medieval
 through Modern European Painting, and Modern
 European Sculpture, Art Institute of Chicago.
12. Vollard to Monfreid, 17 7bre [September] 1903: unpub-
 lished letter, Research Library, Getty Research Institute,
 2001.M.24.
13. In 1906 they were in the group of "Dessins" Vollard
 loaned to the Gauguin retrospective that was part of
 the Salon d'Automne.

104. *fig. 71*

PAUL GAUGUIN
Te Atua (The Gods)

Winter/spring 1894

a. Woodcut (first state) in black on cream Japanese paper
Image 8 x 13⅞ in. (20.2 x 35.4 cm); sheet 8⅛ x 14 in.
(20.5 x 35.7 cm)
The Art Institute of Chicago, William McCallin McKee
Memorial Collection 1942.349
New York and Chicago only

CATALOGUE RAISONNÉ: Mongan, Kornfeld, and Joachim
1988, no. 17, state I

PROVENANCE: Georges Chaudet, Paris, probably on consign-
ment from the artist, by June 1895; Ambroise Vollard, Paris
(possibly acquired from Chaudet acting on behalf of
Gauguin), October 19, 1895, by exchange; Henri M. Petiet,
Paris; Jean Goriany, New York; by 1942; bought by The Art
Institute of Chicago, 1942

b. Woodcut (second state) in brown, orange, and black
on thin cream wove paper
Image 8 x 14 in. (20.4 x 35.5 cm), sheet 8⅛ x 14 in. (20.7 x
35.7 cm)
The Art Institute of Chicago, gift of the Print and
Drawing Club 1953.326
New York and Chicago only

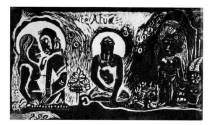

104a

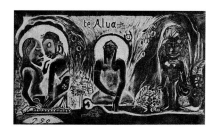

104b

CATALOGUE RAISONNÉ: Mongan, Kornfeld, and Joachim 1988, no. 17, state II

PROVENANCE: Georges Chaudet, Paris, probably on consignment from the artist, by June 1895; Ambroise Vollard, Paris (possibly acquired from Chaudet acting on behalf of Gauguin), October 19, 1895, by exchange; The New Gallery, New York, by 1953; bought by The Art Institute of Chicago, 1953

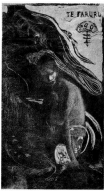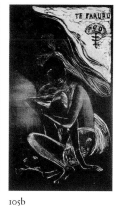

105a 105b

105. *fig. 70*

PAUL GAUGUIN
Te Faruru (Here We Make Love)

Winter/spring 1894

a. Woodcut (second state) from a boxwood block in black, with hand-colored additions in red watercolor, on tan Japanese tissue
Image 14 x 8 in. (35.6 x 20.2 cm)
The Art Institute of Chicago, Clarence Buckingham Collection 1948.257
New York and Chicago only

CATALOGUE RAISONNÉ: Mongan, Kornfeld, and Joachim 1988, no. 15, state II

PROVENANCE: Georges Chaudet, Paris, probably on consignment from the artist, by June 1895; Francisco "Paco" Durrio y Madrón, Paris, by 1906–at least 1931; Walther Geiser, Basel; bought by The Art Institute of Chicago, 1948

b. Woodcut (third state) in ochre and black, with hand-applied and transferred watercolors and waxy media, on cream Japanese paper
Image/sheet 14 x 8 in. (35.6 x 20.2 cm)
The Art Institute of Chicago, Clarence Buckingham Collection 1950.158
New York and Chicago only

CATALOGUE RAISONNÉ: Mongan, Kornfeld, and Joachim 1988, no. 15, state III

PROVENANCE: Georges Chaudet, Paris, probably on consignment from the artist, by June 1895; possibly Ambroise Vollard, Paris (possibly acquired from Chaudet acting on behalf of Gauguin), October 19, 1895, by exchange; Gérald Cramer, Geneva, by 1950; bought by The Art Institute of Chicago, 1950

Shortly before the November 1893 exhibition of his Tahitian work at Durand-Ruel's gallery, Gauguin began a first draft of what he described as a "book on Tahiti." Eventually titled *Noa Noa*—Tahitian for "fragrance"—his romanticized account of his spiritual and artistic rejuvenation in the South Pacific was intended to be "helpful in making my painting understood."[1] Early in 1894, Gauguin made a suite of ten woodcuts incorporating motifs from his Tahitian canvases that were conceived of as the book's visual complement.[2]

Given the current fashion for lithography and the highly refined print Gauguin had made in that medium, his decision to work in woodcut was noteworthy. Coarse by comparison with other print media and long out of fashion, woodcut—associated with "primitive," medieval printmaking—better suited Gauguin's expressive aims. He combined aspects of woodcut with the more current technique of wood engraving, working on blocks constructed from hard, endgrain boxwood and employing tools as diverse as knife, gouge, chisel, needle, and sandpaper.

Gauguin's experimental approach is evident in the progressive working states for each woodcut and even more so in their printing. In impressions like those included here, which Gauguin himself printed from the blocks, he increased the expressive valence of the medium by such methods as staining the paper support with color prior to printing, applying inks to the block inconsistently, and exerting uneven pressure during the printing. The resulting images appear to move in and out of focus; they are blurry, indeterminate, and mysterious. Each impression is virtually unique.[3] In displaying his prints, Gauguin drew attention to his ability to thus realize variations on a theme by pasting together two different impressions of the same woodcut on a single mount (he presented the related watercolor monotypes in similar fashion).[4]

Early in December 1894, Gauguin organized a weeklong exhibition at his Paris studio that included his recent woodcuts and monotypes. Vollard, as would subsequently become evident, found the prints interesting, but given the high prices Gauguin placed on them (Degas paid 50 francs for a pair of monotypes),[5] bided his time. Two months later, at the February 18 auction of Gauguin's work at the Hôtel Drouot, the dealer bought a pair of woodcut impressions for 7.55 francs—the only purchase he made.[6] He acquired four more pairs of *Noa Noa* woodcut impressions the following October, as part of the exchange Georges Chaudet made with him on Gauguin's behalf (see cat. 101). In this transaction, the eight impressions were assigned the pre-

posterously low combined value of 10 francs, or 2.50 francs apiece.

Over the course of 1895 Vollard sold several Gauguin prints—including hand-colored impressions of the 1889 lithographs and more recent color woodcuts—for between 20 and 50 francs each.[7] But in May 1896 the dealer was able to acquire ten more Gauguin prints, probably woodcuts as well as monotypes, for a mere 20 francs total, this time from Gauguin's friend and fellow painter-printmaker Armand Séguin.[8]

In the summer of 1896 Vollard mounted an ambitious exhibition of works by *peintres-graveurs*. Included were Gauguin drawings acquired from Chaudet and five items listed as "color woodcuts, trial proofs, 2 states."[9] He had already approached Gauguin directly for more in the same medium (see cat. 106). DD

1. Gauguin to his wife, Mette, October 1893, in Malingue 1946, p. 249, letter CXLIII.
2. In his letter to Charles Morice of about April 1894 (transcribed in the catalogue for the sale of the library of Lucien Graux, Hôtel Drouot, Paris, December 11–12, 1958, pt. 8), Gauguin writes that he had just completed the prints.
3. More legible and consistent are the impressions of the final states that Gauguin had printed in an edition of about thirty by artist Louis Roy, who nonetheless made a conscious attempt to preserve Gauguin's aesthetic of suggestive indeterminacy.
4. See the two impressions of the woodcut *Oviri* that Gauguin presented to Mallarmé (collection of the Art Institute of Chicago, 1947.686.1 and 1947.686.2), in Washington–Chicago–Paris 1988–89, p. 374, no. 213.
5. See Washington–Chicago–Paris 1988–89, p. 352, and New York 1997–98, vol. 2, p. 56, no. 492.
6. Vollard Archives, MS 421 (4,3), fol. 15, February 18, 1895 [Registre de caisse, an account book].
7. Vollard Archives, MS 421 (4,2), fol. 15, July 6, 1895 [Registre des ventes, a sales book]; MS 421 (4,3), fol. 29, August 24, 1895 [Caisse]; MS 421 (4,3), fol. 29, September 5, 1895 [Caisse]; MS 421 (4,2), fol. 23, November 14, 1895 [Ventes]. The purchasers included Julius Meier-Graefe and Maurice Fabre.
8. Vollard Archives, MS 421 (4,3), fol. 48, May 30, 1896 [Caisse].
9. Nos. 78–82 in the catalogue of the exhibition "Les Peintres-Graveurs" (see "Exhibitions *chez* Vollard" in this volume).

106a. *fig. 74*

PAUL GAUGUIN
Love, And You Will Be Happy

1898
Woodcut (second state) in black on cream Japanese tissue, laid down over woodcut (first state) in ochre on ivory wove paper
Image/sheet 6⅜ x 10⅞ in. (16.2 x 27.6 cm)
The Art Institute of Chicago, Joseph Brooks Fair Collection 1949.932
New York and Chicago only

CATALOGUE RAISONNÉ: Mongan, Kornfeld, and Joachim 1988, no. 55, state I and state II,b

PROVENANCE: Sent by the artist from Tahiti on consignment to Daniel de Monfreid, Paris, after January 1900; consigned by Monfreid on behalf of Gauguin to Ambroise Vollard, Paris, October 1900; retrieved by Monfreid at the request of Gauguin from Vollard, November 1901; Maurice Denis, Paris; Daniel Sickles, ?Chicago; The Art Institute of Chicago, 1949

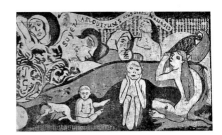

106a

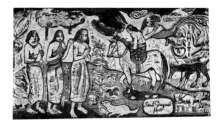

106b

106b. *fig. 74*

Paul Gauguin
Change of Residence

1899
Woodcut (second state) in black on cream Japanese tissue,
laid down over woodcut (first state) in ochre on ivory
wove paper
Image/sheet 6½ x 11⅞ in. (16.4 x 30.1 cm)
The Art Institute of Chicago, The Albert H. Wolf
Memorial Collection 1939.322
New York and Chicago only

Catalogue raisonné: Mongan, Kornfeld, and Joachim
1988, no. 54, State I,b and II,b

Provenance: Sent by the artist from Tahiti on consignment
to Daniel de Monfreid, Paris, after January 1900; consigned
by Monfreid on behalf of Gauguin to Ambroise Vollard,
October 1900; retrieved by Monfreid at the request of
Gauguin from Vollard, November 1901; Maurice Denis, Paris;
Jean A. Goriany, New York; The Art Institute of Chicago, 1939

Early in 1896, Vollard, involved in plans to publish
an *Album des peintres-graveurs,* wrote to Gauguin
proposing he make a new woodcut in an edition of
one hundred and stipulating that the artist do the
printing himself. Gauguin, lacking both paper and a
press, fumed to his friend Émile Schuffenecker: "But
what is he thinking of? How does he expect me to do
this here?"[1] Although Gauguin refused Vollard's
request, the dealer's implicit admiration for the sug-
gestive visual effects the artist had realized by print-
ing his woodcuts himself (see cat. 104) ultimately
stimulated new experimentation. His belated
responsiveness, resulting in a remarkable group of
woodcuts eventually produced in 1899, typifies
Gauguin's push-pull relationship with Vollard.

Vollard pursued Gauguin for prints and at the
end of 1896 purchased "crayons et papier" for him.[2]
Their purpose can be inferred from Gauguin's let-
ter to Vollard of April 1897 questioning why Vollard
would not contemplate his working in transfer
lithography, a medium practically suited to his sit-
uation: he could make drawings on transfer paper
and send them to Paris, there to be transferred to
the lithographic stone, and his artist friend Armand
Séguin could perform any necessary retouching.
But evidently Vollard wanted "proper lithographs,"

that is, drawn directly by the artist on the litho-
graphic stone. In any event, Gauguin wanted cash
up front, reminding Vollard: "During my stay in
Paris I tried my hand at printmaking without any
results as far as money goes. I therefore have good
reason to be skeptical." However, while dismissing
all of Vollard's current requests for prints, drawings,
and sculpture, Gauguin added a breezy postscript
that, together with the enclosure, reveals his delayed
responsiveness to the request of the previous year for
woodcuts: "Some poor attempts at making wood-
cuts, but my eyesight is becoming very bad for this
kind of work. I don't have any good wood, and for
the printing!!! No press."[3]

Gauguin pursued his experiments and came up
with an ingenious procedure—evidenced in the two
prints exhibited here—for realizing two-color images
from a single block that could be printed in an edi-
tion yet exhibit something of the modulated surface
qualities characteristic of the unique *Noa Noa*
impressions. Gauguin's process involved working the
block, printing it in an edition, then further work-
ing the block's surface, after which a second edition
is printed in a different color on tissue-thin paper.
This second print is then pasted over the first. Gauguin
had made a group of these and more traditionally
realized woodcuts by the end of 1899, when he received
a letter from Vollard that led to their contract.

Responding to the dealer's specific requests,
Gauguin also volunteered that he would soon send
Monfreid "about 475 impressions of woodcuts—
each [subject] pulled in numbered editions of 25 to
30, then the blocks destroyed." He continues, "Half
of the blocks, moreover, have been used twice, and
I alone am capable of printing in this way. . . . Given
the way they are created they should be profitable to
a dealer, I think, because there are so few impressions
of each. I am asking 2,500 francs for the lot, or else
4,000 if sold by the piece. Half the money at once
and the balance in three months."[4]

Gauguin considered his woodcuts "very special"
in ways that he believed, as he later told Vollard,
would be "just the thing" for the dealer.[5] But Gauguin
miscalculated. Involved in lithography publications,
Vollard was indifferent to the woodcuts that Daniel
de Monfreid delivered to him in October 1900.[6]

In August 1901, Gauguin asked Monfreid to re-
trieve his woodcuts from the unappreciative dealer,
arguing that time would bear out the special interest
of these woodcuts that "recall the primitive age of
printmaking." The artist asked Monfreid to have
some of the impressions framed either singly or in
twos to show them to potential buyers.[7]

Monfreid contacted Vollard, who replied that
the group of prints "is worthless to me."[8] Monfreid
agreed that Gauguin wanted too much money.[9] In
November 1901 the dealer dispatched the prints.[10] By
the time of Gauguin's death in May 1903, Monfreid
had managed to sell only four of the 475 impressions
at 10 francs each.[11] He probably gave away a number
of them to friends of the artist, per Gauguin's instruc-
tion.[12] In 1905 Vollard wrote Monfreid inquiring how
many of the woodcuts were still in his possession and
how much he wanted for them.[13]

DD

1. See Gauguin to Schuffenecker, April 10, 1896, transcribed
 in *Précieux Autographes de Monsieur Alfred Dupont,* sale
 cat., Hotel Drouot, Paris, December 3–4, 1958, no. 115.
2. Vollard Archives, MS 421 (4,3), fol. 59, December 1, 1896
 [Registre de caisse, an account book].

3. Gauguin to Vollard, April 1897: French typescript,
 Department of Medieval through Modern European
 Painting, and Modern European Sculpture, Art Institute
 of Chicago. English translation in Rewald 1943 (1986 ed.),
 pp. 178–79, modified by the author. In a letter to
 Monfreid also written in April 1897, Gauguin included a
 print and a somewhat similar explanation. Joly-Segalen
 1950, pp. 104–5, letter XXXI.
4. Gauguin to Vollard, January 1900: French typescript,
 Department of Medieval through Modern European
 Painting, and Modern European Sculpture, Art Institute
 of Chicago. English translation in Rewald 1943 (1986 ed.),
 pp. 189–90, modified by the author.
5. Gauguin to Vollard, September 1900: French typescript,
 Department of Medieval through Modern European
 Painting, and Modern European Sculpture, Art Institute
 of Chicago. English translation in Rewald 1943 (1986 ed.),
 pp. 194–95, modified by the author.
6. The unpublished receipt made out by Vollard for Monfreid
 dated October 17, 1900 (Loize Archives, Musée de Tahiti et
 des Îles, Punaauia) includes, as the last item: "Reçu en outre
 un paquet d'estampes imprimées faisant partie du dernier
 envoi de Gauguin *compte de Gauguin*—prix à débattre."
7. Gauguin to Monfreid, August 1901, in Joly-Segalen 1950,
 pp. 180–83, letter, LXXVII.
8. Vollard to Monfreid, September 16, 1901, in Joly-Segalen
 1950, pp. 223–25.
9. Monfreid to Vollard, September 29, 1901: unpublished
 letter, photocopy of original letter in the Department of
 Medieval through Modern European Painting, and
 Modern European Sculpture, Art Institute of Chicago.
10. Vollard Archives, MS 421 (4,9), fol. 104, November 18,
 1901. See also Vollard to Monfreid, November 18, 1901:
 unpublished letter, Archives, Musée Départemental Maurice
 Denis, Saint-Germain-en-Laye, Donation de la famille
 Denis, MS Vollard 5401a,b. Monfreid acknowledged
 receipt in his letter to Vollard, November 23, 1901: unpub-
 lished letter, photocopy of original letter in the
 Department of Medieval through Modern European
 Painting, and Modern European Sculpture, Art Institute of
 Chicago.
11. Monfreid arranged for four impressions to be included in
 the spring 1902 exhibition of the Société des Beaux-Arts in
 Béziers. Four were sold at 10 francs each, from which the
 Société took a 10 percent commission. See Monfreid to
 Gauguin, June 7, 1902, in Joly-Segalen 1950, pp. 228–29,
 repeated in Monfreid to Gauguin, July 5, 1902, in Joly-
 Segalen 1950, pp. 229–31.
12. Gauguin raised this idea in a postscript to his letter to
 Monfreid, June 1900, in Joly-Segalen 1950, p. 160, letter LXV.
 Monfreid offers Alexandre Natanson an impression in his
 letter from May 15, 1908: unpublished letter, Research Library,
 The Getty Research Institute, Los Angeles, 2001.M.24.
13. Vollard to Monfreid, May 19, 1905: unpublished letter,
 Research Library, Getty Research Institute, 2001.M.24.

107. *fig. 67*

Paul Gauguin
Decorated Pot

Ca. 1886–87
5⅛ x 6 x 4⅝ in. (13 x 15.1 x 11.6 cm)
Musée d'Orsay, Paris, Gift of Lucien Vollard, 1943
AF 14329-6

Catalogues raisonnés: Gray 1963, no. 15; Bodelsen 1964,
no. 39

Provenance: Bought from the artist by Ambroise Vollard,
Paris, possibly January 2, 1895–his d. 1939; by descent to
Lucien Vollard, 1939; his gift to the Musée de la France
d'Outre-Mer (later Musée National des Arts de l'Afrique et
de l'Océanie), Paris, 1943; Musée du Louvre (Jeu de Paume),
Paris, 1971; Musée d'Orsay, Paris, 1986

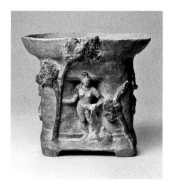

107

108

108. *fig. 66*

PAUL GAUGUIN
Marchand d'esclaves (Fantastic Vase)

1889
Glazed stoneware
H. 10⅜ in. (26.5 cm)
Private collection
New York and Chicago only

CATALOGUES RAISONNÉS: Gray 1963, no. 69; Bodelsen 1964,
no. 52

PROVENANCE: Félicien? Champsaur, by 1895; bought by
Ambroise Vollard, Paris, September 6, 1895; bought by
Gustave Fayet, Igny and Béziers, possibly by 1901 but cer-
tainly by 1906–his d. 1925; by descent to his daughter, Mme
Paul Bacou, Puisallicon, 1925; Mme Guy Viennet, Béziers;
private collection

In January 1895 Vollard purchased directly from
Gauguin two stoneware pieces made in the 1880s for
the remarkably modest sum of 40 francs.[1] One of
these, a piece Vollard listed as "horns," was a personal
favorite of Gauguin's; he had included it in several
paintings and had asked that his "pot with horns" be
sent to him in Arles during his stay there with
Vincent van Gogh in the fall of 1888.[2] This sale to
Vollard, seemingly an act of desperation on Gauguin's
part, fed his opinion of the dealer as ruthlessly oppor-
tunistic and was a source of regret. In October 1895,
four months after the artist set sail for Tahiti, his
confidant Georges Chaudet would reacquire the
piece on his behalf in an exchange with Vollard
involving drawings Gauguin had left in his care. For
purposes of this trade, Vollard valued the ceramic at
100 francs, five times what he had paid the artist.[3]

Possibly the pot featuring a woman under a tree
(cat. 107) was the second ceramic involved in the
January 1895 sale.[4] Vollard included one or both of

the two objects with Gauguin's pre-Tahitian canvases
when he featured the artist—as well as a canvas by
Édouard Manet and several Van Goghs—at his gallery
in March 1895. Critic Camille Mauclair singled out
"an original piece of pottery, richly and superbly
worked."[5] Such praise, together with the esteem
expressed by artists including Odilon Redon, may
have reinforced the admiration Vollard, uncharac-
teristically, expressed in his *Recollections:* "It was
a fact that Gauguin turned everything that fell into
his hands—clay, wood, metal and so forth—into
little marvels."[6]

Vollard's singular interest in Gauguin's ceramics led
him to acquire a large stoneware piece at auction in
Paris in April 1895, which he sold for a 300 percent pro-
fit seven months later to Redon's friend the Bordeaux
collector Maurice Fabre.[7] While this ceramic remains
unknown, the one that Vollard purchased the follow-
ing September from Champsaur (possibly writer
Félicien Champsaur) for the relatively hefty sum of
165 francs can be identified. It was recorded in
Vollard's account book as *Le marchand d'esclaves,*[8]
the same title that appears on a label written in
Gauguin's hand on the bottom of the glazed
stoneware piece shown here (cat. 108).

It is likely that the *Marchand d'esclaves*—and pos-
sibly also *Decorated Pot*—were among the works in
the Gauguin exhibition that Vollard held at his new
quarters in November 1896. In his review published
in the *La Revue blanche,* Thadée Natanson drew
attention to the group of "stoneware, ceramics, and
carved wood," observing that by including the glazed
stoneware Vollard afforded viewers the opportunity
to see a little-known aspect of the artist's production.[9]

Vollard later sold the *Marchand d'esclaves* to
Gustave Fayet, with whom he was doing business by
1900.[10] Possibly it is the unidentified ceramic that
Fayet, writing to Gauguin in November 1901, noted
was in his collection of the artist's works. Gauguin
confided to Monfreid that he could not imagine
what ceramic Fayet meant.[11]

DD

1. Vollard Archives, MS 421 (4,3), fol. 13, January 2, 1895
 [Registre de caisse, an account book].
2. See Gauguin's letter to Émile Schuffenecker, October 25,
 1888, which included a sketch of the work; see Merlhès 1989,
 pp. 125–26. There is also a sketch of it in the Département
 des Arts Graphiques, fonds du Musée d'Orsay, Paris; see
 Washington–Chicago–Paris 1988–89, p 91, no 41. The
 ceramic (Gray 1963, no. 57) appears in Gauguin's paintings
 Madame Alexandre Kohler (1887/1888, National Gallery of
 Art, Washington, D.C., W 314, W-2001 258) and *Still Life
 with Fan* (Musée d'Orsay, Paris; W 377, W-2001 259).
3. Vollard Archives, MS 421 (4,2), fols. 21–22, October 25,
 1895 [Registre de ventes, a sales book].
4. On this work, see Washington–Chicago–Paris 1988–89,
 pp. 154–55, no. 87, where it is dated 1889–90.
5. Mauclair 1895b.
6. See Vollard 1936, p. 174, and Vollard 1937, p. 196. Vollard
 noted Redon's admiration.
7. Vollard Archives, MS 421 (4,3), fol. 19, April 6, 1895 [Caisse].
8. Vollard Archives, MS 421 (4,3), fol. 29, September 6, 1895
 [Caisse]. On the piece, see Gray 1963, no. 69; Bodelsen
 1964, no. 52; and Washington–Chicago–Paris 1988–89,
 pp. 148–49, no. 82.
9. Natanson 1896.
10. Vollard to Monfreid, 28 9bre [November] 1900: unpub-
 lished letter, Archives, Musée Départemental Maurice
 Denis, Saint-Germain-en-Laye, Donation de la famille
 Denis, MS Vollard 5397.
11. Fayet to Gauguin, November 1, 1901, in Joly-Segalen 1950,
 pp. 201–2. Gauguin to Monfreid, March 1902, in Joly-
 Segalen 1950, pp. 186–87, letter LXXIX.

109

109. *fig. 64*

PAUL GAUGUIN
Oviri

1894
Partially glazed stoneware
29½ x 7½ x 10⅜ in. (75 x 27 x 19 cm)
Musée d'Orsay, Paris OAO 1114

CATALOGUES RAISONNÉS: Gray 1963, no. 113; Bodelsen 1964,
no. 57

PROVENANCE: Paul Gauguin, until his d. 1903 (consigned by
the artist to Lévy, Paris, spring 1895; consigned by the artist to
Georges Chaudet, Paris, June 1895; consigned by Chaudet on
behalf of Gauguin to Ambroise Vollard, Paris, late 1896/early
1897; retrieved from Vollard by Daniel de Monfreid at the
request of Gauguin, early 1901; placed on deposit by Monfreid
with Gustave Fayet, Béziers; by April 1901); bought from the
artist's widow, Mette Gauguin (through Monfreid), by Fayet,
1905, for 1,500 francs; bought from Fayet by Vollard, 1925;
Lucien Vollard, Paris, 1939; Jacques Ulmann, Paris, by 1964;
Ulmann heirs; Galerie Daniel Malingue, Paris, by 1987;
bought by Musée d'Orsay, Paris, February 1987

Gauguin considered *Oviri*—realized in Ernest
Chaplet's studio in 1894 (see cat. 110) and meaning
"wild" or "savage" in Tahitian—one of his finest
achievements.[1] It was on view at Lévy's gallery by
spring 1895,[2] but attempts to place it privately or
publicly came to naught, and the ceramic, along
with other sculptures, was left with Georges Chaudet
when Gauguin departed for Tahiti in June.[3] Chaudet
put *Oviri* on deposit with Vollard; his inventory
(fig. 72) listed a "statue céramique" with an assigned
value of 2,000 francs, the highest of any work in that
document.[4] Possibly it was among the Gauguins
that Vollard displayed in November 1896.

Early in 1897, Vollard wrote Gauguin about
sculptures that might be cast in bronze. Gauguin's
first thought was *Oviri*: ". . . I believe that my large
statue in ceramic, the *Tueuse* [*Oviri*], is an excep-
tional piece such as no ceramist has made until now
and that, in addition, it would look very well cast in
bronze (without retouching and without patina)."
Appealing to the dealer's commercial interests, he
added, "In this way the buyer would not only have
the ceramic piece itself, but also a bronze edition
with which to make money."[5] Vollard did not bite.

Following Chaudet's death in fall 1899, Gauguin
grew concerned about the fate of his sculptures and
asked that Daniel de Monfreid check with Vollard
to see what he still had on deposit, observing: "He
must still have . . . all the wood and ceramic sculp-
tures."[6] Gauguin feared this small body of work
would "be scattered and end up with people who

would not appreciate it."[7] But he had a special purpose for *Oviri:* "I should like to have it here to put upon my tomb in Tahiti, and before that use it as an ornament in my garden."[8] He asked Monfreid to ship it to him.[9]

Monfreid had already contacted Vollard, and the latter's itemization of sculptures in his possession included the "large ceramic statue, [that] represents a monstrous standing woman that could be used for flowers" (a physical impossibility if water were required).[10] Monfreid made clear that the sculpture was not to be sold but rather transferred to his care.[11]

Monfreid had in fact been successfully trying to interest Gustave Fayet in *Oviri,* and Gauguin decided that it would be better to sell *Oviri* to Fayet for 2,000 francs than ship it to Tahiti.[12] Vollard, himself now working with Fayet, learned of this development, let Monfried know, and tried, ineffectively, to insert himself.[13] Monfreid reclaimed the wood and ceramic sculptures from Vollard, and *Oviri* was shipped to Fayet.[14] However, Fayet found the price too high and declined to purchase *Oviri,* but he arranged for it to be included in the spring 1901 exhibition of contemporary art in Béziers.[15] Gauguin, financially strapped, was disappointed.[16] *Oviri* was still on deposit with Fayet in the spring of 1902, when Gauguin received Vollard's letter expressing renewed interest in sculpture and proposing that Gauguin make him "a statue, a nude female."[17] Gauguin countered with *Oviri,* "not only as the best thing of mine, but also perhaps *the only example* of a ceramic sculpture in the vein of Chaplet's ceramics, because everything else in the way of sculpture done by artists is molded and has the same characteristics as the plaster it is taken from . . . I proudly maintain that nobody has ever done this before."[18]

Though Gauguin preferred to sell his masterpiece to a serious collector for 1,500 francs rather than to Vollard for 2,000, neither option was his.[19] When the artist died, *Oviri* was still with Fayet. The latter, involved in the speculation following Gauguin's death, made no definitive move until late 1905, offering first 700 francs, then 1,000, and finally 1,500.[20] The offer was accepted, and *Oviri* remained in the Fayet collection until 1925, when Vollard, at last, acquired it. DD

1. For the most recent information on *Oviri,* see Pingeot 2004 and Claire Frèches-Thory in Washington–Chicago–Paris 1988–89, pp. 369–73, no. 211.

2. On May 1, 1895, according to a note from Monfreid published in Loize 1951, p. 25.

3. At Lévy's gallery, Monfreid showed it to a potential buyer and Stéphane Mallarmé possibly came to see it in response to the urgings of Gauguin's friend Charles Morice. Morice hoped to raise 3,000 francs to buy what he called *Diane Chasseresse* for the state by finding fifty supporters, and wrote Mallarmé in spring 1895 to enlist him in the project. See Frèches-Thory in Washington–Chicago–Paris 1988–89, pp. 369–73, no. 211. On Gauguin's woodcuts, featuring *Oviri,* that he dedicated to Mallarmé (Art Institute of Chicago, 1947.686.1 and 1947.686.2), see Washington–Chicago–Paris 1988–89, pp. 374–76, no. 213. Possibly *Oviri* was left with Lévy and then passed to Chaudet, but Gauguin explicitly stated to Monfreid (letter of January 1900, in Joly-Segalen 1950, pp. 152–55, letter LX) that Chaudet had all of his wood and ceramic sculptures.

4. Chaudet inventory, Documentation du Musée d'Orsay, Paris. See also the author's essay on Gauguin in this volume.

5. Gauguin to Vollard, April 1897: French typescript, Department of Medieval through Modern European Painting, and Modern European Sculpture, Art Institute of Chicago. English translation in Rewald 1943 (1986 ed.), pp. 178–79.

6. Gauguin to Monfreid, January 1900, in Joly-Segalen 1950, pp. 152–55, letter LX.

7. Gauguin to Monfreid, October 1900, in Joly-Segalen 1950, pp. 163–66, letter LXVIII. Gauguin was indignant that while his masterpiece went unsold, "those ugly pots" of the ceramist Auguste Delaherche sold for high prices and went into museums.

8. Ibid. English translation in Pingeot 2004, p. 136, translation modified by the author.

9. On Gauguin's identification with *Oviri,* see Jirat-Wasiutyński 1979.

10. Vollard to Monfreid, 21 Xbre [December] 1900: unpublished letter, Archives, Musée Départemental Maurice Denis, Saint-Germain-en-Laye, Donation de la famille Denis, MS Vollard 5398a,b. Published in part in English in Washington–Chicago–Paris 1988–89, p. 372, no. 211.

11. Monfreid to Vollard, December 27, 1900: photocopy of original letter in the Department of Medieval through Modern European Painting, and Modern European Sculpture, Art Institute of Chicago. For Vollard's response to Monfreid of December 31, 1900, see Malingue 1987, pp. 271–72.

12. Fayet to Monfreid, December 22, 1900, in Loize 1951, p. 144, no. 428. See also Gauguin to Monfreid, January 1901, in Joly-Segalen 1950, pp. 169–70, letter LXXI.

13. Vollard to Monfreid, February 21, 1901: unpublished letter, Research Library, The Getty Research Institute, Los Angeles, 2001.M.24.

14. "Les bois et céramiques ont été repris par vous . . ." Vollard to Monfreid, September 16, 1901, in Joly-Segalen 1950, pp. 223–25.

15. The Béziers exhibition was organized by the local Société des Beaux-Arts and ran from April to May 1901; see Loize 1951, pp. 146–47, no. 445.

16. See Gauguin to Monfreid, June 1901, in Joly-Segalen 1950, pp. 175–77, letter LXXV. The artist fared better in fall 1901 with two wood sculptures sent from Tahiti, for which Fayet—with Monfreid as middleman—agreed to pay 1,500 francs. See Monfreid to Gauguin, September 7, 1901, in Joly-Segalen 1950, pp. 218–20. See also Fayet to Gauguin, November 1, 1901, in Joly-Segalen 1950, pp. 201–2.

17. Vollard to Gauguin, May 18, 1902: unpublished letter, photocopy of original letter in the Department of Medieval through Modern European Painting, and Modern European Sculpture, Art Institute of Chicago.

18. Gauguin to Vollard, August 25, 1902, published in part in Danielsson 1975, p. 302, n. 105. English translation in Washington–Chicago–Paris 1988–89, pp. 372–73; translation modified by the author.

19. Gauguin to Monfreid, August 25, 1902, in Joly-Segalen 1950, pp. 189–91, letter LXXXII.

20. Fayet to Monfreid, November 2, 1903, published in part in Loize 1951, p. 145, letter 433. Fayet to Monfreid, October 2, 7, and December 2, 1905, in Loize 1951, pp. 145–46, nos. 437–439. See also Pingeot 2004, p. 138.

110

110. *fig. 65*

Paul Gauguin
Mask of a Savage

1894 (original ceramic), after spring 1902 (bronze cast)
Bronze
9⅞ x 7⅛ x 4¾ in. (25 x 18 x 12 cm)
Musée d'Orsay, Paris, Gift of Lucien Vollard, 1944
AF 14392

CATALOGUE RAISONNÉ: Gray 1963, no. 110

PROVENANCE: Ambroise Vollard, Paris, cast after spring 1902–his d. 1939; by descent to Lucien Vollard, 1939; his gift to the Musée de France d'Outre-Mer (later Musée National des Arts de l'Afrique et de l'Océanie), Paris, 1944; Musée du Louvre (Jeu de Paume), Paris, 1971; Musée d'Orsay, Paris, 1986

The *Mask of a Savage* and *Oviri* (cat. 109) were the fruits of Gauguin's reengagement with the medium of stoneware in late December 1894, when he returned to the Parisian studio of ceramist Ernest Chaplet (he had last worked there prior to his Tahitian trip).[1]

Gauguin was fond of his glazed ceramics and two years later, in December 1896, wrote Daniel de Monfreid from Tahiti, asking him to "send me here the *glazed* head of a savage (Mask). It's a unique ceramic piece and it would give me enormous pleasure to have it, especially since I have a *collector* here."[2] But Gauguin had evidently left the mask with Georges Chaudet (along with other sculptures),[3] and Chaudet had in turn consigned it to Vollard, no doubt as part of his transactions with the dealer in the summer and fall of 1896. It was from Vollard that Monfreid retrieved it in April 1897.[4]

That same month, Gauguin wrote Monfreid that Vollard had asked him for "models of sculptures to be cast in bronze."[5] To Vollard himself Gauguin responded with ill-disguised frustration, "You . . . want wood sculptures, models for bronze casts, etc. . . . For four years now all those things have been in Paris without any sales. Either they are bad, and then the new ones I might make would also be bad, and thus unsalable, or else they are works of art.— In that case why don't you sell them?" The artist then suggested two works for casting, *Oviri* and "the mask, *Head of a Savage [Tête Sauvage],* what a beautiful bronze it would make, and not expensive. I am convinced that you could easily find thirty collectors who would pay 100 francs, which would mean 3,000 francs, or 2,000 after deduction of expenses. Why don't you consider this?"[6]

It was not until the spring of 1902 that Vollard, then entering the third year of his contractual agreement with Gauguin, returned to the subject of the mask in the context of his new appreciation for Gauguin's sculpture:

I want to have wood sculptures by you, I would like this very much, most of all for myself; I mean that if I don't sell them, it's all the same to me. You must be wondering how it is that I didn't buy the ones that I had on hand for so long; it's because they now interest me much more. . . . I would also very much like the mask that Monfreid arranged to have sent back to you. . . .[7]

It is not clear when and how Vollard finally acquired the ceramic mask that was inherited by Lucien Vollard and became part of the latter's 1947 donation to the Musée Léon-Dierx in his native La Réunion. This bronze cast, one of two (there is in

addition a painted plaster), seems to have been realized during Vollard's lifetime.[8] DD

1. See Richard Brettell in Washington–Chicago–Paris 1988–89, pp. 367–69, nos. 209, 210, and 210a; and Pingeot 2004.
2. Gauguin to Monfreid, December 1896, in Joly-Segalen 1950, pp. 96–98, letter XXVII.
3. This is also implied in the provenance given for the ceramic published in New Delhi and other cities 1999–2001, p. 101, no. 57 (entry for *Masque de sauvage*).
4. See the receipt dated April 9, 1897: photocopy of original receipt in the Department of Medieval through Modern European Painting, and Modern European Sculpture, Art Institute of Chicago. Monfreid wrote to Gauguin on March 12, 1897 (in Joly-Segalen 1950, pp. 205–6) about his request regarding the "tête de sauvage émaillée," making no mention of Vollard, apparently not yet aware it was no longer with Chaudet.
5. Gauguin to Monfreid, April 1897, in Joly-Segalen 1950, pp. 104–5, letter XXXI.
6. Gauguin to Vollard, April 1897: the first passage from a French typescript in the Department of Medieval through Modern European Painting, and Modern European Sculpture, Art Institute of Chicago; the second passage is published in French in New Delhi and other cities 1999–2001, p. 101, no. 57 (entry for *Masque de sauvage*). English translation in Rewald 1943 (1986 ed.), pp. 178–79.
7. Vollard to Gauguin, May 18, 1902: unpublished letter, copy in the Department of Medieval through Modern European Painting, and Modern European Sculpture, Art Institute of Chicago.
8. For color reproductions of the Orsay bronze and the ceramic in the Musée Léon-Dierx, see Richard Brettell in Washington–Chicago–Paris 1988–89, p. 368, nos. 209, 210a, and Claire Frèches-Thory in Punaauia 2003, pp. 108–9.

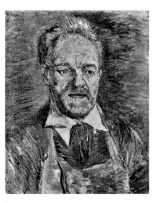

III

III. *fig. 6*

VINCENT VAN GOGH
Julien Tanguy

1887
Oil on canvas
17⅞ x 13⅜ in. (45.5 x 34 cm)
Ny Carlsberg Glyptotek, Copenhagen MIN 1908

CATALOGUE RAISONNÉ: Faille 1970, no. 263

PROVENANCE: Julien (Père) Tanguy, Paris; Ambroise Vollard, Paris, 1901; Dr. J[ean] Keller, Paris; Galerie Druet (Eugène Druet), Paris, 1910; Galerie Bernheim-Jeune, Paris, 1911; Octave Mirbeau, Paris, by February 1919; his sale, Galerie Durand-Ruel, Paris, February 24, 1919, no. 19; Collection Wilhelm Hansen, Charlottenlund, near Copenhagen; Ny Carlsberg Glyptotek, Copenhagen (gift of Ny Carlsberg-Fondet), 1923

Julien (Père) Tanguy, a left-wing activist who barely escaped being shot during the uprising of the Commune in Paris in 1870, set himself up as an artists'

color merchant at 14, rue Clauzel in Montmartre. As Vollard recalled in his memoirs, "Having been spared he knew not why, and established himself later on as a colour-merchant, he patronised the new painters, in whom it pleased him to see rebels like himself."[1] In this portrait Van Gogh has shown Tanguy as a workingman dressed in the apron that he wore in his shop. During the 1870s, when there was little market for the Impressionists' works, Tanguy was prepared to accept their canvases as deposits in return for paint and other materials. By the mid-1880s his shop had come to resemble a small museum of Impressionist paintings.

Van Gogh, who met Tanguy during the autumn of 1886, was a frequent visitor to the store, where he acquired firsthand knowledge of the Impressionists; in the 1890s Tanguy displayed the works of both Van Gogh and Cézanne. An American critic writing in 1892 noted, "His shop was very difficult to find, as he is constantly shifting his quarters, from inability to pay his rent. No one knows what or where he eats; he sleeps in a closet among his oils and varnishes, and gives up all the room he can to his beloved pictures. There they were, piled up in stacks: violent or thrilling Van Goghes [*sic*]."[2] In June 1894, following Tanguy's death, the works he had owned were offered at auction; Vollard bought Cézannes and Van Goghs. It is not known exactly when Vollard acquired this portrait of Tanguy, but it was in his possession by 1901.[3] AD and JPP

1. Vollard 1936, p. 25.
2. Waern 1892, p. 541, cited in S. A. Stein 1986, p. 293.
3. Vollard is listed as the lender in the catalogue of a Van Gogh exhibition held at the Galerie Bernheim-Jeune, Paris, March 1901, no. 13; see Faille 1970, no. 263. According to Faille, the subsequent owner was a J. Keller, Paris. There is no reference to this name in the Vollard Archives.

112

112. *fig. 232*

VINCENT VAN GOGH
A Pair of Boots

1887
Oil on canvas
13½ x 16¼ in. (34 x 41.3 cm)
The Baltimore Museum of Art, The Cone Collection, formed by Dr. Claribel Cone and Miss Etta Cone of Baltimore, Maryland BMA 1950.302

CATALOGUE RAISONNÉ: Faille 1970, no. 333

PROVENANCE: Julien Tanguy, Paris; his widow; her sale, Hôtel Drouot, Paris, June 2, 1894, no. 64; Ambroise Vollard, Paris; Eugène Blot, Paris, by 1900; his sale, Hôtel Drouot, Paris, May 9, 1900, no. 163 (bought in); Jos. Hessel, Paris, possibly on consignment from Blot; Paul Cassirer, Berlin,

possibly on consignment from Blot; Eugène Blot, Paris; second Blot sale, Hôtel Drouot, Paris, May 10, 1906, no. 83; Alfred Edwards, Paris; Paul Vallotton Art Gallery, Lausanne; Marquis de Biron, Geneva; Paul Vallotton Art Gallery, Lausanne; bought by Claribel Cone, Baltimore, September 3, 1927–her d. 1929; by descent to her sister, Etta Cone, Baltimore, 1929–her d. 1949; acquired with the Cone Collection by the Baltimore Museum of Art, 1949

Van Gogh made seven paintings of workers' boots, most of which were painted in Paris in 1887.[1] It is likely that Vollard bought this work at the Tanguy sale in June 1894 for 30 francs.[2] The little Montmartre shop of the color merchant Julien (Père) Tanguy was one of the few places in Paris to see work by Van Gogh in the years following the artist's death in 1890. Tanguy himself died in February 1894, and in June of that year an auction for the benefit of his widow, organized by Octave Mirbeau, was held at the Hôtel Drouot, a well-known Paris auction house. The sale included works of art that had belonged to Tanguy as well as paintings donated by artists and friends as an expression of gratitude to him. Vollard bought four paintings by Cézanne, one by Van Gogh, a Gauguin, a Guillaumin, and a Pissarro.[3] Only a few months before, in September 1893, he had opened his first gallery in the rue Laffitte, and the fact that in the Tanguy sale records his name appears as "Volat" indicates that he was not yet a well-known figure on the Paris art scene. A few months before, Tanguy had expressed his optimism about the market for Van Gogh,[4] but this was not borne out by the low prices paid at the sale.

Despite his minimal outlay, Vollard was taking a chance in acquiring a stock of works by Van Gogh, who was still generally considered a "difficult" artist. On June 26, a few weeks after this purchase, Vollard appears to have sold the painting to the collector Eugène Blot for 50 francs.[5] A Van Gogh painting of shoes was included in Vollard's first Van Gogh exhibition, which he held in his rue Laffitte gallery in June 1895. There was no checklist for this exhibition and very few reviews. However, the Dutch critic E. den Dulk, referring to works in the show, mentioned "a still life of just a few leather shoes."[6] For this rather small exhibition Vollard borrowed works from dealers and friends, so it is possible that he could have gotten the Baltimore painting from Blot.[7]

Subsequently, the Baltimore *Pair of Boots* was acquired by the dealer Jos. Hessel and then by the Berlin dealer Paul Cassirer, who was the first to promote Van Gogh's work in Germany. It then returned to Blot, who sold it to Alfred Edwards, the husband of Misia Nathanson. Later, on September 3, 1927, the painting was purchased by the famous Baltimore collector Claribel Cone,[8] who, with her sister, Etta, was among the first major collectors of Matisse. They bequeathed their distinguished collection to the Baltimore Museum of Art in 1949.

AD

1. Faille 1970, nos. 255, 331–33, 461, 607. F 461 was painted in Arles in August 1888, and F 607 was also painted in Arles at the end of the same year.
2. The work was titled *Les Brodequins;* Tanguy Sale 1894, no. 64. See Faille 1970, no. 333.
3. According to the official record of the Tanguy sale, the pictures Vollard bought were Cézanne, *Village* (R 497), for 175 francs, *Les Dunes* (R 382), for 95 francs, *Corner of a Village* (R 502), for 215 francs, and *Le Pont* (R 500), for 170 francs; Van Gogh, *A Pair of Boots*, for 30 francs; Gauguin, *Les Sapins*, for 76 francs; Guillaumin, *Vache*, for 41 francs; Pissarro, *Le Paon blanc*, for 36 francs; and Korochonsky,

La Prairie, for 7 francs. Les Archives de Paris, D48E3 79, cited Bodelsen 1968, p. 346.

4. Tanguy to Andries Bonger, September 6, 1893(?): "Je suis certain qu'un jour à venir ils seront mieux appréciés et l'on pourra les vendre plus facilement tout en les vendant plus cher. (I am certain that in the future [van Gogh's works] will be better appreciated and that one will be able to sell them more easily and for higher prices.)" Archives, Van Gogh Museum, Amsterdam, MS b1206V/1962.

5. Vollard Archives, MS 421 (4,2), fol. 2: "Doit Monsieur Blot à Paris / 1 tableau de van Gogh." On the same date Vollard sold a work by Guillaumin to Blot for 250 francs.

6. Den Dulk 1895.

7. Other possibilities for the painting of shoes in the exhibition are *Pair of Shoes* (private collection; F 332a), which belonged to the mother of Albert Aurier, from whom Vollard had acquired other works by Van Gogh, and *Three Pairs of Shoes* (Fogg Art Museum, Harvard University, Cambridge, Massachusetts; F 332), which depicts three pairs of boots and perhaps corresponds more closely to Den Dulk's description of "just a few leather shoes."

8. This date is given for the purchase of the Baltimore painting in B. Richardson 1985, p. 176. Richardson also includes the information that Claribel Cone bought the work from Paul Vallotton's Gallery in Lausanne for 25,000 Swiss francs, together with Odilon Redon's *Peonies* (ca. 1900–1905, Baltimore Museum, 1950.281), included in the price.

113

113. *fig. 49*

VINCENT VAN GOGH
Sunflowers

1887
Oil on canvas
17 x 24 in. (43 x 61 cm)
The Metropolitan Museum of Art, New York, Rogers Fund, 1949 49.41

CATALOGUE RAISONNÉ: Faille 1970, no. 375

PROVENANCE: Gift of the artist to Paul Gauguin, Paris, late 1887 or early 1888 (consigned to Ambroise Vollard, Paris, late 1894/early 1895); bought by Vollard, April 10, 1896; bought by Cornelis Hoogendijk, The Hague, either September 1, 1897, May 17, 1899, or July 12, 1899–his d. 1911; his estate sale, Frederik Muller, Amsterdam, May 21–22, 1912, no. 31; bought by Alphonse Kann, probably 1912; bought through Carl Montag by E. Richard Bühler, Winterthur, December 19, 1917; bought by Justin K. Thannhauser, New York, October 1, 1928; bought by the Metropolitan Museum, New York, 1949

Sunflowers first caught Vollard's eye in 1894, when he saw it hanging in Paul Gauguin's rue Vercingétorix studio in Paris. As Vollard recalled in his memoirs, "Three Van Goghs hung above his bed: in the middle a landscape in a mauve tonality; to right and left, *Sunflowers*—the same, I believe, that were so much admired at the Degas sale."[1] The painting at the Degas sale was *Two Cut Sunflowers* (1887, Kunstmuseum Bern; F 376), which Vollard sold to Degas on October 29, 1895.[2] The two canvases are

identical in size and would have formed the two outer panels of the "triptych" that Vollard saw in Gauguin's studio. Both paintings had been given to Gauguin by Van Gogh in late 1887 or 1888.[3] Trying to raise money for his second and last visit to Tahiti in 1895, Gauguin consigned *Sunflowers* to Vollard in late 1894 or early 1895. Indeed, it is possible that this was the painting described as "Soleils de Van Gogh," for which Vollard advanced 400 francs to Gauguin on January 9, 1895.[4]

The Metropolitan's *Sunflowers* was probably shown in Vollard's first Van Gogh exhibition, which inaugurated his gallery at 39, rue Laffitte in June 1895. There is no surviving checklist for the exhibition, and only a few reviews record what was shown. As *Sunflowers* was in Vollard's possession at this date, however, it is likely that he included it in the show.

Sunflowers was one of about nine Van Gogh paintings that Vollard sold to the eccentric and wealthy Dutch collector Cornelis Hoogendijk (1866–1911).[5] Hoogendijk is known to have visited Vollard in Paris at least seven times in 1897, 1898, and 1899 and also bought works by Cézanne, Caillebotte, Vuillard, and Steinlen.[6] AD and JPP

1. Vollard 1936, p. 174. The other painting of sunflowers is *Two Cut Sunflowers* (1887, Kunstmuseum Bern; F 376), which Gauguin also acquired from Van Gogh.

2. Vollard sold this work to Degas in exchange for two small sketches of dancers valued at 400 francs in October 1895: Vollard Archives, MS 421 (4,2), fol. 22, October 29, 1895.

3. Vincent van Gogh to his brother Theo, January 19, 1889, "If he [Gauguin] is not content with the exchange, . . . he can take back his little canvas . . . and his portrait, giving me back my portrait and my two canvases of sunflowers which he took in Paris." Quoted in Faille 1970, no. 376.

4. Vollard Archives, MS 421 (2,3), p. 72. The provenance of *Sunflowers* is the subject of scholarly speculation. Louis van Tilborgh and Ella Hendriks have suggested that either this work or *Two Cut Sunflowers* (F 376) was sold by Vollard to the dealer Félix Roux on February 15, 1895, who returned it to Vollard for 300 francs on October 23, 1895, for 350 francs, although they acknowledge that it is generally assumed that the work in question is F 376. Vollard Archives, MS 421 (4,2), fols. 8, 21. See Van Tilborgh and Hendriks 2001, p. 25, n. 51.

5. It is impossible to tell the exact date of the sale as Vollard did not list titles, but sales of works by Van Gogh to Hoogendijk are recorded on September 1, 1897, and May 17 and July 12, 1899: Vollard Archives, MS 421 (4,2), fol. 41, and MS 421 (4,3), fols. 131, 138. Faille (1970) records nine works as having belonged to Hoogendijk and having been bought from Vollard: F 203, F 353, F 354, F 368, F 375, F 395, F 397, F 432, and F 502.

6. Henkels 1993. *Sunflowers* was one of nine paintings and four drawings included in the sale of Hoogendijk's collection, after his death, at Frederik Muller, Amsterdam, May 21–22, 1912, no. 31; see Henkels 1993, p. 294. However, Hoogendijk at one time owned more works by Van Gogh. Faille 1970 lists eighteen; see Jonathan Pascoe Pratt's essay on Vollard and the works of Van Gogh in this volume.

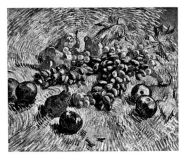

114

114. *fig. 53*

VINCENT VAN GOGH
Still Life with Apples, Pears, Lemons, and Grapes

1888
Oil on canvas
18¼ x 21¾ in. (46.5 x 55.2 cm)
The Art Institute of Chicago, gift of Kate L. Brewster 1949.215
Chicago and Paris only

CATALOGUE RAISONNÉ: Faille 1970, no. 382

PROVENANCE: Émile Bernard, Paris (possibly gift of Andries Bonger, ca. March 1894, or bought from Julien Tanguy); bought by Ambroise Vollard, Paris, August 14, 1894; acquired by Edgar Degas, Paris, possibly October 1895–his d. 1917; Degas Collection Sale I, Galerie Georges Petit, Paris, March 26–27, 1918, no. 92 (*Pommes, poires, citron et raisin*); bought by Paul Rosenberg, Paris; Henry-Jean Laroche, Paris, by 1928; Chester H. Johnson Galleries, Chicago; Mr. and Mrs. Walter S. Brewster, Chicago, by 1929; their bequest to The Art Institute of Chicago, 1949

Still Life with Apples, Pears, Lemons, and Grapes was given to the artist Émile Bernard by Andries Bonger, Theo van Gogh's brother-in-law, probably for his help in sending Theo's collection of works by Vincent back to the Netherlands in March 1894.[1] On August 14, 1894, Vollard bought the painting for 100 francs via Bernard's mother.[2] Van Gogh's art was little appreciated in the years immediately following his death in 1890. Bernard had been a friend of Van Gogh and, along with the artist's brother Theo, his most ardent champion. He helped organize an exhibition of Vincent's work in Theo's apartment in September 1890; in 1892, after Theo's death, he worked with the dealer Louis-Léon Le Barc de Boutteville to put on an exhibition of sixteen paintings and several drawings.[3]

If the work was still in his possession in June 1895, Vollard might have included it in his first Van Gogh exhibition. In the absence of a checklist, however, this cannot be determined. Vollard sold the Chicago still life to Degas, who noted in his handwritten inventory: "black and white Muscat grapes and lemons, bought from Vollard."[4] Degas does not give a date for the purchase, which is not recorded in the Vollard ledgers.[5] In the 1890s Degas amassed a great collection of paintings, drawings, and prints by Ingres, Delacroix, Manet, Cézanne, Gauguin, and others. He acquired a number of works from Vollard, including three by Van Gogh.[6]

AD and JPP

1. Stolwijk and Veenenbos 2002, p. 25, n. 33.

2. In a letter of July 1894 from Bernard to his mother, he mentions selling Van Gogh's "les raisins et les pommes" to Vollard for 100 francs: Private archives. Vollard's accounts

record a payment of 300 francs to Mme Bernard for three canvases, one Gauguin and two Van Goghs: Vollard Archives, MS 421 (4,3), fol. 4, August 14, 1894. Since there are no other transactions between Vollard and Mme Bernard between July and August 14, 1894, the Van Goghs referred to must include the work mentioned in Bernard's letter.

3. See S. A. Stein 2005b, pp. 28–29.

4. Recorded in Degas's inventory (private collection), no. 173. See New York 1997–98, vol. 1, pp. 12, 68, n. 67, vol. 2, p. 66, no. 595. It is not recorded as having been purchased in October 1895 when Degas bought *Two Cut Sunflowers* (1887, Kunstmuseum Bern; F 376).

5. An entry for February 27, 1895, notes the sale of a painting to Degas for 200 francs but does not specify the artist or the title: Vollard Archives, MS 421 (4,3), fol. 16.

6. In addition to this work, he owned *Two Cut Sunflowers* (1887, Kunstmuseum Bern; F 376), acquired from Vollard on October 29, 1895, and a drawing *Peasant Woman Gleaning*, 1885 (probably F 1262a; probably at Sotheby's, London, May 4, 1960, no. 183) probably acquired from Vollard. See New York 1997–98, vol. 2, p. 66, nos. 596, 597.

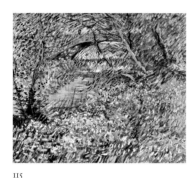

115

115. fig. 56

Vincent van Gogh

Banks of the Seine with Pont de Clichy in the Spring

1887
Oil on canvas
19 x 22½ in. (48.3 x 57.2 cm)
Dallas Museum of Art, gift of Mr. and Mrs. Eugene McDermott in memory of Arthur Berger 1961.99

Catalogue raisonné: Faille 1970, no. 352

Provenance: Probably sent by Johanna van Gogh-Bonger, Amsterdam (Theo van Gogh's widow), to Ambroise Vollard, Paris, December 1896; apparently bought from Vollard by Mme Olivier Sainsère, Paris, 1900–her d. 1947; her estate, from 1947; bought by Wildenstein & Co., Paris and New York, by 1961; bought by Mr. and Mrs. Eugene McDermott, Dallas, 1961; their gift to Dallas Museum of Art, 1961

This painting is one of several views of the banks of the Seine that Van Gogh painted in Paris in 1887. It is close in style and size to *Fishing in Spring, the Pont de Clichy (Asnières)* (cat. 116). This similarity, together with the fact that each canvas has a red painted border, suggests that they may have been conceived as part of an integrated scheme or as the two outer wings of a triptych (see discussion under cat. 116).

Banks of the Seine was probably part of the consignment of works that Jo van Gogh-Bonger sent to Vollard for the second exhibition of her brother-in-law's work, which opened in his rue Laffitte gallery in December 1896. In the list that Van Gogh-Bonger compiled of these works, she mentions *Bords de Seine à Clichy* as one of what appear to be three triptychs.[1] Possibly the present canvas formed part of a

triptych that may have included the related *Fishing in Spring* (cat. 116) and another work such as *Woman in a Garden* (cat. 117), which also has a red border, as the central panel. AD

1. Typed list of works lent by Jo van Gogh-Bonger to Vollard: Archives, Van Gogh Museum, Amsterdam, MS b1437V/1962. *Bords de Seine à Clichy* is no. 82 on the list of Van Gogh's work prepared in 1890 by Émile Bernard and Andries Bonger: Archives, Van Gogh Museum, MS b3055. See also cat. 116, note 4.

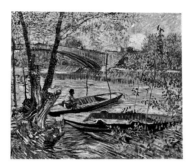

116

116. fig. 57

Vincent van Gogh

Fishing in Spring, the Pont de Clichy (Asnières)

1887
Oil on canvas
19⅞ x 23⅝ in. (50.5 x 60 cm)
The Art Institute of Chicago, gift of Charles Deering McCormick, Brooks McCormick, and Roger McCormick 1965.1169

Catalogue raisonné: Faille 1970, no. 354

Provenance: Probably sent by Johanna van Gogh-Bonger, Amsterdam (Theo van Gogh's widow), to Ambroise Vollard, Paris, December 1896; Cornelis Hoogendijk, The Hague, by 1906–his d. 1911; by descent to his sister Mme Van Blaaderen-Hoogendijk, 1911; T. Van Blaaderen, Bussum, by 1946; bought by E. J. Van Wisselingh & Co. Gallery, Amsterdam, June 24, 1946; bought by Katz Art Gallery (H. Katz), Bussum and The Hague, also June 24, 1946; M. Knoedler & Co., New York; Mr. and Mrs. Chauncey McCormick, by 1949; their gift to The Art Institute of Chicago, 1965

This view along the Seine bears a strong relationship to *Banks of the Seine with Pont de Clichy in Spring*, also painted in 1887 (cat. 115), which features the other half of the bridge. The comparable atmosphere, light, feathery technique, and palette of spring colors in both, as well as the similar size of the canvases and the striking red painted borders, suggest that they may have been intended as components of a panoramic frieze comprising several scenes of the banks of the Seine,[1] or possibly the two outer wings of a triptych. In her introduction to her 1914 edition of Van Gogh's correspondence, Jo van Gogh-Bonger, the widow of Vincent's brother Theo, mentioned that the artist painted triptychs in Paris: "In the spring [1887] came better times in every respect. Vincent could work outside again and often went to Asnières, where he produced such works as the magnificent triptychs of L'Île de la Grande Jatte, the banks of the Seine with their merry colorful restaurants, the little boats on the rivers and gardens[,] all sparkling with light and color."[2]

For his second Van Gogh exhibition, which opened in the rue Laffitte gallery in December 1896, Vollard took a consignment of paintings and drawings from Van Gogh-Bonger.[3] The list that she sent with this consignment to Vollard appears to refer to three triptychs.[4] The works that constituted these triptychs have not been identified with certainty, although different proposals have been made (see cat. 117).[5] It seems probable that the Chicago painting formed a part of one of these triptychs.

Like *Woman in a Garden, Fishing in Spring* was bought by the eccentric and impulsive Dutch collector Cornelis Hoogendijk.[6] AD

1. Martigny 2000, pp. 144–46.
2. Jo van Gogh-Bonger in Van Gogh Letters 1914, translated in Stolwijk and Veenenbos 2002, pp. 142–43, n. 12/7.
3. Archives, Van Gogh Museum, Amsterdam, MS b1847.
4. Item no. 17 on this list, *La Grande Jatte,* was marked "triptyque." This was bracketed with item 18, *Bords de Seine Clichy,* and 19, *Bords de Seine Clichy*. See Stolwijk and Veenenbos 2002, p. 143, n. 12/7.
5. See discussion under catalogue number 117, especially note 9.
6. Faille 1970, no. 354. Vollard's ledgers record sales of works by Van Gogh to Hoogendijk, but no titles are specified. The Chicago painting was included in the estate sale of Hoogendijk's collection after his death in 1911. Henkels 1993.

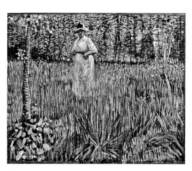

117

117. fig. 58

Vincent van Gogh

Woman in a Garden

1887
Oil on canvas
20⅛ x 24⅝ in. (51 x 62.5 cm)
Private collection

Catalogue raisonné: Faille 1970, no. 368

Provenance: Émile Bernard, Paris; bought by Ambroise Vollard, Paris; bought by Cornelis Hoogendijk, The Hague, either September 1, 1897, May 17, 1899, or July 1899–his d. 1911; his estate sale, Frederik Muller & Cie., Amsterdam, May 21–22, 1912, no. 6 (erroneously listed as a Caillebotte); bought by Ambroise Vollard, 1912; M. Gieseler, The Hague, by 1926; his sale, A. Mak van Waay, Amsterdam, May 11, 1926, no. 41; bought at an auction by Galerie d'Art Frans Buffa & Zonen, Amsterdam, 1926; bought by C. W. Kraushaar Art Gallery, New York, 1926; bought by Mrs. Esther Slater Kerrigan, New York, 1927; sale, Esther Slater Kerrigan Collection, Sotheby Parke-Bernet, New York, January 8–10, 1942, no. 48; Edward J. Bowes, New York, likely 1942; Ann B. Warner, Los Angeles, possibly 1946; bought by Richard L. Feigen & Co., New York, 1986; bought by Robert Carmel, New York, March 10, 1986–his d. 1996; his sale, Christie's, New York, November 13, 1996, no. 31; bought by private collector; that collector's sale, Sotheby's, London, June 20, 2005, no. 17; bought by the current owner

Woman in a Garden was painted in the spring of 1887 in Paris. According to Faille, the work's first owner was Émile Bernard,[1] who sometimes accompanied Van Gogh on his painting expeditions to sites along the Seine and to public gardens. Vollard made some of his first acquisitions of works by the artist from Bernard,[2] a close friend of Van Gogh who became an ardent champion of his work after his death. Bernard tried unsuccessfully to organize a retrospective of Van Gogh's work in February–March 1891, after which he helped arrange for the return of a large part of the collection to Holland.[3] About one hundred paintings remained in Paris and were stored with the color merchant Julien (Père) Tanguy.[4] In April 1892 Bernard collaborated with the dealer Louis-Léon Le Barc de Boutteville to mount an exhibition at which sixteen paintings and several drawings by Van Gogh were shown.[5] Possibly Vollard acquired *Woman in a Garden* from this store of works, with Bernard acting as an intermediary. In 1911 Vollard would publish Van Gogh's letters to Bernard.[6]

A striking feature of *Woman in a Garden* is its painted red border, which also appears in other views of the Seine painted in 1887. This suggests that Van Gogh may have intended the works as a decorative ensemble—a panoramic frieze or possibly a group of triptychs.[7] The word "tryptich [*sic*]" written in blue crayon, supposedly in Vollard's handwriting, on the back of *Woman in a Garden* indicates that at some point this painting was seen as part of such an ensemble.[8] Various hypotheses have been put forward about the works that presumably made up the triptychs.[9] This exhibition contains three that may have been meant to be grouped or perhaps to form the components of a larger panoramic frieze: *Woman in a Garden, Banks of the Seine with Pont de Clichy in Spring* (cat. 115), and *Fishing in Spring, the Pont de Clichy* (cat. 116), all of which have red borders. A triptych made up of these works would certainly have made a considerable impact at Vollard's 1896–97 Van Gogh exhibition.

Vollard sold *Woman in a Garden* to the eccentric Dutchman Cornelis Hoogendijk, one of his first major clients.[10] In his memoirs Vollard recalled, somewhat fancifully perhaps, how Hoogendijk pulled out names of artists that Vollard had put into a hat: "'I hear an inner voice telling me to follow what chance has determined,' [he declared]. . . . And he chose some fine Van Goghs."[11] Later Hoogendijk was confined to a mental hospital. As Vollard explained, "The experts were unanimous in declaring that . . . the modern paintings—the Cézannes and the Van Goghs—could only have been bought by a madman."[12] Vollard bought back *Woman in a Garden*,[13] which was catalogued as a Caillebotte, at the collector's estate sale in Amsterdam following Hoogendijk's death in 1912.[14]

AD

1. Faille 1970, no. 368.
2. On August 14, 1894, for example, he purchased from Bernard's mother for 300 francs one painting by Gauguin and two by Van Gogh, although the titles are not specified: Vollard Archives, MS 421 (4,3), fol. 4.
3. See Stolwijk and Veenenbos 2002, p. 25.
4. Ibid.
5. Ibid., p. 24, n. 27. See also S. A. Stein 2005b, pp. 28–29.
6. Vollard 1911.
7. Martigny 2000, pp. 144–46.
8. Walter Feilchenfeldt to the author, November 1, 2001. See also Stolwijk and Veenenbos 2002, p. 143, n. 12/7.
9. Bogomila Welsh-Ovcharov in Paris 1988, p. 143, suggests

Lane in a Public Garden (1887; F 277), *The Seine with a Rowboat* (1887; F 298), and *Two Ladies at the Gate of a Public Garden in Asnières* (1887; F 305). Ronald Pickvance (in Martigny 2000) proposed that Vollard bought three triptychs from Van Gogh-Bonger. On stylistic, compositional, and thematic grounds, but without the support of specific source material, he suggests an Asnières triptych, made up of *Bridge across the Seine* (F 240), *View of a River with Rowing Boats* (F 300), and *Bridge across the Seine at Asnières* (F 301), as well as a Clichy triptych, comprising *Banks of the Seine with Pont de Clichy in Spring* (cat. 115), *Banks of the Seine with a Boat* (F 353), and *Two Boats near a Bridge* (F 354). He does not suggest candidates for the Grande Jatte triptych. See Martigny 2000, pp. 144–45, 181, 183, 204, 296–97. Walter Feilchenfeldt has proposed three triptychs: *Seine with a Rowing Boat* (from the collection of Émile Bernard; F 298), *Avenue in Voyer d'Argenson Park, Asnières* (sold in Holland; F 277), and *Entrance of Voyer d'Argenson Park, Asnières* (F 305); the second, *View of a River with Rowing Boats* (F 300), *Bridge across the Seine at Asnières* (F 301), and *The Restaurant de la Sirène at Asnières* (F 312); and the last, *The Bank of the Seine with Boats* (F 353), *Fishing in Spring* (cat. 116), and the present work. See Feilchenfeldt 2006, p. 121.

10. Vollard sold works by Van Gogh to Hoogendijk on September 1, 1897, and May 17 and July 12, 1899 (Vollard Archives, MS 421 [4,2], fol. 41, and MS 421 [4,3], fols. 131, 138), but no titles are mentioned. The Hoogendijk provenance is given in Faille 1970, no. 368.
11. Vollard 1936, p. 128.
12. Ibid., p. 129.
13. Communication from Walter Feilchenfeldt to Jonathan Pratt.
14. Faille 1970, no. 368. Henkels 1993.

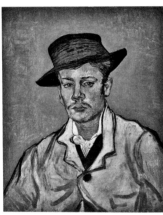

118

118. *fig. 51*

VINCENT VAN GOGH
Armand Roulin

1888
Oil on canvas
26 x 21¾ in. (66 x 55 cm)
Museum Folkwang, Essen G 63
New York and Chicago only

CATALOGUE RAISONNÉ: Faille 1970, no. 492

PROVENANCE: Joseph Roulin, Marseilles; Ambroise Vollard, Paris, ca. 1895; Karl-Ernst Osthaus, Hagen, ca. 1904; Museum Folkwang (Karl-Ernst Osthaus-Museum), Hagen, ca. 1904–21; Museum Folkwang, Essen, 1922

Armand Roulin (1871–1945) was the eldest son of the postal clerk Joseph Roulin, Van Gogh's friend when he lived in Arles in 1888. Armand was seventeen and

apprenticed to a blacksmith when Van Gogh painted him. Toward the end of the year, Van Gogh made portraits of the entire family, as he explained in a letter to Theo: "I have made portraits *of a whole family*, that of the postman whose head I had done previously—the man, his wife, the baby, the little boy, and the son of sixteen [*sic*], all characters and very French. . . . And if I manage to do this *whole family* better still, at least I shall have done something to my liking and something individual."[1] Van Gogh painted two portraits of Armand. In the first he is shown in profile wearing a blue jacket (Museum Boymans Van Beuningen, Rotterdam; F 493). The Essen work is probably one of the more carefully composed portraits done in December 1888.[2]

Vollard acquired this portrait, along with other works, from the Roulin family, but it is difficult to know exactly when. It has generally been thought that he visited the family and bought six paintings in 1894 or 1895, as Roulin's daughter Marcelle recalled in a letter written many years later, in 1959.[3] However, there is no evidence in the Vollard accounts for a purchase of works by Van Gogh at this date, and it is quite possible that Marcelle's memory was vague by the time she composed the letter. From the evidence of the accounts, it seems more likely that Vollard acquired the paintings from Joseph Roulin in 1900 (see cat. 124).[4] In 1901 Vollard lent the painting to the Van Gogh exhibition at the Galerie Bernheim-Jeune in Paris.[5]

Vollard sold this portrait to the German collector and art critic Karl-Ernst Osthaus (1874–1921) in May 1903.[6] Osthaus, the son of a wealthy banker, was introduced to Vollard by the Belgian architect and designer Henry van de Velde (1863–1957). In 1902 he founded the Folkwang Museum in his native city of Hagen in order to display his collection of French Impressionist and Postimpressionist paintings as well as works by the German Expressionists. In 1922, after Osthaus's death, the contents of the museum were transferred to the Folkwang Museum, Essen.

AD and JPP

`1. Vincent van Gogh to his brother Theo, ca. December 2, 1888, in Van Gogh Letters 1999, vol. 3, pp. 101–2, letter 560.
2. Dorn 1990a, pp. 191f., 466f.; and Roland Dorn in Essen–Amsterdam 1990, p. 130.
3. Marcelle Roulin to Vincent Willem van Gogh, February 23, 1959: Archives, Van Gogh Museum, Amsterdam, MS b7015V/1996. If Vollard's visit had occurred at this time, it was probably before June 1894. If it had been later, he would have recorded his acquisitions in his ledgers, which began that month.
4. Vollard Archives, MS 421 (4,9) fols. 17, 24, 43.
5. Exhibited as no. 12 under the title *Portrait de jeune homme (fond jaune)*, with Vollard listed as the lender. See Feilchenfeldt 1988, p. 100.
6. The receipt, signed by Vollard, states, "Reçu de Monsieur Karl Ernst Osthaus la somme de deux mille francs pour deux tableaux de Gauguin, un tableau de Van Gogh et un album de Maurice Denis . . . Paris, le 5 mai 1903": Karl-Ernst Osthaus-Archiv, Karl-Ernst Osthaus-Museum, Hagen, F1/104/1. Cited by Roland Dorn in Essen–Amsterdam 1990, p. 130, n. 3.

119

119. *fig. 54*

VINCENT VAN GOGH
Still Life with Plaster Statuette

1888
Oil on canvas
21⅞ x 18¼ in. (55 x 46.5 cm)
Collection Kröller-Müller Museum, Otterlo KM 105.676
Chicago and Paris only

CATALOGUE RAISONNÉ: Faille 1970, no. 360

PROVENANCE: The artist's brother Theo van Gogh, Paris,
ca. 1887–his d. 1891; by descent to his widow, Johanna van
Gogh-Bonger, Amsterdam, 1891 (sent on consignment to
Ambroise Vollard, Paris, July 3, 1895–until returned at
unknown date); bought by Galerie Paul Cassirer, Berlin, June
1910; bought by Mr. and Mrs. H. Kröller-Müller, The Hague,
August 1912; Kröller-Müller Museum, Otterlo

Still Life with Plaster Statuette was one of the first
works by Van Gogh that Vollard handled. Vollard
never actually met the artist, who had died in 1890.
However, encouraged by Émile Bernard's enthusi-
asm and the growing interest in Van Gogh evinced
by the publication in the *Mercure de France* of his cor-
respondence with Bernard,[1] Vollard began to seek out
works by him.

Vollard opened his new gallery at 39, rue Laffitte
in June 1895 with a small exhibition of Van Gogh's
work. This was only the second commercial Van
Gogh exhibition held in Paris; the first had been
organized by Bernard in 1892 for the gallery of Louis-
Léon Le Barc de Boutteville. To fill out the rather
meager selection of works that he had managed to
borrow from artists such as Gauguin, Bernard, Denis,
and Schuffenecker, Vollard approached Jo van Gogh-
Bonger, the widow of Theo van Gogh, only six days
before the opening of his exhibition. "If I take the
liberty of writing to you, it is to ask if you would be
so kind as to send me some paintings (in this case,
preferably of flowers), otherwise drawings, to aug-
ment the rather small number that I have been able
to assemble."[2] Receiving no answer, Vollard ventured
to write again: "My exhibition has been open for
three days, and it is so successful that I am taking
the liberty of writing to you again to ask you if you
could send a few canvases."[3]

Van Gogh-Bonger accordingly sent ten canvases
and four drawings, including no. 4—"livres, roses
et statuette"—on July 3, 1895.[4] The works arrived
too late to be included in the exhibition, which had
closed on June 30.[5] Vollard kept them on consign-
ment but succeeded in selling only one.[6] The rest,
the present painting among them, were returned to

Van Gogh-Bonger.[7] She kept this work until June
1910, when she sold it to Paul Cassirer's gallery in
Berlin.[8] Vollard developed a business relationship with
Cassirer, the leading dealer in modern art in Germany,
who became an ardent promoter of Van Gogh.[9]

AD and JPP

1. Vollard would later publish Van Gogh's letters to Bernard.
 See Vollard 1911.
2. Vollard to Jo van Gogh-Bonger, May 9, 1895: Archives,
 Van Gogh Museum, Amsterdam, MS b1306V/1962.
3. Vollard to Jo van Gogh-Bonger, June 7, 1895: Archives,
 Van Gogh Museum, Amsterdam, MS b1369V/1962.
4. Jo van Gogh-Bonger to Vollard, July 3, 1895: Vollard
 Archives, MS 421 (2,2), p. 401, and MS 421 (2,3), pp. 361–
 62, "Liste des tableaux chez M. A. Vollard," undated [1895].
 The works arrived on July 6, 1895; an account book records
 a payment of 4.50 francs on that date for "transport d'une
 casse . . . de [Mme] Vve Van Gogh": Vollard Archives, MS
 421 (4,3), fol. 26.
5. The exhibition ran from June 4 to 30, 1895. Invitation:
 Archives, Van Gogh Museum, Amsterdam,
 MS b.7199/1962.
6. *Interior of the Restaurant Carrel in Arles* (F 549), sold to
 Esther Sutro, March 25, 1896: Vollard Archives, MS 421
 (4,3), fol. 43.
7. Vollard to Jo van Gogh-Bonger, March 25, 1896: Archives,
 Van Gogh Museum, Amsterdam, MS b1307V/1962.
8. One of ten works sold to Paul Cassirer, Berlin, in June 1910
 for 14,000 guilders; Stolwijk and Veenenbos 2002, p. 170.
9. See Feilchenfeldt 1988.

120

120. *fig. 238*

VINCENT VAN GOGH
Oleanders

1888
Oil on canvas
23¾ x 29 in. (60.3 x 73.7 cm)
The Metropolitan Museum of Art, New York, gift of
Mr. and Mrs. John L. Loeb, 1962 62.24

CATALOGUE RAISONNÉ: Faille 1970, no. 593

PROVENANCE: The artist's brother Theo van Gogh, Paris,
until his d. 1891; his widow, Johanna van Gogh-Bonger,
Amsterdam, 1891; bought by Galerie Paul Cassirer, Berlin,
October 1905 (one of four works in a 2,000-Reichsmark
[3,853.40 gilders] transaction recorded by Van Gogh-Bonger
on February 17, 1906); bought by Carl Reininghaus, Vienna,
December 1905; Mrs. Redlich, Vienna, before 1924; Galerie
Barbazanges (M. Hodebert), Paris; Reid & Lefèvre, London,
by October–November 1923; bought by Sir Michael E. Sadler,
Oxford, November 1923–at least January 1925; Reid &
Lefèvre, London, 1925; bought by Mrs. R. A. Workman
(Elizabeth Russe Workman, *née* Allan), London, by March
1926 (with Reid & Lefèvre, London, as her agent, by May
1928; with Knoedler Gallery, New York, as her agent, by
November 1928 at least November 1932); Mrs. William

Andrews Clark, New York, by 1934–47; Knoedler, New York,
1948; Mrs. Charles Suydam Cutting, New York, by 1948–61;
Knoedler, New York, 1962; Mr. and Mrs. John L. Loeb, New
York; their gift to the Metropolitan Museum, New York, 1962

In mid-August 1888 Vincent van Gogh wrote to his
brother Theo, "One of these days I hope to make a
study of oleanders."[1] *Oleanders* was probably painted
at the end of the month. As in *Still Life with Plaster
Statuette* (cat. 119), the composition here is com-
pleted by two novels; one of them is Émile Zola's *La
Joie de vivre* (1884).

It has been thought that the Metropolitan's
Oleanders was among the Van Gogh works that
Vollard acquired from the artist's friend Joseph
Roulin in Arles.[2] However, the present picture is
probably the work titled "Oleandres (laurier roses)"
that appears on the list of works sent by Jo van
Gogh-Bonger, Theo's widow, to Vollard's second Van
Gogh exhibition, which opened in his rue Laffitte
gallery in December 1896.[3] The price indicated on
the list is 400 francs.

Vollard sold very few of the works that Van Gogh-
Bonger had sent on consignment, and *Oleanders* was
among many works returned to her unsold. Vollard's
relationship with her ended badly because she was
angered by his delay in paying her. She continued to
energetically promote her brother-in-law's work, and
in late 1905 she sold *Oleanders* to the Berlin dealer
Paul Cassirer, with whom she developed a strong
commercial relationship. Cassirer was responsible for
the first Van Gogh exhibition in Germany, held in
his Berlin gallery in the winter of 1901.[4] He con-
tinued to mount major Van Gogh exhibitions, estab-
lishing a vigorous market for the artist in Germany in
the first decade of the twentieth century.[5] *Oleanders*
was shown in an exhibition at the Cassirer gallery in
Hamburg in September–October 1905.[6]

AD and JPP

1. Van Gogh Letters 1958, vol. 3, p. 15, letter 524.
2. Faille 1970, no. 593, Marcelle Roulin, in a letter dated
 February 23, 1959: identified this picture as one that her
 father sold to Vollard in 1893 or 1894. See also New York
 1984, p. 163, no. 93: "The present painting has an added
 interest. It once belonged to Joseph Roulin, no doubt a gift
 from the artist." That work, however, is probably F 594.
3. The works sent by Jo van Gogh-Bonger are on a typed list
 in the archives of the Van Gogh Museum, Amsterdam,
 MS b1437V/1962; *Oleanders* is no. 28. On a list of
 Van Gogh's works prepared in 1890 by Émile Bernard and
 Andries Bonger, *Oleanders* is no. 215: Archives, Van Gogh
 Museum, MS b3055. This identification has been sup-
 ported, though not definitively confirmed, by Louis
 van Tilborgh, who points out that no. 215 on the original
 Bonger list has a title "Pivoines [Peonies] (20)." The title
 "Peonies" may well be erroneous. The "20" refers to a stan-
 dard size 20 canvas, 28¾ x 23⅝ in. (73 x 60 cm), which cor-
 responds to the dimensions of the Metropolitan's painting.
 Letter to Susan Alyson Stein, February 6, 2006.
4. Feilchenfeldt 1988, p. 10.
5. Ibid., pp. 144–50.
6. Ibid., p. 147.

121

121. *fig. 50*

VINCENT VAN GOGH
Tarascon Diligence (The Tarascon Coaches)

1888
Oil on canvas
28⅛ x 36⅜ in. (71.4 x 92.5 cm)
The Henry and Rose Pearlman Foundation; on long-term
loan to the Princeton University Art Museum
New York only

CATALOGUE RAISONNÉ: Faille 1970, no. 478a

PROVENANCE: Theo van Gogh, the artist's brother (sent on
consignment to Julien [Père] Tanguy, Paris); acquired by
Medardo Rosso, Paris, 1895; Milo Beretta, Montevideo, by 1935;
La Passe Art Gallery, Buenos Aires; De Königsberg Collection,
Buenos Aires, by 1948; Mr. and Mrs. Henry Pearlman, New
York, 1950; the Henry and Rose Pearlman Foundation, on
extended loan to the Princeton University Art Museum

On October 13, 1888, Van Gogh wrote to his brother
Theo, "Have you reread *Tartarin* yet? Be sure not to
forget. Do you remember that wonderful page in
Tartarin, the complaint of the old Tarascon dili-
gence? Well, I have just painted that red and green
vehicle in the courtyard of the inn. You will see it."
Van Gogh, whose letters are full of literary refer-
ences, is here referring to a novel by the Provençal
writer Alphonse Daudet, whom he greatly admired.
In *Tartarin de Tarascon* (1872), the horse-drawn car-
riage complains of being exiled in North Africa. In
the same letter Van Gogh confessed to being ex-
hausted when he finished the painting, suggesting
that he had completed it in one session.[1]

Tarascon Diligence (The Tarascon Coaches) was
possibly one of the paintings that Theo deposited
with the color merchant Julien (Père) Tanguy (see
cat. 117).[2] It was presented in Vollard's first Van Gogh
exhibition, held in June 1895, and attracted the atten-
tion of Thadée Natanson, who wrote in *La Revue
blanche,* "How characteristic, tough, new and vigor-
ously appealing are these pictures, and what pleas-
ure one feels on seeing these green coaches with hard
wheels in yellow wood."[3] Although not very suc-
cessful, this small exhibition was significant because
it was one of the first of Van Gogh's work after his
death in 1890. At a time when there was little under-
standing of the artist's work, this was a bold step on
Vollard's part.

Tarascon Diligence apparently belonged to the
Italian sculptor Medardo Rosso.[4] He may have lent
the work to Vollard's exhibition, but there is no men-
tion of him in the dealer's archives. It seems probable
that Vollard never actually owned this work but bor-
rowed it, as well as a group of Van Gogh works from
various artists, for the exhibition. A number of these
works remained unsold and were returned to the

artists after the exhibition, and thus do not appear in
the accounts.

AD and JPP

1. See New York 1984, pp. 188–89, no. 112; and Van Gogh
 Letters 1999, vol. 3, pp. 77–78, letter 552.
2. See Faille 1970, no. 478a, where he cites "Maison [Julien]
 Tanguy Art Gallery, Paris [in commission from Theo van
 Gogh]." After Theo's death, the majority of the works by
 Van Gogh in his possession were shipped back to Jo van
 Gogh-Bonger in Holland. However, about one hundred
 remained in Paris and were stored with Tanguy. See
 Stolwijk and Veenenbos 2002, p. 25. Possibly *Tarascon
 Diligence* was among those works.
3. Natanson 1895b, p. 572.
4. Margaraet Scolari Barr states that Rosso acquired *Tarascon
 Diligence* from Tanguy during Tanguy's lifetime since the
 picture is not listed in the catalogue of the Tanguy sale of
 June 2, 1894 (see Tanguy Sale 1894). She acknowledges John
 Rewald for this information, but with no documentary evi-
 dence. In 1895, Barr continues, Rosso gave the work to his
 disciple Milo Beretta, who took it back with him to
 Montevideo; see New York 1963, p. 75, n. 134.

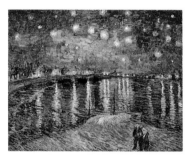

122

122. *fig. 147*

VINCENT VAN GOGH
*Starry Night over the Rhone (Starry
Night, Arles)*

1888
Oil on canvas
28½ x 36¾ in. (72.5 x 92 cm)
Musée d'Orsay, Paris, Life interest gift of M. and Mme
Robert Kahn-Sriber in memory of M. and Mme Fernand
Moch, 1975; entered the collection in 1995 RF 1975-19

CATALOGUE RAISONNÉ: Faille 1970, no. 474

PROVENANCE: Acquired from the artist by his brother Theo
van Gogh, Paris, ca. May 1889–by his d. 1891; by descent to
his widow, Johanna van Gogh-Bonger, Amsterdam, 1891–99
(consigned to Johan Theodoor Uiterwijk [Arts and Crafts Art
Gallery], The Hague, October 1898–sold by January 11, 1899);
Bas Veth, Bussum (likely purchased from Van Gogh-Bonger
through Uiterwijk), by 1905–his d. 1922; his sale, Frederik
Muller, Amsterdam, June 20, 1922, no. 3; Galerie d'Art Frans
Buffa & Zonen, Amsterdam; Fernand Moch, Paris, by 1931;
by descent to Robert Kahn-Sriber; Musée d'Orsay, Paris (life
interest gift of M. and Mme Robert Kahn-Sriber, in memory
of M. and Mme Fernand Moch, 1975), 1995

Starry Night over the Rhone was included in Vollard's
second Van Gogh exhibition, at his larger gallery at
6, rue Laffitte in December 1896. It had been shown
previously at the Salon des Indépendants in 1889,
where it attracted the attention of the distinguished
critic Felix Fénéon: "M. Van Gogh is an amusing
colorist, even in such extravagances as his *Starry

Night:* against the sky, a rough, cross-hatched pat-
tern of flat brushstrokes, stars appear as strobes of
white, pink, yellow that have been laid directly from
the tube; orange triangles are engulfed by the river,
and, near the moored boats, baroquely sinister
figures scurry by."[1] The modest exhibition of Van
Gogh's work that Vollard had put on in June 1895,
although not a great success, had attracted sufficient
critical interest to encourage him to stage a much
more ambitious show the following year. Apart from
a few works he had on consignment from various
artist friends of Van Gogh, such as Émile Bernard,
Émile Schuffenecker, and Paul Gauguin, he borrowed
all the works for the new exhibition from Jo van
Gogh-Bonger. Vollard went to Holland in November
1896 to visit Van Gogh-Bogner and presumably to
make a selection of works. Fifty-six paintings, fifty-
six drawings,[2] and one lithograph were subse-
quently sent to Vollard.[3]

The 1896 exhibition must have been a spectacu-
lar event, for it included major works from every
phase of Van Gogh's career, including *The Potato
Eaters* (1882, Van Gogh Museum, Amsterdam),
Moulin de la Galette (1887, Van Gogh Museum),
Self-Portrait with Bandaged Ear (1889, Courtauld
Institute Galleries, London), and *Starry Night over
the Rhone.*[4] The last is the work that Jo van Gogh-
Bonger seems to have valued the most highly, since
she put the highest price (1,000 francs) on it. Despite
the presence of these works, now considered mas-
terpieces, the Parisian public was not yet ready to
appreciate Van Gogh. The exhibition was a notable
failure, ignored by the press. Vollard found himself
in a difficult position as Van Gogh-Bonger raised the
prices beyond those originally agreed upon.
Eventually he was obliged to send the unsold works,
including *Starry Night over the Rhone,* back to
Holland.[5] Van Gogh-Bonger placed it on consign-
ment with the Arts and Crafts Art Gallery in The
Hague, which sold the work in 1899.[6]

AD and JPP

1. Fénéon 1889 (1970 ed.), cited in S. A. Stein 1986, p. 181.
2. There were fifty-six drawings and not fifty-four, as had
 been previously thought, as three drawings were included
 under no. 16 on the list; see S. A. Stein 2005b, p. 38, n. 27.
3. Typed list of works lent by Jo van Gogh-Bonger to Vollard:
 Archives, Van Gogh Museum, Amsterdam, MS b1437V/1962.
4. Number 121 on the list of Van Gogh's works made in 1890
 by Émile Bernard and Andries Bonger: Archives, Van
 Gogh Museum, MS b3055.
5. Jo van Gogh-Bonger to Vollard, March 27, 1897, in which
 she expresses impatience and demands that the works be
 returned that week: Vollard Archives, MS 421 (2,2), p. 409.
6. Stolwijk and Veenenbos 2002, p. 175.

123. *fig. 55*

VINCENT VAN GOGH
*L'Arlésienne: Madame Joseph-Michel
Ginoux (Marie Julien, 1848–1911)*

1888 or 1889
Oil on canvas
36 x 29 in. (91.4 x 73.7 cm)
The Metropolitan Museum of Art, New York, Bequest of
Sam A. Lewisohn, 1951 51.112.3

CATALOGUE RAISONNÉ: Faille 1970, no. 488

123

of whom I speak in my article, are willing to lend these paintings to the organizer of the exhibition at the Galerie Vollard."

4. Vollard Archives, MS 421 (4,3), fol. 32, October 17, 1895.

5. Henri Laget's letters to Vollard: Vollard Archives, MS 421 (2,2), pp. 122–37; and Vollard to Joseph Ginoux, April 21, 1897: Vollard Archives, MS 421 (2,2), p. 142. As per letter from Laget to Vollard dated May 13, 1896, Vollard had nine paintings by Van Gogh from Ginoux, apparently on commission: Vollard Archives, MS 421 (2,2), pp. 130–31. See also Jonathan Pascoe Pratt, "Patron or Pirate? Vollard and the Works of Vincent van Gogh," in this volume.

PROVENANCE: Gift of the artist to the sitter, Mme Joseph-Michel Ginoux, *née* Marie Julien, Arles, 1889; bought by Ambroise Vollard, Paris, October 17, 1895; Alice Ruben-Faber, Copenhagen, possibly for her sister, Ella Ruben, May 1897; possibly Ella Ruben, Copenhagen, ca. 1897; bought in Copenhagen by Bernt Grönvold, Copenhagen and Berlin, by 1912; bought by Paul Cassirer, Berlin, June 20, 1917; bought by Sally Falk, Mannheim, July 3, 1917; consigned by Falk to Cassirer, April 11, 1918; bought by Moritz Winter, Warsaw, April 17, 1919; Fritz Schön, Basel and Berlin-Grünewald, by 1924–26; Stephan Bourgeois, New York, by 1926; possibly Wildenstein, New York; Adolph Lewisohn, New York, by 1927–his d. 1938; by descent to his son Samuel A. Lewisohn, New York, 1938–51; his bequest to the Metropolitan Museum, New York, 1951

Madame Marie Julien Ginoux and her husband, Joseph, ran the Café de la Gare at 30, place Lamartine in Arles, where Van Gogh rented a room from early May to mid-September 1888. Dressed in full Arlésian traditional costume, Mme Ginoux posed in the Yellow House for both Van Gogh and Gauguin. Van Gogh painted her portrait twice in Arles. On completing the first, more rapidly executed version (Musée d'Orsay, Paris; F 489), he wrote to Theo in early November 1888: "I have an Arlésienne at last, a figure (size 30 canvas) slashed on in an hour, background pale citron, the face gray, the clothes black, black, black, with perfectly raw Prussian blue. She is leaning on a green table and seated in an armchair of orange wood."[1] The Metropolitan's version was probably painted for Mme Ginoux around May 1889, just before Van Gogh left Arles.[2]

The exhibition of Van Gogh's work that Vollard held at 39, rue Laffitte in June 1895 attracted the attention of Henri Laget, the editor of a local periodical entitled *Provence artistique*. On June 15, 1895, he wrote to Vollard enclosing a copy of an article he had written about Van Gogh and suggesting that M. Ginoux would be happy to lend paintings to the exhibition.[3] Vollard was responsive to this proposal. The first painting he bought via Laget was *L'Arlésienne* (probably the Metropolitan's painting) in October 1895, for which he paid Ginoux 60 francs, with a commission of 10 francs to Laget.[4] This proved to be the beginning of a successful and profitable arrangement for Vollard, who acquired a number of works by Van Gogh from Ginoux through Laget in 1896.[5] AD and JPP

1. Van Gogh Letters 1999, vol. 3, pp. 99–101, letter 559.

2. New York 1984, pp. 206–10, no. 121.

3. Vollard Archives, MS 421 (2,2), pp. 122–23. "The owners of paintings by van Gogh, old friends of the painter of Arles

124

124. *fig. 52*

VINCENT VAN GOGH

La Berceuse (Woman Rocking a Cradle) (Augustine-Alix Pellicot Roulin, 1851–1930)

1889
Oil on canvas
36½ x 29 in. (92.7 x 73.7 cm)
The Metropolitan Museum of Art, New York,
The Walter H. and Leonore Annenberg Collection,
Gift of Walter H. and Leonore Annenberg, 1996, Bequest
of Walter H. Annenberg, 2002 1996.435
New York only

CATALOGUE RAISONNÉ: Faille 1970, no. 505

PROVENANCE: The sitter, Augustine-Alix Pellicot Roulin, and her husband, Joseph Roulin, Arles, later Marseilles, 1889; acquired by Ambroise Vollard, Paris, ca. 1895; Amédée Schuffenecker, Saint-Maur/Clamart, 1905; Bernheim-Jeune, Paris, by 1910; Léon Marseille, Paris; Galerie Tanner, Zurich, by 1917; bought by Rudolf Staechelin, Basel, December 29, 1917; transferred to Rudolf Staechelin Foundation, 1932 (consigned to Galeries Wildenstein, Paris and New York, 1967; bought from Staechelin estate through Wildenstein by Walter H. and Leonore Annenberg, Rancho Mirage, California, October 4, 1967; Walter H. and Leonore Annenberg, jointly with the Metropolitan Museum, New York, 1996–until his d. 2002; the Metropolitan Museum, 2002

This is one of the artist's five versions of Augustine Roulin holding the ropes used to rock a cradle. Augustine was the wife of Joseph Roulin, a postal clerk in Arles, whom Van Gogh befriended when he lived in the town in 1888.[1] He painted portraits of all the members of the Roulin family just before he had his breakdown at the end of 1888. The Metropolitan's version seems to have been begun a bit later by January 30, and completed by February 3, 1889.[2] Van Gogh agreed to let Madame Roulin choose one of the three versions he had finished by that date,

and it is thought that she chose the New York painting.[3]

Many years later, the Roulins' daughter Marcelle remembered Vollard visiting her father in 1894 or 1895 and buying all six of the paintings by Van Gogh that he owned for 450 francs.[4] These have been identified as the portraits of her father, her mother, both her brothers (Armand and Camille), herself, and a still life of oleanders in a vase.[5] It has been assumed that the Metropolitan's painting was one of the works acquired at this time.[6] However, there is no record in the Vollard accounts for a transaction with the Roulins at this date,[7] and Marcelle's memory may not have been so accurate about an event that supposedly occurred sixty-four years earlier.

The accounts do, however, record Vollard's acquisition of works by Van Gogh from Roulin at later dates through an intermediary, Henri Laget, editor of a journal called *Provence artistique*. Vollard bought his first two paintings from Roulin on June 1, 1900.[8] A few weeks later he purchased another two paintings, as "tableau de fleurs" and "la petite tête d'enfant,"[9] which he recorded in his accounts on June 29, 1900.[10] Finally, on October 12 Vollard bought four more Van Gogh paintings for 400 francs, settled his account with Roulin, and paid 80 francs as a commission to Laget.[11] Vollard thus bought eight paintings from Roulin, rather than the six previously thought, and it is likely that the Metropolitan's painting was one of those acquired in 1900. By 1905 the painting belonged to Amédée Schuffenecker, a wine merchant and art dealer and the brother of the painter Émile Schuffenecker, who was a friend of Van Gogh and one of the first to collect his works.[12] AD and JPP

1. Faille 1970, nos. 504–8. See New York 1984, pp. 246–48, no. 146; the five variants are discussed on p. 248. See also Lister 2001.

2. Lister 2001, p. 77.

3. Ibid. "I have done 'La Berceuse' three times, and as Mme. Roulin was the model and I only the painter, I let her choose between the three, her and her husband, but on condition that I should make another duplicate for myself of the one she chose, and I am working on it now." Van Gogh Letters 1999, vol. 3, p. 133, letter 576.

4. Marcelle Roulin to Vincent van Gogh, February 23, 1959: Archives, Van Gogh Museum, Amsterdam, MS b7015V/1996. Vollard's visit probably occurred before June 1894. If it had been later he would have recorded his acquisitions in his ledgers, which began that month.

5. Marcelle Roulin identified the paintings to John Rewald, who recorded them in a letter to A. M. Hammacher, April 29, 1962, cited in Faille 1970, under no. 441a. The paintings recorded were *The Baby Marcelle Roulin* (1888, Pierre Gianadda Foundation, Martigny; F 441a); *Portrait of Camille Roulin* (1888, Philadelphia Museum of Art; F 537); *Oleanders* (1888, Metropolitan Museum, New York; F 593); *Armand Roulin* (1888, Philadelphia Museum of Art; F 492); and *La Berceuse* (1889, Metropolitan Museum; F 505).

6. J. N. Priou, in *Revue des postes et télécommunications de France* 1955, pp. 26–32. See note 4 above and Faille 1970, no. 505.

7. Unless the transaction took place before June 1894; see note 4 above.

8. Vollard Archives, MS 421 (4,9), fol. 17.

9. Vollard to Roulin, June 19, 1900: Vollard Archives, MS 421 (4,1), p. 37.

10. "Roulin 140 francs 2 Van Gogh": Vollard Archives, MS 421 (4,9), fol. 24, June 29, 1900.

11. Vollard Archives, MS 421 (4,9), fol. 43, October 12, 1900.

12. Faille 1970, no. 505. It seems likely that Schuffenecker would have bought the work from Vollard, but there is no record of such a transaction in the Vollard ledgers.

125

1. Vincent van Gogh to his brother Theo, January 7, 9, and 17, 1889, in Van Gogh Letters 1958, vol. 3, pp. 112, 115, 118, letters 568, 570, 571; see also New York 1984, pp. 242–45, no. 144.
2. New York 1984, pp. 242–45, no. 144.
3. See Faille 1970, no. 505; Feilchenfeldt 1988, p. 100.
4. See Feilchenfeldt 1988.

Indeed, this statuette is one of Maillol's most famous works. It charmed not only Rodin but also Maillol's Nabi friends.[3] Denis owned a cast, as did Pierre Bonnard. The Städelsches Kunstinstitut in Frankfurt bought one from Vollard in 1908.[4]

EH

1. Invoice and Maillol to Rodin, probably April 1904: Archives, Musée Rodin, Paris.
2. Rodin quoted in Mirbeau 1905, p. 326.
3. Le Normand-Romain 1994, p. 45.
4. Archives, Städelsches Kunstinstitut und Städtische Galerie, Frankfurt.

125. *fig. 254*

VINCENT VAN GOGH
Dr. Félix Rey

1889
Oil on canvas
25¼ x 20⅞ in. (64 x 53 cm)
Pushkin State Museum of Fine Arts, Moscow 3272
New York only

CATALOGUE RAISONNÉ: Faille 1970, no. 500

PROVENANCE: Gift of the artist to Dr. Félix Rey, Arles, on or by January 17, 1889; one of six Van Goghs bought by an unidentified Marseilles dealer (apparently brought to his attention by Charles Camoin, on behalf of Rey), almost certainly acting on behalf of Ambroise Vollard, ca. 1901; Vollard, Paris, ca. 1901; bought by Paul Cassirer, Berlin, November 1904; bought by Eugène Druet, Paris, March 1908; bought by Sergei Shchukin, Moscow, 1909; First Museum of Modern Western Painting, 1918; State Museum of Modern Western Art, Moscow, 1923; Pushkin State Museum of Fine Arts, Moscow, 1948

Félix Rey (1867–1932) was a young doctor who cared for Van Gogh when he was in the hospital in Arles, from December 24, 1888, to January 7, 1889. The day he left the hospital Van Gogh wrote to his brother Theo, "Monsieur Rey came to see the paintings with two of his friends, doctors, and they were uncommonly quick at understanding at least what complementaries are. I now intend to do a portrait of M. Rey." Two days later, he reported a walk with Rey: "He had already told me before this morning that he was fond of painting, though he knew nothing about it, and that he wishes to learn. I told him he ought to turn *collector*, but that he should not try to paint himself." On January 17, Van Gogh wrote to Theo that he had finished the portrait of Rey and given it to him as a souvenir.[1]

According to one account, the doctor's mother hated the portrait and used it to fill a hole in a henhouse. It was discovered about 1901 by the Fauve painter Charles Camoin (whose work Vollard handled) and sold by Rey together with five other canvases by Van Gogh to a dealer in Marseilles who was probably acting on behalf of Vollard.[2] Vollard sold the painting in November 1904[3] to Paul Cassirer, who was the first dealer in Germany to promote the work of Van Gogh.[4] But by 1908 the painting was back in Paris in the hands of the dealer Eugène Druet, who, the following year, sold it to the noted Russian collector Sergei Shchukin, who amassed an extraordinary group of works by Van Gogh, Gauguin, Matisse, and Picasso, several of which he purchased from Vollard. AD and JPP

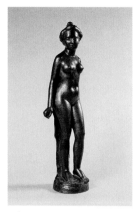

126

126. *fig. 188*

ARISTIDE MAILLOL
Standing Bather

1900/02
Bronze
26⅜ x 5⅞ x 5⅞ in. (67 x 15 x 15 cm)
Musée Rodin, Paris S. 579

PROVENANCE: Ambroise Vollard, Paris; bought by Auguste Rodin, Paris, April 2, 1904, for 50 francs; Musée Rodin, Paris, Donation Rodin, 1916

The *Standing Bather* was based on a wood original that Aristide Maillol had given Vollard on September 10, 1902. Auguste Rodin bought this bronze from Vollard on April 2, 1904. The invoice is preserved in the archives of the Musée Rodin—the statuette cost Rodin 50 francs—along with Maillol's grateful letter to the older sculptor: "This is the true reward, the only one that an artist who loves his art can hope to have for his work. Moreover, it is greatly encouraging for me. One follows one's path with a livelier step when a great artist at the summit of his glorious career casts an eye on the humble worker coming behind him."[1]

The quality of the casting leaves something to be desired, as it is riddled with flaws, but the work must have had a high value for Rodin. "As a sculptor, Maillol ranks among the greatest," he later told Octave Mirbeau. "Maillol has a genius for sculpture. . . . The admirable thing about Maillol, the eternal thing, I might say, is the purity, clarity, and limpidity of his craft and his thinking. In none of his works—at least none that I've seen—is there anything that inhibits the viewer's curiosity. . . ."[2]

There are several other *Standing Bather*s in Maillol's oeuvre, showing variations in the pose of the feet and ankles and the presence or absence of drapery. They are dated, though not definitively, between 1898 and 1900. Their stiffness can be ascribed to the fact that they echo statuettes initially carved from wood blocks. But it was precisely that simple rigidity, that "exquisite awkwardness" (as Maurice Denis put it), that accounts for their seductive power and explains their success.

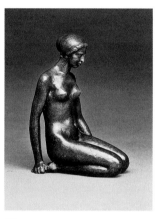

127

127. *fig. 186*

ARISTIDE MAILLOL
Kneeling Woman

Ca. 1900
Bronze
7⅝ x 5⅜ x 3¾ in. (19.5 x 13.8 x 9.5 cm)
Musée d'Orsay, Paris, Bequest of Mr. and Mrs. Raymond Koechlin, 1931 RF 3234

At the turn of the century Maillol stopped producing wood statuettes because they took too long to make. The small-scale female nudes he modeled looked simple, but they were laborious to create. Two variants of a kneeling woman exist: in the present example, the right hand holds the ankle while the left grips the calf, but there is also a statuette in which both hands are posed on the thighs and the knees rest on a cushion.[1] The posture of this figure suggests neither an academic model's pose nor an attitude from daily life; rather, the tightly closed knees, buttocks resting on heels, and lowered head reduce the female body to a geometric form. Still, these works have no traces of formal coldness, and the one shown here exudes a certain melancholy charm.

Requiring little effort to cast in bronze, such statuettes—this one is among the smallest—were easily sold by Vollard to male collectors, who placed them on their mantels or desks. Indeed, a photograph shows this bronze on the writing table of its first owner, Raymond Koechlin (1869–1931).[2] Born into a family of Alsatian industrialists, Koechlin studied political science and became a political journalist. When he inherited the family fortune in 1895, he decided to dedicate himself to his passion for art and the national heritage. He founded the Société des

Amis du Louvre in 1899, became vice president of the Union Centrale des Arts Décoratifs in 1910, and was elected president of the national museum board in 1922. In 1911, when the *Mona Lisa* was stolen, he even launched a fund drive to buy it back from the thief, and he helped acquire Gustave Courbet's *The Painter's Studio* for the Louvre in 1918. A collector and art historian with many varied interests, he was as comfortable buying Japanese art as works by the Italian primitives or the Impressionists. He published art-historical writings and also a survey of modern decorative arts. He bequeathed numerous works to French museums, including the present bronze.

EH

1. For the other version, see Rewald 1939, pp. 102–3.
2. Published in Alfassa 1932, unpaged. See Tomasi 2002, pp. 11–13, ill. p. 13. See also the Koechlin family Web site, http://www.koechlin.net.

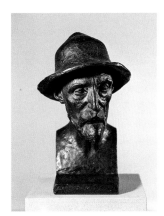

128

128.

fig. 190

ARISTIDE MAILLOL
Auguste Renoir

1907
Bronze
15⅜ x 11 x 10 in. (39 x 28 x 25.5 cm)
Kunsthalle Mannheim

PROVENANCE: Ambroise Vollard, Paris; bought by Kunsthalle Mannheim, 1913, for 480 francs

Renoir and Maillol were true collaborators, a relationship that was in part instigated by Vollard. The dealer wanted Renoir to try his hand at sculpture and enlisted Maillol to help. Ultimately, however, it was Richard Guino who served as Renoir's assistant (from 1913 to 1918), modeling works that the old master, his hands deformed by rheumatoid arthritis, could no longer shape himself.

The circumstances surrounding the creation of this bust are well known, thanks to the memoirs of Jean Renoir, the painter's son, who was a teenager at the time. In July 1907 Maillol visited Renoir in Essoyes, the property in the Champagne region that the painter had bought in 1895. He began modeling a bust of the elder artist. "He worked on it in the studio while my father painted. He never asked Renoir to pose," remembered the painter's son. One night the clay succumbed to the dry summer

weather and crumbled apart. "Maillol was tearing around the garden like a lunatic. He kept repeating at the top of his voice: 'Renoir's fallen down! Renoir's fallen down!' . . . After a few days Maillol summoned up enough courage to start the piece all over again, but judging from what Renoir and Vollard said, I gather he did not succeed in recapturing his first inspiration."[1] It was a difficult undertaking to create a portrait of an old man who was weak and suffering from rheumatism and whose face had grown visibly emaciated.[2] Renoir often declared that the first, crumbled bust had been an absolute masterpiece.

Florentin Godard was hired to cast the final version in bronze. In a letter of 1908, Maillol wrote to Vollard, "I'm going to give the Renoir bust to Gaudard [*sic*]";[3] for this exceptional work the sculptor himself selected the founder, rather than leaving the choice to the dealer. Most of the Maillol bronzes bear the mark of the founder Alexis Rudier. We can therefore speak of a "Maillol edition" with regard to the magnificent bronze at the Fondation Dina Vierny–Musée Maillol in Paris[4] and to this one, bought from Vollard's gallery for 480 francs in 1913.[5] At that time, the Kunsthalle of Mannheim (inaugurated in 1907) was under the directorship of Fritz Wichert, who had an eye for the resolutely modern.[6]

EH

1. J. Renoir 1962, p. 364.
2. Frère 1956, pp. 237ff. See also Haesaerts 1947, pp. 15–16.
3. Maillol to Vollard, undated [1908], Vollard Archives, MS 421 (2,2), p. 176.
4. Berlin and other cities 1996–97, p. 193, no. 58.
5. Ladstetter 1982, p. 474, ill. p. 33.
6. Wichert also bought from Vollard Maillol's bronze *Bather,* a female figure with right arm raised and drapery around the left ankle.

129.

fig. 193

ARISTIDE MAILLOL
Venus with a Necklace

Ca. 1918 (cast in 1928)
Bronze
68⅞ x 24 x 16 in. (175 x 61 x 40.5 cm)
St. Louis Art Museum, Purchase 1:1941
New York and Chicago only

The *Venus with a Necklace* is one of Maillol's most important statues. This large-scale female nude is a milestone that comes between the Seasons series the artist created for Ivan Morozov in 1910–11 (it is based on *Summer*) and the *Three Nymphs* he exhibited in 1937.

As early as 1905, Mirbeau observed that "Maillol's women are robust, flexible, and curvaceous . . . and can be recognized among all the others."[1] Characteristic of Maillol's approach is the slight asymmetry of the front view, brought about by the flexion of the left knee—but tempered by the straight, closely placed feet—and the discreet leftward tilt of the head. The work strikes the viewer as something of complete clarity, "august and familiar, majestic . . . and accessible."[2] But the labor involved in creating it was extensive. According to Judith Cladel, Maillol started working on the piece in 1913, but several other writers date it between 1918 and 1928. Albert Dreyfuss, who visited the sculptor's studio in 1926, described seeing the armless plaster model in the

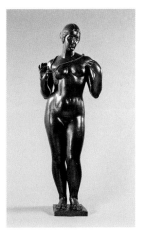

129

process of being altered,[3] and his account is corroborated by a photograph published by Christian Zervos.[4] The figure's legs in particular caused Maillol great difficulty. But he was satisfied with the hips, as he confided to Henri Frère: "'Here's the best part,' he said, tracing the curve of her right flank. 'It is very difficult to render a standing woman.'"[5]

There are two variants of this work: one with the necklace, as it appeared in plaster at the 1928 Salon d'Automne, and one without, a change that might have been suggested by the sculptor's friends.[6] The latter version produces a very curious effect: the position of the fingers, which now grasp at thin air, nevertheless adds a touch of grace. The left hand rests on a shoulder while the right hand sketches in the void a curious gesture that, along with the lowered gaze, recalls the "chaste Venus" type of antiquity. This removal of an attribute occurs in several works by Rodin, such as *The Age of Bronze,* in which the defeated warrior is deprived of the lance on which he had been leaning. While the sculptural practice was quite shocking in 1877, forty years later it had become charming.

Bronzes of both versions were cast by Alexis Rudier.[7] The first became part of the Hahnloser Collection in 1928 and was installed in the garden of the Villa Flora in Winterthur.[8] Later casts were made by Eugène Rudier; there are also lost-wax castings by Valsuani. Maillol's *Venus* met with great success, as attested by the many castings made during the artist's lifetime and after his death. She graces the world's major museums, including the Kunsthalle in Bremen,[9] Tate in London,[10] and the National Gallery of Art in Washington, D.C.[11] There are also versions of the work as a torso—without arms, both headless and with a head—and as a bust.

A bronze of this statue was installed in the foyer of Vollard's home (fig. 292), across from Renoir's *Venus Victorious* (fig. 164).

EH

1. Mirbeau 1905, p. 327.
2. Cladel 1937, p. 113.
3. Dreyfuss 1926.
4. Zervos 1925, pls. 31–33.
5. Frère 1956, pp. 280, 311.
6. Maillol to Vollard, October 8, 1931: Archives, Kunsthaus, Zürich, file, "Plastik International."
7. Rewald 1939, ill. p. 63.
8. Winterthur 1973, no. 121.
9. Bremen 1993, pp. 319–20; Berlin and other cities 1996–97, pp. 197–98, no. 78, ill. p. 170.
10. Alley 1959, pp. 129–30.
11. National Gallery of Art 1965–68, vol. 2, no. 1720.

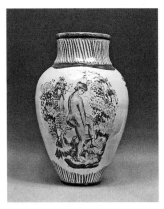

130

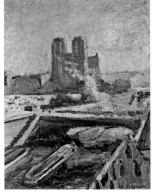

132

ceramics by various artists, including Metthey, given by
Vollard in 1937. See D. Morel 1996.

4. For example the Badisches Landesmuseum, Karslruhe.
 See Cologne–Hannover–Darmstadt 1974–75, pp. 207–12,
 and Berlin and other cities 1996–97, p. 186, nos. 18, 19, ill.
 p. 84.

5. See Clouzot 1922 and more recent articles in *Cahiers de la
 céramique, du verre et des arts du feu* 50 (1971) and in *Revue
 de la céramique et du verre* 19 (November–December 1984)
 and 89 (July–August 1996).

130.

fig. 187

ARISTIDE MAILLOL
Large Vase

Ca. 1906–7
Tin-glazed ceramic
H. 21⅝ in. (55 cm), Diam. 13 in. (33 cm)
Collection Larock-Granoff, Paris

In the years 1906–7, at Vollard's suggestion,[1] Maillol
worked closely with the ceramist André Metthey to
create decorated pottery. Metthey had first special-
ized in sandstone, then in 1903 had begun producing
stoneware and porcelains in his Asnières studio.
Maillol painted his designs on pots turned by
Metthey, who also fired them. The ceramist worked
with several of Maillol's friends as well, including
former Nabis such as Maurice Denis and Ker-Xavier
Roussel and Fauves like Henri Matisse, André
Derain, Maurice de Vlaminck, Jean Puy, and Pierre
Laprade. Approximately one hundred of their pieces
were shown at the 1907 Salon d'Automne,[2] where
they attracted the attention of critics and collectors.

The number of vases that Maillol and Metthey
produced together is small. Several of them are in
the Petit Palais, Paris,[3] a few are in German muse-
ums,[4] and some are in private collections and at the
Fondation Dina Vierny–Musée Maillol in Paris.
Though less studied than the Fauve vases, they war-
rant a publication of their own.[5]

The dating of these works has been a matter of
some debate, as Maillol had tried making glazed ter-
racottas on his own before 1900, when he had access
to his friend Daniel de Monfreid's kiln. However,
it is more likely that the series was executed in
Metthey's studio about 1906–7, probably in response
to Vollard's urging and the prospect of the 1907 Salon
d'Automne. The double monogram "AM," visible on
these ceramics, tends to support the latter hypothesis.

Sporting traditional shapes (the vases are gener-
ally potbellied with narrow necks), these ceramics are
decorated with figures of female nudes in postures
reminiscent of statuettes, set inside frames with
rounded corners. The surrounding designs, inten-
tionally simple, are composed of closely set wavy
lines, false grooves, and floral motifs. The colors are
bright: Metthey was able to obtain lemon yellow and
royal blue glazes, for instance, that proved very pop-
ular among collectors. EH

1. Vollard 1936, p. 249.
2. The catalogue includes several vases under one number;
 see Paris (Salon d'Automne) 1907, no. 1787.
3. The Petit Palais has fifty-seven ceramics by Metthey,
 donated by Émile Chouanard in 1928, and fifty-nine

131

131.

fig. 150

HENRI MATISSE
Still Life with Blue Pot

1900
Oil on canvas
23⅜ x 28⅞ in. (59.5 x 73.5 cm)
Pushkin State Museum of Fine Arts, Moscow 3369
New York only

PROVENANCE: Ambroise Vollard, Paris; bought by Ivan
Morozov, Moscow, 1909, for 2,000 francs; Second Museum of
Modern Western Painting, Moscow, 1918; State Museum of
Modern Western Art, Moscow, 1923; Pushkin State Museum
of Fine Arts, Moscow, 1948

Still Life with Blue Pot was included in Vollard's 1904
Matisse exhibition and was surely among the paint-
ings that prompted Roger Marx to comment on
Matisse's affinity with the art of Cézanne.[1] The
somewhat monochromatic background, placement
of the table, and choice of still-life elements—in
particular, the crumpled white napkin that hangs
over the table's edge—recall works such as Cézanne's
Still Life with Kettle (ca. 1869, Musée d'Orsay, Paris;
R 137), a painting that Vollard had sold to Ivan
Shchukin on August 29, 1897, for 1,000 francs.[2]
Matisse's *Still Life with Blue Pot* was also purchased
by a Russian collector: Ivan Morozov, who paid 2,000
francs for it on September 16, 1909.[3]

RAR

1. Marx 1904a.
2. Vollard Archives, MS 421 (4,3), fol. 81, and MS 421 (4,4),
 fol. 13.
3. Vollard Archives, MS 421 (5,4), fol. 170; see also Vollard to
 Morozov, September 30, 1909: Vollard Archives, MS 421
 (4,1), p. 146.

132.

fig. 152

HENRI MATISSE
Notre-Dame

Ca. 1900
Oil on canvas
18⅛ x 14¾ in. (46 x 37.5 cm)
Tate, Purchased 1949 N05905

PROVENANCE: Alfred Klein, Paris and Le Cannet, ca. 1930;
purchased through the Galerie Rousso by the Tate, London,
1949

Matisse's studio on the quai Saint-Michel (see
cat. 136) overlooked the Seine River. To the right he
had an unobstructed view of the cathedral of Notre-
Dame and, to the left, the Pont Saint-Michel. He
painted both landmarks repeatedly. Two views of the
mid-nineteenth-century bridge were included in his
1904 exhibition at Vollard's, as listed in the catalogue:
number 4, "Effet de neige (vue du Pont Saint-
Michel, Paris)" (*The Pont Saint-Michel, Paris,* 1903,
Foundation E. G. Bührle Collection, Zurich), and
number 26, "Vue du Pont Saint-Michel (Paris)"
(*Pont Saint-Michel,* ca. 1900, former collection of
Mrs. William A. M. Burden, New York).[1] The first
of these is also listed in Vollard's Stockbook B as
number 3410 for 150 francs, although it is not clear
if Vollard purchased it at the time of the Matisse
exhibition or merely accepted it on consignment.
The third view from Matisse's window included in
the exhibition catalogue was number 22, "Vue de
Notre-Dame (Paris)," which has yet to be identified
and may well be the work shown here.

RAR

1. Paris 1904

133

133.	*fig. 151*

HENRI MATISSE
Bouquet of Flowers in a Chocolate Pot

1902
Oil on canvas
24¾ x 17⅞ in. (63 x 45.5 cm)
Musée Picasso, Paris RF 1973-73

PROVENANCE: Ambroise Vollard, Paris, presumably ca. 1904–
8; acquired by Pablo Picasso, Paris, spring 1939–his d. 1973;
Musée Picasso, Paris (Donation Picasso, 1973–78, first on view
at the Musée du Louvre, 1978–85, then at the Hôtel Salé)

Bouquet of Flowers in a Chocolate Pot appears as num-
ber 25 ("Nature morte [cafetière argent]") in the cat-
alogue of the 1904 Matisse exhibition at Vollard's
gallery.[1] The painting is also listed in Vollard's Stock-
book B as number 3413, "Cafetière avec des fleurs,
63 x 46 cm 150 [francs]." Picasso acquired it from
Vollard in the spring of 1939, shortly before the
dealer's death. On July 14, 1940, Matisse wrote to
Picasso about it: "Amongst other things, it's just
occurred to me that when you recently said you'd
bought one of my still lifes from Vollard's, I got it
completely mixed up with a painting which is in
Moscow. . . . Where is the picture? As you found it
interesting, I would very much like to know which
it is. Would it be too much to ask you to make me a
sketch so I can work it out, and send it with all your
news?"[2] That autumn Picasso complied, and from
his wartime studio in Royan he sent Matisse a pho-
tograph of *Bouquet of Flowers in a Chocolate Pot,* as
well as a sketch with color indications.[3]

RAR

1. Paris 1904
2. Matisse to Picasso, July 14, 1940, in London–Paris–New
 York 2002–3, p. 381.
3. Matisse to Pierre Matisse, November 28, 1940, in ibid.

134.	*fig. 149*

HENRI MATISSE
View of the Bois de Boulogne

1902
Oil on canvas
25⅝ x 32⅛ in. (65 x 81.5 cm)
Pushkin State Museum of Fine Arts, Moscow 3300
New York only

PROVENANCE: Galerie Druet, Paris; Sergei Shchukin,
Moscow, by 1911; First Museum of Modern Western Painting,
Moscow, 1918; State Museum of Modern Western Art, Moscow,
1923; Pushkin State Museum of Fine Arts, Moscow, 1948

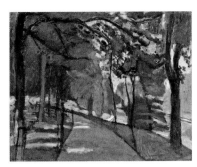

134

This view of the Bois de Boulogne, a sprawling park
in western Paris, was one of twenty landscapes
included in Matisse's 1904 exhibition at Vollard's
gallery. In his catalogue preface, the critic Roger Marx
emphasized the importance of the landscape in
Matisse's art: "Outside, one sees Matisse enamored
with the solemnity of the snowy tops of jagged
mountain summits or in a simpler genre, his depic-
tions of waves battering the shores of Belle-Îsle, the
banks of the Seine buried under snow, Corsica with
flowering almond trees and olive trees with gray-
green foliage beside the blue sea. In the future, he
will be attracted to other festivals of color and light,
and he will never stop trying to record them . . .
and to convey the harmonies of the outside world
through his personal nature, which is both passionate
and gentle."[1]

RAR

1. Marx 1904b.

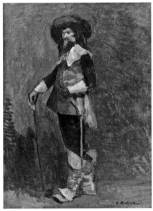

135

135.	*fig. 154*

HENRI MATISSE
The Musketeer

1903
Oil on canvas
31¾ x 23½ in. (80.6 x 59.7 cm)
The Museum of Modern Art, New York, The William S.
Paley Collection SPC70.1990

PROVENANCE: Acquired from the artist by Ambroise Vollard,
Paris, 1904; Collection de Galéa, Paris (Mme de Galéa,
d. 1955; her son Robert, d. 1961); Sam Salz, New York, by
1957; bought by William S. Paley, New York, 1957; The
Museum of Modern Art, New York, The William S. Paley
Collection, 1990

This painting was exhibited as number 27 ("Le mous-
quetaire") in Matisse's 1904 exhibition at Vollard's
gallery.[1] It also appears as one of eleven Matisses
added to the dealer's Stockbook B around the time
of the exhibition; there it appears as number 3415,
"Mousquetaires [*sic*], 81 x 60 cm 150 [francs]." The
palette and pose of the model are typical of the
Academic figure studies painted by Matisse and his
friends Henri Manguin and Jean Puy during this
period. In the past, *The Musketeer* has been identified
as a portrait of the actor Lucien Guitry (1860–1925)
posing as Cyrano de Bergerac, Edmond Rostand's
famous character from the eponymous play, first pre-
sented in Paris in December 1897 to rave reviews.
Matisse's daughter, Marguerite Duthuit, however,
has disputed this identification, stating that the sub-
ject is simply an Academic model who was paid to
pose in costume.[2]

RAR

1. Paris 1904.
2. Information obtained by Christel Force from Wanda de
 Guébriant, Matisse Archives, Paris.

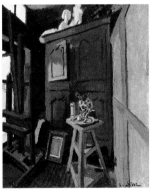

136

136.	*fig. 145*

HENRI MATISSE
Studio Interior

Ca. 1903–4
Oil on canvas
21⅝ x 18⅛ in. (55 x 46 cm)
Tate, Bequeathed by Lord Amulree, 1984 T03889

PROVENANCE: Eugène Blot, Paris, likely fall 1904; his sale,
Hôtel Drouot, Paris, June 2, 1933, no. 76; bought by Vauxcelle
(probably Louis Vauxcelles), Paris; Dr. Albert Charpentier,
Paris; his sale, Galerie Charpentier, Paris, March 30, 1954, no.
23; bought at that sale by O'Hana Gallery, London; bought
by Lord Amulree, London, October 1954; his bequest to the
Tate Gallery, London, 1984

Matisse rented a fifth-floor studio at 19, quai Saint-
Michel, Paris, from 1899 to 1907. This glimpse of the
principle room shows, at left, an empty easel near a
window and, at right, the back of a large stretched
canvas. Plaster casts are visible atop the armoire, and
a small still life is arranged on a sculpture stand (see
fig. 146). The painting is thought to date to the win-
ter of 1903–4, about six months before Matisse's solo
exhibition at Vollard's gallery, where this painting
may have been exhibited as number 2, "Intérieur
d'atelier."[1] However, a little-known review of
the exhibition published in *L'Art décoratif* (July
1904) mentions a painting of a "nude woman in

an 'Intérieur d'atelier,'" thus casting some doubt on this identification.[2] RAR

1. Tate Gallery 1988, pp. 206–8.
2. Riotor 1904.

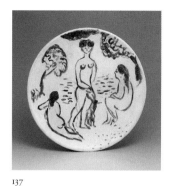

137

137. *fig. 153*

HENRI MATISSE
Three Bathers

1906–7
Tin-glazed ceramic
Diam. 13¾ in. (34.9 cm)
The Metropolitan Museum of Art, New York, The Pierre and Maria-Gaetana Matisse Collection, 2002 2002.456.117
New York only

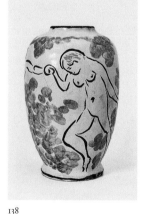

138

138. *fig. 144*

HENRI MATISSE
Green and White Vase with Nude Figures

Ca. 1907
Tin-glazed ceramic
H. 9½ in. (24 cm), Diam. 7¾ in. (20 cm)
Musée d'Art Moderne de la Ville de Paris, Acquisition
AMOA 459

Matisse and many of his friends decorated ceramics at André Metthey's studio at Asnières. The underside of the plate *Three Bathers* (cat. 137) bears two

monograms: an *M* with a circle around it and a superimposed *A* and *V*. The first is the monogram of Metthey; the second is thought to be that of Ambroise Vollard. For more information on Metthey's ceramics, see pages 125–28 in this volume.[1] RAR

1. See also Nice–Bruges 1996 and Saint-Tropez 2002.

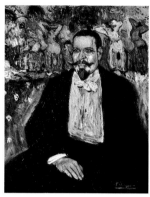

139

139. *fig. 112*

PABLO PICASSO
Gustave Coquiot

1901
Oil on canvas
39⅜ x 31⅞ in. (100 x 81 cm)
Centre Pompidou, Paris, Musée National d'Art Moderne / Centre de Création Industrielle, Gift of Mme Gustave Coquiot, 1933 JP 652 P

CATALOGUES RAISONNÉS: Zervos 1932–78, vol. 1 (1932), no. 84; Daix and Boudaille 1967, no. v.64

PROVENANCE: Acquired from the artist by the sitter, Gustave Coquiot, Paris, probably 1901, possibly in exchange for authorship of Vollard exhibition catalogue; his widow, 1926; her gift to the Musée du Louvre, Paris, 1933 (on deposit at the Musée du Jeu de Paume); transferred to the Musée National d'Art Moderne, first Palais de Tokyo, then Centre Georges Pompidou (on deposit at the Musée Picasso, Paris)

A prolific writer, Gustave Coquiot was a fashionable chronicler of the good life in contemporary Paris. He was a friend of Henri de Toulouse-Lautrec, Auguste Rodin, and other artists, as well as of writers such as Joris-Karl Huysmans. Coquiot was probably commissioned by Picasso's agent, Pere Mañach, to write the preface to the catalogue for Vollard's "Exposition de tableaux de F. Iturrino et de P.-R. Picasso," the first exhibition of Picasso's work ever held in Paris, in 1901.[1] He is said to have assigned the titles to the pictures in that show. In addition to Coquiot, Picasso made portraits of Vollard, Iturrino, Mañach, and himself on the occasion of this exhibition. As much as in any of the works Picasso produced in Paris at this time, the likeness here and the sitter's bearing seem to owe a debt to portraits by Toulouse-Lautrec, such as the famous series of posters depicting Aristide Bruant. Although not listed by name in the catalogue, this painting may have been included in the exhibition, perhaps under number 7, 25, or 62, described simply as "Portrait" or

"Portraits," a designation that would have allowed for the inclusion of works not yet complete when the exhibition opened on June 25. A recently discovered photographic self-portrait that Picasso took in his studio shows Coquiot's portrait leaning on the wall just beneath *The Absinthe Drinker* (DB VI.25), which is generally dated to no earlier than the summer of 1901.[2] Coquiot's portrait may well have been added to the Vollard exhibition before it closed on July 14. AEM

1. Paris 1901b.
2. Gelatin silver print, 4¾ x 3½ in. (12 x 9 cm), Archives, Musée Picasso, Paris, first published in Paris 1994, p. 47, fig. 23. Another work identifiable in the photograph is the framed 1900 canvas *Café Scene*, which was later owned by Gertrude Stein and is now in the Yale University Art Gallery, New Haven, Connecticut (DB II.20).

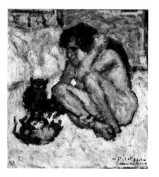

140

140. *fig. 111*

PABLO PICASSO
Crazy Woman with Cats

1901
Oil on pulp board
17¾ x 16⅛ in. (44.1 x 8 cm)
The Art Institute of Chicago, Amy McCormick Memorial Collection 1942.464

CATALOGUES RAISONNÉS: Zervos 1932–78, vol. 1 (1932), no. 93; Daix and Boudaille 1967, no. v.16

PROVENANCE: Acquired as compensation from the artist by Pere Mañach, Paris, 1901; Paul Guillaume, Paris; Reinhardt Galleries, New York, by 1929; Colonel Robert R. McCormick, Chicago, by 1935; gift to The Art Institute of Chicago, 1942

According to Pierre Daix and Georges Boudaille, this work was painted in Paris in 1901, in the brief period between Picasso's arrival there on or about May 15 and the opening of his exhibition at Vollard's on June 25, where it was shown as number 17, *La Folle aux chats*.[1] The title of the painting was presumably assigned by Gustave Coquiot. It is not known how Picasso arrived at this subject, but she is consistent with other marginal and bohemian types Picasso encountered in Montmartre in 1901.

AEM

1. Paris 1901b.

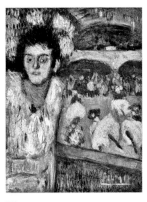

141

141. *fig. 108*

PABLO PICASSO
The Divan Japonais

1901
Oil on board mounted on cradled panel
27⅗ x 21 in. (70 x 53.4 cm)
Private collection

CATALOGUES RAISONNÉS: Zervos 1932–78, vol. 1 (1932),
no. 69; Daix and Boudaille 1967, no. v.13

PROVENANCE: Bought in May or June 1901 by Emmanuel
Virenque, Paris (either from Picasso or his agent, Pere
Mañach), who then exchanged it for *Les courses—At the Races*
(D-B V. 31); M. Knoedler & Co., New York; Dr. and Mrs. T.
Edward Hanley, Bradford, Pennsylvania, by 1966; bought by
Acquavella Galleries, Inc., New York, March 13, 1971; John T.
Dorrance, Philadelphia; his sale, Sotheby's, New York,
October 18, 1989, no. 37, for $8,250,000; sale, Sotheby's, New
York, November 8, 1995, no. 50; José Mugrabi, New York; his
sale Christie's, London, June 20, 2006, no. 124; bought by the
current owner

Emmanuel Virenque, the Spanish consul in Paris,
purchased *The Blue Dancer* directly from Picasso
during the artist's first brief sojourn in the city in
1900;[1] then, according to an anecdote that Pierre
Daix and Georges Boudaille record, Virenque bought
a second Picasso, *The Divan Japonais,* whose subject
so shocked his friends that he was obliged to exchange
it, choosing *At the Races* instead.[2] Indeed, number
39 in the 1901 Vollard exhibition catalogue, *Le Divan
Japonais,* lists the owner as "M. Virenca."[3] The
Divan Japonais was a dance hall that had closed
before Picasso arrived in Paris. Thus, since it was
Gustave Coquiot, not Picasso, who designated the
titles of the pictures on exhibit, the establishment
depicted here may not actually be the Divan Japonais.
Indeed, elements of the interior resemble the Moulin
de la Galette, which Picasso painted in 1900.[4]
 Whatever the case, Picasso would certainly have
known about the Divan Japonais from Henri de
Toulouse-Lautrec's famous 1893 poster.[5] Lautrec had
an enormous appeal for Picasso in 1901, and much of
his exhibition at Vollard's gallery that summer was a
response to the elder artist's ubiquitous graphic
work. Picasso had Lautrec's poster of May Milton
hanging in his studio, which is depicted in a paint-
ing made in the fall of 1901, *The Blue Room.*[6] Lautrec
died prematurely on September 9, 1901.
 A watercolor undoubtedly made for the 1901 exhi-
bition, recently on the New York art market, may
offer another clue to Picasso's familiarity with the
Divan Japonais as a subject.[7] AEM

1. Daix and Boudaille 1967, no. II.23, as private collection.
2. Ibid., no. v.31; sold Christie's, New York, May 7, 2002,
 no. 23; possibly no. 32, *Les Courses,* in the 1901 Vollard
 exhibition catalogue" (Paris 1901b).
3. Daix and Boudaille 1967, no. v13, erroneously assign this
 painting the title *Au Moulin Rouge* (no. 11 in the 1901
 Vollard exhibition catalogue), which may be the source of
 the occasional confusion among subsequent authors.
4. Solomon R. Guggenheim Museum, New York; Daix and
 Boudaille 1967, no. II.10. The features of the interior as
 they appear in the present painting do not, however,
 resemble contemporary depictions of the Moulin
 Rouge.
5. Wittrock 1985, no. P 11.
6. Phillips Collection, Washington, D.C.; Daix and
 Boudaille 1967, no. VI.15; Wittrock 1985, no. P 17.
7. Daix and Boudaille 1967, no. v.77; sold at Sotheby's, New
 York, May 11, 1993, no. 27. In his concordance of works
 included in the 1901 Vollard show, Josep Palau i Fabre
 suggests that in fact this watercolor may have been num-
 ber 39, titled "Le Divan Japonais," although the afore-
 mentioned Lautrec poster that serves as his basis for
 identification is not convincing as a source for the water-
 color. Palau i Fabre 1981, p. 253. More compelling is a
 comparison with the composition of Henry Somm's 1892
 maquette for a poster made for the Divan Japonais, now
 in the Zimmerli Art Museum, Rutgers University, New
 Brunswick, New Jersey (1983.055.008); reproduced in
 Washington–Chicago 2005, fig. 163.

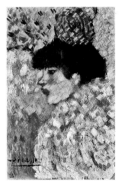

142

142. *fig. 109*

PABLO PICASSO
Girl in Profile

1901
Oil on board mounted on masonite
20⅝ x 13½ in. (52.5 x 34.3 cm)
The Metropolitan Museum of Art, New York, Jacques
and Natasha Gelman Collection, 1998 1999.363.58
New York only

CATALOGUES RAISONNÉS: Zervos 1932–78, vol. 6 (1954),
no. 1461; Daix and Boudaille 1967, no. v.60

PROVENANCE: Acquired from the artist by Ignacio Zuloága,
Paris, likely by exchange, probably ca. 1903–7; by descent to
his son, Antonio Zuloága, by 1945; bought by Jacques and
Natasha Gelman, ca. March 1952; their bequest to the
Metropolitan Museum, New York, 1998

This painting is a reduced version of a contempora-
neous watercolor. The head is enlarged and set into
bold, abstract matrices of broad strokes of color,
whose effect has been compared to that of electric
lighting, a novelty at the time.[1] Josep Palau i Fabre
has conjectured that either the Metropolitan's oil or
the larger work, *At the Moulin Rouge,*[2] was exhibited

under Gustave Coquiot's given title, *La Fille du roi
d'Égypte,* at Vollard's 1901 exhibition.[3]
 The early history of *Girl in Profile* illuminates
Picasso's milieu during the initial phase of his Paris
career. The Basque painter Ignacio Zuloága, the first
owner of this painting, was a close friend of the artist
in 1903–7.[4] He arrived in Paris in 1891 and by 1900
was a world-renowned proponent of Spanish sub-
jects. According to Zuloága's son Antonio, his father
received this painting in an exchange with Picasso;
the elder artist's work has not been traced.[5] But it is
also possible that the picture was an outright gift to
Zuloága in 1905. As Spanish representative to the
Sixth Venice Biennale, Zuloága used his influence to
have Picasso invited to exhibit there, and the
gouache *Acrobat and Young Harlequin* (private col-
lection) was sent, although not shown.[6]
 AEM

1. See Sabine Rewald in New York 1989–90, no. 68.
2. Watercolor on paper, 64.8 x 49.5 cm (Zervos 1932–78,
 vol. 6 (1954), no. 351; DB v.36), sold Christie's, London,
 June 25, 2002, no. 10.
3. Under number 13; see Palau i Fabre 1981, p. 245, figs. 634,
 636, and p. 249. Daix and Boudaille 1967, p. 156, lists
 number 13 as "unidentified."
4. Fernande Olivier, cited by Pierre Daix in Christie's,
 London, sale cat., November 28, 1988, no. 19.
5. The exchange between the artists was described to Jacques
 Gelman by Antonio Zuloága (as related in the collector's
 letter of March 13, 1952, to Sam Salz: Archives, Department
 of Nineteenth-Century, Modern, and Contemporary Art,
 Metropolitan Museum).
6. *Acrobat and Young Harlequin,* gouache on cardboard, 105 x
 76 cm (Zervos 1932–78, vol. 1 [1932], no. 297; DB XII.9),
 sold Christie's, London, November 28, 1988, no. 19. On the
 early history of this work, see Rodríguez 1984–85, cited in
 Daix 1993, pp. 44, 389, nn. 21, 22.

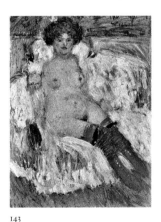

143

143. *fig. 110*

PABLO PICASSO
Nude with Red Stockings

1901
Oil on cardboard mounted on wood
26⅜ x 20¼ in. (67 x 51.5 cm)
Musée des Beaux-Arts, Lyon 1997-44
New York only

CATALOGUES RAISONNÉS: Zervos 1932–78, vol. 1 (1932),
no. 48; Daix and Boudaille 1967, no. v.5

PROVENANCE: Acquired from the artist as compensation by Pere Mañach, Paris, 1901; possibly Ambroise Vollard, Paris; Paul Guillaume, Paris, by 1932; Knoedler & Co., New York; Myran (sometimes Mihran or Mirant) Garabet Eknayan, Neuilly-sur-Seine, until 1985; his widow, Jacqueline Delubac, 1985–her d. 1997; her bequest to the Musée des Beaux-Arts, Lyon, 1997

Like most of the works exhibited at Vollard's in 1901, *Nude with Red Stockings* cannot be identified definitively by title in the catalogue Gustave Coquiot wrote for the exhibition, although Palau i Fabre proposed that the picture may be identical with number 57, "Femme de nuit."[1] It is certain, however, that Picasso painted it for the exhibition. The work exemplifies the marriage of style and subject that led Coquiot to refer to this as the artist's Steinlen or Toulouse-Lautrec period. In subject, execution, and dimensions, it bears comparison to another painting in the 1901 exhibition, *Nude with Blue Stockings*.[2]

No known work fits more closely than either of these two paintings an entry in Vollard's Stockbook B, which lists just one Picasso: "[no.] 3952, provenance Manach, Femme assise sur chaise longue, 52 x 65, 25 f[rancs]." Pere Mañach, Picasso's agent, took possession of all the paintings that remained unsold when the Vollard exhibition ended on July 14. This stockbook entry, then, indicates that Vollard subsequently bought at least one painting from Mañach, and its inventory number is sufficiently close to one of the numbers inscribed on the reverse of the Lyon *Nude*—3930—to be considered circumstantial evidence that he bought more than one.[3]

AEM

1. Palau i Fabre 1981, p. 256.
2. Coquiot 1914, pp. 145–47. For *Nude with Blue Stockings*, see Daix and Boudaille 1967, no. v.62, 65 x 48.3 cm, as private collection.
3. Stockbook A, kept from 1899 to 1904, and Stockbook B, used from 1904 to 1907, both begin with inventory no. 3301. About 1912 Vollard began using a 5000-series inventory number system. Another number on the back of the Lyon painting, 5233, may be a Vollard stock number from a later date.

144. *fig. 107*

PABLO PICASSO
Pierreuse, Her Hand on Her Shoulder,
or *Waiting (Margot)*

1901
Oil on board
27⅜ x 22½ in. (69.5 x 57 cm)
Museu Picasso, Barcelona MPB 4.271
New York only

CATALOGUES RAISONNÉS: Zervos 1932–78, vol. I (1932), no. 63; Daix and Boudaille 1967, no. v.11

PROVENANCE: Acquired from the artist as compensation by Pere Mañach, Paris, 1901; Lluís Plandiura, Barcelona, not before 1901; acquired by the government of Catalunya for the Museo de Arte Moderno, Barcelona, October 1932; transferred to the Museu Picasso, Barcelona, 1963

The Catalan industrialist Lluís Plandiura was a polymath collector who acquired 264 modern works, almost all by Catalan artists, that were purchased by the regional government for the Museo de Arte

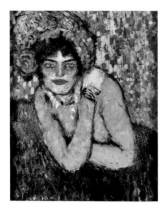

144

Moderno, Barcelona, in 1932. The twenty Picassos in that group are now in Barcelona's Museu Picasso.[1] This painting is traditionally identified with number 9 in Vollard's 1901 show, where it was given the title "Morphinomane."[2] It cannot be stated with certainty that Plandiura bought the work directly from Vollard, although he may have. If not, he may have obtained it from Berthe Weill, who sold Picassos for the artist's agent, Pere Mañach: Plandiura owned at least one other painting that was probably purchased from Weill, *Still Life (The Dessert)*.[3] But it is equally possible that Plandiura bought the present painting directly from Mañach, either in Paris or in Barcelona. Plandiura also owned four works on paper that could have been included under number 65 in Vollard's exhibition, described simply as "Dessins."[4]

AEM

1. On the Catalonian state purchase of the Plandiura collection, see Mendoza 1987, pp. 25–27. See also Subirana et al. 1970, which lists twenty works acquired from Plandiura, all from the period 1899–1903.
2. This painting has been known by other titles as well: *Harlot ["Pierreuse"] with Hand on Her Shoulder* (Zervos 1932–78, vol. I [1932], no. 63; DB v.11; Richardson 1991, pp. 200–201) and *Woman with Heavy Make-Up* (Cirici 1946, no. 60). The titles of the Picassos at the exhibition, traditionally ascribed to Gustave Coquiot, reflect the argot of a worldly Parisian boulevardier; in this they provide a flashy contrast to those attached to Iturrino's paintings at the same exhibition, whose source has not been traced.
3. Museu Picasso, Barcelona, MPB 4.273, tentatively identified as *Still Life*, no. 1, of the Berthe Weill exhibition in April 1902; see Daix and Boudaille 1967, no. v.72.
 The dates of Plandiura's early purchases of modern Catalan paintings are not known. Gudiol wrote that Plandiura began collecting domestic and then foreign posters when he was sixteen years old, exhibiting them at the Círcol Artístic de Sant Lluc, Barcelona, in 1901 and 1903, and that his first two paintings were by Ros i Güell and Joan Llimona; Gudiol 1928, pp. 1–2. Carles Capdevila's account of Plandiura's Picassos in the same issue of *Gaseta de les arts*, which does not seem to be entirely reliable, reads: "[Picasso's] fifteen works in the Plandiura Collection belong to the first stage of his career. There are seven pastel-coloured drawings (1900–02); two oil-paintings with figures of dancing-girls (1899); an oil-painting of a still life (1901); a pastel, with the figures of an old woman and a child (1903); an exceptionally interesting portrait of a woman (1906); two pictures from the blue epoch, and a charcoal-drawing (1904)." Capdevila 1928, pp. 9–10.
4. All four are in the Museu Picasso, Barcelona: *Cancan Dancer* (MPB 4.774; DB IV.14); *Woman in Green* (MPB 4.775; DB v.37); *Woman in the Street* or *The Promenade* (MPB 4.773; DB v.38); and *The Hedonists* (MPB 4.772; DB v.39).

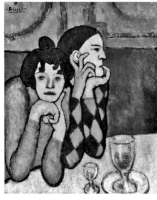

145

145. *frontispiece*

PABLO PICASSO
The Two Saltimbanques (Harlequin and His Companion)

1901
Oil on canvas
28¾ x 23⅝ in. (73 x 60 cm)
Pushkin State Museum of Fine Arts, Moscow 3400

CATALOGUES RAISONNÉS: Zervos 1932–78, vol. I (1932), no. 92; Daix and Boudaille 1967, no. VI.20

PROVENANCE: Likely purchased from the artist by Ambroise Vollard, Paris, not before 1906; bought by Ivan Morozov, Moscow, April 29, 1908, for 300 francs; Second Museum of Modern Western Painting, Moscow, 1918; State Museum of Modern Western Art, Moscow, 1923; transferred to the Pushkin State Museum of Fine Arts, Moscow, 1948

This painting was probably among the twenty-seven that constituted Vollard's first big purchase from Picasso in May 1906.[1] It gained the distinction of being the first work by Picasso to enter a Russian collection when it was purchased by Ivan Morozov (1871–1921) on April 29, 1908, Vollard's dated record of the 50,000-franc sale provides insight into the Picasso's relative value at that moment (the Vlaminck was a gift):

Vendu à Ivan Morosoff les tableaux suivants non payés pour la somme de cinquante mille francs

Cezanne—La jeune fille au piano	20000	[R 149]
Gauguin la femme au fruits	8000	[W 501]
[Gauguin] Le gros arbre	8000	[W 481]
[Gauguin] le bouquet de fleurs	8000	[W 426]
Puy L'été	1200	
Picasso Les 2 saltimbanques	300	
Degas Danseuses	4500	
Vlaminck bord de l'eau	000 00	
	50,000[2]	

In the chronology established by Pierre Daix and Georges Boudaille, the Harlequin makes his first appearance in this painting and in another of 1901, *Harlequin* (Metropolitan Museum). Both are striking, fully formed expressions of a new idea in Picasso's art. Later, in about 1905, the poet Guillaume Apollinaire would encourage Picasso to incorporate alter egos, including Harlequin, into his work.[3] Picasso developed this theme in *At the Lapin Agile* (Metropolitan Museum) of 1904–5, which contains his self-portrait as Harlequin, and in the 1905 Saltimbanques series. Though he would paint various friends and his son Paolo in Harlequin's tights toward the end of World War I, Picasso also continued to personally identify with this figure from the

commedia dell'arte. In the 1930s he sometimes merged Harlequin with his minotaur narrative, and the character recurs in his art right through to the end.

<div style="text-align: right">AEM</div>

1. Vollard Archives, MS 421 (5,1), fol. 89, May 11, 1906.
2. Vollard Archives, MS 421 (5,3), fol. 79. See also the Chronology in this volume, entry for April 28, 1908. The sum was paid in full on May 8, 1908: Vollard Archives, MS 421 (5,3), fol. 87.
2. Discussed in, for example, Richardson 1991, vol. 1, pp. 334, 368–74.

146

146.　　　　　　　　　　　　　　fig. 263

PABLO PICASSO
The Burial of Casagemas

Ca. 1901
Oil on canvas
59 x 35⅝ in. (150 x 90.5 cm)
Musée d'Art Moderne de la Ville de Paris, Gift in 1950
(Ambroise Vollard Estate)　AMVP 1133

CATALOGUES RAISONNÉS: Zervos 1932–78, vol. 1 (1932), no. 55; Daix and Boudaille 1967, no. VI.4

PROVENANCE: Purchased from the artist by Ambroise Vollard, in or after April 1906–his d. 1939; Vollard estate, 1939–50 (held at the National Gallery of Canada, Ottawa, 1940–49); gift of the Vollard heirs to the city of Paris, 1950; Musée des Beaux-Arts de la Ville de Paris (Petit Palais), 1950; transferred to the Musée d'Art Moderne de la Ville de Paris, 1961

After his first brief sojourn in the French capital, Picasso returned to Spain with his friend Carles Casagemas in December 1900. Picasso would remain there six months but asked Casagemas to leave after only a few days. Distraught over the lover he had left behind in Paris, Germaine Gargallo, Casagemas went back to her, then committed suicide on February 17, 1901. When Picasso returned to Paris on or about May 25, 1901, he took over his late friend's rented lodgings at 130*ter*, boulevard de Clichy, sharing them with his agent, Pere Mañach. Picasso painted furiously during the month leading up to the exhibition at Vollard's gallery, which opened on June 25. In exchange for a monthly

stipend of 150 francs and making preparations for the show, Mañach took title to the works that were exhibited.

The painting shown here and another version (private collection), which date to mid- or late 1901, when Picasso introduced black outlines and a broad hatching technique into his paintings, were clearly not a part of this arrangement. Indeed, the paintings made for the Vollard exhibition give no hint of the recent death of a close friend.[1] Picasso broke his contract with Mañach and left for Barcelona in January 1902. In the meantime, Mañach organized an exhibition of his remaining stock of Picasso's work at the Galerie Berthe Weill; it took place April 1–15, 1902. Weill had purchased a few drawings from Picasso on his first visit to Paris, and she bought up the unsold remainder from the April 1902 exhibition, organizing a second exhibition—a group show—from November 15 to December 15, 1902, with Picasso's collaboration.[2] Yet the two versions of *The Burial of Casagemas* must have remained in Picasso's possession for some time thereafter. This one, sometimes called *Evocation,* was first shown at an exhibition Weill held from October 24 to November 20, 1904 (no. 30), while the other, also called *The Mourners,* may not have been exhibited until both pictures were shown together at the Galerie Georges Petit in Paris, in the summer of 1932 (nos. 6, 7; it is not known whether Vollard included the paintings in his 1910–11 retrospective).[3] *The Mourners* was first published in the article "Picasso: Oeuvres inédites anciennes" in 1928.[4] Gertrude Stein mentions the work in her *Autobiography of Alice B. Toklas* (1933). But it is unclear whether or not she saw it on her first visit to the Bateau-Lavoir, Picasso's studio at 13, rue Ravignan, in the fall of 1905, since she conflates this location with the actual scene of Casagemas's death:

> *and we passed another steep little stairway which led to the studio where not long before a young fellow had committed suicide, Picasso painted one of the most wonderful of his early pictures of the friends gathered round the coffin, we passed all this to a larger door where Gertrude Stein knocked and Picasso opened the door and we went in.*[5]

Despite their deeply personal subject matter, Picasso probably sold these paintings to Vollard in the first years of their second association, that is, from May 1906 onward. It was not until 1966 that the existence of two further oils depicting Casagemas in his coffin, which the painter had kept throughout his life, was revealed for the first time.[6]

<div style="text-align: right">AEM</div>

The author would like to thank Christine Nelson, The Pierpont Morgan Library, New York, for her assistance in preparing this entry.
1. Picasso's relationship to Casagemas and the latter's suicide are discussed throughout the literature; see especially Reff 1973.
2. See Daix and Boudaille 1967, pp. 206, 334.
3. Ibid., p. 238; Paris 1932.
4. Zervos 1928, p. 227, ill.
5. G. Stein 1933, p. 26.
6. See Daix and Boudaille 1967, nos. VI.5, VI.6.

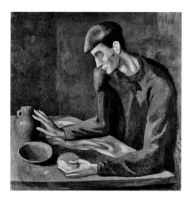

147

147.　　　　　　　　　　　　　　fig. 248

PABLO PICASSO
The Blind Man's Meal

1903
Oil on canvas
37½ x 37¼ in. (95.3 x 94.6 cm)
The Metropolitan Museum of Art, New York, Purchase, Mr. and Mrs. Ira Haupt Gift, 1950　50.188
Paris only

CATALOGUES RAISONNÉS: Zervos 1932–78, vol. 1 (1932), no. 168; Daix and Boudaille 1967, no. X.32

PROVENANCE: Bought from the artist by Ambroise Vollard, Paris, probably 1907 (stock no. 5456); bought by Moderne Galerie (Heinrich Thannhauser), Munich, December 11, 1912, for 3,000 francs; bought by Hertha Koenig, Munich, February 1913 (eventually owned jointly with her brother Helge Siegfried Koenig); consigned to Justin K. Thannhauser by November 1949); bought by Mr. and Mrs. Ira Haupt, New York, 1950; their gift to the Metropolitan Museum, New York, 1950

An early stage of *The Blind Man's Meal* is described in an undated letter Picasso wrote in his charmingly imperfect French, possibly to Max Jacob: "Je fait en tableaux de en homme abeugle assie a un table il a en morceaux de pain dans la main goche et avec la troite il cherche la cruche de vin et en chien au cotet qui le regarde. Je suis assez content il nes encore pas fini."[1] ("I am making a picture of a blind man seated at a table he has a piece of bread in his left hand and with the right he seeks the jug of wine and a dog at the side who looks at him. [The dog was ultimately left out.] I am rather glad it is not yet finished.") Vollard would later describe the painting in very different terms. In recording its sale in 1912 he refers to it as "personnage chauffant" (person warming himself)—later describing it as "personnage accroupi" (crouching person) in the shipping record[2]—designations so cursory and inaccurate that they verge on the irreverent.

Since Vollard produced no catalogue for the retrospective exhibition he mounted in 1910–11, it cannot be confirmed whether *The Blind Man's Meal* was included, though it is likely. But two years later, on the morning of December 11, 1912, it was purchased by Heinrich Thannhauser for his recently opened Moderne Galerie in Munich.[3] This was a busy day at the Galerie Vollard, also occupied by the shipping of works to New York for the Armory Show, which, ironically, included Picassos but none from Vollard. That exhibition, in February 1913, did coincide, however, with the Moderne Galerie's first Picasso exhibition, where the Munich collector Hertha Koenig acquired the painting. Within two years,

Koenig would buy, also from Thannhauser, *The Family of Saltimbanques* (National Gallery of Art, Washington, D.C.), a painting that Vollard, in perhaps his greatest miscalculation, had decided not to purchase. It appears that Thannhauser's son Justin later tried to reacquire *The Blind Man's Meal* for the family firm, but all that is certain is that he was responsible for its eventual sale in the United States in 1950, possibly having had it on consignment since about 1934.

AEM

The author wishes to thank Christel Force for her contribution to this entry.

1. From a letter containing a study, or *ricordo*, of the painting, laid down so that the verso is not legible: Barnes Collection, Merion, Pennsylvania; quoted by John Richardson in a letter to M. Salinger, May 15, 1962: Archives, Department of Nineteenth-Century, Modern, and Contemporary Art, Metropolitan Museum.
2. The inventory number listed in the shipping record, no. 5456, accords with the Galerie Vollard label on the painting's stretcher: Vollard Archives, MS 421 (4,13), fol. 70.
3. Vollard wrote in an entry for that date: "Vendu à M. Thannhauser à Munich les tableaux suivants: . . . Picasso personnage chauffant 3000 [francs] / Picasso esquisse 2000 [francs] / Picasso cubique 2000 [francs]." Vollard Archives, MS 421 (5,8), fol. 226.

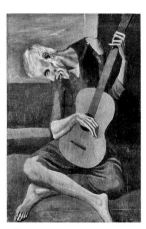

148

148.

fig. 113

PABLO PICASSO
The Old Guitarist

1903/4
Oil on panel
48⅜ x 32½ in. (122.9 x 82.6 cm)
The Art Institute of Chicago, Helen Birch Bartlett Memorial Collection 1926.253
New York and Chicago only

CATALOGUES RAISONNÉS: Zervos 1932–78, vol. 1 (1932), no. 202; Daix and Boudaille 1967, no. IX.34

PROVENANCE: Bought from the artist by Ambroise Vollard, Paris, ca. 1906 (consigned to Carroll Galleries [Harriet Bryant], New York, 1915); bought by John Quinn, New York, March 1915–his d. 1924; Quinn estate, 1924; bought by Paul Rosenberg, New York, ca. 1924; bought by Frederic Clay and Helen Birch Bartlett, Chicago; The Art Institute of Chicago, 1926

This painting was undoubtedly included in one of the first three groups of works that Vollard acquired from Picasso: twenty-seven canvases and gouaches

in May 1906 for 2,000 francs; six oils in November 1906 for 500 francs; and more than twenty-three paintings as well as drawings from February to December 1907, for 2,500 francs.[1] (*The Family of Saltimbanques,* National Gallery, Washington, D.C., and the *Desmoiselles d'Avignon,* Museum of Modern Art, New York, are thought to be the only major works not acquired by Vollard by this date.)

The Old Guitarist was probably exhibited in the 1910–11 retrospective at the Galerie Vollard. In early 1915, Walter Pach, representing Harriet C. Bryant of the Carroll Galleries, New York, approached Vollard to secure works for an exhibition of contemporary French art in March. John Richardson has suggested that the effort was undertaken on behalf of the man who purchased the entire consignment, the collector John Quinn, whom Pach had been advising; and that Vollard and Picasso suspected this was the case. Indeed, on February 26, 1915, Quinn wrote directly to Vollard, offering 21,500 francs for the six Picassos at the Carroll Galleries and proposing four quarterly payments. (This arrangement was justified partly on the grounds that *The Old Guitarist* would require some outlay to repair a crack in the panel on which it was painted.) Vollard cabled his agreement on March 11, and Quinn made his purchase through the Carroll Galleries.[2]

AEM

1. Vollard Archives, MS 421 (5,1), fols. 89, 182, and MS 421 (5,2), fol. 24.
2. The details of the purchase are corroborated in John Quinn's ledgers, fols. 36–37 (microfilm, reel 3798, Archives of American Art, Smithsonian Institution, Washington, D.C.), where *The Old Guitarist* is alternately described as: "Old Man (blue period)" and "The Guitarist," its price given as both 5,000 francs and $1,000, and in correspondence in the John Quinn Memorial Collection, Manuscripts and Archives Division, New York Public Library, Astor, Lenox and Tilden Foundations. See Reid 1968, pp. 207–8; Washington 1978, pp. 32–33, 65, nn. 31, 32, 176; and Richardson 1996, pp. 361–63, 472, n. 20.

149.

fig. 114

PABLO PICASSO
La Coiffure

1906
Oil on canvas
68⅞ x 39¼ in. (174.9 x 99.7 cm)
The Metropolitan Museum of Art, New York, Catharine Lorillard Wolfe Collection, Wolfe Fund, 1951; acquired from The Museum of Modern Art, Anonymous Gift 53.140.3

CATALOGUES RAISONNÉS: Zervos 1932–78, vol. 1 (1932), no. 313; Daix and Boudaille 1967, no. XIV.20

PROVENANCE: Bought from the artist by Ambroise Vollard, ca. 1906–7; Hugo Perls, Berlin, ca. 1924–30; Pierre Matisse, New York, 1930; bought by Stephen C. Clark, New York, 1930; his anonymous gift to the Museum of Modern Art, New York, 1937; deaccessioned by sale to the Metropolitan Museum, New York, December 11, 1953

Recent scholarship by Lucy Belloli has revealed that beneath the surface of *La Coiffure* lie three finished paintings and the beginnings of a fourth, with the earliest dating to 1902.[1] The underlying subjects are, in succession: a Blue Period man and a female child; a beggar with a crutch; an acrobat or juggler; and a

149

fourth, possibly related to *The Two Brothers* (Kunstmuseum, Basel). Belloli concludes that the present state dates to late August or September 1906, after Picasso's return to Paris from a summer trip to the Catalan village of Gósol, where the painter introduced a new planarity to the definition of his forms. That trip was largely made possible by Vollard's acquisition in May of twenty-seven paintings by Picasso.[2] The terminus ad quem established for this canvas strongly suggests that it was part of a second group of six that Vollard bought from Picasso in November 1906—and that the dealer was paying close attention to the direction in which the artist's style was evolving at this time.[3] Here, as elsewhere, Picasso's point of departure was a motif taken from Ingres's *Turkish Bath* (Musée du Louvre, Paris), exhibited at the 1905 Salon d'Automne.

On February 12, 1924, Vollard made a sizable sale to the Berlin dealer Hugo Perls that included three paintings by Picasso as well as "6 albums d'eauxfortes par Picasso." The paintings are described as:

1 tableau de Picasso femme accroupi	(1483)
" " " assise	(2532)
" " " nue [illegible]	(1498)

Two of the Picassos were shipped to Perls four days later but are not identified in Vollard's records. However, given that his descriptions of works in such accounts are often vague, Vollard may indeed have been referring to the protagonist of *La Coiffure* as a squatting (*accroupi* [e]) or seated (*assise*) woman.[4]

AEM

1. Belloli 2005.
2. Vollard Archives, MS 421 (5,1), fol. 89.
3. On November 16, 1906, Vollard noted in his datebook: "Payé à Picasso *mille francs* pour six tableaux achetés par lui": Vollard Archives, MS 421 (5,1), fol. 182.
4. Vollard Archives, MS 421 (5,12), fol. 14. *La Coiffure* is gluelined: none of the numbers (probably stock numbers) listed in Vollard's entry are now visible.
 The shipment four days later included "6 albums eauxfortes orig. de Picasso" and "2 tableaux par Picasso (Partie de la vente du 12 février 1924)": Vollard Archives, MS 421 (4,14), fols. 4–5. The possibility that *La Coiffure* was included in a later shipment or even a later sale cannot be ruled out, since it does not figure in the catalogue of Perls's 1925 exhibition of nineteenth- and twentieth-century French art (Berlin 1925). It is also possible that Perls bought the painting from an intermediate owner; it was exhibited at the Berlin Secession in 1911 (no. 192), where it was offered for sale, although the seller's name is not given.

150

151

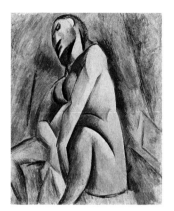

152

150. *fig. 115*

PABLO PICASSO
La Toilette

1906
Oil on canvas
59½ x 39 in. (151 x 99 cm)
Collection Albright-Knox Art Gallery, Buffalo, New York,
Fellows for Life Fund, 1926

CATALOGUES RAISONNÉS: Zervos 1932–78, vol. 1 (1932),
no. 325; Daix and Boudaille 1967, no. xv.34

PROVENANCE: Purchased from the artist by Ambroise
Vollard, Paris, 1906–7; bought by John Quinn, New York,
(collection ledger 2:92; one of five works for 100,000 francs,
or $5,375), October 1923–his d. 1924; his estate, 1924–26;
bought by Albright-Knox Art Gallery, 1926

This painting is the summation of a theme that
Picasso explored in at least eight works made in the
Spanish town of Gósol in the summer of 1906.[1]
While the subject evokes contemporaneous works
by Degas, its most immediate and essential reference
is to Ingres's *Turkish Bath* (Musée du Louvre, Paris),
which was shown at the 1905 Salon d'Automne.
When John Quinn bought the picture in 1923, he
already owned the 1903–4 *Old Guitarist* (cat. 148),
the 1906 *Woman Plaiting Her Hair,* and the 1906
Two Nudes (both, Museum of Modern Art, New
York), all three having been acquired from Vollard
in 1915. Among the other works Quinn purchased
with *La Toilette* was the 1901 *Reclining Nude* (Musée
National d'Art Moderne, Paris).[2]

AEM

1. Daix and Boudaille 1967, nos. xv.29–36.
2. Washington 1978, no. 55.

151. *fig. 117*

PABLO PICASSO
Bust of a Nude

1907
Oil on canvas
24 x 18¼ in. (61 x 46.5 cm)
The State Hermitage Museum, St. Petersburg 9046

CATALOGUES RAISONNÉS: Zervos 1932–78, vol. 2 (1942),
no. 31; Daix and Rosselet 1979, no. 32

PROVENANCE: One of twelve paintings (and a work in stone)
bought from the artist by Ambroise Vollard, Paris, possibly
July 31, 1907 (possibly stock no. 5303); bought by Sergei
Shchukin, Moscow, probably September 13, 1912; First
Museum of Modern Western Painting, 1918; State Museum of
Modern Western Art, Moscow, 1923; State Hermitage
Museum, St. Petersburg, 1948

Pierre Daix and Joan Rosselet have dated *Bust of a
Nude* to June 1907, at the beginning of a series of
approximately fifteen oils in which Picasso devel-
oped themes suggested in the initial stages of *Les
Demoiselles d'Avignon* (Museum of Modern Art,
New York), which was completed in July. The pres-
ent painting bears most directly on the two stand-
ing figures at the center of the finished work.

Although Vollard is generally thought to have
shied away from Picasso's Cubist efforts, this idea is
not borne out in the records; nor could he have
ignored the interest in this style evinced by Russian
and German collectors. Vollard's accounts do not
contain a mention of this painting by name, but it
seems plausible that he purchased it on July 31, 1907,
as part of a group of eleven others, upon Picasso's
completion of the *Desmoiselles* itself.[1] Again, Vollard
exhibits his predilection for selecting works related to
a larger, definitive composition that he opted not to
buy, such as the *The Family of Saltimbanques*
(National Gallery of Art, Washington, D.C.) pur-
chased by André Level for the syndicate La Peau de
l'Ours in 1909. *Bust of a Nude* may be one of the two
paintings that Sergei Shchukin bought from Vollard
on September 13, 1912.[2] Because of the numerous
purchases made by Ivan Morozov and Shchukin,
Picasso's development from 1907 to 1912 is best dis-
played at the Hermitage.

AEM

1. The entry in Vollard's datebook for July 31, 1907, is difficult
to read in its entirety: "Picasso 400 fr[anc]s à c[om]pte—
12 tableaux et un grès achetés pour 1500 fr[anc]s—les
tableaux sont à livrer." Vollard Archives, MS 421 (5,2),
fol. 131. Two other paintings from early 1907 that may have

been included in this group are the *Self-Portrait* in the
Národní Galerie, Prague (DR 25), and *Head and Shoulders
of a Woman* in the Moderna Museet, Stockholm (DR 36).
The "grès"—presumably a sandstone or stoneware sculp-
ture—has not been identified; most of Picasso's early sculp-
ture was executed in clay.
2. The sale of works by Picasso to Shchukin recorded for
September 13, 1912: "Vendu à M. Stchoukine / 1 g[ran]d
Picasso (5369) 3,000 [francs] / 1 petit Rousseau combat
(5303) 800 [francs]." Vollard Archives, MS 421 (5,8),
fol. 160.

152. *fig. 116*

PABLO PICASSO
Seated Female Nude

1908–9
Oil on canvas, 24 x 20 in. (61 x 50.8 cm)
Private collection

CATALOGUES RAISONNÉS: Zervos 1932–78, vol. 2 (1942),
no. 118; Daix and Rosselet 1979, no. 230

PROVENANCE: Probably bought from the artist by Ambroise
Vollard, Paris, ca. 1908–9; Collection de Galéa, Paris
(Mme de Galéa, d. 1955; her son Robert de Galéa, d. 1961);
Mrs. S. H. Stead-Ellis, London; Alex Reid & Lefèvre,
London; Saidenberg Gallery, New York, 1954; Larry Aldrich,
New York; his sale, Parke-Bernet, New York, October 30,
1963, no. 39, sold for $100,000; bought by Mrs. Cecil Blaffer
Hudson; private collection

Vollard did not record which works he bought from
Picasso with any specificity. But the correlation of
his purchase notes (however vague), usually entered
in datebooks, with Picasso's biography and artistic
development sometimes offer compelling circum-
stantial evidence of which works Vollard acquired,
and when. Thus what Daix and Rosselet describe as
the transitional nature of *Seated Female Nude,* which
they date to the winter of 1908–9, seems consistent
with a series of speculative advances that Vollard
apparently made to Picasso beginning on November
30, 1908, after a number of appointments with the
artist earlier in the month and in the preceding
October.[1] Vollard did not sell this painting but
rather bequeathed it to his longtime friend Madame
de Galéa.

AEM

1. Daix and Rosselet 1979, p. 233, introduction to sect. 9, and
no. 230. For the October 1908–February 1909 meetings
and transactions, see notes 36 and 37 in "Vollard and
Picasso" by Gary Tinterow in this volume.

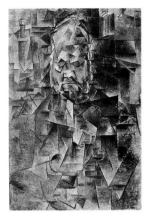

153

fig. 1

153.

PABLO PICASSO
Ambroise Vollard

1910
Oil on canvas
36⅝ x 26 in. (93 x 66 cm)
Pushkin State Museum of Fine Arts, Moscow 3401

CATALOGUES RAISONNÉS: Zervos 1932–78, vol. 2 (1942),
no. 214; Daix and Rosselet 1979, no. 337

PROVENANCE: The sitter, Ambroise Vollard, Paris, 1910;
bought by Ivan Morozov, Moscow, February 20, 1913, appar-
ently for 3,000 francs; Second Museum of Modern Western
Painting, 1918; State Museum of Modern Western Art,
Moscow, 1923; Pushkin State Museum of Fine Arts, Moscow,
1948

Beginning in 1909, as Picasso sought to cement a
relationship with a primary dealer, he painted por-
traits of all the leading candidates. His principal goal
was to obtain a contract as rewarding as the one
Henri Matisse had won with Bernheim-Jeune in
September of that year.[1] In addition to the present
work, these portraits included likenesses of Clovis
Sagot (Kunsthalle, Hamburg), Wilhelm Uhde (Joseph
Pulitzer Jr. Collection, St. Louis), and Daniel-Henry
Kahnweiler (The Art Institute of Chicago). Sagot
was finished by year's end, while Vollard's and Uhde's
may have been started by then; the Uhde was com-
pleted in time for an exhibition in May 1910. Work
on the portrait series was interrupted by a sojourn
in Cadaqués with Fernande Olivier from July 1 to
August 26, 1910. When Kahnweiler declined to offer
a contract upon his return, Vollard bought the bulk
of the work Picasso executed during that stay and
devoted a retrospective exhibition to the artist that
opened in December 1910.[2] Vollard sold the portrait
of himself to his longtime client Ivan Morozov in
February 1913, a mere two months after Kahnweiler
concluded a contract with Picasso.[3]

AEM

1. According to its terms, Bernheim-Jeune was obliged to
 purchase all paintings made in the next three years at
 specified prices from 450 to 1,875 francs, based on size, and
 Matisse retained 25 percent interest of the profits from sales
 as well as exclusive rights on portraits and decorative com-
 missions (FitzGerald 1995, p. 32).
2. Paris 1910b; Richardson 1996, p. 174.
3. "Remis à M. [Chartchewsky] pour le [compte] de
 M. Morosoff 2 tabl[eaux]—Cézanne 'Femme à la crinoline'
 et mon portrait par Picasso": Vollard Archives, MS 421 (5,9),
 fol. 42, February 24, 1913. According to John Richardson,

Morozov paid 3,000 francs for this painting; Richardson
1996, p. 174. See also receipt dated February 24, 1913, from
N. Chartchewsky on behalf of Ivan Morozov for "un
tableau Interieur Cezanne" and "un tableau portrait par
Picasso": Vollard Archives, MS 421 (2,3), p. 34.

154

154.

fig. 118

PABLO PICASSO
Ambroise Vollard

1915
Graphite
18⅜ x 12⅝ in. (46.7 x 32.1 cm)
The Metropolitan Museum of Art, New York, The Elisha
Whittelsey Collection, The Elisha Whittelsey Fund, 1947
47.140

CATALOGUE RAISONNÉ: Zervos 1932–78, vol. 2 (1942),
no. 922

PROVENANCE: Commissioned from the artist for 500 francs
by the sitter, Ambroise Vollard, Paris, 1915–probably until his
d. 1939; Martin Fabiani, Paris; Matignon Art Gallery (Galerie
André Weil), Paris, by 1947; bought through John Rewald by
the Metropolitan Museum, New York, 1947

During the near-hiatus in business imposed by
World War I, Vollard sat for this drawing, his third
portrait by Picasso after that of 1901, now in the
Bührle Foundation, Zurich, and the 1910 Cubist
portrait (cat. 153).[1] The commission is documented in
a previously unpublished letter in the dealer's archives:

August [?], 1915
Dear Monsieur Picasso,

Please find enclosed the 500 francs agreed upon
as the price of my portrait. Because I am unable
to get away myself, I told [the photographer
Étienne] Deletang to pick it up on Saturday,
in the morning, at about 10 o'clock; he will give
you a [photographic] reproduction of it immedi-
ately, and the photos of whatever else I possess
will follow very quickly.

Vollard[2]

The letter confirms that the portrait was com-
pleted upon Picasso's move into his studio in the rue
Schoelcher in August 1915, as had previously been
deduced by Gary Tinterow on the basis of the
woodwork in the background and the chair, which
also appear in the May 1916 portrait drawing of

Guillaume Apollinaire (private collection).[3] These
two drawings and the January 1915 portrait of Max
Jacob (private collection) are executed in a style often
described as both Ingresque and photographic.
Picasso returned to Ingres periodically, from the
Toilette of 1906 (see cat. 150) to the 1962 lithograph
Portrait of a Family.[4] A recent series of exhibitions
organized by Anne Baldassari has shown that
Picasso's use of photographs was more constant, and
in the case of the Jacob and Apollinaire portraits was
especially nuanced.[5] Picasso seems to have depended
on both personal sittings and photographs to work
out subtle details of his sitters' features, but he never
copied slavishly. A comparison of the present por-
trait of Vollard with a circa 1915 photograph of him
(fig. 297) strongly suggests that Picasso made use of
the latter for this drawing, although the pose is
reversed. Vollard also supplied a 1916 photographic
portrait of Auguste Renoir on which Picasso based a
drawing in 1919–20 (both Musée Picasso, Paris).[6]

AEM

1. The sitter in the Bührle Foundation picture has, however,
 been identified by Pierre Daix and Georges Boudaille
 (1967, no. VI.16) and others as Gustave Coquiot.
2. Vollard Archives, MS 421 (4,1), p. 278. The author wishes
 to thank Anne Roquebert and Isabelle Dervaux for assis-
 tance with the orthography of this document.
3. Cambridge–Chicago–Philadelphia 1981, no. 52.
4. Bloch 1971–79, no. 1032; Paris 1995, pp. 170–71,
 figs. 136, 137.
5. See Houston–Munich 1997–98, pp. 142ff. See also Paris
 1994; Paris 1995; and Paris 1997.
6. On the portraits of Renoir, see Houston–Munich 1997–98,
 pp. 146–47, figs. 168, 169.

155.

fig. 124

PABLO PICASSO
Ambroise Vollard

1937
Etching and aquatint
Image 13¾ x 9¾ in. (34.8 x 24.8 cm)
Musée Picasso, Paris MP 2740
Paris only

CATALOGUE RAISONNÉ: Geiser, Scheidegger, and Baer
1933–96, vol. 3 (1985), no. 620

PROVENANCE: Presumably acquired from Ambroise Vollard
by the artist, Paris, 1939–his d. 1973; Musée Picasso, Paris

156.

fig. 121

PABLO PICASSO
Ambroise Vollard

1937
Aquatint with some engraving
Image, 13¾ x 9⅞ in. (35 x 25 cm), sheet 17⁹⁄₁₆ x 13⅜ in.
(44.6 x 34 cm)
The Museum of Modern Art, New York, Gift of Klaus G.
Perls, in memory of Frank Perls, Art Dealer (by exchange),
1983 229.1983
New York and Chicago only

CATALOGUE RAISONNÉ: Geiser, Scheidegger, and Baer
1933–96, vol. 3 (1985), no. 617

155

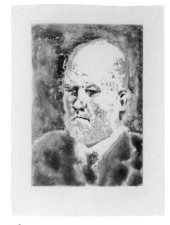

156

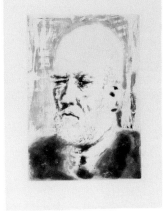

157

158

157. *fig. 122*

PABLO PICASSO
Ambroise Vollard

1937
Aquatint
Image, 13¾ x 9¾ in. (35 x 24.7 cm), sheet, 17¹¹⁄₁₆ x 13¼ in. (45 x 33.7 cm)
The Museum of Modern Art, New York, Acquired through the Lillie P. Bliss Bequest, 1947 253.1947
New York and Chicago only

CATALOGUE RAISONNÉ: Geiser, Scheidegger, and Baer 1933–96, vol. 3 (1985), no. 618

158. *fig. 123*

PABLO PICASSO
Ambroise Vollard

1937
Etching
Image 13⅜ x 9¾ in. (34.6 x 24.8 cm), sheet 17⁹⁄₁₆ x 13⅜ in. (44.6 x 34 cm)
The Museum of Modern Art, New York, The Marnie Pillsbury Fund, 2004 46.2004
New York and Chicago only

CATALOGUES RAISONNÉS: Bloch 1971–79, no. 233; Geiser, Scheidegger, and Baer 1933–96, vol. 3 (1985), no. 619

PROVENANCE: Ambroise Vollard, Paris, until his d. 1939; his estate, 1939; bought by Marcel Lecomte, Paris; Henri Petiet, Paris, until his d. 1980; his heirs; bought by Marc Rosen Fine Art, New York; bought by the Museum of Modern Art, New York, 2004

In 1937 Vollard acquired ninety-seven etched plates with a variety of subjects from Picasso that were eventually to constitute the greater part of the so-called Vollard Suite (see the essay "Vollard and Picasso" by Gary Tinterow in this volume). To round the set at one hundred, Vollard selected the last three of the four portraits reproduced here, which Picasso had made of him on March 4, 1937.[1] It has not been previously noted that the pose, which is the same in all four prints, derives from a photograph (fig. 297) that Picasso used in part as the basis for the portrait drawing the dealer commissioned from him in 1915 (cat. 154). The effect varies markedly from print to print owing to the several mediums—aquatint, dry-point, etching, and scratching—and their various combinations and applications. The portrait shown here, in an impression from the Musée Picasso (cat. 155), is perhaps the least flattering; it was not included in the suite. AEM

1. See Geiser, Scheidegger, and Baer 1933–96, vol. 3 (1985), nos. 617–20. According to Una Johnson (1977, pp. 39, 44, n. 46), Picasso suggested that "he sketch Vollard's portrait each time he paid him a visit, until enough for a suite

should be finished. . . . But [Vollard's] death cut this project short and only three portraits were completed." Johnson was evidently unaware of the fourth portrait.

159. *figs. 119, 218*

PABLO PICASSO
Le Chef-d'oeuvre inconnu, by Honoré de Balzac

Published by Ambroise Vollard, Éditeur, Paris, 1931 ("Achevé d'imprimer" November 12, 1931)
Illustrated book with 13 etchings, 67 wood engravings, and 16 pages reproducing dot-and-line drawings
Page (irreg.) 12¹⁵⁄₁₆ x 9¹⁵⁄₁₆ in. (33 x 25.2 cm)
Printer: Louis Fort (etchings), Aimé Jourde (wood engravings [executed by Georges Aubert] and text)
Copy no. 183 (of a numbered edition of 305, plus additional copies numbered I–XXXV)
The Museum of Modern Art, New York, The Louis E. Stern Collection, 1964 967.1964.1–13
New York and Chicago only

CATALOGUES RAISONNÉS: Horodisch 1962, no. B4; Bloch 1971–79, nos. 82–94; Johnson 1977, no. 94; Goeppert, Goeppert-Frank, and Cramer 1983, no. 20; Geiser, Scheidegger, and Baer 1933–96, vol. 3 (1986), nos. 123–135; Jentsch 1994, no. 24

159

There is general agreement that Vollard asked Picasso to illustrate Honoré de Balzac's 1831 novel *Le Chef-d'oeuvre inconnu* in 1926. The following year, Picasso etched twelve plates on the theme of the painter's studio. Presumably at Vollard's instigation, he then made a thirteenth etching that presents small images of the first twelve in their intended sequence. But it was Vollard's integration of this suite of original etchings with reproductions of preexisting drawings that is the most striking feature of the publication. Vollard selected nearly abstract drawings from sketchbooks that Picasso filled in 1924–26.[1] In the book's first sixteen pages he reproduced fifty-six line-and-dot drawings, and a further group of drawings made in a Cubist idiom were the models for sixty-seven wood engravings executed by Georges Aubert and interspersed throughout the text and on the wrappers. *Le Chef-d'oeuvre inconnu* is a tour de force of the publisher's vision, reconciling various incongruities: the multiplicity of styles offered by Picasso's illustrations, the unapologetic combination of "original" and reproductive techniques involved in their

production, and the artist's own lack of engagement with Balzac's text.

The printing of the book was completed on November 12, 1931, less than three weeks after that of Ovid's *Metamorphoses,* with etchings by Picasso, which was published by Albert Skira in Geneva.[2] Vollard had, however, already exhibited the Balzac edition (or elements of it) in the French section of the Salon International du Livre d'Art, held at the Petit Palais, Paris, from May 20 toAugust 15, 1931.[3]

AEM

1. The four sketchbooks are now in the Musée Picasso, Paris (MP1869–1872). See Léal 1996, vol. 1, nos. 30–33.
2. A portolio containing only the twelve etchings was published separately; see Johnson 1977, no. 191.
3. Paris 1931; André Suarès wrote the catalogue preface for this exhibition.

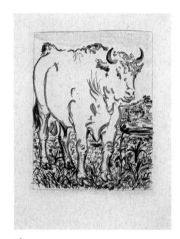

160

160. figs. 120, 219

PABLO PICASSO

Eaux-fortes originales pour des textes de Buffon (Histoire naturelle), written by Buffon (Georges-Louis Leclerc, comte de Buffon)

Published by Martin Fabiani, Paris, 1942 ("Achevé d'imprimer" May 26, 1942)
Illustrated book with 31 prints: aquatints, drypoints, etchings, and/or engravings
Page (irreg.) 14⁹⁄₁₆ x 11 in. (37 x 28 cm)
Printer: Roger Lacourière (etchings); Marthe Féquet and Pierre Baudier (text)
Copy no. 40 (of a numbered edition of 225, plus at least one additional copy)
The Museum of Modern Art, New York, The Louis E. Stern Collection, 1964 976.1964.1–31
New York and Chicago only

CATALOGUES RAISONNÉS: Horodisch 1962, no. B8; Bloch 1971–79, nos. 328–58; Johnson 1977, no. 192; Goeppert, Goeppert-Frank, and Cramer 1983, no. A4; Geiser, Scheidegger, and Baer 1933–96, vol. 3 (1986), nos. 575–606; Jentsch 1994, no. 35

In 1931, as *Le Chef-d'oeuvre inconnu* (cat. 159) neared publication, Vollard asked Picasso to contribute illustrations for an edition of the *Histoire naturelle, générale et particulière* by Georges-Louis Leclerc, comte de Buffon (1707–1788).[1] The artist executed

thirty-one charming animal subjects in etching, aquatint, and other print mediums in 1936,[2] but the project was one of many that remained unpublished upon Vollard's death in 1939. It had reached an advanced state of preparation, however, and eventually was brought out in 1942 by Martin Fabiani, who seems to have published the work exactly as he found it, simply replacing Vollard's name with his own. Picasso executed the etchings without resort to Buffon's text, and Vollard subsequently paired appropriate passages with the images. Consequently, some illustrations accompany multiple pages of text, while others appear without any at all.[3]

AEM

1. Originally published by the Imprimerie Royale, Paris, in 24 vols. between 1749 and 1803.
2. According to his friend and secretary Jaime Sabartés, at one point Picasso executed one etching a day on successive days: Sabartés 1946, p. 138, cited in Horodisch 1962, pp. 54–55, 108, n. 29.
3. Horodisch 1962, no. B8, has suggested that this may have been an economy of wartime.

161. fig. 194

PABLO PICASSO

Head of a Jester

1905 (subsequent Vollard cast)
Bronze
16⅛ x 14⅞ x 9⅜ in. (41 x 37.8 x 23.7 cm)

CATALOGUES RAISONNÉS: Zervos 1932–78, vol. 1 (1932), no. 322; Johnson 1977, no. 227; Spies 2000, no. 4

a. Musée Picasso, Paris MP 231
Paris only

PROVENANCE: Commissioned by Ambroise Vollard as artist's proof, probably cast by Godard, Paris, 1910; Pablo Picasso, by early 1911–his d. 1973; his heirs, 1973–79; Musée Picasso, Dation 1979

b. Hirshhorn Museum and Sculpture Garden, Smithsonian Institution, Washington, D.C., Gift of Joseph H. Hirshhorn, 1966 66.4044
New York and Chicago only

162. fig. 197

Head of Fernande (Rose Period)

Ca. 1906 (subsequent Vollard cast)
Bronze
14¼ x 9½ x 10 in. (36.2 x 24 x 25.4 cm)

CATALOGUES RAISONNÉS: Zervos 1932–78, vol. 1 (1932), no. 323; Johnson 1977, no 228; Spies 2000, no. 6

a. Musée Picasso, Paris MP 234
Paris only

PROVENANCE: Commissioned by Ambroise Vollard as artist's proof, probably cast by Godard, Paris, 1910; Pablo Picasso, by early 1911–his d. 1973; his heirs, 1973–79; Musée Picasso, Dation 1979

b. Allen Memorial Art Museum, Oberlin College, Oberlin, Ohio, R. T. Miller, Jr. Fund, 1955 55.35
New York and Chicago only

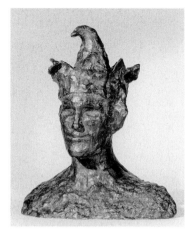

161

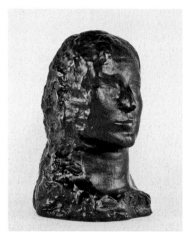

162

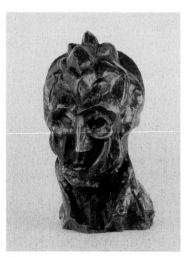

163

163. fig. 198

Head of Fernande (Cubist Period)

1909 (subsequent Vollard cast)
Bronze
16 x 10¼ x 10 in. (40.6 x 26 x 25.4 cm)

CATALOGUES RAISONNÉS: Zervos 1932–78, vol. 2 (1942),
no. 573; Johnson 1977, no. 230; Spies 2000, no. 24

a. Musée Picasso, Paris MP 243
Paris only

PROVENANCE: Commissioned by Ambroise Vollard as artist's
proof, probably cast by Godard, Paris, 1910; Pablo Picasso, by
early 1911–his d. 1973; his heirs, 1973–79; Musée Picasso,
Dation 1979

b. The Art Institute of Chicago, Alfred Stieglitz Collection
49.584
Chicago only

PROVENANCE: Ambroise Vollard, Paris, by January 1912;
bought through Edward Steichen on behalf of Alfred
Stieglitz, New York, January 1912–his d. 1949; his bequest
to The Art Institute of Chicago, 1949

c. The Metropolitan Museum of Art, New York, Bequest of
Florene M. Schoenborn, 1995 1996.403.6
New York only

Picasso's early attempts at sculpture were executed in
clay, terracotta, and plaster in the Paris studios of his
countrymen Francisco Durrieu de Madron, called
Paco Durrio, and Manuel Martinez i Hugué, called
Manolo. Vollard acquired the originals of five sculp-
tures and the rights to reproduce them prior to
the opening of his Picasso exhibition in late 1910,
although no details of the transaction survive.[1] Three
of them are included here. In a photograph datable
to early 1911, bronze casts of all three appear, lined up
in a row "as if recently delivered en bloc"[2]; a mention
in a letter confirms that the Cubist *Fernande* was
on display in Vollard's gallery in April 1913.[3] Vollard
commissioned individual casts as they were ordered
for the remainder of his working life, placing no
upper limit on the size of the edition.

 AEM

1. On the early development of these sculptures, see London
 1994, nos. 1, 2, 5, 6; and Spies 2000, pp. 23–28. The cir-
 cumstances of Vollard's editioning of two other sculptures
 from this period are less well known. These are *Woman
 Arranging Her Hair* (1905–6; Zervos 1932–78, vol. 1 [1932],
 no. 320; Johnson 1977, no. 229; Spies 2000, no. 7) and
 Head of a Man (ca. 1909; Zervos 1932–78, vol. 1 [1932],
 no. 573; Johnson 1977, no. 231; Spies 2000, no. 9).
2. Fletcher 2003, pp. 181–82, fig. 9. This is the single most
 comprehensive study of the editioning of any one of
 the Vollard Picasso bronzes; see also "Vollard and the
 Sculptures of Picasso" by Diana Widmaier Picasso in this
 volume.
3. Emil Filla to Vincenc Kramář, spring 1913: Archives,
 Národní Galerie, Prague, Kramář deposit, individuals I,
 2945/148, translated in Prague–Paris 2000–2002,
 "Chronology," p. 227.

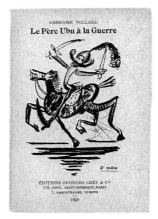

164

164. fig. 225

JEAN PUY
Le Père Ubu à la guerre, by Ambroise Vollard

Published by Georges Crès et Cie, Paris, 1920
Book with 3 reproductions
Page (irreg.) 6³⁄₁₆ x 4¼ in. (15.7 x 10.8 cm)
Unnumbered copy (of a numbered edition of 500, plus
additional copies)
Private collection

PROVENANCE: Ambroise Vollard, Paris; his heirs; their gift to
current owner, 2005

Vollard was Jean Puy's principal dealer from about 1905
through 1926. In December 1908 he devoted a solo
exhibition to the artist.[1] During World War I, Puy
wrote Vollard extensively from the front about the
bombings, chlorine gas attacks, and overall destruc-
tion that he witnessed. Despite the horrors of war,
Puy remained true to his calling: "Right now I am in
an abandoned and completely razed village border-
ing the trenches. The site is odd and not too melan-
choly for a painter; there are loads of interesting
motifs."[2] Puy visited Vollard several times while on
leave in Paris, and Vollard sent the artist some of
his latest Père Ubu texts. On February 3, 1917, Puy
wrote Vollard that he was looking forward to read-
ing the "little Père Ubu à l'hôpital" (cat. 19).[3] That
November he reported having recently reread "Père
Ubu chez les mèdicins" (presumably the same text),
which he found "even more satisfying than on first
reading. It is [written with] a deadpan sort of humor,
quite mocking and, in fact, much less exaggerated
than one would think because one sees these monu-
mental absurdities so often in the military, especially
the personalities: puffed up and ignorant, affluent,
obsessive, rude and arrogant windbags."[4]

 According to Vollard, his ideas for *Père Ubu à
l'hôpital* evolved into the text known as *Père Ubu
à la guerre*. On May 21, 1919, Puy sent Vollard five
drawings for the book, among them Ubu as Parsifal
among the flowers (inspired by Wagner's opera of
1882) and Ubu poking the pope's belly.[5] The artist
confirmed that he would create the etchings himself
but noted that he preferred that his copperplates be
clear of any preparatory sketches, as he had no inter-
est in copying himself. In typical fashion, Vollard
had already proposed an additional book project to
Puy—"L'Histoire de la Mère Ubu"—on which Puy
agreed to begin working as soon as his illustrations
for *Père Ubu à la guerre* were complete.[6]

Vollard's *luxe* edition of *Père Ubu à la guerre* was
published in 1923. However, in 1920 the dealer per-
mitted Georges Crès et Cie to produce a reduced-
format version of the book, an example of which is
exhibited here, illustrated with reproductions after
three of Puy's original designs.

 RAR

1. Morice 1908.
2. Puy to Vollard, April 14, 1916: Vollard Archives, MS 421
 (2,2), p. 226.
3. Puy to Vollard, February 3, 1917: Vollard Archives,
 MS 421 (2,2), p. 252.
4. Puy to Vollard, November 4, 1917: Vollard Archives,
 MS 421 (2,2), p. 256.
5. Puy to Vollard, May 21, 1919: Vollard Archives, MS 421
 (2,2), pp. 264–65. Puy sent Vollard an etching and three
 drawings on June 9, 1919: MS 421 (2,2), p. 266. For other
 letters concerning the project, see Puy to Vollard, June 25,
 1919, and April 9, 1920: MS 421 (2,2), pp. 268, 272.
6. Puy to Vollard, May 21, 1919: Vollard Archives, MS 421
 (2,2), pp. 264–65. For Puy's reaction to reading the text of
 Vollard's "Mère Ubu," see Puy to Vollard, April 29, 1920:
 Vollard Archives, MS 421 (2,2), p. 274.

165. fig. 81

ODILON REDON
Strange Flower (Little Sister of the Poor)

1880
Various charcoals, with touches of black chalk and black
conté crayon
15⅞ x 13⅛ in. (40.4 x 33.2 cm)
The Art Institute of Chicago, David Adler Collection
1950.1433
New York and Chicago only

CATALOGUE RAISONNÉ: A. Wildenstein 1992–98, no. 1183

PROVENANCE: Bought from the artist by Ambroise Vollard,
Paris, December 30, 1897; Henri M. Petiet, Paris, by March
1940; Jean Goriany, New York, by 1941; bought by The Art
Institute of Chicago, 1950

166. fig. 95

ODILON REDON
The Prisoner

Ca. 1880
Charcoal
15¼ x 14⅛ in. (38.8 x 36 cm)
Musée d'Orsay, Paris, on deposit in the Department of
Graphic Arts at the Musée du Louvre, Gift of Claude
Roger-Marx, in memory of his father, brother, and son,
who died for France, 1974 RF 35819
Paris only

CATALOGUE RAISONNÉ: A. Wildenstein 1992–98, no. 1121

PROVENANCE: Bought from the artist by Ambroise Vollard,
Paris, 1897; acquired by Claude Roger-Marx, Paris; his gift
to the Musée du Louvre, Paris, Département des Arts
Graphiques (fonds Orsay), 1974

167. *fig. 96*

ODILON REDON

Head Wearing a Phrygian Cap, on a Salver

1881
Charcoal with black chalk
19⅛ x 14¼ in. (48.6 x 36.3 cm)
The Art Institute of Chicago, David Adler Collection
1950.1416
New York and Chicago only

CATALOGUE RAISONNÉ: A. Wildenstein 1992–98, no. 1145

PROVENANCE: Probably bought from the artist by Ambroise Vollard, Paris, 1899; Henri M. Petiet, Paris, by March 1940; bought through Jean A. Goriany by The Art Institute of Chicago, 1950

168. *fig. 93*

ODILON REDON

The Cask of Amontillado

1883
Charcoal
14⅛ x 12⅜ in. (36.2 x 31.4 cm)
Musée d'Orsay, Paris, on deposit in the Department of Graphic Arts at the Musée du Louvre, Gift of Claude Roger-Marx, in memory of his father, brother, and son, who died for France, 1974 RF 35822
Paris only

CATALOGUE RAISONNÉ: A. Wildenstein 1992–98, no. 418

PROVENANCE: Acquired from the artist by Ambroise Vollard, Paris, February 10, 1899; acquired by Claude Roger-Marx, Paris, possibly June 6, 1924; his gift to the Musée du Louvre, Paris, Département des Arts Graphiques (fonds Orsay), 1974

Vollard, who began his career as a dealer by buying prints from the *bouquinistes* (secondhand booksellers) along the banks of the Seine, would have known of Redon's reputation as a draftsman and printmaker, just as he would have known of Redon's friend Henri Fantin-Latour, both of whom were recognized as having been key players in the revival of lithography well before it became fashionable in the 1890s.[1] On a public level, in fact, Vollard's patronage of both artists seems about equal. When Vollard launched his own version of the *peintres-graveurs* exhibitions that had been held at the Durand-Ruel gallery between 1889 and 1894, he invited these older, established printmakers to show with "les jeunes." Both were commissioned to make one lithograph each for the albums whose publication coincided with Vollard's 1896 and 1897 exhibitions, and both were commissioned to make a lithographic album, each of which was exhibited along with the Nabis' Vollard albums in the spring of 1899.[2] But whereas Vollard owned only very few works by Fantin-Latour (outside the rights to the commissioned prints), he purchased nearly a hundred drawings, pastels, and paintings from Redon in 1899 alone.[3]

Perhaps because Vollard met Redon at a time when the artist was trying to shake off his reputation as "literary," his commercial printing involvement with Redon was limited to a few lithographs, an album (*L'Apocalypse de Saint-Jean*, 1899), and the aborted plates for the Mallarmé book *Un Coup de dés*.[4] Although Vollard exhibited eight of the twenty-

four lithographs from the definitive series of *La Tentation de Saint-Antoine* (begun in 1888) at the 1896 *peintres-graveurs* exhibition, the prints were self-published and given or sold to friends by the artist.[5] At the time Redon endeavored to find a distributor, but he was unsuccessful—the potential publishers he approached were "too timid" or "indifferent."[6] Whether Vollard was among those he approached is not known; it was not until six years later, in 1902, that the dealer purchased the distribution rights. When Vollard reprinted the third series of *Tentation* in 1909, it was a disaster. In his personal accounts, Redon remarked that the plates were left in bad condition and that the prints (by Clot and Blanchard) were consequently of poor quality. While not directly blaming Vollard, he made it clear that the only good proofs were those he made in 1896 (for the original edition), "which were printed under my supervision."[7] Whether or not this was a factor, Redon's close involvement with the dealer ceased about this time.

Vollard played a critical role in the marketing of Redon's works in color and in black and white. Despite the fact that Redon needed cash more desperately than critical notice, he was nonetheless selective in what works he sold to Vollard. A comparison of Stockbooks A and B reveals that Vollard was able to sell Redon's charcoal drawings from the 1880s and more recent works, including pastels and oils, more readily than the artist's earliest drawings, such as the large *Battle* (*La Bataille*, 1865).[8] Included among Vollard's early purchases were *noirs*, variants of original themes, unresolved works, and some that had been abandoned at some early stage such as *Oblique Ray* (1883, The Art Institute of Chicago), a fully conceived background awaiting a subject.[9]

Many of the works Vollard acquired are readily recognizable from the stockbook descriptions. The *noir* known as *Strange Flower* (cat. 165), for example, is entered in Vollard's Stockbook A as "charcoal, from a fragile stem emerges a sort of woman's head, monstrous flower."[10] This is one of several drawings showing a head on a stem, at least two of which were owned by Vollard.[11] In 1882, when it was first exhibited in the offices of the newspaper *Le Gaulois* as *Strange Flower*, Redon's young poet and art critic friend Émile Hennequin described it as a "large yellowish face with dead eyes and a placid smile."[12] The Symbolist author Joris-Karl Huysmans saw it as a head "held up like a host, like a round flower, a bloodless face with pensive features."[13] Both critics saw a bloodless flower, suggesting a malevolence not intended by the artist. Huysmans's likening the face to the Host of the Eucharist—the flat, round wafer used for Communion—came closest to the meaning of Redon's extenuated title "Strange Flower (Little Sister of the Poor)," which alluded obliquely to the Catholic order of that name near his home.[14] In this exegesis, the fragile stem supporting and yet draining the blood from the top-heavy moonlike disk referred to the weakened Catholic church faced with an increasingly secular state.[15] In his list of works begun in the mid-1880s, Redon retitled it very neutrally as "head of a child," with no mention of its "monstrous" (as Vollard called it) or even religious significance.[16] This was one of many works that, about 1899–1900, Redon began reassigning shorter and relatively banal titles, in an effort to reposition himself as an artist of the lyrical rather than of the hallucinatory.[17]

165

166

167

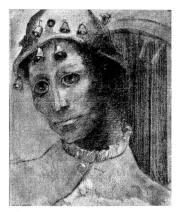

168

Vollard's descriptions of Redon's works, however, preserve the sense of strangeness that made the artist's *noirs* so popular among the Symbolists. They represent a middle ground between the highly personal and complex nature of Redon's original descriptions and his later sanitized titles. This is the case especially for the *noirs* of the 1880s, such as *La Coupe,* which Redon had originally titled *Head Wearing a Phrygian Cap, on a Salver* (cat. 167). The figure can be interpreted as an anxiety-ridden image of the French Republic, a Marianne-like figure who has succumbed to her fate, in the disastrous campaign of the Franco-Prussian War.[18] Vollard's title, *On a Platter, a Woman's Head,* lacks the artist's oblique allusion to war but maintains a proto-Surrealistic quality.[19]

Many of Redon's *noirs* bought by Vollard reflect the artist's fascination with the theme of the severed head, which he would develop in literary themes based on Gustave Flaubert's *Salammbô* and the idea of martyrdom in general. In *The Prisoner* the severed head rests on a tabletop rather than on a salver.[20] Early on, while in the collection of Claude Roger-Marx, it was given a Vollard provenance, although no specific reference has been found in the stockbooks to match the image.[21] This *Prisoner* deviates from Redon's other images of a similar subject in which the sense of enclosure or entrapment is clearly suggested, for example, in *La Lucarne* (*The Window*), which Vollard exhibited in 1896.[22] There Redon seemed to represent an imprisonment of the mind with the juxtaposition of a monk and floating, impish, genie-like heads, representing the realms of the earthly and the otherworldly.

The ambiguous quality of this imagery, like Redon's titles, is what Vollard found so appealing in his works. Vollard kept more of the *noirs* than he sold. For Redon, Vollard's support came at a time when he was slowly letting go of the works that had been so much a part of his past, works that often revisited earlier themes such as *La Folie* or *Mephisto.* Redon's personal title for one such work—*The Cask of Amontillado* (cat. 168)—linked it to the drawings he was doing around the time of his album *To Edgar Poe* (1882).[23] An earlier *noir* (1877), entitled simply *Mephisto, He Shows His Fingernail,*[24] exhibited at the offices of *La Vie moderne* in 1881, was also acquired by Vollard. Both works evoke the Faustian theme of the devil who plays with men's souls. In Poe's creepy cellar-cum-prison, the weak-willed man (clearly under an evil influence) allows himself to be beguiled by the prospect of riches. In the drawing here, in front of the cellar door indicated by the bricked archway, the victim slumps dissolutely, having lost both his humanity and his freedom.[25]

All four drawings date from the early 1880s, the period associated most intensely with Redon's *noirs* and his family home at Peyrelebade. A decade later, when Vollard began to buy his works, the artist was "abandoning black" to move toward subjects that required updated titles that more closely reflected his artistic and moral reincarnation.[26]

GG

1. On Fantin-Latour's importance to Redon, see Druick and Zegers 1994, p. 122.
2. Johnson 1944, pp. 85–86, no. 58, dates Fantin's lithographic portfolio *Suite de six planches* to 1898; Redon's *Apocalypse de Saint-Jean* was published in 1899.
3. Only two Fantin-Latour works were found in Vollard's stockbooks: Stockbook A, no. 4000, "Dessin Le Magicien,

[no provenance given], 99 x 48 cm, [no price given," and no. 4155, "huile; plusieurs personnages [illegible] dans les nuages [in column labeled Provenance] Denys Cochin, 33 x 26 cm, 500 [francs]." For Vollard's bulk purchases of Redon works in 1899, see Vollard Archives, MS 421 (4,3), fol. 120, January 17, 1899: "O. Redon 8 dessins et 3 peintures espèces, [in column labeled *sortie*] 800 [francs]"; MS 421 (4,3), fol. 123, February 10, 1899: "Redon quarante dessins et peintures [sortie] 2000 [francs]"; MS 421 (4,3), fol. 125, March 2, 1899: "Redon dix sept peintures [sortie] 1000 [francs]"; MS 421 (4,3), fol. 146, November 11, 1899: "Redon 25 dessins et peintures à recevoir especes [illegible] [sortie] 1500 [francs]."
4. On the Mallarmé project, see Gamboni 1989, p. 187. See also Lake 1976, no. 373.
5. As were the earlier series and folios of prints: *In Dreams* (1879), *Origins* (1883), *Homage to Goya* (1885), *Night* (1886), *Tentation de Saint-Antoine* (second series 1889 and definitive version in 1896), and *Dreams* (1891). Except for *To Edgar Poe* (1882), these were published by G. Fischbacher, Paris; the first series of *Tentation de Saint-Antoine* (1888) was published by Deman, Brussels.
6. See Sharp 1994b, pp. 250–52.
7. Ibid., p. 411, n. 32.
8. See New York 2005–6, p. 210, for a record of the purchase of this work by Vollard in December 1897. The work is listed again in Vollard Stockbook B as no. 3440, "Bataille (Fusain), [Provenance] Redon, 65 x 112 [cm], 200 [francs]."
9. Mellerio Redon Chronology, 1883, no. 179, "Le rayon oblique (à M. Vollard)"; cited in Chicago–Amsterdam–London 1994–95, p. 452 (Art Institute of Chicago, 1950.1424).
10. Stockbook A, no. 3728, "Fusain, d'un [faible] tige sort un enorme tete de femme, fleur monstrueuse, [Provenance] Redon, [no dimensions given], 95 [francs]."
11. See also Stockbook B, no. 3320, "Tête sur une tige (Fusain), [Provenance] Redon, 52 x 36 cm, [no price given]."
12. Hennequin 1882, p. 136, translated in Dorra 1994, p. 50.
13. Huysmans 1883, p. 299.
14. Druick and Zegers 1994, p. 154, and Chicago–Amsterdam–London 1994–95, p. 439, no. 55.
15. Druick and Zegers 1994, p. 154.
16. Mellerio Redon Account Books: André Mellerio Collection, Ryerson and Burnham Archives, Art Institute of Chicago; cited in Chicago–Amsterdam–London 1994–95, p. 439, no. 55.
17. See Gamboni 1989, pp. 175–76. See also Redon's letter to Émile Bernard, April 14, 1895, about "leaving black"; *Lettres à Émile Bernard* 1942, p. 150.
18. See Druick and Zegers 1994, p. 131.
19. Vollard Stockbook A, no. 3703, "Sur un plat une tête de femme, [Provenance] Redon, 47 x 34 cm, 85 [francs]." See also a related image "Sur la coupe" in Redon's first lithographic album *Dans le Rêve,* plate XX (Mellerio 1913, no. 36), although here the head looks out and is not in a pose of resignation.
20. Also in Paris 1980–81, p. 70, no. 40.
21. Ibid. See also A. Wildenstein 1992–98, no. 1121, which notes that this work has a Vollard provenance.
22. Paris 1896, no. 157, as "dessin." This work may be identified as W 1068, *Le Prisonnier à la lucarne.* See also Druick and Zegers 1994, p. 146, fig. 35, and p. 147, fig. 38. See also *Dans l'angle de la fenêtre* (also called *The Convict*), 1881, Museum of Modern Art, New York, in New York 2005–6, p. 123, pl. 24.
23. Mellerio Redon Chronology, 1883, no. 171, "La barrique d'amantillade": André Mellerio Collection; cited in Chicago–Amsterdam–London 1994–95, p. 452. See also Vollard's Stockbook A, no. 3711, "[Provenance] Redon, 35 x 30 cm, 75 [francs]." The acquisition of this work by Claude Roger-Marx may have taken place on June 6, 1924; see Vollard Archives, MS 421 (5,12), fol. 60: "recu en [illegible] à Cl. Roger Marx [among other works] 2 Redon 150 [francs]."
24. From the French "il montre son ongle" (montrer). Mellerio Redon Chronology, 1877, no. 53: André Mellerio Collection; cited in Chicago–Amsterdam–London 1994–95, p. 451. Vollard's Stockbook A, no. 3621, "dessin; sorte de mephistophéles, les doigts [illegible], le petit doigt interrogateur [illegible] le menton, [Provenance] Redon, 38 x 34 cm, 65 [francs]."
25. Druick and Zegers 1994, p. 128, fig. 5, and Leeman 1994.
26. Redon to Bernard, April 14, 1895, in *Lettres à Émile Bernard* 1942, p. 150.

169

169. *fig. 91*

ODILON REDON
The Beacon

1883 (reworked ca. 1893)
Pastel with various charcoals and touches of black chalk
20¼ x 14⅝ in. (51.5 x 37.2 cm)
The Art Institute of Chicago, gift of Mrs. Theodora W. Brown and Mrs. Rue W. Shaw in memory of Anne R. Winterbotham 1973.513
New York and Chicago only

CATALOGUE RAISONNÉ: A. Wildenstein 1992–98, no. 1059

PROVENANCE: John H. Winterbotham, Chicago, 1928; Theodora Winterbotham Brown and Rue Winterbotham Shaw; their gift to The Art Institute of Chicago, 1973

In one of his early mentions of Vollard's gallery, Camille Pissarro reported having seen "paintings" by Redon.[1] These could have been early oil paintings inspired by Redon's native Bordeaux or his most recent "color" works, including pastel, red chalk, oil, and distemper.[2] Vollard seems to have encouraged Redon's new interest in color, describing him in his memoirs as a graphic artist "who works in both," probably having in mind Redon's color lithograph *Béatrice* included in the dealer's second print album. (Earlier on, Redon had attempted to capitalize on the increasing demand for color lithographs with a color frontispiece for the third series of *La Tentation de Saint-Antoine,* which was never realized.) Although Vollard boasted of having led Redon to color lithography, the *Béatrice* print was a hybrid product. Redon, although involved with the printing by Auguste Clot, referred to the resulting lithograph as a "copy" after his 1885 pastel of the same title, which Vollard acquired from him in 1896.[3] And while he received 150 francs for the print, Redon was less than satisfied with the result and balked at continuing in this direction, feeling that color cheapened the importance of the lithograph.[4]

For the 1885 *Béatrice* pastel, Redon had returned to a previous drawing of the subject, preparing a charcoal underdrawing over which he used pastel from a blunt stick, then applied pastel and gouache

wet with a brush.[5] The resulting work was clearly a pastel. But there are also instances in the mid-1890s when Redon, perhaps motivated by Vollard's interest in showing "color," revisited his earlier *noirs* and entirely reworked them. This is the case with *The Beacon* (possibly "La Chaîne," exhibited at the 1899 Durand-Ruel exhibition).[6] Redon listed it as having been conceived in 1883, close in time to the 1880 charcoal *Strange Flower* (cat. 165); both reflect his other thematic preference for the motif of a disembodied and floating head, hanging from some kind of fragile stem or, in this instance, a heavy chain. A related work, *Diogenes* (W 1058) was purchased from Redon by Vollard about 1900, and similarly features a lantern, not hanging but carried by Diogenes.[7]

Infrared reflectography reveals that blue pastel (new to Redon's work in 1890) completely covers a second head peering from behind the beacon in the present work. This means that Redon not only revisited an earlier *noir,* he changed its meaning, perhaps from the subject of "Diogenes carrying his lantern" that Vollard described for the work mentioned above. Despite the pastel reworkings, *The Beacon* retains much of the earlier *noir* sensibility, although to critics such as Julian Barnes it is a *noir* that "has been prettified and betrayed."[8]

GG

1. See Camille Pissarro to his son Lucien, January 21, 1894, in Rewald and L. Pissarro 2002, p. 227: "A young man I knew through John Lewis Brown, and who was warmly recommended to me by M. Viau, has opened a small gallery in the rue Laffitte. He shows nothing but pictures of the young. There are some very fine early Gauguins, two beautiful things by Guillaumin, as well as paintings by Sisley, Redon, Raffaëlli, de Groux, of this last a very beautiful work." For the original French, see Bailly-Herzberg 1980–91, vol. 3, pp. 419–20, letter 979.
2. On Redon's evolution in color, see Stratis 1994, pp. 366–68.
3. See Vollard Archives, MS 421 (4,3), fol. 56, October 27, 1896: "Acheté à Redon un pastel 'Beatrice' [in column labeled *sortie*] 150 [francs]."
4. Gamboni 1989, p. 191. Gamboni claims Redon made a total of three color lithographs that correspond to Mellerio 1913, nos. 167, 168, and 169: *La Sulamite, Béatrice, Tête d'enfant avec fleurs.* However, Mellerio (1898, p. 20) does not list *Tête d'enfant avec fleurs* as one of Redon's color lithographs, probably because *Tête d'enfant* is a monochromatic lithograph and thus not a true color lithograph.
5. See Stratis 1994, pp. 368–69.
6. This work was no. 77 in the 1899 Durand-Ruel exhibition; see A. Wildenstein 1992–98, vol. 4, "Errata et addenda," no. 1059.
7. Stratis 1994, p. 371. Mellerio Redon Chronology, 1883, no. 185, "Le fanal": André Mellerio Collection, Ryerson and Burnham Archives, The Art Institute of Chicago. Vollard's Stockbook A, no. 3734, "Fusain.—un personnage préhistorique, une lanterne à la main, [Provenance] Redon, 50 x 36 cm, 85 [francs]"; Stockbook B, no. 3313, "Diogène et sa lanterne (Fusain), [Provenance] Redon, 50 x 36 cm [no price given]."
8. J. Barnes 1994, p. 18.

170

170. *fig. 92*

ODILON REDON
Profile of Light

Ca. 1885–91
Charcoal
15¼ x 11⅜ in. (38.8 x 28.9 cm)
Musée d'Orsay, Paris, on deposit in the Department of Graphic Arts at the Musée du Louvre, Gift of Mme René Asselain, 1978 RF 36816
Paris only

CATALOGUE RAISONNÉ: A. Wildenstein 1992–98, no. 268

PROVENANCE: Bought from the artist by Ambroise Vollard, Paris; acquired by Claude Roger-Marx, Paris, possibly June 6, 1924; by descent to his daughter Mme René Asselain, Paris; her gift to the Musée du Louvre, Département des Arts Graphiques (fonds Orsay), 1978

The image of a woman in profile, often in a strong diagonal light, was a recurring theme for Redon. Vollard registered in his stockbooks a "profile of a woman with a veil, very light," which may well refer to this work.[1] The artist himself made several versions of the veiled woman in profile, the best known of which was shown at the Impressionist exhibition in 1886 as "Profile de lumière" (now in the Petit Palais, Paris; W 266).[2] In his inventory Redon noted a "copy" of this subject, possibly referring to the second version of the drawing, also called *The Fairy (Profile of Light)* (now in the Museum of Modern Art, New York; W 267); it was this subject that Redon made into a lithograph, published by Dumont in 1886.

In comparison with the *Profile of Light* shown here, Redon's earlier versions are more hieratic and focused on the exotic attire of the woman who receives enlightenment. Although the precise date for this composition is not known, it is possible that the artist revisited the theme in the early 1890s, when he recorded a "copy" of a *Profile of Light* "made at Peyrelebade" (the Redon family home) in 1891.[3] In this later variant, the more elaborate details of her robe and headwear are stripped to the essentials, except for a ruffled collar, which suggests the ruffled bodice Camille wears in *Profile of a Woman in Shadow.* However oppositional in their conception—light vs. shadow, void vs. floral background—together they speak to Redon's move from the world of half light and shadow to that of figures emerging into the light. More importantly for his evolution in the early 1890s, they speak to his departure from transformed nature to observed nature, from the druid priestess to the Parisian.

GG

1. Possibly Stockbook A, no. 3745, "Fusain; une tete de femme avec un voile très clair, [Provenance] Redon, 38 x 28 cm, 75 [francs]."
2. Sold to Charles Hayem in about 1887 according to A. Wildenstein 1992–98, vol. 4, "Errata et addenda," no. 266. See the Mellerio Redon Chronology, 1881, no. 133: André Mellerio Collection, Ryerson and Burnham Archives, The Art Institute of Chicago; cited in Chicago–Amsterdam–London 1994–95, p. 452.
3. Mellerio Redon Chronology, 1891, no. 255, "Profil de lumière (copie) (vendu par M. Goupil); cited in Chicago–Amsterdam–London 1994–95, p. 452. The destination "vendu par M. Goupil" would suggest a non-Vollard provenance. Although there is no further evidence either in the Redon inventory or Vollard stockbooks that suggests a direct Roger-Marx acquisition, it could possibly have taken place on June 6, 1924. See Vollard Archives, MS 421 (5,12), fol. 60: "recu en [illegible] à Cl. Roger Marx [among other works] 2 Redon 150 [francs]."

171

171. *fig. 89*

ODILON REDON
Armor

1891
Charcoal and conté crayon
20 x 14½ in. (50.7 x 36.8 cm)
The Metropolitan Museum of Art, New York, Harris Brisbane Dick Fund, 1948 48.10.1
New York and Chicago only

CATALOGUE RAISONNÉ: A. Wildenstein 1992–98, no. 264

PROVENANCE: Acquired from the artist by Bailly, 1892; Ambroise Vollard, Paris; Jacques Dubourg, Paris; bought by the Metropolitan Museum, New York, 1948

172. *fig. 94*

ODILON REDON
Eye with Poppy Head

1892
Charcoal
18⅛ x 12⅝ in. (46 x 32 cm)
Musée d'Orsay, Paris, on deposit in the Department of Graphic Arts at the Musée du Louvre, Gift of Claude Roger-Marx, in memory of his father, brother, and son, who died for France, 1974 RF 35821
Paris only

172

CATALOGUE RAISONNÉ: A. Wildenstein 1992–98, no. 1093

PROVENANCE: Acquired from the artist by Ambroise Vollard, Paris; acquired by Claude Roger-Marx, Paris; his gift to the Musée du Louvre, Paris, 1974

Eye with Poppy Head (cat. 172) combines two of Redon's recurrent images—the human eye, which he used to suggest the world unseen, and plantlike creatures that sprout heads. This sheet is related indirectly to Redon's drawing *The Tell-Tale Heart* (1883, Santa Barbara Museum of Art).[1] As Redon recorded in his first writings about the meaning and evolution of his art, "I have made several fantasies using the stem of a flower or the human face. . . ."[2] When the work was exhibited at the Galerie Durand-Ruel in 1894, Redon titled it simply *Oeil-Pavot* (*Eye-Poppy*) instead of *Eye with Poppy*, as he described it in his inventory.[3] Instead of suggesting a mutant plant, the metaphorical title eye-like-a-poppy perhaps refers obliquely to the dreamlike state that the opium plant produces. Here Redon's recurrent image of a disembodied head is reduced to an eye from which a poppy sprouts as if to lift it airborne.[4]

The exaggerated lashes forming a kind of peacock feather around the eye also appear in one of Redon's most enigmatic images, *Armor* (cat. 171).[5] One of four variations on a theme, this drawing is the largest and perhaps the most disturbing in its elegant perversity. It is possible that this is the drawing Redon recorded having "made at Peyrelebade" and sold to Bailly, which would mean that in between this sale and that to Vollard, the drawing was returned to Redon (since Vollard's stockbook indicates he bought it from the artist). That Redon must have discussed this work with the dealer seems evident in the latter's description of a "charcoal, the knight [*chevalier*] or the armor, head, mouth gagged, and around the head, thorns."[6] The French word "chevalier," which is not gender specific, allows different interpretations of this enveloped figure.[7] With its extended eyelashes and sibylline figural type Redon may have wanted to suggest an androgynous figure, but the strict profile calls to mind feminine images such as *Profile of Light* (cat. 170) and *Profile of a Woman in Shadow* (cat. 173) and their variants. Rather than the "enlightenment" they suggest, however, Redon's *chevalier* is wrapped in darkness. Instead of a veil she is "protected" by a spiky helmet. But the helmet (seemingly made of cloth rather than metal) is also dangerous and morphs into a muzzle, to render its wearer "baillonné" or gagged, as

Vollard's descriptive title spells out. This underscores her plight as a victim rather than as an illuminated soul or even a femme fatale of the Symbolists' repertoire.[8] Along the edge of the muzzle are little plant- or possibly thornlike fragments that protrude from the skin as if she remains in the realm of the nonevolved, like the *Cactus Man* (1881, Andrea Woodner Collection, New York), which Vollard also owned.[9] Whereas the famous image of a primitive head sprouting thorns in a decorated planter showed a man powerless to rise above his suffering, *Armor* is all the more disconcerting, since it shows a woman (presumably) whose refined bearing suggests a more developed being whose voice of reason has been stifled. Although the extended title Vollard provided for this work would have undoubtedly reflected Redon's own thinking about this image, in the artist's published assessment of his works, he denied having any specific intentions: "My drawings *inspire* and do not define themselves. They determine nothing. They place us just as music does in the ambiguous world of the indeterminate."[10]

GG

1. See A. Wildenstein 1992–98, no. 1090, and Leeman 1994, p. 183, fig. 101.
2. Translated in Redon 1986, p. 23.
3. Paris 1894, no. 15. For Redon's inventory title, see the Mellerio Redon Chronology, 1892, no. 268: André Mellerio Collection, Ryerson and Burnham Archives, Art Institute of Chicago; cited in Chicago–Amsterdam–London 1994–95, p. 453.
4. See also *Profil au pavot, Le Pavot noir* in which a head in profile looks out on to the peacock eye. Mellerio Redon Chronology 1892, no. 264; cited in Chicago–Amsterdam–London 1994–95, p. 453 (W 335).
5. Mellerio Redon Chronology, 1891, no. 245, "L'Armure (vendu par M. Bailly)"; cited in Chicago–Amsterdam–London 1994–95, p. 452.
6. Stockbook A, no. 3714, "Fusain Le chevalier; ou l'armure tete la bouche baillonné; autour de la tete des piqûres, [Provenance] Redon, 48 x 35 cm, 150 [francs]."
7. See for example, Stephen Eisenman, who described it as a "Man in Armor" and dated it to 1885, comparing it to *Cactus Man,* both of which are cited as examples of Redon's need to "sublimate his own class guilt by inflicting pain on his imaginary alter egos." See Eisenman 1992, p. 194. Klaus Berger 1965, p. 232, no. 685, titled the drawing "Armoured Man in Profile" but A. Wildenstein 1992–98, no. 264, described the figure as feminine. Descriptions by other authors are not gender specific; Vialla 1988, p. 64, speaks about "un personnage, peut-être androgyne."
8. Of the four versions of *Armor,* this is the most effeminate, with the tiny nose and long featherlike strokes suggesting extended eyelashes. It is also the only image in which the protagonist is set in a nearly barren background, which, apart from the long reedlike entities on the right, is barely discernible. The other images of *Armor* are set against either a forest (W 262), the flowerlike bursts that Redon called "eclosions" (W 263), or a combination of an *eclosion* and floating heads (W 265).
9. See Stockbook A, no. 3629, "dessin; La plante grasse d'un sorte de cote sort une tête avec des sortes d'épines, [Provenance] Redon, 48 x 32 cm, 85 [francs]."
10. See Redon 1986, p. 22.

173

173. *fig. 90*

ODILON REDON
Profile of a Woman in Shadow

Ca. 1895
Various charcoals
18½ x 13⅞ in. (47.1 x 35.4 cm)
The Art Institute of Chicago, David Adler Collection
1950.1422
New York and Chicago only

CATALOGUE RAISONNÉ: A. Wildenstein 1992–98, no. 232

PROVENANCE: Acquired from the artist by Ambroise Vollard, Paris, February 10, 1899; Henri M. Petiet, Paris, by March 1940; bought by The Art Institute of Chicago, 1950

Vollard owned numerous charcoals by Redon showing variations of a woman's head in profile, surrounded by flowers, which he listed neutrally as "woman at whose throat emerge flowers," "head above flowers," or, as for this image, "Bust of a Woman looking at flowers."[1] This work, probably inspired by Redon's wife, Camille, whose small, regular features appear in *Béatrice* (for which she posed), is known by a variety of titles—*Profile of Night, Profile of a Woman in the Night,* and *Profile of Shadow*—all of which suggest a particularly otherworldly quality more appropriate for druidesses and veiled priestesses.[2] For further discussion, see *Profile of Light* (cat. 170). GG

1. See Stockbook A, no. 3624, "dessin, Un buste de femme regardant des fleurs"; Stockbook A, no. 3722, "fusain très clair tête de femme au [illegible] gorge emergent qq. fleurs, [Provenance] Redon, 49 x 36 cm, 115 [francs]" (A. Wildenstein 1992–98, no. 230); Stockbook A, no. 3738, "fusain très clair. tête de femme à la gorge de laquelle emergent des fleurs, [Provenance] Redon, 50 x 37 cm, 115 [francs]"; and Stockbook B, no. 3314, "Tête au dessus de fleurs (Fusain), [Provenance] Redon, 47 x 36 cm [no price given]."
2. In fact, this "portraitlike" image has more to do with Redon's pastels of *femmes-fleurs* and portraits of the wives and children of patrons than the druidesses and priestesses on which he gradually would turn his back as he shifted his vision from literary to pictorial.

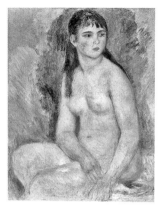

174

174.

fig. 160

AUGUSTE RENOIR
Nude

1880
Oil on canvas
32⅛ x 25⅝ in. (81.5 x 65 cm)
Musée Rodin, Paris P 7334

PROVENANCE: Ambroise Vollard, Paris, by 1892; bought by
Maurice Leclanché, Paris, June 17, 1898; bought by Bernheim-
Jeune, Paris, by May 19, 1910; bought by Auguste Rodin,
Paris, June 2, 1910; Musée Rodin, Paris, Donation Rodin, 1916

In his *Recollections,* Ambroise Vollard notes that
Renoir's *Nude* was one of the first paintings he ever
owned. He had it in his seventh-floor walk-up on
rue des Apennins, where he lived in 1892; his asking
price was 250 francs, and the painting did not sell.
When Vollard opened his shop on rue Laffitte in
1893, Renoir's works had increased slightly in value,
and he timidly asked for 400 francs. "I remember a
'great' admirer saying to me: 'If I had 400 francs to
spare, I should buy that painting to destroy it, it
grieves me so to see my friend Renoir so badly rep-
resented. What woman ever had hands like that?' A
reproach, it may be said in passing, that the painter
incurred all his life with regard to the hands of his
sitters."[1]

In 1898 Vollard wrote to Auguste Rodin that "the
owner of the Renoir Nude you want [would like] a
bronze 'Kiss' in exchange. . . . It would have to be a
very fine bronze with a *very beautiful patina.* Perhaps
you will find this request exorbitant, but as you have
often asked me about this painting, I didn't want to
sell it without checking with you first. If the deal
were to go through, for my commission I'd like a
small bronze of yours, a small subject." Vollard
added that he could hold the painting only until the
following evening and that he wanted a quick reply
because he had several potential buyers on hand and
was afraid the owner would change his mind.[2] On
June 20 Vollard "regretfully announced" that he was
unable to give Rodin "the *Renoir Nude* you desire."[3]
As Rodin could not "offer the *Kiss* in exchange," the
painting's owner had decided not to sell it to him.
Indeed, we know from the Vollard Archives that on
June 17, Vollard had sold the canvas to Maurice
Leclanché for 2,000 francs.[4]

Vollard kept informed of what the more knowl-
edgeable private collectors owned. Years later, on
May 19, 1910, he mentioned the work to Rodin
once again: "The Renoir nude, Seated Woman,

that you wished to acquire in the past and that
belonged to Mr. Leclanché is now with *Bernheim
Jeune at 25 Boulevard de la Madeleine,* who acquired
M. Leclanché's collection. I'm sending this infor-
mation in case it's of use."[5] The sculptor finally
bought the work for 20,000 francs on June 2, 1910.[6]
As so often in his telling of these stories, Vollard
exaggerated a bit by adding, "When Renoir was
finally given his due, this painting, which had passed
through several owners, was bought by Rodin for
twenty-five thousand francs."[7]

AR

1. Vollard 1936, p. 22.
2. Vollard to Rodin, undated [1898], Archives, Musée Rodin,
 Paris.
3. Vollard to Rodin, June 20, 1898; Archives, Musée Rodin.
4. Vollard Archives, MS 421 (4,3), fol. 105.
5. Vollard to Rodin, May 19, 1910; Archives, Musée Rodin.
6. Sales receipt to Bernheim-Jeune et Cie (no. 20[?]45):
 Archives, Musée Rodin.
7. Vollard 1989b, p. 33 (not in the English edition).

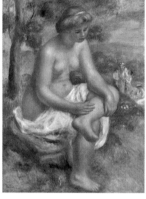

175

175.

fig. 158

AUGUSTE RENOIR
Seated Bather in a Landscape

1895–1900
Oil on canvas
45⅝ x 35 in. (116 x 89 cm)
Musée Picasso, Paris RF 1973-87

CATALOGUE RAISONNÉ: Daulte 1971, no. 392 (as *Eurydice*)

PROVENANCE: Ambroise Vollard, Paris, by 1916; acquired by
Paul Rosenberg, Paris, 1919; bought by Pablo Picasso, Paris,
1919 or 1920–his d. 1973; Musée Picasso, Paris, 1973

Renoir and Vollard enjoyed a long and faithful
friendship. In several of his publications Vollard
sketched rather diverse portraits of the painter, as
whimsical in their way as the portraits Renoir
painted of his dealer, whom he notably depicted as
a bullfighter (cat. 177). In 1919 Vollard published a
monograph on his friend, *La Vie et l'oeuvre de Pierre-
Auguste Renoir.*[1]

When *Seated Bather in a Landscape* was shown
at the Paul Rosenberg gallery in 1917, it belonged to

Vollard and bore the title *Eurydice.* Often presented
in the guise of a historical or biblical figure, the
female nude as a subject haunted the entire nine-
teenth century. But Renoir, unlike many "official"
painters who found favor at the Salon, took very lit-
tle from the stock of esoteric mythological images.
For him, "the truly timeless subjects were the sim-
plest ones. A nude woman should emerge from the
briny deep or from bed. Her name should be Venus
or Nini. You can do no better than that."[2] All of the
painter's sensuality was expressed in these opulently
curvaceous nudes.

To his talents as a draftsman, visible in the sinu-
osity of his female forms, Renoir joined his abilities
as a colorist, orchestrating a harmony of warm tones.
Artists, especially sculptors—Rodin and Picasso
among them—took a particular interest in Renoir's
late nudes, intrigued by their classicism and the way
he rendered their ample forms. Picasso no doubt had
frequent opportunities to see works by the master of
Cagnes; in 1919 the dealer Paul Rosenberg tried to
arrange a meeting between the two men. There are
striking stylistic analogies between Renoir's nudes and
the colossal "large bathers" that Picasso painted in the
1920s, during his return to his personal classicism.

The Vollard Archives are too fragmentary to per-
mit a retracing of the transactions surrounding this
Bather; a few landscapes are the only Renoirs men-
tioned in 1920 as being among the works Rosenberg
bought from his fellow dealer.

AR

1. Vollard 1919b; English translation, Vollard 1925.
2. André 1923, pp. 26–27.

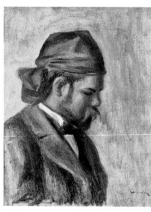

176

176.

fig. 165

AUGUSTE RENOIR
Ambroise Vollard with a Red Scarf

1906
Oil on canvas
11⅞ x 9¾ in. (30 x 25 cm)
Petit Palais, Musée des Beaux-Arts de la Ville de Paris
PPP 0827

PROVENANCE: Ambroise Vollard, Paris, 1906; his gift to the
city of Paris, 1928; Musée des Beaux-Arts de la Ville de Paris
(Petit Palais)

Renoir here depicted Vollard at half length, his eyes lowered,[1] in a perfect right profile—much like the medallion engravings he saw during his apprenticeship. Although the portrait is not dated, the year 1906, given in the caption when it was published in the magazine *Arts et métiers graphiques,* seems likely.[2] Vollard would have been forty years old at the time. His face still looks young, and thinner than in the portrait Renoir painted of him holding a statuette (fig. 296), which is dated 1908.

A second version of the present work (location unknown), in which Vollard is painted bareheaded and faces forward, appears to have been made during the same sittings[3] and gives a similar impression of having been rapidly executed.

The dealer certainly had a fondness for this version with the red scarf, painted by his favorite artist. It was the first of three portraits to become part of the Petit Palais's collection, and the only one to do so during Vollard's lifetime. Accepted in July 1928 after deliberations by the Council of Paris, the painting was actually a replacement for the portrait with the statuette, which was initially bequeathed in the dealer's 1911 will but was then sold to Samuel Courtauld in June 1927 (fig. 296).

This portrait with the red scarf was chosen by the publisher Bernard Grasset for the cover of a new edition of *En Écoutant Cézanne, Degas, Renoir* in 1938.[4]

IC

1. In his *Recollections of a Picture Dealer,* Vollard related that while pretending to be writing letters, he took notes on everything Renoir told him in unguarded moments. Could the slumped posture and closed eyes that characterize several portraits of Vollard be signs of that close attention rather than of his supposed somnolence (a supposition Vollard encouraged)? See Vollard 1936a, pp. 267–68.
2. Vollard 1938c, p. 43.
3. Vollard 1918, no. 249.
4. Vollard 1938a. In October 1937 Grasset asked the Petit Palais to photograph the painting for the cover.

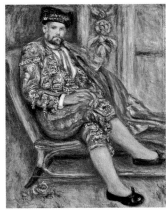

177

177. *fig. 20*

AUGUSTE RENOIR
Vollard as Toreador

1917
Oil on canvas
40¼ x 33 in. (102.6 x 83.6 cm)
Nippon Television Network Corporation, Tokyo

PROVENANCE: Gift of the artist to Ambroise Vollard, Paris, 1917–his d. 1939; by descent to his brother Lucien Vollard, 1939; acquired by Édouard-Léon Jonas, Paris and New York, by 1952; acquired by Walter P. Chrysler, Jr. New York, 1954; his sale, Sotheby's, London, July 1, 1959, no. 32; bought by L. Felheimer, 1959; Mr. and Mrs. B. E. Bensinger, Chicago, by 1972; E. V. Thaw and Co., New York, by November 1976; Stephen Hahn, New York, by September 1979; Nippon Television Network Corporation, Tokyo, by 1984

The last portrait made by Renoir, painted just two years before his death, is the most flamboyant of several that he did of Vollard (see cat. 176 and fig. 296). Vollard had always had a liking for exotic attire and described in his autobiography his childhood fascination with colorful uniforms, especially the French officers' uniforms illustrated in an album that had belonged to his grandfather. The red velvet and gold

braid of the naval doctor's uniform appealed to him so much that for a while the young Vollard was persuaded this was the career he wanted to pursue.[1] Later it was the uniform worn by the footman of King Milan of Serbia, one of his clients, that took his fancy: "I have always been dazzled by gold lace, by all that glitters on sleeves and headgear, and I could not help thinking that if I had been the king, I should have worn the magnificent gold-embroidered garment myself, and given the frock coat to the Chamberlain."[2] He must have enjoyed posing for this portrait in a Spanish bullfighter's outfit, with its fringes and tassels, magnificent red and gold cloak, and pink stockings—the only known painting of him in fancy dress.

There are differing accounts of how this painting came about. Vollard recollected that Renoir asked him to bring back a toreador's costume from Spain, but since he could not find one, he had it made. When a customs official in Paris asked Vollard to put on the costume he attracted a crowd, whereupon he went straight to Renoir's studio in a taxi. The artist, delighted with the spectacle, painted his portrait.[3] This story is contradicted by Vollard himself, however, in his monograph on Renoir; there he states that the portrait was painted at Essoyes, the artist's house in Burgundy.[4] According to Jean Renoir, Renoir's film-director son, it was his father who found the costume, which he had bought in Spain, and got Vollard to dress up in it.[5] Perhaps the most plausible story, recorded by the dealer René Gimpel in his diary, tells that "Vollard appeared before the painter in toreador dress, and Renoir, ravished by the color, did his portrait."[6] A photograph of Vollard posing for this portrait (fig. 21) shows that Renoir accurately portrayed the costume and setting.

Vollard seems to have been particularly attached to this portrait. He displayed it prominently in his mansion in the rue de Martignac,[7] and it was still in his possession when he died in 1939. After Vollard's death the picture embarked on an adventurous phase of its history when, on its way to the United States with other works from Vollard's collection, it was seized by the British navy in Bermuda and held at the National Gallery of Canada, Ottawa, until 1949.[8] It was then released to the Vollard heirs and later acquired by the American collector Walter P. Chrysler, Jr.

AD

1. Vollard 1936, p. 10.
2. Ibid., pp. 106–7.
3. Ibid., p. 221. See Ottawa–Chicago–Fort Worth 1997–98, pp. 262–64, no. 69, for an extensive study of this portrait.

4. Vollard 1920, p. 217.
5. J. Renoir 1962, pp. 399–400.
6. Gimpel 1966, p. 56 (entry for August 15, 1918).
7. Rewald 1991, unpaged.
8. The works seized included several hundred Renoirs and dozens of Cézannes, as well as works by Degas, Gauguin, and Picasso. The British authorities intercepted the shipment because they thought the paintings were being sent to America to raise foreign currency for Germany; see "Art Shipment Seized" 1940. See also the essay by Maryline Assante di Panzillo, "The Dispersal of the Vollard Collection," in this volume.

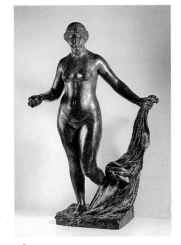

178

178. *fig. 164*

AUGUSTE RENOIR
Venus Victorious

Ca. 1914–16
Bronze
71⅞ x 43¾ x 32 in. (182.6 x 111.1 x 81.3 cm)

a. The Sterling and Francine Clark Art Institute, Williamstown, Massachusetts 1970.11
New York and Chicago only

b. Petit Palais, Musée des Beaux-Arts de la Ville de Paris
PPS 1708
Paris only

CATALOGUE RAISONNÉ: Haesaerts 1947, no. 6

PROVENANCE: b. Ambroise Vollard, Paris, 1916; his gift to the city of Paris, 1931; Musée des Beaux-Arts de la Ville de Paris (Petit Palais)

To his friend the painter Albert André, Renoir described his beginnings as a sculptor: "I tried my hand at sculpture not as a challenge to Michelangelo, nor because I had lost interest in painting, but because M. Vollard gently forced me into it. I had modeled a tiny medallion and a bust of my youngest son. Vollard then cleverly asked me to help out a young and talented sculptor who was creating a piece after one of my paintings. I agreed to do it, and we made a small statuette; then, with more time and more help, we made a full-scale statue."[1]

Increasingly paralyzed in his later years, Renoir "was condemned to spend his life in an armchair, his legs useless, his hands twisted with rheumatism. His fingers were almost dead and had to have now a

paint-brush attached to them, now the wand which the painter, turned sculptor in the last years of his life, used for dictating to the pointer the volumes of his Venus."[2] Richard Guino, a former student of Auguste Maillol's, was the assistant chosen to model the piece under the master's direction.

After making the *Small Standing Venus* they executed the larger version represented here. Venus, the goddess of beauty, holds in her right hand the golden apple, the trophy of her victory after the Judgment of Paris. Renoir even asked Albert André to provide him with the dimensions of a Greek statue of a woman. Guino did the modeling, using drawings made by Renoir, and also working from a live model named Maria, a young woman from Essoyes who often posed for Renoir. Together Renoir and Guino determined how her forms would be rendered, consulting both in the studio and then outside beneath the olive trees. Several witnesses have stated that Renoir was not satisfied with the *Venus* until he hit upon the idea of raising her breasts by several centimeters.

Vollard's fondness for the *Venus Victorious* is conclusively demonstrated by two facts: that the sculpture stood in the foyer of his home on rue de Martignac as a pendant to Maillol's *Venus with a Necklace* (figs. 193, 292) and that Vollard gave the work to the city of Paris in 1931.

AR

1. André 1923, pp. 40–42. See Haesaerts 1947, no. 1, for the medallion (1907), and no. 2, for the bust of Coco (1908).
2. Vollard 1936, pp. 267–68.

179

179. *fig. 210*

AUGUSTE RODIN
Le Jardin des supplices, by Octave Mirbeau

Published by Ambroise Vollard, Éditeur, Paris, 1902
("Achevé d'imprimer" May 24, 1902)
Illustrated book with 20 lithographs, of which 18 are in color
Page (irreg.) 12¾ x 9⅞ in. (32.4 x 25.1 cm)
Printers: Auguste Clot (lithographs), Philippe Renouard (text)
Copy no. 32 (of a numbered edition of 200)
The Metropolitan Museum of Art, New York, Harris Brisbane Dick Fund, 1923 23.19.1
New York and Chicago only

CATALOGUES RAISONNÉS: Thorson 1975, no. III; Johnson 1977, no. 198; Chapon 1987, p. 279; Jentsch 1994, no. 3

Vollard had met Octave Mirbeau and Rodin in the mid-1890s, and Rodin contributed a lithograph to Vollard's *Album d'estampes originales de la Galerie Vollard* (1897). Nonetheless, Vollard recalled that his involvement with the publication of *Le Jardin des supplices* came as something of a surprise: "Rodin, then at the height of his fame, had undertaken to do some lithographs for the *Jardin des supplices,* by Octave Mirbeau. Of course I did not expect to be the publisher. Too many powerful competitors were sure to contend for the masterpiece. So my joy was only equaled by my surprise when Mirbeau came to suggest my publishing the book. No other publisher would have anything to do with it."[1] The three signed a contract for the book on February 10, 1899.[2] It stipulates an edition of 200 copies, each to feature a minimum of twenty works of art, some in color and all made exclusively for this edition. Perhaps because they were so desperate to find a publisher for the controversial work, Mirbeau and Rodin do not seem to have been paid for the edition; the only remuneration recorded in the contract is four copies of the book for each. Three additional copies were set aside for public collections: the British Museum, the Dresden Museum, and an undetermined museum in the United States.

"Readers who like horrors may be commended—if they are of age, for the work is rather strong stuff—to 'Le Jardin des supplices,' by Octave Mirbeau," wrote a reviewer in 1899.[3] Mirbeau's tale, written while the Dreyfus Affair was unfolding, has strong political overtones. It presents torture as a refined, exotic art imbued with decadent eroticism. An anonymous and somewhat dissolute Frenchman who sails to the Far East meets a beautiful Englishwoman, Clara, with whom he has an affair. She takes him to a prison that houses an exquisite torture garden, where rare blooms are nourished by the blood and excrement of victims. The narrator is simultaneously horrified and excited by the executioner's stories and the abuses he witnesses in the garden. Sexually exhausted by the experience, Clara collapses. "Ah, yes!" says the narrator. "The Torture Garden! Passions, appetites, greed, hatred, and lies; law, social institutions, justice, love, glory, heroism, and religion: these are its monstrous flowers and its hideous instruments of eternal human suffering. What I saw today, and what I heard, exists and cries and howls beyond this garden, which is no more than a symbol to me of the entire earth."[4]

With the fiasco surrounding Paul Verlaine's *Parallèlement* a recent memory, the Imprimerie Nationale refused to print such a scandalous text, as did the firm of Didot. Ultimately the text was printed by Philippe Renouard. The master printer Auguste Clot reproduced Rodin's designs so carefully that on first glance some appear to be original graphite-and-watercolor compositions.

RAR

1. Vollard 1936, pp. 255–56.
2. Archives, Musée Rodin, Paris.
3. *Pall Mall Gazette,* April 26, 1899: copy in Archives, Musée Rodin.
4. Translated in Mirbeau 1990, pp. 258–59.

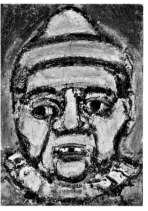

180

180. *fig. 182*

GEORGES ROUAULT
The Dwarf

1937
Oil on paper, mounted on canvas
27¼ x 19¾ in. (69.2 x 50 cm)
The Art Institute of Chicago, Gift of Mr. and Mrs. Max Epstein 1946.96

CATALOGUE RAISONNÉ: Dorival and I. Rouault 1988, no. 1980

PROVENANCE: Acquired from the artist by Ambroise Vollard, Paris, probably on May 2, 1937; Max Epstein, Chicago; gift of Mr. and Mrs. Max Epstein to The Art Institute of Chicago, 1946

Vollard agreed to purchase hundreds of unfinished works from Rouault just before World War I. Over the next twenty-six years, the artist completed many of them and initiated hundreds more. No matter how busy he was with book projects, he always made time to paint, usually in the late afternoon or on weekends. Admirers of Rouault criticized Vollard for not exhibiting his recent work: "Rouault is a famous, unknown painter. The public [and] young artists barely know him. M. Vollard locks away the work in his cellar. From time to time several old Rouaults appear, sad clowns [or] stupefied girls. . . ."[1] In retrospect, it seems that Vollard was biding his time. In 1937, the year *The Dwarf* was completed and transferred to Vollard,[2] the dealer lent fifteen Rouaults to "Les Maîtres de l'Art Indépendant," an important exhibition at the Petit Palais that featured forty-two paintings and watercolors by the artist.[3] The show was a revelation to art historians such as Lionello Venturi, who was inspired to write a monograph about the artist.[4] The following year the Museum of Modern Art in New York hosted an exhibition of Rouault's prints, which was so well received that it toured the United States for two years afterward.[5] Aware that international interest in Rouault's work was building, Vollard tried his best to publish Rouault's remaining *livres d'artiste* but died before he could accomplish this. When the Museum of Modern Art held a second exhibition devoted to Rouault in 1945, *The Dwarf* was among the paintings included.[6]

RAR

1. "Le Carnet des ateliers" 1927, p. 10.
2. The painting seems to be the one listed as number 5 in a list of 102 paintings transferred from the artist to Vollard on May 2, 1937; information courtesy Fondation Georges Rouault, Paris.

3. Paris 1937.
4. Venturi 1940.
5. New York 1938.
6. New York 1945 (1947 ed.) no. 73.

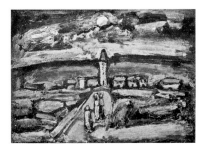

181

181. *fig. 184*

GEORGES ROUAULT
Sunset

1937
Oil and related media on wood pulp board
29⅛ x 41⅜ in. (74 x 105 cm)
Worcester Art Museum, Massachusetts, Gift of
Mrs. Aldus C. Higgins 1965.396

CATALOGUE RAISONNÉ: Dorival and I. Rouault 1988,
no. 1785

PROVENANCE: Acquired from the artist by Ambroise Vollard,
Paris, probably May 2, 1937; Theodore Schempp, Paris and
New York, by 1941; acquired by Mr. and Mrs. Aldus C.
Higgins, 1941; their gift to the Worcester Art Museum, 1965

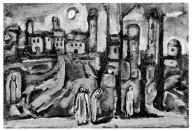

182

182. *fig. 14*

GEORGES ROUAULT
Twilight

1937
Oil on canvas
25¾ x 38⅞ in. (65.4 x 98.8 cm)
The Metropolitan Museum of Art, New York, Gift of
Mr. and Mrs. Nate B. Spingold, 1956 56.230.2

CATALOGUE RAISONNÉ: Dorival and I. Rouault 1988, no. 1719

PROVENANCE: Acquired from the artist by Ambroise Vollard,
Paris, probably May 2, 1937[1] –his d. 1939; his estate, 1939;
acquired by Sam Salz, New York; bought by Mr. and Mrs.
Nate B. Spingold, New York, August 1951; their gift to the
Metropolitan Museum, New York, 1956

The author André Suarès commended Rouault's
interest in "the religious landscape": "You may
arrive at something that has not been done for a
long time. . . . Corot is a delightful pagan, the
Watteau of his century, Cézanne is a great Christian,
the martyr of the tableau, but the mystic landscape,
no painter has succeeded in it for centuries, since
Rembrandt."[2] Rouault painted increasing numbers
of these landscapes in the 1930s, often in horizontal
formats. Both of the paintings shown here are typical
in their subject matter, a timeless scene where robed
figures are depicted at the outskirts of a town in
which a bell tower or minaret dominates the skyline.

Many of Rouault's paintings from this period are
known to have originated as works on paper.[3] When
a composition pleased him he would adhere the
paper to canvas and then paint over the image, with
the result being a particularly thick surface (see, for
example, *The Dwarf,* cat. 180). *Twilight* is one of the
rare works in which Rouault painted directly onto
the canvas, the weave of which is visible in several
places. Vollard had the painting photographed after
it was released to him, as was his customary prac-
tice. Rouault then signed the verso of the photo-
graph, signifying that the painting was complete
and authentic.[4] RAR

1. The date of the transfers of both *Sunset* and *Twilight* from
Rouault to Vollard is courtesy Fondation Georges Rouault,
Paris. The first seems to be the work listed as number 37
and the second, as number 9, in a list of 102 paintings
transferred from the artist to the dealer on May 2, 1937.
2. Suarès to Rouault, May 21, 1922, translated in Dorival and
I. Rouault 1988, vol. 2, p. 15.
3. Information courtesy of the Fondation Georges Rouault.
A small exhibition devoted to the technique was held at the
Phillips Collection, Washington, D.C., in 1994.
4. Information courtesy Fondation Georges Rouault.

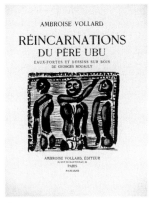

183

183. *fig. 228*

GEORGES ROUAULT
Prospectus for *Les Réincarnations du Père
Ubu,* by Ambroise Vollard

Published by Ambroise Vollard, Éditeur, Paris, 1932
Prospectus with 1 etching and 3 wood engravings
Page (irreg.) 17⁷⁄₁₆ x 12¹³⁄₁₆ in. (44 x 32.5 cm)
Printer: Aux Deux Ours, the handpress of Aimé and
Henri Jourde (wood engravings, executed by Georges
Aubert after Rouault's designs, and text)
Unnumbered copy (1,000 printed)
The Metropolitan Museum of Art, New York, The Elisha
Whittelsey Collection, The Elisha Whittelsey Fund, 1988
1988.1149.6
New York and Chicago only

It has repeatedly been remarked that the Ubu texts
written by Vollard are inferior to the illustrations he
commissioned for them. *Les Réincarnations du Père
Ubu,* a compilation of a number of Vollard's Ubu
writings, is the most notable of these publications,
thanks to Rouault's artwork. The project first appears
in the two men's correspondence as "Ubu aux
colonies," a title that surely derived from Vollard's
invention of "Ubu Colonialist" while collaborating
with Alfred Jarry on the *Almanach illustré du Père
Ubu* (cat. 16). Rouault agreed to collaborate on the
Ubu book because it was his understanding that in
return Vollard would publish his opus, *Miserere et*

Guerre. When Vollard exhibited proofs from the
unfinished "Ubu colon" at the book pavilion of the
1925 Salon des Arts Décoratifs, he was criticized for
emphasizing artwork rather than text, a complaint
that would be echoed for years.

A reduced version of *Les Réincarnations du Père
Ubu,* with some reproductions of Rouault's illustra-
tions, was published by Le Divan in 1925; the artist's
definitive etchings appear in Vollard's deluxe and
expanded edition of 1932. As always, Vollard and
Rouault strove for perfection. Vollard recalled in an
interview that after Georges Aubert engraved his
designs onto wood, they were given to "the master
printer Aimé Jourde, whose son Henri's great talent
as a printing press-man we can also draw on. To get
the finest transparent blacks one has to ink the
blocks as lightly as possible and then exercise a max-
imum of pressure. The ordinary presses, even with
two men working on them, gave only mediocre
results. The engravings were pale and opaque. It was
then that Jourde had a machine constructed after his
own designs, it was extremely precise and sensitive
and gave the happiest results in the manner of
Rouault's woodcuts."[1] This care and attention to
detail were typical of Vollard, who, happily, had the
means to be extravagant. He even included an orig-
inal etching by Rouault in the prospectus. Jourde's
final bill for work on the project came to a breath-
taking 329,170 francs;[2] only thirteen years earlier,
Vollard had paid almost the same amount for his
town house in the chic 7th Arrondisement of Paris.[3]

The back of the prospectus (fig. 222) lists the
specifics of the edition: various papers, additional
suites of loose prints, and prices. Vollard clearly
altered his print run at the last minute. It is likely
that he had not reserved a sufficient quantity of the
handmade Montval paper and was obliged to adjust
his edition accordingly. RAR

1. Zahar 1931, pp. 33–34.
2. Vollard Archives, MS 421 (8,15), fol. 63.
3. Vollard paid 330,000 francs for his town house: Vollard
Archives, MS 421 (13), fol. 1.

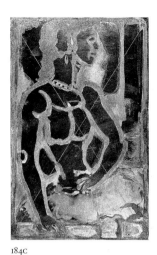

184c

185

2. Chapon and I. Rouault 1978, vol. 2, p. 46. A typewriten copy of Suarès's *Cirque* is in the Vollard Archives, MS 421 (6,7), fols. 1–125.

3. Chapon and I. Rouault 1978, vol. 2, p. 46. A typewriten copy of Suarès's *Cirque* is in the Vollard Archives, MS 421 (6,7), fols. 1–125.
4. Vollard to Rouault, undated: Archives, Fondation Georges Rouault, Paris.
5. Chapon and I. Rouault 1978, vol. 2, p. 48; and Vollard to Rouault, July 8, 1937: Archives, Fondation Georges Rouault.
6. Invoice from Imprimerie Bibliophile Henri Jourde, January 20, 1939: Vollard Archives MS 421 (8,15), fol. 76.

184. *figs. 177, 220*

GEORGES ROUAULT
Preparatory material for *Douce Amère (Bittersweet)*, a plate from *Cirque de l'étoile filante*

1934
Plates and images (irreg.) 12 x 7¾ in. (30.4 x 19.7 cm); pages (irreg.) 17¾ x 13⅜ in. (45 x 34 cm)
Fondation Georges Rouault, Paris

a. Canceled copperplate for printing black ink, with artist's monogram and date at lower right
b. Canceled copperplate for printing green ink
c. Canceled copperplate for printing red ink
d. Aquatint in black, proof impression, annotated with an "x" at lower right
e. Aquatint in black, proof impression, on japan paper
f. Aquatint in color, proof impression with heavy annotations, on Montval paper
g. Aquatint in color, proof impression with annotations, on Montval paper
h. Aquatint in color, highlighted with gouache, on Montval paper, annotated "Bon à tirer" at lower right
i. Aquatint in color, on Montval paper, annotated "épreuve de Bon à tirer, ne rien marquer B"

185.

GEORGES ROUAULT
Cirque de l'étoile filante, by Georges Rouault

Published by Ambroise Vollard, Éditeur, Paris, 1938 ("Achevé d'imprimer" March 5, 1936; title page 1937; cover 1938)
Illustrated book with 17 color aquatints and etchings, many with drypoint, and 74 wood engravings
Image (irreg.) 12 x 7¾ in. (30.4 x 19.7 cm), page (irreg.) 17⅜ x 13⅜ in. (44 x 33.5 cm)
Printer: Roger Lacourière, aquatints; Henri Jourde for Aux Deux Ours (the handpress of Aimé and Henri Jourde), wood engravings (executed by Georges Aubert, after Rouault's designs) and text
Copy no. 171 (of a numbered edition of 250, plus additional copies, numbered I–XXX)
The Museum of Modern Art, New York, The Louis E. Stern Collection, 1964 1043.1964.1–91
New York and Chicago only

CATALOGUES RAISONNÉS: Johnson 1977, no. 200; Chapon and I. Rouault 1978, vol. 2, no. 6; Chapon 1987, p. 282; Jentsch 1994, no. 30

The earliest involvement of the critic and essayist André Suarès with *Cirque de l'étoile filante* (then known as *Cirque*) dates to October 1926, when Rouault invited him to write the text: "You have already seen some of the originals [for *Cirque*], they have been reworked and on your return I can show you some definitive color plates."[1] On July 1927 Suarès reported that he intended to send Vollard his texts for either *Cirque* or *Passion*, or perhaps both, at the end of the month.[2]

Work continued on *Cirque* until May 1932, when Vollard rather belatedly decided to withdraw Suarès's text, which consisted of a thinly veiled attack on contemporary authors and critics such as Julien Benda, Jean Cocteau, André Gide, and Charles Maurras, as well as on the United States.[3] A prolific and published author in his own right, Rouault substituted one of his poems, "Cirque de l'étoile filante" ("Circus of the Shooting Star"), in its place. Over the following months, Rouault refined both the poem and the illustrations. (Vollard eventually resumed production of Suarès's text, which he intended to publish with designs by Rouault; it remained unfinished upon the dealer's death.)

Rouault grew frustrated with Vollard's working methods: "You must finally understand that I cannot be at the press indefinitely. . . . We are jumping from *Cirque* to *Passion* to *Miserere* to *Fleurs du mal*. . . . You understand nothing of how I work on a copperplate—I sometimes return to it five or six [or more] times."[4] Considering every detail of the book, the artist repeatedly revised the proofs. He was disturbed, for example, by the appearance of page numbers on pages already heavy with text and approved the choice of the specific shade of red on the title page because it was "the exact red of old books."[5]

According to the colophon, printing of *Cirque de l'étoile filante* was finally completed on March 5, 1936. Vollard's procrastination and late text changes coupled with Rouault's many revisions to the prints dramatically increased the costs of printing the book, for which Jourde charged an astonishing 466,900 francs.[6] RAR

1. Rouault to Suarés, October 26, 1926, translated in Chapon and I. Rouault 1978, vol. 2, p. 46; see also pp. 46–52 for an excellent discussion of this book.
2. Suarès to Rouault, early July 1927, in Chapon and I. Rouault 1978, vol. 2, p. 46.

186

186. *fig. 185*

GEORGES ROUAULT
Passion, by André Suarès

Published by Ambroise Vollard, Éditeur, Paris, 1939 ("Achevé d'imprimer" February 19, 1939)
Illustrated book with 17 color aquatints with etching, drypoint, and engraving, and 82 wood engravings
Page (irreg.) 17⅞ x 13⁵⁄₁₆ in. (45.5 x 34.5 cm)
Printer: Roger Lacourière, aquatints; Henri Jourde, wood engravings (executed by Georges Aubert after Rouault's designs) and text
Copy no. VI, one of 25 *hors commerce* copies with a suite of states in black, signed by the artist (basic edition is of 245 numbered copies, plus additional copies numbered I–XXV)
The Museum of Modern Art, New York, The Louis E. Stern Collection, 1964 1044.1964.1–103
New York and Chicago only

CATALOGUES RAISONNÉS: Johnson 1977, no. 201; Chapon and I. Rouault 1978, vol. 2, no. 7; Chapon 1987, p. 283; Jentsch 1994, no. 32

Rouault and Suarès collaborated on *Passion* while also working on *Cirque* (see cat. 185). Rouault considered adding a note to the reader in both books explaining their genesis: "It is, so to speak, the first time that this has been tried: giving engravings to the author."[1] Francis Chapon, however, has argued that the production of the books was more complicated, with much give-and-take as both author and artist revised their work based on the other's contributions.

On August 7, 1927, Suarès wrote the collector Jacques Doucet about his book projects with Rouault: "The contrast between my text and Rouault's plates will be astonishing. Far from finding that a bad thing, I think it will be a strength of the work. . . . Rouault's images and my poems do not look to find the other but are parallel. We reflect one another,

here and there, thanks to a certain strength of feeling and a certain derision. . . . I just finished one of my two books: *Passion*. It strikes me as rather curious: There are twenty images of spiritual grandeur and misery: Stations of the Cross of an old and young man, of the poor eternal biped."[2] The theme of the text is man's suffering, which Suarès felt all too acutely: "This time, as in the past, everyone will be against me: some will want my piety, others my blasphemy; the former will want me to be too sensitive; the latter will want me to be unbelieving. . . . Oh it is not easy and it is almost unforgivable to simply be a man."[3]

While Suarès agonized over the text, Rouault reworked the prints. He took great pains to differentiate between the two books and repeatedly informed Vollard that "the woodcuts for *Passion* are going to be different from those for *Cirque de l'étoile filante* and have a distinct feel. So be careful!"[4]

The extensive delays were only exacerbated by increased tension between Rouault and Vollard in the mid-1930s, mostly concerning the still unpublished *Miserere et Guerre*. In March 1936 Vollard visited Suarès, who reported to Rouault, "In short, even though he is as enthusiastic as ever about your art, he seems to be somewhat critical towards you. He showed me some plates and some pages of *Passion*. Regarding the spirit, some appear to me to be the only religious works of our time."[5]

Rouault finished the table of contents for *Passion* in December 1938,[6] and printing was supposedly completed on February 19, 1939.[7] The book was immediately popular with collectors, both in Europe and America, where a New York exhibition of Rouault's prints had generated great interest. *Passion* is the final book published by Vollard before his death later that summer.

RAR

1. Rouault to Suarès, 1931, in *Rouault—Suarès Correspondence* 1983, p. 116, letter 196.
2. Suarès to Jacques Doucet, August 7, 1927, in *Suarès—Doucet* 1994, p. 450.
3. Ibid.
4. Rouault to Vollard, August or September 1934 or 1935: Archives Fondations Georges Rouault.
5. Rouault to Suarès, March 3, 1936, in *Rouault—Suarès Correspondence* 1983, pp. 123–24, letter 231.
6. Suarès to Rouault, December 12, 1938, in *Rouault—Suarès Correspondence* 1983, p. 129, letter 243.
7. For a detailed account of the book's creation, see Chapon and I. Rouault 1978, vol. 2, pp. 52–61.

187. *fig. 24*

HENRI ROUSSEAU

The Representatives of Foreign Powers Coming to Greet the Republic as a Sign of Peace

1907
Oil on canvas
51⅛ x 63 in. (130 x 160 cm)
Musée Picasso, Paris RF 1973–91

CATALOGUE RAISONNÉ: Certigny, 1984, vol. 2, no. 241

PROVENANCE: Bought from the artist by Ambroise Vollard, Paris, December 14, 1909; bought by Pablo Picasso, Paris, August 1913; Musée Picasso, Paris, Donation Picasso, 1973

187

The amateur painter Henri Rousseau, nicknamed "Le Douanier" (the customs officer) because of his job at the Paris customhouse, exhibited regularly at the Salon des Indépendants beginning in 1886. In his *Recollections*, Vollard described his first contacts with Rousseau, recounting how a man came into his shop "with two or three small canvases under his arm: he looked for all the world like a retired clerk."[1] Introducing himself as a painter, Rousseau left behind several works on consignment. We can date this scene to sometime before 1895 on the strength of the receipt signed by Rousseau on January 23, 1895, when he came to take back his canvases.[2] It was not until several years later that Vollard bought paintings from him outright. As Maurice de Vlaminck said jokingly, "Rousseau brought his canvases to Vollard's place the way a baker delivers his bread."[3]

In this fantasy group portrait, Rousseau has painted an allegory of "the concert of nations." Surely inspired by photographs of official ceremonies, the painter here integrated in his work utterly identifiable portraits of more or less exotic heads of state.

When the painting went on exhibition at the 1907 Salon des Indépendants,[4] it was put up for sale. Despite the widespread hilarity it provoked, Douanier Rousseau seems to have nurtured hopes that the State would purchase it from him,[5] as both the subject and the format suggest. Rousseau had participated in open competitions for the decoration of town halls. However, the naive painter was almost uniformly ridiculed by his earliest critics.

By the time of the posthumous exhibition devoted to Rousseau at the 1911 Salon des Indépendants,[6] this work belonged to Vollard. It was then bought by Picasso in 1913.[7] The purchase was logical: in 1908 Picasso had thrown a celebrated banquet for Rousseau in his Bateau-Lavoir studio. Picasso and many others of the generation of avant-garde artists and writers, among them Alfred Jarry, Guillaume Apollinaire, and Robert and Sonia Delaunay, championed the art of Le Douanier Rousseau.

AR

1. Vollard 1936, p. 215.
2. Viatte 1962, p. 331.
3. Shattuck 1985, p. 17.
4. Paris 1907a, no. 4284.
5. Viatte 1962, p. 333.
6. Paris 1911, p. 363, no. 17.
7. Munich 1998, p. 215.

188

188. *fig. 208*

KER-XAVIER ROUSSEL

Paysages (Landscapes)

Ca. 1900
Suite of 6 color lithographs printed on China paper

1. *People at the Seashore*
Image 9¼ x 16½ in. (23.5 x 41.8 cm); sheet 16 x 20¾ in. (40.5 x 52.7 cm)
a. The Art Institute of Chicago, gift of Cyrus Adams 1958.276
New York and Chicago only

b. Petit Palais, Musée des Beaux-Arts de la Ville de Paris
GDUT 10957
Paris only

2. *Woman in Red in a Landscape*
Image 9¼ in. x 15⅜ in. (23.6 x 39.2 cm), sheet 16 x 20¾ in. (40.7 x 52.7 cm)
a. The Art Institute of Chicago, gift of Cyrus Adams, 1958.277
New York and Chicago only
b. Petit Palais, Musée des Beaux-Arts de la Ville de Paris
PPG 2219
Paris only

3. *Woman in a Striped Dress*
Image 8⅜ x 13⅛ in. (21.3 x 33.2 cm), sheet 16⅛ x 20¾ in. (41 x 52.8 cm)
a. The Art Institute of Chicago, gift of the Print and Drawing Club 1954.207
New York and Chicago only
b. Petit Palais, Musée des Beaux-Arts de la Ville de Paris
PPG 2218
Paris only

4. *Bathers*
Image 10 x 16½ in. (25.3 x 42 cm), sheet 15¾ x 21 in. (40 x 53.2 cm)
a. The Art Institute of Chicago, Robert A. Waller Fund 1950.1455
New York and Chicago only
b. Petit Palais, Musée des Beaux-Arts de la Ville de Paris
GDUT 10960
Paris only

5. *Cupids Playing near a Nymph*
Image 8⅜ x 13⅜ in. (21.4 x 34 cm), sheet 15⅞ x 20¾ in. (40.2 x 52.7 cm)
The Art Institute of Chicago, Prints and Drawings Purchase Fund 1936.211
New York and Chicago only

6. *Women in the Country*
Image 9⅜ x 13⅛ in. (23.7 x 33.2 cm), sheet 16 x 20¾ in. (40.7 x 52.7 cm)
The Art Institute of Chicago, Prints and Drawings Purchase Fund 1936.210
New York and Chicago only

CATALOGUE RAISONNÉ: A. Salomon and J. Salomon 1968, nos. 14–19

As with the third album of prints by *peintres-graveurs* that Vollard began but dropped half-way through when the two earlier albums failed to sell, the dealer abandoned the Roussel album he had commissioned in 1897 for lack of funds. Instead of an album, a series of six lithographs was published in about 1900 from the plates Roussel had submitted in 1898. Five more were pulled in only one to three proofs, while an important lithograph (in terms of Roussel's iconography in his later paintings and decorative panels), *The Source,* was printed in an edition of 100 at a later date.[1]

The six lithographs printed by August Clot are remarkable for their pastel palettes, rococo figure types, and fluttering surfaces, which are very different from the artist's earlier flat, outlined Nabi style. The first three depict women and children in contemporary dress, playing in meadows or woodlands;[2] the following three are based on the pastoral, classicizing motifs that would mark his work after 1900. But even within this grouping there are significant differences. *Bathers* is made up of spots and Impressionist-like dashes of color on a cream-colored ground. In *Women in the Country* and *Cupids Playing near a Nymph,* Roussel changed to a nearly monochromatic dark background, from which summarily defined figures emerge. Although these have been linked to Cézanne's 1896 small *Bathers* lithograph published by Vollard, Roussel's dreamy, soft-focused figures seem closer in spirit and technique to Henri Fantin-Latour's black-and-white lithographs of bathing nymphs, also commissioned by Vollard.[3] Indeed, Roussel probably used Fantin's technique of laying transfer paper on a textured support in order to obtain the delicate, shimmering surfaces that characterize his pastels.

GG

1. See Stump 1972, p. 79, and A. Salomon and J. Salomon 1968, nos. 14–25.
2. In several pastels Roussel made preparatory or after the lithographic plates one can make out more clearly the contemporary figures from his familiar circle and the landscape of L'Étang la Ville, forty kilometers outside Paris, where the Roussels lived; see Paris 1990, no. 83, *Baigneuses,* 1898, and no. 85, *Jeune femmes dans un pré;* and Paris 2002, no. 192, *Baigneuses au bord de l'eau.*
3. See Johnson 1977, p. 133, no. 41; and Geneva 1980–81, nos. 138–42, 146.

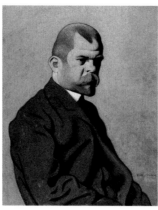

189

189. *fig. 276*

FÉLIX VALLOTTON
Ambroise Vollard

1902
Oil on panel
31 x 24¾ in. (78.8 x 63 cm)
Museum Boijmans Van Beuningen, Rotterdam
2390 (MK)

CATALOGUE RAISONNÉ: Ducrey 2005, no. 396

PROVENANCE: Possibly Ambroise Vollard, Paris; Basler Transport Versicherungsgesellschaft, by 1954; their gift to Museum Boijmans Van Beuningen, Rotterdam, 1954

Between 1901 and 1902 Vallotton painted portraits of Vollard; Cipa Godebski, the half brother of Misia Natanson; and the writer and critic Octave Mirbeau, all notable figures in the Paris art world.[1] Although dated 1902, his portrait of Vollard was probably exe-

cuted a year earlier.[2] In the same years he painted a larger group of portraits of celebrated writers and the composer Hector Berlioz, which he called "decorative portraits."[3] Both groups are characterized by a restricted neutral palette of grays and black and by a strikingly spare, linear style. Here, Vallotton has captured the dealer's familiar brooding expression, but the face and figure are uncharacteristically taut and angular, making the work seem more an expression of the artist's distinctive style than an objective likeness of the sitter. The trenchant line with which Vallotton delineates the figure is also characteristic of his contemporary woodcuts. In a careful preparatory drawing for this portrait (private collection), he used a hard pencil to outline the figure in a clear, thin line.[4] As Vollard remarked in his *Recollections of a Picture Dealer,* "The probity of his drawing led to his being dubbed *le petit Ingres.*"[5]

Vollard knew Vallotton in the 1890s and invited him to participate in the two exhibitions of Nabi artists that he held in his rue Laffitte gallery in 1897 and 1898. He also commissioned woodcuts from Vallotton for his two print albums: *The 1st of January* for the *Album des peintres-graveurs* (1896) and *The Winner* for the *Album d'estampes originales de la Galerie Vollard* (1897), and purchased the artist's album *Intimités* (*Intimacies*) in 1906.[6] However, Vollard's most important acquisition from Vallotton was his great painting *Bathers on a Summer Evening* of 1892 (fig. 289), which he bought in 1902 and kept until the end of his life.[7] Vollard recalled an amusing story of how the painting was found to be missing after he had lent it to an exhibition of nudes and how he recovered it in the house of the mover.[8]

On Vallotton's death, Vollard wrote, "He was a great artist and one of the most honest men that it was possible to meet."[9]

AD

1. Ducrey 2005, vol. 1, p. 223, and no. 396, *Ambroise Vollard,* no. 399, *Cipa Godebski,* and no. 411, *Octave Mirbeau.*
2. See Ducrey 1991, p. 218.
3. The subjects were Fyodor Dostoyevsky, Edgar Allan Poe, Victor Hugo, Émile Zola, Alfred de Vigny, Charles Baudelaire, and Paul Verlaine. See Ducrey 2005, vol. 2, p. 223.
4. Ibid.; the drawing is reproduced on p. 243.
5. Vollard 1936, p. 197.
6. See Ducrey 2005, vol. 2, p. 243.
7. Ibid., p. 73, no. 140, and p. 243.
8. Vollard 1936, p. 198.
9. Vollard to Paul Vallotton, January 19, 1926: Archives, Fondation Félix Vallotton, Lausanne; cited in Ducrey 2005, vol. 2, p. 244.

190. *fig. 133*

MAURICE DE VLAMINCK
Harvest

1904
Oil on canvas
27⅛ x 37¾ in. (69 x 96 cm)
Private collection; courtesy of Sotheby's

PROVENANCE: Ambroise Vollard, Paris; private collection; sale, Sotheby's London, June 20, 2005, no. 9; private collection

191. *fig. 134*

MAURICE DE VLAMINCK
Bank of the Seine at Chatou

Ca. 1905
Oil on canvas
23¼ x 31½ in. (59 x 80 cm)
Musée d'Art Moderne de la Ville de Paris, Gift of Henry-Thomas in 1976 AMVP 2587

PROVENANCE: Likely bought from the artist by Ambroise Vollard, Paris, July 1907; Gabrielle Franc, Paris, by 1943; private collection, by 1950; Mlle Germaine Henry and Professor Robert-Marie Thomas, Clermont-Ferrand, possibly by 1950 (consigned to Leonard Hutton Gallery, New York, 1968; returned unsold); their gift to the Caisse Nationale des Monuments Historiques et des Sites, Paris, 1974; Musée d'Art Moderne de la Ville de Paris, 1976

192. *fig. 259*

MAURICE DE VLAMINCK
View of the Seine

1906
Oil on canvas
21½ x 25¾ in. (54.5 x 65.5 cm)
State Hermitage Museum, St. Petersburg 9112

PROVENANCE: Bought from the artist by Ambroise Vollard, Paris, 1906; his gift to Ivan Morozov, Moscow, 1908; Second Museum of Modern Western Painting, Moscow, 1918; State Museum of Modern Western Art, Moscow, 1923; State Hermitage Museum, St. Petersburg, 1948

These three paintings, probably painted on or near the island of Chatou in the Seine,[1] are outstanding examples of Vlaminck's Fauve period. Inspired by Vincent van Gogh and the latest work of Henri Matisse, Vlaminck and André Derain developed a highly expressive style based on boldly applied, brilliant color, an approach that acquired the name Fauvism at the 1905 Salon d'Automne. Vollard met Vlaminck, Derain, and other members of the Fauve group through Matisse, whose work he had exhibited in 1904. In his *Recollections of a Picture Dealer* he gives an amusing account of his first impression of Vlaminck, a large, boisterous figure wearing a red necktie who struck Vollard as a sort of "militant anarchist."[2] The dealer was no less impressed by Vlaminck's vigorous style of painting, which involved squeezing colors straight from the tube as if "in a fit of rage."[3] After the startling debut of Derain and Vlaminck at the Salon des Indépendants in March 1905, Vollard was quick to recognize their originality and talent. In May 1906 he took the bold step of buying up all forty-eight works in Vlaminck's studio for 1,200 francs.[4]

As a result of a commission from Vollard, Vlaminck also produced a number of exceptionally

190

191

192

dramatic ceramics in collaboration with the ceramicist André Metthey (see cats. 193–197). In March 1910 Vollard mounted an exhibition of the artist's paintings and ceramics.

Although Vollard recorded the purchase of Vlaminck's studio in his ledgers, he did not itemize individual works. However, since Vlaminck had virtually no purchasers for his work at this time, one can assume that the majority of his early Fauve pictures passed through Vollard's hands. *Bank of the Seine at Chatou* may have been one of the works that Vollard bought from Vlaminck in July 1907.[5] *View of the Seine* was a gift from Vollard in 1908 to the great Russian collector Ivan Morozov on the occasion of his purchase, for 50,000 francs, of paintings by Cézanne, Gauguin, Picasso, and Degas.[6] See Albert Kostenevich's essay in this volume on the substantial number of works Morozov bought from Vollard, including Picasso's portrait of the dealer (cat. 153). *Harvest* and *Bank of the Seine at Chatou* were still in Vollard's possession when he died in 1939.

AD

1. *Bank of the Seine at Chatou* has an alternate title, *Plane Trees at Chatou*, written on the back, apparently in Vlaminck's hand: personal communication from Jacqueline Munck, curator at the Musée d'Art Moderne de la Ville de Paris.
2. Vollard 1936, p. 200.
3. Ibid.

4. Vollard Archives, MS 421 (5,1), fol. 101, May 31, 1906.
5. The ledgers record two *Bords de la Seine* and "un grand paysage" as bought from Vlaminck on July 23, 1907: Vollard Archives, MS 421 (5,2), fol. 128.
6. "Vendu à Ivan Morosoff les tableaux suivants . . . pour la somme de cinquante mille francs Cezanne—La jeune fille au piano 20000 / Gauguin La femme au fruits 8000 / [Gauguin] Le gros arbre 8000 / [Gauguin] Le bouquet de fleurs 8000 / Puy L'été 1200 / Picasso Les 2 saltimbanques 300 / Degas Danseuses 4500 / Vlaminck bord de l'eau 000 00 / 50000." Vollard Archives, MS 421 (5,3), fol. 79, April 29, 1908.

193. *fig. 141*

MAURICE DE VLAMINCK
Large Vase with Rooster

Ca. 1906–7
Tin-glazed ceramic
H. 21¼ in. (54 cm), Diam. 15¾ in. (40 cm)
Collection Larock-Granoff, Paris

194. *fig. 137*

MAURICE DE VLAMINCK
Plate

Ca. 1906–7
Tin-glazed ceramic
Diam. 10¼ in. (26 cm)
Collection Larock-Granoff, Paris

195. *fig. 138*

MAURICE DE VLAMINCK
Plate

Ca. 1906–7
Tin-glazed ceramic
Diam. 10¼ in. (26 cm)
Collection Larock-Granoff, Paris

196. *fig. 140*

MAURICE DE VLAMINCK
Plate with Peacock

Ca. 1906–7
Tin-glazed ceramic
Diam. 9 in. (23 cm)
Collection Larock-Granoff, Paris

197. *fig. 136*

MAURICE DE VLAMINCK
Large Vase

Ca. 1906–7
Tin-glazed ceramic
H. 21¼ in. (54 cm)
Musée d'Art Moderne de la Ville de Paris, Gift in 1937 (Vollard) AMOA 203

Vollard approached Vlaminck with the idea of decorating ceramics in collaboration with André Metthey shortly after purchasing the contents of the young painter's studio in the spring of 1906 (see the essay by Jacqueline Munck in this volume for a

193

194

195

196

197

discussion of the Metthey-Vollard ceramic production).[1] Though he had no prior experience with this medium, Vlaminck worked regularly with Metthey until 1910 or 1912 and is estimated to have produced more than three hundred plates, dishes, vases, and tea services. His collaboration with the ceramist was the most significant of Vollard's group of artists, except for that of Rouault.

A selection of Vlaminck's pottery was included in Metthey's display of 108 pieces of stoneware, porcelain, and tin-glazed ceramics (the latter owned by Vollard) at the 1907 Salon d'Automne.[2] Despite the commercial failure of that exhibition—the only substantial manifestation of the Vollard-Metthey collaboration—Vlaminck continued to create ceramics. He exhibited them to great acclaim alongside his paintings at the Galerie Vollard in March 1910.[3] The critic J.-F. Schnerb praised the complementary effect of this juxtaposition, observing that "one can almost confuse the paintings with the decorative faiences and rustic plates . . . the one is explained by the other."[4] Guillaume Apollinaire was also impressed by Vlaminck's ceramics, which he considered "a little barbaric but of the rarest and most sumptuous effect."[5] NM

1. Information for this entry is derived primarily from Valles-Bled 1996.
2. Metthey's entry is no. 1787 in the exhibition catalogue: "Exposition de grès, porcelaine et faïence stannifère. Collaborateurs: MM. Denis, Guy [sic], Rouault, Vlammck [sic], Maillol, Lajarde [sic], Valtat, Matisse." See Paris (Salon d'Automne) 1907.
3. Paris 1910a
4. Schnerb 1910.
5. Apollinaire 1910a.

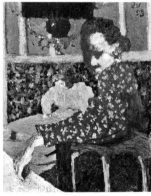

198

198. fig. 97

ÉDOUARD VUILLARD
The Blue Sleeve

1893
Oil on cardboard mounted on cradled panel
10½ x 8¾ in. (26.6 x 22.3 cm)
Collection of Malcolm Wiener

CATALOGUE RAISONNÉ: Salomon and Cogeval 2003, no. IV-147

PROVENANCE: Acquired by Ambroise Vollard, Paris, 1899 (Stockbook A, no. 3814); Wildenstein, New York, by 1940–

at least until 1954; Doris Warner Vidor, New York; sale, Sotheby's, New York, May 20, 1982, no. 235 (as *Woman in Blue*, sold for $60,000); Jan Krugier, Geneva; Malcolm Wiener, New York and Greenwich, Connecticut, 1987

Vuillard's sister, Marie, sits in front of a round table in the artist's newly rented apartment at 346, rue Saint-Honoré. The room, which was used both for dining and as a work area for Marie and other dressmaking assistants, featured partially paneled walls below which hung the busy blue patterned wallpaper shown here.[1] Marie shares the table with another assistant only half her size, who is framed by her bended arm. Several authors have remarked on the peculiarities of this painting, so different in intention from the many scenes of women quietly engaged in their tasks (see cat. 199). In many ways this "portrait" can be compared to Vuillard's own self-portrait *Vuillard and Waroquy* (1889, Metropolitan Museum), in which the secondary figure serves as a formal, and at times psychological, counterpart to the dominant one.[2] Here, in addition to the disjunction in scale, the secondary figure is dressed in light solid colors rather than Marie's blue print and is lit on the right side of her face rather than on the left as Marie is. Scholars have also compared Marie's idleness to the assistant's industriousness, but the two women could equally be interpreted as taking a break from their sartorial task to read the newspaper which Marie clutches in one hand and which is also spread out on the table.

In contrast to the assistant's downward glance, Marie is not so much posed as caught in a pose. She stares blankly out, confronting the viewer while confounding expectations of the typical portrait. She seems caught in deep shadows that mask the direction of her gaze. Compressed to the very front of the picture plane, Marie is illuminated not by the unlit lamp but by an unseen light. As he does in the best of his early, small-scale Nabi works on cardboard, Vuillard exploits the brown-colored support, allowing it to delineate the shadows of the eye sockets and to suggest another veiled dimension to Marie's already impenetrable physiognomy.[3] The harsh light falling on Marie not only lends the painting a mysterious aura recalling the Symbolist stage sets and theater programs Vuillard was making at this time but also exaggerates her receding hairline and thinning hair, habitually bound in a tight bun.[4]

Although Vollard purchased *The Blue Sleeve* in 1899, he no doubt saw it in the fall of 1893 at the gallery Le Barc de Boutteville, from which he had already begun acquiring works.[5] Not surprisingly, given its radical spatial distortions and subversion of the portrait genre, it remained unsold. For Thadée Natanson, Vuillard's friend and early patron, however, it was unforgettable. Reviewing the 1893 exhibition for *La Revue blanche,* he praised especially "that extraordinary woman in a blue dress, her arms outstretched, whose disturbing memory lingers on."[6] GG

1. Vuillard shows another fragment of this room in *The Window,* 1894, Museum of Modern Art, New York (SC IV-155).
2. Ciaffa 1985, p. 177.
3. See Forgione 1992, p. 118.
4. Salomon and Cogeval 2003, vol. 1, p. 87.
5. Ibid., p. 312, no. IV-147. This painting is listed in Stockbook A, no. 3814, "femme en bleue assise [illegible], [Provenance] Vuillard, 27 x 22 cm, 100 [francs]"; see also

Gloria Groom, "Vollard, the Nabis, and Odilon Redon," in this volume.
6. Natanson 1893, translated in Salomon and Cogeval 2003, vol. 1, p. 312, no. IV-147.

199

199. fig. 98

ÉDOUARD VUILLARD
Woman at the Cupboard

Ca. 1894–95
Oil on cardboard mounted on panel
14⅝ x 13⅛ in. (37 x 33.5 cm)
Wallraf-Richartz-Museum–Fondation Corboud, Cologne WRM 3049

CATALOGUE RAISONNÉ: Salomon and Cogeval 2003, no. IV-159

PROVENANCE: Ambroise Vollard, Paris; Étienne Bignou, Paris; Paul Pétridès, Paris; Paul Strecker, Cologne/Wiesbaden/ Paris, by ca. 1942; his brother Wilhelm Strecker, Mainz; sold to Wallraf-Richartz-Museum, Cologne, 1958

In this small painting, Madame Vuillard (identifiable by her girth and headwear) is seen in the open doorway of a kitchen closet in her apartment on the rue Saint-Honoré. Although Vuillard inserts her columnar figure to form one of three vertical sections, she is differentiated from the otherwise flatter painted areas by her lively blue-patterned blouse, which vies with the vertical and horizontal patterns of the plates, glasses, and dishes that she puts away. As in the tightly organized composition of *The Blue Sleeve* (cat. 198), Vuillard exploits the geometry of the paneled walls. Their strict verticality and thicker areas of yellowish white are offset by the strip of whitish paint that suggests a kitchen apron or towel hanging on the pantry door to Madame Vuillard's left.

In this compressed space, Vuillard faithfully records small domestic details, such as the shelf at the top left underneath which is the tiled surface seen in other small paintings, such as *The Kitchen* (*La Cuisine*) (1893, Yale University Art Gallery, New Haven).[1] Other domestic trappings, however, remain ambiguous. The brownish vertical cut off by the dish or linen closet may be a wooden fixture, perhaps a small spice shelf. Or is it a carved clock seen from the side only? And what of the enigmatic brownish black shape at the bottom left? Is it a curved chairback, or a heating brazier? Or is it something equally banal made unrecognizable by Vuillard in order to

stress the physical and emotional overtones of the composition rather than the narrative?[2]

For Vuillard, home was the stage, and its inhabitants the actors he controlled—not in real life but through his art. Just as Ibsen's plays would inspire his set decors, lithographs, and paintings in 1894 (the "year of Ibsen" as he referred to it in his journal), his family and the seamstresses who worked at his home offered themselves up to his own imaginary dramas and aesthetic needs.[3] It was in the ordinary rather than in the esoteric and religious that Vuillard fulfilled his Symbolist yearnings. As he wrote in his journal for August 1893, "Why is it that in the familiar places one's spirit and sensibility find what is truly new?"[4] In *Woman at the Cupboard*, Vuillard returned to this fertile soil for a quietly moving yet mysteriously charged commentary on the transcendent power of daily life. GG

1. Salomon and Cogeval 2003, vol. 1, p. 336, no. IV-202, who date it to 1896–97.
2. Interestingly, although the room and architectural elements of this painting have been identified (notably by Götz Czymmek in Schlagenhaufer 1986, p. 262), the peculiar forms in the left foreground remain undescribed.
3. Salomon and Cogeval 2003, vol. 1, p. 316.
4. Vuillard, "Journal," vol. 1, pt. 2, fol. 75r: Institut de France, Paris, MS 5396.

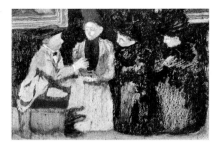

200

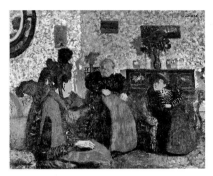

201

200. *fig. 99*

ÉDOUARD VUILLARD
The Lecturer, or *The Guide*

Ca. 1897
Oil on cardboard
10⅛ x 15¼ in. (26 x 40 cm)
Private collection; courtesy Galerie Schmit, Paris

CATALOGUE RAISONNÉ: Salomon and Cogeval 2003, no. V-98

PROVENANCE: Ambroise Vollard, Paris; Étienne Bignou, Paris; A. Nussbaumer, Basel; Hans Loew, Oberaach; Harriet Weiner Goodstein, New York; private collection, Paris

201. *fig. 100*

ÉDOUARD VUILLARD
The Widow's Visit, or *The Conversation*

1898
Oil on paper mounted on panel
19¾ x 24¾ in. (50.2 x 62.9 cm)
Art Gallery of Ontario, Toronto, Purchase, 1937 2422
New York and Chicago only

CATALOGUE RAISONNÉ: Salomon and Cogeval 2003, no. VII-13

PROVENANCE: Acquired from the artist by Bernheim-Jeune, July 1, 1899 (stock no. 9628, *La Conversation,* for 400 francs); Arthur Tooth & Sons, London; bought by Art Gallery of Ontario, Toronto, 1937

Although *The Widow's Visit* (cat. 201) is nearly twice the size of *The Lecturer* (cat. 200) and takes place in Madame Vuillard's drawing room rather than in a gallery or other public space, both are gently humorous scenes about a storyteller and an audience.[1] In

The Widow's Visit, Vuillard's mother and sister Marie listen patiently if not a little distractedly to their visitor, whose elaborate widow's bonnet (like the paintings on the wall in *The Lecturer*) gives away the plot. Unlike *The Lecturer,* with its simplified composition of figures set against a dark wall hung with two paintings, *The Widow's Visit* is replete with pictures within pictures. Like a seventeenth-century Dutch genre scene, it offers up the minutiae of Vuillard's mother's possessions and taste in the public room of their household. The care with which the artist developed the composition can be seen in the amusing sketches of the primary characters, who share the spotlight with the wood-framed mirror, vase of flowers, music cabinet, and piano with dainty decorative motifs that, as Guy Cogeval noted, seem to have been "etched" into the surface with a pencil.[2]

If *The Widow's Visit* has an etched quality, *The Lecturer* is characterized by a kind of paint-and-scrape technique. Using a near-monochromatic palette of blacks, browns and gray-blues, Vuillard applied thinned oils to suggest the bulky seated forms, which he then scraped or possibly blotted so that only a faint wash covers the cardboard support to suggest modeling. Although it is not possible to discern whether the frames in the paintings hold old or modern masters, Vollard must have appreciated this image of art promotion, upon which Vollard was so reluctantly dependent.

Compared with *The Lecturer,* which Vollard purchased from the artist about 1899,[3] *The Widow's Visit,* shown in the April 1898 exhibition at Vollard's, moves away from the flat, simplified, synthetic style of "high Nabism" toward a greater interest in depicting people and their surroundings through the effects of light and shadow. Instead of a frieze of figures against a dark wall, Vuillard turns the widow at a right angle in order to emphasize her distance from Madame Vuillard and Marie. Notable too are the late-afternoon shadows on the walls, which emphasize the numerous household accessories. Thadée Natanson, an early supporter of Vuillard, remarked on the

artist's new attempts to create depth and a more general expression while retaining his fascination for the stuff of life. Commenting upon the Vollard exhibition, Natanson remarked, "Vuillard strives somehow to enclose virtually everything he knows in each canvas, and, despite the infinite variety of things, to endow each with more and more meaning."[4]

Vollard, on the other hand, may have appreciated Vuillard's ability to depict with gentle irony the social relations of the petite bourgeoisie from which both the dealer and the artist came. Having left Réunion at an early age to make it on his own in France, Vollard may have found these vignettes to be an amusing glimpse of French manners—manners to which, judging from all witnesses, Vollard gave little credence. GG

1. On the rue des Batignolles, where they moved in November 1897, see Chivot 2003, p. 1642. Elizabeth Easton maintains that until 1898 the Vuillard family lived on the rue Saint-Honoré. See Houston–Washington–Brooklyn 1989, pp. 67–68, 144.
2. Cogeval in Montreal 1998, p. 121, no. 184.
3. Salomon and Cogeval (2003, vol. 1, p. 439, no. V-98) state that Vollard paid the artist 150 francs for the painting, which they have also identified as Stockbook A, no. 3813.
4. Natanson 1898b, p. 618, translated in Salomon and Cogeval 2003, vol. 2, p. 550, no. VII-13.

202. *figs. 12, 206, 207*

ÉDOUARD VUILLARD
Paysages et intérieurs (*Landscapes and Interiors*)

Published 1899
Suite of 12 color lithographs, plus cover

a. The Art Institute of Chicago, Gift of Walter S. Brewster 1936.191.1, 1936.192–203
New York and Chicago only

b. Petit Palais, Musée des Beaux-Arts de la Ville de Paris
PPG 2205(a), 2205(b), 2206(a), 2236
Paris only

CATALOGUES RAISONNÉS: Marguery 1935, nos. 33–45; Roger-Marx 1948, nos. 31–43; Roger-Marx 1990, nos. 31–43

Cover, 1899
Image 20⁹⁄₁₆ x 15¹³⁄₁₆ in. (52.3 x 40.2 cm), sheet 23¹¹⁄₁₆ x 17⅜ in. (60.7 x 44.2 cm), 1936.191.1

1. *The Game of Checkers,* 1899
Image 14⁹⁄₁₆ x 11³⁄₁₆ in. (36.9 x 28.5 cm), sheet 14¹⁵⁄₁₆ x 12⅛ in. (38 x 30.8 cm), 1936.199

2. *The Avenue,* 1899
Image 12¼ x 16³⁄₁₆ in. (31.1 x 41.1 cm), sheet 13³⁄₁₆ x 17⁷⁄₁₆ in. (33.4 x 44.2 cm), 1936.194

3. *Across the Fields,* 1899
Image 10¼ x 13⅝ in. (26 x 34.6 cm), sheet 12⅜ x 16 in. (31.4 x 40.7 cm), 1936.203

4. *Interior with Hanging Lamp,* 1899
Image 15 x 11³⁄₁₆ in. (38.1 x 28.5 cm), sheet 15³⁄₁₆ x 11¹⁵⁄₁₆ in. (38.5 x 30.3 cm), 1936.201

5. *Interior with Pink Wallpaper I,* 1899
Image 13⁹⁄₁₆ x 10¹³⁄₁₆ in. (35.3 x 27.4 cm), sheet 15⅜ x 12¹⁄₁₆ in. (39.3 x 30.7 cm), 1936.198

6. *Interior with Pink Wallpaper II,* 1899
Image 13¹³⁄₁₆ x 11⅛ in. (35.4 x 28.4 cm), sheet 15⁷⁄₁₆ x 12¼ in. (39.2 x 31.1 cm), 1936.197

202

7. *Interior with Pink Wallpaper III,* 1899
Image 13⅜ x 10¹⁵⁄₁₆ in. (34.2 x 27.5 cm), sheet 14¹¹⁄₁₆ x 11¹³⁄₁₆ in. (37.4 x 30 cm), 1936.195

8. *The Hearth,* 1899
Image 14⁷⁄₁₆ x 10¹⁵⁄₁₆ in. (36.7 x 27.7 cm), sheet 15¹⁵⁄₁₆ x 12⅞ in. (40.4 x 32.7 cm), 1936.200

9. *On the Bridge of Europe,* 1899
Image, including registration marks, 12¼ x 14¹⁵⁄₁₆ in. (31.1 x 37.9 cm), sheet 13³⁄₁₆ x 15⅝ in. (33.4 x 39.5 cm), 1936.193

10. *The Pastry Shop,* 1899
Image 14 x 10¹⁵⁄₁₆ in. (35.6 x 27.7 cm), sheet 15⅞ x 12½ in. (40.3 x 31.8 cm), 1936.192

11. *The Cook,* 1899
Image (max.) 14�1⁄₁₆ x 11 in. (35.7 x 27.9 cm), sheet 14⅜ x 11⁷⁄₁₆ in. (36.4 x 29.1 cm), 1936.202

12. *The Two Sisters-in-Law,* 1899
Image 14⅜ x 11¼ in. (36.4 x 28.6 cm), sheet 15³⁄₁₆ x 12⅜ in. (38.5 x 31.5 cm), 1936.196

In his list of career highlights, Vuillard noted for 1897 the "exposition des Vollard lithographies Villeneuve,"[1] referring to Vollard's April exhibition of Nabi paintings and drawings, as well as the posters and lithographs referenced under number 89 as "uncatalogued." The latter could well have been the prints published two years later in the Vollard-commissioned album *Paysages et intérieurs* (*Landscapes and Interiors*).[2] The seriousness with which Vuillard approached this project is indicated by the number of intermediary pastels, watercolors, and trial proofs.[3] Writing to Félix Vallotton in the summer of 1898, he noted one completed lithograph and work toward another that would take an additional two weeks. His hopes for travel were squelched not only because of his work but because he could not expect payment from Vollard for three months.[4]

Of the four landscapes and nine interiors making up the album, one shows Misia Natanson at a café; three others depict her at her summer home at Villeneuve, including the cover with Misia reading with her dog, and her husband, Thadée, in striped pajamas. The imagery of these "interior landscapes" falls between Denis's highly personalized *Amour* and Bonnard's detached scenes of city life: Vuillard includes his friends, but their encoded attributes and gestures would be recognizable only to those in his inner circle. In addition to the Villeneuve scenes, at least four prints represent the small rooms of the Vuillard family apartment, dominated by busy wallpaper.[5]

The artist used five stones of color to evoke the interwoven, complicated configurations of his easel paintings and decorative panels of the period. In July 1899 Vuillard wrote to Vallotton of his work on another color lithograph, likely for the third and never-realized *peintres-graveurs* album.[6] Although he had made some forty-eight prints without the collaboration of the dealer, the Vollard album represented the apogee of Vuillard's graphic art.[7]

GG

1. See Vuillard, "Journal," vol. 1, pt. 2, fol. 78r: Institut de France, Paris, MS 5396.
2. See also the catalogue for the exhibition, Paris 1897a, no. 89, "Sous ce numéro, les Affiches et Lithographies non cataloguées." The 1897 date provides a terminus post quem for his work, which began in 1896, and according to Jonathan Pascoe Pratt, spanned a seventeen-month period. (See the essay by Jonathan Pascoe Pratt anad Douglas Druick on Vollard's print albums in this volume.)
3. See Paris 2002, nos. 242–45.
4. Vuillard to Vallotton, July 25, 1898, in Guisan and Jakubec 1973–75, vol. 1, pp. 176–77, letter 118.
5. See cat. 201. Other prints in the album revisit earlier lithographs commissioned for the *peintres-graveurs* albums: *Children's Games* (1897), whose silhouetted adults appear in *Across the Fields,* and *The Avenue,* based on a similar dramatic diagonal composition.
6. Vuillard to Vallotton, July 26, 1899, in Guisan and Jakubec 1975, p. 15.
7. See Johnson 1944, pp. 160–61, no. 200. For other, less well-known lithographs and etchings beginning in 1899, see Roger-Marx 1948, nos. 44–46, 48, 50–60, and nos. 62–67.

A Note on the Vollard Archives

"Vollard Archives" is the name used throughout this publication for material housed in the Bibliothèque and Archives of the Musées Nationaux, Paris, where it is classified as Fonds Vollard, MS 421. A voluminous collection of original manuscript materials, the Archives contain correspondence, ledgers, account books, datebooks, and numerous other documents relating to Vollard's business and personal affairs over the course of more than fifty years. (There are, however, chronological gaps, and the records are sometimes incomplete, overlapping, or contradictory.) Photographs that were owned by Vollard are archived at the Musée d'Orsay, Paris. Additional Vollard material cited in this publication is in the Wildenstein Institute, Paris, and in the John Rewald Papers in the Gallery Archives at the National Gallery of Art, Washington, D.C. For a fuller discussion of the Vollard Archives, see Isabelle Cahn's essay, and Jonathan Pratt's essay on Vollard's accounts, in this volume.

The Vollard Archives material catalogued as MS 421 is divided into thirteen sections, designated by numbers in parentheses. In the present publication, documents are cited by these numbers, which are highlighted in the list provided below. The list, which also includes certain essential documents in the Wildenstein Institute and the John Rewald Papers, begins with a summary of the stockbook materials and then moves chronologically through the documents, briefly indicating the contents of each.

STOCKBOOKS

Stockbook entries may include provenance, artist, description, size, medium, Vollard's purchase price, and occasionally the buyer's name, date, and purchase price.

1899–ca. April 1904 **Stockbook A**
(Wildenstein Institute; photocopy in John Rewald Papers)
Inventory numbers 3301–4210.

Ca. June 1904–ca. December 1907 **Stockbook B**
MS 421 (4,5)
(Vollard Archives)
Inventory numbers 3301 (as in Stockbook A)–4560.
Supersedes Stockbook A when a work is listed in both.

Ca. March 1918–ca. 1922 **Stockbook C**
(Wildenstein Institute; photocopy in John Rewald Papers)
Inventory numbers 7016–7609.

January 1, 1922–January 5, 1938 **1922 Inventory**
(Wildenstein Institute)
Inventory numbers 1–5745.

DOCUMENTS LISTED CHRONOLOGICALLY

June 20, 1894–November 3, 1897 **MS 421 (4,2)**
Sales Book (*Registre des ventes*)
Records pictures sold or exchanged on the day of agreement.

June 20, 1894–June 1900 **MS 421 (4,3)**
Account Book (*Registre de caisse*)
Records sales and purchases of works of art, commissions, framing and restoration costs, gallery maintenance, catalogue and exhibition costs, etc., on the date payment was made or received.

January 1896–ca. May 1899 **MS 421 (4,4)**
Notebook of Gallery Activities (*Mouvements de tableaux*)
Notes names of buyers or artists listed by month, often with prices, and additional miscellaneous information.

1899–ca. April 1904 **Stockbook A**
(*Registre des entrées et sorties*)
(Wildenstein Institute; photocopy in John Rewald Papers)
Inventory numbers 3301–4210.

August 3, 1899–May 11, 1922 **MS 421 (4,1)**
Copies of letters sent to clients, organized chronologically.

April 14, 1900–August 1, 1902 **MS 421 (4,9)**
Sales Register (*Petit registre des recettes et paiements*)
Records sales, purchases, and commissions in a cursory fashion, with cross-references to Stockbook A.

January 1904–December 31, 1904 **MS 421 (4,10)**
Account Book
Records sales, purchases, commissions, restoration, framing and photography fees, and shipments, with cross-references to Stockbook B.

Ca. June 1904–ca. December 1907 **MS 421 (4,5)**
Stockbook B (*Registre des entrées et sorties*)
Inventory numbers 3301 (as in Stockbook A)–4560.
Supersedes Stockbook A when a work is listed in both.

December 31, 1904–December 9, 1932 **MS 421 (3,4)**
Restoration receipts from Charles Chapuis
With cross-references to Stockbooks A and B. There is a gap between April 1915 and October 1932.

January 1, 1906–December 31, 1913 **MS 421 (5,1–9)**
Datebooks (*Agendas de la galerie*)
Yearly, with two books in 1911. Daily entries noting sales, purchases, shipments, business appointments, and social engagements.

May 23, 1907–February 1923 **MS 421 (4,13)**
Record of Shipments
Records shipments of works of art, published monographs, and *livres d'artiste*. Some cross-references to Stockbook B; after March 1, 1912, references to numbers in the 5000s, for which no stockbook is known.

Ca. March 1918–ca. 1922 **Stockbook C**
(Wildenstein Institute; photocopy in John Rewald Papers)
Inventory numbers 7016–7609. Cross-references to Vollard's photo archives.

March 2, 1921–February 23, 1933 **MS 421 (4,14)**
Exportation Book (*Livre d'exportations*)

January 1, 1922–January 5, 1938 **1922 Inventory**
(Wildenstein Institute)
Inventory numbers 1–5745. Gives purchase price and, for numbers 5489–5745, dates of entry and provenance.

January 1, 1922–November 1932 **MS 421 (5,10–16)**
Datebooks (*Agendas de la galerie*)
For years 1922–25, 1927, 1931, 1932.

January 23, 1922–December 31, 1928 **MS 421 (4,7)**
Account Book (*Journal de caisse*)
Lists receipts and payments by month and day, with cross-references to 1922 Inventory.

January 23, 1922–October 31, 1929 **MS 421 (4,8)**
Account Book (*Journal de caisse*)
Except for final month, is virtually the same as Account Book listed directly above.

DOCUMENTS NOT ORGANIZED BY DATE

MS 421 (1,1–5)
Annotated typescripts of books by Vollard

MS 421 (2,1–4)
Letters and receipts from artists or their agents, organized alphabetically

MS 421 (3,1)
Gallery receipts and tax documents, primarily from the 1930s

MS 421 (3,3)
Early gallery receipts from framers, restorers, foundries, and others, arranged alphabetically

MS 421 (3,5–6)
Receipts for loans of artworks, primarily from the 1930s

MS 421 (3,9)
Photographs of Vollard, other individuals, and exhibition installations

MS 421 (4,11)
Address book from beginning of gallery operations

MS 421 (6,1–14)
Texts, mostly unpublished, for Éditions Vollard

MS 421 (7, 1–2)
Papers relating to Éditions Vollard, primarily from the 1930s

MS 421 (8,1–31)
Receipts from printers and suppliers involved with Éditions Vollard, primarily from the 1920s and 1930s

MS 421 (9,1–19)
Correspondence and receipts relating to Éditions Vollard

MS 421 (10,1–12)
Personal papers, including school certificates, rent receipts, and gift acknowledgements

MS 421 (11,1–4)
Papers relating to country homes: Bois-Rond near Barbizon, and the property at Le Tremblay-sur-Mauldre

MS 421 (12,1–3)
Bank transactions and personal investments

MS 421 (13)
Papers relating to Vollard's estate

Jayne S. Warman and Jayne Kuchna

Archival Collections

Archives Durand-Ruel, Paris

Archives Matisse, Paris

Archives Nationales, Paris

Les Archives de Paris

Art Institute of Chicago. Ryerson and Burnham Archives. André Mellerio Collection

Ashmolean Museum, Oxford. Pissarro Family Archive

Atelier Cézanne, Aix-en-Provence. Archives

Bibliothèque et Archives des Musées Nationaux, Paris

Bibliothèque Nationale de France, Paris. Département des Manuscrits

Deutsches Literatur Archiv Marbach

Fondation Georges Rouault, Paris. Archives

Fondation Félix Vallotton, Lausanne. Archives

The Getty Research Institute, Los Angeles. Research Library

Florentin Godard Archives. Private collection

Van Gogh Museum, Amsterdam. Archives

Institut de France, Paris. Archives

Institut Néerlandais, Paris. Archives

Kaiser Wilhelm Museum, Krefeld. Archives

Kunsthaus Zürich. Archives

The Metropolitan Museum of Art, New York. Archives

 Department of European Paintings. Weitzenhoffer files

 Department of Nineteenth-Century, Modern, and Contemporary Art. Archives

Musée des Beaux-Arts de Chartres. Archives

Musée Départemental Maurice Denis, Saint-Germain-en-Laye. Archives. Donation de la famille Denis

Musée Gustave Moreau, Paris. Archives

Musée d'Orsay, Paris

Musée du Petit Palais, Paris. Archives

Musée Picasso, Paris. Archives

Musée Rodin, Paris. Archives

Musée de Tahiti et des Îles, Punaauia. Loize Archives

Národní Galerie, Prague. Archives

National Gallery of Art, Washington, D.C. Gallery Archives. John Rewald Papers

New York Public Library, New York City. Astor, Lenox and Tilden Foundations. Manuscripts and Archives Division. John Quinn Memorial Collection

Karl-Ernst Osthaus–Museum, Hagen. Karl-Ernst Osthaus–Archiv

Jean and Michel Puy Archives, Lyon

Städtisches Kunstinstitut und Städtische Galerie, Frankfurt am Main. Archives

Tate, London. Archives

Vollard Archives (see note on p. 409)

Wildenstein Institute, Paris

Yale University, New Haven, Connecticut. Beinecke Rare Book and Manuscript Library

Archives of private individuals who wish to remain anonymous

Key to Catalogue Raisonné Abbreviations

Bonnard
D J. Dauberville and H. Dauberville 1966–74

Caillebotte
B Berhaut 1994

Cassatt
B Breeskin 1979

Cézanne
R Rewald 1996

Courbet
F Fernier 1977–78

Degas
L Lemoisne 1946–49

Gauguin
W G. Wildenstein 1964
W-2001 D. Wildenstein 2001

Van Gogh
F Faille 1970

Manet
RW Rouart and D. Wildenstein 1975

Manguin
S Sainsaulieu 1980

Monet
W D. Wildenstein 1974–86
W-1996 D. Wildenstein 1996

Picasso
DB Daix and Boudaille 1967
DR Daix and Rosselet 1979

Pissarro
PS J. Pissarro and Snollaerts 2005
PV L. R. Pissarro and Venturi 1939

Redon
W A. Wildenstein 1992–98

Renoir
D Daulte 1971

Vuillard
SC Salomon and Cogeval 2003

Bibliography

"Action by M. Rouault" 1946
"Action by M. Rouault; Retouching of Paintings after Sale." *Times* (London), May 25, 1946, p. 3.

Adhémar 1982
Jean Adhémar. "Schnerb, Cézanne, Renoir." *Gazette des beaux-arts*, ser. 6, 99 (April 1982), pp. 147–52.

Adhémar and Cachin 1974
Jean Adhémar and Françoise Cachin. *Degas: The Complete Etchings, Lithographs, and Monotypes.* Translated by Jane Brenton. New York, 1974.

Adriani 1995
Götz Adriani. *Cézanne Paintings.* Essay by Walter Feilchenfeldt. New York, 1995. English translation by Russell Stockman of the exh. cat. for the Cézanne exhibition at the Kunsthalle Tübingen, 1993.

Adriani 2001
Götz Adriani. *Henri Rousseau.* New Haven and London, 2001.

Ainaud de Lasarte and Subirana 1971
Juan Ainaud de Lasarte and Rosa Maria Subirana et al. *Museo Picasso: Catálogo.* Barcelona, 1971.

Alain 1968
Alain [pseud.]. *Introduction à l'oeuvre gravé de K. X. Roussel; accompagnée de 28 dessins en fac-similé.* Essay by Jacques Salomon. 2 vols. Paris, 1968.

"Album Vollard" 1914
Degas: Quatre-vingt-dix-huit reproductions signées par Degas (peintures, pastels, dessins et estampes) [known as the "Album Vollard"]. Paris: Galerie A. Vollard, 1914. Re-issued by Bernheim-Jeune et Cie, Paris, in 1918 with several new plates.

Alexandre 1895
Arsène Alexandre. "Claude Lantier." *Le Figaro,* December 9, 1895.

Alfassa 1932
Paul Alfassa. *Raymond Koechlin.* Paris, 1932.

Alley 1959
Ronald Alley. *The Foreign Paintings, Drawings, and Sculptures.* Tate Gallery Catalogues. London, 1959.

Almanach de Commerce: Ville de Paris 1893
Almanach de commerce, Ville de Paris. Paris: Bottin, 1893.

Ambroise Vollard 1991
Ambroise Vollard, éditeur: Les Peintres-graveurs. Exh. cat. Agnew's, London; 1991. London, 1991.

"Ambroise Vollard, Editeur" 1941
"Ambroise Vollard, Editeur, 1867–1939." *Brooklyn Museum Bulletin* 2, no. 8 (May 1, 1941), p. 2.

"Ambroise Vollard of Paris Dies at 72" 1939
"Ambroise Vollard of Paris Dies at 72." *New York Times,* July 23, 1939, p. 29.

Amherst 1980
The Temptation of Saint Anthony by Odilon Redon. Exh. cat. edited by Frank Trapp. Mead Art Museum, Amherst College; 1980. Amherst, Mass., 1980.

Amishai-Maisels 1997–98
Ziva Amishai-Maisels. "Chagall in the Holy Land: The Real and the Ideal." *Jewish Art* 23–24 (1997–98), pp. 513–42.

Amsterdam–New York 2005
Vincent Van Gogh: The Drawings. Exh. cat. by Colta Ives et al. Van Gogh Museum, Amsterdam; The Metropolitan Museum of Art, New York; 2005. New York, 2005.

Amsterdam–Paris 1999–2000
Theo van Gogh, 1857–1891: Marchand de tableaux, collectionneur, frère de Vincent. Exh. cat. by Chris Stolwijk, Richard Thomson, Sjraar van Heugten. Van Gogh Museum, Amsterdam; Musée d'Orsay, Paris; 1999–2000. Paris, 1999. Also published in English.

André 1923
Albert André. *Renoir.* Paris, 1923.

Anger 2005
Jenny Anger. "Modernism at Home: The Private *Gesamtkunstwerk.*" In *Seeing and Beyond: Essays on Eighteenth- to Twenty-first Century Art in Honor of Kermit S. Champa,* edited by Deborah J. Johnson and David Ogawa, pp. 211–43. New York, 2005.

Apollinaire 1910
Guillaume Apollinaire. "La Vie artistique." *L'Intransigeant,* December 25, 1910, p. 2.

Apollinaire 1910a
Guillaume Apollinaire. "La Vie artistique: Exposition Maurice de Vlaminck." *L'Intransigeant,* March 16, 1910, p. 2.

Apollinaire 1911
Guillaume Apollinaire. "La Vie artistique." *L'Intransigeant,* January 4, 1911, p. 2.

Apollinaire 1913
Guillaume Apollinaire. "La Vie anecdotique: La Cave de la rue Laffitte." *Mercure de France,* June 1, 1913, pp. 661–63.

Apollinaire 1913 (1918 ed.)
Guillaume Apollinaire. "La Cave de M. Vollard." In *Le Flâneur des deux rives,* by Guillaume Apollinaire. Paris, 1918.

Aristide 1919
Aristide. "La Critique d'Aristide; Paul Cézanne." *Aux Écoutes,* July 20, 1919, p. 14.

"Art Shipment Seized" 1940
"Art Shipment Seized." *Art Digest* 15 (October 15, 1940), p. 6.

Assouline 1988
Pierre Assouline. *L'Homme de l'art: D. H. Kahnweiler, 1884–1979.* Paris, 1988.

Assouline 1991
Pierre Assouline. *An Artful Life: A Biography of D. H. Kahnweiler, 1884–1979.* Translated by Charles Ruas. New York, 1991.

Assouline 1997
Pierre Assouline. *Le Dernier des Camondo.* Paris, 1997.

Athanassoglou-Kallmyer 2003
Nina Maria Athanassoglou-Kallmyer. *Cézanne in Provence.* Chicago, 2003.

Athill 1985
Philip Athill. "The International Society of Sculptors, Painters and Gravers." *Burlington Magazine* 127 (January 1985), pp. 21–29.

Atlanta–Seattle–Denver 1999
Impressionism: Paintings Collected by European Museums. Exh. cat. by Ann Dumas et al. High Museum of Art, Atlanta; Seattle Art Museum; Denver Art Museum; 1999. Atlanta, 1999.

"Au Pays des livres" 1926a
P. I. "Au Pays des livres: Bibliophilie et taxe de luxe." *Plaisir de bibliophile* 2 (1926), pp. 58–60.

"Au Pays des livres" 1926b
"Au Pays des livres: Les Arts et le livre." *Plaisir de bibliophile* 2 (1926), pp. 62–63.

Aurier 1890
G.-Albert Aurier. "Les Isolés: Vincent van Gogh." *Mercure de France,* January 1890, pp. 24–29. Translated in S. A. Stein 1986, pp. 181–82, 191–93.

Bachelard 1952
Gaston Bachelard. "La Lumière des origines." *Derrière le miroir* (Paris) 44–45 (March 1952), unpaged.

Baden-Baden 1978
Maillol. Exh. cat. by Dina Vierny and Jochen Ludwig. Staatliche Kunsthalle Baden-Baden; 1978. Baden-Baden, 1978.

Bailly-Herzberg 1980–91
Janine Bailly-Herzberg, ed. *Correspondance de Camille Pissarro.* 5 vols. Paris, 1980–91.

Barcelona 1917
Exposition d'art français: Catalogue illustré. Exh. cat. Municipalité de Barcelona; 1917. Barcelona, 1917.

Bardazzi 1997
Francesca Bardazzi. "Cézanne a Firenze." In *Cézanne, Fattori e il'900 in Italia*, pp. 26–39. Exh. cat. Museo Civico Giovanni Fattori, Livorno; 1997–98. Livorno, 1997.

A. Barnes 1934
Albert C. Barnes. "The Famous Collection of Ambroise Vollard." *London Studio* 7 (January 1934), pp. 24–28.

J. Barnes 1994
Julian Barnes. "Odilon Redon." *Modern Painters* 7, no. 4 (winter 1994), pp. 14–18.

Barr 1951
Alfred Barr, Jr. *Matisse, His Art and His Public.* New York, 1951.

Barskaya and Bessonova 1988
Anna Barskaya and Marina Bessonova. *Paul Gauguin in Soviet Museums.* Leningrad, 1988.

Barskaya, Kantor-Gukovskaya, and Bessonova 1995
Anna Barskaya, Asya Kantor-Gukovskaya, and Marina Bessonova. *Paul Gauguin: Mysterious Affinities.* Bournemouth and St. Petersburg, 1995.

Bart 1986–87
B. F. Bart. "Flaubert and the Graphic Arts: A Model for His Sources, His Texts, and His Illustrators." *Symposium: A Quarterly Journal in Modern Foreign Languages* (Syracuse, N.Y.) 40, no. 4 (winter 1986–87), pp. 259–95.

Basel 1935
Meisterzeichnungen französischer Künstler von Ingres bis Cézanne. Exh. cat. Kunsthalle Basel; 1935. Basel, [1935].

Basel–Bonn 1995–96
Pablo Picasso: Die illustrierten Bücher. Eine Privatsammlung, ergänzt durch Werke aus dem Kupferstichkabinett Basel. Exh. cat. edited by Katharina Schmidt; contributions by Herma Goeppert-Frank and Sebastian Goeppert. Kunstmuseum Basel; Kunstmuseum Bonn; 1995–96. Ostfildern, 1995.

Basler 1925
Adolphe Basler. "Amateurs, curieux et marchands d'art: Monsieur Vollard." *L'Art vivant* 1, no. 12 (June 15, 1925), p. 26.

Bassères 1979
François Bassères. *Maillol mon ami.* [Perpignan], 1979.

Bataille and G. Wildenstein 1961
Marie-Louise Bataille and Georges Wildenstein. *Berthe Morisot: Catalogue des peintures, pastels et aquarelles.* Paris, 1961.

Baudelaire 1975–76
Charles Baudelaire. *Oeuvres complètes.* New ed. Edited and annotated by Claude Pichois, with the collaboration of Jean Ziegler. 2 vols. Paris, 1975–76.

Bavoux 1993
Claudine Bavoux. *Devinettes de l'Océan indien.* Saint-Denis: Université de la Réunion; Paris, 1993.

Belloli 2005
Lucy Belloli. "Lost Paintings beneath Picasso's *La Coiffure*." *Metropolitan Museum Journal* 40 (2005), pp. 151–61.

Benjamin 1987
Roger Benjamin. *Matisse's "Notes of a Painter": Criticism, Theory, and Context, 1891–1908.* Studies in the Fine Arts: Criticism, no. 21. Ann Arbor, 1987.

Benoist 1925
Luc Benoist. "L'Exposition Internationale des Arts Décoratifs et Industriels Modernes. Les Arts graphiques—les arts de la rue et des jardins: Le Livre illustré." *Beaux-Arts* 3, no. 16 (September 15, 1925), pp. 253–65; conclusion by Paul Vitry, pp. 265–68.

Ten Berge 2003
Jos Ten Berge. "The Acquisitive Cornelius Hoogendijk." In *The Paintings of Vincent van Gogh in the Collection of the Kröller-Müller Museum*, edited by Toos van Kooten and Mieke Rijnders, pp. 420–23. Otterlo, 2003.

Berger 1965
Klaus Berger. *Odilon Redon: Fantasy and Color.* Translated by Michael Bullock. New York, 1965.

Berggruen 1997
Heinz Berggruen. *J'étais mon meilleur client: Souvenirs d'un marchand d'art.* Paris, 1997.

Berhaut 1994
Marie Berhaut. *Gustave Caillebotte: Catalogue raisonné des peintures et pastels.* Rev. ed. Paris, 1994.

Berhaut and Vaisse 1983
Marie Berhaut and Pierre Vaisse. "Le Legs Caillebotte . . . Annexe: Documents." *Bulletin de la Société de l'Histoire de l'Art Français*, 1983 (pub. 1985), pp. 201–39.

Berlin 1913
Degas / Cézanne. Exh. cat. Paul Cassirer, Berlin; 1913. Berlin, 1913.

Berlin 1925
Von Delacroix bis Picasso: Hundert Gemälde, Aquarelle, und Zeichnungen, französischer Meister des XIX. Jahrhunderts. Exh. cat. Hugo Perls, Berlin; 1925. Berlin, 1925.

Berlin and other cities 1996–97
Aristide Maillol. Exh. cat. edited by Ursel Berger and Jörg Zutter. Georg-Kolbe Museum, Berlin; Musée Cantonal des Beaux-Arts, Lausanne; Gerhard-Marcks-Haus, Bremen; Städtische Kunsthalle, Mannheim; 1996–97. Munich, 1996.

Berlin–Munich 1996–97
Manet bis Van Gogh: Hugo von Tschudi und der Kampf um die Moderne. Exh. cat. edited by Johann Georg Prinz von Hohenzollern and Peter-Klaus Schuster. Nationalgalerie, Staatliche Museen zu Berlin; Neue Pinakothek, Bayerische Staatsgemäldesammlungen, Munich; 1996–97. Munich and New York, 1996.

Berman 1970
Greta Berman. "The Paradox of Odilon Redon." *Konsthistorisk tidskrift* 39, no. 1–2 (May 1970), pp. 70–79.

Bernard 1907 (2001 ed.)
Émile Bernard. "Souvenirs sur Paul Cézanne et lettres inédites," parts 1, 2. *Mercure de France*, October 1, 16, 1907. Translated in Doran 2001, pp. 50–79.

Bernier 1991
Georges Bernier. *La Revue blanche.* Paris, 1991.

Bessonova and Georgievskaia 2001
Marina Aleksandrovna Bessonova and Eugenia Georgievskaia. *France, Second Half, XIX–XX Century, Collection of Paintings: State Pushkin Museum of Fine Arts.* Moscow, 2001.

Bidou 1911
Henry Bidou. "Petites Expositions: Exposition Picasso (Galerie Vollard)." *La Chronique des arts,* January 14, 1911, p. 11.

Billeter 2001
Felix Billeter. "Zwischen Kunstgeschichte und Industriemanagement: Eberhard von Bodenhausen als Sammler Neoimpressionistischer Malerei." In Pophanken und Billeter 2001, pp. 125–47.

Billy 1945
André Billy. *La Terrasse du Luxembourg.* 7th ed. Paris, 1945.

Binoche Sale 2004
Importantes Sculptures d'Aristide Maillol et de Pablo Picasso, tableaux modernes et contemporains, meuble et objet d'art. Sale cat., Maître Binoche (Firm), Hôtel Drouot, Paris, July 2, 2004. "Découvert d'une collection" (pp. 28–29) and "Les Statuettes de Maillol, matrice d'une oeuvre capital du XXᵉ siècle: Une Ensemble exceptionnel" (pp. 30–33), by Élisabeth Lebon.

Bismarck 1988
Beatrice von Bismarck. "Harry Graf Kessler und die französische Kunst um die Jahrhundertwende." *Zeitschrift des Deutschen Vereins für Kunstwissenschaft* 42, no. 3 (1988), pp. 47–62.

Black and Moorhead 1992
Peter Black and Désirée Moorhead. *The Prints of Stanley William Hayter: A Complete Catalogue.* Mount Kisco, N.Y., 1992.

Blanche 1929
Jacques-Émile Blanche. "L'Illustration des livres."
L'Art vivant 5, no. 120 (December 15, 1929), p. 1002.

Bloch 1971–79
Georges Bloch. *Pablo Picasso.* 4 vols. Bern, 1971–79.

Blot 1934
Eugène Blot. *Histoire d'une collection de tableaux modernes: 50 ans de peinture (de 1882 à 1932).* Paris, 1934.

Bodelsen 1964
Merete Bodelsen. *Gauguin's Ceramics: A Study in the Development of His Art.* London, 1964.

Bodelsen 1967
Merete Bodelsen. "Gauguin Studies." *Burlington Magazine* 109 (April 1967), pp. 216–27.

Bodelsen 1968
Merete Bodelsen. "Early Impressionist Sales, 1874–94, in Light of Some Unpublished 'Procès-Verbaux.'" *Burlington Magazine* 110 (June 1968), pp. 331–49.

Bonn and other cities 1992–94
Kleinplastiken des 19. Jahrhunderts aus der Sammlung der Nationalgalerie. Exh. cat. by Bernhard Maaz. Wissenschaftszentrum, Bonn; and four other institutions in Germany; 1992–94. Berlin, 1992.

"Books for Holidays" 1936
"Books for Holidays; Successes of the Year." *The Times* (London), July 24, 1936, p. 9.

Bordeaux 1985
Odilon Redon, 1840–1916. Exh. cat. by Roseline Bacou. Galerie des Beaux-Arts, Bordeaux; 1985. Bordeaux, 1985.

Bordeaux 1996
Figures d'ombres: Les Dessins de Auguste Rodin. Exh. cat. Musée Goupil, Bordeaux; 1996. Paris, 1996.

Bouillon 1993
Jean-Paul Bouillon. *Maurice Denis.* Geneva, 1993.

Bouillon 1997
Jean-Paul Bouillon. "Le Modèle Cézannienne de Maurice Denis." In *Cézanne aujourd'hui: Actes du colloque organisé par le Musée d'Orsay, 29 et 30 novembre 1995,* edited by Françoise Cachin, Henri Loyrette, and Stéphane Guégan, pp. 145–64. Paris, 1997.

Bouillon 1998
Jean-Paul Bouillon. "Maurice Denis: Four Stages in the History of French Landscape, 1889–1914." In *Framing France: The Representation of Landscape in France, 1870–1914,* edited by Richard Thomson, pp. 119–46. Manchester, 1998.

Bouvet 1981
Francis Bouvet. *Bonnard: The Complete Graphic Work.* Introduction by Antoine Terrasse; translated by Jane Brenton. New York, 1981.

Bowness 1995
Sophie Bowness. "The Presence of the Past: Art in France in the 1930s, with Special Reference to Le Corbusier, Léger and Braque." Ph.D. diss., Courtauld Institute, London, 1995.

Bowness 2000
Sophie Bowness. "Braque's Etchings for Hesiod's 'Theogony' and Archaic Greece Revived." *Burlington Magazine* 142 (April 2000), pp. 204–14.

Braque et al. 1935
Georges Braque, Eugene Jolas, Maria Jolas, Henri Matisse, André Salmon, and Tristan Tzara. "Testimony against Gertrude Stein." *Transition,* no. 23 (February 1935), suppl., pamphlet no. 1.

Brassaï 1964
Brassaï [Gyula Halász]. *Conversations avec Picasso.* Paris, 1964.

Brassaï 1982
Brassaï [Gyula Halász]. *The Artists of My Life.* Translated from the French by Richard Miller. London, 1982.

Brassaï 1999
Brassaï [Gyula Halász]. *Conversations with Picasso.* Translated from the French by Jane Marie Todd. Paris, 1999.

Breazeale 1929
Elizabeth Breazeale. "Your Semester's Leave in France." *Modern Language Journal* 13, no. 5 (February 1929), pp. 360–63.

Breeskin 1979
Adelyn Dohme Breeskin. *Mary Cassatt: A Catalogue Raisonné of the Graphic Work.* 2d ed. Washington, D.C., 1979.

Bremen 1965
Ker-Xavier Roussel, 1867–1944: Gemälde, Handzeichnungen, Druckgraphik. Exh. cat. Kunsthalle Bremen; 1965. Bremen, 1965.

Bremen 1993
Die Skulpturen in der Kunsthalle Bremen. Exh. cat. by Ursula Heiderich. Kunsthalle Bremen; 1993. Bremen, 1993.

Breunig 1958
Leroy C. Breunig. "Studies on Picasso." *College Art Journal* 17, no. 2 (winter 1958), pp. 188–95.

Breunig 2001
Guillaume Apollinaire. *Apollinaire on Art: Essays and Reviews, 1901–1918.* Edited by Leroy C. Breunig. Translated by Susan Suleiman. Boston, 2001.

Brown 1963
Milton W. Brown. *The Story of the Armory Show.* N.p.: Joseph H. Hirschhorn Foundation, 1963.

Bruller 1931
Jean Bruller. "Le Livre d'art en France: Essai d'un classement rationnel." *Arts et métiers graphiques,* no. 26 (November 15, 1931), pp. 41–66. Special issue, *Le Livre d'art international.*

Bruller 1932
Jean Bruller. "L'Oeil du bibliophile." *Arts et métiers graphiques,* no. 27 (January 15, 1932), pp. 35–39.

Bruller 1937
Jean Bruller. "Évolution du livre de collectionneur de 1919 à nos jours." *Arts et métiers graphiques,* no. 59 (1937), pp. 31–36. Special issue, *Les Arts et les techniques graphiques.*

Brussels 1894
Catalogue de la première exposition. La Libre Esthétique. Exh. cat. Brussels, 1894.

Brussels 1897
Catalogue de la quatrième exposition. La Libre Esthétique. Exh. cat. Brussels, 1897.

Brussels 1933
Les Éditions: Ambroise Vollard. Exh. cat. Palais des Beaux-Arts, Brussels; 1933. Brussels, 1933.

Busch 1970
Günter Busch. *Aristide Maillol als Illustrator.* Neu-Isenburg, 1970.

Busch and Reinken 1983
Günter Busch and Liselotte von Reinken, eds. *Paula Modersohn-Becker: The Letters and Journals.* Translated and edited by Arthur S. Wensinger and Carole Clew Hoey. New York, 1983.

Cachin 1988
Françoise Cachin. *Gauguin.* Paris, 1988.

Cahen Sale 1929
Tableaux modernes par Bellangé, Bonington, Chaplin, Corot, Daubigny, Fantin Latour, Guillaumin, Isabey, Lebasque, Lebourg, Pissarro, Raffaëlli, H. Regnault, Ribot, Ricard, Rouget, Sisley, Tassaert, Ziem. Sale cat., Galerie Georges Petit, Paris, May 24, 1929.

Cahn 1996
Isabelle Cahn. "Chronology." In Paris–London–Philadelphia 1995–96, pp. 527–69.

Cahn 1997
Isabelle Cahn. "L'Exposition Cézanne chez Vollard en 1895." In *Cézanne aujourd'hui: Actes du colloque organisé par le Musée d'Orsay, 29 et 30 novembre 1995,* edited by Françoise Cachin, Henri Loyrette, and Stéphane Guégan, pp. 135–44. Paris, 1997.

Cailler 1968
Pierre Cailler. *Catalogue raisonné de l'oeuvre gravé et lithographié de Maurice Denis.* Geneva, 1968.

Cailler 2000
Pierre Cailler. *Catalogue raisonné de l'oeuvre gravé et lithographié de Maurice Denis.* New ed. Reprint of 1968 text with color reproductions. San Francisco, 2000.

Cain 1960
Julien Cain. *The Lithographs of Chagall.* Introduction by Marc Chagall; notes and catalogue by Fernand Mourlot; translated by Maria Jolas. Monte Carlo and London, 1960.

Cambridge–Chicago–Philadelphia 1981
Master Drawings by Picasso. Exh. cat. by Gary Tinterow. Fogg Art Museum, Harvard University, Cambridge, Massachusetts; Art Institute of Chicago; and Philadelphia Museum of Art; 1981. Cambridge, Mass., 1981.

Camo 1950
Pierre Camo. *Maillol mon ami.* Lausanne, 1950.

Capdevila 1928
Carles Capdevila. "Modern Catalan Art in the Plandiura Collection." *Gaseta de les arts* 1, no. 2 (October 1928), pp. 7–11.

"Le Carnet des ateliers" 1927
"Le Carnet des ateliers: Georges Rouault." *Carnet de la semaine,* [May] 1927, p. 10.

Cary 1932
Elisabeth Luther Cary. "Some Illustrated Books." *New York Times,* July 24, 1932, sect. 8, p. XX7.

Cassou 1930
Jean Cassou. "La Fontaine et Marc Chagall." *L'Art vivant* 6 (1930), pp. 198–99.

Cassou 1935
Jean Cassou. "Bonnard." *Arts et métiers graphiques,* no. 46 (April 15, 1935), pp. 9–18.

Cassou 1946
Jean Cassou. "Rouault vs. Vollard." *Art News* 45, no. 9 (November 1946), p. 42.

Cassou 1947
Jean Cassou. "Rouault." *Art News* 46 (May 1947), p. 52.

Castleman 1986
Riva Castleman. "The Prints of Matisse." In *Matisse Prints from the Museum of Modern Art,* pp. 5–16. Exh. cat. Fort Worth Art Museum, Fort Worth, Texas; Art Museum of South Texas, Corpus Christi; Winnipeg Art Gallery, Winnipeg, Manitoba; and other venues; 1986–88. Organized by the Museum of Modern Art, New York. Fort Worth and New York, 1986.

***Catalogue des tableaux modernes* 1895**
Catalogue des tableaux modernes et anciens parmi lesquels on remarque dans l'École Moderne des oeuvres de Barye, Bergeret, Boudin, Chassériau [...] Dumas. Sale cat., Hôtel Drouot, Paris, June 18, 1895.

Céret–Le Cateau-Cambrésis 2005–6
Matisse—Derain, Collioure 1905: Un Été fauve. Exh. cat. by Jack Flam et al. Musée d'Art Moderne, Céret; Musée Matisse, Le Cateau-Cambrésis; 2005–6. Paris, 2005.

Certigny 1984
Henry Certigny. *Le Douanier Rousseau en son temps: Biographie et catalogue raisonné.* 2 vols. Tokyo, 1984.

"Cezanne Pictures and Vollard Visit America" 1936
"Cezanne Pictures and Vollard Visit America." *Art Digest* 11, no. 4 (November 16, 1936), p. 7.

Chabanne 1985
Thierry Chabanne. "Picasso illustre . . . illustre Picasso." In *Autour du Chef-d'oeuvre inconnu de Balzac,* pp. 99–127. Paris, 1985.

Chapon 1979
François Chapon. "Ambroise Vollard, éditeur." *Gazette des beaux-arts,* ser. 6, 94 (July–August 1979), pp. 33–47.

Chapon 1980
François Chapon. "Ambroise Vollard, éditeur." *Gazette des beaux-arts,* ser. 6, 95 (January 1980), pp. 25–38.

Chapon 1987
François Chapon. *Le Peintre et le livre: L'Âge d'Or du livre illustré en France, 1870–1970.* Paris, 1987.

Chapon 1992
François Chapon. *Le Livre des livres de Rouault.* [Paris and Monaco], 1992.

Chapon and I. Rouault 1978
François Chapon and Isabelle Rouault, with Olivier Nouaille Rouault. *Rouault: Oeuvre gravé.* 2 vols. Monte Carlo, 1978.

Chevillot 2005
Catherine Chevillot. "'Prenez la main que je vous tends': Eugène Blot, du milieu des fabricants de bronze à celui des galeries." In *Camille Claudel et Rodin: La Rencontre de deux destins,* by Odile Avral-Clause et al., pp. 260–73. Exh. cat. Musée National des Beaux-Arts, Quebec; Detroit Institute of Arts; Fondation Pierre Gianadda, Martigny; 2005–6. Paris and Quebec, 2005.

Chicago 1995
Claude Monet, 1840–1926. Exh. cat. by Charles F. Stuckey. Art Institute of Chicago; 1995. Chicago, 1995.

Chicago–Amsterdam 2001–2
Van Gogh and Gauguin: The Studio of the South. Exh. cat. by Douglas W. Druick and Peter Kort Zegers, with Britt Salvesen; contributions by Kristin Hoermann Lister and Mary C. Weaver. Art Institute of Chicago; Van Gogh Museum, Amsterdam; 2001–2. Chicago and New York, 2001.

Chicago–Amsterdam–London 1994–95
Odilon Redon: Prince of Dreams, 1840–1916. Exh. cat. by Douglas W. Druick et al. Art Institute of Chicago; Van Gogh Museum, Amsterdam; Royal Academy of Arts, London; 1994–95. London and New York, 1994.

Chicago–Boston–Washington 1998–99
Mary Cassatt: Modern Woman. Exh. cat. organized by Judith A. Barter, with contributions by Erica E. Hirshler et al. Art Institute of Chicago; Museum of Fine Arts, Boston; National Gallery of Art, Washington, D.C.; 1998–99. New York, 1998.

Chicago–New York 2001
Beyond the Easel: Decorative Painting by Bonnard, Vuillard, Denis, and Roussel, 1890–1930. Exh. cat. by Gloria Groom; essay by Nicholas Watkins; contributions by Jennifer Paoletti and Thérèse Barruel. Art Institute of Chicago; The Metropolitan Museum of Art, New York; 2001. Chicago and New Haven, 2001.

Chimirri 1998
Lucia Chimirri, ed. *Catalogo completo dei libri illustrati dell'editore Ambroise Vollard.* Florence, 1998. Published to accompany an exhibition held at the Biblioteca di via Senato, Milan; Gabinetto G. P. Vieusseux, Florence; Villa Pacchiani, Santa Croce sull'Arno; 1998.

Chivot 2003
Mathias Chivot. "Chronology." In Salomon and Cogeval 2003, vol. 3, pp. 1641–44.

Chlomovitch Sale 1981
Collection Erich Chlomovitch, provenance Ambroise Vollard: Remarquable Ensemble d'estampes originales de peintres, manuscrits, autographes d'artistes, très importants tableaux et dessins modernes. Sale cat., Hôtel Drouot, Paris, March 19–20, 1981.

"Chronique des ventes" 1927
G. H. T. "Chronique des ventes." *Plaisir de bibliophile* 3 (1927), pp. 117–23.

Ciaffa 1985
Patricia Ciaffa. "The Portraits of Édouard Vuillard." Ph.D. diss., Columbia University, New York, 1985.

Cifka 1983
Brigitta Cifka. "Lettre inédite de Maillol à József Rippl-Rónai." *Bulletin du Musée Hongrois des Beaux-Arts* (Budapest), nos. 60–61 (1983), pp. 151–57.

Çil 2000
Sakine Çil. "Matisse's Ceramics." *Ceramics: Art and Perception* 42 (2000), pp. 80–83.

"5,000 Chefs-d'oeuvre de la collection Ambroise Vollard ont disparu" 1948
"5,000 Chefs-d'oeuvre de la collection Ambroise Vollard ont disparu: La Justice demande des comptes au frère du collectionneur" (5,000 Masterpieces of the Ambroise Vollard Collection Have Disappeared: Justice Demands an Accounting from the Collector's Brother). *France-Soir,* March 23, 1948.

Cirici 1946
Alexandre Cirici. *Picasso antes de Picasso.* Barcelona, 1946. French ed., *Picasso avant Picasso.* Translated by Marguerite de Floris and Ventura Gasol. Geneva, 1950.

Cladel 1937
Judith Cladel. *Aristide Maillol: Sa Vie—son oeuvre —ses idées.* Paris, 1937.

Cladel 1941
Judith Cladel. "Aristide Maillol." *Valeurs françaises,* 1941, pp. 3–7.

Claverie et al. 2002
Jana Claverie et al., eds. *Vincenc Kramář: Un Théoricien et collectionneur du Cubisme à Prague.* Paris, 2002. Selective translation of Prague–Paris 2000–2002.

Clément-Janin 1925
Clément-Janin. "Exposition Internationale des Arts Décoratifs: Le Livre et ses éléments." *L'Art vivant* 1, no. 16 (August 15, 1925), pp. 26–32.

Clouzot 1922
Henri Clouzot. *André Metthey, décorateur et céramiste.* Paris, [1922].

Coe 1960
Ralph T. Coe. "Letters: Cézanne's 'La Maison abandonnée.'" *Burlington Magazine* 102 (July 1960), p. 329.

Collet 1989
Georges-Paul Collet. *Correspondance Jacques-Émile Blanche—Maurice Denis (1901–1939).* Geneva, 1989.

Cologne–Hannover–Darmstadt 1974–75
Französische Keramik zwischen 1850 und 1900: Sammlung Maria und Hans-Jörgen Heuser, Hamburg. Exh. cat. by Hans-Jörgen Heuser. Kunstgewerbemuseum der Stadt Köln; Kestner-Museum, Hannover; Hessisches Landesmuseum Darmstadt; 1974–75. Munich, 1974.

Compton 1990
Susan Compton. *Marc Chagall: My Life—My Dream. Berlin and Paris, 1922–1940.* Originally published in German as a catalogue for an exhibition held at the Wilhelm-Hack-Museum, Ludwigshafen am Rhein, 1990. Munich, 1990.

Copenhagen 1893
Fortegnelse over kunstvaerkerne paa des Frie udstilling 1893. Exh. cat. Copenhagen, 1893.

Copenhagen 1914
Exposition d'art français du XIXᵉ siècle. Dansk Kunstmuseums Forening, Copenhagen, 1914; traveled to Oslo and Stockholm. Copenhagen, 1914.

Copenhagen 1956
Fra Renoir til Villon: Franske malereir og tegninger udlaant fra Ragnar Moltzaus samling, Oslo. Exh. cat. Ny Carlsberg Glyptotek, Copenhagen; 1956. Copenhagen, 1956.

Coquiot 1914
Gustave Coquiot. *Cubistes, futuristes, passéistes: Essai sur la jeune peinture et la jeune sculpture.* 2nd ed. Paris, 1914.

Courbet Sale 1919
Catalogue des tableaux, études et dessins par Gustave Courbet et provenant de son atelier. Sale cat., Galerie Georges Petit, Paris, July 9, 1919. Annotated catalogue, collection of the Frick Art Reference Library, New York.

Courthion 1930
Pierre Courthion. "Chagall et les 'Fables.'" *Cahiers d'art* 4, no. 5 (1930), pp. 215–21.

Courthion 1951
Pierre Courthion. *Raoul Dufy.* Peintres et sculpteurs d'hier et d'aujourd'hui, 19; Les Grandes Monographies, 1. Geneva, 1951.

Crochet 1971
Bernard Crochet. "Histoire de la Galerie Druet et de ses archives photographiques." Unpublished memoir from École du Louvre, Paris, 1971.

Dagen 1994
Philippe Dagen, ed. *André Derain: Lettres à Vlaminck; suivies de la correspondance de guerre.* Paris, 1994.

Daix 1977
Pierre Daix. *La Vie de peintre de Pablo Picasso.* Paris, 1977.

Daix 1993
Pierre Daix. *Picasso: Life and Art.* Translated by Olivia Emmet. New York, 1993. First published in French as *Picasso créateur* (Paris, 1987).

Daix 1995
Pierre Daix. *Dictionnaire Picasso.* Paris, 1995.

Daix and Boudaille 1967
Pierre Daix and Georges Boudaille. *Picasso: The Blue and Rose Periods; A Catalogue Raisonné of the Paintings, 1900–1906.* Translated from the 1966 French ed. by Phoebe Pool; texts revised by Pierre Daix. Greenwich, Conn., 1967.

Daix and Rosselet 1979
Pierre Daix and Joan Rosselet. *Picasso: The Cubist Years, 1907–1916.* Translated by Dorothy S. Blair. Boston, 1979.

Danielsson 1964
Bengt Danielsson. "När Gauguin censurerades i Stockholm." *Svenska Dagbladet,* November 11, 1964.

Danielsson 1975
Bengt Danielsson. *Gauguin à Tahiti et aux Îles Marquises.* French ed. revised by Marie-Thérèse Danielsson. Papeete, 1975.

G.-P. Dauberville and M. Dauberville 1995
Guy-Patrice Dauberville and Michel Dauberville. *Matisse: Henri Matisse chez Bernheim-Jeune.* 2 vols. Paris, 1995.

J. Dauberville and H. Dauberville 1966–74
Jean Dauberville and Henry Dauberville. *Bonnard: Catalogue raisonné de l'oeuvre peint.* 4 vols. Paris, 1966–74.

J. Dauberville and H. Dauberville 1992
Jean Dauberville and Henry Dauberville. *Bonnard: Catalogue raisonné de l'oeuvre peint.* Vol. 1, *1888–1905.* 2nd ed., revised and augmented by Michel Dauberville and Guy-Patrice Dauberville. Paris, 1992.

Daulte 1971
François Daulte. *Auguste Renoir: Catalogue raisonné de l'oeuvre peint.* Foreword by Jean Renoir; preface by Charles Durand-Ruel. Vol. 1. Lausanne, 1971.

Degas Atelier Sale I 1918
Catalogue des tableaux, pastels et dessins par Edgar Degas et provenant de son atelier. Sale cat., Galerie Georges Petit, Paris, May 6–8, 1918.

Degas Atelier Sale II 1918
Catalogue des tableaux, pastels et dessins par Edgar Degas et provenant de son atelier. Sale cat., Galerie Georges Petit, Paris, December 11–13, 1918.

Degas Atelier Sale III 1919
Catalogue des tableaux, pastels et dessins par Edgar Degas et provenant de son atelier. Sale cat., Galerie Georges Petit, Paris, April 7–9, 1919.

Degas Atelier Sale IV 1919
Catalogue des tableaux, pastels et dessins par Edgar Degas et provenant de son atelier. Sale cat., Galerie Georges Petit, Paris, July 2–4, 1919.

Degas Collection Sale I 1918
Catalogue des tableaux modernes et anciens: Aquarelles—pastels—dessins . . . composant la collection Edgar Degas. Sale cat., Galerie Georges Petit, Paris, March 26–27, 1918.

Degas Collection Sale II 1918
Catalogue des tableaux modernes: Pastels, aquarelles, dessins, anciens et modernes . . . faisant partie de la collection Edgar Degas. Sale cat., Hôtel Drouot, Paris, November 15–16, 1918.

Degas Print Collection Sale 1918
Catalogue des estampes anciennes et modernes . . . composant la collection Edgar Degas. Sale cat., Hôtel Drouot, Paris, November 6–7, 1918.

Degas Print Sale 1918
Catalogue des eaux-fortes, vernis-mous, aqua-tintes, lithographies et monotypes par Edgar Degas et provenant de son atelier. Sale, Galerie Manzi-Joyant, November 22–23, 1918.

Delteil 1919
Loys Delteil. *Le Peintre-graveur illustré (XIXᵉ et XXᵉ siècles).* Vol. 9, *Edgar Degas.* Paris, 1919.

Denis 1905a
Maurice Denis. "De Gauguin, de Whistler et de l'excès de théories." *L'Ermitage, revue mensuelle de littérature et d'art,* November 15, 1905.

Denis 1905b (1993 ed.)
Maurice Denis. "La Peinture." *L'Ermitage,* no. 11 (November 15, 1905), pp. 309–19. Reprinted in Maurice Denis, *Le Ciel et l'Arcadie,* edited by Jean-Paul Bouillon (Paris, 1993), pp. 84–99.

Denis 1907 (1912 ed.)
Maurice Denis. "Cézanne." *L'Occident* 12 (September 1907), pp. 118–33. Reprinted in Maurice Denis, *Théories, 1890–1912: Du symbolisme et de Gauguin vers un nouvel ordre classique,* pp. 237–53. Paris, 1912.

Denis 1912 (1993 ed.)
Maurice Denis. "Hommage à Odilon Redon." *La Vie,* November 30, 1912, p. 129. Quoted in Zürich–Paris 1993.

Denis 1934
Maurice Denis. "L'Époque du Symbolisme." *Gazette des beaux-arts,* ser. 6, 11 (March 1934), pp. 163–79.

Denis 1943
Maurice Denis. "Maillol et les Nabis." *Aristide Maillol, Cahiers Comoedia-Charpentier,* November 1943, pp. 8–12.

Denis 1957–59
Maurice Denis. *Journal.* 3 vols. Paris, 1957–59.

Denoinville 1895
Georges Denoinville. "Un Comblé." *Le Journal des artistes . . . ,* December 1, 1895, p. 1258.

Denvir 1993
Bernard Denvir. *The Chronicle of Impressionism: A Timeline History of Impressionist Art.* Boston, 1993.

Dévigne 1929–30
Roger Desvignes [sic]. "L'Architecture du livre et les recherches contemporaines: Construction et décoration des livres d'art (de 1897 à 1930)," parts 1, 2. *L'Art vivant* 5, no. 120 (December 15, 1929), pp. 983–84; 6, no. 121 (January 1, 1930), pp. 13–14.

Dévigne 1936
Roger Dévigne. "La Lettre et le décor du livre pendant la période 1880–1905." *Arts et métiers graphiques,* no. 54 (August 15, 1936), pp. 53–56.

Dévigne 1937
Roger Dévigne. "Les Décorateurs, les illustrateurs du beau livre, suite." *Arts et métiers graphiques,* no. 59 (1937), pp. 40–48. Special issue, *Les Arts et les techniques graphiques.*

Devoize 2001
Jean-Louis Devoize. "L'Hypersomnie d'Ambroise Vollard, marchand d'art et éditeur d'exception." *Revue du praticien,* no. 51 (2001), pp. 2061–65.

Diffre and Lesieur 2004
Suzanne Diffre and Marie-Josèphe Lesieur. "Gauguin in the Vollard Archives." In Paris–Boston 2003–4, pp. 305–11, 339.

Diolé 1931
Philippe Diolé. "Mme Jeanne Walter, éditeur d'art." *Beaux-Arts* 9, no. 1 (January 1931), p. 15.

Di San Lazzaro 1935
G. Di San Lazzaro. "Ambroise Vollard." *Emporium* 82, no. 492 (December 1935), pp. 304–13.

Distel 1989
Anne Distel. *Les Collectionneurs des impressionnistes, amateurs et marchands.* [Paris], 1989.

Distel 2001
Anne Distel. "Portrait of Paul Signac: Yachtsman, Writer, Indépendant, and Revolutionary." In Paris–Amsterdam–New York 2001, pp. 37–50.

Doran 2001
Michael Doran, ed. *Conversations with Cézanne.* Translated by Julie Lawrence Cochran. Documents of Twentieth-Century Art. Berkeley, 2001.

Dorival and I. Rouault 1988
Bernard Dorival and Isabelle Rouault. *Rouault: L'Oeuvre peint.* 2 vols. Monte Carlo, 1988.

Dormoy 1922
Marie Dormoy. "Un Grand Artiste d'hier: André Metthey." *La Grande Revue,* June 1922, pp. 684–89.

Dormoy 1926
Marie Dormoy. "Die Cézanne-Ausstellung bei Bernheim Jeune." *Kunst und Künstler* 24 (1926), pp. 447–49.

Dormoy 1930
Marie Dormoy. "Die Cézanne-Ausstellung im Théâtre Pigalle." *Kunst und Künstler* 27 (1930), pp. 247–50.

Dormoy 1931
Marie Dormoy. "Ambroise Vollard's Private Collection." *Formes,* no. 17 (September 1931), pp. 112–13.

Dormoy 1935
Marie Dormoy. "Georges Rouault." *Arts et métiers graphiques,* no. 48 (August 15, 1935), pp. 23–30.

Dormoy 1936
Marie Dormoy. "Les Monotypes de Degas." *Arts et métiers graphiques,* no. 51 (February 15, 1936), pp. 33–38.

Dormoy 1936a
Marie Dormoy. "Maillol." *Arts et métiers graphiques,* no. 55 (November 1, 1936), pp. 37–41.

Dormoy 1939
Marie Dormoy. "Cirque de l'étoile filante de Georges Rouault." *Arts et métiers graphiques,* no. 68 (May 15, 1939), pp. 35–40.

Dormoy 1943
Marie Dormoy. "Ambroise Vollard." Unpublished text of lecture given to the Société d'Histoire et d'Archéologie des VIIᵉ et XVᵉ arrondissements de Paris, January 16, 1943. Institut d'Art et d'Archéologie, Paris, MS BXXVIII, pp. 23172–84.

Dormoy 1963
Marie Dormoy. "Ambroise Vollard." In Marie Dormoy, *Souvenirs et portraits d'amis,* pp. 136–63. Paris, 1963.

Dorn 1990
Roland Dorn. "The Artistic Reception of Vincent van Gogh's Work: Prologue." In *Vincent van Gogh and the Modern Movement, 1890–1914,* pp. 189–91. Exh. cat. edited by Inge Bodesohn-Vogel; translated by Eileen Martin. Museum Folkwang Essen; Van Gogh Museum, Amsterdam; 1990. Freren, 1990.

Dorn 1990a
Roland Dorn. *Décoration: Vincent van Goghs Werkreihe für das Gelbe Haus in Arles.* Studien zur Kunstgeschichte, vol. 45. Hildesheim, 1990.

Dorn 1999
Roland Dorn. "Van Gogh's *Sunflowers* Series: The Fifth Toile de 30." *Van Gogh Museum Journal,* 1999, pp. 42–61.

Dorra 1994
Henri Dorra, ed. *Symbolist Art Theories: A Critical Anthology.* Berkeley, 1994.

Dortmund 1991
Pierre Auguste Renoir: Photographien aus seinem privaten Leben / Photographies de sa vie privée. Exh. cat. by Paul Renoir. Dortmund: Grafische Kabinett-Galerie Utermann, 1991.

Dreyfuss 1926
Albert Dreyfuss. "Ein Besuch bei Aristide Maillol." *Kunst und Künstler* 25, no. 3 (December 1, 1926), pp. 83–86.

Druick 1977
Douglas W. Druick. "Cézanne's Lithographs." In New York–Houston 1977–78, pp. 119–37.

Druick 1995
Douglas W. Druick. "Still Lifes." In Paris–Chicago–Los Angeles 1995, pp. 232–37.

Druick and Zegers 1994
Douglas W. Druick and Peter Kort Zegers. "In the Public Eye." In Chicago–Amsterdam–London 1994–95, pp. 120–74, 395–402.

D'Souza 2004
Aruna D'Souza. "Paul Cézanne, Claude Lantier, and Artistic Impotence." *Nineteenth-Century Art Worldwide* 3, no. 2 (autumn 2004). http://19thc-artworldwide.org.

Ducrey 1991
Marina Ducrey. "Vallotton's Secret Garden: Observations on the Artist as Draftsman." In New Haven and other cities 1991–93, pp. 213–33.

Ducrey 2005
Marina Ducrey, with the collaboration of Katia Poletti. *Félix Vallotton, 1865–1925: L'Oeuvre peint.* 3 vols. Lausanne, 2005.

Den Dulk 1895
E. den Dulk. "Tentoonstellingwerken Vincent van Gogh." *De kunstwereld* 24 (June 1895), p. 384.

Dunoyer de Segonzac 1965
Dunoyer de Segonzac. "Pourquoi j'ai choisi Les Géorgiques." In Aimée Lioré and Pierre Cailler, *Catalogue de l'oeuvre gravé de Dunoyer de Segonzac,* vol. 5, pp. 11–14. Catalogues d'oeuvres gravés et lithographiés. Geneva, 1965.

Durand-Ruel 1939
Paul Durand-Ruel. "Mémoires." In Venturi 1939, vol. 2, pp. 143–220.

Easton 2002
Laird McLeod Easton. *The Red Count: The Life and Times of Harry Kessler.* Berkeley, 2002.

Eckermann 2003
Elise Eckermann. *"En lutte contre une puissance formidable": Paul Gauguin im Spannungsfeld von Kunstkritik und Kunstmarkt.* Weimar, 2003.

Edwards 1942
Hugh Edwards. "Redon, Flaubert, Vollard." *Bulletin of the Art Institute of Chicago* 36, no. 1 (January 1942), pp. 4–6.

Eisenman 1992
Stephen F. Eisenman. *The Temptation of Saint Redon: Biography, Ideology, and Style in the Noirs of Odilon Redon.* Chicago, 1992.

Elder 1924
Marc Elder. *À Giverny chez Claude Monet.* Paris, 1924.

Elgar 1952
Frank Elgar. "Les Fables de La Fontaine par Marc Chagall." *Carrefour* (Paris) 7, no. 394 (April 2, 1952), p. 8.

Ely 2003
Bruno Ely. "The Studio in the Days of Marcel Provence." In *Atelier Cézanne, 1902–2002: Le Centenaire,* pp. 79–117. Aix-en-Provence, [2002]. English translation, 2003.

Espezel 1931
Pierre d'Espezel. "M. Ambroise Vollard, éditeur." *Beaux-Arts* 9, no. 2 (February 1931), p. 19.

Essen 2004–5
Cézanne and the Dawn of Modern Art. Exh. cat. edited by Felix A. Baumann, Walter Feilchenfeldt, and Hubertus Gassner; translated by Melissa Thorson Hause. Museum Folkwang Essen; 2004–5. Essen, 2004.

Essen–Amsterdam 1990
Vincent Van Gogh and the Modern Movement, 1890–1914. Exh. cat. edited by Georg-W. Költzsch, Ronald de Leeuw, and Inge Bodesohn-Vogel; contributions by Roland Dorn et al. Translation of *Vincent van Gogh und die Moderne,* by Eileen Martin. Museum Folkwang Essen; Van Gogh Museum, Amsterdam; 1990–91. Freren, 1990.

Essen–Moscow–St. Petersburg 1993–94
Morosow und Schtschukin, die russischen Sammler: Monet bis Picasso. Exh. cat. edited by Georg-W. Költzsch, with contributions by Marina Bessonova et al. Museum Folkwang Essen; Pushkin Museum, Moscow; State Hermitage Museum, St. Petersburg; 1993–94. Cologne, 1993. Also published in English.

"Expositions" 1927
"Les Expositions: Petits Salons." *Plaisir de biblio-phile* 3 (1927), pp. 230–31.

"Expositions nouvelles" 1898
"Expositions nouvelles." *La Chronique des arts,* April 2, 1898, p. 120.

"Expositions nouvelles" 1902
"Expositions nouvelles." *La Chronique des arts,* June 21, 1902, p. 196.

"Expositions nouvelles" 1906
"Expositions nouvelles." *La Chronique des arts,* April 7, 1906, p. 112.

Fabiani 1976
Martin Fabiani. *Quand j'étais marchand de tableaux.* Paris, 1976.

Fagus 1899
Félicien Fagus. "Petite Gazette d'art: Quarante Tableaux de Cézanne." *La Revue blanche* 20 (December 15, 1899), pp. 627–28.

Fagus 1901
Félicien Fagus. "Gazette d'art. L'Invasion espag-nole: Picasso." *La Revue blanche,* July 15, 1901, pp. 464–65.

Fagus 1902a
Félicien Fagus. "Durio, Becquet, Maillol, etc." *La Revue blanche,* January 1902, p. 65.

Fagus 1902b
Félicien Fagus. "Maillol." *La Revue blanche,* May–August 1902, pp. 550–51.

Fagus 1902c
Félicien Fagus. "L'Art de demain." *La Revue blanche,* December 1, 1902, pp. 542–46.

Faille 1970
J.-B. de la Faille. *The Works of Vincent van Gogh: His Paintings and Drawings.* New York, 1970.

Favre 1988
Yves-Alain Favre. "Les Noces de la nature et de l'esprit: La Poétique de Suarès." *Europe* (Paris) 66, no. 709 (May 1988), pp. 98–105.

Feilchenfeldt 1988
Walter Feilchenfeldt. *Vincent van Gogh and Paul Cassirer, Berlin: The Reception of Van Gogh in Germany from 1901 to 1914.* Catalogue of the draw-ings compiled by Han Veenenbos. Cahier Vincent, no. 2. Zwolle, 1988.

Feilchenfeldt 1995
Walter Feilchenfeldt. "The Early Reception of Cézanne's Work, with Emphasis on Its History in Germany." In Adriani 1995, pp. 293–312.

Feilchenfeldt 2006
Walter Feilchenfeldt. *By Appointment Only: Cézanne, Van Gogh and Some Secrets of Art Dealing.* London, 2006.

Fénéon 1889 (1970 ed.)
Félix Fénéon. "Tableaux: Exposition de M. Claude Monet . . . 5ᵉ Exposition de la Société des Artistes Indépendants." *La Vogue,* September 1889. Reprinted in Fénéon 1970, pp. 162–70.

Fénéon 1891 (1970 ed.)
Félix Fénéon. "Quelques Peintres idéistes." *Le Chat noir,* September 19, 1891. Reprinted in Fénéon 1970, pp. 200–202.

Fénéon 1920 (1970 ed.)
Félix Fénéon. "Les Grands Collectionneurs," parts I (Isaac de Camondo), 2 (M. Paul Durand-Ruel), and 3 (Ivan Morosoff). *Bulletin de la vie artistique,* April I, 15, and May 15, 1920. Reprinted in Fénéon 1970, pp. 345–52, 355–58**.** Geneva, 1970.

Fénéon 1970
Félix Fénéon. *Oeuvres plus que complètes.* Vol. I, *Chroniques d'art.* Edited by Joan U. Halperin. Geneva, 1970.

Fernier 1977–78
Robert Fernier. *La Vie et l'oeuvre de Gustave Courbet: Catalogue raisonné.* 2 vols. Lausanne, 1977–78.

Ferretti-Bocquillon 2001
Marina Ferretti-Bocquillon. "Signac as a Collector." In Paris–Amsterdam–New York 2001, pp. 51–66.

Field 1973
Paul Gauguin: Monotypes. Exh. cat. by Richard S. Field. Philadelphia Museum of Art; 1973. Philadelphia, 1973.

Fierens 1931
Paul Fierens. "Paris Letter." *Art News* 29 (January 17, 1931), p. 20.

FitzGerald 1992
Michael Cowan FitzGerald. "Skin Games." *Art in America* 80, no. 2 (February 1992), pp. 71–83, 139–41.

FitzGerald 1995
Michael Cowan FitzGerald. *Making Modernism: Picasso and the Creation of the Market for Twentieth-Century Art.* New York, 1995.

Flam 1973
Jack D. Flam, ed. *Matisse on Art.* London, 1973.

Flam 1986
Jack D. Flam. *Matisse: The Man and His Art, 1869–1918.* Ithaca, 1986.

Flam 1995
Jack D. Flam, ed. *Matisse on Art.* The Documents of Twentieth Century Art. Berkeley, 1995.

Fletcher 2003
Valerie J. Fletcher. "Process and Technique in Picasso's *Head of a Woman (Fernande).*" In *Picasso: The Cubist Portraits of Fernande Olivier,* edited by Jeffrey Weiss, pp. 165–91. Exh. cat. National Gallery of Art, Washington, D.C.; Nasher Sculpture Center, Dallas; 2003–4. Washington, D.C., 2003.

Fleuret 1928
Fernand Fleuret. "Raoul Dufy, illustrateur." *Arts et métiers graphiques,* no. 3 (February 1928), pp. 143–52.

Floury 1927
Jean Floury. "Essai de catalogue de l'oeuvre gravé et lithographié de Pierre Bonnard." In Terrasse 1927, pp. 187–99.

Fontainas 1897
André Fontainas. "Art." *Mercure de France,* May 1897, pp. 411–14.

Fontainas 1899
André Fontainas. "Art moderne." *Mercure de France,* January 1899, pp. 235–42.

Forest 1996
Dominique Forest. "Les Peintres et la céramique au tournant du siècle." In Nice–Bruges 1996, pp. 13–23.

Forest 2003
Dominique Forest. "Dufy, céramiste." In Le Havre–Céret–Roubaix 2003, pp. 33–37.

Forgione 1992
Nancy Ellen Forgione. "Édouard Vuillard in the 1890's: Intimism, Theater, and Decoration." Ph.D. diss., Johns Hopkins University, 1992.

Forthuny 1916
Pascal Forthuny. "L'Invitation de Barcelone aux artistes français." *Excelsior* 7 (March 11, 1916), p. 7.

Fox 1956
Milton S. Fox, ed. *Picasso for Vollard.* Translation of *Suite Vollard* by Norbert Guterman. New York, 1956.

Franklin 1990
Ursula Franklin. "Valéry's Degas and Rilke's Cézanne." In *Essays in European Literature for Walter A. Strauss,* edited by Alice N. Benston and Marshall C. Olds, pp. 125–46. Manhattan, Kans., 1990.

Frèches-Thory 2000
Claire Frèches-Thory. "De Gauguin à Maillol, un art nouveau: La Céramique entre peinture et sculp-ture, 1855–1907." In Marseille 2000, pp. 21–29.

Frèches-Thory 2004
Claire Frèches-Thory. "The Exhibition at Durand-Ruel." In Paris–Boston 2003–4, pp. 83–89, 319–20.

Frèches-Thory and Terrasse 1990
Claire Frèches-Thory and Antoine Terrasse. *Les Nabis.* Paris, 1990.

Freiburg–Essen–Salzburg 1999–2000
Französische Malerbücher von Bonnard bis Picasso aus der Sammlung Christa und Wolfgang Classen. Exh. cat. edited by Sybille Block, with contributions by Wolfgang Classen. Augustinermuseum Freiburg; Folkwangmuseum Essen; Rupertinum Salzburg; 1999–2000. Freiburg, 1999.

Frère 1956
Henri Frère. *Conversations de Maillol.* Geneva, 1956.

Fry 1917
Roger Fry. "'Paul Cézanne' by Ambroise Vollard: Paris, 1915." *Burlington Magazine* 31 (August 1917), pp. 52–61.

Gabory 1931
Georges Gabory. "André Derain: Lithographe, xylographe, aquafortiste." *Arts et métiers graphiques,* no. 21 (January 15, 1931), pp. 119–26.

"Gallery Notes" 1930
"Gallery Notes." *Parnassus* 2, no. 7 (November 1930), p. 16.

Gamboni 1989
Dario Gamboni. *La Plume et le pinceau: Odilon Redon et la littérature.* Paris, 1989.

Gauguin Sale 1891
Catalogue d'une vente de 30 tableaux de Paul Gauguin. Preface by Octave Mirbeau. Sale cat., Hôtel Drouot, Paris, February 23, 1891.

Gauguin Sale 1895
Vente de tableaux et dessins par Paul Gauguin. Sale cat., Hôtel Drouot, Paris, February 18, 1895.

Geelhaar 1992
Christian Geelhaar. *Kunstmuseum Basel: The History of the Paintings Collection and a Selection of 250 Masterworks.* Translated from German by John Mitchell and Isabel Feder. Basel and Zürich, 1992.

Geffroy 1894 (1995 ed.)
Gustave Geffroy. "Cézanne." *Le Journal,* March 25, 1894. Reprinted in *Paul Cézanne et autres textes,* edited by Christian Limousin, pp. 45–56. Paris, 1995.

Geffroy 1895 (1900 ed.)
Gustave Geffroy. "Paul Cézanne." *Le Journal,* November 16, 1895. Reprinted in Gustave Geffroy, *La Vie artistique,* vol. 6, pp. 214–20. Paris, 1900.

Geffroy 1922
Gustave Geffroy. *Claude Monet: Sa Vie, son temps, son oeuvre.* Paris, 1922.

Geiger 1931
Raymond Geiger. "Le Salon International du Livre d'Art." *L'Art vivant,* no. 150 (July 1931), p. 320.

Geiser, Scheidegger, and Baer 1933–96
Bernhard Geiser, Alfred Scheidegger, and Brigitte Baer. *Picasso: Peintre-graveur.* 8 vols. Bern, 1933–96.

Gélineau 2002
Jean-Claude Gélineau. "Jeanne fille d'Auguste Renoir." In *Renoir: O pintor da vida,* edited by Anne Distel, pp. 223–27. Exh. cat. Museu de Arte, São Paulo; 2002. São Paulo, 2002.

Geneva 1980–81
Fantin-Latour lithographies. Exh. cat. by Rainer Michael Mason, Germain Hédiard, et al. Cabinet des Estampes du Musée d'Art et d'Histoire, Geneva; 1980–81. Geneva, 1980.

Geneva 1981
Pierre Bonnard. Exh. cat. by François Daulte. Musée Rath, Geneva; 1981. Geneva, 1981.

Georges-Michel 1942
Michel Georges-Michel. *Peintres et sculpteurs que j'ai connus, 1900–1942.* New York, 1942.

F. Getlein and D. Getlein 1964
Frank Getlein and Dorothy Getlein. *Georges Rouault's Miserere.* Milwaukee, 1964.

Giambruni 1983
Helen Emery Giambruni. "Early Bonnard, 1885–1900." 2 vols. Ph.D. diss., University of California, Berkeley, 1983.

Gilmour 1988
Pat Gilmour, ed. *Lasting Impressions: Lithography as Art.* London, 1988.

Gilmour 1990
Pat Gilmour. "New Light on Paul Signac's Colour Lithographs." *Burlington Magazine* 132 (April 1990), pp. 271–75.

Gilot and Lake 1964
Françoise Gilot and Carlton Lake. *Life with Picasso.* New York, 1964.

Gimpel 1966
René Gimpel. *Diary of an Art Dealer.* Introduction by Sir Herbert Read; translated from the 1963 French ed. by John Rosenberg. New York, 1966.

Godfroy 1997
Caroline Durand-Ruel Godfroy. "Behind the Scenes: Durand-Ruel and the Degas Sale." In New York 1997–98, vol. 1, pp. 263–69. Translation by Mark Polizzotti of "Les Ventes de l'atelier Degas à travers les archives Durand-Ruel," in *Degas inédit: Actes du Colloque Degas, Musée d'Orsay, 18–21 avril 1988,* pp. 263–75. Paris, 1989.

Goeppert, Goeppert-Frank, and Cramer 1983
Sebastian Goeppert, Herma Goeppert-Frank, and Patrick Cramer. *Pablo Picasso, the Illustrated Books: Catalogue Raisonné.* Translated by Gail Mangold-Vine. Geneva, 1983.

Van Gogh Letters 1914
Vincent Van Gogh. *Brieven aan zijn broeder.* With a memoir by Jo van Gogh-Bonger. 3 vols. Amsterdam, 1914.

Van Gogh Letters 1958
The Complete Letters of Vincent van Gogh with Reproductions of All the Drawings in the Correspondence. Introduction by Vincent W. van Gogh. 3 vols. Greenwich, Conn., 1958.

Van Gogh Letters 1999
The Complete Letters of Vincent van Gogh with Reproductions of All the Drawings in the Correspondence. Introduction by Vincent W. van Gogh. 3 vols. 2nd ed. London, 1999. This edition first published 1978.

Gohr 1992
Siegfried Gohr. "Rouault et Cézanne: La Méthode picturale." In Paris–Fribourg 1992, pp. 23–33.

Goldscheider 1989
Cécile Goldscheider. *Auguste Rodin: Catalogue raisonné de l'oeuvre sculpté.* Vol. 1. Paris, 1989.

Gordon 1974
Donald E. Gordon. *Modern Art Exhibitions: 1900–1916.* Translations by Lucius Grisebach (German); Léopold Jaumonet (French); and Sara Lehrman (Russian). 2 vols. Munich, 1974.

Gourmont 1900
Remy de Gourmont. "Épilogues; Le Cas de M. Vollard." *Mercure de France,* December 1900, pp. 778–80.

"Graphic Art from Vollard Collection" 1950
"Auctions: Graphic Art from Vollard Collection." *Art Digest* 24, no. 8 (January 15, 1950), pp. 26–27.

Gray 1963
Christopher Gray. *Sculpture and Ceramics of Paul Gauguin.* Baltimore, 1963.

Green 1987
Nicholas Green. "Dealing in Temperaments: Economic Transformation of the Artistic Field in France during the Second Half of the Nineteenth Century." *Art History* 10 (March 1987), pp. 59–78.

Greenfeld 1987
Howard Greenfeld. *The Devil and Dr. Barnes: A Portrait of an American Art Collector.* New York, 1987.

Groom 1993
Gloria Groom. *Édouard Vuillard: Painter-Decorator; Patrons and Projects, 1892–1912.* New Haven, 1993.

Groom 1994
Gloria Groom. "The Late Work." In Chicago–Amsterdam–London 1994–95, pp. 305–52, 419–27.

Groom 2001
Gloria Groom. "Into the Mainstream: Decorative Painting, 1900–30." In Chicago–New York 2001, pp. 143–68.

Gruetzner-Robins 2000
Anna Gruetzner-Robins, ed. *Walter Sickert: The Complete Writings on Art.* Oxford, 2000.

Gudiol 1928
J. Gudiol. "The Plandiura Collection." *Gaseta de les arts* 1, no. 2 (October 1928), pp. 1–5.

Guenne 1944
Jacques Guenne. *La Vérité sur Vollard.* "Les Cahiers de Belles Lettres," no. 13. Photographs by Brassaï. Neuchâtel, 1944.

Guérin 1945
Marcel Guérin, ed. *Lettres de Degas.* New ed. Paris, 1945. Includes 62 previously unpublished letters, new illustrations, and six letters of Paul Poujaud to Daniel Halévy.

Guérin 1947
Marcel Guérin, ed. *Edgar Degas. Letters.* Translated by Marguerite Kay. Oxford, 1947.

Guérin 1967
Marcel Guérin. *Catalogue raisonné de l'oeuvre gravé et lithographié de Aristide Maillol.* 2 vols. Geneva, 1967.

Guillaume 1917
Paul Guillaume. *Sculptures nègres; 24 photographies.* Preface by Guillaume Apollinaire. Paris, 1917.

Guillot 2004–5
Catherine Guillot. "Ambroise Vollard (1866–1939): Un Marchand et son époque, synthèse sur le fonctionnement de la galerie, état des lieux de la recherche." Thesis, École du Louvre, Paris, 2004–5.

Guisan and Jakubec 1973–75
Gilbert Guisan and Doris Jakubec, eds. *Félix Vallotton: Documents pour une biographie et pour l'histoire d'une oeuvre.* 3 vols. Lausanne, 1973–75.

Guisan and Jakubec 1975
Gilbert Guisan and Doris Jakubec, eds. *Félix Vallotton, Édouard Vuillard et leurs amis de la* Revue blanche. Études de lettres. Lausanne, 1975.

Guth 1950
Paul Guth. "Le Mystère du legs Vollard." *Le Figaro littéraire,* May 20, 1950.

Hacker 1988
Peter Michael Stephan Hacker, ed. *The Renaissance of Gravure: The Art of S. W. Hayter; Incorporating the Catalogue of the Retrospective Exhibition at the Ashmolean Museum, Oxford.* Oxford, 1988.

Haesaerts 1947
Paul Haesaerts. *Renoir, sculpteur.* [Paris], 1947. Also published in English, 1947.

Halévy 1960
Daniel Halévy. *Degas parle.* Paris, 1960.

Halévy 1964
Daniel Halévy. *My Friend Degas.* Translated and edited by Mina Curtiss. Middletown, Conn., 1964. Based on Halévy 1960.

Hamilton 1977
George Heard Hamilton. "Cézanne and His Critics." In New York–Houston 1977–78, pp. 139–49.

Hansen 2001
Dorothee Hansen. "'. . . Die solide Modernität': Bremer Sammler nach der Jahrhundertwende; Heymel, Biermann, Wolde." In Pophanken and Billeter 2001, pp. 185–208.

Hansert 1994
Andreas Hansert. *Geschichte des Städelschen Museums-Vereins Frankfurt-am-Main.* Frankfurt am Main, 1994.

Henkels 1993
Herbert Henkels. "Cézanne en Van Gogh in het Rijksmuseum voor Moderne Kunst in Amsterdam: De collectie van Cornelis Hoogendijk (1866–1911)." *Bulletin van het Rijksmuseum* 41, nos. 3–4 (1993), pp. 155–295. Includes an English summary by Patricia Wardle.

Hennequin 1882
Émile Hennequin. "Beaux-Arts: Odilon Redon." *Revue littéraire et artistique,* March 4, 1882, pp. 136–38. Translated in Dorra 1994, pp. 49–52.

Hepp 1908
Pierre Hepp. "Petites Expositions: Exposition Mary Cassatt (Galerie Vollard)." *La Chronique des arts,* April 18, 1908, pp. 146–47.

Héran 2003
Emmanuelle Héran. Maillol entries. In *Sammlung Oskar Reinhart "Am Römerholz," Winterthur: Gesamtkatalog,* edited by Mariantonia Reinhard-Felice. Basel, 2003.

Hesse 1927a
Raymond Hesse. "La Carrière d'éditeur d'Édouard Pelletan." *Plaisir de bibliophile* 3 (1927), pp. 32–39.

Hesse 1927b
Raymond Hesse. *Le Livre d'art du XIXᵉ siècle à nos jours. À travers l'art français.* Paris, 1927.

Hillairet 1997
Jacques Hillairet. *Dictionnaire historique des rues de Paris.* 10th ed. Vol. 2. Paris: Les Éditions de Minuit, 1997.

Hirsch Sale 1978
The Robert von Hirsch Collection. Vol. 2, *Works of Art.* Sale cat., Sotheby's, London, June 22, 1978.

"L'Historien cruel" 1919
"L'Historien cruel." *Aux Écoutes,* March 9, 1919, p. 11.

Hoetink 1963
H. R. Hoetink. "Mediterrane Meditaties." *Bulletin Museum Boymans-van Beuningen* 14, no. 2 (1963), pp. 30–55.

Hofmann 1961
Werner Hofmann. *Georges Braque: His Graphic Work.* New York, 1961.

Hoog 1992
Michel Hoog. "Une Nature morte de Cézanne reconstituée." *Revue du Louvre* 3 (1992), pp. 63–65.

Hoogendijk Sale 1912
Catalogue des tableaux modernes, aquarelles, dessins et pastels dépendant des collections formées par M.-C. Hoogendijk de La Haye. Sale cat., Frederik Muller & Cie, Amsterdam, May 21–22, 1912.

Hopper 1933
Inslee A. Hopper. "Vollard and Stieglitz." *American Magazine of Art* 26, no. 12 (December 1933), pp. 542–45.

Horodisch 1962
Abraham Horodisch. *Picasso as a Book Artist.* 2nd ed. Cleveland, 1962. First published as *Pablo Picasso als Büchkünstler* (Frankfurt, 1957).

Houston–Munich 1997–98
Picasso and Photography: The Dark Mirror. Exh. cat. by Anne Baldassari; translated by Deke Dusinberre. Museum of Fine Arts, Houston; Fotomuseum, Munich Stadtmuseum; 1997–98. Paris and New York, 1997.

Houston–Washington–Brooklyn 1989–90
The Intimate Interiors of Édouard Vuillard. Exh. cat. by Elizabeth Wynne Easton. Museum of Fine Arts, Houston; Phillips Collection, Washington, D.C.; Brooklyn Museum; 1989–90. Washington, D.C., 1989.

Humbert 1954
Agnès Humbert. *Les Nabis et leur époque, 1888–1900.* Geneva, 1954.

Huysmans 1883
Joris-Karl Huysmans. "Appendice." In Joris-Karl Huysmans, *L'Art moderne,* pp. 298–300. Paris, 1883.

Hyman 1998
Timothy Hyman. *Bonnard.* New York, 1998.

"In the Realm of Art" 1940
"In the Realm of Art: A Potpourri of Shows." *New York Times,* October 20, 1940, p. 143.

Jacob 1927
Max Jacob. "Souvenirs sur Picasso contés par Max Jacob." *Cahiers d'art,* 1927, pp. 199–203.

Jacquinot 1999
Armelle Jacquinot. "La Succession d'Ambroise Vollard." In New Delhi and other cities 1999–2001, pp. 25–37.

Janin 1925
Clément Janin. "Exposition Internationale des Arts Décoratifs: Le Livre et ses éléments." *L'Art vivant* 1, no. 16 (August 15, 1925), pp. 26–32.

Janis 1968
Degas Monotypes: Essay, Catalogue and Checklist. Exh. cat. by Eugenia Parry Janis. Fogg Art Museum, Harvard University, Cambridge, Massachusetts; 1968. Cambridge, Mass., 1968.

Jarry 1899
Alfred Jarry. *Le Petit Almanach du Père Ubu.* Paris: Ambroise Vollard, 1899.

Jarry 1901
Alfred Jarry. "Les Livres: Parallèlement." *La Revue blanche,* February 15, 1901, p. 317.

Jaworska 1957
Wladyslawa Jaworska. "Gauguin-Slewinski-Makowski." *Sztuka i krytyka* 8, no. 3–4 (1957), pp. 165–212.

Jean-Aubry 1908
Georges Jean-Aubry. "Le Salon d'Automne." *L'Art moderne,* November 1, 1908.

Jensen 1994
Robert Jensen. *Marketing Modernism in Fin-de-Siècle Europe.* Princeton, 1994.

Jentsch 1994
Ralph Jentsch. *Ambroise Vollard, éditeur.* Exh. cat. Herzog Anton-Ulrich-Museum, Braunschweig; 1994. Stuttgart, 1994.

Jewell 1931
Edward Alden Jewell. "'Renior and His Tradition' at Museum of French Art." *New York Times,* November 29, 1931, sect. 8, p. x12.

Jewell 1933a
Edward Alden Jewell. "Art in Review: Paintings from Collection of Vollard, Who Befriended Noted Artists, on Exhibition." *New York Times,* November 7, 1933, p. 31.

Jewell 1933b
Edward Alden Jewell. "The Gallic Avalanche: Paintings from the Vollard Collection." *New York Times,* November 12, 1933, sect. 9, p. X12.

Jewell 1936
Edward Alden Jewell. "Americans." *New York Times,* November 15, 1936, sect. 11, p. X9.

Jewell 1939
Edward Alden Jewell. "Vollard." *New York Times,* sect. 9, July 30, 1939, p. X7.

Jirat-Wasiutyński 1979
Vojtěch Jirat-Wasiutyński. "Paul Gauguin's Self-Portraits and the *Oviri:* The Image of the Artist, Eve, and the Fatal Woman." *Art Quarterly* 2, no. 2 (1979), pp. 172–90.

Johnson 1944
Una E. Johnson. *Ambroise Vollard, Éditeur, 1867–1939: An Appreciation and Catalogue.* New York, 1944.

Johnson 1977
Una E. Johnson. *Ambroise Vollard, Éditeur: Prints, Books, Bronzes.* Exh. cat. Museum of Modern Art, New York; Art Gallery of Ontario, Toronto; Krannert Art Museum, University of Illinois at Champaign; Toledo Museum of Art; 1977. New York, 1977.

Joly-Segalen 1950
A. Joly-Segalen, ed. *Lettres de Gauguin à Daniel de Monfreid.* Revised and annotated ed. Paris, 1950. Originally published as *Lettres de Paul Gauguin à Georges-Daniel de Monfreid* (Paris, 1918).

Juka 1980
S. Sophie Juka. "Christianisme et sentiment de la nature chez A. Suarès et chez G. Rouault." *Les Lettres romanes* (Louvain) 34, no. 2–3 (May–August 1980), pp. 247–59.

Kahn 1915
Gustave Kahn. "Art; A. Vollard: Paul Cézanne." *Mercure de France,* August 1, 1915, pp. 755–57.

Kahn 1922
Gustave Kahn. "Revue de la quinzaine; Art." *Mercure de France,* April 15, 1922, pp. 500–501.

Kahnweiler 1971
Daniel-Henry Kahnweiler. *My Galleries and Painters.* Interviewed by François Crémieux; translated by Helen Weaver. New York, 1971.

Kay 1971
Jane Holtz Kay. "Boston's Public Library: A Keeper with Many Keys." *Art in America* 59, no. 1 (January–February 1971), pp. 78–80.

Kellermann 1992–99
Michel Kellermann. *André Derain: Catalogue raisonné de l'oeuvre peint.* 3 vols. Paris, 1992–99.

Kennert 1996
Christian Kennert. *Paul Cassirer und sein Kreis: Ein Berliner Wegbereiter der Moderne.* Frankfurt am Main, 1996.

Kessler 1971
Harry Graf Kessler. *In the Twenties: The Diaries of Harry Kessler.* Introduction by Otto Friedrich; translation of *Tagebücher, 1918–1937,* by Charles Kessler. New York, 1971.

Kessler 2004–5
Harry Graf Kessler. *Das Tagebuch, 1880–1937.* Vol. 3, *1897–1905,* edited by Carina Schäfer and Gabriele Biedermann; vol. 4, *1906–1914,* edited by Jörg Schuster. Stuttgart, 2004–5. Vol. 3 has supplementary booklet containing CD-ROM: *Das Tagebuch: 1880–1911 und 1916–1937, Rohtranskription.*

Klingsor 1907
Tristan Klingsor. "Le Salon d'Automne." *La Phalange,* October 15, 1907.

Klingsor 1908
Tristan Klingsor. "Art." *La Phalange,* July 15, 1908, pp. 86–87.

Kondō 1921
Kōichiro Kondō. "Cézanne Exhibits." *Chūō bijutsu,* April 1921, p. 63.

Kostenevich 1993
Albert Kostenevich. "Russian Collectors of French Art." In Essen–Moscow–St. Petersburg 1993–94 (English ed.), pp. 35–129.

Kostenevich 1999
Albert Kostenevich. *French Art Treasures at the Hermitage: Splendid Masterpieces, New Discoveries.* New York, 1999.

Kostenevich 2002
Albert Kostenevich. "Maurice Denis and Pierre Bonnard: The Morozov Decorative Paintings in the Hermitage Collection." In Toronto–Montreal 2002–3, pp. 149–67, 182.

Kostka 1996
Alexandre Kostka. "Physiologie der Harmonie: Kessler und sein Kreis als führende Vermittler des Neoimpressionismus in Deutschland." In *Farben des Lichts: Paul Signac und der Beginn der Moderne von Matisse bis Mondrian,* edited by Erich Franz, pp. 197–210. Exh. cat. Westfälisches Landesmuseum für Kunst und Kulturgeschichte, Münster; Musée de Grenoble; Kunstsammlungen zu Weimar; 1996–97. 3rd ed. Ostfildern, 1996.

Kostka 1997
Alexandre Kostka. "Harry Graf Kesslers Überlegungen zum modernen Kunstwerk im Spiegel des Dialogs mit Henry van de Velde." In *Harry Graf Kessler: Ein Wegbereiter der Moderne,* ed. Gerhard Neumann and Günter Schnitzler, pp. 161–85. Freiburg im Breisgau, 1997.

Kostka 2000
Alexandre Kostka. "Two Ladies Vanishing: Die 'Poseuses' von Georges Seurat in der Sammlung Harry Graf Kessler. Kunsttransfer als Teilrezeption." In *Jenseits der Grenzen: Französische und deutsche Kunst vom Ancien Régime bis zur Gegenwart; Thomas W. Gaehtgens zum 60. Geburtstag,* edited by Uwe Fleckner, Martin Schieder, and Michael F. Zimmermann, vol. 2, pp. 448–67. Cologne, 2000.

Krahmer 2001
Julius Meier-Graefe. *Kunst ist nicht für Kunstgeschichte da: Briefe und Dokumente.* Edited and annotated by Catherine Krahmer. Göttingen, 2001.

Kropmanns 1997
Peter Kropmanns. *Gauguin und die Schule Pont-Aven im Deutschland nach der Jahrhundertwende.* Sigmaringen, 1997.

Kropmanns 1998a
Peter Kropmanns. "Gauguin in Deutschland: Rezeption mit Mut und Weitsicht." In *Paul Gauguin: Das verlorene Paradies,* edited by Georg-W. Költzsch, pp. 252–71. Exh. cat. Museum Folkwang Essen; Neue Nationalgalerie Berlin; 1998–99. Cologne, 1998.

Kropmanns 1998b
Peter Kropmanns. "Gauguins 'Reiter am roten Strand' in Köln: Felix und Emil vom Rath—ein Sammler und ein Stifter der Moderne." *Kölner Museums-Bulletin: Berichte und Forschungen aus den Museen der Stadt Köln* 2 (1998), pp. 4–13.

Kropmanns 1999
Peter Kropmanns. "The Gauguin Exhibition in Weimar in 1905." *Burlington Magazine* 141 (1999), pp. 24–31.

Labrusse and Munck 2004
Rémi Labrusse and Jacqueline Munck. "André Derain in London (1906–17): Letters and a Sketchbook." *Burlington Magazine* 146 (April 2004), pp. 243–60.

Labrusse and Munck 2005a
Rémi Labrusse and Jacqueline Munck. "André Derain in London (1906–07)." In London 2005–6, pp. 13–29.

Labrusse and Munck 2005b
Rémi Labrusse and Jacqueline Munck. *Matisse, Derain: La Vérité du fauvisme.* Paris, 2005.

Ladstetter 1982
Günther Ladstetter. *Kunsthalle Mannheim: Skulptur, Plastik, Objekte.* Mannheim, 1982.

Lake 1976
Carlton Lake. *Baudelaire to Beckett: A Century of French Art and Literature. A Catalogue of Books, Manuscripts, and Related Material Drawn from the Collections of the Humanities Research Center.* Austin, 1976.

Lang 1937
Léon Lang. "Le Premier Congrès international de la gravure et de l'estampe." *Beaux-Arts* 75, no. 239 (July 30, 1937), p. 4.

Lantoine 1906
Albert Lantoine. "L'Art à Paris, 22ᵉᵐᵉ Salon des Indépendants." *Fédération artistique*, March 25, 1906.

Lapauze 1909
Henry Lapauze. "Un Grand Potier d'aujourd'hui: André Méthey." *L'Art décoratif* 21 (November 1909), pp. 129–38.

Lausanne 1991
Pierre Bonnard: 1867–1947. Exh. cat. Fondation de l'Hermitage, Lausanne; 1991. Lausanne, 1991.

Léal 1996
Brigitte Léal. *Carnets: Catalogue des dessins*. 2 vols. Musée Picasso. Paris, 1996.

Lebon 2003
Élisabeth Lebon. *Dictionnaire des fondeurs de bronze d'art: France, 1890–1950*. Perth, 2003.

Leclercq 1899
Julien Leclercq. "Petites Expositions: Galerie Vollard." *La Chronique des arts*, November 25, 1899, pp. 330–31.

Leeman 1994
Fred Leeman. "Odilon Redon: The Image and the Text." In Chicago–Amsterdam–London 1994–95, pp. 175–94, 402–4.

"Legal Battle Halts Sale" 1981
"Legal Battle Halts Sale of Paris Art Hoard." *The Times* (London), March 20, 1981, p. 7.

Le Havre–Céret–Roubaix 2003
Raoul Dufy: Du motif à la couleur. Exh. cat. Musée Malraux, Le Havre; Musée d'Art Moderne, Céret; Musée d'Art et d'Industrie André Diligent, Roubaix; 2003. Paris, 2003.

Leighton 1990
Patricia Leighton. "Picasso, Primitivism, and Anticolonialism." *Art Bulletin* 72, no. 4 (December 1990), pp. 609–30.

Lemoisne 1946–49
Paul-Andre Lemoisne. *Degas et son oeuvre*. 4 vols. Paris, 1946–49.

Le Normand-Romain 1994
Antoinette Le Normand-Romain. "Aristide Maillol." In *Maillol*, pp. 19–108. Exh. cat. Musée de L'Annonciade, Saint-Tropez; 1994. Saint-Tropez, 1994.

Lenossos 1939
Marc Lenossos. "Ambroise Vollard: L'Homme qui découvrit Paul Cézanne et qui rénova la bibliophilie, est à Strasbourg." *Dernières Nouvelles de Strasbourg*, April 25, 1939. Copy in the Vollard Archives, MS 421 (10,13), fol. 1.

Lenz 1996
Christian Lenz. "Heinz Braune und die Tschudi-Spend." In Berlin–Munich 1996–97, pp. 432–37.

LePage 1986
Raymond G. LePage. "Marc Chagall's Fantastic Vision of La Fontaine's *Fables*." In *Forms of the Fantastic: Selected Essays from the Third International Conference on the Fantastic in Literature and Film*, edited by Jan Hokenson and Howard Pearce, pp. 155–64. Westport, Conn., 1986.

Lettres à Émile Bernard 1942
Lettres à Émile Bernard de Vincent van Gogh, Paul Gauguin, Odilon Redon, Paul Cézanne, Élémir Bourges, Léon Bloy, G. Apollinaire, Joris-Karl Huysmans, Henry de Groux. Brussels, 1942.

"Leurs débuts" 1933
"Leurs débuts." *Les Nouvelles littéraires, artistiques et scientifiques*, June 3, 1933, p. 3.

Levy 1987
Suzy Levy, ed. *Lettres inédites d'Odilon Redon à Bonger, Jourdain, Viñes*. Paris, 1987.

Lhote 1921
André Lhote. "Renoir, par Ambroise Vollard (Crès)." *La Nouvelle Revue française* 17 (August 1921), pp. 227–30.

Lhote 1923
André Lhote. "Rouault." *L'Amour de l'art*, December 12, 1923, pp. 779–82.

Lieberman 1956
William S. Lieberman. *Matisse: 50 Years of His Graphic Art*. New York, 1956.

Limbour 1954–55
Georges Limbour. "La Théogonie d'Hésiode et de Georges Braque." *Verve* (Paris) 71–72 (December 1954–January 1955), unpaged.

Limouzi and Fressonet-Puy 2000
Suzanne Limouzi and Louis Fressonnet-Puy, eds. *Jean Puy (1876–1960)*. Roanne, 2000.

Lioré and Cailler 1958–70
Aimée Lioré and Pierre Cailler. *Catalogue de l'oeuvre gravé de Dunoyer de Segonzac*. 8 vols. Geneva, 1958–70.

"Les Livres de Vollard" 1931
"Les Livres de M. Ambroise Vollard." *Tous les livres*, no. 40 (January 15, 1931), p. 347.

Lodève 2001
Derain et Vlaminck, 1900–1915. Exh. cat. by Jacqueline Munck and Maïthé Vallès-Bled. Musée de Lodève, 2001. Milan, 2001.

Loeb 1945
Pierre Loeb. *Voyages à travers la peinture*. Paris, 1945.

Loize 1951
Jean Loize. *Les Amitiés du peintre Georges-Daniel de Monfreid et ses reliques de Gauguin: De Maillol et Codet à Segalen*. [Paris], 1951. "Documents" (pp. 81–175) describes 745 letters, pictures, notebooks, and additional materials in the "Fonds Monfreid," which concern Monfreid, Gauguin, and other artists and writers.

London 1910–11
Manet and the Post-Impressionists. Exh. cat. Grafton Galleries, London; 1910–11. London, [1911].

London 1945
An Exhibition of French Book Illustration, 1895–1945. Exh. cat. Arts Council of Great Britain; [London, 1945]. London, [1945].

London 1983–84
Raoul Dufy: Paintings, Drawings, Illustrated Books, Mural Decorations, Aubusson Tapestries, Fabric Designs and Fabrics for Bianchini-Férier, Paul Poiret Dresses, Ceramics, Posters, Theatre Designs. Exh. cat. Translated texts by Roberta Bailey and Sarah Wilson. Organized by the Arts Council of Great Britain, held at the Hayward Gallery, London; 1983–84. London, 1983.

London 1994
Picasso: Sculptor/Painter. Exh. cat. by Elizabeth Cowling and John Golding. Tate Gallery, London; 1994. London, 1994.

London 1997
Prints and Portfolios by Odilon Redon. Exh. cat. by Susan Pinsky and Marc Rosen. Fine Art Society, London; 1997. London, 1997.

London 1998
Bonnard: Colour and Light. Exh. cat. by Nicholas Watkins. Tate Gallery, London; 1998. London, 1998.

London 2005–6
André Derain: The London Paintings. Exh. cat. by Ernst Vegelin van Claerbergen and Barnaby Wright; essays by Rémi Labrusse et al. Courtauld Institute of Art Gallery, London; 2005–6. London, 2005.

London–Chicago 1996–97
Degas: Beyond Impressionism. Exh. cat. by Richard Kendall. National Gallery, London; Art Institute of Chicago; 1996–97. London, 1996.

London–Paris–New York 2002–3
Matisse—Picasso. Exh. cat. Tate Modern, London; Galeries Nationales du Grand Palais, Paris; Museum of Modern Art, New York; 2002–3. London, Paris, and New York, 2002.

Luthi 1982
Jean-Jacques Luthi. *Émile Bernard: Catalogue raisonné de l'oeuvre peint*. Paris, 1982.

Lynes 1973
Russell Lynes. *Good Old Modern: An Intimate Portrait of the Museum of Modern Art*. New York, 1973.

Lyon and other cities 1994–95
Maurice Denis, 1870–1943. Exh. cat. by Guy Cogeval. Musée des Beaux-Arts, Lyon; Wallraf-Richartz Museum, Cologne; Walker Art Gallery, Liverpool; Van Gogh Museum, Amsterdam; 1994–95. Ghent, 1994.

Mac Orlan 1929
Pierre Mac Orlan. "Les Illustrateurs et l'aventure littéraire." *L'Art vivant*, no. 120 (December 15, 1929), pp. 997–98.

Mac Orlan 1937
Pierre Mac Orlan. "Les Décorateurs, les illustrateurs du beau livre." *Arts et métiers graphiques*, no. 59 (1937), pp. 36–39. Special issue, *Les Arts et les techniques graphiques.*

Madrid 1933
Exposición de arte francés contemporáneo. Exh. cat. Museo Nacional de Arte Moderno y Sociedad Española de Amigos del Arte, Madrid; 1933. Madrid, 1933.

Makovsky 1912
Sergei Makovsky. "Franzusskie khudozhniki iz sobraniia I. A. Morozova" (French Painters in the Ivan Morozov Collection). *Apollon* 3–4 (1912).

Malingue 1946
Maurice Malingue, ed. *Lettres de Gauguin à sa femme et à ses amis.* Rev. and expanded ed. Paris, 1946.

Malingue 1948
Maurice Malingue, ed. *Paul Gauguin: Letters to His Wife and Friends.* Translated by Henry J. Stenning. London, 1948.

Malingue 1987
Maurice Malingue. *La Vie prodigieuse de Gauguin.* Paris, 1987.

Malraux 1974
André Malraux. *La Tête d'obsidienne.* Paris, 1974.

Marbach am Neckar 1988
Harry Graf Kessler: Tagebuch eines Weltmannes. Exh. cat. by Gerhard Schuster and Margot Pehle. Schiller-Nationalmuseum, Marbach am Neckar; 1988. Marbach am Neckar, 1988.

Marc Chagall 1997
Marc Chagall: The Fables of La Fontaine / Jean de La Fontaine. New York, 1997. Originally published to accompany an exhibition held in 1995–96 at the Musée d'Art Moderne, Céret, and the Musée National Message Biblique Marc Chagall, Nice.

Marguery 1935
Henry Marguery. *Les Lithographies de Vuillard.* Paris, 1935.

Marseille 2000
De la couleur et du feu: Céramiques d'artistes de 1885 à nos jours. Exh. cat. by Claire Frèches-Thory et al. Musée de la Faïence, Château Pastré, Marseille; 2000. Paris and Marseille, 2000.

Martigny 1994
Rodin: Dessins et aquarelles des collections suisses et du Musée Rodin. Exh. cat. by Claudie Judrin, with Marie-Pierre Delclaux and Véronique Mattiussi. Fondation Pierre Gianadda, Martigny, Switzerland; 1994. Martigny, 1994.

Martigny 2000
Van Gogh. Exh. cat. by Ronald Pickvance. Fondation Pierre Gianadda, Martigny, Switzerland; 2000. Martigny, 2000.

Marx 1894
Roger Marx. "Revue artistique: Exposition Paul Gauguin." *Revue encyclopédique* 4, no. 7 (February 1, 1894), pp. 33–34.

Marx 1903
Roger Marx. "Petites Expositions: Exposition Laprade et Minartz." *La Chronique des arts*, May 16, 1903, p. 163.

Marx 1904a
Roger Marx. "Petites Expositions: Exposition Henri Matisse." *La Chronique des arts,* June 18, 1904, pp. 195–96.

Marx 1904b
Roger Marx. Preface to Paris 1904.

Mathews 1984
Nancy Mowll Mathews, ed. *Cassatt and Her Circle: Selected Letters.* New York, 1984.

Matisse 1972
Henri Matisse. *Écrits et propos sur l'art.* Edited by Dominique Fourcade. Paris, 1972.

Matthews 1933
Herbert L. Matthews. "Canny Columbus of Modern Art." *New York Times,* October 29, 1933, sect. 6, p. 10.

Mauclair 1894
Camille Mauclair. "Choses d'art." *Mercure de France,* March 1894, pp. 284–85.

Mauclair 1895a
Camille Mauclair. "Choses d'art." *Mercure de France,* January 1895, pp. 118–21.

Mauclair 1895b
Camille Mauclair. "Choses d'art." *Mercure de France,* March 1895, pp. 358–59.

Mauny 1931
Jacques Mauny. "Comment on Events in the World of Art Over-Seas: A Vollard Exhibition." *New York Times,* April 19, 1931, p. 137.

Maus 1926
Madeleine Octave Maus. *Trente Années de lutte pour l'art: 1884–1914.* Brussels, 1926.

McBride 1913
Henry McBride. "Cézanne at the Metropolitan Museum." *The Sun* (New York), May 18, 1913.

McCully 1982
Marilyn McCully, ed. *A Picasso Anthology: Documents, Criticism, Reminiscences.* [London, 1981], Princeton, 1982.

McCully 2001
Marilyn McCully, ed. *Loving Picasso: The Private Journal of Fernande Olivier.* Translated by Christine Baker and Michael Raeburn. New York, 2001.

Meier-Graefe 1899
Julius Meier-Graefe (identifying himself as "γ"). "Maurice Denis." *Dekorative Kunst* 3 (1899), pp. 187–88, 214–15. The same article, signed "M.G.," was published in French as "M. Maurice Denis," in *L'Art décoratif* 1 (Ferburary 1899), pp. 204–5, 230–31, with an additional wood engraving by Denis.

Meier-Graefe 1904
Julius Meier-Graefe. *Entwicklungsgeschichte der modernen Kunst.* 3 vols. Stuttgart, 1904. Reprint of 3rd ed. in 2 vols. (10 *livres*), Munich, 1966. "Aristide Maillol," *livre* 8, pp. 578–84.

Meier-Graefe 1908
Julius Meier-Graefe. *Modern Art—Being a Contribution to a New System of Aesthetics.* Translated by Florence Simmonds and George W. Chrystal. 2 vols. New York and London, 1908.

Melbourne 1990
The Enchanted Stone: The Graphic Worlds of Odilon Redon. Exh. cat. by Ted Gott. National Gallery of Victoria, Melbourne; 1990. Melbourne, 1990.

Mellerio 1898
André Mellerio. *La Lithographie originale en couleurs.* Paris, 1898.

Mellerio 1899
André Mellerio. "Expositions: Les Éditions Vollard." *L'Estampe et l'affiche* 3, no. 4 (April 1899), pp. 98–99.

Mellerio 1913
André Mellerio. *Odilon Redon.* Paris: Société pour l'Étude de la Gravure Française, 1913.

Mellerio 1923
André Mellerio. *Odilon Redon: Peintre, dessinateur et graveur.* Paris, 1923.

Mendoza 1987
Cristina Mendoza. "Història de les col·leccions [sic]." In *Catàleg de pintura segles XIX i XX: Fons del Museu d'Art Modern*, vol. 1, pp. 10–33. 2 vols. Barcelona, 1987.

Merlhès 1989
Victor Merlhès, ed. *Paul Gauguin et Vincent van Gogh, 1887–1888: Lettres retrouvées, sources ignorées.* Taravao, Tahiti, 1989.

Métérié 1924
Alphonse Métérié. "Échos; Le Souvenir de Cézanne à Aix." *Mercure de France,* December 15, 1924, pp. 789–91.

Metthey 1907
André Metthey. "La Renaissance de la faïence stannifère." *La Grande Revue* 10 (October 1907), pp. 746–49.

Meyer 1957
Franz Meyer. *Marc Chagall: His Graphic Work.* Documentation by Hans Bolliger. New York, 1957.

Michel and Nivet 1988
Octave Mirbeau. *Correspondance avec Auguste Rodin.* Edited by Pierre Michel and Jean-François Nivet. Tusson, Charente, 1988.

Middletown 1980
The Prints of Armand Seguin, 1869–1903. Exh. cat. by Richard S. Field, Cynthia L. Strauss, and Samuel J. Wagstaff Jr. Davison Art Center, Wesleyan University, Middletown, Connecticut; 1980. Middletown, Conn., 1980.

Milan 2003
Chagall: Fiaba e destino. La Trilogia. Acqueforti da Le anime morte *(Gogol'),* Le favole *(La Fontaine),* La Bibbia. Exh. cat. edited by Elena Pontiggia. Fondazione Stelline, Milan; 2003. Milan, 2003.

Milan Sale 1906
Tableaux modernes: Aquarelles, pastels, dessins, objets variés, provenant des successions des rois Milan et Alexandre de Serbie. Sale cat., Hôtel Drouot, Paris, February 16–17, 1906. Annotated copy of catalogue available at Frick Art Reference Library, New York.

Milinovic 1991
Dino Milinovic. "Paris/Belgrade; Family Feud." *Art News* 90, no. 5 (May 1991), pp. 58, 60.

Mirbeau 1891
Octave Mirbeau. "Vincent van Gogh." *L'Écho de Paris,* March 31, 1891. Translated in S. A. Stein 1986, pp. 267–70, 279.

Mirbeau 1905
Octave Mirbeau. "Aristide Maillol." *La Revue,* April 1905, pp. 321–44.

Mirbeau 1988
Octave Mirbeau. *Correspondance avec Auguste Rodin.* Edited by Pierre Michel and Jean-François Nivet. Tusson, Charente, 1988.

Mirbeau 1990
Octave Mirbeau. *The Torture Garden.* Translated by Alvah C. Bessie. Sawtry, 1990.

"Miro's 'Standing Nude'" 1966
"Miro's 'Standing Nude' (City Art Museum, St. Louis)." *Burlington Magazine* 108 (February 1966), p. 89.

Mongan, Kornfeld, and Joachim 1988
Elizabeth Mongan, Eberhard W. Kornfeld, and Harold Joachim. *Paul Gauguin: Catalogue Raisonné of His Prints.* Bern, 1988.

Montreal 1998
Le Temps des Nabis: Bonnard, Denis, Lacombe, Maillol, Ranson, Rippi, Rónai, Roussel, Sérusier, Vallotton, Verkade, Vuillard. Exh. cat. by Guy Cogeval, Claire Frèches-Thory, and Gilles Genty. Musée des Beaux-Arts de Montréal; 1998. Montreal, 1998.

Morane 2000
Daniel Morane. *Émile Bernard, 1868–1941: Catalogue raisonné de l'oeuvre gravé.* With a biographical essay by Laure Harscoët-Maire. Published in association with an exhibition at the Musée de Pont-Aven; 2000. Pont-Aven, 2000.

Moreau-Nélaton 1926
Étienne Moreau-Nélaton. *Manet raconté par lui-même.* 2 vols. Paris, 1926.

D. Morel 1996
Dominique Morel. "Ambroise Vollard et Émile Chouanard: Collectionneurs de céramiques d'André Metthey." In Nice–Bruges 1996, pp. 71–75.

Morel 1992
Jean-Paul Morel. "Mallarmé-Vollard, à qui la faute?" *Poésie* 92 (April 1992), pp. 34–49.

Morel 1994
Jean-Paul Morel, ed. *Tout Ubu colonial et autres textes.* Paris, 1994.

Morel 2000
Jean-Paul Morel. "Ambroise Vollard: Dónde y cómo conocí al Père Ubu." In *Alfred Jarry: De los nabis a la patafísica,* pp. 80–113. Exh. cat. IVAM Centre Julio Gonzàlez, Valencia; 2000–2001. Valencia, 2000.

Morel 2003
Jean-Paul Morel. "Paroles d'homme(s): Le 'Contrat' Gauguin-Vollard." In Punaauia 2003, pp. 61–71.

Morel forthcoming
Jean-Paul Morel. Biography of Ambroise Vollard. Paris: Éditions Séguier, forthcoming.

Morice 1895
Charles Morice. "L'Art et les lettres: Expositions juillet 1895." *L'Idée libre* (Librarie de l'Art Indépendant, Paris), 1895, p. 342.

Morice 1903
Charles Morice. "Art moderne: Exposition de M. Pierre Laprade." *Mercure de France,* June 1903, pp. 813–14.

Morice 1904
Charles Morice. "Art moderne: Exposition Henri Matisse." *Mercure de France,* August 1904, pp. 533–34.

Morice 1908
Charles Morice. "Art moderne: Exposition Jean Puy." *Mercure de France,* December 16, 1908, pp. 734–35.

Mornand 1938a
Pierre Mornand. "Le Livre au début du XXᵉ siècle." *Le Courrier graphique* 3, no. 11 (January 1938), pp. 27–32.

Mornand 1938b
Pierre Mornand. "Le Livre français pendant la guerre." *Le Courrier graphique* 3, no. 13 (March 1938), pp. 27–30.

Mornand 1938c
Pierre Mornand. "Le Livre au XXᵉ siècle: L'Après guerre, frénésie, voyages et aventures." *Le Courrier graphique* 3, no. 14 (April 1938), pp. 31–35.

Mornand 1940
Pierre Mornand. *6 Artistes du livre.* Paris, 1940.

Moscow 1965
Musée Pouchkine, Moscou: Peintures et sculptures d'Europe occidentale (in Russian). Exh. cat. by Irina Antonova et al. Moscow, 1965.

Mourey 1896
Gabriel Mourey. "Studio-Talk." *Studio* (London) 9 (November 1896), pp. 145–46.

Mourey 1897
Gabriel Mourey. "Studio-Talk." *International Studio* 3 (December 1897), pp. 125–26.

Munck 2000
Jacqueline Munck. "Les Peintres fauves." In Marseille 2000, pp. 31–37.

Mundy 1993
Jennifer Mundy. *Georges Braque: Printmaker.* Exh. cat. Tate Gallery, London; 1993. London, 1993.

Munich 1998
Picasso und seine Sammlung. Exh. cat. by Hélène Seckel-Klein, with the collaboration of Emmanuelle Chevrière. Kunsthalle der Hypo-Kulturstiftung, Munich; 1998. Munich, 1998.

Munk and Olesen 1993
Jens Peter Munk and Kirsten Olesen. *Post-Impressionism: Catalogue, Ny Carlsberg Glyptotek.* Copenhagen, 1993.

Muratov 1908
P[avel] P[avlovich] Muratov. "Shchukinskaia Gallereia." *Russkaia mysl',* no. 8 (1908).

Narbonne 1975
Centenaire de la naissance de Pierre Laprade: Narbonne, 1875–Fontenay-aux-Roses, 1931. Exh. cat. Bulletin des Amis de l'Art et de l'Historie de Septimanie, no. 13. Organized by the Musée Archéologique et des Beaux-Arts, held at the Palais des Archevêques, Narbonne; 1975. Narbonne, 1975.

Natanson 1893
Thadée Natanson. "Expositions. Un Groupe de peintres: MM. Maurice Denis, Marc Mouclier, K. X. Roussel, Édouard Vuillard, P. Ranson, P. Seruzier, F. Vallotton, Pierre Bonnard, M. G. Ibels." *La Revue blanche,* November 1893, p. 339. Translated in Salomon and Cogeval 2003, p. 312, under no. IV-147.

Natanson 1895a
Thadée Natanson. "Paul Cézanne." *La Revue blanche,* December 1, 1895, pp. 497–500.

Natanson 1895b
Thadée Natanson. "Jean Carriès—Vincent van Gogh." *La Revue blanche,* June 15, 1895, pp. 572–73.

Natanson 1895c
Thadée Natanson. "En Passant." *La Revue blanche,* November 15, 1895, p. 473.

Natanson 1896
Thadée Natanson. "Peinture." *La Revue blanche,* December 1, 1896, pp. 517–18.

Natanson 1897
Thadée Natanson. "Petite Gazette d'art." *La Revue blanche,* June 5, 1897, pp. 503–4.

Natanson 1898a
Thadée Natanson. "Notes sur l'art des Salons." *La Revue blanche,* June 1, 1898, p. 220.

Natanson 1898b
Thadée Natanson. "Petite Gazette d'art." *La Revue blanche,* April 15, 1898, pp. 614–19. Translated in Salomon and Cogeval 2003, vol. 1, p. 550.

Natanson 1898c
Thadée Natanson. "Petite Gazette d'art: De M. Paul Gauguin." *La Revue blanche,* December 1, 1898, pp. 544–46.

Natanson 1948
Thadée Natanson. *Peints à leur tour.* Paris, 1948.

National Gallery of Art 1965–68
National Gallery of Art, Washington, D.C.
*Summary Catalogue of European Paintings and
Sculpture.* 2 vols. Washington, D.C., 1965–68.

Nectoux 1998
Jean-Michel Nectoux. *Mallarmé: Un Clair Regard
dans les ténèbres.* Paris, 1998.

Neugass 1977
Fritz Neugass. "Ausstellung: Impresario Ambroise
Vollard." *Pantheon* 35 (December 1977), pp. 373–74.

New Brunswick–Baltimore–Boston 1978–79
*The Color Revolution: Color Lithography in France,
1890–1900.* Exh. cat. by Phillip Dennis Cate and
Sinclair Hamilton Hitchings; with a translation of
Mellerio 1898 by Margaret Needham. Rutgers
University Art Gallery, New Brunswick, New
Jersey; Baltimore Museum of Art; Boston Public
Library (smaller exhibition); 1978–79. New
Brunswick, N.J., 1978.

New Delhi and other cities 1999–2001
*La Collection Ambroise Vollard du Musée Léon-
Dierx: Les Donations de 1912 et 1947.* Exh. cat.
National Gallery of Modern Art, New Delhi, and
four other museums; 1999–2001. Paris, 1999.

New Haven and other cities 1991–93
Félix Vallotton. Exh. cat. by Sasha M. Newman,
with essays by Marina Ducrey et al.; edited by
Lesley K. Baier. Yale University Art Gallery,
New Haven, and other museums; 1991–93.
New Haven, 1991.

Newman 1989
Sasha M. Newman. "Nudes and Landscapes." In
New York–Houston–Boston 1989–90, pp. 145–93,
203–7.

New York 1913
*Catalogue of International Exhibition of Modern
Art.* Exh. cat. Association of American Painters and
Sculptors, Armory of the Sixty-ninth Infantry,
New York; 1913. New York, 1913. Exhibition also
traveled to Boston and Chicago.

New York 1915
Masterpieces by Old and Modern Painters. Exh. cat.
M. Knoedler and Co., New York; 1915. New York,
1915.

New York 1930
Masterpieces by Nineteenth Century French Painters.
Exh. cat. Knoedler Galleries, New York; 1930. New
York, [1930].

New York 1933
Paintings from the Ambroise Vollard Collection. Exh.
cat. foreword by Albert C. Barnes; introduction by
Étienne Bignou. M. Knoedler and Co., New York;
1933. New York, 1933. Exhibition also traveled to
the Arts and Craft Club, Detroit.

New York 1936
Modern Painters and Sculptors as Illustrators. Exh.
cat. edited by Monroe Wheeler. Museum of
Modern Art, New York; 1936. New York, 1936.

New York 1936 (1946 ed.)
Modern Painters and Sculptors as Illustrators. Exh.
cat. edited by Monroe Wheeler. Museum of
Modern Art, New York; 1936. New York, 1936.
3rd ed. New York, 1946.

New York 1936a
Paul Cezanne (1839–1906). Exh. cat. Bignou
Gallery, New York; 1936. New York, [1936].

New York 1936b
*Paul Gauguin, 1848–1903: A Retrospective Loan
Exhibition for the Benefit of Les Amis de Paul
Gauguin in the Penn Normal Industrial and
Agricultural School.* Exh. cat. Wildenstein and
Company, New York; 1936. New York, [1936].

New York 1938
The Prints of Georges Rouault. Exh. cat. by Monroe
Wheeler. Museum of Modern Art, New York; 1938.
New York, 1938.

New York 1939
Contemporary French Art. Exh. cat. preface by
Georges Huisman. New York World's Fair, French
Pavilion, Fine Arts Section; 1939. New York, 1939.

New York 1942
*Loan Exhibition of Paintings by Cézanne (1839–
1906) for the Benefit of Fighting France.* Exh. cat.
introduction by Alfred M. Frankfurter. Paul
Rosenberg and Co., New York; 1942. New York,
1942.

New York 1945 (1947 ed.)
Georges Rouault: Paintings and Prints. Exh. cat. by
James Thrall Soby. Museum of Modern Art, New
York; 1945. 3rd ed. New York, 1947.

New York 1963
Medardo Rosso. Exh. cat. by Margaret Scolari Barr.
Museum of Modern Art, New York; 1963. New
York, 1963.

New York 1975
Aristide Maillol, 1861–1944. Exh. cat. by John
Rewald. Solomon R. Guggenheim Museum,
New York; 1975. New York, 1975.

New York 1982
The Art of the French Illustrated Book, 1700 to 1914.
2 vols. Exh. cat. by Gordon Ray. Pierpont Morgan
Library, New York; 1982. New York and Ithaca,
1982.

New York 1984
Van Gogh in Arles. Exh. cat. by Ronald Pickvance.
The Metropolitan Museum of Art, New York;
1984. New York, 1984.

New York 1987
Chagall and the Bible. Exh. cat. by Jean Bloch
Rosensaft. Jewish Museum, New York; 1987.
New York, 1987.

New York 1989–90
*Twentieth-Century Modern Masters: The Jacques
and Natasha Gelman Collection.* Exh. cat. by
Sabine Rewald; edited by William S. Lieberman.
The Metropolitan Museum of Art, New York;
1989–90. New York, 1989.

New York 1993
Splendid Legacy: The Havemeyer Collection. Exh.
cat. by Alice Cooney Frelinghuysen, Gary
Tinterow, Susan Alyson Stein, Gretchen Wold, and
Julia Meech. The Metropolitan Museum of Art,
New York; 1993. New York, 1993.

New York 1994–95
A Century of Artists Books. Exh. cat. by Riva
Castleman. Museum of Modern Art, New York;
1994–95. New York, 1994.

New York 1997–98
The Private Collection of Edgar Degas. Exh. cat.
[Vol. 1, essays] by Ann Dumas, Colta Ives, Susan
Alyson Stein, and Gary Tinterow. [Vol. 2, sum-
mary catalogue] compiled by Colta Ives, Susan
Alyson Stein, and Julie A. Steiner, with Ann
Dumas, Rebecca Rabinow, and Gary Tinterow.
The Metropolitan Museum of Art, New York;
1997–98. New York, 1997.

New York 2002
*The Lure of the Exotic: Gauguin in New York
Collections.* Exh. cat. by Colta Ives and Susan
Alyson Stein, with Charlotte Hale and Marjorie
Shelley. The Metropolitan Museum of Art, New
York; 2002. New York, 2002.

New York 2005–6
Beyond the Visible: The Art of Odilon Redon. Exh.
cat. by Jodi Hauptman; essays by Marina van
Zuylen and Starr Figura. Museum of Modern Art,
New York; 2005–6. New York, 2005.

New York–Houston 1977–78
Cézanne: The Late Work. Exh. cat. essays by
Theodore Reff et al.; edited by William Rubin.
Museum of Modern Art, New York; Museum of
Fine Arts, Houston; 1977–78. New York, 1977.

New York–Houston 2000
*Mary Cassatt: Prints and Drawings from the Artist's
Studio.* Exh. cat. by Marc Rosen and Susan Pinsky;
essays by Warren Adelson et al. Adelson Galleries,
New York; Meredith Long & Co., Houston; 2000.
Princeton, 2000.

New York–Houston–Boston 1989–90
Pierre Bonnard, the Graphic Art. Exh. cat. by Colta
Ives, Helen Giambruni, and Sasha M. Newman.
The Metropolitan Museum of Art, New York;
Museum of Fine Arts, Houston; Museum of Fine
Arts, Boston; 1989–90. New York, 1989.

New York–Paris 1996–97
*Picasso and Portraiture: Representation and
Transformation.* Exh. cat. edited by William Rubin.
Museum of Modern Art, New York; Galeries
Nationales du Grand Palais, Paris; 1996–97.
New York, 1996.

Nice–Bruges 1996
La Céramique fauve: André Metthey et les peintres.
Exh. cat. Cahiers Henri Matisse, 15. Musée
Matisse, Nice; Fondation Saint-Jean, Bruges; 1996.
Nice, 1996.

Nicholas 1994
Lynn H. Nicholas. *The Rape of Europa: The Fate of
Europe's Treasures in the Third Reich and the Second
World War.* New York, 1994.

Nicolson 1951
Benedict Nicolson. "Post-Impressionism and
Roger Fry." *Burlington Magazine* 93 (January 1951),
pp. 10–15.

Nicolson 1960
Benedict Nicolson. "The Recovery of a Degas Race
Course Scene." *Burlington Magazine* 102
(December 1960), pp. 536–37.

"Nouveau Livre de Raoul Dufy" 1930–31
"Une Nouveau Livre de Raoul Dufy." *Plaisir de
bibliophile* 6 (1930–31), pp. 237–38.

"Ocean Travelers" 1936
"Ocean Travelers." *New York Times*, November 11,
1936, p. 25.

Olivier 1964
Fernande Olivier. *Picasso and His Friends.*
Translated by Jane Miller. London, 1964. First
published in French as *Picasso et ses amis* (Paris,
1933).

Olivier 2001
Fernande Olivier. *Picasso et ses amis.* New ed.,
annotated by Hélène Klein. Paris, 2001.

**"On a perdu les richissimes collections
d'Ambroise Vollard" 1948**
"On a perdu les richissimes collections d'Ambroise
Vollard" (The Incredibly Rich Collection of
Ambroise Vollard Has Been Lost). *Ici Paris,* March
30–April 5, 1948.

One Man's Vision 1978–80
*One Man's Vision: The Graphic Works of Odilon
Redon; An Exhibition from the Collection of Edwin
Binney, 3rd.* Exh. cat. Organized by the
Smithsonian Institution Traveling Exhibition
Service; 1978–80. Washington, D.C., 1978.

Oppler 1976
Ellen C. Oppler. "Paula Modersohn-Becker: Some
Facts and Legends." *Art Journal* 35, no. 4 (summer
1976), pp. 364–69.

Ottawa–Chicago–Fort Worth 1997–98
Renoir's Portraits: Impressions of an Age. Exh. cat. by
Colin B. Bailey, with the assistance of John B.
Collins; essays by Colin B. Bailey, Linda Nochlin,
and Anne Distel. National Gallery of Canada,
Ottawa; Art Institute of Chicago; Kimbell Art
Museum, Fort Worth; 1997–98. New Haven, 1997.

"Ouvrages édités par M. Ambroise Vollard" 1931
"Ouvrages édités par M. Ambroise Vollard." *Arts
et métiers graphiques,* no. 23 (May 15, 1931),
pp. LVIII–LX.

Oxford 1988
The Renaissance of Gravure: The Art of S. W. Hayter.
Exh. cat. edited by P. M. S. Hacker. Ashmolean
Museum, Oxford; 1988. Oxford, 1988.

Palau i Fabre 1981
Josep Palau i Fabre. *Picasso: The Early Years, 1881–
1907.* Translated by Kenneth Lyons. New York,
1981. Translated from the Catalan ed., *Picasso
vivent, 1881–1907* (Barcelona, 1980).

Palau i Fabre 1985
Josep Palau i Fabre. *Picasso.* Barcelona, 1985.

Parienté 1990
Robert Parienté. *André Suarès, l'insurgé: Biographie.*
Paris, 1990.

Paris 1884
Exposition des oeuvres de Édouard Manet. Exh. cat.
preface by Émile Zola. École des Beaux-Arts, Paris;
1884. Paris, 1884.

Paris 1891
7ᵐᵉ Salon des Indépendants. Exh. cat. Pavillon de la
Ville de Paris, Champs-Élysées; 1891. Paris, 1891.

Paris 1892
Exposition Van Gogh. Exh. cat. by Émile Bernard.
Galerie Le Barc de Boutteville, Paris; 1892. Paris,
1892.

Paris 1893
Exposition Paul Gauguin. Exh. cat. preface by
Charles Morice. Galeries Durand-Ruel, Paris; 1893.
Paris, 1893.

Paris 1894
Exposition Odilon Redon. Exh. cat., Galeries
Durand-Ruel, Paris; 1894. Paris, 1894.

Paris 1896
"Les Peintres-graveurs." Exhibition, Galerie
Vollard, Paris; 1896. Catalogue published in
L'Estampe, June 21, 1896, unpaged.

Paris 1897a
*Exposition des oeuvres de MM. P. Bonnard, M. Denis,
Ibels, G. Lacombe, Ranson, Rasetti, Roussel, P. Sérusier,
Vallotton, Vuillard.* Exh. cat. Galerie Vollard, Paris;
1897. Paris, 1897.

Paris 1897b
Exposition T.-E. Butler. Exh. cat. Galerie Vollard,
Paris; 1897. Paris, 1897.

Paris 1898a
*Exposition des oeuvres de MM. P. Bonnard—M.
Denis—Ibels—Ranson—X. Roussel—Sérusier—
Vallotton—Vuillard.* Exh. cat. Galerie Vollard,
Paris; 1898. Paris, 1898.

Paris 1898b
Exposition Cézanne. Exh. cat. Galerie Vollard,
Paris; 1898. Paris, 1898.

Paris 1899
Tableaux de René Seyssaud. Exh. cat. preface by
Arsène Alexandre. Galerie Vollard, Paris; 1899.
Paris, 1899.

Paris 1899a
*Exposition André Sinet: Tableaux de voyages; impres-
sions de promenades; notes & souvenirs.* Exh. cat.
preface by Frantz Jourdain. Galerie Vollard, Paris;
1899. Paris, 1899.

Paris 1900
Exposition Chamaillard. Exh. cat. preface by Arsène
Alexandre. Galerie Vollard, Paris; 1900. Paris, 1900.

Paris 1901
Exposition d'oeuvres de Vincent van Gogh. Exh. cat.
Galerie Bernheim Jeune, Paris; 1901. [Paris, 1901.]

Paris 1901a
Tableaux de Émile Bernard (Paris, Bretagne, Égypte).
Exh. cat. preface by Roger Marx. Galerie Vollard,
Paris; 1901. Paris, 1901.

Paris 1901b
*Exposition de tableaux de F. Iturrino et de P.-R.
Picasso.* Exh. cat. preface by Gustave Coquiot.
Galerie Vollard, Paris; 1901. Paris, 1901.

Paris 1902
*Catalogue des ouvrages de peinture, sculpture, dessin,
gravure, architecture et objets d'art.* Exh. cat. Société
Nationale des Beaux-Arts. Grand Palais, Paris;
1902. Paris, 1902.

Paris 1903a
[Exposition de peintures de Pierre Laprade.] Exh.
cat. Galerie Vollard, Paris; 1903. Paris, 1903.

Paris 1903b
Exposition Paul Gauguin. Exh. cat. Galerie Vollard,
Paris; 1903. Paris, 1903.

Paris 1904
Exposition des oeuvres du peintre Henri Matisse.
Exh. cat. preface by Roger Marx. Galerie Vollard,
Paris; 1904. Paris, 1904.

Paris 1904a
Claude Monet: Vues de la Tamise à Londres. Exh.
cat. Galerie Durand-Ruel, Paris; 1904. Paris, 1904.

Paris 1905
*Société des Artistes Indépendants: Catalogue de la
21ᵉᵐᵉ exposition.* Quai d'Orsay, Paris; 1905. Paris,
1905.

Paris 1906a
Alcide Le Beau. Exh. cat. preface by Louis
Vauxcelles. Galerie Vollard, Paris; 1906. Paris,
1906.

Paris 1906b
Alfred Muller. Exh. cat. Galerie Vollard, Paris; 1906.
Paris, 1906.

Paris 1907
Catalogue des oeuvres de Manzana-Pissarro. Exh.
cat. preface by Octave Mirbeau. Galerie Vollard,
Paris; 1907. Paris, 1907.

Paris 1907a
*Société des Artistes Indépendants: Catalogue de la 23ᵉ
exposition.* Quai d'Orsay, Paris; 1907. Paris, 1907.

Paris 1908a
*Exposition de peintures, pastels et gravures de Mˡˡᵉ
Mary Cassatt.* Galerie Vollard, Paris; 1908. Paris,
1908.

Paris 1908b
Exposition Jean Puy. Exh. cat. Galerie Vollard, Paris;
1908. Paris, 1908.

Paris 1909
Exposition des dessins marocains de Jean Hess. Exh.
cat. Galerie Vollard, Paris; 1909. Paris, 1909.

Paris 1910
Exposition d'oeuvres de Paul Gauguin. Exh. cat.
preface by Charles Morice. Galerie Vollard, Paris;
1910. Paris, 1910.

Paris 1910a
Exposition de peintures et faïences décoratives de Vlaminck. Exh. cat. note by Roger Marx. Galerie Vollard, Paris; 1910. Paris, 1910.

Paris 1911
Société des Artistes Indépendants: Catalogue de la 27ᵉ exposition. Quai d'Orsay, Paris; 1911. Paris, 1911.

Paris 1929
Exposition Cézanne, 1839–1906. Exh. cat. introduction, "Quelques souvenirs sur Cézanne," by Ambroise Vollard; documentation by Roger Gaucheron. Galerie Pigalle, Paris; 1929. Paris, 1929.

Paris 1930
Bonnard, Maurice Denis, A. Maillol, K.-X. Roussel, Sérusier, Vallotton, Vuillard: Sept Artistes contemporains. Exh. cat. Galerie Druet, Paris; 1930. Paris, 1930.

Paris 1930a
La Fontaine par Chagall: 100 Fables. Exh. cat. essay by Ambroise Vollard. Galerie Bernheim-Jeune, Paris; 1930. Paris, [1930].

Paris 1930–31
Catalogue complet des Éditions Ambroise Vollard. Exh. cat. Le Portique, Paris; 1930–31. Paris, 1930.

Paris 1931
Catalogue du Salon International du Livre d'Art. Exh. cat. preface by André Suarès. Petit Palais des Beaux-Arts de la Ville de Paris; 1931. Paris, 1931.

Paris 1932
Exposition Picasso. Exh. cat. by Charles Vrancken. Galerie Georges Petit, Paris; 1932. Paris, 1932.

Paris 1934a
Renoir: L'Oeuvre sculpté, l'oeuvre gravé, aquarelles et dessins. Exh. cat. with texts by Ambroise Vollard and Raymond Cogniat. Expositions de "Beaux-Arts" et de "La Gazette des Beaux-Arts," no. 10. Galerie Beaux-Arts, Paris; 1934. Paris, 1934.

Paris 1934b
Les Étapes de l'art contemporain, II: Gauguin et ses amis. L'École de Pont-Aven et l'Académie Julian. Exh. cat. by Raymond Cogniat; introduction by Maurice Denis. Catalogues des expositions de "Beaux-Arts" et de "La Gazette des Beaux-Arts," no. 7. Galerie Beaux-Arts, Paris; 1934. Paris, 1934.

Paris 1934c
Réhabilitation du sujet: Au profit de la Fondation Foch. Exh. cat. preface by Claude Roger-Marx. André J. Seligmann, Paris; 1934. Paris, [1934].

Paris 1937
Les Maîtres de l'art indépendant, 1895–1937. Exh. cat. Musée du Petit Palais, Paris; 1937. Paris, 1937.

Paris 1938
Art sacré moderne. Exh. cat. Musée des Arts Décoratifs, Paris; 1938. Paris, [1938].

Paris 1939
Degas: Peintre du mouvement. Exh. cat. preface by Claude Roger-Marx. Galerie André Weil, Paris; 1939. Paris, 1939.

Paris 1956–57
Odilon Redon. Exh. cat. edited by Roseline Bacou. Musée de l'Orangerie, Paris; 1956–57. Paris, 1956.

Paris 1961
Hommage à Aristide Maillol (1861–1944). Exh. cat. Musée National d'Art Moderne, Paris; 1961. Paris, 1961.

Paris 1966
Paris—Prague, 1906–1930. Exh. cat. Musée National d'Art Moderne, Paris; 1966. Paris, 1966.

Paris 1980–81
Donations Claude Roger-Marx. Exh. cat. by Rosaline Bacou. Cabinet des Dessins, Musée du Louvre, Paris; 1980–81. Paris, 1980.

Paris 1987
Pierre Bonnard: Photographs and Paintings. Exh. cat. by Françoise Heilbrun and Philippe Néagu. Translation of the 1987 French edition. Musée d'Orsay, Paris; 1987. New York, 1988.

Paris 1988
Van Gogh à Paris. Exh. cat. by Françoise Cachin and Bogomila Welsh-Ovcharov. Musée d'Orsay, Paris; 1988. Paris, 1988.

Paris 1990
Au temps des Nabis. Exh. cat. edited by Anisabelle Berès. Huguette Berès (Firm), Paris; 1990. Paris, 1990.

Paris 1994
Picasso photographe, 1901–1916. Exh. cat. by Anne Baldassari. Museé Picasso, Paris; 1994. Paris, 1994.

Paris 1994–95
André Derain: Le Peintre du "trouble moderne." Exh. cat. by Françoise Marquet et al. Musée d'Art Moderne de la Ville de Paris; 1994–95. Paris, 1994.

Paris 1995
Picasso et la photographie: "À plus grande vitesse que les images." Exh. cat. by Anne Baldassari. Musée Picasso, Paris; 1995. Paris, 1995.

Paris 1995–96
Maillol: La Passion du bronze. Exh. cat. edited by Dina Vierny and Bertrand Lorquin. Fondation Dina Vierny-Musée Maillol, Paris; 1995–96. Paris, 1995.

Paris 1995–96a
Manet, Gauguin, Rodin: Chefs-d'oeuvre de la Ny Carlsberg Glyptotek de Copenhague. Exh. cat. edited by Anne-Birgitte Fonsmark. Musée d'Orsay, Paris; 1995–96. Paris, 1995.

Paris 1997
Le Miroir noir: Picasso, sources photographiques, 1900–1928. Exh. cat. by Anne Baldassari. Musée Picasso, Paris; 1997. Paris, 1997.

Paris 1999–2000
Le Fauvisme ou "L'Épreuve du feu": Éruption de la modernité en Europe. Exh. cat. by Suzanne Pagé et al. Musée d'Art Moderne de la Ville de Paris; 1999–2000. Paris, 1999.

Paris 2002
Les Peintres graveurs, 1890–1900. Exh. cat. by Anisabelle Berès and Michel Arveiller. Galerie Berès, Paris; 2002. Paris, 2002.

Paris 2005
Le Théâtre de l'oeuvre, 1893–1900. Exh. cat. edited by Isabelle Cahn. Musée d'Orsay, Paris; 2005. Paris, 2005.

Paris (Salon d'Automne) 1904
Catalogue de peinture, dessin, sculpture, graveur, architecture et des arts décoratifs. Exh. cat. Société du Salon d'Automne. Grand Palais des Champs-Élysées, Paris; 1904. Paris, 1904.

Paris (Salon d'Automne) 1906
Catalogue des ouvrages de peinture, sculpture, dessin, gravure, architecture et art décoratif. Exh. cat. Société du Salon d'Automne. Grand Palais des Champs-Élysées, Paris; 1906. Paris, 1906.

Paris (Salon d'Automne) 1907
Catalogue des ouvrages de peinture, sculpture, dessin, gravure, architecture et art décoratif. Exh. cat. Société du Salon d'Automne. Grand Palais des Champs-Élysées, Paris; 1907. Paris, 1907.

Paris–Amsterdam–New York 2001
Signac, 1863–1935. Exh. cat. by Marina Ferretti-Bocquillon, Anne Distel, John Leighton, and Susan Alyson Stein, with contributions by Kathryn Calley Galitz and Sjraar van Heugten. Galeries Nationales du Grand Palais, Paris; Van Gogh Museum, Amsterdam; The Metropolitan Museum of Art, New York; 2001. New York, 2001.

Paris–Boston 2003–4
Gauguin, Tahiti. Exh. cat. by George T. M. Shackelford and Claire Frèches-Thory, with additional essays by Isabelle Cahn et al. Galeries Nationales du Grand Palais, Paris; Museum of Fine Arts, Boston; 2003–4. Boston, 2004.

Paris–Chicago–Los Angeles 1995
Gustave Caillebotte: Urban Impressionist. Exh. cat. by Anne Distel et al. Galeries Nationales du Grand Palais, Paris; Art Institute of Chicago; Los Angeles County Museum of Art; 1995. New York, 1995.

Paris–Fribourg 1992
Rouault: Première Période, 1903–1920. Exh. cat. edited by Fabrice Hergott. Musée National d'Art Moderne, Centre Georges Pompidou, Paris; Musée d'Art et d'Histoire, Fribourg; 1992. Paris, 1992.

Paris–London–Philadelphia 1995–96
Cézanne. Exh. cat. by Françoise Cachin, Isabelle Cahn, Walter Feilchenfeldt, Henri Loyrette, and Joseph J. Rishel. Galeries Nationales du Grand Palais, Paris; Tate Gallery, London; Philadelphia Museum of Art; 1995–96. Philadelphia, 1996.

Paris–New York 1983
Manet, 1832–1883. Exh. cat. by Françoise Cachin and Charles S. Moffett, with Michel Melot. Galeries Nationales du Grand Palais, Paris; The Metropolitan Museum of Art, New York; 1983. New York, 1983.

Paris–New York 1991–92
Georges Seurat, 1859–1891. Exh. cat. by Robert Herbert et al. Galeries Nationales du Grand Palais, Paris; The Metropolitan Museum of Art, New York; 1991–92. New York, 1991.

Paris–Nice 1898
Exposition Murer. Exh. cat. preface by Adolphe Tabarant. Galerie Vollard, Paris; traveled to Nice; 1898. Paris, 1898.

Paris–Ottawa–New York 1988–89
Degas. Exh. cat. by Jean Sutherland Boggs, Douglas W. Druick, Henri Loyrette, Michael Pantazzi, and Gary Tinterow. Galeries Nationales du Grand Palais, Paris; National Gallery of Canada, Ottawa; The Metropolitan Museum of Art, New York; 1988–89. New York and Ottawa, 1988.

Paris–San Francisco 2003
Chagall: Connu et inconnu. Exh. cat. Galeries Nationales du Grand Palais, Paris; San Francisco Museum of Modern Art; 2003. Paris, 2003.

"Paris Dealer Here" 1936
"Paris Dealer Here; Discovered Cézanne." *New York Times,* October 29, 1936, p. 9.

Pasternak 1975
Leonid Osipovich Pasternak. *Zapisi raznykh let* (Notes of various years). Moscow, 1975.

Patin 1994
Sylvie Patin. *Claude Monet in Great Britain.* Translated by Maev de la Guardia. Paris, 1994.

Paul 1993
Barbara Paul. *Hugo von Tschudi und die moderne französische Kunst im Deutschen Kaiserreich.* Berliner Schriften zur Kunst, vol. 4. Mainz, 1993.

Paulhan—Suarès 1987
Correspondance Jean Paulhan—André Suarès, 1925–40. Edited by Yves-Alain Favre. Cahiers Jean Paulhan 4. Paris, 1987.

Paul-Sentenac 1937
[Pierre] Paul-Sentenac. *Aristide Maillol.* Paris, 1937.

Penrose 1974
Roland Penrose. "Picasso's Portrait of Kahnweiler." *Burlington Magazine* 116 (March 1974), pp. 124–31.

Perez-Tibi 1989
Dora Perez-Tibi. *Dufy.* Paris, 1989.

Perpignan 1979
Maillol au Palais des Rois de Majorque. Exh. cat. Musée Hyacinthe Rigaud, Perpignan; 1979. Perpignan, [1979].

Perry 2000
Victor Perry. *Stolen Art.* Jerusalem, 2000.

Perucchi-Petri 1972
Ursula Perucchi-Petri. *Bonnard und Vuillard im Kunsthaus Zürich.* Sammlungshefte, Kunsthaus Zürich, 3. Zürich, 1972.

Pessey-Lux and Lepage 2003
Aude Pessey-Lux and Jean Lepage. *George-Daniel de Monfreid, 1856–1929: Le Confident de Gauguin.* Paris, 2003. A catalogue raisonné of Monfreid's paintings and the catalogue of an exhibition held at Musée des Beaux-Arts et de la Dentelle, Alençon, and Musée d'Art et d'Histoire, Narbonne; 2003.

"Petites Expositions" 1899
"Petites Expositions: Galerie Vollard." *La Chronique des arts,* April 1, 1899, p. 114.

Pétridès 1978
Paul Pétridès. *Ma Chance et ma réussite.* Paris, 1978.

Phillips 1983
Sandra S. Phillips. "The Art Criticism of Walter Pach." *Art Bulletin* 65, no. 1 (March 1983), pp. 106–22.

Pia 1955
Pascal Pia. "Ambroise Vollard: Marchand et éditeur." *L'Oeil,* no. 3 (March 15, 1955), pp. 18–27.

Picasso 1942
Pablo Picasso. *Eaux-fortes originales pour des textes de Buffon.* Paris, 1942.

Picasso Anthology 1997
A Picasso Anthology: Documents, Criticism, Reminiscences. Edited by Marilyn McCully. Princeton, 1997.

Picasso/Apollinaire 1992
Picasso/Apollinaire: Correspondance. Edited by Pierre Caizurgues and Hélène Seckel[-Klein]. Art et artistes. Paris, 1992.

Pinet 2001
Hélène Pinet. "Eugène Druet, homme-orchestre et gardien du temple." In *Rodin en 1900: L'Exposition de l'Alma,* pp. 274–82. Exh. cat. Paris: Musée du Luxembourg, 2001.

Pingeot 2004
Anne Pingeot. "Oviri." In Paris–Boston 2003–4, pp. 135–41, 323–24.

Pingeot 2006
Anne Pingeot. *Bonnard sculpteur: Catalogue raisonné.* Paris, 2006.

Pinturrichio 1917
Pinturrichio [pseud. Louis Vauxcelles]. "Le Carnet des ateliers; Amateurs." *Le Carnet de la semaine,* January 21, 1917, p. 10.

Pinturrichio 1926a
Pinturrichio [pseud. Louis Vauxcelles]. "Carnet des ateliers." *Le Carnet de la semaine,* January 10, 1926.

Pinturrichio 1926b
Pinturrichio [pseud. Louis Vauxcelles]. "Carnet des ateliers." *Le Carnet de la semaine,* June 20, 1926, p. 8.

J. Pissarro and Snollaerts 2005
Joachim Pissarro and Claire Durand-Ruel Snollaerts, with the collaboration of Alexia de Buffévent, Annie Champié. *Pissarro: Critical Catalogue of Paintings.* 3 vols. Translated by Mark Hutchinson and Michael Taylor. Milan and Paris, 2005.

L. R. Pissarro and Venturi 1939
Ludovico Rodo Pissarro and Lionello Venturi. *Camille Pissarro: Son Art, son oeuvre.* Paris, 1939.

Pissarro Sale 1906
Catalogue de la vente de tableaux par Camille Pissarro provenant de son atelier. Sale cat., Hôtel Drouot, Paris, June 25, 1906. Ambroise Vollard expert; Maître Paul Chevallier.

Pittsburgh 1938
The 36th International Exhibition of Paintings. Exh. cat. Carnegie Institute, Pittsburgh; 1938. Pittsburgh, 1938.

Ploegaerts 1999
Léon Ploegaerts, ed. *Henry van de Velde: Les Mémoires inachevés d'un artiste européen.* 2 vols. Brussels, 1999.

Podoksik 1989
Anatoliĭ Savelevich Podoksik. *Picasso: Le Quête perpétuelle.* Paris, 1989.

Pophanken 1996
Andrea Pophanken. "Privatsammler der französischen Moderne in München." In Berlin–Munich 1996–97, pp. 424–31.

Pophanken and Billeter 2001
Andrea Pophanken and Felix Billeter, eds. *Die Moderne und ihre Sammler: Französische Kunst in deutschem Privatbesitz vom Kaiserreich zur Weimarer Republik.* Berlin, 2001.

Pouterman 1931
J.-E. Pouterman. "Ambroise Vollard." *Arts et métiers graphiques,* no. 23 (May 15, 1931), pp. 231–38.

Pouterman 1938
J.-E. Pouterman. "Les Livres d'Ambroise Vollard." *Arts et métiers graphiques,* no. 64 (September 15, 1938), pp. 45–56.

Prague 1931
L'École de Paris: Francouzské moderní umění. Exh. cat. Prague, 1931.

Prague–Paris 2000–2002
Vincenc Kramář: From Old Masters to Picasso. Exh. cat. Collection of Modern and Contemporary Art, Národní Galerie, Prague; Musée Picasso, Paris; 2000–2002. Prague, 2000.

Pratt 2006
Jonathan Pratt. "Ambroise Vollard, Dealer and Publisher 1893–1900." Thesis, University of London. Forthcoming.

Première 1930
Georges Première. "Les Plus Beaux Livres illustrés des dix dernières années." *Plaisir de bibliophile* 6 (1930), pp. 84–91, 160–67, 211–16.

"Publications récentes" 1924
"Publications récentes." *Mercure de France,* October 15, 1924, pp. 534–35.

Punaauia 2003
Ia Orana Gauguin. Exh. cat. by Claire Frèches-Thory et al. Musée de Tahiti et des Îles, Punaauia, 2003. Paris and Punaauia, 2003.

Puy 1925
Michel Puy. "Publications d'art." *Mercure de France,* February 15, 1925, pp. 236–37.

Quimper 1950
Gauguin et le groupe de Pont-Aven. Exh. cat. by Gilberte Martin-Méry. Musée des Beaux-Arts de Quimper; 1950. [Quimper], 1950.

Redon 1986
Odilon Redon. *To Myself: Notes on Life, Art and Artists.* Translated by Mira Jacob and Jeanne L. Wasserman. New York, 1986.

Reed and Shapiro 1984
Sue Welsh Reed and Barbara Stern Shapiro. *Edgar Degas: The Painter as Printmaker.* Catalogue raisonné published on the occasion of the exhibition at the Museum of Fine Arts, Boston; Philadelphia Museum of Art; Hayward Gallery, London; 1984–85. Boston, 1984.

Reff 1962
Theodore Reff. "Cézanne's Constructive Stroke." *Art Quarterly* 25, no. 5 (autumn 1962), pp. 214–27.

Reff 1973
Theodore Reff. "Themes of Love and Death in Picasso's Early Work." In Daniel-Henry Kahnweiler et al., *Picasso in Retrospect,* pp. 11–47, 264–66. New York, 1973.

Reff 1977
Theodore Reff. "Painting and Theory in the Final Decade." In New York–Houston 1977–78, pp. 13–53.

Reid 1968
Benjamin Lawrence Reid. *The Man from New York: John Quinn and His Friends.* New York, 1968.

J. Renoir 1962
Jean Renoir. *Renoir, My Father.* Translated by Randolph Weaver and Dorothy Weaver. Boston, 1962.

"Revue de la quinzaine" 1919
"Revue de la quinzaine." *Mercure de France,* March 16, 1919, p. 375.

"Revue de la quinzaine" 1924a
"Revue de la quinzaine." *Mercure de France,* June 15, 1924, p. 852.

"Revue de la quinzaine" 1924b
"Revue de la quinzaine." *Mercure de France,* November 15, 1924, p. 274.

Rewald 1937
John Rewald, ed. *Paul Cézanne: Correspondance.* Paris, 1937.

Rewald 1938
John Rewald. *Gauguin.* Paris, 1938.

Rewald 1939
John Rewald. *Maillol.* Edited by André Gloeckner. Paris, 1939. Also published in English (London and New York, 1939).

Rewald 1943
John Rewald, ed. *Paul Gauguin: Letters to Ambroise Vollard and André Fontainas.* San Francisco, 1943.

Rewald 1943 (1986 ed.)
John Rewald, ed. "Paul Gauguin: Letters to Ambroise Vollard and André Fontainas." In Rewald 1986, pp. 168–213.

Rewald 1943a
John Rewald, ed. *The Woodcuts of Aristide Maillol: A Complete Catalogue.* New York, 1943.

Rewald 1946
John Rewald. "Degas and His Family in New Orleans." *Gazette des beaux-arts,* ser. 6, 30 (August 1946), pp. 105–26.

Rewald 1949
John Rewald, ed. and trans. "Extraits du journal inédit de Paul Signac / Excerpts from the Unpublished Diary of Paul Signac, I, 1894–1895." *Gazette des beaux-arts,* ser. 6, 36 (July–September 1949), pp. 97–128, 166–74.

Rewald 1956
John Rewald. "Quelques Notes et documents sur Odilon Redon." *Gazette des beaux-arts,* 6th ser., 48 (November 1956), pp. 81–124. English translation, "Some Notes and Documents on Odilon Redon," in Rewald 1986, pp. 215–43.

Rewald 1968
John Rewald. *Paul Cézanne: A Biography.* Translated by Margaret H. Liebman. New York, 1968.

Rewald 1969
John Rewald. "Choquet and Cézanne." *Gazette des beaux-arts,* ser. 6, 74 (July–August 1969), pp. 33–96.

Rewald 1970
John Rewald. "The Posthumous Fate of Vincent van Gogh, 1890–1970." *Museumjournaal,* August–September 1970. Reprinted in Rewald 1986, pp. 244–54.

Rewald 1973
John Rewald. "Theo van Gogh, Goupil, and the Impressionists," part 2. *Gazette des beaux-arts,* ser. 6, 81 (February 1973), pp. 65–108.

Rewald 1975
John Rewald. "Maillol Remembered." In New York 1975, pp. 7–31.

Rewald 1976
John Rewald, ed. *Paul Cézanne: Letters.* Translated by Marguerite Kay. 4th ed. New York, 1976.

Rewald 1983
John Rewald. *Paul Cézanne, the Watercolors: A Catalogue Raisonné.* Boston, 1983.

Rewald 1984
John Rewald, ed. *Paul Cézanne: Letters.* Rev. ed. Translated by Seymour Hacker. New York, 1984.

Rewald 1986
John Rewald. *Studies in Post-Impressionism.* Edited by Irene Gordon and Frances Weitzenhoffer. New York, 1986.

Rewald 1988
John Rewald. "Dr. Albert C. Barnes and Cézanne." *Gazette des beaux-arts,* ser. 6, 111 (January–February 1988), pp. 173–82.

Rewald 1989
John Rewald, with research assistance by Frances Weitzenhoffer. *Cézanne and America: Dealers, Collectors, Artists, and Critics, 1891–1921.* Bollingen Series 35, no. 28. Princeton, 1989.

Rewald 1991
John Rewald. "Recollections of Vollard." Typescript, November 6, 1991, John Rewald Papers, Gallery Archives, National Gallery of Art, Washington, D.C. Translation of a piece written for *Die Groene Amsterdammer* ("In memoriam Ambroise Vollard"), August 5, 1939.

Rewald 1996
John Rewald, in collaboration with Walter Feilchenfeldt and Jayne Warman. *The Paintings of Paul Cézanne: A Catalogue Raisonné.* 2 vols. New York, 1996.

Rewald and L. Pissarro 1943
John Rewald, ed. *Camille Pissarro: Letters to His Son Lucien.* With the assistance of Lucien Pissarro. Translated by Lionel Abel. New York, 1943.

Rewald and L. Pissarro 1950
John Rewald, ed. *Camille Pissarro: Lettres à son fils Lucien.* With the assistance of Lucien Pissarro. Paris, [1950].

Rewald and L. Pissarro 1972
John Rewald, ed. *Camille Pissarro: Letters to His Son Lucien.* With the assistance of Lucien Pissarro. Translated by Lionel Abel. 3rd ed. London, 1972.

Rewald and L. Pissarro 1980
John Rewald, ed. *Camille Pissarro: Letters to His Son Lucien.* With the assistance of Lucien Pissarro. Translated by Lionel Abel. Reprint of the 3rd ed. London, 1980.

Rewald and L. Pissarro 2002
John Rewald, ed. *Camille Pissarro: Letters to His Son Lucien.* With the assistance of Lucien Pissarro. Translated by Lionel Abel. Boston, 2002.

Rey 1924
Robert Rey. "Maillol." *Art et décoration* 46 (November 1924), pp. 129–36.

Rey 1927
Robert Rey. "La Belle Angèle de Paul Gauguin." *Beaux-Arts* 5, no. 7 (April 1927), pp. 105–6.

Rey 1950
Robert Rey. *Onze Menus de Gauguin: Menus propos.* Geneva, 1950.

Reynolds 1967
Graham Reynolds. *The Engravings of S. W. Hayter.* London, 1967.

Ribaud-Menetière 1947
Jean Ribaud-Menetière. "Une Lettre inédite de Paul Gauguin." *Arts, beaux-arts, littérature, spectacles,* March 28, 1947, p. 8.

Richards 1996
Marvin N. Richards. "Famous Readers of an Infamous Book: The Fortunes of *Gaspard de la Nuit.*" *French Review* (Chapel Hill, N.C.) 69, no. 4 (March 1996), pp. 543–55.

B. Richardson 1985
Brenda Richardson, with the assistance of William C. Ameringer et al. *Dr Claribel and Miss Etta: The Cone Collection of the Baltimore Museum of Art*. Baltimore, 1985.

Richardson 1991
John Richardson, with Marilyn McCully. *A Life of Picasso*. Vol. 1, *1881–1906*. New York, 1991.

Richardson 1996
John Richardson, with Marilyn McCully. *A Life of Picasso*. Vol. 2, *1907–1917: The Painter of Modern Life*. New York, 1996.

Richmond and other cities 1986–87
Art Nouveau Bing: Paris Style, 1900. Exh. cat. by Gabriel Weisberg. Virginia Museum of Fine Arts, Richmond; John and Mable Ringling Museum of Art, Sarasota, Florida; Joslyn Art Museum, Omaha, Nebraska; and Cooper-Hewitt Museum, New York; 1986–87. Organized by the Smithsonian Institution Traveling Exhibition Service. New York, 1986.

Riotor 1904
Léon Riotor. "Expositions: Henri Matisse (Galerie Vollard)." *L'Art décoratif*, July 1904, suppl., unpaged.

Rippl-Rónai 1911
József Rippl-Rónai. *Emlékezései* (Souvenirs). Budapest, 1911.

Rivière 1923
Georges Rivière. *Le Maître Paul Cézanne*. Paris, 1923.

R. de B. Roberts and J. Roberts 1987
Julie Manet. *Growing up with the Impressionists: The Diary of Julie Manet*. Translated and edited by Rosalind de Boland Roberts and Jane Roberts. London, 1987.

Roche 1894
Armand de Roche. "Een collectie teekeningen en schilderijen." *De kunstwereld* (Amsterdam), October 1894.

Rodríguez 1984–85
Jean-François Rodríguez. "Picasso à la Biennale de Venise (1905–1948)." *Atti dell'Istituto Veneto di Scienze, Lettere e Arti* 143 (1984–85).

Roger-Marx 1926
Claude Roger-Marx. "Les Illustrations de Bonnard." *Plaisir de bibliophile* 2 (1926), pp. 1–9.

Roger-Marx 1930–31
Claude Roger-Marx. "Un Grand Éditeur: Ambroise Vollard." *Plaisir de bibliophile* 6, no. 24 (winter 1930–31), pp. 195–210.

Roger-Marx 1931a
Claude Roger-Marx. "L'Oeuvre gravé de Pierre Bonnard." *L'Art vivant*, no. 145 (February 1931), p. 2.

Roger-Marx 1931b
Claude Roger-Marx. "La Lithographie en couleurs." *Arts et métiers graphiques*, no. 22 (March 15, 1931), pp. 193–200.

Roger-Marx 1931c
Claude Roger-Marx. "Rodin: Dessinateur et graveur." *Arts et métiers graphiques*, no. 25 (September 15, 1931), pp. 349–56.

Roger-Marx 1933
Claude Roger-Marx. "L'Eau-forte dans l'illustration du livre." *L'Art vivant*, no. 175 (August 1933), p. 356.

Roger-Marx 1934
Claude Roger-Marx. "Les Lithographies de Vuillard." *Arts et métiers graphiques*, no. 44 (December 15, 1934), pp. 13–17.

Roger-Marx 1936
Claude Roger-Marx. "Un Grand Éditeur: Ambroise Vollard." *L'Art vivant*, no. 203 (May 1936), p. 121.

Roger-Marx 1946
Claude Roger-Marx. "Céramiques de peintres." *Quadrige* 9 (July–August 1946).

Roger-Marx 1948
Claude Roger-Marx. *L'Oeuvre gravé de Vuillard*. Monte Carlo, 1948.

Roger-Marx 1952
Claude Roger-Marx. *Bonnard, lithographe*. Monte-Carlo, 1952.

Roger-Marx 1990
Claude Roger-Marx. *The Graphic Work of Édouard Vuillard*. Translation of Roger-Marx 1948 by Susan Fargo Gilchrist. San Francisco, 1990.

Roger-Marx et al. 1946
Claude Roger-Marx et al. *Anthologie du livre illustré par les peintres et sculpteurs de l'École de Paris*. Geneva, 1946.

Rosenblum 1986
Robert Rosenblum. "The Desmoiselles Sketchbook no. 42, 1907." In *Je suis le cahier: The Sketchbooks of Picasso*, edited by Arnold Glimcher and Marc Glimcher, pp. 53–79. Exh. cat. Pace Gallery, New York; 1986. New York, 1986.

Rotonchamp 1925
Jean de Rotonchamp. *Paul Gauguin, 1848–1903*. Paris, 1925.

Rouart and D. Wildenstein 1975
Denis Rouart and Daniel Wildenstein. *Édouard Manet: Catalogue raisonné*. 2 vols. Lausanne, 1975.

Rouault 1948
Georges Rouault. *Miserere*. Paris, 1948.

Rouault 1952
Georges Rouault. *Miserere*. Facsimile of 1948 ed. Introduction by Monroe Wheeler. New York, 1952.

Rouault 1971
Georges Rouault. *Sur l'art et sur la vie*. Preface by Bernard Dorival. Paris, 1971.

"Rouault Case" 1948
"The Rouault Case." *Liturgical Arts* 16 (May 1948), pp. 91–94, 99–104.

Rouault—Suarès Correspondance 1960
Georges Rouault and André Suarès. *Georges Rouault—André Suarès Correspondance*. Paris, 1960.

Rouault—Suarès Correspondence 1983
Georges Rouault and André Suarès. *Georges Rouault—André Suarès Correspondence, 1911–1939*. Translated and edited by Alice B. Low-Beer. Ilfracombe, Devon, England, 1983.

"Rouault Sues Dealer" 1946
"Rouault Sues Dealer." *Art Digest* 20, no. 17 (June 1, 1946), p. 8.

Rouillac Sale 2005
Sale cat. Philippe Rouillac (Firm), Château de Cheverny, June 5, 2005. "Tableaux modernes dont succession [Madame Marguerite] Bignou": nos. 40–59.

Roulet 1961
Claude Roulet. *Rouault, souvenirs*. Neuchâtel, 1961.

Roussier 1987
François Roussier. *Jacqueline Marval, 1866–1932*. Grenoble, 1987.

Rubin 1994
William Rubin. "The Genesis of *Les Desmoiselles d'Avignon*." In "Les Desmoiselles d'Avignon," special issue of *Studies in Modern Art* 3, pp. 13–144. New York: Museum of Modern Art, 1994.

Russell 1971
John Russell. *Édouard Vuillard, 1868–1940*. Published on the occasion of an exhibition at the Art Gallery of Ontario, Toronto; California Palace of the Legion of Honor, San Francisco; Art Institute of Chicago, 1971–72. Toronto, 1971.

Sabartés 1946
Jaime Sabartés. *Picasso: Portraits & souvenirs*. Translated by Paule-Marie Grand and André Chastel. Paris, 1946.

Sainsaulieu 1980
Marie-Caroline Sainsaulieu. *Henri Manguin: Catalogue raisonné de l'oeuvre peint*. Edited by Lucile Manguin and Claude Manguin. Neuchâtel, 1980.

St. Petersburg 1912
Exposition centennale de l'art français à Saint Pétersbourg, 1812–1912. Exh. cat. introduction by Sergei Makovsky. St. Petersburg, 1912.

Saint-Tropez 2002
La Céramique fauve dans l'atelier d'André Metthey. Exh. cat. by Jean-Paul Monery and Dominique Forest. L'Annonciade, Musée de Saint-Tropez; 2002. Saint-Tropez, 2002.

Salmon 1925
André Salmon. "Raoul Dufy: Un Imagier moderne." *Plaisir de bibliophile* 1 (1925), pp. 123–35.

Salmon 1945
André Salmon. *L'Air de la butte*. Paris, 1945.

Salomon and Cogeval 2003
Antoine Salomon and Guy Cogeval. *Vuillard: The Inexhaustible Glance; Critical Catalogue of Paintings and Pastels*. 3 vols. Milan and Paris, 2003.

A. Salomon and J. Salomon 1968
Alain [Salomon] and Jacques Salomon.
Introduction à l'oeuvre gravé de K. X. Roussel.
[Paris], 1968.

Saltzman 1998
Cynthia Saltzman. *Portrait of Dr. Gachet: The Story
of a Van Gogh Masterpiece. Modernism, Money,
Politics, Collectors, Dealers, Taste, Greed, and Loss.*
New York, 1998.

Saragossa 1989
G. Braque: Oeuvre gravé. Exh. cat. by René Char
et al. Museo Pablo Gargallo, Saragossa; 1989.
Paris, 1989.

Saunier 1904
Charles Saunier. "Les Petites Expositions." *La
Revue universelle* 4 (1904), p. 537.

Sawyer n.d.
David Sawyer. *Prints by André Derain.* N.p.:
Privately printed, n.d.

Schäfer 1997
Carina Schäfer. *Maurice Denis et le comte Kessler
(1902–1913).* Publications Universitaires
Européennes, série 28, Histoire de l'art, vol. 309.
Frankfurt am Main, 1997.

Schäfer 2001
Carina Schäfer. "Theaterintendant mit Faible für
französische Kunst: Die Sammlung Kurt von
Mutzenbecher in Wiesbaden." In Pophanken and
Billeter 2001, pp. 95–124.

Scheffler 1903
Karl Scheffler. "Impressionistische Weltanschauung."
Die Zukunft 11 (October 24, 1903), pp. 138–47.

Schlagenhaufer 1986
Martina Schlagenhaufer, ed. *Wallraf-Richartz-
Museum der Stadt Köln. Von Stefan Lochner bis Paul
Cézanne: 120 Meisterwerke der Gemäldesammlung.*
Cologne, 1986.

Schneider 2002
Pierre Schneider. *Matisse.* Rev. ed. Paris, 2002.

Schnerb 1910
J.-F. Schnerb. "Petites Expositions: Exposition
Vlaminck (Galerie Vollard)." *La Chronique des arts,*
March 26, 1910, p. 99.

Schoonbeek 1997
Christine van Schoonbeek. *Les Portraits d'Ubu.*
[Paris] and Biarritz, 1997.

Schulmann 1997
Didier Schulmann. "The Critics' Response to
Chagall's Gouaches for the Fables of La Fontaine,
1920–1930." In *Marc Chagall 1997,* pp. 15–35.

Seckel-Klein 1998
Hélène Seckel-Klein. *Picasso collectionneur.* Paris,
1998. French edition of Munich 1998.

"Seized French Art" 1940
"Seized French Art Removed to Canada." *Art
Digest* 15, no. 6 (December 15, 1940), p. 9.

Seligmann 1926
Herbert J. Seligmann. "Intimate Talks with Renoir."
New York Times, February 21, 1926, sect. 3, p. 7.

Shackelford 2004
George Shackelford. "Where Do We Come From?
What Are We? Where Are We Going?" In Paris–
Boston 2003–4, pp. 167–203, 326–28.

Shapiro 1984
Barbara Stern Shapiro. "Degas's Copper Plates." In
Reed and Shapiro 1984, pp. 264–66.

Shapiro 2004
Barbara Stern Shapiro. "'I Have Everything a
Modest Artist Could Wish.'" In Paris–Boston
2003–4, pp. 205–21, 328.

Sharp 1994a
Kevin Sharp. "Redon and the Marketplace after
1900." In Chicago–Amsterdam–London 1994–95,
pp. 258–80, 412–16.

Sharp 1994b
Kevin Sharp. "Redon and the Marketplace before
1900." In Chicago–Amsterdam–London 1994–95,
pp. 237–56, 408–11.

Sharp 1998
Kevin Sharp. "How Mary Cassatt Became an
American Artist." In Chicago–Boston–
Washington 1998–99, pp. 145–75.

Shattuck 1985
Roger Shattuck. "Object Lesson for Modern Art."
In *Henri Rousseau,* pp. 11–22. Exh. cat. essays by
Roger Shattuck, Henri Béhar, Michel Hoog,
Carolyn Lanchner, and William Rubin. Galeries
Nationales du Grand Palais, Paris; Museum of
Modern Art, New York; 1984–85. New York, 1985.

Shelley 2002
Marjorie Shelley. "Gauguin's Works on Paper:
Observations on Materials and Techniques." In
New York 2002, pp. 197–215.

Shiff 1984
Richard Shiff. *Cézanne and the End of
Impressionism: A Study of the Theory, Technique,
and Critical Evaluation of Modern Art.* Chicago,
1984.

Shone 1993
Richard Shone. "Matisse in England and Two
English Sitters." *Burlington Magazine* 135 (July
1993), pp. 479–84.

Sisley Sale 1899
*Catalogue de tableaux, études, pastels par Alfred
Sisley et de tableaux, aquarelles, pastels et dessins:
Offerts à ses enfants par les artistes.* Sale cat., Galerie
Georges Petit, Paris, May 1, 1899.

Slatkin 1980
Wendy Slatkin. "The Early Sculpture of Aristide
Maillol, 1895–1900." *Gazette des beaux-arts,* ser. 6,
96 (October 1980), pp. 141–48.

Slatkin 1982
Wendy Slatkin. *Aristide Maillol in the 1890's.*
Studies in the Fine Arts; Avant-Garde, no. 30.
Ann Arbor, 1982.

Smith 1996
Megan Smith. "Vollard at Clark." *On Paper* 1,
no. 2 (November–December 1996), pp. 2–3.

Sorlier 1981
Charles Sorlier. *Marc Chagall et Ambroise Vollard.*
Paris, 1981.

Sorlier 1990
Charles Sorlier. *Marc Chagall: Le Livre des livres /
Marc Chagall: The Illustrated Books.* [France], 1990.

Spies 2000
Werner Spies. *Picasso: Sculpteur.* Catalogue
raisonné of the sculptures, in collaboration with
Christine Piot. Exh. cat. Centre National d'Art et
de Culture Georges Pompidou, Paris; 2000. Paris,
2000. Also published in English.

Spurling 1998
Hilary Spurling. *The Unknown Matisse: A Life of
Henri Matisse. The Early Years, 1869–1908.* New
York, 1998.

Spurling 2005
Hilary Spurling. *Matisse, the Master: A Life of
Henri Matisse. The Conquest of Colour, 1909–1954.*
London, 2005.

G. Stein 1915
Gertrude Stein. "M. Vollard et Cézanne." *The Sun*
(New York), October 16, 1915.

G. Stein 1933
[Gertrude Stein.] *The Autobiography of Alice B.
Toklas; Illustrated.* New York, 1933.

G. Stein 1934
Gertrude Stein. "Vollard, et le premier Salon
d'Automne." *La Nouvelle Revue française* 43
(September 1, 1934), pp. 358–72.

G. Stein—Picasso 2005
Gertrude Stein—Pablo Picasso: Correspondance.
Edited by Laurence Madeline. Art et artistes. Paris,
2005.

L. Stein 1947
Leo Stein. *Appreciation: Painting, Poetry, and Prose.*
New York, 1947.

L. A. Stein 1996
Laurie A. Stein. "German Design and National
Identity, 1890–1914." In *Designing Modernity:
The Arts of Reform and Persuasion, 1885–1945;
Selections from the Wolfsonian,* edited by Wendy
Kaplan, pp. 49–77. Exh. cat. Wolfsonian,
Miami, and three other venues; 1995–97. New
York, 1996.

S. A. Stein 1986
Susan Alyson Stein, ed. *Van Gogh: A Retrospective.*
[New York], 1986.

S. A. Stein 2001
Susan Alyson Stein. "An Artist among Artists:
Signac beyond the Neo-Impressionist Circle." In
Paris–Amsterdam–New York 2001, pp. 67–81.

S. A. Stein 2005a
Susan Alyson Stein. "*Répétitions:* Drawings after
Paintings." In Amsterdam–New York 2005,
pp. 266–77.

S. A. Stein 2005b
Susan Alyson Stein. "The Paper Trail: From
Portfolios to Posterity." In Amsterdam–New York
2005, pp. 21–39.

Stevens et al. 1990
Émile Bernard, 1868–1941: A Pioneer of Modern Art / Ein Wegbereiter der Moderne. Exh. cat. by MaryAnne Stevens et al. Städtische Kunsthalle Mannheim; Van Gogh Museum, Amsterdam; 1990. Zwolle, Amsterdam, and Mannheim, 1990.

Stolwijk and Veenenbos 2002
Chris Stolwijk and Han Veenenbos. *Account Book of Theo van Gogh and Jo van Gogh-Bonger.* Cahier Vincent, no. 8. Amsterdam and Leiden, 2002.

Stonge 1993
Carmen Luise Stonge. "Karl Ernst Osthaus: The Folkwang Museum and the Dissemination of International Modernism." Ph.D. diss., City University of New York, 1993.

Strachan 1969
Walter John Strachan. *The Artist and the Book in France: The Twentieth Century Livre d'Artiste.* New York, 1969.

Stratis 1994
Harriet K. Stratis. "Beneath the Surface: Redon's Methods and Materials." In Chicago–Amsterdam–London 1994–95, pp. 354–77, 427–31.

Stratis 1998
Harriet K. Stratis. "Innovation and Tradition in Mary Cassatt's Pastels: A Study of Her Methods and Materials." In Chicago–Boston–Washington 1998–99, pp. 213–26.

Stretch 2000
Bonnie Barrett Stretch. "Mary Cassatt." *Art News* 99, no. 10 (November 2000), p. 206.

Stump 1972
Jeanne Stump. "The Art of Ker Xavier Roussel." Ph.D. diss., University of Kansas, 1972.

Suarès 1940
André Suarès. "Ambroise Vollard." *La Nouvelle Revue française* 54 (February 1940), pp. 184–93.

Suarès—Doucet 1994
André Suarès and Jacques Doucet. *Le Condottiere et le magicien: André Suarès—Jacques Doucet.* Edited by François Chapon. Paris, 1994.

Subirana et al. 1970
Rosa Maria Subirana et al. *Museo Picasso: Catálogo.* Barcelona, 1970.

Supinen 1990
Marja Supinen. "Julien Leclercq: A Champion of the Unknown Vincent van Gogh." *Jong Holland* 6 (1990), pp. 5–14.

Sutton and Puget 1989
Denys Sutton and Catherine Puget, with the assistance of Caroline Boyle-Turner. *Une Vie de bohème: Lettres du peintre Armand Seguin à Roderic O'Conor, 1895–1903.* [Pont-Aven], 1989.

Sweet 1966
Frederick A. Sweet. *Miss Mary Cassatt, Impressionist from Pennsylvania.* Norman, Okla., 1966.

Tabarant 1931
A[dolphe] Tabarant. *Manet: Histoire catalographique.* Paris, 1931.

Tanguy Sale 1894
Catalogue de tableaux modernes, pastels, aquarelles, dessins, gravures, sculptures dont la vente aura lieu au profit de Mme Vve Tanguy. Sale cat., Hôtel Drouot, Paris, June 2, 1894.

Tate Gallery 1988
Tate Gallery. *The Tate Gallery Illustrated Catalogue of Acquisitions, 1984–86.* London, 1988.

Tedeschi 1985
Martha Tedeschi. *Great Drawings from the Art Institute of Chicago.* Introduction by Esther Sparks and Suzanne Folds McCullagh. New York and Chicago, 1985.

Terey 1929
Edith de Terey. "Mrs. Havemeyer's Vivid Interest in Art." *New York Times,* February 3, 1929, p. 117.

Tériade 1930
E. Tériade [misprinted in article as Terrade]. "Expositions: Les Éditions Ambroise Vollard (Le Portique, 99, boulevard Raspail)." *L'Intransigeant,* December 29, 1930, p. 6.

Tériade 1951
E. Tériade. "Matisse Speaks." *Art News Annual 1952,* no. 21, pp. 40–77. Issued as *Art News* 50, no. 7 (November 1951).

Terrasse 1927
Antoine Terrasse. *Bonnard.* Paris, 1927.

Terrasse 1989
Antoine Terrasse. *Pierre Bonnard: Illustrator.* Translated by Jean-Marie Clarke. New York, 1989.

Terrasse 2001
Antoine Terrasse, ed. *Bonnard, Vuillard: Correspondance.* [Paris], 2001.

B. Thomson 1988
Belinda Thompson. *Vuillard.* New York, 1988.

Thomson 1999
Richard Thomson. "Theo van Gogh: Un Marchand entreprenant, un homme de confiance." In Amsterdam–Paris 1999–2000, pp. 61–152.

Thorold 1993
Anne Thorold, ed. *The Letters of Lucien to Camille Pissarro, 1883–1903.* Cambridge Studies in the History of Art. Cambridge and New York, 1993.

Thorson 1975
Victoria Thorson. *Rodin Graphics: A Catalogue Raisonné of Drypoints and Book Illustrations.* Exh. cat. California Palace of the Legion of Honor, San Francisco; 1975. San Francisco, 1975.

Tiers 1985
Robert Tiers. "Le Testament de Paul Cézanne et l'inventaire des tableaux de sa succession, rue Boulegon à Aix en 1906." *Gazette des beaux-arts,* ser. 6, 106 (November 1985), pp. 176–78.

Van Tilborgh and Hendriks 2001
Louis van Tilborgh and Ella Hendriks. "The Tokyo *Sunflowers:* A Genuine Repetition by Van Gogh or a Schuffenecker Forgery?" *Van Gogh Museum Journal,* 2001, pp. 17–43.

Tinterow 1988
Gary Tinterow. "The 1880s: Synthesis and Change." In Paris–Ottawa–New York 1988–89, pp. 363–74.

Tinterow 1993
Gary Tinterow. "The Havemeyer Pictures." In New York 1993, pp. 3–53.

Tinterow 1997
Gary Tinterow. "Degas's Degases." In New York 1997–98, vol. 1, pp. 75–107.

Tokyo 1972
Vollard: Seiki no daigashō, Vorāru korekushon. Hatsukokai no meiga. Exh. cat. Tokyu Hyakkaten Honten, Tokyo; 1972. Tokyo, 1972.

Tomasi 2002
Michele Tomasi. "Raymond Koechlin, collectionneur et historien de l'art." *Nouvelles de l'INHA* (Institut National d'Histoire de l'Art) 11–12 (November 2002), pp. 11–13.

Toronto–Montreal 2002–3
Voyage into Myth: French Painting from Gauguin to Matisse from the Hermitage Museum, Russia. Exh. cat. by Nathalie Bondil et al. Art Gallery of Ontario, Toronto; Montreal Museum of Fine Arts; 2002–3. Montreal and Toronto, 2002.

Tours 1966
Maurice Denis, illustrateur. Exh. cat. Musée des Beaux-Arts, Tours; 1996. Organized by the Bibliothèque Municipale de Tours. Tours, 1966.

Van Uitert and Hoyle 1987
Evert van Uitert and Michael Hoyle, eds. *The Rijksmuseum Vincent van Gogh.* Amsterdam, 1987.

Valerio 1923
Edith Valerio. "An Artist Scrupulous in the Presence of Nature." *New York Times,* July 8, 1923, sect. 3, p. 10.

Valéry 1960
Paul Valéry. *Degas, Manet, Morisot.* Translated by David Paul. Bollingen Series, 45. His Collected Works, 12. New York, 1960.

Valles-Bled 1996
Maïthé Valles-Bled. "Vlaminck et l'expérience de la céramique." In Nice–Bruges 1996, pp. 109–16.

Vallier 1982
Dora Vallier. "À propos de la 'Théogonie' de Braque." *Nouvelles de l'estampe* (Paris) 66 (1982), pp. 24–26.

Vallier 1988
Dora Vallier. *Braque, the Complete Graphics: Catalogue Raisonné.* Translated by Robert Bononno and Pamela Barr. New York, 1988.

Varnedoe 1987
Kurt Varnedoe. *Gustave Caillebotte.* New Haven, 1987.

Vauxcelles 1904
Louis Vauxcelles. "Notes d'art. Exposition Henri Matisse." *Gil Blas,* June 14, 1904, p. 1.

Vauxcelles 1905a
Louis Vauxcelles. "Un Après-midi chez Claude Monet." *Art et les artistes*, 1905, p. 89.

Vauxcelles 1905b
Louis Vauxcelles. "Le Salon d'Automne." *Gil Blas*, October 17, 1905, suppl., p. 1.

Vauxcelles 1908
Louis Vauxcelles. "Collection de M. P. Gallimard." *Les Arts*, September 1908.

Vauxcelles 1933
Louis Vauxcelles. "Esquisses des annales lithographiques. *L'Art vivant*, no. 175 (August 1933), pp. 352–53.

Van de Velde 1992
Henry van de Velde. *Récit de ma vie: Anvers, Bruxelles, Paris, Berlin*. Vol. 1, *1863–1900*. Edited by Anne van Loo; with collaboration by Fabrice van de Kerckhove. Brussels, 1992.

"Les Ventes Degas continuent" 1919
"Les Ventes Degas continuent." *Aux Écoutes*, April 20, 1919, p. 14.

Venturi 1936
Lionello Venturi. *Cézanne: Son art, son oeuvre.* 2 vols. Paris, 1936.

Venturi 1939
Lionello Venturi. *Les Archives de l'Impressionnisme: Lettres de Renoir, Monet, Pissarro, Sisley, et autres; Mémoires de Paul Durand-Ruel. Documents.* 2 vols. Paris and New York, 1939.

Venturi 1940
Lionello Venturi. *Georges Rouault.* New York, 1940.

Verdet 1952
André Verdet. *Prestiges de Matisse; précédé de visite à Matisse; entretiens avec Matisse.* Paris, 1952.

Vialla 1988
Jean Vialla. *La Vie et l'oeuvre d'Odilon Redon.* Introduction by René Huyghe. Courbevoie (Paris), 1988.

Viatte 1962
Germain Viatte, ed. "[Henri Rousseau]: Lettres inédites à Ambroise Vollard." *Art de France*, no. 2 (1962), pp. 330–36.

Vierny 1958
Dina Vierny. "Notes on the Casting of Maillol's Work." In *An Exhibition of Original Pieces of Sculpture by Aristide Maillol, 1861–1944*, p. 14. Exh. cat. Paul Rosenberg and Co., New York; 1958. New York, 1958.

Vlaminck 1955
Maurice de Vlaminck. "Avec Derain, nous avons créé le fauvisme." *Jardin des arts* 8 (June 1955), pp. 473–79.

Vogt 1983
Paul Vogt. *Museum Folkwang Essen: Die Geschichte einer Sammlung junger Kunst im Ruhrgebiet.* Rev. ed. Cologne, 1983.

Vollard 1896
Ambroise Vollard. *L'Album des peintres-graveurs.* Paris, 1896.

Vollard 1911
Ambroise Vollard, ed. *Lettres de Vincent van Gogh à Émile Bernard.* Paris: Ambroise Vollard, 1911.

Vollard 1914
Ambroise Vollard. *Paul Cézanne.* [Deluxe ed.] Paris: Galerie A. Vollard, 1914.

Vollard 1914a
Ambroise Vollard. "L'Atelier de Cézanne." *Mercure de France*, March 16, 1914, pp. 286–95.

Vollard 1916a
Ambroise Vollard. "Cezanne and Zola." *The Soil* (New York) 1, no. 1 (December 1916), pp. 13–14.

Vollard 1916b
Ambroise Vollard. "Une Figure de 'grand amateur': Le Comte Isaac de Camondo." *Mercure de France*, December 16, 1916, pp. 592–99.

Vollard 1917a
Ambroise Vollard. "Cezanne's Studio." *The Soil* (New York) 1, no. 3 (March 1917), pp. 102–11.

Vollard 1917b
Ambroise Vollard. "How I Came to Know Renoir." *The Soil* (New York), July 1917, pp. 189–93.

Vollard 1918
Ambroise Vollard. *Tableaux, pastels et dessins de Pierre-Auguste Renoir.* 2 vols. Paris: A. Vollard, 1918.

Vollard 1919a
Ambroise Vollard. *Paul Cézanne: Huit phototypies d'après Cézanne; lettres de M. M. Jacques Flach, de l'Institut et André Suarès.* [Standard ed.] Paris and Zürich: Georges Crès & Cie, 1919.

Vollard 1919b
Ambroise Vollard. *La Vie et l'oeuvre de Pierre-Auguste Renoir.* [Deluxe ed.] Paris: Ambroise Vollard, 1919.

Vollard 1920
Ambroise Vollard. *Auguste Renoir (1841–1919) avec onze illustrations, dont huit phototypies.* Standard ed. of Vollard 1919b. Paris: Georges Crès & Cie, 1920.

Vollard 1921
Ambroise Vollard. *Auguste Renoir (1841–1919).* New ed. Paris: Georges Crès & Cie, 1921.

Vollard 1922
Ambroise Vollard. "Die impressionistischen Theorien." *Kunst und Künstler* 20 (1922), pp. 311–16.

Vollard 1924a
Ambroise Vollard. *Degas (1834–1917).* Artistes d'hier et d'aujourd'hui. Paris: Georges Crès & Cie, 1924.

Vollard 1924b
Ambroise Vollard. *Paul Cézanne. 8 phototypies d'après Cézanne.* Rev. and expanded ed. Paris: Georges Crès & Cie, 1924.

Vollard 1925
Ambroise Vollard. *Renoir: An Intimate Portrait.* Translated by Harold L. Van Doren and Randolph T. Weaver. New York: Alfred A. Knopf; London: Constable, 1925.

Vollard 1925a
Ambroise Vollard. "Degas." Translated by Margarete Mauthner. *Kunst und Künstler* 23 (1925), pp. 60–67.

Vollard 1927a
Ambroise Vollard. *Degas: An Intimate Portrait.* Translated by Randolph T. Weaver. New York: Greenberg, 1927.

Vollard 1927b
Ambroise Vollard. *Sainte Monique.* Standard ed. Paris: Émile-Paul Frères, 1927.

Vollard 1929a
Ambroise Vollard. "Autour d'une édition: De La Fontaine à Chagall." *L'Intransigeant*, January 8 and 14, 1929. Translated in *Marc Chagall* 1997, p. 16.

Vollard 1929b
Ambroise Vollard. "Comment je devins éditeur." *L'Art vivant* 5, no. 120 (December 15, 1929), pp. 979–80. Reprinted in Paris 1930–31.

Vollard 1930
Ambroise Vollard. *La Vie de Sainte Monique.* Deluxe ed., illustrated by Pierre Bonnard. Paris: Ambroise Vollard, 1930.

Vollard 1931
Ambroise Vollard. "Souvenirs sur Cézanne." *Cahiers d'art* 6, nos. 9–10 (1931), pp. 386–95.

Vollard 1932
Ambroise Vollard. *Les Réincarnations de Père Ubu.* Illustrated by Georges Rouault. Paris, 1932.

Vollard 1933
Ambroise Vollard. "Georges Rouault." *Les Nouvelles littéraires, artistiques et scientifiques*, June 3, 1933, p. 3.

Vollard 1934
Ambroise Vollard. "Renoir, sculpteur." *Beaux-arts Magazine*, October 12, 1934, p. 1.

Vollard 1935
Ambroise Vollard. "Souvenirs sur Cézanne." *Minotaure*, 1935, pp. 13–16.

Vollard 1936
Ambroise Vollard. *Recollections of a Picture Dealer.* Translated by Violet M. Macdonald. Boston: Little, Brown; London: Constable, 1936. Reprinted New York: Dover, 1978.

Vollard 1937a
Ambroise Vollard. *Paul Cézanne: His Life and Art.* Translated by Harold L. Van Doren. New York: Crown; London: Constable, 1937.

Vollard 1937b
Ambroise Vollard. *Souvenirs d'un marchand de tableaux.* Paris: Albin Michel, 1937.

Vollard 1937b (1984 ed.)
Ambroise Vollard. *Souvenirs d'un marchand de tableaux.* Reprint of 1937 ed. Paris, 1984.

Vollard 1937c
Ambroise Vollard. *Degas: An Intimate Portrait.* New ed. Translated by Randolph T. Weaver. New York: Crown; London: Constable, 1937.

Vollard 1938a
Ambroise Vollard. *En Écoutant Cézanne, Degas, Renoir.* Paris: Bernard Grasset, 1938.

Vollard 1938b
Ambroise Vollard. *Souvenirs d'un marchand de tableaux.* New ed. Paris: Albin Michel, 1938.

Vollard 1938c
Ambroise Vollard. "Mes Portraits." *Arts et métiers graphiques*, no. 64 (September 15, 1938), pp. 39–44.

Vollard 1939a
Ambroise Vollard. "Cézanne, Champsaur et la beauté." *Candide,* March 1, 1939.

Vollard 1939b
Ambroise Vollard. "Mes Portraits." *Verve* (Paris), 1939, p. 134.

Vollard 1948
Ambroise Vollard. *Souvenirs d'un marchand de tableaux.* Rev. ed. Paris, 1948.

Vollard 1952
Ambroise Vollard. "J'édite les Fables de La Fontaine et je choisis Chagall comme illustrateur." *Derrière le miroir* (Paris) 44–45 (March 1952), unpaged.

Vollard 1957
Ambroise Vollard. *Souvenirs d'un marchand de tableaux.* New illustrated ed., with commentary by Simone Lamblin, texts by Gertrude Stein and Guillaume Apollinaire. Paris: Club des Libraires de France, 1957.

Vollard 1989a
Ambroise Vollard. *Pierre-August Renoir: Paintings, Pastels, and Drawings / Tableaux, pastels et dessins.* Revised edition of Vollard 1918 with English translation. San Francisco, 1989.

Vollard 1989b
Ambroise Vollard. *Souvenirs d'un marchand de tableaux.* Paris: Albin Michel, 1989.

Vollard Sale 1957
Lit de Vollard par Derain, table de Vollard par Vlaminck; tableaux modernes. Sale cat., Galerie Charpentier, Paris, June 25, 1957.

Vollard Sale 1992
Fonds Vollard. Sale cat., Hôtel Drouot, Paris, May 19, 1992.

"Vollard Speaks" 1936
"Vollard Speaks." *Art Digest* 11, no. 4 (November 15, 1936), p. 7.

Waern 1892
Cecilia Waern. "Some Notes on French Impressionism." *Atlantic Monthly* 69, no. 414 (April 1892), pp. 535–41.

Waldemar George 1927
Waldemar George [pseud.]. *Maillol; 24 phototypies.* Albums d'Art Druet, no. 2. Paris, 1927.

Waldemar George 1936
Waldemar George [pseud.]. "Oeuvres de vieillesse de Degas." *La Renaissance* 19, nos. 1–2 (January–February 1936), pp. 3–4.

Waldemar George 1965
Waldemar George [pseud.]. *Aristide Maillol.* Translated by Diana Imber. Greenwich, Conn., 1965.

Waldfogel 1965
Melvin Waldfogel. "Caillebotte, Vollard, and Cézanne's 'Baigneurs Au Repos.'" *Gazette des beaux-arts*, ser. 6, 65 (February 1965), pp. 113–20.

Walter 2001
Sabine Walter. "Die Sammlung Harry Graf Kessler in Weimar and Berlin." In Pophanken and Billeter 2001, pp. 67–93.

Wang 1974
Robert Theodore Wang. "The Graphic Art of the Nabis, 1888–1900." Ph.D. diss, University of Pittsburgh, 1974.

Warman 2003
Jayne Warman. "A Dual Legacy." In *Atelier Cézanne, 1902–2002: Le Centenaire*, pp. 169–73. Aix-en-Provence, [2002]. English translation, 2003.

Warnod 1926
André Warnod. "Georges Rouault n'écrira pas sur Ambroise Vollard." *Comoedia*, January 30, 1926.

Warnod 1965
André Warnod. *Les Peintres, mes amis.* Paris, 1965.

Warsaw 1937
Wystawa malarstwa francuskiego: Od Maneta po dzień dzisiejszy / Exposition de la peinture française: De Manet à nos jours. Exh. cat. preface by Claude Roger-Marx. Muzeum Narodowe w Warszawie; 1937. Warsaw, 1937.

Washington 1978
"The Noble Buyer": John Quinn, Patron of the Avant-Garde. Exh. cat. by Judith Zilczer. Hirshhorn Museum and Sculpture Garden, Smithsonian Institution, Washington, D.C.; 1978. Washington, D.C., 1978.

Washington–Chicago 2005
Toulouse-Lautrec and Montmarte. Exh. cat. by Richard Thomson, Phillip Dennis Cate, and Mary Weaver Chapin. National Gallery of Art, Washington, D.C.; Art Institute of Chicago; 2005. Washington, D.C., 2005.

Washington–Chicago–Paris 1988–89
The Art of Paul Gauguin. Exh. cat. by Richard Brettell et al. National Gallery of Art, Washington, D.C.; Art Institute of Chicago; Galeries Nationales du Grand Palais, Paris; 1988–89. English ed. Washington, D.C., 1988.

Washington–Fort Worth–South Hadley 1987–88
Berthe Morisot: Impressionist. Exh. cat. by Charles F. Stuckey and William P. Scott, with Suzanne G. Lindsay. National Gallery of Art, Washington, D.C.; Kimbell Art Museum, Forth Worth; Mount Holyoke College Art Museum, South Hadley, Massachusetts; 1987–88. New York, 1987.

Washington–Los Angeles–New York 1986
Impressionist to Early Modern Paintings from the U.S.S.R.: Works from the Hermitage Museum, Leningrad, and the Pushkin Museum of Fine Arts, Moscow. National Gallery of Art, Washington, D.C.; Los Angeles County Museum of Art; The Metropolitan Museum of Art, New York; 1986. Los Angeles, 1986.

Watkins 1994
Nicholas Watkins. *Bonnard.* London, 1994.

Watson 1941
Jane Watson. "Vollard's Painter-Engravers." *Magazine of Art* 34, no. 6 (June–July 1941), p. 327.

Watson and Morris 2000
Steven Watson and Catherine Morris, eds. *An Eye on the Modern Century: Selected Letters of Henry McBride.* New Haven, 2000.

Watt 1939
Alexander Watt. "Ambroise Vollard." *Apollo* 30 (December 1939), pp. 205–7.

Watt 1947
Alexander Watt. "Paris Commentary." *Studio* (London) 134 (October 1947), pp. 116–17.

Weill 1933
Berthe Weill. *Pan! Dans l'oeil.* Paris, 1933.

Welsh-Ovcharov 1998
Bogomila Welsh-Ovcharov. "The Ownership of Vincent van Gogh's 'Sunflowers.'" *Burlington Magazine* 140 (March 1998), pp. 184–92.

Werner 1969
Alfred Werner. *The Graphic Works of Odilon Redon: 209 Lithographs, Etchings, and Engravings.* New York, 1969. Republication of 1913 *Oeuvre graphique complet,* with additional works added from various sources.

Werner 1977
Alfred Werner. "Vollard's Special Genius." *Art and Artists* (London) 12, no. 4 (August 1977), pp. 8–13.

Werth 1913
Léon Werth. "Aristide Maillol." *L'Art décoratif* 29 (1913), pp. 61–76.

Wertheimer 1953
Klára Wertheimer. "Aristide Maillol levelei Rippl-Rónai Jósefhez." *Müvészettörténeti értesitö*, 1953, pp. 110–18.

White 1984
Barbara Ehrlich White. *Renoir: His Life, Art, and Letters.* New York, 1984.

White 1996
Barbara Ehrlich White. *Impressionists Side by Side: Their Friendships, Rivalries, and Artistic Exchanges.* New York, 1996.

A. Wildenstein 1992–98
Alec Wildenstein. *Odilon Redon: Catalogue raisonné et de l'oeuvre peint et dessiné.* 4 vols. Paris, 1992–98.

D. Wildenstein 1974–86
Daniel Wildenstein. *Claude Monet: Biographie et catalogue raisonné.* 5 vols. Lausanne, 1974–86.

D. Wildenstein 1996
Daniel Wildenstein. *Monet.* [Rev. ed.] 4 vols.
Cologne and Paris, 1996.

D. Wildenstein 2001
Daniel Wildenstein. *Gauguin: Premier itinéraire
d'un sauvage. Catalogue de l'oeuvre peint (1873–
1888).* With contributions by Sylvie Crussard and
Martine Heudron. 2 vols. Paris and Milan, 2001.

D. Wildenstein and Stavridès 1999
Daniel Wildenstein and Yves Stavridès. *Marchands
d'art.* Paris, 1999.

G. Wildenstein 1964
Georges Wildenstein. *Gauguin.* L'Art français.
Paris, 1964.

Wilkin 1996
Karen Wilkin. "Monsieur Pellerin's Collection: A
Footnote to 'Cézanne.'" *New Criterion* 14, no. 8
(April 1996), pp. 18–23.

Willoch 1967
Sigurd Willoch. *Nasjonalgalleriets venner: Kunst i
femti år.* Oslo, 1967.

Windsor 1981
Alan Windsor. "Hohenhagen." *Architectural
Review* 170 (September 1981), pp. 169–75.

Winterthur 1916
Ausstellung französischer Malerei. Exh. cat.
Kunstverein Winterthur; 1916. [Winterthur, 1916.]

Winterthur 1973
*Künstlerfreunde um Arthur und Hedy Hahnloser-
Bühler: Französische und schweizer Kunst, 1890
bis 1940.* Exh. cat. edited by Rudolf Koella.
Kunstmuseum Winterthur; 1973. Winterthur, 1973.

Wittrock 1985
Wolfgang Wittrock. *Toulouse-Lautrec: The Complete
Prints.* Edited and translated by Catherine E.
Kuehn. 2 vols. London and New York, 1985.

Woolf 1936
S. J. Woolf. "Its Foster Father Talks of Modern
Art." *New York Times,* November 15, 1936, sect. 8,
p. 9.

Yokohama–Nagoya 1999–2000
Sezannu ten / Cézanne and Japan. Exh. cat.
Yokohama Museum of Art; Aichi Prefectural
Museum of Art, Nagoya; 1999–2000. Tokyo, 1999.

Zahar 1931
Marcel Zahar. "The Vollard Editions." Interview
with Vollard. *Formes,* no. 12 (February 1931),
pp. 33–34.

Zervos 1925
Christian Zervos. "Aristide Maillol." *L'Art
d'aujourd'hui,* 1925, pls. 31–33.

Zervos 1928
Christian Zervos. "Picasso: Oeuvres inédites
anciennes." *Cahiers d'art* 3, nos. 5–6 (1928),
pp. 205–27.

Zervos 1932–78
Christian Zervos. *Pablo Picasso.* 33 vols. Paris and
New York, 1932–78.

Ziegler 2001
Hendrik Ziegler. "Emil Heilbut, ein früher
Apologet Claude Monets." In Pophanken and
Billeter 2001, pp. 41–65.

Zola 1886
Émile Zola. *L'Oeuvre.* Paris, 1886. Reprint, Paris,
1997. Translated as *The Masterpiece* by Thomas
Walton and Roger Pearson. Oxford, 1993.

Zurcher 1988
Bernard Zurcher. *Georges Braque: Life and Work.*
Translated by Simon Nye. New York, 1988.

Zürich 1917
Französische Kunst des XIX. u. XX. Jahrhunderts.
Exh. cat. Zürcher Kunsthaus, Zürich; 1917. Zürich,
1917.

Zürich–Paris 1993–94
Les Nabis, 1888–1900. Exh. cat. by Claire Frèches-
Thory and Ursula Perucchi-Petri. Kunsthaus
Zürich; Galeries Nationales du Grand Palais, Paris;
1993–94. Paris and Munich, 1993.

Index

List of Owners

Compiled by Asher E. Miller

All owners named in the catalogue provenances are
included, with numbers for current owners in **boldface**.

Duret, Théodore (1838–1927), cat. 46

Durrio y Madrón, Francisco "Paco," cats. 101, 105a

Duveen, Joseph, 1st Baron Duveen of Millbank, cat. 98

Edwards, Alfred, cat. 112

Eknayan, Myran Garabet, cat. 143

Epstein, Max (1875–1954), and Mrs. Epstein, cat. 180

Exsteens, Maurice, cats. 58–66

Fabbri, Egisto (1866–1933), cat. 38

Fabiani, Martin (d. 1989), cat. 154

Fabre, Maurice, cats. 87, 98

Falk, Sally (1888–1962), cat. 123

Faure, Elie (1873–1937), cat. 7

Fayet, Gustave (1865–1925), cats. 103, 108, 109; heirs of (*see also* Mme Paul Bacou), cats. 103, 108

Feigen & Co., Richard L., cat. 117

Feilchenfeldt, Marianne, cat. 48

Felheimer, L., cat. 177

Fénéon, Félix (1861–1944), cat. 7

Feydeau, Georges (1862–1921), cat. 31

Franc, Gabrielle, cat. 191

French Art Galleries, cats. 44, 79

Frizeau, Gabriel (1870–1938), cats. 96, 97

Fry, Roger (1866–1934), cat. 90

Galéa, Collection de, cats. 2, 10, 70, 97, 135, 152

Galerie d'Art Frans Buffa & Zonen, cats. 117, 122

Gauguin, Paul (1848–1903), cats. 1, 113; Mme Gauguin, *née* Mette-Sophie Gad (1850–1920), cat. 109

Geiser, Walther, cat. 105

Gelman, Jacques (1909–1986), and Mrs. Gelman (Natasha), cat. 142

Gérard, Mme Edmond (stepdaughter of William Molard), cat. 91

Getty, J. Paul, Museum, Los Angeles, cat. **29**

Giese, F. Delius. *See* Delius Gallery

Gieseler, M., cat. 117

Ginoux, Mme Joseph-Michel, *née* Marie Julien (1848–1911), cat. 123

Gloannec, Marie-Jeanne (1839–1915), cat. 1

Gogh, Theo van (1857–1891) (*see also* Boussod et Valadon), cats. 119–122

Gogh-Bonger, Johanna van (Mrs. Theo van Gogh, 1862–1925), cats. 115, 116, 119, 120, 122

Gold, Alfred (1874–1958), cat. 96

Goldschmidt, Jakob (d. 1955), cat. 38

Goodspeed, Mrs. Charles B., cat. 101

Goodstein, Harriet Weiner, cat. 200

Goodyear, Anson Conger (1877–1964), cat. 90

Goriany, Jean A., cats. 104a, 106b, 165, 167

Goulandris, Mrs. John, cat. 29

Gray Gallery, Richard, cat. 45

Grönvold, Bernt (1859–after 1917), cat. 123

Guaita, Else von, cat. 89

Guérin, Marcel (1873–1948), cat. 1

Guillaume, Paul (1891–1934), cats. 76, 140, 143

Hahn, Stephen, cat. 177

Hanley, T. Edward (1893–1969), and Mrs. Hanley, *née* Tullah Innes (1924–1993), cat. 141

Hansen, Wilhelm (1868–1936), cat. 111

Harriman, Marie, Gallery, cats. 34, 96

Harriman, W. Averell (1891–1986), and Mrs. Harriman, *née* Marie Norton (1903–1970), cat. 34; Mrs. Harriman, cat. 55; W. Averell Harriman Foundation, cat. 34

Hauke, César Mange de. *See under* Brame, Paul

Haupt, Ira (1899–1963), and Mrs. Haupt, *née* Enid Annenberg (1906–2005), cat. 147

Havemeyer, H. O. (Henry Osborne, 1847–1907), and Mrs. Havemeyer, *née* Louisine Elder (1855–1929), cats. 24, 36, 56

Hecht, Harold (1907–1985), cat. 29

Henry, Germaine (1904–1997), and Robert-Marie Thomas (1900–1979), cat. 192

Hessel, Jos (d. 1942), cats. 37, 44, 45, 53, 94, 112

Higgins, Aldus C[hapin] (b. 1872), and Mrs. Higgins, cat. 181

Higgins, Stephen, cat. 3

Hirsch, Baron Robert von (1883–1977), and Martha von Hirsch, cat. 51

Hirshhorn Museum and Sculpture Garden, Smithsonian Institution, Washington, D.C., cat. **161b**

Hodebert, M. *See* Barbazanges, Galerie

Holzmann, Wilhelm, cat. 8

Hoogendijk, Cornelis (1866–1911), cats. 37, 45, 113, 116, 117

Hudson, Mrs. Cecil Blaffer, cat. 152

Hutton, Leonard, Gallery, cat. 191

Jacobsen, Helge (1882–1946), cat. 100

Johnson Galleries, Chester H., cat. 114

Jonas, Édouard-Léon (1883–1961), cat. 177

Josefowitz, Samuel, cat. 70

Kaganovitch, Max (1891–1978), cats. 75, 77, 92; and Mme Kaganovitch (Rosy, 1900–1961), cats. 77, 92

Kahn-Sriber, Robert (1900–1988), and Mme Kahn-Sriber, cat. 122

Kann, Alphonse (1870–1948), cats. 46, 87, 113

Katz Art Gallery (H. Katz), cat. 116

Keller, Georges, cat. 76

Keller, Jean, cats. 87, 111

Kerrigan, Esther Slater, cat. 117

Kessler, Count Klement Ulrich (Harry) von (1868–1937), cat. 90

Keynes, J[ohn] Maynard, 1st Baron Keynes (1883–1946), cat. 24; Lady Keynes (1892–1981), cat. 24

King's College, Cambridge University, cat. **24**

Klein, Alfred, cat. 132

Kleinmann, Albert, cat. 7

Knoedler & Co., cats. 76, 116, 120, 141, 143

Koechlin, Raymond (1860–1931), and Mme Koechlin, *née* Hélène Bouwens van der Boijen (d. 1893), cat. 127

Koenig, Helge Siegfried, cat. 147

Koenig, Hertha (1884–1976), cat. 147

Kraushaar Art Gallery, C. W., cat. 117

Kröller-Müller, Anton J. (1862–1941), and Mrs. Kröller-Müller (Helene, 1869–1939), cat. 119

Kröller-Müller Museum, Otterlo, cat. **119**

Krugier, Jan, cat. 198

Kunsthalle Mannheim, cat. **128**

Kunsthaus Zürich, cat. **9**

Kunstmuseum Basel, cat. **51**

La Passe Art Gallery, cat. 121

Laroche, Henry-Jean (1866–1935), cat. 114

Larock-Granoff Collection, cats. **74, 81, 83, 130, 193–196**

Leclanché, Maurice (1848–1921), cat. 174

Lecomte, Marcel, cat. 158

Lecomte, René, and Mme Lecomte, *née* Pellerin, cats. 26, 28; heirs of, cats. 26, 28

Lefevre Gallery, cats. 58–66

Lehman, Robert (1892–1969), cat. 78; Robert Lehman Foundation, cat. 78

Leicester Galleries, cat. 101

Lévy, cats. 87, 89, 90, 109

Lévy, Pierre (1907–2002), and Mme Lévy, *née* Denise Liève, cat. 75

Lewisohn, Adolph (1849–1938), cats. 94, 123

Lewisohn, Samuel A. (1884–1951), cats. 94, 123

Loeb, Mr. and Mrs. John L., cat. 120

Loew, Hans, cat. 200

Los Angeles County Museum of Art, cat. **88**

Lung, Frédéric (1863–1942), and Mme Lung, *née* Julie Gugliemetti (1880–1957), cat. 89

Mackenzie, Basil William Sholto, 2nd Baron Amulree (1900–1983), cat. 136

Malingue, Galerie Daniel, cat. 109

Mañach, Pedro (Pere) (d. 1936/39), cats. 140, 141, 143, 144

Marlborough Fine Arts, cat. 8

Marseille, Léon, cat. 124

Matignon Art Gallery (a.k.a. Galerie André Weil), cats. 57, 154

Matisse, Henri (1869–1954), cat. 33

Matisse, Pierre (1900–1989), and Mrs. Matisse (Maria-Gaetana), cat. 137

Matisse, Pierre, Gallery, cat. 149

Matsukata, Prince Kojiro (1865–1950), cat. 95

McCormick, Chauncey (1884–1954), and Mrs. McCormick, *née* Marion Deering (1886–1965), cat. 116

McCormick, Robert R[utherford] (1880–1955), cat. 140

McDermott, Mr. and Mrs. Eugene, cat. 115

McMillan, Putnam Dana (d. 1961), cat. 79

Mellon, Paul (1907–1999), and Mrs. Mellon, cat. 38

Metropolitan Museum of Art, New York, cats. **14b, 15a,** **17–20a,** 36, 39, 49, 56, 57, **71b,** 72, 78, **113,** 120, 123, **124, 137, 142,** 147, 149, 154, **163c, 171, 179, 182, 183**

Minneapolis Institute of Arts, cat. **79**

Mirbeau, Octave (1848–1917), cats. 30, 111

Moch, Fernand, cat. 122

Moderne Galerie (Heinrich Thannhauser, 1859–1934), cat. 147

Moeller Fine Arts, cat. 68

Molard, William (1862–1936), cats. 90, 91

Moltzau, Ragnar, cat. 53

Monet, Claude (1840–1926), cats. 25, 41; his heir, Michel Monet (1877–1966), cats. 25, 41

Monfreid, Daniel de (1856–1929), cats. 89, 93–100, 106a & b, 109

Montag, Charles or Carl (1880–1956), cats. 49, 113

Morozov, Ivan (1871–1921), cats. 43, 99, 131, 145, 153, 192

Mugrabi, José, cat. 141

Musée d'Art Moderne, Troyes, cat. **75**

Musée d'Art Moderne de la Ville de Paris, cats. **80, 82,** **138, 146, 191, 197**

Musée de la France d'Outre-Mer (later Musée National des Arts de l'Afrique et de l'Océanie), Paris, cats. 107, 110

Musée des Beaux-Arts, Lyon, cat. **143**

Musée des Beaux-Arts de la Ville de Paris (Petit Palais), cats. **11, 12b, 14c, 15b, 20b, 23, 33, 47, 67b, 71c,** 80, 146, **176, 178b, 188b(1–4), 202b**

Musée d'Orsay, Paris, cats. **1, 21b, 27, 30, 31, 42, 77, 86,** **89, 91, 92, 95, 107, 109, 110, 122, 127;** on deposit in the Département des Arts Graphiques, Musée du Louvre, cats. **166, 168, 170, 172**

Musée du Jeu de Paume, Paris, cats. 30, 42, 77, 86, 89, 91, 92, 95, 107, 110, 139

Musée du Louvre, Paris, cats. 1, 21b, 30, 31, 42, 77, 86, 89, 91, 92, 95, 107, 110, 139; Département des Arts Graphiques (fonds Orsay), *see under* Musée d'Orsay

Musée du Luxembourg, Paris, cat. 86

Musée National d'Art Moderne (Centre Georges Pompidou), Paris, cats. 1, 21b, **85,** 86, **139**

Musée National des Arts de l'Afrique et de l'Océanie, Paris. *See* Musée de la France d'Outre-Mer

Musée Picasso, Paris, cats. **50, 58–66, 133, 155, 161a,** **162a, 163, 175, 187**

Musée Rodin, Paris, cats. **126, 174**

Musées Nationaux Récupération, Paris, cat. 30

Musées Royaux des Beaux-Arts de Belgique, Brussels, cat. **87**

Museo de Arte Moderno, Barcelona, cat. 144

Museu de Arte de São Paulo, cat. **25**

Museum Boijmans Van Beuningen, Rotterdam, cat. **189**

Museum Folkwang, Essen (previously Hagen), cat. **118**

Museum of Fine Arts, Boston, cat. **96**

Museum of Modern Art, New York, cats. **5, 6, 12a, 13a,** **16, 67a,** 73, **84,** 135, 149, **156–160, 185, 186**

Museum of Modern Western Painting, Moscow, cats. 35, 43, 93, 99, 125, 131, 134, 145, 151, 153, 192

Museu Picasso, Barcelona, cat. **144**

Nasjonalgalleriets Venner, Oslo, cat. 53

National Gallery of Art, Washington, D.C., cats. **34, 38,** **76, 94**

National Gallery of Canada, Ottawa, cat. **54**

National Museum of Art, Architecture, and Design, Oslo, cats. **40, 53**

National Museum of Western Art, Tokyo, cat. **7**

Neumann, J. B., Galerie, cat. 89

Niarchos, Stavros S. (1909–1996), cat. 29

Nippon Television Network Corporation, Tokyo, cat. **177**

Nussbaumer, A., cat. 200

Ny Carlsberg Glyptotek, Copenhagen, cats. **100, 111;** Ny Carlsberg-Fondet, cat. 111

Oberlin, Ohio. *See* Allen Memorial Art Museum

O'Hana Gallery, cat. 136

Osthaus, Karl-Ernst (1874–1921), cat. 118; Karl-Ernst Osthaus–Museum, *see* Museum Folkwang

Pach, Walter (1883–1958) (*see also* Carroll Galleries), cats. 76, 78

Paley, William S. (1901–1990), cat. 135

Pearlman, Henry, and Mrs. Pearlman (Rose), cat. 121; Henry and Rose Pearlman Foundation, cat. **121**

Pellerin, Auguste (1852–1929), cats. 26–29, 39; heirs of, *see* Réne and Mme Lecomte; Jean-Victor Pellerin

Pellerin, Jean-Victor (1889–1970), cats. 27, 29; heirs of, cat. 27

Pellet, Gustave (1859–1919), cats. 58, 60–62, 64–66

Perls, Hugo (1886–1977), cat. 149

Perls, Mme Kaethe, cat. 76

Perls Galleries, cat. 79

Petiet, Henri M. (1894–1980), cats. 104a, 158, 165, 167, 173; heirs of, cat. 158

Petit Palais, Paris. *See* Musée des Beaux-Arts de la Ville de Paris

Pétridès, Paul (b. 1902), cat. 199

Phillips Collection, Washington, D.C., cat. **55**

Picasso, Pablo, cats. 50, 58–66, 133, 161a, 162a, 163a, 175, 187; heirs of, cats. 66, 161a, 162a, 163a

Pick, Grant J., cat. 21a

Pissarro, Camille (1830–1903), cat. 30

Plandiura, Lluís (1882–1956), cat. 144

Private collections, cats. **2, 4, 10, 22, 26, 28, 29, 30, 45,** **48,** 49, 68, **69,** 70, 91, **97, 102, 108, 117, 141, 152,** **164, 190,** 191, 200

Photograph Credits